DISCOVERING

The Humanities

THIRD EDITION

Henry M. Sayre

OREGON STATE UNIVERSITY

PEARSON

In memory of Norwell "Bud" Therien, who first envisioned this project, and for whose friendship I will always be grateful. I miss him.

Editor-in-Chief: Sarah Touborg Sponsoring Editor: Helen Ronan Editorial Assistant: Victoria Engros

Executive Marketing Manager: Wendy Albert Project Management Team Lead: Melissa Feimer Production Project Manager: Joe Scordato Program Manager: Barbara Marttine Cappuccio Senior Operations Supervisor: Mary Fischer Senior Operations Specialist: Diane Peirano

Cover Designer: Kathryn Foot

Senior Digital Media Director: David Alick Digital Media Project Manager: Rich Barnes Digital Imaging Specialist: Corin Skidds Art Management and Manuscript Development:

Laurence King Publishing, Ltd.

Full-Service Project Management: Lumina Datamatics, Inc.

Composition: Lumina Datamatics, Inc.
Printer/Binder: LSC Communications
Cover Printer: LSC Communications

Commissioning Editor: Kara Hattersley-Smith

Senior Editor: Melissa Danny

Picture Researchers: Julia Ruxton, Sarah Hopper

Text Permissions Editor: Nicholas Jewitt

Front cover image: Diego Velázquez, Las Meninas (The Maids of Honor). Detail. 1656. Oil on canvas, 10'¾" × 9'¾". Museo del Prado, Madrid, Spain/Bridgeman Images.

Back cover image: Las Meninas shown in full. © Photo Scala, Florence.

Copyright © 2016, 2013, 2010 by Pearson Education, Inc. or its affiliates. All Rights Reserved. Printed in the United States of America. This publication is protected by copyright, and permission should be obtained from the publisher prior to any prohibited reproduction, storage in a retrieval system, or transmission in any form or by any means, electronic, mechanical, photocopying, recording, or otherwise. For information regarding permissions, request forms and the appropriate contacts within the Pearson Education Global Rights & Permissions department, please visit www.pearsoned.com/permissions/.

Acknowledgements of third party content appear on pages C-1–C-3, which constitute an extension of this copyright page.

PEARSON, ALWAYS LEARNING, and MYARTSLAB are exclusive trademarks in the U.S. and/or other countries owned by Pearson Education, Inc. or its affiliates.

Unless otherwise indicated herein, any third-party trademarks that may appear in this work are the property of their respective owners and any references to third-party trademarks, logos or other trade dress are for demonstrative or descriptive purposes only. Such references are not intended to imply any sponsorship, endorsement, authorization, or promotion of Pearson's products by the owners of such marks, or any relationship between the owner and Pearson Education, Inc. or its affiliates, authors, licensees or distributors.

Library of Congress Cataloging-in-Publication Data

Sayre, Henry M.

Discovering the humanities / Henry M. Sayre, Oregon State University. — Third edition. pages cm

Includes bibliographical references and index.

ISBN 978-0-13-387770-0

1. Civilization—History. 2. Humanities—History. 3. Social change—History. I. Title. CB69.S288 2014

306—dc23

2014008986

Student Edition: ISBN-10: 0-13-387770-1 ISBN-13: 978-0-13-387770-0

Instructor's Resource Copy: ISBN-10: 0-13-387832-5 ISBN-13: 978-0-13-387832-5

à la carte ISBN-10: 0-13-387833-3 ISBN-13: 978-0-13-387833-2

CONTENTS

Preface ix

The Prehistoric Past and the Earliest Civilizations

THE RIVER CULTURES OF THE ANCIENT WORLD 1

The Beginnings of Culture 2

Agency and Ritual: Cave Art 3

Paleolithic Culture and Its Artifacts 4

The Rise of Agriculture 5

Neolithic Çatalhöyük 5

Neolithic Pottery Across Cultures 6

Neolithic Ceramic Figures 7

The Neolithic Megaliths of Northern Europe 8

Myth in Prehistoric Cultural Life 10

Myth in the Native American Cultures of the Southwest 11
Japan and the Role of Myth in the Shinto Religion 12

Mesopotamia: Power and Social Order in the Early Middle East 14

Sumerian Ur 16

Akkad 18

Babylon 19

Mesopotamian Literature and the *Epic of Gilgamesh* 20

The Hebrews 24

The Persian Empire 27

The Stability of Ancient Egypt: Flood and Sun 27

The Nile and Its Culture 28

Pictorial Formulas in Egyptian Art 31

The Old Kingdom 31

The New Kingdom and Its Moment of Change 34

READINGS

- 1.1 Zuni Emergence Tale, Talk Concerning the First Beginning 12
- 1.2 from the Law Code of Hammurabi (ca. 1760 BCE) 20
- 1.3a from the Epic of Gilgamesh, Tablet VI (late 2nd millennium BCE) 21
- 1.3b from the Epic of Gilgamesh, Tablet X (late 2nd millennium BCE) 22
- 1.3c from the Epic of Gilgamesh, Tablet XI (late 2nd millennium BCE) 23
- 1.4 from the Hebrew Bible (Deuteronomy 6:6-9) 25
- 1.5 "This It Is Said of Ptah," from Memphis, ca. 2300 BCE 30

FEATURES

CLOSER LOOK Reading the *Palette of Narmer* 32 **CONTINUITY & CHANGE** Egyptian and Greek Sculpture 37

The Greek World THE CLASSICAL TRADITION 39

Bronze Age Culture in the Aegean 40

The Cyclades 41

Minoan Culture in Crete 42

Mycenaean Culture on the Mainland 45

The Homeric Epics 47

The Rise of the Greek Polis 49

The Greek Gods 50

The Greek Architectural Tradition 50

Greek Sculpture and the Taste for Naturalism 53

Athenian Pottery 56

The Poetry of Sappho 58

The Rise of Democracy and the Threat of Persia 59

The Golden Age 60

The Architectural Program at the Acropolis 60

The Sculptural Program at the Parthenon 63

Philosophy and the Polis 64

The Theater of the People 67

The Hellenistic World 71

The Empire of Alexander the Great 71

Toward Hellenistic Art: Sculpture in the Late Classical Period 73

Aristotle: Observing the Natural World 74

Alexandria 75

Pergamon: Hellenistic Capital 76

READINGS

- 2.1 from Homer, Iliad, Book 24 (ca. 750 BCE) 48
- 2.2a Sappho, lyric poetry 58
- 2.2b Sappho, lyric poetry 58
- 2.3 Thucydides, *History of the Peloponnesian Wars*, Pericles' Funeral Speech (ca. 410 BCE) 60
- 2.4 Plutarch, Life of Pericles (75 cE) 60
- 2.5a Sophocles, Antigone 69
- 2.5b Sophocles, Antigone 69

FEATURES

CLOSER LOOK The Classical Orders 54

CONTINUITY & CHANGE Rome and Its Hellenistic Heritage 81

3 Empire

URBAN LIFE AND IMPERIAL MAJESTY IN ROME, CHINA, AND INDIA 83

Rome 85

Republican Rome 86

Imperial Rome 89

Literary Rome: Virgil, Horace, and Ovid 90

Augustus and the City of Marble 92

Pompeii 99

China 102

Early Chinese Culture 103 Imperial China 106

Ancient India 111

Hinduism and the Vedic Tradition 113 Buddhism: "The Path of Truth" 114

READINGS

- 3.1 Cicero, On Duty, 44 BCE 87
- 3.2 from Virgil, Georgics 90
- 3.3 from Letters of Pliny the Younger 99
- 3.4 from The Book of Songs 105
- 3.5 from The Tao Te Ching (or Dao De Jing) 105
- 3.6 Liu Xijun, "Lament" 107
- 3.7 Fu Xuan, "To Be a Woman" 107

FEATURES

CLOSER LOOK The Tomb of Qin Shihuangdi 10

CONTINUITY & CHANGE Christian Rome 116

iii

The Flowering of Religion FAITH AND THE POWER OF BELIEF IN THE EARLY FIRST MILLENNIUM 119

Developments in Judaic Culture 121

The Rise of Christianity 122

The Evangelists 123

Symbols and Iconography in Christian Thinking and Art 124

Christian Rome 125

The Byzantine Empire and its Church 130

Justinian's Empire 130

The Rise and Spread of Islam 135

The Qur'an 135

The Hadith 138

The Hijra and Muslim Practice 138

The Spread of Islam 139

The Spread of Buddhism 142

READINGS

- 4.1 from the Bible, Romans 5:1-11 123
- 4.2 The Nicene Creed 126
- 4.3 from Augustine, The City of God 130
- 4.4 from the Qur'an, Surah 76 135
- 4.5 from the hadith 138

FEATURES

CLOSER LOOK The Bismillah and the Art of Calligraphy 136 **CONTINUITY & CHANGE** Byzantine Influences 145

Fiefdom and Monastery, **Pilgrimage and Crusade**

THE EARLY MEDIEVAL WORLD IN EUROPE 147

Anglo-Saxon Artistic Style and Culture 149

Beowulf, the Oldest English Epic Poem 150 The Merging of Pagan and Christian Styles 150

Carolingian Culture 153

The Song of Roland: Feudal and Chivalric Values 153

Promoting Literacy 155

The Medieval Monastery 156

Capetian France and the Norman Conquest 159

Pilgrimage Churches and The Romanesque

Cluny and the Monastic Tradition 166

The Crusades 167

Eleanor of Aquitaine and the Art of Courtly Love 169

READINGS

- 5.1 Beowulf, trans. Burton Raffel 150
- 5.2 Song of Roland 154
- 5.3 From Hildegard of Bingen, Scivias 157
- 5.4 From Pope Innocent III, On the Misery of the Human Condition 166
- 5.5 Comtessa de Dia's "Cruel Are the Pains I've Suffered." from Lark in the Morning: The Verses of the Troubadours 170
- 5.6 from Chrétien de Troyes, Lancelot 171

FEATURES

CLOSER LOOK The Bayeux Tapestry 160

CONTINUITY & CHANGE Toward a New Urban Style: The Gothic 173

6 The Gothic and the Rebirth of Naturalism

CIVIC AND RELIGIOUS LIFE IN AN AGE OF INQUIRY 175

Saint-Denis and the Gothic Cathedral 176

Stained Glass 178

Gothic Architecture 179

Gothic Sculpture 180

Music in the Gothic Cathedral: Growing Complexity 183

The Rise of the University 184

Thomas Aguinas and Scholasticism 185

The Radiant Style and the Court of Louis IX 186

The Gothic Style in the French Ducal Courts 187

The Miniature Tradition 188

Civic and Religious Life in Siena and Florence 190

Siena and Florence: Commune and Republic 191

Painting: A Growing Naturalism 192

The Spread of Vernacular Literature in Europe

Dante's Divine Comedy 198

The Black Death and Its Aftermath 199

READINGS

- 6.1 Thomas Aquinas, from Summa Theologica 186
- 6.2 from Dante, Inferno, Canto 34 198
- 6.3 from Boccaccio, Decameron 200
- 6.4 Petrarch, Sonnet 134 202
- 6.5 from Chaucer, The Canterbury Tales, Prologue 202
- 6.6 from Christine de Pizan, Book of The City of Ladies 204
- 6.7 from Christine de Pizan, Tale of Joan of Arc 205

FEATURES

CLOSER LOOK Giotto's Scrovegni Chapel 196 CONTINUITY & CHANGE The Dance of Death 207

The Renaissance

FLORENCE, ROME, AND VENICE 209

The State as a Work of Art: Florence and the Medici

The Gates of Paradise 212

Florence Cathedral 213

Scientific Perspective and Naturalistic Representation 214

The Medici Family and Humanism 217

Lorenzo the Magnificent: "... I find a relaxation in learning." 218

Beyond Florence: The Ducal Courts and the Arts 221

The Montefeltro Court in Urbino 221

Papal Patronage and the High Renaissance in Rome 225

Bramante and the New Saint Peter's Basilica 226

Michelangelo and the Sistine Chapel 227

Raphael and the Stanza della Segnatura 231

The Medici Popes 232

Josquin des Prez and the Sistine Chapel Choir 233

Niccolò Machiavelli and the Perfect Prince 236

The High Renaissance in Venice 237

Venetian Architecture 238

Masters of the Venetian High Renaissance: Giorgione and Titian 239

Women in Italian Humanist Society 242

The Education of Women 242 Women and Family Life 242

Laura Cereta and Lucretia Marinella: Renaissance Feminists 243

Veronica Franco: Literary Courtesan 244

Music of The Venetian High Renaissance 245

READINGS

- 7.1 "A Song for Bacchus," 1490 220
- 7.2 from Pico della Mirandola, Oration on the Dignity of Man (1486) 221
- 7.3 from Baldassare Castiglione, The Courtier, Book 1 (1513-18; published 1528) 222
- 7.4 from Giorgio Vasari, "Life of Leonardo," in Lives of the Most Excellent Painters ... (1550, 1568) 224
- 7.5a from Niccolò Machiavelli, The Prince, Chapter 14 (1513) 236
- 7.5b from Niccolò Machiavelli, The Prince, Chapter 5 (1513) 236
- 7.6 from Baldassare Castiglione. The Courtier. Book 3 (1513–18: published 1528) 243
- 7.7 from Laura Cereta. Defense of Liberal Instruction for Women (1488) 243
- 7.8 from Lucretia Marinella, The Nobility and Excellence of Women ... (1600) 244
- 7.9 from Veronica Franco, Terze rime, Capitolo 13 244

FEATURES

CLOSER LOOK Raphael's School of Athens 234 **CONTINUITY & CHANGE** Palladio and His Influence 247

Renaissance and **Reformation in the North**

BETWEEN WEALTH AND WANT

Art, Commerce, and Merchant Patronage 250

Robert Campin in Tournai

Jan van Eyck in Ghent and Bruges 253

Hieronymus Bosch in 's-Hertogenbosch 255

The German Tradition 258

Humanism and Reformation in the North 261

The Satire of Desiderius Erasmus 262 Martin Luther's Reformation 263

The Spread of the Reformation 264

The Printing Press: A Force for Ideas and Art 267

Music in Print 268

Writing for Print and Play: The New Humanists 268

The English Portrait Tradition 272

READINGS

- 8.1 from Desiderius Erasmus, Julius Excluded from Heaven (1513) 262
- 8.2a from Desiderius Erasmus, In Praise of Folly (1509) 262
- 8.2b from Desiderius Erasmus, In Praise of Folly (1509) 263
- 8.3 from Martin Luther, Preface to Works (1545) 263
- 8.4 from Thomas More, Utopia, Book 2 (1516) 268
- 8.5a from William Shakespeare, Hamlet, Act II, Scene 2 (1623) 270
- 8.5b from William Shakespeare, Hamlet, Act III, Scene 1 (1623) 271

FEATURES

CLOSER LOOK Bosch's Garden of Earthly Delights 256 CONTINUITY & CHANGE The Catholic Church Strikes Back 275

Encounter and Confrontation THE IMPACT OF INCREASING GLOBAL

INTERACTION 277 The Spanish in the Americas 280

The Americas before Contact 280 The Spanish in Peru 283

West African Culture and the Portuguese 284

The Indigenous Cultures of West Africa 285 Portugal and the Slave Trade 288

India and Europe: Cross-Cultural Connections 291

Islamic India: The Taste for Western Art 291 Mogul Architecture: The Taj Mahal 293

The Chinese Empire: Isolation and Trade

The Tang Dynasty in Chang'an, "The City of Enduring Peace" (618-907 CE) 294

The Song Dynasty and Hangzhou, "The City of Heaven" (960-1279 CE) 295

The Yuan Dynasty (1279-1368) 296

The Ming Dynasty (1368-1644) 296

Painting and Poetry: Competing Schools 300

Luxury Arts 301

Japan: Court Patronage and Spiritual Practice 302

The Heian Period: Courtly Refinement 302

The Kamakura Period (ca. 1185–1392): Samurai and Shogunate

The Muromachi Period (1392–1573): Cultural Patronage 305

The Azuchi-Momoyama Period (1573–1615): Foreign Influences

The Closing of Japan 309

READINGS

- 9.1 from Bernal Díaz, True History of The Conquest of New Spain (ca. 1568; published 1632) 280
- 9.2 from Jacob Eghaverba, A Short History of Benin 286
- 9.3 Shah Jahan, inscription on the Taj Mahal, ca. 1658 294
- 9.4 Poems by Li Bai and Du Fu 295
- 9.5 from Marco Polo, Travels 295
- 9.6 from Murasaki Shikibu, Diaries 303
- 9.7 Ki no Tomonori, "This Perfectly Still" 303

FEATURES

CLOSER LOOK Guo Xi's Early Spring 298

CONTINUITY & CHANGE The Influence of Zen Buddhism 311

The Counter-Reformation and the Baroque

EMOTION, INQUIRY, AND ABSOLUTE POWER 313

The Early Counter-Reformation and Mannerism

The Council of Trent and Catholic Reform of the Arts 316

The Rise of Mannerism 317

Cervantes and the Picaresque Tradition 324

The Baroque in Italy 324

Baroque Sculpture: Bernini 325

The Drama of Painting: Caravaggio and the Caravaggisti

Venice and Baroque Music 331

Claudio Monteverdi and the Birth of Opera 332

Antonio Vivaldi and the Concerto 332

The Secular Baroque in The North 333

New Imagery: Still Life, Landscape, and Genre Painting 333 Rembrandt van Rijn and the Drama of Light 336 Baroque Music in the North 340

Absolutism and the Baroque Court 342

The Court at Versailles 343
The Court Arts of England and Spain 348

READINGS

- 10.1 from Pietro Aretino, Letter To Michelangelo (1545) 319
- 10.2 from The Trial of Veronese (1573) 322
- 10.3 from Ignatius Loyola, Spiritual Exercises, Fifth Exercise (1548) 324
- 10.4 from Teresa of Ávila, "Visions," Chapter 29 of The Life of Teresa of Ávila (before 1567) 325
- 10.5 John Donne, "Batter My Heart" (1618) 329
- 10.6 Molière, Tartuffe, Act V (1664) 347

FEATURES

CLOSER LOOK Rembrandt's *The Anatomy Lesson of Dr. Tulp* 338
CONTINUITY & CHANGE Excess and Restraint 351

Enlightenment and Rococo

THE CLAIMS OF REASON AND THE EXCESSES OF PRIVILEGE 353

The English Enlightenment 354

The New Rationalism and the Scientific Revolution 355

The Industrial Revolution 358

Absolutism versus Liberalism: Thomas Hobbes and John Locke 359

John Milton's Paradise Lost 360

Satire: Enlightenment Wit 361

The English Garden 364

Literacy and the New Print Culture 365

The Enlightenment in France 367

The Rococo 368

Art Criticism and Theory 372

The Philosophes 374

Cross-Cultural Contact 376

The South Pacific 376

China and Europe 377

READINGS

- 11.1 from John Dryden, "Annus Mirabilis" (1667) 355
- 11.2 from René Descartes, Meditations (1641) 356
- 11.3 from John Locke's Essay on Human Understanding (1690) 360
- 11.4a from John Milton, Paradise Lost, Book 5 (1667) 361
- 11.4b from John Milton, Paradise Lost, Book 5 (1667) 38
- 11.5 from Jonathan Swift, A Modest Proposal (1729) 362
- 11.6 from Jonathan Swift, Gulliver's Travels, Book 4, Chapter 6 (1726) 362
- 11.7 from Alexander Pope, An Essay on Man (1732–34) 363
- 11.8 from Jane Austen, Pride And Prejudice, Chapter 1 (1813) 366
- **11.9** from "Law of Nature or Natural Law," Diderot's *Encyclopédie* (1751–72) 374
- 11.10 from Jean-Jacques Rousseau, The Social Contract, Book 1, Chapter 4 ("Slavery") (1762) 375
- 11.11 from Jean-Jacques Rousseau, Discourse On The Origin Of Inequality

 Among Men (1755) 375

FEATURES

CLOSER LOOK Watteau's *The Signboard of Gersaint* 370 **CONTINUITY & CHANGE** The End of the Rococo 381

The Age of Revolution FROM NEOCLASSICISM TO ROMANTICISM 383

The American and French Revolutions 384

The Declaration of Independence 384

The Declaration of the Rights of Man and Citizen 386

The Neoclassical Spirit 388

Jacques-Louis David and the Neoclassical Style 388 Napoleon's Neoclassical Tastes 390

Neoclassicism in America 392

The Issue of Slavery 393

The Romantic Imagination 395

The Romantic Poem 396

The Romantic Landscape 397

The Romantic Hero 402

From Classical to Romantic Music 406

The Classical Tradition 406

Beethoven: From Classicism to Romanticism 407

Romantic Music after Beethoven 408

READINGS

- 12.1 from The Declaration of Independence (1776) 385
- 12.2 from The Declaration of the Rights of Man and Citizen (1789) 387
- 12.3 from Olaudah Equiano, The Interesting Narrative of the Life of Olaudah Equiano, or Gustavus Vassa the African (1789) 393
- 12.4 from William Wordsworth, "Tintern Abbey" (1798) 396
- 12.5 from George Gordon, Lord Byron, "Prometheus" (1816) 403
- 12.6 from Johann Wolfgang von Goethe, Faust, Part 1 (1808) 404
- 12.7 from Ludwig van Beethoven, Heiligenstadt Testament (1802) 408

FEATURES

CLOSER LOOK The Sublime, the Beautiful, and the Picturesque 400 **CONTINUITY & CHANGE** From Romanticism to Realism 411

The Working Class and the Bourgeoisie

THE CONDITIONS OF MODERN LIFE 413

The New Realism 417

Marxism 417

Literary Realism 417

Realist Art: The Worker as Subject 419

Representing Slavery and the Civil War 421

Photography: Realism's Pencil of Light 422

Principle of Madamit Paris in the 19

In Pursuit of Modernity: Paris in the 1850s

and 1860s 423

Charles Baudelaire and the Poetry of Modern Life 424 Édouard Manet: The Painter of Modern Life 424 Nationalism and the Politics of Opera 426

Impressionist Paris 428

Monet's *Plein-Air* Vision 429
Morisot and Pissarro: The Effects of Paint 430

Renoir, Degas, Cassatt, and the Parisian Crowd 431

The American Self 433

The Romantic Song of the American Self: Landscape and Experience 436

The Challenge To Cultural Identity 439

The Fate of the Native Americans 439 The British in China and India 440 The Rise and Fall of Egypt 441 The Opening of Japan 441 Africa and Empire 442

READINGS

- 13.1 from Dickens, Sketches By Boz (1836) 418
- 13.2 from Flaubert, Madame Bovary (1856) 418
- 13.3 from Narrative of the Life of Frederick Douglass (1845) 419
- 13.4 Charles Baudelaire, "Carrion," in Les Fleurs du mal (1857) (translation by Richard Howard) 424
- 13.5 from Charles Baudelaire, "The Painter of Modern Life" (1863) 425
- 13.6 from Ralph Waldo Emerson, Nature, Chapter 1 (1836) 438
- 13.7 from Henry David Thoreau, Walden, or Life in the Woods, Chapter 2 (1854) 438
- 13.8 from Walt Whitman, "Crossing Brooklyn Ferry" (1856) 438
- 13.9 from Walt Whitman, "Song of Myself," In Leaves of Grass (1867) 439
- 13.10 from Joseph Conrad, Heart of Darkness (1899) 443

FEATURES

CLOSER LOOK Renoir's Luncheon of the Boating Party 434 CONTINUITY & CHANGE Toward a New Century 445

The Modernist World

THE ARTS IN AN AGE OF GLOBAL CONFRONTATION 447

The Rise of Modernism in the Arts 448

Post-Impressionist Painting 448

Pablo Picasso's Paris: At the Heart of the Modern 453

The Invention of Cubism: Braque's Partnership with Picasso 455

Futurism: The Cult of Speed 457

A New Color: Matisse and the Expressionists 458

Modernist Music and Dance 459

Early Twentieth-Century Literature 461

The Great War and Its Aftermath 462

Trench Warfare and the Literary Imagination 462

Escape from Despair: Dada 464

The Harlem Renaissance 467

The Blues and Jazz 468

Russia: Art and Revolution 470

Freud and the Workings of the Mind 474

The Dreamwork of Surrealist Painting 474

The Stream-of Consciousness Novel 477

READINGS

- 14.1 from Gertrude Stein, The Autobiography of Alice B. Toklas (1932) 453
- 14.2 from Guillaume Apollinaire, "Lundi, Rue Christine" (1913) 461
- 14.3 Ezra Pound, "In a Station of the Metro" (1913) 461
- 14.4 William Carlos Williams, "The Red Wheelbarrow," From Spring And All (1923) 462
- 14.5 Wilfred Owen, "Dulce et Decorum est" (1918)
- 14.6a from T. S. Eliot, The Waste Land (1921) 463
- 14.6b from T. S. Eliot, The Waste Land (1921) 463
- 14.6c from T. S. Eliot, The Waste Land (1921) 464
- 14.6d from T. S. Eliot, The Waste Land (1921) 464
- 14.7 Tristan Tzara, "Dada Manifesto 1918" (1918) 464
- 14.8 from Hugo Ball, "Gadji beri bimba" (1916) 465

- 14.9 Alain Locke, The New Negro (1925) 467
- 14.10 from Langston Hughes, "Jazz Band In A Parisian Cabaret" (1925) 468
- 14.11 from James Joyce, *Ulysses* (1922) 478
- 14.12 from Marcel Proust, Swann's Way (1913) 479

FEATURES

CLOSER LOOK Eisenstein's The Battleship Potemkin, "Odessa Steps Sequence" 472

CONTINUITY & CHANGE Guernica and the Specter of War 481

Decades of Change

THE PLURAL SELF IN A GLOBAL CULTURE

Europe After the War: The Existential Quest 485

The Philosophy of Sartre: Existentialism 485

The Theater of the Absurd 486

America After the War: Triumph and Doubt 486

Action Painting: Pollock and de Kooning 486

Women Abstract Expressionists 488

The Beat Generation 489

Cage and the Aesthetics of Chance 490

Architecture in the 1950s 492

Pop Art 493

The Winds of Change

Black Identity 497

The Vietnam War: Rebellion and the Arts 501

Kurt Vonnegut's Slaughterhouse-Five 501

Artists Against the War 501

The Feminist Movement 504

The Postmodern Era 506

Pluralism and Diversity in Postmodern Painting 507 Pluralism and Diversity in Postmodern Literature 509

Cross-Fertilization in the Visual Arts 510

A Multiplicity of Media: New Technology 513

READINGS

- 15.1 from Jean-Paul Sartre, No Exit (1944) 485
- 15.2a from Samuel Beckett, Waiting for Godot, Act I (1953) 486
- 15.2b from Samuel Beckett, Waiting for Godot, Act II (1953)
- 15.3 from Allen Ginsberg, "Howl" (1956) 490
- 15.4a from Ralph Ellison, Invisible Man (1952) 498
- 15.4b from Ralph Ellison, Invisible Man (1952) 498
- 15.5 Amiri Baraka, "Ka'ba" (1969) 500
- 15.6 from Gil Scott-Heron, "The Revolution Will Not Be Televised" (1970) 500
- 15.7 from Kurt Vonnegut, Slaughterhouse-Five (1969) 501
- 15.8 Anne Sexton, "Her Kind" (1960) 504
- 15.9 from Jorge Luis Borges, "The Analytical Language of John Wilkins," in Other Inquisitions 1937-1952, trans. Ruth L. C. Simms (1964) 509
- 15.10 Jorge Luis Borges, "Borges and I" (1967) Translated by J. E. I. 510
- 15.11 Aurora Levins Morales, "Child of the Americas" (1986) 510

FEATURES

CLOSER LOOK Basquiat's Charles the First 502

CONTINUITY & CHANGE The Environment and the Humanist Tradition 519

Glossarv G-1

Photo and Text Credits C-1

Index I-1

SEE CONTEXT AND MAKE CONNECTIONS...

DEAR READER,

It has been fifteen years since I first sat down to write this book, and now, with the publication of this third edition, I'd like to take the opportunity to reflect a moment on this book and the value of the humanities in general.

The great question facing the humanities fifteen years ago was simple and direct: Do we or do we not include the cultures of the world, beyond the West, in the text? Many of us teaching the course felt unequipped to take on the arts and cultures of Asia, Africa, and Central and South America. Others felt that there was already too much to cover in simply addressing the Western world. But as work on the book proceeded, it became evident to me that taking a global perspective was not only important but essential to the humanistic enterprise in general.

And what, you might well ask, is the humanistic enterprise in the first place? At the most superficial level, a humanities course is designed to help you identify the significant works of art,

architecture, music, theater, philosophy, and literature of distinct cultures and times, and to recognize how these different expressions of the human spirit respond to and reflect their historical contexts. More broadly, you should arrive at some understanding of the creative process and how what we-and others-have made and continue to value reflects what we all think it means to be human. But in studying other cultures-entering into what the British-born, Ghanaian-American philosopher and novelist Kwame Anthony Appiah has described as a "conversation between people from different ways of life"—we learn even more. We turn to other cultures because to empathize with others, to willingly engage in discourse with ideas strange to ourselves, is perhaps the fundamental goal of the humanities. The humanities are, above all, disciplines of openness, inclusion, and respectful interaction. What we see reflected in other cultures is usually something of ourselves, the objects of beauty that delight us, the weapons and the wars that threaten us, the melodies and harmonies that soothe us, the sometimes troubling but often penetrating thoughts that we encounter in the ether of our increasingly digital globe. Through the humanities we learn to seek common ground.

ABOUT THE AUTHOR

Henry M. Sayre is Distinguished Professor of Art History at Oregon State University—Cascades Campus in Bend, Oregon. He earned his Ph.D. in American Literature from the University of Washington. He is producer and creator of the 10-part television series A World of Art: Works in Progress, which aired on PBS in the fall of 1997; and author of seven books, including A World of Art; The Visual Text of William Carlos Williams; The Object of Performance: The American Avant-Garde since 1970; and an art history book for children, Cave Paintings to Picasso.

ACROSS THE HUMANITIES

WHAT'S NEW

Discovering the Humanities helps students see context and make connections across the humanities by tying together the entire cultural experience through a narrative storytelling approach. Written around Henry Sayre's belief that students learn best by remembering stories rather than memorizing facts, it captures the voices that have shaped and influenced human thinking and creativity throughout our history.

For this new edition, we've created an extraordinary new learning architecture: REVEL. Every feature that students formerly accessed through MyArtsLab is now embedded in this new cross-platform environment—music, architectural panoramas, Closer Looks, studio technique videos, self-tests, and so on. You can zoom in on a piece of art, switch on the chapter audio, and listen to the text being read to you while you look at the image. You can begin your day at home, working with a chapter on your laptop, get on the bus, and continue working on your iphone, arrive at school, and open the chapter on your ipad. REVEL is as fully mobile as you are, and you can use it on any device, anywhere, and anytime.

We firmly believe that this new learning architecture will help students engage even more meaningfully in the critical thinking process, helping them to understand how cultures influence one another, how ideas are exchanged and evolve over time, and how this collective process has led us to where we stand today. With several new features, this third edition helps students to understand context and make connections across time, place, and culture.

To prepare the third edition, we partnered with our current users to hear what was successful and what needed to be improved. The feedback we received through focus groups, online surveys, and reviews helped shape and inform this new edition. For instance, many users felt that more literature needed to be included in the book, and we have tried to accommodate that desire by adding discussion of Chaucer, Shakespeare, Alexander Pope, and many modern authors. Where some felt that our coverage fell short—on Hellenic Greece, Mannerism and Postmodernism, for instance—we have extended our discussions. Here are some examples of these changes:

- 1. Chapter 1 introduces the new research at Çatalhöyük.
- 2. Chapter 2 expands the coverage of Hellenic sculpture, including a third image of the Pergamon frieze and the second sculpture from the "Vanquished Gauls" grouping.
- 3. Chapter 6 has significant new coverage of the Limbourg brothers, focusing on January and February from Les Très Riches Heures, and an extended discussion of Chaucer's Canterbury Tales has been added, including a Reading

- from the Prologue, the first instance of an effort to include much more literature in this edition.
- 4. Chapter 7 expands on the coverage of women in Italian humanist society by incorporating Paola Tinagli's arguments in her book Women in Italian Renaissance Art: Gender, Representation, Identity.
- Chapter 8 now includes a much fuller discussion of Shakespeare, including the "O, what a rogue and peasant slave am I" speech from Hamlet Act II, Scene 2, and the "To be, or not to be" soliloguy from Act III, Scene 1.
- 6. Chapter 9 includes additional material on African ritual practice, including two new images.
- Chapter 10 further clarifies Mannerism with a new introduction and the addition of Arcimboldo's Summer, Michelangelo's Pietà, and Parmigianino's The Madonna with the Long Neck.
- 8. Chapter 11 now includes an extended discussion of Alexander Pope's An Essay on Man, and a new section on the English Garden including Pope's Villa at Twickenham.
- 9. Chapter 14 now includes a long section on early twentieth-century literature, including works by Apollinaire, Pound, and Williams. Three long excerpts from The Waste Land have been added to the section on The Great War and Its Aftermath. Finally a new section on The Stream-of-Consciousness Novel has been added, including a long excerpt from the Molly Bloom soliloguy at the end of *Ulysses* and the madeleine moment from Proust's Swann's Way.
- 10. In Chapter 15, the concluding section on The Postmodern Era has been expanded from 3 to 12 pages including a discussion of Borges (and his story "Borges and I" in full), paintings by Gerhard Richter, Pat Steir, and David P. Bradley, and video works by Bill Viola, Pipilotti Rist, Isaac Julien, Phil Collins, and Janine Antoni.

These changes reflect what we have learned about how humanities courses are constantly evolving. We have learned that more courses are being taught online and that instructors are exploring new ways to help their students engage with course material. An edition ago, we developed MyArtsLab with these needs in mind. Now, REVEL moves us in an even more interactive and compelling direction. With powerful learning tools integrated into the book, the textbook experience is now a seamless environment in which all of these tools are available at your fingertips.

All of these changes can be seen through the new, expanded, or improved features shown here.

SEE CONTEXT AND MAKE CONNECTIONS...

NFWI

CONTINUING PRESENCE OF THE PAST

This new feature helps students to understand how the arts of the past remain relevant today. Designed to underscore the book's emphasis on continuity and change, the Continuing Presence of the Past in each chapter, identified with a special icon, connects an artwork from that period to a contemporary artwork in a dynamic digital feature found in REVEL as well as in MyArtsLab.

For example, in Chapter 3, Continuing Presence of the Past focuses on Cai Guo-Qiang's Project to Extend the Great Wall of China by 10,000 Meters: Project for Extraterrestrials, No. 10 in which the artist detonated a series of explosions from the western end of the Great Wall that slithered in a red line on the horizon to form an ephemeral extension of the Great Wall itself. Gunpowder, originally a force for destruction, had now become an act of creation.

LEARNING OBJECTIVES AND THINKING BACK QUESTIONS

Learning Objectives and Thinking Back questions in each chapter focus on learning objectives and reflect the larger learning objectives of not only Discovering the Humanities but also national course outcomes. In addition, the Thinking Back features pose critical-thinking questions as well as reviewing the material covered in the chapter.

CLOSER LOOK

These highly visual features offer an in-depth look at a particular work from one of the disciplines of the humanities. The annotated discussions give students a personal tour of the work—with informative captions and labels—to help students understand its meaning. Critical-thinking questions, Something to Think About, prompt students to make connections and further apply this detailed knowledge of the work.

CONTINUITY & CHANGE ESSAYS

These full-page essays at the end of each chapter illustrate the influence of one cultural period upon another and show cultural changes over time. _

PRIMARY SOURCE EXCERPTS

Each chapter of Discovering the Humanities includes primary source readings in the form of brief excerpts from important works included within the body of the text.

CONTINUITY & CHANGE ICONS

These in-text references provide a window into the past. The eye-catching icons enable students to refer to material in other chapters that is relevant to the topic at hand.

THINKING BACK

CONTINUITY CHANGE

Egyptian and Greek Sculpture

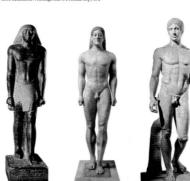

PEARSON CHOICES AND RESOURCES

GIVE YOUR STUDENTS CHOICES

Pearson humanities titles are available in the following formats to give your students more choices—and more ways to save.

Explore REVEL—dynamic content matched to the way today's students read, think, and learn.

Ideal for Sayre's approach to the humanities, REVEL includes

- spoken audio,
- pan/zoom and scale markers for nearly every image,
- 360-degree architectural panoramas and simulations of major monuments,
- media interactives and videos, including "students on site" videos shot and narrated by proficient student learners,
- quizzing that allows students to check their understanding at regular intervals.

Fully mobile, REVEL enables students to interact with course material on the devices they use, anywhere and anytime.

REVEL's assignability and tracking tools help educators

- ensure that students are completing their reading and understanding core concepts
- establish a clear, detailed schedule that helps students stay
- monitor both class assignment completion and individual student achievement

Build your own Pearson Custom course material.

For enrollments of at least 25, the Pearson Custom Library allows you to create your own textbook by

- combining chapters from best-selling Pearson textbooks in the sequence you want
- adding your own content, such as a guide to a local art museum, a map of monuments in your area, your syllabus, or a study guide you've created.

A Pearson Custom Library book is priced according to the number of chapters and may even save your students money. To begin building your custom text, visit www.pearsoncustomlibrary.com or contact your Pearson representative.

Explore additional cost-saving options.

The Books à la Carte edition offers a convenient, threehole-punched, loose-leaf version of the traditional text at a discounted price—allowing students to take only what they need to class. Books à la Carte editions are available both with and without access to MyArtsLab. Students save 35% over the list price of the traditional book. ISBN: 0-13-387833-3

The CourseSmart eTextbook offers the same content as the printed text in a convenient online format—with highlighting, online search, and printing capabilities. With a CourseSmart eText, students can search the text, make notes online, print out reading assignments that incorporate lecture notes, and bookmark important passages for later review. Students save 60% over the list price of the traditional book, www.coursesmart.com

ADDITIONAL RESOURCES

Support Students with MyArtsLab—a robust companion study environment

For those customers who prefer companion study resources, MyArtsLab offers:

- Writing Space, providing a single place to create and evaluate graded writing assignments, featuring tools for developing and assessing concept mastery and critical thinking
- media assignments such as Closer Look tours, panoromas, videos, and simulations
- study resources such as flashcards
- links to book specific test banks for guizzes

INSTRUCTOR RESOURCES

PowerPoints

Instructors who adopt the text may gain access to a robust collection of PowerPoints illustrated with images from the text, additional media, and class discussion prompts.

Instructor's Manual and Test Item File

This is an invaluable professional resource and reference for new and experienced faculty. Each chapter contains the following sections: Chapter Overview, Chapter Objectives, Key Terms, Lecture and Discussion Topics, Resources, and Writing Assignments and Projects. The test bank includes multiple-choice, short-answer, and essay questions. Available for download from www.pearsonhighereducation.com

MyTest

This flexible online test-generating software includes all questions found in the Test Item File. Instructors can quickly and easily create customized tests with MyTest at www.pearsonmytest.com

DEVELOPING DISCOVERING THE HUMANITIES

DISCOVERING THE HUMANITIES

is the result of an extensive development process involving the contributions of over 100 instructors and their students. We are grateful to all who participated in shaping the content, clarity, and design of this text. Manuscript reviewers and focus group participants for the third edition include:

Laura Stevens, Northwest Florida College Cheryl Boots, Boston University Margaret Browning, Hampton University Margaret Chaplin, Richland College Marilyn Edwards, Athens Technical College Billie Gateley, Jackson State Community College Lisette Gibson, Capital University Karen Guerin, Bossier Parish Community College Nat Hardy, Savannah State University Mike Vanden Heuvel, University of Wisconsin-Madison Ira Holmes, College of Central Florida Richard Kortum, East Tennessee State University Carolyn Lawrence, Chattahoochee Technical College Pamela Payne, Palm Beach Atlantic University Chad Redwing, Modesto Junior College Bonnie Smith, Gwinnett Technical College Gary Zaro, Paradise Valley Community College

We are also grateful to all who reviewed the earlier editions of this title:

FIRST EDITION:

Mindi Bailey, Collin County Community College Peggy Brown, Collin County Community College Terre Burton, Dixie College Elizabeth Cahaney, Elizabethtown Community and Technical College Rick Davis, Brigham Young University-Idaho Christa DiMaio Richie, Salem Community College Tiffany Engel, Tulsa Community College Gabrielle Fennmore, St. Thomas University Michael Fremont Redfield, Saddleback College Nat Hardy, Savannah State University Thelma Ithier-Sterling, Hostos Community College Stuart Kendall, Eastern Kentucky University Maria Miranda, Hostos Community College Nathan Poage, Houston Community College Aditi Samarth, Richland College Cheryl Smart, Pima Community College Lynn Spencer, Brevard Community College Alice Taylor, West Los Angeles College

Paul Van Heuklom, Lincoln Land Community College Leila Wells, Griffin Technical College Deborah J. Wickering, Aquinas College

SECOND EDITION:

Paul Beaudoin, Fitchburg State University
Terre Burton, Dixie College
Katherine Harrell, South Florida Community College
Scott Keeton, Chattahoochee Technical College
Sandi Landis, St. Johns River Community College
Aditi Samarth, Richland College
Frederick Smith, Florida Gateway College

In addition, while this revision was in development, I had the chance to learn from a special group of faculty who attended the Pearson Forum for Humanities:

Natalie Biscalia, Hillsborough Community College Joanne Bock, Palm Beach State College Elaine Dale, Santa Fe College Cristy Furr, St. Johns River State College Alyson Gill, Arkansas State University Steven Godby, Broward College: South Campus Eugene Greco, Miami Dade College: Kendall Campus Bobby Hom, Santa Fe College Dale Hoover, Edison State College Michael Hurlburt, Broward College: South Campus Theresa James, South Florida State College Sandi Landis, St. Johns River State College David Luther, Edison State College Brandon Montgomery, State College of Florida Pavel Murdzhev, Santa Fe Collge Christie Rinck, University of South Florida Susan Ross, St. Johns River State College Joseph Savage, St. Johns River State College Henry Sayre, Oregon State University-Cascades Campus Maira Spelleri, State College of Florida Greg Thompson, Hillsborough Community College-Brandon Krista Ubbels, St. Johns River State College Jason Whitmarsh, St. Johns River State College

ACKNOWLEDGMENTS

Discovering the Humanities is a brief version of the larger text, The Humanities: Culture, Continuity and Change, Third Edition, and is inevitably indebted to all who contributed to that revision. No project of this scope could ever come into being without the hard work and perseverance of many more people than its author. In fact, this author has been humbled by a team at Pearson that never wavered in their confidence in my ability to finish this enormous undertaking (or if they did, they had the good sense not to let me know); never hesitated to cajole, prod, and massage me to complete the project in something close to on time; and always gave me the freedom to explore new approaches to the materials at hand. At the down-and-dirty level, I am especially grateful to fact-checker Julia Moore; to Mary Ellen Wilson for the pronunciation guides; for the more specialized pronunciations offered by David Atwill (Chinese and Japanese), Jonathan Reynolds

(African), Nayla Muntasser (Greek and Latin), and Mark Watson (Native American); to Margaret Gorenstein for tracking down the readings; to Laurel Corona for her extraordinary help with Africa; to Arnold Bradford for help with critical thinking questions; and to Francelle Carapetyan for her remarkable photo research. The maps and some of the line art are the work of cartographer and artist Peter Bull, with Precision Graphic drafting a large portion of the line art for the book. I find both in every way extraordinary.

In fact, I couldn't be more pleased with the look of the book, which is the work of Pat Smythe, senior art director. Cory Skidds, senior imaging specialist, worked on image compositing and color accuracy of the artwork. The production of the book was coordinated by Melissa Feimer, managing editor, Barbara Cappuccio, program manager and Joe Scordato, project manager, who oversaw with good humor and patience the day-to-day, hour-to-hour crises that arose. And I want to thank Lindsay Bethoney and the staff at

Lumina Datamatics for working so hard to make the book turn out the way I envisioned it.

The marketing and editorial teams at Pearson are beyond compare. On the marketing side, Jonathan Cottrell, vice president of marketing, and Wendy Albert, executive marketing manager, helped us all to understand just what students want and need. On the editorial side, my thanks to Sarah Touborg, editor-in-chief; Roth Wilkofsky, publisher; Helen Ronan, senior editor; my friend, the late Bud Therien, special projects manager; and Christopher Fegan, editorial assistant. The combined human hours that this group has put into this project are staggering. This book was Bud's idea in the first place, and I know that he would be pleased to see how the project is continuing to flourish; Sarah has supported me every step of the way in making it as good, or even better, than I envisioned. I need to thank, especially, the extraordinary team that has developed the extraordinary new learning architecture that is REVEL. REVEL takes the entire, innovative set of learning tools that was introduced in MyArtsLab and makes it immediately and seamlessly available to the student. Over the course of the last decade, as technology has increasingly encroached on the book as we know it—with the explosion, that is, of the internet, digital media, and new forms of publishing, like the iPad and Kindle—I worried that books like Discovering the Humanities might one day lose their relevance. I envisioned it being supplanted by some as yet unforeseen technological wizardry that would transport my readers, like some machine in a science fiction novel, into a three- or four-dimensional learning space "beyond the book." Well, little did I know that Pearson Education was developing just such a space, one firmly embedded in the book, not beyond it.

Deserving of special mention is the editorial team at Laurence King Publishers in London, particularly Kara Hattersley-Smith, commissioning editor; Melissa Danny, senior editor; Simon Walsh, production; and Julia Ruxton, picture editor. A special thanks to the faculty at Collin County Community College and St. John's River College. Their feedback over the course of the book's development was tremendously valuable and helped shape many of the changes you now see.

Finally, I want to thank, with all my love, my beautiful wife, Sandy Brooke, who has supported this project in every way. She has continued to teach, paint, and write, while urging me on, listening to my struggles, humoring me when I didn't deserve it, and being a far better wife than I was a husband. In some ways, enduring what she did in the first edition must have been tougher in the second, since she knew what was coming from the outset. She was, is, and will continue to be, I trust, the source of my strength.

In memory of Norwell "Bud" Therien, who first envisioned this project, and for whose friendship I will always be grateful. I continue to miss his wisdom and good humor.

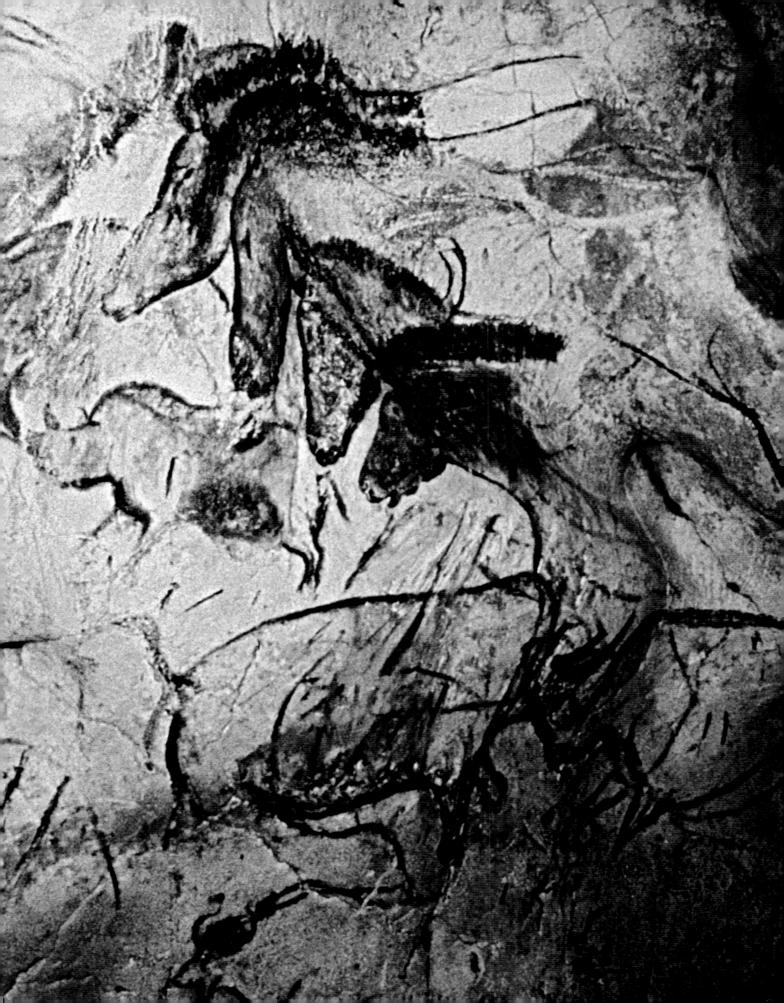

The Prehistoric Past and the Earliest Civilizations

The River Cultures of the Ancient World

LEARNING OBJECTIVES

1.1 Discuss the rise of culture and how developments in art and architecture reflect the growing sophistication of prehistoric cultures.

1.2 Describe the role of myth in prehistoric culture.

1.3 Distinguish among the ancient civilizations of Mesopotamia, and focus on how they differ from that of the Hebrews.

1.4 Account for the stability of Egyptian culture.

n a cold December afternoon in 1994, Jean-Marie Chauvet and two friends were exploring the caves in the steep cliffs along the Ardèche River gorge in southern France. After descending into a series of narrow passages, they entered a large chamber. There, beams from their headlamps lit up a group of drawings that would astonish the three explorers—and the world (Fig. 1.1).

Since the late nineteenth century, we have known that prehistoric peoples—peoples who lived before the time of writing and so of recorded history—drew on the walls of caves. Twenty-seven such caves had already been discovered in the cliffs along the 17 miles of the Ardèche gorge (Map 1.1). But the cave found by Chauvet and his friends transformed our thinking about prehistoric peoples. Where previously discovered cave paintings had appeared to modern eyes as childlike, this cave contained drawings comparable to those a contemporary artist might have done. We can only speculate that other comparable artworks were produced in prehistoric times but have not survived, perhaps because they were made of wood or other perishable materials. It is even possible that art may have been made earlier than 30,000 years ago, perhaps as people began to inhabit the Near East, between 90,000 and 100,000 years ago.

At first, during the Paleolithic era, or "Old Stone Age" (from the Greek *palaios*, "old," and *lithos*, "stone") the cultures of the world sustained themselves on game and wild plants. The cultures themselves were small, scattered, and nomadic, although evidence suggests some interaction among the

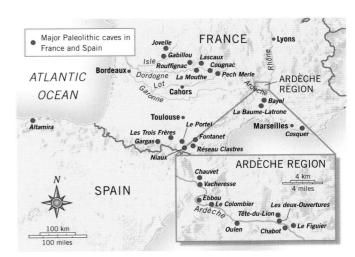

Map 1.1 Major Paleolithic Caves in France and Spain.

▼ Fig. 1.1 Cave painting with horses, Chauvet Cave, Vallon-Pont-d'Arc, Ardèche gorge, France. ca. 30,000 все. Ministère de la Culture et de la Communication. Direction Régionale des Affaires Culturelles de Rhône-Alpes. Service Régional de l'Archéologie. Paint on limestone, approx. height 6'. In the center of this wall are four horses, each behind the other in a startlingly realistic space. Below them, two rhinoceroses fight.

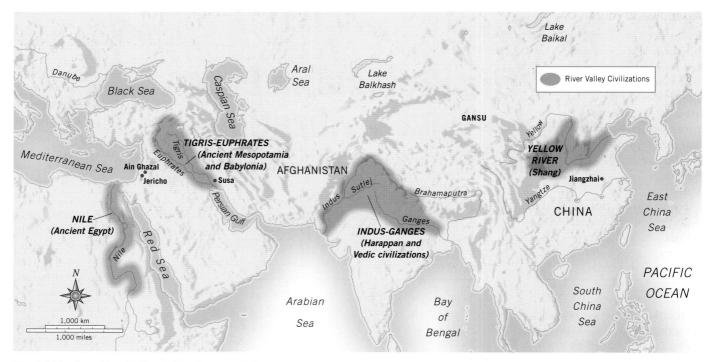

Map 1.2 The Great River Valley Civilizations, ca. 2000 BCE. Agriculture thrived in the great river valleys throughout the Neolithic era, but by the end of the period, urban life had developed there as well, and civilization as we know it had emerged.

various groups. As the ice covering the Northern Hemisphere began to recede, around 10,000 BCE, agriculture began to replace hunting and gathering, and with it, a nomadic lifestyle gave way to a more sedentary way of life. The consequences of this shift were enormous, and ushered in the Neolithic era, or "New Stone Age."

In the great river valleys of the Middle East and Asia (Map 1.2), distinct centers of people involved in a common pursuit began to form more and more sophisticated civilizations. (The rise of these civilizations in India and China is discussed in Chapter 3.) A civilization is a social, economic. and political entity distinguished by the ability to express itself through images and written language. Civilizations develop when the environment of a region can support a large and productive population. An increasing population requires increased production of food and other goods, not only to support itself, but also to trade for other commodities. Organizing this level of trade and production also requires an administrative elite to form and to establish priorities. The existence of such an elite is another characteristic of civilization. Finally, as the history of cultures around the world makes abundantly clear, one of the major ways that societies have acquired the goods they want and simultaneously organized themselves is by means of war.

We begin this book, then, with the first inklings of civilized cultures in prehistoric times, evidence of which survives in cave paintings and in small sculptures dating back more than 25,000 years. Before the invention of writing, sometime after 10,000 BCE, these cultures created myths and legends that explained their origins and relation to the world. Then,

beginning about 4000 BCE, across the ancient world, the science of metallurgy developed. As people learned to separate metals from their ores and then work or treat them to create objects, the stone and bone tools and weapons of the prehistoric world were replaced by metal ones, inaugurating the era archeologists have named the Bronze Age.

THE BEGINNINGS OF CULTURE

How do cultures arise, and how do art and architecture reflect their growing sophistication?

A culture encompasses the values and behaviors shared by a group of people, developed over time, and passed down from one generation to the next. Culture manifests itself in the laws, customs, ritual behavior, and artistic production common to the group. The cave paintings at Chauvet suggest that, as early as 30,000 years ago, the Ardèche gorge was a center of culture, a focal point of group living in which the values of a community find expression. There were others like it: In northern Spain, the first decorated cave was discovered in 1879 at Altamira. In the Dordogne region of southern France, to the west of the Ardèche, schoolchildren discovered the famous Lascaux Cave in 1940 when their dog disappeared down a hole. And in 1991, along the French Mediterranean coast, a diver discovered the entrance to the beautifully decorated Cosquer Cave below the waterline near Marseille.

Agency and Ritual: Cave Art

Ever since cave paintings were first discovered, scholars have been marveling at the skill of the people who produced them, but we have been equally fascinated by their very existence. Why were these paintings made? Most scholars believe that they possessed some sort of agency—that is, they were created to exert some power or authority over the world of those who came into contact with them. Until recently, it was generally accepted that such works were associated with the hunt. Perhaps the hunter, seeking game in times of scarcity, hoped to conjure it up by depicting it on cave walls. Or perhaps such drawings were magic charms meant to ensure a successful hunt. But at Chauvet, fully 60 percent of the animals painted on its walls were never, or rarely, hunted—such animals as lions, rhinoceroses, bears, panthers, and woolly mammoths. One drawing depicts two rhinoceroses fighting horn to horn beneath four horses that appear to be looking on (see Fig. 1.1).

What role, then, did these drawings play in the daily lives of the people who created them? The caves may have served as some sort of ritual space. A ritual is a rite or ceremony habitually practiced by a group, often in religious or quasireligious contexts. The caves, for instance, might be understood as gateways to the underworld and death, as symbols of the womb and birth, or as pathways to the world of dreams experienced in the dark of night, and rites connected with such passage might have been conducted in them. The general arrangement of the animals in the paintings by species or gender, often in distinct chambers of the caves, suggests to some that the paintings may have served as lunar calendars for predicting the seasonal migration of the animals. Whatever the case, surviving human footprints indicate that these

caves were ritual gathering places and in some way served the common good.

At Chauvet, the use of color suggests that the paintings served some sacred or symbolic function. For instance, almost all the paintings near the entrance to the cave are painted with natural red pigments derived from ores rich in iron oxide. Deeper inside the cave, in areas more difficult to reach, the vast majority of the animals are painted in black pigments derived from ores rich in manganese dioxide. This shift in color appears to be intentional, but we can only guess its meaning.

The skillfully drawn images at Chauvet raise even more important questions. The artists seem to have understood and practiced a kind of perspectival drawing—that is, they were able to convey a sense of three-dimensional space on a two-dimensional surface. In the painting reproduced at the beginning of this chapter, several horses appear to stand one behind the other (see Fig. 1.1). The head of the top horse overlaps a black line, as if peering over a branch or the back of another animal. In no other cave yet discovered do drawings show the use of shading, or modeling, so that the horses' heads seem to have volume and dimension. And yet these cave paintings, rendered more than 30,000 years ago, predate other cave paintings by at least 10,000 years, and some by as much as 20,000 years.

One of the few cave paintings that depict a human figure is found at Lascaux, in the Dordogne region of southwestern France. What appears to be a male wearing a bird's-head mask lies in front of a disemboweled bison (Fig. 1.2). Below him is a bird-headed spear thrower, a device that enabled hunters to throw a spear farther and with greater force. (Several examples of spear throwers have survived.) In the Lascaux painting, the hunter's spear has pierced the bison's

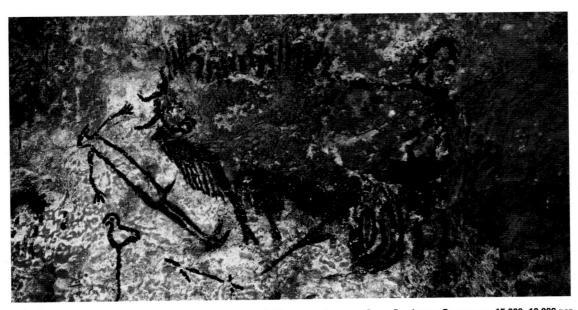

Fig. 1.2 Cave painting with bird-headed man, bison, and rhinoceros, Lascaux Cave, Dordogne, France. ca. 15,000—13,000 BCE. Paint on limestone, length approx. 9'. In 1963, Lascaux was closed to the public so that conservators could fight a fungus attacking the paintings. Most likely, the fungus was caused by carbon dioxide exhaled by visitors. An exact replica called Lascaux II was built and can be visited.

hindquarters, and a rhinoceros charges off to the left. We have no way of knowing whether this was an actual event or an imagined scene. One of the painting's most interesting and inexplicable features is the discrepancy between the relatively naturalistic representation of the animals and the highly stylized, almost abstract realization of the human figure. Was the sticklike man added later by a different, less talented artist? Or does this image suggest that man and beast are different orders of being?

Before the discovery of Chauvet, historians divided the history of cave painting into a series of successive styles, each progressively more realistic. But Chauvet's paintings, by far the oldest known, are also the most advanced in their realism, suggesting the artist's conscious quest for visual naturalism, that is, for representations that imitate the actual appearance of the animals. Not only were both red and black animals outlined, but their shapes were also modeled by spreading paint, either with the hand or with a tool, in gradual gradations of color. Such modeling is extremely rare or unknown elsewhere. In addition, the artists further defined many of the animals' contours by scraping the wall behind so that the beasts seem to stand out against a deeper white ground. Three handprints in the cave were evidently made by spitting paint at a hand placed on the cave wall, resulting in a stenciled image.

Art, the Chauvet drawings suggest, does not necessarily evolve in a linear progression from awkward beginnings to more sophisticated representations. On the contrary, already in the earliest artworks, people obtained a very high degree of sophistication. Apparently, even from the earliest times, human beings could choose to represent the world naturalistically or not, and the choice not to represent the world in naturalistic terms should be attributed not necessarily to lack of skill or sophistication but to other, more culturally driven factors.

Paleolithic Culture and Its Artifacts

Footprints discovered in South Africa in 2000 and fossilized remains uncovered in the forest of Ethiopia in 2001 suggest that, about 5.7 million years ago, the earliest upright humans, or hominins (as distinct from the larger classification of hominids, which includes great apes and chimpanzees as well as humans), roamed the continent of Africa. Ethiopian excavations further indicate that sometime around 2.5 or 2.6 million years ago, hominid populations began to make rudimentary stone tools, although long before, between 14 million and 19 million years ago, the Kenyapithecus ("Kenyan ape"), a hominin, made stone tools in east central Africa. Nevertheless, the earliest evidence of a culture coming into being are the stone artifacts of Homo sapiens (Latin for "one who knows"). Homo sapiens evolved about 100,000-120,000 years ago and can be distinguished from earlier hominids by the lighter build of their skeletal structure and larger brain. A 2009 study of genetic diversity among Africans found the San people of Zimbabwe to be the most diverse, suggesting

that they are the most likely origin of modern humans from which others gradually spread out of Africa, across Asia, into Europe, and finally to Australia and the Americas.

Homo sapiens were hunter-gatherers, whose survival depended on the animals they could kill and the foods they could gather, primarily nuts, berries, roots, and other edible plants. The tools they developed were far more sophisticated than those of their ancestors. They included cleavers, chisels, grinders, hand axes, and arrow- and spearheads made of flint, a material that also provided the spark to create an equally important tool—fire. In 2004, Israeli archeologists working at a site on the banks of the Jordan River reported the earliest evidence yet found of controlled fire created by hominids—cracked and blackened flint chips, presumably used to light a fire, and bits of charcoal dating from 790,000 years ago. Also at the campsite were the bones of elephants, rhinoceroses, hippopotamuses, and small species, demonstrating that these early hominids cut their meat with flint tools and ate steaks and marrow. Homo sapiens cooked with fire, wore animal skins as clothing, and used tools as a matter of course. They buried their dead in ritual ceremonies, often laying them to rest accompanied by stone tools and weapons.

The Paleolithic era is the period of Homo sapiens's ascendancy. These people carved stone tools and weapons that helped them survive in an inhospitable climate. They carved small sculptural objects as well, which, along with the cave paintings we have already seen, appear to be the first instances of what we have come to call "art." Among the most remarkable of these sculptural artifacts are a large number of female figures, found at various archeological sites across Europe. The most famous of these is the limestone statuette Woman, found at Willendorf, in modern Austria (Fig. 1.3), dating from between about 25,000 to 20,000 BCE and sometimes called the Venus of Willendorf. Markings on the Woman and other similar figures indicate that they were originally colored, but what these small sculptures meant and what they were used for remains unclear. Most are 4 to 5 inches high and fit neatly into a person's hand. This suggests that they may have had a ritual purpose. Their exaggerated breasts and bellies and their clearly delineated genitals support a connection to fertility and childbearing. We know, too, that the Woman from Willendorf was originally painted in red ochre, suggestive of menses. And, her navel is not carved; rather, it is a natural indentation in the stone. Whoever carved her seems to have recognized, in the raw stone, a connection to the origins of life. But such figures may have served other purposes as well. Perhaps they were dolls, guardian figures, or images of beauty in a cold, hostile world where having body fat might have made the difference between survival and death.

Female figurines vastly outnumber representations of males in the Paleolithic era, which suggests that women played a central role in Paleolithic culture. Most likely, they had considerable religious and spiritual influence, and their preponderance in the imagery of the era suggests that Paleolithic culture may have been *matrilineal* (in which descent is

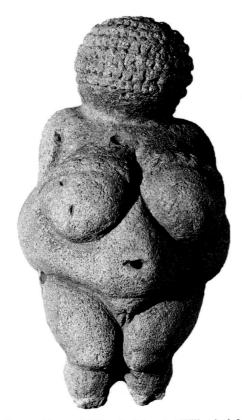

Fig. 1.3 Woman (Venus of Willendorf), found at Willendorf, Austria. ca. 25,000-20,000 BCE. Limestone, height 4". Naturhistorisches Museum, Vienna. For many years, modern scholars called this small statue the Venus of Willendorf. They assumed that its carvers attributed to it an ideal of female beauty comparable to the Roman ideal of beauty implied by the name Venus.

determined through the female line) and matrilocal (in which residence is in the female's tribe or household). Such traditions exist in many primal societies today.

The Rise of Agriculture

For 2,000 years, from 10,000 to 8000 BCE, the ice covering the Northern Hemisphere receded farther and farther northward. As temperatures warmed, life gradually changed. During this period of transition, areas once covered by vast regions of ice and snow developed into grassy plains and abundant forests. Hunters developed the bow and arrow, which were easier to use than the spear at longer range on the open plains. They fashioned dugout boats out of logs to facilitate fishing, which became a major food source. They domesticated dogs to help with the hunt as early as 11,000 BCE, and soon other animals as well—goats and cattle particularly. Perhaps most important, people began to cultivate the more edible grasses. Along the eastern shore of the Mediterranean, they harvested wheat; in Asia, they cultivated millet and rice; and in the Americas, they grew squash, beans, and corn. Gradually, farming replaced hunting as the primary means of sustaining life. A culture of the fields developed—an agriculture, from the Latin ager, "farm," "field," or "productive land."

The rise of agricultural society defines the Neolithic era. Beginning in about 8000 BCE, Neolithic culture concentrated in the great river valleys of the Middle East and Asia, and gradually, as the climate warmed, Neolithic culture spread across Europe. By about 5000 BCE, the valleys of Spain and southern France supported agriculture, but not until about 4000 BCE is there evidence of farming in the northern reaches of the European continent and England.

Meanwhile, the great rivers of the Middle East and Asia provided a consistent and predictable source of water, and people soon developed irrigation techniques that fostered organized agriculture and animal husbandry. As production outgrew necessity, members of the community were freed to occupy themselves in other endeavors—complex food preparation (bread, cheese, and so on), construction, religion, even military affairs. Soon, permanent villages began to appear, and villages began to look more and more like cities.

Neolithic Catalhöyük

Sometime around 7400 BCE, at Çatalhöyük (also known as Chatal Huyuk) in central Turkey, a permanent village began to take shape that would flourish for nearly 1,200 years. At one point or another, as many as 3,000 people lived in close proximity to one another in rectangular houses made of mud bricks held together with plaster. These houses stood side by side, one wall abutting the next, with entrances through the roof and down a ladder. There were no windows, and the only natural light in the interior came from the entryway. The roof appears to have served as the primary social space, especially in the summer months. Domed ovens were placed both on the roof and in the interior.

The people of Çatalhöyük were apparently traders, principally of obsidian, a black, volcanic, and glasslike stone that can be carved into sharp blades and arrowheads, which they mined at Hasan Dag, a volcano visible from the village. The rows of windowless houses that composed the village, the walls of which rose to as high as 16 feet, must have served a defensive purpose, but they also contained what archeologists have come to view as an extraordinary sense of communal history. Their interior walls and floors were plastered and replastered, then painted and repainted with a white lime-based paint, again and again over hundreds of years. Beneath the floors of some—but not all—of the houses were burials, averaging about six per house, but sometimes rising to between 30 and 62 bodies. For reasons that are not entirely clear, from time to time, these bodies were exhumed, and the skulls of long-deceased ancestors were removed. The skulls were then reburied in new graves or in the foundations of new houses as they were built and rebuilt. Whatever the rationale for such ceremonies, they could not have helped but create a sense of historical continuity in the community.

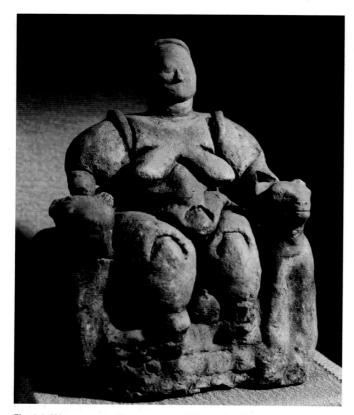

Fig. 1.4 Woman seated between two felines, Çatalhöyük, Turkey. ca. 6850–6300 BCE. Terra cotta, height 45%". Museum of Anatolian Civilizations, Ankara. The woman's head in this sculpture is a modern addition.

Çatalhöyük was first extensively excavated from 1958 by Sir James Mellaart, who concluded that the village's culture was matrilineal, based in no small part on his discovery of a number of female figurines including a clay sculpture of a seated woman (Fig. 1.4), who represented, he believed, a Fertility or Mother Goddess. Found in a grain bin—evidence of the community's growing agricultural sophistication—she sits enthroned between two felines, perhaps in the process of giving birth. But Ian Hodder of Cambridge University, who took up the excavation of the site in 1993, after a nearly 30-year hiatus, has recently concluded that she is something other than a Fertility Goddess. "There are full breasts on which the hands rest," he wrote in 2005,

and the stomach is extended in the central part. There is a hole in the top for the head which is missing. As one turns the figurine around one notices that the arms are very thin, and then on the back of the figurine one sees a depiction of either a skeleton or the bones of a very thin and depleted human. The ribs and vertebrae are clear, as are the scapulae and the main pelvic bones. The figurine can be interpreted in a number of ways—as a woman turning into an ancestor, as a woman associated with death, or as death and life conjoined. . . . Perhaps the importance of female imagery

Fig. 1.5 Reconstruction of a "shrine," Çatalhöyük, Turkey. ca. 6850–6300 BCE. Museum of Anatolian Civilizations, Ankara. The relief sculpture below the arch in the center of the room appears to be a decapitated animal or even, possibly, human form.

was related to some special role of the female in relation to death as much as to the roles of mother and nurturer.

Supporting Hodder's theories is a burial of a deceased woman who holds in her arms the plastered and painted skull of a male. Similarly, Mellaart believed that many of the rooms that contained large numbers of bodies were shrines or temples (Fig. 1.5). The walls of these rooms were decorated with the skulls of cows and the heads and horns of bulls. Found under the floors of some houses were boar tusks, vulture skulls, and fox and weasel teeth. But Hodder has found evidence that these houses—he calls them "history houses"—were not shrines at all, but more or less continuously occupied, suggesting that art and decoration were integral to the daily lives of the community's residents.

Neolithic Pottery Across Cultures

The transition from cultures based on hunting and fishing to cultures based on agriculture led to the increased use of pottery vessels. Ceramic vessels are fragile, so hunter-gatherers would not have found them practical for carrying food, but people living in the more permanent Neolithic settlements could have used them to carry and store water, and to prepare and store certain types of food.

Some of the most remarkable Neolithic painted pottery comes from Susa, on the Iranian plateau. The patterns on one particular beaker (Fig. 1.6) from around 5000 to 4000 BCE are highly stylized animals. The largest of these is an ibex, a popular decorative feature of prehistoric ceramics from Iran. Associated with the hunt, the ibex may have been a symbol of plenty. The front and hind legs of the ibex are rendered by two triangles, the tail hangs behind it like a feather, the head

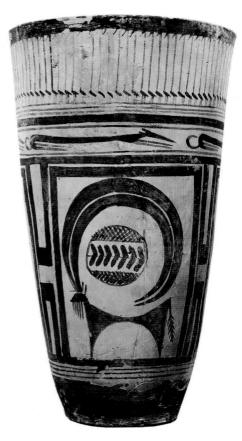

Fig. 1.6 Beaker with ibex, dogs, and long-necked birds, from Susa, southwestern Iran. ca. 5000-4000 BCE. Baked clay with painted decoration, height 11¼". Musée du Louvre, Paris. The ibex was the most widely hunted game in the ancient Middle East, a fact that probably accounts for its centrality in this design.

is only marginally connected to the body, and the horns rise in a large, exaggerated arc to encircle a decorative circular form. Hounds race around the band above the ibex, and wading birds form a decorative band across the beaker's top.

In Europe, the production of pottery apparently developed some time later, around 3000 BCE. By this time, the potter's wheel was in use in the Middle East as well as China. A machine created expressly to produce goods, the potter's wheel represents the first mechanical and technological breakthrough in history. As skilled individuals specialized in making and decorating pottery, and traded their wares for other goods and services, the first elemental forms of manufacturing began to emerge.

Neolithic Ceramic Figures

It is a simple step from forming clay pots and firing them to modeling clay sculptural figures and submitting them to the same firing process. Examples of clay modeling can be found in some of the earliest Paleolithic cave sites, where, at Altamira, for instance, in Spain, an artist added clay to an existing rock outcropping in order to underscore the rock's natural resemblance to an animal form. At Le Tuc d'Audoubert, south of Lascaux, in France, an artist shaped two clay bison, each 2 feet long, as if they were leaning against a rock ridge.

But these Paleolithic sculptures were never fired. One of the most interesting examples of Neolithic fired clay figurines was the work of the so-called Nok peoples who lived in modern Nigeria. We do not know what they called themselves—they are identified instead by the name of the place where their artifacts were discovered. In fact, we know almost nothing about the Nok. We do not know how their culture was organized, what their lives were like, or what they believed. But while most Neolithic peoples in Africa worked in materials that were not permanent, the Nok fired clay figures of animals and humans that were approximately life-size.

These figures were first unearthed early in the twentieth century by miners over an area of about 40 square miles. Carbon-14 and other forms of dating revealed that some of these objects had been made as early as 800 BCE and others as late as 600 ce. Little more than the hollow heads has survived intact, revealing an artistry based on abstract geometric shapes (Fig. 1.7). In some cases, the heads are represented as ovals; in others they are cones, cylinders, or spheres. Facial features are combinations of ovals, triangles, graceful arches, and straight lines. These heads were probably shaped with wet clay and then, after firing, finished by carving details into the hardened clay. Some scholars

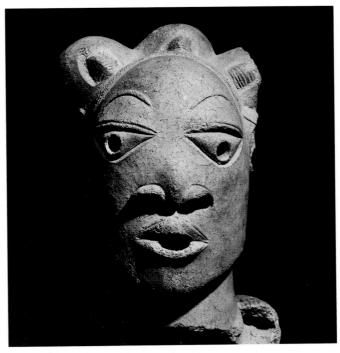

Fig. 1.7 Head, Nok. ca. 500 BCE-200 CE. Terra cotta, height 143/16". This slightly larger-than-life-size head was probably part of a complete body, and shows the Nok people's interest in abstract geometric representations of facial features and head shape. Holes in the eyes and nose were probably used to control temperature during firing.

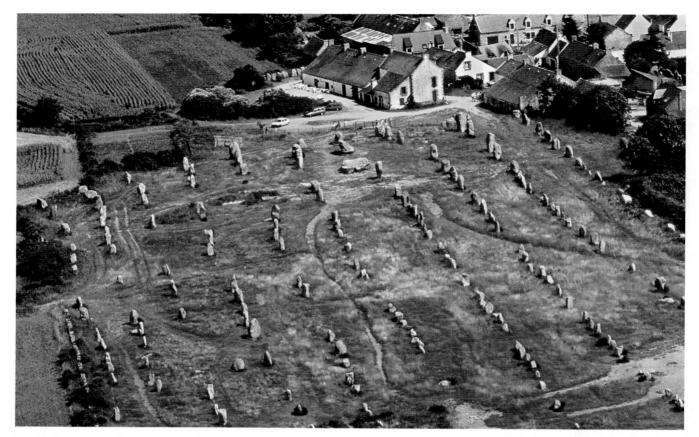

Fig. 1.8 Neolithic menhir alignments at Ménec, Carnac, Brittany, France. ca. 4250–3750 BCE. According to an ancient legend, the Carnac menhirs came into being when a retreating army was driven to the sea. Finding no ships to aid their escape, they turned to face their enemy and were transformed into stone.

have argued that the technical and artistic sophistication of works by the Nok and other roughly contemporaneous groups suggests that it is likely there are older artistic traditions in West Africa that have not yet been discovered. Certainly, farther to the east, in the sub-Saharan regions of the Sudan, Egyptian culture had exerted considerable influence for centuries, and it may well be that Egyptian technological sophistication had worked its way westward.

The Neolithic Megaliths of Northern Europe

A distinctive kind of monumental stone architecture appears late in the Neolithic period, particularly in what is now Britain and France. Known as megaliths, or "big stones," these works were constructed without the use of mortar and represent the most basic form of architectural construction. Sometimes, they consisted merely of posts—upright stones stuck into the ground—called menhirs, from the Celtic words men, "stone," and hir, "long." These single stones occur in isolation or in groups. The largest of the groups is at Carnac, in Brittany (Fig. 1.8), where some 3,000 menhirs arranged east to west in 13 straight rows, called alignments, cover a 2-mile stretch of plain. The stones stand about 3 feet tall at the east end, and gradually get larger and larger until, at the west end, they attain a

height of 13 feet. This east—west alignment suggests a connection to the rising and setting of the sun and to fertility rites. Scholars disagree about the stones' significance: some speculate that they may have marked out a ritual procession route, while others think they symbolized the human body and the process of growth and maturation. But there can be no doubt that megaliths were designed to be permanent structures, where domestic architecture was not. Quite possibly the megaliths stood in tribute to the strength of the leaders responsible for assembling and maintaining the considerable labor force required to construct them.

Perhaps the best-known type of megalithic structure is the **cromlech**, from the Celtic *crom*, "circle," and *lech*, "place." Without doubt, the most famous megalithic structure in the world is the cromlech known as Stonehenge (Fig. 1.9), on Salisbury Plain, about 100 miles west of London. A henge is a special type of cromlech, a circle surrounded by a ditch with built-up embankments, presumably for fortification.

The site at Stonehenge reflects four major building periods, extending from about 2750 to 1500 BCE. By about 2100 BCE, most of the elements visible today were in place. In the middle was a U-shaped arrangement of ten posts grouped in pairs, each pair topped by a capstone—what we today call **post-and-lintel** construction. The one at the bottom of the U stands taller than the rest, rising

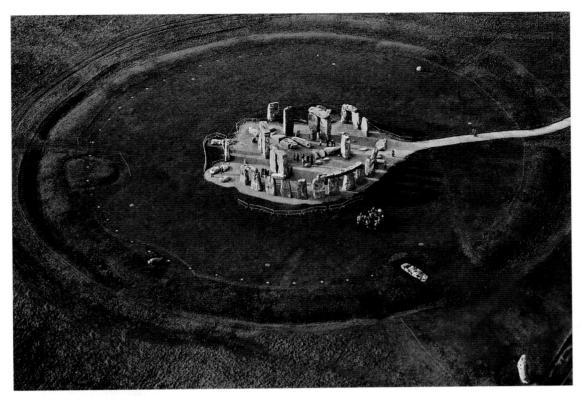

Fig. 1.9 Stonehenge, Salisbury Plain, Wiltshire, England. ca. 2750–1500 BCE. Like most Neolithic sites, Stonehenge invites speculation about its significance. Of this, however, we are certain: At the summer solstice, the longest day of the year, the sun rises directly over the Heel Stone, visible at the bottom right of this photograph. This suggests that the site was intimately connected to the movement of the sun.

to a height of 24 feet, with a 15-foot lintel 3 feet thick. A continuous circle of sandstone posts, each weighing up to 50 tons and all standing 20 feet high, surrounded the five trilithons. Across their top was a continuous lintel 106 feet in diameter. This is the Sarsen Circle. Just inside the Sarsen Circle was once another circle, made of bluestone—a bluish dolerite—found only in the mountains of southern Wales, some 120 miles away.

Why Stonehenge was constructed remains something of a mystery, although a recent discovery at nearby Durrington Walls has shed new light on the problem. Durrington Walls lies about 2 miles northeast of Stonehenge itself (see Map 1.3). It consists of a circular ditch surrounding a ring of postholes out of which very large timber posts would have risen. The circle was the center of a village of as many as 300 houses. The site is comparable in scale to Stonehenge itself. These discoveries together with the ability to carbon-date human remains found at Stonehenge with increased accuracy—suggest that Stonehenge was itself a burial ground. Archeologist Mike Parker Pearson of the University of Sheffield speculates that villagers would have transported their dead down an avenue leading to the River Avon, then journeyed downstream in a ritual symbolizing the passage to the afterlife, finally arriving at an avenue leading up to Stonehenge from the river. "Stonehenge wasn't set in isolation," Parker

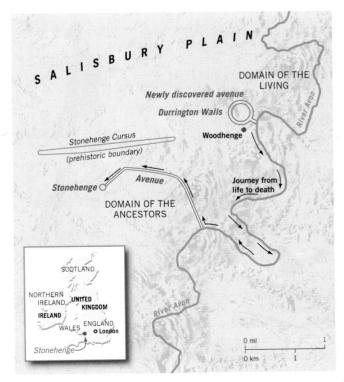

Map 1.3 Durrington Walls in relation to Stonehenge. Courtesy of National Geographic.

Pearson says, "but was actually one-half of this monumental complex. We are looking at a pairing—one in timber to represent the transience of life, the other in stone marking the eternity of the ancestral dead."

MYTH IN PREHISTORIC CULTURAL LIFE

What role does myth play in prehistoric cultures?

Much of our understanding of prehistoric cultures comes from stories that have survived in cultures around the world that developed without writing—that is, **oral cultures**—such as the San cultures of Zimbabwe and the Oceanic peoples of Tahiti in the South Pacific. These peoples passed down their myths and histories over the centuries, from generation to generation, by word of mouth. Although, chronologically speaking, many of these cultures are contemporaneous with the medieval, Renaissance, and even modern cultures of the West, they are actually closer to the Neolithic cultures in terms of social practice and organization. Especially in terms of myths and the rituals associated with them, they can help us to understand the outlook of actual Neolithic peoples.

A myth is a story that a culture assumes is true. It also embodies the culture's views and beliefs about its world, often serving to explain otherwise mysterious natural phenomena. Myths stand apart from scientific explanations of the nature of reality, but as a mode of understanding and explanation, myth has been one of the most important forces driving the

development of culture. Although myths are speculative, they are not pure fantasy. They are grounded in observed experience. They serve to rationalize the unknown and to explain to people the nature of the universe and their place within it.

Both nineteenth-century and more recent anthropological work among the San people suggests that their belief systems can be traced back for thousands of years. As a result, the meaning of their rock art that survives in open-air caves below the overhanging stone cliffs atop the hills of what is now Matobo National Park in Zimbabwe (Fig. 1.10), some of which dates back as far as 5,000 to 10,000 years ago, is not entirely lost. A giraffe stands above a group of smaller giraffes crossing a series of large, white, lozenge-shaped forms with brown rectangular centers, many of them overlapping one another. To the right, six humanlike figures are joined hand in hand, probably in a trance dance. For the San people, prolonged dancing activates num, a concept of personal energy or potency that the entire community can acquire. Led by a shaman, a person thought to have special ability to communicate with the spirit world, the dance encourages the num to heat up until it boils over and rises up through the spine to explode, causing the dancers to enter a trance. Sweating and trembling, the dancers variously convulse or become rigid. They might run, jump, or fall. The San believe that in many instances, the dancer's spirit leaves the body, traveling far away, where it might enter into battle with supernatural forces. At any event, the trance imbues the dancer with almost supernatural agency. The dancers' num is capable of curing illnesses, managing game, or controlling the weather.

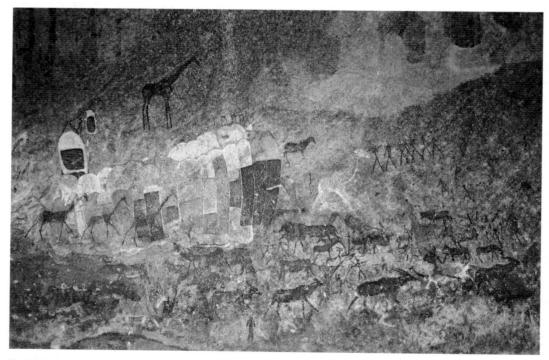

Fig. 1.10 Cave painting with giraffes, zebra, eland, and abstract shapes, San people, Inanke, Matobo National Park, Zimbabwe. Before 1000 ce. Photo: Christopher and Sally Gable © Dorling Kindersley. The animals across the bottom are elands, the largest species of antelope, resembling cattle.

Fig. 1.12 Roof construction of a kiva. After a National Park Service pamphlet.

Fig. 1.11 Spruce Tree House, Mesa Verde. Anasazi culture, ca. 1200-1300 CE. The courtyard was formed by the restoration of the roofs over two underground kivas.

Myth in the Native American Cultures of the Southwest

The Pueblo peoples of the American Southwest trace their ancestry back to the Anasazi, who lived in the region from about 900 to 1300 ce, a time roughly contemporaneous with the late Middle Ages in Europe. They have maintained the active practice of their ancient Anasazi religious rites and ceremonies, which they have chosen not to share with outsiders.

The Anasazi left us no written record of their culture, only ruins and artifacts. As William M. Ferguson and Arthur H. Rohn, two prominent scholars of the Anasazi, have described them, "They were a Neolithic people without a beast of burden, the wheel, metal, or a written language, yet they constructed magnificent masonry housing and ceremonial structures, irrigation works, and water impoundments." At Mesa Verde, in what is today southwestern Colorado, their cliff dwellings (Fig. 1.11) resemble many of the Neolithic cities of the Middle East, such as 'Ain Ghazal ("spring of the gazelles"), just outside what is now Amman, Jordan. Although 'Ain Ghazal flourished from about 7200 to 5000 BCE, thousands of years before the Mesa Verde community, both complexes were constructed with stone walls sealed with a layer of mud plaster. Their roofs were made of wooden beams cross-layered with twigs and branches and sealed with mud. Like other Neolithic cultures, the Anasazi were accomplished in pottery making, decorating their creations with elaborately abstract, largely geometric shapes and patterns.

The Anasazi abandoned their communities in the late thirteenth century, perhaps because of a great drought that lasted from about 1276 to 1299. Today, their descendants include the Hopi and the Zuni. (Anasazi is in fact a Navajo word meaning "enemy ancestors"—we do not know what the Anasazi called themselves.) What is remarkable about the Pueblo peoples, who despite the fact that they speak several different languages share a remarkably common culture, is that many aspects of their culture have survived and are practiced today much as they were in ancient times. For all Pueblo peoples, the village is not just the center of culture but the very center of the world. And the cultural center of the village life is the kiva (Fig. 1.12), two of which have been restored at Spruce Tree House to form the plaza visible in Fig. 1.11. They are constructed of horizontally laid logs built up to form a dome with an access hole. The roof thus created is used as a common area. Down below, in the enclosed kiva floor, was a sipapu, a small, round hole symbolic of the Anasazi creation myth, which told of the emergence of the Anasazi's ancestors from the depths of the earth. In the parched Southwestern desert country, it is equally true that water, like life itself, also seeps out of small fissures in the earth. Thus, it is as if the Anasazi community, and everything necessary to its survival, emerged from Mother Earth.

Most Pueblo peoples do not allow their ceremonial dances to be photographed. These dance performances tell stories that relate to the experiences of the Pueblo peoples, from planting, hunting, and fishing in daily life, to the larger experiences of birth, puberty, maturity, and death. Still other stories explain the origin of the world, the emergence of a particular Pueblo people into the world, and their history. Most Pueblo people believe that they originated in the womb of Mother Earth and, like seeds sprouting from the soil in the springtime, were called out into the daylight by their Sun Father. This belief about origins is embodied in a type of narrative known as an emergence tale, a form of creation myth (Reading 1.1).

READING 1.1

Zuni Emergence Tale, Talk Concerning the First Beginning

Yes, indeed. In this world there was no one at all. Always the sun came up; always he went in. No one in the morning gave him sacred meal; no one gave him prayer sticks; it was very lonely. He said to his two children: "You will go into the fourth womb. Your fathers, your mothers, käeto-we, tcu-eto-we, mu-eto-we, le-eto-we, all the society priests, society pekwins, society bow priests, you will bring out yonder into the light of your sun father."

So begins this emergence tale, which embodies the fundamental principles of Zuni religious society. The Zuni, or "Sun People," are organized into groups, each responsible for a particular aspect of the community's well-being, and each group is represented by a particular <code>-eto·we</code>, or fetish, connecting it to its spiritual foundation in the Earth's womb. The pekwins mentioned here are sun priests, who control the ritual calendar. Bow priests oversee warfare and social behavior. In return for corn and breath given them by the Sun Father, the Zuni offer him cornmeal and downy feathers attached to painted prayer sticks symbolizing both clouds—the source of rain—and breath itself. Later in the tale the two children of the Sun Father bring everyone out into the daylight for the first time:

Into the daylight of their sun father they came forth standing. Just as early dawn they came forth. After they came forth there they set down their sacred possessions in a row. The two said, "Now after a little while when your sun father comes forth standing to his sacred place you will see him face to face. Do not close your eyes." Thus he said to them. After a little while the sun came out. When he came out they looked at him. From their eyes the tears rolled down. After they had looked at him, in a little while their eyes became strong. "Alas!" Thus they said. They were covered all over with slime. With slimy tails and slimy horns, with webbed fingers, they saw one another. "Oh dear! is this what we look like?" Thus they said.

Then they could not tell which was which of their sacred possessions.

From this point on in the tale, the people and priests, led by the two children, seek to find the sacred "middle place," where things are balanced and orderly. Halona-Itiwana it is called, the sacred name of the Zuni Pueblo, "the Middle Ant Hill of the World." In the process they are transformed from indeterminate salamander-like creatures into their ultimate human form, and their world is transformed from chaos to order.

At the heart of the Zuni emergence tale is a moment when, to the dismay of their parents, many children are transformed into water creatures—turtles, frogs, and the like—and the Hero Twins instruct the parents to throw these

children back into the river. Here they become *kachinas* or *katcinas*, deified spirits, who explain:

May you go happily. You will tell our parents, "Do not worry." We have not perished. In order to remain thus forever we stay here. To Itiwana but one day's travel remains. Therefore we stay nearby. . . . Whenever the waters are exhausted and the seeds are exhausted you will send us prayer sticks. Yonder at the place of our first beginning with them we shall bend over to speak to them. Thus there will not fail to be waters. Therefore we shall stay quietly nearby.

The Pueblo believe that kachina spirits, not unlike the *num* of the San people of Africa, manifest themselves in performance and dance. Masked male dancers impersonate the kachinas, taking on their likeness as well as their supernatural character. Through these dance visits the kachinas, although always "nearby," can exercise their powers for the good of the people. The nearly 250 kachina personalities embody clouds, rain, crops, animals, and even ideas such as growth and fertility. Although kachina figurines are made for sale as art objects, particularly by the Hopi, the actual masks worn in ceremonies are not considered art objects by the Pueblo people. Rather, they are thought of as active agents in the transfer of power and knowledge between the gods and the men who wear them in dance. In fact, kachina dolls made for sale are considered empty of any ritual power or significance.

Pueblo emergence tales, and the ritual practices that accompany them, reflect the general beliefs of most Neolithic peoples. These include the following:

- belief that the forces of nature are inhabited by living spirits, which we call **animism**;
- belief that nature's behavior can be compared to human behavior (we call the practice of investing plants, animals, and natural phenomena with human form or attributes anthropomorphism), thus explaining what otherwise would remain inexplicable;
- belief that humans can communicate with the spirits of nature, and that, in return for a sacrificial offering or a prayer, the gods might intercede on their behalf.

Japan and the Role of Myth in the Shinto Religion

A culture's religion—that is, its understanding of the divine—is thus closely tied to and penetrated by mythical elements. Its beliefs, as embodied in its religion, stories, and myths, have always been closely tied to seasonal celebrations and agricultural production—planting and harvest in particular, as well as rain—the success of which was understood to be inextricably linked to the well-being of the community. In a fundamental sense, myths reflect the community's ideals, its history (hence the preponderance of creation myths in both ancient societies and contemporary religions), and its aspirations. Myths also tend to mirror the

culture's moral and political systems, its social organization, and its most fundamental beliefs.

A profound example is the indigenous Japanese religion of Shinto. Before 200 CE, Japan was fragmented; its various regions were separated by sea and mountain, and ruled by numerous competing and often warring states. The Records of Three Kingdoms, a classic Chinese text dating from about 297 CE, states that in the first half of the third century CE many or most of these states were unified under the rule of Queen Himiko. According to the Records, "The country formerly had a man as ruler. For some 70 or 80 years after that there were disturbances and warfare. Thereupon the people agreed upon a woman for their ruler. Her name was Himiko." After her rule, Japan was more or less united under the Yamato emperors, who modeled their rule on the Chinese, and whose imperial court ruled from modern-day Nara Prefecture, then known as Yamato province. Its peoples shared a mythology that was finally collected near the end of the Yamato period, in about 700 CE, called the Kojiki or Chronicles of Japan.

According to the *Kojiki*, the islands that constitute Japan were formed by two *kami*, or gods—Izanagi and his consort, Izanami. Among their offspring was the sun goddess, Amaterasu Omikami, from whom the Japanese Imperial line later claimed to have descended. In other words, Japanese emperors could claim not merely to have been put in position by the gods; they could claim to be direct descendants of the gods, and hence divine.

Amaterasu is the principal goddess of the early indigenous religious practices that came to be known as Shinto.

She is housed in a shrine complex at Ise, a sacred site from prehistoric times. In many respects, Shinto shares much with Pueblo religions. In Shinto, trees, rocks, water, and mountains—especially Mount Fuji, the volcano just outside Tokyo, which is said to look over the country, as its protector—are all manifestations of the kami, which, like kachinas, are the spirits that are embodied in the natural world. Even the natural materials with which artists work, such as clay, wood, and stone, are imbued with the kami and are to be treated with the respect and reverence due to a god. The kami are revered in matsuri, festivals that usually occur annually, in which, it is believed, past and present merge into one, everyday reality fades away, and people come face to face with their gods. The matsuri serve to purify the territory and community associated with the kami, restoring them from the degradation inevitably worked upon them by the passing of time. During the festival, people partake of the original energies of the cosmos, which they will need to restore order to their world. Offerings such as fish, rice, and vegetables, as well as music and dancing, are presented to the kami, and the offerings of food are later eaten.

The main sanctuary, or *shoden*, at Ise consists of undecorated wooden beams and a thatched roof (Fig. 1.13). Ise is exceptional in its use of these plain and simple materials, which embody not only the basic tenet of Shinto—reverence for the natural world—but also the continuity and renewal of a tradition where wood, rather than stone, has always been the principal building material. The most prominent festival at Ise is the *shikinensengu* ceremony, which involves the installation of the deity in a

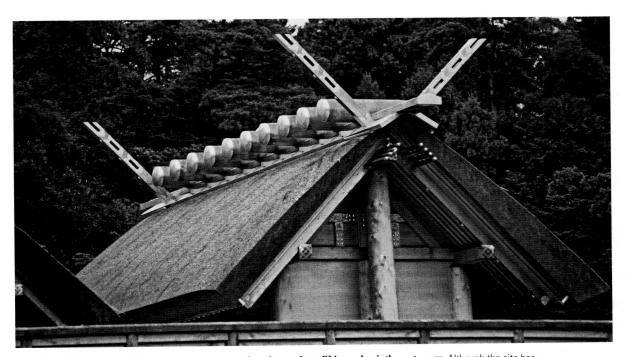

Fig. 1.13 Naiku (Inner) Shrine housing Amaterasu, Ise, Japan. Late fifth—early sixth century cc. Although the site has been sacred to Shinto since prehistoric times, beginning in the reign of the emperor Temmu (r. 673—86 cE), the Shinto shrine at Ise has been rebuilt by the Japanese ruling family, with some inevitable lapses, every 20 years. The most recent reconstruction occurred in 2013; it will be rebuilt again in 2033.

new shrine in a celebration of ritual renewal held every 20 years. The shrine buildings are rebuilt on empty ground adjacent to the older shrine, the deity is transferred to the new shrine, and the older shrine is razed, creating empty ground where the next shrine will be erected. The empty site is strewn with large white stones and is left totally empty except for a small wooden hut containing a sacred wooden pole, a practice that scholars believe dates back to very ancient times. This cycle of destruction and renewal connects the past to the present, the human community to its gods and their original energies.

The three sacred treasures of Shinto—a sword, a mirror, and a jewel necklace—were said to be given by Amaterasu to the first emperor, and they are traditionally handed down from emperor to emperor in the enthronement ceremony. The mirror is housed at Ise, the sword at the Atsuta Shrine in Nagoya, and the jewel necklace at the Imperial Palace in Tokyo. These imperial regalia are not considered mere symbols of the divine but "deity-bodies" in which the powers of the gods reside, specifically wisdom in the mirror, valor in the sword, and benevolence in the jewel necklace. To this day, millions of Japanese continue to practice Shinto, and they undertake pilgrimages to Ise each year.

MESOPOTAMIA: POWER AND SOCIAL ORDER IN THE EARLY MIDDLE EAST

What characteristics distinguish the ancient civilizations of Mesopotamia, and how do they differ from that of the Hebrews?

In September 1922, British archeologist C. Leonard Woolley boarded a steamer, beginning a journey that would take him to Iraq. There, Woolley and his team would discover one of the richest treasure troves in the history of archeology in the ruins of the ancient city of Ur. Woolley concentrated his energies on the burial grounds surrounding the city's central ziggurat, a pyramidal temple structure consisting of successive platforms with outside staircases and a shrine at the top (Figs. 1.14, 1.15). Digging there in the winter of 1927, he unearthed a series of tombs with several rooms, many bodies, and spectacular objects—vessels, crowns, necklaces, statues, and weapons—as well as jewelry and lyres made of electrum and the deep blue stone lapis lazuli. With the same sense of excitement that was felt by Jean-Marie Chauvet and

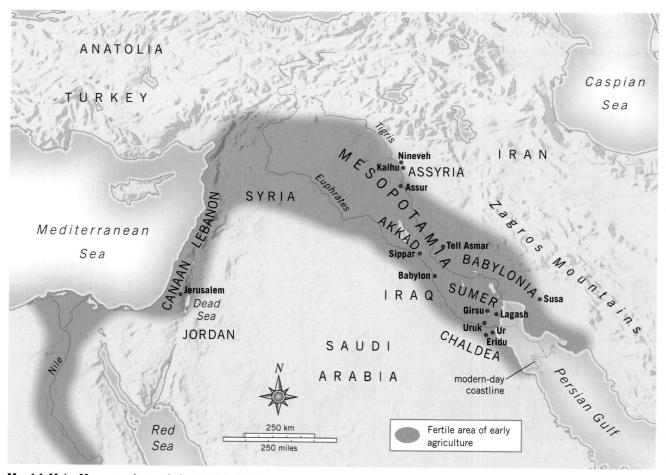

Map 1.4 Major Mesopotamian capitals, ca. 2600-500 BCE.

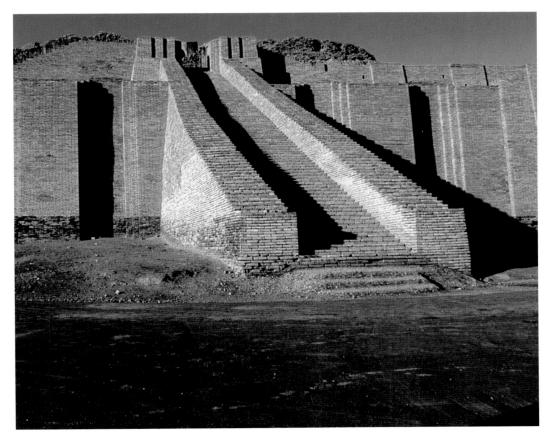

Fig. 1.14 The ziggurat at Ur (present-day Muqaiyir, Iraq). ca. 2100 BCE. The best-preserved and most fully restored of the ancient Sumerian temples, this ziggurat was the center of the city of Ur, on the banks of the Euphrates River.

his companions when they first saw the paintings on the wall of Chauvet Cave, Woolley was careful to keep what he called the "royal tombs" secret. On January 4, 1928, he telegrammed his colleagues in Latin. Translated to English, his message read:

I found the intact tomb, stone built, and vaulted over with bricks of queen Shubad [later known as Puabi] adorned with a dress in which gems, flower crowns and animal figures are woven. Tomb magnificent with jewels and golden cups.

-Woolley

When Woolley's discovery was made public, it was worldwide news for years.

Archeologists and historians were especially excited by Woolley's discoveries because they opened a window onto the larger region we call Mesopotamia, the land between the Tigris and Euphrates rivers. Ur was one of 30 or 40 cities that arose in Sumeria, the southern portion of Mesopotamia (Map 1.4). In fact, its people abandoned Ur more than 2,000 years ago, when the course of the Euphrates moved away from the city.

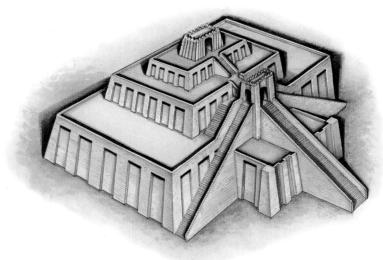

Fig. 1.15 Reconstruction drawing of the ziggurat at Ur (present-day Muqaiyir, Iraq). ca. 2100 BCE. British archeologist Sir Leonard Woolley undertook reconstruction of the ziggurat in the 1930s. In his reconstruction, a temple on top, which was the home of the patron deity of the city, crowned the three-tiered platform, the base of which measures 140 by 200 feet. The entire structure rose to a height of 85 feet. Woolley's reconstruction was halted before the second and third platforms were completed.

Sumerian Ur

Ur is not the oldest city to occupy the southern plains of Mesopotamia, the region known as Sumer. That distinction belongs to Uruk, just to the north. But the temple structure at Ur is of particular note because it is the most fully preserved and restored. It was most likely designed to evoke the mountains surrounding the river valley, which were the source of the water that flowed through the two rivers and, so, the source of life. Topped by a sanctuary, the ziggurat might also have symbolized a bridge between heaven and earth. Woolley, who supervised the reconstruction of the first platform and stairway of the ziggurat at Ur, speculated that the platforms of the temple were originally not paved but covered with soil and planted with trees, an idea that modern archeologists no longer accept.

Visitors—almost certainly limited to members of the priesthood—would climb the stairs to the temple on top. They might bring an offering of food or an animal to be sacrificed to the resident god—at Ur, it was Nanna or Sin, god of the moon. Visitors often placed in the temple a statue that represented themselves in an attitude of perpetual prayer. We know this from the inscriptions on many of the statues. One, dedicated to the goddess Tarsirsir, protector of Girsu, a city-state across the Tigris and not far upstream from Ur, reads:

To Bau, gracious lady, daughter of An, queen of the holy city, her mistress, for the life of Nammahani . . . has dedicated as an offering this statue of the protective goddess of Tarsirsir which she has introduced to the courtyard of

Bau. May the statue, to which let my mistress turn her ear, speak my prayers.

A group of such statues, found in 1934 in the shrine room of a temple at Tell Asmar, near present-day Baghdad, includes seven men and two women (Fig. 1.16). The men wear belted, fringed skirts. They have huge eyes, inlaid with lapis lazuli (a blue semiprecious stone) or shell set in bitumen. The single arching eyebrow and crimped beard (only the figure at the right is beardless) are typical of Sumerian sculpture. The two women wear robes. All figures clasp their hands in front of them, suggestive of prayer when empty and of making an offering, when holding a cup. Scholars once believed that the tallest man represents Abu, god of vegetation, because of his especially large eyes. Today this theory is discounted, but all the figures are probably worshipers.

Religion in Ancient Mesopotamia Although power struggles among the various city-states dominate Mesopotamian history, with one civilization succeeding another, and with each city-state or empire claiming its own particular divinity as chief among the Mesopotamian gods, the nature of Mesopotamian religion remained relatively constant across the centuries. With the exception of the Hebrews, the religion of the Mesopotamian peoples was polytheistic, consisting of multiple gods and goddesses connected to the forces of nature—sun and sky, water and storm, earth and its fertility. We know many of them by two names, one in Sumerian and the other in the Semitic language of the later, more powerful Akkadians.

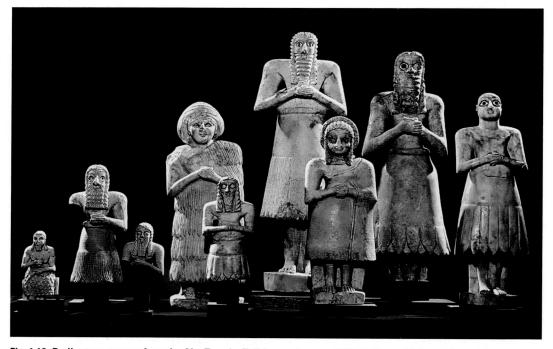

Fig. 1.16 Dedicatory statues, from the Abu Temple, Tell Asmar, Iraq. ca. 2900–2700 BCE. Marble, alabaster, and gypsum, height of tallest figure approx. 30". Excavated by the Iraq Expedition of the Oriental Institute of the University of Chicago, February 13, 1934. Courtesy of the Oriental Institute of the University of Chicago. The wide-eyed appearance of these figures is probably meant to suggest that they are gazing in perpetual awe at the deity.

To the Mesopotamians, human society was merely part of the larger society of the universe governed by these gods, and a reflection of it. Anu, father of the gods, represents the authority, which the ruler emulates as lawmaker and giver. Enlil, god of the air—the calming breeze as well as the violent storm—is equally powerful, but he represents force, which the ruler emulates in his role as military leader. The active principles of fertility, birth, and agricultural plenty are those of the goddess Belitili, while water, the life force itself, the creative element, is embodied in the god Ea, or Enki, who is also god of the arts. Both Belitili and Ea are subject to the authority of Anu. Ishtar, goddess of both love and war, is subject to Enlil, ruled by his breezes (in the case of love) and by his storm (in the case of war). A host of lesser gods represented natural phenomena, or, in some cases, abstract ideas, such as truth and justice.

The Mesopotamian ruler, often represented as a "priest-king," and often believed to possess divine attributes, acts as the intermediary between the gods and humankind. His ultimate responsibility is the behavior of the gods—whether Ea blesses the crop with rains, Ishtar his armies with victory, and so on.

Royal Tombs of Ur Religion was central to the people of Ur, and the cemetery there, discovered by Sir Leonard Woolley in 1928, tells us a great deal about the nature of their beliefs. Woolley unearthed some 1,840 graves, most dating from between 2600 and 2000 BCE. The greatest number of graves were individual burials of rich and poor alike. However, some included a built burial chamber rather than just a coffin and contained more than one body, in some cases as many as 80. These multiple burials, and the evidence of elaborate burial rituals, suggest that members of a king or queen's court accompanied the ruler to the grave. The two richest burial sites, built one behind the other, are now identified as royal tombs, one belonging to Queen Puabi, the other to an unknown king (but it is not that of her husband, King Meskalamdug, who is buried in a different grave).

One of Woolley's most important discoveries in the Royal Cemetery was the so-called *Standard of Ur* (Fig. 1.17). The main panels of this rectangular box of unknown function are called "War" and "Peace," because they illustrate, on one side, a military victory and, on the other, the subsequent

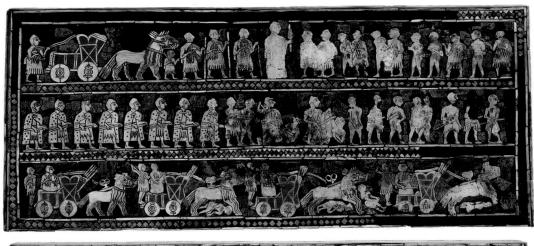

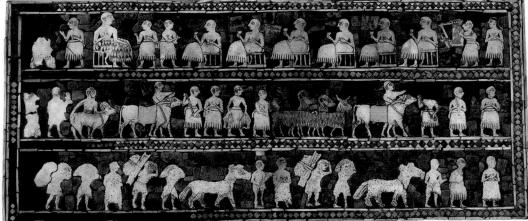

Fig. 1.17 Standard of Ur, front ("War") and back ("Peace") sides, from tomb 779, cemetery at Ur (present-day Muqaiyir, Iraq). ca. 2600 BCE. Shell, lapis lazuli, and red limestone, originally on a wooden framework, height 8', length 19". © The Trustees of the British Museum. For all its complexity of design, this object is not much bigger than a sheet of legal paper. Its function remains a mystery, although it may have served as a pillow or headrest. Woolley's designation of it as a standard was purely conjectural.

banquet celebrating the event, or perhaps a cult ritual. Each panel is composed of three **registers**, or self-contained horizontal bands, within which the figures stand on a **ground** line, or baseline.

At the right side of the top register of the "Peace" panel (the lower half of Fig. 1.17), a musician plays a lyre, and behind him another, apparently female, sings. The king, at the left end, is recognizable because he is taller than the others and wears a tufted skirt, his head breaking the register line on top. In this convention, known as social perspective, or hieratic scale, the most important figures are represented as larger than the others. In other registers on the "Peace" side of the Standard, servants bring cattle, goats, sheep, and fish to the celebration. These represent the bounty of the land and perhaps even delicacies from lands to the north. (Notice that the costumes and hairstyles of the figures carrying sacks in the lowest register are different from those in the other two.) This display of consumption and the distribution of food may have been intended to dramatize the power of the king by showing his ability to control trade routes.

On the "War" side of the *Standard*, the king stands in the middle of the top register. War chariots trample the enemy on the bottom register. (Note that the chariots have solid wheels; spoked wheels were not invented until approximately 1800 BCE.) In the middle register, soldiers wearing leather cloaks and bronze helmets lead naked, bound prisoners to the king in the top register, who will presumably decide their fate. Many of the bodies found in the royal tombs were wearing similar military garments. The importance of the *Standard of Ur* is not simply as documentary evidence of Sumerian life but as one of the earliest examples we have of historical narrative.

Akkad

At the height of the Sumerians' power in southern Mesopotamia, a people known as the Akkadians arrived from the north and settled in the area around present-day Baghdad. Their capital city, Akkad, has never been discovered, and in all likelihood lies under Baghdad itself. Under Sargon I (r. ca. 2332-2279 BCE), the Akkadians conquered virtually all other cities in Mesopotamia, including those in Sumer, to become the region's most powerful city-state. Sargon named himself "King of the Four Quarters of the World" and equated himself with the gods, a status bestowed upon Akkadian rulers from his time forward. Legends about Sargon's might and power survived in the region for thousands of years. Indeed, the legend of his birth gave rise to what amounts to a narrative genre (a class or category of story with a universal theme) that survives to the present day: the boy from humble origins who rises to a position of might and power, the socalled rags-to-riches story.

As depicted on surviving clay tablets, Sargon was an illegitimate child whose mother deposited him in the Euphrates River in a basket. There, a man named Akki (after whom Akkad itself is named) found him while drawing water from the river and raised him as his own son. Such stories of

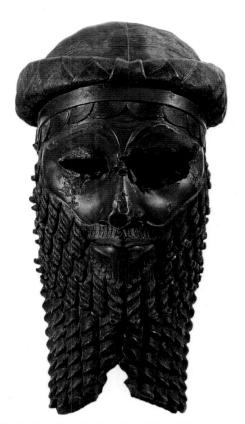

Fig. 1.18 Head of an Akkadian Man, from Nineveh (present-day Kuyunjik, Iraq). ca. 2300–2200 BCE. Copper alloy, height 141/2". Iraq Museum, Baghdad. Note that the figure is life-size.

abandonment, orphanhood, and being a foundling raised by foster parents have become a standard feature in the narratives of mythic heroes.

Although the Akkadian language was very different from Sumerian, through most of the third millennium BCE—that is, until Sargon's dynastic ambitions altered the balance of power in the region—the two cultures coexisted peacefully. The Akkadians adopted Sumerian culture and customs and their style of cuneiform writing, a script made of wedge-shaped characters, although not their language. In fact, many bilingual dictionaries and Sumerian texts with Akkadian translations survive. The Akkadian language was Semitic in origin, having more in common with other languages of the region, particularly Hebrew, Phoenician, and Arabic. It quickly became the common language of Mesopotamia, and peoples of the region spoke Akkadian, or dialects of it, throughout the second millennium and well into the first.

Although Akkad was arguably the most influential of the Mesopotamian cultures, few Akkadian artifacts survive, perhaps because Akkad and other nearby Akkadian cities have disappeared under Baghdad and the alluvial soils of the Euphrates plain. Two impressive sculptural works do remain, however. The first is the bronze head of an Akkadian man (Fig. 1.18), found at Nineveh. It was once believed to be Sargon the Great himself, but many modern scholars now think it was part of a statue of Sargon's grandson

Naram-Sin (ca. 2254–2218 BCE). It may be neither, but it is certainly the bust of a king. Highly realistic, it depicts a man who appears both powerful and majestic. In its damaged condition, the head is all that survives of a life-size statue that was destroyed in antiquity. Its original gemstone eyes were removed, perhaps by plundering soldiers, or possibly by a political enemy who recognized the sculpture as an emblem of absolute majesty. In the fine detail surrounding the face—in the beard and elaborate coiffure, with its braid circling the head—it testifies to the Akkadian mastery of the lost-wax casting technique, which originated in Mesopotamia as early as the third millennium BCE. It is the earliest monumental work made by that technique that we have.

Babylon

The Akkadians dominated Mesopotamia for just 150 years, their rule collapsing not long after 2200 BCE. For the next 400 years, various city-states thrived locally. No one in Mesopotamia matched the Akkadians' power until the first decades of the eighteenth century BCE, when Hammurabi of Babylon (r. 1792–1750 BCE) gained control of most of the region.

Hammurabi imposed order on Babylon, where laxity and disorder, if not chaos, reigned. A giant stele-an upright stone slab carved with a commemorative design or inscription—survives, upon which is inscribed the so-called Law Code of Hammurabi (Fig. 1.19). By no means the first of its kind, although by far the most complete, the stele is a record of decisions and decrees made by Hammurabi over the course of some 40 years of his reign. Its purpose was to celebrate his sense of justice and the wisdom of his rule. Atop the stele, in sculptural relief, Hammurabi receives the blessing of Shamash, the sun god; notice the rays of light coming from his shoulders. The god is much larger than Hammurabi: in fact, he is to Hammurabi as Hammurabi, the patriarch, is to his people. If Hammurabi is divine, he is still subservient to the greater gods. At the same time, the phallic design of the stele, like such other Mesopotamian steles as the Stele of Naram-Sin, asserts the masculine prowess of the king.

Below the relief, 282 separate "articles" cover both sides of the basalt monument. One of the great debates of legal history is the question of whether these articles actually constitute a code of law. If by *code* we mean a comprehensive, systematic, and methodical compilation of all aspects of Mesopotamian law, then it is not. It is instead selective, even eccentric, in the issues it addresses. Many of its articles seem to be "reforms" of already existing law, and as such they define new principles of justice.

Chief among these is the principle of *talion*—an eye for an eye, a tooth for a tooth—which Hammurabi introduced to Mesopotamian law. (Sections of earlier codes from Ur compensate victims of crimes with money.) This principle punished the violence or injustice perpetrated by one free person upon another, but violence by an upper-class person on a lower-class person was penalized much less severely. Slaves

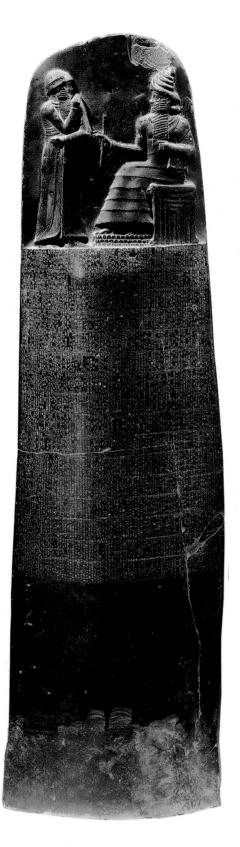

Fig. 1.19 Stele of Hammurabi, from Susa (present-day Shush, Iran). ca. 1760 BCE. Diorite, height of stele approx. 7'; height of relief 28". Musée du Louvre, Paris. This stele was stolen by invading Elamites and removed to Susa, where it was excavated by the French in 1898.

(who might be either war captives or debtors) enjoyed no legal protection at all—only the protection of their owner.

The code tells us much about the daily lives of Mesopotamian peoples, including conflicts great and small. In rules governing family relations and class divisions in Mesopotamian society, inequalities are sharply drawn. Women are inferior to men, and wives, like slaves, are the personal property of their husbands (although protected from the abuse of neglectful or unjust husbands). Incest is strictly forbidden. Fathers cannot arbitrarily disinherit their sons—a son must have committed some "heavy crime" to justify such treatment. The code's strongest concern is the maintenance and protection of the family, although trade practices and property rights are also of major importance.

The following excerpts from the code, beginning with Hammurabi's assertion of his descent from the gods and his status as their favorite (Reading 1.2), give a sense of the code's scope. But the code is, finally and perhaps above all, the gift of a king to his people, as Hammurabi's epilogue, at the end of the excerpt, makes clear:

READING 1.2

from the Law Code of Hammurabi (ca. 1760 BCE)

When the august god Anu, king of the Anunnaku deities, and the god Enlil, lord of heaven and earth, who determines the destinies of the land, allotted supreme power over all peoples to the god Marduk, the firstborn son of the god Ea, exalted him among the Igigu deities, named the city of Babylon with its august name and made it supreme exalted within the regions of the world, and established for him within it eternal kingship whose foundations are as fixed as heaven and earth, at that time, the gods Anu and Bel, for the enhancement of the well-being of the people, named me by my name, Hammurabi, the pious prince, who venerates the gods, to make justice prevail in the land, to abolish the wicked and the evil, to prevent the strong from oppressing the weak, to rise like the Sun-god Shamash over all humankind, to illuminate the land. . . .

- **1.** If a man accuses another man and charges him with homicide but cannot bring proof against him, his accuser shall be killed. . . .
- **8.** If a man steals an ox, a sheep, a donkey, a pig, or a boat—if it belongs either to the god or to the palace, he shall give thirtyfold; if it belongs to a commoner, he shall replace it tenfold; if the thief does not have anything to give, he shall be killed. . . .
- **32.** If there is either a soldier or a fisherman who is taken captive while on a royal campaign, a merchant redeems him, and helps him get back to his city—if there are sufficient in his own estate for the redeeming, he himself shall redeem himself: if there are not sufficient means in his estate to redeem him he shall be redeemed by his city's temple; if there are not sufficient means in his city's temple to redeem him, the palace shall redeem him; but his field, orchard, or house shall not be given for his redemption. . . .

- **143.** If [a woman] is not circumspect, but is wayward, squanders her household possessions, and disparages her husband, they shall cast that woman into the water. . . .
- **195.** If a child should strike his father, they shall cut off his hand.
- **196.** If an *awilu* [in general, a person subject to law] should blind the eye of another *awilu*, they shall blind his eye.
- **197.** If he should break the bone of another *awilu*, they shall break his bone. . . .
- **229.** If a builder constructs a house for a man but does not make his work sound, and the house he constructs collapses and causes the death of the householder, that builder shall be killed. . . .
- **282.** If a slave should declare to his master, "You are not my master," he (the master) shall bring charge and proof against him that he is indeed his slave, and his master shall cut off his ear. . . .

These are the decisions which Hammurabi, the able king, has established, and thereby has directed the land along the course of truth and the correct way of life.

I am Hammurabi, noble king . . .

May any king who will appear in the land in the future, at any time, observe the pronouncements of justice that I have inscribed upon my stele. May he not alter the judgments that I rendered and verdicts that I gave, nor remove my engraved image. If that man has discernment, and is capable of providing just ways for his land, may he heed the pronouncements I have inscribed upon my stele, may the stele reveal for him the traditions, the proper conduct, the judgments of the land that I rendered, the verdicts of the land that I gave and may he, too, provide just ways for all humankind in his care. . . .

I am Hammurabi, king of justice. . . .

Even if Hammurabi meant only to assert the idea of justice as the basis for his own divine rule, the stele established what amounts to a uniform code throughout Mesopotamia. It was repeatedly copied for more than 1,000 years, long after it was removed to Susa in 1157 BCE, and it established the rule of law in Mesopotamia for a millennium. From this point on, the authority and power of the ruler could no longer be capricious, subject to the whim, fancy, and subjective interpretation of his singular personality. The law was now, at least ostensibly, more objective and impartial. The ruler was required to follow certain prescribed procedures. But the law, so prescribed in writing, was now also hard to change, much less flexible, and much more impersonal. Exceptions to the rule were few and difficult to justify. Eventually, written law would remove justice from the discretion of the ruler and replace it with a legal establishment of learned judges charged with enacting the king's statutes.

Mesopotamian Literature and the Epic of Gilgamesh

Sumerian literature survives on nearly 100,000 clay tablets and fragments. Many deal with religious themes in the form of poems, blessings, and incantations to the gods. One of the

great surviving manuscripts of Mesopotamian culture, and the oldest story ever recorded, is the *Epic of Gilgamesh*. An **epic** is a long narrative poem in elevated language. It follows characters of a high position through a series of adventures, often including a visit to the world of the dead. For many literary scholars, the epic is the most exalted poetic form. The central figure is a legendary or historical figure of heroic proportion, in this case the Sumerian king Gilgamesh. Homer's *Iliad* and *Odyssey* (see Chapter 2) had been considered the earliest epics until late in the nineteenth century, when *Gilgamesh* was discovered in the library of King Ashurbanipal at Nineveh, believed to be the first library of texts systematically collected and organized in history.

The scope of an epic is large. The supernatural world of gods and goddesses usually plays a role in the story, as do battles in which the hero demonstrates his strength and courage. The poem's language is suitably dignified, often consisting of many long, formal speeches. Lists of various heroes or catalogs of their achievements are frequent.

Epics are often compilations of preexisting myths and tales handed down from generation to generation, often orally, and finally unified into a whole by the epic poet. Indeed, the outline of the story is usually known to its audience. The poet's contribution is the artistry brought to the subject, demonstrated through the use of epithets, metaphors, and similes. **Epithets** are words or phrases that characterize a person (for example, "Enkidu, the protector of herdsmen," or "Enkidu, the son of the mountain"). **Metaphors** are words or phrases used in place of another to suggest a similarity between the two, as when Gilgamesh is described as a "raging flood-wave who destroys even walls of stone." **Similes** compare two unlike things by the use of the word "like" or "as" (for example, "the land shattered like a pot").

Perhaps most important, the epic illuminates the development of a nation or race. It is a national poem, describing a people's common heritage and celebrating its cultural identity. It is hardly surprising, then, that the Assyrian king Ashurbanipal (r. 668–627 BCE), preserved the *Epic of Gilgamesh* in his great library, a collection of 20,000 to 30,000 cuneiform tablets containing approximately 1,200 distinct texts. The *Epic of Gilgamesh* preserves the historical lineage of all Mesopotamian kings—Sumerian, Akkadian, Assyrian, and Babylonian. The tale embodies their own heroic grandeur, and thus the grandeur of their peoples.

Gilgamesh consists of some 2,900 lines written in Akkadian cuneiform script on 11 clay tablets, none of them completely whole. It was composed sometime before Ashurbanipal's reign, possibly as early as 1200 BCE, by Sinleqqiunninni, a scholar-priest of Uruk. This would make Sinleqqiunninni the oldest known author. We know that Gilgamesh was the fourth king of Uruk, ruling sometime between 2700 and 2500 BCE. (The dates of his rule were recorded on a clay tablet, the Sumerian King List.) Recovered fragments of his story date back nearly to his actual reign, and the story we have, known as the Standard Version, is a compilation of these earlier versions.

At the center of the poem, in Tablet VI, Ishtar, goddess of both love and war, offers to marry Gilgamesh. Gilgamesh refuses, which unleashes Ishtar's wrath. She sends the Bull of Heaven to destroy Gilgamesh and Enkidu, but they slay it instead (Reading 1.3a).

READING 1.3a

from the *Epic of Gilgamesh*, Tablet VI (late 2nd millennium BCE)

A Woman Scorned

... When Gilgamesh placed his crown on his head Princess, Ishtar raised her eyes to the beauty of Gilgamesh. "Come along, Gilgamesh, be you my husband, to me grant your lusciousness.1

Be you my husband, and I will be your wife. I will have harnessed for you a chariot of lapis lazuli and gold,

with wheels of gold . . .

Bowed down beneath you will be kings, lords, and princes.

The Lullubu people² will bring you the produce of the mountains and countryside as tribute.

Your she-goats will bear triplets, your ewes twins, your donkey under burden will overtake the mule, your steed at the chariot will be bristling to gallop, your ox at the yoke will have no match."

Gilgamesh addressed Princess Ishtar saying: "Do you need oil or garments for your body? Do you lack anything for food or drink? I would gladly feed you food fit for a god, I would gladly give you wine fit for a king . . . a half-door that keeps out neither breeze nor blast, a palace that crushes down valiant warriors, an elephant who devours its own covering, pitch that blackens the hands of its bearer, a waterskin that soaks its bearer through. limestone that buckles out the stone wall, a battering ram that attracts the enemy land, a shoe that bites its owner's feet! Where are your bridegrooms that you keep forever? . . . You loved the supremely mighty lion, yet you dug for him seven and again seven pits. You loved the stallion, famed in battle,

and the lash, ordained for him to gallop for seven and seven hours, ordained for him drinking from muddied waters,³ you ordained for his mother Silili to wail continually. You loved the Shepherd, the Master Herder, who continually presented you with bread baked in embers,

and who daily slaughtered for you a kid.
Yet you struck him, and turned him into a wolf,

yet you ordained for him the whip, the goad,

¹Literally "fruit."

²The Lullubu were a wild mountain people living in the area of modern-day western Iran. The meaning is that even the wildest, least controllable of peoples will recognize Gilgamesh's rule and bring tribute.

³Horses put their front feet in the water when drinking, churning up mud.

so his own shepherds now chase him and his own dogs snap at his shins. You loved Ishullanu, your father's date gardener, who continually brought you baskets of dates, and brightened your table daily. You raised your eyes to him, and you went to him: 'Oh my Ishullanu, let us taste of your strength, stretch out your hand to me, and touch our

Ishullanu said to you:

"vulva."'4

'Me? What is it you want from me? . . . '

As you listened to these his words you struck him, turning him into a dwarf(?),5 . . . And now me! It is me you love, and you will ordain for me as for them!"

Her Fury

When Ishtar heard this in a fury she went up to the heavens. going to Anu, her father, and crying, going to Antum, her mother, and weeping:

"Father, Gilgamesh has insulted me over and over, Gilgamesh has recounted despicable deeds about me, despicable deeds and curses!"

Anu addressed Princess Ishtar, saying:

"What is the matter? Was it not you who provoked King Gilgamesh?

So Gilgamesh recounted despicable deeds about you, despicable deeds and curses!"

Ishtar spoke to her father, Anu, saying:

"Father, give me the Bull of Heaven, so he can kill Gilgamesh in his dwelling. If you do not give me the Bull of Heaven, I will knock down the Gates of the Netherworld, I will smash the door posts, and leave the doors flat down.

and will let the dead go up to eat the living! And the dead will outnumber the living!"

Anu addressed Princess Ishtar, saying:

"If you demand the Bull of Heaven from me, there will be seven years of empty husks for the land

Have you collected grain for the people?

Have you made grasses grow for the animals?"

Ishtar addressed Anu, her father, saying:

"I have heaped grain in the granaries for the people, I made grasses grow for the animals,

in order that they might eat in the seven years of empty

I have collected grain for the people,

I have made grasses grow for the animals. . . . "

When Anu heard her words.

he placed the nose-rope of the Bull of Heaven in her hand. Ishtar led the Bull of Heaven down to the earth.

When it reached Uruk . . .

It climbed down to the Euphrates . . .

⁴This line probably contains a word play on hurdatu as "vulva" and "date palm," the latter being said (in another unrelated text) to be "like the vulva." 5Or "frog"?

At the snort of the Bull of Heaven a huge pit opened up, and 100 Young Men of Uruk fell in.

At his second snort a huge pit opened up.

and 200 Young Men of Uruk fell in.

At his third snort a huge pit opened up,

and Enkidu fell in up to his waist.

Then Enkidu jumped out and seized the Bull of Heaven by its horns.

The Bull spewed his spittle in front of him, with his thick tail he flung his dung behind him(?).

Enkidu addressed Gilgamesh, saying:

"My friend, we can be bold(?) . . .

Between the nape, the horns, and . . . thrust your

Enkidu stalked and hunted down the Bull of Heaven. He grasped it by the thick of its tail and held onto it with both his hands(?), while Gilgamesh, like an expert butcher, boldly and surely approached the Bull of Heaven. Between the nape, the horns, and . . . he thrust his sword. . . . Ishtar went up onto the top of the Wall of Uruk-Haven, cast herself into the pose of mourning, and hurled her woeful curse:

"Woe unto Gilgamesh who slandered me and killed the Bull of Heaven!"

When Enkidu heard this pronouncement of Ishtar, he wrenched off the Bull's hindquarter and flung it in her face:

"If I could only get at you I would do the same to you! I would drape his innards over your arms!" . . .

Gilgamesh said to the palace retainers:

"Who is the bravest of the men?

Who is the boldest of the males?

-Gilgamesh is the bravest of the men,

the boldest of the males!

She at whom we flung the hindquarter of the Bull of Heaven in anger,

Ishtar has no one that pleases her . . . "

But Gilgamesh and Enkidu cannot avoid the wrath of the gods altogether. One of them, the gods decide, must die, and so Enkidu suffers a long, painful death, attended by his friend Gilgamesh, who is terrified (Reading 1.3b):

READING 1.3b

from the Epic of Gilgamesh, Tablet X (late 2nd millennium BCE)

My friend. . . . Enkidu, whom I love deeply, who went through every hardship with me, the fate of mankind has overtaken him. Six days and seven nights I mourned over him and would not allow him to be buried until a maggot fell out of his nose. I was terrified by his appearance, I began to fear death, and so roam the wilderness. The issue of Enkidu, my friend, oppresses me, so I have been roaming long trails through the wilderness. How can I stay silent, how can I be still? My friend whom I love has turned to clay. Am I not like him? Will I lie down, never to get up again?

Dismayed at the prospect of his own mortality, Gilgamesh embarks on a journey to find the secret of eternal life from the only mortal known to have attained it, Utnapishtim, who tells him the story of the Great Flood. Several elements of Utnapishtim's story deserve explanation. First of all, this is the earliest known version of the flood story that occurs also in the Hebrew Bible, with Utnapishtim in the role of the biblical Noah. The motif of a single man and wife surviving a worldwide flood brought about by the gods occurs in several Middle Eastern cultures, suggesting a single origin or shared tradition. In the Sumerian version, Ea (Enki) warns Utnapishtim of the flood by speaking to the wall, thereby technically keeping the agreement among the gods not to warn mortals of their upcoming disaster. The passage in which Ea tells Utnapishtim how to explain his actions to his people without revealing the secret of the gods is one of extraordinary complexity and wit (Reading 1.3c). The word for "bread" is kukku, a pun on the word for "darkness," kukkû. Similarly, the word for "wheat," kibtu, also means "misfortune." Thus, when Ea says, "He will let loaves of bread shower down,/ and in the evening a rain of wheat," he is also telling the truth: "He will let loaves of darkness shower down, and in the evening a rain of misfortune."

READING 1.3c

from the Epic of Gilgamesh, Tablet XI (late 2nd millennium BCE)

Utnapishtim spoke to Gilgamesh, saying: "I will reveal to you, Gilgamesh, a thing that is hidden, a secret of the gods I will tell you! Shuruppak, a city that you surely know, situated on the banks of the Euphrates, that city was very old, and there were gods inside it. The hearts of the Great Gods moved them to inflict the

Ea, the Clever Prince, was under oath with them so he repeated their talk to the reed house: 'Reed house, reed house! Wall, wall! Hear, O reed house! Understand, O wall! O man of Shuruppak, son of Ubartutu: Tear down the house and build a boat! Abandon wealth and seek living beings! Spurn possessions and keep alive human beings! Make all living beings go up into the boat. The boat which you are to build, its dimensions must measure equal to each other: its length must correspond to its width, Roof it over like the Apsu.' I understood and spoke to my lord, Ea: 'My lord, thus is your command.

I will heed and will do it.

But what shall I answer the city, the populace, and the Elders?'

Ea spoke, commanding me, his servant: '... this is what you must say to them: "It appears that Enlil is rejecting me so I cannot reside in your city, nor set foot on Enlil's earth. I will go . . . to live with my lord, Ea, and upon you he will rain down abundance, a profusion of fowls, myriad fishes. He will bring you a harvest of wealth, in the morning he will let loaves of bread shower down, and in the evening a rain of wheat." . . .

I butchered oxen for the meat(?), and day upon day I slaughtered sheep. I gave the workmen(?) ale, beer, oil, and wine, as if it were so they could make a party like the New Year's Festival. . . . The boat was finished. . . . Whatever I had I loaded on it: whatever silver I had I loaded on it, whatever gold I had I loaded on it. All the living beings that I had I loaded on it, I had all my kith and kin go up into the boat, all the beasts and animals of the field and the craftsmen I

the weather was frightful to behold! I went into the boat and sealed the entry. . . . Just as dawn began to glow there arose on the horizon a black cloud. Adad rumbled inside it. . . . Stunned shock over Adad's deeds overtook the heavens, and turned to blackness all that had been light. The . . . land shattered like a . . . pot.

I watched the appearance of the weather—

had go up. . . .

All day long the South Wind blew . . . , blowing fast, submerging the mountain in water, overwhelming the people like an attack. No one could see his fellow, they could not recognize each other in the torrent. The gods were frightened by the Flood, and retreated, ascending to the heaven of Anu. The gods were cowering like dogs, crouching by the outer

Ishtar shrieked like a woman in childbirth. . . . Six days and seven nights came the wind and flood, the storm flattening the land. When the seventh day arrived, the storm was pounding, the flood was a war-struggling with itself like a woman writhing (in labor). The sea calmed, fell still, the whirlwind (and) flood stopped

I looked around all day long—quiet had set in and all the human beings had turned to clay!

The terrain was flat as a roof.

I opened a vent and fresh air (daylight?) fell upon the side of my nose.

I fell to my knees and sat weeping, tears streaming down the side of my nose.
I looked around for coastlines in the expanse of the sea, and at twelve leagues there emerged a region (of land).
On Mt. Nimush the boat lodged firm,
Mt. Nimush held the boat, allowing no sway."

When the gods discover Utnapishtim alive, smelling his incense offering, they are outraged. They did not want a single living being to escape. But since he has, they grant him immortality and allow him to live forever in the Faraway. As a reward for Gilgamesh's own efforts, Utnapishtim tells Gilgamesh of a secret plant that will give him perpetual youth. "I will eat it," he tells the boatman who is returning him home, "and I will return to what I was in my youth." But when they stop for the night, Gilgamesh decides to bathe in a cool pool, where the scent of the plant attracts a snake who steals it away, an echo of the biblical story of Adam and Eve, whose own immortality is stolen away by the wiles of a serpent—and their own carelessness. Broken-hearted, Gilgamesh returns home empty-handed.

The Epic of Gilgamesh is the first known literary work to confront the idea of death, which is, in many ways, the very embodiment of the unknown. Although the hero goes to the very ends of the earth in his quest, he ultimately leaves with nothing to show for his efforts except an understanding of his own, very human, limitations. He is the first hero in Western literature to yearn for what he can never attain, to seek to understand what must always remain a mystery. And, of course, until the death of his friend Enkidu, Gilgamesh had seemed, in his self-confident confrontation with Ishtar and in the defeat of the Bull of Heaven, as near to a god as a mortal might be. In short, he embodied the Mesopotamian hero-king. Even as the poem asserts the hero-king's divinity—the poem first introduces him as two parts god, one part human—it emphasizes his humanity and the mortality that accompanies it. By making literal the first words of the Sumerian King List—"After the kingship had descended from heaven"—the Epic of Gilgamesh acknowledges what many Mesopotamian kings were unwilling to admit, at least publicly: their own, very human, limitations, and their own powerlessness in the face of the ultimate unknown—death.

The Hebrews

The Hebrews (from *Habiru*, "outcast" or "nomad") were a people forced out of their homeland in the Mesopotamian basin in about 2000 BCE. According to their tradition, it was in the delta of the Tigris and Euphrates rivers that God created Adam and Eve in the Garden of Eden. It was there that Noah survived the same great flood that Utnapishtim survived in the *Epic of Gilgamesh*. And it was out of there that Abraham of Ur led his people into Canaan, in order to escape the warlike Akkadians and the increasingly powerful

Babylonians. There is no actual historical evidence to support these stories. We know them only from the Hebrew Bible—a word that derives from the Greek biblia, "books"—a compilation of hymns, prophecies, and laws transcribed by its authors between 800 and 400 BCE, some 1,000 years after the events the Hebrew Bible describes. Although the archeological record in the Near East confirms some of what these scribes and priests wrote, especially about more contemporaneous events, the stories themselves were edited and collated into the stories we know today. They recount the Assyrian conquest of Israel, the Jews' later exile to Babylon after the destruction of Jerusalem by the Babylonian king Nebuchadnezzar in 587 BCE, and their eventual return to Jerusalem after the Persians conquered the Babylonians in 538 BCE. The stories represent the Hebrews' attempt to maintain their sense of their own history and destiny. But it would be a mistake to succumb to the temptation to read the Hebrew Bible as an accurate account of the historical record. Like all ancient histories, passed down orally through generation upon generation, it contains its fair share of mythologizing.

The Hebrews differed from other Near Eastern cultures in that their religion was monotheistic—they worshiped a single god, whereas others in the region tended to have gods for their clans and cities, among other things. According to Hebrew tradition, God made an agreement with the Hebrews, first with Noah after the flood, later renewed with Abraham and each of the subsequent patriarchs (scriptural fathers of the Hebrew people): "I am God Almighty; be fruitful and multiply; a nation and a company of nations shall come from you. The land which I gave to Abraham and Isaac I will give to you, and I will give the land to your descendants after you" (Genesis 35:11–12). In return for this promise, the Hebrews, the "chosen people," agreed to obey God's will. "Chosen people" means that the Jews were chosen to set an example of a higher moral standard ("a light unto the nations")—not chosen in the sense of favored, which is a common misunderstanding of the term.

Genesis, the first book of the Hebrew Bible, tells the story of the creation of the world out of a "formless void." It describes God's creation of the world and all its creatures, and his continuing interest in the workings of the world, an interest that would lead, in the story of Noah, to God's near-destruction of all things. It also posits humankind as easily tempted by evil. It documents the moment of the introduction of sin (and shame) into the cosmos, associating these with the single characteristic separating humans from animals—knowledge. And it shows, in the example of Noah, the reward for having "walked with God," the basis of the covenant.

Moses and the Ten Commandments The biblical story of Moses and the Ten Commandments embodies the centrality of the written word to Jewish culture. The Hebrew Bible claims that in about 1600 BCE drought forced the Hebrew people to leave Canaan for Egypt, where they prospered until the Egyptians enslaved them in about 1300 BCE. Defying the rule of the pharaohs, the Jewish patriarch Moses led his people out of Egypt. According to tradition, Moses led the Jews across the Red Sea (which miraculously parted to facilitate the escape) and into the desert of the Sinai peninsula. (The story

became the basis for the book of Exodus.) Most likely, they crossed a large tidal flat, called the Sea of Reeds; subsequently that body of water was misidentified as the Red Sea. Unable to return to Canaan, which was now occupied by local tribes of considerable military strength, the Jews settled in an arid region of the Sinai desert near the Dead Sea for a period of 40 years, which archeologists date to sometime between 1300 and 1150 BCE.

In the Sinai desert, the Hebrews forged the principal tenets of a new religion that would eventually be based on the worship of a single god. There, too, the Hebrew god supposedly revealed a new name for himself—YHWH, a name so sacred that it could neither be spoken nor written. The name is not known and YHWH is a cipher for it. There are, however, many other names for God in the Hebrew Bible, among them Elohim, which is plu-

ral in Hebrew, meaning "gods, deities"; Adonai ("Lord"); and El Shaddai, literally "God of the fields" but usually translated "God Almighty." Some scholars believe that this demonstrates the multiple authorship of the Bible. Others argue that the Hebrews originally worshiped many gods, as did other Near Eastern peoples. Still other scholars suggest that God has been given different names to reflect different aspects of his divinity, or the different roles he might assume—the guardian of the flocks in the fields, or the powerful master of all. Translated into Latin as "Jehovah" in the Middle Ages, the name is now rendered in English as "Yahweh." This God also gave Moses the Ten Commandments, carved onto stone tablets, as recorded in Deuteronomy 5:6-21. Subsequently, the Hebrews carried the commandments in a sacred chest, called the Ark of the Covenant (Fig. 1.20), which was lit by seven-branched candelabras known as menorahs. The centrality to Hebrew culture of these written words is even more apparent in the words of God that follow the commandments (Reading 1.4):

READING 1.4

from the Hebrew Bible (Deuteronomy 6:6-9)

- **6** Keep these words that I am commanding you today in your heart.
- **7** Recite them to your children and talk about them when you are at home and when you are away, when you lie down and when you rise.
- **8** Bind them as a sign on your hand, fix them as an emblem on your forehead,
- **9** and write them on the doorposts of your house and on your gates.

Fig. 1.20 Menorahs and Ark of the Covenant, wall painting in a Jewish catacomb, Villa Torlonia, Rome. 3rd century $c\epsilon$. 3'11" \times 5'9". Two menorahs (seven-branched candelabras) flank the Ark. The menorah is considered a symbol of the nation of Israel and its mission to be "a light unto the nations" (Isaiah 42:6). Instructions for making it are outlined in Exodus 25:31–40. Relatively little ancient Jewish art remains. Most of it was destroyed as the Jewish people were conquered, persecuted, and exiled.

Whenever the Hebrews talked, wherever they looked, wherever they went, they focused on the commandments of their God. Their monotheistic religion was thus also an ethical and moral system derived from an omnipotent God. The Ten Commandments were the centerpiece of the Torah, or Law (literally "instructions"), consisting of Genesis, Exodus, Leviticus, Numbers, and Deuteronomy. (Christians would later incorporate these books into their Bible as the first five books of the Old Testament.) The Hebrews considered these five books divinely inspired and attributed their original authorship to Moses himself, although, as we have noted, the texts as we know them were written much later.

The body of laws outlined in the Torah is quite different from the code of Hammurabi. The code was essentially a list of punishments for offenses; it is not an *ethical* code (see Fig. 1.19 and Reading 1.2). Hebraic and Mesopotamian laws are distinctly different. Perhaps because the Hebrews were once themselves aliens and slaves, their law treats the lowest members of society as human beings. As Yahweh declares in Exodus 23:6: "You will not cheat the poor among you of their rights at law." At least under the law, class distinctions, with the exception of slaves, did not exist in Hebrew society, and punishment was levied equally. Above all else, rich and poor alike were united for the common good in a common enterprise, to follow the instructions for living as God provided.

After 40 years in the Sinai had passed, it is believed that the patriarch Joshua led the Jews back to Canaan, the Promised Land, as Yahweh had pledged in the covenant. Over the next 200 years, they gradually gained control of the region through a protracted series of wars described in

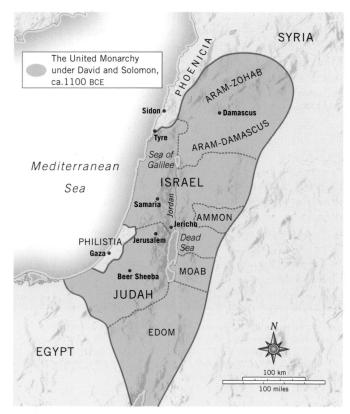

Map 1.5 The United Monarchy of Israel under David and Solomon, ca. $1100 \ \text{BCE}.$

the books of Joshua, Judges, Samuel, and Kings in the Bible, which together make up a theological history of the early Jewish peoples. The Jews named themselves the Israelites, after Israel, the name that was given by God to Jacob. The nation consisted of 12 tribes, each descended from one of Jacob's 12 sons. By about 1000 BCE, Saul had established himself as king of Israel, followed by David, who as a boy rescued the Israelites from the Philistines by killing the giant Goliath with a stone thrown from a sling, as described in First Samuel, and later united Israel and Judah into a single state (Map 1.5).

Solomon, the Prophets, and the Diaspora Solomon undertook to complete the building campaign begun by his father, and by the end of his reign, Jerusalem was, by all reports, one of the most beautiful cities in the Near East. A magnificent palace and, most especially, a splendid temple dominated the city. First Kings claims that Yahweh himself saw the temple and approved of it.

The scriptural covenant between God and the Hebrews was the model for the relationship between the Hebrew king and his people. Each provided protection in return for obedience and fidelity. The same relationship existed between the family patriarch and his household. His wife and children were his possessions, whom he protected in return for their unerring faith in him.

After Solomon's death, the United Monarchy of Israel split into two separate states. To the north was Israel, with its capital in Samaria, and to the south, Judah, with its capital in Jerusalem. In this era of the two kingdoms, Hebrew culture was dominated by prophets, men who were prophetic not in the sense of foretelling the future, but rather in the sense of serving as mouthpieces and interpreters of Yahweh's purposes, which they claimed to understand through visions. The prophets instructed the people in the ways of living according to the laws of the Torah, and they more or less freely confronted anyone guilty of wrongful actions, even the Hebrew kings. They attacked, particularly, the wealthy Hebrews whose commercial ventures had brought them unprecedented material comfort and who were inclined to stray from monotheism and worship Canaanite fertility gods and goddesses. The moral laxity of these wealthy Hebrews troubled the prophets, who urged the Hebrew nation to reform spiritually.

In 722 BCE, Assyrians attacked the northern kingdom of Israel and scattered its people, who were thereafter known as the Lost Tribes of Israel. The southern kingdom of Judah survived another 135 years, until Nebuchadnezzar and the Babylonians overwhelmed it in 587 BCE, destroying the Temple of Solomon in Jerusalem and deporting the Hebrews to Babylon. Not only had the Hebrews lost their homeland and their temple, but the Ark of the Covenant itself disappeared. For nearly 70 years, the Hebrews endured what is known as the Babylonian Captivity, as recorded in Psalm 137: "By the rivers of Babylon, there we sat down, yea we wept, when we remembered Zion."

Finally, invading Persians, whom they believed had been sent by Yahweh, freed them from the Babylonians in 520 BCE. They returned to Judah, known now, for the first time, as the Jews (after the name of their homeland). They rebuilt a Second Temple of Jerusalem, with an empty chamber at its center, meant for the Ark of the Covenant should it ever return. And they welcomed back other Jews from around the Mediterranean, including many whose families had left the northern kingdom almost 200 years earlier. Many others, however, were by now permanently settled elsewhere, and they became known as the Jews of the Diaspora or the "dispersion."

Hebrew culture would have a profound impact on Western civilization. The Jews provided the essential ethical and moral foundation for religion in the West, including Christianity and Islam, both of which incorporate Jewish teachings into their own thought and practice. In the Torah, we find the basis of the law as we understand and practice it today. So moving and universal are the stories recorded in the Torah that over the centuries they have inspired—and continue to inspire—countless works of art, music, and literature. Most important, the Hebrews introduced to the world the concept of ethical monotheism: the idea that there is only one God, and that God demands that humans behave in a certain way, and rewards and punishes accordingly. Few, if any, concepts have had a more far-reaching effect on history and culture.

The Persian Empire

In 520 BCE, the Persians, formerly a minor nomadic tribe that occupied the plateau of Iran, defeated the Babylonians and freed the Jews. Their imperial adventuring had begun in 559 BCE with the ascension of Cyrus II (called the Great, r. 559–530 BCE), the first ruler of the Achaemenid dynasty, named after Achaemenes, a warrior-king whom Persian legend says ruled on the Iranian plateau around 700 BCE. By the time of Cyrus' death, the Persians had taken control of the Greek cities in Ionia on the west coast of Anatolia. Under King Darius (r. 522–486 BCE), they soon ruled a vast empire that stretched from Egypt in the south, around Asia Minor, to the Ukraine in the north. The capital of the empire was Parsa, which the Greeks called Persepolis, or city of the Persians, located in the Zagros highlands of presentday Iran. Built by artisans and workers from all over the Persian Empire, including Greeks from Ionia, it reflected Darius' multicultural ambitions. If he was, as he said, "King of Kings, King of countries, King of the earth," his palace should reflect the diversity of his peoples.

Rulers are depicted at Persepolis in relief sculptures with Assyrian beards and headdresses (Fig. 1.21). In typical

The CONTINUING PRESENCE

of the PAST

Mesopotamian fashion, they are larger than other people in the works. These decorations further reflect the Persians' sense that all the peoples of the region owed them allegiance. Mesopotamian, Assyrian, Egyptian, and Greek styles all intermingle in the palace's architecture and decoration. The relief in Fig. 1.21, from the stairway to the audience hall where Darius and his son Xerxes received visitors, is covered with images of their subjects bringing gifts to the palace—23 subject nations in all, including Ionian, Babylonian, Syrian, and Susian, each culture recognizable by its beards and costumes. Darius can be seen receiving tribute as Xerxes stands behind him, as if waiting to take his place as the Persian ruler. These are the same two Persian leaders who, in the first decades of the fifth century BCE, would invade Greece, the son destroying, as we will see in the next chapter, the city of Athens, but in his destruction of the Greek capital, ushering in the great building campaign that was the hallmark of the Greek Golden Age.

THE STABILITY OF ANCIENT EGYPT: FLOOD AND SUN

What accounts for the stability of Egyptian culture?

Civilization in Mesopotamia developed across the last three millennia BCE almost simultaneously with civilization in Egypt. The two civilizations have much in common. Both formed around river systems—the Tigris and Euphrates in Mesopotamia; the Nile in Egypt. Both were agrarian societies that depended on irrigation, and their economies were

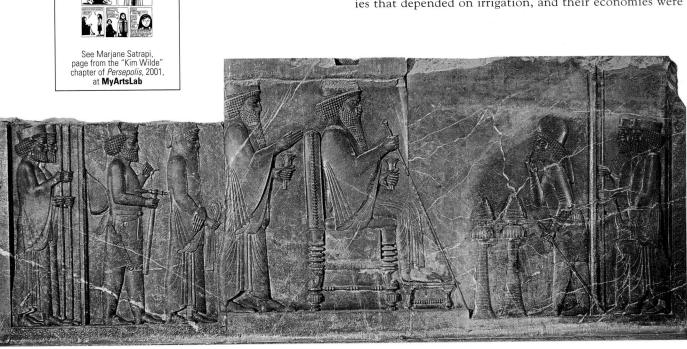

Fig. 1.21 Darius and Xerxes Receiving Tribute, detail of a relief from a stairway leading to the Hall of One Hundred Columns, ceremonial complex, Persepolis, Iran. 491–486 BCE. Limestone, height 8'4". Iranbastan Museum, Teheran. This panel was originally painted in blue, scarlet, green, purple, and turquoise. Objects such as Darius' necklace and crown were covered in gold.

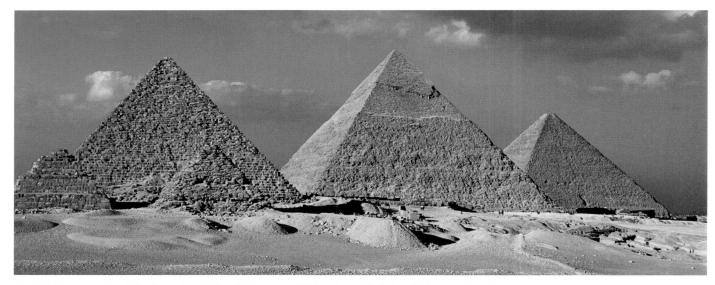

Fig. 1.22 The pyramids of Menkaure (ca. 2470 BCE), Khafre (ca. 2500 BCE), and Khufu (ca. 2530 BCE) at Giza. Giza was an elaborate complex of ritual temples, shrines, and ceremonial causeways, all leading to one or another of the three giant pyramids.

hostage to the sometimes fickle, sometimes violent flow of their respective river systems. As in Mesopotamia, Egyptians learned to control the river's flow by constructing dams and irrigation canals, and it was probably the need to cooperate with one another in such endeavors that helped Mesopotamia to thrive and Egypt to create the civilization that would eventually arise in the Nile Valley.

The Mesopotamians and the Egyptians built massive architectural structures dedicated to their gods—the ziggurats in Mesopotamia (see Fig. 1.15) and the pyramids in Egypt (Fig. 1.22). Although the former appears to be dedicated, at least in part, to water and the latter to the sun, both unite earth and sky in a single architectural form. Indeed, the earliest Egyptian pyramids were stepped structures on the model of the Mesopotamian ziggurat. Both cultures developed forms of writing, although the cuneiform script of Mesopotamian culture and the hieroglyphic script of Egyptian society were very different. There is ample evidence that the two civilizations traded with each other, and to a certain degree influenced each other.

What most distinguishes Egyptian from Mesopotamian culture, however, is the relative stability of the former. Mesopotamia was rarely, if ever, united as a single entity. Whenever it was united, it was through force, the power of an army, not the free will of a people striving for the common good. In contrast, political transition in Egypt was dynastic—that is, rule was inherited by members of the same family, sometimes for generations. As in Mesopotamia, however, the ruler's authority was cemented by his association with divine authority. He was, indeed, the manifestation of the gods on Earth. In fact, there is clear reason to believe that the sculptural image of a ruler was believed to be, in some sense, the ruler himself.

The Nile and Its Culture

Like the Tigris and Euphrates in Mesopotamia, the Nile could be said to have made Egypt possible. The river begins in the heart of Africa, one tributary in the mountains of Ethiopia and another at Lake Victoria in Uganda, from which it flows north for over 4,000 miles. Egyptian civilization developed along the last 750 miles of the river's banks, extending from the granite cliffs at Aswan north to the Mediterranean Sea (Map 1.6).

Nearly every year, torrential rains caused the river to rise dramatically. Most years, from July to November, the Egyptians could count on the Nile flooding their land. When the river receded, deep deposits of fertile silt covered the valley floor. Fields would then be tilled, and crops planted and tended. If no flood occurred for a period of years, famine could result. The cycle of flood and sun made Egypt one of the most productive cultures in the ancient world, and one of the most stable. For 3,000 years, from 3100 BCE until the defeat of Mark Antony and Cleopatra by the Roman general Octavian in 31 BCE, Egypt's institutions and culture remained remarkably unchanged.

As a result of the Nile's annual floods, Egypt called itself Kemet, meaning "Black Land." In Upper Egypt, from Aswan to the Delta, the black, fertile deposits of the river covered an extremely narrow strip of land. Surrounding the river's alluvial plain were the "Red Lands," the desert environment that could not support life, but where rich deposits of minerals and stone could be mined and quarried. Lower Egypt, consisting of the Delta itself, began some 13 miles north of Giza, the site of the Great Pyramids, across the river from what is now Cairo.

In this land of plenty, great farms flourished, and wildlife abounded in the marshes. In fact, the Egyptians linked the

marsh to the creation of the world, and represented it that way in the famous hunting scene that decorates the tomb of Nebamun at Thebes (Fig. 1.23). Nebamun is about to hurl a snake-shaped throwing stick into a flock of birds as his wife and daughter look on. The painting is a sort of visual pun, referring directly to procreation. The verb "to launch a throwing stick" also means "to ejaculate," and the word for "throwing stick" itself, to "create." The hieroglyphs written between Nebamun and his wife translate as "enjoying oneself, viewing the beautiful, . . . at the place of constant renewal of life."

Scholars divide Egyptian history into three main periods of achievement. Almost all the conventions of Egyptian art were established during the first period, the Old Kingdom. During the Middle Kingdom, the "classical" literary language that would survive through the remainder of Egyptian history was first produced. The New Kingdom was a period of prosperity that saw a renewed interest in art and architecture. During each of these periods, successive dynasties—or royal houses—brought peace and stability to the country. Between them were "Intermediate Periods" of relative instability.

Egypt's continuous cultural tradition—lasting more than 3,000 years—is history's clearest example of how peace and prosperity go hand in hand with cultural stability. As opposed to the warring cultures of Mesopotamia, where city-state vied with city-state and empire with successive empire, Egyptian culture was predicated on unity. It was a theocracy, a state ruled by a god or by the god's representative—in this case a king (and very occasionally a queen), who ruled as the living representative of the sun god, Re. Egypt's government was indistinguishable from its religion, and its religion manifested itself in nature, in the flow of the Nile, the heat of the sun, and in the journey of the sun through the day and night and through the seasons. In the last judgment of the soul

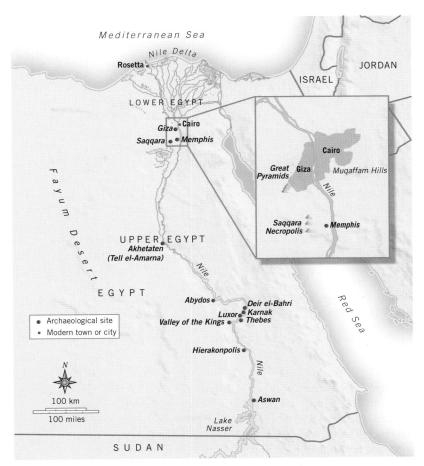

Map 1.6 Nile River Basin with archeological sites in relation to present-day Cairo. The broad expanse of the Lower Nile Delta was crisscrossed by canals, allowing easy transport of produce and supplies.

Fig. 1.23 Nebamun Hunting Birds, from the tomb of Nebamun,
Thebes. Dynasty 18, ca. 1400 BCE. Fresco on dry plaster, height approx. 2'8".

© The Trustees of the British Museum. The fish and the birds, and the cat, are completely realistic, but this is not a realistic scene. It is a conventional representation of the deceased, in this case Nebamun, spearing fish or hunting fowl, almost obligatory for the decoration of a tomb.

after death, Egyptians believed that the heart was weighed to determine whether it was "found true by trial of the Great Balance." Balance in all things—in nature, in social life, in art, and in rule—this was the constant aim of the individual. the state, and, Egyptians believed, the gods.

Whereas in Mesopotamia the flood was largely a destructive force, in Egypt it had a more complex meaning. It could, indeed, be destructive, sometimes rising so high that great devastation resulted. But without it, the Egyptians knew, their culture could not endure. So, in Egyptian art and culture, a more complex way of thinking about nature, and about life itself, developed. Every aspect of Egyptian life is countered by an opposite and equal force, which contradicts and negates it, and every act of negation gives rise to its opposite again. As a result, events are cyclical, as abundance is born of devastation and devastation closely follows abundance. Likewise, just as the floods brought the Nile Valley back to life each year, the Egyptians believed that rebirth necessarily followed death. So their religion, which played a large part in their lives, reflected the cycle of the river itself.

Egyptian Religion: Cyclical Harmony The religion of ancient Egypt, like that of Mesopotamia, was polytheistic, consisting of many gods and goddesses who were associated with natural forces and realms. When represented, gods and goddesses have human bodies and human or animal heads, and wear crowns or other headgear that identifies them by their attributes. The religion reflected an ordered universe in which the stars and planets, the various gods, and basic human activities were thought to be part of a grand and harmonious design. A person who did not disrupt this harmony did not fear death because his or her spirit would live on forever.

At the heart of this religion were creation stories that explained how the gods and the world came into being. Chief among the Egyptian gods was Re, god of the sun. According to these stories, at the beginning of time, the Nile created a great mound of silt, out of which Re was born. It was understood that Re had a close personal relationship with the king, who was considered the son of Re. But the king could also identify closely with other gods. The king was simultaneously believed to be the personification of the sky god, Horus, and was identified with deities associated with places like Thebes or Memphis when his power resided in those cities. Although not a full-fledged god, the king was netjer nefer, literally, a "junior god." That made him the representative of the people to the gods, whom he contacted through statues of divine beings placed in all temples. Through these statues, Egyptians believed, the gods manifested themselves on earth. Not only did the orderly functioning of social and political events depend upon the king's successful communication with the gods, but so did events of nature—the ebb and flow of the river chief among them.

Like the king, all the other Egyptian gods descend from Re, as if part of a family. As we have said, many can be traced back to local deities of predynastic times who later assumed greater significance at a given place—at Thebes, for instance, the trinity of Osiris, Horus, and Isis gained a special

significance. Osiris, ruler of the underworld and god of the dead, was at first a local deity in the eastern Delta. According to myth, he was murdered by his wicked brother Seth, god of storms and violence, who chopped his brother into pieces and threw them into the Nile. But Osiris's wife and sister, Isis, the goddess of fertility, collected all these parts. put the god back together, and restored him to life. Osiris was therefore identified with the Nile itself, with its annual flood and renewal. The child of Osiris and Isis was Horus, who defeated Seth and became the mythical first king of Egypt. The actual, living king was considered the earthly manifestation of Horus (as well as the son of Re). When the living king died, he became Osiris, and his son took the throne as Horus. Thus, even the kingship was cyclical.

At Memphis, the triad of Ptah, Sekhmet, and Nefertum held sway. A stone inscription at Memphis describes Ptah as the supreme artisan and creator of all things (Reading 1.5):

READING 1.5

"This It Is Said of Ptah," from Memphis, ca. 2300 BCE

This it is said of Ptah: "He who made all and created the gods." And he is Ta-tenen, who gave birth to the gods, and from whom every thing came forth, foods, provisions, divine offerings, all good things. This it is recognized and understood that he is the mightiest of the gods. Thus Ptah was satisfied after he had made all things and all divine words.

He gave birth to the gods, He made the towns, He established the nomes [provinces], He placed the gods in their shrines, He settled their offerings, He established their shrines. He made their bodies according to their wishes, Thus the gods entered into their bodies. Of every wood, every stone, every clay, Every thing that grows upon him In which they came to be.

Sekhmet is Ptah's female companion. Depicted as a lioness, she served as protector of the king in peace and war. She is also the mother of Nefertum, a beautiful young man whose name means "perfection," small statues of whom were often carried by Egyptians for good luck.

The cyclical movement through opposing forces, embodied in stories such as that of Osiris and Isis, is one of the earliest instances of a system of religious and philosophic thought that survives even in contemporary thought. Life and death, flood and sun, even desert and oasis, were part of a larger harmony of nature, one that was predictable both in the diurnal cycle of day and night and in its seasonal patterns of repetition. A good deity, such as Osiris, was necessarily balanced by a bad deity, such as Seth. The fertile Nile Valley was balanced by the harsh desert surrounding it. The narrow reaches of

30

the upper Nile were balanced by the broad marshes of the Delta. All things were predicated upon the return of their opposite, which negates them, but which in the process completes the whole and regenerates the cycle of being and becoming once again.

Pictorial Formulas in Egyptian Art

This sense of duality, of opposites, informs even the earliest Egyptian artifacts, such as the Palette of Narmer, found at Hierakonpolis in Upper Egypt (see Closer Look, pages 32–33). A palette is technically an everyday object used for grinding pigments and making body or eye paint. The scenes on the Palette of Narmer are in low relief. Like the Standard of *Ur* (see Fig. 1.17), they are arranged in registers that provide a ground line upon which the figures stand (the two liontamers are an exception). The figures typically face to the right, although often, as is the case here, the design is balanced left and right. The artist represents the various parts of the human figure in what the Egyptians thought was their most characteristic view. So, the face, arms, legs, and feet are in profile, with the left foot advanced in front of the right. The eve and shoulders are in front view. The mouth, navel and hips, and knees are in three-quarter view. As a result, the viewer sees each person in a composite view, the integration of multiple perspectives into a single unified image.

In Egyptian art, not only the figures but also the scenes themselves unite two contradictory points of view into a single image. In the Palette of Narmer, the king approaches his dead enemies from the side, but they lie beheaded on the ground before him as seen from above. Egyptian art often represents architecture in the same terms. At the top center of the Palette of Narmer, the external facade of the palace is depicted simultaneously from above, in a kind of ground plan, with its niched facade at the bottom. The design contains Narmer's Horus-name, consisting of a catfish and a chisel. The hieroglyphic signs for Narmer could not be interpreted until the nineteenth century, but we are still not sure whether it is to be read "Narmer," which are the later phonetic values of the signs. In fact, later meanings of these signs suggest that it might be read "sick catfish," which seems rather unlikely.

The Old Kingdom

Although the *Palette of Narmer* probably commemorates an event in life, as a votive object it is, like most surviving Egyptian art and architecture, chiefly concerned with burial and the afterlife. The Egyptians buried their dead on the west side of the Nile, where the sun sets, a symbolic reference to death and rebirth, since the sun always rises again. The pyramid was the first monumental royal tomb. A massive physical manifestation of the reality of the king's death, it was also the symbolic embodiment of his eternal life. It would endure for generations, as, Egyptians believed, would the king's *ka*. This idea is comparable to an enduring "soul" or "life force," a concept found in many other

Some of the Principal Egyptian Gods

- A Horus, son of Osiris, a sky god closely linked with the king; pictured as a hawk, or hawk-headed man.
- B Seth, enemy of Horus and Osiris, god of storms; pictured as an unidentifiable creature (some believe a wild donkey), or a man with this animal's head.
- C Thoth, a moon deity and god of writing, counting, and wisdom; pictured as an ibis, or ibis-headed man, often with a crescent moon on his head.
- D Khnum, originally the god of the source of the Nile, pictured as a bull who shaped men out of clay on his potter's wheel; later, god of pottery.
- E Hathor, goddess of love, birth, and death; pictured as a woman with cow's horns and a sun disk on her head.
- F Sobek, the crocodile god, associated both with the fertility of the Nile, and, because of the ferocity of the crocodile, with the army's power and strength.
- G Re, the sun god in his many forms; pictured as a hawk-headed man with a sun disk on his head.

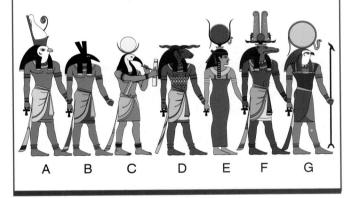

religions. The ka, which all persons possessed, was created at the same time as the physical body, itself essential for the person's existence since it provided the ka with an individual identity in which its personality, or ba, might also manifest itself. This meant that it was necessary to preserve the body after death so that the ba and ka might still recognize it for eternity. All the necessities of the afterlife, from food to furniture to entertainment, were placed in the burial chamber of the pyramid with the king's body.

Monumental royal sculpture was designed to embody the enduring nature of the royal ka. The word for sculpture in Egyptian is the same as that for giving birth. Indeed, funerary sculpture served the same purpose as the pyramids themselves—to preserve and guarantee the king's existence after death, thereby providing a kind of rebirth. The stone materials used for funerary images had to be the hardest, most durable kind, as enduring as the ka itself. Sandstone or limestone would not do. The materials of choice were diorite, schist, and granite, stones that can also take on a high polish and,

CLOSER LOOK

he Egyptians created a style of writing very different from that of their northern neighbors in Mesopotamia. It consists of hieroglyphs, "writing of the gods," from the Greek hieros, meaning "holy," and gluphein, "to engrave." Although the number of signs increased over the centuries from about 700 to nearly 5,000, the system of symbolic communication underwent almost no major changes from its advent in the fourth millennium BCE until 395 CE, when Egypt was conquered by the Roman Empire. It consists of three kinds of sign: pictograms, or stylized drawings that represent objects or beings, which can be combined to express ideas; phonograms, which are pictograms used to represent sounds; and determinatives, signs used to indicate which category of objects or beings is in question. The Palette of Narmer is

an early example of the then-developing hieroglyphic style. It consists largely of pictograms, though in the top center of each side, Narmer's name is represented as a phonogram.

The circle formed by the two elongated lions' necks intertwined on the *recto*, or front, of the palette is a bowl for mixing pigments. The palette celebrates the defeat by Narmer (r. ca. 3000 BCE) of his enemies and his unification of both Upper and Lower Egypt, which before this time had been at odds. So on the recto side, Narmer wears the red cobra crown of Lower Egypt, associated with the cobra goddess Wadjir of Buto in the Delta, and on the *verso*, or back, he wears the white crown of Upper Egypt, associated with Wadjit's sister, the vulture goddess Nekhbet of Nekheb in southern Egypt—representing his ability (and duty) to harmonize antagonistic elements.

Flanking the top of each side of the palette is a goddess wearing cow's horns; such headdresses represent the divine attributes of the figure. Later, **Hathor**, the sky mother, a goddess embodying all female qualities, would possess these attributes, but this early image probably represents the cow goddess, **Bat**.

The **mace** was the chief weapon used by the king to strike down enemies, and the scene here is emblematic of his power.

As on the other side of the palette, the king is here accompanied by his sandal-bearer, who stands on his own ground line. He carries the king's sandals to indicate that the king, who is barefoot, stands on **sacred ground**, and that his acts are themselves sacred.

Narmer, wearing the white crown of Upper Egypt, strikes down his enemy, probably the embodiment of **Lower Egypt** itself, especially since he is, in size, comparable to Narmer himself, suggesting that he is likewise a leader.

Two more figures represent the defeated enemy. Behind the one on the left is a small aerial view of a **fortified city**; behind the one on the right, a **gazelle trap**. Perhaps together they represent Narmer's victory over both city and countryside.

The reproductive r

The hawk is a symbolic representation of the god **Horus**. The king was regarded as the earthly embodiment of Horus. Here, Horus has a human hand with which he holds a rope tied to a symbolic representation of a conquered land and people.

A human head grows from the same ground as six **papyrus** blossoms, possibly the symbol of Lower Egypt.

This hieroglyph identifies the man that Narmer is about to kill, a name that is otherwise unknown.

Palette of Narmer, verso side, from Hierakonpolis. Dynasty 1, ca. 3000 BCE. Schist, height 25¼". Egyptian Museum, Cairo.

Reading the Palette of Narmer

Narmer's Palette was not meant for actual use. Rather, it is a votive, or ritual object, a gift to a god or goddess that was placed in a temple to ensure that the king, or perhaps some temple official, would have access to a palette throughout eternity. It may or may not register actual historical events, although, in fact, Egypt marks its beginnings with the unification of its Upper and Lower territories. Subsequent kings, at any rate, presented themselves in almost identical terms, as triumphing over their enemies, mace in hand, even though they had had no role in a similar military campaign. It is even

possible that by the time of Narmer such conventions were already in place, although our system of numbering Egyptian dynasties begins with him. Whatever the symbolism of the scene depicted, the **pictorial formulas**, or conventions of representation, that Egyptian culture used for the rest of its history are fully developed in this piece.

Something to Think About

Do you see any connection between the Egyptian king Narmer and the depiction of kings in Mesopotamia?

These are two instances of the hieroglyphic sign for **Narmer**, consisting of a catfish above a chisel. Each individual hieroglyph is a pictogram but is utilized here for its phonetic sound. **Nar** is the word for "catfish," and **mer** is the word for "chisel" (or, perhaps, "sickly")—hence "Narmer."In the lower instance, the hieroglyph identifies the

king. In the instance at the top, the king's name is inside a depiction of his palace seen simultaneously from above, as a ground plan, and from the front, as a facade. This device, called a **serekh**, is traditionally used to hold the king's name.

We are able to identify **Narmer** not only from his hieroglyphic name, next to him, but by his relative size. As befits the king, he is larger than anyone else.

Similarly positioned on the other side of the palette and identified by the accompanying hieroglyph, this is the king's sandal-bearer.

The **bull** here strikes down his victim and is another representation of the king's might and power. Note that in the depictions of Narmer striking down his victim and in procession, a bull's tail hangs from his waistband.

Palette of Narmer, recto side, from Hierakonpolis. Dynasty 1, ca. 3000 BCE. Schist, height 251/4". Egyptian Museum, Cairo.

rakonpolis.

The defeated **dead** lie in two rows, their decapitated heads between their feet. Narmer in sacred procession reviews them, while above them, a tiny Horus (the hawk) looks on.

This is the **mixing bowl** of the palette. The lions may represent competing forces brought under control by the king. Each is held in check by one of the king's **lion-tamers**, figures that in some sense represent state authority.

This is a representation of a fortified city as seen both from above, as a floor plan, and from the front, as a facade. It is meant to represent the actual site of Narmer's victory.

because they are not prone to fracture, can be finely detailed when carved. Most Egyptian statues were monolithic (carved out of a single piece of stone), even those depicting more than a single figure. such as the statue of Menkaure with a woman—perhaps his queen, his mother, or even a goddess—that was found at his valley temple at Giza (Fig. 1.24). Here, the deep space created by carving away the side of the stone to expose fully the king's right side seems to free him from the stone. He stands with one foot ahead of the other in the second traditional pose, the conventional depiction of a standing figure. He is not walking. Both feet are planted firmly on

Fig. 1.24 Menkaure with a Queen, probably Khamerernebty, from the valley temple of Menkaure, Giza. Dynasty 4, ca. 2460 BCE. Schist, height 54¼". Museum of Fine Arts, Boston. Harvard University—Boston Museum of Fine Arts Expedition, 11.1738. Photograph © 2014 Museum of Fine Arts, Boston. Note that the woman's close-fitting attire is nearly transparent, indicating a very fine weave of linen.

the ground (and so his left leg is, of necessity, slightly longer than his right). His back is firmly implanted in the stone panel behind him, but he seems to have emerged farther from it than the female figure who accompanies him, as if to underscore his power and might. Although the woman is almost the same size as the king, her stride is markedly shorter than his. She embraces him, her arm reaching round his back, in a gesture that suggests the simple marital affection of husband and wife. The ultimate effect of this sculpture—its solidity and unity, its sense of resolution—testifies finally to its purpose, which is to endure for eternity.

The New Kingdom and Its Moment of Change

Throughout the Middle Kingdom and well into the New Kingdom, Egyptian artistic and religious traditions remained intact. But toward the end of the Eighteenth Dynasty, Egypt experienced one of the few real crises of its entire history when, in 1353 BCE, Amenhotep IV (r. 1353–1337 BCE) assumed the throne of his father, Amenhotep III (r. 1391–1353 BCE).

Although previous Egyptian kings may have associated themselves with a single god whom they represented in human form, Egyptian religion supported a large number of gods. Even the Nile was worshiped as a god. Amenhotep IV abolished the pantheon of Egyptian gods and established a monotheistic religion in which the sun disk Aten was worshiped exclusively. Other gods were still acknowledged, but they were considered too inferior to Aten to be worth worshiping. Whether Amenhotep's religion was henotheistic—the belief and worship of a single god while accepting that other deities might also exist and be worshiped—or truly monotheistic is a matter of some debate. But his religion may well have influenced the Hebrews, whose stay in Egypt was contemporaneous with Amenhotep's rule.

Amenhotep IV believed that the sun was the creator of all life, and he was so dedicated to Aten that he changed his own name to Akhenaten ("The Shining Spirit of Aten") and moved the capital of Egypt from Thebes to a site many miles north that he named Akhetaten (modern Tell el-Amarna). This move transformed Egypt's political and cultural as well as religious life. At this new capital he presided over the worship of Aten as a divine priest and his queen as a divine priestess. Temples to Aten were open courtyards, where the altar received the sun's direct rays.

Why would Amenhotep IV/Akhenaten have substituted a brand of monotheism for Egypt's traditional polytheistic religion? Many Egyptologists argue that the switch had to do with enhancing the power of the pharaoh. With the pharaoh representing the one god who mattered, all religious justification for the power held by a priesthood dedicated to the traditional gods was gone. As we have seen, the pharaoh was traditionally associated with the sun god Re. Now, in the form of the sun disk Aten, Re was the supreme deity, embodying the characteristics of all the other gods, therefore rendering them superfluous. By analogy, Amenhotep IV/Akhenaten was now supreme priest, rendering all other

priests superfluous as well. Simultaneously, the temples dedicated to the other gods lost prestige and influence. These changes also converted the priests into dissidents.

A New Art: The Amarna Style Such significant changes had a powerful effect on the visual arts as well. Previously, Egyptian art had been remarkably stable because its principles were considered a gift of the gods—thus perfect and eternal. But now, the perfection of the gods was in question, and the principles of art were open to re-examination as well. A new art replaced the traditional canon of proportion—the familiar poses of king and queen—with realism, and a sense of immediacy, even intimacy. So Akhenaten allowed himself to be portrayed with startling realism, in what has become known, from the present-day name for the new capital, as the Amarna style.

For example, in a small relief from his new capital, Akhenaten has a skinny, weak upper body, and his belly protrudes over his skirt; his skull is elongated behind an extremely long, narrow facial structure; and he sits in a slumped, almost casual position (Fig. 1.25). (One theory holds that Akhenaten had Marfan's Syndrome, a genetic disorder that leads to skeletal abnormalities.) This depiction contrasts sharply with the idealized depictions of the pharaohs in earlier periods. Akhenaten holds one of his children in his arms and seems to have just kissed

her. His two other children sit with the queen across from him, one turning to speak with her mother, the other touching the queen's cheek. The queen herself, Nefertiti, sits only slightly below her husband and appears to share his position and authority. In fact, one of the most striking features of the Amarna style is Nefertiti's prominence in the decoration of the king's temples. In one, for example, she is shown slaughtering prisoners, an image traditionally reserved for the king himself. It is likely that her prominence was part of Akhenaten's desire to encourage the veneration of his own family (who, after all, represented Aten on earth).

The Return to Thebes and to Tradition Akhenaten's revolution was short-lived. Upon his death, Tutankhaten (r. 1336–1327 BCE), probably Akhenaten's son, assumed the throne and changed his name to Tutankhamun (indicating a return to the more traditional gods, in this case Amun). The new king abandoned Tell el-Amarna, moved the royal family to Memphis in the north, and reaffirmed Thebes as the nation's religious center. He died shortly afterward, and was buried on the west bank of the Nile at Thebes.

Tutankhamun's is the only royal tomb in Egypt to have escaped the total pillaging of looters. When Howard Carter and Lord Carnarvon discovered it under the tomb of the Twentieth Dynasty king Ramses VI in the Valley of the Kings near Deir el-Bahri, they found a coffin consisting of three separate coffins placed one inside the other (Fig. 1.26). These were in turn encased in a quartzite sarcophagus, a rectangular stone coffin that was encased in four gilded, boxlike wooden

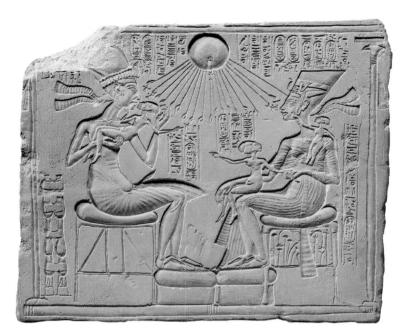

Fig. 1.25 Akhenaten and His Family, from Akhetaten (modern Tell el-Amarna). Dynasty 18, ca. 1345 BCE. Painted limestone relief, 12¾" × 14½". Staatliche Museen, Berlin, Preussischer Kulturbesitz, Ägyptisches Museum. Between Akhenaten and his queen Nefertiti, the sun disk Aten shines down beneficently. Its rays end in small hands, which hold the ankh symbol for life before both the king and queen.

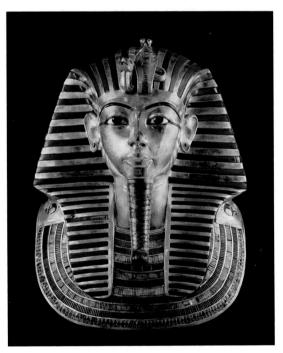

Fig. 1.26 Funerary mask of Tutankhamun. Dynasty 18, ca. 1327 BCE. Gold inlaid with glass and semiprecious stones, height 21¼". Egyptian Museum, Cairo. This death mask was placed over the upper body of the mummified king, which rested inside three other coffins, the innermost of which was made of solid gold.

shrines, also placed one inside the other. In their rigid formality, the coffins within, each depicting the king, hark back to the traditional Egyptian art of the Middle Kingdom.

The elaborate burial process was not meant solely to guarantee survival of the king's ka and ba. It also prepared him for a "last judgment," a belief system that would find expression in the Hebrew faith as well. In this two-part ritual, deities first questioned the deceased about their behavior in life. Then their hearts, the seat of the ka, were weighed against an ostrich feather, symbol of Maat, the goddess of truth,

justice, and order. Egyptians believed the heart contained all the emotions, intellect, and character of the individual, and so represented both the good and bad aspects of a person's life. If the heart did not balance with the feather, then the dead person was condemned to nonexistence, to be eaten by a creature called Ammit, the vile "Eater of the Dead," part crocodile, part lion, and part hippopotamus. Osiris, wrapped in his mummy robes, oversaw this moment of judgment. Tut himself, depicted on his sarcophagus with his crossed arms holding crook and flail, was clearly identified with Osiris.

THINKING BACK

1.1 Discuss the rise of culture and how developments in art and architecture reflect the growing sophistication of prehistoric cultures.

The widespread use of stone tools and weapons by Homo sapiens, the hominid species that evolved around 120,000–100,000 years ago, gives rise to the name of the earliest era of human development, the Paleolithic era. Carvers fashioned stone figures, both in the round and in relief. In cave paintings, such as those discovered at Chauvet Cave, the artists' great skill in rendering animals helps us to understand that the ability to represent the world with naturalistic fidelity is an inherent human skill, unrelated to cultural sophistication. If culture can be defined as a way of living—religious, social, and/or political—formed by a group of people and passed on from one generation to the next, what can the earliest art tell us about the first human cultures? What do the dwellings at Catalhöyük suggest about the growing sophistication of Neolithic peoples? What questions remain a mystery?

1.2 Describe the role of myth in prehistoric culture.

Much of our understanding of the role of myth in prehistoric cultures derives from the traditions that survive in such contemporary Native American tribes as the Hopi and Zuni, who are the direct descendants of the Anasazi. Their legends encapsulate the fundamental religious principles of the culture. Such stories, and the ritual practices that accompany them, reflect the general beliefs of most Neolithic peoples. Can you describe some of these beliefs? What role do sacred sites play, such as those at Ise in Japan?

1.3 Distinguish among the ancient civilizations of Mesopotamia, and focus on how they differ from that of the Hebrews.

The royal tombs at the Sumerian city of Ur reveal a highly developed Bronze Age culture, based on the social order of the city-state, which was ruled by a priestking acting as the intermediary between the gods and the people. The rulers also established laws and encouraged record keeping, which in turn required the development of a system of writing known as cuneiform script. In Sumer and subsequent Mesopotamian cultures, monumental structures such as ziggurats were dedicated to the gods, and in each city-state one of the gods rose to prominence as the city's protector. How would you characterize the general relationship between Mesopotamian rulers and the gods? The Hebrews practiced a monotheistic religion. They considered themselves the "chosen people" of God, whom they called Yahweh. The written word is central to their culture, and it is embodied in a body of law, the Torah. What does the Torah have in common with the Law Code of Hammurabi? How does it differ? How do the stories in Genesis, the first book of the Hebrew Bible, compare to the Epic of Gilgamesh?

1.4 Account for the stability of Egyptian culture.

The annual cycle of flood and sun, the inundation of the Nile River valley that annually deposited deep layers of silt, followed by months of sun in which crops could grow in the fertile soil, helped to define Egyptian culture. This predictable cycle helped to create a cultural belief in the stability and balance of all things that lasted for more than 3,000 years. Can you describe this belief in terms of cyclical harmony? How does the Egyptian religion reflect this belief system? Most surviving Egyptian art and architecture was devoted to burial and the afterlife, the cycle of life, death, and rebirth. In what way do the statues of Egyptian kings and queens reflect this?

Egyptian and Greek Sculpture

that is, sculpture dating from about 600–480 BCE—is notable for its stylistic connections to 2,000 years of Egyptian tradition. The Late Period statue of Mentuemhet (Fig. 1.27), from Thebes, dating from around 660 BCE, differs hardly at all from Old Kingdom sculpture at Giza (see Fig. 1.24), and even though the Anavysos Kouros (Fig. 1.28), from a cemetery near Athens, represents a significant advance in relative naturalism over the Greek sculpture of just a few years before, it still resembles its Egyptian ancestors. Remarkably, since it follows upon the Anavysos Kouros by only 75 years, the Doryphoros (Spear Bearer) (Fig. 1.29) is significantly more naturalistic. Although this is a Roman copy of a

lost fifth-century BCE bronze Greek statue, we can assume it reflects the original's naturalism, since the original's sculptor, Polyclitus, was renowned for his ability to render the human body realistically. But this advance, characteristic of Golden Age Athens, represents more than just a cultural taste for naturalism. It also represents a heightened cultural sensitivity to the worth of the individual, a belief that as much as we value what we have in common with one another—the bond that creates the city-state—our *individual* contributions are at least of equal value. By the fifth century BCE, the Greeks clearly understood that individual genius and achievement could be a matter of civic pride.

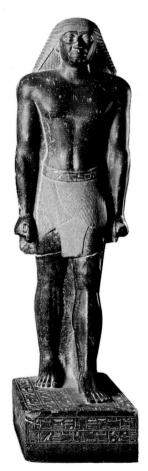

Fig. 1.27 *Mentuemhet*, from Karnak, Thebes, Egypt. ca. 660 BCE. Granite, height 54". Egyptian Museum, Cairo.

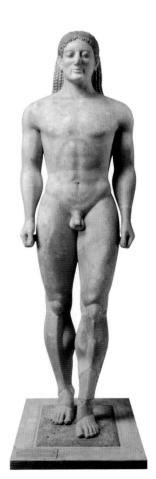

Fig. 1.28 Anavysos Kouros, from Anavysos cemetery, near Athens. ca. 525 BCE. Marble with remnants of paint, height 6'4". National Archeological Museum, Athens.

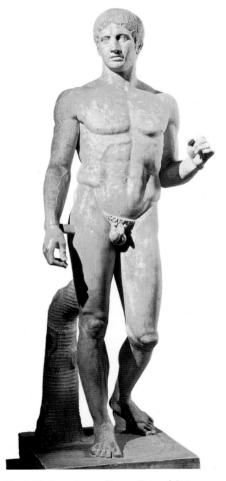

Fig. 1.29 *Doryphoros (Spear Bearer)*, Roman copy after the original bronze by Polyclitus of ca. 450–440 BCE. Marble, height 6'6". Museo Archeologico Nazionale, Naples.

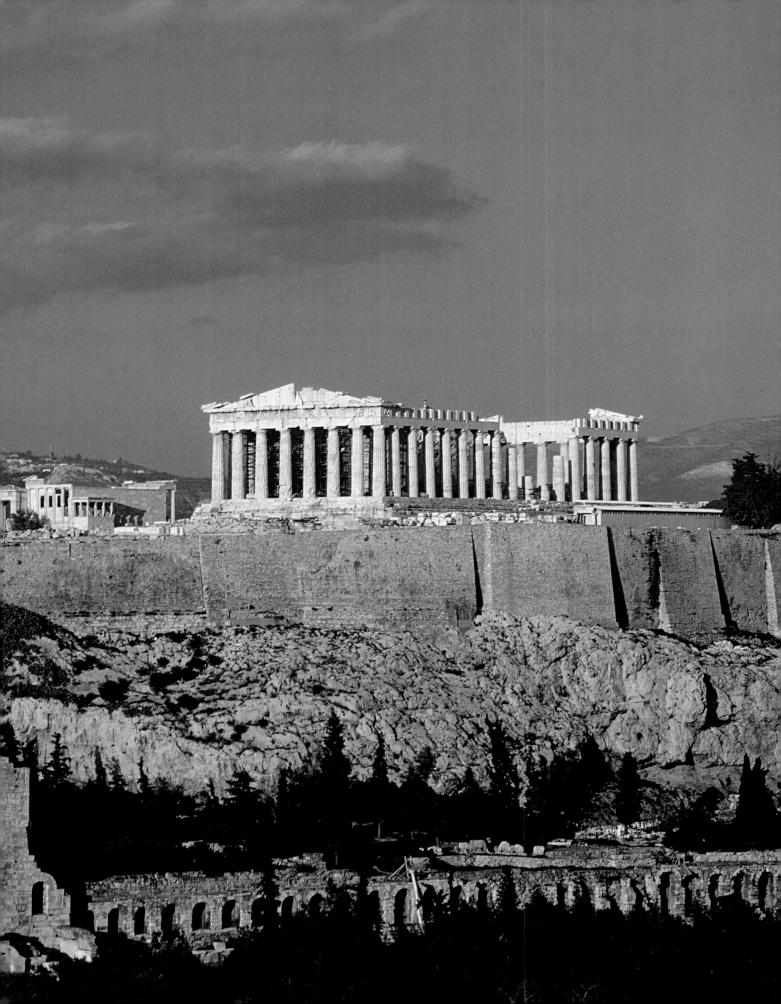

The Greek World

2

The Classical Tradition

LEARNING OBJECTIVES

- 2.1 Outline how the Cycladic, Minoan, and Mycenaean cultures contributed to the later Greeks' sense of themselves.
- 2.2 Define the polis and explain how it came to reflect the values of Greek culture.
- 2.3 Describe how Pericles defined and shaped Golden Age Athens.
- 2.4 Characterize the values of the Hellenistic world in terms of politics, philosophy, and art.

n the fourth and fifth centuries BCE, Athens was the center of the Greek world. Still predominantly rural and agricultural, it was one polis among some 8,000 poleis—or city-states—that stretched across the Greek Peloponnese, the islands of the Aegean Sea, and even farther around the Mediterranean to the Italian peninsula and the mainland of Asia Minor (Map 2.1). In fact, the Greek poleis are distinguished by their isolation from one another and their fierce sense of independence. The Greek mainland is a very rugged country of mountains separating small areas of arable land. The sea naturally separates each of the Greek islands from the mainland and one another. In this fractured geography, each polis came to think of itself less as a place and more as a cultural center in its own right. Each citizen owed allegiance and loyalty to the polis. They depended upon and served in its military. And they asserted their identity, first of all, by participating in the affairs of their own particular city-state. And yet, curiously, they maintained an identity as Greeks.

Like most poleis, the polis of Athens consisted of an urban center, small by modern standards, surrounding a natural citadel that could serve as a fortification, but which usually functioned as the city-state's religious center (Fig. 2.1). The Greeks called this citadel an acropolis—literally, the "top of the city." On lower ground, at the foot of the acropolis, was the agora, a large open space that served as public meeting place, marketplace, and civic center. The principal architectural feature of the agora was the stoa (Fig. 2.2), a

long, open arcade supported by **colonnades**, rows of columns. While Athenians could buy grapes, figs, flowers, and lambs in the agora, it was far more than just a shopping center. It was the place where citizens congregated, debated the topics of

Fig. 2.2 The Stoa of Attalus, Athens, Greece. 150 BCE. This stoa, reconstructed at the eastern edge of the modern agora, retains traditional form. The broad causeway on the right was the Panathenaic Way, the route of the ritual processions to the Acropolis in the distance. The original agora buildings lie farther to the right and overlook the Panathenaic Way.

■ Fig. 2.1 The Acropolis, Athens, Greece. Rebuilt in the second half of the 5th century BCE. After the
Persians destroyed Athens in 479 BCE, the entire city, including the Acropolis, had to be rebuilt. This afforded
the Athenians a unique opportunity to create one of the greatest monumental spaces in the history of Western
architecture.

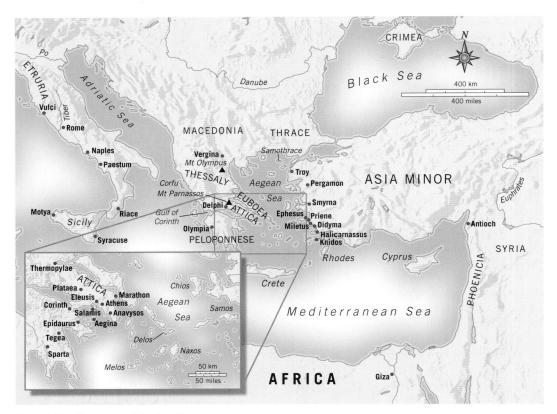

Map 2.1 The City-states of Ancient Greece.

the day, argued points of law, settled disputes, and presented philosophical discourse. In short, it was the place where they practiced their politics.

The Greek philosopher Aristotle (384–322 BCE) described the Athenian polis in his Politics: "The partnership finally composed of several villages is the polis; it has at last attained the limit of virtually complete self-sufficiency, and thus while it comes into existence for the sake of mere life, it exists for the sake of the good life." For Aristotle, the essential purpose of the polis was to guarantee, barring catastrophe, that each of its citizens might flourish. Writing in the fourth century BCE, Aristotle is thinking back to the Athens of the fifth century BCE, the so-called Golden Age. During these years the pursuit of what Aristotle called eudaimonia, "the good or flourishing life," resulted in a culture of astonishing sophistication and diversity. For eudaimonia is not simply a happy or pleasurable existence; rather, the polis provides the conditions in which each individual may pursue an "activity of soul in accordance with complete excellence." For Aristotle, this striving for "complete excellence" defines Athens in the Golden Age. The polis produced a body of philosophical thought so penetrating and insightful that the questions it posed—on the relationship between individual freedom and civic responsibility, the nature of the beautiful, the ideal harmony between the natural world and the intellectual or spiritual realm, to name a few—and the conclusions it reached dominated Western inquiry for centuries to come.

This chapter traces the rise of Greek culture from its earliest roots in the pre-literary cultures of the Aegean Sea, from whom the Greeks believed their own great culture sprang, through its Golden Age in the fifth century BCE, when Athens became a place of absolute cultural ascendancy, to Greece's cultural domination of the Eastern Mediterranean world and beyond, until, in the first century BCE, Rome came to challenge Greek ascendancy across the Mediterranean basin.

BRONZE AGE CULTURE IN THE AEGEAN

What differentiates the cultures of the Aegean from one another, and how did they contribute to the later Greeks' sense of themselves?

The Aegean Sea, in the eastern Mediterranean, is filled with islands. Here, beginning in about 3000 BCE, seafaring cultures took hold. So many were the islands, and so close to one another, that navigators were always within sight of land. In the natural harbors where seafarers came ashore, port communities developed and trade began to flourish.

The later Greeks thought of the Bronze Age Aegean peoples as their ancestors—particularly those who inhabited the Cyclades islands, the island of Crete, and

Mycenae, on the Peloponnese—and considered their activities and culture as part of their own prehistory. They even had a word for the way they knew them—archaiologia, "knowing the past." They did not practice archeology as we do today, excavating ancient sites and scientifically analyzing the artifacts discovered there. Rather, they learned of their past through legends passed down, at first orally and then in writing, from generation to generation. Interestingly, the modern practice of archeology has confirmed much of what was legendary to the Greeks.

The Cyclades

The Cyclades are a group of more than 100 islands in the Aegean Sea between mainland Greece and the island of Crete. They form a roughly circular shape, giving them their name, from the Greek word kyklos, "circle" (also the origin of our word "cycle"). No written records of the early Cycladic people remain, although archeologists have found a good deal of art in and around hillside burial chambers. The most famous of these artifacts are marble figurines in a highly simplified and abstract style that appeals to the modern eye (Fig. 2.3). The Cycladic figures originally looked quite different because they were painted. Most of the figurines depict females, but male figures, including seated harpists and acrobats, also exist. The figurines range in height from a few inches to life-size, but anatomical detail in all of them is reduced to essentials. With their toes pointed down, their heads tilted back, and their arms crossed across their chests, the fully extended figures are corpselike. Their function remains unknown, but some scholars suggest they were used for home worship and then buried with their owner.

By about 2200 BCE, trade with Crete to the south brought the Cyclades into the larger island's political orbit and radically altered late Cycladic life. Evidence of this influence survives in the form of wall paintings such as the *Miniature Ship Fresco*, a frieze at the top of at least three walls, which suggests a prosperous seafaring community engaged in a celebration of the sea (Fig. 2.4). People lounge on terraces and rooftops as boats glide by, accompanied by leaping dolphins. The painting was discovered in 1967 on the island of Thera (today known as Santorini), at Akrotiri,

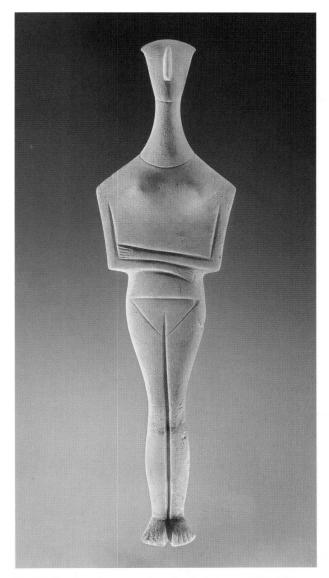

Fig. 2.3 Figurine of a woman from the Cyclades. ca. 2400–2100 BCE. Marble, height 17". Antikensammlung, Staatliche Museen, Berlin. Larger examples of such figurines may have been objects of worship.

Fig. 2.4 *Miniature Ship Fresco* (detail from the left section), from Room 5, West House, Akrotiri, Thera (Santorini). Before 1623 BCE. Height 145/16". National Archeological Museum, Athens. The total length of this fresco is over 24 feet. Harbors such as this one provided shelter to traders who sailed between the islands of the Aegean Sea as early as 3000 BCE.

a community that had been buried beneath one of the largest volcanic eruptions in the last 10,000 years. About 7 cubic miles of magma spewed forth, and the ash cloud that resulted during the first phase of the eruption was about 23 miles high. The enormity of the eruption caused the volcano at the center of Thera to collapse, producing a caldera, a large basin or depression that filled with seawater. The present island of Thera is actually the eastern rim of the original volcano (small volcanoes are still active in the center of Thera's crescent sea).

The eruption was so great that it left evidence worldwide—in the stunted growth of tree rings as far away as Ireland and California, and in ash taken from ice core samples in Greenland. With this evidence, scientists have dated the eruption to 1623 BCE. In burying the city of Akrotiri, it also preserved it. Not only were the community's homes elaborately decorated—with mural paintings such as the Miniature Ship Fresco, which was made with water-based pigments on wet plaster, and which extended across the top of at least three walls in a second-story room, suggesting a prosperous, seafaring community—but its citizens also enjoyed a level of personal hygiene unknown elsewhere in Western culture until Roman times. Clay pipes led from interior toilets and baths to sewers built under winding, paved streets. Straw reinforced the walls of the houses, protecting them against earthquakes and insulating them from the heat of the Mediterranean sun.

Minoan Culture in Crete

Just to the south of the Cyclades lies Crete, the largest of the Aegean islands. Bronze Age civilization developed there as early as 3000 BCE. Trade routes from Crete established communication with such diverse areas as Turkey, Cyprus, Egypt, Afghanistan, and Scandinavia, from which the island imported copper, ivory, amethyst, lapis lazuli, carnelian, gold, and amber. From Britain, Crete imported the tin necessary to produce bronze. A distinctive culture called Minoan flourished on Crete from about 1900 to 1375 BCE. The name comes from the legendary king Minos, who was said to have ruled the island's ancient capital of Knossos.

Many of the motifs in the frescoes at Akrotiri, in the Cyclades, also appear in the art decorating Minoan palaces on Crete, including the palace at Knossos. This suggests the mutual influence of Cycladic and Minoan cultures by the start of the second millennium BCE. Unique to Crete, however, is emphasis on the bull, the central element of one of the best-preserved frescoes at Knossos, the *Toreador Fresco* (Fig. 2.5). Three almost nude figures appear to toy with a charging bull. (As in Egyptian art, women are traditionally depicted with light skin, men with a darker complexion.) The woman on the left holds the bull by the horns, the man vaults over its back, and the woman on the right seems to have either just finished a vault or to have positioned herself to catch the man. It is unclear whether this is a ritual

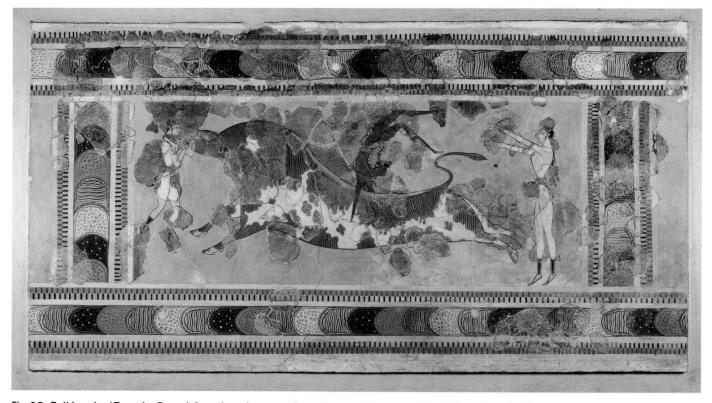

Fig. 2.5 Bull Leaping (Toreador Fresco), from the palace complex at Knossos, Crete. ca. 1450–1375 BcE. Fresco, height approx. 24½". Archeological Museum, Iráklion, Crete. The darker patches of the fresco are original fragments. The lighter areas are modern restorations.

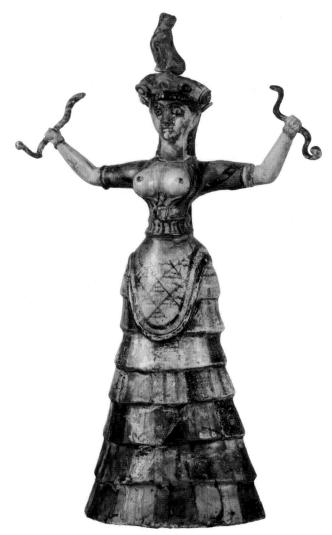

Fig. 2.6 Snake Goddess or Priestess, from the palace at Knossos, Crete. ca. 1500 BCE. Faience, height 11%". Archeological Museum, Iráklion, Crete. Faience is a kind of earthenware ceramic decorated with glazes. Modern faience is easily distinguishable from ancient because it is markedly lighter in tone.

activity, perhaps part of a rite of passage. What we do know is that the Minoans regularly sacrificed bulls, as well as other animals, and that the bull was at least symbolically associated with male virility and strength.

Female Deities The people of Thera and Crete seem to have shared the same religion as well as similar artistic motifs. Ample archeological evidence tells us that the Minoans in Crete worshiped female deities. We do not know much more than that, but some students of ancient religions have proposed that the Minoan worship of one or more female deities is evidence that in very early cultures the principal deity was a goddess rather than a god.

It has long been believed that one of the Minoan female deities was a snake goddess, but recently, scholars

have questioned the authenticity of most of the existing snake goddess figurines. Sir Arthur Evans (1851–1941), who first excavated at the Palace of Minos on Crete, identified images of the Cretan goddess as "Mountain Goddess," "Snake Goddess," "Dove Goddess," "Goddess of the Caves," "Goddess of the Double Axes," "Goddess of the Sports," and "Mother Goddess." Evans saw all these as different aspects of a single deity, or Great Goddess. A century after he introduced the Snake Goddess (Fig. 2.6) to the world, scholars are still debating its authenticity. In his book Mysteries of the Snake Goddess (2002), Kenneth Lapatin makes a convincing case that craftspeople employed by Evans manufactured artifacts for the antiquities market. He believes that the body of the statue is an authentic antiquity, but the form in which we see it is largely the imaginative fabrication of Evans's restorers. Many parts were missing when the figure was unearthed, and so an artist working for Evans fashioned new parts and attached them to the figure. The snake in the goddess's right hand lacked a head, leaving its identity as a snake open to question. Most of the goddess's left arm, including the snake in her hand, were absent and later fabricated. When the figure was discovered, it lacked a head, and this one is completely fabricated. The cat on the goddess's head is original, although it was not found with the statue. Lapatin believes that Evans, eager to advance his own theory that Minoan religion was dedicated to the worship of a Great Goddess, never questioned the manner in which the figures were restored. As interesting as the figure is, its identity as a snake goddess is at best questionable. We cannot even say with certainty that the principal deity of the Minoan culture was female, let alone that she was a snake goddess. There are no images of snake goddesses in surviving Minoan wall frescoes, engraved gems, or seals, and almost all the statues depicting her are fakes or imaginative reconstructions.

It is likely, though, that Minoan female goddesses were closely associated with a cult of vegetation and fertility, and the snake is an almost universal symbol of rebirth and fertility. We do know that the Minoans worshiped on mountaintops, closely associated with life-giving rains, and deep in caves, another nearly universal symbol of the womb in particular and origin in general. And in early cultures, the undulations of the earth itself—its hills and ravines, caves and riverbeds—were (and often still are) associated with the curves of the female body and genitalia. But until early Minoan writing is deciphered, the exact nature of Minoan religion will remain a mystery.

The Palace of Minos The Snake Goddess was discovered along with other ritual objects in a storage pit in the Palace of Minos at Knossos. The palace as Evans found it is enormous, covering more than 6 acres. There were originally two palaces at the site—an "old palace," dating from 1900 BCE, and a "new palace," built over the old one after an enormous earthquake in 1750 BCE. This "new palace" was the focus of Evans's attention.

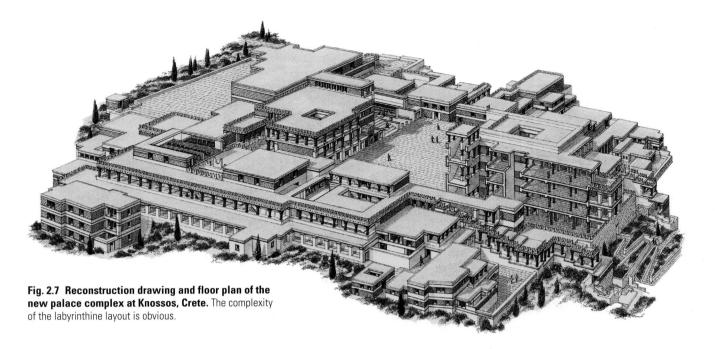

The palace at Knossos was only loosely organized around a central, open courtyard, as a reconstruction drawing makes clear (Fig. 2.7). Leading from the courtyard were corridors, staircases, and passageways that connected living quarters, ritual spaces, baths, and administrative offices, in no discernable order or design. Workshops surrounded the complex, and vast storerooms could easily provide for the needs of both the palace population and the population of the surrounding countryside. In just one storeroom, excavators discovered enough ceramic jars to hold 20,000 gallons of olive oil.

Hundreds of wooden columns decorated the palace. Only fragments have survived, but we know from paintings and ceramic house models how they must have looked. Evans created concrete replicas, which are displayed today at the West Portico and the Grand Staircase (Fig. 2.8). The originals were made of huge timbers cut on Crete and then turned upside down so that the top of each is broader than the base. The columns were painted bright red with black capitals, the sculpted blocks that top them. The capitals are shaped like pillows or cushions. (In fact, they are very close to the shape of an evergreen's root ball, as if the original design were suggested by trees felled in a storm.) Over time, as the columns rotted or were destroyed by earthquakes or possibly burned by invaders, they must have become increasingly difficult to replace, for Minoan builders gradually deforested the island. This may be one reason why the palace complex was abandoned sometime around 1450 BCE.

Representations of double axes decorated the palace at every turn, and indeed the Palace of Minos was known in Greek times as the House of the Double Axes. In fact, the Greek word for the palace was *labyrinth*, from *labrys*, "double ax." Over time, the Greeks came to associate the House of the Double Axes with its inordinately complex layout, and *labyrinth* came to mean "maze."

The Legend of Minos and the Minotaur The Greeks solidified the meaning of the labyrinth in a powerful legend. King Minos boasted that the gods would grant him anything he wished, so he prayed that a bull might emerge from the sea that he might sacrifice to the god of the sea, Poseidon. A white bull did emerge from the sea, one so beautiful that Minos decided to keep it for himself and sacrifice a different one from his herd instead. This angered Poseidon, who took revenge by causing Minos' queen, Pasiphae, to fall in love

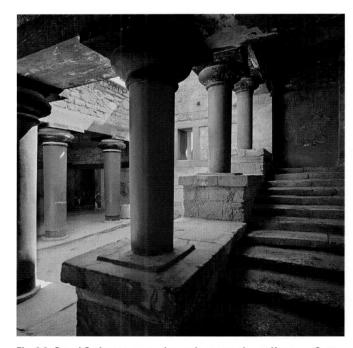

Fig. 2.8 Grand Staircase, east wing, palace complex at Knossos, Crete. ca. 1500 BCE, as reconstructed by Sir Arthur Evans. The staircase served as a light well and linked all five stories of the palace.

with the bull. To consummate her passion, she convinced Minos' chief craftsperson, Daedalus, to construct a hollow wooden cow into which she might place herself and attract the bull. The result of this union was a horrid creature, half man, half bull: the Minotaur.

To appease the monster's appetite for human flesh, Minos ordered the city of Athens, which he also ruled, to send him 14 young men and women each year as sacrificial victims. Theseus, son of King Aegeus of Athens, vowed to kill the Minotaur. As he set sail for Crete with 13 others, he promised his father that he would return under white sails (instead of the black sails of the sacrificial ship) to announce his

victory. At Crete, he seduced Ariadne, daughter of Minos. Wishing to help Theseus, she gave him a sword with which to kill the Minotaur and a spindle of thread to lead himself out of the maze in which the Minotaur lived. Victorious, Theseus sailed home with Ariadne but abandoned her on the island of Naxos, where she was discovered by the god of wine, Dionysus, who married her and made her his queen. Theseus, sailing into the harbor at Athens, neglected to raise the white sails, perhaps intentionally. When his father, King Aegeus, saw the ship still sailing under black sails, he threw himself into the sea, which from then on took his name, the Aegean. Theseus, of course, then became king.

The story is a creation or origin myth, like the Zuni emergence tale (see Reading 1.1 in Chapter 1) or the Hebrew story of Adam and Eve in Genesis. But it differs from them in one important point: Rather than narrating the origin of humankind in general, it tells the story of the birth of one culture out of another. It is the Athenian Greeks' way of knowing their past, their archaiologia. The tale of the labyrinth explained to the later Greeks where and how their culture came to be. It correctly suggests a close link to Crete, but it also emphasizes Greek independence from that powerful island. It tells us, furthermore, much about the emerging Greek character, for Theseus would, by the fifth century BCE, achieve the status of a national hero. The great tragedies of Greek theater represent Theseus as wily, ambitious, and strong. He stops at nothing to achieve what he thinks he must. If he is not altogether admirable, he mirrors behavior the Greeks attributed to their gods. Nevertheless, he is anything but idealized or godlike. He is, almost to a fault, completely human.

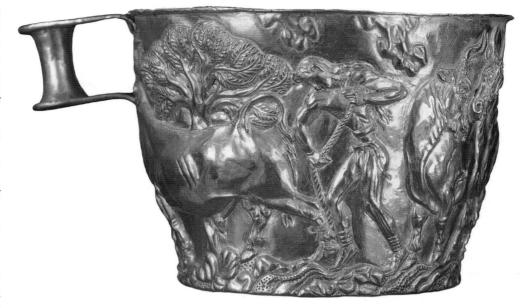

Fig. 2.9 Vaphio Cup, from a tomb at Vaphio, south of Sparta, Greece. ca. 1650–1450 BCE. Gold, height 3½". National Archeological Museum, Iráklion, Crete. Mycenaean invaders used Crete as a base for operations for several centuries, and probably acquired the cup there.

It was precisely this search for the origins of Greek culture that led Sir Arthur Evans to the discovery of the Palace of Minos in Crete. He confirmed "the truth" in the legend of the Minotaur. If there was no actual monster, there was indeed a labyrinth. And that labyrinth was the palace itself.

Mycenaean Culture on the Mainland

When the Minoans abandoned the palace at Knossos in about 1450 BCE, warriors from the mainland culture of Mycenae, on the Greek mainland, quickly occupied Crete (see Map 2.1). One reason for the abandonment of Knossos was suggested earlier—the deforestation of the island. Another might be that Minoan culture was severely weakened in the aftermath of the volcanic eruption on Thera, and therefore susceptible to invasion or internal revolution. A third might be that the Mycenaean army simply overwhelmed the island. The Mycenaeans were certainly acquainted with the Minoan culture some 92 miles to their south, across the Aegean.

Minoan metalwork was prized on the mainland. Its fine quality is very evident in the *Vaphio Cup*, one of two golden cups found in the nineteenth century in a tomb at Vaphio, just south of Sparta, on the Peloponnese (Fig. 2.9). This cup was executed in **repoussé**, a technique in which the artist hammers out the design from the inside. It depicts a man in an olive grove capturing a bull by tethering its hind legs. The bull motif is classically Minoan. The Mycenaeans, however, could not have been more different from the Minoans. Whereas Minoan towns were unfortified, and battle scenes were virtually nonexistent in their art, the Mycenaeans lived in communities surrounding fortified hilltops, and battle and hunting scenes dominate their art. Minoan culture appears to

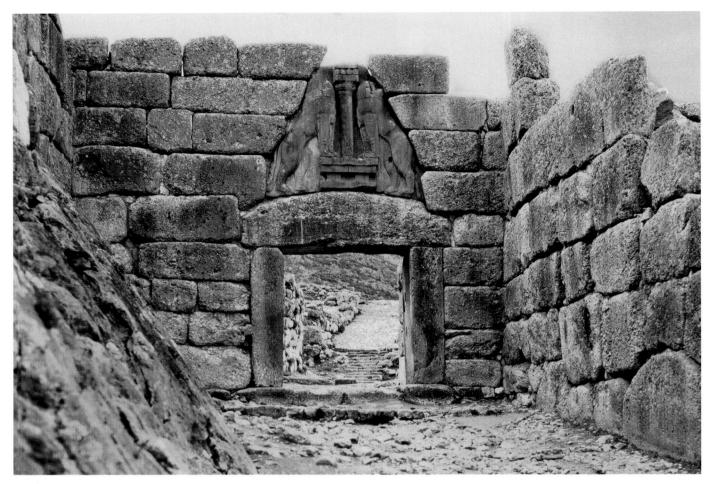

Fig. 2.10 Lion Gate, Mycenae, Greece. ca. 1300 BCE. Limestone relief, panel approx. 9'6" high. The lionesses are carved on a triangle of stone that relieves the weight of the massive doorway from the lintel. The original heads, which have never been found, were attached to the bodies with dowels.

have been peaceful, while the warlike Mycenaeans lived and died by the sword.

The ancient city of Mycenae, which gave its name to the larger Mycenaean culture, was discovered by German archeologist Heinrich Schliemann (1822-1890) in the late nineteenth century, before Sir Arthur Evans discovered Knossos. Its citadel looks down across a broad plain to the sea. Its walls—20 feet thick and 50 feet high—were built from huge blocks of rough-hewn stone, in a technique called cyclopean masonry because it was believed by later Greeks that only a race of monsters known as the Cyclopes could have managed them. Visitors to the city entered through a massive Lion Gate at the top of a steep path that led from the valley below (Fig. 2.10). The lionesses that stood above the gate's lintel were themselves 9 feet high. It is likely that their missing heads originally turned in the direction of approaching visitors, as if to ward off evil or, perhaps, humble them in their tracks. They were probably made of a different stone from the bodies and may have been plundered at a later time. From the gate, a long, stone street wound up the hill to the citadel itself. Here, overseeing all, was the king's palace.

Mycenae was only one of several fortified cities on mainland Greece that were flourishing by 1500 BCE and that have come to be called Mycenaean. Mycenaean culture was the forerunner of ancient Greek culture and was essentially feudal in nature—that is, a system of political organization held together by ties of allegiance between a lord and those who relied on him for protection. Kings controlled not only their own cities but also the surrounding countryside. Merchants, farmers, and artisans owed their own prosperity to the king and paid high taxes for the privilege of living under his protection. More powerful kings, such as those at Mycenae itself, also expected the loyalty (and financial support) of other cities and nobles over whom they exercised authority. A large bureaucracy of tax collectors, civil servants, and military personnel ensured the state's continued prosperity. Like the Minoans, they engaged in trade, especially for the copper and tin required to make bronze.

The feudal system allowed Mycenae's kings to amass enormous wealth, as Schliemann's excavations confirmed. He discovered gold and silver death masks of fallen heroes (Fig. 2.11), as well as swords and daggers inlaid with imagery of

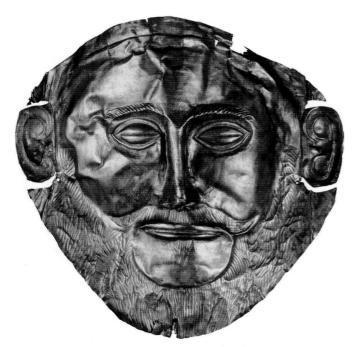

Fig. 2.11 Funerary mask (*Mask of Agamemnon*), from Grave Circle A, Mycenae, Greece. ca. 1600–1550 BCE. Gold, height approx. 12". National Archeological Museum, Athens. When Schliemann discovered this mask, he believed it was the death mask of King Agamemnon, but it predates the Trojan War by some 300 years. Recent scholarship suggests that Schliemann may have added the handlebar mustache and large ears, perhaps to make the mask appear more "heroic."

events such as a royal lion hunt. He also found delicately carved ivory, from the tusks of hippopotamuses and elephants, suggesting if not the breadth of Mycenae's power, then the extent of its trade, which clearly included Africa. It seems likely, in fact, that the Mycenaean taste for war, and certainly its occupation of Crete, was motivated by the desire to control trade routes throughout the region.

The Homeric Epics

In about 800 BCE, the Greeks began to write down the stories from and about their past—their archaiologia—that had been passed down, generation to generation, by word of mouth. The most important of these stories were composed by an author whom history calls Homer. Homer was most likely a bard, a singer of songs about the deeds of heroes and the ways of the gods. His stories were part of a long-standing oral tradition that dated back to the time of the Trojan War, which we believe occurred sometime around 1200 BCE. Out of the oral materials he inherited, Homer composed two great epic poems, the Iliad and the Odyssey. The first narrates an episode in the tenyear Trojan War, which, according to Homer, began when the Greeks launched a large fleet of ships under King Agamemnon of Mycenae to bring back Helen, the wife of his brother King Menelaus of Sparta, who had eloped with Paris, son of King Priam of Troy. The Odyssey narrates the adventures of one of the principal Greek leaders, Odysseus (also known as Ulysses), on his return home from the fighting.

Most scholars believed that these Homeric epics were pure fiction until the discovery by Heinrich Schliemann in the 1870s of the actual site of Troy, a multilayered site near modern-day Hissarlik, in northwestern Turkey. The Troy of Homer's epic was discovered in the sixth layer. (Schliemann also believed that the shaft graves at Mycenae, where he found so much treasure, were those of Agamemnon and his royal family, but modern dating techniques have ruled that out.) Suddenly, the *Iliad* assumed, if not the authority, then the aura of historical fact.

By the sixth century BCE, the *Iliad* was recited every four years in Athens (without omission, according to law), and many copies of it circulated in Greece in the fifth and fourth centuries BCE. Finally, in Alexandria, Egypt, in the late fourth century BCE, scribes wrote the poem on papyrus scrolls, perhaps dividing it into the 24 manageable units we refer to today as the poem's books.

The poem was so influential that it established certain epic conventions, standard ways of composing an epic that were followed for centuries to come. Examples include starting the poem *in medias res*, Latin for "in the middle of things," that is, in the middle of the story; invoking the muse at the poem's outset; and stating the poem's subject at the outset.

The *Iliad* tells but a small fraction of the story of the Trojan War, which was launched by Agamemnon of Mycenae and his allies to attack Troy around 1200 BCE. The tale begins after the war is under way and narrates what is commonly called "the rage of Achilles," a phrase drawn from the first line of the poem. Already encamped on the Trojan plain, Agamemnon has been forced to give up a girl that he has taken in one of his raids, but he takes the beautiful Briseis from Achilles as compensation. Achilles, by far the greatest of the Greek warriors, is outraged. He suppresses his urge to kill Agamemnon, but withdraws from the war. He knows that the Greeks cannot succeed without him, and in his rage he believes they deserve their fate. Indeed, Hector, the great Trojan prince, soon drives the Greeks back to their ships, and Agamemnon sends ambassadors to Achilles to offer him gifts and beg him to return to the battle. Achilles refuses: "His gifts, I loathe his gifts. . . . I wouldn't give you a splinter for that man! Not if he gave me 10 times as much, 20 times over." When the battle resumes, things become desperate for the Greeks. Achilles partially relents, permitting Patroclus, his close friend and perhaps his lover, to wear his armor in order to put fear into the Trojans. Led by Patroclus, the Achaeans, as Homer calls the Greeks, drive the Trojans back.

The most notable feature of the poem is the unflinching verbal picture Homer paints of the realities of war, not only its cowardice, panic, and brutality, but also its compelling attraction. In this arena, the Greek soldier is able to demonstrate one of the most important values in Greek culture, his areté, often translated as "virtue," but actually meaning something closer to "being the best you can be" or "reaching your highest human potential." Homer uses the term to describe

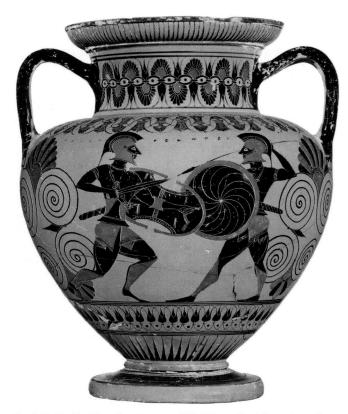

Fig. 2.12 Botkin Class Amphora. ca. 540–530 Bcs. Black figure decoration on ceramic, height 11% π, diameter 9½". Museum of Fine Arts, Boston, Henry Lillie Pierce Fund, 98.923. Photograph © 2014 Museum of Fine Arts, Boston. On the other side of this vase are two heavily armed warriors, one pursuing the other.

both Greek and Trojan heroes, and it refers not only to their bravery but also to their effectiveness in battle.

The sixth-century BCE painting on the side of the Botkin Class Amphora—an amphora is a Greek jar, with an eggshaped body and two curved handles, used for storing oil or wine—embodies the concept of areté (Fig. 2.12). Here, two warriors, one armed with a sword, the other with a spear, confront each other with unwavering determination and purpose. At one point in the Iliad, Homer describes two such warriors, holding their own against each other, as "rejoicing in the joy of battle." They rejoice because they find themselves in a place where they can demonstrate their areté. The following passage, from Book 24, the final section of the Iliad, shows the other side of war and the other side of the poem, the compassion and humanity that distinguish Homer's narration (Reading 2.1). Hector, son of the king of Troy, has struck down Patroclus with the aid of the god Apollo. On hearing the news, Achilles is devastated and finally enters the fray. Until now, fuming over Agamemnon's insult, he has sat out the battle, refusing, in effect, to demonstrate his own areté. But now, he redirects his rage from Agamemnon to the Trojan warrior Hector, whom he meets and kills. He then ties Hector's body to his chariot and drags it to his tent. The act is pure sacrilege, a violation of the dignity due the great Trojan warrior and an insult to his memory. Late that night, Priam, the king of Troy, steals across enemy lines to Achilles' tent and begs for the body of his son:

READING 2.1

from Homer, *Iliad*, Book 24 (ca. 750 BCE)

"Remember your own father, great godlike Achillesas old as I am, past the threshold of deadly old age! No doubt the countrymen round about him plague him now, with no one there to defend him, beat away disaster. No one—but at least he hears you're still alive and his old heart rejoices, hopes rising, day by day, to see his beloved son come sailing home from Troy. But I-dear god, my life so cursed by fate . . . I fathered hero sons in the wide realm of Troy and now not a single one is left, I tell you. Fifty sons I had when the sons of Achaea came, nineteen born to me from a single mother's womb and the rest by other women in the palace. Many, most of them violent Ares cut the knees from under. But one, one was left me, to guard my wall, my peoplethe one you killed the other day, defending his fatherland, my Hector! It's all for him I've come to the ships now, to win him back from you—I bring a priceless ransom. Revere the gods, Achilles! Pity me in my own right, remember your own father! I deserve more pity . . . I have endured what no one on earth has ever done before-I put to my lips the hands of the man who killed my son."

Those words stirred within Achilles a deep desire to grieve for his own father. Taking the old man's hand he gently moved him back. And overpowered by memory both men gave way to grief. Priam wept freely for man-killing Hector, throbbing, crouching before Achilles's feet as Achilles wept himself, now for his father, now for Patroclus once again, and their sobbing rose and fell throughout the house. . . . Then Achilles called the serving-women out: "Bathe and anoint the body—bear it aside first. Priam must not see his son." He feared that, overwhelmed by the sight of Hector, wild with grief, Priam might let his anger flare and Achilles might fly into fresh rage himself, out the old man down and break the laws of Zous

wild with grief, Priam might let his anger flare and Achilles might fly into fresh rage himself, cut the old man down and break the laws of Zeus. So when the maids had bathed and anointed the body sleek with olive oil and wrapped it round and round in a braided battle-shirt and handsome battle-cape, then Achilles lifted Hector up in his own arms and laid him down on a bier, and comrades helped him raise the bier and body onto a sturdy wagon. . . . Then with a groan he called his dear friend by name: "Feel no anger at me, Patroclus, if you learn—ever there in the House of Death—I let his father have Prince Hector back. He gave me worthy ransom and you shall have your share from me, as always, your fitting, lordly share."

Homer clearly recognizes the ability of these warriors to exceed their mere humanity, to raise themselves not only to a level of great military achievement, but also to a state of compassion, nobility, and honor. It is this exploration of the "doubleness" of the human spirit, its cruelty and its humanity, its blindness and its insight, that perhaps best defines the power and vision of the Homeric epic.

Homer's second epic, the *Odyssey*, narrates the adventures of Odysseus on his ten-year journey home from the war in Troy—his encounters with monsters, giants, and a seductive enchantress, a sojourn on a floating island and another in the underworld. But above all the poem's subject is Odysseus' passionate desire once more to see his wife, Penelope, and Penelope's fidelity to him. Where anger and lust drive the *Iliad*—from Achilles' angry sulk to Helen's fickleness—love and familial affection drive the *Odyssey*. Penelope is gifted with *areté* in her own right, since for the 20 years of her husband's absence she uses all the cunning in her power to ward off the suitors who flock to marry her, convinced that Odysseus is never coming home.

In later Greek culture, the *Iliad* and the *Odyssey* were the basis of Greek education. Every schoolchild learned the two poems by heart. They were the principal vehicles through which the Greeks came to know the past, and through the past, they came to know themselves. The poems embodied what might be called the Greeks' own cultural as opposed to purely personal *areté*, their desire to achieve a place of preeminence among all states. But in defining this larger cultural ambition, the *Iliad* and *Odyssey* laid out the individual values and responsibilities that all Greeks understood to be their personal obligations and duties if the state were ever to realize its goals.

THE RISE OF THE GREEK POLIS

How are the values of the Greek polis reflected in its art and architecture?

The Greek city-state, or polis, arose during the ninth century BCE, around the time of Homer. Colonists set sail from cities on the Greek mainland to establish new settlements. Eventually, there were as many as 1,500 Greek city-states scattered around the Mediterranean and the Black Sea from Spain to the Crimea, including large colonies in Italy (Fig. 2.13). Since the fall of Mycenae in about 1100 BCE, some 100 years after the Trojan War, Greece had endured a long period of cultural decline that many refer to as the Dark Ages. Greek legend has it that a tribe from the North, the Dorians, overran the Greek mainland and the Peloponnese. Historical evidence suggests that the Dorians possessed iron weapons and easily defeated the bronze-armored Greeks. Scattered and in disarray, the Greek people almost forgot the rudiments of culture, and reading and writing fell into disuse. For the most part, the Greeks lived in small rural communities that often warred with one another. But despite these conditions, which hardly favored the development of art and architecture, the Greeks managed to sustain a sense of identity and even, as the survival of the Trojan War legends suggests, some idea of their cultural heritage.

Gradually, across Greece, communities began to organize themselves and exercise authority over their own limited geographical regions, which were defined by natural boundaries—mountains, rivers, and plains. The population of even the largest communities was largely dedicated to agriculture, and agricultural values—a life of hard, honest

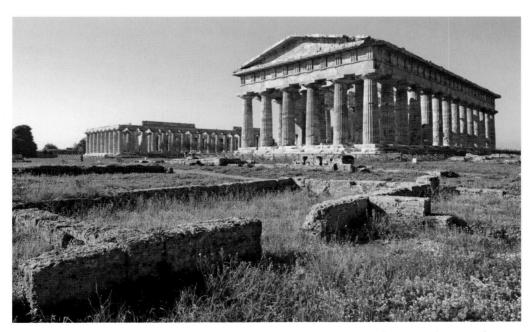

Fig. 2.13 The Temple of Hera I (background), ca. 560 BCE, and the Temple of Hera II (foreground), ca. 460 BCE, Paestum, Italy. Two of the best-preserved Greek temples can be found in Italy, at Paestum, south of Naples, in a place the Greeks called Poseidonia, after the god of the sea, Poseidon.

work and self-reliance—predominated. The great pastoral poem of the poet Hesiod (flourished ca. 800 BCE), Works and Days, testifies to this. Works and Days was written at about the same time as the Homeric epics in Boeotia, the region of Greece dominated by the city-state of Thebes. Hesiod gives us a clear insight not only into many of the details of Greek agricultural production, but into social conditions as well. He mentions that all landowners possessed slaves (taken in warfare), who comprised over half the population. He also speaks of the Greek gods Zeus, king of the gods and master of the sky, and Demeter, goddess of agriculture and grain, and the necessity of working hard in order to please them. In fact, it was Hesiod, in his Theogony (The Birth of the Gods), who first detailed the Greek pantheon (literally, "all the gods").

The Greek Gods

The religion of the Greeks informed almost every aspect of daily life. The gods watched over the individual at birth, nurtured the family, and protected the city-state. They controlled the weather, the seasons, health, marriage, longevity, and the future, which they could foresee. Each polis traced its origins to a particular founding god—Athena for Athens, Zeus for Sparta. Sacred sanctuaries were dedicated to others.

The Greeks believed that the 12 major gods lived on Mount Olympus, in northeastern Greece. While the number of gods on Olympus was fixed at 12, over time different gods were included and others excluded, so that some 15 gods were considered "major" at one time or another. There they ruled over the Greeks in a completely human fashion. They quarreled and meddled, loved and lost, exercised justice or not—and they were depicted by the Greeks in human form. There was nothing special about them except their power, which was enormous, sometimes frighteningly so. But the Greeks believed that as long as they did not overstep their bounds and try to compete with the gods—the sin of hubris, or pride—the gods would protect them.

Among the major gods (with their later Roman names in parentheses) are:

Zeus (Jupiter): King of the gods, usually bearded, and associated with the eagle and thunderbolt.

Hera (Juno): Wife and sister of Zeus, and the goddess of marriage and maternity.

Athena (Minerva): Goddess of war, but also, through her association with Athens, of civilization; the daughter of Zeus, born from his head; often helmeted, shield and spear in hand; the owl (wisdom) and the olive tree (peace) are sacred to her.

Ares (Mars): God of war, and son of Zeus and Hera, usually armored.

Aphrodite (Venus): Goddess of love and beauty; Hesiod says she was born when the severed genitals of Uranus, the Greek personification of the sky, were cast into the sea and his sperm mingled with sea foam to create her. Eros is her son.

Apollo (Phoebus): God of the sun, light, truth, prophecy, music, and medicine; he carries a bow and arrow,

sometimes a lyre; he is often depicted riding a chariot across the sky.

Artemis (Diana): Goddess of the hunt and the moon; Apollo's sister, she carries bow and arrow, and is accompanied by hunting dogs.

Demeter (Ceres): Goddess of agriculture and grain.

Dionysus (Bacchus): God of wine and inspiration, closely aligned to myths of fertility and sexuality.

Hermes (Mercury): Messenger of the gods, but also god of fertility, theft, dreams, commerce, and the marketplace; usually wearing winged sandals and a winged hat, he carries a wand with two snakes entwined around it.

Hades (Pluto): God of the underworld, accompanied by his monstrous dog Cerberus.

Hephaestus (Vulcan): God of the forge and fire; son of Zeus and Hera and husband of Aphrodite; wears a blacksmith's apron and carries a hammer.

Hestia (Vesta): Goddess of the hearth and sister of Zeus.

Poseidon (Neptune): Brother of Zeus and god of the sea; carries a trident (a three-pronged spear); the horse is sacred to him.

Persephone (Proserpina): Goddess of fertility, Demeter's daughter, carted off each winter to the underworld by her husband Hades, but released each spring to restore the world to plenty.

Of particular interest here—as in Homer's Iliad—is that the gods are as susceptible to Eros, or Desire, as is humankind. In fact, the Greek gods are sometimes more human than humans—susceptible to every human foible. Like many a family on Earth, the father, Zeus, is an all-powerful philanderer, whose wife, Hera, is watchful, jealous, and capable of inflicting great pain on rivals for her husband's affections. Their children are scheming and self-serving in their competition for their parents' attention. The gods think like humans, act like humans, and speak like humans. They sometimes seem to differ from humans only in the fact that they are immortal. Unlike the Hebrew God, who is admittedly sometimes portrayed as arbitrary—consider the Book of Job—the Greek gods present humans with no clear principles of behavior, and the priests and priestesses who oversaw the rituals dedicated to them produced no scriptures or doctrines. The gods were capricious, capable of changing their minds, susceptible to argument and persuasion, alternately obstinate and malleable. If these qualities created a kind of cosmic uncertainty, they also embodied the intellectual freedom and the spirit of philosophical inquiry that would come to define the Greek state.

The Greek Architectural Tradition

The Greek poleis were distinguished by their physical isolation from one another and their fierce independence. In competition for the few really fertile lands on the mainland, they often warred with one another. And inevitably certain city-states became more powerful than others. Before the ninth century BCE, many Athenians had migrated to Ionia in southwestern Anatolia (modern Turkey), and relations with the Near East helped Athens to flourish. Corinth, situated on the isthmus

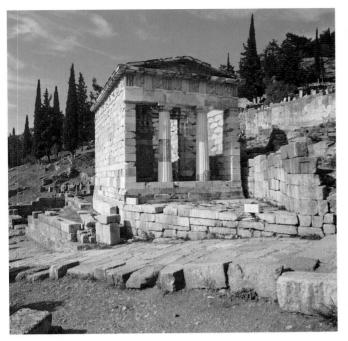

Fig. 2.14 The Athenian Treasury, Delphi, and plan. ca. 510 BCE. The sculptural program around the Treasury, just below the roof line, depicts the adventures of two great Greek mythological heroes, Theseus and Heracles.

between the Greek mainland and the Peloponnese, controlled north-south trade routes from early times, but after it built a towpath to drag ships over the isthmus on rollers, it soon controlled the sea routes east and west as well. The Spartans, on the Peloponnese, traced their ancestry back to the legendary Dorians, whose legacy was military might. But despite their many differences, a common architectural tradition began to arise among the poleis, one that not only demonstrated their common cultural heritage, but has also had a lasting influence on Western architecture as a whole.

As early as the eighth century BCE, various poleis began to establish sanctuaries where they could come together to share music, religion, poetry, and athletics. The sanctuary was a large-scale reflection of another Greek invention, the symposium, literally a "coming together" of men (originally of the same military unit) to share poetry, food, and wine. At the sanctuaries, people from different city-states came together to honor their gods and, by extension, to celebrate, in the presence of their rivals, their own accomplishments.

Delphi The sanctuaries were sacred religious sites. They inspired the city-states, which were always trying to outdo one another, to create the first monumental architecture since Mycenaean times. At Delphi, high in the mountains above the Gulf of Corinth, and home to the Sanctuary of Apollo, the city-states, in their usual competitive spirit, built monuments and statues dedicated to the god, and elaborate treasuries to store offerings. Many built hostels so that pilgrims from home could gather. Delphi was an especially important site. Here, the Greeks believed, the Earth was attached to the sky by its navel. Here, too, through a deep crack in the

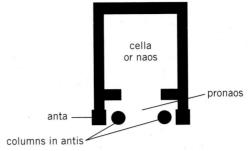

ground, Apollo spoke, through the medium of a woman called the Pythia. Priests interpreted the cryptic omens and messages she delivered. The Greek author Plutarch, writing in the first century CE, said that the Pythia entered a small chamber beneath the temple, smelled sweet-smelling fumes, and went into a trance. This story was dismissed as fiction until recently, when geologists discovered that two faults intersect directly below the Delphic temple, allowing hallucinogenic gases to rise through the fissures, specifically ethylene, which has a sweet smell and produces a narcotic effect described as a floating or disembodied euphoria.

The facade of the Athenian Treasury at Delphi consisted of two columns standing in antis (that is, between two-squared stone pilasters, called antae). Behind them is the pronaos, or enclosed vestibule, at the front of the building, with its doorway leading into the cella (or naos), the principal interior space of the building (see the floor plan, Fig. 2.14).

We can see the antecedents of this building type in a small ceramic model of an early Greek temple dating from the eighth century BCE and found at the Sanctuary of Hera near Argos (Fig. 2.15). Its projecting porch supported by two columns anticipates the antis columns and pronaos of the Athenian Treasury. The triangular area over the porch created by the pitch of the roof, called the pediment, is not as steeply pitched in the Treasury.

Fig. 2.15 Model of a temple, found in the Sanctuary of Hera, Argos. Mid-8th century BCE. Terra cotta, length 4½". National Archeological Museum, Athens. We do not know if later temples were painted like the model here.

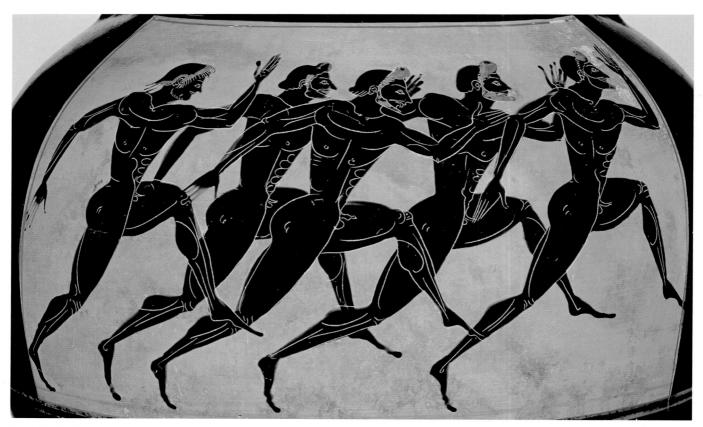

Fig. 2.16 The Euphiletos Painter, Black-figure amphora showing a foot-race at the Panathenaic Games in Athens (detail). ca. 530 BCE. Terra cotta, height $24\frac{1}{2}$ ". The Metropolitan Museum of Arts, New York. Rogers Fund, 1914 (14.130.12). Greek athletes competed nude. In fact, our word *gymnasium* derives from the Greek word for "naked," *gymnos*.

The Temples of Hera at Paestum From this basic form, surviving in the small treasuries at Delphi, the larger temples of the Greeks would develop. Two distinctive orders—systems of proportion that include the building's plan, its elevation (the arrangement and appearance of the temple's foundation, columns, and lintels), and decorative scheme—developed before 500 BCE, the Doric order and the Ionic order (see Closer Look, pages 54–55). Later, a third, Corinthian order would emerge. Among earliest surviving examples of a Greek temple of the Doric order are the Temples of Hera I and II in the Sanctuary of Hera at Paestum, a Greek colony established in the seventh century BCE in Italy, about 50 miles south of present-day Naples (see Fig. 2.13). As the plan of the Temple of Hera I makes clear, the earlier of the two temples was a large, rectangular structure, with a pronaos containing three (as opposed to two) columns and an elongated cella, behind which is an adyton, the innermost sanctuary housing the place where, in a temple with an oracle, the oracle's message was delivered. Surrounding this inner structure was the peristyle, a row of columns that stands on the stylobate, the raised platform of the temple. The columns swell about one-third of the way up and contract again at the top, a characteristic known as entasis, and are topped by the two-part capital of the Doric order with its rounded enchinus and tabletlike abacus.

Olympia and the Olympic Games The Greeks date the beginning of their history to the first formal Panhellenic ("all-Greece") athletic competition, held in 776 BCE. These first Olympic Games were held at Olympia. There, a sanctuary dedicated to Hera and Zeus also housed an elaborate athletics facility. The first contest of the first games was a 200-yard dash the length of the Olympia stadium, a race called the stadion (Fig. 2.16). Over time, other events of solo performance were added, including chariot racing, boxing, and the pentathlon (from Greek penta, "five," and athlon, "contest"), consisting of discus, javelin, long jump, sprinting, and wrestling. There were no second or third prizes. Winning was all. The contests were conducted every four years during the summer months and were open only to men (married women were forbidden to attend, and unmarried women probably did not attend). The Olympic Games were held for more than 1,000 years, until the Christian Byzantine emperor Theodosius banned them in 394 ce. They were revived in 1896 to promote international understanding and friendship.

The Olympic Games were only one of numerous athletic festivals held in various locations. These games comprised a defining characteristic of the developing Greek national identity. As a people, the Greeks believed in *agonizesthai*, a verb meaning "to contend for the prize." They were driven by competition. Potters bragged that their work was better

than any other's. Playwrights competed for best play, poets for best recitation, athletes for best performance. As the city-states themselves competed for supremacy, they began to understand the spirit of competition as a trait shared by all.

Greek Sculpture and the Taste for Naturalism

Greek athletes performed nude, so it is not surprising that athletic contests gave rise to what may be called a "cult of the body." The physically fit male not only won accolades in athletic contests, but also represented the conditioning and strength of the military forces of a particular polis. The male body was also celebrated in a widespread genre of sculpture known as the kouros, meaning "young man" (Figs. 2.17 and 2.18). This celebration of the body was uniquely Greek. No other Mediterranean culture so emphasized the depiction of the male nude. Several thousand kouroi (plural of kouros) appear to have been carved in the sixth century BCE alone. They could be found in sanctuaries and cemeteries, most often serving as votive offerings to the gods or as commemorative grave markers. Their resolute features suggest their determination in their role as ever-watchful guardians.

Although we would never mistake an early Greek figure (such as Fig. 2.17) for the work of an Egyptian sculptor—its nudity and much more fully realized anatomical features are clear differences—still, its Egyptian influences are obvious, as can be seen in the comparison between a late Egyptian sculpture and the two *kouroi* dating from 600 BCE and 525 BCE respectively (see Fig. 1.27).

CONTINUITY & CHANGE

Mentuemhet, p. 37

In fact, as early as 650 BCE, the Greeks were in Egypt, and by the early sixth century

early sixth century BCE, 12 cooperating city-states had established a trading outpost in the Nile Delta. The Greek sculpture serves much the same funerary function as its Egyptian ancestors. In fact, an inscription on the base of Fig. 2.17 reads: "Stop and grieve at the dead Kroisos, slain by wild Ares in the front rank of battle.

This is a monument to a fallen hero, killed in the prime of youth."

During the course of the sixth century, *kouroi* became distinguished by *naturalism*. That is, they increasingly reflect the artist's desire to represent the human body as it appears in nature. This in turn probably reflects the growing role of the individual in Greek political life. We do not know why sculptors wanted to realize the human form more naturalistically,

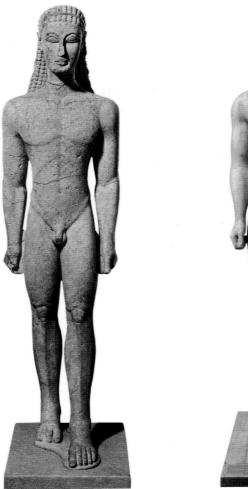

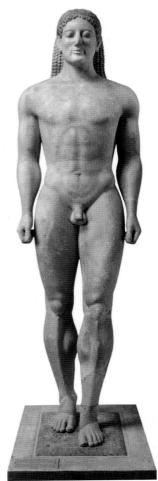

Fig. 2.17 (left) *New York Kouros.* **ca. 600 BCE.** Marble, height 6'4". The Metropolitan Museum of Art, New York. Fletcher Fund, 1932 (32.11.1).

Fig. 2.18 (right) *Anavysos Kouros*, from Anavysos cemetery, near Athens. ca. **525** BCE. Marble with remnants of paint, height 6'4". National Archeological Museum, Athens. The sculpture on the left is one of the earliest known life-size standing sculptures of a male in Greek art. The one on the right represents 75 years of Greek experimentation with the form. Note its closed-lip "Archaic smile," a symbol of liveliness and vitality.

but we can surmise that the reason must be related to agonizesthai, the spirit of competition so dominant in Greek society. Sculptors must have competed against one another in their attempts to realize the human form. Furthermore, since it was believed that the god Apollo manifested himself as a well-endowed athlete, the more lifelike and natural the sculpture, the more nearly it could be understood to resemble the god himself.

At the center of Athenian life was the worship, on the Acropolis, of the goddess Athena, the city's protector. Just as the *kouros* statue seems related to Apollo, statues of *korai*, or "maidens" (singular *kore*), appear to have been votive offerings to Athena and were apparently conceived as gifts to the goddess. Male citizens dedicated *korai* to her as a gesture of both piety and evident pleasure in the beauty of the sculpture itself. From the mid-sixth century BCE on, the sculptural production of *korai* flourished in Athens.

CLOSER LOOK

lassical Greek architecture is composed of three vertical elements—the platform, the column, and the entablature—which comprise its elevation. The relationship of these three units is referred to as the elevation's order. There are three orders—Doric, Ionic, and Corinthian—each distinguished by its specific design.

The Classical Greek orders became the basic design elements for architecture from ancient Greek times to the present day. A major source of their power is the sense of order, predictability, and proportion that they embody. Notice how the upper elements of each order—the elements comprising the entablature—change as the column supporting them becomes narrower and taller. In the Doric order, the architrave (the bottom layer of the entablature) and the frieze (the flat band just above the architrave decorated with sculpture, painting, or moldings) are comparatively massive. The Doric is the heaviest of the columns. The Ionic is lighter and noticeably smaller. The Corinthian is smaller yet, seemingly supported by mere leaves.

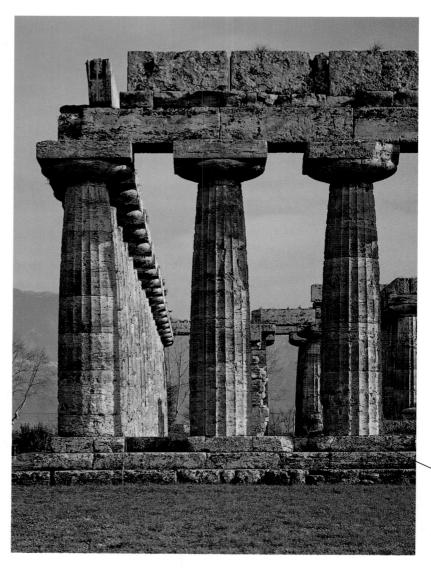

Doric columns at the Temple of Hera I, and plan. Paestum, Italy. ca. 540 BCE. The floor plan of all three orders is essentially the same, although in the Doric order the last two columns were set slightly closer together—corner contraction, as it is known—resulting in the corner gaining a subtle visual strength and allowing regular spacing of sculptural elements in the entablature above.

Something to Think About . . .

The base, shaft, and capital of a Greek column have often been compared to the feet, body, and head of the human figure. How would you compare the Doric, Ionic, and Corinthian orders to Figs. 2.17, 2.18, and 2.27?

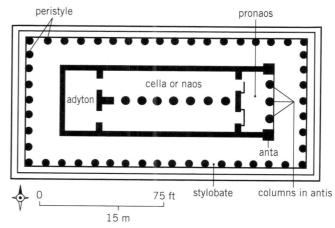

The Classical Orders

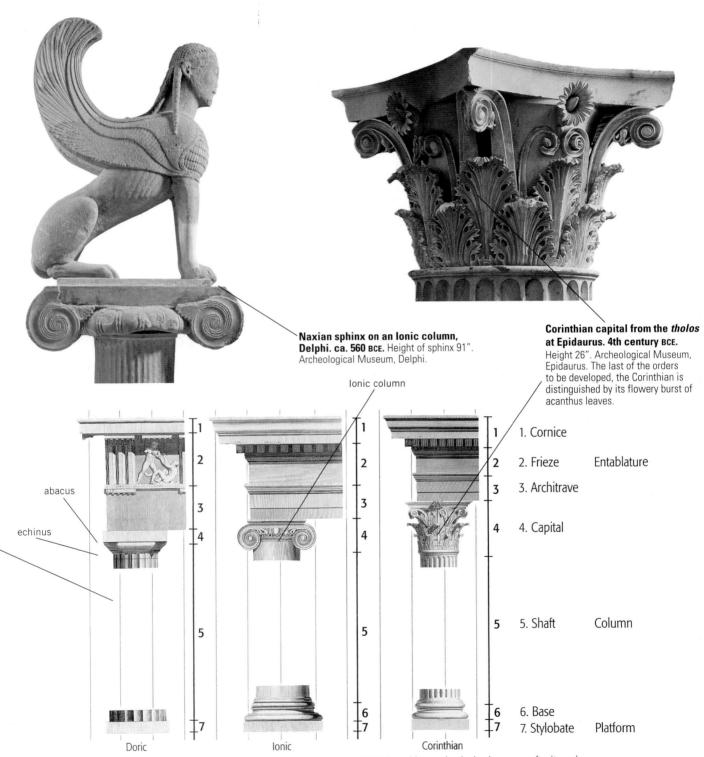

The Classical Orders, from James Stuart, *The Antiquities of Athens*, London, 1794. An architectural order lends a sense of unity and structural integrity to a building as a whole. By the century BCE, the Greeks had developed the Doric and the lonic orders. The former is sturdy and simple. The latter is lighter in proportion and more elegant in detail, its capital characterized by a scroll-like motif called a **volute**. The Corinthian order, which originated in the last half of the century BCE, is the most elaborate of all. It would become a favorite of the Romans.

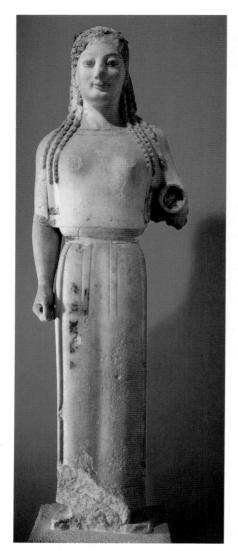

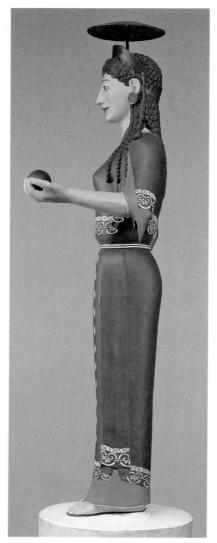

Fig. 2.19 *Peplos Kore* and cast reconstruction of the original, from the Acropolis, Athens. **Dedicated 530 BCE.** Polychromed marble, height 47%". Acropolis Museum, Athens (original), and Museum of Classical Archaeology, University of Cambridge, UK (cast). The extended arm, probably bearing a gift, was originally a separate piece, inserted in the round socket at her elbow. Note the small size of this sculpture, more than 2 feet shorter than the male *kouros* sculptures (Fig. 2.17 and Fig. 2.18).

As with the *kouros* statues, the *korai* also became more naturalistic during the century. This trend is especially obvious in their dress. In the sculpture known as the *Peplos Kore* (Fig. **2.19**), anatomical realism is suppressed by the straight lines of the sturdy garment known as a *peplos*. Usually made of wool, the *peplos* is essentially a rectangle of cloth folded down at the neck, pinned at the shoulders, and belted. Another *kore*, also remarkable for the amount of original paint on it, is the *Kore* dating from ca. 520 BCE found on the Athenian Acropolis (Fig. **2.20**). This one wears a *chiton*, a garment that by the last decades of the century had become much more popular than the pelos. Made of linen, the chiton clings more closely to the body and is gathered to create pleats and folds that allow the artist to show off his virtuosity.

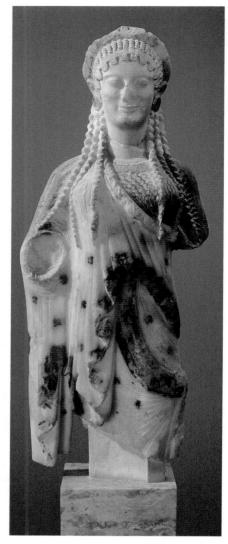

Fig. 2.20 Kore, from the Acropolis, Athens. ca. 520 BCE. Polychromed marble, height 21". Acropolis Museum, Athens. Although missing half its height, the sculpture gives us a clear example of the elaborate dress of the last years of the sixth century BCE.

Athenian Pottery

The same trend toward increasing naturalism is also evident in the decorative painting on Greek pottery. By the middle of the sixth century BCE, Athens had become a major center of pottery making. Athenian potters were helped along by the extremely high quality of the clay available in Athens, which turned a deep orange color when fired.

As with Athenian sculpture, the decorations on Athenian vases grew increasingly naturalistic and detailed until, generally, only one scene filled each side of the vase. The Greeks soon developed two types of vase, characterized by the relationship of figure to ground: black- and red-figure vases. The figures on black-figure vases are painted with slip, a mixture of clay and water, so that after firing they

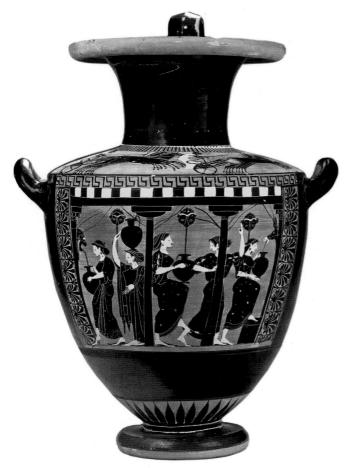

Fig. 2.21 Priam Painter, Women at the Fountain. ca. 520–510 BCE. Black-figure decoration on a hydria (water jug). Height 201/k, diameter 141/16". Museum of Fine Arts, Boston. Reproduced with permission. Photograph © 2014 Museum of Fine Arts, Boston. All rights reserved. The convention of depicting women's skin as white is also found in Egyptian and Minoan art.

remain black against an unslipped red background. Women at the Fountain (Fig. 2.21) is an example. Here, the artist, whom scholars have dubbed the Priam Painter, has added touches of white by mixing white pigment into the slip. By the second half of the sixth century, new motifs, showing scenes of everyday life, became increasingly popular. This hydria, or water jug, shows women carrying similar jugs as they chat at a fountain house of the kind built by the tyrant Pisistratus in the sixth century BCE at the ends of the aqueducts that brought water into the city. Such fountain houses were extremely popular spots, offering women, who were for the most part confined to their homes, a rare opportunity to gather socially. Water flows from animal-head spigots at both sides and across the back of the scene. The composition's strong vertical and horizontal framework, with its Doric columns, is softened by the rounded contours of the women's bodies and the vases they carry. This vase underscores the growing Greek taste for realistic scenes and naturalistic representation.

Many Greek pots depict gods and heroes, including representations of the Iliad and Odyssey. An example of this tendency is a krater, or vessel in which wine and water were mixed, that shows the Death of Sarpedon. It was made by the potter Euxitheos and painted by Euphronius by 515 BCE (Fig. 2.22). Euphronius was praised especially for his ability to render human anatomy accurately. Here Sarpedon has just been killed by Patroclus (see Reading 2.1). Blood pours from his leg, shoulder, and carefully drawn abdomen. The winged figures of Hypnos (Sleep) and Thanatos (Death) are about to carry off his body as Hermes, messenger of the gods, who guides the dead to the underworld, looks on. But the naturalism of the scene is not the source of its appeal. Rather, its perfectly balanced composition transforms the tragedy into a rare depiction of death as an instance of dignity and order. The spears of the two warriors left and right mirror the edge of the vase, the design formed by Sarpedon's stomach muscles is echoed in the decorative bands at top and bottom, and the handles of the vase mirror the arching backs of Hypnos and Thanatos.

The Death of Sarpedon is an example of a red-figure vase. The process is the reverse of the black-figure process, and more complicated. Here, the slip is used to paint the background, outlining the figures. Using the same slip, Euphronius also drew details on the figure (such as Sarpedon's abdomen) with a brush. The vase was then fired in three stages, each with a different amount of oxygen allowed into

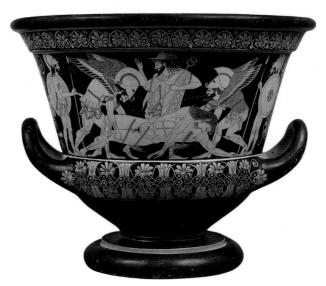

Fig. 2.22 Euphronius (painter) and Euxitheos (potter), Death of Sarpedon. ca. 515 BCE. Red-figure decoration on a calyx krater. Ceramic, height of krater 18". Museo Nazionale di Villa Giulia, Rome. This type of krater is called a calyx krater because its handles curve up like the calyx flower. The krater was housed in the collection of the Metropolitan Museum of Art in New York until it became clear that it was illegally excavated in Italy in the early 1970s. The Museum returned the piece to Italy in 2008.

the kiln. In the first stage, oxygen was allowed into the kiln, "fixing" the whole vase in one overall shade of red. Then, oxygen in the kiln was reduced to the absolute minimum, turning the vessel black. At this point, as the temperature rose, the slip became vitrified, or glassy. Finally, oxygen entered the kiln again, turning the unslipped areas—in this case, the red figures—back into a shade of red. The areas painted with the now vitrified slip were not exposed to oxygen, so they remained black.

The Poetry of Sappho

The poet Sappho (ca. 610–ca. 580 BCE) was hailed throughout antiquity as "the tenth Muse," and her poetry celebrated as a shining example of female creativity. We know little of Sappho's somewhat extraordinary life. She was born on the island of Lesbos, and probably married. She mentions both a brother and a daughter, Cleis, in her poetry. As an adult poet, she surrounded herself with a group of young women who together engaged in the celebration of Aphrodite (love), the Graces (beauty), and the Muses (poetry). Her own poetry gives rise to the suggestion that her relation to these women was erotic. It seems clear that her circle shared their lives with one another only for a brief period before marriage.

Sappho produced nine books of lyric poems on themes of love and personal relationships, often with other women. Only fragments of Sappho's poetry have survived. It is impossible to convey the subtlety and beauty of her poems in translation, but their astonishing economy of feeling does come across. In the following poem (Reading 2.2a), one of the longest surviving fragments, she expresses her love for a married woman:

READING 2.2a

Sappho, lyric poetry

He is more than a hero He is a god in my eyes the man who is allowed to sit beside you-he who listens intimately to the sweet murmur of your voice, the enticing laughter that makes my own heart beat fast. If I meet you suddenly, I can't speak-my tongue is broken; a thin flame runs under my skin; seeing nothing hearing only my ears drumming, I drip with sweat; trembling shakes my body and I turn paler than dry grass. At such times death isn't far from me.

Such poems such were sung to the accompaniment of a lyre, as depicted in a red-figure vase by Polygnotos (Fig. 2.23). We have little knowledge of what Greek music actually sounded like. The only complete work of music to have

survived is a *skolion*, or drinking song, by Seikolos, found chiseled on the first-century BCE gravestone of his wife, Euterpe. The Greek system for writing musical notation, apparently borrowed from the Phoenicians, marked the position of the fingers on the strings of the instrument.

Sappho's talent is the ability to condense the intensity of her feelings into a single breath, a breath that, as the following poem suggests, lives on (Reading 2.2b). Even in so short a poem, Sappho realizes concretely the Greek belief that we can achieve immortality through our words and deeds:

READING 2.2b

Sappho, lyric poetry

Although they are only breath, words which I command are immortal.

Sappho's work was collected into nine volumes (arranged according to meter) by the Library of Alexandria, but these are now lost, like most of the rest of the library's 700,000 volumes. After Homer, she was probably the most admired poet in antiquity, but where Homer's poetry was concerned with creating a national, Hellenic identity, Sappho's lyrics were more personal, establishing her own, individual sense of self.

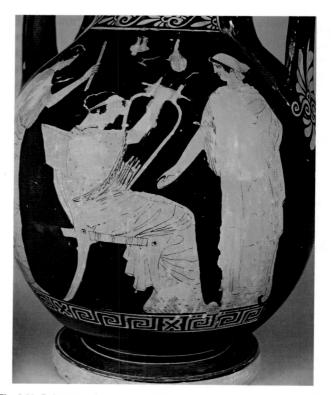

Fig. 2.23 Polygnotos (vase painter), Two women, one playing a lyre. 5th century BCE. Red-figure decoration on a *pelike* (two-handled vase similar to an amphora). Musée du Louvre, Paris. Most of Sappho's poems were written to be sung by a performer accompanying herself on the lyre.

The Rise of Democracy and the Threat of Persia

The growing naturalism of sixth-century BCE sculpture, to say nothing of the highly personal poetry of Sappho, coincides with the rise of democratic institutions in Athens, and reflects this important development. Both bear witness to a growing Greek spirit of innovation and accomplishment, and both testify to a growing belief in the dignity and worth of the individual.

In 508 BCE, the Athenian aristocrat Cleisthenes instituted the first Athenian political democracy—from the Greek demokratia, the rule (kratia) of the people (demos) an innovation in self-government that might not have been possible had the Athenians not just endured more than 50 years of tyranny, beginning in 560 BCE when Pisistratus assumed rule in Athens. Then, the urban and rural regions of the Athenian polis were wracked by division. Wealthy landowners from the plains, poorer hill people living on the mountainsides, Athenian merchants, and aristocracy, all vied for power. Pisistratus had controlled this division with a heavy hand, ruling as a tyrant—that is, as a dictator without consulting the people. Although he succeeded in providing jobs for the entire population by commissioning large-scale public works, he exiled aristocrats who did not support him, and he often kept sons of noble families as his personal hostages to guarantee their families' loyalty. His son Hippias, who followed him to power in 527 BCE, was harsher still, exiling more nobles and executing many others. In 510 BCE the exiled nobles revolted with aid from Sparta, Hippias escaped to Persia, and Cleisthenes took over.

"Nothing is worse for a city than a tyrant," the Greek playwright Euripides would later write in his play The Suppliant Women. "One man rules, and frames the law himself. Equality doesn't exist. But when laws are written down, both rich and poor have the same right to justice. This is freedom's rallying cry: 'What man has good advice to give the city? Make it public, and earn a reputation. . . . For the city's sake, what could be better than that? When the people are the pilots of the city, they control their own destiny." In other words, politics—a dedication to the wellbeing of the polis through discussion, consensus, and united action—depends upon democracy. In a tyranny, there can be no politics because there can be no debate. Whatever their diverging views, the citizens of the polis were free to debate the issues, to speak their minds. They spoke as individuals, and they cherished the freedom to think as they pleased. But they spoke out of a concern for the common good, for the good of the polis, which, after all, gave them the freedom to speak in the first place. When Aristotle says, in his Politics, that "man is a political animal," he means that man is a creature of the polis, bound to it, dedicated to it, determined by it, and, somewhat paradoxically, liberated by it as well.

These principles were well understood by Cleisthenes, who reorganized the Athenian political system into *demes*, small local areas comparable to precincts or wards in a modern city. Because all citizens—remember, only males were citizens—registered in their given *deme*, landowners

and merchants had equal political rights. Cleisthenes then grouped the *demes* into ten political "tribes," whose membership cut across all family, class, and regional lines, thus effectively diminishing the power and influence of the noble families. Each tribe appointed 50 of its members to a Council of Five Hundred, which served for 36 days. There were thus ten separate councils per year, and no citizen could serve on the council more than twice in his lifetime. With so many citizens serving on the council for such short times, it is likely that nearly every Athenian citizen participated in the government at some point during his lifetime.

The new Greek democracy was immediately threatened by the rise of the Persian Empire in the east (see Chapter 1). In 499 BCE, probably aware of the newfound political freedoms in Athens and certainly chafing at the tyrannical rule of the Persians, the Ionian cities rebelled, burning down the city of Sardis, the Persian headquarters in Asia Minor. In 495 BCE, the Persian ruler Darius struck back. He burned down the most important Ionian city, Miletus, slaughtering the men and taking its women and children into slavery. Then, probably influenced by Hippias, who lived in exile in his court, Darius set his sights on Athens, which had sent a force to Ionia to aid the rebellion.

In 490 BCE, a huge Persian army, estimated at 90,000, landed at Marathon, on the northern plains of Attica. They were met by a mere 10,000 Greeks, led by a professional soldier named Miltiades, who had once served under Darius in Persia, and who understood the weakness of Darius' military strategy. Miltiades struck Darius' forces at dawn, killing 6,000 Persians and suffering minimal losses himself. The Persians were routed. The anxious citizens of Athens heard news of the victory from Phidippides, who ran the 26 miles between Marathon and Athens, thus completing the original marathon, a run that the Greeks would soon incorporate into their Olympic Games. (Contrary to popular belief, Phidippides did not die in the effort.)

Darius may have been defeated, but the Persians were not done. Even as the Greeks basked in victory, Darius and his son Xerxes were once again solidifying their power at Persepolis, and after Darius died fighting in Egypt in 486 BCE, Xerxes (r. 486–465 BCE) assumed the throne. By 481 BCE, it was apparent that Xerxes was preparing to attack Greece once again. Themistocles (ca. 524–ca. 460 BCE), an Athenian statesman and general, had been anticipating the invasion for a decade. He convinced the Athenians to unite with the other Greek poleis under the direction of the Spartans, the strongest military power. When a large supply of silver was discovered in 483 BCE, Themistocles, convinced that the Persians could not be defeated on land, persuaded Athens to use its newfound wealth to build a fleet.

Finally, in 480 BCE, Xerxes led a huge army into Greece. In his nine-volume *Histories* (430 BCE), written 50 years after the events, Herodotus, the first Greek historian, says that Xerxes' army numbered five million men and that whole rivers were dried up when the army stopped to drink. These are doubtless exaggerations, but Xerxes' army was probably the

largest ever assembled until that time. Modern estimates suggest that it was composed of at least 150,000 men. Herodotus also tells us that the Delphic oracle had prophesied that Athens would be destroyed and advised the Athenians to put their trust in "wooden walls." Themistocles knew that the Persians had to be delayed so that the Athenians would have time to abandon the city and take to the sea. At a narrow pass between the sea and the mountains called Thermopylae, a band of 300 Spartans, led by their king, Leonidas, gave their lives so that the Athenians could escape.

The Persians sacked Athens, and, as Themistocles hoped, quickly pursued the Athenians out to sea. At Salamis, off the Athenian coast, the Greeks won a stunning victory, led by Themistocles. The Persian fleet, numbering about 800 galleys, faced the Greek fleet of about 370 smaller and more maneuverable *triremes*, galleys with three tiers of oars on each side. Themistocles lured the Persian fleet into the narrow waters of the strait at Salamis. The Greek triremes then attacked the crowded Persian fleet and used the great curved prows of their galleys to ram and sink about 300 Persian vessels. The Greeks lost only about 40 of their own fleet, and Xerxes was forced to retreat, never to threaten the Greek mainland again.

THE GOLDEN AGE

What did Pericles believe to be the source of Athenian greatness, and how is that greatness reflected in the art of the Golden Age?

After the Persian invasion, the Athenians returned to a devastated city. They initially vowed to keep the Acropolis in a state of ruin as a reminder of the horrible price of war; however, the statesman Pericles (ca. 495-429 BCE) convinced them to rebuild it, ushering in a "Golden Age." No person dominated Athenian political life in the fifth century BCE more than Pericles. An aristocrat by birth, he was nonetheless democracy's strongest advocate. Late in his career, in 431 BCE, he delivered a speech honoring soldiers who had fallen in early battles of the Peloponnesian War, a struggle for power between Sparta and Athens that would eventually result in Athens's defeat in 404 BCE, long after Pericles' own death. Pericles begins his speech by saying that, in order to honor the dead properly, he would like "to point out by what principles of action we rose to power, and under what institutions and through what manner of life our empire became great." First and foremost in his mind is Athenian democracy. But Pericles is not concerned with politics alone. He praises the Athenians' "many relaxations from toil." He acknowledges that life in Athens is as good as it is because "the fruits of the whole earth flow in upon us." And, he insists, Athenians are "lovers of the beautiful" who seek to "cultivate the mind." "To sum up," he concludes (Reading 2.3):

READING 2.3

Thucydides, *History of the Peloponnesian* Wars, Pericles' Funeral Speech (ca. 410 BCE)

I say that Athens is the school of Hellas, and that the individual Athenian in his own person seems to have the power of adapting himself to the most varied forms of action with the utmost versatility and grace. This is no passing and idle word, but truth and fact; and the assertion is verified by the position to which these qualities have raised the state. . . . I have dwelt upon the greatness of Athens because I want to show you that we are contending for a higher prize than those who enjoy none of these privileges, and to establish by manifest proof the merit of these men whom I am now commemorating. Their loftiest praise has been already spoken. For in magnifying the city, I magnify them, and men like them whose virtues made her glorious.

When Pericles says that Athens is "the school of Hellas," he means that it teaches all of Greece by its example. He insists that the greatness of the state is a function of the greatness of its individuals. The quality of Athenian life depends on this link between individual freedom and civic responsibility—which most of us in the Western world recognize as the foundation of our own political idealism (if, too often, not our political reality).

As for rebuilding the Acropolis, Pericles argued that, richly decorated with elaborate architecture and sculpture, the Acropolis could become a fitting memorial not simply to the Persian war but especially to Athena's role in protecting the Athenian people. Furthermore, at Persepolis, the defeated Xerxes and then his son and successor Artaxerxes I (r. 465–424 BCE), were busy expanding their palace, and Athens was not about to be outdone. Pericles placed the sculptor Phidias in charge of the sculptural program for the new buildings on the Acropolis, and Phidias may have been responsible for the architectural project as well.

The Architectural Program at the Acropolis

The cost of rebuilding the Acropolis was enormous, but despite the reservations expressed by many over such extravagant expenditure, financed mostly by tributes that Athens assessed upon its allies, the project had the virtue of employing thousands of Athenians—citizens, metics (free men who were not citizens because they came from somewhere in the Greek world other than Athens), and slaves alike—thus guaranteeing its popularity. Writing a *Life of Pericles* five centuries later, the Greek-born biographer Plutarch (ca. 46–after 119 ce) gives us some idea of the project and its effects (**Reading 2.4**):

READING 2.4

Plutarch, Life of Pericles (75 CE)

The raw materials were stone, bronze, ivory, gold, ebony, and cypress wood. To fashion them were a host of craftsmen: carpenters, molders, coppersmiths, stonemasons, goldsmiths, ivory-specialists, painters,

textile-designers, and sculptors in relief. Then there were the men detailed for transport and haulage: merchants, sailors, and helmsmen at sea; on land, cartwrights, drovers, and keepers of traction animals. There were also the rope-makers, the flax-workers, cobblers, roadmakers, and miners. Each craft, like a commander with his own army, had its own attachments of hired laborers and individual specialists organized like a machine for the service required. So it was that the various commissions spread a ripple of prosperity throughout the citizen body.

The Parthenon The centerpiece of the project was the Parthenon (Fig. 2.24), which was completed in 432 BCE after 15 years of construction. As Pericles had argued, it was built to give thanks to Athena for the salvation of Athens and Greece in the Persian Wars, but it was also a tangible sign of the power and might of the Athenian state, designed to impress all who visited the city. It was built on the foundations

and platform of an earlier structure, but the architects Ictinus and Callicrates clearly intended it to represent the Doric order in its most perfect form. It has 8 columns at the ends and 17 on the sides. The entasis of each column (a feature also used in the Temple of Hera I at Paestum more than 100 years earlier) counters the eye's tendency to see the uninterrupted parallel columns as narrowing as they rise and to give a sense of "breath" or liveliness to the stone. The columns also slant slightly inward, so that they appear to the eye to rise straight up. And since horizontal lines appear to sink in the middle, the platform beneath them rises nearly 5 inches from each corner to the middle. There are no true verticals or horizontals in the building, a fact that lends its apparently rigid geometry a sense of liveliness and animation.

In the clarity of its parts, the harmony among them, and its overall sense of proportion and balance, the Parthenon represents the epitome of Classical architecture. The building's Classical sense of beauty manifests itself in the architects' use of a system of proportionality in order to coordinate

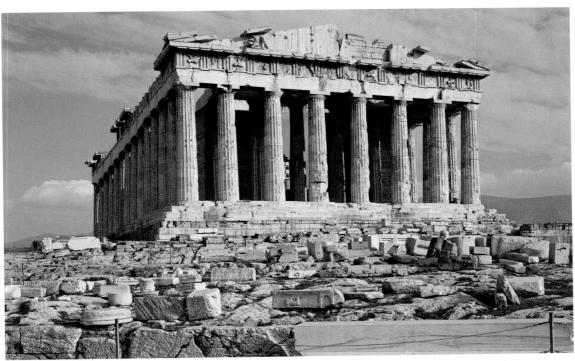

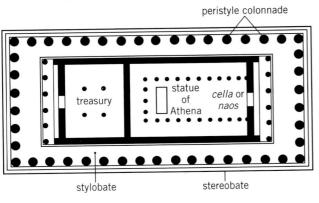

Fig. 2.24 Ictinus, with contributions by Callicrates, the Parthenon and its plan, Acropolis, Athens. 447–438 BCE. Sculptural program completed **432 BCE.** The temple measures about $228' \times 101'$ on the top step. The temple remained almost wholly intact (although it served variously as a church and then a mosque) until 1687, when the attacking Venetians exploded an Ottoman powder magazine housed in it. The giant, 40-foot-high sculpture of Athena Parthenos was located in the Parthenon's cella or naos, the central interior room of a temple in which the cult statue was traditionally housed.

the construction process in a way that resulted in a harmonious design. The ratio controlling the Parthenon's design can be expressed in the algebraic formula x = 2y + 1. The temple's columns, for instance, reflect this formula: There are 8 columns on the short ends and 17 on the sides, because $17 = (2 \times 8) + 1$. The ratio of the stylobate's length to width is 9:4, because $9 = (2 \times 4) + 1$. This mathematical regularity is central to the overall harmony of the building.

Other Architectural Projects on the Acropolis One of the architects employed in the project, Mnesicles, was charged with designing the propylon, or large entry way, where the Panathenaic Way approached the Acropolis from below. Instead of a single gate, he created five, an architectural tour de force named the Propylaia (the plural of propylon), flanked with porches and colonnades of Doric columns. The north wing included a picture gallery featuring paintings of Greek history and myth, none of which survive. Contrasting with the towering mass of the Propylaia was the far more delicate Temple of Athena Nike (Fig. 2.25), situated on the promontory just to the west and overlooking the entrance way. Graced by slender Ionic columns, the diminutive structure (it measures a mere 27 by 19 feet) was designed by Callicrates and built in 425 BCE, not long after the death of Pericles. It was probably meant to celebrate what the Athenians hoped would be their victory in the Peloponnesian Wars, as nike is Greek for "victory." Before the end of the wars, between 410 and 407 BCE, it was surrounded by a parapet, or low wall, faced with panels depicting Athena together with her winged companions, the Victories.

To the left of the Parthenon, visitors would have seen the Erechtheion (Fig. 2.26). Its asymmetrical and multileveled structure is unique, resulting from the rocky site on which it is situated. Flatter areas were available on the Acropolis, so its demanding position is clearly intentional. The building surrounds a sacred spring dedicated to Erechtheus, the first

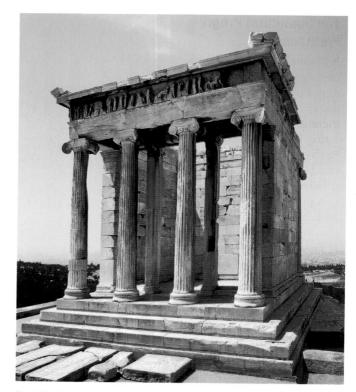

Fig. 2.25 Temple of Athena Nike, Acropolis, Athens. ca. 425 BCE.

Overlooking the approach to the Propylaia, the temple's lighter lonic columns contrast dramatically with the heavier, more robust Doric columns of the gateway.

legendary king of Athens, after whom the building is named. Work on the building began after the completion of the Parthenon, in the 430s BCE, and took 25 years. Among its unique characteristics is the famous Porch of the Maidens, facing the Parthenon. It is supported by six caryatids, female figures serving as columns. These figures illustrate both

the idea of the temple column as a kind of human figure and the idea that the stability of the polis depends on the conduct of its womenfolk. All assume a classic contrapposto pose, the three on the left with their weight over the right leg, the three on the right with their weight over the left. Although each figure is unique—the folds on their chitons fall differently, and their breasts are different sizes and shapes—together they create a sense of balance and harmony.

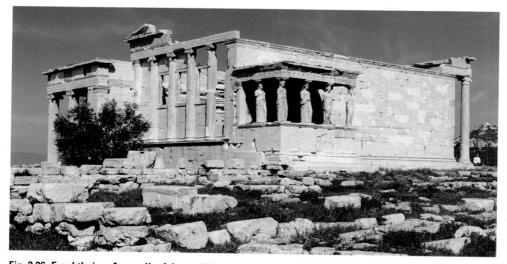

Fig. 2.26 Erechtheion, Acropolis, Athens. 430s—405 BCE. The Erechtheion, with its irregular and asymmetrical design, slender lonic columns, and delicate Porch of the Maidens, contrasts dramatically and purposefully with the more orthodox and highly regular Parthenon across the Acropolis to the south.

The Sculptural Program at the Parthenon

If Phidias' hand was not directly involved in carving the sculpture decorating the Parthenon, most of the decoration is probably his design. He was, of course, heir to the everincreasing interest in naturalistic representation that had developed at the end of the sixth century BCE in Athenian kouros sculpture (see Figs. 2.17 and 2.18). A sculpture attributed to Kritios (Fig. 2.27), found in 1865 in a pile of debris on the Acropolis pushed aside by Athenians cleaning up after the Persian invasion (its head was found 25 years later in a separate location), demonstrates the increasing naturalism of Greek sculpture during the first 20 years of the fifth century BCE. The boy's head is turned slightly to the side. His weight rests on the left leg, and the right leg extends forward, bent slightly at the knee. The figure seems to twist around its axis, or imaginary central line, the natural result of balancing the body over one supporting leg. The term for this stance, coined during the Italian Renaissance, is contrapposto ("counterpoise"), or weightshift. The inspiration for this development seems to have been a growing desire by Greek sculptors to dramatize the stories narrated in the decorative programs of temples and sanctuaries. Liveliness of posture and gesture and a sense of capturing the body in action became their primary sculptural aims and the very definition of classical beauty.

An even more developed version of the contrapposto pose can be seen in the Doryphoros, or Spear Bearer (Fig. 2.28), whose weight falls on the forward right leg. An idealized portrait of an athlete or warrior, originally done in bronze, the Doryphoros is a Roman copy of the work of Polyclitus, one of the great artists of the Golden Age. The sculpture was famous throughout the ancient world as a demonstration of Polyclitus' treatise on proportion known as The Canon (from the Greek kanon, meaning "measure" or "rule"). In Polyclitus' system, the ideal human form was determined by the height of the head from the crown to the chin. The head was one-eighth the total height, the width of the shoulders

was one-quarter the total height, and so on, each measurement reflecting these ideal proportions. For Polyclitus, these relations resulted in the work's *symmetria*, the origin of our word "symmetry," but meaning, in Polyclitus' usage, "commensurability," or "having a common measure." Thus, the figure, beautifully realized in great detail, right down to the veins on

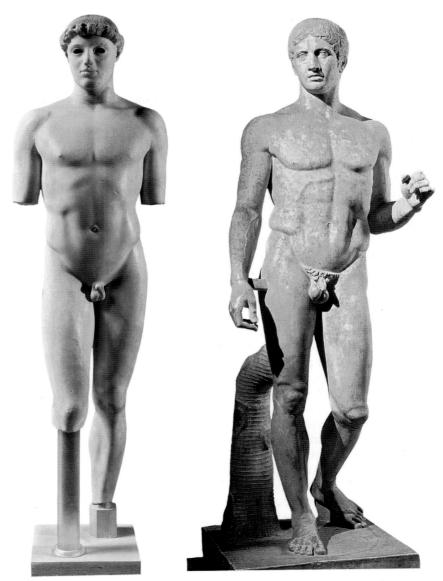

Fig. 2.27 Kritios Boy, from Acropolis, Athens. ca. 480 BCE. Marble, height 46". Acropolis Museum, Athens. The growing naturalism of Greek sculpture is clear when one compares the Kritios Boy to the kouros figures discussed earlier in the chapter. Although more naturalistic, this figure still served a votive function.

Fig. 2.28 Doryphoros (Spear Bearer), Roman copy after the original bronze by Polyclitus of ca. 450–440 BCE. Marble, height 6'6". Museo Archeologico Nazionale, Naples. There is some debate about just what "measure" Polyclitus employed to achieve his ideal figure. Some argue that his system of proportions is based on the length of the figure's index finger or the width of the figure's hand across the knuckles. The idea that it is based on the distance between the chin and the hairline derives from a much later discussion of proportion by the Roman writer Vitruvius, who lived in the first century CE. It is possible that Vitruvius had firsthand knowledge of Polyclitus' Canon, which was lost long ago.

the back of the hand, reflects a higher mathematical order and embodies the ideal harmony between the natural world and the intellectual or spiritual realm.

The sculptures decorating the Parthenon proper were in three main areas—in the pediments at each end of the building, on the **metopes**, or the square panels between the beam

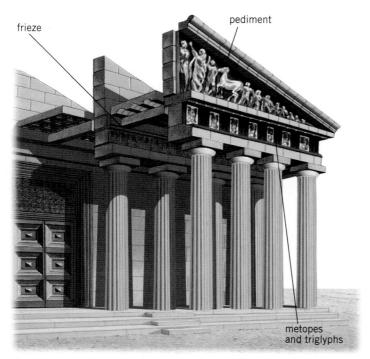

Fig. 2.29 Cutaway drawing of the Parthenon porch showing friezes, metopes, and pediment. Evident here is the architect Ictinus' juxtaposition of the Doric order, used for the columns with their capitals and the entablature on the outside, with the lighter lonic order of its continuous frieze, used for the entablature inside the colonnade.

ends under the roof, and on the frieze that runs across the top of the outer wall of the cella (Fig. 2.29). Brightly painted, these sculptures must have appeared strikingly lifelike. The 3-foot-high frieze that originally ran at a height of nearly 27 feet around the central block of the building depicts a ceremonial procession (Fig. 2.30). Traditionally, the frieze has been interpreted as a depiction of the Panathenaic procession, a civic festival occurring every four years in honor of

Athena. Some 525 feet long, the frieze consists of horsemen, musicians, water carriers, maidens, and sacrificial beasts. All the human figures have the ideal proportions of the *Doryphoros* (see Fig. 2.28).

The sculptural program in the west pediment depicts Athena battling with Poseidon to determine who was to be patron of Athens. Scholars debate the identity of the figures in the east pediment, but it seems certain that overall it portrays the birth of Athena with gods and goddesses in attendance (Fig. 2.31). The 92 metopes, each separated from the next by triglyphs, square blocks divided by grooves into three sections, narrate battles between the Greeks and four enemies—the Trojans on one side, and on the other three. giants, Amazons (perhaps symbolizing the recently defeated Persians), and centaurs, mythological beasts with the legs and bodies of horses and the trunks and heads of humans. Executed in high relief (Fig. 2.32), these metopes represent the clash between the forces of civilization—the Greeks and their barbarian, even bestial opponents. The male nude reflects not only physical but also mental superiority, a theme particularly appropriate for a temple to Athena, goddess of both war and wisdom.

Philosophy and the Polis

The extraordinary architectural achievement of the Acropolis is matched by the philosophical achievement of the great Athenian philosopher Socrates, born in 469 BCE, a decade after the Greek defeat of the Persians. His death in 399 BCE arguably marks the end of Athens's Golden Age. Socrates' death was not a natural one. His execution was ordered by a polis in turmoil after its defeat by the Spartans in 404 BCE. The city had submitted to the rule of the oligarchic government installed by the victorious Spartans, the so-called Thirty Tyrants, whose power was ensured by a gang of "whip-bearers." They deprived the courts of their power and initiated a set of trials against rich men and democrats

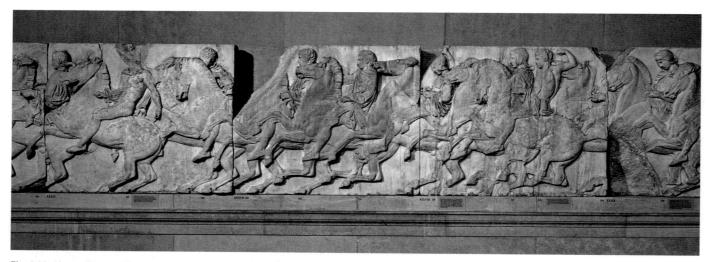

Fig. 2.30 Young Men on Horseback, segment of the north frieze, Parthenon, Athens. ca. 440 BCE. Marble, height 41". © The Trustees of the British Museum. This is just a small section of the entire procession, which extends completely around the Parthenon.

Fig. 2.31 A Recumbent God (Dionysus or Heracles), east pediment of the Parthenon. ca. 435 BCE. Length approx. 51". © The Trustees of the British Museum. In 1801, Thomas Bruce, Earl of Elgin and British ambassador to Constantinople, brought the marbles from the east pediment, as well as some from the west pediment and the south metopes, and a large part of the frieze, back to England—the source of their name, the Elgin Marbles. The identities of the figures are much disputed, but the greatness of their execution is not. Now exhibited in the round, in their original position on the pediment, they were carved in high relief. As the sun passed over the three-dimensional relief on the east and west pediments, the sculptures would have appeared almost animated by the changing light and the movement of their cast shadows.

who opposed their tyranny. Over 1,500 Athenians were subsequently executed. Socrates was brought to trial, accused of subversive behavior, corrupting young men, and introducing new gods, though these charges may have been politically motivated. He antagonized his jury of citizens by insisting that his life had been as good as anyone's and that far from committing any wrongs, he had greatly benefited Athens. He was convicted by a narrow majority and condemned to die by drinking poisonous hemlock. His refusal to flee and his willingness to submit to the will of the polis and drink the potion testify to his belief in the very polis that condemned him. His eloquent defense of his decision to submit is recorded in the Crito, a dialogue between Socrates and his friend Crito, actually written by Plato, Socrates' student and fellow philosopher. Although the Athenians would continue to enjoy relative freedom for many years to come, the death of Socrates marks the end of their great experiment with democracy. Although Socrates was no defender of democracy he did not believe that most people were really capable of exercising good government—he became the model of good citizenship and right thinking for centuries to come.

The Philosophical Tradition in Athens To understand Socrates' position, it is important to recognize that the crisis confronting Athens in 404 BCE was not merely political, but deeply philosophical. Furthermore, a deep division existed between the philosophers and the polis. Plato, Socrates' student, through whose writings we know Socrates' teachings,

Fig. 2.32 Lapith Overcoming a Centaur, south metope 27, from the Parthenon. 447–438 BCE. Marble relief, height 4'5". © The Trustees of the British Museum. The Lapiths are a people in Greek myth who defeated drunken centaurs at the wedding of their king, Pirithous. The Greeks identified centaurs with the Persians, whom they considered the embodiment of chaos, possessing centaur-like forces of irrationality.

believed that good government was unattainable "unless either philosophers become kings in our cities or those whom we now call kings and rulers take to the pursuit of philosophy." He well understood that neither was likely to happen, and that good government was, therefore, something of a dream. To complicate matters further, there were two distinct traditions of Greek *philosophia*—literally, "love of wisdom"—pre-Socratic and Sophist.

The oldest philosophical tradition, that of the pre-Socratics, the Greek philosophers who preceded Socrates, was chiefly concerned with describing the natural universe the tradition inaugurated by Thales of Miletus. "What," the pre-Socratics asked, "lies behind the world of appearance? What is everything made of? How does it work? Is there an essential truth or core at the heart of the physical universe?" In some sense, then, they were scientists who investigated the nature of things, and they arrived at some extraordinary insights. Pythagoras (са. 570–490 все) was one such pre-Socratic thinker. He conceived of the notion that the heavenly bodies appear to move in accordance with the mathematical ratios and that these ratios also govern musical intervals producing what was later called "the harmony of the spheres." Leucippus (fifth century BCE) was another. He conceived of an atomic theory in which everything is made up of small, indivisible particles and the empty space, or void, between them (the Greek word for "indivisible" is atom). Democritus of Thrace (ca. 460-ca. 370 BCE) furthered the theory by applying it to the mind. He taught that everything from feelings and ideas to the physical sensations of taste, sight, and smell could be explained by the movements of atoms in the brain. Heraclitus of Ephesus (ca. 540–ca. 480 BCE) argued for the impermanence of all things. Change, or flux, he said, is the basis of reality, although an underlying Form or Guiding Force (*logos*) guides the process, a concept that later informs the Gospel of John in the Christian Bible, where *logos* is often mistranslated as "word."

Socrates was heir to the second tradition of Greek philosophy, that of the Sophists, literally "wise men." The Sophists no longer asked, "What do we know?" but, instead, "How do we know what we think we know?" and, crucially, "How can we trust what we think we know?" In other words, the Sophists concentrated not on the natural world but on the human mind, fully acknowledging the mind's many weaknesses. The Sophists were committed to what we have come to call humanism—that is, a focus on the actions of human beings, political action being one of the most important.

Protagoras (ca. 485–410 BCE), a leading Sophist, was responsible for one of the most famous of all Greek dictums: "Man is the measure of all things." By this he meant that each individual human, not the gods, not some divine or all-encompassing force, defines reality. All sensory appearances and all beliefs are true for the person whose appearance, or belief, they are. The Sophists believed that there were two sides to every argument. Protagoras' attitude about the gods is typical: "I do not know that they exist or that they do not exist."

The Sophists were teachers who traveled about, imparting their wisdom for pay. Pericles championed them, encouraging the best to come to Athens, where they enjoyed considerable prestige despite their status as metics. Their ultimate aim was to teach political virtue—areté—emphasizing skills useful in political life, especially rhetorical persuasion, the art of speaking eloquently and persuasively. Their emphasis on rhetoric—their apparent willingness to assume either side of any argument merely for the sake of debate—as well as their critical examination of myths, traditions, and conventions, gave them a reputation for cynicism. Thus, their brand of argumentation came to be known as sophistry—subtle, tricky, superficially plausible, but ultimately false and deceitful reasoning.

Socrates and the Sophists Socrates despised everything the Sophists stood for, except their penchant for rhetorical debate, which was his chief occupation. He roamed the streets of Athens, engaging his fellow citizens in dialogue, wittily and often bitingly attacking them for the illogic of their positions. He employed the dialectic method—a process of inquiry and instruction characterized by continuous question-and-answer dialogue intent on disclosing the unexamined premises held implicitly by all reasonable beings. Unlike the Sophists, he refused to demand payment for his teaching, but like them, he urged his fellow men not to mistake their personal opinions for truth. Our beliefs, he knew, are built mostly on a foundation of prejudice and historical conditioning. He differed from the Sophists most crucially in his emphasis on virtuous behavior. For the Sophists, the true, the good, and the just were relative things. Depending on the situation or one's point of view,

anything might be true, good, or just—the point, as will become evident in the next section, of many a Greek tragedy.

For Socrates, understanding the true meaning of the good, the true, and the just was prerequisite for acting virtuously, and the meaning of these things was not relative. Rather, true meaning resided in the psyche, the seat of both intelligence and character. Through inductive reasoning—moving from specific instances to general principles, and from particular to universal truths—it was possible, he believed, to understand the ideals to which human endeavor should aspire. Neither Socrates nor the Sophists could have existed without the democracy of the polis and the freedom of speech that accompanied it. Even during the reign of Pericles, Athenian conservatives had charged the Sophists with the crime of impiety. In questioning everything, from the authority of the gods to the rule of law, they challenged the stability of the very democracy that protected them. It is thus easy to understand how, when democracy ended, Athens condemned Socrates. He was democracy's greatest defender, and if he believed that the polis had forsaken its greatest invention, he himself could never betray it. Thus, he chose to die.

Plato's Republic and Idealism So far as we know, Socrates himself never wrote a single word, and his thinking is known only through the writings of Plato (ca. 428–347 BCE). Thus, it may be true that the Socrates we know is the one Plato wanted us to have, and that when we read Socrates' words, we are encountering Plato's thought more than Socrates'.

As Plato presents Socrates to us, the two philosophers, master and pupil, have much in common. They share the premise that the psyche is immortal and immutable. They also share the notion that we are all capable of remembering the psyche's pure state. But Plato advances Socrates' thought in several important ways. Plato's philosophy is a brand of **idealism**—it seeks the eternal perfection of pure ideas, untainted by material reality. He believes that there is an invisible world of eternal Forms, or Ideas, beyond everyday experience, and that the psyche, trapped in the material world and the physical body, can catch only glimpses of this higher order. Through a series of mental exercises, beginning with the study of mathematics and moving on to the contemplation of the Forms of Justice, Beauty, and Love, the student can arrive at a level of understanding that amounts to superior knowledge.

Socrates' death deeply troubled Plato—not because he disagreed with Socrates' decision, but because of the injustice of his condemnation. The result of Plato's thinking is The Republic. In this treatise, Plato outlines his model of the ideal state. Only an elite cadre of the most highly educated men were to rule—those who had glimpsed Plato's ultimate Form, or Idea—the Good. In The Republic, in a section known as the "Allegory of the Cave," Socrates addresses Plato's older brother, Glaucon, in an attempt to describe the difficulties the psyche encounters in its attempt to understand the higher Forms. The Form of Goodness, Socrates says, is "the universal author of all things beautiful and right, parent of light and of the lord of light in this visible world, and the immediate source of reason and truth in the intellectual; and . . . this is the power

upon which he who would act rationally, either in public or private life, must have his eye fixed." The Form of Goodness, then, is something akin to the common understanding of God (although not God, from whom imperfect objects such as human beings descended, but more like an aspect of the Ideal, of which, one supposes, God must have some superior knowledge). The difficulty is that, once having attained an understanding of the Good, the wise individual will appear foolish to the people, who understand not at all. And yet, Plato argues, it is precisely these individuals, blessed with wisdom, who must rule the commonwealth.

In many ways, Plato's ideal state is reactionary—it certainly opposes the individualistic and self-aggrandizing world of the Sophists. Plato is indifferent to the fact that his wise souls will find themselves ruling what amounts to a totalitarian regime. He believes their own sense of Goodness will prevail over their potentially despotic position. Moreover, rule by an intellectual philosopher king is superior to rule by any person whose chief desire is to satisfy his own material appetites.

To live in Plato's Republic would have been dreary indeed. Sex was to be permitted only for purposes of procreation. Evervone would undergo physical and mental training. Although he believed in the intellectual pursuit of the Form or Idea of Beauty, Plato did not champion the arts. He condemned certain kinds of lively music because they affected not the reasonable mind of their audience but the emotional and sensory tendencies of the body. (But even for Plato, a man who did not know how to dance was uneducated—Plato simply preferred more restrained forms of music.) He also condemned sculptors and painters, whose works, he believed, were mere representations of representations—for if an actual bed is once removed from the Idea of Bed, a painting of a bed is twice removed, the

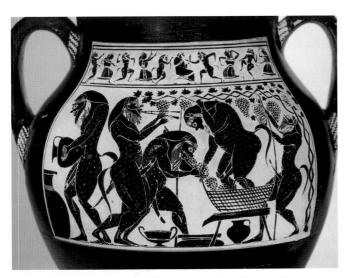

Fig. 2.33 The Amasis Painter (?), Satyrs making wine, detail of Athenian black-figure amphora. ca. 540-530 BCE. Martin von Wagner Museum, University of Würzburg. The entire ritual of wine production is depicted here, from harvesting the grapes, to stomping them to render their juice, to pouring the juice into large vats for fermentation. All lead to the state of ecstasy (ekstasis) painted across the top band.

faintest shadow. Furthermore, the images created by painters and sculptors appealed only to the senses. Thus he banished them from his ideal republic. Because they gave voice to tension within the state, poets were banned as well.

The Theater of the People

The Dionysian aspects of the symposium—the drinking, the philosophical dialogue, and sexual license—tell us something about the origins of Greek drama. The drama was originally a participatory ritual, tied to the cult of Dionysus (god of wine and inspiration). A chorus of people participating in the ritual would address and respond to another chorus or to a leader, such as a priest, perhaps representing (thus "acting the part" of) Dionysus. These dialogues usually occurred in the context of riotous dance and song—befitting revels dedicated to the god of wine. Sexual license was the rule of the day. On a mid-sixth-century amphora used as a wine container (Fig. 2.33) we see five satyrs, minor deities with characteristics of goats or horses, making wine, including one playing pipes. Depicted in the band across the top is Dionysus himself, sitting in the midst of a rollicking band of satyrs and maenads—the frenzied women with whom he cavorted.

This kind of behavior gave rise to one of the three major forms of Greek drama, the satyr play. Always the last event of the daylong performances, the satur play was farce, that is, broadly satirical comedy, in which actors disguised themselves as satyrs, replete with extravagant genitalia, and generally honored the "lord of misrule," Dionysus, by misbehaving themselves. One whole satyr play survives, the Cyclops of Euripides, and half of another, Sophocles' Trackers. The spirit of these plays can perhaps be summed up best by Odysseus' first words in the Cyclops as he comes ashore on the island of Polyphemus (the same story as that related by Homer in the Odyssey): "What? Do I see right? We must have come to the city of Bacchus. These are satyrs I see around the cave." The play, in other words, spoofs or lampoons traditional Greek legend by setting it in a world turned topsy-turvy, a world in which Polyphemus is stronger than Zeus because his farts are louder than Zeus' thunder.

Comedy Closely related to the satyr plays was comedy, an amusing or lighthearted play designed to make its audience laugh. The word itself is derived from the komos, a phallic dance, and nothing is sacred to comedy. It freely slandered, buffooned, and ridiculed politicians, generals, other public figures, and especially the gods. Foreigners, as always in Greek culture, are subject to particular abuse, as are women; in fact, by our standards, the plays are racist and sexist. Most of what we know about Greek comedies comes from two sources: vase painting and the plays of the playwright Aristophanes.

Comedic action was a favorite subject of vase painters working at Paestum in Italy in the fourth century BCE. They depict actors wearing masks and grotesque costumes distinguished by padded bellies, buttocks, and enlarged genitalia.

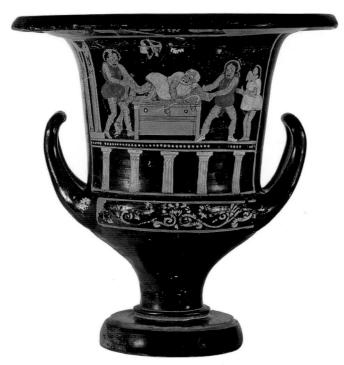

Fig. 2.34 Assteas, red-figure krater depicting a comedy, from Paestum, Italy. ca. 350 BCE. Staatliche Museen, Berlin. On a stage supported by columns, with a scenic backdrop to the left, robbers try to separate a man from his strongbox.

These vases show a theater of burlesque and slapstick that relied heavily on visual gags (Fig. 2.34).

The works of Aristophanes (ca. 445–388 BCE) are the only comedies to have survived, and only 11 of his 44 plays have come down to us. *Lysistrata* is the most famous. Sexually explicit to a degree that can still shock a modern audience, it takes place during the Peloponnesian Wars and tells the story of an Athenian matron who convinces the women of Athens and Sparta to withhold sex from their husbands until they sign a peace treaty. First performed in 411 BCE, seven years before Sparta's victory over Athens, it has its serious side, begging both Athenians and Spartans to remember their common traditions and put down their arms. Against this dark background, the play's action must have seemed absurd and hilarious to its Athenian audience, ignorant of what the future would hold for them.

Tragedy It was at **tragedy** that the Greek playwrights truly excelled. As with comedy, the basis for tragedy is conflict, but the tensions at work in tragedy—murder and revenge, crime and retribution, pride and humility, courage and cowardice—have far more serious consequences. Tragedies often explore the physical and moral depths to which human life can descend. The form also has its origins in the Dionysian rites—the name itself derives from *tragoidos*, the "goat song" of the half-goat, half-man satyrs—and tragedy's seriousness of purpose is not at odds with its origins. Dionysus was also the god of immortality, and an important aspect of his cult's influence is that he promised his followers life after death, just as the grapevine

regenerates itself year after year. If tragedy can be said to have a subject, it is death—and the lessons the living can learn from the dead.

The original chorus structure of the Dionysian rites survives as an important element in tragedy. Thespis, a playwright from whom we derive the word *thespian*, "actor," first assumed the conscious role of an actor in the mid-sixth century BCE and apparently redefined the role of the **chorus**. At first, the actor asked questions of the chorus, perhaps of the "tell me what happened next" variety, but when two, three, and sometimes four actors were introduced to the stage, the chorus began to comment on their interaction. In this way, the chorus assumed its classic function as an intermediary between actors and audience. Although the chorus's role diminished noticeably in the fourth century BCE, it remained the symbolic voice of the people, asserting the importance of the action to the community as a whole.

Greek tragedy often focused on the friction between the individual and his or her community, and, at a higher level, between the community and the will of the gods. This conflict manifests itself in the weakness or "tragic flaw" of the play's **protagonist**, or leading character, which brings the character into conflict with the community, the gods, or some **antagonist** who represents an opposing will. The action occurs in a single day, the result of a single incident that precipitates the unfolding crisis. Thus the audience feels that it is experiencing the action in real time, that it is directly involved in and affected by the play's action.

During the reign of the tyrant Pisistratus, the performance of all plays was regularized. An annual competitive festival for the performance of tragedies called the City Dionysia was celebrated for a week every March as the vines came back to life, and a separate festival for comedies occurred in January. At the City Dionysia, plays were performed in sets of four—tetralogies—all by the same author, three of which were tragedies, performed during the day, and the fourth a satyr play, performed in the evening. The audiences were as large as 14,000, and audience response determined which plays were awarded prizes. Slaves, metics, and women judged the performances alongside citizens.

Aeschylus Although many Greek playwrights composed tragedies, only those of Aeschylus, Sophocles, and Euripides have come down to us. Aeschylus (ca. 525–ca. 456 BCE), the oldest of the three, is reputed to have served in the Athenian armies during the Persian Wars and fought in the battles at Marathon and Salamis. He won the City Dionysia 13 times. It was Aeschylus who introduced a third actor to the tragic stage, and his chorus plays a substantial role in drawing attention to the underlying moral principles that define or determine the action. He also was a master of the visual presentation of his drama, taking full advantage of stage design and costume. Three of his plays, known as the *Oresteia*, form the only complete set of tragedies from a **tetralogy** that we have.

The plays narrate the story of the Mycenaean king Agamemnon, murdered by his adulterous wife Clytemnestra and mourned and revenged by their children, Orestes and Electra. In the first play, Agamemnon, Clytemnestra murders

her husband, partly in revenge for his having sacrificed their daughter Iphigenia to ensure good weather for the invasion of Troy, and partly to marry her lover, Aegisthus. In the second play, *The Libation Bearers*, Orestes murders Aegisthus and Clytemnestra, his mother, to avenge his father's death. Orestes is subsequently pursued by the Furies, a band of *chthonian* gods (literally "gods of the earth," a branch of the Greek pantheon that is distinguished from the Olympian, or "heavenly" gods), whose function is to seek retribution for wrongs and blood-guilt among family members. The Furies form the Chorus of the last play in the cycle, the *Eumenides*, in which the seemingly endless cycle of murder comes to an end. In this play, Athens institutes a court to hear Orestes' case. The court absolves him of the crime of matricide, with Athena herself casting the deciding vote.

None of the violence in the plays occurs on stage—either the chorus or a messenger describes it. And in fact, the ethical dimension of Aeschylus' trilogy is underscored by the triumph of civilization and law, mirrored by the transformation of the Furies—the blind forces of revenge—into the Eumenides, or "Kindly Ones," whose dark powers have been neutralized.

Sophocles Playwright, treasurer for the Athenian polis, a general under Pericles, and advisor to Athens on financial matters during the Peloponnesian Wars, Sophocles (ca. 496–406 BCE) was an almost legendary figure in fifth-century BCE Athens. He wrote over 125 plays, of which only 7 survive, and he won the City Dionysia 18 times. In Oedipus the King, Sophocles dramatizes how the king of Thebes, a polis in east central Greece, mistakenly kills his father and marries his mother, then finally blinds himself to atone for his crimes of patricide and incest. In Antigone, Sophocles dramatizes the struggle of Oedipus' daughter, Antigone, with her uncle, Creon, the tyrannical king who inherited Oedipus' throne. Antigone struggles for what amounts to her democratic rights as an individual to fulfill her familial duties, even when this opposes what Creon argues is the interest of the polis. Her predicament is doubly complicated by her status as a woman.

As the play opens, Antigone's brothers, Polynices and Eteocles, have killed each other in a dispute over their father's throne. Creon, Oedipus' brother-in-law, who has inherited the throne, has forbidden the burial of Polynices, believing Eteocles to have been the rightful heir. Antigone, in the opening scene, defends her right to bury her brother, and this willful act, which she then performs in defiance of Creon's authority, leads to the tragedy that follows. She considers the burial her duty, since no unburied body can enjoy an afterlife. The play begins as Antigone explains her action to her sister, Ismene, who thoroughly disapproves of what she has done (Reading 2.5a):

READING 2.5a

Sophocles, Antigone

ISMENE Oh my sister, think think how our own father died, hated, his reputation in ruins, driven on by the crimes he brought to light himself to gouge out his eyes with his own handsthen mother . . . his mother and wife, both in one. mutilating her life in the twisted nooseand last, our two brothers dead in a single day, both shedding their own blood, poor suffering boys, battling out their common destiny hand-to-hand. Now look at the two of us, left so alone. . . think what a death we'll die, the worst of all if we violate the laws and override the fixed decree of the throne, its power we must be sensible. Remember we are women, we're not born to contend with men. Then too, we're underlings, ruled by much stronger hands, so we must submit in this, and things still worse. I, for one, I'll beg the dead to forgive me-I'm forced, I have no choice-I must obey the ones who stand in power. Why rush to extremes? It's madness, madness,

The conflict between Antigone and Creon is exacerbated by their gender difference. The Greek male would expect a female to submit to his will. But it is, in the end, Antigone's "rush to extremes" that forces the play's action—that, and Creon's refusal to give in. Creon's "fatal flaw"—his pride (hubris)—leads to the destruction of all whom he loves, and Antigone herself is blindly dedicated to her duty to honor her family. Her actions in the play have been the subject of endless debate. Some readers feel that she is far too hard on Ismene, and certainly a Greek audience would have found her defiance of male authority shocking. Nevertheless, her strength of conviction seems to many—especially modern audiences—wholly admirable.

But beyond the complexities of Antigone's personality, one of Sophocles' greatest achievements, the play really pits two forms of idealism against each other: Antigone's uncompromising belief in herself plays off Creon's equally uncompromising infatuation with his own power and his dedication to his political duty, which he puts above devotion even to family.

The philosophical basis of the play is clearly evident in the essentially Sophist debate between Creon and his son Haemon, as Haemon attempts to point out the wrong in his father's action (Reading 2.5b):

READING 2.5b

Sophocles, Antigone

HAEMON Father, the gods implant reason in men, the highest of all things that we call our own. Not mine the skill—far from me be the quest!—to say wherein thou speakest not aright; and yet another man, too, might have some useful thought. . . . No, though a man be wise, 'tis no shame for him to learn many things, and to bend in season. Seest thou, beside the wintry torrent's course, how the trees that yield to it save every twig, while the stiffnecked perish root and branch? And even thus he

who keeps the sheet of his sail taut, and never slackens it, upsets his boat, and finishes his voyage with keel uppermost.

Nay, forego thy wrath; permit thyself to change. For if I, a younger man, may offer my thought, it were far best, I ween, that men should be all-wise by nature; but, otherwise—and oft the scale inclines not so—'tis good also to learn from those who speak aright. . . .

CREON Men of my age are we indeed to be schooled, then, by men of his?

HAEMON In nothing that is not right; but if I am young, thou shouldest look to my merits, not to my years.

CREON Is it a merit to honour the unruly?

HAEMON I could wish no one to show respect for evil-doers.

CREON Then is not she tainted with that malady?

HAEMON Our Theban folk, with one voice, denies it. . . .

CREON Am I to rule this land by other judgment than mine own?

HAEMON That is no city which belongs to one man.

CREON Is not the city held to be the ruler's?

HAEMON Thou wouldst make a good monarch of a desert.

CREON This boy, it seems, is the woman's champion.

HAEMON If thou art a woman; indeed, my care is for thee.

CREON Shameless, at open feud with thy father!

HAEMON Nay, I see thee offending against justice.

CREON Do I offend, when I respect mine own prerogatives?

HAEMON Thou dost not respect them, when thou tramplest on the gods' honours. . . .

CREON Thou shalt rue thy witless teaching of wisdom.

HAEMON Wert thou not my father, I would have called thee unwise.

CREON Thou woman's slave, use not wheedling speech with me.

HAEMON Thou wouldest speak, and then hear no reply?

CREON Sayest thou so? Now, by the heaven above us—be sure of it—thou shalt smart for taunting me in this opprobrious strain. Bring forth that hated thing, that she may die forthwith in his presence—before his eyes—at her bridegroom's side!

Finally, the play demonstrates the extreme difficulty of reconciling the private and public spheres—one of Greek philosophy's most troubling and troubled themes—even as it cries out for the rational action and sound judgment that might have spared its characters their tragedy.

Euripides The youngest of the three playwrights, Euripides (ca. 480–406 BCE), writing during the Peloponnesian Wars, brought a level of measured skepticism to the stage. Eighteen of his 90 works survive, but Euripides won the City Dionysia only four times. His plays probably angered more conservative Athenians, which may be why he moved from

Athens to Macedonia in 408 BCE. In *The Trojan Women*, for instance, performed in 415 BCE, he describes, disapprovingly, the Greek enslavement of the women of Troy, drawing an unmistakable analogy to the contemporary Athenian victory at Melos, where women were subjected to Athenian abuse.

Euripides' darkest play, and his masterpiece, is *The Bacchae*, which describes the introduction to Thebes of the worship of Dionysus by the god himself, disguised as a mortal. Pentheus, the young king of the city, opposes the Dionysian rites both because all the city's women have given themselves up to Dionysian ecstasy and because the new religion disturbs the larger social order. Performed at a festival honoring Dionysus, the play warns of the dangers of Dionysian excess as the frenzied celebrants, including Pentheus' own mother, mistake their king for a wild animal and murder him. Euripides' play underscores the fact that the rational mind is unable to comprehend, let alone control, all human impulses.

Greek theater itself, particularly the tragedies of Aeschylus, Sophocles, and Euripides, would become the object of study in the fourth century BCE, when the philosopher Aristotle, Plato's student, attempted to account for tragedy's power in his *Poetics*. And despite the fact that the tragedies were largely forgotten in the Western world until the sixteenth century, they have had a lasting impact on Western literature, deeply influencing writers from William Shakespeare to the modern American novelist William Faulkner.

The Performance Space During the tyranny of Pisistratus, plays were performed in an open area of the Agora called the orchestra, or "dancing space." Spectators sat on wooden planks laid on portable scaffolding. Sometime in the fifth century BCE, the scaffolding collapsed, and many people were injured. The Athenians built a new theater (theatron, meaning "viewing space"), dedicated to Dionysus, into the hillside on the side of the Acropolis away from the Agora and below the Parthenon. Architecturally, it was very similar to the best preserved of all Greek theaters, the one at Epidaurus (Figs. 2.35 and 2.36), built in the early third century BCE. The orchestra has been transformed into a circular performance space, approached on each side by an entry way called a parados, through which the chorus would enter the orchestra area. Behind this was an elevated platform, the **proscenium**, the stage on which the actors performed and where painted backdrops could be hung. Behind the proscenium was the skene, literally a "tent," and originally a changing room for the actors. Over time, it was transformed into a building, often two stories tall. Actors on the roof could portray the gods, looking down on the action below. By the time of Euripides, it housed a rolling or rotating platform that could suddenly reveal an interior space.

Artists were regularly employed to paint stage sets, and evidence suggests that they had at least a basic knowledge of perspective (although the geometry necessary for a fully realized perspectival space would not be developed until around 300 BCE, in Euclid's *Optics*). Their aim was, as in sculpture, to approximate reality as closely as possible. We know from literary sources that the painter Zeuxis "invented" ways to shade or model the figure in the fifth

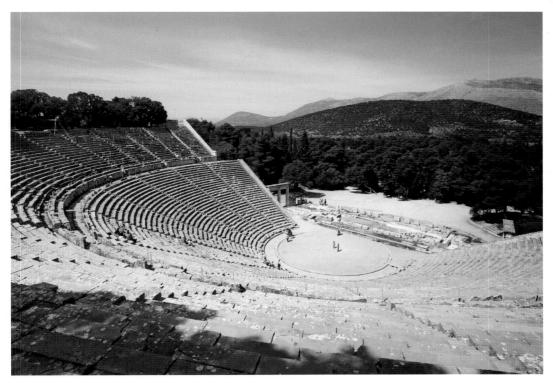

Fig. 2.35 Theater, Epidaurus. Early 3rd century BCE. This theater is renowned for its democratic design—not only is every viewer equally well situated, but also the acoustics of the space are unparalleled. A person sitting in the very top row can hear a pin drop on the *orchestra* floor.

century BCE. Legend also had it that he once painted grapes so realistically that birds tried to eat them. The theatrical sets would have at least aimed at this degree of naturalism.

THE HELLENISTIC WORLD

How are the values of the Hellenistic world reflected in its politics, philosophy, and art?

Both the emotional drama of Greek theater and the sensory appeal of its music reveal a growing tendency in the culture to value emotional expression at least as much as, and sometimes more than, the balanced harmonies of Classical art. During the Hellenistic age in the fourth and third centuries BCE, the truths that the culture increasingly sought to understand were less idealistic and universal, and more and more empirical and personal. This shift is especially evident in the new empirical philosophy of Aristotle (384–322 BCE), whose investigation into the workings of the real world supplanted, or at least challenged, Plato's idealism. In many ways, however, the ascendancy of this new aesthetic standard can be attributed to the daring, the audacity, and the sheer awe-inspiring power of a single figure, Alexander of Macedonia, known as Alexander the Great (356–323 BCE). Alexander aroused the emotions and captured the imagination of not just a theatrical audience, but an entire people—perhaps even the entire Western world—and created a legacy that established Hellenic Greece as the model against which all cultures in the West had to measure themselves.

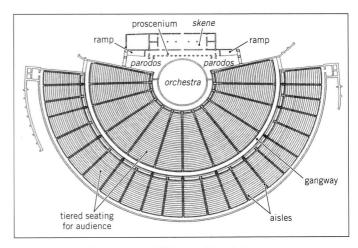

Fig. 2.36 Plan of the theater at Epidaurus. Early 3rd century BCE.

The Empire of Alexander the Great

Alexander was the son of Philip II (382–336 BCE) of Macedonia, a relatively undeveloped state to the north whose inhabitants spoke a Greek dialect unintelligible to Athenians. Recognizing that after the Peloponnesian Wars, the Greek poleis were in disarray, in 338 BCE Philip defeated the combined forces of Athens and Thebes and unified all of Greece, with the exception of Sparta. He then turned his attention to Persia, and when he was assassinated in 336 BCE, Alexander quickly took control.

Within two years of conquering Thebes, Alexander had crossed the Hellespont into Asia and defeated Darius III of Persia at the battle of Issus (just north of modern Iskenderon, Turkey). The victory continued Philip's plan to repay the Persians for their role in the Peloponnesian Wars and to conquer Asia as well. By 332 BCE, Alexander had conquered Egypt, founding the great city of Alexandria (named, of course, after himself) in the Nile Delta (Map 2.2). Then he marched back into Mesopotamia, where he again defeated Darius III and then marched into both Babylon and Susa without resistance. After making the proper sacrifices to the Akkadian god Marduk—and thus gaining the admiration of the locals—he advanced on Persepolis, the Persian capital, which he burned after seizing its royal treasures. Then he entered present-day Pakistan.

Alexander's object was India, which he believed was relatively small. He thought if he crossed it, he would find what he called Ocean, and an easy sea route home. Finally, in 326 BCE, his army reached the Indian Punjab. Under Alexander's leadership, it had marched over 11,000 miles without a defeat. It had destroyed ancient empires, founded many cities (in the 320s BCE, Alexandrias proliferated across the world), and created the largest empire the world had ever known.

When Alexander and his army reached the banks of the Indus River in 326 BCE, he encountered a culture that had long fascinated him. His teacher Aristotle had described it, wholly on hearsay, as had Herodotus before him, as the farthest land mass to the east, beyond which lay the Endless Ocean that encircled the world. Alexander stopped first at Taxila (20 miles north of present-day Islamabad, Pakistan; see Map 2.2), where King Omphis greeted him with a gift of 200 silver talents, 3,000 oxen, 10,000 sheep, and 30 elephants, and bolstered Alexander's army by giving him 700 Indian cavalry and 5,000 infantry.

While Alexander was in Taxila, he became acquainted with the Hindu philosopher Calanus. Alexander recognized in Calanus and his fellow Hindu philosophers a level of wisdom and learning that he valued highly, one clearly reminiscent of Greek philosophy, and his encounters with them represent the first steps in a long history of the crossfertilization of Eastern and Western cultures.

But in India the army encountered elephants, whose formidable size proved problematic. East of Taxila, Alexander's troops managed to defeat King Porus, whose army was equipped with 200 elephants. Rumor had it that farther to the east, the kingdom of the Ganges, their next logical opponent, had a force of 5,000 elephants. Alexander pleaded with his troops: "Dionysus, divine from birth, faced terrible tasks—and we have outstripped him! . . . Onward, then: let us add to our empire the rest of Asia!" The army refused to budge. His conquests thus concluded, Alexander himself sailed down the Indus River, founding the city that would later become Karachi. As he returned home, he contracted fever in Babylon and died in 323 BCE. Alexander's life was brief, but his influence on the arts was long-lasting.

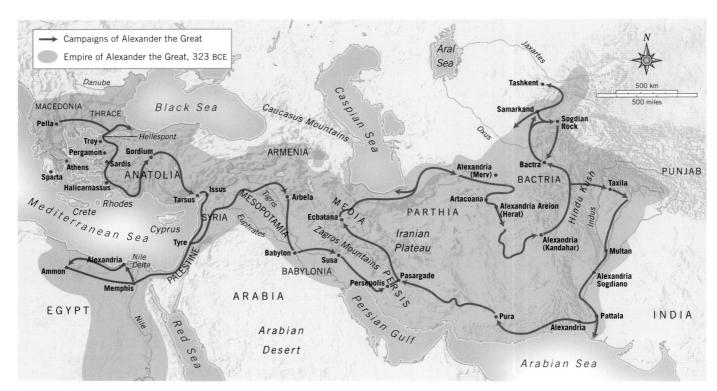

Map 2.2 Alexander's empire at his death in 323 BCE and the route of his conquests. Alexander founded over 70 cities throughout his empire, naming many after himself.

Toward Hellenistic Art: Sculpture in the Late Classical Period

During Alexander's time, sculpture flourished. Ever since the fall of Athens to Sparta in 404 BCE, Greek artists had continued to develop the **Classical** style of Phidias and Polyclitus, but they modified it in subtle yet innovative ways. Especially notable was a growing taste for images of men and women in quiet, sometimes dreamy and contemplative moods, which increasingly replaced the sense of nobility and detachment characteristic of fifth-century Classicism and found its way even into depictions of the gods. The most admired sculptors of the day were Lysippus, Praxiteles, and Skopas. Very little of the last's work has survived, although he was noted for high-relief sculpture featuring highly energized and emotional scenes. The work of the first two is far better known.

The Heroic Sculpture of Lysippus Alexander hired the sculptor Lysippus (flourished fourth century BCE) to do all his portraits. Despite his cruel treatment of the Thebans early in his career, Alexander was widely admired by the Greeks. Even during his lifetime, but especially after his death, sculptures celebrating the youthful hero abounded, almost all of them modeled on Lysippus' originals. Alexander is easily recognizable—his disheveled hair long and flowing, his gaze intense and melting, his mouth slightly open, his head alertly turned on a slightly tilted neck (Fig. 2.37).

Fig. 2.37 Alexander the Great, head from a Pergamene copy (ca. 200 BcE) of a statue, possibly after a 4th-century BCE original by Lysippus. Marble, height 161/6". Archaeological Museum, Istanbul. Alexander is traditionally portrayed as if looking beyond his present circumstances to greater things.

Lysippus dramatized his hero. That is, he did not merely represent Alexander as naturalistically as possible, he also animated him, showing him in the midst of action. In all likelihood, he idealized him as well. The creation of Alexander's likeness was a conscious act of propaganda. Early in his conquests the young hero referred to himself as "Alexander the Great," and Lysippus' job was to embody that greatness. Lysippus challenged the Classical kanon of proportion created by Polyclitus: smaller heads and more slender bodies lent his heroic sculptures a sense of greater height. In fact, he transformed the Classical tradition in sculpture and began to explore new possibilities that, eventually, would define Hellenistic art, with its sense of animation, drama, and psychological complexity. In a Roman copy of a lost original by Lysippus known as the Apoxyomenos (Fig. 2.38), or The Scraper, an athlete removes oil and dirt from his body

Fig. 2.38 Lysippus, *Apoxyomenos (The Scraper)*, Roman copy of an original Greek bronze of ca. 350–325 BCE. Museo Pio Clementino, Vatican Museums, Vatican State. Marble, height 6'8". According to the Roman Pliny the Elder, writing in his *Natural History* in the first century CE, Lysippus "made the heads of his figures smaller than the old sculptors used to do." In fact, the ratio of the head size to the body in Lysippus' sculpture is 1:9, compared to Polyclitus' Classical proportions of 1:8.

with an instrument called a strigil. Compared to the *Doryphoros* (*Spear Bearer*) of Polyclitus (see Fig. 2.28), *The Scraper* is much slenderer, his legs much longer, his torso shorter. *The Scraper* seems much taller, although in fact the sculptures are very nearly the same height. The arms of *The Scraper* break free of his frontal form and invite the viewer to look at the sculpture from the sides as well as the front. He seems detached from his circumstances, as if recalling his athletic performance. All in all, he seems both physically and mentally uncontained by the space in which he stands.

The Sensuous Sculpture of Praxiteles Competing with Lysippus for the title of greatest sculptor of the fourth century BCE was the Athenian Praxiteles (flourished 370-330 BCE). Praxiteles was one of the 300 wealthiest men in Athens, thanks to his skill, but he also had a reputation as a womanizer. The people of the port city of Knidos, a Spartan colony in Asia Minor, asked him to provide them with an image of their patron goddess, Aphrodite, in her role as the protectress of sailors and merchants. Praxiteles responded with a sculpture of Aphrodite as the goddess of love, here reproduced in a later Roman copy (Fig. 2.39). She stands at her bath, holding her cloak in her left hand. The sculpture is a frank celebration of the body—reflecting in the female form the humanistic appreciation for the dignity of the human body in its own right. (Images of it on local coins suggest that her original pose was far less modest than that of the Roman copy, her right hand not shielding her genitals.) The statue made Knidos famous, and many people traveled there to see it. She was enshrined in a circular temple, easily viewed from every angle, the Roman scholar Pliny the Elder (23-79 cE) tells us, and she quickly became an object of religious attention—and openly sexual adoration. The reason for this is difficult to assess in the rather mechanical Roman copies of the lost original.

Praxiteles' Aphrodite of Knidos may be the first fully nude depiction of a woman in Greek sculpture, which may be why it caused such a sensation. Its fame elevated female nudity from a sign of low moral character to the embodiment of beauty, even truth itself. Paradoxically, it is also one of the earliest examples of artwork designed to appeal to what some art historians describe as the male gaze that regards woman as its sexual object. Praxiteles' canon for depicting the female nude—wide hips, small breasts, oval face, and centrally parted hair—remained the standard throughout antiquity.

Aristotle: Observing the Natural World

We can only guess what motivated Lysippus and Praxiteles so to dramatize and humanize their sculptures, but it is likely that the aesthetic philosophy of Aristotle played a role. Aristotle was a student of Plato's. Recall that, for Plato, all reality is a mere reflection of a higher, spiritual truth, a higher dimension of Ideal Forms that we glimpse only through philosophical contemplation.

Aristotle disagreed. Reality was not a reflection of an ideal form, but existed in the material world itself, and by observing the material world, one could come to know universal truths. So Aristotle observed and described all aspects of the

Fig. 2.39 Praxiteles, Aphrodite of Knidos, Roman copy of an original of ca. 350 BCE. Marble, height 6'8". Vatican Museums, Vatican State. The head of this figure is from one Roman copy, the body from another. The right forearm and hand, the left arm, and the lower legs of the Aphrodite are all seventeenth- and eighteenth-century restorations. There is reason to believe that her hand was not so modestly positioned in the original.

world in order to arrive at the essence of things. His methods of observation came to be known as *empirical investigation*. And although he did not create a formal **scientific method**, he and other early empiricists did create procedures for testing their theories about the nature of the world that, over time, would lead to the great scientific discoveries of Bacon, Galileo, and Newton. Aristotle studied biology, 200logy, physics, astronomy, politics, logic, ethics, and the various genres

of literary expression. Based on his observations of lunar eclipses, he concluded as early as 350 BCE that the Earth was spherical, an observation that may have motivated Alexander to cross India in order to sail back to Greece. He described over 500 animals in his *Historia Animalium*, including many that he dissected himself. In fact, Aristotle's observations of marine biology were unequaled until the seventeenth century and were still much admired by Charles Darwin in the nineteenth.

Aristotle also understood the importance of formulating a reasonable hypothesis to explain phenomena. His Physics is an attempt to define the first principles governing the behavior of matter—the nature of weight, motion, physical existence, and variety in nature. At the heart of Aristotle's philosophy is a question about the relation of identity and change (not far removed, incidentally, from one of the governing principles of this text—the idea of continuity and change in the humanities). To discuss the world coherently, we must be able to say what it is about a thing that makes it the thing it is, that separates it from all the other things in the world. In other words, what is the attribute that we would call its material identity or essence? What it means to be human, for instance, does not depend on whether one's hair turns gray. Such "accidental" changes matter not at all. At the same time, our experience of the natural world suggests that any coherent account requires us to acknowledge process and change—the change of seasons, the changes in our understanding associated with gaining knowledge in the process of aging, and so on. For Aristotle, any account of a thing must accommodate both aspects: We must be able to say what changes a thing undergoes while still retaining its essential nature. Aristotle thus approached all manner of things—from politics to the human condition—with an eye toward determining what constituted their essence.

Aristotle's Poetics What constitutes the essential nature of literary art, and the theater in particular, especially fascinated Aristotle. Like all Greeks, he was well acquainted with the theater of Aeschylus, Euripides, and Sophocles, and in his *Poetics* he defined their literary art as "the imitation of an action that is complete and whole." Including a whole action, or a series of events that ends with a crisis, gives the play a sense of unity. Furthermore, he argued (against Plato, who regarded imitation as inevitably degrading and diminishing) that such imitation elevates the mind ever closer to the universal.

One of the most important ideas that Aristotle expressed in the *Poetics* is **catharsis**, the cleansing, purification, or purgation of the soul. As applied to drama, it is not the tragic hero who undergoes catharsis, but the audience. The audience's experience of catharsis is an experience of change, just as change always accompanies understanding. In the theater, what moves the audience to change is its experience of the universality of the human condition—what it is that makes us human, our weaknesses as well as our strengths. At the sight of the action on stage, they are struck with "fear and pity." Plato believed that both these emotions were pernicious. But Aristotle argued that the audience's emotional response to the plight of the characters on stage clarified for them the fragility

and mutability of human life. What happens in tragedy is universal—the audience understands that the action could happen to anyone at any time.

The Golden Mean In Aristotle's philosophy, such Classical aesthetic elements as unity of action and time, orderly arrangement of the parts, and proper proportion all have ethical ramifications. He argued for them by means of a philosophical method based on the **syllogism**, two premises from which a conclusion can be drawn. The most famous of all syllogisms is this:

All men are mortal; Socrates is a man; Therefore, Socrates is mortal.

In the *Nicomachean Ethics*, written for and edited by his son Nicomachus, Aristotle attempts to define, once and for all, what Greek society had striven for since the beginning of the polis—the good life. The operative syllogism goes something like this:

The way to happiness is through the pursuit of moral virtue; The pursuit of the good life is the way to happiness; Therefore, the good life consists in the pursuit of moral virtue.

The good life, Aristotle argued, is attainable only through balanced action. Tradition has come to call this the Golden Mean—not Aristotle's phrase but that of the Roman poet Horace—the middle ground between any two extremes of behavior. Thus, in a formulation that was particularly applicable to Aristotle's student Alexander the Great, the Golden Mean between cowardice and recklessness is courage. Like the arts, which imitate an action, human beings are defined by their actions: "As with a flute-player, a statuary [sculptor], or any artisan, or in fact anybody who has a definite function, so it would seem to be with humans. . . . The function of humans is an activity of soul in accordance with reason." This activity of soul seeks out the moral mean, just as "good artists . . . have an eye to the mean in their works."

Despite the measure and moderation of Aristotle's thinking, Greek culture did not necessarily reflect the balanced approach of its leading philosopher. In his emphasis on catharsis—the value of experiencing "fear and pity," the emotions that move us to change—Aristotle introduced the values that would define the age of Hellenism, the period lasting from 323 to 31 BCE, that is, from the death of Alexander to the Battle of Actium, the event that marks in the minds of many the beginning of the Roman Empire.

Alexandria

Perhaps the most spectacular of all Alexander's capitols was Alexandria in Egypt. Alexander conceived of all the cities he founded as centers of culture. They would be hubs of trade and learning, and Greek culture would radiate from them to the surrounding countryside. But Alexandria exceeded even Alexander's expectations.

The city's ruling family, the Ptolemies (heirs of Alexander's close friend and general, Ptolemy I), built the world's first museum—from the Greek mouseion, literally, "temple to the muses"—conceived as a meeting place for scholars and students. Nearby was the largest library in the world. It contained over 700,000 volumes. Plutarch later claimed that it was destroyed in 47 BCE, after Julius Caesar ordered his troops to set fire to the Ptolemaic fleet and winds spread the flames to warehouses and dockyards. We now know that the library survived—the Roman geographer Strabo worked there in the 20s BCE. But here were collected the great works of Greek civilization, the writings of Plato and Aristotle, the plays of the great tragedians Aeschylus, Sophocles, and Euripides, as well as the comedies of Aristophanes. Stimulated by the intellectual activity in the city, the great mathematician Euclid formulated the theorems of plane and solid geometry here.

The city was designed by Alexander's personal architect, Dinocrates of Rhodes (flourished fourth century BCE), laid out in a grid, enclosed by a wall, and accessible by four gates at the ends of its major avenues. It was blessed by three extraordinary harbors. One was connected to the Nile, allowing the transfer of the river's enormous agricultural wealth. It was a cosmopolitan city, exceeding even Golden Age Athens in the diversity of its inhabitants. As its population approached one million at the end of the first century BCE, commerce was its primary activity. Banks conducted transactions. Peoples of different ethnic backgrounds—Jews, Africans, Greeks,

Egyptians, various races and tribes from Asia Minor—all came together with the single purpose of making money.

Gradually, Hellenistic and Egyptian cultures merged, a fact underscored by the Egyptian king Ptolemy I (r. 323–285 BCE) when he diverted the funeral train of Alexander the Great from its Macedonian destination to Egypt. Burying him either in Memphis or Alexandria (his tomb has never been found), Ptolemy guaranteed that the city would forever be associated with the cult of Alexander himself. Tomb decorations at Luxor depict Alexander in the traditional role and style of an Egyptian pharaoh.

Pergamon: Hellenistic Capital

Upon his death, Alexander left no designated successor, and his three chief generals divided his empire into three successor states: the kingdom of Macedonia (including all of Greece), the kingdom of the Ptolemies (Egypt), and the kingdom of the Seleucids (Syria and what is now Iraq). But a fourth, smaller kingdom in western Anatolia, Pergamon (present-day Bergama, Turkey), soon rose to prominence and became a center of Hellenistic culture. Ruled by the Attalids—descendants of a Macedonian general named Attalus—Pergamon was founded as a sort of treasury for the huge fortunes Alexander had accumulated in his conquests. It was technically under the control of the Seleucid kingdom. However, under the leadership of Eumenes I (r. 263–241 BCE), Pergamon achieved virtual independence.

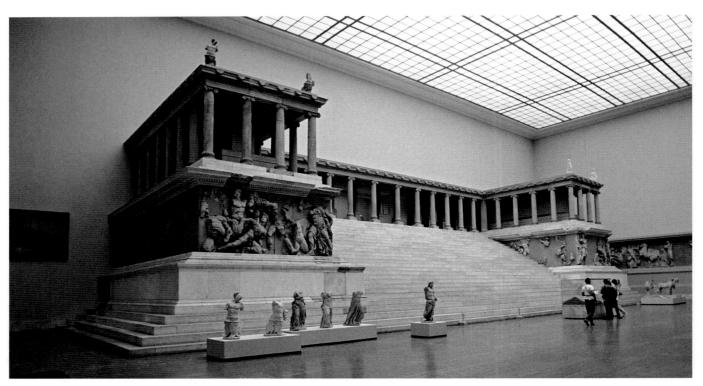

Fig. 2.40 Reconstructed west front of the Altar of Zeus, from Pergamon. ca. 165 BCE. Marble, Staatliche Museen, Berlin, Antikensammlung, Pergamonmuseum. The Pergamon altar was exported to Germany with the permission of the Ottoman authorities in 1899, but in recent years, Turkish authorities have expressed interest in its return with ever-increasing insistence.

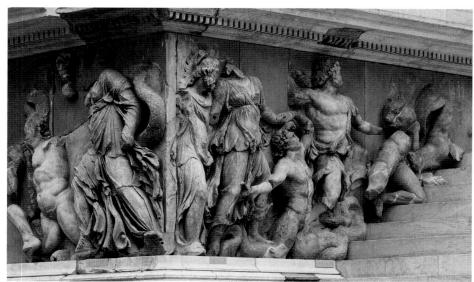

Fig. 2.41 Reconstructed west staircase frieze of the Altar of Zeus, from Pergamon. ca. 165 BCE. Marble. Staatliche Museen, Berlin, Antikensammlung, Pergamonmuseum. Particularly notable here is the extended arm of the kneeling warrior in the center, which reaches several feet into the viewer's space.

Parthenon, and is 7½ feet high. Its subject is a mythical battle of the gods and the giants for control of the world. The giants are depicted with snakelike bodies that coil beneath the feet of the triumphant gods (Fig. 2.42). These figures represent one of the greatest examples of the Hellenized style of sculpture that depends for its effects on its expressionism, that is, the attempt to elicit an emotional response in the viewer. The theatrical effects of Lysippus are magnified into

The Library at Pergamon The Attalids created a huge library filled with over 200,000 Classical Athenian texts. These were copied onto parchment, a word that derives from the Greek pergamene, meaning "from Pergamon," and refers to sheets of tanned leather. Pergamon's vast treasury allowed the Attalids the luxury of investing enormous sums of money in decorating their acropolis with art and architecture. Especially under the rule of Eumenes II (r. 197–160 BCE), the building

program flourished. It was Eumenes II who built the library, as well as the theater and a gymnasium. And he was probably responsible for the Altar of Zeus (Fig. 2.40), which is today housed in Berlin. The staircase entrance to the altar is 68 feet wide and nearly 30 feet deep. It rises to an Ionic colonnade. As opposed to the Parthenon, where the frieze is elevated above the colonnade, the first thing the viewer confronts at the Altar of Zeus is the frieze itself, a placement that draws attention to its composition of nearly 200 separate twisted, turning, and animated figures. Notice how, as the frieze narrows and rises up the stairs (Fig. 2.41), the figures seem to break free of the architectural space that confines them and crawl out onto the steps of the altar.

A New Sculptural Style The altar is decorated with the most ambitious sculptural program since the

Fig. 2.42 Detail of the east frieze of the Altar of Zeus, from Pergamon. ca. 165 BCE. In this image, Athena grabs the hair of a winged, serpent-tailed monster, who is identified on the base of the monument as Alkyoneos, son of the earth goddess Ge. Ge herself rises up from the ground on the right to avenge her son. Behind Ge, a winged Nike flies to Athena's rescue.

a heightened sense of drama. Where Classical artists sought balance, order, and proportion, this frieze, with its figures twisting, thrusting, and striding in motion, stresses diagonal forces that seem to pull each other apart. Swirling bodies and draperies weave in and out of the sculpture's space, and the relief is so three-dimensional that contrasts of light and shade add to the dramatic effects. Above all, the frieze is an attempt to evoke the emotions of fear and pity that Aristotle argued led to catharsis in his *Poetics*, not the intellectual order of Classical tradition.

The relief was designed to celebrate Pergamon's role as the new center of Hellenism, its stature as the "new Athens." To that end, most authorities agree that the relief depicts the Attalid victory over the Gauls, a group of non-Greekspeaking and therefore "barbarian" central European Celts who had begun to migrate south through Macedonia as early as 300 BCE, and who had eventually settled in Galatia, just east of Pergamon. Sometime around 240–230 BCE, Attalos I (r. 241–197 BCE) defeated the Gauls in battle. Just as the Athenians had alluded to the battle between the forces of civilization and inhuman, barbarian aggressors in the metopes of the Parthenon (see Fig. 2.32), so too the Pergamenes suggested the nonhumanity of the Gauls by depicting the giants as snakelike and legless, unable even to begin to rise to the level of the Attalid victors.

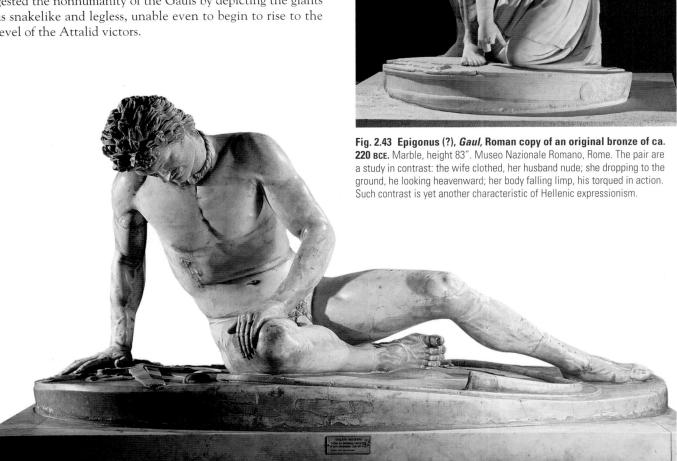

Fig. 2.44 Epigonus (?), *Dying Gaul*, Roman copy of an original bronze of ca. 220 BCE. Marble, height 37". Museo Capitolino, Rome. The Gaul seems both resigned to his fate—pressing against the ground to support himself as if pushing futilely against death—and also determined to show his valor and strength to the end—holding himself up as long as he can. Such emotional ambiguity is an integral aspect of Hellenistic art.

When Attalus I defeated the Gauls, he commissioned a group of three life-size figures to decorate the sanctuary of Athena Nikephoros (the "Victorybringer") on the acropolis of Pergamon. Possibly the work of the sculptor Epigonus, the original bronze versions of these sculptures, which represent the vanquished Gauls, no longer exist, and how they related to one another is not clear. Nevertheless, the drama of their presentation and their appeal to the emotions of the viewer is unmistakable. In what was probably the centerpiece of the installation (Fig. 2.43), a Gallic chieftain, having just killed his wife in order to prevent her capture, possible abuse at the hands of the Pergamenes, and almost certain sale into slavery, now turns his sword on himself. He twists in an expressive theatricality, his arms

and body rising to the task in marked contrast to the limp collapse of his wife beside him. A second sculpture, which probably flanked the suicide in the center of the installation, depicts a wounded Gallic trumpeter (Fig. 2.44). The Gaul's identity is established by the horn that lies at his feet, by his tousled hair and mustache (uncharacteristic of Greeks), and by his golden Celtic torc, or choker, the only item of clothing the Gauls wore in combat. He is dying from a chest wound that bleeds profusely below his right breast. The brutal realism together with the nobility and heroism of the defeated Gaul places this work among the earliest examples of Hellenistic expressionism.

One other Hellenistic sculpture deserves particular attention: the Nike of Samothrace (Fig. 2.45). Convincing arguments date it anywhere from 300 BCE to as late as 31 BCE, the preponderance of evidence suggesting the third or early second centuries BCE. Most agree that it was probably commissioned to celebrate a naval victory. It originally stood (with head and arms that have not survived, except for a single hand) upon the sculpted prow of a ship that was dramatically set in a pool of water at the top of a cliff on the island of Samothrace in the north Aegean. The dynamic forward movement of the striding figure is balanced dramatically by the open gesture of her extended wings and the powerful directional lines of her windblown gown across her body. When light rakes across the deeply sculpted forms of this figure, it emphasizes the contrasting textures of feathers, fabric, and flesh. With the Altar of Zeus, this sculpture reflects a new direction in art. Not only is this new art more interested in non-Greek subjects (Gauls and Trojans, for instance), but also the calm and restraint of Classical art have disappeared, replaced by the freedom to explore the emotional extremes of the human experience.

Fig. 2.45 Nike (Victory) of Samothrace, from the Sanctuary of the Great Gods, Samothrace. ca. 300–190 BCE. Marble, height 8'1". Musée du Louvre, Paris. Discovered by French explorers in 1863, the Nike appears so immediate and alive that the viewer can almost feel the gust of wind that blows across her body.

2.1 Outline how the Cycladic, Minoan, and Mycenaean cultures contributed to the later Greeks' sense of themselves.

The later Greeks traced their ancestry to the cultures that arose in the islands of the Aegean Sea. The art of the Cyclades consisted of highly simplified Neolithic figurines and later, probably under the influence of Minoan culture to the south, elaborate wall frescoes depicting everyday events. Unique to Minoan culture is an emphasis on the bull, associated with the legend of King Minos and the Minotaur, and the double ax, symbol of the palace of Minos at Knossos, whose complex layout gives rise to the word "labyrinth." Mycenaean warriors from the Greek mainland invaded Crete in about 1450 все. There is abundant archeological evidence that they had valued Minoan artistry long before and had traded with the Minoans. But from all appearances their two cultures could not have been more different. In what ways did Minoan and Mycenaean cultures differ?

Around 800 BCE, Homer's great epics, the *Iliad* and the *Odyssey*, were transcribed. The stories had been passed down orally for generations. The *Iliad* tells of the anger of the Greek hero Achilles and its consequences during a war between Mycenae and Troy, which occurred sometime around 1200 BCE. The *Odyssey* follows the Greek commander Odysseus on his adventure-laden journey home to his faithful wife, Penelope. These stories, and such legends as the myth of the Minotaur, comprised for the Greeks their *archaiologia*, their way of knowing their past. How do the *Iliad* and the *Odyssey* both embody the Greek value of *areté*?

2.2 Define the polis and explain how it came to reflect the values of Greek culture.

The rural areas of Greece, separated from one another by mountainous geography, gradually began to form into a community—the polis, or city-state—that exercised authority over its region. Inevitably, certain of these poleis became more powerful than others. At Delphi, Olympia, and even in colonies such as Paestum on the Italian peninsula, the city-states came together to honor their gods at sanctuaries. What role did these sanctuaries play in the development of Greek culture?

2.3 Describe how Pericles defined and shaped Golden Age Athens.

In the fifth century, the statesman Pericles dominated Athenian political life. In his funeral speech honoring the war dead, delivered early in the Peloponnesian Wars, he claimed "excellence" for Athenians in all aspects of endeavor, leading Greece by its example. How would you

characterize the contributions of Pericles to the Greeks' sense of themselves?

The Athenians realized the excellence of their sculpture, which became increasingly naturalistic even as it embodied an increasingly perfect sense of proportion. They realized it even more dramatically on the Acropolis, where Pericles instituted a massive architectural program that included what is perhaps the highest expression of the Doric order, the Parthenon. How would you define the Idea of Beauty (a Platonic notion) as reflected in Greek sculpture? In Greek architecture as exemplified by the Parthenon? Why have we come to call this work "Classical"?

Pericles also championed the practice of philosophy in Athens. His Athens inherited two distinct philosophical traditions, that of the pre-Socratics, who were chiefly concerned with describing the natural universe, and that of the Sophists, who were primarily concerned with understanding the nature of human "knowing" itself. Pericles was particularly interested in the Sophists. Why? The Sophist philosophy was, however, rejected by Socrates. In what ways does the philosophy of Socrates differ from that of the Sophists? Socrates never wrote a word himself, but his student Plato recorded his thoughts. How does Plato extend Socratic thought in the *Republic*?

Greek theatrical practice arose out of rites connected with Dionysus, god of wine. In what ways do both Greek comedy and Greek tragedy reflect this common origin? What is the role of the chorus in tragedy? What tension does tragedy most often exploit?

2.4 Characterize the values of the Hellenistic world in terms of politics, philosophy, and art.

The influence of Alexander the Great extended across North Africa and Egypt, into the Middle East, and as far as the Indian subcontinent, creating the largest empire the world had ever known. During his reign, sculpture flourished as a medium, the two masters of the period being Lysippus and his chief competitor, Praxiteles. How does the work of the two sculptors compare? What new direction in sculpture did they introduce and how did later Hellenistic sculptors exploit that direction?

Alexander's tutor, the philosopher Aristotle, emphasized the importance of empirical observation in understanding the world, distinguishing between a thing's identity—its essence—and the changes that inevitably occur to it over time. How would you compare Aristotle's philosophy to Plato's? How does Aristotle's *Poetics* inform later Hellenistic sculpture?

Rome and Its Hellenistic Heritage

Aeneas, who at the end of the Trojan War sailed off to found a new homeland for his people. The Roman poet Virgil (70–19 BCE) would celebrate Aeneas' journey in his epic poem the Aeneid, written in the last decade of his life. There, he describes how the gods who supported the Greeks punished the Trojan priest Laocoön for warning his countrymen not to accept the "gift" of a wooden horse from the Greeks:

I shudder even now, Recalling it—there came a pair of serpents With monstrous coils, abreast the sea, and aiming Together for the shore. . . . Straight toward Laocoön, and first each serpent Seized in its coils his two young sons, and fastened The fangs in those poor bodies. And the priest Struggled to help them, weapons in his hand. They seized him, bound him with the mighty coils, Twice round his waist, twice round his neck, they squeezed With scaly pressure, and still towered above him Straining his hands to tear the knots apart, His chaplets¹ stained with blood and the black poison, He uttered horrible cries, not even human, More like the bellowing of a bull when, wounded, It flees the altar, shaking from the shoulder The ill-aimed axe.

¹Chaplets: Garlands for the head.

It is likely that as he wrote the *Aeneid*, Virgil had seen the sculpture of *Laocoön and His Sons* (Fig. **2.46**), carved in about 150 BCE. (Some argue that the sculpture, discovered in 1506 in the ruins of a palace belonging to the emperor Titus [r. 79–81 CE] in Rome, is a copy of the now-lost original.) Whatever the case, the drama and expressionism of the sculpture are purely Hellenic. So too are its complex interweaving of elements and diagonal movements reminiscent of Athena's struggle with the giants on the frieze of the Altar of Zeus at Pergamon (see Fig. 2.42).

In fact, even though Rome conquered Greece in 146 BCE (at about the time that the *Laocoön* was carved), Greece could be said to have "ruled" Rome, at least culturally. Rome was a fully Hellenized culture—it fashioned itself in the image of Greece almost from its beginnings. Indeed, many of the works of Greek art reproduced in this book are not Greek at all but later Roman copies of Greek originals. The emperor Augustus (r. 27 BCE–14 CE) sought to transform Rome into the image of Pericles' Athens. A sculpture by Lysippus was a favorite of the emperor Tiberius (r. 14–57 CE), who had it removed from public display and placed in his bedroom. So outraged were the public, who considered the sculpture theirs and not the emperor's, that he was forced to return it

to its public place. Later Roman emperors, notably Caligula and Nero, raided Delphi and Olympia for works of art.

It was not, in the end, its art on which Rome most prided itself. "Others," Virgil would write in his poem, "no doubt, will better mold the bronze." He concludes:

... remember, Roman,
To rule the people under law, to establish
The way of peace, to battle down the haughty,
To spare the meek. Our fine arts, these, forever.

Fig. 2.46 Hagesandros, Polydoros, and Athanadoros of Rhodes, Laocoön and His Sons. Hellenistic, 2nd–1st century BCE, or marble copy of an original, Rome, 1st century CE. Marble, height 6'10". Museo Pio Clementino, Vatican Museums, Vatican State. Pliny the Elder attributes the sculpture to the three artists from Rhodes. If this is a copy of a lost original (and scholars debate the issue), it was probably inspired by Virgil's poem.

Empire

3

Urban Life and Imperial Majesty in Rome, China, and India

LEARNING OBJECTIVES

3.1 Characterize imperial Rome, its dual sense of origin, and its debt to the Roman Republic.

3.2 Describe the impact of the competing schools of thought that flourished in early Chinese culture—Daoism, Confucianism, and Legalism.

3.3 Discuss the ways in which both Hinduism and Buddhism shaped Indian culture.

hamugadi, modern Timgad, Algeria, is one of the few totally excavated towns in the Roman Empire, and its ruins tell us as much or more about Roman civilization as any other Roman city, including Rome itself. It was founded in about 100 ce as a colony for retired soldiers of the Roman legions who had served the Empire as it constantly expanded its borders in Africa. Whereas Rome had grown haphazardly over hundreds of years and under many rulers, Thamugadi was an entirely new city and a model, if not of Rome itself, then of the Roman sense of order. It was based on the rigid grid of a Roman military camp and was divided into four quarters defined by east-west and north-south arteries, broad avenues lined with columns (Fig. 3.1), with a forum, or public square, at their crossing. The town had 111 insulae (apartment blocks), and all the amenities of Roman life were available: 14 public baths, a library, a theater, and several markets, including one that sold only clothes (Fig. 3.2).

Thamugadi is the product of the conscious Roman decision to "Romanize" the world, a symbol of empire itself. By the middle of the third century BCE, Rome had begun to seek control of the entire Mediterranean basin and its attendant wealth. The Roman military campaigns led to the building of these cities, with their amphitheaters, temples, arches, roads, fortresses, aqueducts, bridges, and monuments of every description. From Scotland in the north to the oases of the Sahara desert in the south, from the Iberian peninsula in the west to Asia Minor as far as the Tigris River in the east, local

Fig. 3.2 City plan of Thamugadi. ca. 200 ce. The layout of Thamugadi is a symbol of Roman reason and planning—efficient and highly organized.

▼ Fig. 3.1 Colonnaded street in Thamugadi, North Africa. View toward the Arch of Trajan. Late 2nd century ce. Thamugadi was established in about 100 ce as a colony for retired soldiers of the Roman Third Legion. It represents the deep imprint Rome left upon its entire empire. aristocrats took up Roman customs (Map 3.1). Roman law governed each region. Rome remained the center of culture all others at the periphery imitated.

If most empires, including Rome's but also Alexander the Great's before it (see Chapter 2) and those of the great maritime empires of the sixteenth and seventeenth centuries, including Portugal and Spain (see Chapter 9), begin with military campaigns designed to win territory and the wealth associated with that territory, the resulting empires are not usually held together by force. Rather, the conquered people—who may indeed suffer considerably as they are overcome, victimized by enslavement and even extermination (as would happen in both Africa and the Americas in the sixteenth century)—are often won over by the enhanced economic opportunities afforded them by the larger markets

opened up by participation in the empire's network of trade. But perhaps most importantly of all, empires like Rome's bring together diverse cultures, religions, philosophical ideas, and artistic tastes in an environment of mutual influence. As much as Rome imposed its will and ways of life on the entire Mediterranean, the cultures of the Mediterranean—especially those of Greece and the Near East—affected Rome as well. Empire is the first step in the globalization of world culture.

Rome admired Greece for its cultural achievements, from its philosophy to its sculpture, and, as we have seen, its own art developed from Greek-Hellenic models. But Rome admired its own achievements as well, and its art differed from that of its Hellenic predecessors in certain key respects. Instead of depicting mythological events and heroes,

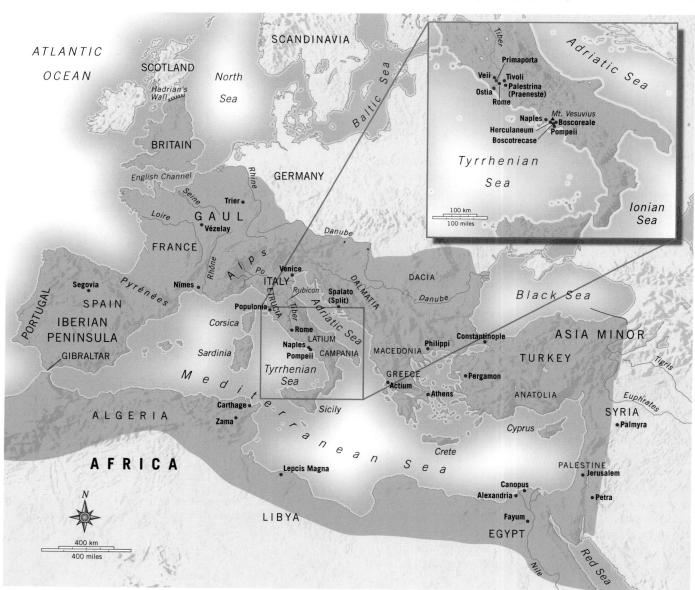

Map 3.1 The Roman Empire at its greatest extent, ca. 180 ce. By 180 ce the Roman Empire extended from the Atlantic Ocean in the west to Asia Minor, Syria, and Palestine in the east, and from Scotland in the north to the Sahara desert in North Africa.

Roman artists depicted current events and real people, from generals and their military exploits to leaders and recently deceased citizens. They celebrated the achievements of a state that was their chief patron, so that all the world might stand in awe of the state's accomplishments. And this sense of accomplishment is what cities like Thamugadi and the monuments of Rome itself also represent.

This chapter traces the rise of Roman civilization from its Greek and Etruscan origins in the sixth century BCE to about 313 CE, when the empire was Christianized. At roughly the same time, in China and in the river valleys of the Asian subcontinent of India, other empires took shape as well. In both China and India, national literatures arose, as did religious and philosophical practices that continue to this day and are influential worldwide; but in the ancient world, East and West had not yet met. The peoples of the Mediterranean world and those living in the Yellow and Indus river valleys were isolated from one another. As trade routes stretched across the Asian continent, these cultures would eventually cross paths. Gradually, Indian thought, especially Buddhism, would find its way into China, and Chinese goods would find their way to the West. Even more gradually, intellectual developments in ancient China and India, from Daoism to the teachings of Confucius and Buddha, would come to influence cultural practice in the Western world. But throughout most of the period studied in this chapter, until roughly 200 CE, the cultures of China and India developed independently of those in the West.

The Etruscan homeland, Etruria, occupied the part of the Italian peninsula that is roughly the same as present-day Tuscany. It was bordered by the Arno River to the north (which runs through Florence) and the Tiber River to the south (which runs through Rome). Rome itself developed geographically between two cultures—the Greek colonies to the south of the Tiber and the Etruscan settlements to the north. Its situation, in fact, is geographically improbable. Rome was built on a hilly site (on seven hills, to be precise) on the east bank of the Tiber. Its low-lying areas were swampy and subject to flooding, while the higher elevations of the hillsides did not easily lend themselves to building. The River Tiber itself provides a sensible explanation for the city's original siting, since it gave the city a trade route to the north and access to the sea at its port of Ostia to the south. And so does one of the river's primary crossings from the earlier times, Tiber Island, next to the Temple of Portunus. Thus, Rome was physically and literally the crossing place of Etruscan and Greek cultures.

The city also had competing foundation myths. The first is embodied in Virgil's Aeneid, in the story of its founding by the Trojan warrior Aeneas, who at the end of the Trojan War sailed off to found a new homeland for his people (see Continuity & Change, Chapter 2). The other was Etruscan. Legend had it that twin infants named Romulus and Remus were left to die on the banks of the Tiber but were rescued by a shewolf who suckled them (Fig. 3.3). Raised by a shepherd, the twins decided to build a city on the Palatine Hill above the spot where they had been saved (accounting, in the manner

ROME

What characterizes imperial Rome, and how did it continue to reflect its dual sense of origin and its Republican heritage?

The origins of Roman culture are twofold. On the one hand, there were the Greeks, who as early as the eighth century BCE colonized the southern coastal regions of the Italian peninsula and Sicily and whose Hellenic culture the Romans adopted for their own. On the other hand, there were the Etruscans. Scholars continue to debate whether the Etruscans were indigenous to Italy or whether they migrated from the Near East. In the ninth and eighth centuries BCE, the Etruscans became known to the outside world for their mineral resources, and by the seventh and sixth centuries they were major exporters of fine painted pottery, a black ceramic ware known as bucchero, bronzework, jewelry, oil, and wine. By the fifth century BCE, they were known throughout the Mediterranean for their skill as sculptors in both bronze and terra cotta.

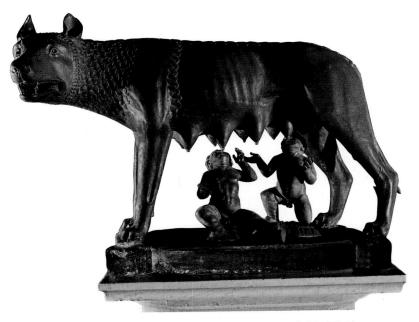

Fig. 3.3 She-Wolf. ca. 500—480 BCE. Bronze, with glass-paste eyes, height 33". Museo Capitolino, Rome. Scholars have recently suggested that the sculpture dates from medieval times. The two suckling figures representing Romulus and Remus are Renaissance additions. Nevertheless, the bronze, which became a symbol of Rome, combines a ferocious realism with the stylized portrayal of, for instance, the wolf's geometrically regular mane.

of foundation myths, for the unlikely location of the city). Soon, the two boys feuded over who would rule the new city. In his *History of Rome*, the Roman historian Livy (59 BCE–17 CE) briefly describes the ensuing conflict:

Then followed an angry altercation; heated passions led to bloodshed; in the tumult Remus was killed. The more common report is that Remus contemptuously jumped over the newly raised walls and was forthwith killed by the enraged Romulus, who exclaimed, "Shall it be henceforth with every one who leaps over my walls." Romulus thus became sole ruler, and the city was called after him, its founder.

The date, legend has it, was 753 BCE.

Republican Rome

By the time of Virgil, the Greek and Etruscan myths had merged. Thus, according to legend, Aeneas' son founded the city of Alba Longa, just to the south of Rome, which was ruled by a succession of kings until Romulus brought it under Roman control.

Romulus, it was generally accepted, inaugurated the traditional Roman distinction between **patricians**, the landowning aristocrats who served as priests, magistrates, lawyers, and judges, and **plebeians**, the poorer class who were craftspeople, merchants, and laborers. When, in 510 BCE, the Romans expelled the last of the Etruscan kings and decided to rule themselves without a monarch, the patrician/plebeian distinction became very similar to the situation in fifthcentury BCE Athens. There, a small aristocracy who owned the good land and large estates shared citizenship with a much larger working class.

In Rome, as in the Greek model, every free male was a citizen, but in the Etruscan manner, not every citizen enjoyed equal privileges. The Senate, the political assembly in charge of creating law, was exclusively patrician. In reaction, the plebeians formed their own legislative assembly, the Consilium Plebis (Council of Plebeians), to protect themselves from the patricians, but the patricians were immune to any laws the plebeians passed, known as *plebiscites*. Finally, in 287 BCE, the plebiscites became binding law for all citizens, and something resembling equality of citizenship was assured.

The expulsion of the Etruscan kings and the dedication of the Temple of Jupiter on the Capitoline Hill in 509 BCE mark the beginning of actual historical records documenting the development of Rome. They also mark the beginning of the Roman Republic, a state whose political organization rested on the principle that the citizens were the ultimate source of legitimacy and sovereignty. Many people believe that the Etruscan bronze head of a man (Fig. 3.4) is a portrait of Lucius Junius Brutus, the founder and first consul of the Roman Republic. However, it dates from approximately 100–200 years after Brutus' life, and it more likely represents a noble "type," an imaginary portrait of a Roman founding father, or pater, the root of the word patrician. This role is conveyed through the figure's strong character and strength of purpose.

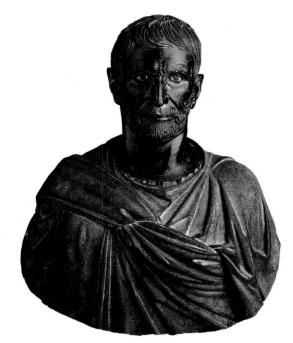

Fig. 3.4 Head of a Man (possibly a portrait of Lucius Junius Brutus). ca. 300 BCE. Bronze, height 27½". Museo Capitolino, Palazzo dei Conservatori, Rome. The eyes, which look slightly past the viewer, and the intensely furrowed brow, give the figure an almost visionary force and suggest the influence of Lysippus (compare Fig. 2.37 in Chapter 2).

In republican Rome, every plebeian chose a patrician as his patron—and, indeed, most patricians were themselves clients of some other patrician of higher status—whose duty it was to represent the plebeian in any matter of law and provide an assortment of assistance in matters, primarily economic. This paternalistic relationship—which we call patronage—reflected the family's central role in Roman culture. The pater protected not only his wife and family but also his clients, who submitted to his patronage. In return for the pater's protection, family and client equally owed the pater their total obedience—which the Romans referred to as pietas, "dutifulness." So embedded was this attitude that when toward the end of the first century BCE the Republic declared itself an empire, the emperor was called pater patriae, "father of the fatherland."

Roman Rule By the middle of the third century BCE, the Republic had embarked on a series of military exploits known as the Punic Wars that recall Alexander's imperial adventuring of the century before. Whenever Rome conquered a region, it established permanent colonies of veteran soldiers who received allotments of land, virtually guaranteeing them a certain level of wealth and status. These soldiers were citizens. If the conquered people proved loyal to Rome, they could gain full Roman citizenship. Furthermore, when not involved in combat, the local Roman soldiery transformed themselves into engineers—building roads, bridges, and civic projects of all types, significantly improving the region, as at Thamugadi in Algeria (see Figs. 3.1 and 3.2). In this way, the Republic

diminished the adversarial status of its colonies and gained their lovalty.

The prosperity brought about by Roman expansion soon created a new kind of citizen in Rome. They called themselves equites ("equestrians") to connect them to the cavalry, the elite part of the military, since only the wealthy could afford the necessary horses. The equites were wealthy businessmen, but not often landowners and therefore not patricians. The patricians considered the commercial exploits of the equites crass and their wealth ill-gotten. Soon the two groups were in open conflict, the equites joining ranks with the plebeians.

The Senate was the patrician stronghold, and it feared any loss of power and authority. When the general Pompey the Great (106–48 BCE) returned from a victorious campaign against rebels in Asia Minor in 62 BCE, the Senate refused to ratify the treaties he had made in the region or to grant the land allotments he had given his soldiers. Outraged, Pompey joined forces with two other successful military leaders. One had put down the slave revolt of Spartacus in 71 BCE. The other was Gaius Julius Caesar (100-44 BCE), a military leader from a prestigious patrician family that claimed descent from Aeneas and Venus. The union of the three leaders became known as the First Triumvirate.

A Divided Empire Wielding the threat of civil war, the First Triumvirate soon dominated the Republic's political life, but theirs was a fragile relationship. Caesar accepted a five-year appointment as governor of Gaul, present-day France. By 49 BCE, he had brought all of Gaul under his control. He summed up this conquest in his Commentaries in the famous phrase "Veni, vidi, vici"—"I came, I saw, I conquered"—a statement that captures, perhaps better than any other, the militaristic nature of the Roman state as a whole. He was preparing to return home when Pompey joined forces with the Senate. They reminded Caesar of a long-standing tradition that required a returning commander to leave his army behind, in this case on the Gallic side of the Rubicon River, but Caesar refused. Pompey fled to Greece, where Caesar defeated him a year later. Again Pompey fled, this time to Egypt, where he was murdered. The third member of the Triumvirate had been captured and executed several years earlier.

Now unimpeded, Caesar assumed dictatorial control over Rome. He treated the Senate with disdain, and most of its membership counted themselves as his enemies. On March 15, 44 BCE, the Ides of March, he was stabbed 23 times by a group of 60 senators at the foot of a sculpture honoring Pompey on the floor of the Senate. This scene was memorialized in English by Shakespeare's great play Julius Caesar and Caesar's famous line, as he sees his ally Marcus Junius Brutus (85-42 BCE) among the assassins, "Et tu, Brute?"— "You also, Brutus?" Brutus and the others believed they had freed Rome of a tyrant, but the people were outraged, the Senate disgraced, and Caesar considered a martyr.

Cicero and the Politics of Rhetoric In times of such political upheaval, it is not surprising that one of the most powerful

figures of the day would be someone who specialized in the art of political persuasion. In pre-Augustan Rome, that person was the rhetorician (writer and public speaker, or orator) Marcus Tullius Cicero (106–43 BCE). First and foremost, Cicero recognized the power of the Latin language to communicate with the people. Although originally used almost exclusively as the language of commerce, Latin, by the first century ce, was understood to be potentially a more powerful tool of persuasion than Greek, still the literary language of the upper classes. The clarity and eloquence of Cicero's style can be quickly discerned, even in translation, as an excerpt (Reading 3.1) from his essay On Duty demonstrates.

READING 3.1

from Cicero, On Duty (44 BCE)

That moral goodness which we look for in a lofty, highminded spirit is secured, of course, by moral, not physical strength. And yet the body must be trained and so disciplined that it can obey the dictates of judgment and reason in attending to business and in enduring toil. But that moral goodness which is our theme depends wholly upon the thought and attention given to it by the mind. And, in this way, the men who in a civil capacity direct the affairs of the nation render no less important service than they who conduct its wars: by their statesmanship oftentimes wars are either averted or terminated; sometimes also they are declared. . . . And so diplomacy in the friendly settlement of controversies is more desirable than courage in settling them on the battlefield; but we must be careful not to take that course merely for the sake of avoiding war rather than for the sake of public expediency. War, however, should be undertaken in such a way as to make it evident that it has no other object than to secure peace.

The dangers attending great affairs of state fall sometimes on those who undertake them, sometimes upon the state. In carrying out such enterprises, some run the risk of losing their lives, others their reputation and the good-will of their fellow-citizens. It is our duty, then, to be more ready to endanger our own than the public welfare and to hazard honor and glory more readily than other advantages. . . .

Philosophically, Cicero's argument extends back to Plato and Aristotle, but rhetorically—that is, in the structure of its argument—it is purely Roman. It is purposefully deliberative in tone—that is, its chief concern is to give sage advice rather than to engage in a Socratic dialogue to elicit that advice.

Portrait Busts, Pietas, and Politics This historical context helps us to understand a major Roman art form of the second and first centuries BCE, the portrait bust. These are generally portraits of patricians (and upper-middle-class citizens wishing to emulate them) rather than equites. Roman portrait busts share with their Greek ancestors an affinity for

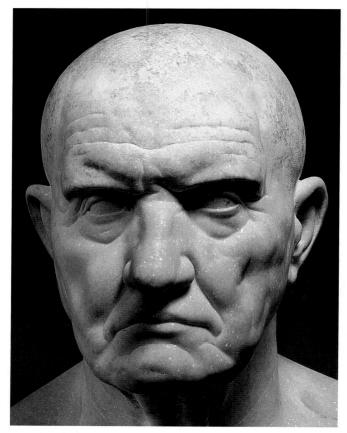

Fig. 3.5 A Roman Man. ca. 80 BCE. Marble, life-size. The Metropolitan Museum of Art, Rogers Fund, 1912 (12.233). His face creased by the wrinkles of age, this man is the very image of the pater, the man of gravitas (literally "weight," but also "presence" or "influence"), dignitas ("dignity," "worth," and "character"), and fides ("honesty" and "conscientiousness").

naturalistic representation, but they are even more realistic, revealing their subjects' every wrinkle and wart (Fig. 3.5). This form of realism is known as **verism** (from the Latin *veritas*, "truth"). Indeed, the high level of naturalism may have resulted from their original form, wax ancestral masks, usually made at the peak of the subject's power, called *imagines*, which were then transferred to stone.

Compared to the Greek Hellenistic portrait bust—recall Lysippus' portrait of Alexander (see Fig. 2.37 in Chapter 2), copies of which proliferated throughout the Mediterranean in the third century BCE—the Roman portrait differs particularly in the age of the sitter. Both the Greek and Roman busts are essentially propagandistic in intent, designed to extol the virtues of the sitter, but where Alexander is portrayed as a young man at the height of his powers, the usual Roman portrait bust depicts its subject at or near the end of life. The Greek portrait bust, in other words, signifies youthful possibility and ambition, while the Roman version claims for its subject the wisdom and experience of age. These images celebrate pietas, the deep-seated Roman virtue of dutiful respect toward the gods, fatherland, and parents. To respect one's parents was tantamount, for the Romans, to respecting

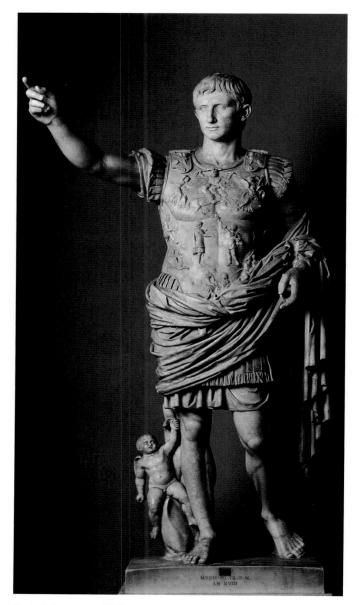

Fig. 3.6 Augustus of Primaporta. ca. **20** BCE. Marble, height 6'8". Vatican Museums, Vatican State. On the breastplate, a bearded Parthian from Asia Minor hands over Roman standards that had been lost in a battle of 53 BCE. In 20 BCE, when the original version of this statue was carved—most scholars believe this is actually a later copy—Augustus had won them back.

one's moral obligations to the gods. The respect one owed one's parents was, in effect, a religious obligation.

If the connection to Alexander—especially the emphasis on the power of the gaze—is worth considering, the Roman portrait busts depict a class under attack, a class whose virtues and leadership were being threatened by upstart generals and equites. They are, in other words, the very picture of conservative politics. Their furrowed brows represent their wisdom, their wrinkles their experience, and their extraordinarily naturalistic representation their character. They represent the Senate itself, which should be honored, not disdained.

Imperial Rome

On January 13, 27 BCE, Octavian came before the Senate and gave up all his powers and provinces. It was a rehearsed event. The Senate begged him to reconsider and take Syria, Gaul, and the Iberian Peninsula for his own (these provinces just happened to contain 20 of the 26 Roman legions, guaranteeing him military support). They also asked him to retain his title of consul of Rome, with the supreme authority of imperium, the power to give orders and exact obedience, over all of Italy and subsequently all Roman-controlled territory. He agreed "reluctantly" to these terms, and the Senate, in gratitude, granted him the semidivine title Augustus, "the revered one." Augustus (r. 27 BCE-14 CE) thereafter portrayed himself as a near-deity. The Augustus of Primaporta (Fig. 3.6) is the slightly-larger-than-life-size sculpture named for its location at the home of Augustus' wife, Livia, at Primaporta, on the outskirts of Rome. Augustus is represented as the embodiment of the famous admonition given to Aeneas by his dead father (Aeneid, Book 6): "To rule the people under law, to establish/ The way of peace." Augustus, like Aeneas, is duty bound to exhibit pietas, the obligation to his ancestor "to rule earth's peoples."

The sculpture, though recognizably Augustus, is nevertheless idealized. It adopts the pose and ideal proportions of Polyclitus' *Doryphoros* (see Fig. 2.28 in Chapter 2). The gaze, reminiscent of the look of Alexander the Great, purposefully recalls the visionary hero of Greece who died 300 years earlier. The right arm is extended in the gesture of *ad locutio*—he is giving a (military) address. The military garb announces his role as commander-in-chief. Riding a dolphin at his feet is

a small Cupid, son of the goddess Venus, laying claim to the Julian family's divine descent from Venus and Aeneas. Although Augustus was more than 70 years old when he died, he was always depicted as young and vigorous, choosing to portray himself, apparently, as the ideal leader rather than the wise, older pater.

Augustus was careful to maintain at least the trappings of the Republic. The Senate stayed in place, but Augustus soon eliminated the distinction between patricians and equites, and fostered the careers of all capable individuals, whatever their origin. Some he made provincial governors, others administrators in the city, and he encouraged still others to enter political life. Soon the Senate was populated with many men who had never dreamed of political power. All of them—governors, administrators,

and politicians—owed everything to Augustus. Their loyalty further solidified his power.

Family Life Augustus also quickly addressed what he considered to be another crisis in Roman society—the demise of family life. Adultery and divorce were commonplace. There were more slaves and freed slaves in the city than citizens, let alone aristocrats. And family size, given the cost of living in the city, was diminishing. He reacted by criminalizing adultery and passed several other laws to promote family life. Men between the ages of 20 and 60 and women between the ages of 20 and 50 were required to marry. A divorced woman was required to remarry within six months, a widow within a year. Childless adults were punished with high taxes or deprived of inheritance. The larger an aristocrat's family, the greater his political advantage. It is no coincidence that when Augustus commissioned a large monument to commemorate his triumphal return after establishing Roman rule in Gaul and restoring peace to Rome, the Ara Pacis Augustae (Altar of Augustan Peace), he had its exterior walls on the south decorated with a retinue of his own large family, a model for all Roman citizens, in a procession of lictors (the class of citizens charged with guarding and attending to the needs of magistrates), priests, magistrates, senators, and other representatives of the Roman people (Fig. 3.7).

Art historians believe that the Ara Pacis Augustae represents a real event, perhaps a public rejoicing for Augustus' reign (it was begun in 13 BCE when he was 50), or the dedication of the altar itself, which occurred on Livia's fiftieth birthday in 9 BCE. The realism of the scene is typically Roman. A sense of spatial depth is created by depicting figures farther

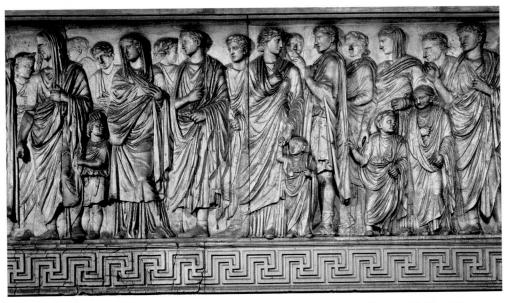

Fig. 3.7 Ara Pacis Augustae, detail of Imperial Procession, south frieze, Rome. 13–9 BCE. Marble, width approx. 35'. At the left is Marcus Agrippa, Augustus' son-in-law, married to his daughter Julia. The identities of the other figures are not secure, but scholars speculate that clinging to Agrippa's robe is either a foreign child belonging to Agrippa's household or Augustus' grandson Gaius Caesar, who with his brother Lucius often traveled with their grandfather and whom Augustus taught to imitate his own handwriting. The child looks backward and up at Augustus' wife, Livia, one of the most powerful people in Rome. Behind Livia is her son by an earlier marriage, Tiberius, who would succeed Augustus as emperor.

away from us in low relief and those closest to us in high relief, so high in fact that the feet of the nearest figures project over the architectural frame into our space. This technique would have encouraged viewers—the Roman public—to feel that they were part of the same space as the figures in the sculpture itself. The Augustan peace is the peace enjoyed by the average Roman citizen, the Augustan family a metaphor for the larger family of Roman citizens.

But perhaps above all, the *Ara Pacis Augustae* offers the peaceful continuity of family life from generation to generation as a metaphor and model for the peaceful continuity of the empire from one ruler to the next. Three generations of Augustus' family are depicted in the relief. It also demonstrates the growing prominence of women in Roman society. Augustus' wife, Livia, is depicted holding Augustus' family together, standing between her stepson-in-law, Marcus Agrippa, and her own sons, Tiberius and Drusus.

Livia became a figure of idealized womanhood in Rome. She was the "female leader" of Augustus' programs of reform, a sponsor of architectural projects, and a trusted advisor to both her husband and son. While Livia enjoyed greater power and influence than most Roman women, all possessed the rights of citizenship, although they could not vote or hold public office. Still, married women retained their legal identity. They controlled their own property and managed their own legal affairs. Elite women modeled themselves on Livia, wielding power through their husbands and sons.

Literary Rome: Virgil, Horace, and Ovid

When Augustus took control of Rome, he arranged for all artistic patronage to pass through his office. During the civil wars, the two major poets of the day, Virgil and Horace, had lost all their property, but Augustus' patronage allowed them to keep on with their writings. Because the themes they pursued were subject to Augustus' approval, they tended to glorify both the emperor and his causes. He was far less supportive of the poet Ovid, whom he banished permanently from Rome.

Virgil and the Aeneid After Augustus' triumph over Antony and Cleopatra at the battle of Actium in 31 BCE, Virgil retired to Naples, where he began work on an epic poem designed to rival Homer's *Iliad* and to provide the Roman state—and Augustus in particular—with a suitably grand founding myth. Previously he had been engaged with two series of pastoral idylls, the *Eclogues* (or *Bucolics*) and the *Georgics*. The latter poems (**Reading 3.2**) are modeled on Hesiod's *Works and Days* (see Chapter 2). They extol the importance of hard work, the

READING 3.2

from Virgil, Georgics

In early spring-tide, when the icy drip
Melts from the mountains hoar, and Zephyr's breath
Unbinds the crumbling clod, even then 'tis time;
Press deep your plow behind the groaning ox,

And teach the furrow-burnished share to shine. That land the craving farmer's prayer fulfils, Which twice the sunshine, twice the frost has felt; Ay, that's the land whose boundless harvest-crops Burst, see! the barns.

necessity of forging order in the face of a hostile natural world, and, perhaps above all, the virtues of agrarian life.

The political point of the *Georgics* was to celebrate Augustus' gift of farmlands to veterans of the civil wars, but in its exaltation of the myths and traditions of Italy, it served as a precursor to the *Aeneid*. It was written in **dactylic hexameter**, the verse form that Homer had used in the *Iliad* and *Odyssey*. (The metrical form of the translation above, however, is iambic pentameter—five rhythmic units, each short long, as in *dee-dum*—a meter much more natural to English than the Latin dactylic hexameter.) In dactylic hexameter each line consists of six rhythmic units, or **feet**, and each foot is either a **dactyl** (long, short, short, as in *dum-diddy*) or a **spondee** (long, long, as in *dum-dum*). Virgil reportedly wrote the *Georgics* at a pace of less than one line a day, perfecting his understanding of the metrical scheme in preparation for the longer poem.

The Aeneid opens in Carthage, where, after the Trojan War, Aeneas and his men have been driven by a storm, and where they are hosted by the Phoenician queen Dido. During a rainstorm Aeneas and Dido take refuge in a cave, where the queen, having fallen in love with the Trojan hero, gives herself willingly to him. She now assumes that she is married, but Aeneas, reminded by his father's ghost of his duty to accomplish what the gods have predetermined—a classic instance of pietas—knows he must resume his destined journey. An angry and accusing Dido begs him to stay. When Aeneas rejects her pleas, Dido vows to haunt him after her death and to bring enmity between Carthage and his descendants forever (a direct reference on Virgil's part to the Punic Wars). As his boat sails away, she commits suicide by climbing a funeral pyre and falling upon a sword. The goddesses of the underworld are surprised to see her. Her death, in their eyes, is neither deserved nor destined, but simply tragic. Virgil's point is almost coldly hardhearted: All personal feelings and desires must be sacrificed to one's responsibilities to the state. Civic duty takes precedence over private life.

The poem is, on one level, an account of Rome's founding by Aeneas, but it is also a profoundly moving essay on human destiny and the great cost involved in achieving and sustaining the values and principles upon which culture—Roman culture in particular, but all cultures by extension—must be based. Augustus, as Virgil well knew, claimed direct descent from Aeneas, and it is particularly important that the poem presents war, at which Augustus excelled, as a moral tragedy, however necessary.

In Book 7, Venus gives Aeneas a shield made by the god Vulcan. The shield displays the important events in the future history of Rome, including Augustus at the Battle of Actium. Aeneas is, Virgil writes, "without understanding . . . proud and happy . . . [at] the fame and glory of his children's children." But in the senseless slaughter that ends the poem, as Aeneas and the Trojans battle Turnus and the Italians, Virgil demonstrates that the only thing worse than not avenging the death of one's friends and family is, perhaps, avenging them. In this sense the poem is a profound plea for peace, a peace that Augustus would dedicate himself to pursuing.

The Horatian Odes Quintus Horatius Flaccus, known as Horace (65-8 BCE), was a close friend of Virgil. Impressed by Augustus' reforms, and probably moved by his patronage, Horace was won over to the emperor's cause, which he celebrated directly in two of his many odes, lyric poems of elaborate and irregular meter. Horace's odes imitated Greek precedents. The following lines open the fifth ode of Book 3 of the collected poems, known simply as the Odes:

Jove [the Roman Zeus, also called Jupiter] rules in heaven, his thunder shows; Henceforth Augustus earth shall own Her present god, now Briton foes And Persians bow before his throne.

The subject matter of the Odes ranges from these patriotic pronouncements to private incidents in the poet's own life, the joys of the countryside (Fig. 3.8), the pleasures of wine, and so on. Horace's villa offered him an escape from the trials of daily life in Rome itself. But no Roman poet more gracefully harmonized the Greek reverence for beauty with the Roman concern with duty and obligation.

Ovid's Art of Love and Metamorphoses Augustus' support for poets did not extend to Publius Ovidius Naso, known as Ovid (43 BCE-17 CE). Ovid's talent

was for love songs designed to satisfy the notoriously loose sexual mores of the Roman aristocrats, who lived in somewhat open disregard of Augustus and Livia's family-centered lifestyle. His Ars Amatoria (Art of Love) angered Augustus, as did some undisclosed indiscretion by Ovid. As punishment probably more for the indiscretion than for the poem—Augustus permanently exiled him to the town of Tomis on the Black Sea, the remotest part of the Empire, famous for its wretched weather. The Metamorphoses, composed in the years just before his exile, is a collection of stories describing or revolving around one sort of supernatural change of shape or another, from the divine to the human, the animate to the inanimate, the human to the vegetal.

In the Ars Amatoria, the poet describes his desire for the fictional Corinna. Ovid outlines the kinds of place in Rome where one can meet women, from porticoes to gaming houses, from horse races to parties, and especially anywhere wine, that great banisher of inhibition, can be had. Women,

Fig. 3.8 Idyllic Landscape, wall painting from a villa at Boscotrecase, near Pompeii. 1st century BCE. Museo Archeologico Nazionale, Naples. This landscape depicts the love of country life and the idealizing of nature that is characteristic of the Horatian Odes. It contrasts dramatically with urban life in Rome.

he says, love clandestine affairs as much as men; they simply do not chase after men, "as a mousetrap does not chase after mice." Become friends with the husband of a woman you desire, he advises. Lie to her—tell her that you only want to be her friend. Nevertheless, he says, "If you want a woman to love you, be a lovable man."

Ovid probably aspired to Virgil's fame, although he could admit, "My life is respectable, but my Muse is full of jesting." His earliest major work, the Amores (Loves), begins with many self-deprecating references to Virgil's epic, which begins with the famous phrase, "Arms and the man I sing":

Arms, warfare, violence—I was winding up to produce A regular epic, with verse-form to match—

Hexameters, naturally. But Cupid (they say) with a

Lopped off one foot from each alternate line.

"Nasty young brat," I told him, "who made you Inspector of Metres?"

Nevertheless, Ovid uses dactylic hexameter for the *Meta-morphoses* and stakes out an epic scope for the poem in its opening lines:

My intention is to tell of bodies changed To different forms; the gods, who made the changes, Will help me—or I hope so—with a poem That runs from the world's beginning to our own days!

If the *Metamorphoses* is superficially more a collection of stories than an epic, few poems in any language have contributed so importantly to later literature. It is so complete in its survey of the best-known Classical myths, plus stories from Egypt, Persia, and Italy, that it remains a standard reference work. At the same time, it tells its stories in an utterly moving and memorable way. The story of Actaeon, for instance, is a cautionary tale about the power of the gods. Actaeon happens to see the virgin goddess Diana bathing one day when he is out hunting with his dogs. She turns him into a stag to prevent him from ever telling what he has seen. As his own dogs turn on him and savagely tear him apart, his friends call out for him, lamenting his absence from the kill. But he is all too present:

Well might he wish not to be there, but he was there, and well might he wish to see

And not to feel the cruel deeds of his dogs.

In the story of Narcissus, Echo falls in love with the beautiful youth Narcissus, but when Narcissus spurns her, she

fades away. He in turn is doomed to fall in love with his own image reflected in a pool, according to Ovid, the spring at Clitumnus. So consumed, he finally dies beside the pool, his body transformed into the narcissus flower. In such stories, the duality of identity and change, Aristotle's definition of the essence of a thing, becomes deeply problematic. Ovid seems to deny that any human characteristic is essential, asserting that all is susceptible to change. To subsequent generations of readers, from Shakespeare to Freud, Ovid's versions of myths would raise the fundamental questions that lie at the heart of human identity and psychology.

Augustus and the City of Marble

Of all the problems facing Augustus when he assumed power, the most overwhelming was the infrastructure of Rome. The city was, quite simply, a mess. Seneca reacted by preaching Stoicism. He argued that Rome was what it was, and one should move on as best one can. Augustus reacted by calling for a series of public works, which would serve the people of Rome and, he well understood, himself. The grand civic improvements Augustus planned would be a kind of imperial propaganda, underscoring not only his power but also his care for the people in his role as pater patriae. Public works could—and indeed did—elicit the public's loyalty.

Rome had developed haphazardly, without any central plan, spilling down the seven hills it originally occupied into

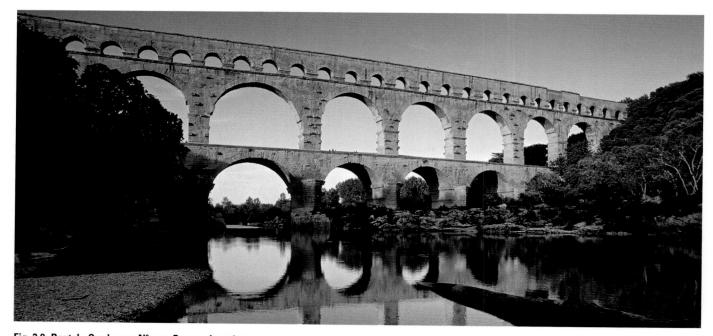

Fig. 3.9 Pont du Gard, near Nîmes, France. Late 1st century BCE—early 1st century CE. Height 180'. The Roman city of Nîmes received 8,000—12,000 gallons of water a day via this aqueduct.

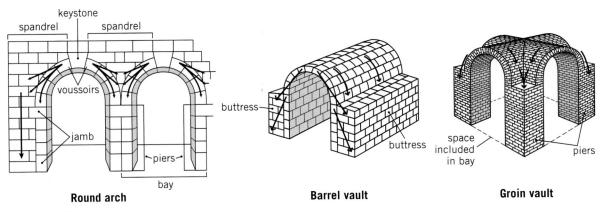

Fig. 3.10 Arches.

the valleys along the Tiber. By contrast, all the Empire's provincial capitals were conceived on a strict grid plan, with colonnaded main roads leading to an administrative center, and were adorned with public works such as baths, theaters, and triumphal arches. In comparison, Rome was pitiable. Housing conditions were dreadful, water was scarce, and food was in short supply. Because the city was confined by geography to a small area, space was at a premium.

Augustus could not do much about the housing situation, although he did build aqueducts to bring more water into the city. But most of all he implemented an ambitious building program designed to provide elegant public spaces where city dwellers could escape from their cramped apartments. He once claimed that he had restored 82 temples in one year. But if he could boast, "I found a city of brick, and left it a city of marble," that was largely because he had put a lot of marble veneer over brick walls. By the second century ce, the city would be one of the most beautiful in the world, but the beauty was only skin-deep. The housing situation that Augustus inherited had barely improved.

Public Works: The Aqueduct and the Arch Augustus inaugurated what amounted to an ongoing competition among the emperors to outdo their predecessors in the construction of public works and monuments. His ambitions are reflected in the work of the architect Vitruvius (flourished late first century BCE to early first century CE). A military engineer for Julius Caesar, under Augustus' patronage, Vitruvius wrote the ten-volume On Architecture. The only work of its kind to have survived from antiquity, it would become extremely influential more than 1,000 years later, when Renaissance artists became interested in classical design. In its large scale, the work matches its patron's architectural ambitions, dealing with town planning, building materials and construction methods, the construction of temples, the Classical orders, and the rules of proportion.

Vitruvius also wrote extensively about one of Rome's most pressing problems—how to satisfy the city's need for water. In fact, one of the most significant contributions of the Julio-Claudian dynasty, which extends from Augustus through Nero (r. 54–68 cE), was an enormous aqueduct, the Aqua Claudia. Such aqueducts depended on Roman ingenuity in perfecting the arch and vault so that river gorges could be successfully spanned to carry the pipes bringing water to a city miles away. The Aqua Claudia delivered water from 40 miles away into the very heart of the city, not so much for private use as for the fountains, pools, and public baths.

Aqueduct construction depended largely on the arch. While the arch was known to cultures such as the Mesopotamians, the Egyptians, and the Greeks, it was the Romans who perfected it, evidently learning its principles from the Etruscans but developing those principles further. The Pont du Gard, a beautiful Roman aqueduct near the city of Nîmes in southern France (Fig. 3.9), is a good example.

The Romans understood that much wider spans than the Etruscans had bridged could be achieved with the round arch (left, Fig. 3.10) than with post-and-lintel construction. The weight of the masonry above the arch is displaced to the supporting upright elements (piers or jambs). The arch is constructed with a supporting scaffolding that is formed with wedge-shaped blocks, called voussoirs, and capped with a large, wedge-shaped stone, called the keystone, the last element put in place. The space inside the arch is called a bay, and the wall areas between the arches of an arcade (a succession of arches, such as seen on the Pont du Gard) are called spandrels.

When a round arch is extended, it forms a barrel vault (middle, Fig. 3.10). To ensure that the downward pressure from the arches does not collapse the walls, a buttress support is often added. When two barrel vaults meet each other at a right angle, they form a groin vault (right, Fig. 3.10).

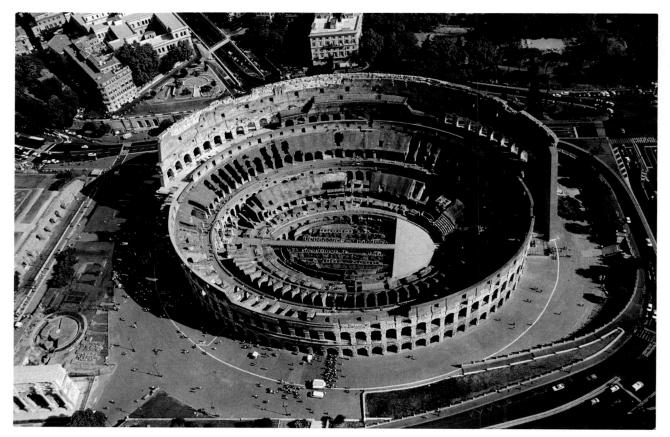

Fig. 3.11 Aerial view of Colosseum, Rome. Constructed 72–80 cE. The opening performance at the Colosseum in 80 cE lasted 100 days. During that time, 9,000 wild animals—lions, bears, snakes, boars, even elephants, imported from all over the Empire—were killed, and so were 2,000 gladiators.

The Colosseum The interior corridors of the Colosseum in Rome make use of both barrel and groin vaulting. This huge arena (Fig. 3.11) was built by Vespasian (r. 69–79 ce), the former commander in Palestine, who succeeded Nero when the latter's lavish lifestyle led to his ouster and subsequent suicide. Vespasian built the Colosseum across from Nero's ostentatious palace, known as the Golden House. He named it after the Colossus, a 120-foot-high statue of Nero as sun god that stood in front of it. The Colosseum formed a giant oval, 615 feet long, 510 feet wide, and 159 feet high, and audiences, estimated at 50,000, entered and exited through its 76 vaulted arcades in a matter of a few minutes.

These vaults were made possible by the use of concrete, which, like the arch itself, was known to the Mesopotamians, the Egyptians, and the Greeks, but perfected by the Romans, who evidently learned its principles from the Etruscans. Mixed with volcanic aggregate from nearby Naples and Pompeii, it set more quickly and was stronger than any building material yet known. The Colosseum's wooden floor, the arena (Latin for "sand," which covered the floor), lay over a maze of rooms and tunnels that housed the gladiators, athletes, and wild animals that entertained the masses. The top story of the building housed an awning system that could be

extended on an array of pulleys and ropes to shield part of the audience from the hot Roman sun. Each level employed a different architectural order: the Tuscan order on the ground floor, the Ionic on the second, and the Corinthian, the Romans' favorite, on the third. All the columns are engaged and purely decorative, serving no structural purpose. The facade thus moves from the heaviest and sturdiest elements at the base to the lightest, most decorative at the top, a logic that is both structurally and visually satisfying.

The Imperial Roman Forum The Colosseum stands at the eastern end of the Forum Romanum, or Roman Forum (Fig. 3.12). This vast building project was among the most ambitious undertaken in Rome by the Five Good Emperors, under whose rule Rome thrived: Nerva (r. 96–98 ce), Trajan (r. 98–117 ce), Hadrian (r. 117–38 ce), Antoninus Pius (r. 138–61 ce), and Marcus Aurelius (r. 161–180 ce). The Forum Romanum was the chief public square of Rome, the center of Roman religious, ceremonial, political, and commercial life. Originally, a Roman forum was comparable to a Greek agora, a meeting place in the heart of the city. Gradually, the forum took on a symbolic function as well, becoming a symbol of imperial power that testified to the

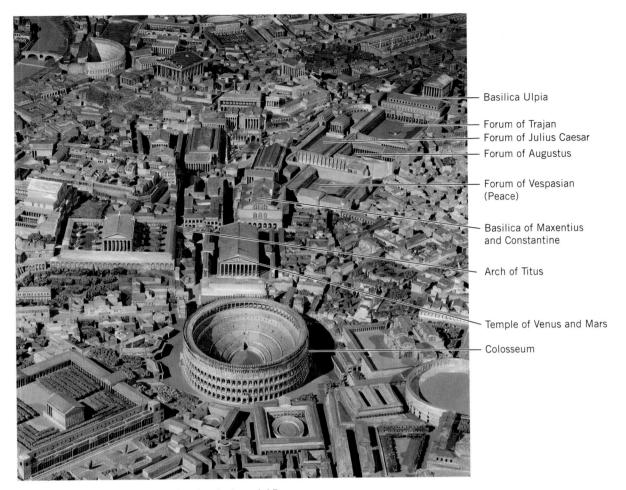

Fig. 3.12 Model of Imperial Rome showing the Imperial Forums.

prosperity—and peace— bestowed by the emperor upon Rome's citizenry. Julius Caesar was the first to build a forum of his own, in 46 BCE, just to the north of the Forum Romanum. Augustus subsequently paved it over, restored its Temple of Venus, and proceeded to build his own forum with its Temple of Mars the Avenger. Thus began what amounted to a competition among successive emperors to outdo their predecessors by creating their own more spectacular forums. These imperial forums lined up north of and parallel to the great Roman Forum, which over the years was itself subjected to new construction. The result was an extremely densely built city center.

The last and largest of these forums was Trajan's. It sheltered the Column of Trajan (see Fig. 3.16), Trajan's Market, and the Basilica Ulpia (Fig. 3.13) A basilica is a large rectangular building with a rounded extension, called an apse, at one or both ends, and easy access in and out. It was a general-purpose building that could be adapted to many uses. Designed by Trajan's favorite architect, the Greek Apollodorus of Damascus, the Basilica Ulpia was 200 feet wide and 400 feet long.

The stability and prosperity of the city was due, at least in part, to the fact that none of these emperors except Marcus

Fig. 3.13 Reconstruction drawing of the central hall, Basilica Ulpia, Forum of Trajan, Rome. 113 cs. Relatively plain and massive on the outside, the basilica is distinguished by its vast interior space, which would later serve as the model for some Christian churches.

Aurelius had a son to whom he could pass on the Empire. Thus, each was handpicked by his predecessor from among the ablest men in the Senate. When, in 180 ce, Marcus

Aurelius' decadent and probably insane son Commodus (r. 180–92 ce) took control, the empire quickly learned that the transfer of power from father to son was not necessarily a good thing.

Triumphal Arches and Columns During Vespasian's reign, his son Titus defeated the Jews in Palestine, who were rebelling against Roman interference with their religious practices. Titus' army sacked the Second Temple of Jerusalem in 70 ce. To honor this victory and the death of Titus 11 years later, a memorial arch was constructed in Rome. Originally, the Arch of Titus was topped by a statue of a four-horse chariot and driver. Such arches, known as triumphal arches because triumphant armies marched through them, were composed of a simple barrel vault enclosed within a rectangle, and enlivened with sculpture and decorative engaged columns (Fig. 3.14). They would deeply influence later architecture, especially the facades of Renaissance cathedrals. Hundreds of arches of similar form were built throughout the Roman Empire. Most were not technically triumphal, but, like all Roman monumental architecture, they were intended to symbolize Rome's political power and military might.

The Arch of Titus was constructed of concrete and faced with marble, its inside walls decorated with narrative reliefs. One of them shows Titus' soldiers marching with the treasures of the Second Temple in Jerusalem (Fig. 3.15). In the foreground, the soldiers carry what some speculate might

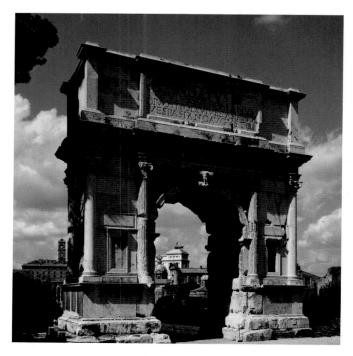

Fig. 3.14 Arch of Titus, Rome. ca. 81 ce. The inscription at the top of the arch, which reads "The Senate and the Roman people to the Deified Titus Vespasian Augustus, son of the Deified Vespasian," was chiseled deeply into the stone, so that it might catch the light, allowing it to be read from a great distance.

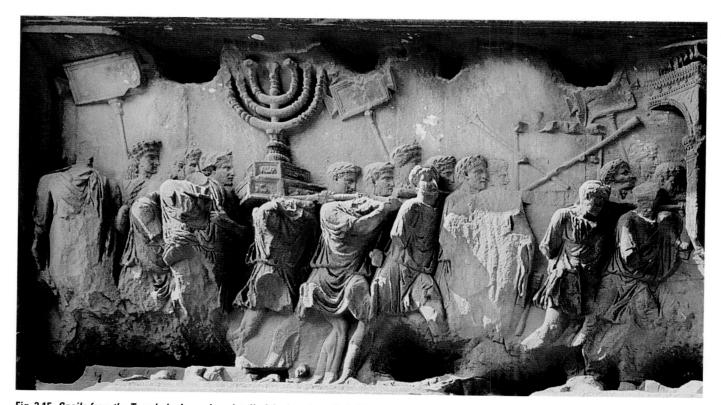

Fig. 3.15 Spoils from the Temple in Jerusalem, detail of the interior relief of the Arch of Titus. ca. 81 CE. Height of relief approx. 7'10". The figures in the relief are nearly life-size. The relief has been badly damaged, largely because in the Middle Ages, a Roman family used the arch as a fortress, constructing a second story in the vault. Holes for the floor beams appear at the top of the relief.

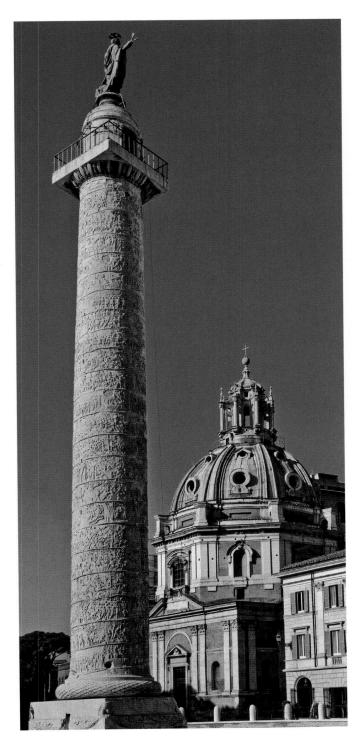

Fig. 3.16 Column of Trajan, Forum of Trajan, Rome. 106–113 cs. Marble, overall height with base 125'. Winding through the interior of the shaft is a staircase leading to a viewing platform at the top.

be the golden Ark of the Covenant, and behind that a *menorah*, the sacred Jewish candelabrum, also made of gold. They bend under the weight of the gold and stride forward convincingly. The carving is extremely deep, with nearer figures and elements rendered with undercutting and in higher relief

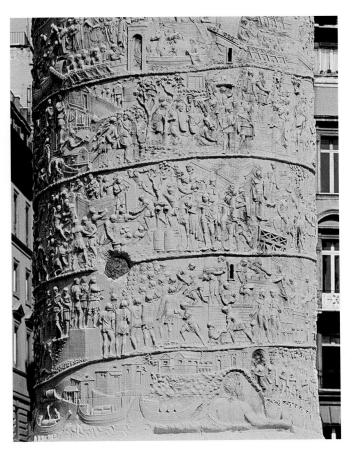

Fig. 3.17 Lower portion of the Column of Trajan, Forum of Trajan, Rome, 106–113 cs. To the left of the second band, Trajan addresses his troops. To the right of that scene, his troops build a fortification.

than more distant ones. This creates a sense of real space and, when light and shadow play over the sculptural relief, even a sense of movement.

Another type of monument favored by the Romans and with similar symbolic meaning—suggestive not only of power but also of virility—is the ceremonial column. Like the triumphal arch, it was a masonry and concrete platform for narrative reliefs. Two of the emperors who ruled during the era of the Five Good Emperors (96 ce-193 ce)—Trajan and Marcus Aurelius—built columns to celebrate their military victories. Trajan's Column, perhaps the most complete artistic statement of Rome's militaristic character, consists of a spiral of 150 separate scenes from his military campaign in Dacia, across the Danube River in what is now Hungary and Romania. If laid out end to end, the complete narrative would be 625 feet long (Figs. 3.16 and 3.17). At the bottom of the column, the band is 36 inches wide; at the top it is 50 inches, so that the higher elements might be more readily visible. In order to eliminate shadow and increase the legibility of the whole, the carving is very low relief. At the bottom of the column, the story begins with Roman troops crossing the Danube on a pontoon bridge. A river god looks on with some interest. Battle scenes constitute less than a quarter of the entire narrative. Instead, we witness the Romans building fortifications, harvesting crops,

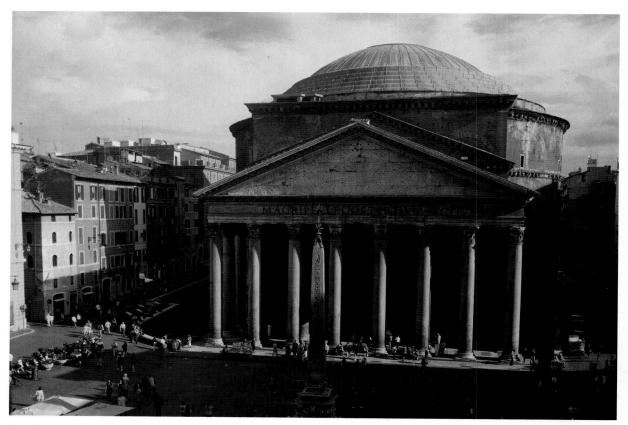

Fig. 3.18 The Pantheon, Rome. 118–125 CE. The Pantheon is an impressive feat of architectural engineering, and it would inspire architects for centuries to come. However, Hadrian humbly (and politically) refused to accept credit for it. He passed off the building as a "restoration" of a temple constructed on the same site by Augustus' closest friend, colleague, and son-in-law, Marcus Agrippa, in 27–25 BCE. Across the architrave (the bottom element in an entablature above the columns) of the facade is an inscription that serves both propagandistic and decorative purposes: "Marcus Agrippa, son of Lucius, three times consul, made this."

participating in religious rituals. All in all, the column's 2,500 figures are carrying out what Romans believed to be their destiny—they are bringing the fruits of civilization to the world.

The Pantheon Hadrian's Pantheon ranks with the Forum of Trajan as one of the most ambitious building projects undertaken by the Good Emperors. The Pantheon (from the Greek pan, "all," and theoi, "gods") is a temple to "all the gods," and sculptures representing all the Roman gods were set in recesses around its interior. The facade is a Roman temple, originally set on a high podium, with its eight massive Corinthian columns and deep portico, behind which are massive bronze doors (Fig. 3.18). Photography presents little evidence of its monumental presence, elevated above its long forecourt (Fig. 3.19). Today, both the forecourt and the elevation have disappeared beneath the streets of modern Rome. Figure 3.18 shows the Pantheon as it looks today.

The facade gives no hint of what lies beyond the doors. The interior of the Pantheon consists of a cylindrical space topped by a dome, the largest built in Europe before the twentieth century (Fig. 3.20). The whole is a perfect hemisphere—the diameter of the rotunda is 144 feet, as is the height from floor to ceiling. The weight of the dome rests on eight massive

supports, each more than 20 feet thick. The dome itself is 20 feet thick at the bottom but narrows to only 6 feet thick at the oculus, the circular opening at the top. The oculus is 30 feet in diameter. Recessed panels, called coffers, further lighten the weight of the roof. The oculus, or "eye," admits light, which forms a round spotlight that moves around the building during

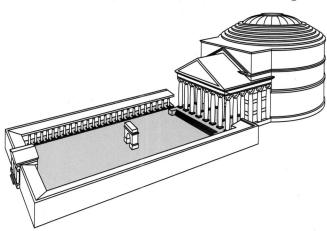

Fig. 3.19 The Pantheon, Rome. Schematic drawing showing the original forecourt.

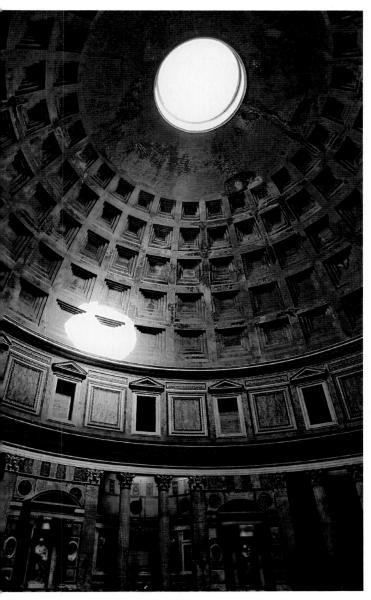

Fig. 3.20 Interior of the Pantheon, Rome. The sun's rays entering through the *oculus* form a spotlight on the Pantheon's interior, moving and changing intensity with the time of day.

the course of a day (it admits rain, as well, which is drained out through small openings in the floor). For the Romans, this light may well have symbolized Jupiter's ever-watchful eye cast over the affairs of state, illuminating the way.

In the vast openness of its interior, the Pantheon mirrors the cosmos, the vault of the heavens. Mesopotamian and Egyptian architecture had created monuments with exterior mass. Greek architecture was a kind of sculptural event, built up of parts that harmonized. But the Romans concentrated on sheer size, including the vastness of interior space. Like the Basilica Ulpia (see Fig. 3.13) in the Forum of Trajan, the Pantheon is concerned primarily with realizing a single, whole, uninterrupted interior space.

In this sense, the Pantheon mirrors the Empire. It too was a single, uninterrupted space, stretching from Hadrian's

Wall in the north of England to the Rock of Gibraltar in the south, across North Africa and Asia Minor, and encompassing all of Europe except what is now northern Germany and Scandinavia (see Map 3.1). Like Roman architecture, the Empire was built up of parts that were meant to harmonize in a unified whole, governed by rules of proportion and order. And if the monuments the Empire built to celebrate itself were grand, the Empire was grander still.

Pompeii

In 79 ce, during the rule of the Emperor Titus, the volcano Vesuvius erupted southeast of Naples, burying the seaside town of Pompeii in 13 feet of volcanic ash and rock. Its neighboring city Herculaneum was covered in 75 feet of a ground-hugging avalanche of hot ash that later solidified. Living in retirement nearby was Pliny the Elder, a commander in the Roman navy and the author of *The Natural History*, an encyclopedia of all contemporary knowledge. At the time of the eruption, his nephew Pliny the Younger (ca. 61–ca. 113 ce) was staying with him. This is his eyewitness account (**Reading 3.3**):

READING 3.3

from Letters of Pliny the Younger

On 24 August, in the early afternoon, my mother drew his [Pliny the Elder's] attention to a cloud of unusual size and appearance. He had been out in the sun, had taken a cold bath, and lunched while lying down, and was then working at his books. He called for his shoes and climbed up to a place which would give him the best view of the phenomenon. It was not clear at that distance from which mountain the cloud was rising (it was afterwards known to be Vesuvius); its general appearance can best be expressed as being like an umbrella pine, for it rose to a great height on a sort of trunk and then split off into branches, I imagine because it was thrust upwards by the first blast and then left unsupported as the pressure subsided, or else it was borne down by its own weight so that it spread out and gradually dispersed. . . .

They debated whether to stay indoors or take their chance in the open, for the buildings were now shaking with violent shocks, and seemed to be swaying to and fro as if they were torn from their foundations. Outside, on the other hand, there was the danger of falling pumice-stones, even though these were light and porous; however, after comparing the risks they chose the latter. In my uncle's case one reason outweighed the other, but for the others it was a choice of fears. As a protection against falling objects they put pillows on their heads tied down with cloths. . . .

We also saw the sea sucked away and apparently forced back by the earthquake: at any rate it receded from the shore so that quantities of sea creatures were left stranded on dry sand. On the landward side a fearful black cloud was rent by forked and quivering bursts of flame, and parted to reveal great tongues of fire, like flashes of lightning magnified in size. . . .

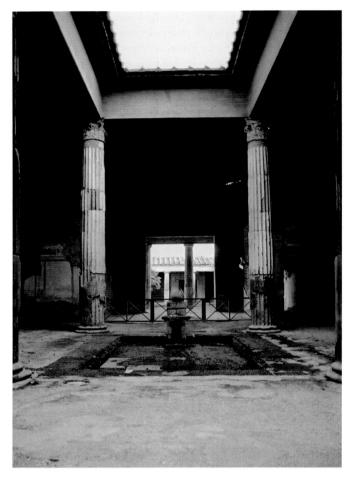

Fig. 3.21 Atrium, House of the Silver Wedding, Pompeii. 1st century BCE. Erich Lessing/akg-images. This view looks through the atrium to the main reception area and the peristyle court. The house gets its name from the silver wedding anniversary of Italy's King Humbert and his queen, Margaret of Savoy, in 1893, the year it was excavated. They actively supported archeological fieldwork at Pompeii, which began in the mid century.

You could hear the shrieks of women, the wailing of infants, and the shouting of men; some were calling their parents, others their children or their wives, trying to recognize them by their voices. People bewailed their own fate or that of their relatives, and there were some who prayed for death in their terror of dying. Many besought the aid of the gods, but still more imagined there were no gods left, and that the universe was plunged into eternal darkness for evermore. . . .

Pliny the Elder, interested in what was happening, made his way toward Vesuvius, where he died, suffocated by the poisonous fumes. Pliny the Younger, together with his mother, survived. Of the 20,000 inhabitants of Pompeii, 2,000 died, mostly slaves and the poor left behind by the rich who escaped the city after early warning shocks.

Much of what we know today about everyday Roman life is the direct result of the Vesuvius eruption. Those who survived left their homes in a hurry, and were unable to recover

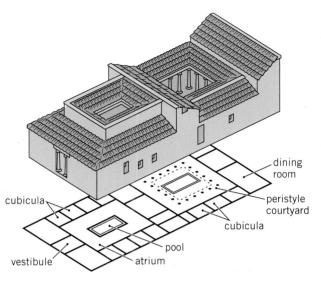

Fig. 3.22 Plan of the House of the Silver Wedding, Pompeii. 1st century BCE.

anything they left behind. Buried under the ashes were not only homes and buildings but also food and paintings, furniture and garden statuary, even pornography and graffiti. The latter include the expected—"Successus was here," "Marcus loves Spendusa"—but also the unexpected and perceptive—"I am amazed, O wall, that you have not collapsed and fallen, since you must bear the tedious stupidities of so many scrawlers." When Pompeii was excavated, beginning in the eighteenth century, many of the homes and artifacts were found to be relatively well preserved. The hardened lava and ash had protected them from the ravages of time. But eighteenth-century excavators also discovered something unexpected. By filling the hollows where the bodies of those caught in the eruption had decomposed, they captured images of horrific death.

Domestic Architecture: The Domus Although by no means the most prosperous town in Roman Italy, Pompeii was something of a resort, and, together with villas from other nearby towns, the surviving architecture gives us a good sense of the Roman domus—the townhouse of the wealthier class of citizen. The domus was oriented to the street along a central axis that extended from the front entrance to the rear of the house. The House of the Silver Wedding at Pompeii is typical in its design (Figs. 3.21 and 3.22). An atrium, a large space with a shallow pool for catching rainwater below its open roof, extends directly behind the vestibule. The atrium was the symbolic heart of the house: the location for the imagines, the wax masks from which portrait busts were later made (see Fig. 3.5), and the main reception area. Imagines were also housed in the reception rooms just off the main one, which in turn opens onto a central peristyle courtyard, surrounded by a colonnaded walkway. The dining room faces into the courtyard, as do a number of *cubicula*, small general-purpose rooms often used for sleeping quarters. At the back of the house, facing into the courtyard, is a hall furnished with seats for discussion. Servants probably lived upstairs at the rear of the house.

100

The *domus* was a measure of a Roman's social standing, as the vast majority lived in apartment blocks or *insulae*. The house itself was designed to underscore the owner's reputation. Each morning, the front door was opened and left open. Gradually, the atrium would fill with clients—remember, the head of a Roman household was patron to many—who came to show their respect in a ritual known as the *salutatio*. Passersby could look in to see the crowded atrium, and the patron himself was generally seated in the open area between the atrium and the peristyle courtyard, silhouetted by the light from the peristyle court behind. Surrounded by the busts of his ancestors, the symbol of his social position and prestige, he watched over all who entrusted themselves to his patronage.

At the center of the Roman domus was the garden of the peristyle courtyard, with a fountain or pond in the middle. Thanks to the long-term research of the archeologist Wilhelmina Jashemski, we know a great deal about these courtyard gardens. At the House of G. Polybius in Pompeii, excavators carefully removed ash down to the level of the soil on the summer day of the eruption in 79 ce, when the garden would have been in full bloom. They were able to collect pollen, seeds, and other evidence, including root systems (obtained by pouring plaster into the surviving cavities), and thus determine what plants and trees were cultivated in it. Polybius' garden was lined, at one end, with lemon trees in pots, which were apparently trained and pruned to cover the wall in an espalier—a geometric trellis. Cherry, pear, and fig trees filled the rest of the space. Gardens at other homes suggest that most were planted with nut- and fruitbearing trees, including olive, which would provide the family with a summer harvest. Vegetable gardens are sometimes found at the rear of the domus, a source of more fresh produce.

The garden also provided visual pleasure for the family. In the relatively temperate Roman climate, the garden was in bloom for almost three-quarters of the year. It was the focus of many rooms in the *domus*, which opened onto the garden. And it was evidently a symbol for the fertility, fecundity, and plenty of the household itself, for many a Roman garden was decorated with statuary referencing the cult of Dionysus.

Wall Painting Mosaics decorated many floors of the *domus*, and paintings adorned the walls of the atrium, the hall, the dining room, and other reception rooms throughout the villa. Artists worked with pigments in a solution of lime and soap, sometimes mixed with a little wax, polished with a special metal or glass, and then buffed with a cloth. Even the *cubicula* bedrooms were richly painted.

Writing in the second century CE, the satirist and rhetorician Lucian (ca. 120–after 180 CE) describes what he takes to be the perfect house—"lavish, but only in such degree as would suffice a modest and beautiful woman to set off her beauty." He continues, describing the wall paintings:

The ... decoration—the frescoes on the walls, the beauty of their colors, and the beauty, exactitude and truth of each detail—might well be compared with the face of spring and with a flowery field, except that those things fade and wither and change and cast their beauty, while this is spring eternal, field unfading, bloom undying.

Just outside Rome, at the villa of Livia at Primaporta, a wall painting depicting a garden full of fresh fruit, songbirds, and flowers reflects this sensibility (Fig. 3.23). It is rendered as if it were an extension of the room itself, as if Livia and

Fig. 3.23 *Garden Scene*, detail of a wall painting from the Villa of Livia at Primaporta, near Rome. Late 1st century BCE. Museo Nazionale Romano, Rome. The artist created a sense of depth by setting a wall behind a fence with its open gate.

Fig. 3.24 The Canal (reflecting pool) at Hadrian's Villa, Tivoli. ca. 125–135 ce. At the far end of the pool is an outdoor dining room, with concrete benches. These would have been covered with cushions for comfort.

Augustus and their visitors could, at any time, step through the wall into their "undying" garden. Thus, although naturalistically rendered, it is an idealistic representation.

Hadrian's Villa at Tivoli If the domus was the urban townhouse of Rome's wealthier class of citizen, the villa, or country residence, was often far more luxurious, and among the most luxurious ever constructed was the emperor Hadrian's at Tivoli, some 18 miles east of Rome at the edge of the Sabine Hills. Situated in over 300 acres on a slope overlooking the surrounding countryside, it was a masterful blending of inventive buildings, waterworks, and gardens. At the turning of almost every corner, a surprising new vista reveals itself. The buildings themselves were copies of Hadrian's favorite places throughout the entire Empire, including the Stoa from the Athenian agora (see Fig. 2.2 in Chapter 2), the Ptolemaic capital of Egypt, Alexandria, and the Academia in Athens, where Plato conversed with his students in the shade of an olive grove. One of the complex's most attractive features is a long reflecting pool, called the Canal (Fig. 3.24). It was surrounded by a colonnade with alternating arched and linteled entablatures. Between the columns, Hadrian set copies of the most famous sculptures of ancient Greece, including a marble

copy of the *Discobolus*, or *Discus Thrower*, originally cast in bronze by the Greek sculptor Myron in the middle of the fifth century BCE. Hadrian was so enamored of Greek sculpture that he had the caryatids from the Erechtheion on the Athenian Acropolis (see Fig. 2.26 in Chapter 2) copied for the villa. In its architectural and sculptural scope, the villa embodies the imperial reach of Rome itself.

CHINA

How did Daoism, Confucianism, and Legalism impact early Chinese culture?

The North China plain lies in the large, fertile valley of the Yellow River (Map 3.2). Around 7000 BCE, when the valley's climate was much milder and the land more forested than it is today, the peoples inhabiting this region began to cultivate the soil, growing primarily millet. Archeologists recognize at least three separate cultural groups in this region during this period, distinguished by their different pottery styles and works in jade. As Neolithic tribal people, they used stone tools, and although they domesticated

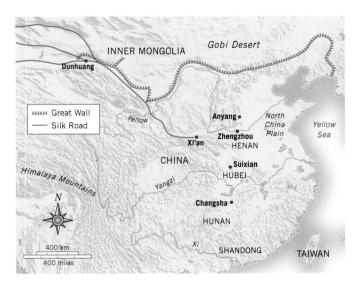

Map 3.2 Map of China, ca. 1600 CE.

animals very early on, they maintained the shamanistic practices of their hunter-gatherer heritage. Later inhabitants of this region would call this area the "Central Plain" because they believed it was the center of their country. During the ensuing millennia, Chinese culture in the Central Plain coalesced in ways that parallel developments in the Middle East and Greece during the same period, as China transformed itself from an agricultural society into a more urban-centered state.

By the third century BCE, at about the same time that Rome began establishing its imperial authority over the Mediterranean world, the government of China was sufficiently unified that it could build a Great Wall (Fig. 3.25) across the hills north of the Central Plain to protect the realm from the intruding Central Asians who lived beyond its northern borders. Some sections of the wall were already in place, built in previous centuries to protect local areas. These were rebuilt and connected to define a frontier stretching some 1,500 miles from northeast to northwest China. New roads and canal systems were built linking the entire nation, a large salaried bureaucracy was established, and a new imperial government headed by an emperor collected taxes, codified the law, and exerted control over a domain of formerly rival territories. Unification—first achieved here by the Qin dynasty—has remained a preeminent problem throughout China's long history.

Early Chinese Culture

Very few of the built edifices of ancient Chinese civilization have been found. We know that by the middle of the second millennium BCE, Chinese leaders ruled from large capitals, rivaling those in the West in their size and splendor. Beneath present-day Zhengzhou, for instance, lies an early metropolitan center with massive earthen walls. Stone was scarce in this area, but abundant forests made wood plentiful, so it was used to build cities. As impressive as they were, cities built of wood were vulnerable to fire and military

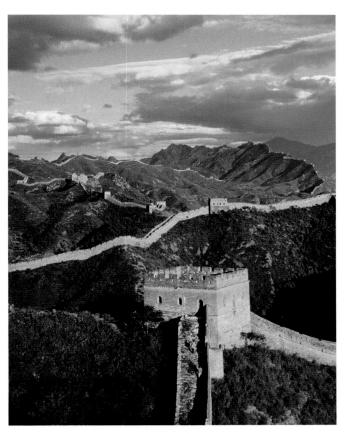

Fig. 3.25 The Great Wall, near Beijing, China. Begun late 3rd century BCE. Length approx. 4,100 miles, average height 25'. In the third century BCE, Qin Shihuangdi, the first emperor of China, ordered his army to reconstruct, link, and augment walls on the northern frontier of China in order to form a continuous barrier protecting his young country from northern peoples.

attack, and no sign of them remains. Nevertheless, we know a fair amount about early Chinese culture from the remains of its written language and the tombs of its rulers. Even the most ancient Chinese writing—found on oracle bones and ceremonial bronze vessels—is closely related to modern Chinese. And archeologists discovered that royal Chinese tombs, like Egyptian burial sites, contain fur-

of the PAST

The CONTINUING PRESENCE

See Cai Guo-Qiang, Project to Extend the Great Wall of China by 10,000 Meters: Project for Extraterrestrials No. 10, 1993, at MyArtsLab

nishings, implements, luxury goods, and clothing that—together with the written record—give us a remarkably vivid picture of ancient China.

The Shang Dynasty (ca. 1700–1045 BCE) Chinese records say that King Tang established the Shang dynasty. The Shang state was a linked collection of villages, stretching across the plains of the lower Yellow River Valley. But it was not a contiguous state with distinct borders; other villages separated some of the Shang villages from one another, and were frequently at war with the Shang. The royal family surrounded itself with shamans, who soon developed into a kind of nobility, and, in time, walled urban centers formed around the nobles' palaces or temples. The proliferation of bronze vessels, finely carved jades, and luxury goods produced for the Shang elite suggests that well-organized centers of craft production were located nearby. The Shang nobility organized itself into armies—surviving inscriptions describe forces as large as 13,000 men—that controlled the countryside and protected the king.

The first classic of Chinese literature, *The Book of Changes*, or *Yi Jing*, compiled later from ideas that developed in the Shang era, is a guide to interpreting the workings of the universe. A person seeking to understand some aspect of his or her life or situation poses a question and tosses a set of straws or coins. The arrangement they make when they fall leads to one of 64 readings (or hexagrams) in the *Yi Jing*. (Fu Xi, the culture-hero who invented writing, is also said to have invented the eight trigrams that combine in pairs to form the 64 hexagrams.) Each hexagram describes the circumstances of the specific moment, which is, as the title suggests, always a moment of transition, a movement from one set of circumstances to the next. The *Yi Jing* prescribes certain behaviors appropriate to the moment. Thus, it is a book of wisdom.

This wisdom is based on a simple principle—that order derives from balance, a concept the Chinese share with the ancient Egyptians. The Chinese believe that over time, through a series of changes, all things work toward a condition of balance. Thus, when things are out of balance, diviners might reliably predict the future by understanding that the universe tends to right itself. For example, the eleventh hexagram, entitled *T'ai*, or "Peace," indicated the unification of heaven and earth. The image reads:

Heaven and earth unite: the image of PEACE.

Thus the ruler

Divides and completes the course of heaven and earth,

And so aids the people.

In fact, according to the Shang rulers, "the foundation of the universe" is based on the marriage of Qian (at once heaven and the creative male principle) and Kun (the earth, or the receptive female principle), symbolized by the Chinese symbol of yin yang (Fig. 3.26). Yin is soft, dark, moist, and cool; yang is hard, bright, dry, and warm. The two combine to create the endless cycles of change, from night to day, across the four seasons of the year. They balance the five elements (wood, fire, earth, metal, and water) and the five powers of creation (cold, heat, dryness, moisture, and wind). The yin yang sign, then, is a symbol of harmonious integration, the perpetual interplay and mutual relation among all things. And note that each

Fig. 3.26 Yin yang symbol.

side contains a small circle of the same value as its opposite—neither side can exist without the other.

The interlocking of opposites illustrated by the *yin yang* motif is also present in the greatest artistic achievement of the Shang, their bronze casting. In order to cast bronze, a negative shape must be perfected first, into which the molten metal is then poured to make a positive shape. Through the manufacture of ritual vessels, such as the *guang* or wine vessel illustrated here (Fig. 3.27), the Shang developed an extremely sophisticated bronze-casting technology, as advanced as any ever used. Made for offerings of food, water, and wine during ceremonies of ancestor worship, these bronze vessels were kept in the ancestral hall and brought out for banquets. Like formal dinnerware, each type of vessel had a specific shape and purpose.

The conduct of the ancestral rites was the most solemn duty of a family head, with explicit religious and political significance. While the vessel shapes originally derived from the shapes of Neolithic pottery, in bronze they gradually became decorated with fantastic, supernatural creatures, especially

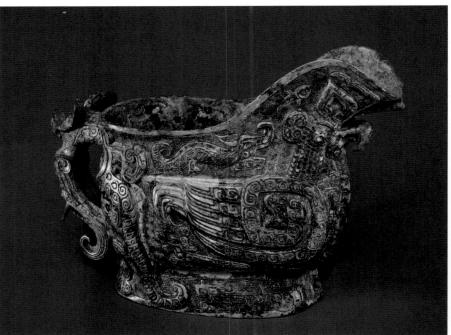

Fig. 3.27 Spouted Ritual Wine Vessel (*guang*). Shang dynasty, early Anyang period, 13th century BCE. Bronze, height 8½". The Metropolitan Museum of Art, New York. Rogers Fund, 1943. (43.25.4). Coiled serpents emerging from the wings and roaring tiger-dragons decorate the sides. Serving as a handle is a horned bird that is transformed into a dragon-serpent.

dragons. For the Shang, the bronzes came to symbolize political power and authority. Leaders made gifts of bronze as tokens of political patronage, and strict rules governed the number of bronzes a family might possess according to rank.

The Zhou Dynasty (1027–256 BCE) The Shang believed that their leaders were the sole conduit to the heavenly ancestors. However, in 1027 BCE, a rebel tribe known as the Zhou overthrew the Shang dynasty, claiming that the Shang had lost the Mandate of Heaven—that is, the right to rule as granted by the gods—by not ruling virtuously. The Zhou asserted that the legitimacy of a ruler derived from divine approval, and that the Shang had lost this favor because of their decadent extravagances. Even so, the Zhou took measures to intermarry with the elite whom they had overthrown, and took pains to conserve and restore what they admired of Shang culture. In fact, both the Book of Changes and the yin yang symbol were originated by the Shang but codified and written down by the Zhou.

The Zhou ushered in an era of cultural refinement and philosophical accomplishment. One example is the oldest collection of Chinese poetry, the Book of Songs (Shi jing), still taught in Chinese schools today. According to tradition, government officials were sent into the countryside to record the lyrics of songs that expressed the feelings of the people. The collection that survives, first compiled by the Zhou, consists of 305 poems from between the eleventh and seventh centuries BCE. The poems address almost every aspect of life. There are love poems, songs celebrating the king's rule, sacrificial hymns, and folk songs. Descriptions of nature abound—over 100 kinds of plant are mentioned, as well as 90 kinds of animal and insect. Marriage practices, family life, clothing, and food are all subjects of poems. One of the oldest celebrates the harvest as an expression of the family's harmony with nature, the symbol that the family's ancestors are part of the same natural cycle of life and death, planting and harvest, as the universe as a whole (Reading 3.4):

READING 3.4

from the Book of Songs

Abundant is the year, with much millet, much rice; But we have tall granaries, To hold myriads, many myriads and millions of grain. We make wine, make sweet liquor, We offer it to ancestor, to ancestress, We use it to fulfil all the rites, To bring down blessings upon each and all.

The songs in the *Shi jing* are contemporary with the poems that make up the *Dao de Jing* (*The Way of Life*), the primary philosophical treatise, written in verse, of Daoism, the Chinese mystical school of thought. The *Dao* ("the way") is deeply embedded in nature, and to attain it, the individual

must practice the art of "not-doing." (It is said that those who speak about the Dao do not know of it, and those who know about the Dao do not speak of it.) The book, probably composed in the third century BCE, is traditionally ascribed to Lao Tzu ("the Old One"), who lived during the sixth century BCE. In essence, it argues for a unifying principle in all nature, the interchangeability of energy and matter, a principle the Chinese call *qi*. The *qi* can be understood only by those who live in total simplicity, and to this end the Daoist engages in strict dietary practices, breathing exercises, and meditation. In considering such images as the one expressed in the following poem, the first in the volume, the Daoist finds his or her way to enlightenment (Reading 3.5):

READING 3.5

from the Tao Te Ching (or Dao de Jing)

There are ways but the Way is uncharted; There are names but not nature in words: Nameless indeed is the source of creation But things have a mother and she has a name.

The secret waits for the insight Of eyes unclouded by longing; Those who are bound by desire See only the outward container.

These two come paired but distinct By their names. Of all things profound, Say that their pairing is deepest, The gate to the root of the world.

The final stanza seems to be a direct reference to the principle of *yin yang*, itself a symbol of the *qi*. But the chief argument here, and the outlook of Daoism as a whole, is that enlightenment lies neither in the visible world nor in language, although to find the "way" one must, paradoxically, pass through or use both. Daoism thus represents a spiritual desire to transcend the material world.

If Daoism sought to leave the world behind, another great canon of teachings developed during the Zhou dynasty sought to define the proper way to behave *in* the world. The Zhou controlled most of China until internal feuding and a *coup d'état* forced them to move their capital east in 771 BCE. From that point on, the power of the Zhou rulers gradually declined. For 515 years, until the final collapse of the Zhou in 256 BCE, China was subjected to ever greater political turmoil as warring political factions, with at best only nominal allegiance to the emperor, struggled for power. Reacting to this state of affairs was the man many consider China's greatest philosopher and teacher, Kong Fuzi, or, as he is known in the West, Confucius.

Confucius was born to aristocratic parents in the province of Shandong in 551 BCE, the year before Pisistratus came to power in Athens. By his early twenties, Confucius had begun

to teach a way of life, now referred to as Confucianism, based on self-discipline and proper relations among people. If each individual led a virtuous life, then the family would live in harmony. If the family lived in harmony, then the village would follow its moral leadership. If the village exercised proper behavior toward its neighbor villages, then the country would live in peace and thrive.

Traditional Chinese values—values that Confucius believed had once guided the Zhou, such as self-control, propriety, reverence for one's elders, and virtuous behavior—lie at the core of this system. Tradition has it that Confucius compiled and edited the Book of Changes, the Book of Songs (which he edited down to 305 verses), and four other "classic" Chinese texts: the Book of Documents, containing speeches and pronouncements of historical rulers; the Book of Rites, which is essentially a code of conduct; the Spring and Autumn Annals, a history of China up to the fifth century BCE; and a lost treatise on music.

Confucius particularly valued the Book of Songs. "My little ones," he told his followers, "why don't you study the Songs? Poetry will exalt you, make you observant, enable you to mix with others, provide an outlet for your vexations; you learn from it immediately to serve your parents and ultimately to serve your prince. It also provides wide acquaintance with the names of birds, beasts, and plants."

After his death, in 479 BCE, Confucius' followers transcribed their conversations with him in a book known in English as the Analects. Where the Dao de Jing is a spiritual work, the Analects is a practical one. At the heart of Confucius' teaching is the principle of li—propriety in the conduct of the rites of ancestor worship. The courtesy and dignity required when performing the rites lead to the second principle, ren, or benevolent compassion and fellow feeling, the ideal relationship that should exist among all people. Based on respect for oneself, ren extends this respect to all others, manifesting itself as charity, courtesy, and, above all, justice. De, or virtue, is the power of moral example that an individual, especially a ruler, can exert through a life dedicated to the exercise of li and ren. Finally, wen, or culture, will result. Poetry, music, painting, and the other arts will all reveal an inherent order and harmony reflecting the inherent order and harmony of the state. Like an excellent leader, brilliance in the arts illuminates virtue. The Chinese moral order, like that of the Greeks (see Chapter 2), depended not upon divine decree or authority, but instead upon the people's own right actions. Its emphasis on respect for age, authority, and morality made Confucianism extremely popular among Chinese leaders and the artists they patronized. It embraced the emperor, the state, and the family in a single ethical system with a hierarchy that was believed to mirror the structure of the cosmos. By the early second century BCE, the Han dynasty (206 BCE-220 CE discussed later in this chapter), adopted Confucianism as the Chinese state religion, and a thorough knowledge of the Confucian classics was subsequently required of any politically ambitious person.

Imperial China

Whereas Rome's empire derived from outward expansion, China's empire arose from consolidation at the center. From about the time of Confucius onward, seven states vied for control. They mobilized armies to battle one another; iron weapons replaced bronze; they organized bureaucracies and established legal systems; merchants gained political power; and a "hundred schools of thought" flowered.

The Qin Dynasty (221–206 BCE): Organization and Control This period of warring states culminated when the western state Qin (the origin of our name for China) conquered the other states and unified them under the Qin Empire in 221 BCE. Under the leadership of Qin Shihuangdi (r. 221–210 BCE), who declared himself "First Emperor," the Qin worked very quickly to achieve a stable society. To discourage nomadic invaders from the north, they built the Great Wall of China (see Fig. 3.25). The wall was constructed by soldiers, augmented by criminals, civil servants who found themselves in disfavor, and conscripts from across the countryside. Every family was required to provide one able-bodied adult male to work on the wall each year. It was made of rammed earth, reinforced by continuous horizontal courses of brushwood, and faced with stone. Watchtowers were built at high points, and military barracks were constructed in the valleys below. At the same time, the Chinese constructed nearly 4,350 miles of road, linking even the farthest reaches of the country to the Central Plain. By the end of the second century CE, China had some 22,000 miles of road serving a country of nearly 1.5 million square miles.

Such massive undertakings could only have been accomplished by an administrative bureaucracy of extraordinary organizational skill. Indeed, in the 15 years that the Qin ruled China, the written language was standardized, a uniform coinage was introduced, all wagon axles were required to be the same width so that they would uniformly fit in the existing ruts on the Chinese roads (thus accommodating trade and travel), a system of weights and measures was introduced, and the country was divided into the administrative and bureaucratic provinces much as they exist to the present day.

Perhaps nothing tells us more about Qin organization and control than the tomb of its first emperor, Qin Shihuangdi (see Closer Look, pages 108-109). When he died, battalions of lifesize earthenware guards in military formation were buried in pits beside his tomb. (More than 8,000 have been excavated so far.) Like the Great Wall, this monumental undertaking required an enormous workforce, and we know that the Qin enlisted huge numbers of workers in this and its other projects.

To maintain control, in fact, the Qin suppressed free speech, persecuted scholars, burned classical texts, and otherwise exerted absolute power. They based their thinking on the writings of Han Feizi, who had died in 233 BCE, 12 years before the Qin took power. Orthodox Confucianism had been codified by Meng-zi, known as Mencius (ca. 370–300 BCE), an itinerant philosopher and sage who argued for the innate goodness of the individual. He believed that bad character was a result of society's inability to provide a positive, cultivating atmosphere in which individuals might realize their capacity for goodness. Han Feizi, on the other hand, argued that human beings were inherently evil and innately selfish (exactly the opposite of Mencius' point of view). **Legalism**, as Han Feizi's philosophy came to be called, required that the state exercise its power over the individual, because no agency other than the state could instill enough fear in the individual to elicit proper conduct. The Qin Legalist bureaucracy, coupled with an oppressive tax structure imposed to pay for their massive civil projects, soon led to rebellion, and after only 15 years in power, the Qin collapsed.

The Han Dynasty (206 BCE–220 CE): The Flowering of Culture In place of the Qin, the Han dynasty came to power, inaugurating more than 400 years of intellectual and cultural growth. The Han emperors installed Confucianism as the official state philosophy and established an academy to train civil servants. Where the Qin had disenfranchised scholars, the Han honored them, even going so far as to give them an essential role in governing the country.

Under Emperor Wu, Chinese literary arts flourished. In 120 BCE, he established the Yue fu, the so-called Music Bureau, which would come to employ some 829 people charged with collecting the songs of the common people. The folk style of the yuefu songs was widely imitated by court poets during the Han and throughout the history of Chinese poetry. The lines are of uneven length, although often of five characters, and emphasize the joys and vicissitudes of daily life. A case in point is a poem by Liu Xijun, a Chinese princess who, around 110 BCE, was married for political reasons to the chief of the Wusun, a band of nomads who lived on the steppes of northwest China. Her husband, as it turned out when she arrived, was old and decrepit, spoke almost no Chinese, and by and large had nothing to do with her, seeing her every six months or so. This is her "Lament" (Reading 3.6):

READING 3.6

Liu Xijun, "Lament"

My family married me off to the King of the Wusun. and I live in an alien land a million miles from nowhere. My house is a tent, My walls are of felt. Raw flesh is all I eat, with horse milk to drink. I always think of home and my heart stings, O to be a yellow snow-goose floating home again!

The poem's last two lines—what might be called the flight of Liu Xijun's imagination—are typical of Chinese poetry, where time and again the tragic circumstances of life are overcome through an image of almost transcendent natural beauty.

As Liu Xijun's poem suggests, women poets and scholars were common—and respected—during the Han dynasty. But as the circumstances surrounding Liu Xijun's poem also suggest, women did not enjoy great power in society. The traditional Chinese family was organized around basic Confucian principles: Elder family members were wiser, and therefore superior to the younger, and males were superior to females. Thus, while a grandmother might hold sway over her grandson, a wife owed unquestioning obedience to her husband. The unenviable plight of women is the subject of a poem by Fu Xuan, a male poet of the late Han dynasty who apparently was one of the most prolific poets of his day, although only 63 of his poems survive (Reading 3.7):

READING 3.7

Fu Xuan, "To Be a Woman"

It is bitter to be a woman, the cheapest thing on earth. A boy stands commanding in the doorway like a god descended from the sky. His heart hazards the four seas. thousands of miles of wind and dust, but no one laughs when a girl is born. The family doesn't cherish her. When she's a woman she hides in back rooms, scared to look a man in the face. They cry when she leaves to marry a brief rain, then mere clouds. Head bowed, she tries to compose her face, her white teeth stabbing red lips. She bows and kneels endlessly, even before concubines and servants. If their love is strong as two stars she is like a sunflower in the sun, but when their hearts are water and fire a hundred evils descend on her. The years change her jade face and her lord will find new lovers. They who were close like body and shadow will be remote as Chinese and Mongols. Sometimes even Chinese and Mongols meet but they'll be far as polar stars.

The poem is notable for the acuity and intensity of its imagery—her "white teeth stabbing red lips," the description of a close relationship as "like body and shadow," and, in the last lines, the estrangement of their relationship to a point as far apart as "polar stars," farther apart even than the Chinese and Mongols. (And who, one must ask, is more like the barbarian hordes, the male or the female?)

What we know about the domestic setting of Han dynasty society we can gather mostly from surviving poetic images describing everyday life in the home, but our understanding of domestic architecture derives from ceramic models. A model of a house found in a tomb, presumably provided for the use of the departed in the afterlife, is four stories high and

CLOSER LOOK

ne day in 1974, peasants digging a well on the flat plain 1,300 yards east of the huge Qin dynasty burial mound of the Emperor Qin Shihuangdi in the northern Chinese province of Shaanxi unearthed parts of a life-size clay soldier—a head, hands, and body. Archeologists soon discovered an enormous subterranean pit beneath the fields containing an estimated 6,000 infantrymen, most standing four abreast in 11 parallel trenches paved with bricks. In 1976 and 1977, two smaller but equally spectacular sites were discovered north of the first one, containing

another 1,400 individual warriors and horses, complete with metal weaponry.

Qin Shihuangdi's actual tomb has never been excavated. It rises 140 feet above the plain. Historical records indicate that below the mound is a subterranean palace estimated to be about 400 feet by 525 feet. According to the *Shi Ji* (*Historical Records*) of Sima Qian, a scholar from the Han dynasty, the emperor was buried there in a bronze casket surrounded by a river of mercury. Scientific tests conducted by Chinese archeologists confirm the presence of large quantities of

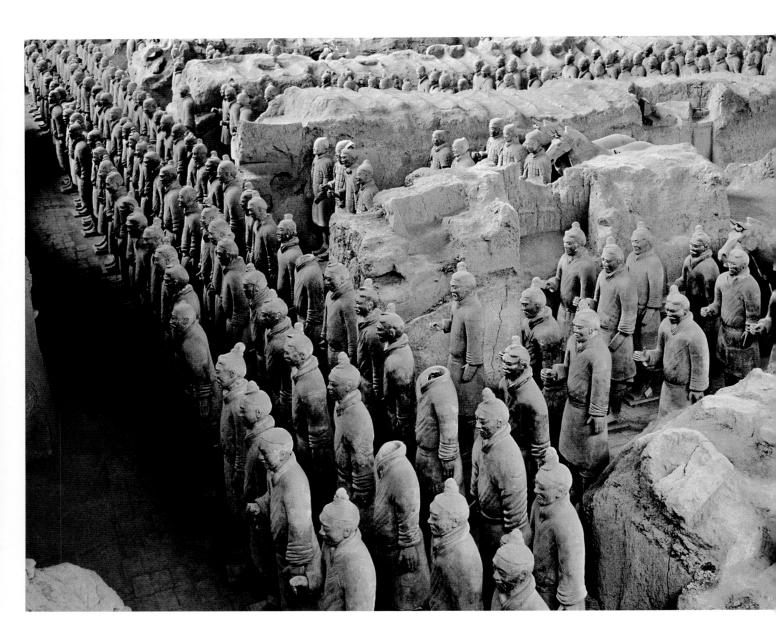

The Tomb of Qin Shihuangdi

mercury in the soil of the burial mound. Magnetic scans of the tomb have also revealed large numbers of coins, suggesting the emperor was buried with his treasury.

Something to Think About . . .

Why do you suppose the ceramic army was deployed outside the tomb of Qin Shihuangdi and not in it?

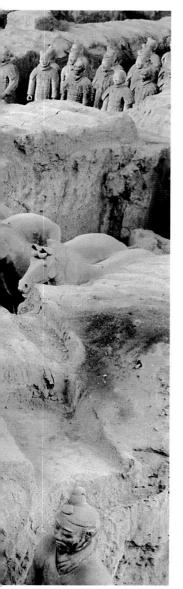

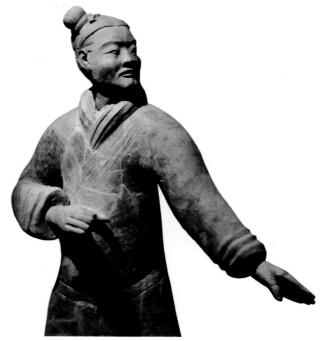

Two terra-cotta soldiers from the burial mound of Qin Shihuangdi, Shaanxi province, China. Both ca. 210 BCE. On the right, a kneeling archer, height 48"; above, an infantryman poised for hand-to-hand combat, height 70". The bodies of most of the soldiers in the tomb appear to have been mass-produced in molds. After each stylized body was baked, head and hands were added. No two heads are alike. Many seem to possess unique, individual facial features, and they exhibit a variety of hairstyles. They were subsequently painted in vivid colors, and most carried actual weapons. Knives, spears, swords, and arrowheads have been found at the site.

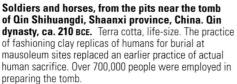

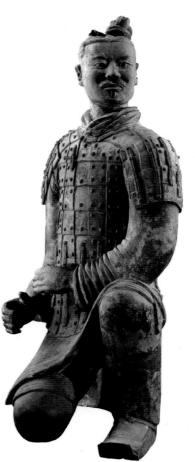

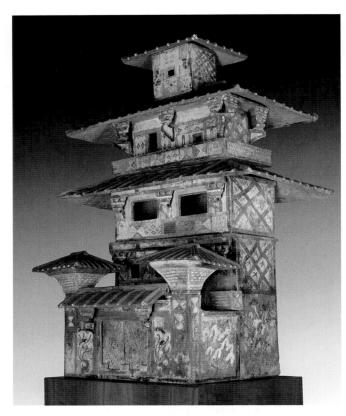

Fig. 3.28 Model of a house, Eastern Han dynasty (25–220 cE), 1st century cE. Painted earthenware with unfired pigments, $52'' \times 33 \frac{1}{2}'' \times 27''$. The Nelson-Atkins Museum of Art, Kansas City, Missouri. This is one of the largest and most complete models of a Han house known.

topped by a watchtower (Fig. 3.28). The family lived in the middle two stories, while livestock, probably pigs and oxen, were kept in the gated lower level with its courtyard extending in front of the house.

Architecturally, the basic form of the house is commonly found across the world—rectangular halls with columns supporting the roof or the floor above. The walls serve no weight-bearing function. Rather, they serve as screens separating the inside from the outside, or one interior room from another. Distinctive to Chinese architecture are the broad eaves of the roof, which would become a standard feature of East Asian construction. Adding playful charm is the elaborate decoration of the facade, including painted trees flanking the courtyard.

Aside from their military value, horses advanced the growth of trade along the Silk Road. Nearly 5,000 miles long, this trade route led from the Yellow River Valley to the Mediterranean, and along it, the Chinese traded their most exclusive commodity, silk. The quality of Han silk is evident in a silk banner from the tomb of the wife of the Marquis of Dai, discovered on the outskirts of present-day Changsha in Hunan (Fig. 3.29). Painted with scenes representing the underworld, the earthly realm, and the heavens, it represents the Han conception of the cosmos. Long, sinuous lines representing dragons' tails, coiling serpents, long-tailed birds, and flowing draperies unify the three

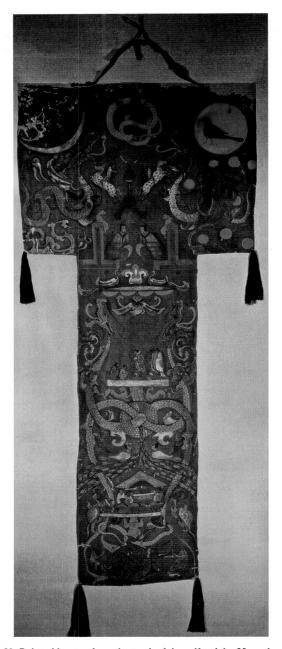

Fig. 3.29 Painted banner from the tomb of the wife of the Marquis of Dai, Mawangdui, Changsha, Hunan province. Han dynasty, ca. 160 BCE. Colors on silk, height 6'8½". Hunan Provincial Museum, Changsa. The banner was found in the innermost of the nested coffins opened in 1972.

realms. In the right corner of the heavenly realm, above the crossbar of the T, is an image of the sun containing a crow, and in the other corner is a crescent moon supporting a toad. Between them is a deity entwined within his own long, red serpent tail. The deceased noblewoman herself stands on the white platform in the middle region of the banner. Three attendants stand behind her and two figures kneel before her, bearing gifts. On a white platform in the lower realm, bronze vessels contain food and wine for the deceased.

The Han were especially inventive. In the West, the limitations of papyrus as a writing medium had led to the invention of parchment at Pergamon, but the Chinese invention of cellulose-based paper in 105 cE by Cai Lun, a eunuch and attendant to the Imperial Court who held a post responsible for manufacturing instruments and weapons, enabled China to develop widespread literacy much more quickly than the West. Although modern technology has simplified the process, his method remains basically unchanged—the suspension in water of softened plant fibers that are formed in molds into thin sheets, couched, drained, and then dried. Motivated by trade, the Han also began to make maps, becoming the world's first cartographers. They invented important agricultural technology such as the wheelbarrow and horse collar. They learned to measure the magnitude of earthquakes with a crude but functional seismograph. But persistent warring with the nomadic peoples to the north required money to support military and bureaucratic initiatives. Unable to keep up with increased taxes, many peasants were forced off the land and popular rebellion ensued. By the third century ce, the Han dynasty had collapsed. China reentered a period of political chaos lasting from 220 until 589 CE, when imperial rule finally regained its strength.

ANCIENT INDIA

How did the Hindu and Buddhist faiths help to shape the cultures of ancient India?

Indian civilization was born along the Indus River in the northwest corner of the Indian subcontinent in present-day Pakistan somewhere around 2700 BCE in an area known as Sind—from which the words *India* and *Hindu* originate (Map 3.3).

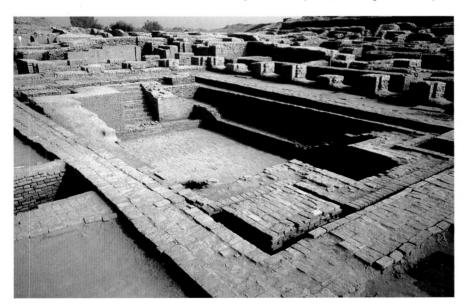

Fig. 3.30 Large water tank, possibly a public or ritual bathing area, from Mohenjo-Daro, Indus Valley civilization. ca. 2600–1900 BCE. It measures approximately 39½' north—south and 23' wide, with a maximum depth of almost 8'.

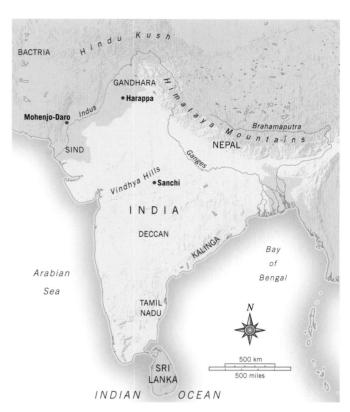

Map 3.3 India around 1500 BCE. Cut off from the rest of Asia by high mountains to the north, India was nevertheless a center of trade by virtue of its prominent maritime presence.

The earliest Indian peoples lived in at least two great cities in the Indus Valley—Mohenjo-Daro, on the banks of the Indus, and Harappa, on the River Ravi, downstream from present-day Lahore. These great cities thrived until around

1900 BCE and were roughly contemporaneous with Sumerian Ur, the Old Kingdom of Egypt, and Minoan civilization in the Aegean.

The cities were discovered by chance in the early 1920s and excavations have continued since. The best preserved of the sites is Mohenjo-Daro. Built atop a citadel is a complex of buildings, presumably a governmental or religious center, surrounded by a wall 50 feet high. Set among the buildings on the citadel is a giant pool (Fig. 3.30). Perhaps a public bath or a ritual space, it has finely fitted bricks, laid on edge and bound together with gypsum plaster, which made it watertight. The bricks on the side walls of the tank were covered with a thick layer of bitumen (natural tar) to keep water from seeping through the walls and up into the superstructure. The pool was open to the air and surrounded by a brick colonnade.

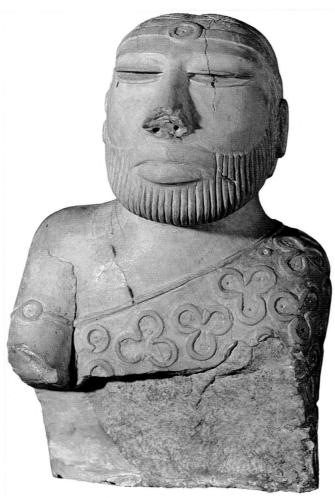

Fig. 3.31 Torso of a "priest-king" from Mohenjo-Daro, Indus Valley civilization. ca. 2000-1900 BCE. Steatite, height 67/8". National Museum of Pakistan, Karachi, The look created by the figure's half-closed eyes suggests that this might be a death mask of some sort. The trefoil, or three-lobed decorations on the garment that crosses his chest were originally filled with red paint.

Outside the wall and below the citadel, a city of approximately 6 to 7 square miles, with broad avenues and narrow side streets, was laid out in a rough grid. It appears to have been home to a population of between 20,000 and 50,000. Most of the houses were two stories tall and built around a central courtyard. A network of covered drainage systems ran through the streets, channeling waste and rainwater into the river. The houses were built with standard sizes of baked brick, each measuring $2\frac{3}{4} \times 5\frac{1}{2} \times 11$ inches, a ratio of 1:2:4. A brick of identical ratio but larger— $4 \times 8 \times 16$ inches—was used in the building of platforms and city walls. Unlike the sun-dried bricks used in other cultures at the time. Mohenio-Daro's bricks were fired, making them much more durable. All this suggests a civilization of considerable technological know-how and sophistication.

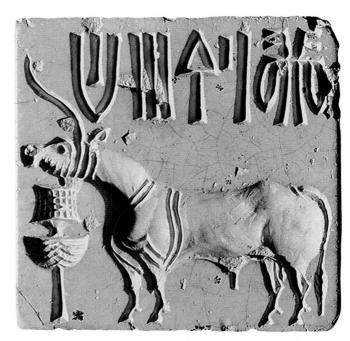

Fig. 3.32 Seal depicting a horned animal, Indus Valley civilization. ca. 2500-1900 BCE. Steatite, approx. 11/4" × 11/4". National Museum of Pakistan, Karachi. The function of seals like this remains unknown.

The arts of the Indus civilizations include human and animal figurines made of stone, terra cotta, bronze, and other materials—including the so-called priest-king found at Mohenjo-Daro (Fig. 3.31)—terra-cotta pottery, and various styles of decorative ornament for human wear, including beads and stoneware bangles. Over 2,000 small seals have been unearthed. Carved from steatite stone, coated with alkali, and then fired to produce a luminous white surface, many depict animals with an extraordinary naturalism, especially considering that they are rendered in such miniature detail (Fig. 3.32). Depictions of warfare or conquered enemies are strikingly absent in representational art. As the top of this seal shows, the peoples of the valley had a written language, although it remains undeciphered.

Sometime around 1500 BCE, the Aryas, nomads from the north, invaded the Indus River Valley and conquered its inhabitants, making them slaves. Thus began the longestlasting set of rigid, class-based societal divisions in world history, the Indian caste system. By the beginning of the first millennium BCE, these castes consisted of five principal groups, based on occupation: At the bottom of the ladder was a group considered "out of caste," people whose occupations or habits were, by definition, impure or polluted. Next in line were the Shudras, unskilled workers. Then came the Vaishvas, artisans and merchants. They were followed by the Kshatriyas, rulers and warriors. At the highest level were the Brahmins, priests and scholars.

Hinduism and the Vedic Tradition

The social castes were sanctioned by the religion the Aryas brought with them, a religion based on a set of sacred hymns to the Aryan gods. These hymns, called Vedas, were written in the Aryan language, Sanskrit, and they gave their name to an entire period of Indian civilization, the Vedic period (ca. 1500–322 BCE). From the Vedas in turn came the Upanishads, a book of mystical and philosophical texts that date from sometime after 800 BCE. Taken together, the Vedas and the Upanishads form the basis of the Hindu religion, with Brahman, the universal soul, at its center. The religion has no single body of doctrine, nor any standard set of practices. It is defined above all by the diversity of its beliefs and deities. Indeed, several images of mother goddesses, stones in the phallic form, as well as a seal with an image that resembles the Hindu god Shiva, have been excavated at various Indus sites, leading scholars to believe that certain aspects and concepts of Hinduism survived from the Indus civilizations and were incorporated into the Vedic religion.

The *Upanishads* argue that all existence is a fabric of false appearances. What appears to the senses is entirely illusory. Only Brahman is real. Thus, in a famous story illustrating the point, a tiger, orphaned as a cub, is raised by goats. It learns, as a matter of course, to eat grass and make goat sounds. But one day it meets another tiger, who takes it to a pool to look at itself. There, in its reflection in the water, it discovers its true nature. The individual soul needs to discover the same truth, a truth that will free it from the endless cycle of birth, death, and rebirth and unite it with the Brahman in **nirvana**, a place or state free from worry, pain, and the external world.

Brahman, Vishnu, and Shiva As Hinduism developed, the functions of Brahman, the divine source of all being, were split among three gods: Brahma, the creator; Vishnu, the preserver; and Shiva, the destroyer. Vishnu was one of the most popular of the Hindu deities. In his role as preserver, he is the god of benevolence, forgiveness, and love, and like the other two main Hindu gods, he was believed capable of assuming human form, which he did more often than the other gods because of his great love for humankind. Among Vishnu's most famous incarnations is his appearance as Rama in the oldest of the Hindu epics, the Ramayana (Way of Rama), written by Valmiki in about 550 BCE. Like Homer in ancient Greece, Valmiki gathered together many existing legends and myths into a single story, in this case narrating the lives of Prince Rama and his queen, Sita. The two serve as models of Hindu life. Rama is the ideal son, brother, husband, warrior, and king, and Sita loves, honors, and serves her husband with absolute and unquestioning fidelity. These characters face moral dilemmas to which they must react according to dharma, good and righteous conduct reflecting the cosmic moral order that underlies all existence. For Hindus, correct actions can lead to cosmic harmony; and bad actions,

violating dharma, can trigger cosmic tragedies such as floods and earthquakes.

An equally important incarnation of Vishnu is as the charioteer Krishna in the later Indian epic the Mahabharata, composed between 400 BCE and 400 CE. In the sixth book of the Mahabharata, titled the Bhagavad Gita, Krishna comes to the aid of Arjuna, a warrior who is tormented by the conflict between his duty to fight and kill his kinsmen in battle and the Hindu prohibition against killing. Krishna explains to Arjuna that as a member of the Kshatriya caste—that is, as a warrior—he is freed from the Hindu sanction against killing. In fact, by fighting well and doing his duty, he can free himself from the endless cycle of birth, death, and reincarnation, and move toward spiritual union with the Brahman.

But Vishnu's popularity is probably most attributable to his celebration of erotic love, which to Hindus symbolizes the mingling of the self and the absolute spirit of Brahman. In the *Vishnu Puranas* (the "old stories" of Vishnu), collected about 500 CE, Vishnu, in his incarnation as Krishna, is depicted as seducing one after another of his devotees. In one story of the *Vishnu Puranas*, he seduces an entire band of milkmaids: "They considered every instant without him a myriad of years; and prohibited (in vain) by husbands, fathers, brothers, they went forth at night to sport with Krishna, the object of their affection." Allowing themselves to be seduced does not suggest that the milkmaids were immoral, but shows an almost inevitable manifestation of their souls' quest for union with divinity.

If Brahma is the creator of the world, Shiva takes what Brahma has made and embodies the world's cyclic rhythms. Since in Hinduism, the destruction of the old world is followed by the creation of a new world, Shiva's role as destroyer is both positive and necessary. In this sense, he possesses reproductive powers, and in this manifestation of his being, he is frequently represented as a *linga* (phallus), often carved in stone on temple grounds or at shrines.

The Goddess Devi Goddess worship is fundamental to Hindu religion. Villages usually recognize goddesses as their protectors, and the goddess Devi is worshiped in many forms throughout India. She is the female aspect without whom the male aspect, which represents consciousness or discrimination, remains impotent and void. For instance, in the *Devi Mahatmayam*, another of the Puranas, composed like the *Vishnu Puranas* around 500 ce, Vishnu was asleep on the great cosmic ocean, and because of his slumber, Brahma was unable to create. Devi intervenes, kills the demons responsible for Vishnu's slumber, and helps to wake up Vishnu. Thus continues the cycle of life.

Devi is synonymous with Shakti, the primordial cosmic energy, and represents the dynamic forces that move through the entire universe. Shaktism, a particular brand of Hindu faith that regards Devi as the Supreme Brahman itself, believes that all other forms of divinity, female or male, are themselves simply forms of Devi's diverse

113

Fig. 3.33 The Goddess Durga Killing the Buffalo Demon, Mahisha (Mahishasuramardini), Bangladesh or India. Pala period, 12th century CE. Argillite, height 55/16". The Metropolitan Museum of Art, New York. Durga represents the warrior aspect of Devi.

manifestations. But she has a number of particular manifestations. In an extraordinary miniature carving from the twelfth century, Devi is seen in her manifestation as Durga (Fig. 3.33), portrayed as the sixteen-armed slayer of a buffalo inhabited by the fierce demon Mahisha. Considered invincible, Mahisha threatens to destroy the world, but Durga comes to the rescue. In this image, she has just severed the buffalo's head and Mahisha, in the form of a tiny, chubby man, his hair composed of snake heads, emerges from the buffalo's decapitated body and looks up admiringly at her even as his toes are being bitten by her lion. Durga smiles serenely as she hoists Mahisha by his hair and treads gracefully on the buffalo's body.

Buddhism: "The Path of Truth"

Because free thought and practice mark the Hindu religion, it is hardly surprising that other religious movements drew on it and developed from it. Buddhism is one of those. Its founder, Shakyamuni Buddha, lived from about 563 to 483 BCE. He was born Prince Siddhartha Gautama, child of a ruler of the Shakya clan—Shakyamuni means "sage of the Shakyas"—and was raised to be a ruler himself. Troubled by what he perceived to be the suffering of all human beings, he abandoned the luxurious lifestyle of his father's palace to live in

the wilderness. For six years he meditated, finally attaining complete enlightenment while sitting under a banyan tree at Bodh Gaya. Shortly thereafter he gave his first teaching, at the Deer Park at Sarnath, expounding the Four Noble Truths:

- 1. Life is suffering.
- 2. This suffering has a cause, which is ignorance.
- 3. Ignorance can be overcome and eliminated.
- 4. The way to overcome this ignorance is by following the Eightfold Path of right view, right resolve, right speech, right action, right livelihood, right effort, right mindfulness, and right concentration.

Living with these truths in mind, one might overcome what Buddha believed to be the source of all human suffering—the desire for material things, which is the primary form of ignorance. In doing so, one would find release from the illusions of the world, from the cycle of birth, death, and rebirth, and ultimately reach nirvana. These principles are summed up in the *Dhammapada*, the most popular canonical text of Buddhism, which consists of 423 aphorisms, or sayings, attributed to Buddha and arranged by subject into 26 chapters. Its name is a compound consisting of *dhamma*, the vernacular form of the formal Sanskit word *dharma*, mortal truth, and *pada*, meaning "foot" or "step"—hence it is "the path of truth." The aphorisms are widely admired for their wisdom and their sometimes stunning beauty of expression.

The Buddha (which means "Enlightened One") taught for 40 years until his death at age 80. His followers preached that anyone could achieve Buddhahood, the ability to see the ultimate nature of the world. Persons of very near total enlightenment, but who have vowed to help others achieve Buddhahood before crossing over to nirvana, came to be known as **bodhisattvas**, meaning "those whose essence is wisdom." In art, bodhisattvas wear the princely garb of India, while Buddhas wear a monk's robe.

The Maurya Empire Buddhism would become the official state religion of the Maurya Empire, which ruled India from 321 to 185 BCE. The Empire was founded by Chandragupta Maurya (r. ca. 321–297 BCE) in eastern India. Its capital was Pataliputra (present-day Patna) on the Ganges River, but Chandragupta rapidly expanded the Empire westward, taking advantage of the vacuum of power in the Indus Valley that followed Alexander the Great's invasion of 326 BCE. In 305 BCE, the Hellenistic Greek ruler Seleucus I, ruler of one of the three states that succeeded Alexander's empire, the kingdom of the Seleucids, tried to reconquer India once again. He and Chandragupta eventually signed a peace treaty, and diplomatic relations between Seleucid Greece and the Maurya Empire were established. Several Greeks ambassadors were soon residing in the Mauryan court, the beginning of substantial relations between East and West. Chandragupta was succeeded by his son Bindusara (r. ca. 297-273 BCE), who also had a Greek ambassador at his court, and who extended the Empire southward, conquering almost all the Indian peninsula and establishing the Maurya

Fig. 3.34 The Great Stupa, Sanchi, Madhya Pradesh, India, view of the West Gateway. Founded 3rd century BCE, enlarged ca. 150–50 BCE. Shrine height 50', diameter 105'. In India, the stupa is the principal monument to Buddha. The stupa symbolizes, at once, the World Mountain, the Dome of Heaven, and the Womb of the Universe.

Empire as the largest Empire of its time. He was in turn succeeded by his son Ashoka (r. ca. 273–232 BCE).

It was Ashoka who established Buddhism as the official state religion. On a battlefield in 261 BCE, he was appalled by the carnage he had inflicted in his role as a warrior king. As he watched a monk walking slowly among the dead, Ashoka was moved to decry violence and force of arms and to spread the teachings of Buddha. From that point, Ashoka, who had been described as "the cruel," began to be known as "the pious." At a time when Rome was engaged in the Punic Wars, Ashoka pursued an official policy of nonviolence. The unnecessary slaughter or mutilation of animals was forbidden. Sport hunting was banned, and although the limited hunting of game for the purpose of consumption was tolerated, Ashoka promoted vegetarianism. He built hospitals for people and animals alike, preached the humane treatment of all living things, and regarded all his subjects as equals, regardless of politics, religion, or caste. He also embarked on a massive Buddhist architectural campaign, erecting as many as 8,400 shrines and monuments to Buddha throughout the empire. Soon, Buddhism spread bevond India, and Buddhist monks from China traveled to India to observe Buddhist practices.

The Great Stupa Among the most famous of the Buddhist monuments that Ashoka erected is the Great Stupa at Sanchi (Fig. 3.34), which was enlarged in the second century BCE. A stupa is a kind of burial mound. The earliest eight of them were built around 483 BCE as reliquaries for Buddha's remains, which were themselves divided into eight parts. In the third century, Ashoka opened the original eight stupas and further divided Buddha's relics, scattering them among a great many other stupas, probably including that at Sanchi.

Fig. 3.35 Elevation and plan of the Great Stupa, Sanchi. One of the most curious aspects of the Great Stupa is that its four gates are not aligned on an axis with the four openings in the railing. Some scholars believe that this arrangement is derived from gates on farms, which were designed to keep cattle out of the fields.

The stupa as a form is deeply symbolic, consisting first and foremost of a hemispheric dome, built of rubble and dirt and faced with stone, evoking the Dome of Heaven (Fig. 3.35). Perched on top of the dome is a small square platform, in the center of which is a mast supporting three circular discs or "umbrellas," called *chatras*. These signify both the banyan tree beneath which Buddha achieved enlightenment and the three levels of Buddhist consciousness—desire, form, formlessness—through which the soul ascends to enlightenment. The dome is set on a raised base, around the top of which is a walkway. As pilgrims to the stupa circle the walkway, they symbolically follow Buddha's path, awakening to enlightenment. The whole is a mandala (literally "circle"), the Buddhist diagram of the cosmos.

Ashoka's missionary ambition matched his father's and grandfather's military zeal, and he sent Buddhist emissaries as far west as Syria, Egypt, and Greece. No Western historical record of these missions survives, and their impact on Western thought remains a matter of speculation.

3.1 Characterize imperial Rome, its dual sense of origin, and its debt to the Roman Republic.

Roman culture developed out of both Greek and indigenous Etruscan roots. The Etruscans also provided the Romans with one of their founding myths, the legend of Romulus and Remus; Virgil's *Aeneid* was the other. According to legend, it was Romulus who inaugurated the traditional Roman distinction between patricians and plebeians with its system of patronage and *pietas*. Describe this system.

During the era of the Roman republic in the first century, the powerfully eloquent and persuasive writing of the rhetorician Cicero helped to make Latin the chief language of the empire. His essay *On Duty* helped to define *pietas* as a Roman value. How is this value evidenced in the portrait busts of the era?

In 27 BCE, the Senate granted Octavian the imperial name Augustus and the authority of *imperium* over all the empire. In what way did Augustus idealize himself in the monumental statues dedicated to him? How did he present his wife, Livia, and his family to the public, and what values did he wish his family to embody?

Under Augustus, Roman literature also thrived. But Augustus' greatest achievement, and that of the emperors to follow him, was the transformation of Rome into, in Augustus' words, "a city of marble." Why did the Roman emperors build so many public works? What did they symbolize or represent? In the private sphere, how does the architecture of the *domus* reflect Roman values?

3.2 Describe the impact of the competing schools of thought that flourished in early Chinese culture—Daoism, Confucianism, and Legalism.

During the Shang (ca. 1700–1045 BCE) and Zhou (1045-256 BCE) dynasties, the two great strains of Chinese philosophy—Daoism, a mystical quietism based on harmony with nature, and Confucianism, a pragmatic political philosophy based on personal cultivation—came into full

flower. The philosophical symbol of *yin yang* was devised during this early period, too. Can you detect the workings of the yin-yang philosophy in the poetry of the *Book of Songs* and in the later philosophy of Confucius? How did Confucianism contribute to the workings of the Chinese state? Why is Daoism less suited as a political philosophy?

Under the leadership of the first emperor, Qin Shihuangdi, the Qin dynasty (221–206 BCE) unified China and undertook massive building projects, including the 4,000-mile-long Great Wall, enormous networks of roads, and the emperor's own tomb, guarded by nearly 8,000 life-size ceramic soldiers, projects that required the almost complete reorganization of Chinese society. This reorganization was made possible by placing totalitarian authority in the hands of a ruthless dictator. How did Han Feizi's Legalism support the emperor's approach? How do the massive building projects of the Qin dynasty compare those of the Roman Empire in the West?

During the Han dynasty (206 BCE–220 CE), the scholars and writers disenfranchised by the Qin were restored to respectability. How does Han culture reflect Confucian values?

3.3 Discuss the ways in which both Hinduism and Buddhism shaped Indian culture.

Before 2000 BCE, in the Indus Valley, sophisticated cultures arose at cities such as Mohenjo-Daro. But after the invasion of the Aryans in about 1500 BCE, the Hindu religion took hold in India. The *Vedas* and *Upanishads* were its two basic texts. Its three major gods were Brahma, the creator; Vishnu, the preserver; and Shiva, the destroyer, who is also a great dancer, embodying the sacred rhythms of creation and destruction, birth, death, and rebirth. What does this religion share with Buddhism, the official Indian state religion adopted by the Maurya emperor Ashoka? In what ways did Ashoka seek to spread Buddhism as the dominant Indian faith?

CONTINUITY

Christian Rome

hroughout its history, the Roman Empire had been a polytheistic state in which literally dozens of religions were tolerated. But as Christianity became a more and more dominant force in the Empire, it threatened the political and cultural identity of the Roman citizen. No longer was a Roman first and foremost Roman. Increasingly, that citizen was first and foremost Christian.

In reaction to this threat to imperial authority, during the chaotic years after the fall of the Severan emperors in 235 ce, Christians were blamed, as their religion spread across the Empire (see Map 3.1), for most of Rome's troubles. By the end of the third century, there were about five million Christians in the Roman Empire, nearly a tenth of the population. Rome had a particularly large Christian congregation with

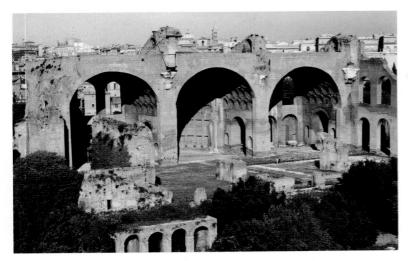

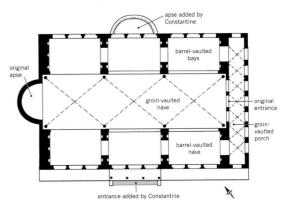

Figs. 3.36 and 3.37 The Basilica of Maxentius and Constantine, also known as the Basilica Nova, and plan. Rome. 306–313 cs. Constantine added an imposing entrance on the southwest side of Maxentius' basilica and another apse across from it, perhaps to accommodate crowds.

considerable influence, since its leadership was believed to be descended from Jesus' original disciples, Peter and Paul. In 303, the emperor Diocletian (r. 284–305 cE) unleashed a furious persecution of Christians that lasted for eight years.

Diocletian saw the Roman Church as a direct threat to his own authority, recognizing that it had achieved an almost monarchical control over the other dioceses, or Church territories, in the Empire. He forbade Christian worship, ordered churches destroyed, burned books, and had all bishops arrested. Under penalty of death, Christians were compelled to make sacrifices to the emperor, whom non-Christian Romans considered divine. Thousands refused, and the martyrdom they thus achieved fueled rather than diminished the Church's strength.

In 305, Diocletian retired owing to bad health, ushering in a period of instability. Finally, Constantine I, known as "Constantine the Great" (r. 306–37), won a decisive battle at the Milvian Bridge, at the entrance to Rome, on October 28, 312, establishing himself as emperor. Two years earlier, as Constantine was advancing on Rome from Gaul, the story had circulated that he had seen a vision of the sun god Apollo accompanied by Victory (Nike) and the Roman numeral XXX symbolizing the 30 years he would reign. By the end of his life, he claimed to have seen, instead, above the sun, a single cross, by then an increasingly common symbol of Christ, together with the legend, "In this sign you shall conquer." At any rate, it seems certain that at the Battle of the Milvian Bridge, Constantine ordered that his troops decorate their shields with crosses, and perhaps the Greek

letters *chi* and *rho* as well. These letters stood for *Christos*, although *chi* and *rho* had long meant *chrestos*, "auspicious," and Constantine probably meant only this and not Jesus Christ. While Constantine himself reasserted his devotion to the Roman state religion, within a year, in 313, he issued the Edict of Milan, which granted religious freedom to all, ending religious persecution in the Empire.

Constantine's architectural program in Rome would leave a lasting mark on subsequent Christian architecture, particularly his work on a basilica at the southern end of the line of Imperial Forums (see Fig. 3.12). Originally built by Maxentius, it was the last of the great imperial buildings erected in Rome (Figs. 3.36 and 3.37). Like all Roman basilicas, the Basilica of Maxentius and Constantine (also known as the Basilica Nova) was a large rectangular building with a rounded extension, called an apse, at one or both ends and easy access in and out. It was, similarly, an administrative center-courthouse, council chamber, and meeting hall-and its high vaulted ceilings were purposefully constructed on the model of large Roman baths. Its nave, the large central area, rose to an elevation of 114 feet. One entered through a triple portico at the southeast end and looked down the nave some 300 feet to the original apse at the other end of the building, which acted as a focal point. The basilica plan, with the apse as its focal point, would exert considerable influence on later Christian churches. These later churches would transform the massive interiors from administrative spaces to religious sanctuaries, whose vast interior spaces elicited religious awe.

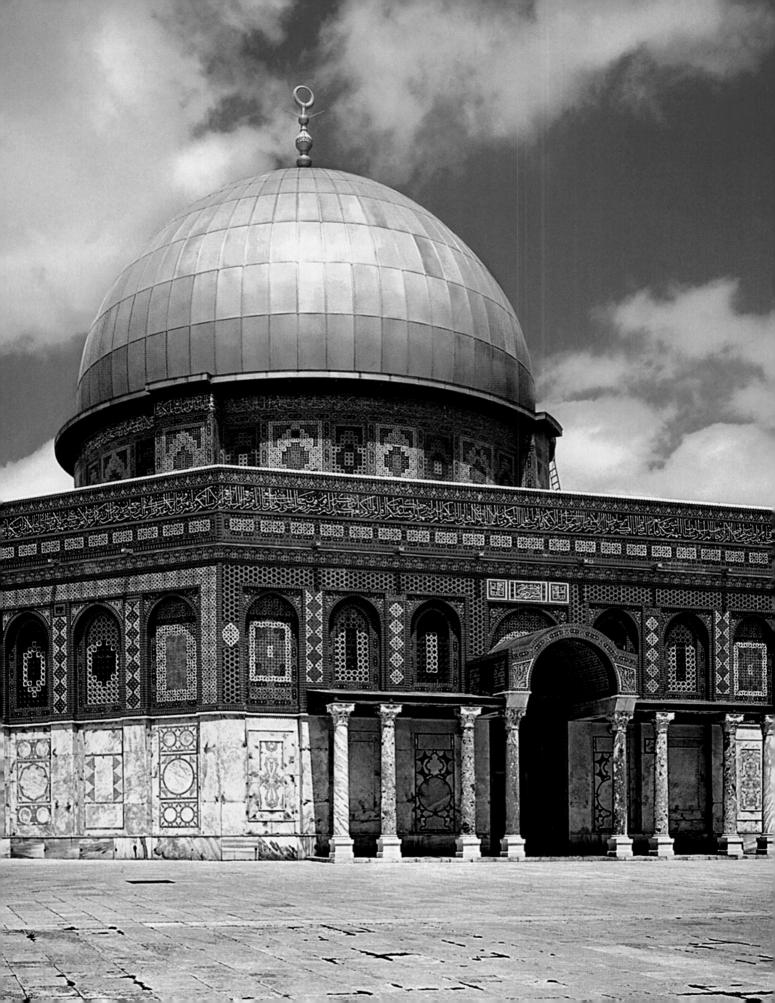

The Flowering of Religion

Faith and the Power of Belief in the Early First Millennium

LEARNING OBJECTIVES

- 4.1 Examine the impact of Roman rule on Judaic culture.
- 4.2 Discuss the development of Christianity from its Jewish roots to its rapid spread through the Roman world.
- 4.3 Describe the new Byzantine style of art and discuss how it reflects the values of the Byzantine emperors, especially Justinian.
- 4.4 Outline the principal tenets of the Muslim faith, and account for its rapid spread.
- 4.5 Characterize the spread of Buddhism from India north into China.

he Dome of the Rock (Fig. 4.1) stands atop the Temple Mount in Jerusalem, on the site where, in Jewish tradition, Abraham prepared to sacrifice his son Isaac. The Jewish Temple of Solomon originally stood here, and the site is further associated—by Jews, Christians, and Muslims alike—with God's creation of Adam. The Second Temple of Jerusalem also stood on this spot until it was destroyed by Roman soldiers when they sacked the city in 70 ce, to put down a Jewish revolt, an event commemorated on the Arch of Titus in Rome (see Fig. 3.15 in Chapter 3). Only the Wailing Wall remains, part of the original retaining wall for the platform supporting the Temple Mount and for Jews the most sacred site in Jerusalem. To this day, the plaza in front of the wall functions as an open-air synagogue where daily prayers are recited and other Jewish rituals are performed. On Tisha B'Av, the ninth day of the month of Av, which occurs in either July or August, a fast is held commemorating the destruction of the successive temples on this site, and people sit on the ground before the wall reciting the Book of Lamentations.

One of the earliest examples of Muslim architecture, built in the 680s, the Dome encloses an **ambulatory**, a circular, colonnaded walkway that in turn encloses a

projecting rock lying directly beneath the golden dome. By the sixteenth century, Islamic faithful claimed that the Prophet Muhammad ascended to heaven from this spot, on a winged horse named Buraq, but there is no evidence that this story was in circulation when the Dome was originally built. Others thought that it represents the ascendancy of Islam over Christianity in the Holy Land. Still others believed the rock is the center of the world, or that it could refer to the Temple of Solomon, the importance of which is fully acknowledged by Muslims, who consider Solomon a founding father of their own faith. All this suggests that the Dome was meant to proselytize, or convert both Jews and Christians to the Muslim faith.

The sanctity of this spot, then, at the heart of Jerusalem, is recognized equally by the three great faiths of the Western world—Judaism, Christianity, and Islam—and the intersection of these religions, together with the spread of Buddhism in Asia, is the subject of this chapter. As Christianity came to differentiate itself from its Judaic heritage, it came into increasing conflict with imperial Rome. Both Rome and the Church demanded absolute allegiance and loyalty of the citizen/believer. Until the Emperor Constantine granted religious freedom to all Romans in 313 CE,

▼ Fig. 4.1 The Dome of the Rock, Jerusalem. Late 680s—691. The golden dome of the building rises above a projecting rock that is surrounded by an ambulatory. The building's function remains unclear. It is not a mosque, although it is certainly some kind of religious memorial. Inscriptions from the Qur'an decorate its interior. These are the oldest excerpts from the text to have survived.

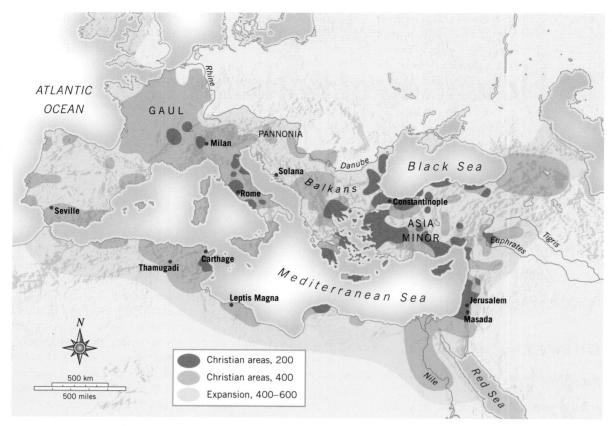

Map 4.1 The spread of Christianity by 600 ce.

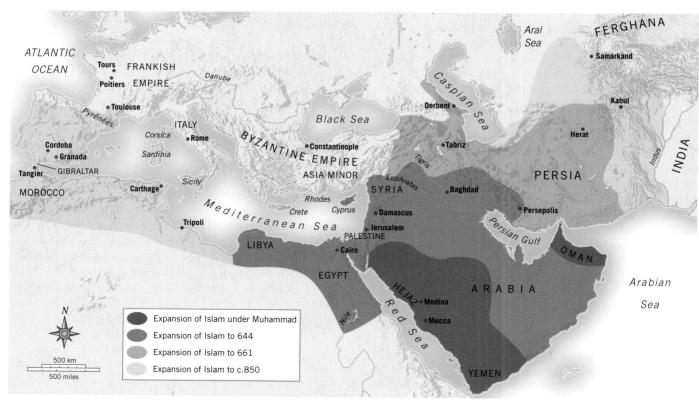

Map 4.2 The expansion of Islam to 850 ce.

the power of the state was at odds with the power of Christian faith. And when, in 325 ce, Constantine moved the imperial capital of the Roman Empire to Constantinople, named after himself, on the shores of the Bosporus, the straits linking the Black Sea with the Aegean, Christianity found itself divided in a contest of belief and doctrine between the Western (Catholic) Church, centered in Rome, and the Eastern (Orthodox) Church, centered in Constantine's new capital. When, in the seventh century CE, Islam arose as a religious force on the Arabian peninsula, the Christian world as a whole was quickly challenged. One need only compare two maps, the first showing the spread of Christianity to the year 600 CE (Map 4.1), and the second showing the expansion of Islam to 850 ce (Map 4.2), to recognize the points of conflict, stretching from the Caspian Sea south around the eastern Mediterranean, including Palestine and Jerusalem, across Egypt and North Africa, all the way to Spain in the west, as the two religions vied for followers. Meanwhile, Buddhism, which had originated in India, began to spread across Asia.

DEVELOPMENTS IN JUDAIC CULTURE

How did Roman rule impact Judaic culture?

From the time of the Babylonian Captivity, when, in the sixth century BCE, the Jews were held captive in Babylonia, to the rise of rabbinic Judaism (the Judaism of the rabbis, the scholars and teachers of the Jewish faith), at about the time of the Roman destruction of the Second Temple, the Jewish religion had become increasingly messianic—that is, it prophesied that the world would end in apocalypse, the coming of God on the day of judgment, and that the postapocalyptic world would be led by a Messiah, or Anointed One, in everlasting peace. These feelings were first fueled in 168 BCE, when the Seleucid king Antiochus IV tried to impose worship of the Greek gods on the Jews, placing a statue of Zeus in the Second Temple of Jerusalem and allowing pigs to be sacrificed there. The Jews were outraged. From their point of view, the Greek conquerors had not merely transformed the sacred temple into a pagan shrine, but had replaced the Ark with a "graven image." The slaughter of pigs rendered the Temple impure. Still worse, Antiochus made observance of the Hebrew law punishable by death. Led by Judas Maccabeus, a priest of the Maccabean family, the Jews revolted, defeating Antiochus, purifying the temple, and reestablishing Jewish control of the region for the period 142-63 BCE. In 63 BCE, the Romans, led by their great general Pompey, conquered Judea (modern Israel).

By this time, large numbers of people claiming to be the Messiah and larger numbers of apocalyptic preachers roamed Judea. This situation was complicated by the growing sectarianism of Judaism itself. Much of what we know about this time comes from the writings of Josephus, a Jewish historian (ca. 37–ca. 100 ce). Josephus' *Jewish War*, completed in the early 80s ce, outlines Jewish history from the rise of the Maccabees to the destruction of the temple in 70 ce and the subsequent fall of Masada, a citadel fortress high above the Dead Sea where

the last Jewish rebels held out against the Romans until 74 CE. "There are three philosophical sects among the Jews," Josephus writes, "the followers of the first of which are the Pharisees, a scribal group associated with the masses; of the second, the Sadducees, priests and high priests associated with the aristocracy; and the third sect, which pretends to a severer discipline, are called Essenes."

A sect is a small, organized group that separates itself from the larger religious movement because it asserts that it alone understands God's will and therefore it alone embodies the ideals of the religion. As a result, a sect generally creates strongly enforced social boundaries between its members and all others. Finally, members of a sect often view themselves as good and all others as evil. Of the three sects Josephus described (there were many more), the Essenes were the most conservative, going so far as to ban women from their community so that they might live in celibacy and purity. The Essenes are generally identified with the group of Jews who lived at Qumran, on the Dead Sea southeast of Jerusalem, where in 1947 a Bedouin shepherd discovered the oldest extant version of the Hebrew Scriptures, dating from around the time of Jesus—the so-called Dead Sea Scrolls. These documents are the richest source of our knowledge of Jewish sectarianism, for they include the Hebrew Scriptures—the Torah (the five books of Moses), Nevi'im (the Prophets), and Ketubim (the Writings), what Christians call the Old Testament—as well as other works originating in sectarian circles within and outside the Qumran community.

The Jews of Qumran abandoned their coreligionists to seek salvation on their own. Unlike the Pharisees and Sadducees, they never engaged in the Jewish political struggle with the Romans or with the other sects. The Pharisees and Sadducees argued, sometimes violently, over questions of philosophy, the temple, and purity. Philosophically, the Sadducees denied the resurrection of the dead, while the Pharisees affirmed it.

The Jewish purity laws were a point of special contention with far-reaching implications for the temple. According to Leviticus and Numbers (two books of the Hebrew Bible), the house of God (the temple) must be pure, and that which is impure must be expelled. In practice, the laws of purity prevented normal social relations between those who observed them and those who did not, to the point that even routine physical contact (a handshake, for instance) with a nonobserver was forbidden. Since all the sects developed their own purity laws, they were in essence forbidding contact with one another. The Qumran Essenes withdrew completely from Jewish society. Furthermore, the sectarian communities, especially the Pharisees, considered the Jerusalem Temple, the traditional center of Jewish worship, to be polluted, its priests—particularly the Sadducees—corrupt, and its rituals debased. The Pharisees, and perhaps the Sadducees as well, considered the house of God to be the larger state of Judea rather than just the temple in Jerusalem, and they felt compelled to expel the "impure" Romans from their midst.

The Romans, for their part, installed a client king, Herod the Great, who claimed to be Jewish but was not according to Jewish law. He tried, nevertheless, to reconcile Jews and Romans, primarily through religious tolerance and a massive

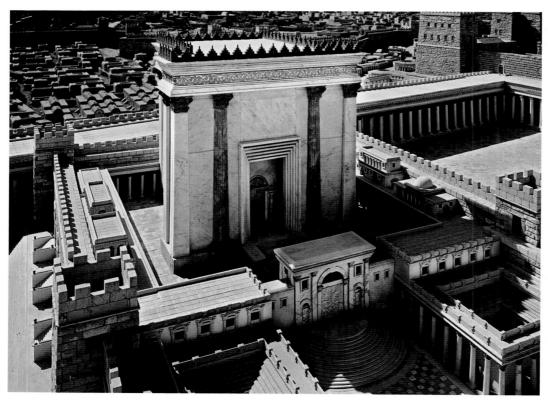

Fig. 4.2 Model of the Second Temple of Jerusalem. ca. 20 BCE. Only the Western Wall of Herod's temple survives today, and for Jews it remains the most sacred site in Jerusalem. It serves as a reminder of both the First Temple, totally destroyed by the Babylonians in 586 BCE, and, of course, the destruction of the Second Temple by the Romans. As a result of the sense of loss associated with the site and the lamentations it provokes, for centuries it has been known as the Wailing Wall.

building program. During his reign (37–4 BCE), he rebuilt the city of Jerusalem, constructing a large palace and enlarging the Second Temple (Fig. 4.2). We can see the Hellenistic influence in its tall, engaged Corinthian columns and its decorative frieze, and its Roman roots in its triple-arched gateway. Herod also engaged in other massive building programs, including a port at Caesarea and the fortress at Masada. Although Herod's three sons ruled briefly after their father's death, Rome became less and less tolerant of the Jewish faith—the laws of Rome often coming into conflict with the Biblical law—and direct Roman rule was soon imposed.

Finally, in 66 ce, the Jews revolted. In 68 ce, the Romans destroyed Qumran. In 70 ce, they sacked the temple in Jerusalem, as depicted on the Arch of Titus in Rome (see Fig. 3.15 in Chapter 3). At Masada, a band of zealots held out until 74 ce. The Roman general Flavius Silva surrounded the mountain with a wall and eight encampments, then built a huge earthen ramp up the mountainside. Rather than submit to the Romans, the Jews inside the fortress committed mass suicide, each man responsible for killing his own family and then himself. The Romans changed the name of the province from Judea, "land of the Jews," to Palestine, "land of the Philistines"—the ancient enemy of the Jews, but a culture that had disappeared long before Herod's time (the giant Goliath, slain by David, as told in the Book of Samuel, had

been a Philistine). It was as if the history of the Jewish presence in the region were to be permanently erased. Finally, in 135 ce, after yet another Jewish revolt, the Emperor Hadrian rebuilt Jerusalem as a Roman city, which Jews were forbidden to enter. Hundreds of thousands of Jews were killed or sold into slavery, their land and property were confiscated, and the survivors fled throughout the Mediterranean and the Middle East. The diaspora that had begun with the Assyrian invasion of Israel in 722 BCE was now complete. Not until 1948, when the state of Israel was established by the United Nations, would Jews control their homeland again.

THE RISE OF CHRISTIANITY

How did Christianity develop from its Jewish roots to spread rapidly through the Roman world?

The development of Christianity, the religion that would have such a profound effect upon the history of the Western world, can be understood only in the context of Jewish history. It developed as one among many other minor sects of Judaism, at first so inconsequential that Josephus mentions it only briefly. Later theological writings, as opposed to

actual historical accounts written at the time, tell us that in Judea's sectarian climate, Jesus of Nazareth was born to Mary and Joseph of Judea in about 4 BCE. At about the age of 30, Jesus began to lead the life of an itinerant rabbi. He preached repentance, compassion for the poor and meek, love of God and neighbor, and the imminence of the apocalypse, which he called the coming of the kingdom of God.

Although his teachings were steeped in the wisdom of the Jewish tradition, they antagonized both Jewish and Roman leaders. Jesus, in the spirit of reform, had challenged the commercialization of the Jewish Temple in Jerusalem, especially the practice of money-changing within its sacred precincts, alienating the Sadducee sect that managed it. After his followers identified him as the Messiah, or Savior—he did not make the claim for himself—both conservative Jewish leaders and Roman rulers were threatened. The proclamation by his followers that he was the son of God amounted to a crime against the Roman state, since the emperor was considered to be the only divine human on earth. In fact, since Jews were monotheistic and refused to worship other gods, including the emperor, their beliefs were a political threat to the Romans. The Christian sect's belief in the divinity of Jesus posed a special problem.

An enemy of the state, denounced by the other Jews that he had antagonized, betrayed by his disciple Judas (a betrayal now called into question with the publication of the Gospel of Judas), Jesus was crucified in about 30 CE, a degrading fate reserved for criminals and non-Roman citizens. Christian tradition has it—we possess no actual historical account—that the Crucifixion occurred outside the city walls on a hillside known as Golgotha, now the site of the Church of the Holy Sepulchre (Fig. 4.3), and that Jesus was buried in a rock tomb just behind the site. Three days later, his followers reported that he rose from the dead and reappeared among them. The promise of resurrection, already a fundamental tenet of the Pharisee and Essene sects, became the foundation of Christian faith.

the hillside dug away in the 4th century to allow the church to be built around the Tomb

Fig. 4.3 Cutaway drawing of the Church of the Holy Sepulchre, Jerusalem, showing the site of Christ's Tomb. This site was originally a small rocky hill, Golgotha, upon which Jesus was crucified, and unused stone quarry in which tombs had been cut. The first basilica on the site was built by the emperor Constantine between 326 and 335 ce.

The Evangelists

Upon his death, Jesus' reputation grew as word of his life and resurrection was spread, first by his evangelists (the word "evangelist" comes from the Greek evangelos, meaning "bearer of good"—and note the root angel in the word as well) and then by his apostles, literally "those who have been sent" by God as his witnesses. Preeminent among the latter was Paul, who had persecuted Jews in Judea before converting to the new faith in Damascus (in present-day Syria) in 35 ce. Paul's epistles, or letters, are the earliest writings of the new Christian faith. In letters written to churches he founded or visited in Asia Minor, Greece, Macedonia, and Rome, which comprise 14 books of the Christian Scriptures, he argues the nature of religious truth and interprets the life of Christ—his preferred name for Jesus, one that he coined. "Christ" means, literally, "the Anointed One." It refers to the Jewish tradition of anointing priests, kings, and prophets with oil, and the fact that by Jesus' time Jews had come to expect a savior who embodied all the qualities of priest, king, and prophet. In true sectarian tradition, for Paul, the only correct expression of Judaism included faith in Christ. Paul conflated Jewish tradition, then, with his belief that Jesus' Crucifixion was the act of his salvation of humankind. He argued that Christ was blameless and suffered on the cross to pay for the sins of humanity. Resurrection, he believed, was at the heart of the Christian faith, but redemption was by no means automatic—sinners had to show their faith in Christ and his salvation. Faith, he argues in his Epistle to the Church in Rome, ensures salvation (Reading 4.1):

READING 4.1

from the Bible, Romans 5:1-11

¹Therefore, since we are justified by faith, we have peace with God through our Lord Jesus Christ, ²through whom we have obtained access to this grace in which we stand; and we boast in our hope of sharing the glory of God. ³And not only that, but we also boast in our sufferings, knowing that suffering produces endurance, ⁴and endurance produces character, and character produces hope, ⁵and hope does not disappoint us, because God's love has been poured into our hearts through the Holy Spirit that has been given to us.

⁶For while we were still weak, at the right time Christ died for the ungodly . . . ⁸But God proves his love for us in that while we still were sinners Christ died for us. ⁹Much more surely then, now that we have been justified by his blood, will we be saved through him from the wrath of God. ¹⁰For if while we were enemies, we were reconciled to God through the death of his Son, much more surely, having been reconciled, will we be saved by his life. ¹¹But more than that, we even boast in God through our Lord Jesus Christ, through whom we have now received reconciliation.

Fifteen centuries after Paul wrote these words, the Church would find itself divided between those who believed that salvation was determined by faith alone, as Paul argues, and those who believed in the necessity of good works to gain entry to Heaven, a tradition that survives in the Epistle of James—"What use is it, my brethren, if a man says he has faith, but he has no works?" (2:14). Other aspects of Paul's writings would also have lasting significance, particularly his emphasis, like that of the Essene sect, on sexual chastity. Although it was better to marry than to engage in sexual activity out of marriage, it was better still to live chastely. In later years, the celibate lives of priests, monks, and nuns, as well as the Church's teaching that sexuality was sinful except for the purposes of procreation, were directly inspired by Paul's position.

Not long after Paul's death, as the religion spread rapidly through Asia Minor and Greece, other evangelists began to write gospels, or "good news," specifically narrating the story of Jesus' life. What would become the first three books of the Christian New Testament, the Gospels of Matthew, Mark, and Luke, are believed by scholars to have been written between 70 and 90 ce. Each emphasizes slightly different aspects of Jesus' life, although all focus particularly on his last days. It is important to recognize that many early Christian documents do not describe a virgin birth or a Resurrection, a difference from Paul that reflects sectarian differences already present in the lewish community. Evidence suggests that both the virgin birth and the Resurrection were Matthew and Luke's additions to Mark's Gospel. Luke also wrote the Acts of the Apostles, narrating the activities of Jesus' apostles, immediately after the Resurrection. The apostles were originally those who had seen or lived with Jesus, and the book contains descriptions of miraculous events, signs from God that validate the apostles' teachings.

Symbols and Iconography in Christian Thinking and Art

The new Christian faith did not immediately abandon its traditions as a Jewish sect. Jesus, for instance, never thought of himself as anything other than a Jew. All his associates and disciples were Jews. He regularly participated in Jewish communal worship and he preached from the Torah, the authority of which he never denied. The major distinction was that Christian Jews believed in Jesus' Resurrection and status as Messiah, while non-Christian Jews did not. Christian Jews regarded the failure of the larger Jewish community to recognize the importance of Jesus as reason to separate themselves from that community to pursue what they believed to be the true will of God. Not until sometime in the early second century ce did Christianity cease to be a lewish sect. By then, Christians had abandoned Jewish rituals, including circumcision, but even as it slowly distinguished itself from its Jewish roots, Christianity had to come to terms with those roots. In doing so, it found a distinctive way to accept the Hebrew Scriptures.

Christians believed the stories in the Hebrew Scriptures prefigured the life of Jesus. For example, Adam and Eve's fall from grace in the Garden of Eden—the original sin that was believed to doom all of humanity—was seen as anticipating the necessity of God's sacrifice of his son, Jesus, to atone for the

sins of humankind. Similarly, Christians interpreted Abraham's willingness to sacrifice his son Isaac as prefiguring God's sacrifice of his son. This view of history is called **typology**, from the Greek *tupos*, meaning "example" or "figure." Thus Solomon, in his wisdom, is a **type** for Christ.

Very little early Christian art survives, and most of what we have dates from the third and fourth centuries. In paintings decorating catacombs, underground cemeteries, and a few sculptures, certain themes and elements are so prevalent that we can assume they reflect relatively long-standing representational traditions. In almost all these works, it is not so much the literal meaning of the image that matters, but rather its symbolic significance. Likewise, the aesthetic dimension of the work is clearly less important than its message. A very common image is that of Christ as the Good Shepherd, which derives from Jesus' promise, "I am the good shepherd. A good shepherd lays down his life for the sheep" (John 10:11). The overwhelming message of this symbolism involves the desire of the departed to join Jesus' flock in heaven, to be miraculously reborn like Jonah. As the Lamb of God, a reference to the age-old role of the lamb in sacrificial offerings, Jesus is, of course, both shepherd and sheep guardian of his flock and God the Father's sacrificial lamb. In fact, it is unclear whether images such as the free standing representation of The Good Shepherd (Fig. 4.4) represent Christ or symbolize a more general concept of God caring

for his flock, perhaps even capturing a sheep for sacrifice. The naturalism of the sculpture echoes Classical and Hellenistic traditions. The shepherd adopts a contrapposto pose, reminiscent of Polyclitus' *Doryphoros* of the fifth century BCE (see Fig. 2.28 in Chapter 2). His body is confidently modeled beneath the drapery of his clothing. He turns as if engaged with

some other person or object outside the scope of the sculpture itself, animating the space around him. And the sheep he carries on his back seems to struggle to set itself free.

These examples make clear the importance of symbolism to Christian thinking. Over the course of the first 200 years of Christianity, before freedom of worship was legalized, Christians developed many symbols that served to identify them to one another and to mark the articles of their faith. Their symbols allowed them to represent their faith in full view of a general populace that largely rejected it. They adopted the symbol of the fish, for instance, because the Greek word for fish, ichthys, is a form of acronym, a combination of the first letters of the Greek words for "Jesus Christ, Son of God, Savior." The first and last letters of the Greek alphabet, alpha and omega, symbolize Christ's presence from the beginning to the end of time. The alpha and omega often flank the initials I and X, the first letters of Jesus and Christ in Greek, and the initials XP were the first two letters of the word Christos (Fig. 4.5).

Over the years, Christians developed a consistent iconography—the subject matter of a work, both literal

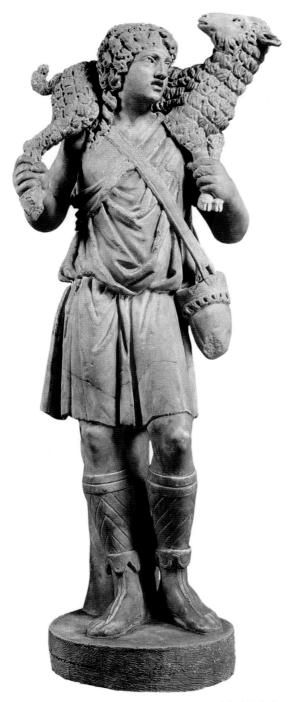

Fig. 4.4 The Good Shepherd. ca. 300 ce. Marble, height 39". Vatican Museums, Vatican State. The legs of this figure have been restored. Freestanding sculptures such as this one are rare in the early Christian period. Much more common are wall paintings.

(factual) and figurative (symbolic)—in their art and literature. A story or person might be a type for some other story or person. A figure might symbolize something else, as particular figures symbolized each of the four evangelists—a man with wings for Matthew, symbolizing his humanity; a lion for Mark; an ox for Luke; an eagle for John. And the stories surrounding Jesus' life coalesced into distinct story

Fig. 4.5 Traditional Christian symbols.

"cycles," each part in some sense signifying the whole, and all of them becoming standard themes in the arts throughout the history of the West.

Christian Rome

Christianity spread rapidly across the Roman Empire (see Map 4.1). As the map indicates, Christian areas of the empire increased dramatically from 200 to 400 ce, and as Christian authority increased, Roman authority naturally waned. The emperor Constantine's predecessor, Diocletian (see Chapter 3, Continuity & Change), had unleashed a furious persecution of Christians that lasted for eight years beginning in 303, but he also moved to cement Roman authority by implementing a scheme of government known as the tetrarchy, a four-part monarchy. Diocletian ruled from Salona, a city on the Adriatic near present-day Split, Croatia, and controlled the East; the other regions of the Empire were governed by monarchs in Milan, the Balkans, and Gaul.

This shift of the Empire's administration from Rome to its provincial capitals had dramatic implications for Rome itself. Perhaps most important was Diocletian's removal to Salona. There, he almost completely deified the role of the emperor, presenting himself more as the divine manifestation of the gods than as a leader of a citizen-state. He dressed in robes of blue- and gold-threaded silk, glittering with jewels, to symbolize sky and sun. He had his fingernails gilded and gold dust sprinkled in his hair to create the sense of a halo or nimbus encircling his head. When he entered the throne room, servants sprinkled perfume behind him and fan-bearers spread the scent through the room. All kneeled in his presence. He was addressed as dominus, "lord," and his right to rule, he claimed, was derived not from the people but from God.

The Nicene Creed Constantine recognized that Diocletian's scheme for controlling the Empire was, in most respects, sound. Particularly important was an imperial presence near the eastern and Danubian frontiers of the Empire. To provide this imperial presence in the East, in 324 CE, Constantine founded the city of Constantinople, present-day Istanbul, on the site of the Greek city of Byzantium. The city was dedicated with both pagan rites and Christian ceremonies on May 11, 330. Constantine's own Christianity became more and more pronounced in his new Eastern capital. Although he did not persecute pagans, he officially rejected pagan practices, openly favored Christians as officials, and admitted Church clergy to his court. Perhaps his most

important act was to convene the first ecumenical, or worldwide, council of Church leaders in 325 ce at Nicaea (present-day Iznik), just southeast of Constantinople, in order to address, particularly, the claims of Bishop Arius of Alexandria. Arius argued that Father and Son were not of the same substance, and therefore not coequal and not coeternal. The council rejected the Arian position and produced a document, the Nicene Creed, that unified the Church behind a prescribed doctrine, or dogma, creating, in effect, an orthodox faith. Church leaders believed that by memorizing the Creed, laypeople would be able easily to identify deviations from orthodox Christianity.

The Creed was revised and extended in 381 by a Second Ecumenical Council in Constantinople, and is quoted here in that form (Reading 4.2):

READING 4.2

The Nicene Creed

We believe in one God the Father All-Sovereign, maker of heaven and earth, and of all things visible and invisible;

And in one Lord Jesus Christ, the only-begotten Son of God, Begotten of the Father before all the ages, Light of Light, true God of true God, begotten not made, of one essence with the Father, through whom all things were made; who for us men and for our salvation came down from the heavens, and was made flesh of the Holy Spirit and the Virgin Mary, and became man, and was crucified for us under Pontius Pilate, and suffered and was buried, and rose again on the third day according to the Scriptures, and ascended into the heavens, and sitteth on the right hand of the Father, and cometh again with glory to judge living and dead, of whose kingdom there shall be no end;

And [we believe] in the Holy Spirit, the Lord and the Life-giver, that proceedeth from the Father, who with Father and Son is worshiped together and glorified together, who spake through the prophets:

[And we believe] in one holy catholic and apostolic Church: We acknowledge one baptism unto remission of sins. We look for a resurrection of the dead, and the life of the age to come.

The Creed is an article of mystical faith, not a doctrine of rational or empirical observation. In its very first line, it states its belief in the invisible. It argues for the virgin birth of Jesus, for a holy "spirit," for the resurrection of the dead. It imagines what cannot be rationally known: Jesus in heaven at the right hand of God (perhaps not coincidentally an image evocative of Diocletian modeling himself as *dominus*, "lord," ruling at the will of and beside God). Nothing could be further from the Aristotelian drive to describe the knowable world and to represent it in naturalistic terms.

But perhaps most important, the Nicene Creed establishes "the one holy catholic and apostolic Church," that is, a united church that is universal ("catholic") and based on

the teachings of the apostles ("apostolic"). The Church was organized around the administrative divisions of the Roman state—archbishops oversaw the provinces, bishops the dioceses, and priests the parishes—an organization that provided Constantine with the means to impose the Creed throughout the Empire, eliminate rivalries within the Empire, and rule over both Church and state. Finally, the Church's liturgy, the rites prescribed for public worship, was established. In Rome, Saint Jerome (ca. 342–420) translated the Hebrew Bible and the Greek books of the New Testament into Latin. The resulting Vulgate, meaning "common" or "popular," became the official Bible of the Roman Catholic Church. As the version of the Bible known by the faithful for more than 1,000 years, from about 400 to 1530, it would exert an influence over Western culture, which came to consider it virtually infallible.

Music in the Liturgy The Roman prelate Ambrose (339–397), bishop of Milan, wrote hymns to be sung by the congregation, an important part of the new liturgy. Recognizing that common people, with no musical training, were to sing along with the clergy, Ambrose composed simple, melodic songs or psalms, generally characterized by one syllable for each note of the hymn. "The psalm is our armor by night," he wrote, "our instructor by day. The dawn of the day resounds with the psalm, and the psalm re-echoes at sunset." Saint Augustine, whose writings are discussed later in this chapter, tells us in his Confessions that "the practice and singing of hymns and psalms . . . was established so that the people [of Milan] would not become weak as a result of boredom or sorrow. It has been retained from that day to this; many, in fact, nearly all of God's flocks now do likewise throughout the rest of the world." These hymns and songs, Augustine says, represented a "kind of consolation and exhortation, in which the voice and the hearts of the brethren joined in zealous harmony."

Ambrose's authorship is certain for only four hymns, all attributed to him by Augustine. The melodies survive only in tenth- and eleventh-century versions, and their authenticity is disputed. Each hymn is composed of eight four-line stanzas, each written in a strict **iambic tetrameter** (short-long, short-long, short-long). Ambrose also seems to have introduced an **antiphonal** method of chanting, where one side of the choir responds to the other.

Roman and Greek Influences on Christian Churches and Rituals The community that developed around the new liturgy required a physical church, and Constantine obliged with a building that became a model for many subsequent churches: Saint Peter's Basilica, begun in 320 on the site of Peter's tomb in Rome (Figs. 4.6 and 4.7). Its original dimensions are difficult to fathom, but an eighteenth-century print of a nearly contemporary church in Rome, Saint Paul's Outside the Walls, gives us a fair idea (Fig. 4.8). The church was as long, as high, and as wide as the Roman basilicas upon which it was modeled (see Figs. 3.36 and 3.37 in Chapter 3). Entering through a triple-arched gateway (again reminiscent of Roman triumphal arches), visitors found themselves in a colonnaded atrium

with a fountain in the center (reminiscent of the Roman *domus*, Fig. 3.21 in Chapter 3—perhaps suggesting the "House of God").

The church proper consisted of a narthex, or entrance hall, and a nave, with two aisles on each side. At the eastern end was an apse, housing the altar framed by a giant triumphal arch, where the sacrament of Holy Communion was administered. A transverse aisle, or transept, crossed

between the nave and the apse; in other church plans, it could be extended north and south to form a Latin cross (a long arm, the nave, with three shorter arms—the apse and the arms of the transept). The nave was two stories high, the aisles one story, allowing for a clerestory, a zone with windows that lit the length of the church. Open timberwork trusses supported the roof (making the structure particularly susceptible to fire).

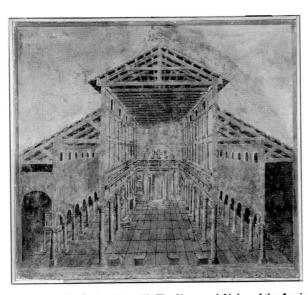

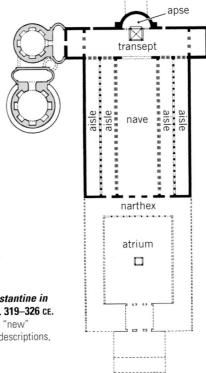

Figs. 4.6 and 4.7 Domenico Tasselli, *The Nave and Aisles of the Ancient Basilica of Constantine in Rome Looking Toward the Entrance Wall* and plan (atrium added in the late 4th century). 319–326 ce. Fresco. Sacristy, Saint Peter's Basilica, Vatican State, Rome. What we know of Old Saint Peter's (a "new" Saint Peter's replaced it in the sixteenth century) comes from modern archeological finds, written descriptions, drawings made both before and during its destruction, and the surviving churches it inspired.

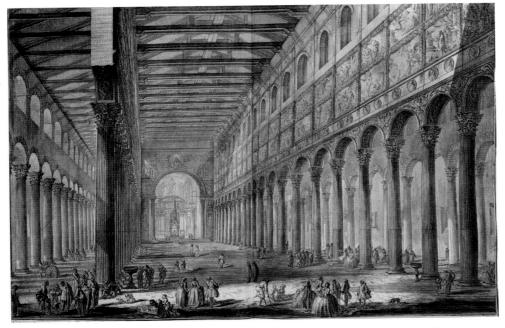

Fig. 4.8 Interior of Saint Paul's Outside the Walls, Rome. Begun 386 cs. Etching by Gianbattista Piranesi, 1749. Note the wooden trusses of the ceiling and the spaciousness of the interior, reminiscent of Roman baths.

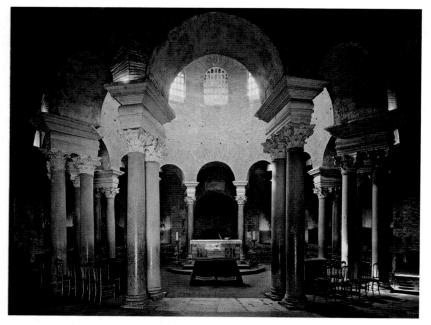

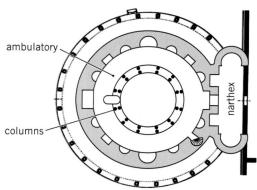

Figs. 4.9 and 4.10 Interior view and plan of the Church of Santa Costanza, Rome. ca. 350 ce. The view on the left is from the ambulatory into the central space. This is the earliest surviving central-plan building in the world. Originally, the central plan was used for mausoleums or shrines. Another central-plan church very much like this one originally covered Christ's tomb in Jerusalem, but it was later incorporated into the basilica. The Church of Santa Costanza was originally attached to the now-destroyed basilica of Saint Agnes Outside the Walls.

All in all, the basilica church was far more than an assembly hall. It was a richly decorated spiritual performance space, designed to elicit awe and wonder in its worshipers. As the liturgy was performed, the congregation—consisting of literally thousands—raised their voices together in song and then fell silent in prayer. The effect would have been stunning. No one, it was hoped, could leave without reenergized faith.

A second type of Christian church also first developed in Rome, although it was initially conceived as a mausoleum for Constantine's daughter, a devout Christian who died in 354. Santa Costanza is a central-plan church, so called because of its circular structure, topped by a dome (Figs. 4.9 and 4.10). The architectural forerunners of this type of church include the high, domed space of the Pantheon (see Fig. 3.18 in Chapter 3). The ambulatory is elaborately decorated with mosaics (Fig. 4.11), consisting of an overall vine pattern interspersed with small scenes, such as laborers picking grapes and putting them into carts, transporting them to a press, and then crushing them underfoot. One of the Christian references here is to the use of wine in the Eucharist, symbolizing the blood of Christ. But the Dionysian implications of the scene, with its unruly swirls of undulating lines—the very opposite of the Roman (and Classical) sense of order and proportion—are unmistakable. Used to decorate a church, these lines imply the very nature of faith—that is, its

abandonment of reason and logic, the very principles of Classical balance and proportion.

The design makes clear, in fact, the ways in which Christianity incorporated many Greek and Roman mythic traditions—a practice known as **syncretism**, the reconciliation of different rites and practices into a single philosophy

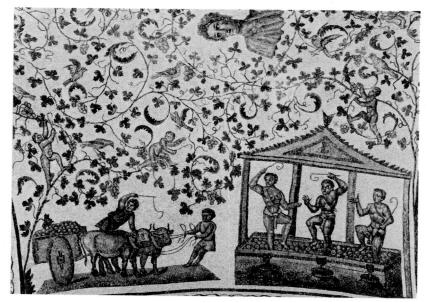

Fig. 4.11 Ambulatory vault mosaic, Church of Santa Costanza, Rome. ca. 350 ce. The figure at the top of this reproduction (actually positioned in the center of the grapevine motif) is probably Constantine's daughter Constantia herself.

or religion. This occurred not only in the design of Christian churches but also in the symbolism of its art and literature—and it makes perfect sense. How better to convert pagan peoples than to present your religious program in their own terms? After all, the Greek wine god Dionysus had, like Christ, promised human immortality in the manner of the grapevine itself, which appears to die each autumn only to be reborn in the spring. Just as Christians had found prefigurings of Christ in the Hebrew Bible, so it was possible to argue that Dionysus was a pagan type of Christ.

The cult of Bacchus, as the Romans referred to Dionysus, was extremely popular in Rome. So high-spirited were the drunken orgies engaged in by the cult of Dionysus that the Roman Senate had restricted its activities in 186 BCE. Other cults, known as **mystery cults** because their initiation rites were secret, were also popular among the Romans, and Christianity borrowed freely from these as well. In fact, the evidence suggests a remarkable process of cross-fertilization, each cult adapting elements from the others that were attractive or popular as they competed for followers.

The cult of Isis in Rome had originated in Egypt and was based on the ebb and flow of the Nile. Each summer, Isis would see Egypt's arid desert landscape and would be moved to tears of compassion for the Egyptian people. Her tears, in turn, would cause the Nile to flood, bringing the land back to life—regarded by the Isis cult as an act of resurrection, not unlike the return of the vines in the Dionysian cult.

The secret cult of Mithras, which originated in Persia perhaps as far back as Neolithic times, became very popular among the Roman troops stationed in Palestine at the time of Christ. In the second through fourth centuries, it spread across the Empire, and examples of its iconography can be found in Mithraic temples from Syria to Britain. Almost no texts explaining the cult survive; its rites and traditions were likely passed down orally among initiates. What we know of it comes from wall paintings and relief sculptures in its sanctuaries. In the most widespread of his representations, Mithras is depicted killing a bull by stabbing him in the neck, as a snake and dog lap up the bull's blood and a scorpion clutches the bull's testicles (Fig. 4.12). The end of the bull's tail is metamorphosed into an ear of wheat. At the top left and right are busts of the sun and moon. Zoroastrian sources suggest that Mithras was sent to earth by a divine bull, and all living things sprang from the bull's blood. The story can be read as a reverse version of God's sacrifice of Jesus. Mithras sacrifices his "father"—or, at least, his divine ruler, the bull—in order to create life itself. The cult had seven stages of initiation, one of which was baptism. We also know that the birthday of Mithras was celebrated each year on December 25. When this date was adopted in about 350 cE as the traditional birth date of Jesus, the choice was most likely an attempt to appropriate the rites of Mithraic cults, then still active throughout the Roman Empire, to Christianity.

Augustine and Early Christian Philosophy There is one other aspect of Mithras' cult that we also know—he was the god of truth and light. How much the Mithras cult influenced

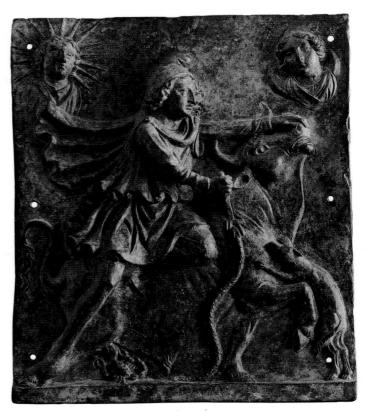

Fig. 4.12 Mithraic relief. Early 3rd century. The Metropolitan Museum of Art, New York. Gift of Mr. and Mrs. Klaus G. Peris, 1997 (1997.145.3). Similar versions of this image have been found throughout the Roman Empire.

the Church Fathers is unclear, but light played an important role in their writing, and images of light appear often in the writings of early Christians. The Roman prelate Ambrose's "Ancient Morning Hymn," for instance, refers to God as the "Light of light, light's living spring." Perhaps the most important of the early Church Fathers, Augustine of Hippo (present-day Annaba, Algeria) describes the moment of his conversion to Christianity as one in which he was infused with "the light of full certainty."

Augustine, who lived from 354 to 430 CE, was in his forties and had recently been made bishop of Hippo when he felt the need to come to terms with his past. He did this in the form of a prose work, the Confessions, the first Western autobiography. Augustine's storytelling is so compelling that the Confessions became one of the most influential books of the Middle Ages. The frankness of Augustine's autobiographical self-assessment—for instance, he is not proud of the follies of his youth, although he is clearly still fascinated by them—would also make it influential later, in the context of the general rediscovery of the self that defines the great awakening to awareness of the human body known as the Renaissance.

But the Confessions is also a profoundly religious treatise that became influential on the merits of its religious arguments as well as its narrative power. For Augustine, humankind is capable of understanding true ideas only when they are illuminated by the soul of God. He adds to the Platonic emphasis on pure ideas a Christian belief in the sacred word of God, in which God's "light" is understood to shine. In the Confessions, too, Augustine codified the idea of typological readings of the Bible, proposing, for example, Eve, the biological mother of humanity, as a type for Mary, the spiritual mother. Similarly, he saw the deliverance of the Israelites from Egypt as a prefiguration of the redemption of Jesus.

Augustine was a prolific writer and thinker and a renowned teacher. One of his most important works is *The City of God*, written between 413 and 425. It is a reinterpretation of history from a theological point of view. In many ways, the book was a response to the sack of Rome by the Visigoths in 410. What had happened to the once powerful empire that had controlled the world, in a common phrase, "to its very edge?" How had such a disaster come to pass? Augustine attempts to answer these questions.

Many Romans blamed the Christians for the city's downfall, but Augustine argued, to the contrary, that pagan religion and philosophy, and particularly the hubris, or arrogance, of the emperors in assuming to be divine had doomed Rome from the beginning. Even more to the point, Augustine argued that the fall of Rome was inevitable, since the city was a product of humankind, and thus corrupt and mortal. Even a Christian Rome was inevitably doomed. History was a forward movement—at least in a spiritual sense—to the Day of Judgment, a movement from the earthly city, with its secular ways, to the heavenly city, untouched by worldly concerns (Reading 4.3):

READING 4.3

from Augustine, The City of God

The two cities were created by two kinds of love: the earthly city by a love of self even to the point of contempt for God, the heavenly city by a love of God carried even to the point of contempt for self. Consequently, the earthly city glories in itself while the heavenly city glories in the Lord. . . . In the one, the lust for dominion has dominion over its princes as well as over the nations it subdues; in the other, both those put in charge and those placed under them serve one another in love, the former by their counsel, the latter by their obedience. . . .

Augustine's world view is essentially dualistic, composed of two parts. In his writings, the movement of history (and that of life itself) follows a linear progression from darkness to light, from body to soul, from evil to goodness, from doubt to faith, and from blindness to understanding. His own life story, as described in *Confessions*, revealed him as the sinner saved. He saw himself, in fact, as a type for all Christians, whose ultimate place, he believed, would one day be the City of God.

THE BYZANTINE EMPIRE AND ITS CHURCH

What differentiates Byzantine art from earlier, Classical models and how does it reflect the values of the Empire and its church?

Constantine had built his new capital at Constantinople in 325 CE in no small part because Rome was too vulnerable to attack from Germanic tribes. Located on a highly defensible peninsula, Constantinople was far less susceptible to threat, and indeed, while Rome finally collapsed after successive Germanic invasions in 476, Constantinople would serve as the center of Christian culture throughout the early Middle Ages, surviving until 1453, when Ottoman Turks finally succeeded in overrunning it.

In Constantine's Constantinople, Christian basilicas stood next to Roman baths, across from a Roman palace and Senate, the former connected to a Roman hippodrome, all but the basilicas elaborately decorated with pagan art and sculpture gathered from across the Empire. Christians soon developed an important new understanding of these pagan works: They could ignore their pagan elements and think of them simply as *art*. This was the argument of Basil the Great (ca. 329–79), the major theologian of the day. In his twenties he had studied the classics of Greek literature in Athens and had fallen in love with them. He believed it was possible to understand them as literature, not theology, as great works of art, not as arguments for the existence of pagan gods.

Nonetheless, Roman pagan ways soon gave way to Christian doctrine. Constantine himself outlawed pagan sacrifices, and although the emperor Julian the Apostate (r. 361–63) briefly attempted to reinstate paganism, by the time of Theodosius I's rule (379–95), all pagan temples were closed throughout the Empire, and Christianity was the official religion. However, Roman law, not Biblical law, remained the norm in Byzantine culture, schools taught Classical Greek texts, especially Homer's *Iliad*, and important writers still modeled their work on Classical precedents. Nevertheless, by the middle of the sixth century, the emperor Justinian had closed the Academy of Athens, the last pagan school of philosophy in the Empire, and over 100 churches and monasteries stood in Constantinople alone.

Justinian's Empire

After Rome collapsed in 476, Odoacer, a Germanic leader, named himself king of Italy (r. 476–93), which he governed from the northern Italian city of Ravenna. Finally, the Ostrogothic ("Eastern Gothic") king Theodoric the Great overthrew Odoacer in 493 and ruled Italy until 526. The Byzantine emperors tolerated Theodoric's rule in Italy largely because he was Christian and had been raised in the imperial palace in Constantinople. But after a new young emperor, Justinian (r. 527–65), assumed the Byzantine throne, things quickly changed. Justinian launched a massive campaign to rebuild Constantinople, including the construction of a giant new Hagia Sophia (Fig. 4.13) at the site of the old one when the latter

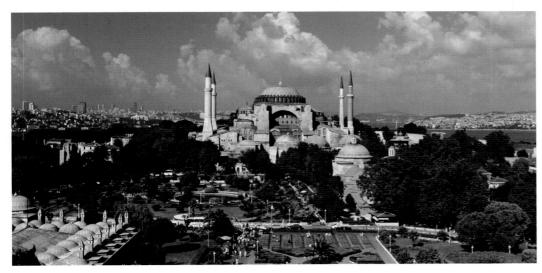

Fig. 4.13 Hagia Sophia, Istanbul (formerly Constantinople). 532–37. Originally dedicated to Christ as the personification of Holy (*hagia*) Wisdom (*sophia*), the church was transformed into a mosque by Muslim conquerors in 1453. Today, it serves as a museum, although it remains one of the oldest religious sanctuaries in the world.

was burned to the ground in 532 by rioting civic "clubs"—that probably were more like modern "gangs." The riots briefly caused Justinian to consider abandoning Constantinople, but his queen, Theodora, persuaded him to stay: "If you wish to save yourself, O Emperor," she is reported to have counseled, "that is easy. For we have much money, there is the sea, here

are the boats. But think whether after you have been saved you may not come to feel that you would have preferred to die." Justinian may well have begun construction of the new Hagia Sophia to divert attention from the domestic turmoil stirred up by the warring gangs. And he may have conceived his imperial adventuring to serve the same end (Map 4.3). In 535, he retook

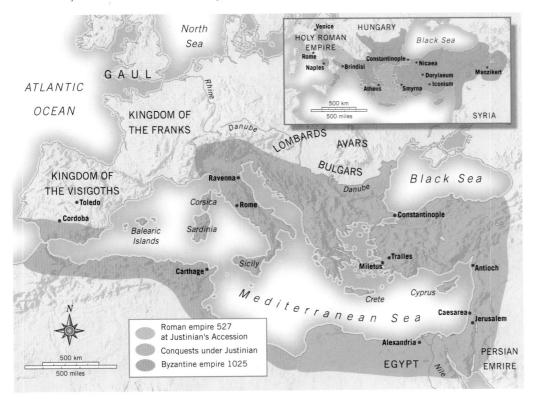

Map 4.3 The Byzantine Empire at the Death of Justinian in 565 and in 1025. The insert shows the Empire nearly 500 years after Justinian's reign, in 1025. Although it had shrunk, the Byzantine Empire remained a powerful force in the Eastern Mediterranean throughout the Middle Ages.

North Africa from the Visigoths, and a year later, he launched a campaign, headed by his general Belisarius, to retake Italy from the successors of Theodoric. But through his massive building program, especially, Justinian aimed to assert not only his political leadership but his spiritual authority also. His rule was divine, as his divine works underscored.

Hagia Sophia At the emperor's request, Procopius of Caesarea (ca. 490–ca. 560), Justinian's official court historian, wrote a treatise, On Justinian's Buildings, celebrating the emperor's building campaign. Book 1 is dedicated to the new Hagia Sophia, which Justinian erected on the site of the one that had burned down. As a result of Procopius' writings, we know a great deal about the building itself, including the identity of its architects, two mathematicians named Isidorus of Miletus and Anthemius of Tralles. Isidorus had edited the works of Archimedes, the third-century BCE geometrician who established the theory of the lever in mechanics, and both Isidorus and Anthemius had made studies of parabolas and curved surfaces. Their deep understanding of mathematics and physics is evident in their plan for Hagia Sophia.

Their completely original design consisted of a giant dome on a square base, the thrust of the dome carried on

four giant arches that make up each side of the square (Figs. 4.14 and 4.15). Between these arches are triangular curving vault sections, called pendentives, that spring from the corners of the base. The dome that rises from these pendentives has around its base 40 windows, creating a circle of light that makes the dome appear to float above the naos, underscoring its symbolic function as the dome of heaven. The sheer height of the dome adds to this effect—it is 184 feet high (41 feet higher than the Pantheon), and 112 feet in diameter. To the east and west, beneath the arches, are conch domes, or half domes, semicircular structures that spread out from a central dome, extending the space. These in turn are punctuated by yet smaller conch domes. Thus, a succession of curving spaces draws the visitor's eyes both upward to the symbolically heavenly space of the dome and forward to the sanctuary apse, seat of the altar and the liturgy. The intricate and lacy carving on the lower levels lends the stonework an almost ethereal lightness. The domes above are believed to have been covered with mosaics, probably consisting in the sixth century of plain gold grounds ornamented with crosses. Light from the windows around the base of the dome and conch domes would have ricocheted around the gold-covered interior, creating magical, even celestial light.

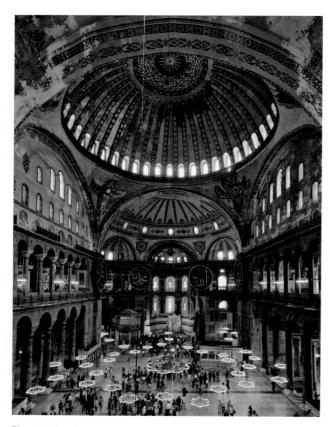

Fig. 4.14 Interior of Hagia Sophia, Istanbul. 532–37. So vast is the central dome of the church that it was likened, in its own time, to the Dome of Heaven. It was said that to look up at the dome from below was akin to experiencing the divine order of the cosmos.

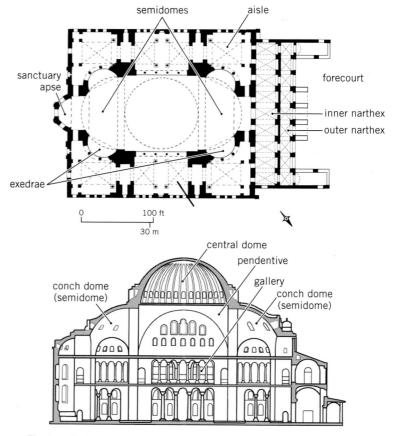

Fig. 4.15 Anthemius of Tralles and Isidorus of Miletus, Plan and section of Hagia Sophia, Istanbul. 532–37.

Saint Catherine's Monastery Justinian was not content merely to rebuild Constantinople. Bridges, roads, aqueducts, monuments, churches, and monasteries sprang up around the Empire. Not the least important of these sixth-century works was the fortress and monastery known as Saint Catherine's, at the foot of Mount Sinai, in the desert near the tip of the Sinai peninsula, in modern Egypt. It was at Mount Sinai that, according to the Old Testament, God gave Moses the Ten Commandments. The monastery was sited on the spot of the burning bush, where tradition held that God had first addressed Moses and instructed him to go to Egypt and lead the Jews to the Promised Land. Thus, the monastery had great symbolic significance.

Especially important to Justinian's architectural program were the embellishments—icons, or images—that his artists added to church interiors. Among the earliest examples of icons are a set of paintings on wooden panels from Saint Catherine's, among them a Theotokos and Child (Fig. 4.16). Theotokos means "God-bearing," an epithet defining Mary as the Mother of God, an official Orthodox Church view after 431. If Mary is the mother of Jesus, the Church argued, and if Jesus is God, then Mary is the Mother of God. Such images, and the doctrine associated with them, were expected to stir the viewer to prayer. Mary's eyes are averted from the viewer's, but the Christ Child, like the two military saints, Theodore (left) and George, who flank the central pair, looks straight out. The two angels behind raise their eyes to the sky, from which God's hand descends in blessing. The words of the sixth-century Byzantine poet Agathias (ca. 536-82) are useful here: "The mortal man who beholds the image directs his mind to a higher contemplation. . . . The eyes encourage deep thoughts, and art is able by means of colors to ferry over the prayer of the mind." Thus, the icon was in some sense a vessel of prayer directed to the saint, and, given Mary's military escort, must have offered the viewer her protection.

But such imagery soon became the focus of controversy. The sudden rise of Islam as a powerful military force had a chilling effect on Byzantine art. The Byzantine emperor Leo III (r. 717-41), who came to power during the second Muslim siege of Constantinople, began to formulate a position opposing the use of holy images. He understood that the Muslims, who were still regarded as Christian heretics, had barred images from their mosques and, so the logic went, their military successes against the Byzantine Empire were a sign both of God's approval of their religious practice and of disapproval of Byzantium's. Like the Muslims, Leo argued that God had prohibited religious images in the Ten Commandments—"Thou shalt not make any graven image, or any likeness of any thing that is in heaven above, or that is in the earth beneath, or that is in the water under the earth: Thou shalt not bow down thyself to them nor serve them" (Exodus 20:4-5). Therefore, anyone worshiping such images was an idolater and was offending God. The solution was to ban images.

Thus was inaugurated a program of iconoclasm, from the Greek eikon ("icon" or "image") and klao (to "break" or "destroy"), the practice of destroying religious images. While iconoclasts like Leo III set out to destroy religious images, iconophiles ("lovers of images") defended their use, usually in terms very similar to those expressed by the poet Agathias quoted above. But whatever position one assumed, the artistic style of the icons was employed in almost every form of artistic endeavor.

Byzantine icons employed a standardized shorthand to depict the events. It is as if their artistic vocabulary consisted of a limited repertoire of feet, hands, robes, and faces, all of which could be used over and over again in any context, the most important figure being the largest. We call this style, which is at once formally abstract and priestly, hieratic.

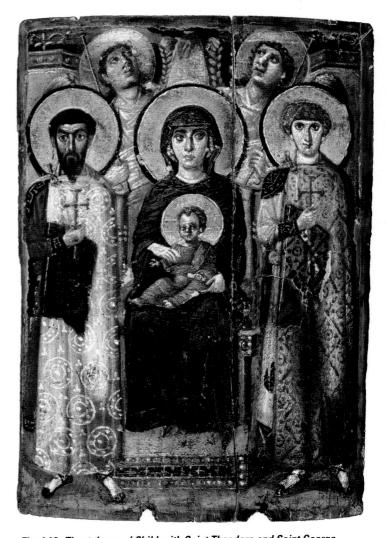

Fig. 4.16 Theotokos and Child with Saint Theodore and Saint George. 6th century. Encaustic on board, 27" × 19¾". Saint Catherine's Monastery, Mount Sinai. Byzantine culture rarely, if ever, referred to Mary as "the Virgin." Instead she was the Theotokos, the "Mother of God."

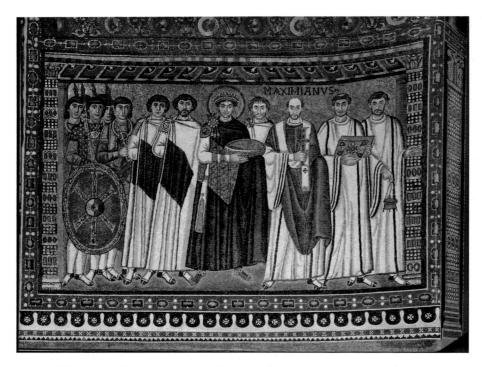

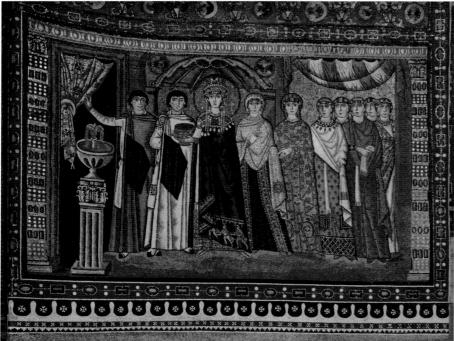

Figs. 4.17 and 4.18 (top) Emperor Justinian with Maximian, Clergy, Courtiers, and Soldiers; and (bottom) Empress Theodora with Courtiers and Ladies of Her Court; wall mosaics, San Vitale, Ravenna. ca. 547. Standing between and behind Justinian and Maximian is Julianus Argentarius, the benefactor of the church.

The Art of Ravenna The most extensive examples of Byzantine art and this hieratic style survive in Ravenna, a relatively small city in northern Italy near the Adriatic Sea. There, Justinian's new Orthodox clergy oversaw the construction of the church of San Vitale. On the side walls of the apse, level with the windows, are two mosaics, one featuring the emperor Justinian (Fig. 4.17) and the other the empress Theodora (Fig. 4.18). The emperor and empress lead retinues of courtiers toward the back of the apse. Possibly they proceeded toward reunion with Christ in paradise, as depicted in the conch-dome mosaic of the apse. A haloed Justinian carries a paten, the plate on which the bread is placed in the celebration of the Eucharist. On the other side of the apse, the empress holds a chalice of wine for the Eucharist, and on the bottom of her robe are the Three Magi, who like her come bearing gifts to the Virgin and Child. These mosaics possess a distinct political agenda, serving as propaganda to remind the faithful of the emperor's divine authority the union of the political and spiritual spheres.

The most intriguing aspect of the two mosaics, however, is their composition. Even though Theodora, for instance, stands before a scalloped half-dome niche and the attendant to her right pulls back a curtain as if to reveal the space beyond, these mosaics do not represent a view into a natural world extending back toward a distant horizon (compare Fig. 3.23 in Chapter 3). Rather, Byzantine artists conceived of space as extending forward from the picture plane, with parallel lines converging on the eve of the beholder. This technique, known as reverse perspective, makes objects appear to tip upward—note the top of the fountain to Theodora's right—and

elongates and heightens figures. Human eyesight, Byzantine artists believed, is imperfect and untrustworthy, a fact demonstrated by the apparent decrease in the size of objects as they recede in the distance. By depicting objects in reverse perspective and in shallow space, Byzantine artists rejected earthly illusion, privileging the sacred space of the image over the mundane space of the viewer.

THE RISE AND SPREAD OF ISLAM

What are the principal tenets of the Muslim faith, and why did it spread so rapidly?

The iconoclastic controversy that swept the Byzantine Empire in the seventh and eighth centuries was a direct result of the increasing influence of Islam on the Mediterranean world. Mecca, the holiest city of Islam, is located about 50 miles inland from the Red Sea on the Arabian peninsula in present-day Saudi Arabia (see Map 4.2). There, in about 570, the prophet Muhammad was born to a prominent family that traced its ancestry back to Ishmael, son of Abraham. Orphaned at age six, Muhammad received little formal education. He worked in the desert caravan trade, first as a camel driver for his uncle, and then, after marrying a wealthy widow 15 years his senior, as head of his wife's flourishing caravan firm. At the age of 40, in 610, he heard a voice in Arabic—the Archangel Gabriel's, as the story goes-urging him, "Recite!" He responded, "What shall I recite?" And for the next 22 years, he claimed to receive messages, or "recitations," from God through the agency of Gabriel. These he memorized and dictated to scribes, who collected them to form the scriptures of Islam, the Qur'an (or Koran), which means "recitations." Muhammad also claimed that Gabriel commanded him to declare himself the "Seal of the Prophets," that is, the messenger of the one and only Allah (the Arab word for God) and the final prophet in a series of prophets extending from Abraham and Moses to Iesus.

At the core of Muhammad's revelations is the concept of submission to God—the word *Islam*, in fact, means "submission" or "surrender." God, or Allah, is all—all-powerful, all-seeing, all-merciful. Because the universe is his creation, it is necessarily good and beautiful, and the natural world reflects Allah's own goodness and beauty. To immerse oneself in nature is thus to be at one with God. But the most beautiful creation of Allah is humankind, which God made in his own image. In common with Christians, Muslims believe that human beings possess immortal souls and that they can live eternally in heaven if they surrender to Allah and accept him as the one and only God.

Muslims, or practitioners of Islam, dedicate themselves to the "five pillars" of the religion:

- 1. Shahadah: The repetition of the *shahadah*, or "creed," which consists of a single sentence: "There is no God but Allah; Muhammad is the messenger of Allah."
- 2. Prayer: The practice of daily prayer, recited facing Mecca, five times each day, at dawn, midday, midafternoon, sunset, and nightfall, and the additional requirement for all men to gather for a noon prayer and sermon on Fridays.
- **3.** Alms: The habit of giving alms to the poor and needy, consisting of at least one-fortieth of a Muslim's assets and income.

- **4. Fasting:** During the lunar month of Ramadan (which, over a 33-year period, will occur in every season of the year), the ritual obligation to fast by abstaining from food, drink, medicine, tobacco, and sexual intercourse from sunrise to sundown each day.
- 5. Hajj: At least once in every Muslim's life, in the twelfth month of the Muslim calendar, the undertaking of a pilgrimage (called the *hajj*) to Mecca.

The five pillars are supported by the teachings of the Qur'an, which, slightly shorter than the Christian New Testament, consists of 114 surahs, or chapters, each numbered but more commonly referred to by its title. Each begins, as do most Muslim texts, with the *bismillah*, the first word of a sacred invocation, *bismillah al-rahman al-rahim*, which can be translated "In the name of Allah, the Beneficent, Ever-Merciful" (see *Closer Look*, pages 136–37). When, after Muhammad's death in 632, the Qur'an's text was established in its definitive form, the 114 surahs were arranged from the longest to the shortest. Thus, the first surah contains 287 *ayas*, or verses, while the last consists of only 3. The mandatory ritual prayer (*salat*) that is performed five times a day consists of verses from Surahs 2, 4, and 17.

The Qur'an

As the direct word of God, the beauty of the Qur'an's poetry rises above what any worldly poet might create, even though, in pre-Islamic Arabia, poetry was considered the highest form of art. But the beautiful, melodic qualities of the Arabic language are completely lost in translation, a fact that has helped to inspire generations of non-Arabicspeaking Muslims to learn the language. Almost all Muslims regularly read the Qur'an in Arabic, and many have memorized it completely. Translations of the Qur'an are problematic on another, more important level. Since the Our'an is believed to be the direct word of God, it cannot be modified, let alone translated—a translation of the Qur'an is no longer the Qur'an. Nevertheless, something of the power of the work's imagery can be understood in translation. Consider a passage describing paradise from the Surah 76, known as "Time" (Reading 4.4):

READING 4.4

from the Qur'an, Surah 76

- **76.11** Therefore Allah will guard them from the evil of that day and cause them to meet with ease and happiness;
- **76.12** And reward them, because they were patient, with garden and silk,
- 76.13 Reclining therein on raised couches, they shall find therein neither (the severe heat of) the sun nor intense cold.
- 76.14 And close down upon them (shall be) its shadows, and its fruits shall be made near (to them), being easy to reach.

CLOSER LOOK

he bismillah consists of the phrase "In the name of Allah, the Beneficent, Ever-Merciful." Every pious Muslim begins any statement or activity with it, and it inaugurates each chapter of the Qur'an. For Arab calligraphers, to write the bismillah in as beautiful a form as possible brings the scribe forgiveness for sins, and the phrase appears in the Islamic world in many different forms—even in the shape of a parrot. By 700 it had become an important part of architectural practice as well. It first appears in written form on a band of mosaic script around the interior walls and above the entrance of the Dome of the Rock in Jerusalem (see Fig. 4.1). The fourteenth-century ceramic tile decoration on a mihrab niche (see page 137), a design feature in all Islamic mosques, commemorating the spot at Medina where Muhammad planted his lance to indicate the direction in

which people should pray, gives some indication of how the calligraphic script could blend with floral motifs and geometric designs to create an elaborate ornamental surface.

The importance of writing in spreading the new faith suggests one reason that Muslim calligraphers were held in such high esteem. Most Westerners think of handwriting as a form of self-expression. But the Muslim calligrapher's

Bismillah in the form of a parrot, from Iran. 1834–35. Ink on paper under wax coating. Cincinnati Art Museum, Franny Bryce Lehmer Fund. 1977.65. The parrot reads right to left, beginning over the large dot beneath its tail. The word *Allah* appears at the back of its head. The parrot is to humankind as humankind is to Allah. That is, it mimics human language without understanding it, just as humans recite the words of Allah without fully understanding them.

Page from a Qur'an Manuscript, probably Tunisia, late 9th—early 10th century. Gold on blue vellum, 9¾" × 13½". Surah al-Bagarah (Chapter 2), part of verse 109 through part of verse 114. Seattle Art Museum, Eugene Fuller Memorial Collection, 69.37. From a luxurious Qur'an known as the "Blue Qur'an," this manuscript page was written in ink made of gold dust mixed with emulsion (glair or gum), applied to animal-skin vellum dyed indigo. The dye was itself harvested from tiny sea shells.

style has a much more important role to play: to attract the attention of the reader, eliciting admiration for the beauty of the script, and in turn reflecting the beauty of the Muslim faith. The Muslim calligrapher is considered the medium through which Allah expresses himself. The more beautiful the calligraphic script, the more fully Allah's beauty is realized. Hence, over time, many styles of elaborate cursive script developed, as illustrated on the next page. At the same time, everyday affairs required the development of simpler, less artistic forms, and the *riq'a* script is an example.

Mastering the art of calligraphy was, in this sense, a form of prayer, and it was practiced with total dedication. A famous story about an incident that happened in the city of Tabriz, in northern Iran, during the great earthquake of 1776–77 illustrates this. The quake struck in the middle of the night and buried many in the rubble. Survivors stumbled through the debris looking for signs of life. In the basement of a ruined house, rescuers discovered a

The Bismillah and the Art of Calligraphy

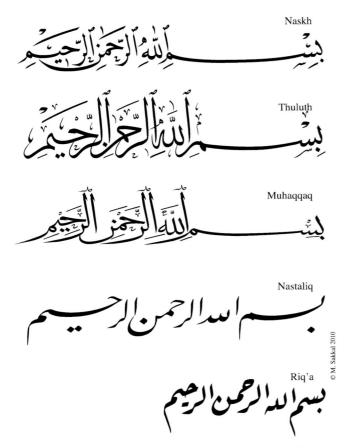

Five examples of the bismillah in different Islamic cursive scripts.

Naskh, literally "copying," was developed in the tenth century, and refined into a fine art form in Turkey in the sixteenth century. Thuluth evolved over the centuries

The CONTINUING PRESENCE of the PAST

See Wijdan (Jordanian, born Iraq, 1939), *Karbala Series: Hussein,* 1993, at **MyArtsLab**

© Wijdan/ © The Trustees of the British Museum

into a more impressive, stately calligraphic style, often used for titles or epigrams rather than lengthy texts, and found in many variations on architectural monuments, as well as on glass, metalwork, textiles, and wood. It is the script employed on the *mihrab* niche right. *Muhaqqaq* emerged in the eleventh century in the art of making manuscripts of the Qur'an. *Nastaliq* developed in Iran in the fourteenth and fifteenth centuries. It is the most fluid and expressive of the scripts presented here, and is used extensively in copying romantic and mystical epics in Persian. *Riq'a*, the simpler style of everyday writing, is very economical and easy to write.

Something to Think About . . .

How might modern technology—from type to the Internet—pose a challenge to the calligraphic tradition in Islam?

man sitting on the floor absolutely absorbed in his work. He did not respond to their yells for him to hurry out before an aftershock buried him. Finally, he looked up and complained that they were disturbing him. They told him that thousands had been killed in an earthquake, and if he did not hurry up, he would be next. "What is all that to me?" he replied. "After many thousands of attempts I have finally made a perfect 'waw' [meaning 'and']." He showed them the letter, indeed a very difficult letter to make. "Such a perfect letter," he exclaimed, "is worth more than the whole city!"

Mihrab niche, Isfahan, Iran. ca. 1354–55. Mosaic of polychrome-glazed cut tiles on fritware body; set into plaster, 135½6" × 1131½6". The Metropolitan Museum of Art, New York. Harris Brisbane Dick Fund, 1939 (39.20). The words in the rectangle in the center of the niche read: "The Prophet, peace be upon him, said, 'The mosque is the house of every person.'"

- **76.15** And there shall be made to go round about them vessels of silver and goblets which are of glass,
- 76.16 (Transparent as) glass, made of silver; they have measured them according to a measure.
- 76.17 And they shall be made to drink therein a cup the admixture of which shall be ginger,
- 76.18 (Of) a fountain therein which is named Salsabil.
- 76.19 And round about them shall go youths never altering in age; when you see them you will think them to be scattered pearls.
- **76.20** And when you see there, you shall see blessings and a great kingdom.
- 76.21 Upon them shall be garments of fine green silk and thick silk interwoven with gold, and they shall be adorned with bracelets of silver, and their Lord shall make them drink a pure drink.
- **76.22** Surely this is a reward for you, and your striving shall be recompensed.

This vision of paradise addresses all the senses—touch, taste, and smell (the fruit so "easy to reach," the drink of ginger), sight ("when you see there, you shall see blessings"), and sound (in the very melody of the verse itself). All is transformed into riches. Even the young people in attendance will appear to be "scattered pearls."

The Hadith

In addition to the Qur'an, another important source of Islamic tradition are collections of hadith, meaning "narratives" or "reports," which consist of sayings of Muhammad and anecdotes about his life. The hadith literature was handed down orally, as was common in Arab society until about 100 years after Muhammad's death, when followers began to write the sayings down (Reading 4.5).

READING 4.5

from the hadith

- "Actions are but by intention and every man shall have but that which he intended."
- "None of you [truly] believes until he wishes for his brother what he wishes for himself."
- "Get to know Allah in prosperity and He will know you in adversity. Know that what has passed you by was not going to befall you; and that what has befallen you was not going to pass you by. And know that victory comes with patience, relief with affliction, and ease with hardship."
- "If you feel no shame, then do as you wish."
- "Everyone starts his day and is a vendor of his soul, either freeing it or bringing about its ruin."

- "O My servants, it is but your deeds that I reckon up for you and then recompense you for, so let him who finds good [i.e., in the hereafter] praise Allah, and let him who finds other than that blame no one but himself."
- "Renounce the world and Allah will love you, and renounce what people possess and people will love you."

The Hijra and Muslim Practice

In 622, Muhammad was forced to flee Mecca when its polytheistic leadership became irritated at his insistence on the worship of only one God. In a journey known as the *hijra* (or *hegira*, "emigration"), he and his followers fled to the oasis of Yathrib, 200 miles north, which they renamed al-Medina, meaning "the city of the Prophet." Here Muhammad created a community based not on kinship, the traditional foundation of Arab society, but on common submission to the will of God. Such submission did not need to be entirely voluntary. Muslims were obliged to pursue the spread of their religion, and they did so by means of the *jihad*, the impassioned religious struggle that could take either of two forms: a lesser form, holy war; or a greater form, self-control over the baser human appetites. In order to enforce submission, Muhammad raised an army of some 10,000 men and returned to Mecca, conquering the city.

It was especially important for Muhammad to return to Mecca because it was the site of the Kaaba, literally "cube" (Fig. 4.19). Built with a bluish-grey stone from the hills surrounding Mecca, it is now usually covered with a black curtain. The Kaaba also held a sacred Black Stone, probably a meteorite, which reportedly "fell from heaven." To this day, practitioners of the Muslim faith from all over the world face toward the Kaaba when they pray. They believe it is their place of origin, the site of the first "house of God," built at God's command by the biblical Abraham and his son Ishmael. the ancestors of all Muslims, on the spot where Abraham, in Islamic tradition, prepared to sacrifice his son Ishmael (not Isaac, as in the Christian tradition). Thus, walking around the Kaaba is a key ritual in the Muslim pilgrimage to Mecca, the hajj, for the cube represents the physical center of the planet and the universe. It is the physical center of Muslim life, around which all things turn and to which all things in the universe are connected, symbolic of the cosmos itself.

The community of all Muslims, which came to be known as the *Umma*, was such a departure from tradition that its creation required a new calendar. Based on lunar cycles, the Muslim year is about 11 days shorter than the Christian year, resulting in a difference of about three years per century. The calendar began in 622 ce. Thus, in the year 2011, the Muslims celebrated the start of their year 1432.

The Mosque At Medina, Muhammad built a house that surrounded a large, open courtyard, which served as a community gathering place, on the model of the Roman forum. There the men of the community would gather on Fridays to pray and listen to a sermon delivered by Muhammad. It thus became known as the *masjid*, the Arabic word for

mosque, or "place of prostration." At the north and south ends of the courtyard, covered porches supported by palm tree trunks and roofed by thatched palm fronds protected the community from the hot Arabian sun. This many-columned covered area, known as a hypostyle space (from the Greek hupostulos, "resting upon pillars"), would later become a required feature of all mosques. Another required feature was the qibla, a wall that indicated the direction of Mecca. On this wall were both the minbar, or stepped pulpit for the preacher, and the mihrab, a niche commemorating the spot at Medina where Muhammad planted his lance to indicate the direction in which people should pray.

Women in Islam Although Muslim practice today varies widely, in Muhammad's time, women were welcome in the mosque. In the Qur'an, Muhammad teaches that women and men are equal partners: "The faithful men and the faithful women are protecting friends for each other" (Surah 9:7). The husband's honor becomes an integral part of his wife's honor, and vice versa. They share equally in each other's prosperity and adversity. But Muhammad further allowed Muslim men to have up to four wives, provided they treated all justly and gave each equal attention. (Polygamy was widely practiced in the Arab world at the time, and marrying the widow of a deceased comrade, for instance, was understood to be an act of protective charity.) Muhammad himself—and subsequently other prophets as well—was exempt from the four-wife limitation. Although he had only one wife for 28 years, after she died when he was 53, he married at least 10 other women. The Qur'an describes the wives of Muhammad—and by extension, the wives of all Muslim men—as "Mothers of the Faithful" whose duty was the education of the *Umma*'s children. They helped them along their spiritual path, transmitting and explaining the teaching of Muhammad in all spheres of life.

One of the most discussed and most controversial aspects of Muslim faith (even among Muslims) is the *hijab*, literally "curtain," the requirement that women be covered or veiled. Its origins can be traced to Islam's Jewish heritage and the principle of tzenuit, which in Hebrew means "modesty" in both dress and behavior and which requires, among other strictures, that all married women cover their hair whenever non-family members are present. Islamic covering ranges from a simple scarf covering the hair to the chador, which covers the wearer from head to toe, leaving only her hands and her face (or part of her face) exposed. This full covering is currently popular, especially in Iran. Interestingly, the Our'an is not explicit about the covering. Women are advised to dress in a way that enables them to avoid harassment by not drawing attention to their beauty, or zinat, a word that means both physical beauty and material adornment in Arabic. The basic message and instruction expressed in the Qur'an is for Muslims to act modestly and dress modestly, a rule that applies to men and women.

The Spread of Islam

Following the death of the Prophet in 632, the **caliphs**, or successors to Muhammad, assumed political and religious authority. The first two caliphs were Abu Bakr (r. 632–34) and Umar (r. 634–44), both of whom were fathers to two of Muhammad's

wives. Waiting in the wings was Ali, the Prophet's cousin, second convert to Islam (after the prophet's wife Khadija), and husband of Fatima, Muhammad and Khadija's daughter. But when Umar died in 644, disciples responsible for choosing the new caliph, among them the two leading candidates for caliph, Ali and Uthman, a member of the Ummayad clan of Mecca, passed over Ali and selected the 70-year-old Uthman (r. 644–56). When Uthman was assassinated in 656, victim of an Egyptian revolt, Ali (r. 656–61) was finally named caliph, but over the objections of the Umayvad clan. In 661, Ali was assassinated by a rival faction, led by Muawiya, Uthman's cousin, that opposed Ali's rise to power, blaming him for refusing to avenge Uthman's death. A more conservative group, the Kharijites, supported the assassination of Ali on grounds of his moral weakness. Muawiya (r. 661-80) became caliph, establishing the Umayyad dynasty, and moving the Caliphate

Fig. 4.19 The Kaaba, center of the Haram Mosque, Mecca, Saudi Arabia. Traditionally, all Muslims must make a pilgrimage to Mecca at least once in their lives. Once there, they must walk around the Kaaba seven times. The Kaaba has been rebuilt many times over the years, the last time in 1631.

Fig. 4.20 Djingareyber Mosque, Timbuktu, Mali. ca. 1312. Today the mosque—and the entire city of Timbuktu—is in danger of becoming a desert, as the sands from the Sahara overtake what was once the Mali savanna.

from Medina in Arabia to Damascus in Syria. (This tension between Ali's followers and the Umayyad caliphs exists to this day. Those who believe that only descendants of Ali should rule are known as Shiites [Shi'a, or "followers of Ali"], and they live largely in Iran and Iraq. Another group, known as Sunnis, who today represent the vast majority of Muslims, believe that religious leaders should be chosen by the faithful. These two groups continue to vie for power in present-day Islam, especially in Iraq. The more conservative Kharijites still survive in Oman and North Africa.)

Despite this turmoil, Islam spread with a rapidity that is almost unimaginable (see Map 4.2). Damascus fell to the caliphs in 634, Persia in 636, Jerusalem in 638, and Egypt in 640. By 710, all of North Africa and Spain were under Muslim rule. The speed of the conquest can be partially accounted for by the fact that the Byzantine and Persian empires were exhausted by a long war. Soon after the Byzantine emperor Heraclius (r. 610–40) captured Egypt, Palestine, Syria, and Asia Minor from the Persians, Muslim armies struck, driving the Byzantine armies out of their newly acquired territories and overrunning most of the Persian Empire as well. Most of the peoples in these territories, although Christian, were of the same linguistic and ethnic background as their new Muslim conquerors. Furthermore, the brand of Greek Orthodox Christianity that the Byzantine rulers had imposed on them was far too conservative for many. From Persia to Egypt, many peoples accepted their Muslim conquerors as preferable to the Byzantine rulers who had preceded them.

The successes of Islam must also be attributed to its appeal both as a religion and as a form of social organization. It denied neither Judaism nor Christianity, but merely superseded them. As opposed to the Jewish faith, which was founded on a common ethnic identity, Islam opened its arms to any and all comers—a feature it shared with Christianity. But unlike Christianity, it did not draw any special distinction between the clergy and the laity. It brought people together in the mosque, which served as a community meeting house, courthouse, council chamber, military complex, and administrative center. Traders naturally migrated to it, as did poets, artists, and scholars. In fact, the mosque was closer in function to the Classical agora than to the Christian tabernacle. The sense of community that the mosque inspired played a central role in the spread of Islam.

By the eleventh century, a madrasa, or teaching college, was attached to mosques, and mosques became centers of learning as well. Here students studied the Qur'an, the hadith, and Islamic law, as well as mathematics, poetry, and astronomy. The madrasas eventually contributed to the rise of an intellectual elite, the ulama (people possessing "correct knowledge"), a group that functioned more or less in the manner of Christian priests or Jewish rabbis. Yet any man of great religious learning could serve as an alim (the singular form of ulama), and ulama had the singular role of overseeing the rulers of Islam, guaranteeing that they followed the letter of the law as stated in the Qur'an.

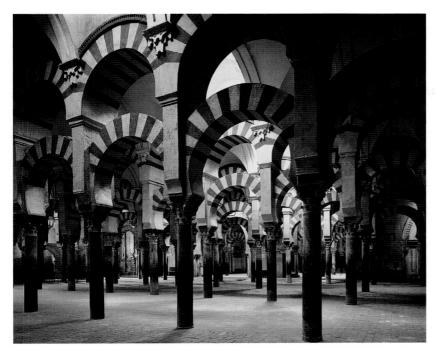

Fig. 4.21 Great Mosque of Córdoba. Begun 785, extensions 852, 950, 961–76, and 987. The caliphs of Spain intended their mosque to rival those in Jerusalem, Damascus, and Iraq. The forestlike expanse of the interior is a result of these aspirations. Even though only 80 of the original 1,200 columns survive, the space appears infinite, like some giant hall of mirrors.

Islamic Africa The Muslim impact on the culture of North Africa cannot be overstated. Beginning in about 750, not long after Muslim armies had conquered most of North Africa, Muslim traders, following the trade routes created by the Saharan Berber peoples, began trading for salt, copper, dates, and especially gold with the sub-Saharan peoples of the Niger River drainage. Gradually, they came to dominate the trans-Saharan trade routes, and Islam became the dominant faith of West Africa. By the ninth century, a number of African states existed in the broad savanna south of the Sahara desert known as the Sudan (which literally means "land of the blacks"). These states seemed to have formed in response to the prospects of trade with the Muslim and Arab world.

Ghana, which means "war chief," is an early example, and its name suggests that a single chieftain, and later his family, exerted control over the material goods of the region, including gold, salt, ivory, iron, and particularly slaves. Muhammad, who considered slaves the just spoils of war, explicitly authorized slavery. Between the ninth and twelfth centuries, the slave trade grew from 300,000 to over a million, and it was so lucrative that the peoples of the Sudan, all eager to enslave one another for profit, fought one another. (There is some reason to believe that many African converts to Islam were initially attracted to the religion as a way to avoid becoming slaves, since the faithful were exempt from servitude.) Finally, the empire of the Malpeople subsumed Ghana under the leadership of the warrior-king Sunjata (r. 1230–55), and gained control of the great trade routes north out of the savanna,

through Timbuktu, the leading trading center of the era.

In 1312, Mansa Moussa (mansa is the equivalent of the term "emperor") came to the Malian throne. A devout Muslim, he built magnificent mosques throughout his empire, including the Djingareyber Mosque in Timbuktu (Fig. 4.20). Still standing today and made of burnt brick and mud, it dominates the city. Under Moussa's patronage, Timbuktu grew in wealth and prestige and became a cultural focal point for the finest poets, scholars, and artists of Africa and the Middle East. To draw further attention to Timbuktu, and to attract more scholars and poets to it, Mansa Moussa embarked on a pilgrimage to Mecca in 1334. He arrived in Cairo at the head of a huge caravan of 60,000 people, including 12,000 servants, with 80 camels carrying more than two tons of gold to be distributed among the poor. Five hundred of the servants carried staffs of pure gold. In fact, Moussa distributed so much gold in Egypt that the value of the precious metal fell dramatically and did not recover for a number of years. When Moussa returned from the holy cities of Mecca and Medina, he built mosques, libraries, and madrasas throughout his kingdom.

Islamic Spain Like Islamic Africa, Islamic Spain maintained its own indigenous traditions while it absorbed Muslim ones, thus creating a distinctive cultural and political life. In 750, the Abbasids, a large family that claimed descent from Abbas, an uncle of Muhammad, overthrew the Umayyad caliphs. The Abbasids shifted the center of Islamic power from Mecca to a magnificent new capital in Iraq popularly known as Baghdad. Meanwhile, Spain remained under Umayyad control, initially under the leadership of Abd ar-Rahman (r. 756-88), who had escaped the Abbasid massacre of Umayyads in Syria in 750 by fleeing to Córdoba. The Spain he encountered had been controlled by a Germanic tribe from the north, the Visigoths, for more than three centuries, but gradually he solidified Muslim control of the region, first in Córdoba, then in Seville, Toledo (the former Visigothic capital), and Granada.

The Great Mosque of Córdoba In the last years of his reign, secure in his position, Abd ar-Rahman built a magnificent new mosque in Córdoba, converting an existing Visigothic church into an Islamic institution, for which the Christian church was handsomely reimbursed. Abd ar-Rahman's original design included a double-tiered system of reused Roman and Visigothic columns and capitals supporting horseshoe-shaped double arches, all topped by a wooden roof (Fig. 4.21). The double arches may have served a practical function. The Visigoths tended to build with relatively short, stubby columns. To create the loftier space for the mosque, the architects superimposed another set of columns on top, creating the double tier. But the design also echoes the double-tiered design

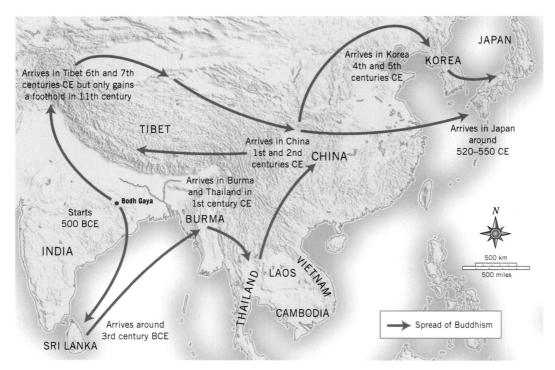

Map 4.4 The Spread of Buddhism, 500 BCE-11th century CE.

found at the Great Mosque at Damascus, which also reuses Roman columns, and the architects may have simply copied the Damascus model. The arches also employ a distinctive design of alternating stone and red-brick voussoirs, the wedge-shaped stones used to build an arch. The use of two different materials is functional as well, combining the flexibility of brick with the strength of stone. The hypostyle plan of the mosque was infinitely expandable, and subsequent Umayyad caliphs enlarged the mosque in 852, 950, 961–76, and 987, until it was more than four times the size of Abd ar-Rahman's original and incorporated 1,200 columns.

Under the Umayvad caliphs, Muslim Spain thrived intellectually. Religious tolerance was extended to all. (It is worth noting that Muslims were exempt from taxes, while Christians and Jews were not—a practice that encouraged conversion.) Spanish Jews, who had been persecuted under the Visigoths, welcomed the Muslim invasion and served as scientists, scholars, and even administrators in the caliphate. Classical Greek literature and philosophy had already been translated into Arabic in Abbasid Baghdad. The new School of Translation established by the Umayyads in Toledo was soon responsible for spreading the nearly forgotten texts throughout the West. Muslim mathematicians in Spain invented algebra and introduced the concept of zero to the West, and soon their Arabic numerals replaced the unwieldy Roman system. By the time of Abd ar-Rahman III (r. 912-61), Córdoba was renowned for its medicine. science, literature, and commercial wealth, and it became the most important center of learning in Europe. The elegance of Abd ar-Rahman III's court was unmatched, and his tolerance and benevolence extended to all, as Muslim students from across the Mediterranean soon

found their way to the mosque-affiliated *madrasa* that he founded—the earliest example of an institution of higher learning in the Western world.

THE SPREAD OF BUDDHISM

What characterizes the spread of Buddhism from India north into China?

Not long after the emperor Ashoka was embarking on his massive Buddhist architectural program in India (see Chapter 3), Buddhist missionaries from India began spreading the religion east into Southeast Asia and north into China and Korea. By 600 ce, Buddhism had reached all the way into Japan (Map 4.4).

The first Chinese Buddhist monk to set out on the Silk Road in search of Buddhist scripture to translate into Chinese was Zhu Shixing of Hunan province. His journey took place about 260 CE. At the same time, far away on the Silk Road, a resident of Dunhuang began his life's work as a translator of Buddhist texts. One of the most telling manifestations of the religion's spread is the appearance everywhere of images of Buddha. In early Buddhist art, the Buddha was never shown in figural form. It was believed to be impossible to represent the Buddha, since he had already passed to nirvana. Instead, his presence was symbolized by such things as his footprints, the banyan tree (see Chapter 3), the wheel (representing Buddha's teachings in which, it is said, "he set the wheel of the law in motion"), or elephants (traditional symbols of authority and spiritual strength).

By the fourth century, during the reign of the Gupta rulers in India, the Buddha was commonly represented in human

form. Typically his head is oval, framed by a halo. Atop his head is a mound, symbolizing his spiritual wisdom, and on his forehead is a "third eye," symbolizing his spiritual vision. His demeanor is gentle, reposed, and meditative. His elongated ears refer to his royal origins, and his hands are set in one of several symbolic gestures, called mudra. At Bamiyan, on the Silk Road in present-day Afghanistan, two massive Buddhas, 175 and 120 feet tall, were carved into a cliff face in the third century CE (Fig. 4.22). These figures were completely destroyed by the fundamentalist Islamic Taliban in 2001. However, many surviving replicas from the Silk Road era suggest that the hands of these Buddhas, which succumbed to natural forces long ago, were held up in the Dharmachakra mudra, the teaching pose. This mudra symbolizes intellectual debate and is often associated with Buddhist centers of learning. Painted gold and studded with jewels, and surrounded by caves decorated with Buddhist wall paintings, these enormous images reflect the magnitude of Buddha's eternal form, at which the earthly body can barely hint.

A seated Buddha from another cave, in Yungang, Shaanxi, China (Fig. 4.23), exhibits the *Dhyana* mudra, a gesture of meditation and balance. The lower hand represents the physical world of illusion, the upper, nirvana. Together they symbolize the path to enlightenment. The bodhisattva—a person of near total enlightenment who has vowed to help others achieve it—standing next to him is exhibiting the *Abhaya* mudra, a gesture of reassurance, blessing, and protection.

After the fall of the Han dynasty in 220 CE (see Chapter 3), China entered an uneasy period. Warring factions vied for control of greater or lesser territories, governments rose to power and fell again, civil wars erupted, and tribes from Central Asia

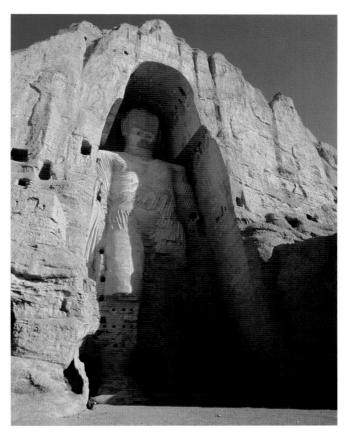

Fig. 4.22 Colossal Buddha, Bamiyan, Afghanistan. ca. 3rd century cs. Stone, height 175'. This and another colossal sculpture of Buddha nearby were destroyed in February 2001 by the fundamentalist Islamic Taliban, who evidently felt that as false idols they were an affront to Muhammad.

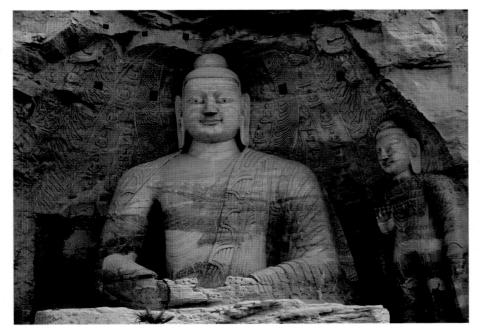

Fig. 4.23 Large Seated Buddha with Standing Bodhisattva, from cave 20, Yungang, Shaanxi, China, Northern Wei dynasty. ca. 460–70 cs. Stone, height 44'. By the second half of the fifth century, when this sculpture was carved, the Chinese Wei rulers, who lived near the eastern end of the Silk Road, had become acquainted with the Indian Buddhist religion.

continually invaded. During this time, Buddhism began to spread through the culture. The ethical system based on the teachings of Confucius, which stressed selfdiscipline, propriety, reverence for elders, and virtuous behavior (see Chapter 3), seemed to have resulted in civil and cultural dysfunction. In contrast, Buddhism offered an ethical system based less on social and civic duty and more on each person's responsibility for his or her actions. Especially in its emphasis on meditation and enlightenment, Buddhism was compatible with Daoism and its emphasis on harmony with nature (also discussed in Chapter 3). By the seventh century CE. Chinese leaders had learned to take the best from all three—Confucianism, Buddhism, and Daoism—and the culture was once again unified.

4.1 Examine the impact of Roman rule on Judaic culture.

By the first century CE, Judaism had become increasingly sectarian in nature, each sect believing that it possessed the one true understanding of God's will. It had also become increasingly messianic and apocalyptic. The Jews chafed under Roman rule. The Romans were particularly insensitive to Jewish purity laws. Despite a massive building campaign on the part of Herod, Rome's client king, the Jews revolted in 66 CE. In 70 CE, the Romans sacked the Second Temple. They also changed the name of the province of Judea to Palestine. Why?

4.2 Discuss the development of Christianity from its Jewish roots to its rapid spread through the Roman world.

How did Christianity develop out of the Roman occupation of Judea? How did the evangelists contribute to the spread of Christianity across the Roman world?

To incorporate its Jewish heritage, early Christianity viewed its history as a typology. How does typology work? Early Christian art is clearly indebted to Classical and Hellenistic precedents, but it includes many symbols designed to indicate the Christian content of the image. What are some of the iconographic features of these symbols?

In 313, Constantine I ("Constantine the Great"), who had assumed total authority over the Roman Empire the year before, granted religious freedom to all Romans in the Edict of Milan. Constantine became increasingly supportive of Christianity, convening the first ecumenical council of Church leaders in 325 at Nicaea, near his new capital at Constantinople. What are the basic tenets of the resulting Nicene Creed? How does it serve to define the nature of Christian belief?

One of the first religious philosophers of the era was Augustine of Hippo. His Confessions are the first Western autobiography, describing his conversion to Christianity. What temptations does he find most difficult to overcome and how do you think these difficulties have affected Western theology? His City of God argues that the demise of the Roman Empire was caused by the arrogance of its emperors and the worldly concerns of the citizens of the earthly city. Romans, he argues, might be saved if they turn their attention to the heavenly City of God. Much of the argument is based on an allegorical reading of the Bible. How do you see allegory developing out of the tradition of typological reading in Christian thought?

4.3 Describe the new Byzantine style of art and discuss how it reflects the values of the Byzantine emperors, especially Justinian.

When in 325 the emperor Constantine began to build his new capital at Byzantium, he modeled it on Rome, but instead of temples dedicated to the Roman gods, he erected Christian basilicas. By the sixth century, when the emperor Justinian closed the last pagan school of philosophy in the Empire, there were over 100 churches and monasteries in the city.

Justinian ordered the mammoth new church Hagia Sophia to be built and oversaw construction of bridges, roads, aqueducts, monuments, churches, and monasteries all around the Empire. In Byzantine art, the naturalism that dominates classical Greek and Roman art disappeared. What replaced it? Why? What is an icon? The clergy installed by Justinian in the Italian capital city of Ravenna constructed a new central-plan church, San Vitale, decorated with two mosaics featuring Justinian and Theodora. How do these compare to Byzantine icons?

4.4 Outline the principal tenets of the Muslim faith, and account for its rapid spread.

According to tradition, beginning in 610 the Muslim prophet Muhammad began to recite messages from God, which he dictated to scribes who collected them to form the scriptures of Islam, the Qur'an. At the core of the Qur'an is the concept of "submission" or "surrender" to Allah, the all-merciful, all-seeing, all-powerful God. Other than the Qur'an, what work forms the basis of Islamic faith? How is the idea of community reflected in the mosque and its attendant rituals? How is it reflected in the idea of the jihad? What are the "lesser" and "greater" forms of the jihad?

How do you account for the rapid spread of Islam throughout the Middle East, North Africa, and Spain? How does the mosque contribute to this spread, and what role does the *madrasa*, or teaching college, built at mosques, play?

4.5 Characterize the spread of Buddhism from India north into China.

As Buddhist missionaries spread the teachings of Buddha between the first and third centuries CE, Buddha was increasingly represented in figural form. Typically his head is oval, and atop it is a mound. What does this mound symbolize? His demeanor is gentle, reposed, and meditative. His elongated ears refer to his royal origins, and his hands are set in one of several symbolic gestures, called *mudra*. Can you describe one or more of these mudra and what they symbolize?

Byzantine Influences

ocated at the crossroads of Europe and Asia and serving as the focal point of a vast trade network that reached as far east as China, Constantinople was the economic center of first the Roman Empire and then the entire Mediterranean for nearly 1,000 years. Only Venice would ever rival it as a center of trade, and Venice would finally conquer Constantinople during the Fourth Crusade in 1204 in order to draw the city into its own sphere of influence. Venetian mercenaries looted the city in the process, taking back to Italy art and artifacts representing more than 900 years of accumulated wealth and artistic tradition. In the early years of the twelfth century, Venetian artists copied more than 110 scenes for the atrium of Saint Mark's Cathedral from Byzantine originals. And Saint Mark's itself

was directly inspired by Byzantine architecture and decoration, including a set of four life-size bronze horses set above the central portal (Fig. 4.24). (Today, the originals have been removed for conservation purposes into the interior of the church, and replicas have replaced them.)

The wealth of Constantinople in artifacts would spread to the north as well. In 1238, Venetian merchants purchased from Byzantine officials one of the most precious relics of Western Christendom, the Crown of Thorns, supposedly worn by Jesus during the Crucifixion. The same year, King Louis IX of France paid the Venetians 13,304 gold coins to take the crown to Paris and place it in his newly dedicated Gothic church, Sainte-Chappelle.

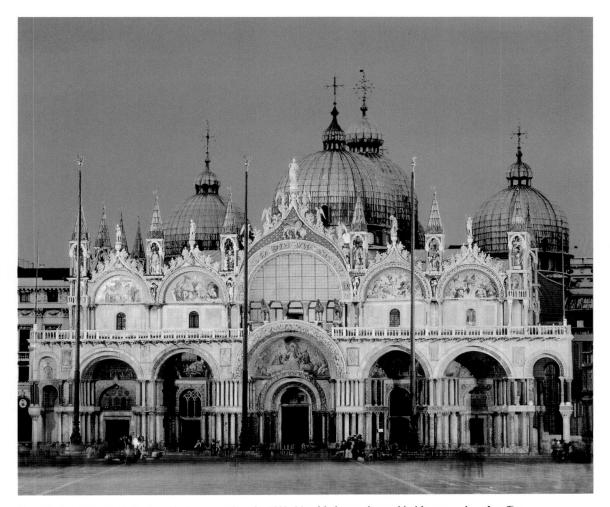

Fig. 4.24 Saint Mark's Cathedral, Venice, west facade. 1063–94, with decorations added for centuries after. The original brick front of the cathedral is inlaid with marble slabs and carvings, much of it looted from Constantinople in 1204.

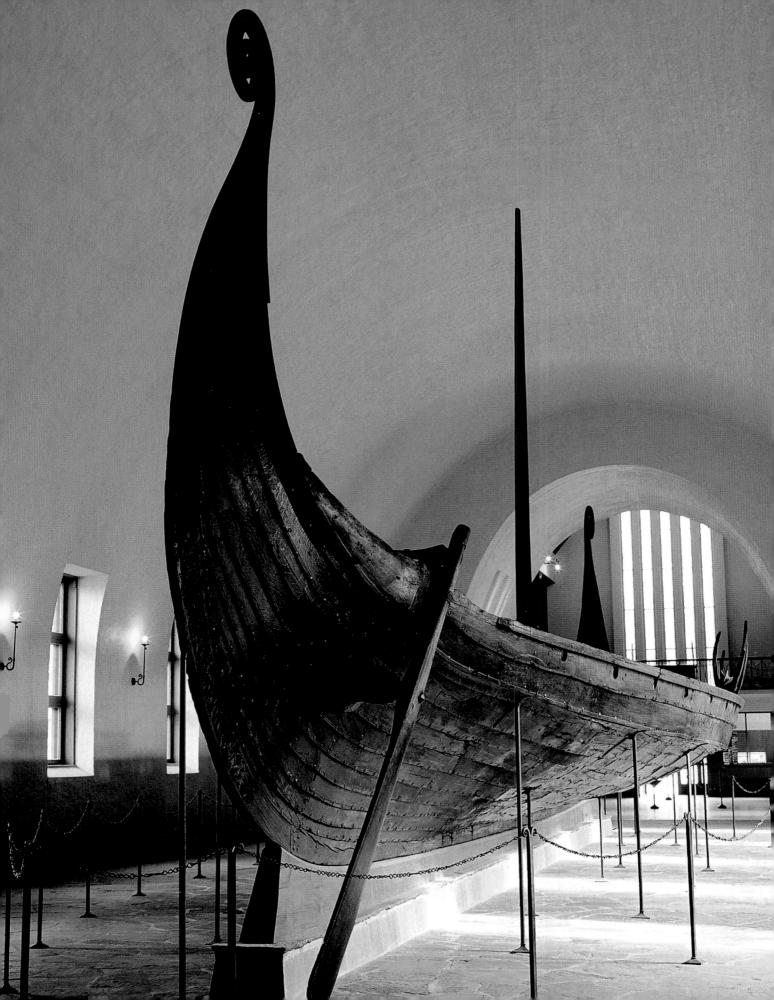

Fiefdom and Monastery, Pilgrimage and Crusade

The Early Medieval World in Europe

LEARNING OBJECTIVES

- 5.1 Describe what Anglo-Saxon art and literature tell us about Anglo-Saxon culture.
- 5.2 Discuss Charlemagne's impact on medieval culture and the legacy of his rule.
- 5.3 Define the Romanesque and its relation to pilgrimage churches and the Cluniac abbey.
- 5.4 Examine the motivations for the Crusades and appraise their outcome.
- 5.5 Explain the courtly love tradition as it manifests itself in the literature of the period.

utton Hoo lies near the modern city of Ipswich, England, in the county of Suffolk, East Anglia (Map 5.1). There, a burial mound contains the remains of a wealthy and powerful Anglo-Saxon man, probably a seventh-century king. (Coins found at the site date to the late 630s.) The burial mound concealed a ship, 90 feet long and 14 feet wide, a little larger than a similar burial ship excavated in 1904 from Oseberg, just outside Oslo, Norway (Fig. 5.1). The burial ship at Sutton Hoo had been dragged up a 100-foot hill-or "hoo"-above the River Deben and laid in a trench. Midway between the ship's bow and stern, a house had been constructed. Inside the house was the coffin, accompanied by a treasure horde of richly decorative ornaments and armor, gold coins from France, silver spoons and bowls from the Eastern Mediterranean, and a wooden harp. The trench was filled in and a mound was raised over it. For 1,300 years it remained untouched, high above the Deben estuary, as if the dead warrior were standing perpetual guard over East Anglia, looking eternally out to sea.

The site was first excavated in 1939. Only two objects discovered there show any evidence of Christian culture—two silver spoons inscribed with the names Saulos and Paulos in Greek lettering. The names might refer to the biblical King Saul of the Hebrew Bible and Saint Paul of the New Testament. Christianity had, in fact, almost completely disappeared in England shortly after the Romans left in 406. Over the next 200 years, Germanic and Norse

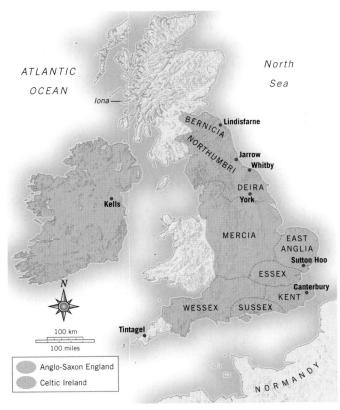

Map 5.1 Anglo-Saxon England and Celtic Ireland.

[▼] Fig. 5.1 Burial ship, from Oseberg, Norway. ca. 800. Wood, length 75'6". Vikingskiphuset, Universitets Oldsaksamling, Oslo. This ship served as a burial chamber for two women. They were laid out on separate beds in a cabin containing wooden chests (empty, but probably once filled with precious objects) and several wooden, animal-head posts.

tribes—Angles, Saxons, Jutes, and Frisians—invited in as mercenaries by Romanized British leaders, began to operate on their own. Their Anglo-Saxon culture, steeped in Germanic and Norse values and traditions, soon came to dominate cultural life in Britain. Nevertheless, at the time of the Sutton Hoo burial, the late 630s, Christianity had begun to reassert itself in England. There is some speculation that the elaborate Sutton Hoo burial ceremony, which included cremation—forbidden by Christianity—and apparent human and animal sacrifice, represented an open defiance of Christian practices.

At the time of its seventh-century burials, Sutton Hoo was, at best, a remote outpost of Anglo-Saxon culture, but no other archeological site has revealed more about the Anglo-Saxons. Whoever was buried there was a lord or chief to whom his followers owed absolute loyalty. This was the basis of the feudal societies that would later dominate European life in the Middle Ages. Feudalism is related to the Roman custom of patronage (see Chapter 3), under which a patron, usually a lord or nobleman, provided protection to a person who worked for him in exchange for his loyalty. In the Middle Ages, this relationship developed into an agriculturally based economic system, in which the tenant was obliged to serve the nobleman (often militarily) and pay him with goods or produce in exchange for the use of a piece of land—called a fief—and the nobleman's protection.

The rudiments of this system were in place in sixth-century England. The Anglo-Saxons comprised only about one-tenth of a total population of roughly one million; the remainder were Britons. The Anglo-Saxons controlled the land while the Britons largely worked it, and the wealth the Anglo-Saxons extracted from this relationship is everywhere apparent in the treasures discovered at Sutton Hoo. The nobles in control of their various fiefdoms in turn owed allegiance to their king, who was overlord of all the fiefdoms in his kingdom. In return for their loyalty, the king rewarded his nobles with gold, weaponry, and elaborately decorated items of personal adornment, like the artifacts buried at Sutton Hoo.

When Christianity was reintroduced to Anglo-Saxon England, the Church adapted the principles of feudalism. Instead of the tenant owing allegiance to his nobleman and the nobleman to his king, all owed allegiance to the Christian God. Briton and Anglo-Saxon alike might make gifts to the Church, and in return the Church offered them not protection, but salvation. As a result, the Church quickly became wealthy. To decorate its sanctuaries, the Church promoted the same refined and elaborate handiwork as the feudal lords had commissioned for their personal use, incorporating Christian themes and imagery into the animal and interlace styles of Germanic and Norse culture. And it acquired large parcels of property overseen by a clergy who were feudal lords themselves. These properties soon developed into large working monasteries, where like-minded individuals gathered in the pursuit of religious perfection. The monasteries in turn became great centers of learning.

These monasteries soon began to promote the idea of doing penance for one's sins by embarking on religious pilgrimages. Part of the reason seems to have been the increasing urbanization of Europe, and with it, worsening hygienic conditions that spread disease. Believing that disease was related to sinfulness, pilgrims sought to atone for their sins, saving themselves from sickness and contagion on earth and perpetual damnation in the afterlife. Political and religious motives also played a role. The pilgrimage to Mecca had played an important role in Islamic tradition, and the economic benefits realized by that relatively remote city on the Arabian peninsula were not lost on Rome. But more important, the religious value of a Christian pilgrimage to Jerusalem—the most difficult and hence potentially most rewarding of Christian pilgrimages—demanded that the Western Church eliminate Muslim control of the region, a prospect the Church frankly relished. By 1100, thousands of pilgrims annually were making their way to Jerusalem, which Christian forces retook in 1099 in the First Crusade, and to Rome, where the remains of Saints Peter and Paul were housed. Large numbers of pilgrims traveled across Europe to Santiago de Compostela, in the northwest corner of present-day Spain, where the body of the apostle Saint James the Greater lay at rest, and in England, pilgrims would soon journey to Canterbury to worship at the shrine of Saint Thomas à Becket, the Archbishop of Canterbury, who had staunchly defended the authority of the Church over that of the English throne, resulting, in 1170, in his assassination.

This chapter outlines the rise to power of feudal society and the adaptation of feudal practices by the medieval kings and emperors and by the Christian Church. Perhaps the most important ruler to codify and adopt these practices was Charlemagne, who dreamed not only of unifying Europe under his rule, but also of unifying Church and State in a single administrative and political bureaucracy. Although Charlemagne's empire dissolved with his death in 814, within 30 years of his death, subsequent rulers, such as the Ottonian kings in Germany, followed his example by building a tightly knit political bureaucracy and championing the arts. But the Church competed with the kings for the loyalty of the people, and in its architecture. its art, and the music of its liturgy, the Church sought to appeal to the emotions of the people, calling on them to reject the worldly aspirations of the court and seek the rewards of heaven. The Church's power cannot be overstated. Churches at pilgrimage sites, and others along the routes, were designed to accommodate large numbers of pilgrims, giving rise to what is today known as the Romanesque style. Religious zeal defined the era, highlighted by the call to recapture Jerusalem from Muslim control and the military Crusades to the Middle East that followed. A new, secular literature arose as well, a poetry and prose of courtly love.

ANGLO-SAXON ARTISTIC STYLE AND CULTURE

What can we learn about Anglo-Saxon culture from its art and literature?

A purse cover from the Sutton Hoo site (Fig. 5.2) is a fine example of the artistic style of this non-Christian Germanic culture. It is a work of cloisonné, a technique in which strips of gold are set on edge to form small cells. The cells are then filled with a colored enamel glass paste and fitted with thin slices of semiprecious stones (in this case, garnet). At the top of the purse cover shown here, two hexagons flank a central motif of animal interlace. In this design two pairs of animals and birds, facing each other, are elongated into serpentine ribbons of decoration, a common Scandinavian motif. Below this, two Swedish hawks with curved beaks attack a pair of ducks. On each side of this design, a male figure stands between two animals. This animal style was used in jewelry design throughout the Germanic and Scandinavian world in the era before Christianity. Notice its symmetrical design, its combination of interlaced organic and geometric shapes, and, of course, its animal motifs. Throughout the early Middle Ages, this style was imitated in manuscripts, stone sculpture, church masonry, and wood sculpture.

In many ways, the English language was shaped by Anglo-Saxon traditions. Our days of the week are derived from the names of Saxon gods: Tuesday and Wednesday are named after two Saxon gods of war, Tiw and Woden. Thursday is named after Thor, the god of thunder, and Friday after Frigg, Woden's wife. Similarly, most English placenames have Saxon origins. Bury means fort, and Canterbury means the

fort of the Cantii tribe. *Ings* means tribe or family; Hastings is where the family of chief Haesta lived. *Strat* refers to a Roman road; Stratford-on-Avon designates the place where the Roman road fords the river Avon. *Chester* means Roman camp, as in Dorchester; *minster* means monastery, as in Westminster; and *ham* means home, as in Nottingham.

Anglo-Saxon culture revolved around the king and his thanes (lords). The king possessed his own large estate, as did each of his thanes, and the king and his retinue moved continually among the estates of the thanes, who owed hospitality and loyalty to the throne. Aside from these few powerful persons, feudal society was composed of peasants. Some were ceorls, or churls, free men who owned farms of 90 to 100 acres. Others rented land from the thanes, usually in lots of 20 acres. They paid their lord in goods—sheep or grain—and worked his fields two or three days per week. All employed serfs (day laborers) and thralls (slaves), often captives of wars. (Evidence suggests that by the eighth century, the Anglo-Saxons were routinely marketing slaves abroad, in France and Rome particularly.) Runaway slaves were punished by death, as were those convicted of disloyalty to their thanes.

Anglo-Saxon law was based on the idea of the wergeld, or "life-price" of an individual. A thane's value was roughly six times that of a churl, and a thrall had no value at all. If a thane were killed (or injured), his family (or, in the case of injury, he himself) was entitled to be compensated at the highest fixed rate. But a thane could kill or injure a thrall with no wergeld due at all. The wergeld for men and women was identical, although a pregnant woman was worth as much as three times the usual rate, and a woman's potential as a bearer of children could raise her value even if she were not pregnant.

Fig. 5.2 Purse cover, from Sutton Hoo burial ship. ca. 625. Gold with Indian garnets and cloisonné enamels, originally on an ivory or bone background (now lost), length 8". © The Trustees of the British Museum. This elaborate purse lid-would have been attached to the owner's belt by hinges. In the Sutton Hoo burial mound, the purse contained gold coins and ingots.

Beowulf, the Oldest English Epic Poem

This rigidly hierarchical nature of feudal society is probably nowhere better demonstrated than in the oldest English epic poem, *Beowulf*. In the poem, a young hero, Beowulf, comes from afar to rid a community of monsters, headed by the horrific Grendel, who have been ravaging it. He returns home to his native Sweden and rules well for 50 years, until he meets a dragon who is menacing his people. Beowulf demonstrates his fierce courage and true loyalty to his vassals by taking the dragon on, but it kills him. The lesson drawn from his fate is a simple one: "So every man must yield/ the leasehold of his days."

Beowulf concludes with the hero's warriors burning his body along with his treasures on a funeral pyre, thus rounding out a story that opens with a burial as well. A treasure very much like that found in the Sutton Hoo ship burial is described just 26 lines into the poem, when the death of Danish king Shild Sheafson is described (Reading 5.1):

READING 5.1

Beowulf, trans. Burton Raffel

When his time was come the old king died, Still strong but called to the Lord's hand. His comrades carried him down to the shore. Bore him as their leader had asked, their lord And companion, while words could move on his tongue. Shild's reign had been long; he'd ruled them well. There in the harbor was a ring-prowed fighting Ship, its timbers icy, waiting, And there they brought the beloved body Of their ring-giving lord, and laid him near The mast. Next to that noble corpse They heaped up treasures, jeweled helmets. Hooked swords and coats of mail, armor Carried from the ends of the earth; no ship Had ever sailed so brightly fitted, No king sent forth more deeply mourned. Forced to set him adrift, floating As far as the tide might run, they refused To give him less from their hoards of gold Than those who'd shipped him away, an orphan And a beggar, to cross the waves alone. High up over his head they flew His shining banner, then sadly let The water pull at the ship, watched it Slowly sliding to where neither rulers Nor heroes nor anyone can say whose hands Opened to take that motionless cargo.

The findings at Sutton Hoo, as well as the ship discovered at Oseberg (see Fig. 5.1), suggest that *Beowulf* accurately reflects many aspects of life in the northern climates of Europe in the Middle Ages. The poem was composed in Anglo-Saxon, or Old English, sometime between 700 and 1000 ce, handed down first as an oral narrative and later transcribed. Its 3,000 lines represent a language that predates the merging of French and English tongues after 1066, when William

the Conqueror, a Norman duke, invaded England. The poem survived in a unique tenth-century manuscript, copied from an earlier manuscript and itself badly damaged by fire in the eighteenth century. It owes its current reputation largely to J.R.R. Tolkien, author of *The Lord of the Rings*, who in the 1930s argued for the poem's literary value. The source of Tolkien's attraction to the poem will be obvious to anyone who knows his own great trilogy.

Beowulf is an English poem, but the events it describes take place in Scandinavia. One of its most notable literary features, common to Old English literature, is its reliance on compound phrases, or **kennings**, substituted for the usual name of a person or thing. Consider, for instance, the following line:

Hwæt we Gar-Dena in gear-dagum So. The Spear-Danes in days gone by

Instead of saying "the past," the poem says gear-dagum, which literally means "year-days." Instead of "the Danes," it says Spear-Danes, implying their warrior attributes. The poet calls the sea the fifelstréam, literally the "sea-monster stream," or "whale-path," and the king, the "ring-giver." A particularly poetic example is beado-leoma, "battle-light," referring to a flashing sword. In a sense, then, these compound phrases are metaphoric riddles that context helps to explain. Beowulf contains many such compounds that occur only once in all Anglo-Saxon literature—hapax legomena, as they are called, literally "said or counted once"—and context is our only clue to their meaning.

Some have interpreted phrases such as Shild Sheafson's crossing "over into the Lord's keeping" as evidence that the poem is a Christian allegory. But although Beowulf does indeed give "thanks to Almighty God," and admit that his victory over the monster Grendel would not have been possible "if God had not protected me," there is nothing in the poem to suggest that this is the Christian God. There are no overtly Christian references in the work. The poem teaches its audience that power, strength, fame, and life itself are fleeting—a theme consonant with Christian values, but by no means necessarily Christian. And although Beowulf, in his arguably foolhardy courage at the end of the poem, displays a Christlike willingness to sacrifice himself for the greater good, the honor and courage he exhibits are fully in keeping with the values of feudal warrior culture.

The Merging of Pagan and Christian Styles

Whatever *Beowulf*'s relation to Christian tradition, it is easy to see how the poem might have been read, even in its own time, in Christian terms. But after the Romans withdrew from Britain in 406, Christianity had survived only in the westernmost reaches of the British Isles—in Cornwall, in Wales, and in Ireland, where Saint Patrick had converted the population between his arrival in 432 and his death in 461. Around 563, an Irish monk, Columba, founded a monastery on the Scottish island of Iona. He traveled widely through Scotland and converted many northern Picts, a Scottish tribe, to Christianity. In about 635, almost simultaneous with

the pagan burial at Sutton Hoo, in which only a few if any Christian artifacts were discovered, a monk from Iona built another monastery at Lindisfarne, an island off the coast of Northumbria in northeast England. The "re-Christianization" of Britain was underway.

Meanwhile, in 597, Pope Gregory I (papacy 590-604) sent a mission to England of 40 monks, headed by the Benedictine prior Augustine (d. 604)—not the same Augustine who had written The Confessions and The City of God—to convert the pagan Anglo-Saxons. Gregory urged Augustine not to eliminate pagan traditions overnight, but to incorporate them into Christian practice. In a letter sent to Augustine in 601, he wrote: "For it is certainly impossible to eradicate all errors from obstinate minds at one stroke, and whoever wishes to climb a mountaintop climbs gradually step by step, and not in one leap." This is one reason that the basic elements of the animal style, evident in the purse cover from Sutton Hoo (see Fig. 5.2), appear in a manuscript page from the Lindisfarne Gospels, designed by Bishop Eadfrith of Lindisfarne in 698 (Fig. 5.3). Notice particularly how the geometric grids in the border decoration of the purse cover are elaborated in the central circle of the Lindisfarne carpet page (a descriptive term, not used in the Middle Ages, that refers to the resemblance between such pages and Turkish or Islamic carpets). The animal interlace of the purse cover reappears in the corner designs that frame the central circle of the carpet page, where two birds face outward and two inward. And the beasts that turn to face each

other in the middle of the purse cover are echoed in the border figures of the carpet page, top and bottom, left and right. The pre-Christian decorative vocabulary of the Sutton Hoo treasure, created to honor a pagan king, has been transformed to honor the Christian conception of God.

This syncretic style—a style in which different practices and principles are combined—which flourished in England and Ireland during the early Middle Ages, is called *Hiberno-Saxon*

Fig. 5.3 Bishop Eadfrith, Carpet Page, from the *Lindisfarne Gospels*, Northumbria, England. ca. 698. Tempera on vellum, 13½" × 9¾". British Library, London. An inscription on the manuscript identifies Eadfrith as its scribe and decorator, Ethelwald as its binder, Billfrith as the monk who adorned it with gems, and Aldred as its translator into Anglo-Saxon: "Thou living God be mindful of Eadfrith, Ethelwald, Billfrith, and Aldred a sinner; these four have, with God's help, been engaged upon this book."

(Hibernia is the Latin name for Ireland). Hiberno-Saxon manuscript illustration is notable particularly for its unification of Anglo-Saxon visual culture with the textual tradition of Christianity. In the monastic scriptoria (singular scriptorium)—the halls in which monks worked to copy and decorate biblical texts—artists soon began to decorate the letterforms themselves, creating elaborate capitals at the beginning of important sections of a document. One of the

Fig. 5.4 *Chi Rho lota* page, *Book of Matthew, Book of Kells*, probably made at lona, Scotland. Late 8th or early 9th century. Tempera on vellum, 13" × 9½". Trinity College Library, Dublin, MS 58 (A.1.6.), fol. 34v. While the abbreviation for *Christi—XPI* or *Chri—*dominates the page, the remainder of the verse from Matthew is at the bottom right. *Autem* appears as an abbreviation resembling the letter *h*, followed by *generatio*, which is fully written out. So common were abbreviations in manuscript illumination, saving both time and space, that the scribes were often given the title of official court "abbreviator."

most beautiful capitals is a page from the *Book of Kells*, made at Iona in the late eighth century (Fig. **5.4**). The basis of the design consists of the Greek letters *chi*, *rho*, and *iota* (*X*, *P*, and *I*, or *chri*), an abbreviation of *Christi*. In this instance, the text begins *Christi autem generatio*, "Now this is how the birth of Jesus Christ came about," quoting Matthew 1:18. The dominant letterform is *chi*, a giant unbalanced *X* much larger on the left than on the right. Below the right side of the *chi* is *rho*, which curves around and ends with the head of a red-haired youth, possibly a depiction of Christ, which also dots the *I*. Not long after Ionian monks completed this manuscript, Vikings began to threaten the Scottish coast, and the monks retreated to Kells in the interior of Ireland. So great was the renown of the book they had created that in 1006 it was referred to as "the chief relic of the Western world."

The task of Christian missionaries in England was to transfer the allegiance of the people from their king, or thane, to God. They could not offer gold, or material wealth, but only

salvation, or spiritual fulfillment. They had to substitute for the great treasure at Sutton Hoo the more subtle treasures of faith and hope. The missionaries' tactic was simple—they bathed the spiritual in material splendor. They illuminated their manuscripts with a rich decorative vocabulary. They adorned Christianity in gold and silver, jewels and enamel, and placed it within an architecture of the most magnificent kind. And they transplanted pagan celebrations to the context of the Christian worship service.

A manuscript page probably created at Canterbury in the first half of the eighth century is revealing on this last point (Fig. 5.5). It depicts an enthroned David, author of the Psalms, surrounded by court musicians. The scene could as easily illustrate an episode in *Beowulf* when a great celebration takes place in Hrothgar's hall after Beowulf defeats the monster Grendel:

Hrothgar's hall resounded with the harp's High call, with songs and laughter and the telling Of tales, stories sung by the court Poet as the joyful Danes drank And listened, seated along their mead-benches.

Beowulf, Il. 1063-67

Fig. 5.5 Page with *David and Court Musicians*, now fol. 30b, but likely once the frontispiece of the *Vespasian Psalter*, Canterbury, England.

First half of 8th century. British Library, MS Cotton Vespasian A.i. A psalter is a book of psalms. One of the most interesting aspects of this illustration is that it suggests that instrumental music may have played a role in Christian liturgy long before the twelfth century, when instrumentation is usually thought to have been introduced.

David, indeed, is a Judeo-Christian version of "the court poet," only his king is the Christian God. More to the point, the harp that David plays in the manuscript illustration is very like the six-stringed wooden harp discovered at Sutton Hoo. As the animal-style frames and borders of the scene suggest, this is a celebration any Anglo-Saxon noble would have recognized. In the centuries to come, Christianity would create its own treasure trove, its own celebratory music, its own great halls (the cathedrals), and its own armored warriors fighting their own heroic battles (the Crusades). Beowulf's Grendel would become the infidel Muslim, and his king, his Lord God.

CAROLINGIAN CULTURE

How did Charlemagne change medieval culture, and what was his legacy to the Frankish kings?

Although England was slow to Christianize, the European continent was not. Christianity was firmly established in 732, at Poitiers, France, just south of Tours in the Loire Valley. There Charles Martel, king of the Franks, defeated the advancing Muslim army, which had entered Spain in 711 and had been pushing northward ever since. The Arabs retreated south, beyond the Pyrenees, and settled in Spain. The Franks were one of many Germanic tribes—like the Angles and Saxons in England—that had moved westward beginning in the fourth century CE. Most of these tribes adopted most of the Christian beliefs of the Roman culture they conquered, most notably the Ostrogoths in Italy, the Visigoths in southern Gaul (France) and Spain, the Vandals in North Africa, and the Franks, who controlled most of modern France.

Within a hundred years the Franks would come to control most of Western Europe under the leadership of Charlemagne, "Charles the Great" (r. 768–814) (Fig. 5.6). (It is for him that historians have labeled this the Carolingian era, from Carolus, Latin for Charles.) Charlemagne brought one after another pagan tribe to submission, forcing them to give up their brand of Christianity and submit to Rome's Nicene Creed. Charlemagne's kingdom grew to include all of present-day France, Holland, Belgium, Switzerland, almost all of Germany, northern Italy and Corsica, and Navarre in northern Spain (Map 5.2). Even larger areas paid him tribute. In return for his Christianization of this vast area, Pope Leo III crowned him emperor on Christmas Day, 800, creating what would later be known as the Holy Roman Empire.

The Song of Roland: Feudal and Chivalric Values

Charlemagne's military might was the stuff of legend. For centuries after his rule, tales of his exploits circulated throughout Europe in cycles of poems sung by *jongleurs*, professional entertainers or minstrels who moved from

Fig. 5.6 Equestrian statue of a Carolingian ruler. Early 9th century. Bronze with traces of gilt, height $9\frac{1}{2}$ ". Musée du Louvre, Paris. We are not certain who this statue represents, but he is representative of Carolingian kings. The real Charlemagne stood $6^{\circ}3\frac{1}{2}$ " tall, remarkably tall for the time.

court to court and performed chansons de geste ("songs of deeds"). The oldest of these, and the most famous, is the Song of Roland, a poem built around a kernel of historical truth transformed into legend and eventually embellished into an epic. Four thousand lines long, composed of tensyllable lines grouped in stanzas, it was transmitted orally for three centuries and finally written down in about 1100, by which time the story of a military defeat of little consequence had become an epic drama of ideological importance. The jongleurs sang the poem accompanied by a lyre. The only surviving musical notation for the poem are the letters AOI that end some verses. The exact meaning of this phrase is unclear, but it probably indicates a musical refrain, repeated throughout the performance. Most likely, the poem was sung in a syllabic setting, one note per syllable, in the manner of most folk songs even today. Its melody was probably also strophic—that is, the same music repeated for each stanza of the poem.

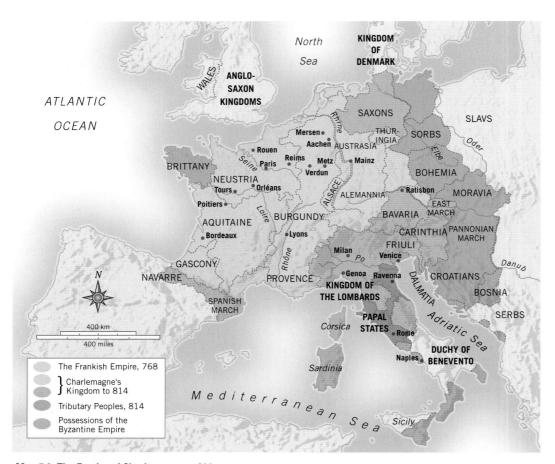

Map 5.2 The Empire of Charlemagne to 814.

The Song of Roland tells the story of an event that occurred in 778, when Charlemagne's rear guard, led by his nephew Roland, Roland's friend Oliver, and other peers, was ambushed by Muslim forces as Charlemagne's army returned from his invasion of Spain. (In fact, it was Basque Christians who ambushed Charlemagne, and he had actually been invited into Spain by Muslim Saracens to help them to fight other Muslims. However, over time, the story's villains were transformed from Basque Christians into Muslims for political and propagandistic purposes, as armies were organized to fight in the Middle East for the liberation of Jerusalem from Islam.)

The story is a simple one: The heroic Roland's army is betrayed by Ganelon, who tells the Saracen Muslim army of Roland's route through Roncevaux, where his 20,000 soldiers are attacked by 400,000 Muslims. Roland sounds his ivory horn, alerting Charlemagne to the Saracen presence, but by then the Frankish guard has been defeated. Discovering Roland and his army dead, Charlemagne executes the treacherous Ganelon, and an epic battle between Charlemagne and the Muslims ensues. Charlemagne is victorious—but not without divine intervention. Charlemagne's prayer keeps the sun from setting, allowing his army time to defeat the Saracens.

Roland as the Ideal Feudal Hero The poem embodies the values of feudalism, celebrating courage and loyalty to one's ruler above all else, in this case Roland's loyalty to Charlemagne. Although the feudal obligation of the vassal to his lord had long been established in Germanic culture—among the Anglo-Saxons, for instance—its purest form was probably Carolingian. Roland is an ideal feudal hero, courageous and loyal, but he possesses—or is possessed by—a sense of pride that inevitably leads to his demise, just as Beowulf's self-confidence leads to his. In the following reading (Reading 5.2), Roland's companion Oliver counsels Roland that the Muslim (Saracen) army is so great that he ought to use his horn, Oliphant, to call Charlemagne to help him, but Roland's pride prevails.

READING 5.2

Song of Roland

85 "Roland, my friend, I pray you, sound your horn! King Charlemagne, crossing the mountain pass, Won't fail, I swear it, to bring back all his Franks." "May God forbid!" Count Roland answers then. "No man on earth shall have the right to say

That I for pagans sounded the Oliphant!
I will not bring my family to shame.
I'll fight this battle; my Durendal shall strike
A thousand blows and seven hundred more.
You'll see bright blood flow from the blade's keen steel,
We have good men; their prowess will prevail,
And not one Saracen shall live to tell the tale."

86 Oliver says, "Never would you be blamed; I've seen the pagans, the Saracens of Spain. They fill the valleys, cover the mountain peaks; On every hill, and every wide spread plain, Vast hosts assemble from that alien race; Our company numbers but a few."
Roland replies, "The better, then, we'll fight! If it please God and His angelic host, I won't betray the glory of sweet France! Better to die than learn to live with shame—Charles loves us more as our keen swords win fame."

87 Roland is brave, and Oliver is wise; Both are so brave men marvel at their deeds. When they mount chargers, take up their swords and shields, Not death itself could drive them from the field. They are good men; their words are fierce and proud.

The loyalty of the Franks—and of Roland and Oliver in particular—to Charlemagne is expressed in these words, uttered by Roland a moment later:

In his lord's service, a man must suffer pain, Bitterest cold and burning heat endure; He must be willing to lose his flesh and blood. . . . And if I die, whoever takes my sword Can say its master has nobly served his lord.

It is out of a sense of duty that Roland turns to face the Saracens—duty to Charlemagne, his lord, and by extension, duty to the Christian God in the battle against Islam. Roland's insistence that he "will strike great blows with Durendal" (his sword is itself a gift from Charlemagne) expresses the Christian nature of the combat. Durendal's golden hilt conceals four relics (venerated objects associated with saints or martyrs), including hairs of Saint Denis, the patron saint of France, whose name the Franks shout as a battle cry. Thus, each blow is a blow for Christendom. The reward for such dutiful combat is, as he says, the love of his king. But it is also the love of the whole Christian world, demonstrated by the many visual retellings of episodes from the epic in church art and in manuscripts. Indeed, Roland ultimately sacrifices all for his king and his God. Mortally wounded in combat, he "knows that death is very near/ His ears give way, he feels his brain gush out." Explicit and vivid language heightens the intensity of the moment, and the directness lends credence to characters who are otherwise reduced to stereotypes ("Roland is brave, and Oliver is wise"). But, finally, in his slow and painful death—"Count Roland feels the very grip of death/ Which from his head is reaching for his heart"—he becomes a type for Jesus, sacrificing himself for all of Christendom.

The Chivalric Code The Song of Roland is one of the earliest expressions of feudalism's chivalric code. The term chivalry (from the French chevalier, "horseman") expressed the qualities of an ideal knight, and may in fact more nearly reflect the values of the eleventh century (when the poem was written down) than the eighth-century practices of Charlemagne's day. Nevertheless, something very like this set of values already exists in Beowulf. The chevalier was a knight (from the German knecht, "young soldier"), and he was guided by a strict, though unwritten, code of conduct: courage in battle, loyalty to his lord and peers, and a courtesy verging on reverence toward women. Although in practice these values often broke down, feudalism and chivalry were powerful mechanisms for maintaining social order and political harmony throughout medieval Europe.

Promoting Literacy

Across Europe, the Church had traditionally served as the chief guardian of culture. In its monastic centers, the Roman love of learning had been maintained, especially in the manuscripts transcribed by monastic copyists. But literacy was anything but widespread. Charlemagne sought to remedy this situation at his court at Aachen (modern Aix-la-Chapelle), which soon attracted leading scholars and artists, whose efforts Charlemagne rewarded handsomely. Chief among these was an Englishman, perhaps even of Anglo-Saxon origin, Alcuin of York (735–804), who in 782 became head of Charlemagne's court school. One of the foremost grammarians and theologians of the period, Alcuin served as Charlemagne's personal tutor.

Alcuin's main purpose in Aachen was to create a curriculum to promote literacy that could be disseminated throughout the Carolingian Empire. Schools designed to teach children basic skills in reading and writing and some further study in the liberal arts and theology were established in Lyon, Orléans, Mainz, Tours, Laon, and Metz, which was a center for singing and liturgy (see Map 5.2). By 798, a decree from Aachen ordered prelates and country clergy throughout the empire to start schools for children. The emphasis was on educating males. The work of the state bureaucracy would fall to them, and by receiving a Christian education, they would lead in accordance with Church principles. But there is evidence that girls, especially those of noble birth, were also admitted to the local schools created by Alcuin.

There was also a more specifically religious motive in educating the people. Charlemagne believed that to spread the gospel, people should be able to read aloud and sing in church, to say nothing of grasping the fundamental truth believed to be revealed in the Bible. Education thus furthered the traditional role of the Church. It provided a means for the Church—and Charlemagne's state as agent of the Church—to insert itself into the lives of every individual. Alcuin published a book of Old and New Testament passages to be read

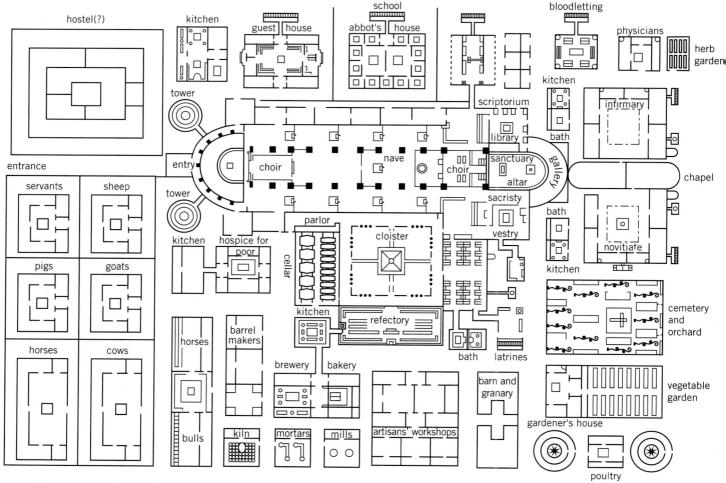

Fig. 5.7 Plan for a monastery at Saint Gall, Switzerland. ca. 820. Redrawn from an original in red ink on parchment (inscriptions translated into English from Latin). 28" × 441/6". Stiftsbibliothek, Saint Gall.

during Mass, as well as a book of prayers and rites that was made obligatory for all churches in the empire in 785. The last eight years of Alcuin's life were dedicated to producing a corrected version of the Latin Vulgate Bible that would become the standard text throughout the Middle Ages.

The Medieval Monastery

The monastery was a central part of Carolingian culture, arguably its most important institution. Before the Carolingian era, monastic life varied widely across Europe. In Italy, the rule of solitude (the Greek word monos, from which monasticism derives, means "alone") was barely enforced, and life in a monastery could be positively entertaining. If, as in Ireland, more austere conditions prevailed, still the lively intellectual climate of the monastery attracted men and women seeking a vocation. Even from monastery to monastery, different conditions and rules prevailed.

Charlemagne imposed on all monasteries in the Frankish kingdom the rule of Benedict of Nursia, an Italian monk who had lived two centuries earlier (ca. 480–547). The Rule

of Saint Benedict defined monastic life as a community of like-minded individuals, all seeking religious perfection, under the direction of an abbot elected by the monks. Monks were to live a family life in the pursuit of religious perfection. They were to possess nothing of their own, accepting worldly poverty. They were to live in one place and not wander, guaranteeing the community's stability. And they were never to marry, acknowledging their chastity. Each day was divided into eight parts, the horarium (from the Latin hora, "hour"). The horarium is the daily prayer schedule of liturgical praise called the Divine Office (the word "Office" comes from the Latin officium, meaning "duty"), marked by recitations of the psalms and the chanting of hymns and prayers at eight specific times of the day, between early morning and bedtime. Between services, the monks studied, worked, and ate a light breakfast and heartier dinner. They lived by the motto of their order: "Pray and work."

The Ideal Monastery: Saint Gall In about 820, Charlemagne sent a plan to the Swiss monastery of Saint Gall, near Lake Constance, representing his ideal monastery. Although there

is no evidence that it was ever actually employed, its functional, orderly arrangement was used in many Benedictine monasteries. As medieval historian Walter Horn pointed out in the 1970s, the original plan was laid out in modules, or standard units, of 21/2 feet, and the entire complex was composed of multiples or parts of this standard unit. The nave and the transept of the church, each 40 feet wide, are composed of 16 modules. The area where they cross is a perfect square with 16 modules on a side. Each arm of the transept is equal to the crossing square—that is, 16 modules square. The area between the transept and the apse is also one crossing square. And the nave is 4½ crossing squares long—or 56 modules. The rest of the monastery is built on this rational and orderly plan. The length of each monk's bed was to be 21/2 modules, the width of each garden path 11/4 modules, and so on. This systematic arrangement (Fig. 5.7) reflects an increasing tendency in medieval thinking to regard Christianity as a logical and rational philosophy of life, based on carefully constructed arguments and precise definition of parts as orderly as the "rule" of the day in the horarium.

Adjacent to the church, with its imposing western facade, is a cloister, or rectangular courtyard, typically arcaded and dedicated to contemplation and reflection. Beside it, on the east side, are the monks' dormitories, latrines, and baths, and on the west, storage cellars. To the south of the cloister is the refectory, or dining hall. Farther to the south, and to the west and east, behind and adjacent to the refectory are outbuildings housing all the facilities necessary to support a community of approximately 100 monks—a kitchen, a brewery, a bakery, a mill, workshops for artisans, barns for various animals, a vegetable garden (with its own gardener), and an orchard that doubles as a cemetery. This side of the monastery was reserved for the members of the community. Surrounding the entire complex were fields in which the brothers worked.

The general public could enter the north side of the monastery. Here, beside the entrance to the church, we find a hostel, or inn, for housing less well-to-do visitors, as well as a guesthouse for nobility, and between them a special kitchen (Saint Benedict had directed that monasteries extend hospitality to all visitors). Directly to the north of the church is the monastery school, dedicated, by imperial decree, to educating the youth of local nobility. Another school, the novitiate, to the east of the church, was dedicated to the education and housing of young novicesthose hoping to take vows and become brothers. In the northeast corner of the monastery was a public hospital, including an herb garden for remedies, the physician's quarters, and a facility for bloodletting-in the Middle Ages and until the nineteenth century the most common means of curing severe illness.

Women in Monastic Life Although the religious life offered women an alternative to life as housewife or worker, life in the convent or nunnery was generally available only to the daughters of aristocrats. Within the monastic system,

women could achieve significant prestige. Saint Benedict himself had a sister, Scholastica (d. ca. 543), who was the head of a monastery not far from his own. Hilda, abbess of Whitby (614–80), ran one of the most prominent Anglo-Saxon monasteries, a community of both monks and nuns. One of her most important acts was to host a Council at Whitby in an attempt to reconcile Celtic and Latin factions of the Church in England. She is one of the first women to have risen to a prominent position within the largely male medieval Church.

Roswitha of Gandersheim (ca. 935–75) never achieved Hilda's political prominence, but she was one of the notable playwrights of her day. Forgotten until the late fifteenth century, her plays concentrate on women whose personal strength and sense of self-worth allow them to persevere in the face of adversity and challenges to their modesty and chastity.

One of the foremost women of the age was Hildegard of Bingen (1098-1179), who ran the monastery at Bingen, near Frankfurt, Germany. She entered the convent at the age of eight and eventually became its abbess. Extraordinarily accomplished—she wrote tracts on natural science, medicine, and the treatment of disease, an allegorical dialogue between the vices and virtues, as well as a significant body of devotional songs (see the next section on monastic music)—she is best known as the first in a long line of female Christian visionaries and mystics, a role anticipated in Western culture by the Delphic priestesses (see Chapter 2). Her visions are recorded in the Scivias, a work whose title derives from the Latin Scite vias domini, "Know the ways of the Lord" (Reading 5.3). The Scivias was officially designated by the pope as divinely inspired. A zealous advocate for Church reform, Hildegard understood that this recognition lent her the authority to criticize her secular and Church superiors, including the pope himself, and she did not hesitate to do so.

READING 5.3

from Hildegard of Bingen, Scivias

In the year 1141 of the incarnation of Jesus Christ the Son of God, when I was forty-two years and seven months of age, a fiery light, flashing intensely, came from the open vault of heaven and poured through my whole brain.

And suddenly I could understand what such books as the psalter, the gospel and the other catholic volumes of the Old and New Testament actually set forth.

Indeed, from the age of girlhood, from the time that I was fifteen until the present, I had perceived in myself, just as until this moment, a power of mysterious, secret, and marvelous visions of a miraculous sort. . . . I have not perceived these visions in dreams, or asleep, or in a delirium, or with my bodily eyes, or with my external mortal ears, or in secreted places, but I received them awake and looking attentively about me with an unclouded mind, in open places, according to God's will.

Fig. 5.8 Facsimile of page with *Hildegard's Vision, Scivias*. ca. 1150—1200. Hildegard wrote 33 visionary tracts, collected in the *Scivias*, which were acknowledged by the Church as divine. The original manuscript was lost during World War II.

The page from the *Scivias* reproduced here (Fig. **5.8**) illustrates this passage. Hildegard is shown recording her divine revelation, as her copyist waits to transcribe her words. Such images were directly supervised by Hildegard herself.

Later in the *Scivias*, Hildegard has a vision of the devil embodied as a monstrous worm who oversees a marketplace full of material goods. After describing her vision, she interprets some of the key images. Hildegard's impulse to interpret her own words is typical of religious literature in the Middle Ages: Its primary purpose was to teach and instruct. But, more than that, Hildegard's *Scivias* shares with other visionary and mystical writing of the period an impulse to make the unknowable vividly present in the mind's eye of her audience. Like the Delphic priestess, she directly encounters the divine through revelation and vision.

Monastic Music Hildegard is responsible for more surviving compositions than any other musician, male or female, who worked before the early fourteenth century. Her *Ordo virtutum* ("Play of the Virtues") is a composition of texts and 82 melodies that dramatizes the conflict between good and evil. In it the devil, who never sings but shouts all his

lines, confronts a personification of each of the 16 Virtues. Hildegard collected all her liturgical works in a *Symphonia armonie electium revelationum* ("Symphony of the Harmony of Celestial Revelations"). Like her *Scivias*, Hildegard's music is designed to illuminate spiritual truths. She believed that in singing and playing music, the mind, heart, and body become one, discord among celebrants is healed, and the harmony of the heavens is realized on earth.

By the time Hildegard was composing, the liturgy, and particularly its music, had become remarkably unified. This had been accomplished at Charlemagne's insistence. Although we have no written melodies from Charlemagne's time, most scholars agree that he adopted a form that later became known as Gregorian chant—named after Pope Gregory the Great, the same pope who sent Augustine to England in 597. Called cantus planus, plainsong or plainchant, it consisted of monophonic songs (that is, songs for one or many voices singing a single melodic line with no harmony). The style of Gregorian chant probably originated in the way that ancient Jews sang the Psalms. In its simplest form, the chant is sung a capella (that is, without musical accompaniment) and performed in a syllabic style (a single note for each syllable). Often the final word of each phrase is emphasized by the addition of one or two other notes:

This is the opening line of Psalm 109 ("The Lord said to my Lord: sit on my right hand"). Its four-line staff would become the traditional Gregorian notation, with each note, or **neume**, indicated by a small square. Neumatic chant derives its name from these notes. In **neumatic** chant, the syllabic style gives way to a form in which each syllable is sung to two or three notes (track **5.1**). In later medieval chant, a single syllable may be sung to many notes, a practice known as **melismatic** chant (track **5.2**):

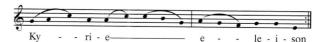

Kyrie eleison from opening of Mass

The Mass Since the earliest times, the celebration of the mass was a central rite of the Christian Church. It is a celebration of the Eucharist, the fulfillment of Jesus' instruction (recorded in 1 Corinthians 11:24–25) to do in memory of him what he did for his disciples at the Last Supper—that is, Jesus gave his disciples bread, saying, "This is my body," and wine, saying, "This is my blood." Christians generally recognized, in its celebration, the presence of Christ. In the medieval Mass, the *Kyrie*, which is either the first or the second element in every Mass, consists of three phrases: *Kyrie eleison* ("Lord, have mercy") is sung three times, followed by *Christe*

eleison ("Christ, have mercy"), likewise sung three times, and then another *Kyrie eleison*, set to different music, repeated three times again. The repetition of three phrases three times each is deeply symbolic, the number three referring to the Trinity, and the three squared (three times three) signifying absolute perfection.

The plainchant composed by Hildegard of Bingen is unique in the range of musical effects it employs. In contrast to the rather narrow scope of most chants of her day, she uses extremes of register to create "soaring arches" that, she believed, brought heaven and earth together. Although traditional plainchant rarely employed intervals greater than a second or third (one or two notes apart on a keyboard), Hildegard regularly used wider intervals such as fourths and fifths, again to create a sense of moving between the divine and the mundane. Her melodies ascend rapidly as if toward the heavens. She combines neumatic and melismatic passages; the former seem grounded in the everyday, while the latter suggest the joy of salvation. Her unique style can be more readily appreciated by comparing track 5.3 to the more traditional approaches to plainchant represented in tracks 5.1 and 5.2.

The most important single element in determining the nature of a given plainchant melody is its function in the liturgy, which remained consistent from the time of Charlemagne through the sixteenth century. Certain chants, focusing on the Psalms, were composed specifically for the eight *horarium* (hours) of the Divine Office and sung exclusively by cloistered monks and nuns. The Rule of Saint Benedict required that all 150 Psalms be recited each week.

The Mass had its own repertoire of plainchant. It was celebrated once each day, between 6 AM and 9 AM in every church, convent, and monastery, and was open to any baptized member of the community or congregation. Some elements were part of every Mass, including the Credo, a musical setting of the Nicene Creed (see Chapter 4), while others were sung only on special Sundays or feast days of the liturgical year. The liturgical year revolves around two major feast days, Christmas and Easter; each is preceded by a season of penitence.

Charlemagne standardized the liturgy by creating several singing schools, including one at Saint Gall, where plain-chant was taught to choirmasters from throughout the empire. "In every bishop's see," he ordered in 789, "instruction shall be given in the psalms, musical notation, chant, the computation of the years and seasons, and grammar."

Capetian France and the Norman Conquest

In the middle of the ninth century, Northern Europe was invaded by Normans—that is, "Northmen"—Viking warriors from Scandinavia. The Viking onslaught was devastating, as they plundered and looted across the north European seas, targeting especially isolated but wealthy monasteries such as Lindisfarne, which they had attacked even earlier, in 793. The Viking invasions fragmented the former empire and caused nobility, commoners, and peasants alike to attach themselves to anyone who might provide military

protection—thus cementing the feudal system. By the tenth century, they had raided, explored, and settled territories from North America, which the explorer Leif Eriksson reached about the year 1000, to Iceland, Greenland, the British Isles, and France. In France, they besieged Paris in 845 and gained control of the lower Seine Valley. In 915, the Frankish king Charles III (r. 893–923) was forced to grant the Norse leader Rolf, or Rollo, permanent control of the region. Rollo became the first duke of Normandy.

The rest of the western Carolingian Empire, now called France, remained fragmented, with various counts and dukes competing for power. Finally, in 987, Hugh Capet, lord of the Île-de-France, a relatively small domain stretching from Paris and its environs south to Orléans in the Loire Valley, was selected to serve as king. Hugh began a dynasty of Capetian kings that ruled for the next 350 years. From the beginning, the Capetians concentrated their energy on building a tightly knit administrative bureaucracy. Their most contentious relationship was with the dukes of Normandy, who were fiercely independent, going so far as to claim England for themselves, independent of Capetian influence.

The Normans invaded England in 1066, a story narrated in the famous *Bayeux Tapestry* (see *Closer Look* on pages 160–61). England and northern France thus became one country, with one king, William I, the Conqueror, and a small group of barons who owned estates on both sides of the English Channel. To both pacify and defend themselves against the Saxons, the Normans constructed **motte and bailey** castles (Fig. **5.9**). A motte is a raised earth mound, and a bailey is the enclosed courtyard at its base. Archeologists estimate that the Normans

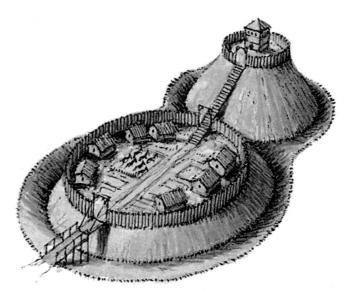

Fig. 5.9 Motte and bailey castle. When Normans first landed in England, they constructed mounds, called *mottes*, upon which they built a square wooden tower called a *keep*. First used as a lookout tower and elevated fighting point, the keep later became an accommodation for the lord of the castle. At the foot of the motte was a flat area called a *bailey*, surrounded by a wooden stockade. Domestic buildings, including stables, kitchens, and servants' quarters, were located in the bailey. A moat, or trench filled with water, often surrounded the castle—a natural result of digging dirt for the motte.

CLOSER LOOK

he Bayeux Tapestry—actually a 231-foot embroidery—was sewn between 1070 and 1080, almost certainly by women at the School of Embroidery at Canterbury, in Kent, England. It is one of the few surviving works by women we have from the period. The embroiderers of the Bayeux Tapestry worked with twisted wool, dyed in eight colors, and used only two basic stitches. It was commissioned by Bishop Odo of Bayeux, half-brother of William, Duke of Normandy, whose conquest of England in 1066 it narrates in both pictures and words (in Latin). Like the Column of Trajan (see Fig. 3.16 in Chapter 3) in Rome, its story is both historical and biased. The tapestry was designed to be hung around the choir of Odo's Bayeux Cathedral—an unabashed act of self-promoting propaganda on the part of the Normans.

When the English king Edward the Confessor died on January 5, 1066, without an heir, William, Duke of Normandy, claimed the throne, swearing that Edward had promised William the English throne when Edward died. But on his deathbed, Edward named Harold of Wessex king, while two other contenders, Harold Hardrada of Norway and Tostig, Earl of Northumbria, also laid their claims. Battle was inevitable.

William was particularly unhappy with Harold of Wessex's claim to the throne. Harold had visited Normandy, sometime between 1064 and the end of 1065, at the insistence of King Edward. In fact, the *Bayeux Tapestry* begins at this point. The tapestry narrates the Norman point of view, so its reliability is uncertain, but according to both the tapestry and other Norman sources, during his stay, Harold recognized William as Edward's heir. Whether Harold did so willingly is debatable—even the tapestry shows Harold being taken prisoner by a vassal of William.

Harold was back in England before Edward died, and he became king, abrogating whatever oath he may have sworn to William. The tapestry shows him in February with Halley's Comet in the sky—interpreted by the Anglo-Saxons as a portent of disaster and resulting, the tapestry implies, from his having broken his oath. Ghost ships, perhaps from a dream, decorate the border below the troubled king, foreshadowing the invasion to come.

As William prepared to invade England from the south, Harold Hardrada and the Norwegians prepared to press their own claims from the north. The weather determined the course of battle. Strong northerly winds kept William docked in Normandy, but the same winds favored the Norwegians, who soon landed on the north coast. Harold met them at Stamford Bridge, near York, on September 25, 1066, and

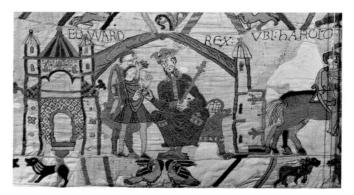

The Bayeux Tapestry. 1070–80. Embroidered wool on linen, height 6'. Entire length of fabric 231'. Musée de la Tapisserie, Bayeux, France. With special authorization of the city of Bayeux/The Bridgeman Art Library. This, the first section of the tapestry, depicts King Edward the Confessor talking to Harold, Earl of Wessex, his wife's brother. He is sending Harold on a mission to France, ostensibly to tell William, Duke of Normandy, that he will be Edward's successor.

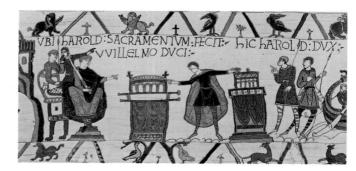

The Bayeux Tapestry. 1070–80. Musée de la Tapisserie, Bayeux, France. With special authorization of the city of Bayeux/The Bridgeman Art Library. Harold swears allegiance to William, his right hand on the altar between them, and his left on a chest that presumably houses sacred objects from the cathedral at Bayeux.

defeated them. By then, the winds had changed, and William sailed from the south, landing in Sussex. Harold turned his troops southward, but exhausted from both battle and the hurried march, they were defeated by William's army at Hastings on October 14, 1066. Harold died in the battle. The embroidery ends with a simple statement—"and the English turned and fled"—as if there is nothing more to say.

For seven centuries, the tapestry was cared for at Bayeux Cathedral, where it was hung round the nave on feast days and special occasions. It escaped destruction in the French Revolution in 1789, and was taken to Paris in the early eighteenth century when Napoleon exhibited it in his own propaganda campaign as he prepared to invade England.

The Bayeux Tapestry

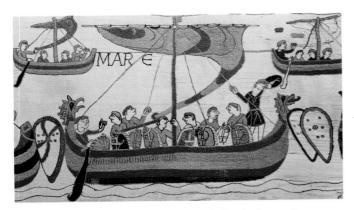

The Bayeux Tapestry. 1070–80. Musée de la Tapisserie, Bayeux, France. With special authorization of the city of Bayeux/The Bridgeman Art Library. The Normans sail for England. Note the animal-head prow of the ship, which underscores the Norse origins of the Normans.

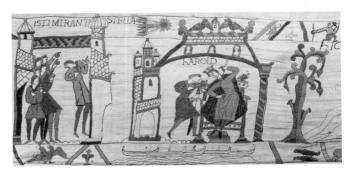

The Bayeux Tapestry. 1070–80. Musée de la Tapisserie, Bayeux, France. With special authorization of the city of Bayeux/The Bridgeman Art Library. Having returned to England just before Edward's death and having assumed the throne, Harold is disturbed by the arrival of a comet with a fiery tail, visible in the top border.

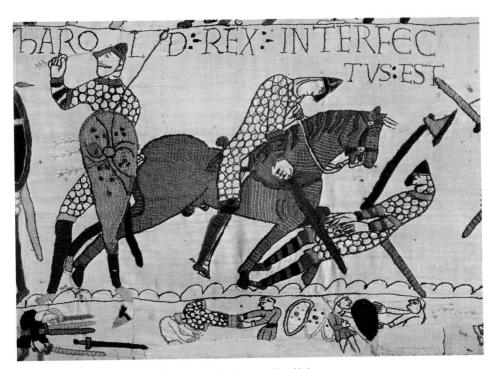

The Bayeux Tapestry. 1070–80. Erich Lessing/Art Resource New York. Harold, with the green shield, receives an arrow to the eye at the Battle of Hastings. Immediately to the right, a Norman soldier slays him. Note the soldiers stripping armor from the dead in the bottom border.

Something to Think About . . .

Looking more closely at the sections of the narrative reproduced here, in what ways does the tapestry reveal itself to be a work of propaganda?

built about 500 of them between 1066 and 1086, or one every two weeks. Such fortifications could be built in as little as eight days. In time, elaborate stone castles would replace these fire-prone wooden fortifications.

Fearing an invasion from Denmark, William I ordered a complete survey of the country so that he could more accurately determine how much tax he could raise to provide a new army. Known as the Domesday (or "Judgment") Book, it measured the population of England at about 1 million, with fully threequarters of the country's wealth resting in the hands of the king and 300 landowners. Two hundred of these were French nobles, and only two were English. The other hundred were archbishops, bishops, and the heads of monasteries. The rest of the land was in the hands of small farmers, and 90 percent of the population worked on the land. Some were freemen, but most owed at least partial allegiance to a local lord. Ten percent of the people were serfs, who owned no land at all. The Domesday Book gives us a remarkable view of medieval society and of the great gulf between rich and poor on which it was based.

PILGRIMAGE CHURCHES AND THE ROMANESQUE

How does the Romanesque style manifest itself in both pilgrimage churches and the Cluniac abbey?

Throughout the Middle Ages, it was customary for Christians to go on religious pilgrimages to holy places or sites containing sacred objects. People believed that their prayers for forgiveness, healing, fertility, or anything else would have a better chance of being fulfilled if they were

able to get physically close to a holy object, person, or site. The pilgrimage was also an act of piety, demonstrating the pilgrim's faith, and, in part, an act of penance. As Europe became increasingly urbanized, worsening hygienic conditions spread disease. Believing that disease was related to sinfulness, pilgrims sought to atone for their sins, saving themselves from sickness and contagion on earth and perpetual damnation in the afterlife.

Perhaps because it was closer to Northern Europeans than either Jerusalem or Rome, Santiago de Compostela was by far the most popular site of pilgrimages in the

Map 5.3 The pilgrimage routes through France and Spain.

Fig. 5.10 Abbey Church of Sainte-Foy, Conques, Auvergne, France. ca. 1050–1120. Sainte-Foy was the second church on the route to Santiago de Compostela that began at the church of Saint Michel d'Aiguilhe at Le Puyen-Velay.

eleventh through thirteenth centuries. It had also developed a reputation for repeated miracles, and by the midtwelfth century, a *Pilgrim's Guide to Santiago de Compostela* had appeared. Written in Latin, probably by monks in southern France, it describes and illustrates the towns and monuments on the major pilgrimage routes through France and Spain (Map 5.3).

Specific routes soon developed that allowed pilgrims to visit other sacred sites along the way. These sites housed the relics—bones, clothing, or other possessions—of Christian saints and martyrs. Relics arrived, virtually by the boatload, from the Middle East, where Crusaders, fighting the Muslims for control of Jerusalem and other sites sacred to Christianity, purchased them for resale in the West. The resale of these artifacts, whose authenticity was often questionable, helped to finance the Crusades. What was reputed to be the tunic that the Virgin Mary wore when she gave birth to Christ was housed at Chartres. At Vézelay, the starting point of one of the four routes to Santiago de Compostela, pilgrims could pray to what were asserted to be the bones of Mary Magdalene.

The Abbey Church of Sainte-Foy at Conques is the oldest of the major pilgrimage churches (Fig. 5.10). It is one of the earliest examples of a style that art historians have come to call the Romanesque, "in the manner of the Romans," because it revives elements of Roman architectural tradition. The basilica tradition that extends back to the Roman Basilica Nova (see Fig. 3.36 in Chapter 3) became the model for the Romanesque church floor plan, although the wooden ceilings of such churches as Old Saint Peter's (see Figs. 4.6 and 4.7 in Chapter 4) were replaced by much more fire-resistant barrel vaults.

The portals of the new pilgrimage churches were modeled on the triumphal arches of Rome, but they celebrate the triumph of the Christian God, not a worldly leader. Such a

CONTINUITY & CHANGE

The Arch of Titus, p. 96

revival of architectural tradition, reaching back for almost an entire millennium, represents in part a lack of technological innovation rather than a philosophical return to Roman traditions. However, the Christian adoption of Roman architectural styles also underscores the long-standing Christian rejection of its Judaic heritage—the Temple and the synagogue—

as well as a growing identification with the Greco-Roman West. As this identification took hold, religious fervor came to define the age.

The Abbey Church at Conques housed the relics of Saint Foy ("Saint Faith" in English), a child who was martyred in 303 for refusing to worship pagan gods. Her remains were contained in an elaborate jeweled **reliquary** (Fig. **5.11**), a container used to protect and display sacred relics. It stood in the choir of the church, where pilgrims could view it from the ambulatory. The head of the reliquary, which is disproportionately large, was salvaged from a late Roman wooden mask and covered with gold foil. Many of the precious stones that decorate the reliquary were gifts from pilgrims. The actual remains of the saint were housed in a recess carved into the back of the reliquary, and below it, on the back of her throne, was an engraving of the Crucifixion, indicating the connection between Saint Foy's martyrdom and that of Christ.

In common with the largest of the pilgrimage churches, the Abbey Church of Sainte-Foy was constructed to

Fig. 5.11 Reliquary effigy of Saint Foy, made in the Auvergne region, France, for the Abbey Church of Sainte-Foy, Conques. Mostly 983–1013, with later additions. Gold and silver over a wooden core, studded with precious stones and cameos, height 34". Church Treasury, Conques. This jewel-encrusted reliquary survived because monks hid it in the wall of the church when Protestants burned the abbey in 1568. It was not discovered until restoration of the church in the 1860s.

© 2014 Artists Rights Society (ARS), New York/VG Bild Kunst, Bonn

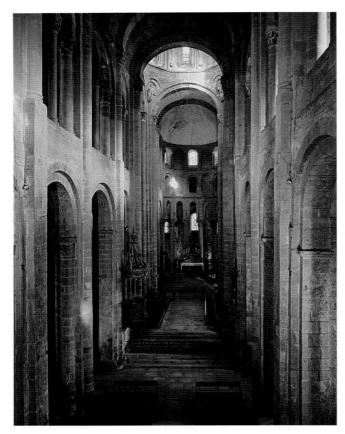

Figs. 5.12 and 5.13 Floor plan and interior of the nave, Abbey Church of Sainte-Foy, Conques. ca. 1050–1120. Some of the innovations of the Romanesque cathedral can be explained, at least in part, by the need to allow pilgrims to pass through the church without disturbing the monks as they attended to their affairs at the main altar in the choir. Thus, an ambulatory extended around the transept and the apse where pilgrims could walk.

accommodate large numbers of visitors. Its west portal was large and opened directly into the nave (Figs. 5.12 and 5.13). Wide aisles skirted the nave and continued around the transept, choir, and apse, creating the ambulatory. A second-story gallery was built over the side aisles; it both accommodated still more people and served structurally to support the extra weight of the arched stone ceilings of the nave's barrel vault. These vaults are one of the distinctive features of Romanesque architecture. As we saw in Chapter 3, barrel vaults are elongated arched masonry structures spanning an interior space and shaped like a half cylinder. In Romanesque churches, the space created by such vaults was designed to raise the worshiping pilgrims' eyes and thus direct their thoughts to heaven.

The pilgrimage churches evidently competed with one another in decorating their basilicas. Writing in the eleventh century, the French Benedictine monk Raoul Glaber noted: "throughout the world, especially in Italy and Gaul, a rebuilding of church basilicas [is occurring], . . . each Christian people striving against the others to erect nobler ones." The portals to the churches were of special importance. Not only was the portal the first thing the visitor would see, it also

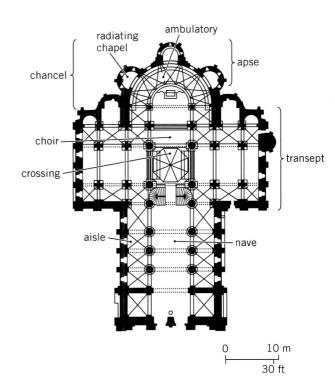

marked the boundary between secular and sacred space. The space created under the portal arch, called the **tympanum**, was filled with sculptural relief.

All the elements of Romanesque portals were equally subject to decorative relief (see Fig. 5.14): the lintel, jambs (the vertical elements on both sides of the door supporting the lintel or arch), trumeau (the column or post in the middle of a large door supporting the lintel), and the archivolt (the curved molding formed by the voussoirs making up the arch). The tympanum of Sainte-Foy at Conques depicts the Last Judgment (Figs. 5.15 and 5.16). At the center of the tympanum, Christ raises his right arm to welcome those who are saved. His lowered left hand points to hell, the destination of the damned. He sits enthroned in a mandorla, an almond-shaped oval of light signifying divinity, a motif imported to the Western world from the Far East, through Byzantium, and one widely used by Romanesque artists. Below Christ's feet, the weighing of souls is depicted as a contest between the archangel Michael and a desperate demon who cheats by pressing his forefinger onto the pan, nevertheless failing to overcome the goodness of the soul in question.

The lintel is divided by a partition into two parts: on the left, heaven, and on the right, hell. An angel welcomes the saved, while on the other side, a demon armed with a bludgeon shoves the damned into hell's monstrous jaws. Situated frontally under the arches of heaven, the saved give the appearance of order and serenity, while all is confusion and chaos on hell's side. Satan stands in the center of the right lintel, presiding over an astonishing array of tortures. On his left, a figure symbolizing Pride is thrown

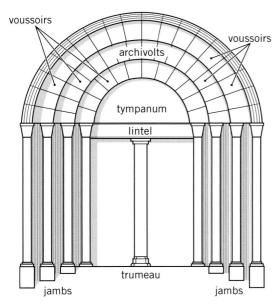

Fig. 5.14 Diagram of a Romanesque portal.

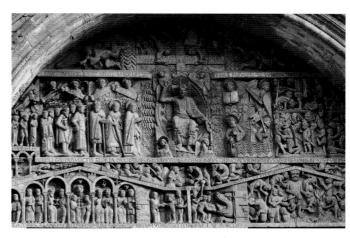

Fig. 5.15 Last Judgment, tympanum and detail of west portal, Sainte-Foy, Conques. ca. 1065. This depiction of the Last Judgment uses composition subtly and effectively to distinguish the saved from the damned. To Christ's left, the action is chaotic—figures twist and turn in often unpredictable directions. To his right, on the other hand, everyone stands upright under orderly arrangements of arches.

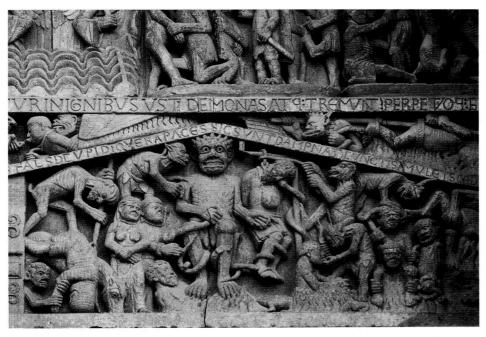

Fig. 5.16 Detail of west portal tympanum of Sainte-Foy, Conques. Showing, in the lower register Satan meting out punishments and torture.

from his high horse, stabbed through with a pitchfork. Next to them, a bare-breasted adulteress and her lover await Satan's wrath. A figure symbolizing Greed is hung from on high with his purse round his neck and a toad at his feet. A demon tears the tongue out of Slander. In the small triangular space at the right above Satan, two fiendish-looking rabbits roast a poacher on a spit. In the corresponding triangular space to the left, a devil devours the brain of a damned soul who commits suicide by plunging a knife into his throat. Close by, another hunchbacked devil has just grabbed the harp of a damned soul and tears his tongue with a hook. Such

images were designed to move the pilgrim to the right hand of Christ, not the left.

These themes are the focus of perhaps the most famous sermon of the Middle Ages, On the Misery of the Human Condition. Pope Innocent III (papacy 1198–1216) wrote this tract before his ascension to the papacy; on his election, the Church cardinals unanimously approved it as official Church doctrine. In the sermon, Innocent rails at length on the wretchedness and worthlessness of human beings, their weaknesses, folly, selfishness, vileness, their crimes, and their sins. He describes the human body as putrid in both

life and death: "In life, [man] produced dung and vomit; in death he produces rottenness and stench." But perhaps most dramatically, he catalogues the fate that awaits them in hell (Reading 5.4):

READING 5.4

from Pope Innocent III, On the Misery of the Human Condition

There shall be weeping and gnashing of teeth, there shall be groaning, wailing, shrieking, and flailing of arms and screaming, screeching, and shouting; there shall be fear and trembling, toil and trouble, holocaust and dreadful stench, and everywhere darkness and anguish; there shall be asperity, cruelty, calamity, poverty, distress, and utter wretchedness; they will feel an oblivion of loneliness and namelessness; there shall be twistings and piercings, bitterness, terror, hunger and thirst, cold and hot, brimstone and fire burning, forever and ever world without end. . . .

Such imagery is meant to strike terror into the soul of listeners by serving as a *memento mori*, a "reminder of death." Faced with such prospects, pilgrims were willing to endure the physical hardship and considerable danger their journeys entailed. Some brought many valuables with them—gold, silver, jewelry, at least enough money to pay for their lodging and meals. If they inaugurated a new economy of hospitality

in their travels, they also invited larceny, even murder, and bandits plagued the pilgrimage routes.

Cluny and the Monastic Tradition

One of the most influential of the Romanesque monasteries was the Abbey of Cluny. Like Charlemagne's Saint Gall (see Fig. 5.7), Cluny, founded in about 910, was a reformed Benedictine monastery. The Cluniac order enjoyed a special status in the Church hierarchy, reporting directly to the pope and bypassing all feudal or ecclesiastic control. No secular ruler could exercise any control over the monastery (the origin of our modern insistence on the separation of Church and State). Furthermore, the Cluniac order insisted on the celibacy of its monks and nuns—the Church was to be their only lord and spouse. Celibacy was not the rule elsewhere, and was not officially imposed on Catholic priests until 1139. Even then, Cluny's abbot was among the most powerful men in Europe; Abbot Hugh de Semur, who ruled the abbey from 1049 to 1109, was the most influential of these. In 1088, Hugh began work on a new church for the abbey, supported financially by King Alfonso VI of León and Castile, in northern Spain. Known as Cluny III because it was the third church built on the site, it was described by a contemporary as "shining on the earth like a second sun" (Fig. 5.17). Today, only a portion of its south transept and tower remain—the rest was destroyed in the late eighteenth century by French revolutionaries.

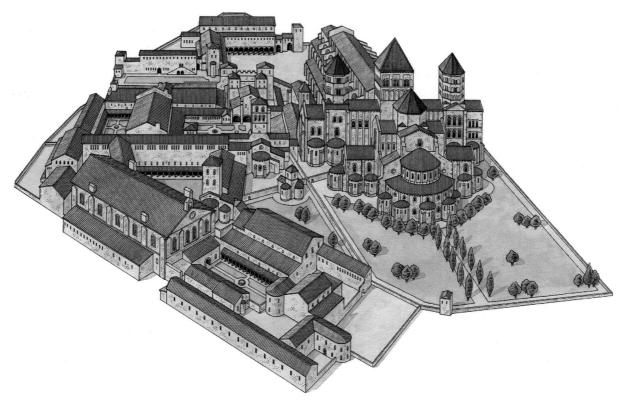

Fig. 5.17 Reconstruction drawing of the Abbey Church (Cluny III), Cluny, Burgundy, France. 1088–1130. View from the east (after Kenneth Conant).

Fig. 5.18 Diagram of melismatic organum from Léonin's "Alleluia, dies sanctificatus."

Choral Music Benedictine monks at Cluny introduced choral music into the liturgy sometime in the first half of the tenth century. Odo of Cluny (879–942), the monastery's second abbot, was an important musical theorist. He is often credited with developing one of the first effective systems of musical notation, used to teach choral music to other monasteries in the Cluniac fold. The method used the letters A through G to name the seven notes of the Western scale. Working from Odo's example, 100 years later Guido of Arezzo (ca. 990–ca. 1050) introduced the idea of depicting notes on a staff of lines so that the same note always appears on the same line. With this innovation, modern musical notation was born.

Choral music introduces the possibility of polyphony two or more lines of melody—as opposed to the monophonic quality of Gregorian chant. The earliest form of this new polyphonic music was called organum. It simply consists of voices singing note-to-note in parallel. Probably the first instance of this would have been adult monks singing a monophonic chant in parallel with boys' voices singing the same melody at a higher pitch. Soon the second voice began to move in contrary motion to the bass chant (free organum), or to add numerous notes to individual syllables above the bass chant (melismatic organum). An excellent example of melismatic organum is the "Alleluia, dies sanctificatus" by the composer Léonin, who worked from 1163 to 1190 at Notre-Dame Cathedral in Paris (track 5.4). The movement of the two voices could be diagrammed as shown in Fig. 5.18. The lower voices hold unusually long notes, while the upper voices move rapidly and freely, creating two independent musical lines. One can only imagine how music like this, performed by as many as 100 voices, might have sounded in Cluny III, which was famous for its acoustics.

THE CRUSADES

Why did the Crusades occur and what, if anything, did they accomplish?

On November 25, 1095, at the Council of Clermont (present-day Clermont-Ferrand), Pope Urban II (papacy 1088–1099) preached the First Crusade. The pope had received his training as a monk at Cluny, under the direct tutelage of Hugh de Semur. What motivated the First Crusade is difficult to say. We know that throughout Christendom there was a wide-spread desire to regain free access to Jerusalem, which had

been captured by the Arabs in 638. In part, however, the aim was to bring peace to Europe. Because of the feudal **primogeniture** system, by which the eldest son in a family inherited all of its property, large numbers of aristocratic younger brothers were disinherited and left to their own devices. They had taken to feuding with one another (and with their elder brothers) and raiding other people's land. The Crusades organized these disenfranchised men with the promise of reward, both monetary and spiritual: "Jerusalem," Urban preached, "is the navel of the world; the land is fruitful above all others, like another paradise of delights. . . . Undertake the journey [also] for the remission of your sins, with the assurance of the imperishable glory of the kingdom of heaven." The pope also presented the Crusades as a Holy War:

A race from the kingdom of the Persians, an accursed race, a race utterly alienated from God... has invaded the lands of the Christians and has depopulated them by the sword, pillage, and fire.... They destroy the altars, after having defiled them with their uncleanness.... When they wish to torture people by a base death, they perforate their navels, and dragging forth the extremity of the intestines, bind it to a stake; then with flogging they lead the victim around until the viscera having gushed forth the victim falls prostrate upon the ground... What shall I say of the abominable rape of the women?... On whom therefore is the labor of avenging these wrongs and of recovering this territory, if not upon you?

It was convincing rhetoric. Nearly 100,000 young men signed on.

The First Crusade was thus motivated by several forces: religious zeal, the desire to reduce conflict at home by sending off Europe's feuding aristocrats, defending Christendom from barbarity, the promise of monetary reward otherwise unavailable to the disenfranchised young nobility, and, not least of all, that nobility's own hot blood and sense of adventure. The First Crusade was a low point in Christian culture. Late in the year 1098, having destroyed the city of Antioch, the Frankish army (called the Franj by the Muslims) attacked the city of Ma'arra (present-day Ma'arrat an Nu'man in Syria). "For three days they put people to the sword," the Arab historian Ibn al-Athir wrote, "killing more than a hundred thousand people and taking many prisoners." This is undoubtedly an exaggeration, since the city's population was then something under 10,000, but the horror of what happened next somewhat justifies Ibn al-Athir's numbers. As reported by Frankish chronicler Radulph of Caen, "In Ma'arra our troops boiled pagan adults in cooking pots; they impaled children on spits and devoured them grilled." In an official letter to the pope, the commanders explained: "A terrible famine racked the army in Ma'arra, and placed it in the cruel necessity of feeding itself upon the bodies of the Saracens." An anonymous poet of Ma'arra lamented: "I know not whether my native land be a grazing ground for wild beasts or yet my home!" Descriptions of the slaughter of the citizens of Jerusalem, when the Crusaders finally took that city on July 15, 1099, are no less gruesome.

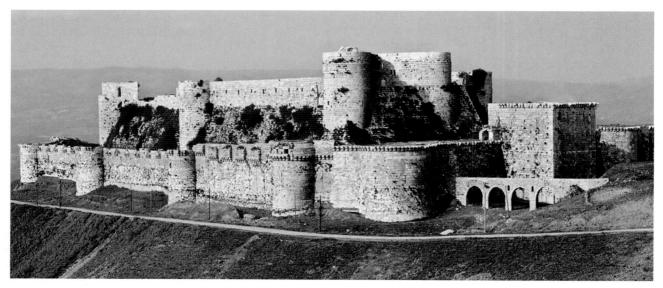

Fig. 5.19 Krak des Chevaliers, Syria. First occupied 1109. Two lines of defense made the castle virtually impenetrable. An aqueduct brought water, which was stored in huge cisterns beneath the outer ward. If during siege the water supply was cut off, the knights could hold out for several months.

The Muslim peoples of the Middle East were not the only victims of the Crusades. During the early days of the First Crusade in 1096, Count Emicho of Leiningen, in present-day Germany, making his way down the Rhine to embark for Jerusalem, robbed and murdered all the Jews he could find, killing 800 in Worms and wiping out the entire Jewish population of both Mainz and Cologne. Emicho seems to have been motivated by the need for funds to support his army, but his was a religious war as well. In his eyes, the Jews, like the Muslims, were the enemies of Christ. Local bishops, to their credit, attempted to stop the carnage, and Bernard of Clairvaux would later preach against the persecution of Jews, but in the Middle East, once Jerusalem was taken, Jews were burned alive or sold into slavery. The small number who survived did so by converting to Christianity.

The First Crusade was militarily successful. But by the middle of the eleventh century, Islamic armies had recaptured much of the Middle East, prompting a Second Crusade from 1147 to 1149, and then a Third in 1189. Politically and religiously, the first three Crusades were failures. Rather than freeing the Holy Land from Muslim influence, they cemented it more firmly than ever. But they did succeed in stimulating Western trade with the East. Merchants from Venice, Genoa, and Pisa followed the Crusaders into the region, and soon new wealth, generated by these new markets, flowed into Europe. The Fourth Crusade in 1202 was motivated almost entirely by profit, as Venice agreed to transport some 30,000 Crusaders in return for their destroying its commercial rivals in the Adriatic and Aegean, particularly Constantinople.

Krak des Chevaliers and the Medieval Castle Krak des Chevaliers (Fig. 5.19), in northern Syria, was first occupied by Crusaders in 1109, and, beginning in 1142, it was occupied by the Knights Hospitaller, whose mission was to care

for the sick and wounded. During the Crusades, it was besieged 12 times, finally falling to Berber invaders in 1271.

Krak des Chevaliers was modeled on the castle-fortresses built by the Normans in England and northern France. When the Normans arrived in England in the twelfth century, they needed defenses against the Saxons. To provide protection, they built mounds, or mottes, topped with a wooden tower, or keep (see Fig. 5.9). Beginning in 1078, stone castles gradually replaced these wooden fortifications (Fig. 5.20). The sheer weight of the stone keep required that it be built on solid ground. So, unless a natural hill presented itself, the motte (the mound on which the older wooden towers had been built) was eliminated. Now the keep served as the main residence of the lord and included a main hall, a chapel, and a dungeon. Workshops, kitchens, and storehouses surrounded the bailey. Most stone castles had a well for fresh water in case of siege, a great advantage over the aqueduct supplying Krak des Chevaliers.

Fig. 5.20 Stone castle. Surrounded by a moat, a trench filled with water, the stone castles that replaced motte and bailey castles were eminently defensible, comparatively immune from fire, and, rising as high as 100 feet, imposing symbols of Norman power.

ELEANOR OF AQUITAINE AND THE ART OF COURTLY LOVE

What is courtly love and how does it manifest itself in the literature of the period?

In the Second Crusade, Eleanor of Aquitaine (ca. 1122–1204) accompanied her husband, King Louis VII, into battle in the Middle East, along with 300 ladies of similar mind, all dressed in armor and carrying lances. Her intent was to help the sick and wounded. The women, most of whom eventually returned safely to Europe, never engaged in battle, but theirs was an act of uncommon personal and social bravery. They were widely chided by contemporary commentators, but their actions underscore the changing role of women in medieval society.

Eleanor was, by all accounts, fiercely independent, so much so that, in March 1152, Louis had his marriage to her annulled, technically on the grounds that they were related by blood, but in reality because he suspected her of adultery. Eleanor lost no time in reestablishing her position—just eight weeks after the annulment from Louis, she married Henry of Anjou, soon to be King Henry II of England. Together they had eight children, including the future English kings Richard the Lion-Hearted and John, but Eleanor's relationship with Henry was anything but easy. Henry cheated on her and treated her abusively, until she finally abandoned England for France in 1170. From Poitiers, in 1173, she encouraged her three surviving sons, Richard, John, and Geoffrey, to rebel against their father, and Henry ultimately responded to her meddling by bringing her back to England in 1179 and keeping her under house arrest until his death in 1189.

In the decade that she lived at Poitiers, Eleanor and her daughter by Louis VII, Marie, Countess of Champagne, established that city as the center of a secular culture and literary movement that celebrated the art of courtly love. This was the time when the great oral poems of the first millennium—poems like *Beowulf* and the *Song of Roland*—were first written down. Furthermore, over 2,600 poems survive as texts composed by the **troubadour** poets of Eleanor's own day, and some of these survive with the accompanying music for the poems as well.

Troubadour poetry originated in the south of France, in Provence, the area around the lower Rhone Valley, and slightly later spread north (the Northern poets are sometimes called trouvère poets to distinguish them from their Southern forebears—and far more trouvère music survives than troubadour). The troubadour poets, most of them men, although a few were women, usually accompanied themselves on a lyre or lute, and in their poems they can be said to have "invented" romantic love as we know it today—not the feelings and emotions associated with love, but the conventions and vocabulary that we use to describe it. The primary feeling is one of longing, of a knight or nobleman for a woman (usually unattainable because married or of a higher status) (Fig. 5.21), or, when the troubadour was a woman—a trobairitz—the reverse. Thus, to love is to suffer, to wander aimlessly, unable to concentrate on anything but the mental image of the beloved, to lose one's appetite, to lie sleepless at night—in short, to give up life for a dream. There was, in addition, a quasi-religious aspect to courtly love. Recognizing that he is beset by earthly desires, the lover sees his ability to resist these temptations and rise above his own base humanity as evidence of his spiritual purity. Finally, in the courtly

Fig. 5.21 Casket with scenes of courtly love, from Limoges. ca. 1180. Champlevé enamel, $3\% \times 8\% \times 6\%$ ". © The Trustees of the British Museum. At the left, a lady listens, rather sternly, as a troubadour poet expresses his love for her. In the center is a knight, sword in one hand and key to the lady's heart in the other. On the right, the knight kneels before the lady, his hands shaped in a heart; a rope around his neck, held by the lady, signifies his fidelity to her.

love tradition, the smitten knight or nobleman must be willing to perform any deed to win his lady's favor. In fact, the loyalty that he once conferred upon his lord in the feudal system is, in courtly love, transferred to his lady (who is often, in fact, his lord's wife). If the courtly love tradition reduced women to little more than objects of male desire, in some measure it also allowed them to share in the power enjoyed by their husbands.

We know of 12 or so trobairitz, or woman troubadour poets. Of these, one of the best is Beatriz de Dia, wife of William, Count of Poitiers. While married, Beatriz fell in love with a knight and, according to a contemporary chronicler, wrote "many good songs" dedicated to him. Four of these late twelfth- or early thirteenth-century songs survive. Beatriz's "Cruel Are the Pains I've Suffered" is an example of the remarkable freedom of expression that a trobairitz could enjoy. She clearly regrets her choice to remain true to her husband, and in fact the poem reads as a frank invitation to adultery (Reading 5.5):

READING 5.5

Comtessa de Dia's "Cruel Are the Pains I've Suffered," from Lark in the Morning: The Verses of the Troubadours

Cruel are the pains I've suffered For a certain cavalier Whom I have had. I declare I love him-let it be known forever. But now I see that I was deceived: When I'm dressed or when I languish In bed, I suffer a great anguish-I should have given him my love.

One night I'd like to take my swain To bed and hug him, wearing no clothes-I'd give him reason to suppose He was in heaven, if I deigned To be his pillow! For I've been more In love with him than Floris was With Blanchefleur: my mind, my eyes I give to him; my life, mon cor.1

When will I have you in my power, Dearest friend, charming and good? Lying with you one night I would Kiss you so you could feel my ardor. I want to have you in my husband's Place, of that you can rest assured-Provided you give your solemn word That you'll obey my every command.

¹Mon cor means "my heart" and alludes to a popular French romance. Floris et Blanchefleur.

That poems such as this survived, let alone that they became well-known, underscores the remarkable personal freedom of court women of the age. In fact, we know that aristocratic women, particularly in France, gained many rights during the period, among them the right to hold property, administer estates, and create wills—all at least partially attributable to the need for women to manage their husbands' estates while the men were fighting in the Crusades or other wars. That they also felt free to confess to loving men other than their husbands suggests that Eleanor's notorious relationship with Henry II was hardly unique.

The Romance: Chrétien de Troyes' Lancelot Because the poetry of the courtly love tradition was written in the vernacular—the common language of everyday life—and not in the Latin of the highly educated, a broader audience was able to enjoy it. And longer forms, such as the Song of Roland, also began to circulate widely, some of them in prose.

One of the most popular works of the day, Chrétien de Troyes' Lancelot, appeared around 1170. Centered on the adventures of Lancelot, a knight in the court of the legendary King Arthur of Britain, and focusing particularly on his courtly-love-inspired relationship with Guinevere, Arthur's wife, the poem is an example of the medieval romance. The term "romance" derives from the Old French term romans, which referred to the vernacular, everyday language of the people, as opposed to Latin. The medieval romance was designed to entertain a broad audience with stories of adventure and love, while it pretended to be an actual historical account of Charlemagne, King Arthur, or Roman legend.

Lancelot, subtitled The Knight of the Cart, opens with a challenge offered to King Arthur and his court on Ascension Day by a knight named Sir Meleagant of Gorre. Sir Meleagant claims to hold many of Arthur's knights in prison, but offers to free them if any knight dares to escort the beautiful Queen Guinevere into the forest and defend her against him. Arthur's brother Kay asks to take on the mission, and Arthur agrees. Knowing Kay to be a poor knight, Sir Gawain and the other knights of the Round Table quickly chase after him into the forest. Too late, they come upon Kay's riderless horse, all that remains of a scene of recent combat. Lancelot takes one of Gawain's horses and charges off after Meleagant, who has abducted Guinevere. Gawain catches up with Lancelot, finds the horse he has lent him dead, the victim of a fierce battle, and then discovers Lancelot on foot, having overtaken a cart of the kind used to take criminals to their execution. The cart is driven by a dwarf, who has told Lancelot that if he boards the cart, he will soon know Guinevere's fate. To board such a cart is a great dishonor, but Lancelot reluctantly agrees, and the next day, Lancelot and Gawain learn the way to Meleagant's kingdom of Gorre from a damsel standing at a fork in the road.

Both forks lead to Gorre, one by way of the perilous Underwater Bridge, the other by the even more perilous Sword Bridge. Gawain takes the first, Lancelot the second. Lancelot faces many challenges and temptations but finally arrives at the Sword Bridge, which he crosses by virtue of his love for Guinevere (Fig. 5.22). He subsequently defeats Meleagant but spares his life at Guinevere's behest. Guinevere. to his dismay, behaves coldly toward him, offended at his earlier hesitation to enter the cart. He should not have put his own honor before love, she explains. After reuniting with Gawain, who was preparing to take on Meleagant himself in Lancelot's absence, Lancelot overcomes Meleagant once and for all, and he and Guinevere are reconciled. Guinevere agrees to meet Lancelot in Meleagant's castle secretly at night. There he kneels before her, "holding her more dear than the relic of any saint," a scene in which the "religion of love"—so marvelous in its physical joy that the narrator cannot tell of it, "for in a story it has no place"—is confounded with spiritual ecstasy. This feature is surely indebted to Islamic notions of physical love as a metaphor for the love of God and in the love songs popular in the Islamic Spanish courts, where the bilingual minstrels who inaugurated the troubadour tradition first flourished.

The love of woman celebrated in medieval romance and troubadour poetry was equated in the Christian mind with love for the Virgin Mary. As Mother of Heaven and of Christ,

pritimers, erade a dur cedepu pale poor contr cetus qui te dour a d'ecini lot fair melangat to Wett par ie ne fin mie et an contraint of the absented encondur. or is vor gour drong mant de voltenn gannne ever tom homod Bor dlat 4 d viv batann hour thurms on fur encuon And is me dos as chie combane de fine plan done is me bounts . Il quot anere; deman dar aus nel po to the que we men this Minnes Bran ce fine le gout- ne dementu ja homis fin for he sont ne vot bodes fle to chount of almost hour to voc Soun Thur enorgioner pur 7 bonog das minoreather out mountarou d and h mode dime den me inte hinege . 4 to gener die bine stig que mether nertu pomechur bot ornere; human abecnotoupl monde con f la guir procese quient point-suicon irious din convinci point-suicon irious din convinci process se la group din bin suico erpon or the len vor undoor far parante ce que vocertes venus de granceres plur ingrevence. Es a le vostore par la constitue de la lectore. Es que vocertes venus de lectore. ed monte; Bittu bour guit alemi Simy benque bereiter futtich enta cire dio fair li porcourrer en ournat games cami ante Laptur celes chambre que tor teas h bond on monde por em w service plut. Dormo, brantire threatme-Sina ceme; abec in & rouge gent me bae; qui come brie; confeit de no bante fle ta fee fe cett le vanrer temes par que deco gere ty . or to but time; liberg or & mos she is no both onques note Welt mir ne cometter-flores he three those and one; que to contro mos cont anomige of guil honor cuma dronture diffendre e'r enced im lange abatt na gante Brun, Her enn, sent mann one gues mot the orde Sponte die is chii pun'que cuibus armet poster on it and the date to the correction grandate Janon & Cloung nemny me goich for endatantons propincio aperromour hardi June cirett quia Boy arruenceur been and Bank of hypes omer four h Bont ferry one Ameny que not vanont ben te betonege que en fruter tans que me omercement di duy cingen of or by our gene, divert, 21 pec 9, orthir land par la forque th sender bonor arone for mans . to dot a qui met fil; iet ie ne fai che clue me loe, vor fair aselvagan; fleit net que cu fan . Cu w ne las ur chierene car qui de care bu le tacher, ste ta en ma que tou enface de te dura for ! encore bent warme non Bont que le re lactores que en teré danter la voure ounvenneures cur ni de le Curore de bour que dans la cu unpo ne not fera un fora de por m betreet mon guree quelue une divir entiteme de en uni de

Fig. 5.22 Page with Lancelot Crossing the Sword Bridge and Guinevere in the Tower, from Romance of Lancelot. ca. 1300. Illuminated manuscript, 13½" × 10". © The Pierpont Morgan Library/Art Resource, NY. In this trial, Lancelot crosses a raging stream, cutting himself on a long, sharpened sword, but "even his suffering is sweet to him" with Guinevere in sight.

as the all-compassionate mediator between the Judgment seat and the horrors of hell, Mary was increasingly recognized as the spiritual equivalent of the lady of chivalry, crowned the Queen of Heaven, overseeing her heavenly court. Songs were sung to her, cathedrals built in her honor (all cathedrals named Notre Dame, "Our Lady," are dedicated to her), and a Cult of the Virgin developed around her.

Lancelot was written at the request of Eleanor of Aquitaine's daughter Marie—herself named after the Virgin—as its laudatory prologue, a standard feature of the form, attests (Reading 5.6):

READING 5.6

from Chrétien de Troyes, Lancelot

Since my lady of Champagne wishes me to undertake to write a romance. I shall very gladly do so, being so devoted to her service as to do anything in the world for her, without any intention of flattery. But if one were to introduce any flattery upon such an occasion, he might say, and I would subscribe to it, that this lady surpasses all others who are alive, just as the south wind which blows in May or April is more lovely than any other wind. But upon my word, I am not one to wish to flatter my lady. I will simply say: "The Countess is worth as many queens as a gem is worth of pearls and sards." Nay I shall make no comparison, and yet it is true in spite of me; I will say, however, that her command has more to do with this work than any thought or pains that I may expend upon it. Here Chrétien begins his book. . . . The material and the treatment of it are given and furnished to him by the Countess, and he is simply trying to carry out her concern and intention.

Chrétien presents himself as the servant of Marie who devotes his writer's skill to doing her bidding, just as the knight Lancelot serves Queen Guinevere with his knightly skill, and as the Christian serves the Virgin Mary. Similarly, Chrétien's story transforms the heroism of the Song of Roland, which is motivated by feudal loyalty to king and country, to a form of chivalry based on the allegiance of the knight to his lady. In a medieval romance, the knight is driven to heroic action not so much by the lure of greater glory as by his own desire for his lady. To the knight, the lady is a prize to be won, an object to be possessed. Beyond the drama of his exploits and his lady's distress, the conflict between the sexual desires of both knight and lady and the hypothetical purity of their "spiritual" love gives the story its narrative power. In a medieval romance, as well as in the troubadour poem, perhaps the greatest test the lovers face is their own sexuality—an almost sure-fire guarantor of the form's popularity.

5.1 Describe what Anglo-Saxon art and literature tell us about Anglo-Saxon culture.

The burial mound at Sutton Hoo has revealed more about the art and culture of Anglo-Saxon England than any other archeological site. Buried in the mound was a lord or chief to whom his followers owed absolute loyalty. Can you describe the nature of the economic relationship between the lord and his followers? How is this relationship reflected in the epic poem *Beowulf*? How does it compare to the Roman system of patronage?

Although by no means a Christian poem, Beowulf contains themes that are consonant with Christian values, teaching its audience that power, strength, fame, and life itself are transitory. Christianity survived the end of Roman control over Britain only in the farthest reaches of the British islands—in Cornwall, Wales, and Ireland. But in 597, Pope Gregory I sent a mission to England, headed by the Benedictine prior Augustine, to convert the pagan Anglo-Saxons. The pope urged Augustine not to try to eliminate pagan traditions but to incorporate them into Christian practice. How is this reflected in the manuscripts produced in the monasteries?

5.2 Discuss Charlemagne's impact on medieval culture and the legacy of his rule.

Charlemagne gained control of most of the European continent, creating what would later be known as the Holy Roman Empire. Charlemagne's exploits were celebrated in many poems, chief among them the Song of Roland. What feudal values are reflected in this poem? How do they differ from those of Beowulf? Why do we call the Song of Roland's value system a "chivalric code"?

Arguably the most important institution of the Carolingian era was the monastery. Charlemagne imposed the Rule of Saint Benedict on all monasteries and created what he believed to be the ideal monastery at Saint Gall. What is the Rule of Saint Benedict? What role does music play in monastic life? What role did women have in monastic life, and how was Hildegard of Bingen unique among them?

5.3 Define the Romanesque and its relation to pilgrimage churches and the Cluniac abbey.

Churches such as the Abbey Church of Sainte-Foy in Conques, France, became the focus of Western culture in the Middle Ages as Christians began to do penance for their sins by undertaking pilgrimages to churches housing the relics of venerated saints. The churches were Romanesque. How would you define this architectural style?

Most of the pilgrimage churches were controlled by the Abbey of Cluny. Cluny's abbot was among the most powerful men in Europe, and the church at Cluny was a model for all pilgrimage churches. Music was central to the Cluniac liturgy. Can you describe the musical practices at Cluny? How do they differ from those of Charlemagne's time? Why did Bernard, abbot of the Cistercian monastery at Clairvaux, object to Cluniac practice?

5.4 Examine the motivations for the Crusades and appraise their outcome.

On November 25, 1095, Pope Urban II, who had been trained at Cluny, preached the First Crusade, pleading with Christians to retake Jerusalem from the Muslims. Nearly 100,000 young men signed up. Why? In the Middle East the Crusaders built giant fortresses such as the Krak des Chevaliers, modeled on the fortified castles built by the Normans in England. In general, how would you describe the outcome of the first and the three subsequent Crusades?

5.5 Explain the courtly love tradition as it manifests itself in the literature of the period.

Eleanor of Aquitaine accompanied her husband, King Louis VII of France, on the Second Crusade. At Poitiers, Eleanor and her daughter Marie de Champagne championed a literary movement that celebrated the art of courtly love. How does courtly love reflect feudal traditions? How does it also reflect certain religious ideals? How are these values reflected in the work of troubadour poets and in medieval romances?

Toward a New Urban Style: The Gothic

Romanesque art and architecture thrived, especially along the pilgrimage routes in the south of France, from roughly 1050 to 1200. But in the 1140s, a new style began to emerge in the North that today we call Gothic. New cathedrals—at Saint-Denis, just outside Paris, and at Chartres—were dominated by soaring spires and stained-glass windows. Decorative sculpture proliferated. Pointed arches, as opposed to the rounded arches of the Romanesque barrel vault, lifted interior spaces to new heights. All these new elements were anticipated in the Romanesque, in the magnificent stained glass at Poitiers, in the sculpture of the pilgrimage-route church portals, and in the pointed arches of Fontenay Abbey. And like their Romanesque forebears, most of the new Gothic cathedrals were built to house precious relics and to accommodate large crowds of pilgrims.

The Romanesque style was a product of rural monastic life, separated from worldly events and interaction, but the Gothic style was a creation of the emerging city—of the craft guilds and artisans, merchants, lawyers, and bankers who gathered there. It represents the first step in a gradual shift in the West from a spiritually centered culture to one with a more secular focus. No longer was religion—worshiping at a pilgrimage church or fighting a Crusade—the dominant motive for travel. Instead, trade was. Merchants and bankers grew in importance. Craftsmen flourished. Secular rulers became more ambitious. In fact, personal ambition and success

Fig. 5.23 Angel Subduing Demon, decorated column capital, Church of Sainte-Madeleine, Vézelay, France. ca. 1089–1206.

would increasingly be defined in worldly, rather than spiritual, terms.

The Gothic does not give up its interest in the spiritual. Although the architecture was intended to invoke intensely spiritual feelings, we also see the beginning of a renewed interest in worldly things. This shift is evident in two images of angels. The flattened, distorted features of the angel on the Romanesque capital from Vézelay (Fig. 5.23) contrast dramatically with the heightened naturalism of the angel from the portal at Reims (Fig. 5.24). The Romanesque angel is depicted in profile, its wings flattened behind it. The folds of the drapery covering its body are realized by parallel bands of shallowly incised lines. But freed from the stone backdrop of relief sculpture, the Gothic angel steps forward with an amazingly lifelike gesture. Where the gender of the Romanesque angel is indeterminate, the Reims sculpture is so lifelike—and clearly feminine—that it seems to have been modeled on a real person. Nothing of the formulaic vocabulary of Romanesque sculpture remains. The winsome smile and delicate figure of the Gothic angel are, finally, more worldly than angelic. In fact, she seems so much a part of our world that we hardly miss the halo that identifies her Romanesque forebear.

Fig. 5.24 The Angel of the Annunciation, central portal, west facade, Reims Cathedral, Reims, France. ca. 1245–55 (detail of Fig. 6.12 in Chapter 6).

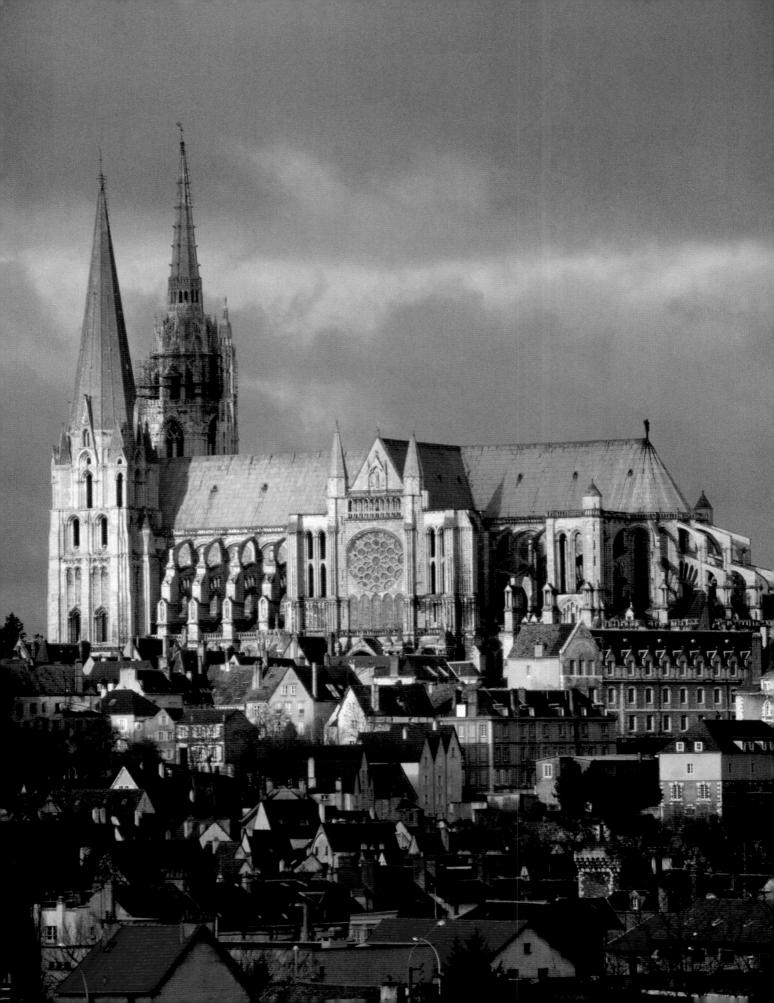

The Gothic and the Rebirth of Naturalism

6

Civic and Religious Life in an Age of Inquiry

LEARNING OBJECTIVES

- 6.1 Outline the ideas, technological innovations, and stylistic developments that distinguish the Gothic style in France.
- 6.2 Explain why the University of Paris was preeminent among medieval institutions of higher learning.
- 6.3 Define the Radiant style.
- 6.4 Compare and contrast art and civic life in Siena and Florence.
- 6.5 Examine the spread of a vernacular literary style in European culture.

n June 11, 1144, King Louis VII, his queen, Eleanor of Aquitaine, and a host of dignitaries traveled a few miles north of Paris to the royal Abbey of Saint-Denis, where they dedicated a new choir for the royal church. It would be the crowning achievement of the king's personal domain, the Île-de-France. Designed by Abbot Suger of Saint-Denis, the choir would quickly inspire a new style of architecture and decoration that came to be known as Gothic. Gothic was originally a derogatory term, adopted in sixteenth-century Italy to describe the art of Northern Europe, where, it was believed, Classical traditions had been destroyed by Germanic invaders—that is, by the Goths. In its own time, this style was known as opus modernum (modern work) or opus francigenum (French work). These terms highlight the style's decidedly new and contemporary flavor as well as its place of origin.

By the end of the twelfth century and the beginning of the thirteenth, town after town across northern France would imitate Suger's design at Saint-Denis. At Chartres, just to the west of the Île-de-France on the Eure River (Fig. 6.1), to the north at Rouen, Amiens, and Beauvais, to the east at Laon and Reims, to the south at Bourges, and in Paris itself, Gothic cathedrals sprang up with amazing rapidity. Much of the rest of Europe would soon follow suit.

With the rise of this new Gothic style came a new standard of beauty in Western architecture and decoration. A new masonry architecture developed, eventually resulting in intricate stonework that was almost skeletal in its lightness and soaring ever higher to create lofty interior spaces. Gothic architecture matched the decorative richness of stained glass with sculptural programs that were increasingly inspired by Classical models of naturalistic representation. A new, richer liturgy developed as well, and with it, polyphonic music that by the thirteenth century was accompanied by a new instrument—the organ. The Île-de-France was the center of all these developments. It was there, as well, at the University of Paris, founded in 1200, that a young Dominican monk named Thomas Aguinas initiated the most important theological debates of the age, inaugurating a style of intellectual inquiry that we associate with higher learning to this day.

▼ Fig. 6.1 The Cathedral of Notre-Dame, Chartres, France. ca. 1134—1220. Chartres Cathedral rises majestically, crowning the town surrounding it. Such cathedrals were the cultural centers of their communities, the source of the community's pride and prestige.

Even as an elaborate and flamboyant new style of Gothic architecture developed in the North, closely associated with the court of King Louis IX (r. 1226–70) in Paris, the Gothic arrived in Italy, where it was adapted to local traditions in Florence and Siena particularly. The two cities competed for preeminence during the thirteenth and fourteenth centuries. Out of this competition, the modern Western city as we know it—a more or less self-governing center of political, economic, and social activity, with public spaces, government buildings, and urban neighborhoods—was born. Republican Rome (see Chapter 3) and Golden Age Athens (see Chapter 2) were both models, but what distinguished Florence and Siena from these earlier republics was the role that the citizenry played in expressing their civic pride. The churches, monuments, and buildings of these late medieval cities were the work not of enlightened rulers but of the people themselves. Perhaps because the people were the great artistic patrons of the era, a new type of literature developed, written in Italian, not Latin, and often focusing on the more ordinary aspects of everyday life as lived by common people. The citizenry was genuinely thankful to God for its wellbeing and gave thanks by building, maintaining, and embellishing cathedrals. They built churches for the new monastic orders that served the cities' common folk. As in France, the cult of the Virgin inspired artists in both cities, and both cities placed themselves under her protection.

Until 1348, despite the ups and downs each city experienced, the Virgin seemed to bless both with good fortune. But that year, as many as half the population of both cities died of the plague. To many, the Black Death represented the vengeance of an angry God punishing the people for their sins. But, in its wake, artists, writers, merchants, and scholars discovered greater personal freedom and opportunity. Perhaps inspired by the harsh realities they confronted during the plague, artists created works of ever-greater realism and candor.

SAINT-DENIS AND THE GOTHIC CATHEDRAL

What ideas, technological innovations, and stylistic developments mark the rise of the Gothic style in France?

Even as a pupil at the monastery school, Abbot Suger had dreamed of transforming the Abbey of Saint-Denis into the most beautiful church in France. The dream was partly inspired by his desire to lay claim to the larger territories surrounding the Île-de-France. Suger's design placed the royal domain at the center of French culture, defined by an architecture surpassing all others in beauty and grandeur.

After careful planning, Suger began work on the Abbey in 1137, painting the walls, already almost 300 years old, with gold and precious colors. Then he added a new facade with twin towers and a triple portal. Around the back of the ambulatory he added a circular string of chapels, all lit with large stained-glass windows (Fig. 6.2), "by virtue of

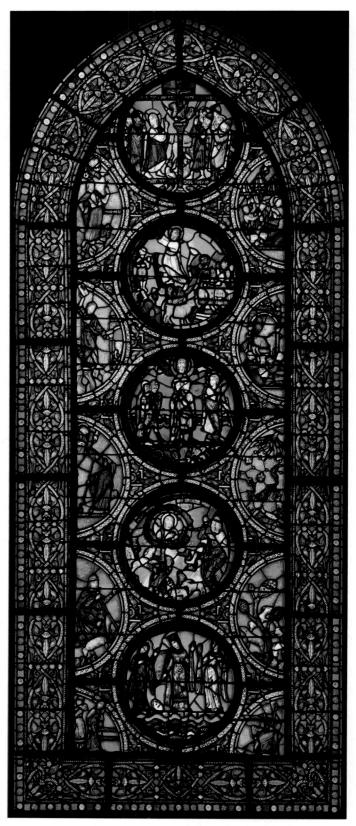

Fig. 6.2 Moses window, Abbey Church of Saint-Denis, Saint-Denis, France. 1140–44. This is the best preserved of the original stained-glass windows at Saint-Denis. Scholars have speculated that Moses was a prominent theme at the royal Abbey of Saint-Denis because his leadership of the Israelites was the model for the French king's leadership of his people.

which," Suger wrote, "the whole would shine with the miraculous and uninterrupted light."

This light proclaimed the new Gothic style. In preparing his plans, Suger had read what he believed to be the writings of the original Saint Denis. (We now know that he was reading the mystical tracts of a first-century Athenian follower of Saint Paul.) According to these writings, light is the physical and material manifestation of the Divine Spirit. Suger would later survey the accomplishments of his administration and explain his religious rationale for the beautification of Saint-Denis:

Marvel not at the gold and the expense but at the craftsmanship of the work.

Bright is the noble work; but being nobly bright, the work

Should brighten the minds, so that they may travel, through the true lights,

To the True Light where Christ is the true door.

The church's beauty, therefore, was designed to elevate the soul to the realm of God.

When Louis VII and Eleanor left France for the Second Crusade in 1147 (see Chapter 5), just three years after Suger's dedication of his choir, they also left the abbot without the funds necessary to finish his church. It was finally completed a century after he died in 1151. Much of its original sculptural and stained-glass decoration was destroyed in the late eighteenth century during the French Revolution. Although it was partially restored in the nineteenth and twentieth centuries, only five of its original stained-glass windows remain, and we must turn to other churches modeled on its design to comprehend its full effect. Chief among these is the Cathedral of Notre-Dame at Chartres, which, like the other Gothic cathedrals in both the Île-de-France and its surrounding territories, drew its inspiration from Paris.

The cathedral's spires can be seen for miles in every direction, lording over town and countryside as if it were the very center of its world (Fig. 6.3). Chartres was, in fact, located in the heart of France's grain belt, and its economy thrived as France exported grain throughout the Mediterranean basin. But more important, Chartres was the spiritual center of the cult of the Virgin, which throughout the twelfth and thirteenth centuries assumed an increasingly important role in the religious life of Western Europe. The popularity of this cult contributed, perhaps more than any other factor, to the ever-increasing size of the era's churches. Christians worshiped the Virgin as the Bride of Christ, Personification of the Church, Queen of Heaven, and prime Intercessor with God for the salvation of humankind. This last role was especially important, for in it the Virgin could intervene to save sinners from eternal damnation. The cult of the Virgin manifested itself especially in the French cathedrals, which are often dedicated to Notre Dame, "Our Lady."

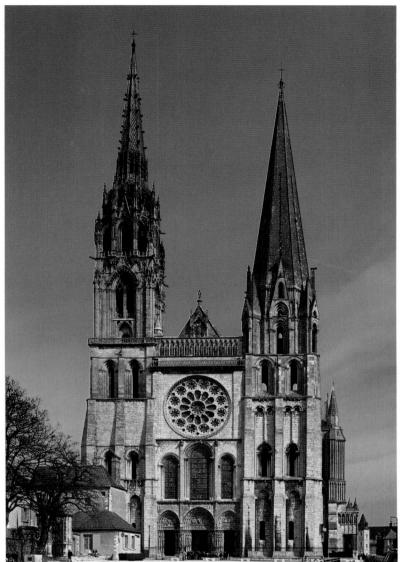

Fig. 6.3 West facade, Chartres Cathedral, France. ca. 1134–1220; south spire ca. 1160; north spire 1507–13. The different designs of the two towers reflect the Gothic dismissal of Romanesque absolute balance and symmetry as well as the growing refinements of the Gothic style. The later, north tower (left) was much more elaborately decorated and, in the more open framework of its stonework, more technically advanced.

Soon after the first building phase was completed at Chartres, between about 1140 and 1150, pilgrims thronged to the cathedral to pay homage to what the Church claimed was the Virgin's tunic, worn at Jesus' birth. This relic was housed in the cathedral and was believed to possess extraordinary healing powers. But in 1194, the original structure was destroyed by fire, except for the west facade, a few stained-glass windows, and the tunic of the Virgin. The survival of the window and the tunic was taken as a sign of divine providence, and a massive reconstruction project was begun in gratitude. Royalty and local nobility contributed

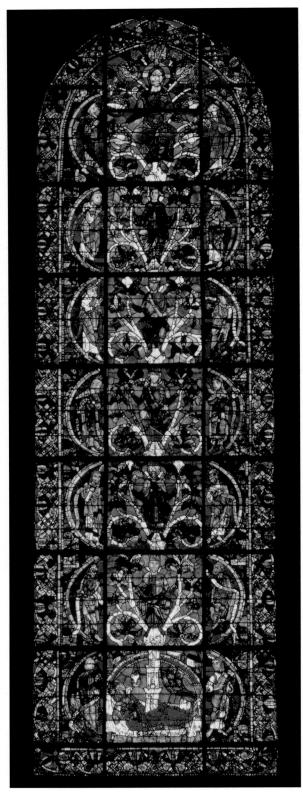

Fig. 6.4 The Tree of Jesse window, Chartres Cathedral. ca. 1150–70. Jesse was the father of King David, who, according to the Gospels, was an ancestor of Mary. At the base of the window lies the body of Jesse, a tree growing out of him. The tree branches into the four kings of Judea, one on each row. Mary is just below Christ. Seven doves, representing the seven gifts of the Holy Spirit, encircle Christ. In half-moons flanking each section of the tree stand the 14 prophets.

their financial support, and the local guilds gave both money and work.

Behind the more-or-less Romanesque west facade, with its round-arch windows, rose what many consider to be the most magnificent of all Gothic cathedrals, its stained glass unrivaled in Europe.

Stained Glass

The stained-glass program at Chartres is immensely complex. The innovative engineering that marks Gothic architecture (discussed in the next section) freed the walls of the need to bear the weight of the structure. It also freed the walls to contain glass.

The purpose of the stained-glass programs in all Gothic cathedrals was to tell the stories of the Bible in a compelling way to an audience that was largely illiterate. The art allowed them to read the scriptural stories for themselves. At Chartres, 175 glass panels, containing more than 4,000 figures, are carefully designed, in Abbot Suger's words, "to show simple folk . . . what they ought to believe." Two windows are notable for their role in the cult of the Virgin. One of these depicts the so-called Tree of Jesse (Fig. 6.4). Jesse trees are a common motif in twelfth- and thirteenth-century manuscripts, murals, sculpture, and stained glass, and their associated traditions are still celebrated by Christians during the season of Advent. They were thought to represent the genealogy of Christ, since they depict the Virgin Mary as descended from Jesse, the father of King David, thus fulfilling a prophecy in the book of Isaiah (11:1): "And there shall come forth a rod out of the stem of Jesse and a branch shall grow out of his roots." Most Jesse trees have at their base a recumbent Jesse with a tree growing from his side or navel. On higher branches of the tree are various kings and prophets of Judea. At the top are Christ and Mary. Sometimes the Virgin holds the infant Jesus, but here, as in a similar window at Saint-Denis, she appears in the register below Jesus. Since Jesse trees portray Mary as descending from royal lineage, they played an important role in the cult of the Virgin.

A second window in the north transept of the cathedral also evokes the Virgin (Fig. 6.5). A rose window—a round window with mullions (framing elements) and traceries extending outward from its center in the manner of the petals of a rose—it is symbolic of the Virgin Mary in her role as the Mystic Rose—the root plant, it was believed, of the Jesse Tree. It measures 42 feet in diameter.

The stained glass at Chartres covers more than 32,000 square feet of surface area, and the overall effect of so many windows can hardly be imagined. The windows were donated by the royal family, by noblemen, and by merchant guilds. On an average day, the light outside the cathedral is approximately 1,000 times greater than the light inside. Thus the windows, backlit and shining in the relative darkness of the nave, seem to radiate with an ethereal and immaterial glow, suggesting a spiritual beauty beyond the here and now.

Gothic Architecture

As the Gothic style developed, important architectural innovations contributed to the goal of elevating the souls of worshipers to the spiritual realm. Key among these innovations was rib vaulting (Fig. 6.6). The principles of rib vaulting were known to Romanesque architects, but Gothic architects used these techniques with increasing sophistication. Rib vaults are a form of groin vault (see Fig. 3.10 in Chapter 3). They are based on the pointed arch, which can reach to a greater height than a rounded arch. At the groins, structural moldings called ribs channel the vault's thrust outward and downward. These ribs were constructed first and supported the scaffolding upon which masonry webbing was built. These ribs were essentially a "skeleton" filled with a lightweight masonry "skin." Rib vaulting allowed the massive stonework of the Romanesque style to be replaced, inside and out, by an almost lacy play of thin columns and patterns of ribs and windows, all pointing upward in a gravity-defying crescendo that carries the viewer's gaze toward the heavens. Extremely high naves—Chartres' nave is 120 feet high, Reims' is 125, and the highest of all, Beauvais', is 157, the equivalent of a 15-story building—add to this emphasis on verticality, contributing a sense of elevation that is both physical and spiritual.

The preponderance of pointed rather than rounded arches contributes to this feeling as well. The pointed arch, in fact, possesses structural properties that contribute significantly to the Gothic style—the flatter or rounder an arch is, the greater outward thrust or pressure it puts on the supporting walls. By reducing outward thrust, the pointed arch allows larger windows and lighter **buttresses**, pillars traditionally built against exterior walls to brace them and strengthen the vault. **Flying buttresses** (Figs. 6.7, 6.8,

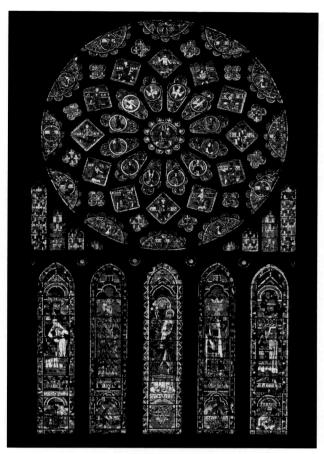

Fig. 6.5 Rose window and lancets, north transept, Chartres. ca.
1210–30. The rich blue colors of this rose window were especially treasured because legend had it that Abbot Suger had produced the blues by grinding up sapphires. The richness of the blues, however, derives from a cobalt oxide.

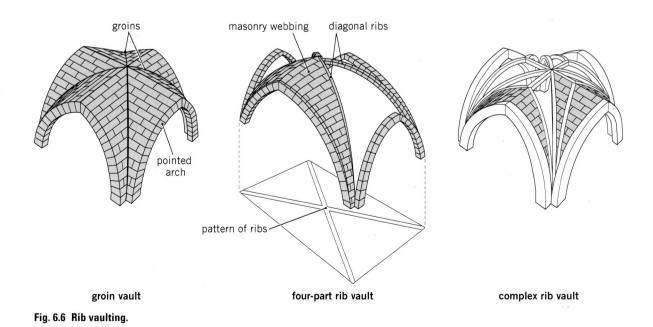

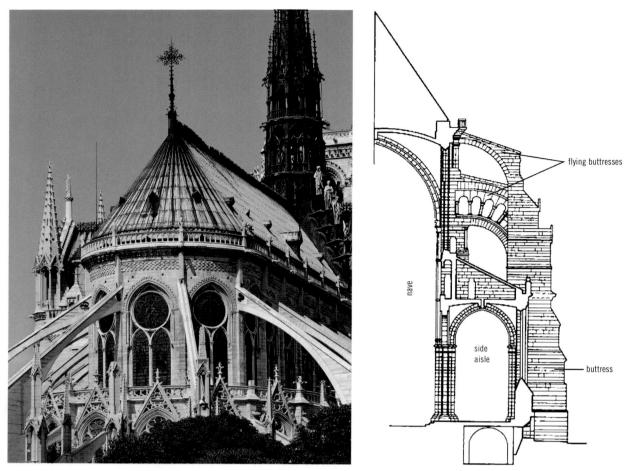

Figs. 6.7 and 6.8 Flying buttresses, Cathedral of Notre-Dame, Paris, France. 1211–90. Romanesque architects used buttressing, but concealed it under the aisle roofs. Moving the buttresses to the outside of the structure created a sense of light bridgework that contributed to the aesthetic appeal of the building as much as to its structural integrity.

and visible as well on the exterior of Chartres Cathedral, Fig. 6.1) allow even lighter buttressing and more windows. They extend away from the wall, employing an arch to focus the strength of the buttress's support at the top of the wall, the section most prone to collapse from the outward pressure of the vaulted ceiling. A flying buttress is basically a huge stone prop that pushes in against the walls with the same force with which the vaults push out. The thrust of the vaulted ceilings still comes down the piers and walls, but also moves down the arms of the flying buttresses, down the buttresses themselves, and into the ground. The flying buttresses help to spread the weight of the vaults over more supporting stone, allowing the walls to be thinner while still supporting as much weight as earlier, thicker walls. As the magnificent flying buttresses at Notre-Dame Cathedral in Paris demonstrate, they also create a stunning visual spectacle, arching winglike from the building's side as if defying gravity.

During the thirteenth century, architects began to adorn the exteriors of their cathedrals with increasingly elaborate decoration. Stone **crockets**, leaflike forms that curve outward, their edges curling up, were added to the pinnacles, spires, and gables of the cathedrals. These were topped by finials, knoblike architectural forms also found on furniture. The textural richness of these forms is evident in the comparison of Chartres Cathedral (see Fig. 6.3), where they are relatively absent, and Amiens Cathedral, where they are abundant (Fig. 6.9). The facade of Amiens is also elaborately decorated with sculpture. Most of the sculptures were made in a 20-year period by a large workshop in Amiens itself, lending the entire facade a sense of unity and coherence.

Gothic Sculpture

If we look at developments in architectural sculpture from the time of the decoration of the west portal of Chartres Cathedral (1145–70) to the time of the sculptural plan of the south transept portal (1215–20), and, finally, to the sculptures decorating the west front of Reims Cathedral (1225–55), we can see that, in a little over 100 years, Gothic sculptors had begun to reintroduce Classical principles of sculptural composition into Western art.

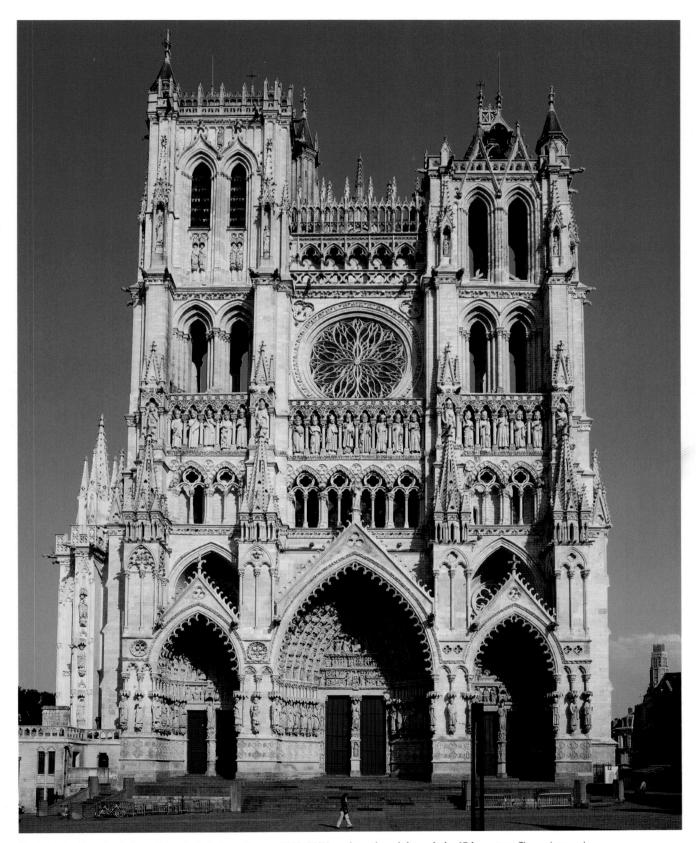

Fig. 6.9 West facade, Amiens Cathedral, Amiens, France. 1220–36/40, and continued through the 15th century. The sculptors who decorated the facade quickly became famous and traveled across Europe, carrying their style to Spain and Italy.

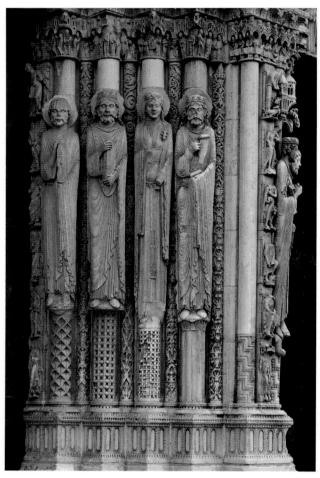

Fig. 6.10 Jamb statues, west portal, Chartres Cathedral. 1145–70. The decorative patterns at the bottom of these jamb columns are, interestingly, reminiscent of Islamic designs in Spain.

Although they seem almost Byzantine in their long. narrow verticality, feet pointing downward, the jamb sculptures on the west portal of Chartres mark a distinct advance in the sculptural realization of the human body (Fig. 6.10). These, and five more sets, flank the three doorways of the cathedral's Royal Portal. The center tympanum of the portal depicts Christ enthroned in Royal Majesty, the north tympanum the Ascension of Christ, and the south the Virgin and Child enthroned. The jamb sculptures represent figures from the Hebrew Bible considered to be precursors of Christ. These works have little in common with Romanesque relief sculpture, typified by the Last Judgment tympanum on the Cathedral of Sainte-Foy in Conques (see Fig. 5.15 in Chapter 5). While the Chartres figures remain contained by the form of the colonnade behind them, they are fully rounded and occupy a space in front of the column itself.

When Chartres was rebuilt after the fire of 1195, a new sculptural plan was realized for the transept doors. The figures stand before a colonnade, as do the jamb figures on the west portal, but their form is hardly determined by it (Fig. 6.11).

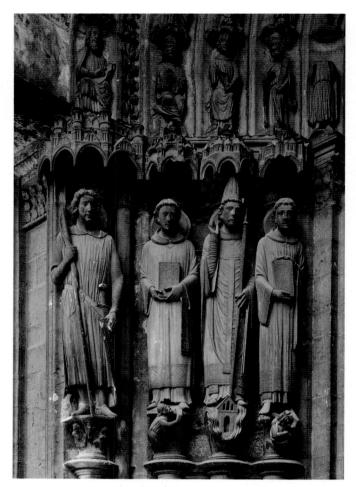

Fig. 6.11 Jamb statues, south transept portal, Chartres Cathedral. ca. 1215–30. The statue of Saint Theodore, on the left, is meant to evoke the spirit of the Crusades.

Now they stand flat-footed. Their faces seem animated, as if they see us. The monk just to the right of the dividing column seems quite concerned for us. The portrait of the knight Saint Theodore, to the left of the column, is particularly remarkable. For the first time since antiquity, the figure is posed at ease, his hip thrusting slightly to the right, his weight falling on his right foot. He stands, in other words, in a contrapposto position. (Recall the Greek sculptures of the fifth century BCE, carved in that posture, such as the Doryphoros [Spear Bearer], Fig. 2.28 in Chapter 2.) The weight of his sword belt seems to have pulled his cloak off to the right. Then, below the belt, the cloak falls back to the left. The strict verticality of the west portal is a thing of the past.

The sculptures at Reims break even further from Romanesque tradition. They are freed of their backdrop (Fig. 6.12). The Angel of the Annunciation tells Mary (the figure next to the angel on the right) that she is with child. The next two figures, to the right, represent the Visitation, when Mary tells her cousin Elizabeth that she is with child and Elizabeth in turn announces the divinity of the baby in Mary's womb. Note how the drapery adorning the pair on the left, with its simple, soft folds,

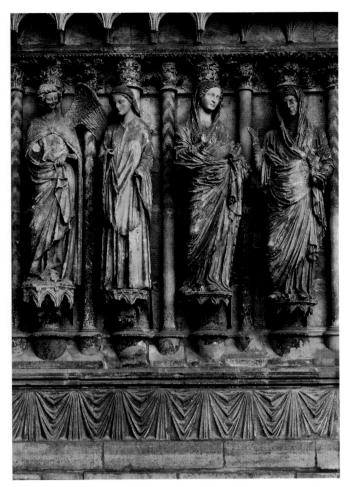

Fig. 6.12 Annunciation and Visitation, central portal, west facade, Reims Cathedral, Reims, France. Angel of the Annunciation, ca. 1245–55; Virgin of the Annunciation, 1245; Visitation group, ca. 1230–33. If these sculptures seem more naturalistic than any for nearly a thousand years, it is partly because they engage with one another. It is as if, looking at them, we can overhear their conversation. Note that the most naturalistic sculpture, the Angel of the Annunciation, dates from 15 or 20 years after the Visitation group, suggesting an extraordinary advance in, and preference for, naturalism in a very short span of years.

differs profoundly from the drapery of the pair on the right, whose robes are Roman in their complexity. The earlier Mary bears little, if any, resemblance to the other Mary. The first was probably carved by a sculptor trained in Roman traditions, the latter by one seeking something less bulky and lighter in feel.

The two pairs are as different, in fact, as the two towers of Chartres Cathedral (see Fig. 6.3), which reflect both a weakening of the Romanesque insistence on balance and symmetry and the fact that both were done at different times. And yet the two pairs of sculptures share a certain emotional attitude—the good-humored smile of the angel, the stern but wise concern of Elizabeth. Even the relative ages of the people depicted are apparent, where age would have been of no

concern to a sculptor working in the Romanesque tradition. These are, in short, the most fully human, most natural sculptures since Roman times. During the Gothic period artists developed a new visual language. The traditional narratives of biblical tradition could no longer speak through abstracted and symbolic types, but instead required believable, individual bodies to tell their stories. This new language invests the figures of Jesus, Mary, the saints, and even the Angel of the Annunciation with personality.

Music in the Gothic Cathedral: Growing Complexity

With its vast spaces and stone walls, the Gothic cathedral could be as animated by its acoustics as by its light, or, as at Reims, the liveliness of its sculpture. Ecclesiastical leaders were quick to take advantage of this quality in constructing their liturgy. At the School of Notre-Dame in Paris, the first collection of music in two parts, the Magnus Liber Organi (The Great Book of Polyphony), was widely distributed in manuscript by about 1160. Among its many anonymous composers was Léonin (see track 5.4). The Magnus Liber Organi was arranged in song cycles to provide music for all the feast days of the Church calendar. The Magnus Liber was created at a time when most polyphony was produced and transmitted only orally. What makes it so significant is that it represents the beginning of the modern sense of "composition"—that is, works attributable to a single composer.

At the end of the century, Léonin's successor, Pérotin, revised and renotated the *Magnus Liber*. One of his most famous works is *Viderunt Omnes* (All Have Seen), a four-part polyphonic composition based on the traditional plainchant of the same name, meant to be sung in the middle of the Christmas Mass at Notre-Dame Cathedral in Paris (see track 6.1). Throughout the piece, the choir sings a smooth, monophonic plainchant, while three soloists sing the second, third, and fourth melodic lines in **counterpoint**, that is, in opposition, to the plainchant. The clear but intertwined rhythms of the soloists build to a crescendo of sustained harmony and balance that must have inspired awe in the congregation. The music seems to soar upward, imitating the architecture of the cathedral and elevating the faithful to new heights of belief.

The words are simple, but because each syllable is sung across a range of notes and rhythms, the music takes almost 12 minutes to perform. What follows is the Latin and its translation:

Viderunt omnes fines terrae salutare Dei nostri. Jubilate Deo omnis terra. Notum fecit Dominus salutare suam. Ante conspectum gentium revelavit justitiam suam. All the ends of the earth have seen the salvation of our God. Praise God all the earth.

The Lord has made known his salvation. Before the face of the people he has revealed his justice.

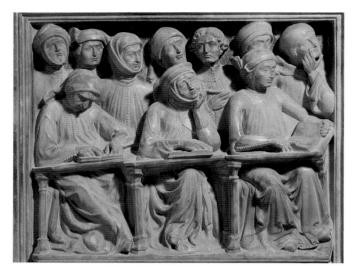

Fig. 6.13 Jacobello dalle Masegne and Pier Paolo dalle Masegne (fl. 1383–1409). Law Students, relief sculpture on tomb of a law professor at the University of Bologna, Italy. ca. 1200. Marble. Museo Civico, Bologna. Although women were generally excluded from the professions of medicine and law, there were exceptions. In this group of law students, the central figure in the front row appears to be a woman, Novella d'Andrea (1312–66). She lectured at the university on both philosophy and law, although it is said that she was required to speak from behind a curtain so as not to distract the male students.

The complexity of such rhythmic invention mirrors the growing textural complexity of the facade of Gothic cathedrals, with their spires, gables, crockets, and finials. Developing from this polyphony was an even more complex musical form, the motet, consisting of three (sometimes four) voices. The tenor—from the Latin tenere, "to hold"—generally maintained a traditional line based on ecclesiastical chant. The tenor line might be sung or played, perhaps by the organ, which began to replace the choir in the performance of many of these songs. In some ways, this was a practical gesture, since large choirs of the caliber needed to perform the liturgical songs were not easy to organize. The origins of the organ date back to as early as the fourth to third centuries BCE in Greece, with the invention of the hydraulis, which used water pressure to push air through the pipes. By the ninth century CE, the instrument had been modified to use air pressure, supplied by manually operated bellows, to push the air through the pipes. At any rate, the rich tones of the organ, resonating through the nave of the cathedral, gained increasing favor through the Middle Ages, and the organ became necessary to every large cathedral. In the motet, above the tenor line, two or three voices sang interweaving melodies.

By the late thirteenth century, a motet might be sung in either Latin or vernacular French, or even both simultaneously, and might consist of two, three, or four parts only loosely, if at all, related in content—sacred Latin hymns sung together with a vernacular French love song, or even a street vendor's call put to music. All these competing lines were held together like the complex elements of the Gothic

facade—balanced but competing, harmonious but at odds. They reflected, in short, the great debates—between Church and State, faith and reason—that defined the age.

These debates raged at centers of higher learning, where music was part of the regular liberal arts curriculum. It was studied as a branch of the *quadrivium* (the mathematical arts), alongside arithmetic, geometry, and astronomy, all fields dependent upon proportion and universal harmony. (The other liberal arts constituted the *trivium*, the language arts: grammar, rhetoric, and dialectic.) At the Cathedral School of Notre-Dame in Paris, the purpose of which was to train clergy, music was emphasized as an all-important liturgical tool. But by the middle of the twelfth century, cathedral schools began allowing nonclerical students to attend lectures. In 1179, a papal decree ordered the schools to provide for the teaching of the *laity* (nonclerics), the decree that would eventually give rise to the university as an institution.

THE RISE OF THE UNIVERSITY

Why did the University of Paris become preeminent among medieval institutions of higher learning?

In 1158, Christian Europe's first degree-granting university was founded in Bologna, Italy. It was preceded in the tenth century by the renowned center of higher learning in the Muslim court at Córdoba, Spain (see Chapter 4), which was in turn preceded by the University of Al-Qarawiyyin, founded in 859 in Fes, Morocco. Although closely aligned with the mosque's madrasa, nonclerical students and professors alike pursued matters of learning beyond the context of their religious significance, and this common pursuit of knowledge became the model for Christian Europe's emerging university system. At first, the term university meant simply a union of students and the instructors with whom they contracted to teach them. Universitas was an umbrella term for collegia, the groups of students who shared a common interest or, as at Bologna, hailed from the same geographic area. The University of Bologna quickly established itself as a center for the study of law (Fig. 6.13), an advanced discipline for which students prepared by mastering the seven liberal arts.

Proficiency in Latin was mandatory, and students studied Latin in all courses of their first four years of study. They read the writings of the ancient Greeks—Aristotle, Ptolemy, Euclid—in Latin translation. Augustine of Hippo's On Christian Doctrine was required reading, as were Boethius' writings on music and arithmetic. To obtain their bachelor of arts (BA) degree, students took oral exams after three to five years of study. Further study to acquire mastery of a special field led to the master of arts (MA) degree and might qualify a student to teach theology or practice medicine or law. Four more years of study were required to acquire the title of doctor

(from the Latin *doctus*, learned), culminating in a defense of a thesis before a board of learned examiners.

The University of Paris was chartered in 1200, and soon after came Oxford University and the University of Cambridge in England. These northern universities emphasized the study of theology. In Paris, a house or college system was organized, at first to provide students with accommodation and then to help them to focus their education. The most famous of these was organized by Robert de Sorbon in 1257 for theology students. The Sorbonne, named after him, remains today the center of Parisian student life.

Heloise and Abelard The quality of its teaching most distinguished the University of Paris. Because books were available only in handwritten manuscripts, they were extremely expensive, so students relied on lectures and copious notetaking for their instruction. Peter Abelard (1079-ca. 1144), a brilliant logician and author of the treatise Sic et Non ("Yes and No"), was one of the most popular lecturers of his day. Crowds of students routinely gathered to hear him. He taught by the dialectical method—that is, by presenting different points of view and seeking to reconcile them. This method of teaching originated with Socrates, but whereas Socratic dialogue consisted of a wise teacher who was questioned by students, or even fools, Abelard's dialectical method presumed no such hierarchical relationships. Everything, to him, was open to question. "By doubting," he famously argued, "we come to inquire, and by inquiring we arrive at truth."

Needless to say, the Church found it difficult to deal with Abelard, who demonstrated time and again that various Church Fathers—and the Bible itself—held hopelessly opposing views on many subjects. Furthermore, the dialectical method itself challenged unquestioning faith in God and the authority of the Church. Abelard was particularly opposed by Bernard of Clairvaux, who in 1140 successfully prosecuted him for heresy. By then, Abelard's reputation as a teacher had not faded, but his moral position had long been suspect. In 1119, he had pursued a love affair with his private student, Heloise. Abelard not only felt that he had betrayed a trust by falling in love with her and subsequently impregnating her, but also was further humiliated by Heloise's angry uncle, in whose home he had tutored and seduced the girl. Learning of the pregnancy, the uncle hired thugs to castrate Abelard in his bed. Abelard retreated to the monastery at Saint-Denis, accepting the protection of the powerful Abbot Suger. Heloise joined a convent and later served as abbess of Paraclete, a chapel and oratory founded by Abelard.

The Education of Women Heloise's story reveals much about the education of women in the Middle Ages. Intellectually brilliant, she became Abelard's private student because women were not allowed to study at the university. There were some exceptions, particularly in Italy. At Bologna, Novella d'Andrea (1312–66) lectured on philosophy and law. At Salerno, in southern Italy, the chair of medicine was held by Trotula (d. 1097), one of the most famous physicians

of her time, although some scholars debate whether she was actually a woman, and convincing evidence suggests that her works are actually compendiums of works by three different authors. Concerned chiefly with alleviating the suffering of women, the major work attributed to her is *On the Diseases of Women*, commonly known throughout the Middle Ages as the *Trotula*. As the author says at the beginning of the treatise.

Because women are by nature weaker than men and because they are most frequently afflicted in childbirth, diseases very often abound in them. . . . Women, from the condition of their fragility, out of shame and embarrassment do not dare reveal their anguish over their diseases (which happen in such a private place) to a physician. Therefore, their misfortune, which ought to be pitied, and especially the influence of a certain woman stirring my heart, have impelled me to give a clear explanation regarding their diseases in caring for their health.

In 63 chapters, the book addresses problems with menstruation, conception, pregnancy, and childbirth, along with general ailments and diseases. It champions good diet, warns of the dangers of emotional stress, and prescribes the use of opiates during childbirth, a practice otherwise condemned for centuries to come. It even explains how an experienced woman might pretend to be a virgin. The standard reference work in gynecology and obstetrics for midwives and physicians throughout the Middle Ages, the *Trotula* was translated from Latin into almost all vernacular languages, and was widely disseminated.

Thomas Aquinas and Scholasticism

In 1245, Thomas Aquinas (1225–74), a 20-year-old Dominican monk from Italy, arrived at the University of Paris to study theology, walking into a theological debate that had been raging for 100 years, ever since the conflict between Abelard and Bernard: How does the believer come to know God? With the heart? With the mind? Or with both? Do we come to know the truth intuitively or rationally? Aquinas took on these questions directly and soon became the most distinguished student and lecturer at the university.

Aquinas was accompanied to Paris by another Dominican, his teacher Albertus Magnus (ca. 1200–80), a German who taught at both Paris and Cologne and who later produced a biological classification of plants based on Aristotle. The Dominicans had been founded in 1216 by the Spanish priest Dominic (ca. 1170–1221) as an order dedicated to the study of theology. Aquinas and Magnus, and others like them, increasingly trained by Dominicans, were soon labeled *scholastics*. Their brand of theological inquiry, which was based on Abelard's dialectical method, was called **Scholasticism**.

Most theologians understood that there was a seeming conflict between faith and reason, but, they argued, since both proceeded from God, this conflict must, by definition, be a misapprehension. In the universities, rational inquiry

and Aristotle's objective descriptions of physical reality were all the rage (see Chapter 2), so much so that theologians worried that students were more enthralled with logical argumentation than right outcomes. Instead of studying heavenly truths and Scriptures, they were studying pagan philosophy. dating from the fourth century BCE. Scholasticism sought to reconcile the two. One of the greatest efforts in this direction is Aguinas' Summa Theologica, begun in 1265 when he was 40 years old. At Albertus Magnus' request, Aquinas set out to write a theology based entirely on the work of ancient philosophers, demonstrating the compatibility of Classical philosophy and Christian religion. The Summa Theologica takes on virtually every theological issue of the age, from the place of women in society and the Church, to the cause of evil, the question of free choice, and whether it is lawful to sell a thing for more than it is worth. The medieval summa was an authoritative summary of all that was known on a traditional subject, and it was the ultimate aim of every highly educated man to produce one.

In a famous passage, Aquinas takes on the largest issue of all—the *summa* of *summas*—attempting to prove the existence of God once and for all. Notice particularly the Aristotelian reliance on observation and logically drawn conclusions (**Reading 6.1**):

READING 6.1

Thomas Aquinas, from Summa Theologica

Is there a God?

REPLY: There are five ways in which one can prove there is a God.

The FIRST . . . is based on change. Some things . . . are certainly in the process of change: this we plainly see. Now anything in the process of change is being changed by something else. . . . Hence one is bound to arrive at some first cause of change not itself being changed by anything, and this is what everybody understands by God.

The SECOND is based on the nature of causation. In the observable world causes are found to be ordered in series. . . . Such a series must however stop somewhere. . . . One is therefore forced to suppose some first cause, to which everyone gives the name "God."

The THIRD way is based on what need not be and on what must be. . . . Some . . . things can be, but need not be for we find them springing up and dying away. . . . Now everything cannot be like this [for then we must conclude that] once upon a time there was nothing. But if that were true there would be nothing even now, because something that does not exist can only be brought into being by something already existing. . . . One is forced therefore to suppose something which must be . . . [and] is itself the cause that other things must be.

The FOURTH way is based on the gradation observed in things. Some things are found to be more good, more true, more noble. . . and other things less [so]. But such comparative terms describe varying degrees of approxi-

mation to a superlative . . . [something that is] the truest and best and most noble of things. . . . There is something, therefore, which causes in all other things their being, their goodness, and whatever other perfection they have. And this we call "God."

The FIFTH way is based on the guidedness of nature. An orderedness of actions to an end is observed in all bodies obeying natural laws. . . ; they truly tend to a goal and do not merely hit it by accident. . . . Everything in nature, therefore, is directed to its goal by someone with intelligence, and this we call "God."

Such a rational demonstration of the existence of God is, for Aquinas, what he called a "preamble of faith." What he calls the "articles of faith" necessarily follow upon and build on such rational demonstrations. So, although Christians cannot rationally know the essence of God, they can, through faith, know its divinity. Faith, in sum, begins with what Christians can know through what God has revealed to them in the Bible and through Christian tradition. Aquinas maintains, however, that some objects of faith, including the Incarnation, lie entirely beyond our capacity to understand them rationally in this life. Still, since we arrive at truth by means of both faith and reason—and, crucially, since all truths are equally valid—there should be no conflict between those arrived at through either faith or reason.

Although conservative Christians never quite accepted Aquinas' writings, arguing, for instance, that reason can never know God directly, his influence on Christian theology was profound and lasting. In the scope of its argument and the intellectual heights to which it soars, the Summa Theologica is at one with the Gothic cathedral. Like the cathedral, it is an architecture, built of logic rather than of stone, dedicated to the Christian God.

THE RADIANT STYLE AND THE COURT OF LOUIS IX

What is the Radiant style?

By the middle of the thirteenth century, the Gothic style in France had been elaborated into increasingly flamboyant patterns of repeated traceries and ornament that we have come to refer to as the Rayonnant, or Radiant style. This style was associated closely with the court of Louis IX, in Paris, which was considered throughout Europe to be the model of perfect rule. Louis was a born reformer, as much a man of the people as any medieval king could be. Under his rule the scholastics and Aquinas argued theology openly in the streets of Paris, just across the river from the royal palace. Louis believed in a certain freedom of thought, but even more in the rule of law. He dispatched royal commissioners into all the provinces to check up on the Crown's representatives and ensure that they were treating the people fairly. He abolished serfdom and made private wars—which many believe to have been the ultimate motivation for the First

Crusade—illegal. He reformed the tax structure and gave his subjects the right to appeal decisions in court. He was, in short, something of a saint. Indeed, the Church later beatified him as Saint Louis.

The Church especially valued Louis' dedication to its well-being. One of his most important contributions to the Church, and to the history of Gothic architecture, is the royal chapel of Sainte-Chapelle (Fig. 6.14), constructed in the center of the royal palace on the Île de la Cité not far from Notre-Dame de Paris. Louis had the chapel designed so that the royal family could enter directly from the palace, at the level of the stained glass, thus symbolizing his own eminence, while others—court officials and the like—entered through a smaller, ground-level chapel below. He created for himself, in other words, a palatine chapel—a palace chapel—on the model of Charlemagne, thus connecting himself to his great predecessor.

The chapel was nothing short of a reliquary built large. While on Crusade, Louis purchased what was believed to be the Crown of Thorns that Christ wore at the Crucifixion, as well as other precious objects, from the emperor of Constantinople. These precious pieces were destined to be housed in Sainte-Chapelle. No other structure in the Gothic era so completely epitomized the Radiant style even as it embodied the original vision of Abbot Suger:

Thus, when—out of my delight in the beauty of the house of God—the loveliness of the many-colored gems [of stained glass] has called me away from external cares, and worthy meditation has induced me to reflect, transferring that which is material to that which is immaterial, on the diversity of the sacred virtues. Then it seems to me that I see myself dwelling, as it were, in some strange region of the universe which neither exists entirely in the slime of the earth nor entirely in the purity of heaven; and that, by the grace of God, I can be transported from this interior to that higher world in an analogical manner.

Bathing the viewer in the light of its stained glass—light so bright, in fact, that the viewer can hardly distinguish the details of its biblical narrative—Sainte-Chapelle is designed to relieve the faithful of any external cares and transport them to a realm of heavenly beauty. It is spiritual space, the immateriality of its light comparable, in Suger's perspective, to the immateriality of the immortal soul. The ratio of glass to stone is higher than in any other Gothic structure, the windows separated by the slenderest of columns. The lower parts of the walls, beneath the windows, are richly decorated in red, blue, and gilt, so that stone and glass seem one and the same. Golden stars shine down from the deep blue of the delicately vaulted ceiling. Louis' greatest wish was to make Paris a New Jerusalem, a city as close to paradise as could be found on earth. For many visitors, he came as close as may be humanly possible in Sainte-Chapelle.

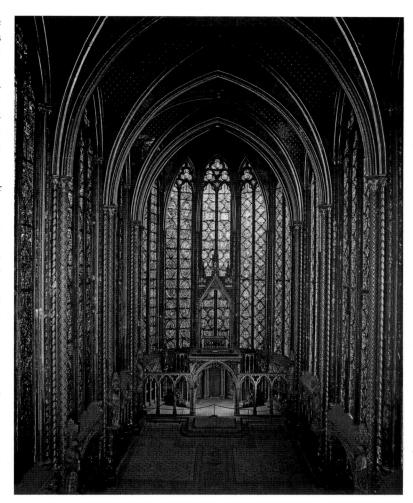

Fig. 6.14 Interior, Upper Chapel, Sainte-Chapelle, Paris. 1243—48. Although the chapel was originally surrounded by the royal castle—today it is surrounded by the Ministry of Justice—it remains more or less intact, save for a nineteenth-century repainting. Its acoustics were originally among the best in Paris and remain so today.

The Gothic Style in the French Ducal Courts

In the fourteenth century, the authority of the French king, though never challenged, was rivaled by the power of the ducal courts outside the Paris region. Among these dukes were the king's relatives, the dukes of Anjou, Berry, and Burgundy, who fashioned magnificent courts in their own capitals and employed vast numbers of artists charged with decorating them in a Gothic style directly indebted to the Radiant style of the century before.

The Burgundian dukes ruled from Dijon in eastern France, but they controlled as well the region of Flanders, encompassing present-day Holland, Belgium, and Luxembourg. When, in the early fifteenth century, they moved from Dijon to Flanders, their favorite destination was Bruges, which, of all the Flemish towns, had been the first to build a town hall

(Fig. 6.15). Its lavish Gothic ornamentation—from the tracery patterns in the upper windows to the ornamentation of the roofs and towers—was designed to recall the palaces of the French and Burgundian nobility. Interestingly, Bruges' adaptation of this style for its civic government—a government at least theoretically independent of ducal authority—underscores not only its citizens' sense of self-worth, but also their growing independence from the very nobles they imitated.

Through the late Middle Ages, the population of Bruges ranged between 40,000 and 50,000, quite large by northern European standards. (Most cities averaged just 2,000 to 3,000 inhabitants, and across Northern Europe, 70 percent of the population still lived in the countryside.) Wages in Bruges were the highest in Northern Europe, especially for craftspeople, and the city took pride in providing one of the most extensive social-care networks anywhere—including 11 hospitals and hospices. The port in Bruges was one of the leading trade depots in northern Europe, where fish from the Baltic, timber, grain, and furs from Poland and Russia, and silver from the mines of central Europe were exchanged for highly prized Flemish textiles and garments, and for commodities including spices, sugar, silk, and cotton. These arrived via the Venetian fleet, which, by the early fifteenth century, was dispatching 45 merchant galleys annually to Bruges and other nearby northern ports, each carrying over 250 tons of cargo.

The Miniature Tradition

It is perhaps no accident that a culture so concerned with material goods and material well-being should develop, in its art, a taste for detailed renderings of material reality. The northern European attention to detail in art derives, first of all, from the Gothic predilection for intricate tracery, the winding interplay

Fig. 6.15 Anonymous Flemish architects, Town Hall (center and right) and Greffe (at left), Bruges, Belgium. Town Hall 1376–1402; Greffe 1534–37. The Greffe is the office of civil clerks. The present-day sculptural decoration of the Town Hall dates from 1853. The original was destroyed during the French Revolution.

of ornamental buds and leaves so often apparent in Gothic stone- and woodwork. As we have also seen, in the sculptural decoration of churches such as that at Reims (see Fig. 6.12), by the middle of the thirteenth century, there was a developing taste for naturalism in art. It is in the work of the medieval miniature painters of the fifteenth-century French and Burgundian courts that these two directions first merge.

A miniature is a very small painting associated with illumination, the painstakingly detailed, hand-painted decoration of manuscripts, usually in tempera on vellum. The most famous miniature painters were the Limbourg brothers (flourished 1380–1416), Paul, Jan, and Hermann, sons of a sculptor from the Netherlands. The brothers migrated to Paris in the late fourteenth century. There, they were sponsored by their uncle, the court painter to Philip the Bold, the Duke of Burgundy (r. 1363–1404). After Philip the Bold died, the Limbourgs began working for his brother Jean, Duke of Berry (r. 1360–1416). Jean was the wealthiest man in Europe at the dawn of the fifteenth century—not surprisingly, as his subjects paid the heaviest taxes in all of Europe. With those taxes, the duke funded ambitious projects designed to celebrate his status and interests. One of his most important commissions to the Limbourg brothers was the Très Riches Heures du Duc de Berry (The Very Sumptuous Hours of the Duke of Berry), an illuminated Book of Hours begun in 1411. The brothers died five years later, most likely of the plague, and the work remained unfinished.

A Book of Hours typically begins with a calendar illustrated with images showing daily life or special events associated with each month of the year. It continues with short prayers to be recited during the eight designated times for prayer, or the canonical hours (see Chapter 5). The calendar section of the *Très Riches Heures* provides us with extraordinary insight

into the daily lives of both nobility and peasants. The contrast between the illustration for the first calendar month, January (Fig. 6.16), and the second, February (Fig. 6.17), could not be more dramatic. In the first, Jean de Berry presides over a New Year's feast. At the time, New Year was known as the étrenne, a time for the ritual exchange of gifts. They favored, particularly, the exchange of jewelry, flasks, enameled figurines, and saltcellars. We know, for instance, that in 1411, one of Jean de Berry's sons-in-law gave him as an étrenne a silver saltcellar "in the fashion of an ostrich, with a belly of pearl shell, and seated on a terrace of silver-gilt enameled with green." The duke sits in profile, framed by the round firescreen behind him. He is dressed in a loose blue overgown called a houpplande, trimmed with fur and covered with gold embroidery and diamonds. In the center of the table before him is a nef, a prized New Year's gift, used to store foodstuffs. Art historian Brigitte Buettner has described the January scene in an article that appeared in the Art Bulletin in 2001:

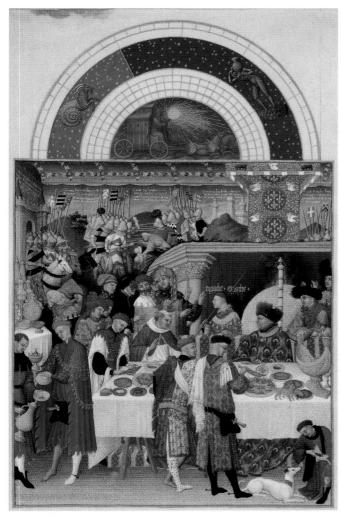

Fig. 6.16 Limbourg Brothers, January: The Feast of the Duke of Berry, from Les Très Riches Heures du Duc de Berry. ca. 1415. Illumination on parchment, 6%" × 4½". Musée Condé, Chantilly. Note that two small dogs enjoy the duke's table as much as his courtiers.

In the Limbourgs' miniature, there is an almost overwhelming sensory overload—things are carried and examined, food smelled and tasted; when looking long enough, one even starts to hear the noises made by cutting, pouring, shuffling, and rubbing, or the clinking of gilded belts and metal vessels, the crackling of the fire, the dogs barking and people shouting.

The duke in fact is exclaiming "Aproche, Aproche"—
"Approach, Approach"—words written in gilded lettering
above his head. Behind the scene is a tapestry depicting the
Trojan War, a tragic episode that could be said to have resulted from a failure to maintain the civility and hospitality of
Jean de Berry's court.

This resplendent image of material well-being contrasts dramatically with the next scene, representing February. Here we see three peasants warming themselves at a fire, one of

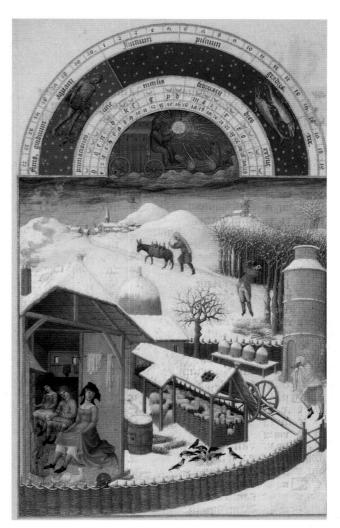

Fig. 6.17 Limbourg Brothers, February: Winter Scene, from Les Très Riches Heures du Duc de Berry. ca. 1415. Illumination on parchment, 6¾" × 4½". Musée Condé, Chantilly. In the calendar page for July, a woman in this same blue dress and black hat is depicted shearing what may well be these same sheep.

them, probably the "lady" of the house, with her skirts raised somewhat modestly just below her knees to reveal her knickers, but the two others, clearly peasants, immodestly exposing themselves. Outside in the snowy landscape are three others: one inadequately bundled against the cold and seemingly warming her hands with her breath; a second cutting firewood, no doubt to fuel the fire the others are enjoying; and the third driving a donkey to the distant village. By contrast with the refined world of the duke himself, these peasants are boorish and vulgar. Their warmth is no better than that of the sheep huddled in their pen; their "feast" probably closer to that of the birds scratching for seed than to the duke's; their shelter a far remove from even that of the bees whose hives they keep.

If the Limbourg brothers (and by extension, their patron, Jean de Berry) intended to contrast the duke's life with that of his people, there can be no doubt of the duke's superiority, but there can also be no doubt that the peasantry who owe

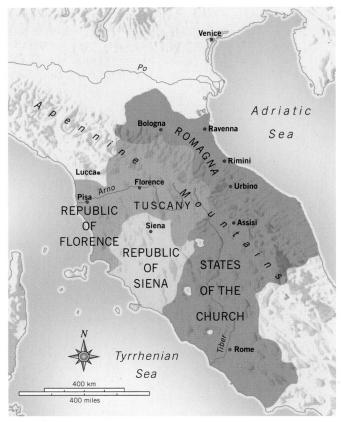

Map 6.1 Central Italy in about 1494, showing the Republics of Florence and Siena and the Papal States.

him allegiance and work his lands are, by medieval standards, relatively well off. Their farm is tidy and, apparently, prosperous. It may be, in fact, that we are witness, in the figure of the man driving a donkey to the village perhaps to sell wood to the village dwellers, to the dawn of economic capitalism. By the fifteenth century, at any rate, feudalism was dying, a middle class (of which, perhaps, the "lady" in blue is a member) was beginning to take shape, and the power of men like Jean de Berry was beginning to wane. But these images underscore the duke's continuing prestige and his mastery of his world.

CIVIC AND RELIGIOUS LIFE IN SIENA AND FLORENCE

How do the art and civic life of Florence and Siena compare?

Life in the southern regions of Europe was dramatically different from life in the north. By the thirteenth century, Italian life and politics were dominated by two prominent city-states, Siena and Florence. So weakened was the Church that, despite the fact that it controlled considerable territory, it exercised little real influence. Siena lies in the mountainous southern region of Tuscany, at the center of a rich agricultural zone famous for its olive oil and wine. Florence is located in the Arno River valley, the region's richest agricultural district (Map 6.1).

The two cities were fierce rivals, their division dating back to the contest for supremacy between the pope and the Holy

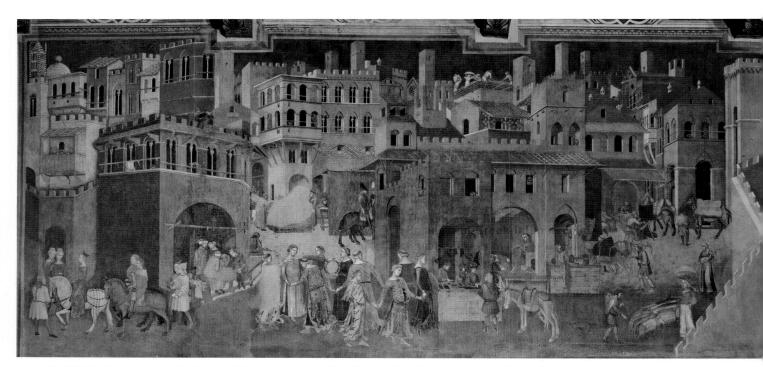

Fig. 6.18 Ambrogio Lorenzetti, Allegory of Good Government: The Effects of Good Government in the City and Country, fresco in the Sala della Pace, Palazzo Pubblico, Siena. 1338–39. Fresco, length approx. 46'. Across from this painting, Lorenzetti also painted an Allegory of Bad Government, in which there is no commerce, no dancing, only man killing man, destruction and darkness all around.

Roman Emperor during the time of Charlemagne (see Chapter 5). One faction, known as the Guelphs, sided with the pope, while another faction, the Ghibellines, sided with the emperor. Siena was generally considered a Ghibelline city, and Florence a Guelph stronghold, although factions of both parties competed for leadership within each city, especially in Florence. By the end of the thirteenth century, the pope retaliated against Siena for its Ghibelline leanings by revoking the city's papal banking privileges and conferring them instead on Florence. As a result, by the fourteenth century, Florence had become the principal economic and political power in Tuscany.

Both Siena and Florence were republics; the nobility did not rule them. Out of their competition with one another was born the modern Western city. What distinguished Florence and Siena from these earlier republics was the role that the citizenry played in expressing their civic pride.

The governments of both cities were controlled by *arti*, or **guilds**, associations or groups of people with similar, often occupation-based interests, which exercised power over their members. Leading the way in Siena was the merchants' guild, organized as early as 1192. The richest merchant families lent money (charging interest on their loans, despite a papal ban on the practice) and dealt in wax, pepper, and spices, as well as Flemish cloth, shoes, stockings, and belts. Other guilds, such as those of masons, carpenters, innkeepers, barbers, butchers, and millers, soon established themselves as well, but none was as powerful as the merchants' guild. By 1280, its members controlled city government, excluding the nobility and declaring that only "good popular merchants"

should be eligible to serve on the city council. By the end of the twelfth century in Florence, there were 7 major guilds and 14 minor ones. The most prestigious was the lawyers' guild (Arte dei Giudici), followed closely by the wool guild (Arte della Lana), the silk guild (Arte di Seta), and the cloth merchants' guild (Arte di Calimala). Also among the major guilds were the bankers, the doctors, and other merchant classes. Butchers, bakers, carpenters, and masons composed the bulk of the minor guilds.

Siena and Florence: Commune and Republic

Throughout the late Middle Ages, Siena had been one of the most powerful cities in Europe. When it established itself, in 1125, as a free **commune** (a collective of people gathered together for the common good), it achieved an immense advantage over

its feudal neighbors. "Town air brings freedom" was a common saying in the late Middle Ages. As the prospect of such freedom attracted an increasing number of people to Siena, its prosperity was soon unrivaled.

Crucial to the growing town's success was a new model of government, celebrated in 1338 by the painter Ambrogio Lorenzetti (flourished 1319–47) in a fresco called *Allegory of Good Government* (Fig. 6.18), commissioned for the council chamber of Siena's city

The CONTINUING PRESENCE of the PAST

See Newton Harrison and Helen Mayer Harrison, Vision for the Green Heart of Holland, installation view, Catheren Chapel, Gouda, Holland, 1995, at MyArtsLab

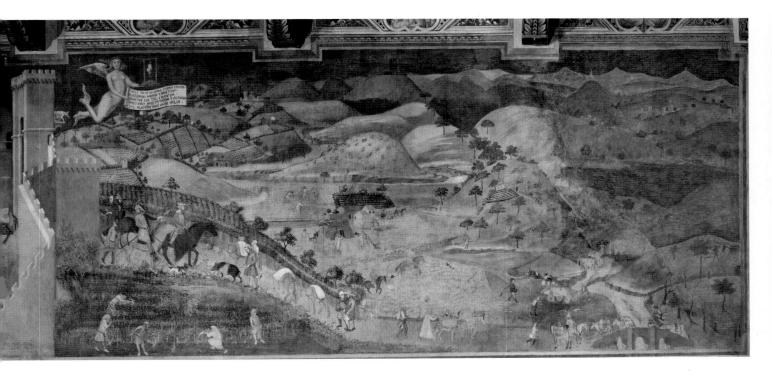

hall, the Palazzo Pubblico. The fresco depicts Siena as it actually appeared. Richly dressed merchants dance in the street, one couple passing beneath the arching arms of another, followed by a chain of revelers dancing hand in hand. To the left, in an arched portico, three men play a board game. To their right is a shoe shop, behind that a schoolroom where a teacher expounds to a row of students, and beside the schoolroom, a wine shop. At the very top, masons construct a new building. Outside the city gate, to the right, the surrounding countryside is lush. Farmers bring livestock and produce to market, workers till the fields and labor in the vineyards. Above them all, floating in the sky, is the nearly nude figure of Securitas ("Security"), carrying a gallows in one hand and a scroll in the other, to remind citizens that peace depends upon justice. At the horizon, the sky is ominously dark, suggesting perhaps that Siena's citizens thought of themselves as living in a uniquely enlightened place.

Like Siena, Florence was extremely wealthy, and that wealth was based on trade. By the twelfth century, Florence was the center of textile production in the Western world and played a central role in European trade markets. The Arno River provided ample water for washing and rinsing sorted wool and finished cloth. The city's dyeing techniques were unsurpassed—to this day, the formulas for the highly prized Florentine reds remain a mystery. Dyestuffs were imported from throughout the Mediterranean and even the Orient, and each year, Florentine merchants traveled to England, Portugal, Spain, and Flanders to purchase raw wool for their manufactories.

As in Siena, it was the city's bankers and money lenders who made Florence a vital player in world trade. Florentine bankers invented checks, credit, even life insurance. Most importantly, in 1252, they introduced Europe's first single currency, the gold *florin*. By 1422, over 2 million florins were in circulation throughout Europe. This was a staggering number considering that a family could live comfortably on about 150 florins a year, and the finest palace cost about 1,000 florins. Florence was Europe's bank, and its bankers were Europe's true nobility.

In Florence, the merchants, especially the Arte della Lana, controlled the government. They were known as the *Popolo Grasso* (literally, "the fat people"), as opposed to *Popolo Minuto*, the ordinary workers, who comprised probably 75 percent of the population and had no voice in government. Only guild members could serve in the government. Their names were written down, the writing was placed in leather bags (*borse*), and nine names were drawn every two months in a public ceremony. (The period of service was short to reduce the chance of corruption.) Those *signori* selected were known as the *Priori*, and their government was known as the *Signoria*—hence the name of the Piazza della Signoria, the plaza in front of the Palazzo Vecchio, the Florentine city hall. Of the nine Priori, six came from the major guilds, two from the minor guilds, and there was one standard-bearer.

The Florentine republic might have been a true democracy except for two details: First, the guilds were very close-knit so that, in general, selecting one or the other of their

membership made little or no political difference; and second, the available names in the *borse* could be easily manipulated. However, conflict inevitably arose, and throughout the thirteenth century, other tensions made the problem worse, especially feuds between Guelphs and Ghibellines. In Florence, the Guelphs were generally merchants and the Ghibellines nobility. Thus, the battle lines between the two were drawn in class terms, often resulting in family feuds and street violence. In fact, the tower of the Palazzo Vecchio was built on the site of a preexisting Ghibelline tower of the palace of the noble Uberti family, and the plaza in front was created by razing the remainder of the Uberti palace complex. Thus, both city hall and the public gathering place represented the triumph of Guelph over Ghibelline, the merchant class over the aristocracy.

Painting: A Growing Naturalism

Even though Saint John the Baptist was the patron saint of Florence, the city, like Siena, relied on the Virgin Mary to protect it. Her image appeared frequently in the Florentine churches and elsewhere, and these images were said to perform miracles. Pilgrims from Tuscany and beyond flocked to Florence to receive the Madonna's good graces. As in Siena, whenever the city was threatened—by war, by flood, by plague—the Madonna's image was carried through the city in ceremonial procession. The two cities put themselves under the protection of the Virgin, and it was not long before they were competing to prove who could paint her the most magnificently. In the process, they began to represent her less in the stiff, abstracted manner of the Byzantine icon and more as a real person of flesh and blood.

Duccio and Simone Martini After the Venetian rout of Constantinople in the Fourth Crusade in 1204, Byzantine imagery flooded Europe. One of the first artists to break from the Byzantine tradition was the Sienese native Duccio di Buoninsegna (flourished 1278–1318). In 1308, the commune commissioned Duccio to paint a *Maestà*, or *Virgin and Child in Majesty* (Fig. **6.19**), to be set under the dome of Siena's cathedral.

The finished work was greeted with a great celebration: "On the day that it was carried to the [cathedral]," a contemporary chronicler reports,

the shops were shut, and the bishop conducted a great and devout company of priests and friars in solemn procession, accompanied by . . . all the officers of the commune, and all the people, and one after another the worthiest with lighted candles in their hands took places near the picture, and behind came the women and children with great devotion . . . making the procession around the Campo, as is the custom, all the bells ringing joyously, trumpets and bagpipes playing, out of reverence for so noble a picture as is this.

Duccio was well aware of the greatness of his achievement. Along the base of the Virgin's throne he wrote these words:

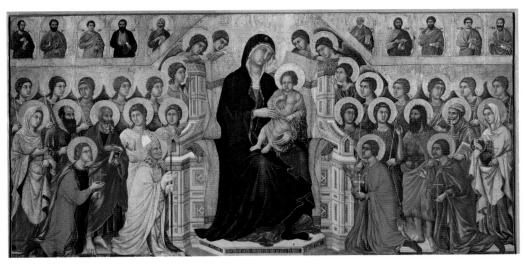

Fig. 6.19 Duccio di Buoninsegna. *Maestà*, main panel of *Maestà Altarpiece*, from Siena Cathedral. 1308–11. Tempera and gold on wood, 7' × 13'6\%". Museo dell'Opera del Duomo, Siena. The Madonna's throne imitates the stone facade of the cathedral.

"Holy Mother of God, give Siena peace and Duccio life because he painted Thee thus," announcing both the artist's piety and pride in his work and the growing prominence of artists in Italian society as a whole.

Duccio's Maestà begins to leave the conventions of the Byzantine icon behind and incorporates the Gothic tendency

the drapery falling

CONTINUITY & CHANGE

Theotokos and Child , p. 133

to naturalism. (Compare the Byzantine painting of Mary from Saint Catherine's monastery; see Fig. 4.16 in Chapter 4.) Duccio's Christ Child seems to be an actual baby, and a slightly chubby one at that. Similarly, beneath the Madonna's robes, we can sense a real body. Her knee especially asserts itself, and

from it drops in long, gentle curves, much more natural-looking than the rigid, angular drapery of earlier Byzantine works. Four angels peer over the top of the Madonna's throne, gazing on the child like proud relations. The saints who kneel in the front row appear to be individuals rather than types. Notice especially the aging and bearded cleric at the left. All are patron saints of the city, underscoring the fact that Duccio's painting is both an ecclesiastical and a civic commission.

If Duccio's Maestà reflects the growing realism of Sienese art, the Maestà of Simone Martini (1284–1344), in the Council Chamber in Siena's Palazzo Pubblico, is even more naturalistic (Fig. 6.20). Simone had worked on the cathedral Maestà as Duccio's apprentice from 1308 to 1311, and he probably modeled his own work on it. Situated in a public building, overlooking

the workings of civic administration, Simone's painting announces, even more dramatically than Duccio's, the blending of the sacred and secular in Tuscan culture.

One of the great innovations of Simone's fresco is the Virgin's crown, which signifies her status as Queen of Heaven. Surrounded by her celestial "court," she reveals the growing influence of French courtly poetry (see Chapter 5) in Italy. She becomes a model for human behavior, an emblem in the spiritual realm for the most noble types of secular love and devotion, including devotion to the right conduct of government. Highlighting the secular message, Jesus holds a parchment, adhered to the surface of the fresco, that reads, "Love Justice you who judge the earth." Like Duccio's painting, Simone's fresco carries a propagandistic message to

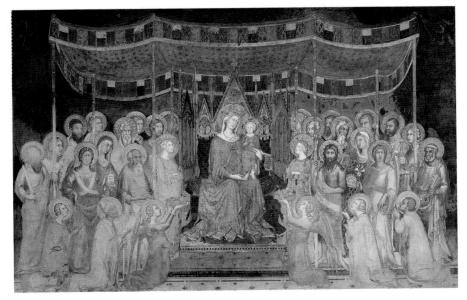

Fig. 6.20 Simone Martini, *Maestà*, Council Chamber, Palazzo Pubblico, Siena. ca. 1311–17, repaired 1321. Fresco, 25' × 31'9". Martini's fresco covers the end wall of the Council Chamber, symbolically submitting that civic body's deliberations to the Madonna's watchful gaze and care.

the city fathers. Inscribed at the base of the throne are these words: "The angelic little flowers, roses and lilies, Which adorn the heavenly meadow, do not please me more than good counsel." The painting suggests that the Virgin is as interested in worldly affairs as divine ones. Because of the realistic way Simone has represented her, she is as human as she is divine.

Stylistic differences separate the two works as well. As in many Byzantine icons, Duccio's Madonna wears no crown, her brows turn without interruption down into the length of her nose, she is draped in blue, with an orange undergarment, and her rounded hood echoes the halo behind her head. She is much larger than those attending her, conforming to the hierarchies of Byzantine art. In Simone's version of the theme, the Virgin and surrounding figures are depicted almost in the same scale. As opposed to Duccio's painting, with its stacked receding space, Simone's Virgin sits in a deep space of the canopy with its delicate Gothic arches behind the throne. Both of the Virgin's knees are visible, with the Christ Child standing firmly on one of them. Her head and neck, rather than being shrouded behind an all-embracing hood, are rounded and full beneath the crown and its softly folded train, which is itself fully rounded in shadow behind her neck. Her robe, neglecting convention, is composed of rich, transparent silks, beneath which we can see her right arm. Above all, her porcelain-white skin, tinged with pink, gives her complexion a realistic tone. Blood flows through her body, rouging her cheeks, and her flesh breathes with life. She embodies, in fact, a standard of beauty absent in Western art since Classical times—the physical beauty of the flesh as opposed to the divine beauty of the spirit.

Cimabue and Giotto Florence, too, had its master painters of the Virgin. Even before Duccio became active in Siena, a painter

known as Cimabue had produced a large-scale Virgin for the altarpiece of the Church of Santa Trinità in Florence (Fig. 6.21). Cimabue's Madonna Enthroned with Angels and Prophets solidified his position as the leading painter in Florence. Although its Byzantine roots are clear—following closely, for instance, a Byzantine hierarchy of figures, with the Madonna larger than the figures that surround her—the painting is remarkable on several fronts. First, it is enormous. Standing

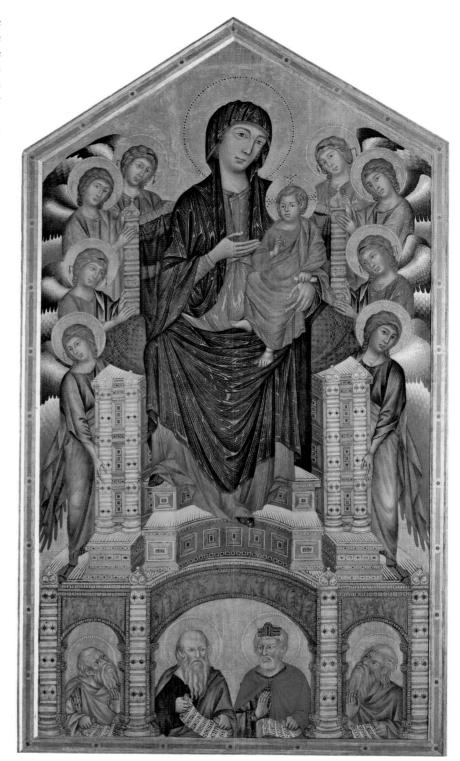

Fig. 6.21 Cimabue, Madonna Enthroned with Angels and Prophets, from the high altar of Santa Trinità, Florence. ca. 1285. Tempera and gold on wood, 11'7½' × 7'4". Galleria degli Uffizi, Florence. The later Renaissance historian Giorgio Vasari would claim that Cimabue had been apprenticed to a Greek painter from whom he learned the fundamentals of Byzantine icon painting.

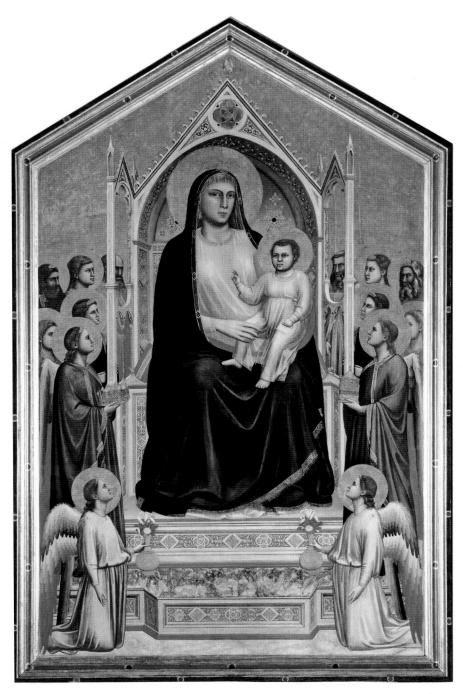

Fig. 6.22 Giotto di Bondone, *Madonna Enthroned with Saints and Angels*, from the Church of the Ognissanti, Florence. ca. 1310. Tempera and gold on wood, $10'8'' \times 6'814''$. Galleria degli Uffizi, Florence. Giotto's contemporary, the writer Boccaccio, discussed later in this chapter, said that he "brought back to light that art which had for many ages lain buried beneath the blunders of those who painted rather to delight the eyes of the ignorant than to satisfy the intelligence of the wise."

nearly 12 feet high, it seems to have begun a tradition of large-scale altarpieces, helping to affirm the altar as the focal point of the church. But most important are Cimabue's concern for spatial volume and his treatment of human figures with naturalistic expressions. The throne is especially interesting, creating as it does a spatial setting for the scene, and the angels seem to be standing on the architectural frame; the front two clearly are. If the Virgin and Child are stock Byzantine figures, the four prophets at the base of the throne are surprisingly individualized, suggesting the increasing prominence of the individual personality in the era, an especially important characteristic, as we will see later in the chapter, of the literature of the period. These remarkably individual likenesses also tell us that Italian artists were becoming more skillful in painting with tempera, which allowed them to portray the world in ever-increasing detail. Perhaps most interesting of all is the position of the Virgin's feet, the right one propped upon the throne in an almost casual position.

According to an old story, one day Cimabue discovered a talented shepherd boy by the name of Giotto di Bondone and tutored him in the art of painting. The pupil soon surpassed the teacher. Vasari would later say that Giotto set "art upon the path that may be called the true one, learned to draw accurately from life and thus put an end to the crude Greek [i.e., Byzantine] manner."

Giotto's Madonna Enthroned with Angel and Saints (Fig. 6.22) of about 1310, painted just a quarter century after Cimabue's, represents as remarkable a shift toward naturalism as Simone's Maestà does over Duccio's. While it retains a Byzantine hierarchy of figures—the Christ Child is

almost as big as the angels and the Virgin three or four times their size—it is spatially convincing in a way that Cimabue's painting is not. Giotto apparently learned to draw accurately from life, and his figures reveal his skill. He was a master of the human face, capable of revealing a wide range of emotion and character. This skill is particularly evident in the frescoes of the Scrovegni Chapel, named after the family who commissioned the work (see *Closer Look*, pages 196–197). (The chapel is also known as the Arena Chapel, after the ancient Roman arena in which it is situated.) The total effect is to humanize Christ, the Virgin, and the saints—to portray them as real people.

CLOSER LOOK

Chapel in Padua, painted around 1305. Giotto covered virtually every space of the barrel-vaulted family chapel of the Scrovegni family with *buon fresco*, the technique of painting on wet plaster. In *buon fresco*, a rough, thick undercoat of plaster is applied to a wall. When the wall has dried, the artist's assistants transfer a full-size drawing of the work—called a **cartoon**—to the wall. Typically, small holes were pricked in the paper cartoon, through which a dotted image of the drawing was transferred onto the plaster. The resulting drawing on the wall, often elegantly filled out and perfected in charcoal, is known as a **sinopia**.

Assistants next applied a fresh, thin coat of plaster over a section of the sinopia, and pigments, mixed with water, were painted on just before this coat set. Since the paint had

The Scrovegni Chapel, Padua. The Life of Christ and the Virgin frescoes by Giotto. 1305–06. In the bottom layer of images, closest to the floor, figures of the Virtues and Vices appear as painted, black-and-white simulations of sculpture, a technique known as *grisaille*. On the back wall above the door is a Last Judgment, figured as the final episode in the life of Christ.

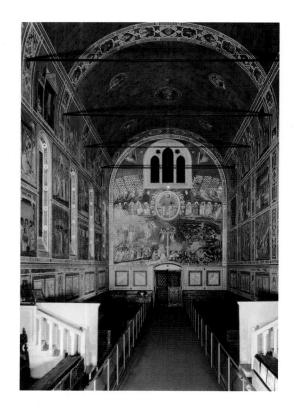

Even the angels are wracked with grief.

The blue void at the center of the painting is a metaphor for the emptiness felt by the mourners.

The direction of the Virgin Mary's grief-stricken gaze continues down the diagonal — line created by the barren ridge, reinforcing its emptiness.

Giotto was the first artist since antiquity to depict figures from behind, contributing to the sense that we are viewing a real drama.

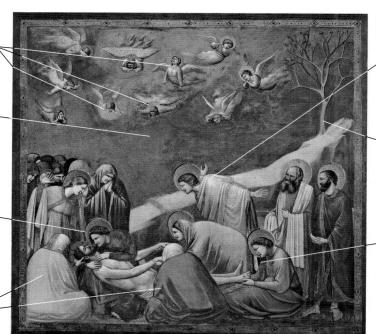

Giotto, The Lamentation, Scrovegni Chapel, Padua. 1305–06. Fresco, $78\frac{1}{2}$ " \times 73". Among the most moving scenes in the chapel is Giotto's depiction of human suffering. The painter focused on the real pain felt by Jesus' followers upon his death, rather than the promise of salvation that it symbolized.

John the Evangelist flings his arms back in a gesture that echoes that of the angels, almost as if his arms were wings.

The single leafless tree is a traditional symbol of death. It sits on a barren ridge that plunges in a stark diagonal toward the dead Christ.

Mary Magdalene, recognizable by her long hair, is traditionally represented at the Crucifixion kissing Christ's feet. Here, the Crucifixion over, she holds his feet in her hands, in an act of consummate tenderness and affection.

Giotto's Scrovegni Chapel

Halley's Comet made one of its regular appearances in 1301, just a few years before this painting was made. It was also depicted in the Bayeux Tapestry of 1066 (see Chapter 5, *Closer Look*, pages 160–161). Giotto apparently modeled the star that guides the Magi on that phenomenon.

The boy looks up at the Magi's camels in astonishment. This expression of emotion is typical of Giotto's frescoes. Giotto had probably never seen a camel: These have blue eyes and cows' feet.

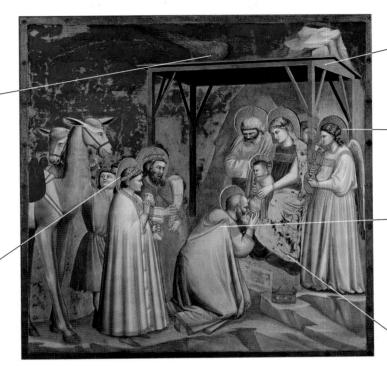

Giotto, *The Adoration of the Magi*, Scrovegni Chapel, Padua. 1305–06. Fresco, 78½" × 73". Boccaccio, author of the extraordinarily realistic story-cycle the *Decameron*, admired Giotto's painterly realism: "There is nothing in the whole creation he cannot depict." Boccaccio wrote.

Note Giotto's attempt to render the wooden shed in perspective. If he does not quite "get it," he is coming close.

Giotto has abandoned the Byzantine hierarchy of figures. The angels, the Magi, the Virgin, and the Child are all drawn to the same scale. (For a comparison, see Duccio's Maestà Altarpiece. Fig. 6.19.)

The king Caspar has removed his crown and placed it at the foot of the angel receiving gifts. The gesture signifies his understanding that Christ is the "King of Kings."

The blue of Mary's skirt has almost completely flaked off. Lapis lazuli, the stone used to make blue pigment, does not combine with wet plaster, so the blue had to be painted on after the plaster had dried, leaving it far more susceptible to heat and humidity, which eventually caused flaking.

to be applied on a wet wall, only sections small enough to be completed in a single day—before the plaster dried—could be worked. The boundaries of these sections, known as **giornata**, literally a "day's work" in Italian, often conform to the contours of major figures and objects. If the area to be painted was complex—a face, for instance—the *giornata* might be no larger. Detailed work was added later.

At the Arena Chapel, the top of the vault is a starry blue sky, painted with lapis lazuli. Lapis lazuli does not properly combine with wet plaster, so it was applied on a dry wall. As a result, the blues of the ceiling and other blues in the frescoes have faded far more than the other colors, most of which still look fresh. On the side walls are scenes from the life of the Virgin and of Christ.

Above the door is a depiction of the Last Judgment, in which the patron, Enrico Scrovegni, offers a model of the chapel to the Virgin. The purpose of the chapel seems clear: It was meant as penance on Enrico's part for his own and his father's sins—notably their flagrant usury.

The paintings depicting the life of Christ and the Virgin deliberately abandon the balance and symmetry that

distinguish Byzantine painting (and, for that matter, the Maestàs of the period) in order to create a heightened sense of reality. In The Lamentation, for instance, Giotto places Christ in the lower left-hand corner of the work, at the bottom of a stark diagonal. Throughout the cycle, the action takes place on a narrow platform at the front of the painting. The architecture in the paintings is small in comparison to the figures, as in the Adoration of the Magi. Giotto may have been influenced by the stage sets made for the contemporary revival in Padua of Roman theater. Whatever the case, the drama of Giotto's paintings is undeniable. They possess a psychological intensity and emotional immediacy that involve the viewer directly in the scene.

Something to Think About . . .

If Giotto's paintings do, in fact, possess an intensity and immediacy that serve to involve the viewer directly in the scene, how might his paintings be compared to the role of music in the liturgy?

THE SPREAD OF VERNACULAR LITERATURE IN EUROPE

What is the vernacular style and what accounts for its spread?

Until the early twelfth century, the language of almost all educated circles in Europe, and certainly in literature, was Latin. Gradually, however, writers began to address their works to a wider lay audience and to write in the **vernacular**, the language spoken in the streets. The French led the way, in twelfth-century works such as the *Song of Roland* and Chrétien de Troyes' *Lancelot* (see Chapter 5), but early in the fourteenth century, vernacular works began to appear throughout Italy as well, spreading from there to the rest of Europe.

Dante's Divine Comedy

One of the greatest medieval Italian writers working in the vernacular was the poet Dante Alighieri (1265–1321). In about 1308, he began one of the greatest works of the literary imagination, the *Divine Comedy*. This poem records the travels of the Christian soul from Hell to Purgatory and finally to Salvation in three books—the *Inferno*, *Purgatorio*, and *Paradiso*. It is by no means an easy journey. Dante, who is the leading character in his own poem, is led by the Roman poet Virgil, author of the *Aeneid* (see Chapter 3). (Virgil, too, visits the underworld in the sixth book of his poem.)

Virgil cannot lead Dante into Heaven in the Paradiso. since he is a pagan who is barred from salvation. He is thus condemned to Limbo, the first level of Hell, a place of sorrow without torment, populated by virtuous pagans, the great philosophers and authors, unbaptized children, and others unfit to enter the Kingdom of Heaven. Among those who inhabit the realm with Virgil are Caesar, Homer, Socrates, and Aristotle. There is no punishment here, and the atmosphere is peaceful, yet sad. Virgil is, in fact, the model of human rationality, and in the Inferno, he and Dante study the varieties of human sin. Many of the characters who inhabit Dante's Hell are his contemporaries—the lovers Paolo and Francesca from Ravenna and Rimini, the usurer Reginaldo Scrovegni (patron of the chapel painted by Giotto; see Closer Look, pages 196-197), and so on. Dante also makes much of the Guelph/Ghibelline rivalries in his native Florence. He was himself a Guelph, but so divided were the Guelphs among themselves—into factions called the Blacks and the Whites, papal versus imperial bankersthat his efforts to heal their schism as one of the *Priori*, one of the nine leaders of the Florentine commune, resulted in a two-year exile beginning in 1302. Embittered, he never returned to Florence.

Dante's *Inferno* is composed of nine descending rings of sinners undergoing punishment, each more gruesome than the one before it. In the poem's first canto, the poet is lost in a Dark Wood of Error, where Virgil comes to his rescue,

promising to lead him "forth to an eternal place." In Hell, the two first encounter sinners whose passion has condemned them to Hell—Paolo and Francesca, whose illicit love was motivated, they tell Dante, by reading Chrétien de Troyes' Lancelot. The lovers are forever condemned to unreconciled love, to touch each other but never consummate their feelings. In the next ring are the gluttonous, condemned to wallow like pigs in their own excrement. Sinners, in other words, are punished not for their sins but by their sins. Dante finds intellectual dishonesty more sinful than any sin of passion, and thus flatterers, hypocrites, and liars occupy the next lower rings of hell. The violent are further down, immersed for eternity in boiling blood. And finally, at the very bottom of the pit, imprisoned in ice "like straws in glass," are the traitors. Among the lowest of the low are Guelphs and Ghibellines from all over Tuscany who betrayed their cities' well-being. Finally, in Canto 34, Dante once again integrates the pagan and Christian worlds as Satan himself chews on the worst of all traitors—Judas (thought to have betraved Jesus) and Brutus and Cassius (assassins of Julius Caesar) (Reading 6.2):

READING 6.2

from Dante, Inferno, Canto 34

... With what a sense of awe I saw his head towering above me! for it had three faces: one was in front, and it was fiery red;

the other two, as weirdly wonderful, merged with it from the middle of each shoulder to the point where all converged at the top of the skull;

the right was something between white and bile; the left was about the color one observes on those who live along the banks of the Nile.

Under each head two wings rose terribly, their span proportioned to so gross a bird: I never saw such sails upon the sea.

They were not feathers—their texture and their form were like a bat's wings—and he beat them so that three winds blew from him in one great storm:

it is these winds that freeze all Cocytus. He wept from his six eyes, and down three chins the tears ran mixed with bloody froth and pus.²

In every mouth he worked a broken sinner between his rakelike teeth. Thus he kept three in eternal pain at his eternal dinner.

For the one in front the biting seemed to play no part at all compared to the ripping: at times the whole skin of his back was flayed away.

"That soul that suffers most," explained my Guide, "is Judas³ Iscariot, he who kicks his legs on the fiery chin and has his head inside.

Of the other two, who have their heads thrust forward, the one who dangles down from the black face is Brutus: note how he writhes without a word.

Fig. 6.23 Jean Le Noir, pages with *The Three Living* (left) and *The Three Dead* (right), from the *Psalter and Book of Hours of Bonne of Luxembourg.* Before 1349. *Grisaille*, color, gilt, and brown ink on vellum, 5" × 3½". The Metropolitan Museum of Art, New York. The Cloisters Collection, 1969 (69.86). On the left page, three horsemen contemplate the three cadavers on the right page who are in increasing states of decay. One horseman brings a handkerchief to his nose to fight off the stench. The cadavers address the horsemen: "What you are we were and what we are you will be!"

And there, with the huge and sinewy arms, 4 is the soul of Cassius. But the night is coming on and we must go, for we have seen the whole." . . .

Notes

'three faces: Numerous interpretations of these three faces exist. What is essential to all explanation is that they be seen as perversions of the qualities of the Trinity.

²bloody froth and pus: The gore of the sinners he chews which is mixed with his slaver (saliva).

³Judas: Note how closely his punishment is patterned on that of the Simoniacs (Canto 19).

⁴huge and sinewy arms: The Cassius who betrayed Caesar was more generally described in terms of Shakespeare's "lean and hungry look." Another Cassius is described by Cicero (*Catiline III*) as huge and sinewy. Dante probably confused the two.

In the universe of the *Divine Comedy*, Virgil, as the embodiment of rationality, can take Dante no further than Hell and Purgatory, since in order to enter Paradise, faith must triumph over reason, something impossible for the pagan Roman. Dante's guide through Paradise is Beatrice, the love of his life. Beatrice was the daughter of the Florentine nobleman Folco Potinari, and Dante first saw her when she was nine years old and he was eight. He describes meeting her in his first major work, *La Vita Nuova*: "Love ruled my soul . . . and began to hold such sway over me . . . that it was necessary for me to do completely all his pleasure. He commanded me often that I should endeavor to see this youthful angel, and I saw her in such noble and praiseworthy deportment that truly of her might be said these words of the poet Homer—"She appeared to be born not of mortal man but of God."

Dante wrote these words in 1293. Ten years earlier, when she was 18, Beatrice had entered into a marriage, arranged when she was eight, with Simone di Bardi. It lasted only seven years, ending in her death at age 25. Dante's love for her was, then, the classic love of the courtier for his lady, marked by an unconsummated physical desire necessarily transformed into a spiritual longing that leads him, at the end of the *Divine Comedy*, to a comprehension of God's love as he contemplates "in a great flash of light" a vision so powerful that he can barely find words to express it.

The Black Death and Its Aftermath

In 1316 and 1317, not long before Dante's death, crop failures across Europe resulted in the greatest famine the continent had ever known. For two summers, the sun rarely shone (no one knew that huge volcanic eruptions thousands of miles away in Indonesia had sent vast clouds of ash into the atmosphere). Furthermore, between 1000 and 1300, the continent's population had doubled to a point where it probably exceeded its ability to feed itself even in the best of times. In these dark

years, which were followed by a century-long cooling period marked by too much rain to allow good grain harvests, common people were lucky to eat, let alone eat well. Then, in December 1347, rats infested with fleas carrying bubonic plague arrived on the island of Sicily. They were carried on four Genoese ships that had set sail from Kaffa, a Genoese trading center on the Black Sea.

The disease began in the lymph glands of the groin or armpits, which slowly filled with pus and turned black. The inflammations were called buboes—hence the name bubonic plague—and their black color lent the plague its other name, the Black Death. Since it was carried by rodents, which were commonplace even in wealthy homes, hardly anyone was spared. It was an egalitarian disease—archbishops, dukes, lords of the manor, merchants, laborers, and peasants fell equally before it (Fig. 6.23). For those who survived the pandemic, life seemed little more than an ongoing burial service. In many towns, traditional funeral services were abandoned, and the dead were buried in mass graves. By 1350, all of Europe, with the exception of a few territories far from traditional trade routes, was devastated by the disease. In Tuscany, the death rate in the cities was near 60 percent. In Florence, on June 24, 1348, the feast day of the city's patron saint, John the Baptist, 1,800 people reportedly died, and another 1,800 the next day—about 4 percent of the city's population in two days. Severe outbreaks of the plague erupted again in 1363, 1374, 1383, 1388, and 1400.

Literature after the Black Death: Boccaccio's Decameron

The frank treatment of reality found in the visual arts carried over into literature, where the direct language of the vernacular proved an especially appropriate vehicle for rendering truth. The *Decameron*, or "Work of Ten Days," is a collection of framed prose tales. The Florentine writer Giovanni Boccaccio (1313–75), who lived through the plague, sets the stage for the 100 prose stories of the collection with a startlingly direct description of Florence in the ravages of the disease (**Reading 6.3**):

READING 6.3

from Boccaccio, Decameron

The virulence of the plague was all the greater in that it was communicated by the sick to the well by contact, not unlike fire when dry or fatty things are brought near it. But the evil was still worse. Not only did conversation and familiarity with the diseased spread the malady and even cause death, but the mere touch of the clothes or any other object the sick had touched or used, seemed to spread the pestilence. . . .

Meanwhile, in the midst of the affliction and misery that had befallen the city, even the reverend authority of divine and human law had almost crumbled and fallen into decay, for its ministers and executors, like other men, had either died or sickened, or had been left so entirely without assistants that they were unable to attend to their duties. As a result everyone had leave to do as he saw fit. . . .

It used to be common, as it is still, for women, friends and neighbors of a dead man, to gather in his house and mourn there with his people. . . . Now, as the plague gained in violence, these customs were either modified or laid aside altogether. . . . It was a rare occasion for a corpse to be followed to church by more than ten or twelve mourners—not the usual respectable citizens, but a class of vulgar gravediggers who called themselves "sextons" and did these services for a price. . . .

More wretched still were the circumstances of the common people and, for a great part, of the middle class, for, confined to their homes either by hope of safety or by poverty, and restricted to their own sections, they fell sick daily by thousands. There, devoid of help or care, they died almost without redemption. A great many breathed their last in the public streets, day and night; a large number perished in their homes, and it was only by the stench of their decaying bodies that they proclaimed their death to their neighbors. Everywhere the city was teeming with corpses. A general course was now adopted by the people, more out of fear of contagion than of any charity they felt toward the dead. Alone, or with the assistance of whatever bearers they could muster, they would drag the corpses out of their homes and pile them in front of the doors, where often, of a morning, countless bodies might be seen. Biers were sent for. When none was to be had, the dead were laid upon ordinary boards, two or three at once. It was not infrequent to see a single bier carrying husband and wife, two or three brothers, father and son, and others besides. . . .

So many bodies were brought to the churches every day that the consecrated ground did not suffice to hold them, particularly according to the ancient custom of giving each corpse its individual place. Huge trenches were dug in the crowded churchyards and the new dead were piled in them, layer upon layer, like merchandise in the hold of a ship. . . .

Boccaccio describes a world in virtual collapse. The social breakdown caused by the plague is especially evident in the widespread death of the ruling class and the rise of the class of men who called themselves "sextons," technically guardians of the church edifice, treasures, and vestments, but now a vile band of mercenary gravediggers. All tradition has been abandoned.

Nevertheless, a good deal of the power of Boccaccio's book is that in this atmosphere of dark matter-of-factness, he inaugurates something entirely different, suggesting that society might be ready to be reborn:

[O]n a Tuesday morning after Divine Service the venerable church of Santa Maria Novella was almost deserted save for the presence of seven young ladies habited sadly¹ in keeping with the season. All were connected either by blood or at least as friends or neighbors; and fair and of good understanding were they all, as also of noble birth, gentle manners, and a modest sprightliness. In age none exceeded twenty-eight, or fell short of eighteen years. . . .

1 habited sadly: dressed in mourning

One of the citizens, Pampinea, observing the dire nature of their plight, makes this suggestion:

"I should deem it most wise in us, our case being what it is, if, as many others have done before us, and are still doing, we were to quit this place, and, shunning like death the evil example of others, betake ourselves to the country, and there live as honorable women on one of the estates, of which none of us has any lack, with all cheer of festal gathering and other delights, so long as in no particular we overstep the bounds of reason. There we shall hear the chant of birds, have sight of verdant hills and plains, of cornfields undulating like the sea, of trees of a thousand sorts; there also we shall have a larger view of the heavens, which, however harsh toward us, yet deny not their eternal beauty; things far fairer for eyes to rest on than the desolate walls of our city. Moreover, we shall there breathe a fresher air, find ampler store of things meet [fitting] for such as live in these times, have fewer causes of annoy[ance]."

Three young men, all of whom the women know, happen to enter the church, and it is determined that they should be invited to join them, even though, as one of the young women mentions, it is well known "that they love some of us here . . . [and] if we take them with us, we may thereby give occasion for scandal and censure. . . ."

Thus, the entire enterprise takes place in an atmosphere of potential scandal—certainly an atmosphere outside the bounds of normal social behavior. They enter a new moral space, evidenced by the difference between the Florence they have left behind and their new surroundings:

The estate lay upon a little hill some distance from the nearest highway, and, embowered in shrubberies of divers hues, and other greenery, afforded the eye a pleasant prospect. On the summit of the hill was a palace with galleries, halls, and chambers, disposed around a fair and spacious court, each very fair in itself, and the goodlier to see for the gladsome pictures with which it was adorned; the whole set amidst meads and gardens laid out with marvelous art, wells of the coolest water, and vaults of the finest wines, things more suited to dainty drinkers than to sober and honorable women.

The reader is aware that this idyllic island is surrounded by the terror of the Black Death, and that the sensual atmosphere of the setting offers—as arguably some of the best fiction always does—a refuge from the reality of everyday life.

The group determines that each day it will gather together and each will tell a story to entertain the others. As one of the young men, Dioneo, puts it, "I pray you, either address yourselves to make merry, to laugh and sing with me (so far, I mean, as may consist with your dignity), or give me leave to hie me back [return] to the stricken city." Dioneo's plea turns out to be an invitation for the group to take a certain liberty with their own sense of dignity, and his own worldliness, in fact, gives Boccaccio license to exceed the bounds of heretofore acceptable literary decorum. Many of the 100 tales that follow are frankly ribald—that is, vulgar and indecent—although all ten of the storytellers are aristocrats. A great many of their tales involve people of the lower, especially middle classes, and their characters, in their shrewdness and wit, ingenuity, and resourcefulness, unscrupulous behavior and bawdy desires, introduce into Western literature a kind of social realism previously unexplored. Perhaps reflecting the reality of death that surrounds them, the stories depict daily life as it is truly lived. Boccaccio's stories express the realities of life in a way that the classic tales of medieval chivalry could only intimate. His world is of flesh and blood, not knights in shining armor. If the world of the Decameron is a fictitious one, in its penetrating revelation of the workings of human psychology, it also represents an unprecedented brand of literary realism.

Petrarch's Sonnets One of Boccaccio's best friends was the itinerant scholar and poet Francesco Petrarca (1304–74), known as Petrarch (Fig. 6.24). Raised near Avignon, in France, where the papacy had established itself in 1309 and where it remained for most of Petrarch's life, Petrarch studied at Montpellier and Bologna and traveled throughout northern France, Germany, and Italy. He was always in search of manuscripts that preserved the priceless literary works of antiquity—copying those he could not pry loose from monastic libraries. As he wrote to a friend in 1351, these manuscripts, in Classical Latin and hard for monks to decipher, were in danger of being lost forever:

It is a state of affairs that has resulted in an incredible loss to scholarship. Books that by their nature are a little hard to understand are no longer multiplied [i.e., copied and distributed], and have ceased to be generally intelligible, and so have sunk into utter neglect, and in the end have perished. This age of ours consequently has let fall, bit by bit, some of the richest and sweetest fruits that the tree of knowledge has yielded; has thrown away the results of the vigils and labors of the most illustrious men of genius, things of more value, I am almost tempted to say, than anything else in the whole world.

It was Petrarch who rediscovered the forgotten works of the Roman orator and statesman Cicero, and his own private library consisted of over 200 Classical texts. He persuaded Boccaccio to bring the Greek scholar Leo Pilatus to Venice to teach them to read Greek. Boccaccio learned the language, but, put off by Pilatus' bad manners, Petrarch did not. Both, however, benefited from Pilatus' translation of Homer into Latin prose, as well as from his genealogy of the Greek gods.

Perhaps Petrarch's greatest work was his book of over 300 poems, the *Canzoniere* (*Songbook*), inspired by his love for a woman named Laura, whom he first met in 1327 in Avignon, where he was working for an influential cardinal. She is generally believed to have been the 19-year-old wife of

Fig. 6.24 Andrea del Castagno, *Francesco Petrarca*. ca. **1450**. Fresco transferred to wood, 97%" × 60%". Galleria degli Uffizi, Florence. So great was Petrarch's zeal for the classics that he would become known as the Father of Humanism, the revival of Greco-Roman culture that would come to define the Renaissance in the two centuries to follow.

Hugues de Sade. Whether Petrarch ever revealed his love to Laura, or simply poured it into his verses, remains a matter of speculation.

The majority of Petrarch's verses to Laura take the form of the **Italian sonnet**, known also as the **Petrarchan sonnet** because he perfected the form. The Petrarchan sonnet is composed of 14 lines divided into two parts: an *octave* of eight lines that presents a problem, and a *sestet* of six lines that either attempts to solve the problem or accepts it as unsolvable. The octave is further divided into two four-line *quatrains*. The first presents the problem and the second develops the idea. Many of Petrarch's verses to Laura were composed after her death from the bubonic plague in 1348, and it seems likely that her death motivated Petrarch to circulate them. His devastation is clear in these three lines from Sonner 338:

Earth, air, and sea should weep together, for the human lineage, once she's gone, becomes a meadow stripped of flowers, a gemless ring.

More influential, however, were the pure love poems. One of the most famous of these is Sonnet 134, in which Petrarch explores the complexities of his feelings—all the ambivalence, contradiction, and paradox—in the face of his love for Laura (Reading 6.4):

READING 6.4

Petrarch, Sonnet 134

I find no peace, and yet I am not warlike;
I fear and hope, I burn and turn to ice;
I fly beyond the sky, stretch out on earth;
my hands are empty, yet I hold the world.
One holds me prisoner, not locked up, not free;
won't keep me for her own but won't release me;
Love does not kill me, does not loose my chains,
he'd like me dead, he'd like me still ensnared.
I see without my eyes, cry with no tongue,
I want to die and yet I call for help,
hating myself but loving someone else.
I feed on pain, I laugh while shedding tears,
both death and life displease me equally;
and this state, Lady, is because of you.

Such poems would have a lasting influence, especially in the poetry of the English Elizabethan Age, because they seemed to capture all the emotional turbulence of love.

Chaucer's Canterbury Tales The first Englishman to translate Petrarch was Geoffrey Chaucer (ca. 1342–1400). Well-educated, able to read both Ovid and Virgil in the original Latin, Chaucer was a middle-class civil servant and diplomat. In 1368, both he and Petrarch were guests at a wedding in Milan Cathedral, and four years later, he was in Florence, where he probably met Boccaccio. Chaucer's masterwork, *The Canterbury Tales*, is modeled roughly on Boccaccio's *Decameron*, but it is written in verse, not prose, and is composed in

heroic couplets. Like the *Decameron*, it is a framed collection of stories, this time told by a group of pilgrims traveling from London to the shrine of Saint Thomas à Becket, Archbishop of Canterbury. In 1170, Becket had been murdered in Canterbury Cathedral by followers of King Henry II in a dispute over the rights and privileges of the Church.

Chaucer had planned to write 120 tales. Before his death, he completed only 22 tales and fragments of two others, but they are extraordinary in the range of characters and social types they portray. Not only are the characters in the stories fully developed, but so are their narrators, and as a result the stories reflect perhaps the most fully developed realism of the era. Consider Chaucer's description of the Wife of Bath (Fig. 6.25) from the Prologue to the work (Reading 6.5):

READING 6.5

from Chaucer, The Canterbury Tales, Prologue

A worthy woman there was from near the city Of Bath, but somewhat deaf, and more's the pity. For weaving she possessed so great a bent She outdid the people of Ypres and Ghent.1 No other woman dreamed of such a thing As to precede her at the offering. Or if any did, she fell in such a wrath She dried up all the charity in Bath. She wore fine kerchiefs of old-fashioned air. And on a Sunday morning, I could swear. She had ten pounds of linen on her head. Her stockings were the finest scarlet-red, Laced tightly, and her shoes were soft and new. Bold was her face, and fair, and red in hue. She had been an excellent woman all of her life. Five men in turn had taken her to wife, Not counting other youthful company— But let that pass for now! Over the sea She'd traveled freely; many a distant stream She crossed, and visited Jerusalem Three times. She had been at Rome and at Boulogne, At Compostella's shrine, and at Cologne. She'd wandered by the way through many a scene. Her teeth were set with little gaps between.2 Easily on her ambling horse she sat. She was well wimpled, and she wore a hat As wide in circuit as a shield or targe,3 A skirt swathed up her hips, and they were large. Upon her feet she wore sharp-roweled spurs. She was a good fellow; a ready tongue was hers. All remedies of love she knew by name, For she had all the tricks of that old game.

¹Ypres and Ghent: Centers of the weaving industry in Flanders.
 ²teeth...gaps between: For a woman to be gap-toothed was considered a sign of being highly sexed.
 ³targe: A type of shield.

Fig. 6.25 Wife of Bath, from Geoffrey Chaucer's Canterbury Tales ("The Ellesmere Chaucer"). ca. 1400–05. Illumination on vellum. Victoria and Albert Museum, London. This image is from the earliest complete surviving text of Chaucer's work, which contains 23 portraits of the storytellers.

Chaucer accomplishes what few writers before him had—he creates character and personality through vivid detail and description. This elaborately dressed, gaptoothed, large-hipped, easy-riding survivor of five husbands comes off as a real person. The tales themselves sometimes rival Boccaccio's in their bawdy realism, but the variety of the pilgrims and the range of their moral characters creates at least as profound a moral world as Boccaccio's, one whose scope even rivals that of Dante. The integrity of the Knight plays against the depravity of the Pardoner, just as the sanctity of the Parson plays against the questionable morals of the Wife of Bath. Chaucer's characters come from all three estates, or social ranks—the nobility, the clergy, and the common people—a fact that has led some to refer to his work as an "estates satire," a critique of social relations in his day.

Chaucer wrote *The Canterbury Tales* in the English of his day, a language we now call Middle English. After the Norman invasion in 1066, the common people spoke one language—Anglo-Saxon (or Old English)—and the nobility another, French. The language of the learned continued to be Latin. In Chaucer's time, a new spoken vernacular, Middle English, had supplanted Anglo-Saxon among the common people. It combined elements of French, Anglo-Saxon,

and the Scandinavian languages. Chaucer himself spoke French, and that he chose to write *The Canterbury Tales* in the Middle English of his day (actually a London dialect, one of about five dialects used across Britain at the time) is a significant development in the history of the English language.

Before 1385, roughly the time that Chaucer began the Tales, English had replaced French as the language of instruction for children. By 1362, the Chief Justice opened Parliament with a speech in English. That same year, Parliament enacted the Statute of Pleading, providing that "All pleas which shall be pleaded in his [the King's] courts whatsoever, before any of his justices whatsoever . . . shall be pleaded, shewed, defended, answered, debated, and judged in the English tongue." Still, the records of the pleas were kept in Latin. By mid-century, then, even the nobility, though raised speaking French, also spoke English. Chaucer's London dialect became the dominant one thanks largely to William Caxton, the London printer of Chaucer's works, who used it—the English of Britain's intellectual, political, and commercial center—in all his publications, thus making it the standard.

To provide an idea of the history of the language, here are the opening lines of the General Prologue of *The Canterbury Tales* in Middle English, as Chaucer wrote them, followed by a modern rendition.

Whan that Aprill with his shoures soot

When April with its sweet-smelling showers The droghte of March hath perced to the roote,

Has pierced the drought of March to the root,

And bathed every veyne in swich licour

And bathed every vein [of the plants] in such liquid Of which vertu engendred is the flour;

By the power of which the flower is created; Whan Zephirus eek with his sweete breeth

When the West Wind also with its sweet breath Inspired hath in every holt and heeth

In every wood and field has breathed life into *The tendre croppes, and the yonge sonne*

The tender new leaves, and the young sun Hath in the Ram his half cours yronne,

Has run half its course in Aries,

And smale foweles maken melodye,

And small fowls make melody,

That slepen al the nyght with open ye

Those that sleep all the night with open eyes (So priketh hem Nature in hir corages),

(So Nature incites them in their hearts),

Thanne longen folk to goon on pilgrimages. . . .

Then folk long to go on pilgrimages. . . .

Chaucer understood the power of this new vernacular English to evoke the reality of fourteenth-century English life, and his keen ear for the cadences and phrasing of actual speech underscores the reality of his characters and the tales they tell.

Christine de Pizan: An Early Feminist As the example of Eleanor of Aquitaine makes clear (see Chapter 5), women were beginning to play an increasingly active role in the courts of Europe. In 1404, Philip the Bold, Duke of Burgundy, commissioned Christine de Pizan (1364–ca. 1430) to write a biography of his deceased brother, titled *The Book of the Deeds and Good Manners of the Wise King Charles V*. Christine had been educated at the French court, apparently against her mother's wishes, by her father, a prominent Venetian physician, who had been appointed court astrologer to King Charles V. Her husband, secretary and notary to the king, further promoted her education. But when her father and husband died, she needed to support three children, a niece, and her mother. To do so she became the first female professional writer in European history.

As she gradually established her reputation as a writer, she worked as a copyist and illustrator, and her first successes were books of poems and ballads. In 1402, she made her reputation by attacking as misogynistic and demeaning to women the popular thirteenth-century poem the *Roman de la Rose* (*Romance of the Rose*). Two years later, in her *Book of the City of Ladies*, she again attacked male misogyny by recounting the accomplishments of women throughout the ages in an allegorical debate between herself and Lady Reason, Lady Rectitude, and Lady Justice (Fig. 6.26). Her most immediate source was Boccaccio's *Concerning Famous Women*, but her treatment is completely different, treating only good women and freely mixing pagan and Christian examples. Her city's queen is the Virgin Mary herself,

a figure whose importance confirms the centrality of women to Christianity. Thus, she opens the book by wondering why men are so inclined to demean women (**Reading 6.6**):

READING 6.6

from Christine de Pizan, Book of the City of Ladies

[I wondered] how it happened that so many different men—and learned men among them—have been and are so inclined to express both in speaking and in their treatises and writings so many wicked insults about women and their behavior. Not only one or two . . . but, more generally, from the treatises of all philosophers and poets and from all the orators—it would take too long to mention their names—it seems that they all speak from one and the same mouth. Thinking deeply about these matters, I began to examine my character and conduct as a natural woman and, similarly, I considered other women whose company I frequently kept, princesses, great ladies, women of the middle and lower classes, who had graciously told me of their most private and intimate thoughts, hoping that I could judge impartially and in good conscience whether the testimony of so many notable men could be true. To the best of my knowledge, no matter how long I confronted or dissected the problem. I could not see or realize how their claims could be true when compared to the natural behavior and character of women.

Fig. 6.26 Anonymous, *La Cité des Dames de Christine de Pizan*. ca. 1410. Illumination on parchment, page size $434'' \times 7''$. Bibliothèque nationale de France. On the left stands Christine de Pizan, engaged in composition while receiving the visit of Reason, Rectitude, and Justice. On the right, Christine and one of the royal ladies build the Ideal City.

De Pizan then turns to God for guidance and is granted a dream vision in which the three allegorical ladies encourage her to build an Ideal City, peopled with a variety of women, from Sappho to her own name-saint, all of whom help her to redefine what it means to be female.

De Pizan was writing in the context of the so-called Hundred Years' War between England and France, generally dated at 1337 to 1429. The origins of the war went all the way back to 1216, when the English Normans (who had invaded England from France in 1066) finally lost control of all their possessions on the continent. In the early fourteenth century, the French throne was increasingly contested, and the English king proclaimed himself the rightful heir. Thus the stage was set for war, driven largely by the English Normans' desire to recapture their homeland in Normandy. The war was fought entirely on French soil, and although the English were usually outnumbered by as much as three to one, they were generally victorious because of two technological innovations. First, the longbow's 6-foot length allowed the English infantry to pierce the chain-mail armor of the French. Second, the introduction of gunpowder and cannon made armor altogether irrelevant. Suddenly the model of heroic hand-to-hand combat, the basis of the chivalric ideal, was obsolete, and with it the codes of loyalty, honor, and courage upon which the entire French literary tradition since the Song of Roland had been based.

Even more damaging to this masculine tradition was the fact that it was a woman, Joan of Arc, who saved the French. A 17-year-old peasant girl, she approached the French king and begged him to allow her to obey the voices of the saints who ordered her to drive the English out of France. Christine de Pizan, who had retired to an abbey in 1418, after the arrival of the Burgundian troops in Paris had forced her and many others to seek protection outside the city, was overjoyed. The year before her death, de Pizan wrote a 61-stanza poem that glorified Joan's achievements (rendered in prose in **Reading 6.7**):

READING 6.7

from Christine de Pizan, Tale of Joan of Arc

I, Christine, who have wept for eleven years in a walled abbey . . . begin to laugh heartily for joy . . .

Oh! What honor for the female sex! It is perfectly obvious that God has special regard for it when all these wretched people who destroyed the whole Kingdom—now recovered and made safe by a woman, something that 5000 men could not have done—and the traitors [have been] exterminated. Before the event they would scarcely have believed this possible.

A little girl of sixteen (isn't this something quite supernatural?) who does not even notice the weight of the arms she bears—indeed her whole upbringing seems to have prepared her for this, so strong and resolute is she! And her enemies go fleeing before her, not one of them can stand up to her. She does all this in full view of everyone, and drives her enemies out of France, recapturing castles and towns. Never did anyone see greater strength, even in hundreds or thousands of men!

For Christine, Joan's achievement was a victory as much for women as for France. Christine, though, would not live to see her captured by the English, betrayed (probably by Burgundian French), then tried and executed as a heretic in March 1431. Joan's mysticism, like that of Hildegard of Bingen before her (see Chapter 5), undermined the authority and (male) hierarchy of the Church. But the chief charge against her was cross-dressing! She dared to challenge, in other words, the human-constructed gender roles that the Church fathers assumed to be the will of God. Still, probably no figure better sums up the growing self-assurance of women in late medieval society and the sense of personal worth—both male and female—that would increasingly inform European society as the fifteenth century unfolded.

6.1 Outline the ideas, technological innovations, and stylistic developments that distinguish the Gothic style in France.

The Gothic style originated at the Abbey Church of Saint-Denis just north of Paris, which was dedicated in 1144. It was the work of Saint-Denis' abbot, Suger. How did stained glass fit into his ambitions? Chartres Cathedral, to the southwest, soon followed suit, after a fire destroyed the original structure in 1194, leaving only the west facade. The church was rebuilt into what many consider the most magnificent of all Gothic cathedrals, its stained glass unrivaled in Europe.

As the Gothic style developed, important architectural innovations contributed to the goal of elevating the soul of worshipers to the spiritual realm. What makes the extremely high naves of Gothic cathedrals possible? How did music contribute to this ambition? How, during the thirteenth century, did architects begin to embellish the exteriors of their cathedrals? How did their sculptural programs begin the re-classicizing of Western art?

With its vast spaces and stone walls, the Gothic cathedral could easily be as animated by its acoustics as it was by light. At the School of Notre-Dame, in Paris, the first collection of music in two parts, the Magnus Liber Organi (The Great Book of Polyphony), chiefly the work of the composers Léonin and Pérotin, was widely distributed in manuscript by about 1160. Among their most significant innovations are their emphasis on counterpoint and the complex musical form of the motet. What role did the organ play in this new music?

6.2 Explain why the University of Paris was preeminent among medieval institutions of higher learning.

In 1179, a papal decree ordered the cathedral schools to provide for the teaching of the laity (nonclerics), and the university as an institution was born. The quality of the teaching at the University of Paris distinguished it from the others. Peter Abelard, who taught by the dialectical method, was the school's most renowned lecturer. How would you describe the dialectical method? How does it differ from the Socratic method? But probably the most important scholar at the University of Paris was Thomas Aquinas, who adapted Abelard's dialectical method to his own Scholasticism. What is Scholasticism and how does Aquinas' Summa Theologica reflect it?

6.3 Define the Radiant style.

By the middle of the thirteenth century, the Gothic style in France had been elaborated into increasingly flamboyant patterns of repeated traceries and ornament that we refer to as the Radiant style. How does the royal chapel of Sainte-Chapelle in Paris reflect this style? In what way does the material well-being embodied in the Radiant style manifest itself in the miniature tradition?

6.4 Compare and contrast art and civic life in Siena and Florence.

Tuscany was dominated by two competing city-states, Siena and Florence. Both were republics, and central to their success was a new form of government in which Church and State were closely aligned. Siena established itself in 1125 as a free commune. What is a commune? By the twelfth century, Florence was the center of textile production in the Western world and played a central role in European trade markets. As in Siena, it was the city's bankers and money lenders who made Florence such a vital player in world trade. Also as in Siena, in Florence the guilds controlled the commune. How would you define a guild?

In both Siena and Florence, artists began to break from the Byzantine style. One of the first was Duccio, who began to incorporate the Gothic tendency to naturalism into his Maestà, painted for Siena's cathedral. Even more naturalistic is Simone Martini's Maestà, painted for the city hall. How would you compare them? Florence, too, had its master painters of the Virgin, Cimabue and Giotto. In what way did the latter exceed the others in terms of the naturalism of his art?

6.5 Examine the spread of a vernacular literary style in European culture.

In the early twelfth century, writers across Europe began to address their works to a wider lay audience and to write in the vernacular. How would you define the vernacular? What does it imply about the audience for this new literature? One of the greatest medieval Italian vernacular writers was the poet Dante Alighieri, whose Divine Comedy records the travels of the Christian soul from Hell to Purgatory and finally to Salvation in three books—the Inferno, Purgatorio, and Paradiso. How does Dante's poem reflect the epic tradition? Describe the ways in which Sienese and Florentine painters approached the depiction of the Virgin. Why do you suppose Dante admired Giotto more than the others? After the Black Death, the realistic treatment of life continued in vernacular literature. What moved Giovanni Boccaccio to represent life as it is truly lived in his Decameron? What attracted Geoffrey Chaucer to the vernacular style? How does Christine de Pizan explore new possibilities for expressing the reality of contemporary life?

The Dance of Death

e do not know who, in 1474, painted a series of pictures representing a Dance of Death along the walls backing the charnel houses—houses where the bones of the dead were stored—that ran the length of the Cemetery of the Holy Innocents on the Rue de la Ferronnerie in Paris. These paintings were undoubtedly inspired by a clergy bent on encouraging Christian feeling and sentiment in their parishioners and on reminding them of their Christian duties in the face of certain death. Every rank and order

of human society was represented in this procession, the pope and emperor at its head (Fig. 6.27), a fool and an author pulling up the rear. Verses attributed to the Chancellor of the University of Paris, Jean de Charlier de Gerson, accompany the paintings:

By divine sentence No matter what your estate Whether good or evil, you will be Eaten by worms. Alas, look at us, Dead, stinking, and rotten. You will be like this, too.

The toll the Black Death wreaked on the arts was indeed devastating. In Siena, Ambrogio Lorenzetti was among the many victims of the Black Death. In Florence, almost all Giotto's best students succumbed. But since the plague destroyed people and not possessions, the enormous decrease in population resulted in a corresponding increase in per capita wealth, and those who survived invested in religious art—chapels and hospitals, altarpieces and votive statues—in gratitude for being spared or in the hope of preventing future infection. Painters and sculptors turned their attention to the representation of the sufferings of Christ, the sorrows rather than the joys of the Virgin, and the miracles of the saints. The Art of Dying Well and the Triumph of Death became

Fig. 6.27 Dance of Death. ca. 1490. Woodcut. Library of Congress, Washington, D. C. Lessing J. Rosenwald Collection. This print is one of a series copying the images on the charnel house walls of the Cemetery of the Holy Innocents.

important themes in art and literature. The new humanism, or belief in the value of individuals and their human potential, so evident in the realist art of Giotto and in the writings of Petrarch, Boccaccio, and Chaucer, suggests that the plague stimulated the Western imagination perhaps more than it defeated it.

Nevertheless, the specter of death, which the Black Death so thoroughly embedded in the popular imagination, haunted Western society for at least 400 years. The Cemetery of the Holy Innocents, which was the size of a large city block and occu-

pied the area of Paris today known as Les Halles, accommodated many of the dead, but by the middle of the eighteenth century, the cemetery was almost literally exploding with corpses. Many people, who now possessed at least a rudimentary understanding of infection, argued that this cemetery was a breeding ground of disease. On December 1, 1780, a cellar wall on the Rue de la Ferronnerie burst, releasing noxious gases and fluids into the streets, and the cemetery was permanently closed. The charnel houses were demolished—along with the Dance of Death images that covered their walls. As for the dead, they were reburied in catacombs dug from ancient quarries beneath the city streets, today a tourist site.

This vast removal of the dead amounted to a banishment of the specter of death from the daily life of the city, culminating finally, in 1804, with the Emperor Napoleon's Imperial Decree on Burials. Henceforth, burial was banned within the city. Each corpse would have an individual plot, permanent if space allowed, in one of four gardens outside the city proper—among them, the bucolic Père Lachaise Cemetery, which even today attracts Parisians to its hills and paths. All were designed to aid in absorbing what the Ministry of Interior called "cadaverous miasmata." It was envisioned that in these new Elysian Fields, children would periodically scatter flowers over the tombs. Thus, the idea of the cemetery as a kind of landscape garden, as we know it today, was born. ■

The Renaissance

7

Florence, Rome, and Venice

LEARNING OBJECTIVES

- 7.1 Discuss the influence of the Medici family on Florentine art and the development of humanist thought.
- 7.2 Describe how other Italian courts followed the lead of the humanist court in Florence.
- 7.3 Examine the impact of papal patronage on the art of the High Renaissance in Rome.
- 7.4 Compare the social fabric and artistic style of Renaissance Venice to that of both Florence and Rome.
- 7.5 Outline the place of women in Renaissance Italy.

he word *Renaissance*, from the Italian *rinascita*, "rebirth," became widely used in the nineteenth century as historians began to assert that the beliefs and values of the medieval world were transformed in Italy, and in Florence particularly. Where the Middle Ages had been an age of faith, in which the salvation of the soul was an individual's chief preoccupation, the Renaissance was an age of intellectual exploration, inspired by a resurgence of interest in the art and literature of Classical antiquity, in which the **humanist** strove to understand in ever more precise and scientific terms the nature of humanity and its relationship to the natural world.

This chapter traces the rise of the humanist Renaissance city-state as a center of culture in Italy in the fifteenth century, concentrating on Florence, Rome, and Venice (Map 7.1). In Florence the Medici family, whose wealth derived from their considerable banking interests, did much to position the city as a model that others felt compelled to imitate.

In Rome, the wealth at the disposal of the papacy, and the willingness of the Church to bestow that wealth in the form of commissions to artists and architects in an effort to restore that city to the greatness it enjoyed more than a thousand

years earlier at the height of the Roman Empire, essentially guaranteed its rebirth as a new and vital center of culture. And the citizenry of Venice—where goods from northern Europe flowed into the Mediterranean, and goods from the Mediterranean and points east flowed into Europe—thought of themselves as the most cosmopolitan and the most democratic people in the world. In this environment of enlightened leadership, the arts flourished.

THE STATE AS A WORK OF ART: FLORENCE AND THE MEDICI

How did the Medici family help shape humanist Florence?

The preeminent Italian city-state in the fifteenth century was Florence. Centered around its great cathedral (Fig. 7.1), it was so thoughtfully and carefully constructed by the ruling Medici family that later scholars would come to view it as a work of art in its own right. The Medici were the

[▼] Fig. 7.1 Florence, Italy. The Duomo, Florence's magnificent cathedral, rises over the city. Its octagonal baptistery sits in the square before it. Just above and to the right of its bell tower, or campanile, designed by Giotto and built between 1334 and 1359, is the tower of the Palazzo Vecchio, the city hall.

Map 7.1 Major Italian city-states during the Renaissance.

most powerful family in Florentine affairs from 1418, when they became bankers to the papacy, until 1494, when irate citizens removed them from power. A family of bankers with offices in Pisa, Rome, Bologna, Naples, Venice, Avignon, Lyon, Geneva, Basel, Cologne, Antwerp, Bruges, and London during the fifteenth century, the Medici never ruled Florence outright, but instead managed its affairs from behind the scenes.

No event better exemplifies the nature of the Italian Renaissance and anticipates the character of Florence under the Medici than a competition held in 1401 to choose a designer for a pair of bronze doors for the north entrance to the city's **baptistery** (see Fig. 7.1). The baptistery is a building standing in front of the cathedral and used for the Christian rite of baptism.

In many ways, it is remarkable that the competition to find the best design for the Baptistery doors could even take place. As much as four-fifths of the city-state's population had died in the Black Death of 1348, and the plague had returned, though less severely, in 1363, 1374, 1383, 1388, and 1400. Finally, in the summer of 1400, it came again, this time killing 12,000 Florentines, about one-fifth of the

remaining population. Perhaps the guild hoped that a facelift for the Baptistery might appease an evidently wrathful God. Furthermore, civic pride and patriotism were also at stake. Milan, the powerful city-

state to the north, had laid siege to Florence, blocking trade to and from the seaport at Pisa and creating the prospect of famine. The fate of the Florentine Republic seemed to be in the balance.

So the competition was not merely about artistic talent. The general feeling was that if God looked with favor on the enterprise, the winner's work might well be the city's salvation. In fact, during the summer of 1402, as the competition was concluding, the duke of Milan died in his encampment outside the walls of Florence. The siege was over, and Florence was spared. If the Wool Guild could not take credit for these events, no one could deny the coincidence.

Thirty-four judges—artists, sculptors, and prominent citizens, including a Medici—chose the winner from among the seven entrants. Each artist was asked to create a bronze relief panel depicting the Hebrew Bible's story of the Sacrifice of Isaac (Genesis 22) in a 21-by-17½-inch quatrefoil (a four-leaf clover shape set on a diamond). All but two designs were eliminated, both by little-known 24-year-old goldsmiths: Filippo Brunelleschi (1377–1446) and Lorenzo Ghiberti (1378–1455).

The Sacrifice of Isaac is the story of how God tested the faith of the patriarch Abraham by commanding him to sacrifice Isaac, his only son. Abraham took Isaac into

Fig. 7.2 Filippo Brunelleschi, Sacrifice of Isaac, competition relief commissioned for the doors of the Baptistery. 1401–02. Parcel-gilt bronze, 21" × 17½". Museo Nazionale del Bargello, Florence. Brunelleschi's background seems to be little more than a flat surface against which his forms are set.

the wilderness to perform the deed, but at the last moment, an angel stopped him, implying that God was convinced of Abraham's faith and would be satisfied with the sacrifice of a ram instead. Brunelleschi and Ghiberti both depicted the same aspect of the story, the moment when the angel intervenes. Brunelleschi placed Isaac in the center of the panel and the other figures, whose number and type were probably prescribed by the judges, all around (Fig. 7.2). The opposition between Abraham and the angel, as the angel grabs Abraham's arm to stop him from plunging his knife into his son's breast, is highly dramatic and realistic, an effect achieved by the figures' jagged movements. Ghiberti, in contrast, set the sacrifice to one side of the panel (Fig. 7.3). He replaced a sense of physical strain with graceful rhythms, so that Isaac and Abraham are unified by the bowed curves of their bodies, Isaac's nude body turning on its axis to face Abraham. The angel in the upper right corner is represented in a more dynamic manner than in Brunelleschi's panel. This heavenly visitor seems to have rushed in from deep space. The effect is achieved by foreshortening, a technique used to suggest that forms are sharply receding. In addition, the strong diagonal of the landscape, which extends from beneath the sacrificial altar and rises up into a large rocky outcrop behind the other figures, creates a more vivid sense of real space than Brunelleschi's scene.

Fig. 7.3 Lorenzo Ghiberti, *Sacrifice of Isaac*, competition relief commissioned for the doors of the Baptistery. 1401–02. Parcel-gilt bronze, 21" × 17½". Museo Nazionale del Bargello, Florence. As opposed to Brunelleschi's, Ghiberti's background seems to be real, deep space.

Despite the artistic differences in the two works, the contest might have been decided by economics. Brunelleschi cast each of his figures separately and then assembled them on the background. Ghiberti cast separately just the body of Isaac, a method that required only two-thirds of the bronze used by his rival. The process also resulted in a more unified panel, and this may have given Ghiberti the edge. Disappointed, Brunelleschi left Florence for Rome and gave up sculpture forever. Their competition highlights the growing emphasis on individual achievement in the young Italian Renaissance: The work of the individual craftsperson was replacing the collective efforts of the guild or workshop in decorating public space. The judges valued the originality of Brunelleschi's and Ghiberti's conceptions. Rather than placing their figures on a shallow platform, as one might expect in the shallow space available in a relief sculpture, both sought to create a sense of a deep, receding space, enhancing the appearance of reality.

As humanists, Ghiberti and Brunelleschi valued the artistic models of antiquity and looked to Classical sculpture for inspiration—notice, for instance, the twisting torso of Ghiberti's nude Isaac. But, above all, the artworks they created captured human beings in the midst of a crisis of faith with which every viewer might identify. In all this, their competition looks forward to the art that defines the Italian Renaissance itself.

Fig. 7.4 Lorenzo Ghiberti, *Gates of Paradise*, east doors of the Baptistery, Florence. ca. 1425–52. Gilt bronze, height 15'. Ghiberti wrote of the doors in his *Commentaries* (ca. 1450–55): "I strove to imitate nature as clearly as I could, and with all the perspective I could produce, to have excellent compositions with many figures."

The Gates of Paradise

Ghiberti worked on the north-side doors for the next 22 years, designing 28 panels in four vertical rows illustrating the New Testament (originally the subject had been the Hebrew Bible, but the guild changed the program). Immediately upon their completion in 1424, the Wool Guild commissioned a second set of doors from Ghiberti for the east side of the Baptistery. These would take him another 27 years. Known as the Gates of Paradise because they open onto the paradiso, Italian for the area between a baptistery and the entrance to its cathedral, these doors depict scenes from the Hebrew Bible in ten square panels (Fig. 7.4). The borders surrounding them contain other biblical figures, as well as a self-portrait (Fig. 7.5). The artist's head is slightly bowed, perhaps in humility, but perhaps, situated as it is just above the average viewer's head, so that he might look out upon his audience. The proud image functions as both a signature and a bold assertion of Ghiberti's own worth as an artist and individual.

Each of the panels in the east doors depicts one or more events from the same story. For instance, the first panel, at the upper left of the doors (Fig. 7.6), contains four episodes from the book of Genesis: the Creation of Adam, at the bottom left; the Creation of Eve, in the center; the Temptation, in the distance behind the Creation of Adam; and the Expulsion, at the bottom right. This portrayal of sequential events in the same frame harks back to medieval art. But if the content of the space is episodic, the landscape is coherent and realistic, stretching in a single continuum from the foreground

into the far distance. The figures themselves hark back to Classical Greek and Roman sculpture. Adam, in the lower left-hand corner, resembles the recumbent god from the east pediment of the Parthenon (see Fig. 2.31 in Chapter 2), and Eve, in the right-hand corner, is a Venus of recognizably Hellenistic origin; compare Praxiteles' fourth-century BCE Aphrodite of Knidos (see Fig. 2.39 in Chapter 2).

Ghiberti meant to follow the lead of the ancients in creating realistic figures in realistic space. As he wrote in his memoirs, "I strove to observe with all the scale and proportion, and to endeavor to imitate Nature... on the planes one sees the figures which are near appear larger, and those that are far off smaller, as reality shows." Not only do the figures

Fig. 7.5 Lorenzo Ghiberti, self-portrait from the *Gates of Paradise*, east doors of the Baptistery, Florence. ca. 1425–52. Gilt bronze. Ghiberti included his self-portrait among the prophets and other biblical figures framing the panels, as he had earlier on the north doors. The extreme naturalism of this self-portrait underscores the spirit of individualism that characterizes the Renaissance

Fig. 7.6 Lorenzo Ghiberti, *The Story of Adam and Eve*, from the *Gates of Paradise*, east doors of the Baptistery, Florence. ca. 1425–52. Gilt bronze, 31¼" × 31¼". The influence of Classical antiquity is clear in the portrayal of Eve, whose pose, at the center, derives from Birth of Venus sculptures, and, on the right, from images of the Venus Pudica, or "modest" Venus.

farther off appear smaller, but also they decrease in their projection from the panel, so that the most remote are in very shallow relief, hardly raised above the gilded bronze surface.

Whereas medieval artists regarded the natural world as an imperfect reflection of the divine, and hardly worth attention (see Chapter 5), Renaissance artists understood the physical universe as an expression of the divine and thus worth copying in the greatest detail. To understand nature was, in some sense, to understand God. Ghiberti's panel embodies this growing desire in the Renaissance to reflect nature as accurately as possible. It is a major motivation for the development of perspective in painting and drawing.

The work had political significance as well. The only panel to represent a single event in its space is the *Meeting of Solomon and Sheba* (Fig. 7.7). Here, the carefully realized symmetry of the architecture, with Solomon and Sheba framed in the middle of its space, was probably designed to represent the much-hoped-for reunification of the Eastern Orthodox and Western Catholic branches of the Church. Solomon was traditionally associated with the Western Church, while the figure of Sheba, queen of the Arabian state of Sheba, was meant to symbolize the Eastern. Cosimo de' Medici would finance a Council of Churches that convened in Florence in 1438, and as Ghiberti finished the doors a year earlier it seemed possible, even likely, that reunification might become a reality. This would have restored

Fig. 7.7 Lorenzo Ghiberti, *Meeting of Solomon and Sheba*, from the *Gates of Paradise*, east doors of the Baptistery, Florence. ca. 1425–52. Gilt bronze, 31¼" × 31¼". The reunification of the Eastern and Western Churches, symbolically represented here, was announced on the steps of Florence Cathedral on July 9, 1439, with the emperor of Byzantium present. The agreement was short-lived, and by 1472, the Eastern church had formally rejected the Florence accords.

symmetry and balance to a divided Church, just as Ghiberti had achieved balance and symmetry in his art. But above all, especially in the context of the other nine panels—all of which depict multiple events with multiple focal points—this composition's focus on a single event reflects the very image of the unity sought by the Church.

Florence Cathedral

Construction of the Duomo (see Fig. 7.1), as Florence Cathedral is known, began in 1296 under the auspices of the Opera del Duomo, which was controlled by the Wool Guild. The cathedral was planned as the most beautiful and grandest in all of Tuscany. It was not consecrated until 140 years later, and even then, was hardly finished. Over the years, its design and construction became a group activity as an everchanging panel of architects prepared model after model of the church and its details were submitted to the Opera and either accepted or rejected.

Brunelleschi's Dome During visits to Rome, Brunelleschi had carefully measured the proportions of ancient buildings, including the Colosseum, the Pantheon, the remains of the Baths of Caracalla, and the Domus Aurea (Golden Palace) of Nero. Using these studies, Brunelleschi produced the winning design for the dome of Florence Cathedral. The design guaranteed his reputation as one of the geniuses of Renaissance Florence, even in his own day.

Fig. 7.8 Diagram of ribs and horizontal bands within Brunelleschi's dome. The ribs meet at the oculus, over which Brunelleschi constructed hislantern. The horizontal ribs absorbed the pressure caused by the thrust of the ribs against the wall of the dome.

Brunelleschi's design for the dome solved a number of technical problems. For one thing it eliminated the need for the temporary wooden scaffolding normally used to support the dome vaulting as it was raised. Although critics disagreed, Brunelleschi argued that a skeleton of eight large ribs, visible on the outside of the dome, alternating with eight pairs of thinner ribs beneath the roof, all tied together by only nine sets of horizontal ties, would be able to support themselves as the dome took form (Fig. 7.8).

Brunelleschi completed the dome in 1436. In yet another competition, he then designed a **lantern** (a windowed turret at the top of a dome, visible in Fig. 7.1) to cover the oculus and thus put the finishing touch on the dome. It was made of over 20 tons of stone. Brunelleschi designed a special hoist to raise the stone to the top of the dome, but construction had barely begun when he died in 1446.

"Songs of Angels": Music for Church and State For the consecration of Florence Cathedral, rededicated as Santa Maria del Fiore (Saint Mary of the Flower) on March 25, 1436, Brunelleschi constructed a 1,000-foot walkway, 6 feet high and decorated with flowers and herbs, on which to guide celebrated guests into the cathedral proper. These included Pope Eugenius IV and his entourage of 7 cardinals, 37 bishops, and 9 Florentine officials (including Cosimo de' Medici), all of whom were observed by the gathered throng. Once inside, the guests heard a new musical work, picking up the floral theme of the day, called Nuper rosarum flores ("The Rose Blossoms") (track 7.1). It was composed especially for the consecration by French composer Guillaume Dufay (ca. 1400–74), who worked in both France and Italy. The piece is a motet, the form of polyphonic vocal work that had gained increasing popularity since the midthirteenth century (see Chapter 5). Dufay's motet introduced a richer and fuller sonority to the form, combining both voices and instruments. (The use of instruments, other than the organ, in church performance would remain

a matter of controversy for many centuries in the Catholic Church.) The **cantus firmus**—or "fixed melody"—on which the composition is based is stated in not one but two voices, both moving at different speeds.

Cantus firmus melody from Dufay's Nuper rosarum flores

The melody derives from a chant traditionally used for the dedication of new churches, *Terribilis est locus iste* ("Awesome Is This Place").

Dufay's motet also reflects the ideal proportions of the Temple of Solomon in Jerusalem (see Chapter 1), which, according to I Kings, was laid out in the proportions 6:4:2:3, with 6 being the length of the building, 4 the length of the nave, 2 the width, and 3 the height. Florence Cathedral followed these same proportions, and Dufay mirrors them in his composition by repeating the cantus firmus four times, successively based on 6, 4, 2, and 3 units per breve (equivalent to two whole notes in modern notation). Hearing the entire work, one witness wrote: "It seemed as though the symphonies and songs of the angels and divine paradise had been sent forth from Heaven to whisper in our ears an unbelievable celestial sweetness." It is not surprising, given this reaction, that Dufay was regarded as the greatest composer of the fifteenth century. It is even less surprising that the Florentines selected him to celebrate the consecration of their new cathedral and its dome by creating an original work. In performing this service he announced the preeminence of both the cathedral and the city that had built it.

Scientific Perspective and Naturalistic Representation

No aspect of the Renaissance better embodies the spirit of invention evidenced by both Brunelleschi's dome and Dufay's music than scientific or linear perspective, which allowed artists to translate three-dimensional space onto a twodimensional surface, thereby satisfying the age's increasing taste for naturalistic representations of the physical world. It was the basis of what would later come to be called buon disegno, literally "good design" or "drawing," but the term refers more to the intellectual conception of the work than to literal drawing. Giorgio Vasari, whose Lives of the Most Excellent Painters, Architects, and Sculptors is one of our most important sources of information about Italian Renaissance art in the fourteenth, fifteenth, and sixteenth centuries, defined it as follows: "Design (disegno) is the imitation of the most beautiful things of nature in all figures whether painted or chiseled, and this requires a hand and genius to transfer everything which the eye sees, exactly and correctly, whether it be in drawings, on paper panel, or other surface, both in relief and sculpture." It distinguished, in his mind, the art of Florence above all others.

Brunelleschi, Alberti, and the Invention of Scientific Perspective It was Brunelleschi who first mastered the art of scientific perspective sometime in the first decade of the fifteenth century. The ancient Greeks and Romans had at least partially understood its principles, but their methods had been lost. Brunelleschi almost certainly turned to them for the authority, at least, to "reinvent" it. His investigation of optics in Arab science also contributed to his understanding, particularly Alhazen's *Perspectiva* (ca. 1000 cE), which integrated the Classical works of Euclid, Ptolemy, and Galen. Their understanding of the principles of geometry, and the sense of balance and proportion that geometry inspired, affected every aspect of Brunelleschi's architectural work.

But it was geometry's revelation of the rules of perspective that most fascinated Brunelleschi. As he surveyed the Roman ruins, plotting three-dimensional architectural forms on flat paper, he mastered its finer points. Back in Florence, he would demonstrate the principles of perspective in his own architectural work. Brunelleschi's findings were codified in 1435 by the architect Leon Battista Alberti (1404-74) in his treatise On Painting. Painting, Alberti said, is an intellectual pursuit, dedicated to replicating nature as accurately as possible. A painting's composition should be based on the orderly arrangement of parts, which relies on rendering space in one-point perspective. He outlined step-by-step instructions for the creation of such space, and provided diagrams as well (Fig. 7.9). The basic principles of the system are these: (1) All parallel lines in a visual field appear to converge at a single vanishing point on the horizon (think of train tracks merging in the distance); (2) These parallel lines are realized

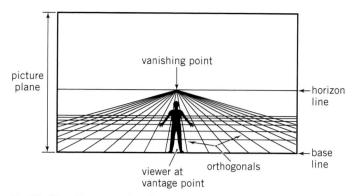

Fig. 7.9 Alberti's perspective diagram.

on the picture plane—the two-dimensional surface of the panel or canvas, conceived as a window through which the viewer perceives the three-dimensional world—as diagonal lines called **orthogonals**; (3) Forms diminish in scale as they approach the vanishing point along these orthogonals; and (4) The vanishing point is directly opposite the eye of the beholder, who stands at the **vantage point**, thus, metaphorically at least, placing the individual (both painter and viewer) at the center of the visual field.

Perspective and Naturalism in Painting: Masaccio Although Alberti dedicated On Painting first and foremost to Brunelleschi, he also singled out several other Florentine artists. One of these was Masaccio (1401–28), whose masterpiece of naturalistic representation is *The Tribute Money* (Fig. 7.10). Commissioned by a member of the Brancacci family in the

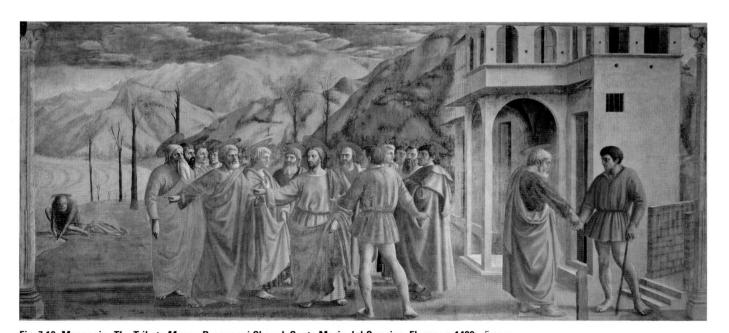

Fig. 7.10 Masaccio, *The Tribute Money*, Brancacci Chapel, Santa Maria del Carmine, Florence. 1420s. Fresco, 8'1¼" × 19'7". When this fresco was restored between 1981 and 1991, cleaning revealed that every character in this scene originally had a gold-leaf halo, except the tax collector, probably not a Christian. Masaccio drew these halos according to the laws of scientific perspective.

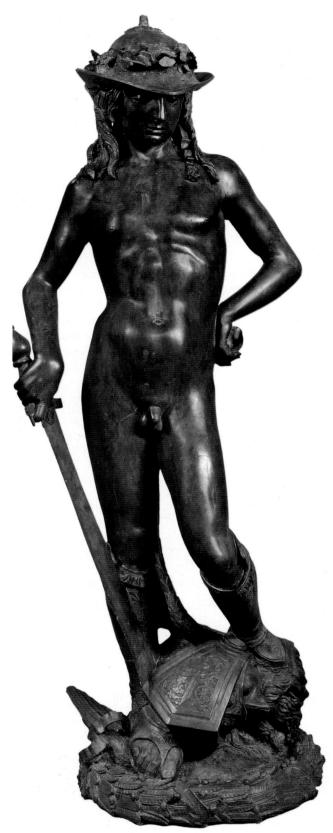

Fig. 7.11 Donatello, *David.* **1440s.** Bronze, height 62½". Museo Nazionale del Bargello, Florence. By 1469, this sculpture stood in the courtyard of the Medici palace as a symbol of the Florentine state.

1420s as part of a program to decorate the family's chapel in the church of Santa Maria del Carmine in Florence, it illustrates an event in the Gospel of Matthew (17:24–27). Christ responds to the demand of a Roman tax collector for money by telling Saint Peter to catch a fish in the Sea of Galilee, where he will find, in its mouth, the required amount. This moment occurs in the center of the painting. Behind the central group, to the left, Saint Peter finds the money, and to the right, he pays the tax. The vanishing point of the painting is behind the head of Christ, where the orthogonals of the architecture on the right converge. In fact, the function of the architecture appears to be to lead the viewer's eyes to Christ, identifying him as the most important figure in the work.

Another device, known as atmospheric perspective, also gives the painting the feeling of naturalism. This system depends on the observation that the haze in the atmosphere makes distant elements appear less distinct and bluish in color, even as the sky becomes paler as it approaches the horizon. As a result, the house and trees on the distant hills in this fresco are loosely sketched, as if we see them through a hazy filter of air. The diminishing size of the barren trees at the left also underscores the fact that, in a perspectival rendering of space, far-off figures seem smaller (as does the diminished size of Saint Peter at the edge of the sea).

Perhaps the greatest source of naturalism in the scene comes from the figures themselves, who provide a good imitation of life through their dynamic gestures and poses, their individuality, and their emotional engagement in the events. Here the human figure is fully alive and active. This is especially evident in the *contrapposto* pose of the Roman tax collector, whom we see both with his back to us in the central group of figures and at the far right, where Saint Peter is paying him. Christ, too, throws all of his weight to his right foot. This is a naturalistic device that Masaccio borrowed from antiquity. Indeed, the blond head of Saint John is almost surely a copy of a Roman bust.

The Classical Tradition in Freestanding Sculpture: Donatello Masaccio probably learned about the Classical disposition of the body's weight from Donatello (ca. 1386–1466), who had accompanied Brunelleschi to Rome years before. Many of Donatello's own works seem to have been inspired by antique Roman sculpture.

Although it dates from nearly 15 years after Masaccio's *The Tribute Money*, Donatello's *David* (Fig. **7.11**), which celebrates this Hebrew Bible hero's victory over the giant Goliath, indicates how completely the sculptor had absorbed Classical tradition. The first life-size freestanding nude sculpted since

antiquity, it stands in a fully Classical contrapposto pose reminiscent of Greek sculpture such as Polyclitus' Doryphorus (see Fig. 2.28 in Chapter 2). It is revolutionary in other ways as well. The contrapposto pose is almost exaggerated, especially the positioning of the back of the hand against the hip. The young adolescent's youthful

Doryphoros, p. 63

gaze stands in marked contrast to the bearded head of Goliath at his feet. Donatello seems to celebrate not just the human body, but also its youthful vitality, a vitality his figure shared with the Florentine state itself.

It is difficult, in other words, to imagine that such a slight, adolescent figure could have slain a giant. It is as if Donatello portrayed David as an unconvincing hero in order to underscore the ability of virtue, in whatever form, to overcome tyranny. And so this young man might represent the vigor and virtue of the Florentine republic as a whole and the city's persistent resistance to domination. In fact, when in 1469 the statue stood in the courtyard of the Medici palace, it bore the following inscription: "The victor is whoever defends the fatherland. All-powerful God crushes the angry enemy. Behold a boy overcame the great tyrant. Conquer, O citizens." The Medici thus secularized the religious image even as they implicitly affirmed their right to rule as granted by an all-powerful God whose might they shared.

The Medici Family and Humanism

The Medici family had been prominent in Florentine civic politics since the early fourteenth century. The family had amassed a fortune by skill in trade—especially the banker's trade in money—and became strong supporters of many of the city's smaller guilds. But their power was only fully cemented by Cosimo de' Medici (1389–1464).

Cosimo inherited great wealth from his father and secured the family's hold on the political fortunes of the city. Without upsetting the appearance of republican government, he mastered the art of behind-the-scenes power by controlling appointments to chief offices. But he also exerted considerable influence through his patronage of the arts. His father had headed the drive to rebuild the church of San Lorenzo, which stood over the site of an early Christian basilica dedicated in 393. San Lorenzo thus represented the entire Christian history of Florence, and after his father's death, Cosimo himself paid to complete its construction and decorate it. In return, it was agreed that no family crest other than the Medici's would appear in the church. Cosimo also rebuilt the old monastery of San Marco for the Dominican Order, adding a library, cloister, chapter room, bell tower, and altarpiece. In effect, Cosimo had made the entire religious history of Florence the family's own.

Marsilio Ficino and Neoplatonism Humanist that he was, Cosimo was particularly impressed by one scholar, the young priest Marsilio Ficino (1433–99). Beginning in about 1453, Cosimo supported Ficino in his translation and interpretation of the works of Plato and later philosophers of Platonic thought. As described in Chapter 2, Platonic thought distinguished between a sphere of being that is eternal and unchanging and the world in which we actually live, in which nothing is fixed forever. Following Plato's lead, Ficino argued that human reason belonged to the eternal dimension, as human achievement in mathematics and moral philosophy demonstrated, and that through human reason we can commune with the eternal sphere of being.

Ficino coined the term **Platonic love** to describe the ideal spiritual (never physical) relationship between two

people, based on Plato's insistence on striving for and seeking out the good, the true, and the beautiful. The source of Ficino's thought is his study of the writings of Plotinus (ca. 205-70 ce), a Greek scholar of Platonic thought who had studied Indian philosophy (both Hinduism and Buddhism) and who believed in the existence of an ineffable and transcendent One, from which emanated the rest of the universe as a series of lesser beings. For Plotinus, human perfection (and, therefore, absolute happiness) was attainable in this world through philosophical meditation. This Neoplatonist philosophy (a modern usage) recast Platonic thought in contemporary terms. It appealed immensely to Cosimo. He could see everywhere in the great art and literature of antiquity the good, the true, and the beautiful he sought, and so he surrounded himself with art and literature, both contemporary and Classical, and lavished them upon his city.

Domestic Architecture for Merchant Princes In 1444, Cosimo commissioned for the family a new palazzo ("palace") that would redefine domestic architecture in the Renaissance. He first rejected a plan by Brunelleschi, considering it too grand, and built instead a palace designed by Michelozzo di Bartolommeo (1396–1472), now known as the Palazzo Medici-Riccardi (Fig. **7.12**). He filled it with the art

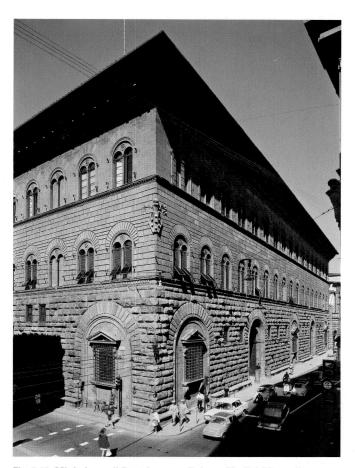

Fig. 7.12 Michelozzo di Bartolommeo, Palazzo Medici-Riccardi, Florence. Begun 1444. If it seems odd to think of such a structure as a palace, it is worth remembering that the Italian word *palazzo* refers to any reasonably large urban house.

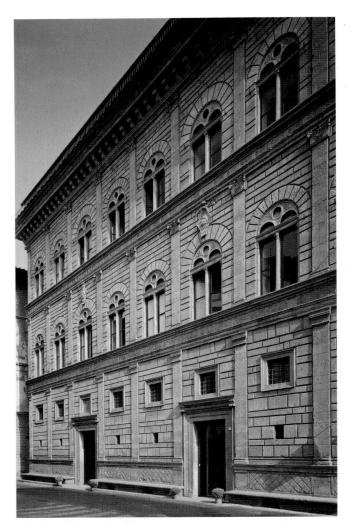

Fig. 7.13 Leon Battista Alberti, Palazzo Rucellai, Florence. 1446–51. In Alberti's time, the house extended to the right by four more bays and one more doorway, or portal.

of the day (including Donatello's *David*, Fig. 7.11). The bottom story is 20 feet high and made of rough-cut stone meant to imitate the walls of ancient Roman ruins and designed to suggest the Medici's adherence to tradition. The outside of the second story, which housed the living quarters, is cut into smooth stones, with visible joints between them. The outside of the third story, reserved for servants, is entirely smooth, thus giving the facade the appearance of decreasing mass and even airiness.

The Palazzo Medici became the standard for townhouses of wealthy Florentine merchants. Two years later, Leon Battista Alberti, author of *On Painting* and a close friend and advisor to Cosimo, designed a home for the Florentine patrician Giovanni Rucellai that brought the more or less subtle Classical references of Michelozzo's design for Cosimo to full light. The Palazzo Rucellai (Fig. **7.13**) reflects on a domestic level many of the ideas that Alberti would publish in about 1450 in his *On the Art of Building*.

For Alberti, architecture is the highest art and all buildings must properly reflect their social "place." Thus the Duomo, which Alberti believed to be the most important building in Florence, is at the heart of the city and rises high above it, the very center of Florentine culture. It follows that leading families should live in houses that reflect those families' stability and strength.

The Palazzo Rucellai does that and more. In direct imitation of the Roman Colosseum (see Fig. 3.11 in Chapter 3), Alberti uses three Classical orders, one for each of the three stories: the Tuscan (substituting for the Doric) at the bottom, the Ionic at the second story, and

the Corinthian at the top. As at the Colosseum, the columns are engaged (that is, decorative rather than functional), and an arch is set between them. Many people thought Alberti's plan too grand because, in its reference to the Colosseum, it embodies not Republican but imperial Rome. However, Alberti's design reflects the real state of affairs in Florence at that time. For the city was ruled by what was in fact a hereditary monarchy—the Medici—supported by a wealthy, albeit mercantile, "nobility," consisting of families such as the Rucellai.

Lorenzo the Magnificent: "... I find a relaxation in learning."

After Cosimo's death in 1464, his son Piero (1416–69) followed in his footsteps, championing the arts, supporting the Platonic Academy, and otherwise working to make Florence the cultural center of Europe. But when Piero died only five years after his father, his 20-year-old son Lorenzo (1449–92) assumed responsibility for leading the family and the city. So great and varied were his accomplishments that in his own time he was known as *il Magnifico*—"the Magnificent."

As a young man, Lorenzo had been tutored by Ficino, and among his favorite pastimes was spending the evening talking with Ficino and other friends. "When my mind is disturbed with the tumults of public business," he wrote Ficino in 1480, "and my ears are stunned with the clamors of turbulent citizens, how would it be possible for me to support such contentions unless I found a relaxation in learning?" In support of learning, he rebuilt the University of Pisa and continued to support the study of Greek philosophy and literature in Florence at the Platonic Academy.

Lorenzo's own circle of acquaintances included many of the greatest minds of the day. Delighted by a copy of an ancient Greek or Roman faun's head made by an unknown adolescent named Michelangelo Buonarroti, Lorenzo invited the sculptor to live in the Medici palace, and the young man was soon a regular in the philosophical discussions that occupied Lorenzo for so many evenings. Besides Ficino, other frequent guests included the composer Heinrich Isaac, the poet Poliziano, the painter Sandro Botticelli, and the philosopher Pico della Mirandola.

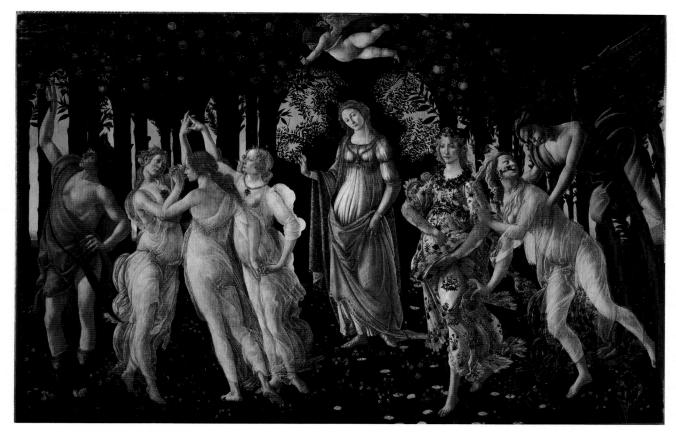

Fig. 7.14 Sandro Botticelli, *Primavera*. Early 1480s. Tempera on panel, 6'8" × 10'4". Galleria degli Uffizi, Florence. *Primavera* means both "spring" and "first truth" in Italian. Although the title is strongly allegorical, its exact meaning is still debated.

Sandro Botticelli: Humanist Painter It seems very likely that these discussions inspired Sandro Botticelli (1445– 1510) to paint his Primavera (Spring), perhaps on commission from Lorenzo di Pierfrancesco de' Medici, Lorenzo the Magnificent's cousin and a student of Ficino (Fig. 7.14). In the painting, the nymph stands in the center, depicted as Venus, goddess of Love, surrounded by other mythological characters, who appear to move through the garden setting from right to left. To the humanists in Lorenzo's court, Venus was an allegorical figure who represented the highest moral qualities. According to Ficino, she was the very embodiment of "Humanitas . . . her Soul and mind are Love and Charity, her eyes Dignity and Magnanimity, the hands Liberality and Magnificence, the feet Comeliness and Modesty. The whole, then, is Temperance and Honesty, Charm and Splendor." On the far right of the embodiment of the humanities, Zephyrus, god of the west wind, attempts to capture Chloris, the nymph of spring, in his cold, blue grasp. But Flora, goddess of flowers, who stands beside the nymph, ignores the west wind's threat, and distributes blossoms across the path. To the left of Venus, the three Graces, daughters of Zeus and personifications of beauty, engage in a dance that recalls a specific one created for three people by Lorenzo the Magnificent in the 1460s. Lorenzo called the dance

"Venus" and described it as based on the movement of two figures around a third one:

First they do a slow side-step, and then together they move with two pairs of forward steps, beginning with the left foot; then the middle dancer turns round and across with two reprises, one on the foot sideways and the other on the right foot, also across; and during the time that the middle dancer is carrying out these reprises the other two go forward with two triplet steps and then give half a turn on the right foot in such a way as to face each other.

Finally, to the left, Mercury, messenger of the gods, holds up his staff as if to brush away the remnants of a stray cloud. Over the whole scene and positioned just above the head of Venus, Cupid reigns.

Primavera captures the spirit of the Medici. It celebrates love, not only in a Neoplatonic sense, as a spiritual, humanist endeavor, but also in a more direct, physical way. For Lorenzo hardly shied away from physical pleasure. He was himself a prolific poet, and his most famous poem, the 1490 "A Song for Bacchus," deliberately invites the kind of carefree behavior we associate with carnivals, lavish festivities that Lorenzo regularly sponsored, complete with floats, processions through mythological settings, dance, and song (Reading 7.1):

READING 7.1

"A Song For Bacchus," 1490

How beautiful our Youth is That's always flying by us! Who'd be happy, let him be so: Nothing's sure about tomorrow.

Here are Bacchus, Ariadne, Lovely, burning for each other: Since deceiving time must flee, They seek their delight together. These nymphs, and other races, Are full of happiness forever. Who'd be happy, let him be so: Nothing's sure about tomorrow.

These delighted little satyrs
With their nymphs intoxicated,
Set a hundred snares now for them,
In the caves and in the bushes:
Warmed by Bacchus, all together
Dancing, leaping there forever,
Who'd be happy, let him be so:
Nothing's sure about tomorrow.

In fact, it seems likely that Botticelli's painting decorated Lorenzo di Pierfrancesco's wedding chamber. Clearly, a lighthearted spirit of play tempered all Lorenzo the Magnificent's followers. As Machiavelli would later say of him: "If one examines the light and serious side of his life, one sees in him two different persons joined in an almost impossible conjunction."

Heinrich Isaac: Humanist Composer Lorenzo's love of music was equaled only by his love of painting and poetry, and music was an important part of Florentine life, so much so that in 1433, the Opera del Duomo commissioned a series of eight reliefs from Luca della Robbia celebrating music. The reliefs were to be displayed in a gallery above the north door of the sacristy (Fig. 7.15). They were conceived to illustrate Psalm 150, which calls for worshipers to praise God "with sound of the trumpet . . . with psaltery and harp . . . with timbrels and dance . . . with stringed instruments and organs . . . upon the high-sounding cymbals." Luca's youthful figures are the very embodiment of the joy and harmony that made music such an ideal manifestation of the humanist spirit.

Lorenzo's household employed its own private music master, and in 1475, Lorenzo appointed the Flemish composer Heinrich Isaac (1450–1517) to the position. Isaac oversaw the Medici's five household organs, taught music to Lorenzo's sons, served as organist and choirmaster at Florence Cathedral, and, before he knew it, found himself collaborating with Lorenzo on songs for popular festivals.

Fig. 7.15 Luca della Robbia, *Drummers* (detail of the *Cantoria*). 1433–40. Marble, 421/8" × 41". Museo dell'Opera del Duomo, Florence. The 17-foot length of the space containing the *Cantoria* would have accommodated small choirs and portable organs.

The scores for many of the songs produced by this collaboration survive. They are examples of a musical genre known as the *frottola*, from the Italian for "nonsense" or "fib," and are extremely lighthearted. These *frottole* offer evidence of a strongly Italian movement away from the complex polyphony and counterpoint of church music (see the discussions of music in Chapters 5 and 6) in favor of simple harmonies and dancelike rhythms. Most *frottole* consist of three musical parts, with the melody in the highest register. The melodic line is generally taken by a soprano voice, accompanied in the two lower parts by either a lute and viol, two viols, other instruments, or two other voices. A typical *frottola* rhythm, such as from "Un di Lieto" ("One of Good Cheer"), might go something like this:

Typical frottola rhythm

From Lorenzo's point of view, such songs, sung in his native Italian, not Greek or Latin, demonstrated once and for all that Italian was the most harmonious and beautiful of languages when set to music. This sentiment would have lasting impact, especially on the development of the musical genre known as *opera* in the sixteenth and seventeenth centuries.

Pico della Mirandola: Humanity "at the . . . center of the world" Cultural life in Lorenzo's court was grounded on moral philosophy. The young humanist philosopher Pico della Mirandola (1463–94) shared Lorenzo's deep interest in

the search for divine truth. By age 23, in 1486, Pico had compiled a volume of some 900 theological and philosophical theses, 13 of which Pope Innocent VIII (papacy 1484–92) considered heretical. When Pico refused to recant those few theses, Innocent condemned all 900.

Pico's thinking was based on wide reading in Hebrew, Arabic, Latin, and Greek, and he believed that all intellectual endeavors shared the same purpose—to reveal divine truth. Pico proposed defending his work, in public debate in Rome, against any scholar who might dare to confront him, but the pope banned the debate and even imprisoned him for a brief time in France, where he had fled. Lorenzo offered Pico protection in Florence, defying the pontiff in a daring assertion of secular versus papal authority. As a result, Pico became an important contributor to Lorenzo's humanist court.

In his Oration on the Dignity of Man of 1486—the introduction to his proposed debate and one of the great manifestos of humanism—Pico argued that humanity was part of the "great chain of being" that stretches from God to angels, humans, animals, plants, minerals, and the most primal matter. This idea can be traced to the Idea of the Good developed by Plato in Book 7 of the Republic, an idea of perfection to which all creation tends. Plotinus' brand of Neoplatonic thought took it a step further in proposing that the material world, including humanity, is but the shadowy reflection of the celestial, a condition that the pursuit of knowledge allows humanity, if it chooses, at least to begin to overcome. According to Pico, humanity finds itself in a middle position in the great chain of being—not by natural law but by the exercise of its own free will. Humans, then, are not fixed in the middle position. They are, in fact, pure potential, able to make of themselves what they wish. Humanity, it follows, is God's greatest miracle: "There is nothing to be seen more wonderful than man," Pico wrote. In his Oration, he has God explain to Adam that he has placed him "at the very center of the world" and given him the gift of pure potential to shape himself (Reading 7.2):

READING 7.2

from Pico della Mirandola, Oration on the Dignity of Man (1486)

We have given you, Oh Adam, no visage proper to yourself, nor any endowment properly your own, in order that whatever place, whatever form, whatever gifts you may, with premeditation, select, these same you may have and possess through your own judgment and decision. The nature of all other creatures is defined and restricted within laws which We have laid down; you, by contrast, impeded by no such restrictions, may, by your own free will, to whose custody We have assigned you, trace for yourself the lineaments of your own nature. I have placed you at the very center of the world, so that from that vantage point you may with greater ease glance round about you on all that the world contains. . . . You may, as the free and proud shaper of your own being, fashion yourself in the

form you prefer. It will be in your power to descend to the lower, brutish forms of life; [or] you will be able, through your own decision, to rise again to the superior orders whose life is divine.

For Pico, the role of the philosopher in this anthropocentric (human-centered) world is as "a creature of heaven and not of earth." This is because "unmindful of the body, withdrawn into the inner chambers of the mind," the philosopher is part of "some higher divinity, clothed with human flesh." It is imperative, therefore, in Pico's view, for individuals to seek out virtue and knowledge, even while knowing their capability of choosing a path of vice and ignorance. Taking the idea of "freedom of judgment" to a new level, Pico argues that humanity is completely free to exercise its free will. And this gift of free will makes humans "the most fortunate of living things."

Such thinking reflects what may be the most important transformation wrought by Renaissance thinkers on medieval ideas. Art, literature, and philosophy, as the free expression of the individual's creative power, can, if they aim high enough, express not only the whole of earthly creation but also the whole of the divine. The human being is a parvus mundus, a "small universe."

BEYOND FLORENCE: THE DUCAL COURTS AND THE ARTS

How did the art and literature created in the ducal courts of Italy reflect Florentine humanist values?

Pico's message of individual free will and of humanity's ability to choose a path of virtue and knowledge inspired Lorenzo's circle and the courts of other Italian city-states as well. These leaders were almost all nobles, not merchants like the Medici (who, it must be said, had transformed themselves into nobility in all but name), and each court reflected the values of its respective duke—and, very often, his wife. But if they were not about to adopt the republican form of government of Florence, they all shared the humanistic values that were so thoroughly developed there.

The Montefeltro Court in Urbino

One of the most prominent of these city-states was Urbino, some 70 miles east of Florence across the Apennines (see Map 7.1), where the learned military strategist duke Federigo da Montefeltro (1422–82) ruled. Federigo surrounded himself with humanists, scholars, poets, and artists, from whom he learned and from whom he commissioned works to embellish Urbino. He financed this expenditure through his talents as a *condottiero*, a mercenary soldier who was a valuable and highly paid ally to whomever could afford both him and his army. His court was also a magnet for young men who wanted to learn the principles of noble behavior.

Baldassare Castiglione and "L'uomo Universale" One of the most important books of the age, written between 1513 and 1518, recalled conversations, probably imaginary, that took place in 1507 among a group of aristocrats at the Urbino court of Guidobaldo da Montefeltro (1472–1508), the son of Federigo. The Book of the Courtier by Baldassare Castiglione (1478–1529) takes the form of a dialogue in which the eloquent courtiers at Urbino compete with one another to describe the perfect courtier—the man (or woman) whose education and deportment are best fashioned to serve the prince. It was not published until 1528, but by 1600, it had been translated into five languages and reprinted in 57 editions.

The Book of the Courtier is, in essence, a nostalgic recreation of Castiglione's nine years (1504–12) in the Urbino court, which he labeled "the very abode of joyfulness." It takes place on four successive evenings in the spring of 1507. The dialogue is in the form of a dialectic, as the viewpoints of some speakers are challenged and ridiculed by others. The first two books debate the qualities of an ideal gentleman. The goal is to be a completely well-rounded person, l'uomo universale. Above all, a courtier must be an accomplished soldier (like Federigo), not only mastering the martial arts but also demonstrating absolute bravery and total loyalty in war. His liberal education must include Latin and Greek, other modern languages such as French and Spanish (necessary for diplomacy), and study of the great Italian poets and writers, such as Petrarch and Boccaccio, so that he might imitate their skill in his own verse and prose, both in Latin and in the vernacular. The courtier must also be able to draw, appreciate the arts, and excel in dance and music (although one must avoid the wind instruments since they deform the face). Above all, the courtier must demonstrate a certain grazia ("gracefulness") (Reading 7.3):

READING 7.3

from Baldassare Castiglione, *The Courtier*, Book 1 (1513–18; published 1528)

I wish then, that this Courtier of ours should be nobly born and of gentle race; . . . for noble birth is like a bright lamp that manifests and makes visible good and evil deeds, and kindles and stimulates to virtue both by fear of shame and by hope of praise. . . .

Besides this noble birth, then, I would have the Courtier favored in this regard also, and endowed by nature not only with talent and beauty of person and feature, but with a certain grace and (as we say) air that shall make him at first sight pleasing and agreeable to all who see him; and I would have this an ornament that should dispose and unite all his actions, and in his outward aspect give promise of whatever is worthy the society and favor of every great lord.

Grazia must be tempered by *gravitas* ("dignity") in all things. This balanced character trait is obtained, Castiglione explains in *The Book of the Courtier*, by means of "one universal rule":

Flee as much as possible . . . affectation; and, perhaps to coin a word . . . make use in all things of a certain *sprezzatura*, which conceals art and presents everything said and done as something brought about without laboriousness and almost without giving it any thought.

Sprezzatura means, literally, "undervaluing" or "setting a small price" on something. For the courtier, it means simply doing difficult things as if effortlessly and with an attitude of nonchalance. The ideal gentleman, in other words, is a construction of absolute artifice, a work of art in his own right who cuts *una bella figura*, "a fine figure," that all will seek to emulate. Ultimately, Castiglione suggests, a state led by such perfect gentlemen would itself reflect their perfection, and thus the state does not create great individuals so much as great individuals create the perfect state, in the kind of exercise of free will that Pico discussed.

The Sforza Court in Milan and Leonardo da Vinci The Sforza family's control over the court of Milan was somewhat less legitimate than most other ducal city-states in Italy. Francesco Sforza (1401–66) became ruler of Milan by marrying the illegitimate daughter, but sole heir, of the duke of Milan. His own illegitimate son, Ludovico (1451–1508), called il Moro, "the Moor," because of his dark complexion, wrested control of the city from the family of Francesco's legitimate brother and proclaimed himself duke of Milan in 1494. Both Francesco and Ludovico understood the tenuousness of their claims to rule, and they actively sought to win the support of the people through the arts. They welcomed artists from throughout central Italy to their city, and embraced humanism.

The most important of these artists was Leonardo da Vinci (1452–1519), who first arrived in Milan in 1482 as the emissary of Lorenzo de' Medici to present a silver lyre, perhaps made by Leonardo himself, to Ludovico Sforza. Ludovico was embroiled in military matters, and Leonardo pronounced himself a military engineer, capable of constructing great "machines of war," including designs for a catapult and covered vehicles that resemble present-day armored cars.

Leonardo's restless imagination, in fact, led him to the study of almost everything: such natural phenomena as wind, storms, and the movement of water; anatomy and physiology; physics and mechanics; music; mathematics; plants and animals; geology; and astronomy, to say nothing of painting and drawing. Leonardo was a humanist, and as such was deeply swayed by Neoplatonic thought. He saw connections among all spheres of existence and wrote of them:

If man has in himself bones, the supports and armature for the flesh, the world has the rocks, the supports of the earth; if man has in himself the lake of blood, in which the lungs increase and decrease in breathing, the body of the earth has its oceanic sea, which likewise increases and decreases every six hours with the breathing of the world; if from the said lake veins arise, which proceed to ramify

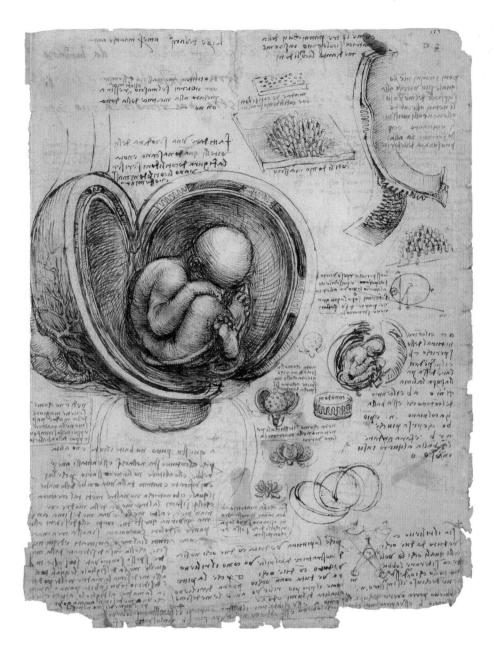

Fig. 7.16 Leonardo da Vinci, *Embryo in the Womb.* ca. 1510. Pen and brown ink, $11\%" \times 8\%"$. The Royal Collection © 2011 Her Majesty Queen Elizabeth II. Leonardo's notes on this page from one of his notebooks relate not only to standard questions of anatomy and physiology, including the nourishment of the fetus, but also to the relationship of the fetus's soul to that of its mother.

throughout the human body, the oceanic sea fills the body of the earth with infinite veins of water.

Thus, the miracle of the fetus in the womb, which Leonardo depicts in a famous anatomical study from his notebooks (Fig. 7.16), is analogous in his mind to the mysteries that lie deep within the body of the earth. "I came to the entrance of a great cavern," he writes in one note. "There immediately arose in me two feelings—fear and desire—fear of the menacing, dark cavity, and

desire to see if there was anything miraculous within." Leonardo's fascination with the human body—an image, for him, of both attraction and repulsion—led him to produce this and his other precisely drawn dissections of it in 1510–12, probably working under the direction of a young professor of anatomy.

In his Lives of the Most Excellent Painters, Architects, and Sculptors, which first appeared in 1550 and was subsequently revised and greatly expanded in 1568, Giorgio Vasari underscores the inquisitiveness that Leonardo's dissections reveal.

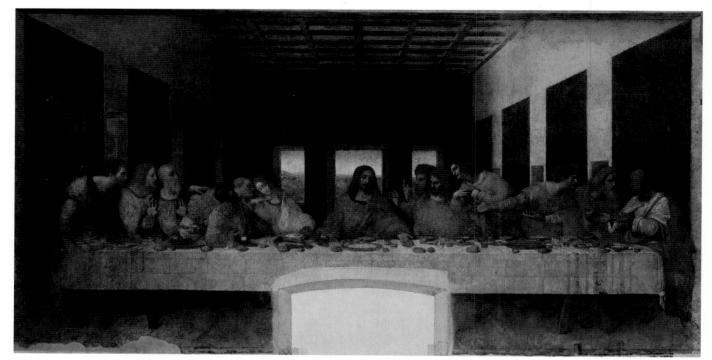

Fig. 7.17 Leonardo da Vinci, *Last Supper*, wall painting in refectory, Convent of Santa Maria delle Grazie, Milan. ca. 1495–98. Fresco, oil, and tempera on plaster, 15'1½" × 28'10½". Today, even after "restoration," Leonardo's original painting remains in very bad shape. The fault is almost entirely Leonardo's—or maybe Ludovico Sforza's, who rushed him to complete it. Instead of using the established fresco technique of painting tempera on wet plaster, Leonardo applied oil and tempera to dry plaster. As early as 1517, the paint began to flake off, unable to adhere to the wall

Born in 1511, Vasari could never have known Leonardo personally, but as a painter and architect, as well as an historian, he did know many other Renaissance artists, including Michelangelo, and his *Lives* remains one of our primary sources on Renaissance art. He focuses on demonstrating the individual creative genius of each artist he discusses. Vasari's treatment of Leonardo is typical of the other biographies in *Lives*. From the very opening lines, Vasari presents him as a prototypical Renaissance man (Reading 7.4):

READING 7.4

from Giorgio Vasari, "Life of Leonardo," in Lives of the Most Excellent Painters . . . (1550, 1568)

The greatest gifts are often seen, in the course of nature, rained by celestial influences on human creatures; and sometimes, in supernatural fashion, beauty, grace, and talent are united beyond measure in one single person, in a manner that to whatever such a one turns his attention, his every action is so divine, that, surpassing all other men, it makes itself clearly known as a thing bestowed by God (as it is), and not acquired by human art. This was seen by all mankind in Leonardo da Vinci, in whom, besides a beauty of body never sufficiently extolled, there was an infinite grace in all his actions; and so great was his genius, and such its growth, that to whatever

difficulties he turned his mind, he solved them with ease. In him was great bodily strength, joined to dexterity, with a spirit and courage ever royal and magnanimous; and the fame of his name so increased, that not only in his lifetime was he held in esteem, but his reputation became even greater among posterity after his death.

In 1495, Ludovico commissioned Leonardo to paint a monumental fresco of the Last Supper for the north wall of the refectory of the Dominican convent of Santa Maria delle Grazie. The intent was that at every meal the monks would contemplate Christ's last meal in a wall-sized painting. The Last Supper illusionistically extends the refectory walls in a modified one-point perspective (the tabletop is tipped toward the viewer), carrying the present of architectural space into the past of the painting's space (Fig. 7.17).

The moment Leonardo chose to depict is just after Christ has announced to the apostles that one of them will betray him. Each apostle reacts in his characteristic way. Saint Peter grabs a knife in anger, while Judas turns away and Saint John appears to faint. The vanishing point of the painting is directly behind Christ's head, focusing the viewer's attention

Fig. 7.18 Leonardo da Vinci, Mona Lisa. 1503–15. Oil on wood, $3014''' \times 21''$. Musée du Louvre, Paris. Recent research tends to suggest that the woman in this picture is the wife of the Florentine patrician Francesco del Giocondo. She is seated on a balcony, originally between two columns that have been cut off (the base of the left column is just visible).

and establishing Christ as the most important figure in the work. He extends his arms, forming a perfect equilateral triangle at the center of the painting, an image of balance and a symbolic reference to the Trinity. What is unique about this painting of an otherwise completely traditional subject for a refectory is the psychological realism that Leonardo lends to it. We see this in the sense of agitated doubt and confusion among the apostles, their intertwined bodies twisting and turning as if drawn toward the self-contained and peaceful image of Christ. The apostles, even Judas, are revealed in all their humanity, while Christ is composed in his compassion for them.

Leonardo's fascination with revealing the human personality in portraiture is nowhere more evident than in his Mona Lisa (Fig. 7.18), where he fuses his subject with the landscape behind her by means of light. This technique is called *sfumato* ("smokiness"). Its hazy effects, which create

a half-waking, dreamlike quality reminiscent of dusk, could only be achieved by building up color with many layers of transparent oil paint—a process called **glazing**. But it is the mysterious personality of Leonardo's sitter that most occupies the viewer's imagination. For generations, viewers have asked, Who is this woman? What is she thinking about? What is her relation to the artist? Leonardo presents us with a particular personality, whose half-smile suggests that he has captured her in a particular, if enigmatic, mood. And the painting's hazy light reinforces the mystery of her personality. Apparently, whatever he captured in her look he could not give up. The *Mona Lisa* occupied Leonardo for years, and it followed him to Rome and then to France in 1513, where King Louis XII offered him the Château of Cloux near Amboise as a residence. Leonardo died there on May 2, 1519.

In 1499, the French, under Charles VIII, deposed Ludovico and imprisoned him in France, where he died in 1508. Leonardo abandoned Milan, eventually returning to Florence in about 1503. Both of Ludovico's sons would briefly rule as duke of Milan in the early sixteenth century, but both were soon deposed, and the male line of the Sforza family died out.

PAPAL PATRONAGE AND THE HIGH RENAISSANCE IN ROME

How did papal patronage impact the arts in Rome?

When Brunelleschi arrived in Rome in 1402, shortly after the competition for the Baptistery doors in Florence, the city must have seemed a pitiful place. Its population had shrunk from around 1 million in 100 ce to around 20,000. It was located in a relatively tiny enclave across the Tiber from the Vatican and Saint Peter's Basilica, and was surrounded by the ruins of a once-great city. Even 150 years later, in the sixteenth century, the city occupied only a small fraction of the territory enclosed by its third-century ce walls. The ancient Colosseum was now in the countryside, the Forum a pasture for goats and cattle. The ancient aqueducts that had once brought fresh water to the city had collapsed. The popes had even abandoned the city when, in 1309, under pressure from the king of France, who sought to assert secular authority over the clergy, they left Italy and established Avignon as the seat of the Church. When Rome finally reestablished itself as the titular seat of the Church in 1378, succeeding popes rarely chose to visit the city, let alone live in it. The city held little appeal, except perhaps for the ruins themselves, and, as we have already seen, it was to the ruins of Rome that Brunelleschi was most attracted.

After 1420, when Pope Martin V (papacy 1417–31) brought the papacy back to Rome for good, it became something of a papal duty to restore the city to its former greatness. Because as many as 100,000 visitors might swarm into Rome during religious holidays, it was important that they

Fig. 7.19 Leonardo da Vinci, *Vitruvian Man.* ca. **1485–90.** Pen and ink, $13\frac{1}{2}$ " $\times 9\frac{1}{2}$ ". Gallerie dell'Accademia, Venice. Vitruvius specifically related the harmonious physical proportions of man, which reflect their divine creator, to the proportions of architecture.

be "moved by its extraordinary sights," as one pope put it, and thus find their "belief continually confirmed and daily corroborated by great buildings . . . seemingly made by the hand of God." In other words, the popes were charged with the sacred duty of becoming great patrons of the arts and architecture of Rome.

By and large, Rome imported its artists from Florence. In 1481, Botticelli and a group of his fellow Florentine painters arrived to decorate the walls of the Vatican's Sistine Chapel. When Pope Julius II (papacy 1503-13) began a massive campaign to rebuild Saint Peter's Basilica and the Vatican, he commanded Michelangelo to leave Florence for Rome in 1505 and commissioned major paintings and monuments from the then 30-year-old artist. In 1508, Michelangelo was followed by Raphael (Raffaello Santi or Sanzio, 1483–1520), a young painter from Urbino who had arrived in Florence in about 1505. Julius set him the task of decorating the papal apartments. Rome must have seemed something of a Florentine place. In November 1494, the domination of Florence by the Medici family had come to an end. But when the Medici returned to power in Florence in 1512, they did so under the sway of two great Medici popes: Leo X (papacy 1513-21), who was Lorenzo the Magnificent's son, Giovanni de' Medici; and Clement VII (papacy 1523–34), who was Lorenzo's nephew, Giulio de' Medici. Whether in the church or the republic, Rome or Florence, the males of this patrician family were the dominant force in the Renaissance political world.

Bramante and the New Saint Peter's Basilica

Shortly after he was elected pope in 1503, Julius II made what may have been the most important commission of the day. He asked the architect Donato Bramante (1444-1514) to renovate the Vatican Palace and serve as chief architect of a plan to replace Saint Peter's Basilica with a new church. The pope's chosen architect, Bramante, had worked with Leonardo da Vinci in Milan, and Julius was deeply impressed by Leonardo's understanding of the writings of the ancient Roman architectural historian Vitruvius. For Vitruvius, whose acquaintance with Polyclitus' Canon of proportion is our only firsthand account of the now-lost original (see Chapter 2), the circle and square were the ideal shapes. Polyclitus' proportion was the geometrical equivalent of Pythagoras' music of the spheres, the theory that each planet produced a musical sound, fixed mathematically by its velocity and distance from Earth, which harmonized with those produced by other planets and was audible but not recognized on Earth. Thus, according to Vitruvius, if the human head is one-eighth the total height of an idealized figure, then the human body itself fits into the ideal musical interval of the octave, the interval that gives the impression of duplicating the original note at a higher or lower pitch. Leonardo had captured this notion in his Vitruvian Man, a drawing in which he placed the human figure at the center of a perfect circle inscribed over a square (Fig. 7.19).

In Rome, Bramante quickly applied this emphasis on geometrical figures to one of his earliest commissions, a small freestanding circular chapel in the courtyard of a Spanish church in Rome, San Pietro in Montorio, directly over what was revered as the site of Saint Peter's martyrdom. Because of its small size and the fact that it was modeled on a Classical temple that was excavated in Rome during the reign of Sixtus IV, this structure is known as the Tempietto (Little Temple) (Fig. 7.20). The 16 exterior columns are Doric—in fact, their shafts are original ancient Roman granite columns and the frieze above them is decorated with objects of the Christian liturgy in sculptural relief. The diameter of the shafts defines the entire plan. Each shaft is spaced four diameters from the next, and the colonnade they form is two diameters from the circular walls. In its Classical reference, its incorporation of original Classical Roman columns into its architectural scheme, and, above all, the mathematical orderliness of its parts, the Tempietto is the very embodiment of Italian humanist architecture in the High Renaissance.

The task of replacing Old Saint Peter's was a much larger project and Bramante's most important one. Old Saint Peter's was a *basilica*, a type of ancient Roman building with a long central nave, double side aisles set off by colonnades (see Fig. 4.6 in Chapter 4), an apse in the wall opposite the main door, and a transept near the apse so that large numbers of visitors could approach the shrine to Saint Peter. In his plan for a new Saint Peter's (Fig. 7.21a), Bramante adopted the Vitruvian square, as illustrated in Leonardo's drawing, placing inside it a **Greek cross** (a cross in which

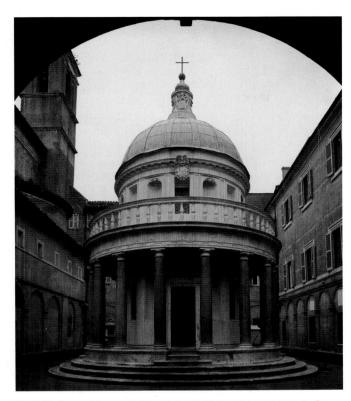

Fig. 7.20 Donato Bramante, Tempietto. 1502. San Pietro in Montorio, Rome. This chapel was certainly modeled on a Classical temple. It was commissioned by King Ferdinand and Queen Isabella of Spain, financiers of Christopher Columbus's voyages to America. It was undertaken in support of Pope Alexander VI, who was himself Spanish.

the upright and transverse shafts are of equal length and intersect at their middles) topped by a central dome purposely reminiscent of the giant dome of the Pantheon (see Fig. 3.18 in Chapter 3). The resultant central plan is essentially a circle inscribed

within a square. In Renaissance thinking, the central plan and dome symbolized the perfection of God. Construction began in 1506. Julius II financed the project through the sale of indulgences, remissions of penalties to be suffered in the afterlife, especially release from purgatory. This was the place where, in Catholic belief, individuals temporarily reside after death as punishment for their sins. Those wanting to enter heaven more rapidly than they otherwise might could shorten their stay in purgatory by purchasing an indulgence. The Church had been selling these documents since the twelfth century, and Julius's building campaign intensified the practice. (In protest against the sale of indulgences, Martin Luther would launch the Protestant Reformation in Germany in 1517; see Chapter 8.) New Saint Peter's would be a very expensive project, but there were also very many sinners willing to help to pay for it. With the deaths of both pope and architect, in 1513 and 1514 respectively, the project came to a temporary halt. Its final plan would be developed in 1546 by Michelangelo (Fig. 7.21b).

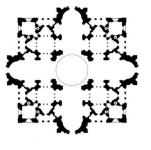

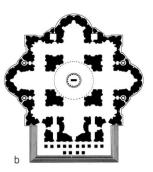

Fig. 7.21 Plans for Saint Peter's, Rome, by (a) Donato Bramante and (b) Michelangelo. Bramante's original plan (a), in the form of a Greek cross, was sporadically worked on after Julius II's death in 1513. The project came to a complete halt for a decade after the Sack of Rome by the troops of the Habsburg Emperor Charles V in 1527. In 1547, Pope Paul III appointed Michelangelo as architect, and he revived Bramante's original plan but added more support for the dome and thickened the walls. He also added a portico consisting of 10 columns in the second row and 4 in the front, which created the feeling of a Latin cross, especially when extended by his other addition to Bramante's scheme, the massive flight of steps rising to the main portal (b).

Michelangelo and the Sistine Chapel

After the fall of the Medici in 1494, a young Michelangelo, not yet 20 years old, had left Florence for Rome. There must have seemed little prospect for him in Florence, where a Dominican friar, Girolamo Savonarola (1452-98), abbot of the monastery of San Marco, wielded tremendous political influence. Savonarola appealed, first and foremost, to a moralistic faction of the populace that saw, in the behavior of the city's upper classes, and in their humanistic attraction to Classical Greek and Roman culture, clear evidence of moral decadence. Savonarola railed against the Florentine nobility—the Medici in particular—going so far as to organize troops of children to collect the city's "vanities"—everything from cosmetics to books and paintings—and burn them on giant bonfires. Finally, in June 1497, an angry Pope Alexander VI excommunicated him for his antipapal preachings and for disobeying his directives for the administration of the monastery of San Marco. Savonarola was commanded not to preach, an order he chose to ignore. On May 28, 1498, he was forcibly removed from San Marco, tortured as a heretic along with two fellow friars, hanged until nearly dead, and then burned at the stake. His ashes were subsequently thrown into the Arno River. Florence felt itself freed from tyranny.

With the fall of Savonarola, the Signoria, Florence's governing body, quickly moved to assert the republic's survival in visual terms. It moved Donatello's *David* (see Fig. 7.11) from the Medici palace to the Palazzo della Signoria, where the governing body met to conduct business. It also asked Michelangelo to return to Florence in 1501 to work on a huge cracked block of marble that all other sculptors had abandoned in dismay. It was to be another freestanding

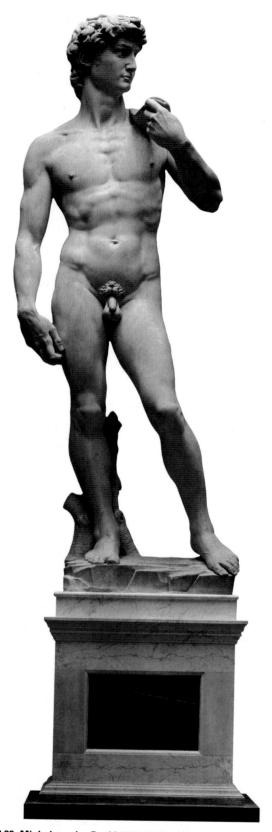

Fig. 7.22 Michelangelo, *David.* **1501–04.** Marble, height 17'3". Accademia, Florence. The *David* was originally conceived to be placed high on the facade of Florence Cathedral. It was probably situated in the Piazza della Signoria because it could not be lifted into place.

statue of the biblical hero David, but colossal in scale. Michelangelo rose to the challenge.

The completed figure (Fig. 7.22), over 17 feet high—even higher on its pedestal—intentionally references Donatello's boyish predecessor but then challenges it. Michelangelo represents David before, not after, his triumph, sublimely confident, ready to take on whatever challenge faces him, just as the republic itself felt ready to take on all-comers. The nudity of the figure and the *contrapposto* stance are directly indebted to the Medici celebration of all things ancient Greek. Its sense of self-contained, even heroic individualism captures perfectly the humanist spirit. Michelangelo's triumph over the complexity of the stone transformed it into an artwork that his contemporaries lauded for its almost unparalleled beauty. It was an achievement that Michelangelo would soon equal, in another medium, in his work on the Sistine Chapel ceiling at the Vatican, in Rome.

The fate of the *David* underscores the political and moral turbulence of the times. Each night, as workers installed the statue in the Piazza della Signoria, supporters of the exiled Medici hurled stones at it, understanding, correctly, that the statue was a symbol of the city's will to stand up to any and all tyrannical rule, including that of the Medici themselves. Another group of citizens soon objected to the statue's nudity, and before it was even installed in place, a skirt of copper leaves was prepared to spare the general public any possible offense. The skirt is long gone, but it symbolizes the conflicts of the era, even as the sculpture itself can be thought of as truly inaugurating the High Renaissance.

But it is Michelangelo's work on the Sistine Chapel in Rome that remains one of the era's crowning achievements. Just as the construction of New Saint Peter's was about to get under way, Julius II commissioned Michelangelo to design his tomb. It would be a three-story monument, over 23 feet wide and 35 feet high, and it represents Michelangelo's first foray into architecture. For the next 40 years, Michelangelo would work sporadically on the tomb, but from the beginning he was continually interrupted, most notably in 1506 when Julius himself commanded the artist to paint the 45-by-128-foot ceiling of the Sistine Chapel, named after Sixtus IV, Julius's uncle, who had commissioned its construction in 1473. Ever since its completion, the chapel has served as the meeting place of the conclave of cardinals during the election of new popes. Michelangelo at first refused Julius's commission, but in 1508, he reconsidered, signed the contract, and began the task.

Julius first proposed filling the spandrels between the windows with paintings of the 12 apostles and then decorating the ceiling proper with ornamental designs. But when Michelangelo objected to the limitations of this plan, the pope freed him to paint whatever he liked, and Michelangelo undertook for himself a far more ambitious task—nine scenes from Genesis, the first book of the Hebrew Bible, on the ceiling proper, surrounded by prophets, Sibyls, the ancestors of Christ, and other scenes (Figs. 7.23 and 7.24). Thus, the ceiling would narrate events before the coming of the law of Moses, and would complement the narrative cycles on the walls below.

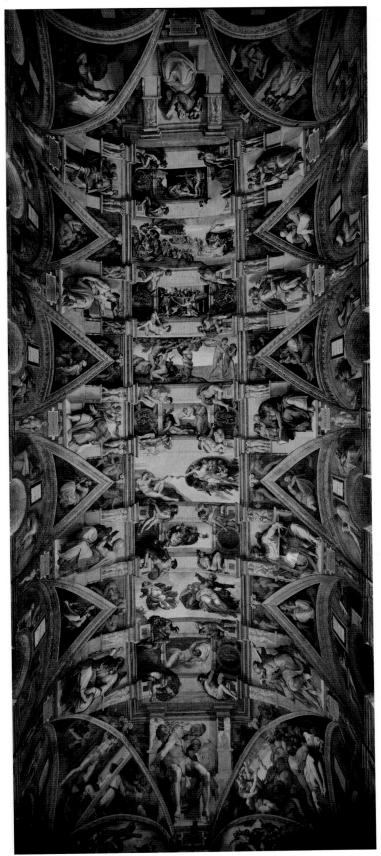

Figs. 7.23 and 7.24 Michelangelo, Sistine Chapel ceiling and plan of its narrative program, Vatican, Rome. 1508–12. Fresco, 45′ × 128′. The intense and vibrant colors of the ceiling were revealed after a thorough cleaning, completed in 1990. Centuries of smoke and grime were removed by a process that involved the application of a solvent, containing both a fungicide and an antibacterial agent, mixed with a cellulose gel that would not drip from the ceiling. This mixture was applied in small sections with a bristle brush, allowed to dry for three minutes, and then removed with sponge and water. Until the cleaning, no one for centuries had fully appreciated Michelangelo's daring, even sensual, use of color.

David and Zacharias Holofernes		
Joel	Drunkenness of Noah	Delphic Sibyl
Zorobabel	The Flood	Josiah
Eritrean Sibyl	Sacrifice of Noah	Isaiah
Ozias	Temptation and Expulsion	Ezekias
Ezekiel	Creation of Eve	Cumaean Sibyl
Roboam	Creation of Adam	Asa
Persian Sibyl	Separation of Land from Water	Daniel
Salmon	Creation of Sun, Moon, and Planets	Jesse
Jeremiah	Separation of Light from Darkness	Libyan Sibyl
Death of Haman Jonah of Brass		

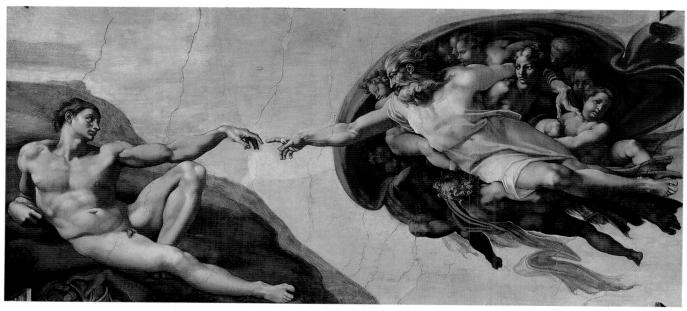

Fig. 7.25 Michelangelo, Creation of Adam, Sistine Chapel, Vatican, Rome. 1510. Fresco. Note the analogy Michelangelo creates between Adam and God, between the father of humankind and God the Father. Although they face each other, Adam and God are posed along parallel diagonals, and their right legs are in nearly identical positions. The connection is further highlighted by the fluttering green ribbon in God's space that echoes the colors of the ground upon which Adam lies.

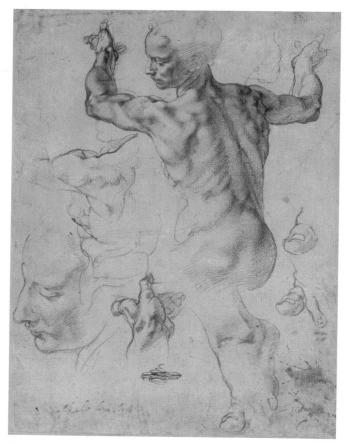

Fig. 7.26 Michelangelo, Studies for the Libyan Sibyl. ca. 1510. Red chalk, $11\%" \times 8\%6"$. The Metropolitan Museum of Art, New York, Joseph Pulitzer Bequest, 1924 (24.197.2). Very few of Michelangelo's drawings for the Sistine Chapel survive, even though he prepared hundreds as he planned the ceiling.

Fig. 7.27 Michelangelo, *Libyan Sibyl*, Sistine Chapel, Vatican, Rome. 1512. Fresco. In Michelangelo's program for the ceiling, the Sibyls alternate with Hebrew Bible prophets around the room. One of the most striking characteristics of these figures is the way they seem to project in front of the decoration and enter into the real space of the chapel, creating a stunning illusionistic effect.

Throughout the ceiling Michelangelo includes the della Rovere heraldic symbols of oak (rovere) and acorn to symbolize the pope's patronage, usually in the hands of **ignudi**, nude youths who sit at the four corners of alternate central panels. These same panels are framed by bronze shields that underscore the patron's military prowess. The whole is contained in an entirely illusionistic architecture that appears to open at each end to the sky outside. Only the spandrels over the windows and the **pendentives** (concave triangular sections that form a transition between a rectilinear and a dome shape) at each corner are real.

The nine central panels tell the story, in three panels each, of the Creation, Adam and Eve, and Noah. The series begins over the chapel altar with the Separation of Light from Darkness, a moment associated with the eternal struggle between good and evil, truth and falsehood. In fact, this pairing of opposites characterizes the entire program. At the center of the ceiling is the Creation of Eve. Life and death, good and evil, the heavenly and the earthly, the spiritual and the material, pivot around this central scene. Everything between here and the altar represents Creation before the knowledge of good and evil was introduced to the world by the temptation of Eve in the Garden of Eden, a scene represented, together with the Expulsion, in the panel just to the right. From here to the panel over the door to the chapel, we witness the early history of fallen humankind, for viewers entering the chapel look up to see directly above them the Drunkenness of Noah, an image symbolic of their own frailty. They see the goodness and truth of God's creation only at the greatest remove from them, far away at the chapel's other end.

The tension between the spiritual and the material worlds is nowhere better represented on the ceiling than in the *Creation of Adam* (Fig. 7.25). Adam is earthbound. He seems lethargic, passive, barely interested, while a much more animated God flies through the skies carrying behind him a bulging red drapery that suggests both the womb and the brain, creativity and reason. Under his arm is a young woman, who may be Eve, who prefigures the Virgin, while God's left hand touches the shoulder of an infant, who may symbolize the future Christ. The implication of the scene is that in just one moment, God's finger will touch Adam's and infuse him with not just energy but soul, not just life but the future of humankind.

Michelangelo worked on the ceiling from May 1508 until 1512. His accomplishment becomes even clearer when we compare the final painting to the preparatory studies. In a drawing of one of the later figures painted, the *Libyan Sibyl* (Fig. 7.26), the figure's hands are balanced evenly, at the same level, but by the time he painted her (Fig. 7.27), the left hand had dropped below the right to emphasize her downward turn, underlining the fact that she is bringing knowledge down to the viewer. The artist has paid special attention to the left foot, seeing the need to splay the four smaller toes backward. And finally, his model in the drawing was apparently male. In his reworking of the face at the lower left of the drawing, he softens the figure's cheekbones and fills out her lips. In the final painting, he reduces the model's prominent brow, hides the musculature of the model's back, and exaggerates the

buttocks and hips, feminizing the original masculine sketch. As graceful as it is powerful and majestic, the *Libyan Sibyl* is a virtuoso display of technical mastery.

Raphael and the Stanza della Segnatura

Meanwhile, in about 1505, a young painter named Raphael (Raffaello Santi or Sanzio) arrived in Florence from Urbino and began to receive a great deal of attention as a painter of portraits of wealthy Florentine citizens. He also produced a series of small, beautifully executed paintings of the Virgin and Child. The latter, of course, embraced a theme that stretched back to the Byzantine icon, down through the work of the Sienese painters Duccio and Martini and the Florentines Cimabue and Giotto (see Chapter 6). However, the naturalism that these earlier painters had striven to achieve reached new heights in Raphael's work. His paintings were immediately approachable—linearly precise, coloristically rich, and compositionally simple.

The Small Cowper Madonna (Fig. 7.28) is an example. Both Virgin and Child are imbued with an almost celestial serenity—owing in no small part to the fact that their heads are framed by the radiant light of Raphael's sky. But what

Fig. 7.28 Raphael, Small Cowper Madonna. ca. 1505. Oil on panel, $23\%6" \times 175\%6"$. National Gallery of Art, Washington, D.C., Widener Collection (1942.9.57). Photograph © Board of Trustees, National Gallery of Art. The painting takes its name from its owner, George Nassau Clavering, the third Earl Cowper (1738–89), who visited Italy in 1760 and remained there for the rest of his life, amassing an extraordinary collection of Italian Renaissance paintings.

strikes us most is their very humanity—the fact that they seem absolutely alive with a sense of touch, the Child's toes resting on her right hand, her left supporting his naked buttocks. Lending the scene a sense of reality is the landscape itself, which is a real one, featuring the church of San Bernardino, 2 miles outside Raphael's native Urbino. But perhaps more than anything else, the self-reflective gaze of the Virgin captures the viewer's imagination, as if we have caught her literally in the moment, thinking who knows what, but deep in thought nonetheless. Divinity and humanity are here perfectly balanced.

In 1508, the young Raphael left Florence to arrive in Rome as Michelangelo was beginning work on the Sistine Chapel ceiling, and he quickly secured a commission from Julius II to paint the pope's private rooms in the Vatican Palace. The first of these rooms was the so-called Stanza della Segnatura (Room of the Signature), where subsequent popes signed official documents, but which Julius used as a library. Julius had determined the subjects. On each of the four walls, Raphael was to paint one of the four major areas of humanist learning: Law and Justice, to be represented by the Cardinal Virtues; the Arts, to be represented by Mount Parnassus; Theology, to be represented by the Disputà, or Dispute over the Sacrament; and Philosophy, to be represented by the School

Fig. 7.29 Raphael, *Pope Leo X with Cardinals Giulio de' Medici and Luigi de' Rossi.* 1517. Panel, $60\%'' \times 47''$. Galleria degli Uffizi, Florence. The illuminated manuscript on the table in front of the pope is from his private collection. It contributes significantly to the highly naturalistic feeling of the scene, even as it symbolizes his humanism.

of Athens (see Closer Look, pages 234–35). In an apparent attempt to balance Classical paganism and Christian faith, a gesture completely in keeping with Julius's humanist philosophy, two of these scenes—Mount Parnassus and the School of Athens—had Classical themes, the other two Christian.

The Medici Popes

Pope Julius II died in 1513, not long after Michelangelo had completed the Sistine Chapel ceiling and Raphael the Stanza della Segnatura. He was succeeded by Leo X, born Giovanni de' Medici, son of Lorenzo the Magnificent. Leo's papacy began a nearly 21-year period of dominance from Rome by the Medici popes, which ended with the death of Clement VII in 1534. The patronage of these Medici popes had a significant effect on art.

After Raphael's work in the Stanza, Leo was quick to hire him for other commissions. When Bramante died in 1514, Leo appointed the young painter as papal architect, though Raphael had never worked on any substantial building project. It was not long before Leo asked Raphael to paint his portrait.

Pope Leo X with Cardinals Giulio de' Medici and Luigi de' Rossi (Fig. 7.29), painted in 1517, suggests a new direction in Raphael's art. The lighting is more somber than in the vibrantly lit paintings of the Stanza della Segnatura. Architectural detail is barely visible as the figures are silhouetted, seated against an intensely black ground. Although posed as a group, the three figures look in different directions, each preoccupied with his own concerns. It is as if they have just heard something familiar but ominous in the distance, something that has given them all pause. There is, furthermore, a much greater emphasis on the material reality of the scene. One can almost feel the slight stubble of Leo's beard, and the beards of the two cardinals are similarly palpable. The velvet of Leo's ermine-trimmed robe contrasts dramatically with the silk of the cardinals' cloaks. And the brass knob on the pope's chair reflects the rest of the room like a mirror, including a brightly lit window that stands in total opposition to the darkness of the rest of the scene. All in all, the painting creates a sense of drama, as if we are witness to an important historical moment.

In fact, in 1517, the papacy faced some very real problems. To the north, in Germany, Martin Luther had published his Ninety-Five Theses, attacking the practice of papal indulgences and calling into question the authority of the pope (see Chapter 8). Back in Florence, where the Medici had resumed power in 1512, the family maintained control largely through its connections to Rome, and that control was constantly threatened. Despite these difficulties, as Leo tried to rule the Church in Rome and Florence from the stanze of the Vatican, he continued his patronage of the arts unabated. He commissioned Raphael to decorate more rooms in the papal apartments and to develop a series of cartoons (full-scale drawings used to transfer a design onto another surface) for tapestries to cover the lower walls of the Sistine Chapel. Leo also celebrated his papacy with a series of commissions at

San Lorenzo, the neighborhood church in Florence that had served as the Medici family mausoleum for nearly 100 years. He hired Michelangelo to design a new funerary chapel there, the so-called New Sacristy, for recently deceased members of the family.

When Leo X died in 1521, he was briefly succeeded by a Dutch cardinal who deplored the artistic patronage of the Medici popes as both extravagant and inappropriate. He died only a year into his reign, and when Giulio de' Medici succeeded him as Clement VII, artists and humanists reacted enthusiastically. As cardinal, he had commissioned major works from Raphael and others, and he had worked closely with Leo on Michelangelo's New Sacristy at San Lorenzo in Florence. But Clement was never able to sustain the scale of patronage in Rome that his uncle had managed. This failure resulted in part from the Sack of Rome by the German mercenary troops of Holy Roman Emperor Charles V in 1527. During this crisis, many of the artists' workshops in the city were destroyed, and many artists abandoned the city altogether.

Josquin des Prez and the Sistine Chapel Choir

The inventiveness that marks the patronage of the Medici popes and cardinals as well as the work of Raphael, Leonardo, and Michelangelo was a quality shared by Renaissance musicians, especially in the virtuosity of their performances. Such originality was the hallmark of the Sistine Chapel Choir, founded in 1473 by Sixtus IV. It performed only on occasions when the pope was present, and typically consisted of between 16 and 24 male singers. The choir's repertory was limited to the polyphonic forms common to the liturgy: motets, masses, and psalm settings. These were arranged in four parts (voices), for boy sopranos, male altos, tenors, and basses. The choir usually sang without instrumental accompaniment,

a cappella, "in the manner of the chapel," an unusual practice at the time, since most chapel choirs relied on at least organ accompaniment.

Composers from all over Europe were attracted to the Sistine Chapel Choir. Between 1489 and 1495, one of the principal members of the choir was the Franco-Flemish composer Josquin des Prez (ca. 1450–1521). Afterward, beginning in about 1503, he served as musical director of the chapel at the court of Ferrara. During his lifetime, he wrote some 18 masses, almost 100 motets (see Chapter 6 and the discussion of Guillaume Dufay earlier in this chapter), and some 70 songs, including three Italian *frottole*.

Josquin's last mass, the Pange lingua ("Sing, My Tongue"), written sometime after 1513, is structured by means of paraphrase. In paraphrase structure, all voices elaborate on an existing melody. One voice introduces a musical idea that is subsequently repeated with some variation in sequence by each of the other voices throughout the entire work or section of a work, so that all the parts are rhythmically and melodically balanced. This creates the richly polyphonic texture of the whole. This contrasts with cantus firmus, which is the plainchant (monophonic) "fixed melody" on which the composition is based (see Chapter 5). The source of Josquin's melody in Pange lingua is a very well-known plainchant hymn written in the sixth century by Venantius Fortunatus (ca. 530-609), one of the earliest medieval poets and composers. Josquin transforms the original into a completely new composition, even as he leaves the melody entirely recognizable.

The opening *Kyrie* (Fig. **7.30**) (track **7.2**) is based on the opening of the Fortunatus plainchant. In a technique known as **point of imitation**, this musical theme is taken up by all the voices of Josquin's polyphonic composition in succession so that all four voices weave round one another in imitation. This kind of innovative play upon a more or less

Fig. 7.30 Score of the opening bars of Josquin des Prez's *Pange lingua* mass. 16th century. The four voices of the mass are represented here, each one indicated by the decorative capital at the beginning of the line.

CLOSER LOOK

he School of Athens, also known as Philosophy, is generally acknowledged as the most important of Raphael's four paintings for the Stanza della Segnatura of the Vatican Palace in Rome. Its Classicism is clearly indicated in several ways: by its illusionistic architectural setting, based on ancient Roman baths; by its emphatic one-point perspective, which directs the viewer's attention to the two central figures, Plato and Aristotle, fathers of philosophy; and by its subject matter, the philosophical foundation of the Renaissance humanistic enterprise. All the figures here—the Platonists on the left, the Aristotelians on the right, although not all have been identified—were regarded by Renaissance humanists as embodying the ideal of continual pursuit of learning and truth. The clarity, balance, and symmetry that distinguish this Raphael composition became a touchstone for painters in centuries to come.

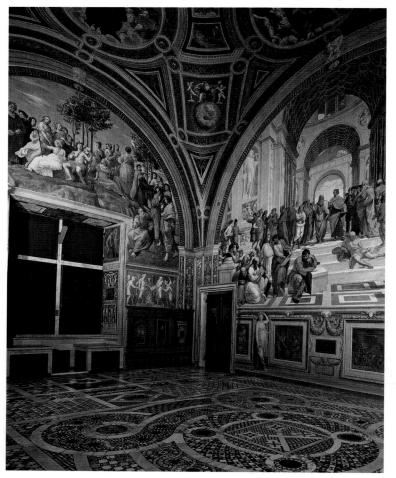

Plato (ca. 428–347 BCE) resembles a self-portrait of Leonardo da Vinci. He points upward to the realm of ideas. (Note the resemblance of this gesture to that of Doubting Thomas in Leonardo's *Last Supper*, Fig. 7.17). He carries the Timaeus, the dialogue on the origin of the universe, in which he argued that the circle is the image of cosmic perfection.

Apollo, holding a lyre, is god of reason, patron of music, and symbol of philosophical enlightenment.

Epicurus (341–270 BCE) reads a text and wears a crown of grape leaves, symbolic of his philosophy that happiness could be attained through the pursuit of pleasures of the mind and body.

Pythagoras (ca. 570–490 BCE), the Greek mathematician, illustrates the theory of proportions to interested students—among them, wearing a turban, the Arabic scholar Averroës (1126–98).

Something to Think About . . .

Why do you suppose that Raphael chose to use so many of his contemporaries as models for the figures from Classical antiquity depicted in the painting?

Stanza della Segnatura, Vatican, Rome. Fresco on the left lunette, *Parnassus*; on the right lunette, *School of Athens*.

Raphael's School of Athens

Aristotle (384–322 BCE) carries his *Nicomachean Ethics* and gestures outward toward the earthly world of the viewer, emphasizing his belief in empiricism—that we can understand the universe only through the careful study and examination of the natural world.

Minerva, the goddess of wisdom, is the traditional patron of those devoted to the pursuit of truth and artistic beauty.

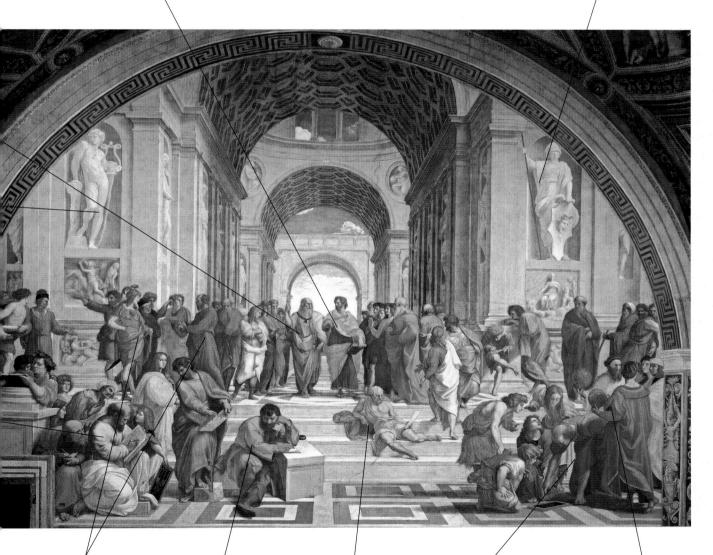

Alexander the Great (356–323 BCE) debates with Socrates (469–399 BCE), who makes his points by enumerating them on his fingers. Heraclitus (ca. 540–480 BCE), the brooding Greek philosopher who despaired at human folly, wears stonecutter's boots and is actually a portrait of Michelangelo.

Diogenes the Cynic (ca. 412–323 BCE), who roamed the streets of Athens looking for an honest man, hated worldly possessions, and lived in a barrel.

Euclid (third century BCE), whose *Elements* remained the standard geometry text down to modern times, is actually a portrait of **Bramante**.

Ptolemy, the second-century astronomer and philosopher, holds a terrestrial globe, while Zoroaster (ca. 628–551 BCE) faces him holding a celestial globe. Both turn toward a young man who looks directly out at us. This is a self-portrait of Raphael.

Raphael, School of Athens. 1510–11. Fresco, 19' × 27'. Stanza della Segnatura, Vatican, Rome.

standard theme is testimony to Josquin's ingenuity and humanist individualism. And it brings a level of expressiveness to the liturgy that far exceeds the more or less unemotional character of the plainchant. Largely because of this expressiveness, his compositions were among the first polyphonic works to be widely performed long after the death of their composer.

Niccolò Machiavelli and the Perfect Prince

If Josquin des Prez represents the inventiveness of the Renaissance individual in remaking musical tradition, the political philosopher Niccolò Machiavelli (1469–1527) represents the individual's capacity to ignore tradition altogether and follow the dictates of pragmatic self-interest. Machiavelli's treatise *The Prince* (1513) is part of a long tradition of literature giving advice to rulers that stretches back to the Middle Ages. But Machiavelli's revolutionary political pragmatism sets the work apart. Humanist education had been founded on the principle that it alone prepared people for a life of virtuous action. Machiavelli's *Prince* challenged that assumption.

Machiavelli had served the Florentine city-state for years, assuming the post of second chancellor of the Republic in 1498. He had studied the behavior of ancient Roman rulers and citizens at great length, and he admired particularly their willingness to act in defense of their country. On the other hand, he disdained the squabbling and feuding that marked Italian internal relations in his own day. Assessing the situation in the Italian politics of his day, he concluded that only the strongest, most ruthless leader could impose order on the Italian people.

From Machiavelli's point of view, the chief virtue any leader should display is that of ethical pragmatism. For the statesman's first duty, he believed, was to preserve his country and its institutions, regardless of the means he used. Thus, a prince's chief preoccupation, and his primary duty, says Machiavelli, is to wage war (Reading 7.5a):

READING 7.5a

from Niccolò Machiavelli, *The Prince,* Chapter 14 (1513)

A Prince . . . should have no care or thought but for war, and for the regulations and training it requires, and should apply himself exclusively to this as his peculiar province; for war is the sole art looked for in one who rules, and is of such efficacy that it not merely maintains those who are born Princes, but often enables men to rise to that eminence from a private station; while, on the other hand, we often see that when Princes devote themselves rather to pleasure than to arms, they lose their dominions.

His attention turned to war, the prince must be willing to sacrifice moral right for practical gain, for "the manner in which we live, and that in which we ought to live, are things so wide asunder, that he who quits the one to betake himself to the other is more likely to destroy than to save himself." Therefore, "it is essential . . . for a Prince who desires to maintain his position, to have learned how to be other than good." Goodness, from Machiavelli's point of view, is a relative quality anyway. A prince, he says, "need never hesitate . . . to incur the reproach of those vices without which his authority can hardly be preserved; for if he well consider the whole matter, he will find that there may be a line of conduct having the appearance of virtue, to follow which would be his ruin, and that there may be another course having the appearance of vice, by following which his safety and well-being are secured." The well-being of the prince, in other words, is of the utmost importance because upon it rests the well-being of the state.

Machiavelli further argues that the prince, once engaged in war, has three alternatives for controlling a state once he has conquered it: He can devastate it, live in it, or allow it to keep its own laws. Machiavelli recommends the first of these choices, especially if the prince defeats a republic (Reading 7.5b):

READING 7.5b

from Niccolò Machiavelli, *The Prince*, Chapter 5 (1513)

In republics there is a stronger vitality, a fiercer hatred, a keener thirst for revenge. The memory of their former freedom will not let them rest; so that the safest course is either to destroy them, or to go and live in them.

This is probably a warning directed at the absentee Medici popes, far away in Rome and not tending to business in Florence, for Machiavelli originally planned to dedicate the book to Giovanni de' Medici, by then Pope Leo X. (He eventually dedicated it to Lorenzo de' Medici, then duke of Florence, hoping to secure political favor.) Its lessons, drawn from Roman history, were intended as a guide to aid Italy in rebuffing the French invasions.

Finally, according to Machiavelli, the prince should be feared, not loved, for "Men are less careful how they offend him who makes himself loved than him who makes himself feared." This is because "love is held by the tie of obligation, which, because men are a sorry breed, is broken on every whisper of private interest; but fear is bound by the apprehension of punishment which never relaxes."

From Machiavelli's point of view, humans are "fickle," "dishonest," "simple," and, as he says here, all in all a "sorry breed." The state must be governed, therefore, by a morality different from that governing the individual. Such moral and ethical pragmatism was wholly at odds with the teachings of the Church. In 1512, Pope Julius II's troops overran the Florentine republic, restored the Medici to power in Florence, and dismissed Machiavelli from his post as second chancellor. Machiavelli was then (wrongfully) accused of involvement in a plot to overthrow the new heads of state, imprisoned, tortured, and finally exiled permanently to a country home

Fig. 7.31 Vittore Carpaccio, *Lion of Saint Mark.* 1516. Oil on canvas, 4'6¾" × 12'1". Doge's Apartments, Doge's Palace, Venice. Venetians believed that an angel visited Saint Mark and prophesied that he would be buried in Venice, on the very spot where Saint Mark's Cathedral stands. So they felt justified in removing his relics from Egypt and bringing them to Venice.

in the hills above Florence. It is there, beginning in 1513, that he wrote *The Prince*.

Although widely circulated, *The Prince* was too much at odds with the norms of Christian morality to be well received in the sixteenth century. Throughout the seventeenth and eighteenth centuries, it was more often condemned than praised, particularly because it appeared to be a defense of absolute monarchy. Today, we value *The Prince* as a pioneering text in political science. As an essay on political power, it provides a rationalization for the political expediency and duplicity that society has all too often witnessed in modern political history.

THE HIGH RENAISSANCE IN VENICE

What distinguishes Venetian culture from that of Florence and Rome?

In a mid-fifteenth-century painting by Vittore Carpaccio (1450–1525) of Saint

Mark's lion (Fig. 7.31), symbol of the Republic, the lion stands with its front paws on land and its rear paws on the sea, symbolizing the importance of both elements to the city. In the sixth or seventh century, invading Lombards from the north had forced the local populations of the Po River delta to flee to the swampy lagoon islands that would later become the city of Venice. Ever since, trade had been the lifeblood of Venice.

Not only did the city possess the natural fortification of being surrounded by water (Map 7.2), but also, as a larger

Map 7.2 Venice and the Venetian *Terraferma*, the Venetian-controlled mainland, at the end of the 15th century. Venice controlled all the land inside the red area. Its territories extended almost to Milan in the west, northward into the Alps, and almost as far as Ferrara and Mantua to the south. A causeway connecting Venice to the mainland was constructed in the middle of the nineteenth century. Until then, the city was approachable only by water.

city-state, it controlled the entire floodplain north of the Po River, including the cities of Padua and Verona and extending eastward nearly to Milan. This larger territory was called *Terraferma* (from the Latin *terra firma*, "firm ground"), to distinguish it from the watery canals and islands of the city proper. From *Terraferma*, the Venetians established trade routes across the Alps to the north, and eastward across Asia Minor, Persia, and the Caucasus. As one Venetian historian put it in a thirteenth-century history of the city, "Merchandise passes through this noble city as water flows through

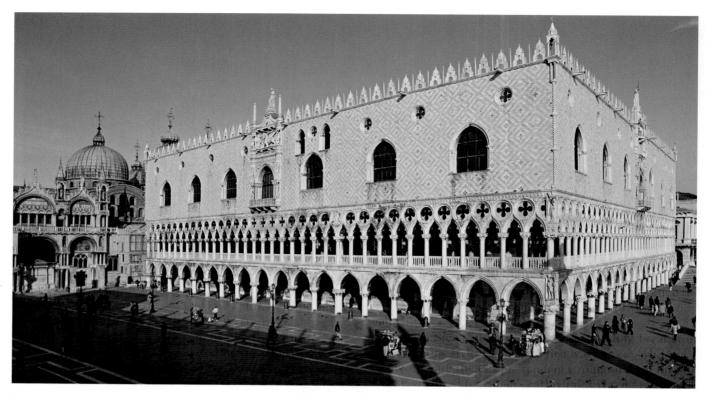

Fig. 7.32 View of the Doge's Palace, Venice, with Saint Mark's Cathedral to the left. During the Renaissance, an elaborate, more sensuous style of art would develop in Venice, influenced by the elaborate Gothic style of facades such as this one.

fountains." By the fifteenth century, the city had become a center of fashion. In 1423, the doge, the Venetian Republic's leader, whom they elected for life, observed, "Now we have invested in our silk industry a capital of 10 million ducats [roughly \$39 million today] and we make 2 million [roughly \$7.8 million] annually in export trade; 16,000 weavers live in our city." These weavers produced satins, velvets, and brocades that were in demand across the continent. On this tide of merchandise flowed even greater wealth. As a result, the city became a great naval power and a preeminent center of shipbuilding, able to protect and contribute to its maritime resources as no other European city (except possibly Genoa) could even imagine.

Venice considered itself blessed by Saint Mark, whose relics resided in the cathedral of Saint Mark's. Protected by its patron saint, the city could prosper in peace. "Peace unto you, Mark my evangelist," reads the Latin inscription in the book the lion holds with its right paw in Carpaccio's painting. Behind the lion, visible across the lagoon, is the Piazza San Marco (Saint Mark's Square), with its tall campanile, or bell tower, the domes of Saint Mark's, and the Palace of the Doge. In almost every other Italian city, Church and State were physically separated, but in Venice, the political and religious centers of the city stood side by side. Peace, prosperity, and unity of purpose were the city's greatest assets—and the citizens of Venice believed, above all, in those principles.

Venetian Architecture

During the Renaissance, an elaborate, sensuous style of architecture would develop in Venice, influenced by the elaborate Gothic style of facades on such buildings as the Doge's Palace, which was begun in 1340 (Fig. 7.32). There is no hint in this building of any need to create a defensible space to protect the state. Two stories of open arcades, rising in pointed arches and topped by open quatrefoils, provide covered walkways around the outside, as if to invite the citizenry into its halls. The diamond pattern of the stonework in the upper stories creates a sense of lightness on what might otherwise seem a massive facade. And the color of the ornament and stonewhite and pink—seem calculated to reflect light itself, so that the building might shine like a gemstone set in the public square, literally a reflection of the city's wealth and well-being. This emphasis on texture and the play of light and shadow across richly elaborated surfaces would become one of the hallmarks of Venetian art and architecture.

The wealth and general well-being of Venice were evident along the city's main, curving thoroughfare, the Grand Canal, where its most important families built their homes. One of the most magnificent of these is the Ca' d'Oro (Fig. 7.33), built by the head of the Contarini family. (Ca' is a Venetian abbreviation of *casa*, "house," and Ca' d'Oro means "House of Gold.") Although built in the Renaissance, the house, like the Doge's Palace (see Fig. 7.32), is distinctly Gothic in character. Venetian palazzi and civic architecture retained

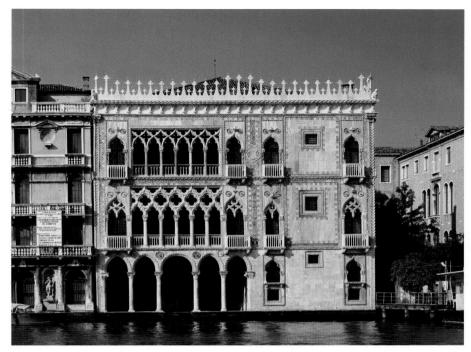

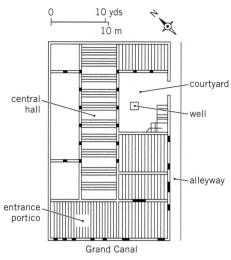

Fig. 7.33 Giovanni and Bartolomeo Bon, Ca' d'Oro ("House of Gold"), Contarini Palace, Venice. 1421–37, and floor plan of ground level. The Ca' d'Oro, built for one of Venice's most prominent families, is still spectacular today. We can only imagine how it must have looked with its original gilded ornamental detail. The attic, where servants lived, is not visible in this view.

Gothic elements for so long probably because the citizens regarded their continued use as a sign of the stability of the city's culture.

The asymmetry of the Ca' d'Oro facade, with its three distinct loggias, or arcades, is characteristic of the design of other moderate-sized Venetian palazzi. Originally, Contarini ordered that the stone carved for the tracery work be painted with white lead and oil to make it shine like marble. The red Verona marble used in the detailing was oiled and varnished to bring out its deepest and richest hues. The balls atop the facade's parapet, the rosettes at the bottom of the arches, the leaves on the capitals at the corners, the architectural moldings, window finials, and the roundels over the windows and the portico arches were all gilded—giving the house its name. Finally, the backgrounds of the capitals, and other details, were painted with very expensive ultramarine blue, made of ground lapis lazuli, an imported semiprecious stone.

The Contarini finished the Ca' d'Oro just seven years before Cosimo de' Medici began the Medici palace in Florence (see Fig. 7.12), but nothing could be more distant in feeling and taste. Contarini's palace, with its airy traceries and orna-

CONTINUITY & CHANGE

THE STATE OF THE STATE

mentation, is light and refined; Cosimo's palace, with its monumental facade, is massive—a wall of stone. One opens to the canal; the other turns inward away from the street. The Ca' d'Oro is an ostentatious celebration of personal wealth

and social status; the Medici palace projects state authority and power. The pomp and extravagance we sense in Venetian homes such as this one, the sensitivity to light and air, the luxury of detail and design, and the opulent variety of pattern and texture all define the Venetian visual world, and all came to define Venetian art and architecture in the Renaissance.

Masters of the Venetian High Renaissance: Giorgione and Titian

The two great masters of painting in the Venetian High Renaissance were Giorgione da Castelfranco, known simply as Giorgione (ca. 1478–1510), and Titian (ca. 1488–1576). Both painters were students of the Venetian master, Giovanni Bellini (ca. 1429–1507), and Giorgione had been especially inspired by Leonardo's visit in 1500. In the first decade of the sixteenth century, they worked sometimes side by side with Bellini, gaining increased control of their surfaces, and building up color by means of glazing, as Leonardo did in his soft, luminous landscapes. Their paintings, like the great palaces of Venice whose reflections shimmered on the Grand Canal, demonstrate an exquisite sensitivity to the play of light and shadow, to the luxurious display of detail and design, and to an opulent variety of pattern and texture.

Giorgione The mysterious qualities of Leonardo's highly charged atmospheric paintings like the *Mona Lisa* (see Fig.

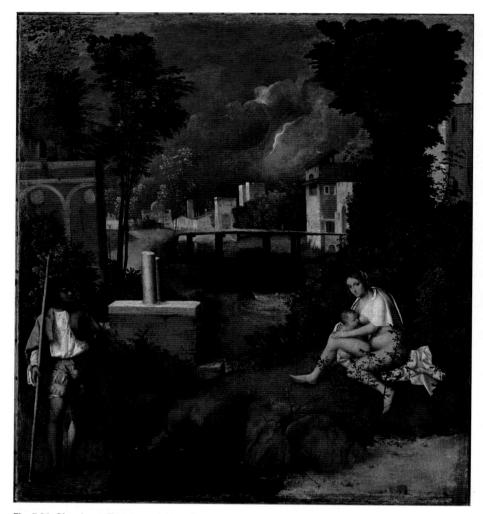

Fig. 7.34 Giorgione, *Tempest.* ca. 1509. Oil on canvas, $31\%'' \times 28\%''$. Gallerie dell'Accademia, Venice. There is nothing about this painting that could be called controlled. The landscape is overgrown and weedy—just as the man and woman are disheveled and disrobed. It is as if, for a moment, the lightning has revealed to the viewer a scene not meant to be witnessed.

7.18) are fully realized in Giorgione's Tempest (Fig. 7.34). The first known mention of the painting dates from 1530, when it surfaced in the collection of a Venetian patrician. We know almost nothing else about it, which contributes to its mystery. At the right, an almost nude young woman nurses her child. At the left, a somewhat disheveled young man, wearing the costume of a German mercenary soldier, gazes at the woman and child with evident pride. Between them, in the foreground, stands a pediment topped by two broken columns. A creaky wooden bridge crosses the estuary in the middle ground, and lightning flashes in the distance, illuminating a densely built cityscape. What, we must ask, is the relationship between the two figures? Are they husband and wife? Or are they lovers, whose own tempestuous affair has resulted in the birth of a child? These are questions that remain unanswered.

Giorgione evidently began work on his paintings without preliminary drawings, and X-ray examination of this one reveals that in the young man's place there originally stood a second young woman stepping into the pool between the two figures. At the time that the work surfaced in a wealthy Venetian's collection in 1530, it was described simply as a small landscape with a soldier and a gypsy. It seems to have satisfied the Venetian taste for depictions of the affairs of everyday life, and even though its subject remains obscure, the painting continues to fascinate us.

The fact that Giorgione did not make preliminary drawings for his paintings led Vasari, in his Lives of the Most Excellent Painters, Architects, and Sculptors, to charge that he was simply hiding his inability to draw well beneath a virtuoso display of surface color and light. The shortcoming of all Venetian artists, Vasari claimed, was their sensuous painterly technique, as opposed to the intellectual pursuits of the Florentines, epitomized by their careful use of scientific perspective and linear clarity.

Titian In a certain sense, Vasari was right. Sensuality, even outright sexuality, would become a primary subject of Venetian art, as many of Titian's paintings make clear. When Giorgione died of the plague in 1510, at only 32 years of age, it seems likely that his friend Titian, 10 years younger, finished several of his paintings. While lacking the sense of intrigue that his elder mentor captured in the *Tempest*, Titian's

Sacred and Profane Love (Fig. 7.35) similarly addresses the relations between the sexes, only a little more indirectly. The nude figure at the right holds a lamp, perhaps symbolizing divine light and connecting her to the Neoplatonic ideal of the celestial Venus and thus sacred love. The luxuriously clothed, fully dressed figure on the left, whom we might think of as the "earthly lady," or profane love, holds a bouquet of flowers, a symbol of her fecundity. Between the two, Cupid reaches into the fountain.

The painting was a commission from Niccolò Aurelio on the occasion of his marriage to Laura Bagarotto in 1514. Behind the clothed figure on the left, two rabbits cavort in the grass, underscoring the conjugal theme of the image. It seems probable that the two female figures represent two aspects of the same woman, and thus embody the roles that the Renaissance woman filled for her humanist husband, combining Classical learning and intelligence with a candid celebration of sexual love in marriage.

Titian's Venus of Urbino (Fig. 7.36), painted for Duke Guidobaldo della Rovere of Urbino in 1538, more fully

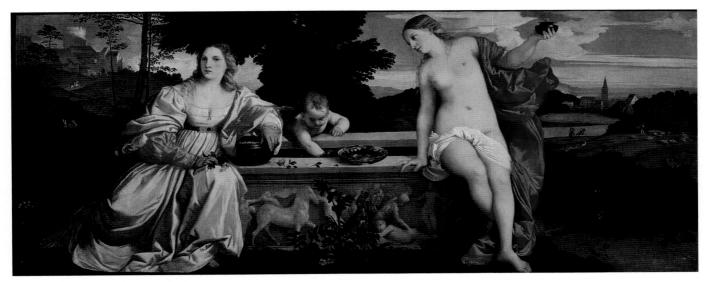

Fig. 7.35 Titian, Sacred and Profane Love. ca. 1514. Oil on canvas, 46½" × 109½". Galleria Borghese, Rome. The painting was commissioned by Niccolò Aurelio, a Venetian, to celebrate his marriage to Laura Bagarotto, and was probably intended for the couple's sleeping chamber. The husband's coat of arms is carved on the fountain; the wife's is inside the silver bowl on the fountain's ledge.

acknowledges the sexual obligations of most Renaissance women. This "Venus"—more a real woman than an ethereal goddess, and referred to by Guidobaldo as merely a "nude woman"—is frankly available. She stares out at the viewer, Guidobaldo himself, with a matter-of-factness suggesting that she is totally comfortable with her nudity.

(Apparently the lady-in-waiting and maid at the rear of the palatial rooms are searching for suitably fine clothing in which to dress her.) Her hand both covers and draws attention to her genitals. Her dog, a traditional symbol of both fidelity and lust, sleeps lazily on the white sheets at her feet. She may be, ambiguously, either a courtesan or a bride.

(The chest from which the servant is removing clothes is a traditional reference to marriage.) In either case she is, primarily, an object of desire.

As Titian's work continued to develop through the 1550s, 1560s, and 1570s, his brushwork became increasingly loose and gestural (see Chapter 10). The frank sensuality conveyed by crisp contours in Sacred and Profane Love and the Venus of Urbino found expression, instead, in the artist's handling of paint itself. Indeed, the viewer can feel Titian's very hand in these later works, for he would actually paint with his fingers and the stick end of his brush too. But Titian's mastery of color—the rich varieties of warm reds, the luminosity of his glazes—so evident in these paintings, never altered. In fact, his color came to define the art of Venice itself. When people speak of "Venetian" color, they have Titian in mind.

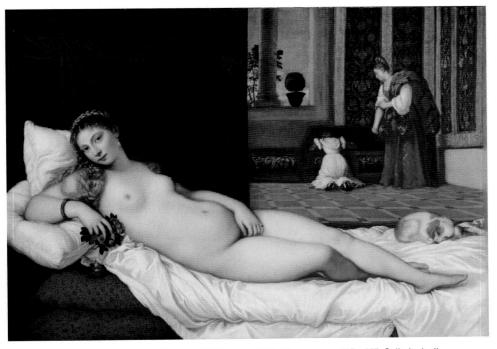

Fig. 7.36 Titian, Reclining Nude (Venus of Urbino). ca. 1538. Oil on canvas, 47" × 65". Galleria degli Uffizi, Florence. Titian's technique contributes significantly to the power of the painting. Although not visible in reproduction, the nude's skin is built up of layers of semitransparent yellow-whites and pinks that contrast with the cooler bluish-whites of the bedsheets. Behind her, the almost black panel and curtain further contrast with the luminous light on her body.

WOMEN IN ITALIAN HUMANIST SOCIETY

How did women fare in the Italian Renaissance?

The paintings of both Giorgione and Titian raise the issue of the place of women in Italian humanist society. It remained commonplace, especially in Venice, to paint portraits of women whose identity was unknown but who represented ideal beauty. Titian's La Bella (Fig. 7.37) seems to be the same person depicted in the Venus of Urbino (and she appears in at least two other Titian portraits), but her identity is a mystery, if in fact she was ever a "real" woman and not simply the embodiment of Titian's idea of "true" beauty. Something of a canon of female beauty had been codified by Petrarch, in his sonnets, and Poliziano in his poems (see Reading 6.5 in Chapter 6). In her book Women in Italian Renaissance Art: Gender, Representation, Identity, Paola Tinagli sums up the canon: "Writers praised [painters for] the attractions of wavy hair gleaming like gold; of white skin similar to snow, to marble, to alabaster or to milk; they admired cheeks which looked like lilies and roses, and eyes that shone like the sun or the stars. Lips are compared to rubies, teeth to pearls, breasts to snow or apples." Portraits of Venetian women who embodied such traits are emblems of the beautiful more than representations of real beings.

But as humanist values helped to redefine the relation of the individual to the state throughout the Italian city-states and gave male citizens a greater degree of freedom, women began to benefit as well. While at all levels of culture their role might still be relegated to the domestic side of life, they were increasingly better educated and therefore better able to assert themselves. This is particularly true of middle- and upper-class women. And occasionally these women, through their accomplishments, achieved a remarkable level of stature.

The Education of Women

In the Italian humanist courts, the wives of rulers and their daughters—who were, after all, prospective wives of other rulers—received a humanist education. Like the medieval author of the *Book of the City of Ladies*, Christine de Pizan (see Chapter 6), they possessed knowledge of French and Latin, the ability to write in their native language with grace and ease, a close acquaintance with both Classical and vernacular Italian literature, and at least a passing knowledge of mathematics and rhetoric. They were expected to be good musicians and dancers. In addition, the rise of the merchant class to a position of wealth and social responsibility necessitated at least some degree of education for the women whose husbands were members of the guilds and confraternities of the city.

The Florentine mercantile system required of every man a working knowledge of mathematics and accounting and the ability to read. As we have seen, the guilds, where these skills were practiced daily, were also the chief sponsors of public works, from cathedrals and churches to the sculptures and paintings that adorned them. In general, the wives of these merchant guildsmen were not only conversant with their

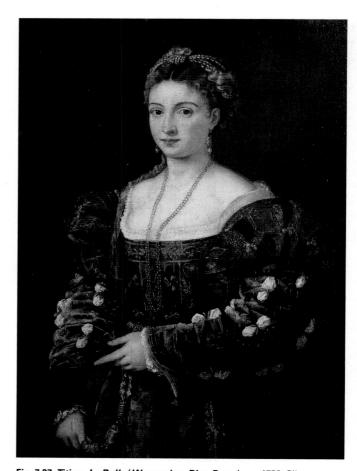

Fig. 7.37 Titian, La Bella (Woman in a Blue Dress). ca. 1538. Oil on canvas, $39\%" \times 30"$. Palazzo Pitti, Florence. The sumptuousness of the dress adds considerably to the sense of beauty Titian seeks to convey. It was painted with extremely expensive lapis lazuli pigments.

husbands' affairs, but also with the greater affairs of the city. Many took a more active role in both. Indeed, since women customarily married between the ages of 13 and 17 and to men generally much older than themselves, they often inherited the family businesses. In order to maintain their financial and personal independence, many chose not to remarry.

The most influential women in Rome, for instance, were connected to the Church hierarchy either by blood or by marriage. Their brothers and brothers-in-law, uncles and nephews were the cardinals and popes who lavished the city with their wealth and largesse. As executors of their husbands' estates and as widows, many of these women became important patrons of convents, where they were able to escape the social strictures of widowhood.

Women and Family Life

Still, for most women the husband's role was one of active, public life, and the wife's was to manage domestic affairs. In On the Family, a book published in 1443 by the same Leon Battista Alberti whose On Painting had outlined the principles of perspective, the author approvingly quotes a young groom introducing his bride to his household:

After my wife had been settled in my house a few days, and after her first pangs of longing for her mother and family had begun to fade, I took her by the hand and showed her around the whole house. . . . At the end there were no household goods of which my wife had not learned both the place and purpose. Then we returned to my room and having locked the door, I showed her my treasures, silver, tapestry, garments, jewels, and where each thing had its place.

For Alberti, clearly, the family is an orderly system. Each thing in the household has its proper place, just as, not coincidentally, each object in a perspectival drawing has its right and proper place. And the woman's proper place was in the service of her husband.

Much of what we know about what was accepted as the proper behavior of ladies of the court derives from Castiglione's Book of the Courtier, since, as part of its concern with the conduct of the aristocratic gentleman, it details the gentleman's expectations of his lady. It was generally agreed, for instance, by the conversationalists at the Urbino court that a courtier's lady should profit from most of the rules that serve the courtier. Thus, her accomplishments should demonstrate the casual effortlessness of sprezzatura. In one of the book's conversations, for instance, Giuliano de' Medici addresses a gathering of ladies and gentlemen, intent on pointing out what the lady needs beyond the accomplishments of her husband (Reading 7.6):

READING 7.6

from Baldassare Castiglione, *The Courtier*, Book 3 (1513–18; published 1528)

[The court lady] must have not only the good sense to discern the quality of him with whom she is speaking, but knowledge of many things, in order to entertain him graciously; and in her talk she should know how to choose those things that are adapted to the quality of him with whom she is speaking, and should be cautious lest occasionally, without intending it, she utter words that may offend him. . . . Let her not stupidly pretend to know that which she does not know, but modestly seek to do herself credit in that which she does know. . . . I wish this Lady to have knowledge of letters, music, painting, and to know how to dance and make merry; accompanying the other precepts that have been taught the Courtier with discreet modesty and with the giving of a good impression of herself. And thus, in her talk, her laughter, her play, her jesting, in short, in everything, she will be very graceful, and will entertain appropriately, and with witticisms and pleasantries befitting her, everyone who shall come before her. . . .

Whereas, for Castiglione, the courtier must strive to exemplify the perfectly well-rounded *l'uomo universale*, the court lady must use her breeding and education to further the perfection of the home.

Laura Cereta and Lucretia Marinella: Renaissance Feminists

Many fifteenth-century women strove for a level of education beyond the mere "knowledge of letters, music, painting" called for by Castiglione. One of the most interesting is Laura Cereta (1469–99). She was the eldest child of a prominent family from the city of Brescia in the Venetian Terraferma. Until she was 11, she was educated by nuns at a convent school. There, she studied reading, writing, embroidery, and Latin until her father called her home to help to raise her siblings. But he encouraged her to continue her studies, and in his library, she read deeply in Latin, Greek, and mathematics. At 15, however, Cereta chose motherhood over the pursuit of her studies and married a local merchant. When he died, two years later, she returned to her studies. In 1488, at just 19 years of age, she published Family Letters, a Latin manuscript containing 82 letters addressed to friends and family, an unusually large number of them women, as well as a mock funeral oration in the Classical style.

Cereta's letter, known as the *Defense of Liberal Instruction* for Women, is one of the most remarkable fifteenth-century Italian documents. It is a response to a critic who had praised her as a prodigy, implying that true women humanist scholars were rare and that, perhaps, her father had authored her letters. In the *Defense*, Cereta explains why so few women were scholars and then defends her own learning (**Reading 7.7**):

READING 7.7

from Laura Cereta, Defense of Liberal Instruction for Women (1488)

Only the question of the rarity of outstanding women remains to be addressed. The explanation is clear: women have been able by nature to be exceptional, but have chosen lesser goals. For some women are concerned with parting their hair correctly, adorning themselves with lovely dresses, or decorating their fingers with pearls and other gems. Others delight in mouthing carefully composed phrases, indulging in dancing, or managing spoiled puppies. Still others wish to gaze at lavish banquet tables, to rest in sleep, or, standing at mirrors, to smear their lovely faces. But those in whom a deeper integrity yearns for virtue, restrain from the start their youthful souls, reflect on higher things, harden the body with sobriety and trials, and curb their tongues, open their ears, compose their thoughts in wakeful hours, their minds in contemplation, to letters bonded to righteousness. For knowledge is not given as a gift, but [is gained] with diligence. The free mind, not shirking effort, always soars zealously toward the good, and the desire to know grows ever more wide and deep. It is because of no special holiness, therefore, that we [women] are rewarded by God the Giver with the gift of exceptional talent. Nature has generously lavished its gifts upon all people, opening to all the doors of choice through which reason sends envoys to the will, from which they learn and convey its desires. The will must choose to exercise the gift of reason.

Cereta's argument parallels Pico della Mirandola's in the Oration on the Dignity of Man. Women, like men, can choose to exercise their free will in the pursuit of learning. If Adam could choose to fashion himself in whatever form he might prefer, so could Eve.

One hundred years later, in Venice, things had hardly changed, as is evident in Lucretia Marinella's (1571–1653) The Nobility and Excellence of Women and the Defects and Vices of Men, published in Venice around 1600 and widely circulated. Marinella was one of the most prolific writers of her day. She published many works, including a pastoral drama, musical compositions, religious verse, and an epic poem celebrating Venice's role in the Fourth Crusade, but her sometimes vitriolic polemic against men is unique in the literature of the time. The Nobility and Excellence of Women is a response to a contemporary diatribe, The Defects of Women, written by her Venetian contemporary Giuseppe Passi.

It is clear enough to Marinella, who had received a humanistic education, that any man who denigrates women is motivated by such reasons as anger and envy (Reading 7.8):

READING 7.8

from Lucretia Marinella, The Nobility and Excellence of Women . . . (1600)

When a man wishes to fulfill his unbridled desires and is unable to because of the temperance and continence of a woman, he immediately becomes angry and disdainful, and in his rage says every bad thing he can think of, as if the woman were something evil and hateful. . . . When a man sees that a woman is superior to him, both in virtue and in beauty, and that she is justly honored and loved even by him, he tortures himself and is consumed with envy. Not being able to give vent to his emotions in any other way, he resorts with sharp and biting tongue to false and specious vituperation and reproof. . . . But if with a subtle intelligence, men should consider their own imperfections, oh how humble and low they would become! Perhaps one day, God willing, they will perceive it.

From Marinella's point of view, Renaissance women possess the fullest measure of Castiglione's moral virtue and humanist individualism, not the courtiers themselves. The second part of the book, on the defects and vices of *men*, is a stunning and sometimes amusing reversal of Passi's arguments, crediting men with all the vices he attributes to women. But perhaps Marinella's most important distinction is her insistence that women are autonomous beings, who should not be defined only in relation to men.

Veronica Franco: Literary Courtesan

Among Venice's most educated citizens were its so-called honest courtesans who, unlike common prostitutes, who sold only their sexual favors, were highly sophisticated intellectuals who gained access to the city's aristocratic circles. "Thou wilt find the Venetian Courtesan a good Rhetorician and an elegant discourser," wrote one early seventeenth-century visitor to the city. Although subject to the usual public ridicule—and often blamed, together with the city's Jews, for any troubles that might befall the republic—they were understood, by writers such as Lucretia Marinella, to be more products of men's own shortcomings and desires than willful sinners in their own right. This group of courtesans, in fact, dominated the Venetian literary scene. Many of their poems transform the clichés of courtly love poetry into frankly erotic metaphors, undermining the superior position of men in Italian society in ways comparable to the proto-feminist writings of the likes of Cereta and Marinella.

Perhaps the most remarkable Venetian courtesan was Veronica Franco (1546–91), who published two volumes of poetry: *Terze rime* (1575), named after the plural of the Italian poetic form first introduced by Dante in his *Divine Comedy* (see Chapter 6), and *Homely Letters to Diverse People* (1580). She also collected the works of other leading writers in respected anthologies, and founded and funded a charity for courtesans and their children.

Franco first gained notoriety in the 1570s at a renowned Venetian literary salon where male and female poets read and exchanged their works. Her poetry celebrates her sexual expertise as a courtesan and, in the slightly veiled imagery of the courtly tradition, promises to satisfy her interlocutor's desires. Consider *Capitolo* 13, in which she playfully challenges a lover to a "duel" (Reading 7.9):

READING 7.9

from Veronica Franco, Terze rime, Capitolo 13

No more words! To deeds, to the battlefield, to arms! For, resolved to die, I want to free myself from such merciless mistreatment.

Should I call this a challenge? I do not know, since I am responding to a provocation; but why should we duel over words? If you like, I will say that you challenged me; if not, I challenge you; I'll take any route, and any opportunity suits me equally well. Yours be the choice of place or of arms, and I will make whatever choice remains; rather, let both be your decision. . . .

Come here, and, full of most wicked desire, braced stiff for your sinister task, bring with daring hand a piercing blade.

Whatever weapon you hand over to me, I will gladly take, especially if it is sharp and sturdy and also quick to wound.

Let all armor be stripped from your naked breast, so that, unshielded and exposed to blows, it may reveal the valor it harbors within.

Let no one else intervene in this match, let it be limited to the two of us alone, behind closed doors, with all seconds sent away. . . .

To take revenge for your unfair attack, I'd fall upon you, and in daring combat, as you too caught fire defending yourself, I would die with you, felled by the same blow. O empty hopes, over which cruel fate forces me to weep forever!

But hold firm, my strong, undaunted heart, and with that felon's final destruction, avenge your thousand deaths with his one.

Then end your agony with the same blade.

Here Franco transforms the language of chivalric knighthood into the banter of the bedroom in a masterful use of **double entendre**, a figure of speech in which a phrase can be understood in either of two ways. This duality, the simultaneous expression of intellectual wit and erotic sensuality, is fundamental to the Venetian style.

Music of the Venetian High Renaissance

Almost without exception, women of literary accomplishment in the Renaissance were musically accomplished as well. Courtesans such as Veronica Franco could both sing and play. By the last decades of the sixteenth century, we know that women were composing music as well. The most famous of these was the Venetian Maddalena Casulana.

Maddalena Casulana's Madrigals Maddalena Casulana (ca. 1544–ca. 1590) was the first professional woman composer to see her own compositions in print. In 1566, her anthology entitled *The Desire* was published in Venice. Two years later, she dedicated her first book of songs to Isabella de' Medici Orsina with these words: "I would like . . . to show the world . . . the vain error of men, who so much believe themselves to be the masters of the highest gifts of the intellect, that they think those gifts cannot be shared equally by a woman."

Casulana's known work consists almost entirely of madrigals. The madrigal is a secular vocal composition for three or more voices. It became popular throughout Italy in the sixteenth century, where it dominated secular music. Whereas the frottola uses the same music for each successive stanza (see page 220), the madrigal is through-composed—that is, each line of text is set to new music (allowing the repetition of various earlier themes or motives). This allows word-painting, where the musical elements imitate the meaning of the text in mood or action. Anguish, for example, is conveyed with an unusually low pitch, as in Casulana's Morir non può il mio cuore ("My Heart Cannot Die") (track 7.2). The song laments a relationship gone bad, and the narrator contemplates driving a stake through her heart because it is in so much pain. When she says that her suicide might kill her beloved—so che morreste voi ("I know that you would die")—the word-painting by rising progression of the melody suggests that, for her, his death might not be such a bad thing.

The ladies of the courts of Mantua and Ferrara were especially well known for their vocal accomplishments. At Ferrara, the "Ensemble of Ladies" attracted many of the most prominent madrigal composers of the day. But even when such ensembles were not available, madrigals and other songs could be performed by a single voice, accompanied by, perhaps, a flute and a lute. The words themselves were of paramount importance, however the music was performed.

Adrian Willaert's Innovations for Polyphonic Form Despite Casulana's success, the figure most responsible for the popularity of the madrigal genre in sixteenth-century Venice was Adrian Willaert (1490–1562), a Netherlander who in 1527 was appointed to the highest musical position in Venice, choirmaster of Saint Mark's. He brought to his position a deeply felt humanist spirit, one dedicated to innovation and originality even as it acknowledged the great achievements of the past. Willaert's chief interest was polyphonic music such as the motet and the madrigal. To both these genres he brought radical new ideas as exemplified in the corpus of 27 motets and 25 madrigals for between four and seven voices called *New Music*, published in 1559 but probably written for the most part between the late 1530s and mid-1540s.

The madrigals of the *New Music* departed from all previous ones by consistently setting complete sonnets—all but one of them by the fourteenth-century Italian poet Petrarch (see Chapter 6)—in the form of the motet and by adapting a dense counterpoint formerly reserved for sacred music. Willaert's chief aim was to present Petrarch's words with as much clarity and restraint as possible. His choice of the Petrarchan sonnet, with its sense of gravitas, as the source of his lyrics was most likely driven by a desire to raise secular song to the level of the religious motet. Both were, at least musically, of equal weight and importance. And although Petrarch's sonnets spoke of worldly love, they most often did so as a metaphor for spiritual love.

Willaert's love of polyphonic forms led to other innovations as well. At Saint Mark's, he regularly used two choirs sometimes more—to create a polychoral style in which choirs on either side of the church sang to and against each other in increasingly complicated forms that anticipate by more than four centuries the effects of stereophonic music. This arrangement drew notice after the publication in 1550 of his Salmi spezzati (literally "broken psalms," but a reference to alternating choirs). He also added new instrumental forms to the liturgy, including an organ intonazione (short prelude) and a virtuoso prelude, also for organ, called the toccata (from the Italian toccare, "to touch"), designed to feature both the range of the instrument and the manual dexterity of the performer. Both were soon widely emulated across Europe. The richness of musical experience in Willaert's Venice, then, was not unlike the richness of its painting—full of light and emotion, as words found their emotional equivalent in sound.

7.1 Discuss the influence of the Medici family on Florentine art and the development of humanist thought.

Florence was the center of the cultural revival that we have come to call the Renaissance, a "rebirth" that amounted to a revolution in human consciousness founded on humanist inquiry. How does the Baptistery Doors competition of 1401 exemplify this new consciousness? How does Lorenzo Ghiberti's new set of doors, the Gates of Paradise, articulate Renaissance values even more?

By 1418 Florence Cathedral still lacked a dome above its octagonal crossing. Brunelleschi won the competition for the dome's design, a feat of architectural engineering unsurpassed in his day. For the cathedral's consecration on March 25, 1436, the French composer Guillaume Dufay created a new musical work, a motet called *Nuper rosarum flores* ("The Rose Blossoms"). How does Dufay's composition reflect Brunelleschi's feat?

Brunelleschi was also the first Renaissance artist to master the art of scientific perspective. What values does the interest in scientific perspective reflect? How does the work of the sculptor Donatello also reflect these values?

Medici control of Florentine politics was secured by Cosimo de' Medici, who surrounded himself with humanists. How would you describe Marsilio Ficino's Neoplatonist philosophy? How does it recast Platonic thought? Cosimo's grandson, Lorenzo, "the Magnificent," continued the Medici tradition. His own circle of acquaintances included many of the greatest minds of the day, including the composer Heinrich Isaac, the painter Sandro Botticelli, and the philosopher Pico della Mirandola. Can you describe how the work of each reflects humanistic principles?

7.2 Describe how other Italian courts followed the lead of the humanist court in Florence.

Lorenzo's court inspired the courts of the leaders of other Italian city-states, who were almost all nobles. At the Urbino court of Duke Federigo da Montefeltro, Baldassare Castiglione wrote *The Book of the Courtier*. How does this treatise define *l'uomo universale?* In Milan, Ludovico Sforza commissioned Leonardo da Vinci to paint the *Last Supper* for the Dominican convent of Santa Maria delle Grazie. What would you say is Leonardo's greatest strength as a painter? How does his portraiture reflect humanistic values?

7.3 Examine the impact of papal patronage on the art of the High Renaissance in Rome.

In the fifteenth century, the grandeur that had once distinguished the city of Rome had almost entirely vanished. But beginning with the ascension of Sixtus IV to the papacy in 1471, the patronage of the popes and their cardinals transformed Rome. This period is known as the High Renaissance. Many of the greatest works of the

period, including Donato Bramante's Tempietto and his new basilica for Saint Peter's, Michelangelo's ceiling for the Sistine Chapel, and Raphael's frescoes for the Stanza della Segnatura, were commissioned by Pope Julius II. How would you describe Julius II's personality?

Julius II was followed in 1513 by Leo X, born Giovanni de' Medici. Niccolò Machiavelli's treatise *The Prince* reflects the turmoil surrounding papal politics in this era. What does he suggest is the prince's primary duty? Do you think Machiavelli's outlook is applicable today?

Renaissance musicians shared with other artists of the age its spirit of inventiveness. The Sistine Chapel Choir, founded in 1473 by Sixtus IV, usually sang a cappella (without instrumental accompaniment). Between 1489 and 1495, one of the principal members of the Sistine Chapel Choir was the Franco-Flemish composer Josquin des Prez. His compositions include 18 masses.

7.4 Compare the social fabric and artistic style of Renaissance Venice to that of both Florence and Rome.

Fifteenth-century Venice defined itself as both the most cosmopolitan and the most democratic city in the world. Its religious and political centers—Saint Mark's Cathedral and the Doge's Palace—stood side by side, symbolizing peace, prosperity, and, above all, unity of purpose. The wealth and general well-being of Venice was displayed along the Grand Canal, where its most important families built their homes. These magnificent homes were Gothic in character. How can we account for the city's taste for this medieval style? Two of the most important Venetian painters of the early fifteenth century were Giorgione and Titian. In what ways does their painting style differ from other High Renaissance painters such as Michelangelo and Raphael?

7.5 Outline the place of women in Renaissance Italy.

In many ways the paintings of both Giorgione and Titian reflect Venetian attitudes toward women. What does Titian's La Bella reveal about these attitudes? Several notable women strove for a level of education beyond the mere "knowledge of letters, music, painting" called for by Castiglione. Among these were Laura Cereta and Lucretia Marinella, who frankly rebelled against male attitudes. What is the relation between Cereta's Defense of Liberal Instruction for Women and Pico della Mirandola's Oration on the Dignity of Man? How would you describe Marinella's sense of women's place?

The Venetian literary scene was dominated by a group of so-called honest courtesans whose reputations were built upon the ability to combine sexual and intellectual pursuits. The poetry of one of these courtesans, Veronica Franco, exemplifies their literary production. Maddalena Casulana, the first professional woman composer to see her own compositions in print, composed madrigals, a form mastered by the choirmaster at Saint Mark's, Adrian Willaerts.

Palladio and His Influence

he setting of Titian's Sacred and Profane Love represents an escapist tendency that we first saw in Boccaccio's Decameron (Chapter 6). In Boccaccio's stories, a group of young men and women flee the onset of the plague in Florence, escape to the country, and for 10 days entertain one another with a series of tales, many of which are alternately ribald and erotic, moral and exemplary. Renaissance humanists considered retreats to the country to be an honored ancient Roman tradition, the pleasures of which were richly documented by such Roman poets as Horace in his Odes (Chapter 3):

How in the country do I pass the time? The answer to the question's brief: I lunch and drink, I sing and play, I wash and dine, I rest.

By the High Renaissance, wealthy Venetian families, following strong Classical precedent, routinely escaped from the heat and humidity of the city to private villas in the countryside. The Villa La Rotonda by Adrea Palladio (1508-80) (Fig. 7.38), located just outside the city of Vicenza, set the standard for the country villa. As in so much Venetian architecture, the house looks outward, toward the light of the countryside, rather than inward to the shadow of a courtyard. It is situated on the crest of a hill. On each of its four sides Palladio has placed a pedimented loggia, approached by a broad staircase, designed to take advantage of the view.

Built in the 1560s for a humanist churchman, Villa Rotonda has a centralized plan that recalls Leonardo's Vitruvian Man (see Fig. 7.19). Palladio was, in fact, a careful student of Vitruvius, as was Leonardo. It is not surprising, then, that the central dome of La Rotonda is modeled on the Pantheon (see Fig. 3.18 in Chapter 3), which was itself known in the sixteenth century as La Rotonda, as was any large, domed, circular room. Although lacking the Pantheon's coffered ceiling and size, Palladio's villa was originally distinguished by a 7-foot-diameter oculus, like that at the Pantheon open to the sky, but today covered by a small cupola. Directly below the oculus, a stone drain in the shape of a faun's face allowed rainwater to fall into the basement. Although Venice depended on the agricultural economy of the *Terraferma*, the Villa Rotonda was not designed to be a working farm. Rather, the house was intended for family life and entertaining.

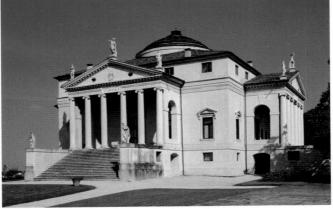

Figs. 7.38 and 7.39 (top) Andrea Palladio, Villa La Rotonda. Begun 1560s. (bottom) Thomas Jefferson, Monticello, Charlottesville, VA. 1770–84, 1796–1806.

Palladio built many villas in the vicinity of Venice. Each of them is interesting in a different way, and they constitute an important body of High Renaissance architecture that influenced architects in many countries and later centuries down to our own day. More than 300 years after Palladio's death, Thomas Iefferson would model his own country estate at Monticello (Fig. 7.39) on Palladio's example. Set atop a hill outside Charlottesville, Virginia, it commanded vistas that were in every way comparable to those of the Villa Rotonda. As opposed to La Rotonda, Monticello was the centerpiece of a working farm, where Jefferson continually experimented with agricultural techniques and methods. But Jefferson recognized in Palladio's use of elemental geometric forms circle, cube, and sphere—a sense of order and harmony that seemed, from his point of view, ideal for the architecture of his new American republic.

Renaissance and Reformation in the North

Between Wealth and Want

LEARNING OBJECTIVES

8.1 Describe the effect of commerce and mercantile wealth on the development of both religious and secular painting in Northern Europe.

8.2 Explain the causes of the Reformation and assess its impact on the art and literature of the era.

ifteenth- and sixteenth-century Italy did not hold a monopoly on the arts in Europe. To the north, the Flemish city of Bruges was a major center of culture, rivaling the Italian city-states in both art and commerce. The financial capital of the North, the city was home to the Medici banking interests in the region and had a strong merchant class of its own. Although inland, its link to the North Sea gave Bruges access to other mercantile centers by a waterway, closed off at the mouth of the sea by a lock, where, in the words of one sixteenth-century report, "It is a pleasure and a marvel to behold the wild sea let in and out, as it were, through a wooden door, with artfulness and human ingenuity." Waterborne commerce terminated at the Waterhalle in the heart of the city. But heavy cargoes, such as barrels of beer and wine, were unloaded further north on the Kraanrei, "Crane canal," where by 1290, the city had constructed a large wooden crane propelled by "crane children" who powered it by walking on a circular treadmill (Fig. 8.1).

The city's prosperous merchant class, like the nobility, actively supported the arts. This chapter outlines the development of a commercial art market in several Northern European centers of culture like Bruges—Antwerp, Paris, and London especially—that would permanently change the nature of artistic culture in the West. A spirit of innovation dominated the arts, spurred on largely by competition in the marketplace. Civic and mercantile patronage

would begin to rival that of the nobility and Church, and artistic workshops increasingly functioned as businesses. In London, audiences of all classes flocked to the south bank of the Thames River to see plays performed by theatrical companies competing for profits sufficient to support them.

But there was a darker side to the North's growing prosperity. In his classic text on the rise of the Renaissance in the North, *The Autumn of the Middle Ages*, Johan Huizinga describes the tensions that informed life in the North:

There was less relief available for misfortune and for sickness; they came in a more fearful and more painful way. Sickness contrasted more strongly with health. The cutting cold and the dreaded darkness of winter were more concrete evils. Honor and wealth were enjoyed more fervently and greedily because they contrasted still more than now with lamentable poverty. A fur-lined robe of office, a bright fire in the oven, drink and jest, and a soft bed still possessed . . . high value for enjoyment. . . .

So intense and colorful was life that it could stand the mingling of the smell of blood and roses. Between hellish fears and the more childish jokes, between cruel harshness and sentimental sympathy the people stagger—like the giant with the head of a child, hither and thither. Between the absolute denial of all worldly joys and a frantic yearning for wealth and pleasure, between dark hatred and merry conviviality, they live in extremes.

Fig. 8.1 Crane in Bruges. 16th century. Miniature. Bayerishe Staatsbibliothek, Munich, Germany.
The Bruges crane was at once a symbol of mechanical ingenuity and mercantile prosperity. It signaled the preeminence of the city as a center of commercial activity and trade.

The Church itself offered little solace since it seemed to many the very center of sin and corruption. In the magnificence of the art it commissioned to glorify God, a Northerner would likely be reminded of the poverty and darkness that surrounded him. The Northern imagination was, in fact, pervaded by a sense of pessimism. From a pessimist's point of view, Christ's Crucifixion represented the inevitability of pain and suffering, not the promise of the glory of the afterlife. In art, this pessimism was reflected in the painstakingly rendered depictions of suffering, realized particularly in Germany. At the same time, humanist ideals imported from Italy began to assert themselves as well.

ART, COMMERCE, AND MERCHANT PATRONAGE

How did commerce and mercantile wealth influence the development of both religious and secular painting in Northern Europe?

In Bruges, painting was a major commodity, second only to cloth. The Corporation of Imagemakers produced for sale many small devotional panels, private prayer books, portraits, and town views. Each May, the city of Bruges sponsored a great fair, where painters, goldsmiths, booksellers, and jewelers displayed their wares in over 180 rented stalls on the grounds and in the cloister of a Franciscan monastery. Especially popular, because they were relatively inexpensive, were oil paintings. The medium of oil painting had been known for several centuries, and medieval painters had used oils to decorate stone, metal, and occasionally,

Fig. 8.2 Johannes Stradanus, Oil Painting, or Jan van Eyck's Studio. Late 16th century. 8" × 10½". Stedelijke Museum, Bruges. LUKAS, Art in Flanders, Belgium. In his *Lives of the Painters*, Giorgio Vasari wrote that van Eyck had discovered oil painting. Vasari had met Stradanus, from whom he learned of van Eyck's work.

plaster walls. As we will see, oil painting enabled artists such as Jan van Eyck to add the kind of detail and subtle color and value gradations to their paintings that resulted in a remarkable realism. For many art historians this detailed naturalism is the most distinctive feature of Northern European art. By the sixteenth century, at any rate, Bruges printmaker Johannes Stradanus popularized the idea of van Eyck's mastery of the medium with the publication of his print *Jan van Eyck's Studio* (Fig. 8.2). This print shows van Eyck's Bruges studio as a factory where paintings are made as goods for consumption by a rising middle class.

By the middle of the fifteenth century, the Flanders city of Antwerp, on the River Scheldt, had supplanted Bruges in importance. In a quirky instance of geography influencing history, silt built up in Bruges' canal system, making its harbor inaccessible to large vessels. Antwerp did not hesitate to take advantage. All artwork in Antwerp was sold at its fair. By the middle of the sixteenth century, huge quantities of art were bought and sold at the building where the fair was held, and nearly 300 painters lived nearby. In 1553 alone, Spanish and Portuguese ships left the Antwerp docks with more than 4 tons of paintings and 70,000 yards of tapestries—all purchased at the fair. And the trade in art went both ways. While Antwerp was the chief distribution center for the arts in Northern Europe, it also received goods from centers of culture across the region (Map 8.1). Art and commerce were now inextricably linked.

One of the greatest differences between the Renaissance cultures of the North and South is the nature of patronage that developed in each. In the south of Europe, the most important patrons were the politically powerful families. The Medici, the Sforzas, and the Montefeltros—

and the popes (often members of these same families)—all used their patronage to increase their political prestige. In the North, trade had created a wealthy and relatively large class of merchants, who soon rivaled the French and Burgundian courts as the most important patrons of the day. Wealthy nobles, such as Philip the Good of Burgundy, certainly influenced artistic developments, but gradually, the taste of the new business class came to dominate the production and distribution of works of art. This new business class represented a new audience for artists, in both the North and South. Motivated by the marketplace, artists sought to please this new class. In turn, members of the business class fostered the careers of several artists who were highly skilled in the use of oil paint. These artists, Robert Campin, Jan van Eyck, Rogier van der Weyden, and Hieronymus Bosch, are associated with particular Northern centers of culture.

Map 8.1 Chief financial, commercial, and artistic centers in Northern Europe in the 15th and 16th centuries.

Robert Campin in Tournai

The growing influence of the merchant class pervades the Mérode Altarpiece (Fig. 8.3), painted by Robert Campin (ca. 1375–1444). Campin was a member of the painters'

guild and the city council in Tournai. Since the Middle Ages, this city near the southern border of Flanders was known for metalwork, jewelry, and architectural sculpture. We know little about Campin's life, but we do know

Fig. 8.3 Robert Campin (Master of Flémalle), *Mérode Altarpiece*. ca. 1426. Oil on panel, center $25\%6^{\circ} \times 24\%6^{\circ}$, each wing $25\%6^{\circ} \times 10\%6^{\circ}$. The Metropolitan Museum of Art, New York. The Cloisters Collection. 1956 (56.70). The two donors kneel at the left; Mary and the archangel Gabriel are in the center; and Joseph works in his carpenter's shop at the right.

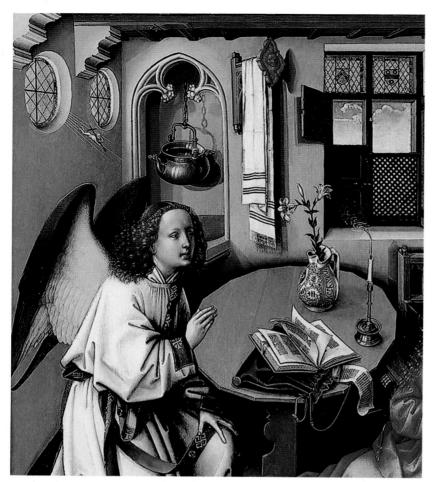

Fig. 8.4 Robert Campin (Master of Flémalle), *Mérode Altarpiece*, detail. ca. 1426. The Metropolitan Museum of Art, New York. The Cloisters Collection. 1956 (56.70). The extraordinarily fine detail of Campin's painting was made possible by his use of oil paint.

that the Tournai city fathers banished him for leading a dissolute life with his mistress. His punishment was reduced to a fine, but the story shows the moral seriousness of Northern European culture in the fifteenth century, a seriousness that would become even greater during the later Protestant Reformation.

The Mérode Altarpiece is a three-part work, or triptych. The left-hand panel depicts the altarpiece's patrons, Ingelbrecht of Mechlin and his wife, kneeling. They are ordinary people, though a little wealthier than most, and their family coats of arms decorate the top windows in the center panel. Here, in the living room of a middleclass Flemish home, the magic of the Annunciation takes place. Mary sits on the footrest of a wooden settee before the fireplace, intently reading a book. Another book, richly illustrated, lies on the table beside her. Finials. or ornamental tops, at each corner of the settee depict dogs, symbols of fidelity and domesticity, and lions, symbols of Jesus and his Resurrection. The archangel Gabriel approaches Mary from the left, almost blocking the view of the two patrons, who peer in through the doorway. Seven rays of sunlight illuminate the room and fall

directly on Mary's abdomen. On one of the rays, a miniature Christ carrying the Cross flies into the room (Fig. 8.4). Campin is telling the viewers that the entire life of Christ, including the Passion itself, enters Mary's body at the moment of conception. The candle on the table beside her, symbolic of the "old faith" (that is, Judaism), is extinguished by the "true light" of Christ entering the room. This potent theological proposition kindled the anti-Jewish sentiment that erupted in medieval Spain and during the Crusades (see Chapter 5). It would also underlie anti-Semitic feelings from the later Renaissance Inquisitions, in which Jews were required to convert to Christianity or face exile or death, down to the Holocaust in the twentieth century. The lilies in the vase on the table are a traditional symbol of Mary's purity, although, since there are three of them, they may also represent the Trinity.

In the next room, behind the fireplace and settee next to which Mary is depicted in the right-hand panel, Joseph works as a carpenter. On the table in front of him is a recently completed mousetrap, probably a reference to a metaphor created by Saint Augustine to the effect that the Passion of Christ is a trap baited by Christ's own blood to catch Satan. Another mousetrap sits outside on the window ledge, apparently for sale. Joseph is in the act of boring holes in a piece of wood, perhaps a grape press and thus another reference to the blood of Christ—

Christ's declaration of wine as his own blood in the Eucharist. Through the window, its shutters latched to the ceiling above, we can see the main square of a typical Flemish town, perhaps Tournai itself.

This Annunciation is clearly an entirely local and bourgeois affair. Mary is a Flemish housewife, Joseph a Flemish carpenter and owner of the house, even though the two were not yet married at the time of Annunciation. Time has collapsed—the New Testament becomes a current event. Every element seems a necessary and real part of every-day Flemish life. Each common object in this middle-class home serves a real, material purpose as well as a religiously symbolic one.

Another noteworthy aspect of Campin's triptych is its astonishingly small size for an altarpiece. If its two side panels were closed over the central panel, as they are designed to work, the altarpiece is just over 2 feet square—making it easily portable. Flemish artists understood that by working with oils they could create layers of paint with greater or lesser translucency, depending on the density of the pigment suspended in the oil. As light penetrates the paint layers (Fig. 8.5), it is reflected back at the viewer, creating a

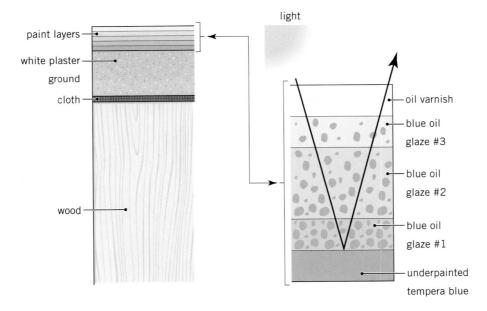

Fig. 8.5 Diagram of a section of a 15th-century Flemish painting, demonstrating the luminosity of the oil medium. The large arrow suggests the way light penetrates the translucent glazes of the medium and is reflected back to the viewer.

gemlike brilliance of color. This sense of seeing colored light in the painting is the distinguishing characteristic of Flemish oil painting.

Oil offers other advantages as a painting medium. It dries much more slowly than tempera, and the drying process can be further slowed by adding extra oil. Slow-drying paint allows artists to blend the colors in minute amounts, creating subtle modulations of tone that suggest light falling across an object. Furthermore, using oil paint, the artist can work with extremely soft, fine brushes, eliminating any hint of brushstrokes. The smooth finish that results heightens the illusion that the viewer is looking at the object itself. Implicit in the Flemish artist's sensitivity to the light-enhancing qualities of the oil medium is the understanding that light suggests spiritual truth. So, as light falls across an object and is literally reflected back at the viewer, the object assumes, at least potentially, a deeper symbolic resonance or meaning. From this point of view, the world and its objects become "alight" with the Creator, and painters can find in their task a profound spiritual importance.

Light seems to emanate from within Campin's canvas. Gabriel's wings glow, an effect created by layering very thin, almost transparent coats of oil paint on the surface of the painting—the same glazing process used by Leonardo (see Chapter 7), who, in turn, probably learned of it from Northern artists. The wings literally contain light, lending the archangel a physical presence and material reality. The spiritual is made real. In fact, the archangel appears no less (and no more) "real" than the brass pot above his head.

Because of its intimacy and portability, its realism and emphasis on physical things, the Mérode Altarpiece and other Northern Renaissance paintings like it introduced a new set of possibilities for painting. Patrons in the South gained personal satisfaction and even honor from their patronage—compare the Medici patronage in Florence—but such acts were intended to enhance the glory of the city-state, the guild, or the Church. But here, the motive of Ingelbrecht of Mechlin and his wife seems wholly personal. Under the patronage of the merchant class of the North, painting began to function something like the mousetrap Joseph has set outside his window for sale; that is, as a commodity. And in fact, the patrons of the Mérode Altarpiece may have conceived of it as a kind of object of barter. Its commission may have been a form of indulgence, or payment, which spares them from purgatory and paves their way into heaven. One of the most distinctive features of Campin's painting is the everyday appearance of the scene. This ordinariness lends the image of Christian miracle a reality never before seen in European painting. The reality was heightened by the depiction of objects through the medium of oil paint.

Jan van Eyck in Ghent and Bruges

The celebration of individual identity marks Renaissance art in both the North and South. It is especially apparent in van Eyck's double portrait of Giovanni Arnolfini, an Italian merchant representing Medici interests in Bruges, and his wife (Fig. 8.6). Scholars continue to

debate the meaning and purpose of the work, but most have agreed that the couple are exchanging marriage vows in a bedroom before two witnesses. One of them is van Eyck himself, who is reflected in the mirror at the back of the room (Fig. 8.7). (Above the mirror, he inscribed in Latin "Johannes de Eyck fuit hic. 1434"

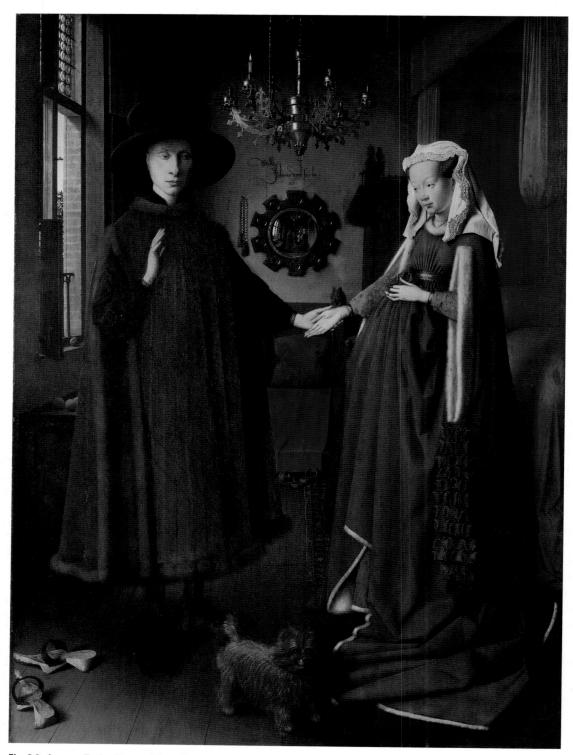

Fig. 8.6 Jan van Eyck, Giovanni Arnolfini and His Wife ca. 1434. Oil on panel, 32%". National Gallery, London. Arnolfini's wife may look pregnant, but she is probably not. However, she has pulled her robe up before her abdomen and dressed in green to suggest her fertility.

["Jan van Eyck was here, 1434"]). Recently a persuasive argument has been made that this scene represents an engagement rather than a marriage—a touching of the hands was the traditional sign of an agreement to wed—and that the scene takes place in the front parlor of a Dutch home, a room that was commonly decorated with a canopied bed as a symbol of hospitality.

The painting abounds with other symbolic elements, transforming what is at first glance a wholly secular image into one filled with religious significance, a characteristic feature of Northern art. Many scholars speculate that the little dog at the feet of the couple represents fidelity, and the two pairs of shoes, at the left front of the painting and at the back of the room, suggest that the couple stand on ground hallowed by the sacred character of the ceremony that engages them. The chandelier, with its single burning candle, is traditionally thought to represent the presence of God. The fruits on the window ledge and table behind Arnolfini suggest abundance. Atop the high chairback at the back of the room is a sculptured finial representing either Saint Margaret, the patron saint of childbirth, or Saint Martha, the patron saint of housewives. The dusting brush beside it probably symbolizes the wife's household duties. Above all,

the painting seems to celebrate the couple's spiritual and material well-being. Its many textures, from Arnolfini's fur robe to the rich red velvet of the bed, symbolize what we might call "the good life," a phrase with a long classical history.

In his paintings, van Eyck expresses his love of detail through his ability to render in oil paint the texture of objects and the way light plays across their surfaces. This skill is apparent in the green wool of his wife's dress and the ermine of Giovanni Arnolfini's robe. This love of detail, presented through a smooth surface that does not show brushstrokes, is the hallmark of Northern Renaissance painting, the characteristic that distinguishes it most from painting in the South.

Hieronymus Bosch in 's-Hertogenbosch

Hieronymus Bosch (1450–1516) was born, lived, and worked in the town of 's-Hertogenbosch (now in southern Holland). The town owed its prosperity to wool and cloth. Bosch was a contemporary of the painters in Southern Europe who worked in the so-called High Renaissance. Such a distinction seems inappropriate in the North, where there was greater continuity between fifteenth- and sixteenth-century art. (Only Albrecht Dürer, a German, discussed later in the chapter, fits

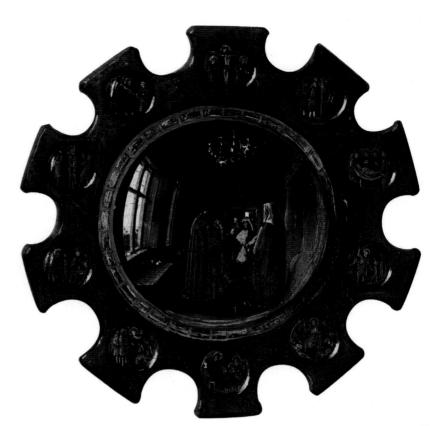

Fig. 8.7 Jan van Eyck, Giovanni Arnolfini and His Wife detail. ca. 1434. Each of the ten small circles around the mirror contains a scene from Christ's Passion.

comfortably into the High Renaissance cult of the individual creative genius.)

Bosch's work is, furthermore, permeated with a sense of doom characteristic of the North. It continues from the medieval sermon tradition exemplified by Pope Innocent III's On the Misery of the Human Condition (see Reading 5.4 in Chapter 5) through the devastation of the Black Death. From the 1340s well into the sixteenth century, the plague periodically ravaged northern cities because of the colder climate and harsher conditions that defined day-to-day life in the North.

Northern pessimism manifests itself most dramatically in Bosch's most ambitious painting, a triptych with closing doors known as the *Garden of Earthly Delights*, painted around 1505 to 1510 (see *Closer Look*, pages 256–257). Although the painting takes the form of a triptych altarpiece, it was never intended for a religious setting. The *Garden of Earthly Delights* hung in a palace in Brussels, where invading Spanish troops seized it in 1568 and took it to Madrid, where it remains.

The painting is really a **conversation piece**, a work designed to invite discussion of its meaning. Bosch has given us an enigmatic essay on what the world might be like if the fall of Adam and Eve had never happened. It presents, in other words, a world technically without sin, yet rampant

CLOSER LOOK

ieronymus Bosch's *Garden of Earthly Delights* is full of strange hybrid organisms, part animal or bird, part human, part plant, sometimes part mechanical contraption. In the left panel of the triptych, we see the Garden of Eden, populated with such strange creatures as albino giraffes

and elephants, unicorns, and flying fish. In the right panel, we see Bosch's deeply disturbing vision of hell, in which fire spits from the skyline and tortured souls are impaled on musical instruments or eaten alive by monsters. The central panel presents an image of life on earth, with hundreds of naked young men and women frolicking in a garden full of giant berries and other fruits. Lovers are variously contained in transparent columns or globes of glass—a reference to the proverb "Happiness and glass, how soon they pass." The world here has gone awry. Illicit lust replaces love of God, wanton seduction replaces beauty, and Bosch's own wild imagination replaces reason.

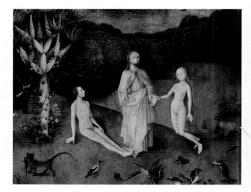

Even as God commands Adam and Eve to "be fruitful and multiply and fill the earth and subdue it," (Gen. 1:28), death is imminent: A cat walks off to the left with a mouse in its teeth, and ravens perch above on the Fountain of Life.

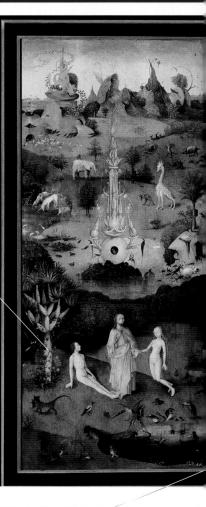

Something to Think About . . .

Bosch's closed triptych differs from its interior most especially in its lack of color. How do you account for this difference?

Hieronymus Bosch, Garden of Earthly Delights, closed. ca.

1505–10. Oil on panel, each wing 7'2½" × 38". Museo del Prado, Madrid. When closed, the triptych reveals the world at the moment of creation. At the top left-hand corner, God floats on a cloud and looks down at the earthly orb. The landscape has no people. Inscribed across the top are these words from Psalms 33:9: "Ipse dixit et facta su[nt]. Ipse ma[n]davit et creata su[n]t"—"He himself spoke, and they were made; he himself commanded, and they were created." The irony of what is hidden inside these exterior panels could not be greater.

Here are the results of God's command to Adam and Eve to "be fruitful and multiply." Recall that it was eating the forbidden fruit of the Garden of Eden that was the Original Sin. Swimmers suck at the blackberry in the middle of the pool or float upside down, with fruit atop their genitals, or peek out of a floating orange, an image of gluttony. In fact, all of the Seven Deadly Sins are here—Pride, Envy, Greed, Gluttony, Anger, Sloth, and, above all, Lust.

Bosch's Garden of Earthly Delights

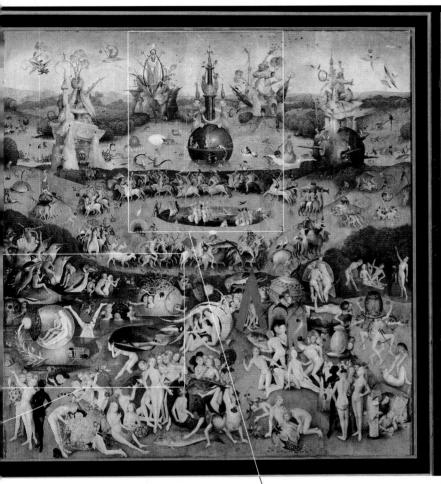

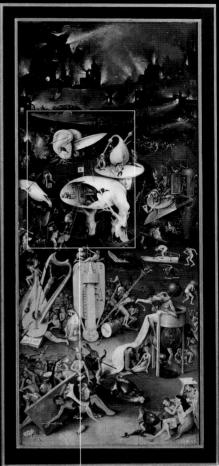

ronymus Bosch, den of Earthly ights, open. ca. 5–10. Oil on el, center ½" × 6'4¾"; each g 7'2½" × 38". Museo Nacional Prado, Madrid. rights reserved.

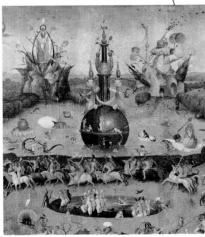

The focus of the central panel is this pool surrounded by the four so-called Castles of Vanity (this detail shows two of them). Horns, a symbol of cuckoldry, decorate the central fountain, known as the Tower of Adulteresses. Circling around the lower pool of bathing women, called the Bath of Venus, young men ride pigs, horses, goats, griffins, and other animals, apparently intent on "riding" the young women as well.

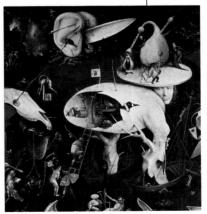

This strange creature presides over hell. Its legs are supported by tree trunks, each standing in a boat; its eggshell stomach is cracked open; and its head, with an astonishingly realistic face, is topped by a disk with bagpipe (a traditional symbol of lust). Behind it, two ears, pierced by arrows, flank a knife blade, like some monstrous cannon or hellish phallus.

The CONTINUING PRESENCE of the PAST

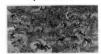

See Raqib Shaw, Garden of Earthly Delights X, 2004, at MyArtsLab

with behavior that its viewers, the fallen sons and daughters of Adam and Eve, could only identify as sinful. Other parts of the painting, the right panel in particular, seem to suggest life after the fall, life in which Adam and Eve's sin has made humankind aware of good and evil. These are the painting's paradoxes and its source of endless fascination. Equally intriguing is its meticulous detail, which gives the most grotesquely imaginative landscapes a sense of reality.

The German Tradition

By 1500, cities in the German-speaking regions to the southeast of Flanders and in the Netherlands to the northeast had begun to grow rapidly. Many of the larger cities had doubled in size in the century after 1400. The population of Cologne, the largest city in Germany, was about 40,000, and Nuremberg, Strasbourg, Vienna, Prague, and Lübeck could all claim between 20,000 and 30,000 residents, which made them substantial centers of culture, though smaller than Florence, Paris, and London, each of which had about 100,000 inhabitants. In all these cities, an increasingly wealthy, self-made mercantile class supported the production of art. Caught

between North and South, between the richly detailed and luminous oil painting of a van Eyck and the more linear, scientific, and Classically idealized style of a Raphael, German painters at the dawn of the sixteenth century exhibited instances of each.

Emotion and the Christian Miracle: The Art of Matthias Grünewald Bosch's preoccupation with the meticulous rendering of detail, as well as the questions of morality that seem to drive his work, are also apparent in the work of Matthias Grünewald (ca. 1470–1528). Multi-talented Grünewald served as architect, engineer, and painter to the court of the archbishops of Mainz. His most famous work is the so-called Isenheim Altarpiece, a monumentally large polyptych painted around 1510–1515 for the hospital of the Abbey of Saint Anthony, a facility in Isenheim, near Strasbourg, dedicated to the treatment of people with skin diseases. These included syphilis, leprosy, and ergotism, a gangrenous condition caused by eating grain contaminated with the ergot fungus. Physical illness was viewed as a function of spiritual illness, and so Grünewald's altarpiece, like Pope Innocent III's sermon On the Misery of the Human Condition of nearly 300 years earlier, is designed to

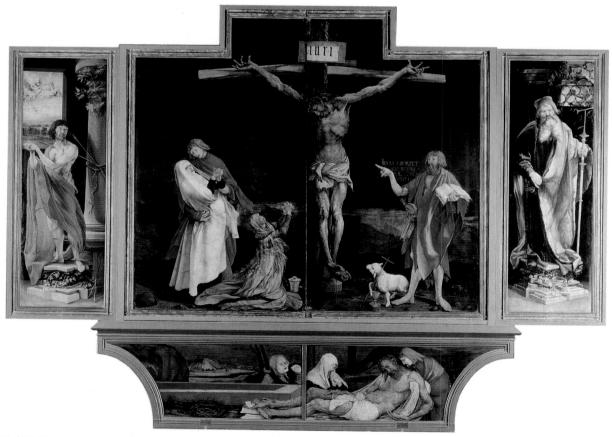

Fig. 8.8 Matthias Grünewald, Isenheim Altarpiece, closed. ca. 1510–15. Main body, Crucifixion; base, Lamentation; side panels, Saint Sebastian (left) and Saint Anthony (right). Oil on wood, center 9'9½" × 10'9"; each wing 8'2½" × 3½"; base 2'5½" × 11'2". Musée d'Unterlinden, Colmar, France. Saint Sebastian appears in his role as protector from the plague. Saint Anthony, patron saint of the Isenheim hospital, stands before a window through which a demon, representing the plague, blows its evil breath. The altarpiece was designed to complement Saint Anthony's shrine.

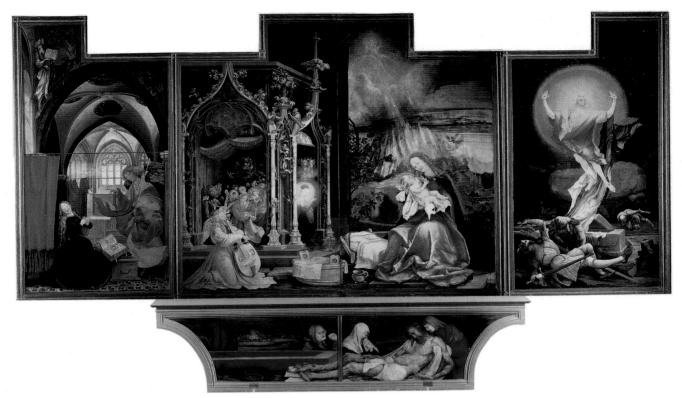

Fig. 8.9 Matthias Grünewald, Isenheim Altarpiece, first opening. ca. 1510–15. Left, Annunciation; middle, Virgin and Child with Angels; right, Resurrection. Oil on panel, center 9'9½" × 10'9"; each wing 9'9½" × 5'4½". Musée d'Unterlinden, Colmar, France. In the left-hand panel, the gesture of the angel of the Annunciation as he points to Mary echoes the gesture of Saint John pointing to the crucified Christ in the closed altarpiece, underscoring the transformation of spirit between the closed and the open doors.

move these sinners to repentance. But more important it offered hope to the hopelessly afflicted, reminding them that they were not alone in their suffering—that Christ had suffered like them.

The Crucifixion in the *Isenheim Altarpiece* is among the grimmest ever painted (Fig. 8.8), and more startlingly realistic in its detail than any Crucifixion ever painted in the South. Christ's flesh is ripped and torn by thorns; his body seems emaciated, his ashen skin drawn tightly across his abdomen and rib cage. He hangs limply from the Cross, which seems to bend under his weight, his hands splayed open, contorted by pain. His lips are blue, and, as if to emphasize Christ's morbidity, Grünewald's palette of purple-green and yellow-brown almost reeks of rotten flesh. All is darkness, echoing the account of the Crucifixion in the Gospel of Mark (15:33): "And when the sixth hour was come, there was darkness over the whole land until the ninth hour." Below, in the predella, or supporting base, of the altarpiece, a Lamentation shows Christ's body, stiff in rigor mortis, as it is settled into the tomb.

The altarpiece is composed of one set of fixed wings, two movable sets, and one set of sliding panels to cover the predella so that the altarpiece could be exhibited in different configurations. Hospital patients saw the horrifying realism of Grünewald's Crucifixion and Lamentation on the closed wings throughout the week, but on holy days and possibly Sundays, the altarpiece was opened to reveal, inside, brightly lit scenes of the Annunciation, the Virgin and Child with Angels, and the Resurrection (Fig. 8.9). In the Annunciation

panel, the angel appears to Mary in a Gothic church. The Bible on her lap is open to Isaiah 11:1: "And there shall come forth a rod out of the stem of Jesse, and a Branch shall grow out of his roots." Above her, the dove of the Holy Spirit hovers on suspended wings and is bathed in a luminous light. In the central panel, Mary cares for the Christ Child in an array of detail that a patient at the hospital of the Abbey of Saint Anthony would recognize—torn linen rags for cleansing the skin, a bed, a tub, a towel, and even a chamberpot. In the Resurrection panel on the right, Christ soars up in an aureole of translucent light, the Roman soldiers blown to the ground as he explodes from the tomb. Christ's skin is now white and pure in contrast to its gangrenous green on the closed panel. So the promise of salvation—the Christian miracle—was always at least latent in the patient's mind, the glory and joy of the hereafter always imaginable behind the pain and suffering of the moment.

Grünewald's altarpiece underscores the Northern European preoccupation with death. In the face of recurring plagues ever since the Black Death of 1348, the fragility of life and the ultimate horror of death were constant thematic concerns. It is hardly surprising that among the most popular texts in Northern Europe was the *Art of Dying Well*. Although its origins are unclear, over 100 different versions appeared in several languages between the 1460s and 1500. Grünewald's altarpiece is typical of Northern European art in its unswerving attention to the reality of death, represented in the minutest detail, but

Fig. 8.10 Albrecht Dürer, *Self-Portrait.* **1500.** Oil on panel, 26¼" × 19¼". Alte Pinakothek, Munich. Dürer's skill as a portraitist is embodied in the story that his dog once barked and wagged its tail at one of his self-portraits. We cannot vouch for the accuracy of the story.

it is also uniquely German in its intense emotionalism and almost mystical sense of transcendence.

Northern Detail Meets Southern Humanism: The Art of Albrecht Dürer Born in 1471 in the city of Nuremberg, Albrecht Dürer represents a trend in German culture distinct from the emotionalism and mysticism of Grünewald, one based on humanism. By his death in 1528, he had become one of the leading painters of the Renaissance, successfully wedding his German-Netherlandish Gothic heritage with the Renaissance interest in perspective, empirical observation, and rules of ideal beauty for representing the human figure.

Like other Northern artists, Dürer was a master of oil painting. His *Self-Portrait* of 1500 (Fig. 8.10) takes full advantage of its oil medium to create a highly textured surface that glows with a light that seems to emanate from within the artist himself. Acknowledging his own skill with oil colors, Dürer inscribed the painting as follows: "Thus I, Albrecht Dürer from Nuremburg, painted myself with undying colors at the age of 28 years." The intimation of artistic immortality embodied in the word "undying" is underscored in the way that Dürer self-consciously paints himself as a sort of icon. His frontal pose, bearded face, and intense gaze recall

traditional images of Christ. At the very least, he means for us to see in his face evidence of divine inspiration. "Art," he would write, "derives from God; it is God who has created all art; it is not easy to paint artistically. Therefore, those without aptitude should not attempt it, for it is an inspiration from above." For Dürer, creating art was a sacred act; it made manifest God's work, from the Creation to Christ's Passion.

But Dürer's real success as an artist derived from his print-making. By the end of the fifteenth century, at any rate, he was not only recognized as a great painter, but also widely held to be the greatest printmaker of the day, a master at both woodcut and engraving. In 1498, he executed a series of prints illustrating the Apocalypse and, in *The Four Horse-men of the Apocalypse*, its chief signs—pestilence, war, famine, and death (Fig. 8.11)—seizing upon widespread popular belief that the Apocalypse was at hand. The prints were reproduced by the thousands and distributed across Germany and the rest of Europe, effectively securing not only Dürer's reputation, but also his income for life.

Fig. 8.11 Albrecht Dürer, *The Four Horsemen of the Apocalypse.* 1498. Woodcut, $15\frac{12}{10} \times 11\frac{16}{10}$. Yale University Art Gallery. Library Transfer. Gift of Paul Mellon B.A. 1929, L.H.D.H. 1967. 1956.16.3e. Dürer represents eight verses of Saint John's vision in the Book of Revelation (6:1–8). The rider with a bow represents pestilence. Next to him, raising his sword, is war. The third rider, with the empty scales, is famine. In the foreground rides Death, sweeping a king and his people backward into the jaws of Hades (at the bottom left).

HUMANISM AND REFORMATION IN THE NORTH

What was the Reformation and how did it impact the art and literature of the era?

There seemed, to many, good reason to think the end of the world was near. Probably no painting more accurately reflects the psychological tone of the era than *The Battle of Issus*, painted in 1529 by Albrecht Altdorfer (ca. 1480–1538) (Fig. **8.12**). Altdorfer's subject was the victory, in 333 BCE, of Alexander the Great over Darius III of Persia on the plain

of Issus, a small port city in Asia Minor near what is now the border between Turkey and Syria. It was a subject of some contemporary moment, since, even as Altdorfer took up his brush, Ottoman Turks, led by Suleiman the Magnificent (r. 1520–66), had gained control of Hungary and were preparing to set siege to the Austrian capital, Vienna, only 200 miles downriver from Regensburg, Altdorfer's home. Altdorfer was, in fact, in charge of preparing Regensburg's defenses against the imminent Turkish threat.

The painting depicts the Battle of Issus in the most minute detail across its bottom third. His lance extended before him, Alexander, dressed in medieval armor, can be seen charging Darius in the very middle of the painting, above the vellow- and red-striped flags that point toward him. Darius retreats in a chariot drawn by three white horses. The middle third of the painting is a representation of the eastern Mediterranean. The island in the middle of the sea is Crete. Just above the pinnacle of the mainland mountain is the Red Sea, and to the right of it, the delta of the Nile. The tumultuous sky mirrors the battle below, but with a sense of apocalyptic doom, for even as the sun sets in the west, the crescent moon of Islam rises in the east. Darkness is about to settle upon the world.

If Alexander succeeded in defeating the Persians, the painting seems to suggest, the Holy Roman Emperor, Charles V, might not be so lucky with Suleiman the Magnificent. But in fact, in 1529, soon after Altdorfer completed this work, Suleiman's army withdrew from its siege of Vienna, unable to subdue the city after repeated attacks, and

demoralized by rain and snow. But the painting's apocalyptic vision was in tune with more than just the Turkish threat. To the embarrassment of Charles V, Rome had been sacked in 1527 by his own troops, angry that the emperor was not able to pay them. They jailed Pope Clement VII (Giulio de' Medici) and forced him to pay a large ransom for his release. And if the Christian world had been torn asunder by those events, it was even more threatened by the challenge of Martin Luther (1483–1546), a rogue priest from Wittenberg, Germany, far to the north on the Elbe River, who on October 31, 1517, had posted *Ninety-Five Theses* on the door of the town's All Saints Church. The door served as a sort of kiosk for university-related announcements, and since Luther was a

Fig. 8.12 Albrecht Altdorfer, *The Battle of Issus.* **1529.** Oil on panel, 62" × 47". Alte Pinakothek, Munich. The banner at the top of the painting, evidently added at a later date, reads in Latin: "The defeat of Darius by Alexander the Great, following the deaths of 100,000 Persian foot-soldiers and more than 10,000 Persian horsemen. King Darius' mother, wife, and children were taken prisoner, together with about 1,000 fleeing horse-soldiers."

professor of theology at the university, it seemed the proper forum to announce the terms of his protest against the practices of the Catholic Church. His aim was to reform the Church, and by 1529, his movement had become known as the Protestant Reformation. As Altdorfer worked on his painting, the Church seemed to be threatened from both within and without. From Luther's point of view, the Sack of Rome signaled the moral bankruptcy of the Church and God's displeasure with it. From the Catholic point of view, Luther's challenge to papal authority signaled the disintegration of belief that presaged the Second Coming and the Day of Judgment (when, they were sure, the likes of Luther would be sent directly to hell). But equally, for both, the Apocalypse seemed at hand.

The Satire of Desiderius Erasmus

Throughout the fifteenth century in Northern Europe, simultaneously with this increasingly apocalyptic mood, a new religious movement, known as the "modern devotion," had taken hold in city after city. Lay citizens gathered in houses organized to promote a lifestyle similar to that of monks and nuns, although they stopped short of taking monastic vows. These Brothers and Sisters of the Common Life, as they came to be known, tried to bring the message of Jesus into daily practice. The life of austerity and simplicity that such popular religious movements promoted clashed sharply with both the prosperity and material pleasures of the Northern mercantile class, and what was seen as the extravagance and corruption of the Church in Rome.

One of the most vigorous opponents of Church excesses was Desiderius Erasmus (ca. 1466–1536). Like Luther, Erasmus was a monk and humanist scholar, but he had been raised in Rotterdam among the Brothers of the Common Life. By his mid-thirties, he had become one of Europe's most soughtafter educators, and he was the first humanist scholar to take advantage of the printing press to disseminate his work.

Luther's own antipapal feelings were inspired, at least in part, by his reading of Erasmus, whose 1516 translation of the Greek New Testament into Latin especially impressed the young Augustinian monk. Luther's early teachers, in common with those of Erasmus, were all Augustinians, so he was predisposed to be impressed by Erasmus's satiric attack on the corruption of the clergy in *In Praise of Folly* (1509) and by Erasmus's anonymously published attack on Pope Julius II in *Julius Excluded from Heaven* (1513). In this satiric dialogue, Saint Peter and the pope encounter each other at the doors to paradise (**Reading 8.1**):

READING 8.1

from Desiderius Erasmus, Julius Excluded from Heaven (1513)

PETER: Immortal God, what a sewer I smell here! Who are you?

JULIUS: . . . so you'll know what sort of prince you insult, listen up. . . . Even though I supported such a great army, celebrated so many splendid triumphs, erected buildings

in so many places, still, when I died I left five million ducats. . . .

PETER: Madman! . . . all I hear about is a leader not of the church but of this world. . . .

JULIUS: Perhaps you are still dreaming of that old church. . . . What if you could see today so many sacred buildings erected by kingly wealth, so many thousands of priests everywhere (many of them very rich), so many bishops equal to the greatest kings in military power and in wealth, so many splendid palaces belonging to priests. . . . What would you say?

PETER: That I was looking at a tyrant worse than worldly, an enemy of Christ, the bane of the church.

Julius believes that his "good works"—his military victories, his public projects, even the wealth he has brought to the Church—are all it takes to get himself admitted to paradise. Saint Peter—and, of course, Erasmus and Luther—believed otherwise. (Although extremely critical of the Church, Erasmus would remain a Catholic to the end of his life.)

In 1509, Desiderius Erasmus wrote *In Praise of Folly* while living in the home of his friend the English humanist, philosopher, and statesman Thomas More (1478–1535) in London (the work's Latin title, *Encomium Moriae*, is a pun that can also be translated as "In Praise of More"). Like the later tract *Julius Excluded from Heaven*, the work, a satiric attack upon the vices and follies of contemporary society, went through more than two dozen editions in Erasmus's lifetime. **Satire**, the literary genre that conveys the contradictions between real and ideal situations, had lain dormant in Western culture since Greek and Roman times, when such writers as Aristophanes, in his comedies, and Horace and Juvenal, in their poems and essays, used it to critique the cultures of their own day. Humanist scholars like Erasmus and More, thoroughly acquainted with these Classical sources, reinvigorated the genre.

In Praise of Folly helped to secure Erasmus's reputation as the preeminent humanist in Europe and was his most influential work. It is written in the voice, or persona, of an allegorical figure named Folly (Moria). She is a fool, and plays the fool. Thus, in the work's opening pages, she addresses her readers as follows, pleading for her reputation by noting how pervasive in human behavior is her rule (Reading 8.2a):

READING 8.2a

from Desiderius Erasmus, In Praise of Folly (1509)

[T]ell me whether fools . . . are not infinitely more free and happy than yourselves? Add to this, that fools do not barely laugh, and sing, and play the good-fellow alone to themselves: but . . . impart their mirth to others, by making sport for the whole company they are at any time engaged in, as if providence purposely designed them for an antidote to melancholy: whereby they make all persons so fond of their society, that

Fig. 8.13 Lucas Cranach the Elder, Martin Luther. ca. 1526. Oil on panel, 15" × 9". Galleria degli Uffizi, Florence. A remarkable aspect of this painting is Luther's sideways glance, which suggests a personality capable of concentrating on more than one thing at once.

they are welcomed to all places, hugged, caressed, and defended, a liberty given them of saying or doing anything; so well beloved, that none dares to offer them the least injury; nay, the most ravenous beasts of prey will pass them by untouched, as if by instinct they were warned that such innocence ought to receive no hurt.

Through the device of Folly, therefore, Erasmus is free to say anything he pleases, and, as Folly reminds us, "It is one further very commendable property of fools, that they always speak the truth." Erasmus spares virtually no one among Folly's "regiment of fools," least of all theologians and Church officials. He attacks, especially, those who "maintain the cheat of pardons and indulgences"—a sentiment that would deeply influence Martin Luther (Reading 8.2b):

READING 8.2b

from Desiderius Erasmus, In Praise of Folly (1509)

By this easy way of purchasing pardons, any notorious highwayman, any plundering soldier, or any bribe-taking judge, shall disburse some part of their unjust gains, and so think all their grossest impieties sufficiently atoned for; so many perjuries, lusts, drunkenness, quarrels, blood-sheds, cheats, treacheries, and all sorts of debaucheries, shall all be, as it were, struck a bargain for, and such a contract made, as if they had paid off all arrears, and might now begin upon a new score.

The rhetorical power of such verbal abuse accounts for much of the appeal of Erasmus's prose. So too does his sense of **irony**, his ability to say one thing explicitly but implicitly mean another—to speak with "tongue in cheek." Irony is, in fact, one of the chief tools of satire, and is embodied in the very title of Erasmus's work. *In Praise of Folly* is, of course, a *condemnation* of human folly.

Martin Luther's Reformation

The satire of Erasmus was rather too lighthearted for Luther himself (Fig. 8.13). If he and Erasmus recognized the same problems with the Church, these were too serious, from Luther's point of view, to be dismissed as mere "folly." Luther's own early years in the Church underscore how seriously he took his calling. He had entered the Order of the Hermits of Saint Augustine in Erfurt in 1505, at the age of 22. This decision was apparently motivated by an oath he had taken when he had promised to become a monk if he survived a particularly severe lightning storm. By 1511, he had moved to the Augustinian monastery in Wittenberg, earning a doctorate in theology in 1512. In the winter semester of 1513–14, he began lecturing at the university there. His primary subject was the Bible.

In the preface to the complete edition of his writings, published just a year before his death, Luther recalled the crisis in belief that preoccupied him between 1513 and 1517 (Reading 8.3):

READING 8.3

from Martin Luther, Preface to Works (1545)

Though I lived as a monk without reproach, I felt that I was a sinner before God with an extremely disturbed conscience. . . . I was angry with God, and said, "As if, indeed, it is not enough, that miserable sinners, eternally lost through original sin, are crushed by every kind of calamity . . . without having God by the gospel threatening us with his righteousness and wrath!" Thus I raged with a fierce and troubled conscience. . . .

At last, by the mercy of God, meditating day and night, I gave heed to the context of the words, namely, "In it the righteousness of God is revealed, as it is written, 'He who through faith is righteous shall live'" [Romans 1:17]. There I began to understand that the righteousness of God is that by which the righteous [person] lives by a gift of God, namely by faith. . . . Here I felt that I was altogether born again and had entered paradise itself through open gates.

Luther's thinking amounts to an almost total rejection of traditional Church doctrine. He argued that the moral virtue that God commands of humanity does not exhibit itself in good deeds or works—in commissioning an altarpiece, for instance—for if this were true, people could never know if they had done enough good works to merit salvation. This was the source of Luther's frustration, even anger. God, Luther was certain, accepts all believers in spite of, not because of, what they do. The Bible, he argued, rejects "the wicked idea of the entire kingdom of the pope, the teaching that a Christian man must be uncertain of the grace of God toward him. If this opinion stands, then Christ is completely useless. . . . Therefore the papacy is a veritable torture chamber of consciences and the very kingdom of the devil." From Luther's point of view, Christ had already atoned for humankind's sins—or what was the point of his sacrifice? and he provided the faithful with the certainty of their salvation. So Luther began to preach the doctrine of salvation by faith rather than by works.

Like Dante, Chaucer, and Erasmus before him, Luther was particularly bothered by the concept of indulgences, remissions of penalties to be suffered in purgatory. Theoretically, indulgences pave the way to heaven for any sinner, and given the apocalyptic fervor of the day, they were especially popular. Luther's specific target was Johannes Tetzel, a Dominican monk notorious as a traveling seller of indulgences (Fig. 8.14). Tetzel had been jointly hired by Archbishop Albrecht of Mainz and Pope Leo X to raise money to cover the archbishop's debts and to fund Leo's rebuilding of Saint Peter's in Rome. The sale of indulgences supported these projects.

In general terms, Luther detested both the secular or materialist spirit evident in Church patronage of lavish decorative programs and the moral laxity of its cardinals in Rome. He longed for the Church to return to the spiritual ways of the early Church and to back away from the power and wealth that were corrupting it. In particular, Luther found the practice of selling indulgences to be contradictory to scripture. In the Ninety-Five Theses, which he nailed to the church door at Wittenberg on October 31, 1517, he wrote: "Those who believe that, through letters of pardon, they are made sure of their own salvation will be eternally damned along with their teachers" (thirty-second thesis). More to the point, he wrote in the eighty-sixth: "Why does not the Pope, whose riches are at this day more ample than those of the wealthiest of the wealthy, build the single Basilica of Saint Peter with his own money rather than with that of poor believers?"

At the heart of his opposition, in fact, was class division. Only the rich could afford to pay for the remission of their sins and those of their families. If the poor did buy them, they

did so at great sacrifice to the well-being of their families. Then they had to watch the proceeds from the practice build the most extravagant, even profligate of projects in Rome. Such injustice and inequity fueled Luther's rage.

On August 7, 1518, Luther was summoned to appear in Rome within 60 days to answer a charge of heresy. As Erasmus declared: "He has committed a great sin—he has hit the monks in their belly and the Pope in his crown!" It was thus inevitable that on January 3, 1521, the Church excommunicated Luther. All his writings were declared heretical and ordered to be burned. By 1526, menaced by threats from France and Turkey, and in order to keep peace at home, the German emperor granted each German territory and city discretion in choosing whether or not to follow Luther's example. However, three years later, he rescinded the order, resulting in 18 German states signing a *protestatio*, the act of protest that actually gave rise to the term *Protestant*.

The Spread of the Reformation

Even as Luther led the Reformation in Germany, other reformists initiated similar movements in France and Switzerland, and still others radicalized his thinking. The appeal of Luther's Reformation was as much caused by its political as its religious implications. His defense of the individual conscience against the authority of the pope was understood to free the German princes—and King Henry VIII in England—of the same papal tyranny that plagued the Church.

Fig. 8.14 Anonymous, *Johannes Tetzel, Dominican Monk.* ca. 1517. The last lines of the poem at the top of this contemporary caricature read: "As soon as the coin in the basin rings, Hurray the soul into heaven springs."

And to many townspeople and peasants, freedom from the pope's authority seemed to justify their own independence from authoritarian rule, whether of a peasant from his feudal lord, a guild from local government, or a city from its prince.

Thomas Müntzer and the Peasant War By 1524, peasant leaders across Germany, many of whom were Lutherans, were openly requesting Luther's support in their struggle for political and economic freedom, especially release from serfdom. Luther was hesitant to endorse the aims of the peasants, but Thomas Müntzer (ca. 1489–1525), a German cleric who had studied at Wittenberg, was not. Müntzer thoroughly believed that reform of the Church required the absolute abolition of the vestiges of feudalism, the rule of what he called the "Godless princes" and the self-serving scholars and priests who worked for them. He numbered Luther among these.

Luther was actually sympathetic to the peasants' plight, but he lacked the militancy of Müntzer, who quickly raised an army. Within days, the troops of the German princes encircled Müntzer's army, but certain that God was on his side, Müntzer led the peasants against the princes in the so-called Peasant War. In the ensuing battle, the princes lost six men, Müntzer 6,000. Ten days later, Müntzer was executed.

The Peasant War was not an isolated incident. The feelings that erupted so violently in Germany were the result of long-standing socioeconomic discontent across Europe. As rising expectations for increased economic prosperity and a moderate degree of social freedom energized the general population—especially the rural peasants—the thought that anyone might thwart those expectations met increasing opposition.

Ulrich Zwingli in Zurich In 1519, Ulrich Zwingli (1484-1531), strongly influenced by Erasmus, entered the contest to be chosen as people's priest of the Great Minster Church in Zurich, Switzerland. Zwingli's candidacy was compromised by the fact that he lived openly with a woman with whom he had fathered six children. The open rejection of celibacy galvanized the electorate, who believed celibacy to be an entirely unfair demand on the clergy. Zwingli was elected, and from that position of power, he soon challenged not only the practice of clerical celibacy, but also such practices as fasting, the veneration of saints, the value of pilgrimages, and the ideas of purgatory and transubstantiation. On this last point, he was especially at odds with Luther. From Zwingli's point of view, communion was symbolic, while Luther held that consubstantiation, the coexistence of the bread and wine with the blood and body of Christ, did indeed occur when the bread and wine of the Eucharist were blessed. Had the two been able to agree on this point, a single, unified Protestant Church might have transpired.

Zwingli quickly instituted a program of iconoclasm in Zurich. Churches were purged of all imagery on the grounds that images provoked at least the potential for idolatry. Such works were seen, as well, as the embodiment of the Catholic taste for material, rather than spiritual, well-being. Outraged at the pomp, expense, and seeming excess with which the Vatican was decorating Rome, Zwingli used the authority of the prohibition against worship of false idols in the Ten Commandments to argue that art's appeal to the senses rather than the intellect was contrary to proper religious practice and unbecoming to the dignity of any place of worship. In Zurich, the churches were closed for 13 days in August 1523, while all offending objects were removed—metal items were melted for reuse and the rest destroyed—and the walls were whitewashed. Zwingli was ecstatic: "In Zurich we have churches which are positively luminous; the walls are beautiful white!"

By the late 1520s, civil war between Protestant and Catholic cantons, or states, broke out in Switzerland. The Protestants won the first major battle, but during the second battle, Zwingli was wounded by his Catholic adversaries, then summarily executed, and his remains scattered so that no relics would survive his death. The compromise that resulted was that each Swiss canton was now free to choose its own religion.

John Calvin in Geneva The iconoclasm that marked Zwingli's Zurich erupted in the canton of Geneva in the mid-1530s, as the residents successfully revolted against their local prince (who also happened to be the bishop), and bestowed power on a city council. In May 1536, the city voted to adopt the Reformation and "to live according to the Gospel and Word of God... [without] any more masses, statues, idols, or other papal abuses." Two months later, with the city essentially purged by iconoclasts, John Calvin (1509–64) arrived.

Calvin was convinced that the city could become a model of moral rectitude and Christian piety. For four years he fought to have Geneva adopt strict moral codes, locking horns with the city's large population of Catholics. In 1538, his insistence that church worship and discipline belonged in the hands of the clergy, not politicians, led to his banishment from the city. But in 1541, the city recalled him, and he began to institute the reforms he thought were necessary.

Calvin believed in a doctrine of **predestination**, the idea that people are "elected" by God to salvation prior to coming into the world, and that anyone so elected self-evidently lives in a way that pleases God. In fact, later Calvinists would come to believe that living a pure and pious life—often coupled with business success—made one's election manifest to one's neighbors. Calvin explained election in his *Institutes of the Christian Religion* (1536): "God divinely predestines some to eternal salvation—the Elect—and others to eternal perdition—the Damned; and since no one knows with absolute certainty whether he or she is one of the Elect, all must live as if they were obeying God's commands." In effect, one could intuit one's election, but would never know it with certainty.

To this end, Calvinist Geneva—a city where all lived by God's commands—prohibited dancing and singing ("If any one sing immoral, dissolute, or outrageous songs, or dance the

virollet or other dance, he shall be put in prison for three days. . . . "), drunkenness ("If any one be found intoxicated he shall pay for the first offense 3 sous ... for the second offense he shall be held to pay the sum of 6 sous, and for the third 10 sous and be put in prison"), and blasphemy. Women were prohibited from wearing rouge, lace, and jewelry; men from gambling and playing cards. Men who beat their wives were severely punished, quickly giving the city a reputation as "a paradise for women." So vigilant—and intolerant—was Calvin's Consistory, the ecclesiastical court that supervised the morals of the city and that was made up of 12 city elders and the pastors of its churches, that in some ways Geneva came to resemble a religious police state. When the theologian and scientist Michael Servetus (1511-53), discoverer of the pulmonary circulation of blood, arrived in Geneva in 1553, Calvin had already condemned his theological writings as the most "impious ravings of all the ages." Servetus argued that infant baptism was diabolical, that there was no such thing as original sin, and that the Trinity was a "three-headed Cerberus," the mythological dog guarding the gates to Hades. He was promptly

arrested—Calvin serving as the chief witness against him—and condemned to death at the stake over a slow-burning green-wood fire.

Nevertheless, by the time he was done instituting these reforms, Calvin was extremely popular. Before his death in 1564, nearly 7,000 religious refugees had arrived in Geneva seeking protection for their own religious practice. Many of these carried his teachings back to their homelands—to France, the Netherlands, England, Scotland, Poland, and even the fledgling Americas. So austere was the life they had learned in Geneva that, in England, they soon became known by the name of "Puritans." The intolerance of Calvin's Geneva migrated with them, especially to the Puritan colonies in North America.

Calvinist iconoclasm spread across Europe in the process, reaching a peak in the summer of 1566 (Fig. 8.15). The extent of the devastation varied from town to town. In Nuremberg, a great sculpture of Mary and Gabriel hanging over the high altar of the Church of Saint Lorenz was spared destruction, but by decree of the town council it was covered over by a cloth. It was not permanently uncovered until the nineteenth century. In Antwerp, iconoclasts destroyed all the sculpture and painting that decorated the city's 30 churches, including most of the cathedral's 70 altars. In Ghent, at Saint Bavo Cathedral, van Eyck's Ghent Altarpiece was dismantled and hidden in the tower by local authorities just three days before the city's churches were sacked.

King Henry VIII and the Anglican Church The English crown's decision to align itself with Protestant reformers was driven much more by political expediency than by religious doctrine. King Henry VIII (r. 1509–47) was, in the first place, a devout Catholic who had attacked Luther in a tract

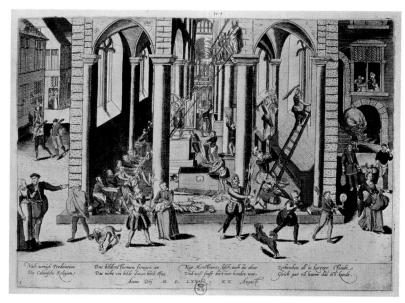

Fig. 8.15 Franz Hogenbergh, *Netherlandish Iconoclasm.* **ca. 1566.** Etching, 16½" × 22". Hamburger Kunsthalle, Hamburg. To the right, the iconoclasts have begun plundering local shops, suggesting that, from Hogenbergh's point of view, the iconoclasm was informed by a certain hooligan element.

delivered to Pope Leo X in 1521, earning him the title "Defender of the Faith." But in 1527, desperately wanting a male heir, he sought to divorce his first wife, Katherine of Aragon, who had delivered only two children, only one of whom had survived, Mary. When his request that the pope annul his marriage was denied—the two had been married, after all, for eighteen years—Henry convened what became known as the Protestant Parliament, which quickly recognized Henry, not the pope, as head of the Church of England. England was now in open defiance of the papacy, and Henry no longer its "Defender of the Faith," although he continued to claim the title for the English crown. What might be called the de facto Protestantization of the Catholic Church, now known as the Anglican Church, quickly followed. In order to assert his kingship, Henry was forced to defy Rome, and in doing so he legitimized English Protestantism.

Relations between Henry and Rome were further exacerbated by the Dissolution Act of 1536, which dissolved the monasteries and sold off Church holdings. Henry's highhanded decree was motivated primarily by a need for money, although Henry's quarrel with the Roman Church and his desire to assert authority as head of the Church in England may have played a part. Considerable wealth was required to support his numerous estates and the palaces he was in the habit of building—as well as the enormous court that followed him everywhere. One day in 1532, for instance, as the king and his traveling household were going to Calais, they reportedly consumed 6 oxen, 8 calves, 40 sheep, 12 pigs, 132 capons, 7 swans, 20 storks, 34 pheasant, 192 partridges, 192 cocks, 56 herons, 84 young hens, 720 larks, 240 pigeons, 24 peacocks, and 192 plovers and teals. Feeding the court alone cost Henry the equivalent of approximately \$9 million per year.

Even though the vast revenues of the monasteries flowed directly into the king's coffers after the Dissolution, it was the sale of the monastic lands that contributed most to his wealth, transforming London in the process. Before the Dissolution, as much as 60 percent of the property in some parts of the city was in ecclesiastical hands, and the Church had vast holdings outside the city as well. Henry sold these properties to wealthy gentry, who used the rural parcels for country estates, and the urban ones for townhouses.

The Dissolution of the Monasteries affected not only the growth of London and the wealth of the Crown but also Henry's political power. This is because those who received properties from him tended to support his split with Rome, and because Parliament was able to raise money without raising taxes. Politically, the city was unique in Renaissance Europe, both self-governing and under royal rule. Its Lord Mayor was the city's voice in dealing with the king as well as the king's agent in the city. A group of aldermen served as justices of the peace and presided over the city's courts and jails. They controlled the city's charities, assisted in levying its taxes, and often served as members of Parliament. Thus, in the city, they exercised something like democratic rule within the overarching rule of the monarch. Henry VIII and his successors, particularly Queen Elizabeth I (r. 1558–1603), rarely meddled in city politics, and in return the city bestowed upon its monarch almost undivided loyalty.

The Printing Press: A Force for Ideas and Art

It is debatable whether the Reformation would have occurred without the invention, a half-century earlier, of the printing press. Sometime between 1435 and 1455, in the German city of Mainz, Johannes Gutenberg (ca. 1390–1468) discovered a process for casting individual letterforms by using an alloy of lead and antimony. These letterforms could be composed into pages of type and then printed on a wooden standing press using ink made of lampblack and oil varnish. Although the Chinese alchemist Pi Sheng had invented movable type in 1045 ce, now, for the first time, the technology was available in the West, and identical copies of written works could be produced over and over again.

In 1455, Gutenberg published his first major work, the Gutenberg Bible (Fig. 8.16)—also known as the Forty-Two Line Bible because each column of type contains 42 lines the first substantial book to be published from movable type in Europe. The text is Saint Jerome's translation into Latin of the original Hebrew and Greek. The book's typeface is heavily influenced by the Gothic manuscript tradition, probably because the printer wanted it to look as if it were hand-copied. The publication of another Bible, the so-called Thirty-Six Line Bible, quickly followed in 1458-61. By the end of the century, printing presses were churning out a wide variety of books in at least 60 German cities and in 200 others throughout Europe. Publishers were quick to print the great humanist texts. Gutenberg's press published the writings of Augustine of Hippo in the early 1460s, the writings of Cicero in 1465, and Dante's Divine Comedy in

Fig. 8.16 Johannes Gutenberg, page from the Gutenberg Bible, text printed with movable letters and hand-painted initials and marginalia: page 162 recto with initials "M" and "E" and depiction of Alexander the Great. Mainz. 1455–56. Staatsbibliothek, Berlin. An artist added the colors of the still Gothic decorative designs by hand after the page was printed to lend the book the feeling of a medieval manuscript. The appearance of Alexander the Great in the design further contributes to the effect.

1472. Even an Arabic edition of the *Qur'an* was printed in Italy in 1500.

More popular than the humanist texts, however, was the Bible, which was the Continent's best seller. Up to this time, the Bible had been an item of some rarity, available only in churches and monasteries. A vellum edition required 170 calfskins or 300 sheepskins, and therefore was prohibitively expensive. Now the less costly, printed Bible found its way into the homes of individual citizens. The excommunicated Martin Luther occupied himself with translating Erasmus's New Testament Bible from Latin into vernacular German, "not word for word but sense for sense," as he put it. His object was to make the Bible available to ordinary people, in the language they spoke on the street, so that they could meditate for themselves on its meanings without the intervention of a priest. No longer would the Catholic Church be the sole authority of biblical interpretation.

Luther's vernacular New Testament was published in 1522. The entire printing of 3,000 copies sold out within three months, and a second printing quickly followed. Considering that the entire population of Wittenberg was only 2,500, the sellout of the first printing was an incredible achievement. By the time of Luther's death in 1546, some 3,830 separate editions of the Bible—altogether about one million copies—had been published, many in vernacular German.

Music in Print

A trained musician, Luther understood the power of a hymn sung in the vernacular by the entire congregation, a form known as the **chorale**, rather than in Latin by a chorus of monks separated from the worshipers. While he did not invent the chorale form, between 1524 and 1545 he composed and compiled nine hymnals, consisting of Latin hymns, popular religious songs, and secular tunes recast with religious lyrics. The most famous of Luther's chorales is *Ein feste Burg ist unser Gott* ("A Mighty Fortress Is Our God") (track **8.1**), still widely sung today. Luther probably wrote the melody, and he adopted the text from Psalm 46 ("God is our refuge and our strength . . ."). When sung in unison by all the voices in the congregation, it embodies Luther's sense that "next to the Word of God, music deserves the highest praise."

In England, Thomas Morley, the organist at Saint Paul's Cathedral and owner of the monopoly on publishing music in England, wrote and published more madrigals than any other English composer, many of them inspired by printed Italian sources. Morley's compositions sometimes employ very short texts and, as a result, repeat each phrase many times. The text of Fyre and Lightning, a madrigal for two tenor voices, reads:

Fyre and lightning from heaven fall And sweetly enflame that hart with love arightfull, O Flora my delightfull, So faire but yet so spightfull.

The musical setting is based on imitation, the two voices copying each other in turn (track 8.2). At times, the imitation is very close, the second voice following the first so quickly that a feeling of emotional intensity or agitation develops. The song ends with both voices singing in homophonic harmony, a unison movement of the voices in chords that employs a dissonant chord to underscore in word-painting the last stinging word, "spitefull."

Writing for Print and Play: The New Humanists

The sudden availability of books in large numbers transformed not only the spread of knowledge but also its production. Suddenly, scholars could work in their own personal libraries and write knowing that their thinking could quickly find its way into print. Similarly, composers could see their music in print and expect it to be performed across the Continent. In short, the printing press created a new

economy that transformed the speed at which information traveled.

Thomas More One of the most popular books of the era was Thomas More's *Utopia*, published in Latin in 1516, but soon translated into virtually all European languages, including English. Places like John Calvin's Geneva can usefully be thought of as attempts to fashion, in their own terms, communities modeled on More's ideal society. But the book was widely understood to be more than just a description of an unrealized, ideal state—in Greek, eu means "good" and topos "place," hence "Good place," but also, the root might be ou meaning "not," hence "No place"—and thus a profound critique of the English political system. At the heart of the critique is More's implicit comparison between his own corrupt Christian society and the ideal society he imagines. This ideal society was inspired, at least in part, by the accounts of explorers returning from the Americas. Its fictional narrator is himself an explorer who has discovered an island culture in which people share goods and property, where war is held in contempt, personal vanity despised, education available to all (except, notably, slaves—a blind spot in More's cultural critique), and freedom of religion a given. Each individual works (six hours a day) for the common good, assuming personal responsibility for social justice rather than entrusting it to some higher authority. Equality, kindness, and charity are the virtues most esteemed by all. In short, Utopia seemed the very antithesis of More's England.

By the time *Utopia* was published, More was Henry VIII's unofficial secretary. As if to endorse More's point of view, Henry promoted him within the year to a position on his advisory council. This was the first of many advancements, culminating in More's appointment as Lord Chancellor, the presiding officer of the House of Lords, in 1529. In *Utopia*, More dedicated considerable discussion to matters of religion, in many ways anticipating the Reformation politics that would begin in the following year. Utopus, king of Utopia, enforces a practice of religion (Reading 8.4):

READING 8.4

from Thomas More, Utopia, Book 2 (1516)

By those among them [the Utopians] that have not received our religion [Christianity], do not fright any from it, and use none ill that goes over to it; so that all the while I was there, one man was only punished on this occasion. He being newly baptized, did, notwithstanding all that we could say to the contrary, dispute publicly concerning the Christian religion with more zeal than discretion; and with so much heat, that he not only preferred our worship to theirs, but condemned all their rites as profane; and cried out against all that adhered to them, as impious and sacrilegious persons, that were to be damned to everlasting burnings. Upon his having frequently preached in this manner, he was seized, and after trial he was condemned to

banishment, not for having disparaged their religion, but for his inflaming the people to sedition: for this is one of their most ancient laws, that no man ought to be punished for his religion. At the first constitution of their government, Utopus having understood that before his coming among them the old inhabitants had been engaged in great quarrels concerning religion . . . he made a law that every man might be of what religion he pleased, and might endeavor to draw others to it by force of argument, and that he ought to use no other force but that of persuasion, and was neither to mix with it reproaches nor violence. . . . This law was made by Utopus, not only for preserving the public peace, which he saw suffered much by daily contentions and irreconcilable heats, but because he thought the interest of religion itself required it.

Eventually More fell victim to the politics of the day himself. He was an ardent Catholic, but when he argued in 1535, that Mary, daughter of Katherine of Aragon, was the rightful heir to the English throne, Henry had him executed, not for his religious beliefs, but for treason.

William Shakespeare: "The play's the thing!" There were many great playwrights in Elizabethan England, during the reign of Elizabeth I (r. 1558–1603), daughter of Henry VIII and Anne Boleyn, including Christopher Marlowe (1564–93) and Thomas Kyd (1558–94). But William Shakespeare (ca. 1564–1616) even in his own time was the acknowledged master of the medium. He wrote 37 plays: great cycles narrating English history; romantic comedies that deal with popular themes such as mistaken identity, the battle of the sexes, lovers' errors in judgment, and so on; romances that treat serious themes but in unrealistic, almost magical settings; and 11 tragedies. Fellow actors prepared the first edition of his collected plays and published them in 1623, after his death (Fig. 8.17).

Shakespeare's plays were produced at a theater called the Globe, but before 1576, no permanent theaters existed in England. Amphitheaters in Southwark, on the south bank of the Thames, were used for bear-baiting, and many inns made natural playhouses, as they were designed around inner court-yards with upstairs rooms looking in. Companies of actors were adopted by noblemen, wore their patron's feudal livery, and were officially his servants. James Burbage belonged to a troupe adopted by the Earl of Leicester, known as Leicester's Men. In the spring of 1576, Burbage opened the Theatre of Shoreditch, just outside the walls of London, and the relationship between actors and patrons changed. Troupes of actors no longer depended completely on their masters; now they could also rely on the popularity of their plays to make profits and support themselves.

The basic price of admission to Burbage's theater was one penny, which in 1600 could buy one chicken or two tankards of ale. A laborer's wage was three or four pence, or pennies, a day. Burbage's theater was thus affordable, which partly

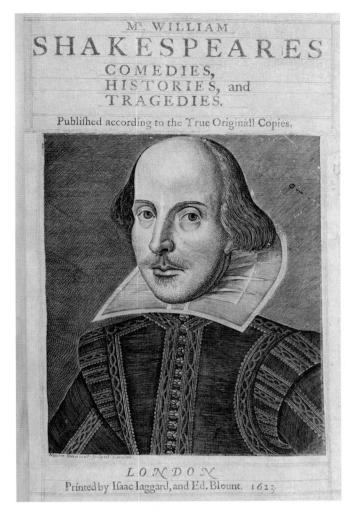

Fig. 8.17 Martin Droeshout, William Shakespeare, frontispiece of the first folio edition of his works, published in London. 1623. British Library, London. The first edition of the collected plays of Shakespeare was prepared by John Heminges and Henry Condell, both his fellow actors at the Globe.

accounts for its success; one penny soon became the standard base price of admission for all London theaters. Although public playhouses varied, in general they were open-air structures consisting of three tiers of covered galleries (in which seats cost between three and six pence). In front of the stage, an open courtyard area held the **groundlings**. These theatergoers paid the one-penny base price of admission, stood throughout the performance, and wandered in and out at will, eating and drinking as they enjoyed the play. A rectangular stage, about 40 feet wide, projected into the courtyard. Behind it were exits to dressing rooms and balconies where players might look out on the action beneath them on the stage proper. Out of a trapdoor, in center stage, a ghost might rise.

In 1598, Burbage's company, now headed by James's son Richard, tore down the Shoreditch theater in a dispute over the lease, and rebuilt it across the river in Southwark at Bankside, in the neighborhood previously associated with

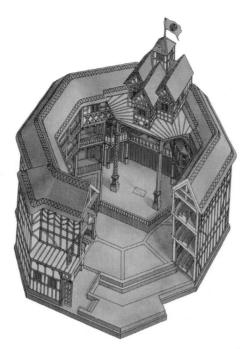

Fig. 8.18 Reconstruction and cross-section of the Globe theater. 1599–1613. The stage was overlooked on three sides by three stories of tiered seating. Groundlings, those who paid one penny, stood in the open area in front of the stage. Admission to the lower gallery was another penny, to the middle galleries yet another.

bear-baiting. He renamed it "The Globe" (Fig. **8.18**). It could seat 3,000 people. The Swan and the Rose, large theaters that were already established at Bankside, could seat about the same numbers. Watermen who transported London audiences across the river to the theaters claimed to carry 3,000 to 4,000 theatergoers to Bankside every afternoon. Including those arriving by foot across London Bridge, as many as 9,000 Londoners descended on the playhouses each day.

Women were prohibited from appearing on stage, and so males—generally boys—played all female roles, which, in turn, required elaborate costuming. Stage props were sometimes minimal, consisting of no more than a chair or two, a chest, or the like, but some companies possessed elaborate sets. Lighting was nonexistent. Thus, under the light of an afternoon sky, the playwright might evoke night or storm by having one of the lesser actors carry a torch or lantern, and the audience would have to suspend its disbelief and imagine the scene (just as they had to accept boys as women). As a result, Elizabethan drama often focuses on the relation between illusion and reality, questioning what is "real" and what is not.

Shakespeare's company was Burbage's newly renamed Lord Chamberlain's Players at the Globe, and he earned 10 percent of its profits. He wrote his plays with specific actors in the company in mind, and played only minor roles himself. Richard Burbage (James' son) was the leading man, playing the title role in Shakespeare's major tragedies *Richard II*, *Romeo and Juliet*, *Hamlet*, *Othello*, and *King Lear*. Although many of Shakespeare's characters sing—and music has an important role in the plays—none of the characters played

by Burbage ever sings a note, because Burbage himself was tone-deaf.

Hamlet is arguably Shakespeare's greatest achievement. It is a revenge play, a type constructed around a murder that must be avenged by the victim's relative, usually at the request of the murdered person's ghost. An Elizabethan audience would have recognized the plot as formulaic, but nothing about the play is standard fare. Hamlet himself, the Danish prince who must avenge the murder of his royal father, is one of the most complex and ambiguous personalities in the history of the theater. Early in the play, his father's ghost reveals to Hamlet that his uncle Claudius murdered his father to replace him as king and as husband to Hamlet's mother. The ghost orders Hamlet to avenge his murder, setting the play in motion. Hamlet alternately behaves like a raving madman and an intellectual of the most refined sensibility, at once deeply perceptive and blind to the most obvious truths. Even in the company of friends, he is alone with himself, an intensely self-reflective soul tormented by the very act of self-reflection.

Consider Hamlet's famous **soliloquy** at the end of Act II. A band of traveling actors has just performed for him some lines concerning the death of King Priam of Troy and the grief borne by his wife, Hecuba. Hamlet marvels at the players' ability to identify emotionally with their roles (**Reading 8.5a**):

READING 8.5a

from William Shakespeare, Hamlet, Act II, Scene 2 (1623)

O, what a rogue and peasant slave am I! Is it not monstrous that this player here, But in a fiction, in a dream of passion, Could force his soul so to his own conceit That from her working all his visage wann'd, Tears in his eyes, distraction in's aspect, A broken voice, and his whole function suiting With forms to his conceit? and all for nothing! For Hecuba! What's Hecuba to him, or he to Hecuba,

That he should weep for her? . . .
[The players are moved by their fiction, while he, Hamlet, burdened by the responsibility of avenging his father but unable to act, seems not moved at all:]

Yet I,

A dull and muddy-mettled¹ rascal, peak,² Like John-a-dreams, unpregnant of³ my cause, And can say nothing—no, not for a king, Upon whose property and most dear life A damn'd defeat was made. . . .

[But even as Hamlet damns himself for procrastinating, he devises a plan of action to "catch the conscience of the king"—he will have a play performed before his uncle the king:]

... I'll have these players
Play something like the murder of my father
Before mine uncle: I'll observe his looks;
I'll tent him to the quick: if he but blench,
I know my course. The spirit that I have seen
May be the devil: and the devil hath power
To assume a pleasing shape; yea, and perhaps
Out of my weakness and my melancholy,
As he is very potent with such spirits,
Abuses me to damn me: I'll have grounds
More relative than this: the play's the thing
Wherein I'll catch the conscience of the king.

¹muddy-mettled: dull-spirited ²peak: mope ³unpregnant: not quickened to action

This is Shakespeare at his most dramatic. Written almost entirely in blank verse (unrhymed iambic pentameter)—a form that Marlowe first introduced in his tragedies and that became known as "Marlowe's mighty line"—the soliloquy is alternately fast or slow, smooth or rough, the rhythm changing at almost every line with Hamlet's emotional twists and turns. By the time Hamlet finishes this soliloquy, with a rhymed couplet to round off the passage, Shakespeare has himself captured the conscience of his audience. Is it not a miracle, we ask ourselves, that this actor playing Hamlet "in a fiction, in a dream of passion, / Could force his soul so to his own conceit" that we are moved to complete identification with his plight?

In the next act, Shakespeare furthers the audience's identification with his play. In Scene 1, Hamlet rejects the love of Ophelia. This is the occasion of what may be his most famous soliloquy, the "To be or not to be" speech, which he delivers as Ophelia sits nearby, "pretending to read a book." The question that the speech raises is timeless. Is Hamlet playacting, pretending to be so tormented in order to convince Ophelia of his madness, or does he not know that Ophelia is present, and is thus sincere in what he says? Such ambiguity goes to the very heart of our understanding of the play (Reading 8.5b):

READING 8.5b

from William Shakespeare, Hamlet, Act III, Scene 1 (1623)

To be, or not to be, that is the question:
Whether 'tis nobler in the mind to suffer
The slings and arrows of outrageous fortune,
Or to take arms against a sea of troubles,
And by opposing end them. To die, to sleep—
No more—and by a sleep to say we end
The heart-ache and the thousand natural shocks
That flesh is heir to. 'Tis a consummation
Devoutly to be wish'd. To die, to sleep;
To sleep, perchance to dream. Ay, there's the rub,¹
For in that sleep of death what dreams may come
When we have shuffled² off this mortal coil,³
Must give us pause. There's the respect⁴

That makes calamity of so long life.5 For who would bear the whips and scorns of time. Th' oppressor's wrong, the proud man's contumely,6 The pangs of despis'd7 love, the law's delay, The insolence of office,8 and the spurns9 That patient merit of th' unworthy takes, When he himself might his quietus¹⁰ make With a bare bodkin?¹¹ Who would fardels¹² bear. To grunt and sweat under a weary life, But that the dread of something after death, The undiscover'd country from whose bourn 13 No traveler returns, puzzles the will, And makes us rather bear those ills we have Than fly to others that we know not of? Thus conscience does make cowards of us all, And thus the native hue¹⁴ of resolution Is sicklied o'er with the pale cast¹⁵ of thought, And enterprises of great pitch¹⁶ and moment¹⁷ With this regard¹⁸ their currents¹⁹ turn awry, And lose the name of action.—Soft you now, The fair Ophelia. Nymph, in thy orisons²⁰ Be all my sins rememb'red.

1 rub (Literally, an obstacle in the game of bowls.) 2 shuffled sloughed, cast 3 coil turmoil 4 respect consideration 5 of . . . life so long-lived 6 contumely insolent abuse 7 despis'd rejected 8 office officialdom 9 spurns insults 10 quietus acquittance; here, death 11 bodkin dagger 12 fardels burdens 13 bourn boundary 14 native hue natural color, complexion 15 cast shade of color 16 pitch height (as of a falcon's flight) 17 moment importance 18 regard respect, consideration 19 currents courses 20 orisons prayers

However, the audience understands that Hamlet's feigned madness—believed by all the characters in the play—is potentially more destructive than productive. In Scene 2, the players perform what has become known as "the play within the play." As Hamlet planned in the soliloquy at the end of Act II, he means the play to move his uncle to such identification with the scene that he will reveal his own involvement in the murder of Hamlet's father. But the audience members recognize that they too must identify with the play they are watching. This is, after all, as Hamlet says at the beginning of the scene, "the purpose of playing, whose end, both at the first and now, was and is, to hold, as 'twere, the mirror up to nature. . . ." The audience members understand, therefore, that they are looking at a reflection of themselves.

In all his contradiction and ambiguity, Hamlet is the most desired role and the most often performed character in the history of the English stage, because he lays himself so bare before us, like some open wound that refuses to heal. He demands our understanding, even as he resists it. In fact, Hamlet represents a new idea of character—no longer a unified and coherent being, but rather a conflicted and driven personality, as mysterious to itself as to others, and as unpredictable as its very dreams. Hamlet is, in this sense, the first modern person. He inaugurates a type who will become in future centuries increasingly recognizable as a version of ourselves.

The English Portrait Tradition

Hamlet represents the logical outcome of the English taste for portraiture, the dramatic embodiment of the nation's humanist emphasis on individualism. One of the most important portraitists of wealthy society in Europe was Hans Holbein the Younger (ca. 1497–1543). One of the most interesting and ambitious of all Holbein's portraits is *The Ambassadors* (Fig. 8.19), which depicts two French ambassadors

to the court of Henry VIII. Jean de Dinteville, on the left, commissioned the painting, and Georges de Selve, on the right, was the bishop elect of Lauvau. Both represent the interests of Francis I, and, therefore, of the Catholic Church (see Chapter 10). It seems clear that both were present at court to negotiate with Henry about his insistence on annulling his marriage to Katherine of Aragon and marrying Anne Boleyn, and the subsequent separation of the Church

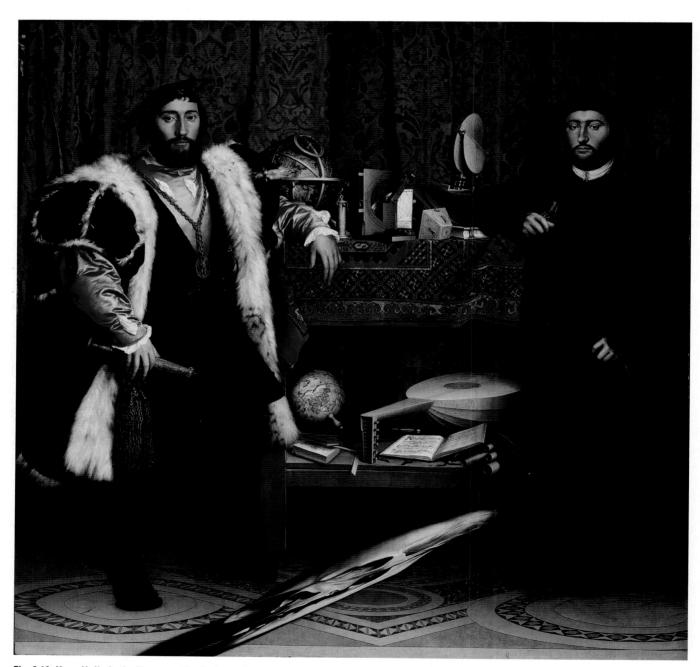

Fig. 8.19 Hans Holbein the Younger, *The Ambassadors*. 1533. Oil on oak panel, 81%" × 82". National Gallery, London. The Lutheran hymnal that lies open beneath the lute is Johannes Walther's *The Little Hymn-Book* (1525). The hymn on the left is "Come, Holy Ghost, our souls inspire," one of Martin Luther's best-known compositions. The hymn on the right is also by Luther: "Man, if thou wouldst live a good life and remain with God eternally."

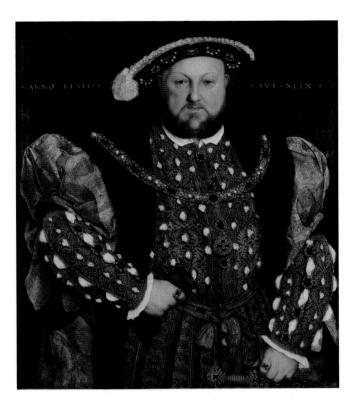

Fig. 8.20 Hans Holbein the Younger, Henry VIII in Wedding Dress. 1540. Oil on panel, $32\%'' \times 29''$. Galleria Barberini, Rome. Henry is in the clothes that he wore when he married the 25-year-old Anne of Cleves in 1540. He was 49.

of England from the Catholic Church. In fact, Henry had married Anne just three months before this work was painted, in January 1533. A cylindrical dial on the table between the two ambassadors tells us that it is April 11, 1533. The tiled floor is a direct copy of the floor of the sacred area in front of the high altar of Westminster Abbey. The tiles are colored glass and stone, from Rome, Egypt, and the Middle East. By using this design, Holbein suggests that his ambassadors stand on holy ground and are engaged in some holy purpose. The skull, placed between the viewer and the ambassadors, in what is known as an anamorphic projection, suggests that the two men understand the fate that awaits us all. The lute is in perfect linear perspective, in contrast to the distorted perspective of the skull, suggesting that one's point of view determines what one is capable of seeing—perhaps the principal lesson of diplomacy. One of the eleven strings is broken, probably symbolizing the lack of harmony between Catholic and Protestant interests. But the other objects on the two-tiered table between the ambassadors—the Lutheran hymnal, the terrestrial globe, the celestial globe, and the astronomical instruments—all indicate the men's willingness to strike a balance between Catholic and Protestant interests.

Holbein painted hundreds of works during his two extended visits to England (1526–28, 1532–43), including many of Henry VIII (Fig. 8.20), four of Henry's six wives, scores of portraits of English courtiers and humanists, and

just as many of London's German merchant community. Each portrait conveyed the sitter's status and captured something of the sitter's identity, in the case of Henry nothing less than his imposing self-confidence—he was, for his time, physically imposing as well, his 6-foot-2-inch frame supporting a 54-inch waistline.

Like her father, Elizabeth was also the subject of many portraits. But few later English painters could match Holbein's skill in depicting volume, texture, and light. Most portraits of Elizabeth, such as the so-called *Darnley Portrait* of Elizabeth I (Fig. 8.21), tend to concentrate on elaborate decorative effects. Set behind the flat patterning of her lace collar, pearl necklaces, and jewel-encrusted dress, Elizabeth appears almost bodiless—the exact opposite of Holbein's emphatically embodied portrait of Henry VIII. And yet, no other portrait of Elizabeth better conveys her steadfast determination, even toughness, while still capturing something of her beauty. By all accounts, she could alternately swear like a common prostitute and charm like the most refined diplomat, the very embodiment of the tensions that dominated her age.

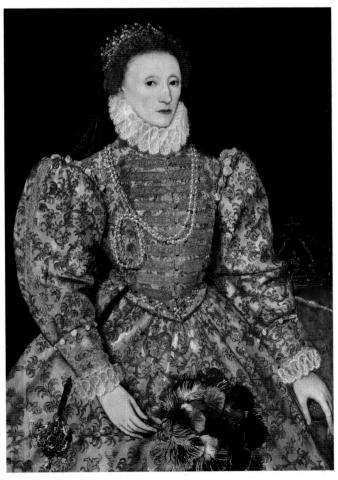

Fig. 8.21 Attributed to Federigo Zuccaro, *The Darnley Portrait of Elizabeth I.* ca. 1575. Oil on panel, 44½" × 31". National Portrait Gallery, London. Behind Elizabeth, on the table at the right, lies her crown.

8.1 Describe the effect of commerce and mercantile wealth on the development of both religious and secular painting in Northern Europe.

The center of commercial activity in Flanders by the beginning of the fifteenth century was Bruges. There, luxury art goods, especially paintings, were sold to a rising merchant class, for both local consumption and export. Flemish painters took oil painting to new heights. Often, the objects depicted in these paintings seem so real that the viewer might actually touch them. What contributes specifically to oil painting's luminosity? What attributes of oil painting make its heightened sense of realism possible? How did Hieronymus Bosch take advantage of these effects?

In Germany, Matthias Grünewald's *Isenheim Altarpiece* is grimly realistic in its portrayal of death, and yet transcendently emotional. How does his work compare to that of the Flemish painters? How does mysticism inform German art and literature? Perhaps the most interesting development in Germany was Nuremburg artist Albrecht Dürer's attempt to synthesize the Northern interest in detailed representation with the traditions of Italian humanism he had assimilated on his visit there in 1505–06. How does this synthesis manifest itself in his art?

8.2 Explain the causes of the Reformation and assess its impact on the art and literature of the era.

On October 31, 1517, the German priest and professor Martin Luther posted his *Ninety-Five Theses* on the door of Wittenberg's Castle Church. His feelings about the Church were in many ways inspired by the writings of the Dutch humanist scholar Desiderius Erasmus, who is most noted for his satirical attack on the corruption of the Roman Catholic Church, entitled *In Praise of Folly*.

In what terms does Erasmus "praise" human folly? What are the characteristics of satire and how does irony contribute to it?

Luther's call for the reform of the Roman Catholic Church unleashed three centuries of social and political conflict. Luther deplored the concept of indulgences and detested the secular spirit apparent in both Church patronage of lavish decorative programs and the moral laxity of the cardinals in Rome. What are indulgences? The Church charged Luther with heresy, but he continued to publish tracts challenging the authority of the pope.

In Germany, Luther's defense of individual conscience against the authority of the pope seemed to peasants a justification for their own independence from their feudal lords. What resulted from this newfound sense of freedom? Ulrich Zwingli, in Zurich, and John Calvin, in Geneva, followed Luther's lead, both convinced that their respective cities could become models of moral rectitude and Christian piety. What was the rationale for the iconoclasm both championed? How did their approach to Church doctrine differ from Luther's? How was Henry VIII's challenge to papal authority in England more different still?

One of the most important contributors to the Reformation was Johannes Gutenberg's printing press. It made the Bible a best seller. How did the widespread distribution of his texts fuel reformist movements? How did Thomas More take advantage of the medium? But, in England, perhaps the greatest artistic achievement of the era was its drama, particularly the plays of William Shakespeare. In what ways is Shakespeare's character Hamlet unique in the theater of the early seventeenth century? How does he reflect England's taste for portraiture?

The Catholic Church Strikes Back

o movement as radical as the Reformation could take place without a strong reaction from the Roman Catholic Church. The challenge of Protestantism to the moral authority of the pope threatened the Church with downfall, and Rome soon recognized this. Yet the Roman Catholic Church had come to some of the same conclusions about its shortcomings as its Northern critics. In self-defense, therefore, it launched a Counter-Reformation, both to strike back against the fundamental ideas defended by reformists like Luther and to implement reforms of its own.

The Counter-Reformation (see Chapter 10) had the support of clergy and laypeople through newly organized groups such as the Modern Devotion and the Oratory of Divine Love. These groups encouraged a return to the principles of simplicity, ethical living, and piety that Erasmus had championed. The Society of Iesus, known more familiarly as the Jesuits, took a tougher approach. Founded by Ignatius of Loyola in the 1530s, it advocated a return to strict and uncompromising obedience to the authority of the Church and its ecclesiastical hierarchy. The society's Rule 13 sums up its notion of obedience: "I will believe that the white that I see is black if the hierarchical Church so defines it." Then, in 1545, Pope Paul III convened the Council of Trent in order to define Church doctrine and recommend far-reaching reforms in the abuses practiced by the Church, particularly the selling of indulgences.

The Council of Trent, which convened in two more sessions between 1545 and 1563, also decided to counter the Protestant threat "by means of the stories of the mysteries of our Redemption portrayed by paintings or other representations, [so that] the people be instructed and confirmed in the habit of remembering and continually revolving in mind the articles of faith." The arts should be directed, the Council said, toward clarity and realism, in order to increase understanding, and toward emotion, in order to arouse piety and religious fervor. While the Council of Trent generally preached restraint in design, its desire to appeal to the emotions of its audience resulted in increasingly elaborate church architecture, so that the severe simplicity of the Calvinist church (Fig. 8.22), devoid of any art, would seem emotionally empty beside the grand expanse of the Catholic interior (Fig. 8.23). Yet the basic configuration would remain the same. For the next two centuries both churches would vie for the souls of Christians in Europe and the Americas.

Fig. 8.22 Interior of a Calvinist Church. 17th century. German National Museum, Nuremberg,

Fig. 8.23 Gianlorenzo Bernini, Baldacchino. Saint Peter's Basilica, Vatican, Rome. 1624-33. Gilt bronze, marble, stucco, and glass, height approx. 100'.

Encounter and Confrontation

The Impact of Increasing Global Interaction

LEARNING OBJECTIVES

- 9.1 Discuss the cultures that preceded that of the Aztecs in the Americas, and the Spanish reaction to Aztec culture.
- 9.2 Describe the impact of the Portuguese on African life and the kinds of ritual traditions that have contributed to the cultural survival of African communities after contact.
- 9.3 Outline the ways in which contact with Europe affected Mogul India.
- 9.4 Assess the impact of contact with the wider world on China and the ways in which the arts reflect the values of the Chinese state.
- 9.5 Explain the tension between spiritual and military life in Japanese culture and the importance of patronage in Japanese cultural life.

n 1519-21, the Aztec empire of Mexico was conquered by the Spanish conquistador ("conqueror") Hernán Cortés (1485-1547) and his army of 600 men through a combination of military technology (gunpowder, cannon, and muskets), disease inadvertently introduced by his troops, and a series of lies and violations of trust. The Aztecs possessed neither guns nor horses, nor much in the way of clothing or armor, all of which made them appear if not uncivilized, then completely vulnerable. They were also vulnerable because other native populations in Mexico deeply resented the fact that the Aztecs regularly raided their villages to obtain victims for blood sacrifice. According to Aztec legend, at the time of their exile from Tula, the supreme spiritual leadership of the culture was assumed by the bloodthirsty Huitzilopochtli, the god of war, who had emerged fully grown from the womb of his mother Coatlicue, the earth goddess, wielding his weapon, the Fire Serpent, Xiuhcoatl. A sculpture depicting Coatlicue may have originally stood in the temple to Huitzilopochtli at the Aztec capital of Tenochtitlán atop the giant temple at the heart of the city, the Templo Mayor (Fig. 9.1).

Her head is composed of two fanged serpents, symbolizing two rivers of blood flowing from her decapitated torso. She wears a necklace of human ears, severed hands, and, at the bottom, a human skull. Her skirt is made of interwoven serpents which, to the Aztecs, represent both childbirth and blood—that is, fertility and decapitation.

Huitzilopochtli was born full-grown out of Coatlicue of necessity. Coatlicue was also mother of Coyolxauhqui, the Moon, and one day, while she was sweeping her temple on top of Coatepec hill, symbolically represented in Tenochtit-lán by the Templo Mayor, she had been miraculously impregnated with Huitzilopochtli by a ball of feathers that floated down from the sky. Coyolxauhqui viewed the pregnancy of her mother as an affront, and she conspired to kill Coatlicue. At that moment, Huitzilopochtli was born. He decapitated his treacherous sister, and cast her down from the top of Coatepec hill. At each tumble of her fall, she was further dismembered. This is the Aztec explanation for the phases of the moon. As, the moon wanes each month, more and more of it disappears.

Fig. 9.1 Coatlicue, Aztec. 15th century. Basalt, height 8'3". National Museum of Anthropology, Mexico City. Coatlicue is represented as headless because, as legend has it, she was decapitated at the beginning of the present creation.

Fig. 9.2 Aztec, *The Moon Goddess Coyolxauhqui*, from the Sacred Precinct, Templo Mayor, Tenochtitlán. ca. 1469. Stone, diameter 10'11". Museo Templo Mayor, Mexico City. The sculpture was found lying at the base of the Templo Mayor, as if cast down by Huitzilopochtli.

A giant disk, over 10 feet across, found at the base of the Templo Mayor depicts the goddess (Fig. 9.2) decapitated, arms and legs dismembered. She is adorned with a two-headed serpent belt bearing a skull, like the necklace of her mother, Coatlicue, in Fig. 9.1. Her torso, with flaccid breasts, is shown frontally. Issuing from her mouth is what appears to be her last breath. Thus victorious over the moon, Huitzilo-pochtli ordered the Aztec priests to search for a cactus with a great eagle perched upon it and there establish a city in his name. They soon found the place on the shores of Lake Texcoco. The cactus bore red fruit in the shape of the hearts that Huitzilopochtli devoured, and the eagle was the symbol of the god himself. The Aztecs proceeded to build their great city, Tenochtitlán, "the place of the prickly pear cactus."

Anthropological evidence suggests that just before Cortés's birth, in about 1450, the Aztecs, in their thirst for blood sacrifice, had wiped out the entire population of Casas Grandes, near present-day Chihuahua in northern Mexico, a trading center containing over 2,000 pueblo apartments. Given such Aztec behavior, other tribes were willing to cooperate with Cortés. Cortés also had the advantage of superior weaponry, and he quickly realized that he could exploit the Aztecs' many vulnerabilities. One of the most important documents of the Spanish conquest, the 1581 History of the Indies of New Spain, by Diego de Durán, depicts Cortés's technological superiority (Fig. 9.3). Durán was a Dominican priest fluent in Nahuatl, the Aztec language. His History is the product of extensive interviews and conversations with the Aztecs themselves. It represents a concerted effort to preserve Aztec culture, recounting Aztec history from its creation story through the Spanish conquest. In this illustration, a well-armed force led by

Pedro de Alvarado, one of Cortés's generals, confronts the Aztec military orders of the Eagle and the Jaguar. The Spanish wear armor and fight with crossbows and firearms, while the Aztecs have only spears.

Despite their technological superiority, Alvarado's men were in some jeopardy. Alvarado was besieged by Aztecs angry at the slaughter of hundreds of their kin during the Fiesta of Toxcatl, staged to impress their Spanish visitors. The massacre by the Spaniards is illustrated in Durán's History (Fig. 9.4). Throughout these events, the Aztec king Motecuhzoma (formerly spelled Montezuma) had remained a prisoner of the Spanish forces. Cortés had pledged his friendship, but once he had been admitted into Tenochtitlán itself, he imprisoned Motecuhzoma. The Spanish conquistador had learned of an Aztec myth concerning Quetzalcóatl, the Feathered Serpent, who was widely worshiped throughout Mexico. In this myth, Quetzalcóatl was dethroned by his evil brother, Tezcatlipoca, god of war, and fled to the Gulf of Mexico, where he burst into flames and ascended to the heavens, becoming the Morning Star, Venus. In yet another version, he sailed away across the sea on a raft of serpents, promising to return one day. It was reputed that Quetzalcóatl was fair-skinned and bearded. Evidently, Motecuhzoma believed that Cortés was the returning Ouetzalcóatl and welcomed him without resistance. Within two years, Cortés's army had crushed Motecuhzoma's people in

Figs. 9.3 and 9.4 (top) Aztecs confront the Spaniards; and (bottom) the Spanish massacre Aztec nobles in the temple courtyard. Both from Diego de Durán's *History of the Indies of New Spain.* 1581. Biblioteca Nacional, Madrid. Durán's work was roundly criticized during his lifetime for helping the "heathen" Aztecs to maintain their culture.

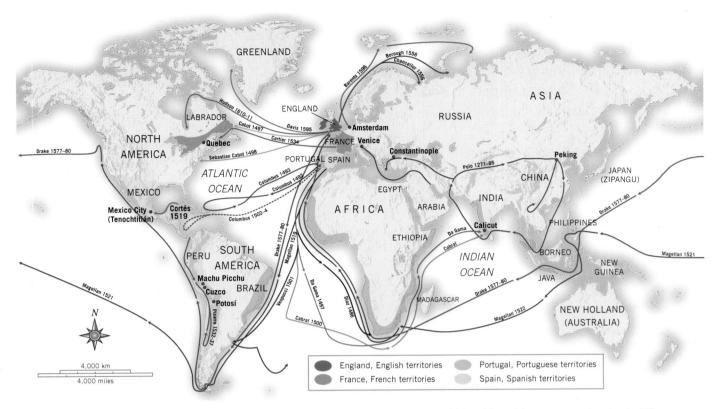

Map 9.1 World exploration. 1486–1611. Note Marco Polo's overland route to China in 1271 to 1295, which anticipated the great sea explorations by 200 years.

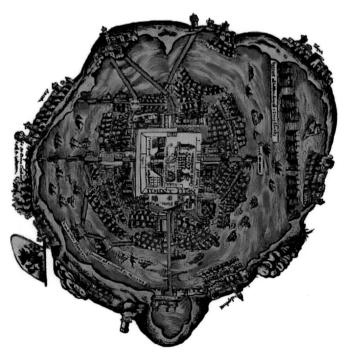

Fig. 9.5 Plan of Tenochtitlán, from Cortés's first letter to the king of Spain. 1521. Bernal Díaz, one of Cortés's conquistadors, compared the plan of Tenochtitlán to Venice. Set in the middle of Lake Texcoco, it was crisscrossed by canals. In the center of the island is the Templo Mayor.

the name of Spain. Of the 20 to 25 million inhabitants of Mexico at that time, only about 2 million survived—the remainder were wiped out by war and disease. Their beautiful capital, Tenochtitlán, surrounded by the waters of Lake Texcoco (Fig. 9.5), would be quickly transformed into the capital of New Spain, its Templo Mayor reduced to rubble.

The imperial adventuring of Cortés in the Americas was mirrored around the globe, as Europeans sought to establish their power not only in the Americas, but also in Africa, India, China, and Japan. This chapter considers the cultures of the Americas, Africa, India, China, and Japan in this period, and considers how Europe transformed these cultures as it explored the world (Map 9.1) and was itself transformed by contact with them. But European contact was not the only interaction these cultures experienced in the era. They also had an impact on one another. From a Western perspective, these cultures represented a wider world with Europe at its center. But from the point of view of these cultures, Europe represented the periphery, a cultural force invading their own centers of culture from the outside.

THE SPANISH IN THE AMERICAS

What are some of the cultures that preceded the arrival of the Spanish in the Americas and how did the Spanish impact the indigenous cultures they found there?

When Cortés entered the Aztec island capital of Tenochtitlán (see Fig. 9.5), more than 200,000 people lived there. Gold-laden temples towered above the city. Gardens rich in flowers and fruit, and markets with every available commodity dominated the city itself; Bernal Díaz (1492–1584), one of Cortés's conquistadors, would later recall the sight (Reading 9.1):

READING 9.1

from Bernal Díaz, *True History of the Conquest of New Spain* (ca. 1568; published 1632)

We were astounded.... These buildings rising from the water, all made of stone, seemed like an enchanted vision.... Indeed some of our soldiers asked whether it was not all a dream.... It was all so wonderful that I do not know how to describe this first glimpse of things never heard of, seen, or dreamed of before....

Let us begin with the dealers in gold, silver, and precious stones, feathers, cloaks, and embroidered goods, and male and female slaves who are also sold there. . . . Next there were those who sold coarser cloth, and cotton goods and fabrics made of twisted threads, and there were chocolate merchants with their chocolate. In this way you could see every kind of merchandise to be found anywhere in New Spain. . . . We were astounded at the great number of people and the quantities of merchandise, and at the orderliness and good arrangements that prevailed.

What most astonished Cortés himself, as it had Díaz, was that Aztec civilization was as sophisticated as his own. "So as not to tire Your Highness with the description of things of this city," Cortés wrote Queen Isabella of Spain, "I will say only that these people live almost like those in Spain, and in as much harmony and order as there, and considering that they are barbarous and so far from the knowledge of God and cut off from all civilized nations, it is truly remarkable to see what they have achieved in all things." This inclination to see a thriving civilization as uncivilized because it is unlike one's own is typical of the attitude of Westerners toward the peoples with whom they came into contact in the Age of Encounter. Other peoples were exactly that—the "Other"—a separate category of being that freed Western colonizers from any obligation to identify these peoples as equal, or even similar, to themselves.

The Americas before Contact

Great cultures had, in fact, developed in the Americas before the arrival of the Spanish. In the arid north of present-day Mexico, a somewhat mysterious but enormously influential civilization centered at Teotihuacán flourished. By the fourth century CE, it was a center of culture comparable in size and influence to Constantinople. In Mesoamerica, comprising present-day Honduras, Guatemala, Belize, and southern Mexico, between 250 and 900 CE the Maya established vast palace complexes that were both the administrative and religious centers of their culture.

These cultures were themselves preceded by others. As early as 1300 BCE, a pre-literary group known as the Olmec came to inhabit the area between Veracruz and Tabasco on the southern coast of the Gulf of Mexico, where they built huge ceremonial precincts in the middle of their communities. In these precincts, they erected giant pyramidal mounds, where an elite group of ruler-priests lived. These pyramids may have been an architectural reference to the volcanoes that dominate Mexico, or they may have been tombs. Excavations may eventually tell us. At La Venta, very near the present-day city of Villahermosa, three colossal stone heads stood guard over the ceremonial center on the south end of the platform (Fig. 9.6), and a fourth guarded the north end by itself. Each head weighs between 11 and 24 tons, and each bears a unique

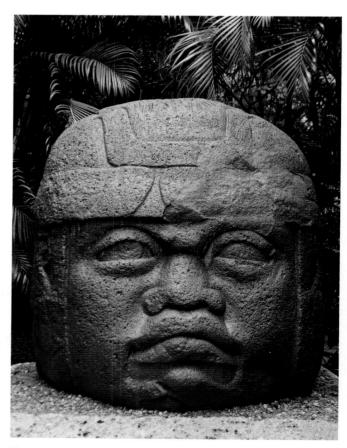

Fig. 9.6 Colossal head, La Venta, Mexico, Olmec culture. ca. 900–500 BCE. Basalt, height 7'5". La Venta Park, Villahermosa, Tabasco, Mexico. The stone heads are generally believed to be portraits of Olmec rulers, and they all share the same facial features, including wide, flat noses and thick lips. They suggest that the ruler was the culture's principal mediator with the gods, literally larger than life.

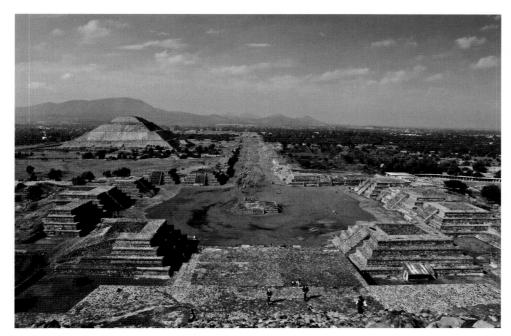

Fig. 9.7 Teotihuacán, Mexico, as seen from the Pyramid of the Moon, looking south down the Avenue of the Dead, the Pyramid of the Sun at the left. ca. 350-650 cs. One of the largest cities in the world by the middle of the first millennium, Teotihuacán covered an area of nearly 9 square miles.

emblem on its headgear, which is similar to old-style American leather football helmets. The heads are carved of basalt, although the nearest basalt quarry is 50 miles to the south in the Tuxtla Mountains. They were evidently at least partially carved at the guarry, then loaded onto rafts and floated downriver to the Gulf of Mexico before going back upriver to their

final resting places. Many of the characteristic features of later Mesoamerican culture, such as pyramids, ball courts, mirror-making, and the calendar system, probably originated with the Olmec.

Teotihuacán Certainly the sense of colossal scale is found again and again throughout Pre-Columbian culture in Mesoamerica. The city of Teotihuacán, for instance, is laid out in a grid system, the basic unit of which is 614 square feet, and every detail is subjected to this scheme, conveying a sense of power and mastery. A great broad avenue, known as the Avenue of the Dead, runs through the city (Figs. 9.7 and 9.8). It links two great pyramids, the Pyramids of the Moon and the Sun, each surrounded by about 600 smaller pyramids, 500 workshops, numerous plazas, 2,000 apartment complexes,

and a giant market area. The Pyramid of the Sun is oriented to mark the passage of the sun from east to west and the rising of the stellar constellation the Pleiades on the days of the equinox. Each of its two staircases contains 182 steps, which, when the platform at its apex is added, together total 365. The pyramid is thus an image of time. This representation of the solar calendar is echoed in another pyramid at Teotihuacán, the Temple of Quetzalcóatl, which is decorated with 364 serpent fangs.

At its height, in about 500 CE, about 200,000 people lived in Teotihuacán, making it one of the largest cities in the world. Scholars believe that a female deity, associated with the moon, as well as cave and mountain rituals played an important role in Teotihuacán culture. The placement of the Pyramid of the Moon, in front of the

dead volcano Cerro Gordo (see Fig. 9.7), supports this theory. It is as if the mountain, seen from a vantage point looking north up the Avenue of the Dead, embraces the pyramid in its flanks. And the pyramid, in turn, seems to channel the forces of nature—the water abundant on the mountain, in particular—into the heart of the city.

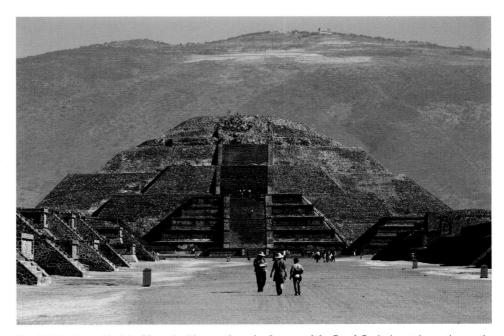

Fig. 9.8 The Pyramid of the Moon, looking north up the Avenue of the Dead. Beginning at the southern end of the city, and culminating at the Pyramid of the Moon, the Avenue of the Dead is 21/2 miles long.

Mayan Culture To the south, another culture, that of the Maya, both predated and postdated that of Teotihuacán. The Maya occupied several regions: the highlands of Chiapas and Guatemala; the southern lowlands of Guatemala, Honduras, El Salvador, Belize, and the Mexican states of Chiapas; and the northern lowlands in the states of Yucatan, Campeche, and Quintano Roo. These were never unified into a single political entity, but rather consisted of many small kingdoms that engaged in warfare with one another over land and resources.

An elaborate calendar system enabled them to keep track of their history—and, evidence suggests, predict the future. It consisted of two interlocking ways of recording time, a 260-day calendar and a 365-day calendar. The 260-day calendar probably derives from the length of human gestation, from a pregnant woman's first missed menstrual period to birth. When both calendars were synchronized, it took exactly 52 years of 365 days for a given day to repeat itself—the

so-called *calendar round*—and the end of each cycle was widely celebrated.

The Mayan calendar was put to many uses. An example is the Madrid Codex (Fig. 9.9), one of the four surviving Mayan codices. It consists of 56 stucco-coated bark-paper leaves, painted, with the exception of one page, on both sides. Over 250 separate "almanacs" that place events of both a sacred and secular nature within the 260-day Mesoamerican ritual calendar fill its pages. It records events concerning particularly the activities of daily life (planting, tending crops, the harvest, weaving, and hunting), rituals, astronomic events, offerings, and deities associated with them. The four horizontal rows in the lower half of each panel are composed of the glyphs of the 20 named days recycling thirteen times. Sky serpents who send the rain and speak in thunder are shown weaving around the rows of glyphs. In the shorter top two leaves, standard numerology can be seen. The Mayans wrote numbers in two ways: as a system of dots and bars, seen here,

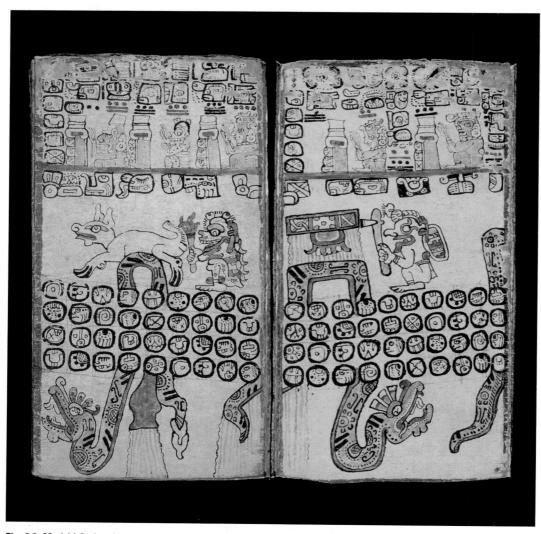

Fig. 9.9 Madrid Codex, leaves 13–16. ca. 1400. Amatl paper, 56 leaves, painted on both sides and screenprinted. Museo de América, Madrid. Diviners would have used this text to predict events such as flood, drought, or an abundant harvest.

and in a set of pictorial variants. Twenty was expressed with a glyph of the moon, and zero with a shell glyph. Zero, incidentally, was used widely in Mesoamerica many centuries before Hindu mathematicians "discovered" it in India.

Among the most important Mayan cities is Palenque, one of the bestpreserved of all Mayan sites. Lost in the jungle for centuries following its decline, which occurred around the year 850, Palenque was rediscovered in 1746 by a Spanish priest who had heard rumors of its existence. The Temple of Inscriptions, facing into the main courtyard of the so-called Palace, which may have been an administrative center rather than a royal residence, rises in nine steps, representing the nine levels of the Mayan Underworld (Fig. 9.10). It is inscribed with the history of the Palenque kings, who were associated with the jaguar. The first recorded king is K'uk B'alam, "Quetzal Jaguar," who, so the inscriptions say, founded the city on March 11, 431. Palenque's most powerful king was K'inich Janaab' Pakal I (Great Sun Shield), known as Pakal (603-83), who ruled for 67 years, and the Temple of Inscriptions was erected over his grave.

In 1952, Alberto Ruz, a Mexican archeologist, discovered the entrance to the tomb of Lord Pakal under the pyramid. It was hidden under large stone slabs in the floor of the temple at the top

of the pyramid. Ruz had to clear the passage down to Pakal's tomb, at the very base of the structure, which had been back-filled with stone debris. When he reached the tomb, he found that Pakal's face was covered with a jade death mask. A small tube connected the tomb with the upper level, thus providing the dead king with an eternal source of fresh air. It also functioned as a form of communication between the living and the ancestor. Pakal was buried in a large uterus-shaped stone sarcophagus weighing over five tons and covered with jade and cinnabar.

By 900 CE, the Mayan culture from which the Aztec eventually emerged had collapsed as a result of a wide variety of events, including overpopulation and accompanying ecological degradation, political competition, and war. Its peoples, who survive in large numbers to this day, returned to simple farming around the ruins of their once-great cities. But, after contact, it seemed paramount to the Spanish crown to begin to raise the native population from its "barbarous" condition by bringing Christianity to it. The Spanish essentially obliterated the traditions of the Native American cultures they encountered, burning all their books, destroying

Fig. 9.10 "Palace" (foreground) and Temple of Inscriptions (tomb pyramid of Lord Pakal),
Palenque, Mexico. Maya culture. 600–900 cs. These two buildings, along with two other temples not
seen in this view, formed the central complex of Palenque. Another complex to the north is composed of five
temples and a ball court, and a third group of temples lies to the south. Palenque was the center of a territory
that may have been populated by as many as 100,000 people.

almost every record of their history that they could lay their hands on, and crippling for all time our ability ever to piece together an adequate picture of their culture. Churches were quickly built in Mexico City. And as the Church sought to convert native populations to the Catholic faith, the musical liturgy became a powerful tool. As early as 1523, Spanish monks created a school for Native Americans in Texcoco, Mexico (just east of Mexico City), and began teaching music, including Gregorian chant, the principles of polyphony, and composition, on an imported organ. Throughout the sixteenth century, missionaries used music, dance, and religious dramas to attract and convert the indigenous population to Christianity. A syncretic culture quickly developed, in which European styles were nativized, and native culture was Christianized.

The Spanish in Peru

An interesting example of the Spanish Christianization of native culture is one of the most elaborately decorated of all Inca sites, the Coricancha (literally, "the corral of gold"), the

Fig. 9.11 Original Inca stone wall of the Coricancha with a Dominican monastery rising above it, Cuzco, Peru. Inca culture. The extraordinary skill of Inca masons is evident in this surviving granite wall, which was made with stone tools and without mortar, and that has, for centuries, withstood earthquakes that have destroyed many later structures.

Inca Temple of the Sun facing the main plaza of Cuzco, the traditional capital of the Inca empire (Fig. 9.11). Dedicated to Inti, the sun god, the original temple was decorated with 700 sheets of gold studded with emeralds and turquoise and designed to reflect the sunlight admitted through its windows. Its courtyard was filled with golden statuary—"stalks of corn that were of gold—stalks, leaves, and ears," the Spanish chronicler Pedro de Cieza de León reported in the mid-sixteenth century. "Aside from this," he continued, there were "more than twenty sheep [llamas] of gold with their lambs and the shepherds who guarded them, all of this metal."

Spain conquered Peru in 1533 through the exploits of Francisco Pizarro (1474-1541) with an army of only 180 men. Pizarro's military strategy was aided by simple deceit. He captured the Inca emperor, Atahuallpa, who offered Pizarro a ransom of 13,420 pounds of gold and 26,000 pounds of silver. Pizarro accepted the ransom and then executed the unsuspecting emperor. He next proceeded to plunder Peru of the gold and silver artifacts that were part of its religious worship of the sun (gold) and moon (silver), including the massive decorations at the Temple of the Sun in Cuzco. In addition, Spanish priests quickly adopted the foundations of the temple to their own purposes, constructing a Dominican church and monastery on the original Inca foundations. The Inca traditionally gathered to worship at the circular wall of the Coricancha, and thus the apse of Santo Domingo was purposefully constructed above it to emphasize Christian control of the native site.

Still, whatever the missionary zeal of the Spanish, the acquisition of gold, silver, and other treasure was a major motivation for their colonial enterprise. Great masses of treasure were sent home from the New World. When the first

Royal Fifth (that is, one-fifth of the treasures collected by Cortés and earmarked by contract for the king) arrived in Brussels, the German artist Albrecht Dürer was present:

I saw the things which were brought to the King from the New Golden Land: a sun entirely of gold, a whole fathom [6 feet] broad: likewise, a moon, entirely of silver, just as big; likewise, sundry curiosities from their weapons, armor, and missiles; very odd clothing, bedding, and all sorts of strange articles for human use, all of which is fairer to see than marvels. These things were all so precious that they were valued at a hundred thousand guilders. But I have never seen in all my days that which so rejoiced my heart, as these things. For I saw among them amazing artistic objects, and I marveled over the subtle ingenuity of the men in these distant lands. Indeed I cannot say enough about the things which were there before me.

Accounts like this helped to give rise to the belief in an entire city of gold, El Dorado, which continued to elude the grasp of the conquistadors under royal order who followed in Pizarro's footsteps in Peru, often with unhappy results. The treasures of gold and silver that were brought back would be melted down for currency, far more important than their artistic value to the warring Spanish monarchy. In fact, almost no gold or silver objects survive from the conquest.

WEST AFRICAN CULTURE AND THE PORTUGUESE

What impact did the Portuguese have on West African life, and how did ritual serve to preserve traditional culture?

Portugal was as active as Spain in seeking trading opportunities through navigation, but focused on Africa and the East instead of the Americas. In 1488, Bartholomeu Dias (ca. 1450–1500), investigating the coast of West Africa (Map 9.2), was blown far south by a sudden storm, and turning northeast, found that he had rounded what would later be called the Cape of Good Hope and entered the Indian Ocean. Following Dias, Vasco da Gama (ca. 1460–1524) sailed around the cape with four ships in 1497 and reached Calicut, India, 10 months and 14 days after leaving Lisbon. Then, in 1500, Pedro Cabral (ca. 1467–ca. 1520), seeking to repeat da Gama's voyage to India, set out from the bulge of Africa. Sailing too far westward, he landed in what is now Brazil, where he claimed the territory for Portugal.

The Indigenous Cultures of West Africa

When the Portuguese arrived, somewhat to their surprise they discovered that thriving cultures had long since established themselves. Several large kingdoms dominated the western African region known as the Sahel, the grasslands that serve as a transition between the Sahara desert and the more temperate zones to the west and south. Among the most important is the kingdom of Mali, discussed in Chapter 4, which shows the great influence Islam had come to have on much of North Africa long before the end of the first millennium CE. Farther south, along the western coast of central Africa, were the powerful Yoruba state of Ife and the kingdom of Benin.

Fig. 9.12 Head of an *Oni* (King). Ife culture, Nigeria. ca. 13th century. Brass, height 117/6". Museum of Ife Antiquities, Ife, Nigeria. The metal used to cast this head is an alloy of copper and zinc, and therefore not technically bronze, but brass.

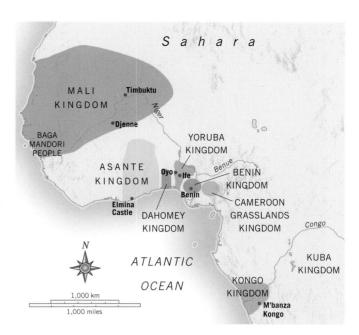

Map 9.2 Sub-Saharan West Africa, 1200–1700. While Muslim traders had extensive knowledge of North Africa, little was known of sub-Saharan Africa before the Portuguese explorations of the fifteenth and sixteenth centuries.

Ife Culture The Ife culture is one of the oldest in West Africa. It developed beginning around the eighth century along the Niger River, in what is now Nigeria. It was centered in the city of Ife. By 1100, it was producing highly naturalistic, sculptural commemorative portraits in clay and stone, probably depicting its rulers, and not long after, elegant brass sculptures as well.

An example of Ife brasswork is the *Head of an Oni* (or *King*) (Fig. 9.12). The parallel lines that run down the face represent decorative effects made by scarring—scarification. A hole in the lower neck suggests that the head may have been attached to a wooden mannequin, and in memorial services, the mannequin may have worn the royal robes of the Ife court. Small holes along the scalp line suggest that hair, or perhaps a veil of some sort, also adorned the head. But the head itself was, for the Ife, of supreme importance. It was the home of the spirit, the symbol of the king's capacity to organize the world and to prosper. Ife culture depended on its kings' heads for its own welfare. Since the Ife did not leave a written record of their cultural beliefs, we can best understand their ancient culture by looking at their contemporary descendants.

The Yoruba people, whose population today is about 11 million, trace their ancestry directly to Ife culture. The Yoruba cosmos consists of the world of the living (aye) and the realm of the gods (orun). The gods are themselves called orisha and among them are the primordial deities, who created the world, as well as forces of nature, such as thunder and lightning, and ancestral heroes who have risen to immortality. Linking these two worlds is the king, who serves as

Fig. 9.13 *Ade*, or beaded crown, Yoruba culture, Nigeria. Late **20th century.** Beadwork, height 6'1½". © The Trustees of the British Museum. Today, approximately 50 Yoruba rulers wear beaded crowns and claim descent from King Oduduwa.

the representative in this world of those existing in *orun*. The king's head is thus sacred, and his crown, or *ade* (Fig. 9.13), rising high above his head, symbolizes his majesty and authority. Rows of beads fall over his face to shield viewers from the power of his gaze. Imagery on the crown varies, but often refers to Ife myths of origin, similar to myths of origin found throughout the world (see Chapter 1). The first Yoruba king, Oduduwa, from whom all subsequent kings descend, is frequently represented. According to legend, Oduduwa was ordered to create a land mass out of the watery reaches of

earth so that it might be populated by people. Oduduwa lowered himself down onto the waters, the legend continues, and emptied earth from a small snail shell onto the water. He then placed a chicken on the sand to spread it and make land. Finally he planted some palm kernels. It was at Ife that he did this, and Ife remains the most sacred of Yoruba sites.

Benin Culture Sometime around 1170, the city-state of Benin, some 150 miles southeast of Ife, also in the Niger basin, asked the *oni* of Ife to provide a new ruler for their territory, which was, legend has it, plagued by misrule and disorder. The *oni* sent Prince Oranmiyan, who founded a new dynasty. Oranmiyan was apparently so vexed by the conditions he found that he named his new state *ibini*, "land of vexation," from which the name Benin derives. After some years, Oranmiyan returned home, but not until after he had impregnated the Benin princess. Their son Eweka would become the first king, or *oba*, as the Benin culture called their ruler, ruling from 1180 to 1246.

Already in place at the capital, Benin City, were the beginnings of a massive system of walls and moats that would become, by the fifteenth century, the world's largest manmade earthwork. According to archeologist Patrick Darling, who has studied the wall and moat system for several decades, they total some 10,000 miles in length, or some four to five times the length of the main Great Wall of China. These earthworks consist of moats, the dirt from which was piled alongside them to make walls up to 60 feet high. They were probably first dug more than a thousand years ago to protect settlements and their farmlands from the nocturnal raids of the forest elephant. But as Benin grew, linear earth boundaries demarcated clan or family territories and symbolically signified the boundary between the real, physical world and the spirit world. When the British arrived in the late nineteenth century, the walls were still largely intact (Fig. 9.14), but they were soon destroyed by British forces, and what remains of them has been increasingly consumed by modern urbanization.

Like the Ife to the north, the Benin rulers also created lifelike images of their ancestor rulers. In the first half of the twentieth century, recognizing that many of the oral traditions of Benin culture were in danger of being lost, the Benin court historian, Chief Jacob Eghaverba (1893–1981), recorded as many traditional tales and historical narratives as he could find and published them in his *Short History of Benin*. This is his account of the origins of the casting of brass oba heads in Benin culture (Reading 9.2):

READING 9.2

from Jacob Eghaverba, A Short History of Benin

Oba Oguola [r. 1274–87] wished to introduce brass casting into Benin so as to produce works of art similar to those sent him from Ife. He therefore sent to the Oni of Ife for a brass-smith and Iguegha was sent to him. Iguegha was very clever and left many designs to his successors, and

Fig. 9.14 Drawing of Benin City as it appeared to an unknown British officer in 1891. This drawing represents a small portion of the more than 2,500 square miles of walls and moats that made up Benin City in the nineteenth century.

was in consequence deified, and is worshiped to this day by brass-smiths. The practice of making brass-castings for the preservation of the records of events was originated during the reign of Oguola.

The artists, members of the royal casters' guild, lived in their own quarters just outside the palace in Benin, where they are located to this day. Only the *oba* could order brasswork from them. These commissions were usually memorial heads, commemorating the king's royal ancestors in royal costume (Fig. 9.15). (The head shown in Fig. 9.15 was made in the mid-sixteenth century, but heads like it were made in the earliest years of bronze production in the culture.) As in Ife culture, the *oba*'s head was the home of the spirit and the symbol of the *oba*'s capacity to organize the world and to prosper.

This power could be described and commemorated in an oral form known as a **praise poem**. Praise poems are a major part of West African culture. By praising something—a king, a god, a river—the poet was believed to gain influence over it. Almost everyone in West African culture has praise poems associated with them. These poems often use a poetic device known as **anaphora**, a repetition of words and phrases at the beginning of successive sentences that, owing to the particularities of the West African languages, is almost impossible to duplicate in translation. But the poems are intended to create a powerful and insistent rhythm that forms a crescendo.

West African Music The rhythm-driven crescendo of the Benin praise poem shares much with African music as a whole. In fact, the poem may have been accompanied by music. African music is part of the fabric of everyday life,

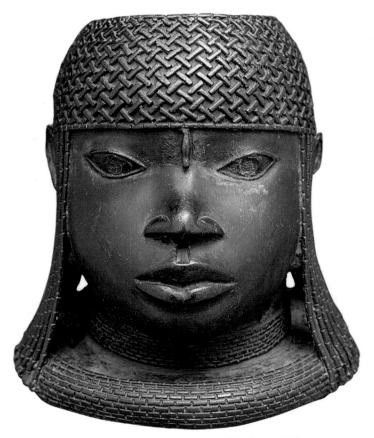

Fig. 9.15 Head of an *Oba.* **Nigeria; Edo, Court of Benin. ca. 1550.** Brass, 9¼" × 95%" × 9". The Metropolitan Museum of Art, New York. Such heads were usually commissioned upon the death of an *oba* by his successor, so that the deceased leader might continue to influence his community.

accompanying work, poetry, ceremony, and dance, and often evoked by visual art. The Western idea that music can be isolated from everyday experience is almost incomprehensible to the African sensibility. Typically consisting of a single line of melody without harmony, African music is generally communal in nature, encouraging a sense of social cohesion by promoting group activity. As a result, one of the most universal musical forms throughout Africa is **call-and-response** music, in which a caller, or soloist, raises the song, and the community chorus responds to it.

Call-and-response music is by no means simple. The Yoruba language, for instance, is tone-based; any Yoruba syllable has three possible tones, and this tone determines its meaning. The Yoruba reproduce their speech in the method of musical signaling known as talking drums (track 9.1), performed with three types of batá drum, which imitate the three tones of the language. In ritual drumming, the drums are played for the Yoruba gods and are essentially praise poems to those gods. Characteristic of this music is its polyrhythmic structure. As many as five to ten different "voices" of interpenetrating rhythms and tones, often repeated over and over again in a call-andresponse form, play off against one another. This method of playing against or "off" the main beat is typical of West African music and exists to this day in the "off-beat" practices of Western jazz.

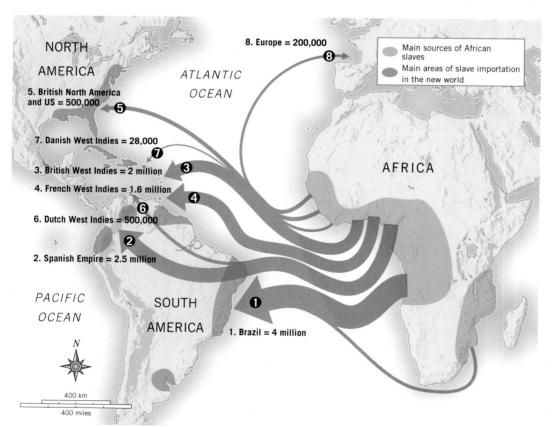

Map 9.3 Transatlantic Slave Trade, 1450–1870. These numbers are approximate, and subject to much scholarly debate.

Portugal and the Slave Trade

After Bartholomeu Dias's exploration of the west coast of Africa, it did not take long for European and African traders to extend existing practices of human exploitation that were common on both continents. This trade in human labor would eventually take on a scope and dimension not previously seen. The Portuguese exploitation of African labor was financed principally by a Florentine banker together with a group of other financiers from Genoa. Over the course of four centuries, the Portuguese transported millions of Africans across the Atlantic on the Middle Passage, so named because it formed the base of a triangular trade system: Europe to Africa, Africa to the Americas (the Middle Passage), and the Americas to Europe. No one can say with certainty just how many slaves made the crossing, although estimates range between 15 and 20 million (Map 9.3). Part of the problem is the unknown numbers who died of disease and harsh conditions during the voyage. For instance, in 1717, a ship reached Buenos Aires with only 98 survivors of an original 594 slaves. Such figures were probably not unusual.

For a while, at least, the Portuguese enjoyed a certain status in Benin as divine visitors from the watery world, the realm of Olokun, god of the sea. They were considered to be the equivalent of the mudfish, because they could both "swim" (in their boats) and walk on land. The mudfish was sacred to the people of Benin, who saw it as a symbol of both

transformation and power. (It lies dormant all summer on dry mudflats until fall when the rains come and it is "reborn.") (The fish is a symbol of power because it can deliver strong electric shocks and possesses fatal spines.) Likewise, the Portuguese seemed to be born of the sea and possessed fatal "spines" of their own—rifles and musketry.

An example of this association of the mudfish with the Portuguese is a decorative design that forms the tiara of an ivory mask worn as a hip pendant by the oba Esigie (r. 1504-50) (Figs. 9.16 and 9.17). (An oba is the supreme traditional head of a Yoruba town.) The pendant probably depicts the queen mother (that is, the oba's mother), or iyoba. Esigie's mother was named Idia, and she was the first

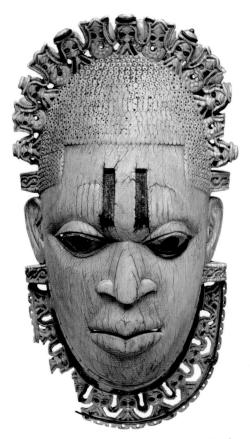

Fig. 9.16 Mask of an *iyoba* (queen mother), probably Idia, Court of Benin, Nigeria. ca. 1550. Ivory, iron, and copper, height 93/6". The Metropolitan Museum of Art, New York. The Michael C. Rockefeller Memorial Collection, Gift of Nelson A. Rockefeller, 1972. (1978.412.323). The scarification lines on the forehead were originally inlaid with iron, and so were its pupils, both forehead and pupils being symbols of strength.

Fig. 9.17 Symbol of a coiled mudfish. Found throughout the art of Benin and in the tiara worn by the *iyoba* in Fig. 9.16.

woman to hold officially the position of *iyoba*. Apparently, when the neighboring Igala people of lower Niger threatened to conquer the Benin, Idia raised an army and by using magical powers helped Esigie to defeat the Igala army. Part of her magic may have been the enlistment of Portuguese help. In acknowledgment of the Portuguese aid, the *iyoba*'s collar bears decorative images of bearded Portuguese sailors and alternating sailors and mudfish at the top of her tiara.

The impact of the Portuguese merchants, and of the Catholic missionaries who followed them, was not transforming,

although it was undeniable and at times devastating. The Benin culture has remained more or less intact since the time of encounter. Today, for instance, during rituals and ceremonies, the *oba* wears at his waist five or six replicas of masks such as the *iyoba*'s, as well as the traditional coral-bead headdress. Oral traditions, like the praise poem, remain in place, despite attempts by Western priests to suppress them. If anything, it has been the last 50 years that have most dramatically transformed the cultures of Africa. But it was the institution of slavery, long practiced in Africa and the Middle East and by the Yoruba of Ife (their founding city) and the Benin peoples, that had the most dramatic impact on Portuguese and Western culture.

At first Benin had traded gold, ivory, rubber, and other forest products for beads and, particularly, brass. The standard medium of exchange was a horseshoe-shaped copper or brass object called a *manilla*, five of which appear in an early sixteenth-century Benin plaque portraying a Portuguese warrior (Fig. 9.18). Such metal plaques decorated the palace and royal altar area particularly, and here the soldier brings with him the very material out of which the plaque is made. If his weapons—trident and sword—suggest his power, it is a power in the service of the Benin king, at least from the Benin point of view.

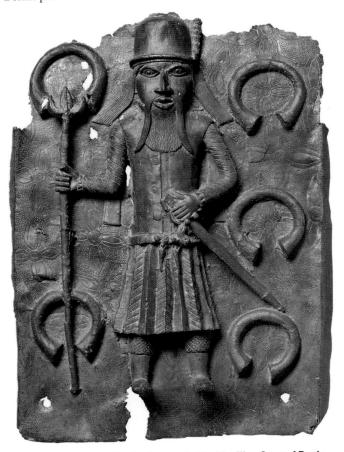

Fig. 9.18 Portuguese Warrior Surrounded by Manillas, Court of Benin, Nigeria. 16th century. Bronze, 18" × 13" × 3". Weltmuseum, Vienna. Notice the background of the bronze, which is incised with images of jungle flowers.

The Portuguese also picked up thousands of small objects—amulets, trinkets, and so on—that they termed fetisso, a sixteenth-century Afro-Portuguese pidgin word from which derives our word fetish, signifying an object believed to have magical powers similar to those of Western objects such as rosaries or reliquaries. But eventually the trade turned to slaves. Africans had long been selling slaves, the victims of war with neighboring territories, to Muslim traders. But the Portuguese dramatically expanded the practice. At the start of the era, around 1492, there were an estimated 140,00 to 170,000 African slaves in Europe, but in about 1551, the Portuguese began shipping thousands more slaves to Brazil to work in the sugar plantations. War captives proved an insufficient source of bodies, and the Portuguese took whomever they could get their hands on. Furthermore, they treated these slaves much more harshly than the Muslims had. They chained them, branded them, and often literally worked them to death. In short, the Portuguese inaugurated a practice of cultural hegemony (cultural domination) that set the stage for the racist exploitation that has haunted the Western world ever since.

Strategies of Survival Almost all African cultures emphasized the well-being of the group over the individual, a conviction invoked, guaranteed, and celebrated by the masked dance. In the face of European challenges to the integrity of African cultures, dance became an especially important vehicle in maintaining cultural continuity. The masked dance is, in fact, a ritual activity so universally practiced from one culture to the next across West Africa that it could be called the focal point of the region's cultures. It unites the creative efforts of sculptors, dancers, musicians, and others. Originally performed as part of larger rituals connected with stages in human development, the passing of the seasons, or stages of the agricultural year, the masked dance in recent years has become increasingly commercial—a form of entertainment disconnected from its original social context. A modern

photograph of the *banda* mask performed by the Baga Mandori people who live on the Atlantic coastline of Guinea is unique, however, in capturing an actual *banda* dance (Fig. 9.19). The *banda* mask is always danced at night, with only torches for illumination, but in 1987 villagers agreed, for the sake of photography, to begin the performance at dusk. The photographs taken that evening by Fred Lamp, Curator of African Art at the Yale University Art Gallery, are the only extant photographs of an actual *banda* performance.

The banda mask is a sort of amalgam of different creatures, combining the jaws of a crocodile, the face of a human, the elaborate hairstyle of a woman, the body of a serpent, the horns of an antelope, the alert ears of a deer,

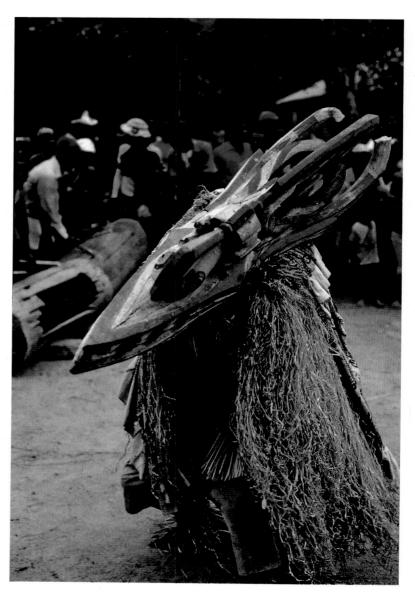

Fig. 9.19 Dance of Banda, Baga Mandori, Guinea, 1987. The choreography of the dance involves the dancer spinning madly while holding the headdress aloft, then twirling the mask in a series of figure eights, finally dashing it down to the ground before returning it to his head, all in one seamless burst of movement.

and, rising between the horns, the tail of a chameleon. The banda mask is generally danced at initiations, harvest ceremonies, and funerals, and is renowned for its spectacular acrobatics, with the wearer spinning high in the air and low to the ground as if in defiance of the enormous weight of the mask itself. Like the cave paintings discussed in Chapter 1, the banda mask is believed to possess agency. That is, it helps to effect change—the transformation (as symbolized by the chameleon's tail) from adolescence to adulthood, from fall to winter, from life to death. And it embodies the collective consciousness of the group by incorporating into its single visage the diversity of the natural world.

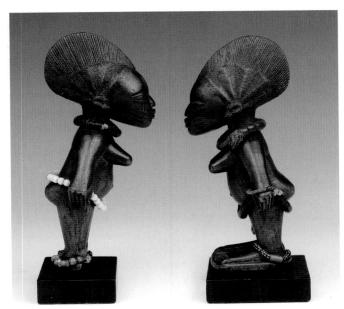

Fig. 9.20 Twin Figures (*ere ibeji*), Yoruba culture, Nigeria. 20th century. Wood, height 77%". The University of Iowa Museum of Art, Stanley Collection. This pair of *ere ibeji* appear to have been carved at the same time, by the same artist in the Yoruba city of Abeokuta. A strong case has been made that they are the work of Akiode, who died in 1936.

Interestingly, African cultures do not have a word for "mask." Rather, each mask has a particular name that is generally the word for the ancestor or supernatural being that the mask helps to make manifest. The ritual use of objects connected to the spirit world is a practice that, from the moment of European contact on, has continued to exhibit a strong presence despite the ongoing influence of Western and Islamic cultures. It is almost certain that many, if not most, of these ritual beliefs, practices, and customs date back centuries and help to establish a very real sense of cultural continuity.

The ritualistic use of objects connected with birth, death, and ancestral connections to the spirit world figure prominently in maintaining this sense of continuity. A fascinating example in Yoruba culture is the carving of ere ibeji, or "twin figures" (Fig. 9.20), when a twin dies. Since the Yoruba have one of the highest rates of twin births in the world (45 for every 1,000 births), and since twins are generally smaller and weaker than single-born infants, twin deaths are comparatively common. While the ere ibeji are being carved, the mother of the deceased child lavishes gifts of food on the carver, and when the sculpture is finished, she carries it home on her back, wrapped as if it were living, while the women of the village sing songs to accompany her. The mother then performs various tasks to honor the figure, washing it as if it were alive, rubbing its body with powder and oil, offering it what are believed to be the favorite foods of twins—beans and palm oil—and dressing it in rich garments and beads. Honored in this way, the spirit of the deceased twin will, it is believed, bring to its parents wealth and good fortune.

INDIA AND EUROPE: CROSS-CULTURAL CONNECTIONS

How did European contact affect Mogul India?

The synthesis of cultures so evident in the pluralistic society that developed in New Spain is also apparent in the art of India during roughly the same period. But in India, the synthesis was far less fraught with tension. The reason has much to do with the tolerance shown by India's leaders in the seventeenth and eighteenth centuries toward forces from the outside, which, in fact, they welcomed.

Islamic India: The Taste for Western Art

India's leaders in the seventeenth and eighteenth centuries were Muslim. Islamic groups had moved into India through the northern passes of the Hindu Kush by 1000 and had established a foothold for themselves in Delhi by 1200. In the early sixteenth century, a group of Turko-Mongol Sunni Muslims known as *Moguls* (a variation on the word *Mongol*) established a strong empire in northern India, with capitals at Agra and Delhi, although the Hindus temporarily expelled them from India between 1540 and 1555.

Their exile, in Tabriz, Persia, proved critical. Shah Tamasp Safavi (r. 1524–76), a great patron of the arts who especially supported miniature painting, received them into his court. The Moguls reconquered India with the aid of the shah in 1556. The new Mogul ruler, Akbar (r. 1556–1605), was just 14 years of age when he took the throne, but he had been raised in Tabriz and he valued its arts. He soon established a school of painting in India, open to both Hindu and Islamic artists, taught by Persian masters brought from Tabriz. He also urged his artists to study the Western paintings and prints that Portuguese traders began to bring into the country in the 1570s. By the end of Akbar's reign, a state studio of more than 1,000 artists had created a library of over 24,000 illuminated manuscripts.

Akbar ruled over a court of thousands of bureaucrats, courtiers, servants, wives, and concubines. Fully aware that the population was largely Hindu, Akbar practiced an official policy of religious tolerance. He believed that a synthesis of the world's faiths would surpass the teachings of any one of them. Thus he invited Christians, Jews, Hindus, Buddhists, and others to his court to debate with Muslim scholars. Despite taxing the peasantry heavily to support the luxurious lifestyle that he enjoyed, he also instituted a number of reforms, particularly banning the practice of immolating surviving wives on the funeral pyres of their husbands.

Under the rule of Akbar's son Jahangir (r. 1605–27), the English taste for portraiture (see Chapter 8) found

favor in India. The painting Jahangir in Darbar is a good example (Fig. 9.21). It shows Jahangir, whose name means "World Seizer," seated between the two pillars at the top of the painting, holding an audience, or darbar, at court. His son, the future emperor Shah Jahan, stands just behind him. The figures in the street are a medley of portraits, composed in all likelihood from albums of portraits kept by court artists. Among them is a Jesuit priest from Europe dressed in his black robes (although nothing in the painting shows a familiarity with Western scientific perspective). The stiff formality of the figures, depicted in profile facing left and right toward a central axis, makes a

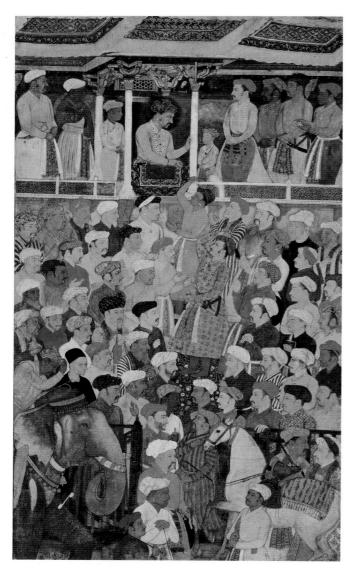

Fig. 9.21 Attributed to Manohar, *Jahangir in Darbar.* **Northern India. Mogul period. ca. 1620.** Opaque watercolor and gold on paper, $13\%" \times 7\%"$. Museum of Fine Arts, Boston. Francis Bartlett Donation of 1912 and Picture Fund 14.654. Photograph © 2013 Museum of Fine Arts, Boston. Nothing underscores the Mogul lack of interest in Western perspective more than the way in which the figure in the middle of the street seems to stand on the head of the figure below him.

sharp contrast to the variety of faces with different racial and ethnic features that fills the scene.

The force behind this growing interest in portraiture was the British East India Company, founded by a group of enterprising and influential London businessmen in 1599. King James I awarded the Company exclusive trading rights in the East Indies. A few years later, James sent a representative to Jahangir to arrange a commercial treaty that would give the East India Company exclusive rights to reside and build factories in India. In return, the company offered to provide the emperor with goods and rarities for his palace from the European market.

Jahangir's interest in all things English is visible in a miniature, *Jahangir Seated on an Allegorical Throne*, by an artist named Bichitr (Fig. 9.22). The miniaturist depicts Jahangir on an hourglass throne, a reference to the brevity of life. The shah hands a book to a Sufi teacher, evidently preferring the mystic's company to that of the two kings who stand below, an Ottoman Turkish ruler who had been conquered by Jahangir's ancient ancestor Tamerlane and, interestingly,

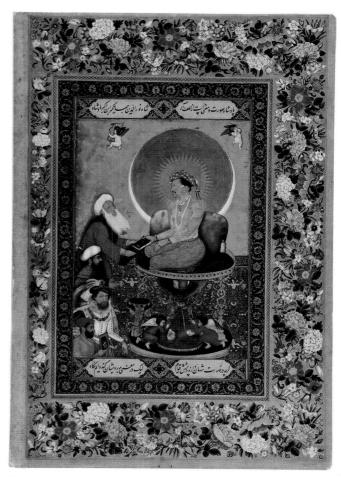

Fig. 9.22 Bichitr. *Jahangir Seated on an Allegorical Throne*, from the *Leningrad Album of Bichitr*. ca. 1625. Opaque watercolor, gold, and ink on paper, 10" × 71/8". Freer Gallery of Art, Smithsonian Institution, Washington, D.C. (42.15V). Behind the shah is a giant halo or nimbus consisting of the sun and a crescent moon. It recalls those behind earlier images of Buddha.

Fig. 9.23 Plan of the Taj Mahal, Agra. ca. 1632–48.

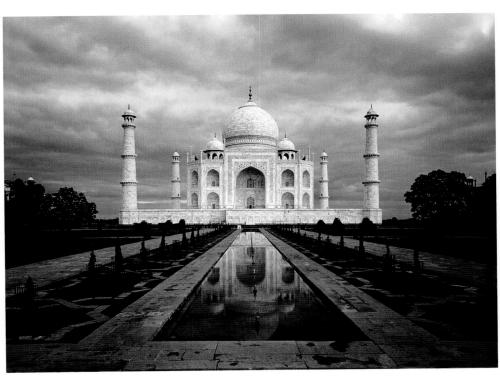

Fig. 9.24 Taj Mahal, Agra. Mogul period. ca. 1632–48. Originally, Shah Jahan planned to build his own tomb across the river, a matching structure in black marble, connected to the Taj Mahal by a bridge. The shah's tomb was never built, however, and he is buried, with his beloved wife, in a crypt in the mausoleum's central chamber.

King James I of England. The English monarch's pose is a three-quarter view, typical of Western portraiture but in clear contrast to the preferred profile pose of the Mogul court, which Jahangir assumes. The figure holding a picture at the bottom left-hand corner of the composition may be the artist, Bichitr, himself. Two Western-style putti (cherubs) fly across the top of the composition: The one at the left is a Cupid figure, about to shoot an arrow, suggesting the importance of worldly love; the one at the right apparently laments the impermanence of worldly power (as the inscription above reads). At the bottom of the hourglass, two Western-style angels inscribe the base of the throne with the prayer, "Oh Shah, may the span of your life be a thousand years." The throne itself is depicted in terms of scientific perspective, but the carpet it rests upon is not. Framing the entire image is a border of Western-style flowers, which stand in marked contrast to the Turkish design of the interior frame. All told, the image is a remarkable blend of stylistic and cultural traditions, bridging the gap between East and West in a single page.

Mogul Architecture: The Taj Mahal

Addicted to wine laced with opium, Shah Jahangir died in 1627, not long after the completion of the miniature wishing him a life of a thousand years. While his son Shah Jahan (r. 1628–58) did not encourage painting to the degree

his father and grandfather had, he was a great patron of architecture. His most important contribution to Indian architecture—and arguably one of the most beautiful buildings in the world—is the Taj Mahal ("Crown of the Palace"), constructed as a mausoleum for Jahan's favorite wife, Mumtaz-i-Mahal (the name means "Light of the Palace"), who died giving birth to the couple's fourteenth child (Figs. 9.23 and 9.24).

Sited on the banks of the Jumna River at Agra in northern India, the Taj Mahal is surrounded by gardens meant to evoke a vision of paradise as imagined in the Qur'an. Measuring 1,000 by 1,900 feet, the garden is divided up by broad pathways, reflecting pools, and fountains that were originally lined by fruit trees and cypresses, symbols, respectively, of life and death. To the west of the building, in the corner of the property, is a red sandstone mosque, used for worship. Rising above the garden, and reflected in its pools, is the delicate yet monumental mausoleum of Taj Mahal itself.

The white marble tomb is set on a broad marble platform with minarets at each corner, their three main sections corresponding to the three levels of the mausoleum proper, thus uniting them with the main structure. At the top of these minarets are *chattri*, or small pavilions that are traditional embellishments of Indian palaces, from which muezzins can call the faithful to worship at the property's mosque. The main structure, the Taj Mahal proper, is basically square,

although each corner is sliced off in order to create a subtle octagon. The facades are identical: a central *iwan* (a traditional Islamic architectural feature consisting of a vaulted opening with an arched portal), flanked by two stories of smaller *iwans*. These voids in the facade contribute to the sense of weightlessness the building seems to possess. Four octagonal *chattris*, one at each corner of the roof, provide a transition to the central onion dome, which rises on its drum in a graceful swelling curve. The facades are inlaid with inscriptions and arabesques of semiprecious stones—carnelian, agate, coral, turquoise, garnet, lapis lazuli, and jasper—but so delicate and lacelike that they emphasize the whiteness of the whole rather than call attention to themselves.

In 1658, Shah Jahan became very ill, and his four sons battled one another for power. The conservative, Aurangzeb (r. 1658–1707), eventually triumphed and confined his father to the Red Fort. Aurangzeb reinstituted traditional forms of Islamic law and worship, ending the pluralism that had defined the Mogul court under his father and grandfather even as he began to reinstate traditional Muslim prohibitions against figural art. But from his rooms in the Red Fort, Shah Jahan could look out over the Jumna River to the Taj Mahal and re-create in poetry the paradise where he believed he would come to rest with his wife (Reading 9.3):

READING 9.3

Shah Jahan, inscription on the Taj Mahal, ca. 1658

Like a garden of heaven a brilliant spot,
Full of fragrance like paradise fraught with ambergris.
In the breadth of its court perfumes from the nose-gay of sweet-hearts rise.

The nymphs of paradise use their eye-lids for cleaning its threshold.

Shah Jahan's tomb is, in fact, next to his wife's in the crypt below the central chamber of the Taj Mahal. Above both tombs are their marble cenotaphs, beautifully inlaid in pietra dura—literally, "hard stone," mosaics of precious and semi-precious stones—by the artisans of northern India.

THE CHINESE EMPIRE: ISOLATION AND TRADE

How did China resist foreign influence even as trade with the wider world flourished?

The cultural syncretism, or intermingling of cultural traditions, that marks Indian art under Akbar and Jahangir was largely resisted by Chinese populations when Europeans arrived on China's shores. The reasons are many, but of great importance was the inherent belief of these cultures in their own superiority. For centuries, the Chinese had resisted Mongolian influence, for instance, and at the same time had come to prefer isolation from foreign influence.

Fig. 9.25 Plan of the Tang capital of Chang'an, China. ca. 600. The location of the capital had been determined, in Han times, by the practice of *feng shui*, literally "wind and water," which assesses the primal energy that flows through a particular landscape. In this case, the hills to the north of the city and the streams running through it were understood to protect the precinct. *Feng shui* is still practiced to this day.

The Tang Dynasty in Chang'an, "The City of Enduring Peace" (618–907 ce)

This is not to say that the Chinese totally removed themselves from the world stage. In 618, the Tang dynasty reestablished a period of peace and prosperity in China that, except for a brief period of turmoil in the tenth century, would last for 660 years. The Tang dynasty was the product of by far the largest and most organized government in the world in the last half of the first millennium. Its capital was the eastern end of the Silk Road, Chang'an, "City of Enduring Peace" (present-day Xi'an, which is about one-seventh the size of the Tang capital). The city had served as the capital of the Han dynasty as well, but as the Tang restored trade along the Silk Road, they created elaborate plans to restore the city too. By the eighth century, its population was well over 1 million, living inside a walled perimeter nearly 26 miles in length and enclosing almost 42 square miles. Outside the walls lived perhaps as many as another million people. Among its inhabitants were Korean, Japanese, Jewish, and Christian communities, and its emperors maintained diplomatic relations with Persia.

Chang'an was the largest city in the world, laid out in a carefully conceived grid that dramatized the Tang commitment to social order and mirrored, they believed, the order of the cosmos (Fig. 9.25). Each of the city's 108 blocks was itself a miniature walled city, with its own interior streets and gates that locked at night. Astronomers laid out the streets by aligning them with the shadow of the sun at noon and the position of the North Star at night, thereby orienting the city to the four cardinal directions. The imperial palace was located at the north end, facing south, thus

symbolizing the emperor looking out over his city and, by extension, his empire. Traditionally, Chinese emperors turned their backs to the north, from where, it was believed, evil spirits (not to mention Huns) came. Government buildings occupied the space in front of the imperial palace. A 500-foot-wide avenue led from these directly to the southern gate.

The Tang valued education above all. The imperial college at Chang'an trained all civil servants (women were excluded), and intellectual achievement was held in high esteem. Confucian and Daoist philosophy dominated the arts, particularly poetry, where two Tang poets, the Daoist Li Bai (701–62) and the Confucian Du Fu (712–70), achieved special prominence. Both relied for inspiration on *The Book of Songs* (see Chapter 3) but extended its range considerably. Their different temperaments are expressed in two short poems (**Reading 9.4**):

READING 9.4

Poems by Li Bai and Du Fu

"Summer Day in the Mountains" by Li Bai

Lazy today, I wave my white feather fan. Then I strip naked in the green forest, untie my hatband and hang it on a stone wall. Pine wind sprinkles my bare head.

"Broken Lines" by Du Fu

River so blue the birds seem to whiten. Flowers almost flame on the green mountainside. Spring is dying yet again. Will I ever go home?

Li Bai and Du Fu both belonged to a group called the Eight Immortals of the Wine Cup, famous for gathering in a garden of peach and plum trees on moonlit spring nights, where they drank wine to unleash their poetic temperaments. Like all the Immortals of the Wine Cup, Li Bai and Du Fu were equally expert in poetry, calligraphy, and painting—as well as statesmanship and philosophy. They present a model of what 500 years later the West would come to call the "Renaissance Man," the perfectly rounded individual, at home in any arena. They also embody the complex characteristics of Tang culture—at once strong and vigorous and passionate and sympathetic, simultaneously realistic and idealistic, intensely personal even while dedicated to public service.

The Song Dynasty and Hangzhou, "The City of Heaven" (960–1279 CE)

By the thirteenth century, Chang'an had been surpassed by Hangzhou, a city of nearly 2 million and the capital of China's Southern Song Dynasty (1127–1279) when Marco Polo (1254–1324), the first Westerner ever to see it, called it "the most splendid city in the world." Polo wrote at length about his journey to Hangzhou in his *Travels*, first

published in 1299. He claimed that he first visited the city as the ambassador of Kublai Khan. Northern Song China was already in Kublai Khan's hands, conquered in 1271, but he would not conquer the Southern Song on the Yangzi River until 1279. So, when Polo first saw Hangzhou, it was still a Song city. Its lakes and parks were so beautiful, filled with floating teahouses from which passengers could view the palaces, pagodas, and temples that dotted the shore, that the city was known as Kinsai, or the "City of Heaven." The entire city, some 200 square miles, was protected by a 30-foot-high wall, with even higher watchtowers rising above it. Inside the walls, a system of canals, which must have reminded Polo of his native Venice, was crisscrossed by some 12,000 bridges. These canals were fed by the most famous and probably most beautiful lake in China, the so-called West Lake, a popular resort. Beautiful women and pleasure-seekers gathered on houseboats on its waters, and writers and artists congregated in the tranquil libraries and monasteries on its shores.

"In this city," Polo would write, "there are 12 guilds of different crafts, and each guild has 12,000 houses in the occupation of its workmen. Each of these houses contains at least 12 men, while some contain 20 and some 40, including the apprentices who work under the masters. All these craftsmen had full employment since many other cities of the kingdom are supplied by this city." In fact, each guild was formed around people from the same province. In Hangzhou, tea and cloth merchants hailed from the eastern province of Anhwui, carpenters and cabinet-makers from the city of Ningbo, and so on. All came together to enjoy the benefits of trade and commerce in the capital. Food-stuffs, silks, spices, flowers, and books filled the markets (Reading 9.5):

READING 9.5

from Marco Polo, Travels

Those markets make a daily display of every kind of vegetable and fruit; and among the latter there are in particular certain pears of enormous size, weighing as much as ten pounds apiece, and the pulp of which is white and fragrant like a confection, besides peaches in their season both yellow and white, of every delicate flavor. . . . From the Ocean Sea also come daily supplies of fish in great quantity, brought 25 miles up river, and there is also great store of fish from the lake, which is the constant resort of fishermen, who have no other business. Their fish is of sundry kinds, changing with the season; and it is remarkably fat and tasty. Anyone who should see the supply of fish in the market would suppose it impossible that such a quantity could ever be sold; and yet in a few hours the whole shall be cleared away; so great is the number of inhabitants who are accustomed to delicate living.

These citizens accustomed to "delicate living" apparently lived remarkably well. "The houses of the citizens are well built and elaborately finished," Polo claims, "and the delight

they take in decoration, in painting and in architecture, leads them to spend in this way sums of money that would astonish you." In other words, Hangzhou was a center of Asian culture that no one in the West, save Marco Polo, could even dream existed, in many ways exceeding anything the West had realized.

The Song dynasty enjoyed tremendous prosperity. It was the world's greatest producer of iron, and its flourishing merchant class traded not only along the Silk Road (see Chapter 3) but also throughout the Southeast Asian seas by boat. The government was increasingly controlled by this wealthy merchant class. Crucial to its rise was the development of movable type, which allowed the Song to begin printing books on paper. The printing press revolutionized the transmission of knowledge in China. (Gutenberg's movable type printing press, which, in the West, we commonly credit with revolutionizing the transmission of knowledge, was 400 years in the future.) The children of the thriving merchant class attended public, private, and religious schools, where they could study the newly printed books—including The Book of Songs, required reading for all Chinese civil servants, and various encyclopedias—as they prepared for government examinations. This new class of highly educated government officials restored Confucianism to dominance and strengthened it with relevant additions from Daoism and Buddhism. Buddhism was officially rejected as foreign, but its explanation of the universe provided an invaluable metaphysical element to Confucianism. As a result, these new officials brought to government a deep belief, based on neo-Confucian teaching, that the well-run society mirrored the unchanging moral order of the cosmos.

Especially important to artists and literati, or literary intelligentsia—artists equally expert in poetry, calligraphy, and painting—in the Song era was the development of Chan Buddhism. "Chan" (better known in the West as "Zen," as it is pronounced in Japanese) derives from the Sanskrit word dhyana, meaning "meditation." Like Daoism, Chan Buddhism teaches that one can find happiness by achieving harmony with nature. By using yoga techniques and sitting meditation, the Chan Buddhist strives for oneness with the Dao ("the Way") and the Confucian li, the principle or inner structure of nature. The Chan Buddhists thought the traditional scriptures, rituals, and monastic rules of classical Buddhism were essentially beside the point, because Buddha's spirit was innate in everyone, waiting to be discovered through meditation. Thus, the poets and artists who practiced Chan Buddhism considered themselves instruments through which the spirit of nature expressed itself.

The essential "rightness" of the Song world is manifested especially in Chinese painting of the Song era, when land-scape painting became the principal and most esteemed means of personal and philosophic expression in the arts. The landscape was believed to embody the underlying principle behind all things, made manifest in the world through its material presence. Closely akin to the spiritual quest of the Dao, the task of the artist was to reveal the unifying

principle of the natural world, the eternal essence of mountain, waterfall, pine tree, rock, reeds, clouds, and sky. Human figures are dwarfed by the landscape, insignificant in the face of nature. Over and over again, the paintings of the period rise from foreground valleys to high mountaintops, the eye following paths, cascading waterfalls, rocky crags, and tall pines pointing ever higher in imitation of "the Way," the path by which one leaves behind the human world and attains the great unifying principle (see *Closer Look*, pages 298–299).

The Yuan Dynasty (1279–1368)

Throughout the period known as the medieval era in the West, China was threatened from the north by nomadic tribes. The Northern Song capital of Bianjing had fallen to tribes from Manchuria in 1126, under the leadership of Chinggis Khan, forcing the Song to retreat south to Hangzhou. Finally, the Song dynasty succumbed to the Mongol leader Chinggis' grandson Kublai Khan in 1279. Kublai Khan ruled from a new capital at present-day Beijing, transforming it into a walled city constructed on a grid plan and extending the Grand Canal to provision the city.

Calling themselves the Yuan dynasty, the Mongols under Chinggis Khan and his descendants controlled the highest posts in the government, but they depended on Chinese officials to collect taxes and maintain order. The Chinese understood the need to cooperate with the Mongols, but they viewed the Mongols as foreigners occupying their homeland.

At the time of Marco Polo's arrival in China, the scholar-painters of the Chinese court, unwilling to serve under foreign domination, were retreating from public life. But while in exile, they created an art symbolic of their resistance. Paintings of bamboo, for instance, abound, because bamboo is a plant that might bend, like the Chinese themselves, but never break. Painted in 1306, Cheng Sixiao's *Ink Orchids* (Fig. 9.26), according to its inscription, was meant to protest the "theft of Chinese soil by the invaders." Orchids, in fact, can live without soil, in rocks or in trees, sustained by the moisture in the air around them, even as Sixiao the painter thrives.

The Ming Dynasty (1368–1644)

The Mongols were finally overthrown in 1368, when Zhu Yuanzhang (r. 1368–98) drove the last Yuan emperor north into the Gobi Desert and declared himself first emperor of the new Ming dynasty. China was once again ruled by the Chinese.

The Ming emperors were consumed by fear of Mongol reinvasion and in defense created what was arguably the most despotic government in Chinese history. Zhu Yuanzhang enlisted thousands of workers to reinforce the Great Wall of China (see Fig. 3.25 in Chapter 3) against invasion from the north, and untold numbers of them perished in the process. He equipped huge armies and assembled a navy to defend against invasion from the sea. Artists whose freedoms had been

296

Fig. 9.26 Cheng Sixiao, *Ink Orchids*. Yuan dynasty, 1306. Ink on paper, 10½" × 16¾". Municipal Museum of Fine Art, Osaka, Japan. Artists of the Yuan dynasty such as Cheng Sixiao painted for their fellow artists and friends, not for the public. Thus, Cheng Sixiao could feel comfortable describing his political intentions in the text accompanying this painting.

severely restricted under the Mongols were even less free under the Ming. But in a bow to scholarship and the arts, Emperor Zhu Di (r. 1402–24) commissioned the compilation of an authoritative 11,095-volume encyclopedia of Chinese learning. He also undertook the construction of an Imperial Palace compound in Beijing on the site of Kublai Khan's ruined capital (Fig. 9.27). The palace complex, known as the Forbidden City, was, among other things, the architectural symbol of his rule.

The name refers to the fact that only those on official imperial business could enter its gates. Although largely rebuilt in the eighteenth century during the Qing dynasty (1644–1912), the general plan is Ming but based on Mongol precedents. In fact, the Mongols had reserved the entire northern side of Beijing for themselves, and the resident Chinese had lived only in the southern third of the city. Ming emperors preserved this division, allowing ministers and officials to live in the northern or Inner City and commoners in the southern or Outer City.

The Forbidden City itself was in the middle of the Inner City. Like the Tang capital of Chang'an, Beijing is laid out on a grid, and the Forbidden City is laid out on a grid within the grid along a north—south axis according to the principles of feng shui (see Fig. 9.25). In Daoist belief,

certain "dragon lines" of energy or *qi* flow through the earth, along mountains and ridges, down streams and rivers, influencing the lives of people near them. Evil forces were believed to come from the north, and so the city opened to the south. Since emperors were considered divine and closely connected to the forces of the cosmos, the practice of *feng shui* was especially crucial in constructing royal compounds.

Fig. 9.27 The Forbidden City, now the Palace Museum, Beijing. Mostly Ming dynasty (1368–1644). View from the south.

CLOSER LOOK

he human presence in nature goes almost unnoticed in Guo Xi's hanging scroll Early Spring. Nature, embodied by the mountain, is all-embracing, a powerful and imposing symbol of eternity. The composition of Guo Xi's painting is based on the Chinese written character for mountain. The fluid gestures of the calligrapher's hand are mirrored in the painting, both in the organization of the whole and in the individual brush-and-ink strokes that render this ideal landscape. Like the calligrapher, Guo Xi is interested in the balance, rhythm, and movement of his line.

A court painter during the reign of the Emperor Shenzong (r. 1068-85), Guo Xi was given the task of painting all the murals in the Forbidden City, the imperial compound in Beijing that foreigners were prohibited from entering. His ideas about landscape painting were recorded by his son Guo Si in a book entitled The Lofty Message of the Forests and Streams. According to this book, the central peak here symbolizes the emperor himself and its tall pines the gentlemanly ideals of the court. Around the emperor the masses assume their natural place, as around this mountain the trees and hills fall into the order and rhythms of nature.

Something to Think About . . .

In the West, landscape painting did not become a popular genre until the eighteenth century. What differences in attitude between East and West during the Middle Ages might account for this?

dynasty, 1072. Hanging scroll, ink and slight color on silk, length 5'. Collection of the National Palace Museum, Taipei, Taiwan, Republic of China. Everything has its proper place in the Chinese universe, and thus the painting possesses multiple points of view. Accordingly, each part of this painting is constructed at the appropriate "distance."

Guo Xi, Early Spring. Song

Chinese character for "mountain."

Barely noticeable, two figures get out of their boat at the bottom left, and another figure stands on the shoreline at the right. Two waterfalls cascade down the hillside behind this second figure, and a small village can be seen nestling on the mountainside above the falls.

Guo Xi's Early Spring

The central mountain is painted so that we gaze up to it in the "high distance," as we would gaze up at the emperor.

On the left side of the painting, we gaze far off into a "level distance," creating a sense of limitless, eternal space.

In the humbling
"deep distance" of the
foreground, far below
our point of view, we see
images that reflect our
own insignificance in
nature.

Following traditional practice, the Forbidden City covers about 240 acres and is walled by 15 miles of fortifications. It is composed of 9,999 buildings and rooms, each constructed with nails, nine nails per row. The number nine in Chinese sounds like the word for "everlasting," and because nine was believed to be the extreme of positive numbers, the maximum of the singular, it was thus reserved for use only by the emperor. The buildings in the complex follow traditional patterns of post-and-lintel construction that date back to the Shang and Zhou periods.

The emperors and their families rarely left the Forbidden City's confines. Visitors entered through a monumental U-shaped Meridian Gate, and then crossed the Golden Water River spanned by five arched marble bridges. Across the courtyard stands the Gate of Supreme Harmony, on the other side of which is another giant courtyard leading to the Hall of Supreme Harmony. Here, on the most important state occasions, the emperor sat on his throne, facing south, his back to the evil forces of the north. Behind the Hall of Supreme Harmony are increasingly private spaces, devoted to day-to-day routine and living quarters. The balance and symmetry of the compound were believed to mirror the harmony of the universe. Situated, as it was believed, in the middle of the world, the Forbidden City was the architectural symbol of the emperor's rule and of his duty as the Son of Heaven to maintain order, balance, and harmony in his land.

Painting and Poetry: Competing Schools

The imperial court and the newly rich merchant class also acquired paintings, considered luxury goods in their own right. As in the Tang dynasty, a class of highly educated literati executed the works. Many paintings combine image and poem, the latter written in a calligraphy distinctly the artist's own.

Late in the Ming dynasty, an artist, calligrapher, theorist, and high official in the government bureaucracy named Dong Qichang (1555–1636) wrote an essay that has affected the way we have looked at the history of Chinese painting ever since, although many scholars, even in Dong Qichang's time, viewed it as oversimplified. He divided the history of Chinese painting into two schools, Northern and Southern, although geography had little to do with it. It was not place but the spirit in which the artist approached the painting that determined its school. A painter was Southern if unorthodox, radical, and inventive, like the Southern brand of Chan (Zen) Buddhism; a painter was Northern if conservative and traditional in approach, like the Northern brand of Chan Buddhism.

Northern School *Hundred Birds Admiring the Peacocks* by Yin Hong, a court artist active in the late fifteenth and early sixteenth centuries, is an example of the Northern style (Fig. 9.28). It has a highly refined decorative style, which emphasizes the technical skill of the painter. It also has a rich use of color and reliance on traditional Chinese painting, in this case the birds-and-flowers genre that had been extremely popular in the Song dynasty, which flourished contemporaneously

Fig. 9.28 Yin Hong, *Hundred Birds Admiring the Peacocks*. Ming dynasty, late 1400s—early 1500s. Hanging scroll, ink and color on silk, 947/6" × 7615/6". The Cleveland Museum of Art, purchase from the J.H. Wade Fund, 1974.31. The Chinese traded in the Middle East for peacocks, considered the most supreme of all ornamental birds, in exchange for silk.

with the Early Middle Ages in the West. Like Guo Xi's Song dynasty painting *Early Spring* (see *Closer Look*, pages 298–299), the Yin Hong painting also has a symbolic meaning that refers directly to the emperor. Just as the central peak in *Early Spring* symbolizes the emperor himself, with the lower peaks and trees subservient to him, here a peacock symbolizes the emperor, and around it "hundreds of birds"—that is, the court officials—gather in respect and submission.

Southern School The Southern style is much more understated than that of the Northern school, preferring ink to color and free brushwork (emphasizing the abstract nature of painting) to meticulously detailed linear representation. For the Southern artist, reality rested in the mind, not the physical world, and so self-expression was the ultimate aim. Furthermore, in the Southern school the work of art more systematically synthesized the three areas of endeavor that any member of the literati should have mastered: poetry, calligraphy, and painting.

So, a Southern-school painting like *Poet on a Mountaintop* by Shen Zhou (1427–1509) radicalizes traditional Chinese landscape (Fig. **9.29**). In the earlier Song dynasty landscapes, the unifying embrace of the natural world dwarfs human figures (see *Closer Look*, pages 298–299). But in Shen

Fig. 9.29 Shen Zhou, *Poet on a Mountaintop*, leaf from an album of landscapes; painting mounted as part of a handscroll. Ming dynasty, ca. 1500. Ink and color on paper, 15½" × 23¾". The Nelson-Atkins Museum of Art, Kansas City, Missouri. Shen Zhou places himself at the center of this composition in a relaxed and casual manner that reflects Chan Buddhism, which is more intuitive than intellectual. Note the informal simplicity of his brushwork and calligraphy.

Zhou's Ming-dynasty painting, the poet is the central figure. He looks out over an airy void in which hangs the very image of his mind, the following poem:

White clouds like a belt encircle the mountain's waist A stone ledge flying in space and the far thin road. I lean alone on my bramble staff and gazing contented into space

Wish the sounding torrent would answer to your flute.

An artist capable of putting himself at the center of both painting and poem would have had no desire to enter the government bureaucracy. Shen Zhou lived out his life in the district of Suzhou, far from court. But, interestingly, it was his style of work, and the style of other literati painters in the Southern school, that the Ming theorist Dong Qichang most preferred and that would become the dominant, orthodox style of painting in the Qing dynasty to follow.

Luxury Arts

The lavish lifestyle of the Ming court ensured the production of vast quantities of decorative luxury goods. In addition, as trade flourished, many Chinese merchants became increasingly wealthy and began to collect paintings, antiques, finely made furniture, and other high-quality objects for themselves. **Lacquerware** was extremely popular. Made from the sap of the Chinese *Rhus vernicifera* tree (a variety of sumac), lacquer is a clear, natural varnish that, when applied to wood, textiles, or other perishable materials, makes

them airtight, waterproof, and resistant to both heat and acid. A surface coated with many thin layers of lacquer can be carved through into all manner of designs. Lacquerware furniture, bowls, dishes, and other small articles were very desirable.

One of the commodities most prized by the Chinese themselves and by those who traded with China was porcelain ceramic ware. The Chinese had invented the process for making porcelain around 1004 cE at Jingdezhen, which by the beginning of the Ming dynasty boasted 20 kilns. At Zhu Di's death in 1424, it had almost tripled in size to 58 kilns.

Ming painters decorated the unfired surfaces of their porcelain ware with blue cobalt glazes, covered everything with a layer of white glaze, and then fired their works. During the reign of Zhu Di, the look of Chinese porcelain improved dramatically. This was largely because of the court official Zheng He (1371–1435), who commanded Zhu Di's "treasure fleet" of 317 ships. The fleet sailed in seven expeditions between 1404 and 1435, throughout the oceans of Southeast Asia to India, Saudi Arabia, and down the African coast. On one of these trade missions Zheng He had traded Chinese produce for a cobalt ore, probably from Kashan, Persia, high in iron and low in manganese (just the opposite of Chinese ore), which allowed for a new richness of color. Among the Ming artists' favorite motifs were fish, waves, and sea monsters, but particularly dragons, because they symbolized the emperor. His veins were said to flow

Fig. 9.30 Pair of porcelain vases with cobalt blue underglaze. Ming dynasty, Xuande period (1426–35). Height 21¾". The Nelson-Atkins Museum of Art, Kansas City, Missouri. As early as the Bronze Age, the Chinese associated the dragon with sudden manifestations of nature, such as wind, rain, and lightning. By the Song and Tang dynasties (fifth—tenth centuries), painting pictures of dragons was a method of praying for rain. For Chan Buddhists, the dragon symbolized sudden enlightenment.

with the dragon's blood (Fig. 9.30). The dragon was everywhere on Ming art, from textiles to lacquerware and jade carvings. Note that the two vases in Fig. 9.30 are mirror images, the finely outlined forms of the dragons seemingly mimicking each other's flight. Their gestures, in fact, suggest the graceful movements of *Tai Qi Quan*, the Chinese martial art that includes solo forms, or routines, and two-person forms, known as "pushing hands." These two dragons, their bony claws reaching toward each other, particularly evoke the "pushing hands" form. The two vases create a sense of balance, like the balance of *yin* and *yang* (see Fig. 3.26 in Chapter 3), the symbol for which is, in fact, the symbol for *Tai Qi* itself.

JAPAN: COURT PATRONAGE AND SPIRITUAL PRACTICE

How does the tension between spiritual and military life inform Japanese culture and how does the institution of patronage contribute to this tension?

Although Buddhism may have been known in Japan earlier, it is commonly believed that it arrived in the Yamato period (before 700 CE; see Chapter 4) from Korea and China. According to the Chronicles of Japan, a statue of Buddha and a

collection of sacred Buddhist texts were given to Japanese rulers by the king of the Baekje region of Korea in 552. Chinese calligraphy was already the basis of the Japanese written language, and to some, Buddhism seemed equally amenable to Japanese adaptation. But Buddhism was by no means welcomed by all. Of the three rival clans then most powerful in Yamato Japan—the Soga, Mononobe, and Nakatomi, each tied to the imperial family through marriage to the emperor—both the Mononobe, who were in charge of the emperor's military, and the Nakatomi, in charge of Shinto ritual, opposed the introduction of Buddhism into the country. But the Soga, managers of imperial estates who were in constant contact with the Koreans and Chinese, were deeply attracted to the religion, and the Yamato emperor allowed them to practice it within their own clan.

These rivalries would influence Japanese culture for centuries to come. As early as 708, the Fujiwara clan, which was directly descended from the Nakatomi and which would rule Japan for 500 years, oversaw the construction of a new capital at Hojeikyo, commonly called Nara after its location in the Nara plain, some

15 miles to the northwest of Asuka (Map 9.4). It was laid out according to the principles of Chinese city planning as a walled city on the model of Chang'an (see Fig. 9.25), 2.7 miles from east to west and about 3.1 miles from north to south, with a broad avenue running north and south in its center culminating at the Heijo Palace. And although the Nakatomi/Fujiwara clan had despised the Buddhist-leaning Soga the century before, at Nara, they officially accepted Buddhism as the state religion. Magnificent temples and monasteries were constructed.

The Heian Period: Courtly Refinement

As early as the seventh century, Buddhist doctrine and Shinto had begun to influence each other. In the eighth century, the Great Buddha at Nara became identified with the Shinto goddess Amaterasu (see Chapter 1), and Buddhist ceremonies were incorporated into Shinto court ritual. But between 784 and 794, the capital of Japan was moved to Heiankyo—modern-day Kyoto—which quickly became the most densely populated city in the world. According to records, the move occurred because the secular court needed to distance itself from the religious influence of the Buddhist monks at Nara.

At Heiankyo, the arts flourished in an atmosphere of elegance and refinement. Life in the Heian court was determined by gender. Men lived public lives; women much more private ones. In fact, women were rarely visible. An

Map 9.4 Japan. Isolated from the Asian mainland, Japan was both slow to develop and susceptible to the influence of the more advanced cultures once it became aware of them.

aristocratic woman might make a public excursion to a Buddhist temple, but she would remain out of public view. She might receive a male visitor, but the two would converse through a portable set of curtain panels. Women were, however, highly educated, and they were expected to contribute to the aesthetic of the Heian court. Many court gatherings took place for the purpose of poetry competitions, in which both men and women participated. Poems were generally composed for a single recipient—a friend or lover—and a reply was expected. In her *Diaries*—or *nikki* in Japanese—Murasaki Shikibu (973/8–aft. 1014), one of the most accomplished women of the Heian court, a lady-in-waiting to the Empress Shoshi (988–1074), describes just such an exchange (Reading 9.6):

READING 9.6

from Murasaki Shikibu, Diaries

I can see the garden from my room beside the entrance to the gallery. The air is misty, the dew is still on the leaves. The Lord Prime Minister is walking there; he orders his men to cleanse the brook. He breaks off a stalk of omenaishi, which is in full bloom by the south end of the bridge. He peeps in over my screen! His noble appearance embarrasses us, and I am ashamed of my morning face. He says, "Your poem on this! If you delay so much the fun is gone!" and I seize the chance to run away to the writing-box, hiding my face:

Flower-maiden in bloom— Even more beautiful for the bright dew, Which is partial, and never favors me. "So prompt!" said he, smiling, and ordered a writing-box to be brought [for himself].

His answer:

The silver dew is never partial. From her heart The flower-maiden's beauty.

1 omenaishi: a flowering plant.

²morning face: a face without powder or makeup.

Something of the flavor of court life is captured in this brief passage, in the private space of the gentlewoman's world, her relation to the gentlemen of the court, the attention of the two poets to natural beauty, and the expression of that beauty as a means of capturing personal feeling.

Diaries comprised an important literary form that tell us much about court life in the Heian period. Murasaki's poems—indeed her entire text—are written in a new, purely Japanese writing system, known as *hiragana*. Beginning in the early ninth century, *hiragana* gradually replaced the use of Chinese characters and enabled writers to spell out the Japanese language phonetically. The university curriculum remained based on Chinese classics and history, and the formal workings of state and government still required the use of Chinese. Chinese was the language of the world of men. Since the Heian court strongly discouraged displays of education in Chinese by women, they were taught the *hiragana* script, even though many court women actually knew Chinese quite well.

The popularity of *hiragana*, even among men, who recognized its convenience, encouraged the development of new Japanese forms of poetry, especially the *waka* (literally the "poetry of Wa," or Japan). A *waka* consists of 31 syllables in 5 lines on a theme drawn from nature and the changing of the seasons. Here is a *waka* by one of the great poets of the Heian period, Ki no Tomonori (flourished 850–904) (**Reading 9.7**):

READING 9.7

Ki no Tomonori, "This Perfectly Still"

This perfectly still
Spring day bathed in the soft light
From the spread-out sky.
Why do the cherry blossoms
So restlessly scatter down?

The tension here, between the calm of the day and the restlessness of the cherry blossoms, is meant to mirror a similar tension in the poet's mind, suggesting a certain sense of anticipation or premonition. *Waka* serves as a model for other Japanese poetic forms, particularly the famous **haiku**, the 3-line, 17-syllable form that developed out of the first three lines of the *waka*.

In addition to her diaries, Murasaki Shikibu is the author of a long book of prose and poetry (over 1,000 pages in English translation), including many exchanges of poetry of the type recorded in her *Diaries*. Many consider it the world's first

novel—certainly no fiction in the Western world matches its scope until the eighteenth century. Called *The Tale of Genji*, it tells the story of Genji, an imperial prince born to the favorite wife of the emperor, although she is too low in rank for her son to be an heir to the throne. Much of the action takes place in the homes and gardens of Heiankyo, and besides being a moving, romantic story covering 75 years of the hero's life, from his birth to his death, the novel presents us with a vivid picture of life in Japanese society at the turn of the millennium.

The Kamakura Period (ca. 1185–1392): Samurai and Shogunate

During the Heian period, the emperors had increasingly relied on regional warrior clans—samurai (literally, "those who serve")—to exercise military control, especially in the countryside. Over time these clans became more and more powerful, until, by 1100, they had begun to emerge as a major force in Japanese military and political life, inaugurating the Kamakura Period, which takes its name from the capital city of the most prominent of these clans, the Minamoto. Their newfound power in many ways represented a resurgence of the familial clan-based system of authority that had been deeply ingrained in Japanese society since at least the time of the Yamato emperors, but almost inevitably, their rise also resulted, as it had among the Yamato clans, in intense rivalry and, eventually, warfare.

Pure Land Buddhist Art As war spread across the country, many Japanese felt that it announced the coming of Mappo, the so-called Third Age of Buddha, often translated as the "Age of Dharma Decline." Prophesied to begin 2,000 years after the death of Shakyamuni Buddha, it would last, so it was believed, for 10,000 years. During this period no one would be able to attain enlightenment and society would descend into a condition of degeneracy and corruption. Pure Land Buddhism seemed to offer a way out. It had originated in the late sixth century in China as a particular form of Mahayana Buddhism. The Mahayana Buddhists believed that compassion for all beings is the foundation of faith and that not nirvana but Buddhahood is one's ultimate goal. They recognized buddhas other than Shakyamuni, among them Amitabha Buddha, the Buddha of Infinite Light and Life, who dwells in a paradise known as the Western Pure Land. This Pure Land Buddhism had been introduced to Japan as early as the seventh century, the Chinese Amitabha Buddha becoming Buddha Amida. Particularly attractive to the Japanese was the Pure Land belief that by chanting Namu Amida Butsu ("Hail to the Buddha Amida"), the faithful would be reborn into the Western Pure Land Paradise where the enlightenment impossible to achieve in the world might finally be attained.

It was commonly believed that if even the most vile sinner uttered one sincere chant, he might be led to the Western Paradise, and one of the most popular expressions of the Paradise's availability was the *raigo* (or "welcoming approach") painting (Fig. 9.31). Amida is seen descending on a white cloud, surrounded by 25 bodhisattvas, toward the veranda of

Fig. 9.31 Tamenari, The Descent of Amida and the Twenty-Five Bodhisattvas to Collect the Soul of the Deceased. Later Heian period, 1053. Byodin Temple, Uji, Kyoto Prefecture, Japan. This and the other paintings at Byodin originally surrounded a golden sculpture of Amida on a tall lotus-blossom pedestal that is still in place.

a nobleman's house. One of ten thematically related paintings on the doors of Phoenix Hall (Hoodo) at the Byodin Temple in Kyoto, the painting is particularly remarkable for its rendering of the landscape. There is no trace of the craggy peaks that distinguish Chinese landscape paintings. Instead, in what is one of the earliest examples of yamato-e painting, we see the gently rolling, pine-capped slopes of what is recognizably the Heian countryside. It is probably no accident that Shinto paintings depicting the Japanese landscape first appear in the mid-eleventh century, contemporaneously with this door painting, and it is no surprise that the Shinto reverence for nature should find expression in Pure Land Buddhist art.

The Arts of Military Culture The Kamakura period actually began when the Minamoto clan defeated its chief rival, the Taira, in 1185, but the contest for power between the two dominated the last years of the Heian period. The complex relationship between the Fujiwara of the Heian era and the samurai clans of the Kamakura is embodied in a long handscroll narration of an important battle of 1160, from the Scrolls of Events of the Heiji Period, painted by an unknown artist in the thirteenth century, perhaps 100 years after the events themselves (Fig. 9.32). In 1156, Go Shirakawa (1127–92; r. 1156–58) ascended to the throne of the Fujiwara to serve in what had become their traditional role

as regent to the emperor, the highest position in the government. But Go Shirakawa resisted the Fujiwara attempt to take control of the government, and in 1157, they recruited one of the two most powerful samurai clans, the Minamoto, to help them stage a coup and imprison him. Night Attack on the Sanjô Palace depicts the moment troops led by Fujiwara Nobuyori attacked the emperor's palace in the middle of the night, taking him prisoner and burning his palace to the ground. The chaos and violence of the events are captured by the sweeping ribbons of flame and smoke rising to the upper right and the confusion of horsemen, warriors, fleeing ladies, the dead, and the dying in the foreground, all framed by an architecture that falls at a steep diagonal to the bottom left. The samurai warriors, dressed in elaborate iron armor, were master horsemen and archers. In this scene, many hold their bows, the lower portions of which are smaller than the top in order that they might pass over a horse's neck. As it turned out, this was a brief moment of triumph for the Minamoto. The rebellion was quickly quashed by the second of the powerful clans, the Taira, and for the next 20 years, the Taira managed to control the Japanese imperial court with the abdicated emperor Go Shirakawa's blessing. But in 1185, the Minamoto samurai army, led by Minamoto Yoshitusune (1159-89), defeated the Taira, killing virtually all male members of the Taira clan and large numbers of their wives and children.

Yoshitusune's brother Yoritomo (1147–99) had sat out the war in Kamakura, and as soon as the war was ended he quickly disposed of all samurai rivals in the region, including his own brother, whom he hunted down, but who managed to commit suicide rather than be captured. Yoritomo demanded that all other samurai lords pledge allegiance to him or risk the fate of his brother, and he soon controlled most of the Japanese archipelago. He established his rule at Kamakura, and thus removed Japanese government from the influence of both the aristocratic court at Heiankyo and the

Buddhist stronghold at Nara. Interestingly, Yoritomo never tried to assume the imperial throne, and neither did any of the subsequent samurai rulers. Instead, he considered himself the emperor's servant, much as the Fujiwara had served the Heian emperors. But in 1192, the imperial court granted him the title of Seiitai Shogun, literally "Barbarian-subduing General," and as **shogun**—that is, general-in-chief of the samurais—his military form of government, known as the shogunate, ruled the country for 150 years.

Yoritomo's shogunate was, in many ways, defined by land reforms that he instituted immediately. In essence he granted the country estates that had belonged formerly to his enemies as gifts to his followers. These new landholders came to be officially known as *daimyo*, literally "great name," by the fifteenth century. They defined themselves first by their absolute allegiance to the shogun, and then by their devotion to military arts and their concern for their "great name"—by extension, their honor, their fame, and their pride in their family or clan. Eventually, when Japan enjoyed an extended period of peace, from 1600 until the mid-nineteenth century, these values were codified and expanded upon by a *daimyo* class whose militarism seemed increasingly irrelevant into a well-defined code of conduct, **bushido**, "the way of the warrior," which continues to influence many aspects of Japanese society to this day.

The Muromachi Period (1392–1573): Cultural Patronage

If the *daimyo* rarely challenged the power of the emperor, they were nonetheless important patrons of the imperial court, as well as major consumers of court-based arts and crafts. The principles and ethics of Zen Buddhism, the Japanese version of Chinese Chan Buddhism, also appealed to them. Throughout the twelfth and thirteenth centuries, Chan teachings gained an increasing foothold in Japan. The carefully ordered monastic lifestyle of Chan monks

Fig. 9.32 Night Attack on the Sanjô Palace, from the Scrolls of Events of the Heiji Period. Kamakura period, late 13th century. Handscroll, ink and colors on paper, 16¼" × 275½". Courtesy Museum of Fine Arts, Boston. Fenollosa-Weld Collection (11.4000). Reproduced with permission. Photograph © 2013 Museum of Fine Arts, Boston. All rights reserved. This is the central scene of the scroll, which begins with the army moving toward the palace from the right and ends with it leaving in triumph to the left.

contrasted dramatically with the sometimes extravagant lifestyles of the Buddhist monasteries of the Heian period. And the Chan advocacy of the possibility of immediate enlightenment through meditation and self-denial presented, like Pure Land Buddhism (with which it competed for followers) an especially attractive spiritual practice.

By 1392, one shogun family, the Ashikaga, had begun to exercise increased authority over Japanese society. They had their headquarters in the Muromachi district of Kyoto (hence the alternative name for the period in which they ruled). It was a period of often brutal civil war as the daimyo vied for power. Although Kyoto remained in a state of near-total devastation—starvation was not uncommon—the Ashikaga shoguns built elaborate palaces around the city as refuges from the chaos outside their walls. One of the most elaborate of these, now known as Kinkakuji, the Golden Pavilion (Fig. 9.33), was built as a setting for the retirement of the Ashikaga shogun Yoshimitsu (1358-1408). Begun in 1399, its central pavilion is modeled on Chinese precedents. Its first floor was intended for relaxation and contemplation of the lake and gardens. A wide veranda for viewing the moon, a popular pastime, fronted its second floor. The top floor was designed as a small Pure Land Buddhist temple, containing a sculpture of Buddha Amida, the Buddha of Infinite Light and Life, who dwells in the paradise of the Western Pure Land, along with 25 bodhisattvas. The gardens surrounding the pavilions at Kinkakuji provided the casual stroller with an ever-changing variety of views, thus creating tension between the multiplicity of scenes and the unity of the whole. As a matter of policy, Yoshimitsu associated himself with the arts in order to lend his shogunate authority and legitimacy. Therefore, he and later Ashikaga shoguns encouraged some of the most important artistic developments of the era in painting and garden design. They also championed important new forms of expression, including the tea ceremony and Noh drama.

Zen Gardens The question of the extent of the influence of Zen on Japanese art is a problematic one. As has often been pointed out, the features normally associated with Zen (Chan) Buddhism in the arts—simplicity of design, suggestion rather than description, and controlling balance through irregularity and asymmetry—are also characteristic of indigenous Japanese taste. But it is indisputable that gardens were a regular feature of Muromachi Zen temples, especially the karesansui, or "withered" or dry landscape garden. Japanese gardeners had long featured water as an important, even primary element, but around Kyoto, with its limited number of springs and mountain streams, gardeners turned their attention away from the streams and ponds that characterize the Golden Pavilion at Kinkakuji and increasingly focused their attention on rocks and a few carefully groomed plants as the primary feature of garden design.

An especially remarkable example is a garden in the precinct of Daisen-in, a subtemple of the Daitokuji compound

Fig. 9.33 Kinkakuji (Temple of the Golden Pavilion), Rokuonji, Kyoto. Rebuilt in 1964 after the original of the 1390s. The original Kinkakuji was set ablaze and completely destroyed in 1950 by a young monk protesting the commercialization of Buddhism after World War II. The restoration closely approximates its original appearance.

founded in 1509 in Kyoto by Kogaku Soko (1465-1548). Its design is usually attributed to the painter Soami (d. 1525). The garden of the Daisen-in is actually a series of separate gardens arranged around Soko's residence, itself decorated with a variety of Soami's paintings. The garden that flanks two sides of the residence is a miniature landscape, the vertical rocks of which represent a mountain (Fig. 9.34). A waterfall, suggested by a vein of white quartz, cascades down one rock, forming a river of white gravel across which a slab of stone has fallen like a natural bridge, connecting islands in the stream. Farther down, a boat-shaped rock sails in the wider expanse of the river. On the other side of the residence, the gravel stream flows into an expanse of carefully raked white gravel punctuated by two cones constructed of the same material. This wide area is meant to suggest the ocean, its raked-lined waves rising to meet what may be two volcanic islands. (This last attribution remains a matter of speculation.) Taken as a whole, the flow of the pebble stream, from mountaintop to ocean, might best be viewed as a narrative, perhaps a metaphor for the passage of time, or even the passage of a Zen Buddhist philosopher from the relative complexity and confusion of early life to the expansive simplicity of enlightenment.

The Tea Ceremony Matcha, literally "finely powdered tea," was introduced into Japan in the late twelfth century, during the early Kamakura period, from China. By the end of that period, tea contests to identify different teas and the regions in which they were grown had become popular. By the early Muromachi period, rules for the ways in which tea was to be drunk began to be codified, especially in Zen temples. By the sixteenth century, these rules would come to be known as the Way of Tea, chanoyu. In small rooms specifically designed for the purpose and often decorated with calligraphy on hanging scrolls or screens, the guest was to leave the concerns of daily life behind and enter a timeless world of ease, harmony, and mutual respect. The master of the ceremony would assemble a few examples of painting and calligraphy, usually karamono, treasures imported from China, of which the Ashikaga shogun Yoshimasa (1430–90), grandson of Yoshimitsu, had the finest collection.

Late in the fifteenth century, in a transformation traditionally attributed to Murata Shuko, a former Zen priest, the taste for displaying *karamono* in the tea ceremony was replaced by a taste for things possessing the quality of *wabi*—that is, things evidencing qualities of austerity and simplicity and showing the effects of time. These objects were thought to reflect a taste more Japanese than Chinese, a taste reflected in a comment attributed to Shuko: "The moon is not pleasing unless partially obscured by a cloud." The master of the ceremony would assemble a few examples of painting and calligraphy together with a variety of different objects and utensils for making tea—the kettle, the water pot, the whisk, the tea caddy, and above all the tea bowl, each prized for its aesthetic shape and texture.

Fig. 9.34 Attributed to Soami, Garden of the Daisen of Daitokuji, Kyoto. Muromachi period, ca. 1510–25. Note the similarity between the rock features in the garden and those in traditional Chinese landscape painting (see *Closer Look*, pages 298–299).

In a quiet, muted light, and on a floor covered with *tatami*, woven straw mats, the master and his guest would contemplate the tea, its preparation, and the objects accompanying the ensemble, which, it was understood, expressed the master's artistic sensibility. Together, guest and master would collaborate in a ritual of meditation to transform the drinking of tea into a work of highly refined art, known as the *wabicha*.

Interestingly, it was not at court where the wabicha developed into the classic tea ceremony, but among the rich merchant classes. Two merchants from Sakai, Takeno Joo (1502–55) and Sen no Rikyu (1522–91) are traditionally credited with inventing the ceremony proper. As Rikyu defined it:

Chanoyu performed in a plain hut is above all an ascetic discipline, based on the Buddhist law, that is aimed at achieving spiritual deliverance. To be concerned about the quality of the dwelling in which you serve tea or the flavor of the food served with it is to emphasize the mundane. It is enough if the dwelling one uses does not leak water and the food served suffices to stave off hunger. This is in accordance with the teachings of Buddha and is the essence of the *chanoyu*. First, we fetch water and gather firewood. Then we boil the water and prepare tea. After offering some to the Buddha, we serve our guests. Finally, we serve ourselves.

The prominence of Rikyu and Joo in the development of the *chanoyu* presages a dramatic shift in Japanese culture, as the military class that had dominated Japanese society for centuries was beginning to give way to the interests of commerce and trade.

Noh Drama The Ashikaga shoguns, including Yoshimitsu and Yoshimasa, also enthusiastically supported the development of the important literary genre of Noh drama. The Noh drama was primarily the result of the efforts of Kan'ami Kiyotsugu (1333–84) and his son Zeami Motokiyo (1363–1443). They conceived of a theater incorporating music, chanting, dance, poetry, prose, mime, and masks to create a world of sublime beauty based on the ideal of *yugen*, which almost defies translation but refers to the suggestion of vague, spiritual profundity lying just below the surface of the Noh play's action (or, rather, the stillness of its inaction).

The word **Noh** means "accomplishment," and it refers to the virtuoso performance of the drama's main character, whose inner conflicts must be resolved before his or her soul can find peace. There were five kinds of Noh play, including "warrior plays" and "woman plays." The main characters of the warrior plays, which did not exist before Zeami, were historical personages of the samurai class derived from the same accounts as the Taira and Minamoto conflicts upon which the scroll painting *Night Attack on the Sanjô Palace* is based (see Fig. 9.32).

Noh is very different from Western drama. Characters often wear beautifully crafted masks. The action is accompanied by a chorus, which narrates events to the sound of wind instruments and drums. The plot, which the audience would know quite well, is almost irrelevant—certainly it does not drive the action of the drama forward. The characters speak their lines in a stylized manner, and make no attempt at realistic tonal inflections. Three drums and a flute accompany their lines, their movements turn into dance, and the performance lasts much longer than it takes simply to read it. In fact, although Noh plays often read well on the page, the total effect is lost without the nonverbal elements.

The Azuchi-Momoyama Period (1573–1615): Foreign Influences

Even as Japanese culture flourished under the patronage of the Ashikaga shoguns, the country simultaneously endured many years of sometimes debilitating civil war. By the middle of the sixteenth century, the Ashikaga family had lost all semblance of power, and various *daimyo* controlled the provinces once again. Finally, one of their number, Oda Nobunaga (1534–82), son of a minor vassal, forged enough alliances to unify the country under a single administration. By 1573, Nobunaga had driven what remained of the Ashikaga out of Kyoto, inaugurating a period now known as the Azuchi-Momoyama, named for the location of Nobunaga's castle at Azuchi on Lake Biwa and that of his successor, Hideyoshi (1537–98), at Momoyama, literally "Peach Hill," after an orchard of peach trees later planted on the ruins of the castle, south of Kyoto.

Nobunaga's victory was aided by the gunpowder and firearms introduced to Japan by Portuguese traders. During the reign of Nobunaga, the West greatly expanded trade throughout Japan. In 1543, Portuguese traders first entered Japanese waters, and, from the Portuguese, the Japanese daimyo soon

Fig. 9.35 Himeji Castle, Hyogo prefecture, near Osaka. Azuchi-Momoyama period, 1581, enlarged 1601–09. The Tokugawa shoguns destroyed most of the Momoyama castles in the early seventeenth century because they believed the castles encouraged other *daimyo* to challenge their power.

learned about Western firearms. Within 30 years, the civil conflict that Hideyoshi would bring to an end in 1590 was being fought with guns and cannon. Almost at the same time, in 1549, the priest Francis Xavier (1506–52), one of the founders of the Jesuits, landed at Kagoshima dedicated to bringing Christianity to Japan. By the 1580s, the Church had converted as many as 150,000 Japanese to Catholicism.

Although the arrival of gunpowder surely encouraged the Azuchi-Momoyama rulers to build much larger, more defensible castles than those of the earlier shogun, the primary purpose of the castles was more to impress upon the world the power and majesty of the *daimyo*. Himeji Castle near Osaka (Fig. 9.35) is an example. In common with most other castles of the era—roughly 40 were constructed across the country—it was built at the crest of a hill topped by a *tenshu*, a defensible refuge of last resort much like the keep of an English castle (see Chapter 5). Lower down the slope of the hill was a massive wall of stone.

The original *tenshu* was three stories high, but three more *tenshu* were added later. Two are three stories and one rises five stories above the hilltop. The resulting fortress is at once

virtually impregnable and almost delicate in appearance, with its winglike white plaster roof lines and sharply pointed triangular tiled gables. In fact, because of the graceful, ascending rhythms of its forms, it has come to be known as White Heron Castle.

The presence of foreign traders in Japan, principally Portuguese and Dutch, soon found its way into Japanese painting, particularly in a new genre of screen painting known as *namban*. *Namban* literally means "southern barbarian," referring to the "barbarian" Westerners who arrived from the south by ship. In the most popular theme of this genre, a foreign galleon arrives in Kyoto harbor (Fig. 9.36). The ship's crew unloads goods, and the captain and his men proceed through the streets of the city to Nambanji, the Jesuit church in Kyoto. The priests themselves are Japanese converts to Christianity.

The uniqueness of these paintings is that they present a convergence of cultures, encouraged by the prospect of trade, not only with Europeans but also with the peoples of other Asian countries, unparalleled in world history. The Portuguese, with the help of slave labor from Africa, had established a base in Macao, which they had been ceded by the Chinese in return for suppressing piracy on the Chinese coast, and they served as the conduit between China and Japan, exchanging Japanese silver for Chinese raw silk, which the Japanese processed into textiles, particularly kimonos, of remarkable quality. Only the cultural syncretism of New Spain even begins to compare.

The *namban* screens are only one example of the many types of screen commissioned by the Azuchi-Momoyama *daimyo* to decorate their palaces and castles. Traditional Japanese interiors consisted of mostly open rooms with little or no furniture. These angular spaces could be softened and

subdivided by the placement of screens. They were often used as a backdrop behind an important person, or to create an eating area, a reception area, or a sleeping area. In addition to *namban* subjects, themes depicted on the screens include cityscapes, mythological scenes, depictions of great battles, and images of dramatic performances, daily life in the court, and the common people working in the countryside.

The Closing of Japan

Nobunaga's successor, Hideyoshi, was deeply suspicious of Christianity. By 1587, he had prohibited the Japanese from practicing it and, in 1597, he went so far as to execute 26 Spanish and Japanese Jesuits and Franciscans in Nagasaki. Succeeding rulers pursued an increasingly isolationist foreign policy. In 1603, Hideyoshi's successor, Tokugawa Ieyasu (1542-1616) instituted a shogunate based at his castle in Edo (present-day Tokyo) that was to last, in peace, for 250 years. Christianity, even as practiced by foreigners, was banned altogether in 1614. The new Tokugawa shoguns affirmed the emperor's place as official head of state, but they were its effective leaders, with 250 or so regional daimyo under the shogun exercising regional authority. The Tokugawa shogunate forbade the Japanese to travel abroad in 1635, and limited foreign trade in 1641 to the Dutch, whom they confined to a small area in Nagasaki harbor, and the Chinese, whom they confined to a quarter within the city of Nagasaki itself.

Japan would remain sealed from foreign influence until 1853, when the American commodore Matthew Perry sailed into Edo Bay with four warships and a letter from the President of the United States urging the Japanese to receive the American sailors. The following year, Japan formally reopened its ports to the world.

Fig. 9.36 School of Kano, *Namban* **six-panel screen. 1593–1600.** Kobe City Museum of Namban Art, Japan. Across the bottom left of the screen, African slaves, dressed in Portuguese costume, carry goods. In the center panel, another holds an umbrella over the head of a figure dressed in red.

9.1 Discuss the cultures that preceded that of the Aztecs in the Americas, and the Spanish reaction to Aztec culture.

The cultures of Mesoamerica were at once sophisticated—producing extraordinarily accurate calendars and magnificent cities—and backward, lacking beasts of burden, the wheel, and bronze or iron. How do cities like Teotihuacán, and, subsequently, the Mayan cities to the south, such as Palenque, nevertheless reflect considerable cultural sophistication? When Spanish conquistadors arrived in the Americas they found the highly developed Aztec culture. The Spanish came in hopes of plundering America's legendary wealth of precious metals. How do you account for the inhuman treatment of native cultures by European explorers and colonial administrators?

9.2 Describe the impact of the Portuguese on African life and the kinds of ritual traditions that have contributed to the cultural survival of African communities after contact.

By 1200, the Yoruba civilization, centered in the west African city of Ife, was producing elegant brass sculptures. In Benin, a huge complex of moats and walls developed at the capital. The art of lost-wax casting, introduced by the Yoruba, was perfected there. What was the purpose of these sculptures? How is this same purpose reflected in praise poems? After 1500, the Portuguese slave trade transported many millions of Africans across the Atlantic on the Middle Passage, and the presence of the Portuguese is evident in much of the art produced in West Africa in the sixteenth century. How were the Portuguese first received in Africa? How is their presence reflected in West African art? African cultures managed to maintain their cultural identity by continuing to engage in ritual practices and traditions. How did dance serve this purpose? What powers did their sculpture contain?

9.3 Outline the ways in which contact with Europe affected Mogul India.

Mogul leaders in India, particularly Akbar and Jahangir, not only introduced conventions of Islamic art to India but also opened the doors of the country to English traders. The style of representation that resulted from this contact is a blend of stylistic and cultural traditions, East and West. The Taj Mahal, on the other hand, is a distinctly Mogul achievement. What aesthetic taste does it reflect?

9.4 Assess the impact of contact with the wider world on China and the ways in which the arts reflect the values of the Chinese state.

What beliefs did the plan of the Tang dynasty capital, Chang'an, reflect? The Tang valued the arts—they were especially gifted ceramic artists—and education. Confucian, Buddhist, and Daoist philosophy informed government affairs. How did these philosophies inform the poetry of such writers as Li Bai and Du Fu as well?

When Marco Polo visited Hangzhou in 1274, it was still the capital city of the Southern Song dynasty. It enjoyed tremendous prosperity, controlled in no small part by a thriving merchant class whose sons had benefited from the invention of the printing press at schools that prepared them for government examinations. What did these students learn from studying the Chinese classics? Many poets and artists of the period practiced the neo-Confucian Chan Buddhism. How were these beliefs reflected in their work?

In 1279, the Song fell to the Mongol leader Kublai Khan, who ruled China from Beijing as founder of the Yuan dynasty. The scholar-painters of the Chinese court, unwilling to serve under foreign domination, retreated into exile. How did their art reflect their resistance?

One of the most important undertakings of the Chinese emperor Zhu Di's reign was the construction of the royal compound in Beijing, known as the Forbidden City. What various cultural traditions does its design draw from? In the Ming court, Dong Qichang wrote an essay dividing the history of Chinese painting into two schools, Northern and Southern. What are the characteristics of each? To what extent were these traditions related to painting elsewhere in the world?

9.5 Explain the tension between spiritual and military life in Japanese culture and the importance of patronage in Japanese cultural life.

The end of the Yamato period was marked by strife as those deeply attracted to Buddhism and those opposed to it fought for control. During the more stable Heian period, conflict continued. Nevertheless, the Heian court was one of extreme elegance and refinement. How would you describe the life of women in the court? How and why did a new, distinctly Japanese, as opposed to Chinese, writing system, the hiragana, influence their writing? Among the most important female writers in the Heian court was Murasaki Shikibu, whose Diaries are surpassed only by her monumental fictional narrative, The Tale of Genji. When, again, conflict among various clans led to the downfall of the Heian dynasty, warriors known as samurai took over the country. The most powerful samurai, Minamoto Yoritomo, took the title of shogun and inaugurated the first shogunate, the Kamakura dynasty. He isolated his government from both the imperial court at Heiankyo and the Buddhist monks at Nara. But both the court and Buddhism still thrived. What form of Buddhism became increasingly popular? Why? In the Muromachi period (1392-1573), the increasing power of local military rulers, who would come to be known as daimyo, was finally mitigated by the ascendency of Ashikaga shoguns. In the midst of what often amounted to civil war, the Ashikaga shoguns were great cultural patrons. Why did they associate themselves with the arts? What elements of Japanese taste began to assert themselves in garden design? In the tea ceremony? In Noh drama? How did trade with the Portuguese in the Azuchi-Momoyama period (1573–1615) influence Japanese culture?

The Influence of Zen Buddhism

nce Japan reopened its doors to world trade in 1853, the culture that it had developed over the 11 preceding centuries had an almost immediate impact on the West. Western artists of the nineteenth century, including Claude Monet, Vincent van Gogh, and Mary Cassatt, were fascinated by Japanese prints, which flooded European and New York markets in what amounted to an avalanche of images. Noh theater generated considerable excitement among Western writers. The German playwright Bertolt Brecht and the Irish poet William Butler Yeats would each write Noh plays of their own, and the American poet Ezra Pound freely adapted a number of traditional Noh plays. Especially appealing to Western sensibilities was Zen Buddhist philosophy, particularly in forms more or less intentionally constructed to appeal to the modern Western mind.

The most influential disseminator of a specifically modern version of Zen Buddhist philosophy in the West was the Japanese scholar D.T. Suzuki (1870-1966). In 1921, he and his wife began publishing The Eastern Buddhist, an English-language quarterly intended mostly for Westerners. His Essays in Zen Buddhism, published in London in 1927 and expanded upon in both 1933 and 1934, firmly established Suzuki's reputation. When, in April 1936, Suzuki was invited to London to speak at the World Congress of Faiths, he met the 20-year-old Alan Watts, who later the same year would publish his own very influential book, The Spirit of Zen.

After spending World War II in seclusion at Enkakuji, an important Zen temple in Kamakura, Suzuki moved to California in 1949, then to New York City, where from 1952 to 1957 he taught seminars on Zen at Columbia University. The composer John Cage attended these seminars for two years, and they deeply influenced his musical direction. A number of other twentieth-century Western intellectuals absorbed Suzuki's teachings as well, including psychoanalyst Carl Jung; poets Thomas Merton, Gary Snyder, and Allen Ginsberg; novelist Jack Kerouac; and potter Bernard Leach.

The many Asian members of the international Fluxus movement of artists, composers, and designers in the 1960s and 1970s, including Yoko Ono, popularized the Zen philosophical practice of posing riddles as a way to lead students to enlightenment. Ono's Fluxus compatriot, the Korean-born Nam June Paik (1932-2006), one of the great innovators of video art, poses just such a riddle in his TV

Figure 9.37 Nam June Paik, TV Buddha. 1974. Video installation with statue. Collection Stedelijk Museum, Amsterdam. Paik was deeply influenced by D.T. Suzuki through his close friendship with the composer John Cage.

Buddha of 1974 (Fig. 9.37). How, if he were alive today, would Buddha withdraw from the culture around him in order to meditate in pursuit of enlightenment? How, in meditating upon his own image reflected back to him on a TV screen, would he escape the charge of self-indulgent narcissism? Or would he escape it at all? What does it really mean to reflect upon oneself? This is the kind of question that a Zen master might ask of Paik's work, just as it is the kind of question a contemporary viewer might ask as well, which begins to suggest just how much Eastern philosophy has come to influence Western thought.

The Counter-Reformation and the Baroque

Emotion, Inquiry, and Absolute Power

LEARNING OBJECTIVES

10.1 Explain Mannerism and how it arose out of the Counter-Reformation.

10.2 Describe how the Baroque style manifested itself in the art, music, and literature of the era.

10.3 Discuss the vernacular Baroque style that developed in the North.

10.4 Define absolutism and discuss how it impacted the arts.

n 1562, a 36-year-old artist from Milan, Giuseppe Arcimboldo, left Italy for the Habsburg court in Vienna. The head of the Habsburg court was also the ruler of the Holy Roman Empire, first constituted by the pope in Charlemagne's time (see Chapter 5). He was also king of Spain, and thus in control of most of the Americas, with all the gold and silver the Western Hemisphere had to offer. For Arcimboldo, the prospects must have been enticing. Between 1549 and 1558, he had worked in Milan Cathedral designing stained-glass windows. In 1556 he began work on a fresco for the Cathedral of Monza, and in 1560 he delivered a cartoon for a tapestry for Como Cathedral. He had also made something of a reputation for himself in Milan as an illustrator of animals, birds, flowers, and plants. A drawing depicting a beetle, a caterpillar, a grasshopper, a chameleon, a lizard, and a salamander dates from 1553. But nothing of Arcimboldo's career before leaving for Vienna prepares us for the work he did there—a series of profile busts of the Four Seasons and the Four Elements composed out of vegetative matter arranged to create composite heads.

Summer (Fig. 10.1) is a virtual inventory of the produce readily available to the Habsburg court in the summer months—a currant for the figure's eye, a peach for its cheek, and a pear for its chin—but there are also less common varieties of crops, such as corn, which had been introduced to Europe from the New World in 1525, and eggplant, common

enough in Andalusian Spain but rarely seen in northern climes. Arcimboldo has woven his signature into the grains forming the collar of the coat and dated the composition on the shoulder.

We can only guess at Arcimboldo's motivation for composing such paintings. They were understood in the court of the Holy Roman Emperor Maximilian II (r. 1564-76) in Vienna as political allegories. The Italian humanist scholar Giovanni Battista Fonteo composed a poem of 308 stanzas in praise of them that was presented to Maximilian on New Year's Day 1569. Between them, the Four Seasons and the Four Elements represented the entire universe, the variety of things composing it existing in harmony, as a product of the peace and prosperity that the emperor's reign had bestowed on the world. We know as well that the emperor was devoted to his botanical gardens, filled with exotic trees whose fruits he served at palace dinners, and he maintained a menagerie full of rare animals, including an elephant, which court scientists studied. And it is this taste for the exotic that perhaps tells us most. The Habsburg court relished all things neverbefore-seen, inventions of wit never-before-heard, entertainments never-before-so-enjoyed. Arcimboldo's paintings satisfied all these tastes. They were, quite literally, fantastic totally and completely original.

Arcimboldo's work represents a new direction in European art, an art of invention that developed as a kind of

[▼] Fig. 10.1 Giuseppe Arcimboldo, Summer. 1563. Oil on limewood, 26¾" × 20". Kunsthistorisches Museum, Vienna. The Emperor Maximilian was so enamored of these paintings that he and his court dressed up as the elements and seasons in a 1571 festival orchestrated by Arcimboldo, in which the emperor played Winter.

counter-statement to the decorum and restraint urged upon artists by the Catholic Church as it tried to respond to the Protestant Reformation. The Church recognized that its own excesses had fueled the Reformation, but the Holy Roman Emperor Charles V (r. 1519–58)—Maximilian II became emperor by virtue of marrying Charles's daughter Mariacontinued to feud with Francis I of France, thus stymying the Church's efforts to respond politically. Still, despite their ongoing conflict—financed, on the Holy Roman Emperor's side, by gold and silver from the newly discovered Americas both monarchs understood the necessity of addressing the threat posed by the Protestant Reformation. They convinced the pope to convene the so-called Council of Trent in 1545. Its charge was to outline a path of reform for the Church itself. The Council called for a return to "simplicity, zeal toward God, and a contempt of vanities" in the lifestyles of its bishops. It believed the Church's art and music should reflect these values as well. In Italy, the Church initiated an Inquisition as a method of enforcing the strictures of the Counter-Reformation. In Spain, an Inquisition had been in place since 1478 as a tool to expel or convert all non-Christian Spaniards, especially Spanish Muslims and Jews, but also Catholic nuns and priests who practiced a brand of mysticism closely related to Jewish mystical tracts.

Even as the early Counter-Reformation would seek to impose a sense of restraint in all aspects of life, a more secular approach to art represented by the likes of Arcimboldo arose, originating in the High Renaissance's love for artistic genius and originality. Increasingly, the courts supported the production of works of art devoid of religious themes and without the restraint and decorum called for by Church reform. A clear division arose between the public face of the courts, which were almost uniformly aligned with the Church, and the tastes for the exotic and the inventive that those courts felt free to indulge in private. And in other lesser cultural centers, namely the princely courts of northern Italy, artists were free to pursue the spirit of originality and invention that had defined the High Renaissance, especially in nonreligious imagery. Inspired by the late work of Michelangelo, the style of painting and sculpture that developed in the courts of the Gonzaga in Mantua and the d'Este in Ferrara was notable for its freedom to experiment, its virtuosity and eccentricity, and its often frank sensuality.

We have come to call this style Mannerist, from the Italian word *maniera*, "style." Mannerism, in general, can be thought of as a style of refined elegance, reflecting the virtuosity and sophistication of its practitioners, often by means of an exaggeration and distortion of proportion that tests the boundaries of the beautiful and ideal. It resulted in an art almost the opposite of that called for by the Council of Trent, and it spawned an equally free and inventive literature. Eventually some artists managed to reconcile the aims of the Counter-Reformation and the inventiveness of Mannerism, creating a style that would pave the way for the Baroque era to come.

The transition from Mannerism to a full-blown Baroque style is the subject of this chapter. Attention to the way

viewers would emotionally experience a work of art is a defining characteristic of the Baroque, a term many believe takes its name from the Portuguese barroco, literally a large, irregularly shaped pearl. It was originally used in a derogatory way to imply a style so heavily ornate and strange that it verges on bad taste. We look at the Baroque first as it developed in Rome, and at the Vatican in particular, as a conscious style of art and architecture dedicated to furthering the aims of the Counter-Reformation; then in Venice, which in the seventeenth century was the center of musical activity in Europe. The Baroque also became the defining style of the royal courts of Europe, and by the start of the eighteenth century, almost every royal court in Europe modeled itself on King Louis XIV's court at Versailles. Louis so successfully asserted his authority over the French people, the aristocracy, and the Church that the era in which he ruled has become known as the Age of Absolutism.

Absolutism is a term applied to strong, centralized monarchies that exert royal power over their dominions, usually on the grounds of divine right. The principle had its roots in the Middle Ages, when the pope crowned Europe's kings, and went back even farther to the man/god kings of ancient Mesopotamia and Egypt. But by the seventeenth century, the divine right of kings was assumed to exist even without papal acknowledgment. The most famous description of the nature of absolutism is by Bishop Jacques-Bénigne Bossuet (1627–1704), Louis's court preacher and tutor to his son. While training the young dauphin for a future role as king, Bossuet wrote *Politics Drawn from the Very Words of Holy Scripture*, a book dedicated to describing the source and proper exercise of political power. In it, he says the following:

God is infinite, God is all. The prince, as prince, is not regarded as a private person: he is a public personage, all the state is in him; the will of all the people is included in his. As all perfection and all strength are united in God, so all the power of individuals is united in the person of the prince. What grandeur that a single man should embody so much!... you see the image of God in the king, and you have the idea of royal majesty.

Absolutism also informs, of course, the politics leading up to the Council of Trent, for although the monarchs of Europe were often at war with one another, they were united in their belief in the power of the throne, their insistence on their actual, if not official authority over the pope, and the role of the arts in sustaining that authority. In France, Louis XIV never missed an opportunity to impress upon the French people (and the other courts of Europe) his grandeur and power. In England, the monarchy struggled to assert its divine right to rule as it fought for power against Puritan factions that denied absolutism. In Spain, the absolute rule of the monarchy was deeply troubled by the financial insolvency of the state, but Philip IV advertised his absolutist position by inviting some of the greatest artists in Europe to his court.

THE EARLY COUNTER-REFORMATION AND MANNERISM

What is Mannerism and how did it arise out of the Counter-Reformation?

In 1493, the year after Columbus arrived in America, Pope Alexander VI decreed that the New World was the property of the Church, and he chose to rent it in its entirety to Spain (he was himself Spanish). Alexander's papal bull made clear that no other country could occupy any of these territories without the pope's permission and, by extension, his direct financial benefit. Thus, the subsequent colonization of North America by France and England was, from the Church's point of view, an act of piracy.

As king of Spain, Charles V was the direct beneficiary of the pope's pronouncements. From his point of view, the Americas served but one purpose—to provide funds for his continuing war against Francis I of France. The two monarchs had been at war since 1521 but never with any clear outcome for any significant period of time. The papacy needed both of them as allies in its campaign against the Protestant Reformation. But it was Charles V whose troops, to his embarrassment, had sacked Rome in 1527 and imprisoned Pope Clement VII (Giulio de' Medici), as a direct response to Clement's alliance with Francis I and Henry VIII of England.

The enmity between Charles V and Francis I went back to the election of Charles as emperor of the Holy Roman Empire in 1521. When, after the death of Emperor Maximilian, Charles out of courtesy informed Francis that he intended to seek election as emperor, Francis had replied, "Sire, we are both courting the same lady." The pope backed Francis, but Charles secured a loan of 500,000 florins from a bank in Augsburg and literally bought the votes of the seven electors.

Charles's empire was immense. By heredity and marriage, it included the Netherlands, where he had been born (in Ghent), the Iberian peninsula, southern Italy, Milan, Austria and parts of present-day Germany, and the Franche-Comté (see brown areas in Map 10.1). To this was added the lands of the Holy Roman Empire (outlined in red in Map 10.1), including all of Germany, Switzerland, and more of Italy. Because of its vast size, Charles's territory was susceptible to attack from virtually all directions, as Suleiman the Magnificent, emperor of the Ottoman Empire, demonstrated when, at Francis's request, he defeated and killed Charles's brotherin-law Louis II of Hungary in 1526. Thus embattled, Charles claimed to want peace so that the Church and its Catholic kings could turn their united attention to the threat of Protestantism. Finally, in 1544, Charles entered France from the Netherlands. Francis was sufficiently frightened, or sufficiently tired of the endless conflict, that he sued for peace. Together the two kings then turned to Pope Paul III and

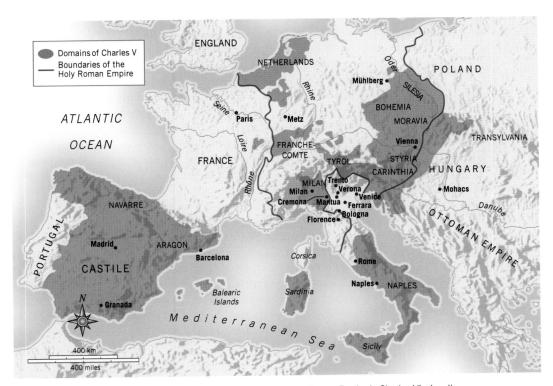

Map 10.1 The empire of Charles V. ca. 1521. The whole of the Holy Roman Empire in Charles V's time lies between the red lines, but Charles was in absolute control of the areas shaded in brown. In addition to the lands shown here, Charles also controlled almost all of the Americas.

pressured him to call a general council to be held at Trento, in northern Italy, beginning on December 3, 1545, to confront their common enemy, the Protestant challenge.

The Council of Trent and Catholic Reform of the Arts

The resolution of the conflict between Charles and Francis marks a moment when historical urgency profoundly affected the direction of humanistic enterprise. The resulting Council of Trent was charged with reforming the Church. It met in three sessions, and owing to war, plague, and the political strategies of the papacy itself, it spanned the careers of four different popes over 18 years: 1545–47, 1551–52, and 1562–63. The Council concentrated on restoring internal Church discipline. It called a halt to the selling of Church offices and religious goods, a common practice used by clergy to pad their coffers. It required bishops, many of whom lived in Rome, to return to their dioceses, where, they were told, they needed to preach regularly, exert discipline over local religious practice, and be active among their parishioners. They were warned not to live ostentatiously:

It is to be desired that those who undertake the office of bishop shall understand... that they are called, not to their own convenience, not to riches or luxury, but to labors and cares, for the glory of God.... Wherefore ... this Council not only orders that bishops be content with modest furniture and a frugal table and diet, but that they also give heed that in the rest of their manner of living and in their whole house there be nothing seen which is alien to this holy institution, and which does not manifest simplicity, zeal toward God, and a contempt of vanities.

The bishops were to maintain strict celibacy, which they had not been required to do before. And they were to construct a seminary in every diocese.

The Council of Trent's injunction against luxury and its assertion of the principle of simple piety were directly translated to the arts. Contrary to many Protestant sects, the Council of Trent insisted on the use of religious imagery:

The images of Christ, of the Virgin Mother of God, and of other saints are to be placed and retained especially in churches... [and] set before the eyes of the faithful so that they... may fashion their own life and conduct in imitation of the saints and be moved to adore and love God and cultivate piety.

Subsequent treatises on art, written by clergy, called explicitly for direct treatment of subjects, unencumbered by anything "sensuous," from brushwork to light effects.

The Council of Trent's order for a visual art that would directly affect the souls of the people influenced the direction in which church music developed as well. The function of music in the liturgy, the Council insisted, was to serve the text, and so the text should be clear and intelligible to the congregation:

The whole plan of singing should be constituted not to give empty pleasure to the ear, but in such a way that the words be clearly understood by all, and thus the hearts of the listeners be drawn to the desire of heavenly harmonies.... They shall also banish from church all music that contains, whether in the singing or in the organ playing, things that are lascivious or impure.

For some, polyphony (two or more voices of equal importance) constituted "lascivious or impure" music, and they argued that only the single line of monophonic plainchant should be performed in the church. The Council rejected this idea.

Legend has it that the Council rejected the replacement of polyphonic music with plainchant because of a particular polyphonic mass, composed in 1567 by Giovanni Pierluigi da Palestrina (ca. 1525–94): Missa Papae Marcelli, or Mass for Pope Marcellus. The story is not true, but that it was widely believed for centuries testifies to the power of Palestrina's choral work. In his career, which included serving as choirmaster at the Capella Giulia in the Vatican for many years, Palestrina wrote 104 settings of the Mass, 375 motets, 80 hymns, and about 140 songs, both sacred and secular. He was the first composer of the sixteenth century to have his complete works published and was one of the most influential composers of his day.

The Missa Papae Marcelli is notable for the way it carries out the requirements of the Council of Trent. Its music is restrained so that the words, when sung by the choir, stand out in utter clarity, especially at the beginning of phrases. Although the voices in the Credo section enunciate each syllable of the text in chordal unison (usually thirds and sixths, or what we have come to recognize as consonant intervals), a constant interplay between counterpoint, in which voices imitate the main melody in succession, and homophony, in which the subordinate voices simply accompany the melody in unison, enlivens the music (track 10.1). Likewise, Palestrina often plays one voice sustaining a single note per syllable against a voice engaged in melisma, or many notes per syllable. Above all, however, the intelligibility of the text is of paramount concern.

This quality is also audible in Palestrina's Super Flumina Babylonis, or By the Rivers of Babylon, one of his most famous motets (track 10.2). The motet, you will remember, was the most important form of polyphonic vocal music in the Middle Ages and Renaissance. From the Renaissance onward, it normally had a Latin sacred text, and, like a mass, was sung during Catholic service. The text of Super Flumina Babylonis is from Psalm 137 of the Bible and expresses the lamentation of the Jewish people:

By the rivers of Babylon, there we sat down and wept, When we remembered you, O Zion.

On the willows, in the midst of everything, we hung up our harps.

The rhythm of each word matches up directly to the musical cadence. The accented syllable of each word is also usually set to a higher note, thus blending text and music with absolute clarity. In Palestrina's own words, the intention is to draw out "the vital impulse given to its words, according to their meaning." In keeping with the thinking of the Council of Trent, Palestrina's music serves to enliven—even glorify—the words, words that the Council believed every member of the congregation must be moved to understand and believe.

The Rise of Mannerism

The demand for clarity and directness that marks the art and music of the Counter-Reformation did not constrain so original an artist as Michelangelo, who introduced a different, more inventive direction in sixteenth-century art. Raphael had already arrived at a new style in the last paintings he executed for the Vatican before his death in 1520. He replaced the clarity, restraint, and order of his School of Athens (see Closer Look, pages 234–235) with a more active, dynamic, even physically distorted realization of the human figure, probably in response to Michelangelo's own innovations in the same direction in the later frescoes for the Sistine Chapel ceiling in the Libyan Sibyl, for instance (see Fig. 7.27 in Chapter 7). This new Mannerist style resulted in distorted, artificial poses, mysterious or obscure settings, and, very often, elongated proportions. It is marked by the rejection of the Classicizing tendencies of the High Renaissance and by the artist's display of virtuosity through manipulation and distortion of the conventional figure.

Michelangelo's *Pietà*, one of the artist's last works, is a fully realized example of the new Mannerist artistic vocabulary (Fig. 10.2). The traditional *contrapposto* pose that evolved from Classical Greek

sculpture in order to give a static figure the illusion of potential movement is here exaggerated by the dynamic, spiral turn of Christ's body as he falls to the ground. The result is what would become known as a **serpentine figure**, with no single predominant view. The right arm twists away from the body even as Christ's right leg seems to fold forward to the right at a 90-degree angle.

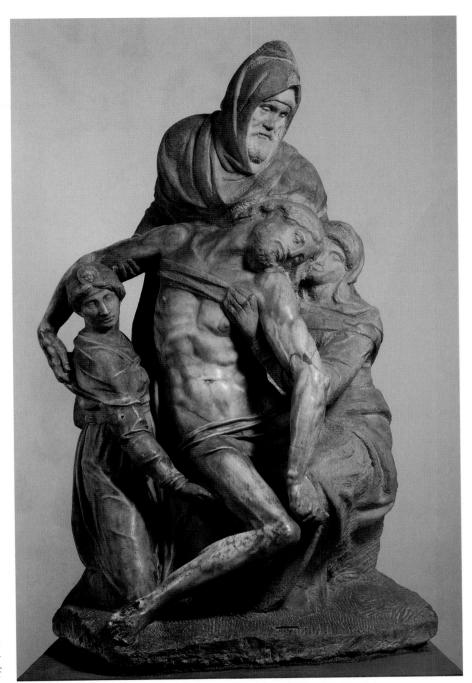

Fig. 10.2 Michelangelo, *Pietà*. 1547–53. Marble, height 89". Museo dell'Opera del Duomo, Florence. The female figure on the left was finished by Tiberio Calcagni, and the whole reconstructed by him, after Michelangelo smashed the sculpture upon discovering, after seven years of work, an imperfection in the marble that he had not previously detected.

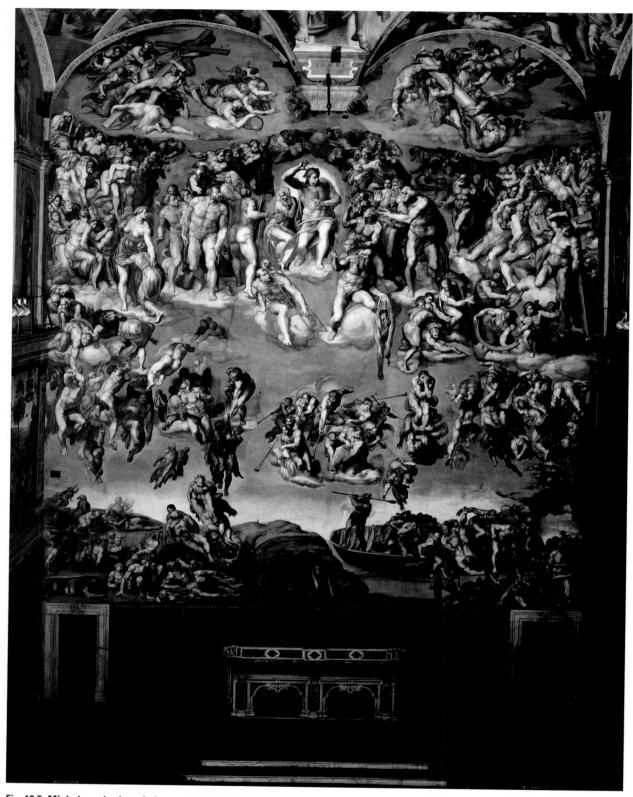

Fig. 10.3 Michelangelo, *Last Judgment.* **1534–41.** Fresco, 48' × 44'. Sistine Chapel, Vatican, Rome. Foto Musei Vaticani. Well to Christ's right, past the nude figure of John the Baptist, is a personification of the Church embracing a woman kneeling before her. The personification is bare-breasted to symbolize her ability to nourish the faithful. Balancing her, at the far right of the painting, a man places a large cross on the Sistine Chapel cornice, a symbolic representation of Christ's sacrifice. The pair, male and female, mirror Christ and Mary in the center of the painting.

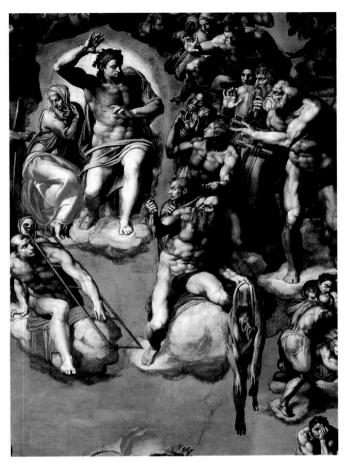

Fig. 10.4 Michelangelo, *Last Judgment.* **1534–41. Detail.** Fresco, 48' × 44'. Sistine Chapel, Vatican, Rome. Foto Musei Vaticani. Nudity such as Michelangelo paints here was virtually unheard of in church decorative programs.

Michelangelo incorporated this serpentine pose somewhat less dramatically into his first commission in Rome after returning in 1534, a Last Judgment fresco for the altar wall of the Sistine Chapel (Fig. 10.3). At the top center of the painting, Mary crouches beside Christ, turning her head away toward the left-hand side of the composition, apparently absorbed in her own thoughts (Fig. 10.4). Christ himself turns his attention to the saints and martyrs on the right-hand side of the composition, such as white-bearded Saint Peter holding gold and silver keys to Heaven. Saint Bartholomew, who was martyred by being skinned alive, sits just below Christ's feet, holding in his right hand a knife, the instrument of his torture, and in his left hand his own flayed skin.

Many scholars believe that the face on the flayed skin is a self-portrait of Michelangelo, suggesting his sense of his own martyrdom under the unrelenting papal commissions of Pope Paul III. These figures, whose bodies were mutilated and maimed in their martyrdom, have been healed and restored as they rise to heaven. At the bottom of the painting, on the left, angels welcome souls ascending from the grave. At the right, demons drag the damned down into Hell as Charon, the mythological boatman of the Classical world, ferries

them across the River Styx. In the bottom center of the painting, directly behind the altar of the Sistine Chapel, is Hell's Mouth, and above it, angels trumpeting the arrival of the Last Judgment.

Michelangelo's *Last Judgment* almost immediately provoked controversy because of its presentation of religious figures nude. The poet Pietro Aretino sent him a letter in 1545 objecting to the fresco, a letter especially interesting when considered in the context of the Council of Trent, which was then in session (**Reading 10.1**):

READING 10.1

from Pietro Aretino, Letter to Michelangelo (1545)

The pagans when they made statues I do not say of Diana who is clothed, but of naked Venus, made them cover with their hand the parts which should not be seen. And here there comes a Christian who, because he rates art higher than faith, deems a royal spectacle martyrs and virgins in improper attitudes, men dragged down by their genitals, things in front of which brothels would shut their eves in order not to see them. Your art would be at home in some voluptuous bagnio [bathhouse], certainly not in the highest chapel in the world.... Restore it to good repute by turning the indecent parts of the damned to flames, and those of the blessed to sunbeams, or imitate the modesty of Florence, who hides your David's shame beneath some gilded leaves. And yet that statue is exposed upon a public square, not in a consecrated chapel.

When Michelangelo did not respond to this letter, Aretino published it. The letter underscores the growing tension between the developing Mannerist style and the aims of the Counter-Reformation, especially in the context of the Council of Trent, which was then in session. In fact, as long as Paul III remained pope, the *Last Judgment* stayed as Michelangelo had painted it. But with the election of Paul IV in 1555, the first new pope after Paul III had convened the Council of Trent in 1545, the painting fell into ever-increasing disfavor. Shortly after Michelangelo's death in 1564, Daniele da Volterra and others painted draperies over the genital areas of the fresco's nude figures, a feat for which they ignominiously earned the name *braghettoni*, "breeches-painters." Even when the painting was cleaned and restored in 1994, the Vatican chose to leave the draperies in place.

As long as painting confined itself to depicting non-religious subjects for nonreligious venues, it was more or less free to do as it pleased. Even the nudity of Michelangelo's Sistine Chapel figures would have been tolerable if painted in some less holy place. The Roman cardinal Cirillo Franco summed up the general attitude in a letter: "I hold the painting and sculpture of Michelangelo to be a miracle of nature; but I would praise it so much more if, when he wants to show the supremacy of his art in all that posturing of naked limbs, and all those nudes... he did not paint it on the vault of the

Fig. 10.5 Correggio, *Jupiter and Io.* **Early 1530s.** Oil on canvas, 69" × 29½". Kunsthistorisches Museum, Vienna. In the myth, Jupiter (Zeus) appears in a dream to Io, daughter of the king of Argos, and takes her to Lerna, a marsh and stream in the eastern Peloponnese, where he seduces her disguised as a cloud. The painting was created for the pleasure chamber of Federico Gonzaga in the Palazzo Ducale, Mantua.

Pope's Chapel, but in a gallery, or some garden loggia." It was a matter of decorum, or propriety. What might be decorous and appropriate in a gallery or garden loggia was absolutely not so in a church.

In the private galleries of the princely courts throughout Europe, this more indecorous but highly inventive imagery thrived. In the early 1530s, for instance, Federico Gonzaga of Mantua commissioned a set of erotic paintings that seem almost intentionally the indecorous embodiment of what the Council of Trent would label "the lascivious or impure." They were the work of the northern Italian artist Correggio (given name Antonio Allegri, ca. 1494–1534) and depicted the loves of Jupiter, or Zeus.

Jupiter and Io, painted in the early 1530s, is one of these (Fig. 10.5). The painting illustrates Jupiter consummating his love for Io, a priestess of Hera (Jupiter's wife). Jupiter appears to Io in the guise of a cloud, his face barely visible behind her, kissing her lightly on the cheek. His bearlike arm embraces her as she abandons herself, quite visibly, to sensual pleasure. In addition to the unabashed sensuality of the presentation, the somewhat bizarre juxtaposition of Io's fully lit and well-defined body with Jupiter's dark and amorphous form is fully Mannerist in spirit.

This same theme occupied Titian in a series of paintings commissioned by Philip II of Spain in the late 1550s. Philip built a special room to house them in the Escorial, his palace complex near Madrid. In The Rape of Europa, Jupiter has assumed the form of a bull to abduct the nymph Europa as she adorns his horns with flowers (Fig. 10.6). What most distinguishes the work is this Venetian artist's loose, sensual way of handling paint—a far cry from the crisp, even cold linearity of Correggio's Mannerist technique in the drapery beneath Io and in the porcelain-like quality of her skin. Titian's lush brushwork mirrors the sensuality of the image. And yet, in the way Europa falls across the bull's back in a serpentine posture emphasized by the spiraling form of the red robe that flies from her hand, the painting demonstrates just how strongly Mannerist expression had entered the vocabulary of sixteenth-century painting as a whole. Like the Mannerists, the later Titian draws attention to his own virtuosity and skill, to the presence of his so-called hand, or stylistic signature through brushwork, in the composition. (The root of maniera, not coincidentally, is mano, "hand.")

Even when Mannerists did find themselves working in a religious context, they tended to paint works designed to unsettle the viewer. When, for instance, Girolamo Francesco Maria Mazzola (1503–40), known as Parmigianino, was commissioned in 1535 to decorate a family chapel in the church of Santa Maria dei Servi in his native Parma (where, not coincidentally, Correggio spent most of his career), the resulting Madonna and Child must have startled more than one viewer. Known as *The Madonna with the Long Neck* (Fig. 10.7), the painting seems, from the very first glance, oddly organized. How much space, for instance, is there between the Madonna and her attendants, compressed into the left three-quarters of the painting, and the figure of Saint Jerome

Fig. 10.6 Titian, *The Rape of Europa.* **1559–62.** Oil on canvas, 5'9¼" × 7'8¼". Isabella Stewart Gardner Museum, Boston. On the distant shore, Europa's maidservants gesture in vain at her abduction.

reading a scroll in the distant, open space at the right? He appears to be standing just a short step below the Madonna's chair, but because Parmigianino has not accounted for the wide gap between the saint and the foreground group, the space in which he stands is visually almost totally incoherent. In fact, he must be standing far below her. We know that Saint Jerome's presence in the painting was a requirement of the commission—he was famous for his adoration of the Virgin, and Parmigianino had even painted a Vision of Saint Jerome in 1527, in which, oddly, the saint is sound asleepbut it is almost as if Parmigianino is scoffing at his patron's wishes, or at least acceding to them in an almost flippant way. The painting, it is worth noting, is over 7 feet high, and thus the miniature Saint Jerome contrasts even more dramatically with the greater-than-life-size Virgin who rises above him almost as if she is analogous in size to the column beside which he stands. Indeed, the Virgin's swanlike neck is a traditional conceit, found in medieval hymns, comparing her neck to an ivory tower or column, a sort of vernacular expression of the Virgin as the allegorical representation of the Church.

But it is not only the spatial ambiguity of the painting that lends it such a sense of the unorthodox. The uncannily long-legged figure at the left inexplicably holds a long, oval amphora, as if he is offering it to the Virgin. It serves no real allegorical purpose. Rather, it defines the compositional principle upon which Parmigianino has organized his painting. Like the amphora, the Virgin's head is oval, and her entire body sweeps across the canvas forming the same oval shape. This oval is transected by the disproportionately long body of the Christ Child, who lies across the Virgin's lap. The Virgin seems to withdraw from the child as if recognizing what will befall him. In one of the painting's oddest effects,

Fig. 10.7 Parmigianino, *The Madonna with the Long Neck*. ca. 1535. Oil on panel, 7'1" × 4'4". Galleria degli Uffizi, Florence. This work was begun in 1535, but the background space above Saint Jerome remained unfinished at Parmigianino's death in 1540.

Parmigianino has posed the Madonna so that, between her glance and the Christ Child's face, the folds of her blouse hang stiffly from a decidedly pointed nipple. Equally unsettling is the way that the Virgin's right foot seems to extend beyond the plane of the support into our own space, so that the gap between ourselves and the world of the painting mirrors the unaccounted-for space that lies between the Virgin and Saint Jerome.

Veronese and the Italian Inquisition A clear example of the need to use invention decorously in art is provided by the fate of a Last Supper, now known as the Feast in the House of Levi, by the Venetian artist Veronese (1528–88). Veronese was born Paolo Cagliari and nicknamed after the city of his birth, Verona. As early as 1542, Pope Paul III had initiated a Roman Inquisition—an official inquiry into possible heresy—and in 1573, Paolo Veronese was called before the Inquisition to answer charges that his

Fig. 10.8 Veronese, Feast in the House of Levi. 1573. Oil on canvas, 18' × 42'. Galleria dell'Accademia, Venice. After his testimony before the Inquisition, Veronese made it clear that his "new" source for the painting was the feast in the house of Levi by citing the biblical reference on the balustrade.

Last Supper (Fig. 10.8), painted with life-size figures for a Dominican monastery in Venice, was heretical in its inappropriate treatment of the subject matter. His testimony before the tribunal illuminates the aesthetic and religious concerns of the era (Reading 10.2):

READING 10.2

from The Trial of Veronese (1573)

VERONESE: This is a picture of the Last Supper that Jesus Christ took with His Apostles in the house of Simon. INQUISITOR: At this Supper of Our Lord have you painted other figures?

VERONESE: Yes, milords.

INQUISITOR: Tell us how many people and describe the gestures of each.

VERONESE: There is the owner of the inn, Simon; beside this figure I have made a steward, who, I imagined, had come there for his own pleasure to see how the things were going at the table. There are many figures there which I cannot recall, as I painted the picture some time ago... INQUISITOR: In this Supper which you made for SS.

Giovanni e Paolo, what is the significance of the man whose nose is bleeding?

VERONESE: I intended to represent a servant whose nose was bleeding because of some accident.

INQUISITOR: What is the significance of those armed men dressed as Germans, each with a halberd in his hand? VERONESE: We painters take the same license the poets and the jesters take and I have represented these two

halberdiers, one drinking and the other eating nearby on the stairs. They are placed there so that they might be of service because it seemed to me fitting, according to what I have been told, that the master of the house, who was great and rich, should have such servants.

INQUISITOR: And that man dressed as a buffoon with a parrot on his wrist, for what purpose did you paint him on that canvas?

VERONESE: For ornament, as is customary...

INQUISITOR: Are not the decorations which you painters are accustomed to add to paintings or pictures supposed to be suitable and proper to the subject and the principal figures or are they for pleasure—simply what comes to your imagination without any discretion or judiciousness? VERONESE: I paint pictures as I see fit and as well as my talent permits.

INQUISITOR: Does it seem fitting at the Last Supper of the Lord to paint buffoons, drunkards, Germans, dwarfs and similar vulgarities?

VERONESE: No, milords.

The tribunal concluded that Paolo Veronese should "improve and correct" the painting in three months' time or face penalties. But rather than change the painting, Veronese simply changed the painting's title to *Feast in the House of Levi*. This title refers to a biblical passage: "Levi gave a great banquet for him [Jesus] in his house, and a large crowd of tax collectors and others were at table with them" (Luke 5:29). Through this strategy Veronese could justify the artistic invention in his crowded scene.

The Spanish Inquisition In sixteenth-century Spain, a brand of religious mysticism threatened the Church from within. The alumbrados, or "illuminated ones," nuns, monks, and priests lit by the Holy Spirit, practiced an extremely individualistic and private brand of faith, which led to accusations that they also claimed to have no need of the sacraments of the Church. The alumbrados were therefore susceptible to charges of heresv. Chief among them were the Carmelite nun Teresa of Ávila (1515–82) and the Carmelite friar Juan de la Cruz (1542–91), known as John of the Cross. Teresa was from a converso family converted Jews—that lived in Ávila, the medieval center of Jewish mystical thought. Dissatisfied with the worldliness that had crept into her Carmelite order, Teresa campaigned to reform it, founding the Discalced (or shoeless) Carmelites, dedicated to absolute poverty and the renunciation of all property. Between 1567 and 1576, she traveled across Spain, founding Discalced convents and a reform monastery for Carmelite men. Juan de la Cruz was one of the first two members, and the two would become close friends. Juan's powers as a teacher, preacher, and poet served to strengthen the movement. Teresa's writings, including an autobiography and The Way to Perfection, both written before 1567, and The Interior Castle, written in 1577, all describe the ascent of the soul to union with the Holy Spirit in four basic stages. In the final of these stages, "devotion of ecstasy or rapture," consciousness of being in the body disappears and the spirit finds itself alternating between the ecstatic throes of a sweet, happy pain and a fearful, glowing fire.

In 1574, Teresa was denounced to the Inquisition as a restless wanderer who under the pretext of religion lived a life of dissipation. As a result, in 1576, she was confined in a convent. Juan de la Cruz suffered an even worse fate. Calced Carmelites arrested him in Toledo on the night of December 3, 1577. They held him in solitary confinement and lashed him before the community weekly until he escaped eight months later. Among the great works written following his escape is *The Dark Night of the Soul*, a book-length account of the author's mystical union with God.

The moral strictures of the Inquisition and the mysticism of the *alumbrados* are recognizable in the art of one of the most original sixteenth-century painters, El Greco, "The Greek" (born Domenico Theotokopoulos; 1541–1614). He trained as an icon painter in his native Crete, in those days a Venetian possession. In 1567 he went to Venice, then three years later to Rome, and in 1576, to Spain, where he soon developed a style that wedded Mannerism with the elongated, iconic figures of his Byzantine training. He used painting to convey an intensely expressive spirituality.

Painted at the turn of the sixteenth century, El Greco's Resurrection is decorous to the extent that draperies carefully conceal all inappropriate nudity (Fig. 10.9). The poses of the writhing Roman soldiers who surround the vision of the triumphant Christ are as artificial and contrived as any in Mannerist art. The verticality of the composition, popular since the time of Correggio, mirrors the elongated anatomy of El Greco's figures. And yet, El Greco's style is unique, singular in the angularity of its draperies, in the drama of the representation, and in its overall composition. The Roman soldiers rise and fall in

elongated, serpentine poses, twisting around Christ like petals on a blossom, with Christ himself as the flower's stamen. If Christ's sexuality has been repressed, the effect of his presence on the soldiers, who swoon in near-hysterical ecstasy, is unmistakable. Above all, this painting celebrates raw physicality, even as it presents the greatest spiritual mystery of the Christian faith. Here the aspirations of the Counter-Reformation and the inventiveness of the Mannerist style are fully united, as they would come to be in the Baroque art of the seventeenth century.

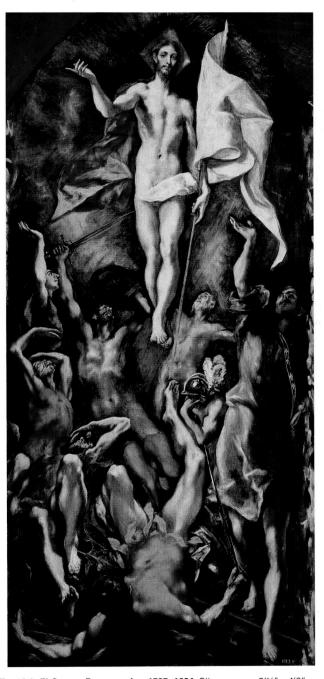

Fig. 10.9 El Greco, *Resurrection.* **1597–1604.** Oil on canvas, $9'\%'' \times 4'2''$. Museo del Prado, Madrid. The image was probably painted for the Colegio de Doña Maria, Madrid, and paired with a depiction of the Pentecost, the descent of the Holy Spirit upon the apostles on the seventh Sunday after Easter.

Cervantes and the Picaresque Tradition

In the last half of the sixteenth century, a literary genre originated in Spain that celebrated inventiveness, particularly suited to Spanish taste, and had a strong effect on literary events in the seventeenth century. This was the picaresque novel, a genre of prose that narrates, in a realistic way, the adventures of a picaro, a roguish hero of low social rank living by his wits in a corrupt society. The first book to introduce the picaresque tradition in Spain was Lazarillo de Tormes, published anonymously in 1554. Raised by beggars and thieves, Lazarillo is a frankly common man, particularly bent on ridiculing and satirizing the Catholic Church and its officials. For that reason and probably because its hero was not highborn, the Spanish crown banned the book and listed it in the Index of Forbidden Books of the Inquisition. A much more complex picaro and undoubtedly the greatest hero of the picaresque tradition in Spanish literature is Don Quixote, the creation of the novelist, poet, and playwright Miguel de Cervantes (1547-1616).

Cervantes was himself a hero in the army of Philip II at the Battle of Lepanto in 1569 (where Spain defeated the Turks, gaining control of the Mediterranean), a captive of Barbary pirates for five years (1575–80), a supplier of provisions for the ill-fated Spanish Armada, and several times imprisoned for debt. In 1605, when he was 58 years of age, he published *The Ingenious Hidalgo Don Quixote de la Mancha*. (A *hidalgo* is a member of the lower Spanish nobility, generally exempt from paying taxes but not necessarily owning any real property.) A second part followed a decade later, a year before his death. The novel is more familiarly known today simply as *Don Quixote*.

Don Quixote is often considered the first great modern novel. It is set in La Mancha, a great arid plain southeast of Madrid. Into this landscape Cervantes places his two principal characters, Don Quixote and his servant Sancho Panza. Don Quixote is obsessed with the old stories of romance literature about questing knights and decides to become one himself. Cervantes presents him as a highly satiric re-creation of the conquistadors, whose exploits in the Americas were, Cervantes understood, similarly inspired by a thirst for romantic adventuring. Don Quixote's enthusiasm and self-deception unintentionally produce comic results. Sancho Panza, on the other hand, is a down-to-earth realist who believes the Don to be a bit crazy but plays along and accompanies him as squire on his adventures, hoping to get rich. The two search for the Don's ideal—and imaginary—lady, Dulcinea. Sancho convinces the Don that she is a plain, poorly dressed peasant riding a donkey and that he cannot recognize her for the beauty he knows Dulcinea to be because his vision has been bewitched by an enchantress. In other scenes, the Don mistakes a common country inn for a castle, a herd of sheep for a pagan army at battle with Christian forces, and two windmills for battling giants sent by an evil enchanter. This last is his most famous adventure, and in it Don Quixote, ever the noble conquistador, proceeds to tilt at the two windmills with his lance.

All these episodes are parables of the relation between illusion and reality, art and life. They anticipate the psychological complexities that will come to define the novel as a form. Don Quixote cannot reconcile his dreams with the realities of life itself, and his comic adventuring becomes his tragic fate. Above all, Don Quixote's adventures underscore both the marvelous possibilities that come from unleashing the imagination and the dangers of leaving the world behind.

THE BAROQUE IN ITALY

What is the Baroque style and how does it manifest itself in art and music?

By the middle of the seventeenth century, then, artists like Bernini were increasingly comfortable working in the inventive and exuberant style that had been inaugurated by Mannerism, while, at the same time, they still fully accepted the edicts of the Council of Trent. The Church's point of view was emphatically supported by the teachings of the Society of Jesus, founded by the Spanish nobleman Ignatius of Loyola (1491–1556). From their headquarters at the Church of Il Gesù in Rome, the Jesuits, as they were known, led the Counter-Reformation in the seventeenth century and the revival of the Catholic Church worldwide. All agreed that the purpose of religious art was to teach and inspire the faithful, that it should always be intelligible and realistic, and that it should be an emotional stimulus to piety.

In his *Spiritual Exercises*, published in 1548, Loyola had called on Jesuits to develop all their senses—an idea that surely influenced the many and richly diverse elements of the Baroque style. For instance, in the Fifth Exercise, a meditation on the meaning of Hell, Loyola invokes all five senses (**Reading 10.3**):

READING 10.3

from Ignatius Loyola, *Spiritual Exercises*, Fifth Exercise (1548)

FIRST POINT: This will be to see in imagination the vast fires, and the souls enclosed, as it were, in bodies of fire.

SECOND POINT: To hear the wailing, the howling, cries, and blasphemies against Christ our Lord and against His saints.

THIRD POINT: With the sense of smell to perceive the smoke, the sulphur, the filth, and corruption.

FOURTH POINT: To taste the bitterness of tears, sadness, and remorse of conscience.

FIFTH POINT: With the sense of touch to feel the flames which envelop and burn the souls.

Such a call to the senses would manifest itself in increasingly elaborate church decoration, epitomized by a ceiling fresco painted by Andrea Pozzo (1642–1709) for the church of Sant'Ignazio in Rome depicting the *Apotheosis of Saint Ignatius of Loyola* (Fig. 10.10). The fresco employs a technique used on the ceilings of many Roman churches and palaces in the

Baroque era to create dynamic and dramatic spatial effects—foreshortening. Foreshortening allowed artists to make the ceiling appear larger than it actually was. To create the illusion of greater space, the artist would paint representations of architectural elements—such as vaults, arches or niches—and then fill the remaining space with foreshortened figures that seem to fly out of the top of the building into the heavens above. Because of Pozzo's masterful use of foreshortening, it is difficult for a visitor to Sant'Ignazio to tell that the space above the nave is a barrel vault. Pozzo painted it over with a rising architecture that seems to extend the interior walls an extra story. A white marble square in the pavement below indicates to the viewer just where to stand to appreciate the perspective properly. On each side of the space overhead are allegorical figures representing the four continents. America is at the upper left, crowned by a feathered headdress of red, white, and blue. Just below the center of the painting, Saint Ignatius, in gray robes, is transported on a cloud toward the waiting Christ, just above him. Other Jesuit saints rise to meet them. In Pozzo's ceiling, the faithful are invited to see not Hell, as Loyola outlines in his Spiritual Exercises, but Heaven. They are invited to hear "in imagination" not wailing but hosannas, smell not smoke but perfume, taste not bitter tears but sweet tears of joy, and touch not flames but the glorious light of God.

Baroque Sculpture: Bernini

Probably nothing sums up the Baroque movement better than Bernini's sculptural program for the Cornaro Chapel. Located in Carlo Maderno's Church of Santa Maria della Vittoria in Rome, the work was a commission from the Cornaro family and executed by Bernini in the middle of the century, at about the same time he was working on the colonnade for Saint Peter's Square. Bernini's theme is a pivotal moment in the life of Teresa of Ávila. Teresa was steeped in the mystical tradition of the Jewish Kabbalah, the brand of mystical lewish thought that seeks to attain the perfection of Heaven while still living in this world by transcending the boundaries of time and space. Bernini illustrates the vision she describes in the following passage (Reading 10.4):

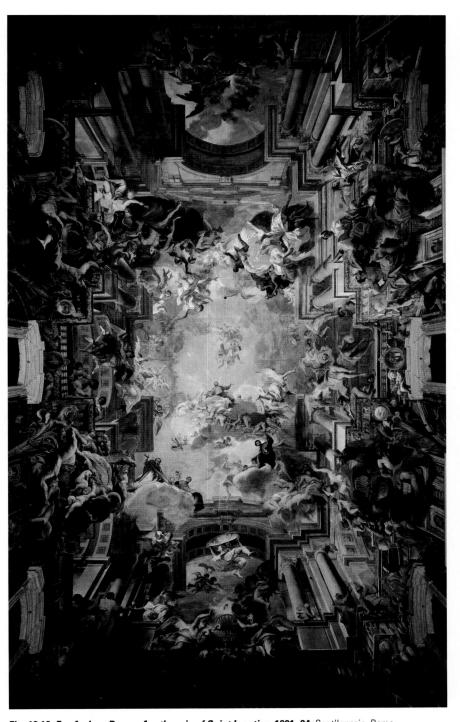

Fig. 10.10 Fra Andrea Pozzo, *Apotheosis of Saint Ignatius.* **1691–94.** Sant'Ignazio, Rome. Ceiling fresco, ca. 56' x 115'. Allegorical works in each corner represent the four continents— Europe, Asia, Africa, and America—where the Society of Jesus carried out its missionary work.

READING 10.4

from Teresa of Ávila, "Visions," Chapter 29 of The Life of Teresa of Ávila (before 1567)

It pleased the Lord that I should sometimes see the following vision. I would see beside me, on my left hand, an angel in bodily form.... He was not tall, but short, and

very beautiful, his face so aflame that he appeared to be one of the highest types of angel who seem to be all afire. They must be those who are called cherubim; they do not tell me their names but I am well aware that there is a great difference between certain angels and others. and between these and others still, of a kind that I could not possibly explain. In his hands I saw a long golden spear and at the end of the iron tip I seemed to see a point of fire. With this he seemed to pierce my heart several times so that it penetrated to my entrails. When he drew it out, I thought he was drawing them out with it and he left me completely afire with a great love for God. The pain was so sharp that it made me utter several moans; and so excessive was the sweetness caused me by this intense pain that one can never wish to lose it, nor will one's soul be content with anything less than God. It is not bodily pain, but spiritual, though the body has a share in it—indeed, a great share. So sweet are the colloquies of love which pass between the soul and God that if anyone thinks I am lying I beseech God, in His goodness, to give him the same experience.

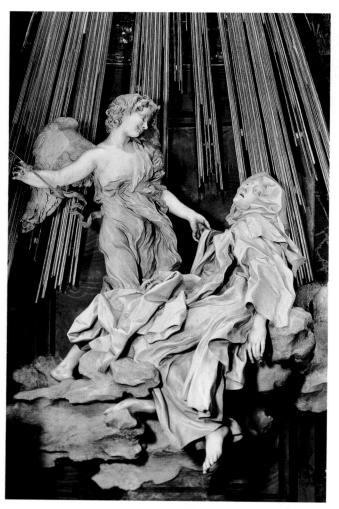

Fig. 10.11 Gianlorenzo Bernini, *The Ecstasy of Saint Teresa*, Cornaro Chapel, Santa Maria della Vittoria, Rome. 1647–52. Marble, height of group 11'6".

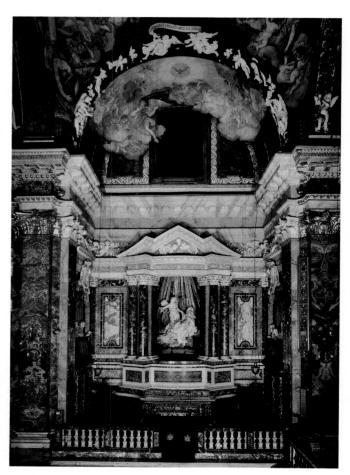

Fig. 10.12 Gianlorenzo Bernini, Cornaro Chapel, Santa Maria della Vittoria, Rome. 1647–52. The Cornaro family portraits are just visible on the left and right walls of the chapel.

Bernini might not have recognized in Teresa's words a thinly veiled description of sexual orgasm. But he probably did understand that the sexuality that Protestantism and the Catholic Counter-Reformation had deemed inappropriate to religious art, but which had survived in Mannerism, had found, in Saint Teresa's vision, a properly religious context, uniting the physical and the spiritual. Thus, the sculptural centerpiece of his chapel decoration is Teresa's ecstatic swoon, the angel standing over her, having just withdrawn his penetrating arrow from her "entrails," as Teresa throws her head back in the throes of spiritual passion (Fig. 10.11).

Bernini's program is far more elaborate than just its sculptural centerpiece (Fig. 10.12). The angel and Teresa are positioned beneath a marble canopy from which gilded rays of light radiate, following the path of the real light entering the chapel from the yellow panes of a window hidden from view behind the canopy pediment. Painted angels, sculpted in stucco relief, descend across the ceiling, bathed in a similarly yellow light that appears to emanate from the dove of Christ at the top center of the composition. On each side of

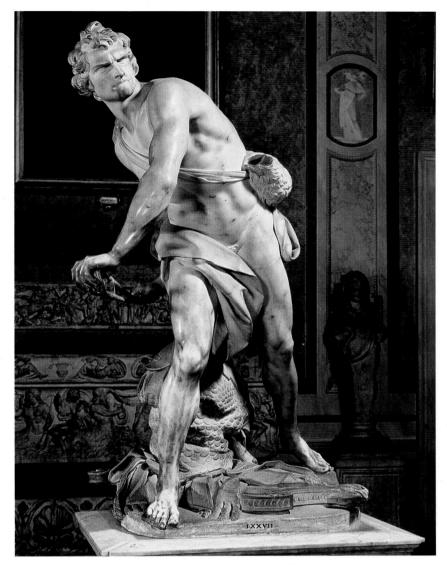

Fig. 10.13 Gianlorenzo Bernini, *David*. 1623. Marble, height 5'7". Galleria Borghese, Rome. Bernini carved this work when he was 25 years old, but he was already carving sculptures of remarkable quality by age 8.

the chapel, life-size marble re-creations of the Cornaro family lean out of what appear to be theater boxes into the chapel proper, as if witnessing the vision of Saint Teresa for themselves. Indeed, Bernini's chapel is nothing less than high drama, the stage space of not merely religious vision, but visionary spectacle. Here is an art designed to appeal to the feelings and emotions of its audience and draw them emotionally into the theatrical space of the work.

The Cornaro Chapel program suggests that the Baroque style is fundamentally theatrical in character, and the space it creates is theatrical space. It also demonstrates how central action was to Baroque representation. Bernini's *David* (Fig. 10.13), commissioned by a nephew of Pope Paul V, appears to be an intentional contrast to Michelangelo's sculpture of the same subject (see Fig. 7.22 in Chapter 7). Michelangelo's hero is at rest, in a moment of calm anticipation before confronting Goliath. In contrast, Bernini's sculpture captures

the young hero in the midst of action. David's body twists in an elaborate spiral, creating dramatic contrasts of light and shadow. His teeth are clenched, and his muscles strain as he prepares to launch the fatal rock. So real is his intensity that viewers tend to avoid standing directly in front of the sculpture, moving to one side or the other in order, apparently, to avoid being caught in the path of his shot.

In part, David's action defines Bernini's Baroque style. Whereas Michelangelo's David seems to contemplate his own prowess, his mind turned inward, Bernini's David turns outward, into the viewer's space, as if Goliath were a presence, although unseen, in the sculpture. In other words, the sculpture is not self-contained, and its active relationship with the space surrounding it—often referred to as its invisible complement—is an important feature of Baroque art. (The light source in his Cornaro Chapel Saint Teresa is another invisible complement.)

The Drama of Painting: Caravaggio and the Caravaggisti

Ever since the Middle Ages, when Abbot Suger of Saint-Denis, Paris, had insisted on the power of light to heighten spiritual feeling in the congregation, particularly through the use of stained glass, light had played an important role in church architecture (see Chapter 6). Bernini used it to great effect in his *Ecstasy of Saint Theresa* (see Fig. 10.11), and Baroque painters, seeking to intensify the viewer's experience of their paintings, sought to manipulate light and dark to great advantage as well. The acknowledged master of light and dark, and perhaps the most influential painter of his day, was Michelangelo Merisi, known as Caravaggio (1571–1610) after the town in northern Italy where he was born. His work inspired many followers, who were called the Caravaggisti.

Master of Light and Dark: Caravaggio Caravaggio arrived in Rome in about 1593 and began a career of revolutionary painting and public scandal. His first major commission in Rome was The Calling of Saint Matthew (Fig. 10.14), arranged for by his influential patron Cardinal del Monte and painted about 1599-1600 for the Contarelli Chapel in the Church of San Luigi dei Francesi, the church of the French community (dei Francesi) in Rome. The most dramatic element in this work is light. The light that streams in from an unseen window at the upper right of the painting is almost palpable. It falls onto the table where the tax collector Levi (Saint Matthew's name before he became one of Jesus' apostles) and his four assistants count the day's take, highlighting their faces and gestures. They are dressed in a style not of Jesus' time, but of Caravaggio's, making it more possible for his audience to identify with them. With Saint Peter at his side, Christ enters from the right, a halo barely visible above his head.

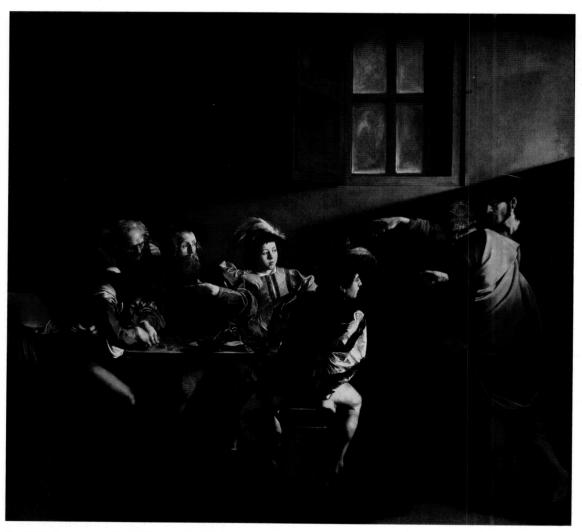

Fig. 10.14 Caravaggio, *The Calling of Saint Matthew*. ca. 1599–1600. Oil on canvas, 11'1" × 11'5". Contarelli Chapel, San Luigi dei Francesi, Rome. The window at the top of the painting is covered by parchment, often used by painters to diffuse light in their studios. This makes the intensity of light entering the room from the right especially remarkable.

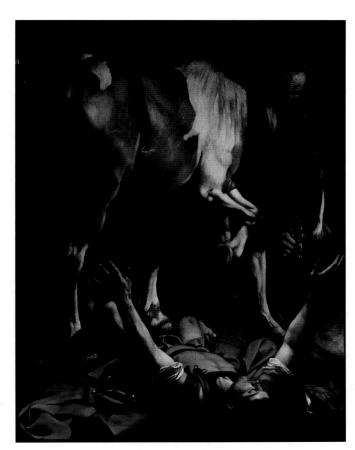

Fig. 10.15 Caravaggio, *Conversion of Saint Paul.* **ca. 1601.** Oil on canvas, $90\%'' \times 68\%''$. Santa Maria del Popolo, Rome. This painting was designed to fill the right wall of the narrow Carasi family chapel in Santa Maria del Popolo. Caravaggio had to paint it to be seen at an angle of about 45 degrees, a viewpoint that can be replicated by tipping this page inward about half open to an angle of 45 degrees to the reader's face. The resulting space is even more dramatic and dynamic.

He reaches out with his index finger extended in a gesture derived from Adam's gesture toward God in the Sistine Chapel ceiling Creation—an homage, doubtless, by the painter to his namesake (see Fig. 7.25). One of the figures at the table—it is surely Levi, given his central place in the composition—points with his left hand, perhaps at himself, as if to say, "Who, me?" or perhaps at the young man bent over at the corner of the table intently counting money, as if to say, "You mean him?" All in all, he seems to find the arrival of Jesus uninteresting. In fact, the assembled group is so ordinary—reminiscent of gamblers seated around a table that the transformation of Levi into Saint Matthew, which is imminent, takes on the aspect of a miracle, just as the light flooding the scene is reminiscent of the original miracle of creation: "And God said, 'Let there be light: and there was light" (Gen. 1:3). The scene also echoes the New Testament, specifically John 8:12, where Christ says: "I am the light of the world; he that followeth me shall not walk in darkness, but shall have the light of life."

Caravaggio's insistence on the reality of his scene is thus twofold: He not only depicts real people of his own day engaged in real tasks (by implication, Christ himself assumes

a human reality as well), but also insists on the reality of its psychological drama. The revelatory power of light—its ability to reveal the world in all its detail—is analogous, in Caravaggio's painting, to the transformative power of faith. Faith, for Caravaggio, fundamentally changes the way we see the world, and the way we act in it. Time and again, his paintings dramatize this moment of conversion through use of the technique known as tenebrism. As opposed to chiaroscuro, which many artists employ to create spatial depth and volumetric forms through slight gradations of light and dark, a tenebrist style is not necessarily connected to modeling at all. Tenebrism makes use of large areas of dark, contrasting sharply with smaller, brightly illuminated areas. In The Calling of Saint Matthew, Christ's hand and face rise up out of the darkness, as if his very gesture creates light itself—and by extension Matthew's salvation.

One of the clearest instances of Caravaggio's use of light to dramatize moments of conversion is the Conversion of Saint Paul, painted around 1601 (Fig. 10.15). Although painted nearly 50 years before Bernini's Ecstasy of Saint Teresa (see Fig. 10.11), its theme is essentially the same, as is its implied sexuality. Here, Caravaggio portrays the moment when the Roman legionnaire Saul (who will become Saint Paul) has fallen off his horse and hears the words, "Saul, Saul, why persecutest thou me?" (Acts 9:4). Neither Saul's servant nor his horse hears a thing. Light, the visible manifestation of Christ's words, falls on the foreshortened soldier. Saul reaches into the air in both a shock of recognition and a gesture of embrace. A sonnet, "Batter My Heart," by the English metaphysical poet John Donne (1572–1631), published in 1618 in his Holy Sonnets, captures Saul's experience in words (Reading 10.5):

READING 10.5

John Donne, "Batter My Heart" (1618)

Batter my heart, three-person'd God, for you As yet but knock, breathe, shine, and seek to mend; That I may rise and stand, o'erthrow me, and bend Your force to break, blow, burn, and make me new. I, like an usurp'd town to'another due, Labor to'admit you, but oh, to no end; Reason, your viceroy in me, me should defend, But is captiv'd, and proves weak or untrue. Yet dearly' I love you, and would be lov'd fain, But am betroth'd unto your enemy; Divorce me,'untie or break that knot again, Take me to you, imprison me, for I, Except you'enthrall me, never shall be free, Nor ever chaste, except you ravish me.

There is no reason to believe the English poet—who was raised a Catholic but converted to the Anglican Church for his own safety and prosperity—knew the Italian's painting, but the fact that the two men share so completely in the ecstasy of the moment of conversion, imaged as physical ravishment, suggests how widespread such conceits were in

the seventeenth century. Both share with Teresa of Ávila a profound mysticism, the pursuit of achieving communion or identity with the divine through direct experience, intuition, or insight. All three believe that such experience is the ultimate source of knowledge or understanding, and they seek to convey that in their art. Such mystical experience, in its extreme physicality and naturalistic representation, also suggests how deeply the Baroque as a style was committed to sensual experience.

Artemisia Gentileschi and Caravaggisti Painting One of Caravaggio's most important followers, and one of the first women artists to achieve an international reputation, was Artemisia Gentileschi (1593–1652/53). Born in Rome,

Artemisia Gentileschi (1593–1652/53). Born in Rome,

Fig. 10.16 Artemisia Gentileschi, *Judith and Maidservant with Head of Holofernes*. **ca. 1625.** Oil on canvas, 72½" × 55¾". The Detroit Institute of Arts. Gift of Leslie H. Green. 52.253. Judith is a traditional symbol of fortitude, a virtue with which Artemisia surely identified.

she was raised by her father, Orazio, himself a painter and Caravaggisto. Orazio was among Caravaggio's closest friends. As a young girl, Artemisia could not have helped but hear of Caravaggio's frequent run-ins with the law—for throwing a plate of artichokes at a waiter, for street brawling, for carrying weapons illegally, and, ultimately, in 1606, for murdering a referee in a tennis match. Artemisia's own scandal would follow. It and much of her painting must be understood within the context of this social milieu—the loosely renegade world of Roman artists at the start of the seventeenth century. In 1612, when she was 19, she was raped by Agostino Tassi, a Florentine artist who worked in her father's studio and served as her teacher. Orazio filed suit against Tassi for injury and damage to his daughter. The transcript of the seven-month

trial survives. Artemisia accused Tassi of repeatedly trying to meet with her alone in her bedroom and, when he finally succeeded, of raping her. When he subsequently promised to marry her, she freely accepted his continued advances, naïvely assuming marriage would follow. When he refused to marry her, the lawsuit followed.

At trial, Tassi accused her of having slept with many others before him. Gentileschi was tortured with thumbscrews to "prove" the validity of her testimony, and was examined by midwives to ascertain how recently she had lost her virginity. Tassi further humiliated her by claiming that Artemisia was an unskilled artist who did not even understand the laws of perspective. Finally, a former friend of Tassi's testified that Tassi had boasted about his exploits with Artemisia. Ultimately, he was convicted of rape but served only a year in prison. Soon after the long trial ended, Artemesia married an artist and moved with him to Florence. In 1616, she was admitted to the Florentine Academy of Design.

Beginning in 1612, Artemisia painted five separate versions of the biblical story of Judith and Holofernes. The subject was especially popular in Florence, which identified with both the Jewish hero David and the Jewish heroine Judith (both of whom had been celebrated in sculptures by Donatello and Michelangelo). When Artemisia moved there, her personal investment in the subject found ready patronage in the city. Nevertheless, it is nearly impossible to see the paintings outside the context of her biography. She painted her first version of the theme during and just after the trial itself, and the last, Judith and Maidservant with Head of Holofernes, in about 1625 (Fig. 10.16), suggesting that in this series she transforms her personal tragedy in her painting. In all of them, Judith is a self-portrait of the artist. In the Hebrew Bible's Book of Judith, the Jewish heroine enters the enemy Assyrian camp intending to seduce their lustful leader, Holofernes, who has laid siege to her people. When Holofernes falls asleep, she beheads him with his own sword and carries her trophy back to her people in a bag. The Jews then go on to defeat the leaderless Assyrians.

Gentileschi lights the scene by a single candle, dramatically accentuating the Caravaggesque tenebrism of the presentation. Judith shades her eyes from its light, presumably in order to look out into the darkness that surrounds her. Her hand also invokes our silence, as if danger lurks nearby. The maid stops wrapping Holofernes's head in a towel, looking on alertly herself. Together, mistress and maid, larger than life-size and heroic, have taken their revenge on not only the Assyrians, but also lust-driven men in general. As is so often the case in Baroque painting, the space of the drama is larger than the space of the frame. The same invisible complement outside Bernini's David (see Fig. 10.13) hovers in the darkness beyond reach of our vision here.

Gentileschi was not attracted to traditional subjects like the Annunciation. She preferred biblical and mythological heroines and women who played major roles. In addition to Judith, she dramatized the stories of Susannah, Bathsheba, Lucretia, Cleopatra, Esther, Diana, and Potiphar's wife. A good businesswoman, Gentileschi also knew how to exploit the taste for paintings of female nudes.

Venice and Baroque Music

In the sixteenth century, the Council of Trent had recognized the power of music to convey moral and spiritual ideals, at the same time rejecting the use of secular music, which by definition it deemed lascivious and impure, as a model for sacred compositions. Renaissance composers such as Guillaume Dufay and Josquin des Prez (see Chapter 7) had routinely used secular music in composing their masses, and Protestants had adapted the chorales of their liturgy from existing melodies, both religious and secular.

The division between secular and religious music was far less pronounced in Venice, a city that had traditionally

chafed at papal authority. As a result, Venetian composers felt freer to experiment and work in a variety of forms, so much so that in the seventeenth century, the city became the center of musical innovation and practice in Europe.

Giovanni Gabrieli and the Drama of Harmony Venice earned its place at the center of the musical world largely through the efforts of Giovanni Gabrieli (1556–1612), the principal organist at Saint Mark's Cathedral. Gabrieli composed many secular madrigals, but he also responded to the Counter-Reformation's edict to make church music more emotionally engaging. To do this, he expanded on the polychoral style that Adrian Willaert had developed at Saint Mark's in the mid-1500s (see Chapter 7). Gabrieli located contrasting bodies of sound in different areas of the cathedral's interior, which already had two organs, one on each side of the chancel (the space containing the altar and seats for the clergy and choir). Playing them against one another, he was able to produce effects of stunning sonority. Four choirs—perhaps a boys' choir, a women's ensemble, basses and baritones, and tenors in another group—sang from separate balconies above the nave. Positioned in the alcoves were brass instruments.

Gabrieli was among the first to write religious music intended specifically for wind ensemble-music that was independent of song and that could not, in fact, be easily sung. One such piece is his Canzona Duodecimi Toni (Canzona in the Twelfth Mode [or Tone]) of 1597, in which two brass ensembles create a musical dialogue (track 10.3). A canzona is a type of contrapuntal instrumental work, derived from Renaissance secular song, like the madrigal, which was increasingly performed in the seventeenth century in church settings. It is particularly notable for its dominant rhythm, LONG-short-short, known as the "canzona rhythm." In Saint Mark's, the two ensembles would have been placed across from each other in separate lofts. The alternating sounds of cornet and trombone or, in other compositions, brass ensemble, choir, and organ, coming from various parts of the cathedral at different degrees of loudness and softness, create a total effect similar to stereo "surround sound."

For each part of his composition, Gabrieli chose to designate a specific voice or instrument, a practice we have come to call **orchestration**. Furthermore, he controlled the **dynamics** (variations and contrast in force or intensity) of the composition by indicating, at least occasionally, the words *piano* ("soft") or *forte* ("loud"). In fact, he is the first known composer to specify dynamics. The dynamic contrasts of loud and soft in the *Canzona Duodecimi Toni*, mirroring the taste for tenebristic contrasts of light and dark in Baroque painting, make it a perfect example of Gabrieli's use of dynamic variety. As composers from across Europe came to Venice to study, they took these terms back with them, and Italian became the international language of music.

Finally, and perhaps most important, Gabrieli organized his compositions around a central note, called the **tonic note** (usually referred to as the **tonality** or **key** of the composition). This tonic note provides a focus for the composition. The ultimate resolution of the composition into the tonic, as in the *Canzona Duodecimi Toni*, where the tonic note is C, the twelfth mode (or "tone") in Gabrieli's harmonic system, provides the heightened sense of harmonic drama that typifies the Baroque.

Claudio Monteverdi and the Birth of Opera

A year after Gabrieli's death, Claudio Monteverdi (1567-1643) was appointed musical director at Saint Mark's in Venice. A violinist, Monteverdi had been the music director at the court of Mantua. In Venice, he proposed a new relation of text (words) and music. Where traditionalists favored the subservience of text to music—"Harmony is the ruler of the text," proclaimed Giovanni Artusi, the most ardent defender of the conservative position—Monteverdi proclaimed just the opposite: "Harmony is the mistress of the text!" Monteverdi's position led him to master a new, text-based musical form, the opera, a term that is the plural of obus, or "work." Operas are works consisting of many smaller works. (The term opus is used, incidentally, to catalogue the musical compositions of a given composer, usually abbreviated op., so that "op. 8" would mean the eighth work or works published in the composer's repertoire.)

The form itself was first developed by a group known as the Camerata of Florence (camerata means "club" or "society"), a group dedicated to discovering the style of singing used by the ancient Greeks in their drama, which had united poetry and music but was known only through written accounts. Over the course of the 1580s and 1590s, Giulio Caccini and others began to write works that placed a solo vocal line above an instrumental line, known as the basso continuo, or "continuous bass," usually consisting of a keyboard instrument (organ, harpsichord, etc.) and bass instrument (usually a cello), that was conceived as a supporting accompaniment, not as the harmonic equivalent, to the vocal line. This combination of solo voice and basso continuo came to be known as monody.

The inspiration for Monteverdi's first opera, Orfeo (1607), was the musical drama of ancient Greek theater. The libretto (or "little book") for Monteverdi's opera was based on the Greek myth of Orpheus and Eurydice. In the opera, shepherds and nymphs celebrate the love of Orfeo (Orpheus) and Eurydice in a dance that is interrupted by the news that Eurydice has died of a snake bite. The grieving Orpheus, a great musician and poet, travels to the underworld to bring Eurydice back. His plea for her return so moves Pluto, the god of the underworld, that he grants it, but only if Orpheus does not look back at Eurydice as they leave. But, anxious for her safety, he does glance back and loses her forever. Monteverdi did, however, offer his audience some consolation (if not really a happy ending): Orpheus's father, Apollo, comes down to take his son back

to the heavens where he can behold the image of Eurydice forever in the stars.

Although *Orfeo* is by no means the first opera, it is generally accepted as the first successfully to integrate music and drama. Monteverdi tells the story through a variety of musical genres—choruses, dances, and instrumental interludes. Two particular forms stand out—the *recitativo* and the *aria*. *Recitativo* (or recitative) is a style of singing that imitates very closely the rhythms of speech. Used for dialogue, it allows a more rapid telling of the story than might be possible otherwise. The aria would eventually develop into an elaborate solo or duet song that expresses the singer's emotions and feelings, expanding on the dialogue of the recitative (in Monteverdi's hands, the aria could still be sung in recitative style).

Orfeo required an orchestra of three dozen instruments—including 10 viols, 3 trombones, and 4 trumpets—to perform the overture, interludes, and dance sequences, but generally only a harpsichord or lute accompanied the arias and recitatives so that the voice would remain predominant. For the age, this was an astonishingly large orchestra, financed together with elaborate staging by the Mantuan court where it was composed and first performed, and it provided Monteverdi with a distinct advantage over previous opera composers. He could achieve what his operatic predecessors could only imagine—a work that was both musically and dramatically satisfying, one that could explore the full range of sound and, with it, the full range of psychological complexity.

Antonio Vivaldi and the Concerto

Perhaps Venice's most important composer of the early eighteenth century was Antonio Vivaldi (1678-1741). In 1703, Vivaldi, son of the leading violinist at Saint Mark's, assumed the post of musical director at the Ospedale della Pietà, one of four orphanages in Venice that specialized in music instruction for girls. (Boys at the orphanages were not trained in music since it was assumed they would enter the labor force.) As a result, many of the most talented harpsichordists, lutenists, and other musicians in Venice were female, and many of Vivaldi's works were written specifically for performance by orphanage girls' choirs and instrumental ensembles. By and large, the orphanage musicians were young girls who would subsequently go on to either a religious life or marriage, but several were middle-aged women who remained in the orphanage, often as teachers, for their entire lives. The directors of the orphanages hoped that wealthy members of the audience would be so dazzled by the performances that they would donate money to the orphanages. Audiences from across Europe attended these concerts, which were among the first in the history of Western music that took place outside a church or theater and were open to the public. People were, in fact, dazzled by the talent of these female musicians; by all accounts, they were as skilled and professional as any of their male counterparts in Europe.

Vivaldi specialized in composing concertos, a three-movement secular form of instrumental music, popular at court. But he systematized the form. The first movement of a concerto is usually allegro (quick and cheerful), the second slower and more expressive, like the pace of an opera aria, and the third a little livelier and faster than the first. Concertos usually feature one or more solo instruments that, in the first and third movements particularly, perform passages of material, called episodes, that contrast back and forth with the orchestral score—a form known as ritornello, "something that returns" (i.e., returning thematic material). At the outset, the entire orchestra performs the ritornello in the tonic—the specific home pitch around which the composition is organized. Solo episodes interrupt alternating with the ritornello, performed in partial form and in different keys, back and forth, until the ritornello returns again in its entirety in the tonic in the concluding section.

In the course of his career, Vivaldi composed nearly 600 concertos—for violin, cello, flute, piccolo, oboe, bassoon, trumpet, guitar, and even recorder. Most of these were performed by the Ospedale ensemble. The most famous is a group of four violin concertos, one for each season of the year, called *The Four Seasons*. It is an example of what would later come to be known as **program music**, or purely instrumental music in some way connected to a story or idea. The program of the first of these concertos, *Spring* (track 10.4), is supplied by a sonnet, written by Vivaldi himself, at the top of the score. The first eight lines suggest the text for the first movement, and the last six lines, divided into two groups of three, the text for the second and third movements:

Spring has arrived, and full of joy
The birds greet it with their happy song.
The streams, swept by gentle breezes,
Flow along with a sweet murmur.
Covering the sky with a black cloak,
Thunder and lightning come to announce the season.
When all is quiet again, the little birds
Return to their lovely song.

The *ritornello* in this concerto is an exuberant melody played by the whole ensemble. It opens the movement, and corresponds to the poem's first line. Three solo violins respond in their first episode—"the birds greet it with their happy song"—imitating the song of birds. In the second episode, they imitate "streams swept by gentle breezes," then, in the third, "thunder and lightning," and finally the birds again, which "Return to their lovely song." The whole culminates with the *ritornello*, once again resolved in the tonic.

In its great rhythmic freedom (the virtuoso passages given to the solo violin), and the polarity between orchestra and solo instruments (the contrasts of high and low timbres, or sounds, such as happy bird song and clashing thunder), Vivaldi's concerto captures much of what differentiates Baroque music from its Renaissance predecessors. Gone are the balanced and flowing rhythms of Palestrina and the polyphonic composition in which all voices are of equal importance.

Perhaps most of all, the drama of beginning a composition in a tonic key, moving to different keys and then returning to the tonic—a process known as **modulation**—could be said to distinguish Baroque composition from what had come earlier. The dramatic effect of this modulation, together with the rich texture of the composition's chord clusters, parallels the dramatic lighting of Baroque painting, just as the embellishment of the solo voice finds its equivalent in the ornamentation of Baroque architecture.

THE SECULAR BAROQUE IN THE NORTH

A more austere Baroque style dominated northern Europe in the seventeenth century. Amsterdam was at its center. The city's economy thrived, sometimes too hotly, as in 1636 when mad speculation sent the market in tulip bulbs skyrocketing (a single bulb in Amsterdam sold for 4,600 florins, 15 or 20 times the annual income of a skilled craftsman). But this tendency to excess was balanced by the conservatism of the Dutch Reformed Church. The Calvinist fathers of the Dutch Reformed Church found no place for art in the Calvinist liturgy, by and large banning art from its churches.

But the prosperous Dutch populace avidly collected pictures. A visiting Englishman, John Evelyn, explained their passion for art this way, in 1641: "The reason of this store of pictures and their cheapness proceeds from want of land to employ their stock [wealth], so that it is an ordinary thing to find a common farmer lay out two or three thousand pounds in this commodity. Their houses are full of them and they vend them at their fairs to very great gains." If Evelyn exaggerates the sums invested in art—a typical landscape painting sold for only three or four guilders, still the equivalent of two or three days' wages for a Delft clothworker—he was accurate in his sense that almost everyone owned at least a few prints and a painting or two.

New Imagery: Still Life, Landscape, and Genre Painting

Despite Dutch Reformed distaste for religious history painting—commissions from the Church had dried up almost completely by 1620—about a third of privately owned paintings in the city of Leiden (one of the most iconoclastic in Holland) during the first 30 years of the seventeenth century represented religious themes. But other, more secular forms of painting thrived. Most Calvinists did not object to sitting for their portraits, as long as the resulting image reflected their Protestant faith. And most institutions wanted visual documentation of their activities, resulting in a thriving industry in group portraiture. Painting also came to reflect the matter-of-fact materialism of the Dutch character—its interest in all manner of things, from carpets, to furnishings, to clothing, collectibles, foodstuffs, and everyday activities. And the Dutch artists themselves were particularly interested in technical developments in the arts, especially

Fig. 10.17 Johannes Goedaert, Flowers in a Wan-li Vase with Blue-Tit. ca. 1660. Oil on panel, 21%" × 14½". Photo: Charles Roelofsz/RKD Images. Bob P. Haboldt & Co., Inc. Art Gallery, New York. The shell in the lower right corner is a symbol of worldly wealth, but as it is broken and empty, it is also a reminder of our vanity and mortality

Series: A Vanitas of Style. 1983-84 at MyArtsLab

The CONTINUING PRESENCE Caravaggio's dramatic lighting. To accommodate the taste of the buying public, Dutch artists developed a new visual vocabulary that was largely vernacular, reflecting the actual time and place in which they lived.

> **Still Life** Among the most popular subjects were still lifes, paintings dedicated to the representation of common household objects and food. At first glance, they seem nothing more than a celebration of abun-

dance and pleasure. But their subject is also the foolishness of believing in such apparent ease of life. Flowers in a Wan-li Vase with Blue-Tit (Fig. 10.17) by Johannes Goedaert (1617-68) is, on the one hand, an image of pure floral exuberance. The arrangement contains four varieties of tulip-somewhat ominously, given the memories of tulipomania—and a wide variety of other flowers, including a Spanish iris, nasturtiums from Peru, fritillaria from Persia, a striped York and Lancaster rose a whole empire's worth of blossoms. The worldliness of the

Fig. 10.18 Jacob van Ruisdael, View of Haarlem from the Dunes at Overveen. ca. 1670. Oil on canvas, 22" × 24%". Mauritshuis, The Hague. The play of light and dark across the landscape can be understood in terms of the rhythms of life itself.

blooms is underscored by the Wan-li vase in which they are placed, a type of Ming dynasty porcelain (see Fig. 9.30) that became popular with Dutch traders around the turn of the century. The short life of the blooms is suggested by the yellowing leaves, and the impermanence of the scene by the fly perched on one of the tulips. But perhaps the most telling detail is the bird at the bottom left of the painting, a blue-tit depicted in the act of consuming a moth. Dutch artists of this period used such details to remind the viewer of the frivolous quality of human existence, our vanity in thinking only of the pleasures of the everyday. Such vanitas paintings, as they are called, remind us that pleasurable things in life inevitably fade, that the material world is not as long-lived as the spiritual, and that the spiritual should command our attention. They are, in short, examples of the memento mori—reminders that we will die. Paintings such as Goedaert's were extremely popular. Displayed in the owner's home, they were both decorative and imbued with a moral sensibility that announced to a visitor the owner's upright Protestant ethic.

Landscapes Another popular subject was landscapes. Landscape paintings such as View of Haarlem from the Dunes at Overveen by Jacob van Ruisdael (ca. 1628-82) reflect national pride in the country's reclamation of its land from the sea (Fig. 10.18). The English referred to the United Provinces as the "united bogs," and the French constantly poked fun at the baseness of what they called the Pays-Bas (the "Low Countries"). But the Dutch themselves considered their transformation of the landscape from hostile sea to tame farmland, in the century from 1550 to 1650, as analogous to God's recreation of the world after the Great Flood.

In Ruisdael's landscape painting, this religious undertone is symbolized by the great Gothic church of Saint Bavo at Haarlem, which rises over a flat, reclaimed landscape where figures toil in a field lit by an almost celestial light. It is no accident that two-thirds of Ruisdael's landscape is devoted to sky, the infinite heavens. In flatlands, the sky and horizon are simply more evident, but more symbolically, the Dutch thought of themselves as *Nederkindern*, the "children below," looked after by an almighty God with whom they had made an eternal covenant.

Genre Scenes Paintings that depict events from everyday life—or **genre scenes**—were another favorite of the Dutch public. *The Dancing Couple* (Fig. 10.19) by Jan Steen (1626–79) is typical. Like many of Steen's paintings, it depicts festivities surrounding some sort of holiday or celebration. Steen was both a painter and a tavernkeeper, and the scene here is most likely a tavern patio in midsummer. An erotic flavor permeates the scene, an atmosphere of flirtation and licentiousness. To the right, musicians play as a seated couple drunkenly watch the dancers. To the left, two men enjoy food at the table, a woman lifts a glass of wine to her lips, and

a gentleman—a self-portrait of the artist—gently touches her chin. Steen thus portrays his own—and, by extension, the Dutch—penchant for merry making, but in typical Dutch fashion he also admonishes himself for taking such license. On the tavern floor lie an overturned pitcher of cut flowers and a pile of broken eggshells, both *vanitas* symbols. Together with the church spire in the distance, they remind us of the fleeting nature of human life as well as the hellfire that awaits those who have fallen into the vices so openly displayed in the rest of the painting.

One of the masters of this type of painting was Johannes Vermeer (1632–75). His paintings illuminate—and celebrate—the material reality of Dutch life. We know very little of Vermeer's life, and his painting was largely forgotten until the middle of the nineteenth century. But today he is recognized as one of the great masters of the Dutch seventeenth century. Vermeer painted only 34 works that modern scholars accept as authentic, and most depict intimate genre scenes that reveal a moment in the domestic world of women.

Fig. 10.19 Jan Steen, *The Dancing Couple.* 1663. Oil on canvas, 40%" × 56%". National Gallery of Art, Washington, D.C., Widener Collection. 1942.9.81. Photography © Board of Trustees, National Gallery of Art. Steen's paintings, whatever their moralizing undercurrents, remind us that the Dutch were a people of great humor and happiness. They enjoyed life.

The example here is Woman with a Pearl Necklace (Fig. 10.20). Light floods the room from a window at the left, where a yellow curtain has been drawn back, allowing the young woman to see herself better in a small mirror beside the window. She is richly dressed, wearing an erminetrimmed yellow satin jacket. On the table before her are a basin and a powder brush; she has evidently completed the process of putting on makeup and arranging her hair as she draws the ribbons of her pearl necklace together and admires herself in the mirror. From her ear hangs a pearl earring, glistening in the light. The woman brims with self-confidence, and nothing in the painting suggests that Vermeer intends a moralistic message of any sort. While the woman's pearls might suggest her vanity—to say nothing of pride because of the way she gazes at them—they also traditionally symbolize

truth, purity, even virginity. This latter reading is supported by the great, empty, and white stretch of wall that extends between her and the mirror. It is as if this young woman is a *tabula rasa*, a blank slate, whose moral history remains to be written.

Rembrandt van Rijn and the Drama of Light

Yet another popular genre of the era was the **group portrait**, a large canvas commissioned by a civic institution to document or commemorate its membership at a particular time. In the hands of Rembrandt van Rijn (1606–69), the group portrait took on a heightened sense of drama. The leading painter in Amsterdam, Rembrandt was a master at building up the figure with short dashes of paint or, alternately, long, fluid lines of loose, gestural brushwork. The

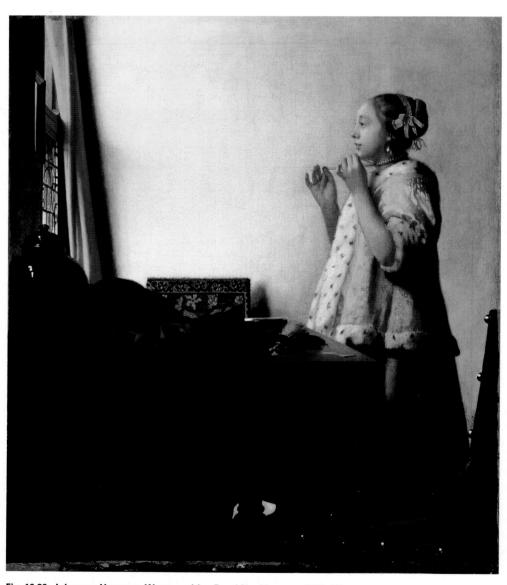

Fig. 10.20 Johannes Vermeer, *Woman with a Pearl Necklace*. ca. 1664. Oil on canvas, 225/32" × 173/4". Post-restoration. Inv.: 912 B. Photo: Joerg P. Anders. Gemäldegalerie, Staatliche Museen, Berlin. The mirror can symbolize both vanity—self-love—and truth, the accurate reflection of the world.

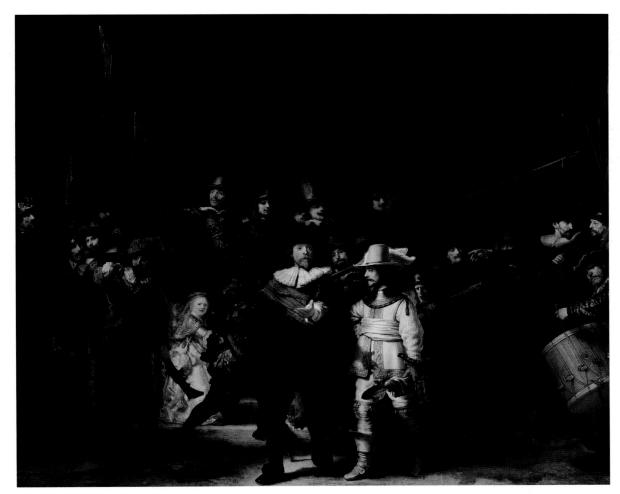

Fig. 10.21 Rembrandt van Rijn, Captain Frans Banning Cocq Mustering His Company (The Night Watch). 1642. Oil on canvas, 11'11" × 14'4". Rijksmuseum, Amsterdam. Recently, the Dutch scholar Dudok van Heel has made a convincing case that the main character in the painting is not Frans Banning Cocq but Frans Bannink Cocq, a member of a much richer and more influential family than Banning Cocq.

result, paradoxically, is an image of extreme clarity, a clarity that has not always been apparent in his group portrait of Captain Frans Banning Cocq Mustering His Company (Fig. 10.21). The enormous canvas (which was originally even larger) was so covered by a layer of grime and darkened varnish that for years it was thought to represent the Captain's company on a night patrol of Amsterdam's streets, and it was known, consequently, as The Night Watch. But after a thorough cleaning and restoration in 1975-76, its true subject revealed itself—the company forming for a parade in a side street of the city. Perhaps more important, the cleaning also revealed one of Rembrandt's important contributions to the art of portraiture—his use of light to animate his figures. Captain Cocq's hand extends toward us in the very center of the painting, casting a shadow across the lemonvellow jacket of his lieutenant. Competing for our attention is a young woman, also dressed in yellow satin studded with pearls, to the captain's right. A chicken hangs from her waist, and below it a money-bag, as if she has encountered the company on her way home from the market. She is such an odd addition to the scene that scholars have for years tried to account for her presence as, for instance, a symbolic representation of the company itself or, alternatively, an ironic commentary on the company's relation to mercantile interests. That said, she certainly adds a dimension of liveliness to the scene, asserting herself as a dramatic presence who underscores the motion and action of the painting as a whole. Everyone seems to be looking in different directions; different conversations abound; the figure in red, at the left, seems to have just discharged his rifle; a dog barks at a drummer entering from the right. Compared to the standard group portrait of the time, in which everybody seems literally to sit still for the portraitist, Rembrandt's group is animated, even noisy. As his figures move in and out of light and shadow, it seems as if the artist has barely managed to capture them.

In one of his most famous group portraits, *The Anatomy Lesson of Dr. Tulp* (see *Closer Look*, pages 338–339), Rembrandt would use this symbolic light for ironic effect. But in his religious works, especially, it would come to stand for the redemption offered to humankind by the example of Christ.

CLOSER LOOK

The Anatomy Lesson of Dr. Tulp was commissioned by Dr. Tulp to celebrate his second public anatomy demonstration, performed in Amsterdam on January 31, 1632. Public dissections were always performed in the winter months in order to preserve the cadaver better from deterioration. The body generally was that of a recently executed prisoner. The object of these demonstrations was purely educational—how better to understand the human body than to inspect its innermost workings? By understanding the human body, the Dutch believed, one could come to understand God. As the Dutch poet Barlaeus put it in 1639, in a poem dedicated to Rembrandt's painting:

Listener, learn yourself! And while you proceed through the parts,

believe that, even in the smallest, God lies hid.

Public anatomies, or dissections, were extremely popular events. Town dignitaries would generally attend, and a ticket-buying public filled the amphitheater. As sobering as the lessons of an anatomy might be, the event was also an entertaining spectacle. An example of the Dutch group portrait, this one was designed to celebrate Tulp's medical knowledge as well as his following. He is surrounded by colleagues, all of whom are identified on the sheet of paper held by the figure standing behind the doctor. Their curiosity underscores Tulp's prestige and the scientific inquisitiveness of the age.

The figures are arranged in a triangle. Dr. Tulp, in the bottom right corner, holds forceps that are the focus of almost everyone's attention. As is characteristic of Rembrandt's work, light plays a highly symbolic role. It shines across the room, from left to right, directly lighting the faces of the three most inquisitive students, suggesting the light of revelation and learning. And it terminates at Tulp's face, almost as if he himself is the source of their light. Ironically, the best-lit figure in the scene is the corpse. Whereas light in Rembrandt's work almost always suggests the kind of lively animation we see on the students' brightly lit faces, here it illuminates death.

Dr. Frans van Loenen points at the corpse with his index finger as he engages the viewer's eyes. The gesture is meant to remind us that we are all mortal.

The pale, almost bluish skin tone of the cadaver contrasts dramatically with the rosy complexions of the surgeons. Typically, the cadaver's face was covered during the anatomy, but Rembrandt unmasked the cadaver's face for his painting. In fact, we know the identity of the cadaver. He is Adriaen Adriaenszoon, also known as "Aris Kindt"—"the Kid"—a criminal with a long history of thievery and assault who was hanged for beating an Amsterdam merchant while trying to steal his cape. Dr. Tulp and his colleagues retrieved the body from the gallows. In another context, a partly draped nude body so well lit would immediately evoke the entombment of Christ with its promise of resurrection. It is the very impossibility of that fate for Adriaen Adriaenszoon that the lighting seems to underscore here.

Dr. Tulp is displaying the flexor muscles of the arm and hand and demonstrating their action by activating various muscles and tendons. It is the manual dexterity enabled by these muscles that physically distinguishes man from beast.

Something to Think About...

While it is the hand that distinguishes man from beast, why would an artist like Rembrandt be especially drawn to representing its dissection?

Rembrandt's The Anatomy Lesson of Dr. Tulp

Dr. Hartman Hartmanszoon holds in his hand a drawing of a flayed body upon which someone later added the names of all the figures in the scene.

Dr. Tulp was born Claes Pieterszoon but took the name *Tulp*—Dutch for "tulip"—sometime between 1611 and 1614 when still a medical student in Leiden, where he encountered the flower in the botanical gardens of the university. Throughout his career, a signboard painted with a single golden yellow tulip on an azure ground hung outside his house.

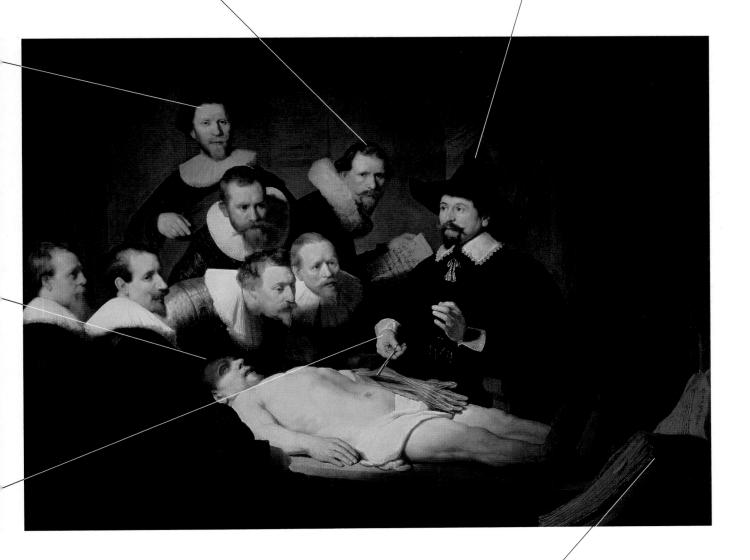

This large book may be the *De humani corporis fabrica*, the first thorough anatomy, published in 1543 by the Dutch scientist Andreis van Wesel (1514–64), known as Vesalius, who had taught anatomy at the University of Padua. Tulp thought of himself as *Vesalius redivivus*, "Vesalius revived."

Rembrandt van Rijn, *The Anatomy Lesson of Dr. Tulp.* **1632.** Oil on canvas, $5'3\%'' \times 7'1\%''$. Royal Cabinet of Paintings, Mauritshuis, The Hague.

Fig. 10.22 Rembrandt van Rijn, *Christ Preaching* (the "Hundred-Guilder Print"). ca. 1648–50. Etching, 11" × 15½". Yale University Art Gallery, New Haven, Connecticut. Fritz Achelis Memorial Collection, Gift of Frederic George Achelis, B.A. 1907. Many of the figures in this etching were suggested by Spanish and Jewish refugees who crowded the streets of Amsterdam and whom Rembrandt regularly sketched.

This is especially apparent in his prints, where the contrast between rich darks and brilliant lights could be exploited to great effect. Among the greatest of these is *Christ Preaching* (Fig. 10.22), also known as the "Hundred-Guilder Print" because it sold for 100 guilders at a seventeenth-century auction, at that time an unheard-of price for a print. The image illustrates the Gospel of Matthew, showing Christ addressing the sick and the lame, grouped at his feet and at his left, and the Pharisees, at his right. Always aware of Albrecht Dürer's great achievements in the medium (see Fig. 8.11 in Chapter 8), Rembrandt here constructs a triangle of light that seems to emanate from the figure of Christ himself, which seems to burst from the deep black gloom of the night. What the light is meant to offer, of course, is hope—and life.

Baroque Music in the North

In the late eighteenth century, the philosopher and sometimes composer Jean-Jacques Rousseau (whose work will be discussed in Chapter 11) described Baroque music in the most unflattering terms: "A baroque music is that in which the harmony is confused, charged with modulation and

dissonances, the melody is harsh and little natural, the intonation difficult, and the movement constrained." In many ways, the description is accurate, although Rousseau's negative reaction to these characteristics reveals more about the musical taste of his own later age than it does about the quality of music in the Baroque era itself. Stylistically, the music of the Baroque era is as varied as the Baroque art of Rome and Amsterdam. Like the art created in both centers, it is purposefully dramatic and committed to arousing emotion in the listener. Religious music, particularly, was devoted to evoking the passion of Christ. Also like Baroque art in both cities, Baroque music sought to be new and original, as Catholic and Protestant churches, North and South, constantly demanded new music for their services. At the same time, Baroque musicians created new secular forms of music as well. Perhaps most significant of all, the Baroque era produced more new instruments than any other. Additionally, even traditional instruments were almost totally transformed. This was the golden age of the organ. The deep intonations of this very ancient instrument, dating from the third century BCE, reached new heights as it commanded the emotions of Catholic and Protestant churchgoers alike. By the first half

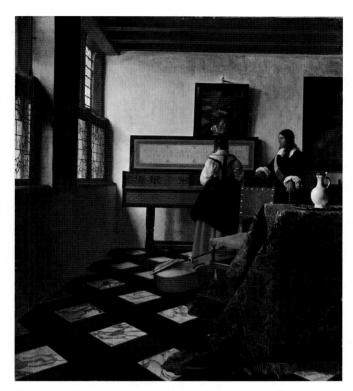

Fig. 10.23 Johannes Vermeer, Lady at the Virginal with a Gentleman (The Music Lesson). ca. 1662–64. Oil on canvas, 29½" × 25½". Royal Collection. In the manner of van Eyck's Giovanni Arnolfini and His Wife (see Fig. 8.6 in Chapter 8), Vermeer includes himself, or at least his easel, reflected in the mirror at the back of the painting.

of the eighteenth century, the piano began to emerge as a vital instrument even as the harpsichord was perfected technically. And for the first time in the history of music, instrumental virtuosos, especially on violin and keyboard, began to rival vocalists in popularity.

One of the primary forms of entertainment at Dutch family gatherings was the performance of keyboard music by the lady of the house, and indeed most of the surviving compositions from the period are scores made for home use. In fact, Vermeer's several paintings of young women playing the virginal, a keyboard instrument, such as his Lady at the Virginal with a Gentleman, also known as The Music Lesson (Fig. 10.23), are emblems of domestic harmony. In Vermeer's painting, the idea of harmony is further asserted by the empty chair and bass viol behind the young woman, which, we can assume, the young gentleman will soon take up in a duet. Inscribed on the lid of the virginal are the words "MVSICA LETITIAE CO[ME]S MEDICINA DOLOR[VM]" ("Music is the companion of joy and balm for sorrow"). In the context of Dutch domestic life, it would not be far-fetched to substitute marriage for music, so close is the analogy.

The North German School: Johann Sebastian Bach Perhaps the greatest master of keyboard music was Johann Sebastian Bach (1685–1750). Born at the end of the seventeenth

century, Bach sought to convey the devotional piety of the Protestant tradition through his religious music. He was an organist, first in the churches of small German towns, then in the courts of the Duke of Weimar and the Prince of Cöthen, and finally at Saint Thomas's Lutheran Church in Leipzig. There he wrote most of the music for the Lutheran church services. For each Sunday service, Bach composed a cantata, a multimovement musical commentary on the chosen text of the day sung by soloists and chorus accompanied by one or more instruments, usually the organ. The first half of the cantata was performed after the scriptural lesson and the second half after the sermon, concluding with a chorale, a hymn sung in the vernacular by the entire congregation. Like operas, cantatas include both recitatives and arias.

Bach's cantatas are usually based on the simple melodies of Lutheran chorales, but are transformed by his genius for counterpoint, the addition of one or more independent melodies above or below the main melody, in this case the line of the Lutheran chorale. The result is an ornate musical texture that is characteristically Baroque. Jesu, der du meine Seele ("Jesus, It Is by You that My Soul") provides a perfect example, and it reveals the extraordinary productivity of Bach as a composer, driven as he was by the Baroque demand for the new and the original. He wrote it in 1724, a week after writing another entirely new cantata, and a week before writing yet another. (Bach was compelled to write them in time for his choir and orchestra to rehearse.) The opening chorus (track 10.5) is based on the words and melody of a chorale that would have been familiar to all parishioners. That melody is always presented by the soprano, and is first heard 21 measures into the composition after an extended passage for the orchestra. Even the untrained ear can appreciate the play between this melody and the others introduced in counterpoint to it.

Over the course of his career, Bach composed more than 300 cantatas, or five complete sets, one for each Sunday and feast day of the church calendar. He also composed large-scale oratorios, lengthy choral works, either sacred or secular, but without action or scenery, performed by a narrator, soloists, a chorus, and an orchestra. One of Bach's greatest achievements in vocal music is The Passion According to Saint Matthew, written for the Good Friday service in Leipzig in 1727. A passion is similar to an oratorio in form but tells the story from the Gospels of the death and Resurrection of Jesus. In addition, Bach wrote instrumental music for almost all occasions, including funerals, marriages, and civic celebrations, and a number of ambitious works for keyboard. Many of these last are included in his Well-Tempered Clavier, probably Bach's greatest contribution to secular instrumental musical history. As Bach wrote on the title page to the first part, the pieces were intended "for the profit and use of musical youth desirous of learning and especially for the pastime of those already skilled in this study."

ABSOLUTISM AND THE BAROQUE COURT

What is absolutism and how did it impact the arts?

By the start of the eighteenth century, almost every royal court in Europe modeled itself on the court of King Louis XIV of France (r. 1643–1715). Louis detested the Louvre, the royal palace in Paris that had been the seat of French government and home to French kings since the Middle Ages. In 1661 he began construction of a new residence in the small town of Versailles, 12 miles southeast of Paris. For 20 years, some 36,000 workers labored to make Versailles the most magnificent royal residence in the world. Landscape architect André Le Nôtre (1613-1700) was in charge of the grounds at Versailles. He believed in the formal garden, and his methodical, geometrical design has come to be known as the French garden. The grounds were laid out around a main axis, emphasized by the giant cross-shaped Grand Canal, which stretched to the west of the palace (Fig. 10.24). Pathways radiated from this central axis, circular pools and basins surrounded it, and both trees and shrubbery were groomed into abstract shapes to match the geometry of the overall site. The king himself took great interest in Le Nôtre's work, even writing a guide to the grounds for visitors. Neat boxwood hedges lined the flower beds near the chateau, and a greenhouse provided fresh flowers to be planted in the gardens as the seasons changed. Over 4 million tulip bulbs, imported from Holland, bloomed each spring, and Louis's gardener had over 2 million flowerpots at his disposal. When Louis permanently moved his court and governmental offices there in 1682, Versailles became the unofficial capital of France and symbol of Louis's absolute power and authority.

The elaborate design of the palace was intended to leave the attending nobility in awe. Charles Le Brun (1619–1690) served as chief painter to the king, and directed the team of artists who decorated the palace's interior. The Hall of Mirrors (Fig. 10.25) was begun in

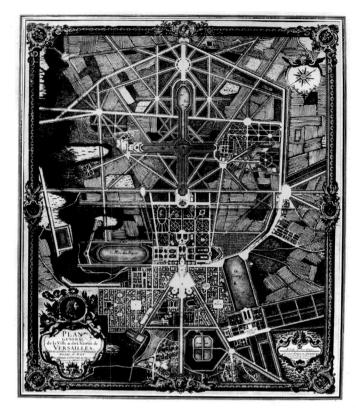

Fig. 10.24 André Le Nôtre, plan of the gardens and park, Versailles. Designed 1661–68, executed 1662–90. Drawing by Leland Roth after Delagive's engraving of 1746. To the right are the main streets of the town of Versailles. Three grand boulevards cut through it to converge on the palace itself.

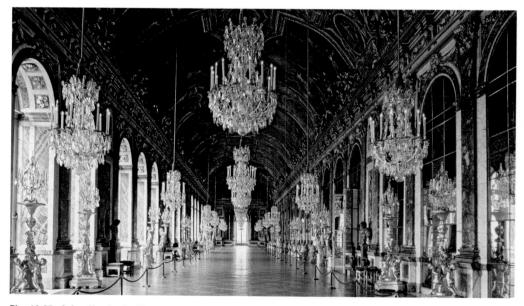

Fig. 10.25 Jules Hardouin-Mansart and Charles Le Brun, Galerie des Glaces (Hall of Mirrors), Palace of Versailles. Begun 1678. The Galerie des Glaces is 233 feet long and served as a reception space for state occasions. It gets its name from the Venetian-style mirrors—extraordinarily expensive at the time—that line the wall opposite windows of the same shape and size, creating by their reflection a sense of space even vaster than it actually is.

1678 to celebrate the high point of Louis XIV's political career, the end of six years of war with Holland. Louis asked Le Brun to depict his government's accomplishments on the ceiling of the hall in 30 paintings, framed by stucco, showing the monarch as a Roman emperor, astute administrator, and military genius. Le Brun balanced the 17 windows that stretch the length of the hall and overlook the garden with 17 arcaded mirrors along the interior wall, all made in a Paris workshop founded to compete with Venice's famous glass factories. Originally, solid silver tables, lamp holders, and orangetree pots adorned the gallery. Louis later had them all melted down to finance his ongoing war efforts.

The Court at Versailles

At court, Louis fully regulated the lives of the nobility. He thought of himself as Le Roi Soleil, "the Sun King," because like the sun (associated with Apollo, god of peace and the arts) he saw himself dispensing bounty across the land. His ritual risings and retirings (the levée du roi and the couchée du roi) symbolized the actual rising and setting of the sun. They were essentially state occasions, attended by either the entire court or a select group of fawning aristocrats who eagerly entered their names on waiting lists. Louis encouraged the noblewomen at court to consider it something of an honor to sleep with him; he had many mistresses and many illegitimate children. Life in his court was entirely formal, governed by custom and rule, so etiquette became a way of social advancement. He required the use of a fork at mealtimes instead of using one's fingers. Where one sat at dinner was determined by rank. In fact, rank determined whether footmen opened one or two of Versailles's glass-

paneled "French doors" for each guest passing through the palace. Louis's control over the lives of his courtiers had the political benefit of making them financially dependent on him. According to the memoirs of the duc de Saint-Simon, Louis de Rouvroy (1675–1755):

He loved splendor, magnificence, and profusion in all things, and encouraged similar tastes in his Court; to spend money freely on equipages and buildings, on feasting and at cards, was a sure way to gain his favour, perhaps to obtain the honor of a word from him. Motives of policy had something to do with this; by making expensive habits the fashion, and, for people in a certain position, a necessity, he compelled his courtiers to live beyond their income, and gradually reduced them to depend on his bounty for the means of subsistence.

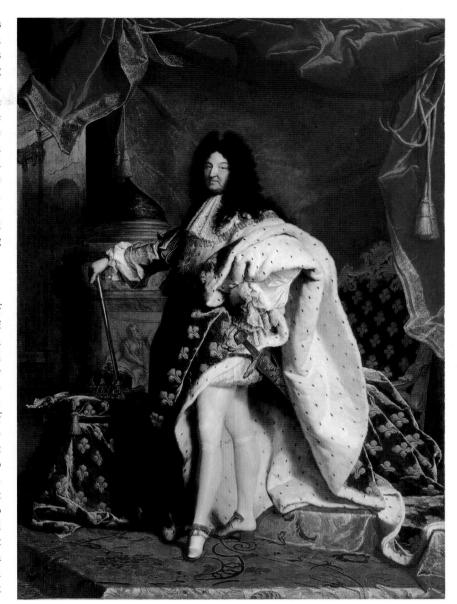

Fig. 10.26 Hyacinthe Rigaud, Louis XIV, King of France. 1701. Oil on canvas, $9'1'' \times 6'4\%''$. Musée du Louvre, Paris. In his ermine coronation robes, Louis both literally and figuratively looks down his nose at the viewer, his sense of superiority fully captured by Rigaud.

Louis's sense of his own authority—to say nothing of his notorious vanity—is wonderfully captured in Hyacinthe Rigaud's official state portrait of 1701 (Fig. 10.26). The king has flung his robes over his shoulder in order to reveal his white stockings and shoes with high, red heels. He designed the shoes himself to compensate for his 5-foot-4-inch height. He is 63 years old in this portrait, but he means to make it clear that he is still a dashing courtier.

The Painting of Peter Paul Rubens: Color and Sensuality One of Louis's favorite artists was the Flemish painter Peter Paul Rubens (1577–1640). Louis's grandmother Marie de' Medici had commissioned Rubens in 1621 to celebrate her life in a

Fig. 10.27 Peter Paul Rubens and his workshop, *The Arrival and Reception of Marie de' Medici at Marseilles*. 1621–25. Oil on canvas, 13' × 10'. Musée du Louvre, Paris. The point of view here is daringly low, perhaps in the water, or oddly floating above it. This creates a completely novel relationship between viewer and painting.

series of 21 monumental paintings. The cycle took four years (1621–25) to complete with the help of studio assistants.

Rubens's pictorial approach to such self-promoting biographical commissions was through lifelike allegory. The Arrival and Reception of Marie de' Medici at Marseilles depicts the day Marie arrived in France from her native Italy en route to her marriage to King Henry IV (Fig. 10.27). The figure of Fame flies above her, blowing a trumpet, while Neptune, god of the sea, and his son Triton, accompanied by three water nymphs, rise from the waves to welcome her. A helmeted allegorical figure of France, wearing a fleur-de-lis robe like that worn by Louis XIV in his portrait

of 1701, bows before her. Marie herself, not known for her beauty, is so enveloped by rich textures, extraordinary colors, and sensuous brushwork that she seems transformed into a vision as extraordinary as the scene itself.

The fleshy bodies of the nymphs in this painting are a signature stylistic component of Rubens's work. In fact, Rubens's style is almost literally a "fleshing out" of the late Italian Renaissance tradition. It is so distinctive that it came to be known as "Rubenesque." His nudes, which often startle contemporary viewers because we have developed almost entirely different standards of beauty, are notable for the way in which their flesh folds and drapes across their bodies. Their beauty rests in the sensuality of this flesh, which in some measure symbolizes the sensual life of selfindulgence and excess. Rubens pushed to new extremes the Mannerist sensibilities of Michelangelo's Last Judgment (see Fig. 10.3), the color and textures of the Venetian school as embodied in Titian's Rape of Europa (see Fig. 10.6), and the play of light and dark of the Caravaggisti (see Fig. 10.14). He brought to the Italian tradition a northern appreciation for observed nature-in particular, the realities of human flesh—and an altogether inventive and innovative sense of space and scale. Only rarely are Rubens's paintings what might be called frontal, where the viewer's position parallels the depicted action. Rather, the action moves diagonally back into space from either the front left or front right corner of the composition.

In a painting like The Kermis, or Peasant Wedding, Rubens transforms a simple tavern gathering—a genre common to northern painting (see Fig. 10.19)—into a monumental celebration (Fig. 10.28). The Kermis is over 8 feet wide. Its wedding celebration spills in a diagonal out of the confines of the tavern into the panoramic space of the Flemish countryside. At the pinnacle of this sideways pyramid of entwined flesh, a young man and a disheveled woman, her blouse fallen fully from her shoulders, run off across the bridge, presumably to indulge their appetites behind some hedge. Like the Hall of Mirrors at Versailles, with its mathematical regularity overlaid with sumptuously rich ornamentation, Rubens's painting seems at once moralistic and libertine. Arms and legs interlace in a swirling, twirling riot that can be interpreted as either a descent into debauchery or a celebration of sensual pleasure, readings that Rubens seems to have believed were not mutually exclusive.

Fig. 10.28 Peter Paul Rubens, *The Kermis (La Kermesse)*. ca. 1635. Oil on canvas, 56%" × 102%". Musée du Louvre, Paris. In this painting, Rubens reveals his Flemish heritage, taking up the traditional subject matter of Jan Steen and others, a genre scene of everyday life.

Such frank sensuality is a celebration of the simple joy of living in a world where prosperity and peace extend even to the lowest rungs of society. Yet in keeping with his Northern roots, Rubens gave the painting moralistic overtones. The posture of the dog with its nose in the cloth-draped tub at the bottom center of the canvas echoes the form of the kissing couple directly behind it and the dancing couples above it and, once more, represents the base, animal instincts that dominate the scene. The nursing babes at breast throughout the painting do not so much imply abundance as animal hunger, the desire to be fulfilled. Rubens knew full well that the bacchanal was not merely an image of prosperity but also one of excess. In his later years, excess enthralled him, and *The Kermis* is a product of this sensibility.

Some 50 years later, in April 1685, Louis XIV purchased *The Kermis* for Versailles. What did the monarch see in this painting? For one thing, it was probably important to the man who considered himself Europe's greatest king to possess the work of the artist widely considered to be Europe's greatest painter. For another, Louis must have appreciated the painting's frank sexuality, which the artist emphasized by his sensual brushwork and color. It recalled the king's own sexual exploits.

The Painting of Nicolas Poussin: Classical Decorum By the beginning of the eighteenth century, 14 other Rubens

paintings had found their way to the court of Louis XIV. Armand-Jean du Plessi, duc de Richelieu (1629-1715), the great-nephew of Cardinal Richelieu (1585–1642), who had served as artistic advisor to Marie de' Medici and Louis XIII, purchased the 14 paintings that had remained in Rubens's personal collection after his death in 1640. Before he acquired his own collection of Rubens's work, Richelieu had wagered and lost his entire collection of paintings by Nicolas Poussin (1594–1665) against Louis's own collection of works by Rubens in a tennis match between the two. A debate had long raged at court as to who was the better painter—Poussin or Rubens. Charles Le Brun had gone so far as to declare Poussin the greatest painter of the seventeenth century. Although a Frenchman, Poussin had spent most of his life in Rome. He particularly admired the work of Raphael and, following Raphael's example, advocated a Classical approach to painting. A painting's subject matter, he believed, should be drawn from Classical mythology or Christian tradition, not everyday life. There was no place in his theory of painting for a genre scene like Rubens's The Kermis, even if portrayed on a monumental scale. Painting technique itself should be controlled and refined. There could be no loose brushwork, no "rough style." Restraint and decorum had to govern all aspects of pictorial composition.

Fig. 10.29 Nicolas Poussin, *The Shepherds of Arcadia* (also called *Et in Arcadia Ego*). 1638–39. Oil on canvas, 33½" × 475½". Musée du Louvre, Paris. Inv.7300. Note how even the bands on the shepherds' sandals parallel other lines in the painting.

This poussiniste style is clearly evident in The Shepherds of Arcadia of 1638-39 (Fig. 10.29). Three shepherds trace out the inscription on a tomb, Et in Arcadia Ego, "I too once dwelled in Arcadia," suggesting that death comes to us all. The Muse of History, standing to the right, affirms this message. Compared to the often exaggerated physiques of figures in Rubens's paintings, the muscular shepherds seem positively understated. Color, while sometimes brilliant, as in the yellow mantle of History, is muted by the evening light. But it is the compositional geometry of horizontals and verticals that is most typically poussiniste. Note how the arms of the two central figures form right angles and how they all fit within the cubical space suggested by the tomb itself. This cubic geometry finds its counterpoint in the way the lighted blue fold of History's dress parallels both the red-draped shepherd's lower leg and the leftmost shepherd's staff. These lines suggest a diagonal parallelogram working both against and with the central cube.

Louis XIV was delighted when he defeated the duc de Richelieu at tennis and acquired his Poussins. But to Louis's surprise, Richelieu quickly rebuilt his collection by purchasing the 14 Rubens paintings and then commissioning Roger de Piles to write a catalog describing his acquisitions. De Piles was a *rubeniste*. He argued that color was the essence of painting. Color is to painting as reason is to man, as he put it. The *poussinistes*, by contrast, were dedicated to drawing, and to the art of Raphael.

Poussin's paintings addressed the intellect, Rubens's the senses. For Poussin, subject matter, the connection of the picture to a Classical narrative tradition, was paramount; for Rubens, the expressive capabilities of paint itself were primary. In 1708, de Piles scored each painter on his relative

merits. Rubens received 18 points for composition, 13 for design, 17 for color, and 17 for expression. Poussin earned 15 points for composition, 17 for design, 6 for color, and 15 for expression. By de Piles's count, Rubens won 65 to 53. In essence, Rubens represented Baroque decorative expressionism and Poussin, Classical restraint. Both would have their supporters over the course of the following decades.

Music and Dance at the Court of Louis

XIV Louis XIV loved the pomp and ceremony of his court and the art forms that allowed him most thoroughly to engage this taste: dance and music. The man largely responsible for entertaining the king at court was Jean-Baptiste Lully (1632–87), who was born in Florence but moved to France in 1646 to pursue his musical education.

Lully composed a number of popular songs, including the famous "Au Clair de la Lune." By the 1660s, he had become a

favorite of the king, who admired in particular his *comédie-ballets*, performances that were part opera and part ballet and that often featured Louis's own considerable talents as a dancer (Fig. 10.30). Louis commissioned many ballets that required increasingly difficult movements of the dancers. As a result, his Royal Academy of Dance soon established the rules for the five positions of ballet that became the basis of classical dance. They valued, above all, clarity of line in the dancer's movement, balance, and, in the performance of the troupe as a whole, symmetry. But in true Baroque fashion, the individual soloist was encouraged to elaborate upon the classical foundations of the ballet in exuberant, even surprising expressions of virtuosity.

Lully used his connections to the king to become head of the newly established Royal Academy of Music, a position that gave him exclusive rights to produce all sung dramas in France. In this role, he created yet another new operatic genre, the *tragédie en musique*, also known as the *tragédie lyrique*. Lully's *tragédies* seamlessly blended words and music. The meter of the music constantly shifts, but the rhythms closely follow the natural rhythms of the French language. Supported and financed by the court, Lully composed and staged one of these *tragédies* each year from 1673 until 1687, when he died of gangrene after hitting his foot with the cane he used to pound out the beat while conducting.

Louis's love of the dance promoted another new musical form at his court, the suite, a series of dances or dance-inspired movements, usually all in the same key, though varying between major and minor modes. Most suites consist of four to six dances of different tempos and meters. In a suite, two moderately fast dances might precede a slower,

Fig. 10.30 Louis XIV as the sun in the *Ballet de la Nuit*. 1653. Bibliothèque nationale de France, Paris. Louis, who was 15 years old at the time, appeared as himself wearing this costume during the ballet's intermezzo, a short musical entertainment between the main acts.

more elegant dance, and the suite might then conclude with something rollicking and exuberant. Although it did not commonly occur in the dance suites themselves, the most important of the new dance forms was the minuet, an elegant triple-time dance of moderate tempo. It quickly became the most popular dance form of the age.

Theater at the French Court When, in 1629, Louis XIII appointed Cardinal Richelieu as his minister of state, he coincidentally inaugurated a great tradition of French theater. This tradition would culminate in 1680 with the establishment of the Comédie Francaise, the French national theater. It was created as a cooperative under a charter granted by Louis XIV to merge three existing companies, including the troupe of the playwright Molière (1622–73).

The son of a court upholsterer, Molière had been touring France for 13 years with a troupe of actors when he was asked, in 1658, to perform a tragedy before the young king Louis XIV. The performance was a miserable failure, but Molière asked if he might perform a farce of his own, *Le Docteur*

Amoureux ("The Amorous Doctor"). The king was delighted with this comedy, and Molière's company was given what was intended to be a permanent home.

Molière's first play to be performed was Les Précieuses Ridicules ("The Pretentious Ladies"), in 1659. It satirized a member of the French court named Madame de Rambouillet, who fancied herself the chief guardian of good taste and manners in Parisian society. At her Parisian home, ladies of the court routinely gather to discuss matters of love, reviving in particular the elegance, manners, and high moral character of Platonic courtly love as they imagined it was practiced in the medieval courts of figures such as Eleanor of Aquitaine (see Chapter 5). Molière scoffed at their pretensions, and the success of the play soon led him to double the admission price. The king himself was so delighted that he honored the playwright with a large monetary reward. But not so, Madame de Rambouillet. Outraged, she tried to drive Molière from the city, but succeeded only in having the company's theater demolished. The king struck back by immediately granting Molière the right to perform in the Théâtre du Palais Royal, in Richelieu's former palace, and there he staged his productions for the rest of his life.

Molière spared no one his ridicule, attacking religious hypocrisy, misers, hypochondriacs, pretentious doctors, aging men who marry younger women, the gullible, and all social parasites. (Ironically, he himself was capable of the most audacious flattery.) His play *Tartuffe*, or *The Hypocrite* (1664), concludes, for instance, with an officer praising the ability of the king to recognize hypocrisy of the kind displayed by Tartuffe in earlier scenes from the play (**Reading 10.6**):

READING 10.6

Molière, Tartuffe, Act V (1664)

We serve a Prince to whom all sham is hateful, A Prince who sees into our inmost hearts, And can't be fooled by any trickster's arts. His royal soul, though generous and human, Views all things with discernment and acumen; His sovereign reason is not lightly swayed, And all his judgments are discreetly weighed. He honors righteous men of every kind, And yet his zeal for virtue is not blind, Nor does his love of piety numb his wits And make him tolerant of hypocrites. 'Twas hardly likely that this man could cozen A King who's foiled such liars by the dozen.

These words undoubtedly warmed the heart of the king, described here as if he were a god. But until Molière's sudden death from an aneurysm during a coughing fit onstage, the playwright remained in disfavor with many in Louis's court who felt threatened by his considerable insight and piercing wit. They recognized what perhaps the king could not—the irony of flattering the king by saying he is above flattery.

The Court Arts of England and Spain

Although the monarchs of Europe were often at war with one another, they were united in their belief in the power of the throne and the role of the arts in sustaining their authority. In England, the arts were dramatically affected by tension between the absolutist monarchy of the English Stuarts and the much more conservative Protestant population. As in France, throughout the seventeenth century, the English monarchy sought to assert its absolute authority, although it did not ultimately manage to do so. The first Stuart monarch, James I (r. 1603–1625), succeeded Queen Elizabeth I in 1603. "There are no privileges and immunities which can stand against a divinely appointed King," he quickly insisted.

James's son Charles I (r. 1625–1649) shared these absolutist convictions, but Charles's reign was beset by religious controversy. Although technically head of the Church of England, he married a Catholic, Henrietta Maria, sister of the French king Louis XIII. Charles proposed changes in the Church's liturgy that brought it, in the opinion of many, dangerously close to Roman Catholicism. Puritans (English Calvinists) increasingly dominated the English Parliament and strongly opposed any government that even remotely appeared to accept Catholic doctrine.

Parliament raised an army to oppose Charles, and civil war resulted, lasting from 1642 to 1648. The key political question was who should rule the country—the king or the Parliament? Led by Oliver Cromwell (1599–1658), the Puritans defeated the king in 1645, and executed him for treason on January 30, 1649, a severe blow to the divine right of kings. Meanwhile, Cromwell tried to lead a commonwealth—a republic dedicated to the common wellbeing of the people—but he soon dissolved the Parliament and assumed the role of Lord Protector. His protectorate occasionally called the Parliament into session, but only to ratify his own decisions. Cromwell's greatest difficulty was requiring the people to obey "godly" laws—in other words, Puritan doctrine. He forbade swearing, drunkenness, and cockfighting. No shops or inns could do business on Sunday. The country, used to the idea of a freely elected parliamentary government, could not tolerate such restriction, and when, in September 1658, Cromwell died, his system of government died with him.

The monarchy was restored, but the threat of the monarchy adopting Catholicism continued to cause dissension among Puritans. Finally, in September 1688, William of Orange, married to the Protestant daughter of James II, who had become king in 1685, invaded Britain from Holland at the invitation of the Puritan population. James II fled, and what has come to be called the Glorious Revolution ensued. Parliament enacted a Bill of Rights endorsing religious tolerance and prohibiting the king from annulling parliamentary law. Constitutional monarchy was reestablished once and for all in Britain, and the divine right of kings permanently suspended.

Anthony van Dyck in England The tension between the Catholic-leaning English monarchy and the Puritan-oriented

Fig. 10.31 Anthony Van Dyck, *Portrait of Charles I Hunting.* **1635.** Oil on canvas, 8'11" × 6'11". Musée du Louvre, Paris. Inv.1236. Charles's posture, his left hand on his hip, and his right extended outward where it is supported by a cane, adopts the positions of the arms in court dance.

Parliament was exacerbated by the flambovant style of the court, which offended more austere Puritan tastes. The court style is embodied in Portrait of Charles I Hunting (Fig. 10.31), by the Flemish artist Anthony Van Dyck (1599–1641), court painter to Charles I. Sometime in his teens, Van Dyck went to work in Rubens's workshop in Antwerp, and he led the studio by the time he was 17. Van Dyck's great talent was portraiture. After working in Italy in the 1620s, in 1632 he accepted the invitation of Charles I of England to come to London as court painter. He was knighted there in 1633. He often flattered his subjects by elongating their features and portraying them from below to increase their stature. In the case of the painting shown here, Van Dyck positioned Charles so that he stands a full head higher than the grooms behind him, lit in a brilliant light that glimmers off his silvery doublet. The angle of his jauntily cocked cavalier's hat is echoed in the trees above his head and the neck of his horse, which seems to bow to him in respect. He is, in fact, the very embodiment of the Cavalier (from the French chevalier, meaning "knight"), as his royalist supporters were known. Like the king here, Cavaliers were famous for their style of dress-long, flowing hair, elaborate clothing, and large, sometimes feathered hats.

Diego Velázquez in Spain Even as England endured its divisive religious wars, Spain remained dogmatically Catholic. But despite the wealth flowing into the country from its American empire, by 1600 Spain had entered a period of decline during which deteriorating economic and social conditions threatened the absolutist authority of its king. Severe inflation, a shift of population away from the countryside and into the cities, and a loss of population and therefore tax revenue brought the absolutist Spanish court to bankruptcy. To make matters worse, Philip IV (r. 1621-65), great-grandson of the Holy Roman Emperor Charles IV, embarked on a number of disastrous, highly costly military campaigns, culminating in 1659 with Spain accepting a humiliating peace with France. Nevertheless, even as the Spanish throne seemed to crumble, the arts flourished under the patronage of a court that recklessly indulged itself. So remarkable was the outpouring of Spanish arts and letters in the seventeenth century that the era is commonly referred to as the Spanish Golden Age.

The Spanish court understood that in order to assert its absolutist authority, it needed to impress the people through

its patronage of the arts. So when Philip IV assumed the Spanish throne at the age of 16, his principal advisor suggested that his court should strive to rival all the others of Europe by employing the greatest painters of the day. The king agreed, hiring Rubens in the 1630s to paint a cycle of 112 mythologies for his hunting lodge. But when the 24-year-old Diego Rodríguez de Silva y Velázquez (1599–1660) was summoned to paint a portrait of the king in the spring of 1623, both the king and his advisor recognized that one of the great painters of seventeenth-century Europe was homegrown. An appointment as court painter quickly followed, and Velázquez became the only artist permitted to paint the king.

In 1628, when Rubens visited the Spanish court, Velázquez alone among artists in Madrid was permitted to visit with the master at work. And Velázquez guided Rubens through the royal collection, which included Bosch's Garden of Earthly Delights (see Closer Look, Chapter 8) and, most especially, Titian's The Rape of Europa (see Fig. 10.6), which had been painted expressly for Philip II. Rubens copied both. He also persuaded Velázquez to go to Italy from 1629 to 1630, where he studied the work of Titian in Venice. In Florence and Rome, Velázquez disliked the paintings of Raphael, whose linear style he found cold and inexpressive.

Velázquez's chief occupation as painter to Philip IV was painting court portraits and supervising the decoration of rooms in the various royal palaces and retreats. Most were portraits of individuals, but *Las Meninas* (*The Maids of Honor*) is a life-size group portrait and his last great royal commission (Fig. 10.32). It elevates the portrait to a level of complexity almost unmatched in the history of art. The source of this complexity is the competing focal points of the composition. At the very center of the painting, bathed in light, is the Infanta Margarita, beloved daughter of King Philip IV and Queen Mariana. In one sense, the painting is the Infanta's portrait, as she seems the primary focus. Yet the title Las Meninas, "The Maids of Honor," implies that her attendants are the painting's real subject. However, Velázquez has painted himself into the composition at work on a canvas, so the painting is, at least partly, also a self-portrait. The artist's gaze, as well as the gaze of the Infanta and her dwarf lady-in-waiting, and perhaps also of the courtier who has turned around in the doorway at the back of the painting, is focused on a spot outside the painting, in front of it, where we as viewers stand. The mirror at the back of the room, in which Philip and Mariana are reflected, suggests that the king and queen also occupy this position, acknowledging their role as Velázquez's patrons. This work continues to inspire artists to this day.

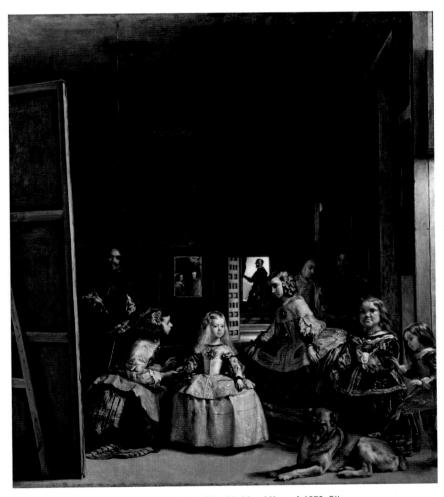

Fig. 10.32 Diego Velázquez, Las Meninas (The Maids of Honor). 1656. Dil on canvas, 10°%" × 9°%". Museo del Prado, Madrid. No other Velázquez painting is as tall as Las Meninas, which suggests that the back of the canvas in the foreground is, in fact, Las Meninas itself. Velázquez thus paints himself painting this painting.

10.1 Explain Mannerism and how it arose out of the Counter-Reformation

The Roman Catholic Church's conscious attempt to reform itself in reaction to the Protestant Reformation culminated in Pope Paul III convening the Council of Trent in 1545. What guiding principles did the Council adopt? How did these principles affect art and music? How does Michelangelo's late work anticipate Mannerism? Many found the nudity in his Last Judgment inappropriate for religious painting, but this lack of decorum was acceptable outside a religious context. How would you describe this less-decorous Mannerist style? In the art of Veronese and El Greco, Mannerist inventiveness sought to accommodate itself to the more conventional aspirations of the Counter-Reformation and to the Roman Catholic Church's Inquisition in Italy and Spain, dedicated to rooting out heresy. What was the Inquisition? Finally, in what many consider the Western world's first great novel, Don Quixote, the writer Miguel de Cervantes captured the complexities of the era in a picaresque character whose imagination isolates him from reality. How would you define the picaresque?

10.2 Describe how the Baroque style manifested itself in the art, music, and literature of the era.

As part of its strategy to respond to the Protestant Reformation, the Catholic Church in Rome championed a new Baroque style of art that appealed to the range of human emotion and feeling, not just the intellect. Bernini's majestic new colonnade for the square in front of Saint Peter's in Rome helped to reveal the grandeur of the basilica itself, creating the dramatic effect of the Church embracing its flock. How does his sculptural program for the Cornaro Chapel in Rome epitomize the Baroque? How are Baroque sensibilities reflected in his sculpture of the biblical hero David? How do action, excitement, and sensuality fulfill the Counter-Reformation objectives in Baroque religious art? What role do the senses play in the theological writings of Saint Ignatius? How is this reflected in Andrea Pozzo's ceiling for the church of Sant'Ignazio?

In painting, Caravaggio utilized the play of light and dark to create works of stunning drama and energy that reveal a new Baroque taste for vividly realistic detail. Artemisia Gentileschi inherited his interest in realism and the dramatic. What role does Gentileschi's biography play in the interpretation of her work? What does Caravaggio share with the mystical writings of Teresa of Ávila and the poetry of the Englishman John Donne?

If Rome was the center of Baroque art and architecture, Venice was the center of Baroque music. In what ways are Giovanni Gabrieli's canzonas, Monteverdi's operas, and Vivaldi's concertos Baroque?

10.3 Discuss the vernacular Baroque style that developed in the North.

Still lifes, landscapes, and genre paintings were especially popular. Most popular of all, however, were portrait paintings, including large-scale group portraits, such as those by Rembrandt. How do you account for the popularity of portraiture in Dutch society? Rembrandt's work is especially notable for its dramatic liveliness. How does his mastery of light and dark contribute to this? What are some characteristics of Baroque music? Can you compare Baroque music to Baroque painting? How do Johann Sebastian Bach's chorales transform the simple melodies of Lutheran chorales?

10.4 Define absolutism and discuss how it impacted the arts.

The court and government of Louis XIV of France were centered at Versailles, the magnificent palace outside Paris designed by Charles Le Brun. André le Nôtre laid out the grounds in the geometric style called the French garden. In what ways does Versailles reflect Louis's sense of his absolute authority? What did he mean to suggest by calling himself *Le Roi Soleil*, "the Sun King"? Various members of the court favored one or the other of two competing styles of art, represented, on the one hand, by the work of Peter Paul Rubens and, on the other, by that of Nicolas Poussin. What compositional features characterize the painting of Rubens, and how do they contrast with the painting of Poussin?

Louis indulged his taste for pomp and ceremony in music and dance, and especially entertainments written by Jean-Baptiste Lully, who created a new operatic genre, the *tragédie en musique*. What characterizes Lully's operas? Louis also strongly promoted dance, the most important form of which was the minuet.

The greatest artist of the English court was Anthony Van Dyck, who had worked in Rubens's studio as his chief assistant. His great talent was portraiture. Philip IV of Spain strove to rival the other great courts of Europe by employing the greatest painters of the day, including Rubens. The young court painter Diego Velázquez, already deeply influenced by Caravaggio, visited Rubens at work. Velázquez's greatest work is *Las Meninas*. What features of this work contribute to its greatness?

Excess and Restraint

n underlying characteristic of the Baroque age is its ultimate trust in the powers of reason. Major breakthroughs in mathematics, astronomy, geology, physics, chemistry, biology, and medical science dominate the history of the age. These products of empirical reasoning constituted a so-called **Scientific Revolution** that transformed the way the Western mind came to understand its place in the universe.

It may seem odd that such painters as Caravaggio, Rubens, and Rembrandt, who appealed to the emotional and dramatic, the sensual and the spectacular, should be products of the same age as the Scientific Revolution. It would seem more reasonable to say that the scientific energies of the age found their painterly expression more in the likes of Poussin than Rubens. And yet Rembrandt's Anatomy Lesson of Dr. Tulp (see Closer Look, pages 338-339) clearly engages the scientific mind, and Rubens's swirling, flowing lines are the product of a mind confident that order and wholeness are the basic underpinnings of experience. In a very real sense, then, Caravaggio and Gentileschi, Rubens and Rembrandt, Velázquez and Cervantes can best be understood in terms of their ability to look beneath the surface of experience for the human truths that motivate us all. Their work—like the plays of William Shakespeare at the beginning of the seventeenth century—announces the dawn of modern psychology.

Still, the Baroque age does embody a certain tension between reason and emotion, decorum and excess, clearly defined in the contest between the poussinistes and the rubenistes for ascendancy in the arts. This tension is evident in a painting that shows Louis XIV visiting the Académie des Sciences in 1671 (Fig. 10.33). Following the lead of King Charles II of England, who had chartered the Royal Society in 1662, Louis created the French Academy of Sciences in 1666. He stands surrounded by astronomical and scientific instruments, charts and maps, skeletal and botanical specimens. Out of the window, the ordered geometry of a classical French garden dominates the view. At the same time, Louis seems alien to his surroundings. Decked out in all his ruffles, lace, ribbons, and bows, he is the very image of ostentatious excess. The tension he embodies will become a defining characteristic of the following century. In the next chapter, we will examine the tension in the eighteenth century between the demands of reason, the value that defines the so-called Enlightenment, and the limits of excess, the aristocratic style that has come to be known as the Rococo. Both equally were the product of the Baroque age that precedes them.

Fig. 10.33 Henri Testelin, Jean-Baptiste Colbert Presenting the Members of the Royal Academy of Science to Louis XIV. ca. 1667. Oil on canvas, 137" × 2321/3". © Chateau de Versailles, France.

Enlightenment and Rococo

11

The Claims of Reason and the Excesses of Privilege

LEARNING OBJECTIVES

11.1 Discuss the role of rationalist thinking in the rise of the English Enlightenment and the literary forms to which the Enlightenment gave rise.

11.2 Explain the relationship of the French philosophes to both the Enlightenment and the Rococo.

11.3 Describe the results of cross-cultural contact between Europeans and peoples of the South Pacific and China.

ondon, the city of elegance and refinement painted in 1747 by the Venetian master of cityscapes Canaletto (Giovanni Antonio Canal; 1697–1768), was rivaled only by Paris as the center of European intellectual life in the eighteenth century (Fig. 11.1). The painting offers no hint that the city had been devastated by fire 80 years earlier. Before dawn on the morning of September 2, 1666, a baker's oven exploded on Pudding Lane. A strong east wind hastened the fire's spread until, by morning, some 300 houses were burning. In his private diaries, Samuel Pepys (1633–1703) recorded what he saw on that fateful day:

I rode down to the waterside,... and there saw a lamentable fire.... Everybody endeavoring to remove their goods, and flinging into the river or bringing them into lighters that lay off; poor people staying in their houses as long as till the very fire touched them, and then running into boats, or clambering from one pair of stairs by the waterside to another....

[I hurried] to [Saint] Paul's; and there walked along Watling Street, as well as I could, every creature coming away laden with goods to save and, here and there, sick people carried away in beds. Extraordinary goods carried in

carts and on backs. At last [I] met my Lord Mayor in Cannon Street, like a man spent, with a [handkerchief] about his neck.... "Lord, what can I do? [he cried] I am spent: people will not obey me. I have been pulling down houses, but the fire overtakes us faster than we can do it."... So... I... walked home; seeing people all distracted, and no manner of means used to quench the fire. The houses, too, so very thick thereabouts, and full of matter for burning, as pitch and tar, in Thames Street; and warehouses of oil and wines and brandy and other things.

From Samuel Pepys, Diary (September 2, 1666)

The fire in these warehouses so fueled the blaze that over the course of the next two days it engulfed virtually the entire medieval city and beyond. Almost nothing was spared. About 100,000 Londoners were left homeless. Eighty-seven churches were burned. Businesses, particularly along the busy wharves on the north side of the Thames, were bankrupted. Responding to this, together with the Great Plague that had killed some 70,000 Londoners just the year before, John Evelyn, one of the other great chroniclers of the age, summed up the situation in what amounts to typical British understatement: "London was, but is no more."

Fig. 11.1 Canaletto, London: The Thames and the City of London from Richmond House (detail). 1747. Oil on canvas, 44½" × 39¾". By permission of the Trustees of the Goodwood Collection. From May 1746 until at least 1755, interrupted by only two visits to Venice in 1750–51 and 1753–54, the Venetian painter Canaletto occupied a studio in Beak Street, London. The geometric regularity and perspectival inventiveness of his paintings reflect the Enlightenment's taste for rationality. But his sense of grandeur and scale is, like Louis XIV's Versailles (see Chapter 10), purely aristocratic.

Such devastation was both a curse and a blessing. While the task of rebuilding London was almost overwhelming, the fire gave the city the opportunity to modernize its center in a way that no other city in the world could even imagine. By 1670, almost all the private houses destroyed by the fire had been rebuilt, and businesses were once again thriving. Over the course of the next century, the city would prosper as much as or more than any other city in the world. "London," as one writer put it, "is the center to which almost all the individuals who fill the upper and middle ranks of society are successively attracted. The country pays its tribute to the supreme city."

This chapter surveys developments in London and Paris, the literary centers of what would come to be known as the Age of Enlightenment. Across Europe, intellectuals began to advocate rational thinking as the means to achieving a comprehensive system of ethics, aesthetics, and knowledge. The rationalist approach owed much to the scientist Isaac Newton, who in 1687 outlined the operating principles governing the systematic workings of the universe. The workings of human society—the production and consumption of manufactured goods, the social organization of families and towns, the functions of national governments, even the arts—were believed to be governed by analogous universal laws.

The most influential Parisian thinkers of the day, the socalled philosophes, "philosophers," dominated the intellectual life of the French Enlightenment. Not philosophers in the strict sense of the word because they did not concentrate on matters metaphysical, but turned their attention to secular and social concerns, the philosophes were almost uniformly alienated from the Church, despising its hierarchy and ritual. They were also if not totally committed to the abolition of the monarchy, which they saw as intolerant, unjust, and decadent, then at least deeply committed to its reform. This tension between the philosophes, who aspired to establish a new social order of superior moral and ethical quality, and the French courtiers, whose taste favored a decorative and erotic excess that the philosophes abhorred, defined French society in the eighteenth century. The nobility now appreciated only an ever more elaborate decoration and ornament—a style we have come to call Rococo—while the philosophes shunned ornamentation altogether, preferring the order, regularity, and balance of the Classical tradition.

The intellectuals of Enlightenment England and France thought of themselves as the guiding lights of a new era of progress that would leave behind, once and for all, the irrationality, superstition, and tyranny that had defined Western culture, particularly before the Renaissance. Still, recognizing that society was deeply flawed, they also satirized it, attacking especially an aristocracy whose taste for elaborate ornamentation and the seemingly frivolous pursuit of pleasure seemed to many not just decadent but depraved. At the same time, an expanding publishing industry and an increasingly literate public offered Enlightenment writers the opportunity to instruct their readers in moral behavior, even as they described vice in often prurient detail.

Fig. 11.2 Christopher Wren, Saint Paul's Cathedral, London, western facade. 1675–1710. A statue of Saint Paul stands on top of the central portico, flanked by statues of Saint John (*right*) and Saint Peter (*left*). The sculptural detail in the portico pediment depicts the conversion of Paul following his vision on the road to Damascus.

THE ENGLISH ENLIGHTENMENT

How did rationalist thinking inform the English Enlightenment and the literary forms to which it gave rise?

After the Great Fire, the architect Christopher Wren (1632–1723) proposed a grand redesign scheme that would have replaced the old city with wide boulevards and great squares. But the need to rebuild the city's commercial infrastructure quickly made his plan impractical, and each property owner was essentially left to his own devices.

Nevertheless, certain real improvements were made. Wood construction was largely banned; brick and stone were required. New sewage systems were introduced, and streets had to be at least 14 feet wide. Just a year after the fire, in a poem celebrating the devastation and reconstruction, "Annus Mirabilis" ("Year of Wonders"), the poet John Dryden (1631–1700) would equate London with the mythological phoenix rising from its own ashes, reborn: "a wonder to all years and Ages... a *Phoenix* in her ashes." Moved by the speed of the city's rebuilding, Dryden is sublimely confident in London's future. Under the rule of Charles II, the city would become even greater than before (Reading 11.1):

READING 11.1

from John Dryden, "Annus Mirabilis" (1667)

More great than human, now, and more august,¹ New-deified she from her fires does rise: Her widening streets on new foundations trust, And, opening, into larger parts she flies....

Now like the maiden queen, she will behold From her high turrets, hourly suitors come: The East with incense, and the West with gold, Will stand like suppliants, to receive her doom.

For Dryden, the Great Fire was not so much a disaster as a gift from God. And Charles II must have thought so as well, for as a way of thanking Dryden for the poem, the king named him Poet Laureate of the nation in 1668.

Although Christopher Wren's plans to redesign the entire London city center after the Great Fire proved impractical, he did receive the commission to rebuild 52 of the churches destroyed in the blaze. Rising above them all was Saint Paul's Cathedral (Fig. 11.2), a complex yet orderly synthesis of the major architectural styles of the previous 150 years. In its design, Wren drew on Classical, Gothic, Renaissance, and Baroque elements. Its imposing two-story facade is crowned by symmetrical twin clock towers and a massive dome. The floor plan—an elongated, cruciform (crosslike) design—is Gothic. The dome is Renaissance, purposefully echoing Bramante's Tempietto (see Fig. 7.20 in Chapter 7) but maintaining the monumental presence of Michelangelo's dome for Saint Peter's. The facade, with its two tiers of paired Corinthian columns, recalls the French Baroque Louvre in Paris. And the two towers are inspired by a Baroque church in Rome. Wren manages to bring all these elements together into a coherent whole.

According to Wren's son, "a memorable omen" occurred on the occasion of his father's laying the first stone on the ruins of the old cathedral in 1675:

When the SURVEYOR in Person [Wren himself, in his role as King's Surveyor of Works] had set out, upon the Place, the Dimensions of the great Dome and fixed upon the center; a common Laborer was ordered to bring a flat stone from the Heaps of Rubbish... to be laid for a Mark and Direction to the Masons; the Stone happened to be a piece of Grave-stone, with nothing remaining on the Inscription but the simple word in large capitals, RESURGAM [the Latin for "REBORN"].

"RESURGAM" still decorates the south transept of the cathedral above a figure of a phoenix rising from the ashes.

Something of the power of Wren's conception can be felt in Canaletto's view of *The Thames and the City of London from Richmond House* (see Fig. 11.1). The cathedral does indeed rise above the rest of the city, not least because, in rebuilding, private houses had been limited to four stories. Only other church towers, almost all built by Wren as well, rise above the roof lines, as if approaching the giant central structure in homage.

The New Rationalism and the Scientific Revolution

The new London was, in part, the result of the rational empirical thinking that dominated the Western imagination in the late seventeenth century. Newly invented instruments allowed scientists to observe and measure natural phenomena with increasing accuracy, and, perhaps more significantly, new methods of scientific and philosophical investigation provided scientists with the theoretical means to exploit the capabilities of these instruments. According to these new ways of reasoning, *Scientia*, the Latin word for "knowledge," was to be found in the world, not in religious belief.

Francis Bacon and the Empirical Method One of the most fundamental principles guiding the new science was the proposition that, through the direct and careful observation of natural phenomena, one could draw general conclusions from particular examples. This process is known as inductive reasoning, and with it, scientists believed they could predict the workings of nature as a whole. When inductive reasoning was combined with scientific experimentation, it produced a manner of inquiry that we call the empirical method. The leading advocate of the empirical method in the seventeenth century was the English scientist Francis Bacon (1561-1626). His Novum Organum Scientiarum (New Method of Science), published in 1620, is the most passionate plea for its use. "One method of delivery alone remains to us," he wrote, "which is simply this: we must lead men to the particulars themselves, and their series and order; while men on their side must force themselves for a while to lay their notions by and begin to familiarize themselves with facts." The greatest obstacle to human understanding, Bacon believed, was "superstition, and the blind and immoderate zeal of religion." For Bacon, Aristotle represented a perfect example (see Chapter 2). While he valued Aristotle's emphasis on the study of natural phenomena, he rejected as false doctrine Aristotle's belief that the experience coming to us by means of our senses (things as they appear) automatically presents to our understanding things as they are. Indeed, he felt that reliance on the senses frequently led to fundamental errors.

A proper understanding of the world could be achieved, Bacon believed, only if we eliminate the errors in reasoning developed through our unwitting adherence to the false notions that every age has worshiped. He identified four major categories of false notion, which he termed "Idols," all described in his *Novum Organum Scientiarum*. The first of these, the Idols of the Tribe, are the common fallacies of all human nature, derived from the fact that we trust, wrongly, in our senses. The second, the Idols of the Cave, derive from our particular education, upbringing, and environment—an individual's religious faith or sense of his or her ethnic or gender superiority or inferiority would be examples. The third, the Idols of the Market Place, are errors that occur

¹ Augusta, the old name of London.

as a result of miscommunication, words that cause confusion by containing, as it were, hidden assumptions. For instance, the contemporary use of "man" or "mankind" to refer to people in general (common well into the twentieth century) connotes a world view in which hierarchical structures of gender are already assumed. Finally, there are the Idols of the Theater, the false dogmas of philosophy not only those of the ancients but also those that "may yet be composed." The object of the empirical method is the destruction of these four Idols through intellectual objectivity. Bacon argued that rather than falling back on the preconceived notions and opinions produced by the four Idols, "Man, [using the last idol] being the servant and interpreter of Nature, can do and understand so much and so much only as he has observed in fact or in thought of the course of Nature; beyond this he neither knows anything nor can do anything."

Bacon's insistence on the scientific observation of natural phenomena led, in the mid-1640s, to the formation in England of a group of men who met regularly to discuss his new philosophy. After a lecture on November 28, 1660, by Christopher Wren, also the Gresham College Professor of Astronomy, they officially founded "a College for the Promoting of Physico-Mathematicall Experimentall Learning." It met weekly to witness experiments and discuss scientific topics. Within a couple of years, the group became known as "The Royal Society of London for Improving Natural Knowledge," an organization that continues to the present day as the Royal Society. It is one of the leading forces in international science, dedicated to the recognition of excellence in science and the support of leading-edge scientific research and its applications.

René Descartes and the Deductive Method Bacon's works circulated widely in Holland, where they were received with enthusiasm. As one seventeenth-century Dutch painter, Constantijn Huygens (1596-1687), put it in his Autobiography, Bacon offered the Dutch "most excellent criticism of the useless ideas, theorems, and axioms which, as I have said, the ancients possessed." But equally influential were the writings of the French-born René Descartes (1596-1650). Descartes, in fact, lived in Holland for more than 20 years, from 1628 to 1649, moving between 13 different cities, including Amsterdam, and 24 different residences. It was in Holland that he wrote and published his Discourse on the Method of Rightly Conducting the Reason and Seeking for Truth in the Sciences (1637). As opposed to Bacon's inductive reasoning, Descartes proceeded to his conclusions by the opposite method of deductive reasoning. He began with clearly established general principles and moved from those to the establishment of particular truths.

Like Bacon, Descartes distrusted almost everything, believing that both our thought and our observational senses can and do deceive us. In his *Meditations on the First Philosophy*, he draws an analogy between his own method and that of an architect (**Reading 11.2**):

READING 11.2

from René Descartes, Meditations (1641)

Throughout my writings I have made it clear that my method imitates that of the architect. When an architect wants to build a house which is stable on ground where there is a sandy topsoil over underlying rock, or clay, or some other firm base, he begins by digging out a set of trenches from which he removes the sand, and anything resting on or mixed in with the sand, so that he can lay his foundations on firm soil. In the same way, I began by taking everything that was doubtful and throwing it out, like sand.

He wants, he says, "to reach certainty—to cast aside the loose earth and sand so as to come upon rock and clay." The first thing, in fact, that he could not doubt was that he was thinking, which led him to the inevitable conclusion that he must actually exist in order to generate thoughts about his own existence as a thinking individual, which he famously expressed in *Discourse on Method* in the Latin phrase "Cogito, ergo sum" ("I think, therefore I am").

At the heart of Descartes' thinking—we refer to Descartes's method as Cartesian—is an absolute distinction between mind and matter, and hence between the metaphysical soul and the physical body, a system of oppositions that has come to be known as Cartesian dualism. The remarkable result of this approach is that, beginning with this one "first principle" in his Discourse on Method, Descartes comes to prove, at least to his own satisfaction, the existence of God. He would repeat this argument many times, most formally in his 1641 Meditations, but the logic, simply stated, is as follows: (1) I think, and I possess an idea of God (that is, the idea exists in me and I can be aware of it as an object of my understanding); (2) The idea of God is the idea of an actually infinite perfect being; (3) Such an idea could only originate in an actually infinite perfect being ("it had been placed in me by a Nature which was really more perfect than mine could be, and which had within itself all the perfections of which I could form any idea"); and (4) Therefore, there is an infinitely perfect being, which we call God. This line of thinking established Descartes as one of the most important founders of deism (from the Latin deus, "god"), the brand of faith that argues that the basis of belief in God is reason and logic rather than revelation or tradition. Descartes did not believe that God was at all interested in interfering in human affairs. Nor was God endowed, particularly, with human character. He was, in Descartes's words, "the mathematical order of nature." Descartes was himself a mathematician of considerable inventiveness, founding analytic geometry, the bridge between algebra and geometry crucial to the invention of calculus. The same year that he published Discourse on Method, Descartes also published a treatise entitled Optics. There, among other things, he used geometry to calculate the angular radius of a rainbow (42 degrees).

Johannes Kepler, Galileo Galilei, and the Telescope

Descartes's Optics was built upon the earlier discoveries in optics of the German mathematician Johannes Kepler (1571–1630). Kepler had made detailed records of the movements of the planets, substantiating the earlier theory of the Renaissance mathematician and astronomer Nicolaus Copernicus (1473–1543), who had been the first to propose that the planets orbited the sun, not the Earth, in 1543. The long-standing tradition of a **geocentric** (Earth-centered) cosmos was definitively replaced with a **heliocentric** (sun-centered) theory. Kepler also challenged the traditional belief that the orbits of the planets were spherical, showing that the five known planets moved around the sun in elliptical paths determined by the magnetic force of the sun and their relative distance from it.

Meanwhile, in Italy, Kepler's friend Galileo Galilei (1564–1642) had improved the design and magnification of the telescope (invented by a Dutch eyeglass-maker, Hans Lippershey). Through the improved telescope, Galileo saw and described the craters of the moon, the phases of Venus, sunspots, and the moons of Jupiter. Galileo also theorized that light takes a certain amount of time to travel from one place to the next, and that either as a particle or as a wave, it travels at a measurable uniform speed. He proposed, too, that all objects, regardless of shape, size, or density, fall at the same rate of acceleration—the law of falling bodies, or gravity. Inspired by Galileo's discoveries, Kepler wrote a study on the optical properties of lenses, in which he detailed a design for a telescope that became standard in astronomical research.

Kepler's and Galileo's work did not meet with universal approval. The Church still officially believed that the Earth was the center of the universe and that the sun revolved around it. Protestant Churches were equally skeptical. The theories of Kepler and Galileo contradicted certain passages in the Bible. Joshua, for instance, is described in the Old Testament as making the sun stand still, a feat that would be impossible unless the sun normally moved around the Earth: "So the sun stood still in the midst of the heaven, and hasted not to go down about a whole day. And there was no day like that before it or after it" (Joshua 10:13-14). Furthermore, it seemed to many that the new theories relegated humankind to a marginal space in God's plan. Thus, in 1615, when Galileo was required to defend his ideas before Pope Paul V in Rome, he failed to convince the pontiff. He was banned from both publishing and teaching his findings. When his old friend Pope Urban VIII was elected pope, Galileo appealed Paul's verdict, but Urban went even further. He demanded that Galileo admit his error in public and sentenced him to life in prison. Through the intervention of friends, the sentence was reduced to banishment to a villa outside Florence. Galileo was lucky. In 1600, when the astronomer Giordano Bruno had asserted that the universe was infinite and without center and that other solar systems might exist in space, he was burned at the stake.

Antoni van Leeuwenhoek, Robert Hooke, and the Microscope In the last decade of the sixteenth century, two Dutch eyeglass-makers, Hans Lippershey and Zacharias Janssen, discovered that if one looked through several lenses in a single

Fig. 11.3 Robert Hooke, Illustrations from *Micrographia*: a flea (top) and a slice of cork (bottom). London. 1665. Hooke was the first person to use the word *cell* to describe the basic structural unit of plant and animal life.

tube, nearby objects appeared greatly magnified. This discovery led to the compound microscope (a microscope that uses more than one lens). Early compound microscopes were able to magnify objects only about 20 or 30 times their natural size. Another Dutch lens-maker, Antoni van Leeuwenhoek (1632–1723), was able to grind a lens that magnified over 200 times. The microscope itself was a simple instrument, consisting of two plates with a lens between, which was focused by tightening or loosening screws running through the plates. Two inches long and one inch across, it could easily fit in the palm of one's hand. Leeuwenhoek was inspired by the publication of English Royal Society Curator of Experiments Robert Hooke's Micrographia in 1665. It was illustrated by drawings of Hooke's observations with his compound microscope: a flea that he said was "adorn'd with a curiously polish'd suite of sable Armour, neatly jointed," and a thin slice of cork, in which he observed "a Honey-comb [of]... pores, or cells"—actually, cell walls (Fig. 11.3).

Leeuwenhoek wrote letters to the Royal Society of London to keep them informed about his observations. In his first letter, of 1673, he described the stings of bees. Then, in 1678, he wrote with a report of discovering "little animals"—actually, bacteria and protozoa—and the society asked Hooke to confirm Leeuwenhoek's findings, which he successfully did. For the next 50 years, Leeuwenhoek's regular letters to the Royal Society, describing, for the first time, sperm cells,

blood cells, and many other microscopic organisms, were printed in the Society's *Philosophical Transactions*, and often reprinted separately. In 1680, Leeuwenhoek was elected a full member of the Society.

Isaac Newton: The Laws of Physics With the 1687 publication of his Mathematical Principles of Natural Philosophy, more familiarly known as the Principia, from the first word of its Latin title, Isaac Newton (1642–1727) had demonstrated to the satisfaction of almost everyone that the universe was an intelligible system, well-ordered in its operations and guiding principles. First and foremost, Newton computed the law of universal gravitation in a precise mathematical equation, demonstrating that each and every object exerts an attraction to a greater or lesser degree on all other objects. Thus, the sun exercises a hold on each of the planets, and the planets to a lesser degree influence one another and the sun. The Earth exercises a hold on its moon, and Jupiter on its several moons. All form a harmonious system functioning as efficiently and precisely as a clock or machine. Newton's conception of the universe as an orderly system would remain unchallenged until the late nineteenth and early twentieth centuries, when the new physics of Albert Einstein and others would once again transform our understanding.

Newton's *Principia* marked the culmination of the forces that had led, earlier in the century, to the creation of the Royal Society in England and the Académie des Sciences in France. Throughout the eighteenth century, the scientific findings of Newton and his predecessors—Kepler and Galileo, in

particular—were widely popularized and applied to the problems of everyday life. Experiments demonstrating the laws of physics became a popular form of entertainment. In his Experiment on a Bird in the Air-Pump (Fig. 11.4), the English painter Joseph Wright of Derby (1734–97) depicts a scientist conducting an experiment before the members of a middle-class household. He stands in his red robe behind an air pump, normally used to study the properties of different gases but here employed to deprive a white cockatoo of oxygen by creating a vacuum in the glass bulb above the pump. The children are clearly upset by the bird's imminent death, while their father points to the bird, perhaps to demonstrate that we all need oxygen to live.

Wright had almost certainly seen such an experiment conducted by the Scottish astronomer James Ferguson, who made scientific instruments in London and toured the country, giving lectures. However, Ferguson rarely used live animals. As he explains in the 1760 edition of his lecture notes:

If a fowl, a cat, rat, mouse or bird be put under the receiver, and the air be exhausted, the animal is at first oppressed as with a great weight, then grows convulsed, and at last expires in all the agonies of a most bitter and cruel death. But as this experiment is too shocking to every spectator who has the least degree of humanity, we substitute a machine called the "lung-glass" in place of the animal; which, by a bladder within it, shows how the lungs of animals are contracted into a small compass when the air is taken out of them.

Wright illustrated the crueler demonstration, and the outcome is uncertain. Perhaps, if the bird's lungs have not yet collapsed, the scientist can bring it back from the brink of death. Whatever the experiment's conclusion, life or death, Wright not only painted the more horrific version of the experiment but also drew on the devices of Baroque painting—dramatic, nocturnal lighting and chiaroscuro—to heighten the emotional impact of the scene. The painting underscores the power of science to affect us all.

Fig. 11.4 Joseph Wright of Derby, An Experiment on a Bird in the Air-Pump. 1768. Oil on canvas, $6' \times 8'$. National Gallery, London. The resurrection of apparently dead birds was a popular entertainment of the day, a trick usually performed by self-styled magicians. In this painting, however, Wright's scientist threatens to take the life of the bird, thus demonstrating to his audience the awesome power of science.

The Industrial Revolution

Among Wright's closest friends were members of a group known as the Lunar Society. The Society met in and around Birmingham each month on the night of the full moon (providing both light to travel home by and the name of the society). Its members included prominent manufacturers, inventors, and naturalists. Among them were Matthew Boulton (1728–1809), whose

Fig. 11.5 Thomas Farnolls Pritchard, Iron Bridge, Coalbrookdale, England. 1779. Cast iron. Pritchard was keenly aware that the reflection of the bridge would form a visual circle, a form repeated in the ironwork at the corners of the bridge.

world-famous Soho Manufactury produced a variety of metal objects, from buttons and buckles to silverware; James Watt (1736-1819), inventor of the steam engine, who would team with Boulton to produce it; Erasmus Darwin (1731–1802), whose writings on botany and evolution anticipate by nearly a century his grandson Charles Darwin's famous conclusions; William Murdock (1754–1839), inventor of gas lighting; Benjamin Franklin (1706-90), who was a corresponding member; and Josiah Wedgwood (1730-95), Charles Darwin's other grandfather and the inventor of mass manufacturing at his Wedgwood ceramics factories. From 1765 until 1815, the group discussed chemistry, medicine, electricity, gases, and any and every topic that might prove fruitful for industry. It is fair to say that the Lunar Society's members inaugurated what we think of today as the Industrial Revolution. The term itself was invented in the nineteenth century to describe the radical changes in production and consumption that had transformed the world.

New machinery in new factories created a supply of consumer goods unprecedented in history, answering an ever-increasing demand for everyday items, from toys, furniture, kitchen utensils, and china, to silverware, watches, and candlesticks. Textiles were in particular demand, and in many ways, advances in textile manufacture could be called the driving force of the Industrial Revolution. At the beginning of the eighteenth century, textiles were made of wool from sheep raised in the English Midlands. A thriving cottage industry, in which weavers used handlooms and spinning wheels, textile manufacture changed dramatically in 1733 when John Kay in Lancashire invented the flying shuttle. Using this device, a weaver could propel the shuttle,

which carries the yarn that forms the weft through the fibers of the warp, beyond the weaver's reach. Cloth could be made both wider and more rapidly. Invention after invention followed, culminating in 1769 when Richard Arkwright patented the water frame, a waterwheel used to power looms. With their increased power, looms could operate at much higher speeds. Arkwright had duped the actual inventors out of their design, and in 1771 installed the water frame in a cotton mill in Derbyshire, on the River Derwent. These first textile mills, needing water power to drive their machinery, were built on fast-moving streams like the Derwent. But after the 1780s, with the application of Watts's steam power, mills soon sprang up in urban

centers. In the last 20 years of the eighteenth century, English cotton output increased 800 percent, accounting for 40 percent of the nation's exports.

Another important development was the discovery of techniques for producing iron of unprecedented quality in a cost-effective manner. Early in the century, Abraham Darby (1678-1717) discovered that it was possible to fire cast iron with coke—a carbon-based fuel made from coal. Darby's grandson Abraham Darby III (1750–91) inherited the patent rights to the process; to demonstrate the structural strength of the cast iron he was able to manufacture, he proposed to build a single-arch cast-iron bridge across the River Severn, high enough to accommodate barge traffic on the river. The bridge at Coalbrookdale (Fig. 11.5) was designed by a local architect, while its 70-foot ribs were cast at Darby's ironworks. The bridge's 100-foot span, arching 40 feet above the river, demonstrated once and for all the structural potential of iron. A century later, such bridges would carry railroad cars, as the need for transporting new mass-produced goods exploded.

Absolutism versus Liberalism: Thomas Hobbes and John Locke

Following the Civil War and the Restoration, one of the most pressing problems of the day was how best to govern the nation, and one of the most important points of view had been published by Thomas Hobbes (1588–1679) in 1651, in Leviathan; or the Matter, Forme, and Power of a Commonwealth, Ecclesiasticall and Civil. His Classical training had convinced Hobbes that the reasoning upon which Euclid's geometry was based could be extended to political and social systems. A visit to Galileo in Italy in 1636 reaffirmed the idea

that Galileo's description of the movement of the solar system—planets orbiting the central sun—could be extended to human relations—a people orbiting their ruler. Hobbes argued that people are driven by two things—the fear of death at someone else's hands and the desire for power—and that the government's role is to check both these instincts, which if uncontrolled would lead to anarchy. Given the context in which Leviathan was written—the English Civil War had raged throughout the previous decade—Hobbes's position is hardly surprising. Most humans, Hobbes believed, recognize their own essential depravity and therefore willingly submit to governance. They accept the social contract, which means giving up sovereignty over themselves and bestowing it on a ruler. They carry out the ruler's demands, and the ruler, in return, agrees to keep the peace. Humankind's only hope, Hobbes argued, is to submit to a higher authority, the "Leviathan," the biblical sea monster who is the absolutist "king over all the sons of pride" (Job 41:34).

John Locke (1632–1704) disagreed. In his Essay on Human Understanding (1690), Locke repudiated Hobbes, arguing that people are perfectly capable of governing themselves. The human mind at birth, he claimed, is a tabula rasa, a "blank slate," and our environment—what we learn and how we learn it—fills this slate (Reading 11.3):

READING 11.3

from John Locke's Essay on Human Understanding (1690)

- 1. Idea is the object of thinking. Every man being conscious to himself that he thinks; and that which his mind is applied about whilst thinking being the ideas that are there, it is past doubt that men have in their minds several ideas—such as are those expressed by the words whiteness, hardness, sweetness, thinking, motion, man, elephant, army, drunkenness, and others: it is in the first place then to be inquired, How he comes by them?...
- 2. All ideas come from sensation or reflection. Let us then suppose the mind to be, as we say, white paper, void of all characters, without any ideas—How comes it to be furnished? Whence comes it by that vast store which the busy and boundless fancy of man has painted on it with an almost endless variety? Whence has it all the materials of reason and knowledge? To this I answer, in one word, from EXPERIENCE. In that all our knowledge is founded; and from that it ultimately derives itself. Our observation employed either about external sensible objects, or about the internal operations of our minds perceived and reflected on by ourselves, is that which supplies our understandings with all the materials of thinking. These two are the fountains of knowledge, from whence all the ideas we have, or can naturally have, do spring.
- 3. The objects of sensation, one source of ideas. First, our Senses, conversant about particular sensible objects, do convey into the mind several distinct perceptions of things... [and] thus we come by those ideas we have

- of yellow, white, heat, cold, soft, hard, bitter, sweet, and all those which we call sensible qualities. . . .
- 4. The operations of our minds, the other source of them. Secondly, the other fountain from which experience furnisheth the understanding with ideas, is the perception of the operations of our own mind within us, as it is employed about the ideas it has got; which operations, when the soul comes to reflect on and consider, do furnish the understanding with another set of ideas, which could not be had from things without. And such are perception, thinking, doubting, believing, reasoning, knowing, willing, and all the different actings of our own minds....

Given this sense that we understand the world through experience, if we live in a reasonable society, it should follow, according to Locke's notion of the tabula rasa, that we will grow into reasonable people. In his Second Treatise of Government, also published in 1690, Locke went further. He refuted the divine rights of kings and argued that humans are "by nature free, equal, and independent." They agree to government in order to protect themselves, but the social contract to which they submit does not require them to surrender their own sovereignty to their ruler. The ruler has only limited authority that must be held in check by a governmental system balanced by a separation of powers. Finally, they expect the ruler to protect their rights, and if the ruler fails, they have the right to revolt in order to reclaim their natural freedom. This form of liberalism—literally, from the Latin, liberare, "to free"—sets the stage for the political revolutions that will dominate the world in the eighteenth and nineteenth centuries.

John Milton's Paradise Lost

The debate between absolutism and liberalism also informs what is arguably the greatest poem of the English seventeenth century, *Paradise Lost* by John Milton (1608–74). Milton had served in Oliver Cromwell's government during the Commonwealth. (He had studied the great epics of classical literature, and he was determined to write his own, one that would, as he puts it in the opening verse of the poem, "justifie the wayes of God to men.") In 12 books, Milton composed a densely plotted poem with complex character development, rich theological reasoning, and long, wavelike sentences of blank verse. The subject of the epic is the Judeo-Christian story of the loss of Paradise by Adam and Eve and their descendants. As described in the Bible, the couple, enticed by Satan, disobey God's injunction that they not eat the fruit of the Tree of Knowledge. Satan had revolted against God and then sought to destroy humanity.

While occasionally virulently anti-Catholic, the poem is, among other things, a fair-minded essay on the possibilities of liberty and justice. In many ways, God assumes the position of royal authority that Hobbes argues for in his *Leviathan*. In Book 5 of Milton's poem, God sends the angel Raphael to Adam to warn him of the nearness of Lucifer (Satan) and to explain how Lucifer became God's enemy. Raphael recounts how God had addressed the angels to announce that he now had a son, Christ, whom all should obey as if he were God, and he did so with the authority of hereditary kingship (Reading 11.4a):

READING 11.4a

from John Milton, *Paradise Lost*, Book 5 (1667)

"Hear all ye angels, Progeny of Light,
Thrones, Dominations, Princedoms, Virtues, Powers,
Hear my Decree, which unrevoked shall stand.
This day I have begot whom I declare
My only Son, and on this holy Hill
Him have anointed, whom ye now behold
At my right hand; your Head I him appoint;
And by my Self have sworn to him shall bow
All knees in Heav'n, and shall confess him Lord."

Lucifer, formerly God's principal angel, is not happy about the news of this new favorite. Motivated by his own desire for power, he gathers the angels loyal to him, and addresses them in terms more in the spirit of Locke than of Hobbes. He begins his speech as God had begun his, invoking the imperial titles of those present; he reminds them, "which assert/ Our being ordain'd to govern, not to serve" (Reading 11.4b):

READING 11.4b

from John Milton, *Paradise Lost*, Book 5 (1667)

Thrones, Dominations, Princedoms, Virtues, Powers, If these magnific Titles yet remain

Not merely titular, since by Decree

Another now hath to himself engrossed

All power, and us eclipsed under the name

Of King anointed....

Will ye submit your necks, and choose to bend The supple knee? ye will not, if I trust To know ye right, or if ye know your selves Natives and Sons of Heav'n possessed before By none, and if not equal all, yet free, Equally free; for Orders and Degrees Jarr not with liberty....

Who can in reason then or right assume Monarchy over such as live by right His equals, if in power and splendor less, In freedom equal?

Lucifer's is a "reasonable" argument. Like Locke, he thinks of himself and the other angels as "by nature free, equal, and independent." The battle that ensues between God and Lucifer is reminiscent of the English Civil War, with its complex protagonists, its councils, and its bids for leadership on both sides. It results in Lucifer's expulsion from Heaven to Hell, where he is henceforth known as Satan. While many readers understood God as a figure for the Stuart monarchy, and Satan as Cromwell, it is not necessary to do so in order to understand the basic tensions that inform the poem. The issues that separate God from Satan are clearly the issues dividing England in the seventeenth century: the tension between absolute rule and the civil liberty of the individual.

Satire: Enlightenment Wit

Not every Englishman was convinced that the direction in which England was heading in the eighteenth century was for the better. London was a city teeming with activity; Canaletto's painting (see Fig. 11.1) was an idealized view of city life. Over the course of the eighteenth century, the rich and the middle class largely abandoned the city proper, moving west into present-day Mayfair and Marylebone, and even to outlying villages such as Islington and Paddington. At the start of the century, these villages were surrounded by meadows and market gardens, but by the century's end they had been absorbed into an ever-growing suburbia.

In the heart of London, a surging population of immigrants newly arrived from the countryside filled the houses abandoned by the middle class, which had been subdivided into tenements. The very poor lived in what came to be called the East End, a semicircle of districts surrounding the area that extended from Saint Paul's in the west to the Tower of London in the East (the area contained by the old London Wall). Here, in the neighborhoods of Saint Giles, Clerkenwell, Spitalfields, Whitechapel, Bethnal Green, and Wapping, the streets were narrow and badly paved, the houses old and constantly falling down, and drunkenness, prostitution, pickpocketing, assault, and robbery were the norm. On the outer edges, pigkeepers and dairymen labored in a landscape of gravel pits, garbage dumps, heaps of ashes, and piles of horse manure.

Although political life in England had stabilized when George I (r. 1714–27) assumed the throne, particularly after he essentially turned over the reigns of the government to Robert Walpole (1676–1745), who can be regarded as the first English prime minister and who dominated English political scene from 1721 to 1742, well after George I's death, thoughtful, truly enlightened persons could look beneath the surface of English society and detect a cauldron of social ferment and moral bankruptcy. By approaching what might be called the "dark side" of the Enlightenment and exposing it to all, dissenting writers and artists like Jonathan Swift (1667–1745), William Hogarth (1697–1764), and Alexander Pope (1688–1744) believed they might, by means of irony and the often deadpan humor that marks their satire, return England to its proper path.

The Satires of Jonathan Swift Perhaps the most biting satirist of the English Enlightenment was Jonathan Swift. In a letter to his fellow satirist and friend Alexander Pope, Swift confided that he hated the human race for having misused its capacity for reason simply to further its own corrupt self-interest. After a modestly successful career as a satirist in the first decade of the eighteenth century, Swift was named Dean of Saint Patrick's Cathedral in Dublin in 1713, and it was there that he wrote his most famous works, Gulliver's Travels, published in 1726, and the brief, almost fanatically savage A Modest Proposal in 1729. There, reacting to the terrible poverty he saw in Ireland, Swift proposed that Irish families who could not afford to feed their children breed them to be butchered and served to the English. With a tongue perhaps never before so firmly lodged in his cheek, Swift concludes (Reading 11.5):

READING 11.5

from Jonathan Swift, A Modest Proposal (1729)

I am not so violently bent upon my own opinion as to reject any offer proposed by wise men, which shall be found equally innocent, cheap, easy and effectual. But before something of that kind shall be advanced in contradiction to my scheme, and offering a better, I desire the author or authors will be pleased maturely to consider two points. First, as things now stand, how they will be able to find food and raiment for 100,000 useless mouths and backs. And secondly, there being a round million of creatures in human figure throughout this kingdom, whose whole subsistence put into a common stock would leave them in debt 2,000,000 £ sterling, adding those who are beggars by profession to the bulk of farmers, cottagers, and laborers, with the wives and children who are beggars in effect; I desire those politicians who dislike my overture, and may perhaps be so bold as to attempt an answer, that they will first ask the parents of these mortals, whether they would not at this day think it a great happiness to have been sold for food at a year old in the manner I prescribe, and thereby have avoided such a perpetual scene of misfortunes as they have since gone through by the oppression of landlords, the impossibility of paying rent without money or trade, the want of common sustenance, with neither house nor clothes to cover them from the inclemencies of the weather, and the most inevitable prospect of entailing the like or greater miseries upon their breed for ever.

I profess, in the sincerity of my heart, that I have not the least personal interest in endeavoring to promote this necessary work, having no other motive than the public good of my country, by advancing our trade, providing for infants, relieving the poor, and giving some pleasure to the rich. I have no children by which I can propose to get a single penny; the youngest being nine years old, and my wife past childbearing.

Such a solution to the problem of starving Irish families—they would, as it were, breed for profit—is meant to be understood as the symbolic equivalent of what was actually happening to Irish families and their children. In fact, many Irishmen worked farms owned by Englishmen who charged them such high rents that they were frequently unable to pay them, and consequently lived on the brink of starvation. As dean of the cathedral in Dublin, Swift was in a position to witness their plight every day. For all practical purposes, he believed, England was consuming the Irish young, if not literally then figuratively, sucking the lifeblood out of them by means of its oppressive economic policies.

In *Gulliver's Travels*, Swift's satire is less direct. Europeans had been familiar with the accounts of travelers' adventures in far-off lands at least since the time of Marco Polo, and after the exploration of the Americas, the form had become quite common. Swift played off the travel adventure narrative to describe the adventures of one Lemuel Gulliver as he moves among lands peopled by miniature people, giants, and other fabulous

creatures. But Swift employs his imaginary peoples and creatures to comment on real human behavior. In Book 1, the Lilliputians. a people that average 6 inches in height, are "little people" not just physically but also ethically. In fact, their politics and religion are very much those of England, and they are engaged in a war with a neighboring island that very closely resembles France. Swift's strategy is to reduce the politics of his day to a level of triviality. In Book 4, Gulliver visits Houyhnhnms, a country of noble horses whose name sounds like a whinnying horse and is probably pronounced hwinnum. Gulliver explains that "the word Houyhnhnm, in their tongue, signifies a horse, and, in its etymology, the perfection of nature." Their ostensible nobility contrasts with the bestial and degenerate behavior of their human-looking slaves, the Yahoos. Of course, Gulliver resembles a Yahoo as well. At one point, Gulliver's Houyhnhnm host compliments him, saying "that he was sure I must have been born of some noble family, because I far exceeded in shape, colour, and cleanliness, all the Yahoos of his nation." Gulliver's response is a model of Swift's satiric invective (Reading 11.6):

READING 11.6

from Jonathan Swift, Gulliver's Travels, Book 4, Chapter 6 (1726)

I made his Honor my most humble acknowledgments for the good opinion he was pleased to conceive of me, but assured him at the same time, "that my birth was of the lower sort, having been born of plain honest parents, who were just able to give me a tolerable education; that nobility, among us, was altogether a different thing from the idea he had of it; that our young noblemen are bred from their childhood in idleness and luxury; that, as soon as years will permit, they consume their vigour, and contract odious diseases among lewd females; and when their fortunes are almost ruined, they marry some woman of mean birth, disagreeable person, and unsound constitution (merely for the sake of money), whom they hate and despise. That the productions of such marriages are generally scrofulous, rickety, or deformed children; by which means the family seldom continues above three generations, unless the wife takes care to provide a healthy father, among her neighbors or domestics, in order to improve and continue the breed. That a weak diseased body, a meager countenance, and sallow complexion, are the true marks of noble blood; and a healthy robust appearance is so disgraceful in a man of quality, that the world concludes his real father to have been a groom or a coachman. The imperfections of his mind run parallel with those of his body, being a composition of spleen, dullness, ignorance, caprice, sensuality, and pride.

Gulliver's Travels was an immediate bestseller, selling out its first printing in less than a week. "It is universally read," said Swift's friend Alexander Pope, "from the cabinet council to the nursery." So enduring is Swift's wit that names of his characters and types have entered the language as descriptive terms—"yahoo" for a coarse or uncouth person, "Lilliputian" for anything small and delicate.

Hogarth and the Popular Print By 1743, thousands of Londoners were addicted to gin, their sole means of escape from the misery of poverty. In 1751, just four years after Canaletto painted his view of London, William Hogarth published Gin Lane, a print that illustrated life in the gin shops (Fig. 11.6). In the foreground, a man so emaciated by drink that he seems a virtual skeleton lies dving, half-naked, presumably having pawned the rest of his clothes. A woman takes snuff on the stairs as her child falls over the railing beside her. At the door to the thriving pawnshop behind her, a carpenter sells his tools, the means of his livelihood, as a woman waits to sell her kitchen utensils, the means of her nourishment. In the background, a young woman is laid out in a coffin, as her child weeps beside her. A building comes tumbling down, a man parades down the street with a bellows on his head and a child skewered on his staff—an allegorical if not realistic detail. In the top story of the building on the right, another man has hanged himself. At the lower left, above the door to the Gin Royal, one of the only buildings in good condition, are these words: "Drunk for a penny/ Dead drunk for two pence/ Clean Straw for Nothing."

In *Gin Lane*, Hogarth turned his attention not to the promise of the English Enlightenment, but to the reality of London at its worst. He did so with the savage wit and broad humor that marks the best social satire. And he did so with the conviction that his images of what he called "modern moral subjects" might not only amuse a wide audience, but also influence that audience's behavior. Hogarth usually painted his subjects first, but recognizing the limited audience of a painting, he produced engraved versions for wider distribution. He recognized that his work appealed to a large popular audience, and that by distributing engravings of his works he might make a comfortable living entertaining it.

The Classical Wit of Alexander Pope The English poet Alexander Pope shared Swift's assessment of the English nobility. For 12 years, from 1715 until 1727, Pope spent the majority of his time translating Homer's Iliad and Odyssey, and producing a six-volume edition of Shakespeare, projects of such popularity that he became a wealthy man. But in 1727, his literary career changed direction and, as he wrote, he "stooped to truth, and moralized his song"—he turned, in short, to satire. His first effort was the mock epic Dunciad, published in 1728 and dedicated to Jonathan Swift. The poem opens with a direct attack on the king, George II (r. 1727–60), who had recently succeeded his father, George I, to the throne. For Pope, this suggested that the goddess Dullness reigned over an England where "Dunce the second rules like Dunce the first." Pope's dunces are the very nobility that Swift attacks in the fourth book of Gulliver-men of "dullness, ignorance, caprice, sensuality, and pride"—and the writers of the day whom Pope perceived to be supporting the policies of Walpole and the king.

Against what he believed to be the debased English court, Pope argues for honesty, charity, selflessness, and the order, harmony, and balance of the classics, values set forth

Fig. 11.6 William Hogarth, *Gin Lane*. 1751. Engraving and etching, third state, 14" × 11%". Private collection. In his *Autobiographical Notes*, Hogarth wrote: "In gin lane every circumstance of its [gin's] horrid effects are brought to view; nothing but Idleness, Poverty, misery, and ruin are to be seen... not a house in tolerable condition but Pawnbrokers and the Gin shop."

in An Essay on Man, published between 1732 and 1734. Pope intended the poem to be the cornerstone of a complete system of ethics that he never completed. His purpose was to show that despite the apparent imperfection, complexity, and rampant evil of the universe, it nevertheless functions in a rational way, according to natural laws. The world appears imperfect to us only because our perceptions are limited by our feeble moral and intellectual capacity. In reality, as he puts it at the end of the poem's first section (Reading 11.7):

READING 11.7

from Alexander Pope, An Essay on Man (1732-34)

All Nature is but Art, unknown to thee;

All Chance, Direction, which thou canst not see;

All Discord, Harmony not understood;

All partial Evil, universal good;

And, spite of Pride in erring Reason's spite,

One truth is clear: WHATEVER IS, IS RIGHT.

Pope does not mean to condone evil in this last line. Rather, he implies that God has chosen to grant humankind a certain imperfection, a freedom of choice that reflects its position in the universe. At the start of the second section of the poem, immediately after this passage, Pope outlines humankind's place:

Know then thyself, presume not God to scan: The proper study of Mankind is Man. Placed on this isthmus of a middle state, A Being darkly wise, and rudely great; With too much knowledge for the Sceptic side, With too much weakness for the Stoic's pride. He hangs between, in doubt to act, or rest; In doubt to deem himself a God, or Beast; In doubt his Mind or Body to prefer; Born but to die, and reas'ning but to err; Alike in ignorance, his reason such. Whether he thinks too little, or too much: Chaos of Thought and Passion, all confused; Still by himself abused, or disabused; Created half to rise, and half to fall: Great lord of all things, yet a prey to all; Sole judge of Truth, in endless Error hurled: The glory, jest, and riddle of the world!

In the end, for Pope, humankind must strive for good, even if in its frailty it is doomed to fail. But the possibility of success also looms large. Pope suggests this through the very form of his poem—heroic couplets, rhyming pairs of iambic pentameter lines (the meter of Shakespeare, consisting of five shortlong syllabic units)—that reflect the balance and harmony of Classical art and thought.

The English Garden

As much as Pope valued balance and harmony as a poetic virtue, he was capable of indulging different aesthetic tastes at his villa at Twickenham, on the River Thames, some 10 miles southwest of the center of London (Fig. 11.7). Pope purchased the villa in 1719 with the considerable proceeds he had realized from his translations of Homer, and transformed it into

Fig. 11.7 Perhaps after Samuel Scott, *Pope's Villa, Twickenham.* 1750–60. Graphite, pen and black ink, and watercolor, $13\%" \times 20\%"$. © The Trustees of the British Museum. The entrance to the grotto was through the arched doorway at the bottom center of the villa.

what might best be described as an essay on man's relationship to nature. A broad expanse of lawn ran down from the three-story house to the river, but directly behind it ran the main road to London. Pope built a tunnel under the villa and the road to connect the front lawn to a large garden designed by John Searle. The tunnel was an artificial grotto, fed by a real underground stream but decorated with a collection of minerals, shells, and shards of glass, most of which were donated by Pope's many friends, in imitation of the encrustations found on the walls of real grottos. The garden itself was, along its central axis, Classical in form, but its linear regularity was bounded by bowers, hills, thickets, and various "wildernesses," as they were called, penetrated by meandering paths.

These side spaces represented a new kind of garden that soon became extremely popular throughout England. Instead of the straight, geometrical layout of the French garden, the walkways of the English garden are, in the words of one garden writer of the day, "serpentine meanders . . . with many twinings and windings." The English found precedent for this new garden in the pastoral poetry of the Roman writers Virgil and Horace (see Chapter 3) and, especially, in Pliny's descriptions of the gardens of his Roman contemporaries, translated in 1728 by Robert Castell in Villas of the Ancients Illustrated. According to Castell, Pliny described three styles of Roman garden: the plain and unadorned; the "regular," laid out "by the Rule and Line"; and the Imitatio Ruris, or the imitation of rural landscapes. This last consisted of "wiggly" paths opening on "vast amphitheaters such as could only be the work of nature." But Castell understood that such landscapes were wholly artificial. For him, the Imitatio Ruris was:

. . . a close Imitation of Nature; where, tho' the Parts are disposed with the greatest Art, the Irregularity is still preserved; so that their Manner may not improperly be said to be an artful Confusion, where there is no Appearance of that Skill which is made use of, their Rocks, Cascades, and Trees, bearing their natural Forms.

The ideal estate was to be "thrown open" in its entirety to become a vast garden, its woods, gardens, lakes, and marshes all partaking of a carefully controlled "artificial rudeness" (in the sense of raw, primitive, and undeveloped).

The gardens at Stowe, in Buckinghamshire, are exemplary. Prior to about 1730, they were composed of straight pathways bordering geometrically shaped woods and lakes with clearly defined linear forms, including, at the bottom of the hill below the house, an octagonal pool. These more regular gardens were adorned by artificial Greek temples designed by James Gibbs (1682–1754) and William Kent (1685–1748). Kent's Temple of Ancient Virtue, built in 1734, contained life-size statues of Homer, Lycurgus (a Spartan lawgiver), Socrates, and Epaminondas (a Theban general and statesman). Across the valley, on lower ground, was a Shrine of British Worthies, containing the busts of 16 famous Englishmen, including Shakespeare, Isaac Newton, and John Locke. After 1740, Lancelot "Capability" Brown (1716–83) took over the gardens' design. Brown

was nicknamed "Capability" because, he argued, any landscape is capable of improvement.

Brown was inspired by the gardens at Stourhead, built in the 1740s by the wealthy banker Henry Hoare (Fig. 11.8). Hoare had built dams on several streams to raise a lake, around which he created a serpentine path offering many views and vistas. These included a miniature Pantheon that he probably modeled on similar buildings in the landscape paintings of the seventeenth-century French artist Claude Lorrain. Lorrain's Italian pastoral landscapes, with their winding streams and arched bridges framed by ruins and deftly placed trees, were widely popular in England (Fig. 11.9).

Aristocratic visitors at such an estate would have arrived to visit with their special "Claude" glasses, tinted yellow so that the landscape would glow with the same warmth as a Claude painting. On the one hand, they would have admired the Classical ruins and the Classical facade of the manor house itself. On the other, they would have discovered, in the grounds, a space in which they might escape emotionally from the very civilization that Classical architecture symbolized.

Literacy and the New Print Culture

Since the seventeenth century, literacy had risen sharply in England, and by 1750 at least 60 percent of adult men and between 40 and 50 percent of adult women could read. Not

Fig. 11.9 Claude Lorrain, *The Rest on the Flight into Egypt (Noon).* 1661. Oil on canvas, $45\%'' \times 62\%''$. Hermitage Museum, Saint Petersburg. Collection of Empress Josephine, Malmaison, 1815. Note how the artist makes the viewer's eye move through the painting from the grouping at the lower right diagonally, across the bridge (following the shepherd boy and his dog) toward the ruin at the left, then in a zigzag down the road and over the arched bridge into the hazy light of the distant landscape. This serpentine organization directly inspired English garden design.

Fig. 11.8 Henry Flitcroft and Henry Hoare, the park at Stourhead, Wiltshire, England. 1744–65. Each vista point along the Stourhead path looks over small reproductions or variants of classical temples and monuments that tells the story of Aeneas' visit to the underworld in Books 3 through 6 of Virgil's Aeneid.

surprisingly, literacy was connected to class. Merchant-class men and women were more likely to read than those in the working class. And among the latter, city dwellers had higher literacy rates than those in rural areas. But even the literate poor were often priced out of the literary marketplace. Few had enough disposable income to purchase even a cheap edition of Milton, which cost about 2 shillings at mid-century. (At Cambridge University, a student could purchase a week's meals for 5 shillings.) And even though, by the 1740s, circulating libraries existed in towns and cities across Britain, the

poor generally could not afford the annual subscription fees. Nevertheless, libraries broadened considerably the periodicals and books—particularly that new, increasingly popular form of fiction, the novel—available to the middle class. Priced out of most books and libraries, the literate poor depended on an informal network of trading books and newspapers. Sharing reading materials was so common, in fact, that the publisher of one popular daily periodical estimated "twenty readers to every paper."

The Rise of the English Novel The novel as we know it was not invented in eighteenth-century England—Cervantes's Don Quixote, written a century earlier, is often considered the first example of the form in Western literature (see Chapter 10). But the century abounded in experiments in fiction writing that anticipated many of the forms that novelists have employed down to the present day. Works that today are called novels (from the French nouvelle and Italian novella, meaning "new") were rarely called "novels" in the eighteenth century itself. That term did not catch on until the very end of the century. Typically, they were

referred to as "histories," "adventures," "expeditions," "tales," or-Hogarth's term-"progresses." They were read by people of every social class. What the novel claimed to be, and what appealed to its ever-growing audience, was a realistic portrayal of contemporary life. It concentrated almost always on the trials of a single individual, offering insight into the complexities of his or her personality. It also offered the promise, more often than not, of upward social mobility through participation in the expanding British economy and the prospect of prosperity that accompanied it. As London's population swelled with laborers, artisans, and especially young people seeking fame and fortune, and as the Industrial Revolution created the possibility of sudden financial success for the inventive and imaginative, the novel endorsed a set of ethics and a morality that were practical, not idealized. Above all, the novel was entertaining. Reading novels offered some respite from the drudgery of everyday life and, besides, was certainly a healthier addiction than drinking gin.

One of the most innovative experiments in the new novelistic form was devised by Samuel Richardson (1689-1761). He fell into novel writing as the result of his work on a "how-to" project commissioned by two London booksellers. Aware that "Country Readers" could use some help with their writing, the booksellers hired Richardson to write a book of "sample letters" that could be copied whenever necessary. Richardson was both a printer and the author of a history based on the letters of a seventeenth-century British ambassador to Constantinople and India. He had never written fiction before, but two letters in his new project suggested the idea of a novel—"A Father to a Daughter in Service, on hearing of her Master's attempting her Virtue," and "The Daughter's Answer." Richardson wrote Pamela, or Virtue Rewarded, in just over two months. It is the first example of what we have come to call the epistolary novel—that is, a novel made up of a series of "epistles," or letters. It was published in two volumes in 1740.

The morality of Richardson's Pamela was praised from church pulpits, recommended to parents skeptical of the novel as a form, and generally celebrated by the more Puritan elements of British society, who responded favorably to the heroine's virtue. Pamela herself asked a question that women readers found particularly important: "How came I to be his Property?" But the novel's smug morality (and the upward mobility exhibited by the novel's heroine) offended many, most notably Richardson's contemporary Henry Fielding (1707–54), who responded, a year after the appearance of Pamela, with Shamela. Fielding's title tips the reader off that his work is a parody, a form of satire in which the style of an author or work is closely imitated for comic effect or ridicule. In Fielding's parody, his lower-class heroine's sexual appetite is every bit a match for her Squire Booby's—and from Fielding's point of view, much more realistic. Fielding presents Pamela's ardent defense of her chastity against her upper-class seducer as a sham; it is simply a calculated strategy, an ambitious hussy's plot to achieve financial security.

One of the first great novels written in English is *Robinson Crusoe* (1719) by Daniel Defoe (1660–1731). The full title of this sprawling work is *The Life and Strange Surprising*

Adventures of Robinson Crusoe of York, Mariner; Who lived Eight and Twenty Years, all alone in an un-inhabited Island on the coast of America, near the Mouth of the Great River of Oronoque; Having been cast on Shore by Shipwreck, wherein all the Men perished but himself. With An Account how he was at last as strangely deliver'd by Pirates. Written by Himself. The last three words are crucial, for they establish Defoe's claim that this novel is actually an autobiography.

Defoe's audience was used to reading accounts of real-life castaways that constituted a form of voyage literature. But far from falling into the primitive degradation and apathy of the average castaway, Robinson Crusoe rises above his situation, realizing, in his very ability to sustain himself, his God-given human potential. So many of Defoe's readers felt isolated and alone, like castaways, in the sea of London. For them, Crusoe represented hope and possibility.

This theme of the power of the average person to survive and flourish is what assured the novel's popularity and accounted for four editions by the end of the year. Defoe followed Robinson Crusoe with a series of other fictitious autobiographies of adventurers and rogues—Captain Singleton (1720), Moll Flanders (1722), Colonel Jack (1722), and Roxanna (1724). In all of them, his characters are in one way or another "shipwrecked" by society and as determined as Crusoe to overcome their situations through whatever means—not always the most virtuous—at their disposal.

Not all readers were charmed and entertained by Fielding's lavish portraits of vice. Many found his narratives deplorable. These readers found an antidote to Fielding in the writing of Jane Austen (1775–1817). Although Austen's best-known novels were published in the first quarter of the nineteenth century, she was more in tune with the sensibilities of the late eighteenth century, especially with Enlightenment values of sense, reason, and self-improvement.

None of Austen's heroines better embodies these values than the heroine of *Pride and Prejudice* (1813), Elizabeth Bennet, one of five daughters of a country gentleman whose wife is intent on marrying the daughters off. The novel famously opens (**Reading 11.8**):

READING 11.8

from Jane Austen, *Pride and Prejudice*, Chapter 1 (1813)

It is a truth universally acknowledged, that a single man in possession of a good fortune, must be in want of a wife.

However little known the feelings or views of such a man may be on his first entering a neighbourhood, this truth is so well fixed in the minds of the surrounding families, that he is considered the rightful property of some one or other of their daughters.

The level of Austen's irony in these opening sentences cannot be overstated, for while she describes the fate that awaits any single, well-heeled male entering a new neighborhood, these lines are a less direct, but devastating reflection upon the possibilities for women in English society. Their prospect in life is to be married. And if they are not themselves well-heeled and attractive—that is, marriageable—their prospects are less than that.

Austen first told this story in First Impressions (1796–97), in the form of an exchange of letters between Elizabeth and Fitzwilliam Darcy, an English gentleman. When we first meet him in Pride and Prejudice, Austen describes him as follows: "He was looked at with great admiration for about half the evening, till his manners gave a disgust which turned the tide of his popularity; for he was discovered to be proud, to be above his company, and above being pleased; and not all his large estate in Derbyshire could then save him from having a most forbidding, disagreeable countenance...." The novel's plot revolves around the two nouns of its title, "pride" and "prejudice." Where Elizabeth at first can see only Darcy's pride, she comes to realize that her view is tainted by her prejudice. Darcy's disdain for country people and manners is a prejudice that Elizabeth's evident pride helps him to overcome. Together, they come to understand not only their own shortcomings but also their society's.

THE ENLIGHTENMENT IN FRANCE

What was the relationship of the French philosophes to both the Enlightenment and the Rococo?

Until his death in 1715, Louis XIV had opened his private apartments in Versailles three days a week to his courtiers, where they entertained themselves by playing games. After his death such entertainments continued, only not at Versailles but also in the *hôtels*—or Paris townhouses—of the

French nobility, where the same crowd who had visited the king's apartments now entertained on their own. The new king, Louis XV, was only five years old, and so there was no point in staying so far out of town in the rural palace where the Sun King had reigned supreme.

The hôtels all had a salon, a room designed especially for social gatherings. Very soon the term "salon" came to refer to the social gathering itself. A number of these rooms still survive, including the Salon de la Princesse, which was designed by Germain Boffrand (1667–1754) to commemorate the marriage in 1737 of the 80-year-old prince of Soubise to the 19-year-old Marie-Sophie de Courcillon (Fig. 11.10). Decorated around the top with eight large paintings by Charles-Joseph Natoire (1700–77) depicting the story of Cupid and Psyche from Ovid's Metamorphoses (Fig. 11.11), the room embodies the eroticism that dominated the art of the French aristocracy in the eighteenth century.

These salons became the center of French culture in the eighteenth century, and by 1850 they were

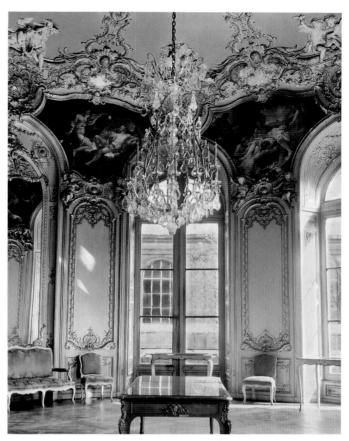

Fig. 11.10 Germain Boffrand, Salon de la Princesse de Soubise (Salon oval), Hôtel de Soubise, Paris. ca. 1740. Oval shape, 33' × 26'. In his 1745 Livre d'architecture (Book on Architecture), Boffrand compared architecture to theater, arguing that it had both a tragic and pastoral mode. In the lightness of its ornament and the eroticism of its paintings, the Salon de la Princesse is an example of the pastoral mode.

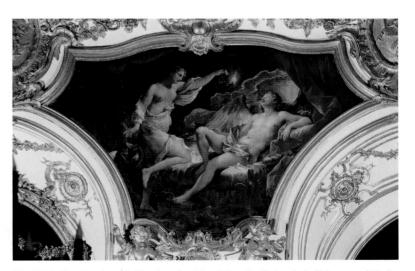

Fig. 11.11 Charles-Joseph Natoire, *Cupid and Psyche*, Salon de la Princesse, Hôtel de Soubise, Paris. 1738. Oil on canvas, 5'7¾" × 8'6¾". Here, Psyche has been brought to the palace of Love where Cupid, under cover of darkness, has consummated their union. Psyche had promised never to seek to know his identity, but she breaks her oath by lighting her lamp to reveal Cupid's face.

emulated across Europe. The new princess de Soubise was perhaps too young to be herself an active *salonnière*, one of the hostesses who presided over the weekly gatherings that soon dominated Parisian social life. Among the most popular salons were those of Jeanne-Julie-Eleonore de Lespinasse (1732–76). In his memoirs, Friederick Melchior, Baron von Grimm (1723–1807), a frequent guest, recalls the ambiance:

Her circle met daily from five o'clock until nine in the evening. There we were sure to find choice men of all orders in the State, the Church, the Court—military men, foreigners, and the most distinguished men of letters. Every one agrees that though the name of M. d'Alembert [an intellectual who lived with Julie de Lespinasse, and who is discussed later in this chapter] may have drawn them thither, it was she alone who kept them there. Devoted wholly to the care of preserving that society, of which she was the soul and the charm, she subordinated to this purpose all her tastes and all her personal intimacies. She seldom went to the theatre or into the country, and when she did make an exception to this rule it was an event of which all Paris was notified in advance. . . . Politics,

religion, philosophy, anecdotes, news, nothing was excluded from the conversation, and, thanks to her care, the most trivial little narrative gained, as naturally as possible, the place and notice it deserved. News of all kinds was gathered there in its first freshness.

The baron numbered among his friends many of the most influential *philosophes* of the day, and in this atmosphere of polite conversation from which no topic was excluded, the excessive style of the French court, exemplified by the decorative program of the Salon de la Princesse at the Hôtel de Soubise, was sure to come into conflict with the taste for the order, regularity, and balance of the Classical tradition that the *philosophes* preferred.

The Rococo

The decorative style fostered by the French court in the eighteenth century and quickly emulated by royal courts across Europe was known as the Rococo. The term is thought to derive from the French word rocaille, a type of decorative rockwork made from round pebbles and curvilinear shells. But it also derives from barocco, the Italian

Fig. 11.12 Jean-Antoine Watteau, *The Embarkation from Cythera*. ca. 1718–19. Oil on canvas, 50¾" × 76%". Staatliche Museen, Schloss Charlottenburg, Berlin. This painting and the one in *Closer Look* (pages 370–71) were purchased by Frederick the Great of Prussia for his own collection. Frederick often staged *fêtes galantes* at his summer palace of Sanssouci near Potsdam.

word for "baroque." In fact, the Rococo style is probably best understood as the culmination of developments in art and architecture that began in the late work of Michelangelo and progressed through Mannerism and the Baroque into the eighteenth century. Along the way, the style became increasingly elaborate, with architectural interiors employing a vocabulary of S- and C-curves, shell, wing, scroll, and plant-tendril forms, and rounded, convex, often asymmetrical surfaces.

Jean-Antoine Watteau The Rococo found its most eloquent expression in France in the paintings of Jean-Antoine Watteau (1684–1721). This is ironic because he did not have aristocratic patrons and was little known during his lifetime beyond a small group of bourgeois buyers, such as bankers and art dealers. One of his most famous paintings in fact served as a signboard for the shop of a Paris art dealer (see Closer Look, pages 370–71). In a very short time, however, Watteau's works became favorites of the Prussian ruler Frederick the Great, and a great many of his paintings entered Frederick's collection.

Watteau was best known for his paintings of fêtes galantes—gallant, and by extension amorous, celebrations or parties enjoyed by an elite group in a pastoral or garden setting. The erotic overtones of these fêtes galantes are immediately apparent in The Embarkation from Cythera in the pedestal statue of Venus at the right side of the painting and the flock of winged cupids darting about among the revelers (Fig. 11.12). The scene is the island of Cythera, the mythical birthplace of the goddess. Below her statue, which the pilgrims have decked with garlands of roses, a woman leans across her companion's lap as three cupids try to push the two closer together. Behind them, a gentleman leans toward his lady to say words that will be overheard by another woman behind them, who gathers roses with her lover as she leans over them both. Further back in the scene a gentleman helps his lady to her feet while another couple turns to leave, the woman looking back in regret that they must depart the garden island.

François Boucher François Boucher (1703-70) began his career, in the mid-1720s, copying the paintings of Watteau owned by Jean de Jullienne, the principal collector of Watteau's works in France. Jullienne, a manufacturer of dyes and fine fabrics, had conceived the idea of engraving Watteau's work so that a wider public could enjoy it, and Boucher was easily the best of Jullienne's copyists. Boucher himself felt he needed more training, so he set off for Rome with his profits from Jullienne. Once there, he found the work of Raphael "trite" and that of Michelangelo "hunchbacked," perhaps a reference to the well-developed musculature of the latter's figures. When he returned he quickly became the favorite painter of Madame de Pompadour (1721-64), born into a middle-class family involved in Parisian financial circles. She was a great defender of the philosophes, but she was also mistress to Louis XV after he assumed full power in 1743. She blocked efforts to have the works of the philosophes suppressed by censors and was successful in keeping works

Fig. 11.13 François Boucher, Madame de Pompadour. 1756. Oil on canvas, 791/81" × 611/81". Bayerische Hypo und Vereinsbank, Alte Pinakothek, Bayerische Staatsgemäldesammlungen, Munich. Boucher's playful and fragile imagery, evident here in the elaborate frills decorating Madame's dress and in the decorative details on the column behind her, was miniatured within gold cartouches on the surfaces of the vases and urns of the Royal Porcelain Manufactory at Sèvres, Madame de Pompadour's pet project.

attacking the *philosophes* out of circulation. And yet, she was also the king's trusted advisor and the subject of many erotic paintings done at court depicting her as Venus. By the time Madame de Pompadour established herself as the king's mistress, Boucher was firmly established as Watteau's heir, the new master of *fêtes galantes*.

In the 33 years since the death of Louis XIV, the court had enjoyed relatively free reign, and the younger king, Louis XV, essentially adapted himself to its carefree ways. He felt free to take a mistress. Madame de Pompadour was by no means the first, although by 1750 the king had apparently left her bed because, so the story went, her health was frail. But she remained his closest and probably most trusted advisor, and she happily arranged for other women to take her place in the king's bed. Given this context, it is hardly surprising that many of Boucher's portraits of Madame de Pompadour are like that of 1756, which portrays her as an intellectual supporter of the French Enlightenment, reading a book, her writing table nearby with her quill inserted in the inkwell (Fig. 11.13).

Somewhat surprising are his many paintings of nude goddesses in which the nude bears a striking resemblance to the

CLOSER LOOK

ean-Antoine Watteau's The Signboard of Gersaint, painted in about 1721, is quite literally a signboard. A little over 5 feet high and 10 feet long, it was commissioned to hang outside Gersaint's art gallery in Paris, and later, in about 1744, it entered the collection of Frederick the Great of Prussia. Gersaint called his gallery Au Grand Monarque ("At the Sign of the Great King"), and in this painting the artist alludes to the recently departed Sun King by showing gallery workers putting a portrait of Louis XIV, probably painted by Hyacinthe Rigaud, into a box for storage. A woman in a pink satin gown steps over the threshold from the street, ignoring, for a moment, her companion's outstretched hand to gaze down at the portrait as it descends into its coffinlike confines. It is as if she is taking one last look at the fading world of Louis XIV before turning her back on it once and for all. In fact, just one day after Louis's death, the aristocracy abandoned the palace and returned to Paris.

Watteau's painting is really the signboard of a social world dominated by the leisure, elegance, and refinement of the aristocratic Parisian elite. But here, he adds an ominous note. An unkempt passerby, stick in hand, stands just to the left of the crate. He too stares down at the Grand Monarque's picture as it is lowered into place, but with a certain disdain. He is the other France, the France that, so marginalized, will erupt in revolution in 1789.

Jean-Antoine Watteau, *The Signboard of Gersaint.* **ca. 1721.** Oil on canvas, $5'4'' \times 10'1''$. Staatliche Museen, Berlin, Preussischer Kulturbesitz, Verwaltung der Staatlichen, Schlösser und Gärten Kunstsammlungen. After it was sold, the work was cut in two halves and displayed as two separate paintings. Its two halves were reunited in the twentieth century.

Something to Think About...

What do the dog, on the far right side of the painting, and the working-class passerby, on the far left, have in common? How do they frame, both literally and figuratively, the world of the painting?

A portrait of King Louis XIV, probably one of several painted by Hyacinthe Rigaud (see Fig. 10.26 in Chapter 10), is deposited in a storage crate.

1986, at **MyArtsLab**

Watteau's The Signboard of Gersaint

Watteau was a great admirer of Rubens and copied his work often. He shared with Rubens a great love of painting flesh, as well as the ability to reflect in the sensuality of his brushwork and color the sensuality of his subject matter. In The Signboard of Gersaint, for instance, Watteau fills the room with Rubeniste canvases. One canvas appears to depict a drunken Silenus, a figure from Greek mythology who is the rotund, older tutor of the god of wine, Dionysus, a scene very much in the spirit of Rubens's many paintings of the same theme. Beside it is a reclining nude.

Two customers are being shown a reclining nude in the painting, emphasizing the eroticism of the exchange between viewer and painting.

The dog is an echo of Rubens's frequent use of a dog as an emblem of the sensual appetites. The art historian Svetlana Alpers has, in fact, identified Watteau's dog as an outright copy, in reverse, of one painted by Rubens in The Coronation of Marie de' Medici, one of the 21 paintings in the series commissioned to celebrate the life of the queen.

Peter Paul Rubens, The Coronation of Marie de' Medici. 1622-25. Oil on canvas, 12'11" × 23'10". Musée du Louvre, Paris.

Fig. 11.14 François Boucher, *The Toilet of Venus*. 1751. Oil on canvas, 42%" × 331%". Signed and dated (lower right): f-Boucher-1751. The Metropolitan Museum of Art, New York. Bequest of William K. Vanderbilt, 1920 (20.155.9). Boucher's contemporaries likened his palette, which favored pinks, blues, and soft whites, to "rose petals floating in milk."

king's mistress. (Boucher was notoriously famous for such nudes.) *The Toilet of Venus*, for instance, was commissioned by Madame de Pompadour for the bathing suites of the chateau of Bellevue, one of six residences just outside Paris that Louis built for her (Fig. 11.14). She had played the title role in a production called *La Toilette de Vénus* staged at Versailles a year earlier, and evidently this is a scene—or more likely an idealized version of one—from that production. The importance of the work is that it openly acknowledges both Madame de Pompadour's sexual role in the court and the erotic underpinnings of the Rococo as a whole.

Jean-Honoré Fragonard Boucher's student Jean-Honoré Fragonard (1732–1806) carried his master's tradition into the next generation. Fragonard's most important commission was a series of four paintings for Marie-Jeanne Bécu, comtesse du Barry, the last mistress of Louis XV. Entitled *The Progress of Love*, it was to portray the relationship between Madame du Barry and the king, but in the guise of young people whose romance occurs in the garden park of the countess's chateau at Louveciennes, itself a gift from Louis.

The series was inspired by an earlier painting, *The Swing* (Fig. 11.15), a work that suggests an erotic intrigue between

two lovers. It implies as well the aesthetic intrigue between the artist and the patron, a conspiracy emphasized by the sculpture of Cupid to the left, holding his finger to his mouth as if to affirm the secrecy of the affair. The painting's subject matter was in fact suggested by another artist, Gabriel-François Doyen, who was approached by the baron de Saint-Julien to paint his mistress "on a swing which a bishop is setting in motion. You will place me in a position in which I can see the legs of the lovely child and even more if you wish to enliven the picture." Doyen declined the commission but suggested it to Fragonard.

Much of the power of the composition lies in the fact that the viewer shares, to a degree, the voyeuristic pleasures of the reclining lover. The entire image is charged with an erotic symbolism that would have been commonly understood at the time. For instance, the lady on the swing lets fly her shoe—the lost shoe and naked foot being a well-known symbol of lost virginity. The young man reaches toward her, hat in hand—the hat that in eighteenth-century erotic imagery was often used to cover the genitals of a discovered lover. Even more subtly, and ironically, the composition echoes the central panel of Michelangelo's Sistine Chapel ceiling, the Creation of Adam (see Fig. 7.25 in Chapter 7). The male lover assumes Adam's posture, and the female lover God's, although she reaches toward Adam-to bring him to life, as it were—with her foot, not her hand.

Art Criticism and Theory

Art was in fact one of the most carefully cultivated pursuits of French intellectuals (and those with intellectual pretensions). By the last half of the eighteenth century, it was becoming increasingly fashionable for educated upper-class people to experience what the English called the "Grand Tour" and the French and Germans referred to as the "Italian Journey." Art and architecture were the focal points of these travels, along with picturesque landscapes and gardens. A new word was coined to describe the travelers themselves—"tourist."

Tourists then, as they do today, wanted to understand what they were seeing. Among the objects of their travel were art exhibitions, particularly the Paris Salon—the official exhibition of the French Royal Academy of Painting and Sculpture. It took place in the Salon Carré of the Louvre, which lent the exhibition its name. It ran from August 25 until the end of September almost every year from 1737 until 1751, and every other year from 1751 to 1791. But few visitors were well-equipped to appreciate or understand what they were seeing, so a new brand of writing soon developed in response: art criticism.

The *philosophe* Denis Diderot (1717–83) began reviewing the official exhibitions of the Paris Salon in 1759 for a private newsletter circulated to a number of royal houses outside France. Many consider these essays (there are nine of them) the first art criticism. Boucher and his fellow Rococo

Fig. 11.15 Jean-Honoré Fragonard, *The Swing.* 1767. Oil on canvas, $32\%" \times 26"$. Wallace Collection, London. Contributing to the erotic overtones of the composition is the lush foliage of the overgrown garden into which the male lover has inserted himself.

artists were the object of his wrath. In 1763, Diderot asked: "Haven't painters used their brushes in the service of vice and debauchery long enough, too long indeed?" Painting, he argued, ought to be "moral." It should seek "to move, to educate, to improve us, and to induce us to virtue." And in his Salon of 1765, Diderot would complain about Boucher:

I don't know what to say about this man. Degradation of taste, color, composition, character, expression, and drawing have kept pace with moral depravity.... And then there's such a confusion of objects piled one on top of the other, so poorly disposed, so motley, that we're dealing not so much with the pictures of a rational being as with the dreams of a madman.

An artist who did capture Diderot's imagination was the still-life and genre painter Jean-Baptiste Chardin

(1699-1779). Considering the small Chardin still life The Brioche (Fig. 11.16), a painting of the famous French bread or cake eaten at the breakfast table, Diderot in the Salon of 1767 wrote: "One stops in front of a Chardin as if by instinct, as a traveler tired of his journey sits down almost without being aware of it in a spot that offers him a bit of greenery, silence, water, shade, and coolness." What impressed Diderot most was Chardin's use of paint: "Such magic leaves one amazed. There are thick lavers of superimposed color and their effect rises from below to the surface.... Come closer, and everything becomes flat, confused, and indistinct; stand back again, and everything springs back into life and shape." What Diderot valued especially in Chardin's work was its detail, what amounts to an almost encyclopedic attention to the everyday facts of the world. As opposed to the Rococo artists of the court, whose fêtes galantes, he complained, conveyed only the affected and therefore false manners and conventions of polite society, Chardin was able to convey the truth of things. "I prefer rusticity to prettiness," Diderot proclaimed.

Despite Diderot's preference for subject matter of a "truthful" kind, he was fascinated with the individual work of art. He expressed this fascination in his description of its painterly surface beyond whatever "subject matter" it might possess. This fascination was part of a broader change in the way that the eighteenth century approached the arts in general.

Fig. 11.16 Jean-Baptiste Chardin, *The Brioche.* **1763.** Oil on canvas, $18\%'' \times 22''$. Musée du Louvre, Paris. Chardin painted from dark to light, the brightest parts of the canvas coming last.

The Philosophes

When in 1753 Chardin exhibited his *Philosopher Occupied* with His Reading in Paris, one French commentator described the painting (Fig. 11.17) as follows:

This character is rendered with much truth. A man wearing a robe and a fur-lined cap is seen leaning on a table and reading very attentively a large volume in bound parchment. The painter has given him an air of intelligence, reverie, and obliviousness that is infinitely pleasing. This is a truly philosophical reader who is not content merely to read, but who meditates and ponders, and who appears so deeply absorbed in his meditation that it seems one would have a hard time distracting him.

In short, this is the very image of the French philosophe.

Most *philosophes* were **deists**, who accepted the idea that God created the universe but did not believe he had much, if anything, to do with its day-to-day workings. Rather, the universe proceeded according to what they termed **natural law**, law derived from nature and binding upon human society. In Newtonian terms, God had created a great clock, and it ran like clockwork, except for the interference of inept humanity. Humans therefore had to take control of their own destinies. Deists viewed the Bible as a work of mythology and superstition, not the revealed truth of God. They scoffed at the idea of the divine right of kings. The logic of their position led the *philosophes* to a simple proposition, stated plainly by Diderot: "Men will not be free until the last king is strangled with the entrails of the last priest."

Denis Diderot and the Encyclopédie The crowning achievement of the philosophes was the Encyclopédie, begun in 1751 and completed in 1772. Its editors were the teacher and translator Denis Diderot and Jean le Rond d'Alembert (1717-83), a mathematician who was in charge of the articles on mathematics and science. Both were active participants in salon society, and, as we have seen, d'Alembert in fact lived with the great hostess Julie de Lespinasse. The work was unpopular in the French court: Louis XV claimed that it was doing "irreparable damage to morality and religion" and twice banned its printing. If, in fact, the Encyclopédie was rather innocently subtitled a Classified Dictionary of the Sciences, Arts. and Trades, the stated intention of the massive 35-volume text, which employed more than 180 writers, was "to change the general way of thinking." Something of the danger that the Encyclopédie presented to the monarchy is evident in the entry on natural law written by the French lawyer Antoine-Gaspard Boucher d'Argis (1708–91) (Reading 11.9):

READING 11.9

from "Law of Nature or Natural Law," Diderot's Encyclopédie (1751-72)

LAW OF NATURE, OR NATURAL LAW, in its most extended sense, refers to certain principles inspired only

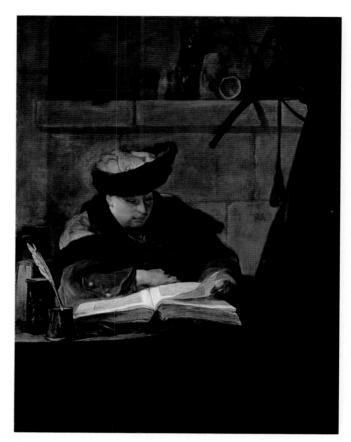

Fig. 11.17 Jean-Baptiste Chardin, A Philosopher Occupied with His Reading. 1734. Oil on canvas, 54%" × 41%". Musée du Louvre, Paris. This is actually a portrait of Joseph Aved, a painter who was a friend of Chardin's.

by nature that are common to men and to animals: on this *law* are based the union of male and female, the procreation of children and concern for their education, the love of liberty, the conservation of one's own person, and the effort each man make to defend himself when attacked by others.

But it is an abuse of the term *natural* law to use it to refer to the impulses that govern the behavior of animals; for they have not the use of reason and are therefore incapable of perceiving any law or justice.

More frequently, we mean by *natural* law certain rules of justice and equity, which natural reason alone has established among men, or to put it better, which God has engraved in our hearts.

Such are the fundamental precepts of law and of all justice: to live honestly, to offend no one, and to render unto every man what belongs to him. From these general precepts are derived many other particular rules, which nature alone, that is to say reason and equity, suggests to men.

Such thinking was fundamental to the Enlightenment's emphasis on human liberty and would fuel revolutions in both America and France. Freedom of thought was, in fact, fundamental to the transmission of knowledge, and any state that suppressed it was considered an obstacle to progress.

So when Louis XV's censors halted publication of the *Encyclopédie* in 1759, the *philosophes* affirmed the despotism of the French state, even if other government officials, prompted by the salon hostesses, secretly labored to ensure the work's continued viability.

Funded by its 4,000 subscribers, the *Encyclopédie* was read by perhaps 100 times that many people, as private circulating libraries rented it to customers throughout the country. In its comprehensiveness, it represents a fundamental principle of the Enlightenment—to accumulate, codify, and preserve human knowledge. Like the *Histoire Naturelle* (*Natural History*) of Georges-Louis Leclerc, published in 36 volumes from 1749 to 1788, which claimed to include everything known about the natural world up to the moment of publication, the *Encyclopédie* claimed to be a collection of "all the knowledge scattered over the face of the earth." The principle guiding this encyclopedic impulse is **rational humanism**, the belief that through logical, careful thought, progress is inevitable.

Jean-Jacques Rousseau and the Cost of the Social Contract

Another contributor to the Encyclopédie was Jean-Jacques Rousseau (1712-78), an accomplished composer originally hired by Diderot to contribute sections on music. Rousseau had been born Protestant, in Geneva, was orphaned early in life, and converted to Catholicism while wandering in Italy. He eventually arrived in Paris. Published after his death, the Confessions is an astonishingly frank account of his troubles, from sexual inadequacy to a bizarre marriage, including his decision to place each of his five children in an orphanage soon after birth. More forthcoming and revealing than any autobiography previously written, it explains in large part the origins of Rousseau's tendency to outbursts of temper and erratic behavior, and makes it very clear why he eventually fell out with the other philosophes. Rousseau was not a social being, even though his writings on social issues were among the most influential of the age.

Rousseau believed in the natural goodness of humankind, a goodness corrupted by society and the growth of civilization. Virtues like unselfishness and kindness were inherent—a belief that gives rise to what he termed the "noble savage"—but he strongly believed that a new social order was required to foster them. In *The Social Contract*, published in 1762, Rousseau describes an ideal state governed by a somewhat mystical "General Will" of the people that delegates authority to the organs of government as it deems necessary. In Chapter 4, "Slavery," Rousseau addresses the subjugation of a people by their monarch (Reading 11.10):

READING 11.10

from Jean-Jacques Rousseau, *The Social Contract*, Book 1, Chapter 4 ("Slavery") (1762)

No man has a natural authority over his fellow, and force creates no right. . . .

If an individual... can alienate his liberty and make himself the slave of a master, why could not a whole people do the same and make itself subject to a king?... It will be said that the despot assures his subjects civil tranquility. Granted; but what do they gain, if the wars his ambition brings down upon them, his insatiable avidity, and the vexatious conduct of his ministers press harder on them than their own dissensions would have done? What do they gain, if the very tranquility they enjoy is one of their miseries? Tranquility is found also in dungeons; but is that enough to make them desirable places to live in?...

To say that a man gives himself gratuitously, is to say what is absurd and inconceivable; such an act is null and illegitimate, from the mere fact that he who does it is out of his mind. To say the same of a whole people is to suppose a people of madmen; and madness creates no right.

Even if each man could alienate himself, he could not alienate his children: they are born men and free; their liberty belongs to them, and no one but they has the right to dispose of it. Before they come to years of discretion, the father can, in their name, lay down conditions for their preservation and well-being, but he cannot give them irrevocably and without conditions: such a gift is contrary to the ends of nature, and exceeds the rights of paternity. It would therefore be necessary, in order to legitimize an arbitrary government, that in every generation the people should be in a position to accept or reject it; but were this so, the government would be no longer arbitrary.

To renounce liberty is to renounce being a man, to surrender the rights of humanity and even its duties.

This passage explains the famous opening line of *The Social Contract*: "Man is born free, and everywhere he is in chains." What Rousseau means is that humans have enslaved themselves, and in so doing have renounced their humanity. He is arguing here, in many ways, against the precepts of the Enlightenment, for it is their very rationality that has enslaved humans.

Even though he was a contributor to it, Rousseau came to reject the aims of the *Encyclopédie*, especially its celebration of manufacturing and invention. In his *Discourse on the Origin of Inequality among Men* (1755), he argues that so long as men tried to do what they could do alone, by themselves, without the help of others, "they lived as free, healthy, good and happy men." But when men found themselves in need of working with others (**Reading 11.11**):

READING 11.11

from Jean-Jacques Rousseau, Discourse on the Origin of Inequality among Men (1755)

... equality disappeared, property was introduced, work became necessary, and vast forests were transformed into pleasant fields which had to be watered with the sweat of men, and where slavery and misery were soon seen to germinate and flourish with the crops. Given such thinking, it is hardly surprising that Rousseau ultimately withdrew from society altogether, suffering increasingly acute attacks of paranoia, and died insane.

Voltaire and French Satire The third great figure among the Parisian *philosophes* was François-Marie Arouet, known by his pen name, Voltaire (1694–1778). So well-schooled, so witty, and so distinguished was Voltaire that to many minds he embodies all the facets of a very complex age. He wrote voluminously—plays, novels, poems, and history. More than any other *philosophe*, he saw the value of other, non-Western cultures and traditions and encouraged his fellow *philosophes* to follow his lead. He was a man of science and an advisor to both Louis XV and Frederick the Great of Prussia. He believed in an enlightened monarchy, but even as he served these rulers, he satirized them. This earned him a year in the Bastille prison in 1717–18, and later, in 1726, another year in exile in London.

Voltaire's year in England convinced him that life under the British system of government was far preferable to life under what he saw as a tyrannical French monarchy. He published these feelings in his Philosophical Letters (1734). Not surprisingly, the court was scandalized by his frankness, so in order to avoid another stint in prison, Voltaire removed himself to the country town of Cirey, home of his patroness the Marquise du Châtelet, a woman of learning who exerted an important intellectual influence on him. In 1744 he returned once again to court, which proved tedious and artificial, but in 1750 he discovered in the court of Frederick the Great what he believed to be a more congenial atmosphere. While there he published his greatest historical work, Le Siècle de Louis XIV (The Century of Louis XIV) (1751). In four brief years he wore out his welcome in Prussia and had to remove himself to the countryside once again. From 1758 to 1778, he lived in the village of Freney in the French Alps. Here he was the center of what amounted to an intellectual court of artists and intellectuals who made regular pilgrimages to sit at his feet and talk.

Voltaire did not believe in the Bible as the inspired word of God. "The only book that needs to be read is the great book of nature," he wrote. He was, more or less, a deist. What he championed most was freedom of thought, including the freedom to be absolutely pessimistic. This pessimism dominates his most famous work, Candide, or Optimism (1758). A prose satire, it tells the tale of Candide, a simple and good-natured but star-crossed youth, as he travels the world struggling to be reunited with his love. Cunegonde. Although Candide survives his adventures a testament to human resilience—and eventually finds his Cunegonde, the book concludes with the famous sentiment: "We must cultivate our garden." We must, in other words, give up our naïve belief that we live in "the best of all possible worlds," tend to the small things that we can do well—thus keeping total pessimism at bay—and leave the world at large to keep on its incompetent, evil, and even horrific way.

CROSS-CULTURAL CONTACT

What were the results of cross-cultural contact between Europeans and peoples of the South Pacific and China?

When Captain James Cook (1728-79) set sail from Plymouth, England, on his ship Endeavour on August 26, 1768, both his sponsors, the Royal Society and the British Admiralty, and Cook himself believed the enterprise to be consistent with the aims of the Enlightenment. While Cook would claim new territories for the British crown, his primary mission was to extend human knowledge: to map the South Seas, record his observations, and otherwise classify a vast area of the world then unknown to European civilization. Although he was careful to document the lives of the people he encountered, he had another, purely scientific mission—to visit Tahiti in order to chart the transit of Venus, that moment when the planet Venus crosses directly between the sun and the Earth. This phenomenon occurs twice, eight years apart, in a pattern that repeats every 243 years; in the eighteenth century, that was in 1761 and 1769. (Astronomers around the world watched in fascination when it occurred in June 2004 and June 2012.) The measurement of the transit of Venus was understood to be useful in calculating the size of the solar system.

The South Pacific

The Royal Society knew of Tahiti because one of its members, the Frenchman Louis-Antoine de Bougainville (1729-1811), had landed on its shores just months before, in April 1768. Bougainville's descriptions of Tahitian life, published in 1771 as Voyage around the World, captured the Enlightenment's imagination. Denis Diderot quickly penned a Supplement to Bougainville's text, arguing that the natives of Tahiti were truly Rousseau's "noble savages." They were free from the tyrannical clutches of social hierarchy and private property—in Diderot's words, "no king, no magistrate, no priest, no laws, no 'mine' and 'thine." All things were held for the common good, including the island's women, who enjoyed, in Diderot's eyes, the pleasures of free love. By following their natural instincts, these people had not fallen into a state of degradation and depravity, as Christian thinkers would have predicted, but rather formed themselves into a nation of gentleness, general well-being, and harmonious tranquility.

Cook, upon his return, took exception to Diderot's picture of Tahitian life. The careful observer would have noticed, he pointed out, a highly stratified social hierarchy of chiefs and local nobility, that virtually every tree on the island was the private property of one of the natives, and that the sexual lives of the Tahitians were in general as morally strict as those of the English (although women in port were as likely in Tahiti as in Plymouth to sell their sexual favors to visiting sailors). But if Cook's position seems at odds with that

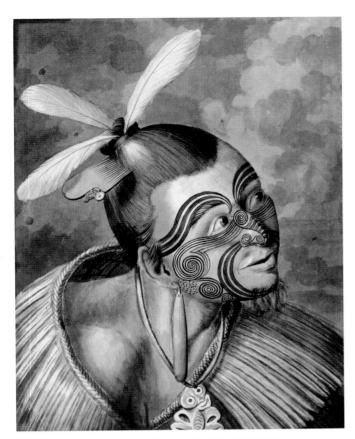

Fig. 11.18 Sydney Parkinson, Portrait of a Maori. 1769. Wash drawing, 15½" × 11¾", later engraved and published as Plate XVI in Parkinson's Journal, 1773 British Library, London, Add, 23920 f.55. Parkinson's drawings provide some of the earliest archeological records of Polynesian life.

of the Enlightenment, it was, in its way, also consistent. Enlightenment philosophers had argued that human nature and behavior were the same all over the world, and in his view the Tahitians proved that point. In addition, Enlightenment economists had argued that private property and social stratification were the basic features of a complex and flourishing society. Cook found both in Tahitian society, and this accounted for the general well-being of that society, he believed.

One of the most distinctive art forms that Cook and his crew encountered in Polynesia was tattooing, a word derived from tatau, the Tahitian term for the practice. One of Cook's crew, Sydney Parkinson, a young draftsman on board to record botanical species, captured the tattooed face of a Maori warrior during the first voyage (Fig. 11.18). The Maori had imported the practice from the Polynesian islands to the north.

Tattooing is an aspect of complex sacred and ritual traditions found throughout the Pacific Islands. The islanders believed that individuals, many places, and a great many objects are imbued with mana, a spiritual substance that is the manifestation of the gods on earth. Chiefs, considered descendants of the gods, were supposedly born with considerable quantities of mana, nobility with less, and commoners with almost none. Anything or anyone possessing mana was protected by tabu, a strict state of restriction indicating that an object or person cannot be touched or a place entered. A chief's food might be protected by tapu. A person might increase his or her mana by skillful or courageous acts, or by wearing certain items of dress, including tattoos. Thus, the warrior depicted by Parkinson possesses considerable mana. This derives from the elegance of his tattoo, from his headdress and comb, his long earring, probably made of greenstone (a form of jade), and his necklace. From it hangs a hei-tiki, a stylized carving of a human figure, a legendary hero or ancestor figure whose mana the warrior carries with him.

Cook's exploration led him to Easter Island, where he discovered the remnants of a culture that had erected moai. monumental heads with torsos, since about 1000 ce. In the western half of New Guinea, he encountered the Asmat, headhunters who believed that in displaying the head of an enemy warrior on elaborately carved poles, they could possess that warrior's strength. In Australia, Cook was the first to encounter Australian Aborigines, whose rock art represents the longest continuously practiced artistic tradition in the world. Finally, in Hawaii, Cook found himself in conflict with King Kamehameha I, the first Hawaiian king to consolidate the islands under one rule, and in 1779 he was killed.

China and Europe

Unlike the cultures of the South Pacific, which were unknown to Europeans until the expeditions of Cook and Bougainville, China and India were well known. The philosophes were especially attracted to China. They recognized that in many respects, China was more advanced than any society in the West. Its people were better educated, with over a million graduates of its highly sophisticated educational system, and its industry and commerce more highly developed. It was also a more egalitarian society (at least for males) than any in the West, for, although a wealthy, landed nobility did exist, it was subject to a government of scholar-bureaucrats drawn from every level of society.

The first Portuguese trading vessels had arrived in China in 1514 (see Chapter 9), and by 1715, every major European trading nation had an office in Canton. Chinese goods-porcelain, wallpaper, carved ivory fans, boxes, lacquerware, and patterned silk-flooded the European markets, creating a widespread taste for what quickly became known as chinoiserie (meaning "all things Chinese"). The vase in Johannes Goedaert's Flowers in a Wan-li Vase with Blue-Tit (Fig. 10.17 in Chapter 10) captures the essence of chinoiserie taste. Central to the rise of chinoiserie was the trade in tea, which was dominated by the Dutch. Across Europe, tea consumption rose from 40,000 pounds in 1699 to an annual average of 240,000 pounds by 1708.

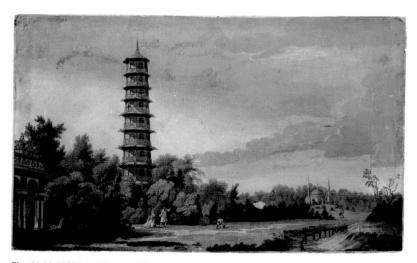

Fig. 11.19 William Marlow, View of the Wilderness at Kew. 1763. Watercolor, sheet $11^1/16^n \times 17^1\%6^n$. Victoria and Albert Museum, London. The Chinese pagoda built by Chambers in 1761 still stands in the gardens today.

The craze for chinoiserie even reached the English garden (Fig. 11.19). A Chinese pagoda in London's Kew Gardens was designed by Sir William Chambers (1726-96). Chambers visited China in the 1740s, and his work on garden architecture, published in 1762 as Dissertation on Oriental Gardening, was widely influential, creating a craze that swept France at the end of the eighteenth century—the jardin anglo-chinois, the English-Chinese garden. Likewise, blue-onwhite porcelain ware—"china," as it came to be known in the West—was especially desirable (see Fig. 9.30 in Chapter 9), and before long, ceramists at Meissen, near Dresden, Germany, had learned how to make their own porcelain. This allowed almost unbounded imitation and sale of Chinese designs on European-manufactured ceramic wares. Even the Rococo court painter François Boucher imitated the blueon-white Chinese style in oil paint (Fig. 11.20). The scene is simply a fête galante in Chinese costume. A balding Chinese man bends to kiss the hand of his lady, who sits with her parasol beneath a statue, not of Venus (as might be appropriate in a European setting), but of Buddha. A blue-on-white Chinese vase of the kind Boucher is imitating rests on a small platform behind the lady, and the whole scene is set in a Rococo-like cartouche.

European thinkers were equally impressed by Chinese government. In his *Discourse on Political Economy*, 1755, Jean-Jacques Rousseau praised the Chinese fiscal system, noting that in China, "taxes are great and yet better paid than in any other part of the world." That was because, as Rousseau explained, food was not taxed, and only those who could afford to pay for other commodities were taxed. It was, for Rousseau, a question of tax equity: "The necessaries of life, such as rice and corn, are absolutely exempt from taxation, the common people are not oppressed, and the duty falls only on those who are well-to-do." And he believed the Chinese emperor to be an exemplary ruler, resolving disputes between officials and the people according to the dictates of the

"general will"—decidedly different from the practices of the French monarchy.

Likewise, in his Essay on the Morals and Customs of Nations (1756), Voltaire praised the Chinese emperors for using government to protect civilization, creating a social stability unmatched in Europe and built upon Confucian principles of respect and service. He somewhat naïvely believed that the Chinese ruling class—in cultivating virtue, refined manners, and an elevated lifestyle-set an example that the rest of its people not only followed, but revered. In England, Samuel Johnson (1709–84), author of the groundbreaking Dictionary of the English Language, published in 1755, praised China's civil service examination system as one of the country's highest achievements, far more significant than their invention of the compass, gunpowder, or printing. He wished Western governments might adopt it.

The China that the West so idealized was ruled by Qing ("clear" or "pure") Manchus, or Manchurians, who had invaded China from the north, capturing Beijing in 1644. They made Beijing their capital and ruled China continuously until 1912, but they solidified their power especially during the very long reign of the Qianlong emperor (r. 1736–95). By 1680, the Qing rulers had summoned many Chinese artists and literati to the Beijing court, and under the Qianlong, the imperial collections of art grew to enormous size, acquired as gifts or by confiscating large quantities of earlier art. (Today the collection is divided between the National Palace Museum in Taipei and the Palace Museum in Beijing.) The collection was housed in the Forbidden City (see Fig. 9.27 in Chapter 9), which the Qing emperors largely rebuilt.

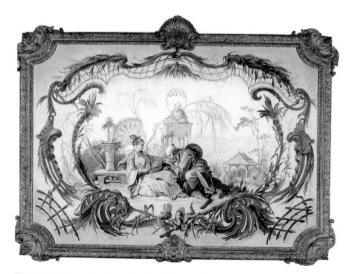

Fig. 11.20 François Boucher, *Le Chinois Galant*. **1742**. Oil on canvas, $41'' \times 57''$. The David Collection, inv. B275. Photo: Pernille Klemp. Boucher also created a suite of tapestries on Chinese themes for the king. The style of both this painting and the tapestries is decidedly Rococo.

While many court artists modeled their work on the earlier masterpieces collected by the emperor. others turned to the study of Western techniques introduced by the Jesuits. The most famous of these Jesuits were Giuseppe Castiglione (1688-1766) and Jean Denis Attiret (1702-68), both of whom had been trained as painters of religious subjects before being sent to China in 1715. Once there, Castiglione virtually abandoned his religious training and worked in the court, where he was known as Lang Shi'ning. He painted imperial portraits, still lifes, horses, dogs, and architectural scenes, and even designed French-style gardens on the model of Versailles. A series of prints made for the Qianlong emperor celebrated the suppression of rebellions in the Western provinces (presentday Xingjiang). The print illustrated here, The Presentation of Uigur Captives, from the series Battle Scenes of the Quelling of Rebellions in the Western Regions, with Imperial Poems, is a fine example of the representation of space through careful scientific perspective, a practice virtually unknown in

Chinese painting before 1700 (Fig. 11.21). It is the kind of work that made Castiglione and Attiret extremely popular in the Qianlong court, for it combines an Eastern appreciation for the order of the political state with the Western use of perspective.

As much as the Qianlong emperor enjoyed Western artistic conventions, he valued traditional Chinese art more. He commissioned large numbers of works painted in the manner of earlier masters, especially those of the Song dynasty (see Chapter 9). A perfect example is *The Colors of Mount Taihang* (Fig. 11.22), painted by Wang Hui (1632–1717). The painting's style is based on that of the northern painter Guan Tong (ca. 906–60), who worked in the unsettled period between the Tang and Song dynasties (see Chapter 9). Although no surviving paintings bear Guan's signature, several works

Fig. 11.21 Jean Denis Attiret, *The Presentation of Uigur Captives*, from *Battle Scenes of the Quelling of Rebellions in the Western Regions, with Imperial Poems*. ca. 1765–74; poem dated 1760. Etching, mounted in album form, 16 leaves plus 2 additional leaves of inscriptions; 20½6" × 34¾". © The Cleveland Museum of Art, John L. Severance Fund. 1998.103.14. In order to indicate his pride in the Qing military, the Qianlong emperor wrote a poem to accompany each etching.

are attributed to him, all of them notable for depicting the angular, rugged mountains of the northern provinces. In the inscription to this painting, Wang writes: "In Guangling [present-day Yangzhou], at the home of a noble person, I once saw a small scroll by Guan Tong. With its cloudy peaks racing together in an oppressive and dense atmosphere, it pierced my heart and shook up my eyes. Today . . . I follow its method and paint this Colors of Taihang. I hope it exhibits some of the deep and heroic atmosphere of the North country, rather than merely posturing with pretty details." Perhaps the most notable transformation that Wang has worked on his master's example is that, where Guan Tong's paintings were almost certainly vertical hanging scrolls, Wang's is a horizontal handscroll. The result is a long, rolling view down into a deep valley on the right, framed by a billowing mountain mass, an undulating landscape to which Wang Hui's contemporaries attached the name "dragon veins." The dragon vein,

wrote one colleague, "is the breath-force of painting.... If the dragon... is lively and vivid, the painting will be true!" From the point of view of his contemporaries, Wang Hui had discovered the basic principle that had driven earlier generations of Chinese painters, and laid it bare to their eyes.

Fig. 11.22 Wang Hui, *The Colors of Mount Taihang*, Qing dynasty (1644–1911). ca. 1669. Handscroll, ink, and color on silk, 10" × 82½". The Metropolitan Museum of Art, New York. Gift of Douglas Dillon, 1978 (1978.423). Wang Hui was known, even in his own day, for his ability to synthesize the techniques of the old masters.

11.1 Discuss the role of rationalist thinking in the rise of the English Enlightenment and the literary forms to which the Enlightenment gave rise.

On September 2, 1666, the better part of London was destroyed by fire. Among the achievements of the rebuilding campaign is Christopher Wren's Saint Paul's Cathedral. At the same time, English intellectuals began to advocate rational thinking as the means to achieve a comprehensive system of ethics, aesthetics, and knowledge. This approach has come to be known as the Enlightenment. In England, Francis Bacon developed the empirical method, a process of inductive reasoning. In Holland, René Descartes developed a separate brand of philosophy based on deductive reasoning. What is the difference between inductive and deductive reasoning? Scientific discoveries supported the philosophies of Bacon and Descartes. Johannes Kepler described functional properties of the human eye, the optical properties of lenses, and the movement of the planets in the solar system. His friend Galileo Galilei perfected the telescope, described the forces of gravity, and theorized the speed of light. How would the Church react to Galileo's discoveries? Meanwhile, in Holland, the microscope had been developed, and soon Antoni van Leeuwenhoek began to describe, for the first time, "little animals"—bacteria and protozoa—sperm cells, blood cells, and many other organisms. How did Isaac Newton's scientific discoveries contribute to Enlightenment thinking? How did the Lunar Society, the group that arguably launched what we think of today as the Industrial Revolution, reflect this same thinking?

Political strife inevitably raised the question of who should govern and how. In *Leviathan*, Thomas Hobbes argued that people should accept a *social contract*. What is that contract? John Locke argued in opposition that humans are "by nature free, equal, and independent." How do their positions play out in John Milton's *Paradise Lost?*

Deeply conscious of the fact that English society fell far short of its ideals, many writers and artists turned to satire. William Hogarth's prints, produced for a popular audience, satirized the lifestyles of all levels of English society. Jonathan Swift aimed the barbs of his wit at the same aristocracy and lambasted English political leaders for their policies toward Ireland in his Modest Proposal. Alexander Pope's Dunciad took on not only the English nobility, but also the literary establishment that supported it. In a more serious vein, his Essay on Man attempts to define a complete ethical system in Classical terms of balance and harmony. But in his garden at Twickenham, Pope developed a different aesthetic. Can you define it? The growing literacy of the English population, matched by an explosion in publishing, gave rise to new genres of writing. At the same time fiction writers experimented with many types of novel. How do you account for the growing popularity of the form?

11.2 Explain the relationship of the French philosophes to both the Enlightenment and the Rococo.

In France, the *philosophes* carried the ideals of the Enlightenment forward, often in open opposition to the absolutist French court. The style of the French court was dominated by the Rococo, a decorative style of art that originated in the *hôtels* and salons of Paris. What are the formal characteristics of the Rococo? Parisian court life was conducted in the Rococo salons of the city's hostesses, where *philosophes*, artists, and intellectuals gathered. Artists, such as Jean-Antoine Watteau, captured the court's Rococo style in paintings of *fêtes galantes*. How would you characterize the emotional content of Watteau's *fêtes galantes*? How is this emotional content carried forward in the paintings of François Boucher and his pupil Jean-Honoré Fragonard?

The philosophes were mostly Deists, who accepted the idea that God created the universe but did not have much if anything to do with its day-to-day workings. What was the guiding principle of Diderot's Encyclopédie? In what ways was Jean-Jacques Rousseau's profoundly personal autobiography, Confessions, antagonistic to Enlightenment ideals? How, nevertheless, did his other writings—like The Social Contract—influence Enlightenment thinking? Finally, the satirist Voltaire challenged all the forms of absolutism and fanaticism that he saw in the world, especially in his satirical narrative Candide. How would you compare Voltaire's satires to those of his English contemporaries, such as Jonathan Swift? The philosophes also contributed to the development of art criticism and theory. In his critical reviews called Salons, Diderot declared Boucher's work depraved. Why did he champion the paintings of Jean-Baptiste-Siméon Chardin?

11.3 Describe the results of cross-cultural contact between Europeans and peoples of the South Pacific and China.

The peoples of the South Seas were seen by many Enlightenment thinkers as unfettered by social hierarchy and private property. But Captain Cook saw things otherwise. How does Cook's thinking equally reflect Enlightenment values?

Trade with China brought luxury goods from Asia to European markets in vast quantities, creating a widespread taste in Europe for "things Chinese"—chinoiserie. How would you define chinoiserie? European thinkers such as Rousseau and Voltaire thought China offered a model of exemplary government, and Samuel Johnson believed that the West should adopt the Chinese civil service examination system. During the Qing dynasty, the West influenced China as well. What Western art technique did the Jesuit priests Giuseppe Castiglione and Jean Denis Attiret introduce to the court of the Qianlong emperor? But the Qianlong emperor valued traditional Chinese art above all else. His court painters copied the masters of the Song and Tang eras.

The End of the Rococo

major talent of the Rococo era was the painter Marie-Louise-Élisabeth Vigée-Lebrun (1755–1842), whose career spanned two centuries. By 1775, when she was only 20 years old, her paintings were commanding the highest prices in Paris. Vigée-Lebrun painted virtually all the famous members of the French aristocracy, including on many occasions Marie-Antoinette, Louis XVI's queen, for whom she served as official portraitist.

Vigée-Lebrun was an ardent royalist, deeply committed to the monarchy. When she submitted Marie-Antoinette en chemise (Fig. 11.23) to the Salon of 1783, she was asked to withdraw it, because many on the committee thought the very expensive gown the queen wore in the painting was lingerie—chemise, in French usage, refers to undergarments. But the queen herself adored the painting, with its soft curves and petal-like textures. It presents her as the ideal Rococo female, the *fêtes galantes*' very object of desire.

Within six years, the French nation was convulsed by revolution and Marie-Antoinette had fallen completely from grace. When Jacques-Louis David (1748–1825) sketched her from a second-story window as she was transported by cart to the guillotine on October 16, 1793, she was dressed in a much humbler chemise and cap (Fig. 11.24). Her chin is thrust forward in defiance and perhaps a touch of disdain, but her erect posture hints at the aristocratic grandeur she once enjoyed. David was one of the great painters of the period, and his career, like Vigée-Lebrun's, spanned two centuries. In fact, his large-scale paintings with their Classical structure and balance explicitly reject the Rococo values of the French monarchy (see Chapter 12). Instead, they embrace the moral authority of the French people who overthrew so corrupt a court.

Meanwhile, Marie-Antoinette's favorite painter, Vigée-Lebrun, escaped from Paris, traveling first to Italy, then Vienna, and finally Saint Petersburg. In all these places, she continued to paint for royal patrons in the Rococo style she had used in France. Finally, in 1802, after 255 fellow artists petitioned the government, she was allowed to return to France, where, ever the ardent royalist, she lived in obscurity for the next 40 years.

Fig. 11.23 Marie-Louise-Élisabeth Vigée-Lebrun, *Marie-Antoinette en chemise*. 1783. Oil on canvas, 35½" × 28¼". Hessische Hausstiftung, Museum Schloss Fasanerie.

Fig. 11.24 Jacques-Louis David, *Marie-Antoinette conduite au supplice* (*Queen Marie-Antoinette on the way to the guillotine*). 1793. Ink drawing, 615/16" × 315/16". Musée du Louvre, Paris. DR 3599 Coll. Rothschild.

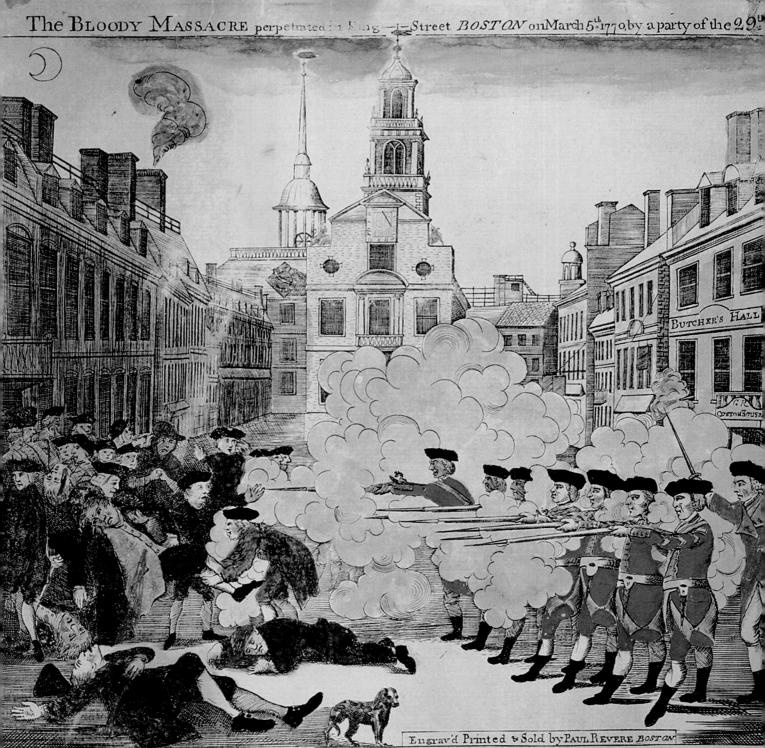

happyBoston! fee thy Sons deplore, ry hallow'd Walks befinear'd with guiltless Gore: nle faithless P-n and his favage Bands. ith murdrous Rancour firetch their blood Hands; The plaintive Chofts of Victims fuch as thefe: | Snatch the relented Svillain from her ke fierce Barbarians griming o'er theu Brey. pprove the Camage, and enjoy the Day.

If fealding drops from Rage from Anguish Wrung But know Fare summons to that awful If speechless Sourows labring for a Tongue where Justice Sirps the Murdirer of h Orifaweeping World can ought appeale The Patriot's copious Tears for each are fined, Keen Execuations on this Plate infe A glorious Tribute which embalins the Dead . Shall reach a Junge who never can't

Should venal C-ts the foundal of the

The unhappy Sufferers were elles Sant Gray Sant Maverick, Jam & Caldwell, Crispus Attucks & Par Killed Sis nounded, two of them (CHRIST MONK & JOHN CLARK) Mortally

The Age of Revolution

12

From Neoclassicism to Romanticism

LEARNING OBJECTIVES

12.1 Compare and contrast the French and American revolutions.

12.2 Describe the Neoclassical style.

12.3 Define Romanticism as it manifests itself in both literature and painting.

12.4 Differentiate between Classical and Romantic music.

n March 5, 1770, an angry mob of Bostonians attacked a small band of British troops stationed at the Boston Custom House to protect its customs agents and tax collectors. Five years earlier, in 1765, the British had challenged the American colonies' growing sense of independence by imposing a Stamp Act, which taxed all sorts of items, from legal documents to playing cards, calendars, liquor licenses, newspapers, and academic degrees. The colonists were infuriated, calling the Stamp Act a "manifest" example of the British desire "to subvert the rights and liberties of the colonies." Tensions finally erupted at the Boston Custom House. The mob was yelling "Kill them! Kill them!" when the British troops opened fire, killing five, including Crispus Attucks, an African American who had escaped slavery 20 years earlier. The silversmith and engraver Paul Revere (1735-1818) quickly produced a print depicting the event called The Bloody Massacre (Fig. 12.1). It was widely distributed, arousing the colonists to even greater resistance, although its depiction of the troops brutally attacking a defenseless crowd misrepresented the facts.

By the last half of the eighteenth century, the demand for freedom had become a rallying cry in America and throughout Europe. In Germany, in fact, the philosopher Immanuel Kant (1724–1804) argued in his essay "What Is Enlightenment?" (1784) that the very precondition of the Enlightenment was freedom:

Dare to know! "Have the courage to use your own understanding"—that is the motto of Enlightenment....

[T]hat the public should enlighten itself is more possible; indeed, if only freedom is granted, enlightenment is almost sure to follow. For there will always be some independent thinkers, even among the established guardians of the great masses, who, after throwing off the yoke of tutelage from their own shoulders, will disseminate the spirit of the rational appreciation of both their own worth and every man's vocation for thinking for himself. It is more nearly possible, however, for the public to enlighten itself; indeed, if it is only given freedom, enlightenment is almost inevitable....

For this enlightenment, however, nothing is required but freedom, and indeed the most harmless among all the things to which this term can properly be applied. It is the freedom to make public use of one's reason at every point.

Enlightenment historian Peter Gay sums up the driving forces of the era as "freedom from arbitrary power, freedom of speech, freedom of trade, freedom to realize one's talents,

Fig. 12.1 Paul Revere, after Henry Pelham, The Bloody Massacre. 1770. Hand-colored engraving, 815/6" × 103/6". © Massachusetts Historical Society, Boston. Although it served to inflame the nation, Revere's print was largely fiction. John Adams defended the British troops in court, arguing that the soldiers had been attacked by a mob. "Facts are stubborn things," he concluded, "and whatever may be our wishes, our inclinations, or the dictums of our passions, they cannot alter the state of facts and evidence." The jury acquitted the British commander and six of the eight soldiers.

freedom of aesthetic response, freedom, in a word, of moral man to make his way in the world."

The drive for these freedoms, first expressed in violence at the Boston Custom House, was repeated in May 1773, when the British introduced another law allowing direct importation of tea into the Americas without the usual colonial tax. It was met with opposition, not only because it thus reduced an important colonial revenue stream without the colonists' consent, but also because it removed colonial middlemen from participation in the tea trade. The following December, Massachusetts Bay colonists gathered at the Boston waterfront and cheered as a group of men dressed as Native Americans, almost all of them with a financial stake in the tea market, emptied three ships of thousands of pounds of tea, dumping it into the harbor. The so-called Boston Tea Party outraged the British, and they soon retaliated. The Revolutionary War was about to begin.

In Paris, 16 years later, on July 14, 1789, a mob gathered outside the Bastille, a prison on the eastern edge of the city, upset by rumors—probably true—that King Louis XVI (r. 1774–92) was about to overthrow the National Assembly. The prison governor panicked and ordered his guard to fire on the crowd. In retaliation, the mob stormed the Bastille, decapitating the prison governor and slaughtering six of the guards. The only practical effect of the battle was to free a few prisoners, but the next day Louis XVI asked if the incident had been a riot. "No, your majesty," was the reply, "it was a revolution."

The social changes produced by these two revolutions strongly influenced world history, and would spur the nine-teenth-century revolutions in South America, again in France, and, in 1848, at the end of the Age of Revolution, all across Europe. The American Revolution was essentially the revolt of an upper class that felt disenfranchised by its distant king, while the French Revolution was a revolt against an absolute monarch whose abuse of power had disenfranchised his own people. But both the French and the Americans looked to Classical antiquity for models upon which to build their new societies. Their societies would be Neoclassical, literally "new" Classical states—stable, balanced, and rational in imitation of their admittedly idealized view of Rome and Athens.

As a style of art reflecting these values, Neoclassicism would hold sway in Europe well into the middle of the nineteenth century, but even in the last years of the eighteenth century, a new style was beginning to arise that seemed to many the very opposite of the Neoclassical. This style, which we have come to call Romanticism, is anticipated in the emotional turbulence that underlies many otherwise Neoclassical works. It values the personal and the individual—with all its psychological complexity—over the social and orderly. It praises the individual's relationship to the myriad forms of nature—from the beautiful to the most wild—over the individual's relation to the state. It distrusts the "checks and balances" that the authors of the American Constitution believed would control government, and worries that its institutions would not so much free humankind

as imprison it. Above all, where Neoclassicists considered human passion a threat to the stability and health of society, the Romantics developed what might best be described as a cult of feeling. To dive into the depths of the emotional world and discover whatever one might was the Romantics' goal. And much of what was found was beyond the bounds of reason, including passions like love, hatred, and the well-springs of creativity itself.

THE AMERICAN AND FRENCH REVOLUTIONS

What do the American and French revolutions have in common and how do they differ?

The American Declaration of Independence was signed on July 4, 1776 (Fig. 12.2), and the French Declaration of the Rights of Man and Citizen on August 26, 1789. The two documents are monuments of Enlightenment thinking, both looking to the writings of the English philosopher John Locke for inspiration (see Chapter 11), and the French Declaration of the Rights of Man and Citizen was influenced as well by the American Declaration of Independence.

The Declaration of Independence

The American Declaration of Independence is one of the Enlightenment's boldest assertions of freedom. The chairman of the committee that prepared the document and its chief drafter was Thomas Jefferson (1743-1826) of Virginia. His argument came from his reading of Locke's vigorous denial of the divine rights of kings. In Two Treatises of Government (1689), Locke asserted that humans are "by nature free, equal, and independent." Jefferson's denunciation of the monarchy was further stimulated by Rousseau's Social Contract (1763) and its principal point: "No man has a natural authority over his fellow," wrote Rousseau, "and force creates no right" (see Chapter 11). Jefferson was influenced, too, by the writings of many of his colleagues in the Continental Congress, who were themselves familiar with the writings of Locke and Rousseau. George Mason had written: "All men are born equally free and independent and have certain inherent natural rights... among which are the enjoyment of life and liberty." An even greater source of inspiration was the writing of Jefferson's friend John Adams (1735-1826), whose Preamble to the Massachusetts State Constitution (1779) reflects their common way of thinking:

The end of the institution, maintenance, and administration of government is to secure the existence of the body politic; to protect it; and to furnish the individuals who compose it with the power of enjoying, in safety and tranquility, their natural rights and the blessings of life; and whenever these great objects are not obtained, the people have a right to alter the government, and to take measures necessary for their safety, happiness, and prosperity.

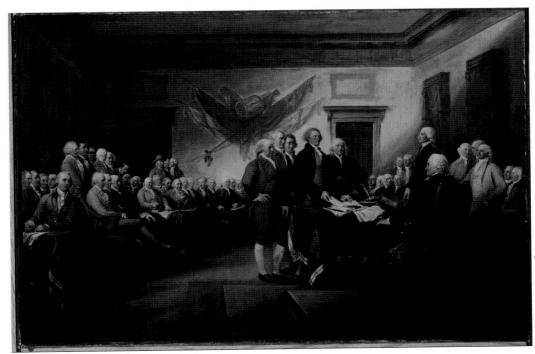

Fig. 12.2 John Trumbull, *The Declaration of Independence, 4 July* 1776. 1786–97. Oil on canvas, 21½" × 31½". Yale University Art Gallery, Trumbull Collection. 1832.3. The canvas portrays 47 of the 56 delegates who signed the Declaration of Independence, and Trumbull painted 36 of them from life. Standing in front of John Hancock are, from left to right, John Adams, Roger Sherman, Robert R. Livingston, Thomas Jefferson, and Benjamin Franklin.

But as powerful as the thinking of Mason and Adams might be, neither man could rise to the level of Jefferson's eloquence (Reading 12.1):

READING 12.1

from the Declaration of Independence (1776)

When in the Course of human events, it becomes necessary for one people to dissolve the political bands which have connected them with another, and to assume among the powers of the earth, the separate and equal station to which the Laws of Nature and of Nature's God entitle them, a decent respect to the opinions of mankind requires that they should declare the causes which impel them to the separation.

We hold these truths to be self-evident, that all men are created equal, that they are endowed by their Creator with certain unalienable Rights, that among these are Life, Liberty and the pursuit of Happiness.—That to secure these rights, Governments are instituted among Men, deriving their just powers from the consent of the governed,—That whenever any Form of Government becomes destructive of these ends, it is the Right of the People to alter or to abolish it, and to institute new Government, laying its foundation on such principles and organizing its powers in such form, as to them shall seem most likely to effect their Safety and Happiness.

As indebted as it is to Locke's *Two Treatises of Government*, Jefferson's Declaration extends and modifies Locke's arguments in important ways. While Locke's writings supported a government *for* the people, he did not reject the idea of a monarchy per se. The people would tell the king what he should do, and the king was obliged to respect their rights and needs. But Jefferson rejected the idea of a monarchy altogether and argued that the people were themselves sovereign, that theirs was a government not *for* the people but *of* and *by* the people. Where Locke, in his *Two Treatises*, had argued for "life, liberty, and property," Jefferson argued for "Life, Liberty, and the pursuit of Happiness." Locke's basic rights are designed to guarantee justice. Jefferson's are aimed at achieving human fulfillment, a fulfillment possible only if the people control their own destiny.

A year after the colonists signed the Declaration of Independence, they adopted the Articles of Confederation, combining the 13 colonies into a loose confederation of sovereign states (that was not, however, ratified until 1781). The war itself continued into the 1780s as well and developed an international scope. France, Spain, and the Netherlands supported the revolutionaries with money and naval forces in order to dilute British power. This alliance was critical in helping the Americans defeat the British at Yorktown, Virginia, in 1781. This victory convinced the British that the war was lost and paved the way for the Treaty of Paris, signed on September 3, 1783. The war was over.

The Declaration of the Rights of Man and Citizen

In France, the situation leading to the signing of the Declaration of the Rights of Man and Citizen was somewhat more complicated. It was, in fact, the national debt that abruptly brought about the events leading to revolution, the overthrow of the royal government, and the country becoming a republic. In the 15 years after Louis XVI ascended to the throne in 1774, the debt tripled. In 1788, fully one-half of state revenues were dedicated to paying interest on debt already in place, despite the fact that two years earlier bankers had refused to make new loans to the government. The cost of maintaining Louis XVI's court was enormous, so the desperate king attempted to levy a uniform tax on all landed property. Riots, led by aristocrat and bourgeois alike, forced the king to bring the issue before an Estates General, an institution little used and indeed half-forgotten (it had not met since 1614).

The Estates General convened on May 5, 1789, at Versailles. It was composed of the three traditional French estates. The First Estate was the clergy, which comprised a mere 0.5 percent of the population (130,000 people) but controlled nearly 15 percent of French lands. The Second Estate was the nobility, consisting of only 2 percent of the population (about 500,000 people) but controlling about 30 percent of the land. The Third Estate was the rest of the population, composed of the bourgeoisie (around 2.3 million people), who controlled about 20 percent of the land, and the peasants (nearly 21 million people), who controlled the rest of the land, although many owned no land at all.

Traditionally, each estate deliberated separately and each was entitled to a single vote. Any issue before the Estates General thus required a vote of at least 2:1—and the consent of the crown—for passage. The clergy and nobility usually voted together, thus silencing the opinion of the Third Estate. But from the outset, the Third Estate demanded more clout, and the king was in no position to deny it. The winter of 1788 to 1789 had been the most severe in memory. In December, the temperature had dropped to -19° Celsius (or -2° Fahrenheit), freezing the Seine over to a considerable depth. The ice blockaded barges that normally delivered grain and flour to a city already filled by unemployed peasants seeking work. With flour already in short supply after a violent hailstorm had virtually destroyed the crop the previous summer, the price of bread almost doubled. As the Estates General opened, Louis was forced to appease the Third Estate in any way he could. First he "doubled the third," giving the Third Estate as many deputies as the other two estates combined. Then he was pressured to bring the three estates together to debate and "vote by head," each deputy having a single vote. Louis vacillated on this demand, but on June 17, 1789, the Third Estate withdrew from the Estates General, declared itself a National Assembly, and invited the other two estates to join it.

A number of the First Estate, particularly parish priests who worked closely with the common people, accepted the Third Estate's offer, but the nobility refused. When the king banned the commoners from their usual meeting place, they gathered nearby at the Jeu de Paume, an indoor tennis court at Versailles that still stands, and there, on June 20, 1789, swore an oath never to disband until they had given France

a constitution. Jacques-Louis David recreated the scene a year later in a detailed sketch for a painting that he would never finish, as events overtook its subjects (Fig. 12.3). David's plan, like Trumbull's celebration of the signing of the Declaration of Independence, was to combine exact observation (he drew the major protagonists from life) with monumentality on a canvas where everyone would be life-size (many of his subjects would soon fall out of favor with the revolution itself and be executed). The "winds of freedom" blow in through the windows as commoners look on. At the top left, these same winds turn an umbrella inside out, signaling the change to come. In the middle of the room, the man

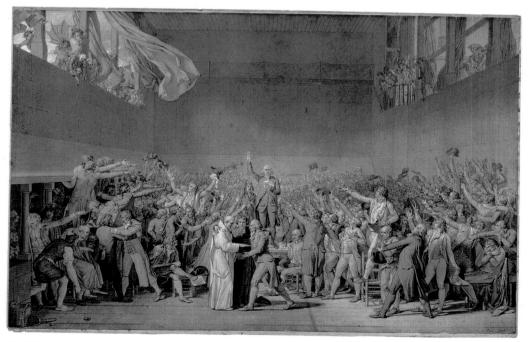

Fig. 12.3 Jacques-Louis David, *The Tennis Court Oath.* 1789–91. Pen and brown ink and brown wash on paper, 26" × 42". Musée National du Château, Versailles. MV 8409: INV Dessins. Note how the figures in this painting, all taking an oath, stretch out their hands in the manner of David's earlier Neoclassical masterpiece, *The Oath of the Horatii* (see Fig. 12.5).

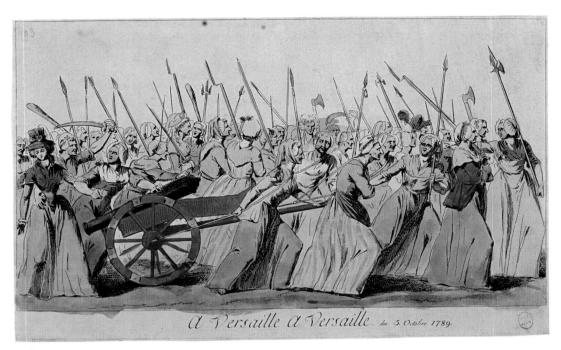

Fig. 12.4 To Versailles, To Versailles, October 5, 1789. Engraving. Musée de la Ville de Paris, Musée Carnavalet, Paris. The despair on the face of the aristocratic woman at the left contrasts sharply with the determined working-class women heading for Versailles.

who would soon become mayor of Paris reads the proclamation aloud. Below him a trio of figures, representing each of the three estates, clasp hands as equals in a gesture of unity. At the actual event, all the members of the National Assembly marched in alphabetical order and signed the Tennis Court Oath, except for one. He signed, but wrote after his name the word "opposed." David depicts him, an object of ridicule, seated at the far right, his arms folded despairingly across his chest. Faced with such unanimity, Louis gave in, and on June 27 he ordered the noble and clerical deputies to join the National Assembly.

But the troubles were hardly over. While the harvest was good, drought had severely curtailed the ability of watermills to grind flour from wheat. Just as citizens were lining up for what bread was available, a false rumor spread through the Paris press that the queen, Marie Antoinette, had flippantly remarked, on hearing that the people lacked bread, "Let them eat cake!" The antiroyalists so despised the queen that they were always willing to believe anything negative said about her. Peasant and working-class women, responsible for putting bread on the table, had traditionally engaged in political activism during times of famine or inflation, when bread became too expensive, and would march on the civic center to demand help from the local magistrates. But now, on October 5, 1789, about 7,000 Parisian women, many of them armed with pikes, guns, swords, and even cannon, marched on the palace at Versailles demanding bread (Fig. 12.4). The next day, they marched back to the city with the king and queen in tow. The now essentially powerless royal couple lived as virtual prisoners of the people in their Paris palace at the Tuileries.

The National Assembly, which also relocated to Paris after the women's march on Versailles, had passed, on August 26, 1789, the Declaration of the Rights of Man and Citizen. It was a document deeply influenced by Jefferson's Declaration of Independence, as well as the writings of John Locke. It listed 17 "rights of man and citizen," among them these first three, which echo the opening of the American document (Reading 12.2):

Due process of law was guaranteed, freedom of religion was affirmed, and taxation based on the capacity to pay was announced.

READING 12.2

from the Declaration of the Rights of Man and Citizen (1789)

- 1. Men are born and remain free and equal in rights....
- The aim of every political association is the preservation of the natural and imprescriptible [inherent or inalienable] rights of man. These rights are liberty, property, security, and resistance to oppression.
- 3. The principle of all sovereignty resides essentially in the nation. No body nor individual may exercise authority which does not proceed from the nation.

For a time, the king managed to appear as if he were cooperating with the National Assembly, which was busy drafting a constitution declaring a constitutional monarchy

on the model of England. Then, in June 1791, just a couple of months before the new constitution was completed, Louis tried to flee France with his family, an act that seemed treasonous to most Frenchmen. The royals were evidently planning to join a large number of French nobility who had removed themselves to Germany, where they were actively seeking the support of Austria and Russia in a counterrevolution. A radical minority of the National Assembly, the Jacobins, had been lobbying for the elimination of the monarchy and the institution of egalitarian democracy for months. Louis's actions strengthened their position. When the Constitutional Convention met, it immediately declared France a republic, the only question being just what kind. Moderates favored executive and legislative branches independent of each other and laws that would be submitted to the people for approval. But Jacobin extremists, led by Maximilien Robespierre (1758–94), argued for what he called a "Republic of Virtue," a dictatorship led by a 12-person Committee for Public Safety, of which he was a member. A second Committee for General Security sought out enemies of the republic and turned them over to the new Revolutionary Tribunal, which over the course of the next three years executed as many as 25,000 citizens of France. These included not only royalists and aristocrats, but also good republicans whose moderate positions were in opposition to Robespierre. Louis XVI himself was tried and convicted as "Citizen Louis Capet" (the last of the Capetian dynasty) on January 21, 1793, and his queen, Marie Antoinette, referred to as "the widow Capet," was executed 10 months later. As Robespierre explained, defending his Reign of Terror:

If virtue be the spring of popular government in times of peace, the spring of that government during a revolution is virtue combined with terror.... Terror is only justice prompt, severe, and inflexible; it is then an emanation of virtue....

It has been said that terror is the spring of despotic government.... The government in revolution is the despotism of liberty against tyranny.

The Constitutional Convention instituted many other reforms as well. Some bordered on the silly—expunging the king and queen from the deck of cards and eliminating use of the formal vous ("thou") in discourse, substituting the informal tu ("you") in its place. Others were of greater import. The delegates banned slavery in all the French colonies. They de-Christianized the country, requiring that all churches become "Temples of Reason." The calendar was no longer to be based on the year of the birth of Christ, but on the first day of the Republic. Year one began, then, on September 21, 1792. New names, associated with the seasons and the climate, were given to the months. "Thermidor," for instance, was the month of Heat, roughly late July through early August. Finally, the idea of the Sunday sabbath was eliminated, and every tenth day was a holiday.

The Reign of Terror ended suddenly in the summer of 1794. Robespierre pushed through a law speeding up the work

of the Tribunal, with the result that in six weeks some 1,300 people were sent to their deaths. Finally, he was hounded out of the Convention to shouts of "Down with the tyrant!" and chased to city hall. There he tried to shoot himself, but he succeeded only in shattering his lower jaw. He was executed the next day with 21 others.

The last act of the convention was to pass a constitution on August 17, 1795. It established France's first bicameral (two-body) legislature, led by a five-person executive Directory. Over the next four years, the Directory improved the lot of French citizens, but its relative instability worried moderates. So, in 1799, the successful young commander of the army, Napoleon Bonaparte (1769–1821), conspired with two of the five directors in the *coup d'état* that ended the Directory's experiment with republican government. This coup would put Napoleon in a position to assume control of the country. He dreamed that he might lead a new classical empire—a Neoclassical empire—modeled on that of Rome.

THE NEOCLASSICAL SPIRIT

What is Neoclassicism in art and architecture?

The rise of the Neoclassical in France, with its regularity, balance, and proportion, can be attributed to the same ideals that would lead to the overthrow of the aristocracy in the French Revolution. The civilizations of Greece and Rome were considered as close to a Golden Age as the Western world had ever come, and the aim of any revolution was to restore the intellectual and artistic values that those Classical civilizations embodied. But France had more recent examples of order and balance as well in, for instance, the formal symmetry of the gardens at Versailles (see Fig. 10.24 in Chapter 10). The Neoclassical could also claim descent from Poussin (see Fig. 10.29) and Palladio, not coincidentally Jefferson's favorite architect (see Fig. 7.38 in Chapter 7). But it was in the painting of Jacques-Louis David (1748–1825) that the Neoclassical found its first full expression.

Jacques-Louis David and the Neoclassical Style

David's career stretches from pre-Revolutionary Paris, through the turmoil of the Revolution and its aftermath, and across the reign of Napoleon Bonaparte. He was, without doubt, the most influential artist of his day. "I do not feel an interest in any pencil but that of David," Thomas Jefferson wrote in a flush of enthusiasm from Paris during his service as minister to the court of Louis XVI from 1885 to 1889. And artists flocked to David's studio for the privilege of studying with him. In fact, many of the major artists of the following century were his students.

David abandoned the traditional complexity of composition that had defined French academic history painting for decades and substituted a formal balance and simplicity that are fully Neoclassical. His works had a frozen

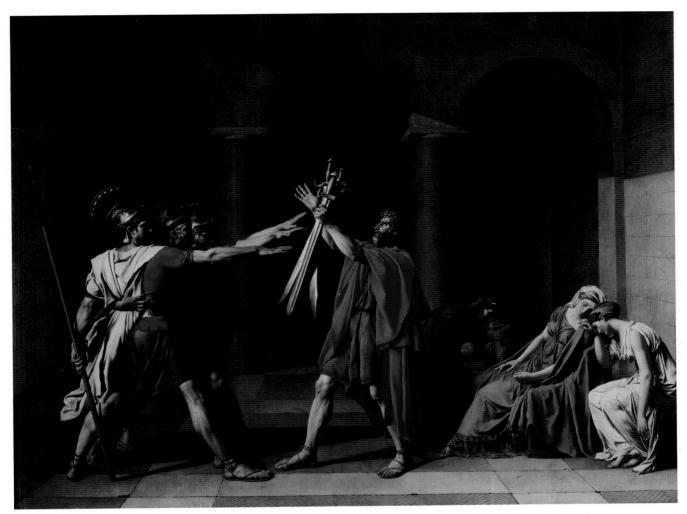

Fig. 12.5 Jacques-Louis David, *The Oath of the Horatii*. 1784–85. Oil on canvas, 10'10" × 13'11½". Musée du Louvre, Paris. The clarity of David's composition is also attributable to the fact that he has reintroduced a frontal, one-point perspective largely abandoned in European painting since Raphael. Compare, for instance, Raphael's *School of Athens* (see *Closer Look*, Chapter 7).

quality to emphasize rationality, and the brushstrokes were invisible to create a clear focus and to highlight details. At the same time, his works had considerable emotional complexity. A case in point is his painting The Oath of the Horatii (Fig. 12.5), commissioned by the royal government in 1784 to 1785. The story is a sort of parable or example of loyal devotion to the state. It concerns the conflict between early Rome, led by Horatius, and neighboring Alba, led by Curatius. In order to spare a war that would be more generally destructive, the two civic leaders agreed to send their three sons—the Horatii and the Curatii—to battle each other. David was contemplating painting the battle's aftermath, when Horatius's youngest son, the sole survivor of the conflict, murders his sister Camilla, whom he discovered mourning the loss of her husband, one of the Curatii.

But David chose instead to present the moment before the battle when the three sons of Horatius swear an oath to their father, promising to fight to the death. The sons on the left, the father in the middle, and the sisters to the right are each clearly and simply contained within the frame of one of three arches behind them. Except for Horatius's robe, the colors are muted and spare, the textures plain, and the paint itself almost flat. The male figures stand rigidly in profile, their legs extending forward tensely, as straight as the spear held by the foremost brother, which they parallel. Their orderly Neoclassical arrangement contrasts with that of the women, who are disposed in a more conventional, Baroque grouping. Seated, even collapsing, while the men stand erect, the women's soft curves and emotional despair contrast with the male realm of the painting. David's message here is that civic responsibility must eclipse the joys of domestic life, just as reason supplants emotion and Classical order supplants Baroque complexity. Sacrifice is the price of citizenship (a message that Louis XVI would have been wise to heed).

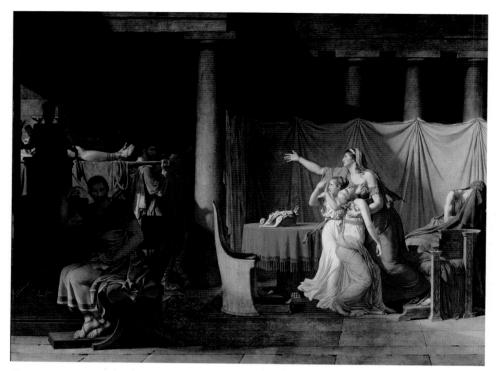

Fig. 12.6 Jacques-Louis David, *The Lictors Returning to Brutus the Bodies of His* **Sons. 1789.** Oil on canvas, $10'7\%'' \times 13'10\%''$. Musée du Louvre, Paris. Brutus' emotional exile from his proper place at the table as patriarch is signaled by the empty chair and the subtle analogy between Brutus' own toes and the scrolling decoration at the base of the table where he once sat.

David's next major canvas, *The Lictors Returning to Brutus* the Bodies of His Sons (Fig. 12.6), was painted in 1789, the year of the Revolution but before it had begun. It is a more complex response to the idea of sacrifice for the state. The painting shares with the *Oath of the Horatii* the theme of a stoic father's sacrifice of his sons for the good of the state, as Brutus' lictors (the officers in his service as ruler) return the sons' bodies to him after their execution.

The hero of the historical tale that is the subject of this painting is the founder of the Roman republic, Lucius Junius Brutus (sixth century BCE; not to be confused with the Brutus who would later assassinate Julius Caesar). He had become head of Rome and inaugurated the republic by eliminating the former monarch, Tarquinius, who himself had assumed the throne by conspiring with the wife of the former king. She murdered her husband, and he his own wife, and the two married. Brutus' sons had conspired to restore the monarchy—their mother was related to Tarquinius—and under Roman law Brutus was required not only to sentence them to death but also to witness the execution.

In David's painting, Brutus sits in shadow at the left, his freshly beheaded sons passing behind him on stretchers carried by the lictors. Brutus points ignominiously at his own head, as if affirming his responsibility for the deed, the sacrifice of family to the patriotic demands of the state. In contrast to the dark shadows in which Brutus sits, the boys' mother, nurse, and

sisters await the bodies in a fully lighted stage space framed by a draperied colonnade. The mother reaches out in a gesture reminiscent of Horatius's in the *Oath of the Horatii*. The nurse turns and buries her head in the mother's robe. One of the sisters appears to faint in her mother's arms, while the other shields her eyes from the terrible sight. Their spotlit anguish emphasizes the high human cost of patriotic sacrifice, whereas the *Oath of the Horatii* more clearly celebrates the patriotic sacrifice itself.

Although David would serve the new French Republic with verve and loyalty as its chief painter after the Revolution, his paintings are rarely as straightforward as they at first appear. In his work, it would seem, the austerity of the Neoclassical style is something of a mask for an emotional turbulence within, a turbulence that the style holds in check.

Napoleon's Neoclassical Tastes

If it was the threat of economic and international chaos—including a new coalition formed against France by England, Austria, Russia, and the Ottomans—that guaranteed Napoleon's successful *coup d'état*, it was, perhaps, his understanding of the power of the Neoclassical style to reflect not chaos but order that led him to adopt it—quite intentionally for propagandistic purposes—as the image of the state. Order was the call of the day, and Napoleon was bent on restoring it.

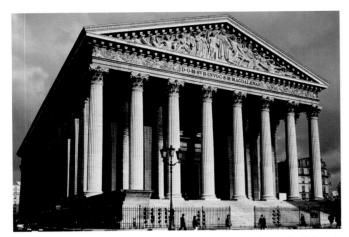

Fig. 12.7 Pierre-Alexandre Vignon, La Madeleine, Paris. 1806–42. Length 350', width 147', height of podium 23', height of columns 63'. The church of La Madeleine was built to culminate a north—south axis that began on the Left Bank of the Seine at the Chamber of Deputies (newly refurbished with a facade of Corinthian columns), crossing a new bridge northward into the Place de la Concorde.

Seeking to lend Paris a sense of order and reason, he soon commissioned the construction of Roman arches of triumph and other classically inspired monuments to commemorate his victories and convey the political message of the glory of his rule. One of the most impressive works was the redesign of a church that had been started under Louis XVI but that Napoleon wanted to see reinterpreted as a new Temple of the Glory of the Grand Army. This work, commissioned in 1806 from Pierre-Alexandre Vignon (1763-1828), was to have been identified by the following dedicatory inscription: "From the Emperor to the soldiers of the Great Army." It was another of the many Parisian churches that were converted to secular temples during the revolution. Ironically, Napoleon reversed his decision to honor the army in 1813 after the unfortunate Battle of Leipzig and the loss of Spain. Although work continued on the building, its original name, the church of La Madeleine,

Not completed until after Napoleon's downfall, but nevertheless to Vignon's original design, La Madeleine is imperially Roman in scale and an extraordinary example of Neoclassical architecture (Fig. 12.7). Eight 63-foot-high Corinthian columns dominate its portico, and 18 more rise to the same height on each side. Beneath the Classical roof line of its exterior, Vignon created three shallow interior domes that admit light through *oculi* at their tops that are hidden by the roofline. They light a long nave without aisles that culminates in an apse roofed by a semidome. This interior evokes traditional Christian architecture, even as the exterior announces its Classicism through the Roman temple features.

Napoleon also modeled his government on ancient Roman precedents. By 1802, he had convinced the legislators to declare him First Consul of the French Republic for life, with the power to amend the constitution as he saw fit. In 1804, he persuaded the Senate to go a step further and declare that "the government of the republic is

entrusted to an emperor." This created the somewhat paradoxical situation of a "free" people ruled by the will of an individual. But Napoleon was careful to seek the consent of the electorate in all these moves. When he submitted his constitution and other changes to the voters in a plebiscite (a "yes" or "no" vote), they ratified them by an overwhelming majority.

Napoleon justified voter confidence by moving to establish stability across Europe by force. To this end, in 1800 he crossed into Italy and took firm control of the regions of Piedmont and Lombardy. Although Napoleon never defeated the British, his principal enemy, from 1805 to 1807 he launched a succession of campaigns against Britain's allies, Austria and Prussia. He defeated both, and by 1807 the only European countries outside Napoleon's sphere of influence were Britain, Portugal, and Sweden. Everywhere he was victorious, he brought the reforms that he had established in France and overturned much of the old political and social order.

David, who had survived the revolutionary era and painted many of its events, went on to portray many of the major moments of Napoleon's career. He celebrated the Italian campaign in *Napoleon Crossing the Saint-Bernard* (Fig. 12.8). Here he depicts Napoleon on horseback leading his troops across the pass at Saint-Bernard in the Alps. In its

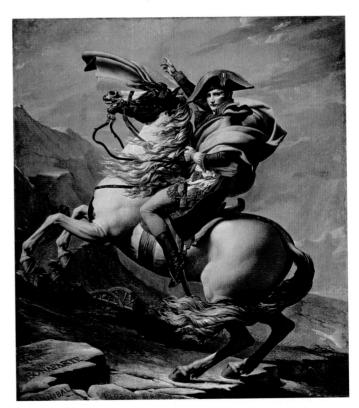

Fig. 12.8 Jacques-Louis David, Napoleon Crossing the Saint-Bernard. 1800–01. Oil on canvas, 8'11" × 7'7". Musée National du Château de la Malmaison, Rueil-Malmaison, France. David would claim to everyone, "Bonaparte is my hero!" This is one of five versions of the painting, which differ significantly in color, painted by David and his workshop. There are also many copies in French museums and elsewhere done by others.

clearly drawn central image and its emphasis on right angles (consider Napoleon's leg, the angle of his pointing arm to his body, the relation of the horse's head and neck, and the angle of its rear legs), the painting is fully Neoclassical. In the background, as is typical of David, is a more turbulent scene as Napoleon's troops drag a cannon up the pass. In the foreground, inscribed on the rocks, are the names of the only generals who crossed the Alps into Italy: Hannibal, whose brilliance in defeating the Romans in the third century BCE Napoleon sought to emulate; Karolus Magnus (Charlemagne); and Napoleon.

Actually, Napoleon did not lead the crossing of the pass but crossed it with his rear guard, mounted on a mule led by a peasant. So the work is pure propaganda, designed to create a proper myth for the aspiring leader. Although still four years from crowning himself emperor, the First Consul in his identification with the great Frankish emperor of the Holy Roman Empire, Charlemagne, makes clear his aspirations to unite Europe and rule it. Napoleon was boldly creating a myth that is probably nowhere better expressed than by the great German philosopher Georg Wilhelm Friedrich Hegel (1770–1831) in a letter of October 13, 1806: "I have seen the emperor, that world soul, pass through the streets of the town on horseback. It is a prodigious sensation to see an individual like him who, concentrated at one point, seated on a horse, spreads over the world and dominates it."

Neoclassicism in America

The founders of the newly created United States of America modeled their new republic on Classical precedents. Their democracy would be modeled on what they believed were the first democracies, those of Athens and Rome. On October 27, 1787, a Federal Convention presented the states

Fig. 12.9 Benjamin Henry Latrobe, *View of Richmond Showing Jefferson's Capitol from Washington Island*. **1796.** Watercolor on paper, ink and wash, $7" \times 10\%"$. Maryland Historical Society, Baltimore. No view of an American capitol in the eighteenth century better captures the almost audacious aspirations of the new nation.

with a new constitution. James Madison (1751–1836) had been responsible for drafting the constitution itself, and his inspiration came from ancient Greece and Rome. (Among his papers was a list of books he thought were essential for understanding the American political system, among them Edward Gibbon's On the Decline of the Roman Empire, Basil Kennett's Antiquities of Rome, Plutarch's Lives, Plato's Republic, and Aristotle's A Treatise on Government.)

The Neoclassical style of architecture dominated the architecture of the new American republic, where it became known as the **Federal style**. Its foremost champion was, of course, Jefferson. Like almost all leaders of the American colonies, Jefferson was well-educated in the classics and knew such works as James Stuart and Nicholas Revett's Antiquities of Athens (1758) and Robert and James Adam's Works in Architecture well. His taste for the classical would affect the design, the furniture, and even the gardens at his home, Monticello, outside Charlottesville, Virginia (see Fig. 7.37 in Chapter 7).

Jefferson's Neoclassical tastes were not limited to his private life. He designed the Virginia State Capitol in Richmond, which was, first of all, a "capitol," the very name derived from Rome's Capitoline Hill (Fig. 12.9). The building was a literal copy of the Maison Carrée in Nîmes, France, a Roman temple built in the first century BCE. To ensure that the country grew in an orderly manner, Jefferson proposed in 1785 that Congress pass a land ordinance requiring all new communities to be organized according to a grid. The measure resulted in a regular system of land survey across the North American continent. It effectively imposed a Neoclassical pattern on the American landscape.

The nation's new capitol in Washington, D.C., would, however, modify Jefferson's rectilinear scheme. President George Washington believed that the swampy, humid site

along the Potomac River required something magnificent, so he hired Major Pierre Charles L'Enfant (1754–1825) to create a more ambitious design. The son of a court painter at Versailles, L'Enfant had emigrated to America from Paris in 1776 to serve in the Continental army. His plan (Fig. 12.10) is a conscious echo of the diagonal approaches and garden pathways at Versailles (see Fig. 10.24 in Chapter 10), superimposed on Jefferson's grid. The result is an odd mixture of angles and straightaways that mirrored, though unintentionally, the complex workings of the new American state. Visiting in 1842, a half century later, the English novelist Charles Dickens would be struck by the city's absurdity: "Spacious avenues... begin in nothing, and lead nowhere; streets, mile-long, that only want houses, roads, and inhabitants; public buildings that need but a public to be complete." It was, he wrote, a city of "Magnificent Intentions," as yet unrealized.

Fig. 12.10 Pierre Charles L'Enfant, plan for Washington, D.C. (detail). 1791. Published in the *Gazette of the United States*, Philadelphia, January 4, 1792. Engraving after the original drawing, Library of Congress, Washington, d.c. The architect, L'enfant, had served as a volunteer in the Revolutionary War. He also designed Federal Hall in New York City, which hosted the first Continental Congress in 1789.

CONTINUITY & CHANGE

The city somewhat oddly combined Neoclassical cultivation with what might be called rural charm. When Jefferson's disciple the architect Benjamin Henry Latrobe (1764–1820) was hired to rebuild the Capitol after the British burned it during the war of 1812, he invented a new design for the capitals of the Corinthian columns in the vestibule and rotunda of the Senate wing, substituting corncobs and

tobacco for the Corinthian acanthus leaves (Fig. 12.11).

The Issue of Slavery

The high-minded idealism reflected in the American adoption of Neoclassicism in its art and architecture was clouded, from the outset, by the issue of slavery. In the debates leading up to the Revolution, slavery had been lumped into the debate over free trade. Americans had protested not only the tax on everyday goods shipped to the colonies from Britain, including glass, paint, lead, paper, and tea, but also the English monarchy's refusal to allow the colonies to trade freely with other parts of the world, and that included the trade in enslaved Africans.

The Atlantic slave trade followed an essentially triangular pattern (see Map 9.3, p. 288). Europe exported goods to Africa, where they were traded for African slaves, who were then taken to the West Indies and traded for sugar, cotton, and tobacco; these goods were then shipped either

Fig. 12.11 Benjamin Henry Latrobe, tobacco-leaf capital for the U.S. Capitol, Washington, D.C. ca. 1815. Despite this unique design, Latrobe used more traditional capitals elsewhere in the Capitol. For the Supreme Court area of the building, he designed Doric capitals in proportions similar to those at Paestum (see Fig. 2.13 in Chapter 2).

back to Europe or north to New England for sale. Since the slaves provided essentially free labor for the plantation owners, these goods, when sold, resulted in enormous profits. Although a port like Boston might seem relatively free of the slave trade, Boston's prosperity and the prosperity of virtually every other port on the Atlantic depended on slavery as an institution. And the American taste for Neoclassical art, epitomized by Josiah Wedgwood's assertion that for "North America we cannot make anything too rich and costly," was in very large part satisfied by the slave trade.

The conditions on board slave ships were described by Olaudah Equiano, a native of Benin, in West Africa, who was kidnapped and enslaved in 1756 at age 11. Freed in 1766, he traveled widely, educated himself, and mastered the English language. In his autobiography, published in England in 1789, he describes the transatlantic journey (Reading 12.3):

READING 12.3

from Olaudah Equiano, The Interesting Narrative of the Life of Olaudah Equiano, or Gustavus Vassa the African (1789)

The stench of the hold while we were on the coast [of Africa] was so intolerably loathsome that it was dangerous to remain there for any time, and some of us had been permitted to stay on the deck for the fresh air, but now that the whole ship's cargo were confined together it became absolutely pestilential. The closeness of the place and the heat of the climate, added to the number in the ship, which was so crowded that each had scarcely room to turn himself, almost suffocated us. This produced copious perspirations, so that the air soon became unfit for respiration from a variety of loathsome smells, and brought on a sickness among the slaves, of which many died, thus falling victims to the improvident avarice, as I may call it, of their purchasers. This wretched situation was again aggravated by the galling of the chains, now become

insupportable; and the filth of the necessary tubs, into which the children often fell and were almost suffocated. The shrieks of the women and the groans of the dying soon rendered the whole a scene of horror almost inconceivable.

Recent biographical discoveries cast doubt on Equiano's claim that he was born and raised in Africa and that he endured the Middle Passage (the name given to the slave ships' journey across the Atlantic Ocean) as he describes. Baptismal and naval records suggest, instead, that he was born around 1747 in South Carolina. Still, if Equiano did fabricate his early life, it appears that he did so based on the verbal accounts of his fellow slaves, for the story he tells, when compared to other sources, is highly accurate. Whatever the case, Equiano's book became a best seller among the over 100 volumes on the subject of slavery published the same year, and it became essential reading for the ever-growing abolitionist movement in both England and the Americas.

The lot of the slaves, once they were delivered to their final destination, hardly improved. One of the most interesting accounts is Narrative of a Five Years' Expedition against the Revolted Negroes of Surinam, in Guiana, on the Wild Coast of South America, from the Year 1772 to 1777, written by John Gabriel Stedman (1747-97) and illustrated by William Blake (1757-1827) (Fig. 12.12). Blake was already an established engraver and one of England's leading poets. Stedman had been hired by the Dutch to suppress rebel slaves in Guiana, but once there, he was shocked to see the conditions the slaves were forced to endure. Their housing was deplorable, but worse, they were routinely whipped, beaten, and otherwise tortured for the nonperformance of impossible tasks, as a means of instilling a more general discipline. Female slaves endured sexual abuses that were coarse beyond belief. The planters maintained what amounted to harems on their estates and freely indulged their sexual appetites.

Slavery pitted abolitionist sentiments against free-thinking economic theory. Free-trade economists, such as Adam Smith (1723–90), would argue that people should be free to do whatever they might to enrich themselves. Thus Smith would claim that a *laissez-faire*, "let it happen as it will," economic policy was the best. "It is the maxim of every prudent master of a family," Smith wrote in *The Wealth of Nations*, published in 1776, "never to make at home what it will cost him more to make than to buy.... What is prudence in the conduct of every private family, can scarce be folly in that of a great kingdom. If a foreign country can supply us with a commodity cheaper than we ourselves can make it, better buy it of them." Labor, it could be argued, was just such a commodity and slavery its natural extension.

In 1776, arguments for and against slavery seemed, to many people, to balance each other out. Economics and practicality favored the practice of slavery, while human sentiment and, above all, the idea of freedom denied it. Although at the time he wrote the Declaration

Fig. 12.12 William Blake, Negro Hung Alive by the Ribs to a Gallows, engraved illustration to John Gabriel Stedman's Narrative of a Five Years' Expedition against the Revolted Negroes of Surinam. 1796.

Private collection. Blake executed the etchings for Stedman's volume after original drawings by Stedman himself. Stedman was impressed that the young man being tortured here stoically endured the punishment in total silence.

of Independence, Jefferson himself owned about 200 slaves and knew that other Southern delegates supported slavery as necessary for the continued growth of their agricultural economy, in his first draft he had forcefully repudiated the practice. Abigail Adams (1744–1818), who, like her husband, John,

The CONTINUING PRESENCE of the PAST

See Kara Walker, Insurrection! (Our Tools Were

Insurrection! (Our Tools Were Rudimentary, Yet We Pressed On), 2000, at MyArtsLab

knew and respected Jefferson, but unlike him owned no slaves, was equally adamant on the subject: "I wish most sincerely," she wrote her husband in 1774, as he was attending the First Continental Congress in Philadelphia, "that there was not a slave in the province. It always seemed a most iniquitous scheme to me—to fight ourselves for what we are daily robbing and plundering from those who have as good a right to freedom as we have."

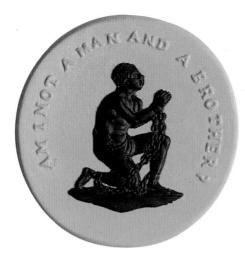

Fig. 12.13 William Hackwood, for Josiah Wedgwood, "Am I Not a Man and a Brother?" 1787. Black-and-white jasperware, 1%" × 1%". The Wedgwood Museum, Barlaston, Staffordshire, England. The image illustrated Erasmus Darwin's poem "The Botanic Garden," which celebrates not only the natural world, but also the rise of British manufacturing at the dawn of the Industrial Revolution. The poem nevertheless severely criticized British involvement in the slave trade, which it deemed highly "unnatural."

Many Britons, looking from across the Atlantic at the American Revolution, shared Abigail Adams's sentiments. As long as the colonies tolerated slavery, their demand for their own liberty seemed hypocritical. The English poet Thomas Day (1748–89) described the typical American as "signing resolutions of independence with one hand, and with the other brandishing a whip over his affrighted slaves."

Abolitionist opposition to slavery in both England and the American colonies began to gain strength in 1771 when Granville Sharp pled the case of an escaped American slave, James Somerset, before the Lord Chief Justice, Lord Mansfield. Somerset's American owner had recaptured him in England, but the Lord Chief Justice set Somerset free, ruling that the laws governing another country carried no weight in England. Leading the fight against slavery were the Quakers as well as the members of the Lunar Society (see Chapter 11). In 1787, Josiah Wedgwood made hundreds of ceramic cameos of a slave in chains, on bent knee, pleading, "Am I Not a Man and a Brother?" (Fig. 12.13). He distributed them widely, and the image quickly became the emblem for the abolitionist movement as a whole. In Philadelphia, Benjamin Franklin, president of the Philadelphia Abolitionist Society, received a set.

THE ROMANTIC IMAGINATION

What is Romanticism and how does it manifest itself in both literature and painting?

Originally coined in 1798 by the German writer and poet Friedrich von Schlegel (1772–1829), the term "Romanticism" described an overt reaction against the

Enlightenment and Classical culture of the eighteenth century. For Schlegel, Romanticism refers mainly to his sense that the common cultural ground of Europe—the Classical past from which it had descended, and the values of which it shared—was disintegrating, as Europeans formed new nation-states based on individual cultural identities.

Schlegel's own thinking was deeply influenced by the philosopher Immanuel Kant. In his Critique of Judgment (1790), Kant defined the pleasure we derive from art as "disinterested satisfaction." By this he meant that contemplating beauty, whether in nature or in a work of art, put the mind into a state of free play in which things that seemed to oppose each other—subject and object, reason and imagination—are united. Schlegel was equally influenced by the perspective on Greek art offered by Johann Winckelmann (1717-68) in his History of Ancient Art (1764)—the first book to include the words "history" and "art" in its title. What the Greeks offered were not works of art to be slavishly imitated, in the manner of Neoclassical artists. For Winckelmann, and for Schlegel, the Greeks provided a new way for the Romantic artist to approach nature: The Greeks studied nature in order to discover its essence. Nature only occasionally rises to moments of pure beauty. The lesson taught by the Greeks, Winckelmann argued, was that art might capture and hold those rare moments.

As a way of approaching the world, the Romantic movement amounts to a revolution in human consciousness. Dedicated to the discovery of beauty in nature, the Romantics rejected the truth of empirical observation, which John Locke and other Enlightenment thinkers had championed. The objective world mattered far less to them than their subjective experience of it. The poet Samuel Taylor Coleridge (1772-1834), one of the founders of the Romantic movement, offered a pithy summary in a letter to a friend: "My opinion is this—that deep Thinking is attainable only by a man of deep Feeling, and that all Truth is a species of Revelation." Knowing the exact distance between the earth and the moon mattered far less than how it felt to look at the moon in the dark sky. And it must be remembered that for Romantics, the night was incomparably more appealing, because it was more mysterious and unknowable, than the daylight world.

Nor did they believe that the human mind was necessarily a thinking thing, as René Descartes had argued, when he wrote, "I think, therefore I am." For the Romantics, the mind was a feeling thing, not distinct from the body as Descartes had it, but intimately connected to it. Feelings, they believed, led to truth, and most of the major writers and artists of the early nineteenth century used their emotions as a primary way of expressing their imagination and creativity. Indeed, since nature stimulated the emotions as it did the imagination, the natural world became the primary subject of Romantic poetry, and landscape the primary genre of Romantic painting. In nature the Romantics discovered not just the wellspring of their own creativity, but the very presence of God, the manifestation of the divine on earth.

The Romantic Poem

The Romantic imagination found its first—and certainly its most articulate—expression in poetry. Poetry by its nature is almost inherently intuitive and personal. It is a medium capable of expressing the most deeply felt emotions. And in the beauty of its expression—the eloquence of its sounds and cadences—it might capture, even mirror, the beauty of nature itself.

William Wordsworth's "Tintern Abbey" Perhaps the most eloquent expression of the Romantic imagination is a poem by William Wordsworth (1770–1850) generally known by the shortened title "Tintern Abbey." Its complete title is "Lines Composed a Few Miles above Tintern Abbey, on Revisiting the Banks of the Wye during a Tour, July 13, 1798." Tintern Abbey is a ruined medieval monastery on the banks of the Wye River in South Wales, Britain. Its roofless buildings were open to the air and its skeletal Gothic arches overgrown with weeds and saplings (Fig. 12.14). In the late eighteenth century, it was common for British travelers to tour the beautiful Wye River, and the final destination of the journey was the abbey itself.

Wordsworth had visited the valley of the Wye five years before he wrote the poem, and he begins his poem by thinking back to that earlier trip (Reading 12.4):

READING 12.4

from William Wordsworth, "Tintern Abbey" (1798)

Five years have passed; five summers, with the length Of five long winters! and again I hear These waters, rolling from their mountain-springs With a soft inland murmur. —Once again Do I behold these steep and lofty cliffs, That on a wild secluded scene impress Thoughts of more deep seclusion; and connect The landscape with the quiet of the sky.

The implication is that the scene evokes thoughts "more deep" than mere appearance, thoughts in which landscape and sky—and perhaps the poet himself—are all connected, united as one.

After describing the scene before him at greater length, the poet then recalls the solace that his memories of the place had brought him in the five intervening years as he had lived "in lonely rooms, and 'mid the din/ Of towns and cities." His memories of the place, he says, brought him "tranquil restoration," but even more important, "another gift," in which "the weary weight/Of all this unintelligible world,/ Is lightened" by allowing the poet to "see into the life of things." Wordsworth does not completely comprehend the power of the human mind here. What the mind achieves at such moments remains to him something of a "mystery." But it seems to him as if his breath and blood, his very body—that

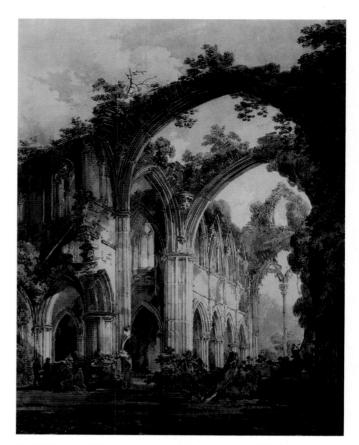

Fig. 12.14 J. M. W. Turner, Interior of Tintern Abbey. 1794. Watercolor, $125\%" \times 97\%"$. Victoria and Albert Museum, London. Turner toured South Wales and the Wye Valley in 1792, when he was 19 years old. This watercolor is based on a sketch made on that trip.

"corporeal frame"—is suspended in a "power /Of harmony" that informs all things.

Wordsworth next describes how he reacted to the scene as a boy. The scene, he says, was merely "an appetite." But now, as an adult, he looks on the natural world differently. He finds in nature a connection between landscape, sky, and thought that is intimated in the opening lines of the poem. Humankind and Nature are united in total harmony:

A motion and a spirit, that impels All thinking things, all objects of all thought, And rolls through all things.

In this perception of the unity of all things, Wordsworth is able to define nature as his "anchor" and "nurse," "The guide, the guardian of my heart, and soul /Of all my mortal being." Wordsworth's vision is informed not just by the scene itself, but by his memory of it, and by his imagination's understanding of its power. As the poem moves toward conclusion, Wordsworth turns to his sister beside him, praying that she too will know, as he does, that "Nature never did betray / The heart that loved her." Indeed, Wordsworth's prayer for his sister Dorothy is really intended as a prayer for us all. We should each of us become, as he is himself, "a worshipper of Nature."

"Tintern Abbey" can be taken as one of the fullest statements of the Romantic imagination. In the course of its 159 lines, it argues that in experiencing the beauty of nature, the imagination dissolves all opposition. Wordsworth suggests that the mind is an active participant in the process of human perception, rather than a passive vessel. There is an ethical dimension to aesthetic experience, a way to stand above, or beyond, the "dreary intercourse of daily life," both literally and figuratively on higher ground. Perhaps most of all, the poem provides Wordsworth with the opportunity for communion, not merely with the natural world, but with his sister beside him, and by extension his readers as well. In individual experience, Wordsworth makes contact with the whole.

The Romantic Landscape

The most notable landscape painting in Europe had developed in Italy and the Netherlands 200 years earlier. Even the term "landscape" derives from the Dutch word landschap, meaning a patch of cultivated ground. Although influenced by Italian artists' use of light and color, the great seventeenthcentury Dutch landscape painters, including Jacob van Ruisdael (see Fig. 10.18 in Chapter 10), were also inspired by a dramatically changing physical geography sparked by the reclamation of hundreds of thousands of acres of land along the coast. The Dutch landscape painters in turn influenced later English landscape painters.

John Constable: Painter of the English Countryside Tension between the timeless and the more fleeting aspects of nature

deeply informs the paintings of John Constable (1776–1837). Constable focused most of his efforts on the area around the valley of the Stour River in his native East Bergholt, Suffolk. Like Wordsworth, Constable believed that his art could be traced back to his childhood, back to the Stour, a place that he had known his whole life. "I should paint my own places best," he wrote to a friend in 1821, "I associate my 'careless boyhood' to all that lies on the banks of the Stour. They made me a painter (& I am grateful)." Also like Wordsworth, Constable wished to depict incidents and situations from common life, including villages, churches, farmhouses, and cottages. But most of all, Constable was, like Wordsworth, "a worshipper of Nature." As Constable wrote in a letter of May 1819, "Every tree seems full of blossom of some kind & the surface of the ground seems quite living—every step I take & on whatever object I turn my Eye that sublime expression of the Scripture 'I am the resurrection and the life' &c, seems verified about me." In fact, the cathedral at the center of so many Constable landscapes symbolizes the permanence of God in nature.

From 1819 to 1825, Constable worked on a series of what he referred to as his "six-footers," all large canvases depicting scenes on the Stour painted in his London studio from sketches and drawings done earlier. The Hay Wain (Fig. 12.15) is one. The painting contains more than one state of mind—the passing storm, indicated by the darkened clouds on the left, contrasts with the brightly lit field below the billowing clouds at the right; the longevity of the tree behind the house with its massive trunk contrasts with the freshly cut hay at the right; the gentleman fisherman contrasts with

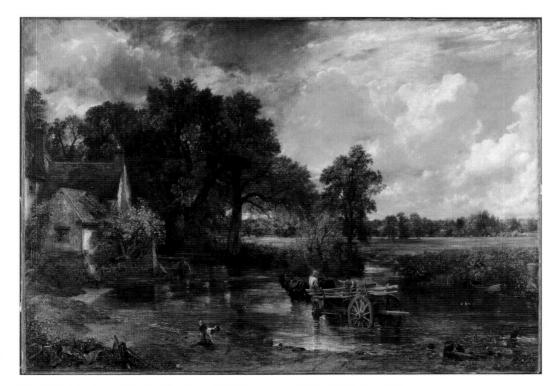

Fig. 12.15 John Constable, The Hay Wain. 1821. Oil on canvas, 51%" × 73". National Gallery, London. Constable failed to sell The Hay Wain when it was exhibited at the Royal Academy in 1821, although he turned down an offer of £70 for it.

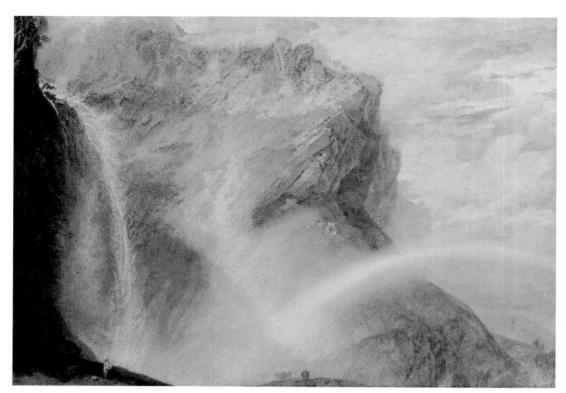

Fig. 12.16 J. M. W. Turner, *The Upper Falls of the Reichenbach*. ca. 1810–15. Watercolor, 10% × 15%6". Yale Center for British Art, Paul Mellon Collection. B1977.14.4702. Turner achieved the transparent effect of the rainbow and the spray rising from the falls by scraping away the watercolor down to the white paper beneath.

the hard-working cart drivers. The house is Willy Lott's. Lott lived in the house his entire 80 years, spending only four nights of his life away from it. For Constable, the house symbolized a stability and permanence that contrasts dramatically with the impermanence of the weather, the constant flux of light and shadow, sun and cloud.

When the painting was first exhibited at the Royal Academy in 1821, Londoners could not accept that this was a "finished" painting because it had been painted in economical, almost abstract terms. Constable used short, broken strokes of color in a variety of shades and tints to produce a given hue (the green of foliage, for example). Nor did they understand how such a common theme deserved so monumental a canvas. Constable subsequently complained to a friend: "Londoners with all their ingenuity as artists know nothing of the feeling of a country life (the essence of Landscape)—any more than a hackney coach horse knows of pasture."

Joseph Mallord William Turner: Colorist of the Imagination The other great English landscape painter of the day, Joseph Mallord William Turner (1775–1851) freely explored what he called "the colors of the imagination." Even his contemporaries recognized, in the words of the critic William Hazlitt (1778–1830), that Turner was interested less in "the objects of nature than... the medium through which they are seen." In Turner's paintings, earth and vegetation seem to dissolve into light and water, into the very medium—gleaming oil or translucent watercolor—with

which he paints them. In *The Upper Falls of the Reichenbach*, for instance, Turner's depiction of the falls, among the highest in the Swiss Alps, seems to animate the rocky precipice (Fig. 12.16). Turner draws our attention not to the rock, cliff, and mountain, but to the mist and light through which we see them.

Perhaps the best way to understand the difference between Constable and Turner is to consider the scale of their respective visions. Constable's work is "close," nearby and familiar, with an abundance of human associations. Turner's is exotic, remote, and even alienating. The human figure in Constable's paintings is an essential and elemental presence, uniting man and nature. The human figure in Turner's paintings is minuscule, almost irrelevant to the painting except insofar as its minuteness underscores nature's very indifference. Not only is The Upper Falls of the Reichenbach removed from the close-at-hand world of Constable's paintings, but also the cowherd and his dog, barely visible at the lower left of the painting, are dwarfed by the immensity of the scene. Cattle graze on the rise at the bottom middle, and another herd is on the ridge across the gorge. The effect is similar to that described by Wordsworth in "Tintern Abbey":

And I have felt A presence that disturbs me with the joy Of elevated thought; a sense sublime Of something far more deeply interfused,

Fig. 12.17 J. M. W. Turner, Snow Storm—Steam-Boat off a Harbour's Mouth. 1842. Oil on canvas, 36" × 48". © Tate, London 2014. Turner bequeathed 19,049 drawings and watercolors to the British nation. Many of these works anticipate the gestural freedom of this painting, with its sweeping linear rhythms.

Whose dwelling is the light of setting suns, And the round ocean and the living air And the blue sky, and in the mind of man: A motion and a spirit, that impels All thinking things, all objects of all thought, And rolls through all things.

We must keep in mind, though, that the sublime is never altogether benign or kind. The viewer has nowhere to stand, except in the path of this mammoth demonstration of nature's force. A painting like Snow Storm—Steam-Boat off a Harbour's Mouth (Fig. 12.17) suggests the "extinction" of the very "hope of man"—a sentiment far removed from Constable's pastoral landscapes or Wordsworth's "natural piety." Originally subtitled The author was in this storm on the night the Ariel left Harwich, the painting is the record of the immersion of the self (and the viewer) into the primal forces of nature. "I wished to show," Turner said, "what such a scene was like. I got the sailors to lash me to the mast to observe it... and I did not expect to escape: but I felt bound to record it if I did."

We have no evidence confirming a ship named *Ariel*. Most likely, Turner imagined this scene of a maelstrom of steam and storm that deposits us at its very heart. We descend into Turner's chaos of light and dark, the very opposite of the Enlightenment ideal of the natural world characterized by clarity, order, and harmony.

The Romantic in Germany: Friedrich and Kant Although Constable and Turner's approaches are very different, both believed that nature provoked their imaginations. In the German Romantic tradition, the imagination is also the fundamental starting point. The painter Caspar David Friedrich (1774-1840) represents the imaginative capacities of the Romantic mind by placing figures, often solitary ones, before sublime landscapes (see Closer Look, pages 400-401). In Monk by the Sea (Fig. 12.18), a figure stands alone, engulfed in the vast expanse of sand and storm, as if facing the void. His is a crisis of faith. How do I know God? he seems to ask. And how, in the face of this empty vastness, do I come to belief? Can I even believe?

These sentiments echo the philosopher Immanuel Kant's Critique of Pure Reason (1781), in which he had argued that the mind is not a passive recipient of information—not, that is, the "blank slate" that Locke had claimed. For Kant, the mind was an active agent in the creation of knowledge.

Fig. 12.18 Caspar David Friedrich, *Monk by the Sea*. 1809–10. Oil on canvas, $47\%" \times 67"$. Alte Nationalgalerie, Staatliche Museen, Berlin. Some art historians believe that the monk is Friedrich himself, which would make this a self-portrait.

CLOSER LOOK

n his 1756 Philosophical Enquiry into the Origin of Our Ideas of the Sublime and the Beautiful, the philosopher Edmund Burke (1729-97) wrote that "the passion caused by the great and sublime in nature is astonishment." "Astonishment." Burke continues, "is that state of the soul in which all its motions are suspended, with some degree of horror." The sublime, in short, is the prospect of anything beyond the ability of the human mind to comprehend fully. Thus, "the sublimity of the ocean is due to the fact that it is an object of no little terror," and "infinity fills the mind with that sort of delightful horror which is the truest test of the sublime." The French art historian Jean Clay notes that "the sublime is evoked through monuments too colossal to be apprehended except by fragments," monuments such as that portrayed in Hubert Robert's Pyramids (opposite). As Burke argued, "Let it be considered that hardly anything can strike the mind with its greatness, which does not make some sort of approach towards infinity; which nothing can do whilst we are able to perceive its bounds."

Great mountain ranges stretching as far as the eye can see, such as the Alps or the American Rockies, evoke the same feelings. As late as 1681, Thomas Burnet, writing in his Sacred Theory of the Earth, could feel confident in con-

demning mountains:

They are placed in no Order one with the other, that can either respect Use or Beauty; and if you consider them singly, they do not consist of any Proportion of Parts that is referable to any Design.... There is nothing in Nature more shapeless or ill-figured, and all that variety that is among them, is but the many various Modes of Irregularity.... They are the greatest examples of Confusion that we know in Nature.

Order, regularity, proportion, and design—these are the hallmarks of beauty to Burnet. And these remain the standards of the beautiful for Burke. The beautiful is self-contained. It can manifest itself as a discrete object—as a building like the Parthenon, or a perfectly proportioned body. But the sublime is limitless, unbounded. In his Critique of Judgment, written some 33 years after Burke's Philosophical Enquiry, in 1790, Immanuel Kant would put it this way: "The beautiful in nature is a question of the form of the object, and this consists in limitation, whereas the sublime is to be found in an object even devoid of form,

so far as it immediately involves, or else by its presence provokes, a representation of *limitlessness*."

Occupying a middle ground between the sublime and the beautiful is the **picturesque**. It finds its roots in the English Garden movement (see Chapter 11), itself inspired by Pliny's descriptions of the gardens of his Roman contemporaries, which were translated by Robert Castell in the 1728 Villas of the Ancients Illustrated. Here, the very disorder and irregularity that Burnet abhorred not half a century earlier are the substance of a garden's appeal. For Castell, the ideal garden takes

the form of a beautiful Country, Hills, Rocks, Cascades, Rivulets, Woods, Buildings &c. [which] were possibly thrown into such an agreeable Disorder, as to have pleased the Eye for several Views, like so many beautiful Landskips... where, tho' the Parts are disposed with the greatest Art, the Irregularity is still preserved; so that their Manner may not improperly be said to be an artful Confusion.

While the beautiful itself remained tied to Classical notions of order, proportion, and harmony of parts, over the course of the eighteenth century, Castell's "beautiful Country" would come to define the picturesque. Late in

Tintern Abbey, Wye Valley, Monmouthshire, Wales. Robert Harding Picture Library.

The Sublime, the Beautiful, and the Picturesque

Hubert Robert, Pyramids. ca. 1750. Oil on wood panel, 24" × 281/2". Smith College Museum of Art, Northampton, MA.

the century, Uvedale Price defined the term in his Essays on the Picturesque (1794–1801) as "roughness and sudden variation joined to irregularity." In fact, the very Wye Tour that had drawn William Wordsworth to Tintern Abbey had been recommended by William Gilpin in his Three Essays: On Picturesque Beauty; On Picturesque Travel; and on Sketching Landscape (1792), and more specifically in his Wye Tour (1782). His other picturesque tours included the Lakes Tour (1786) and the Highlands Tour (1789), and all were designed to introduce their readers to the pleasures of the picturesque. Standing on the hill above Tintern Abbey, Wordsworth

would have been inspired by a picturesque view not unlike the one reproduced opposite.

Something to Think About...

As William Gilpin's travel books make clear, seeking out the picturesque lies at the heart of what would become, in the nineteenth century, the tourist industry. But how might you argue that in the United States, and in its National Park System in particular, the sublime supplanted the picturesque as tourism's primary motive?

Kant believed that the ways we understand concepts like space, time, quantity, the relations among things, and, especially, quality, are innate from birth. We come to understand the world through the operation of these innate mental abilities as they perceive the various aspects of experience. Each of our experiences is various as well, and so each mind creates its own body of knowledge, its own world. No longer was the nature of reality the most important question. Instead, the mind confronting reality was paramount. Kant shifted the basic question of philosophy, in other words, from What do we know? to How do we know?—even to How do we know that we know?

The theme of doubt is a constant in Friedrich's paintings, but more as a stimulant to the imagination than a source of anxiety and tension. In his *Wanderer above the Mists*, Friedrich pictures a lone man with windblown hair positioned directly in front of the viewer on a rocky promontory (Fig. 12.19). Like the monk, we can view him as a projection of ourselves. His view is interrupted by the vast expanse of mist just as ours is cut off by the outcropping of rock. The full magnificence of the scene is only hinted at, a vague promise of eventual revelation. Friedrich, in fact, had this to say about the value of uncertainty:

If your imagination is poor, and in fog you see nothing but gray, then an aversion to vagueness is understandable. All the same, a landscape enveloped in mist seems vaster, more sublime, and it animates the imagination while also heightening suspense—like a veiled woman. The eye and the imagination are generally more intrigued by vaporous distances than by a nearby object available to the eye.

The viewer's imagination is further stimulated by the contrast between near and far, between the rock in the foreground and the ethereal atmosphere stretching into the distance—that is, between the earthly and spiritual realms.

The Romantic Hero

In May 1798, Napoleon set sail for Egypt, accompanied by some 35,000 troops. His army soon took Cairo and installed a French administration in the country. But they were cut off from Europe. In August, the British navy, under the command of Admiral Horatio Nelson, destroyed the French fleet in the Bay of Aboukir, which lies between Alexandria and the mouth of the Nile. Recognizing Napoleon's vulnerability, the Ottoman Turks declared war on France in early 1799, but Napoleon took the initiative, leading an army of 13,000 north into Syria. At the port city of Jaffa (today incorporated into Tel Aviv, but then part of Ottoman Syria), his troops quickly overwhelmed the Ottoman defenses, but then engaged in a senseless bloodbath. Low on ammunition, they bayoneted some 2,000 Turkish soldiers who were trying to surrender, then they turned on the town. Some 3,500 men, women, and children were murdered and raped, their homes and businesses looted and burned. Three days later, faced with the alternative of feeding and guarding another 2,000 to 3,000 Turkish troops who had surrendered to his

Fig. 12.19 Caspar David Friedrich, *The Wanderer above the Mists.* ca. 1817–18. Oil on canvas, $37\%" \times 29\%"$. On permanent loan from the Foundation for the Promotion of the Hamburg Art Collections. Hamburger Kunsthalle, Hamburg. The artist's identification with nature is underscored by the analogy Friedrich establishes between the figure's head and the distant rock at the right.

adjutants, Napoleon ordered that they be executed en masse on the beach.

Within a matter of a couple of days, things turned even more gruesome. Bubonic plague began to spread quickly among Napoleon's troops. Realizing that their soldiers' morale was in jeopardy, Napoleon decided to visit his infected troops at the hospital, a converted mosque, where his doctors were treating the disease. Five years later, Antoine-Jean Gros would celebrate the visit in an enormous painting designed, in many ways, to divert public attention from the horrors of what had really occurred at Jaffa (Fig. 12.20). Napoleon is bathed in light in the center of the painting, laying hands, Christlike, on an infected soldier. The composition is inspired by David's Oath of the Horatii (see Fig. 12.5), its shallow foreground space set in front of a wall of arched porticos, and Napoleon's hand, like Horatius's, is the focal point of the painting. But as much as Napoleon must be admired for putting himself (and his staff, who accompanied him) at risk, before he left Syria, he ordered that those too weak to retreat south—around 50 sick and perhaps already dying soldiers—be poisoned. In all, French casualties in the campaign amounted to around 1,200 killed in action, 2,500 ill or

Fig. 12.20 Antoine-Jean Gros, Napoleon in the Pesthouse at Jaffa. 1804. Oil on canvas, 17'5" × 23'7". Musée du Louvre, Paris. Gros accompanied Napoleon on the Italian campaign in 1797 and would then become one of the most important of those chosen officially to chronicle Napoleon's campaigns.

seriously injured, and about 2,000 dead from the plague. Still besieged by the French navy, Napoleon left for France on his own, leaving his army in Egypt.

So stunningly successful were so many of Napoleon's other military campaigns, so fierce was his dedication to the principles of liberty, fraternity, and equality (abolishing serfdom throughout much of Europe), and so brilliant was his reorganization of the government, the educational system, and civil law, that in the first years of the nineteenth century, he seemed to many a savior. Ultimately, Napoleon was the very personification of the Romantic hero as well as a French national icon, a man of common origin who had risen, through sheer wit and tenacity, to dominate the world

But the promise of Napoleon—his ability to impose Classical values of order, control, and rationality upon a French society that had been racked with revolution and turmoilwas undermined by the darker reality of events like those that transpired at Jaffa. The Romantics, whose fascination with the powers of individual intuition and creativity had led them to lionize Napoleon, would react to his ultimate defeat and to the ensuing disorder that marked the first half of the nineteenth century with a profound pessimism about the course of human events.

To the Romantic imagination, Napoleon was something of a figure for Prometheus. In Greek myth, Prometheus is a member of the race of deities known as Titans. Prometheus stole fire, the source of wisdom and creativity, from the gods and gave it to humankind, to whom Zeus, ruler of the gods, had denied it. For this crime Zeus chained him to a rock,

where an eagle fed daily on his liver, which was restored each night, so that he might suffer the same fate each day. On the one hand, the Romantics revered him as the allsuffering but ever noble champion of human freedom. But on the other, in his reckless ambition to achieve his goals by breaking the laws imposed by supreme authority, as well as in his endless suffering, they also recognized in Prometheus a certain futility and despair.

The Promethean Idea in England: Lord Byron For the poet George Gordon, Lord Byron (1788–1824), Prometheus was the embodiment of his own emphatic spirit of individualism. Byron was a prodigious traveler to foreign countries, a sexual experimenter, and a champion of oppressed nations. In his 1816 ode "Prometheus," Byron rehearses the myth as described in Aeschylus' play Prometheus Bound, and then addresses his mythical hero (Reading 12.5):

READING 12.5

from George Gordon, Lord Byron, "Prometheus" (1816)

Thou art a symbol and a sign To Mortals of their fate and force; Like thee, Man is in part divine, A troubled stream from a pure source: And Man in portions can foresee

His own funereal destiny; His wretchedness, and his resistance, And his sad unallied existence: To which his Spirit may oppose Itself-an equal to all woes,

And a firm will, and a deep sense, Which even in torture can descry Its own concentred recompense, Triumphant where it dares defy, And making Death a Victory.

Prometheus' daring to oppose the Olympian gods was, for Byron, the same daring that he saw in Napoleon, and he balances the poem's sense of almost hopeless resignation with his defiant insistence on the power of the human spirit to overcome any and all troubles it encounters—even death.

In July 1823, Byron sailed to Greece to aid the Greeks in their War of Independence from the Ottoman Turks. Greece was for Byron a Promethean country, longing to be "unbound." Now he would come to its aid himself. But he never did face any action. Instead, he died in 1824 of fever and excessive bleeding, the result of his doctor's mistaken belief that bleeding would cure him. He was buried in his family vault in England, except for his heart and lungs, which were interred at Missolonghi, where he had perished.

Goethe's Faust and the Desire for Infinite Knowledge One of the great ironies in the development of Romanticism is that one of its greatest heroes, Faust (rhymes with "oust"), was the creation of an imagination that defined itself as classical. The creator of this hero, Johann Wolfgang von Goethe (1749–1832), had strong classical tastes and is often categorized as a "classical" author. He had moved to Weimar, one of the great cultural centers of Europe, in 1775, and later filled his house there with Greek and Roman statuary. Indeed he found Romanticism abhorrent. In a famous letter of 1829, Goethe wrote a friend, "The classical I call healthy, the Romantic sick... [the Romantic] is weak, sickly, ill, and the [Classical] is strong, fresh, cheerful...."

Goethe's Faust embodies something of this same ambiguity. Faust is a 12,000-line verse play based on a sixteenth-century German legend about an actual traveling physician named Johann or Georg Faust, who was reputed to have sold his soul to the devil in return for infinite knowledge. To Goethe, he seemed an ideal figure for the Romantic herodriven to master the world, with dire consequences.

Faust is a man of great learning and breadth of knowledge—like Goethe himself—but bored with his station in life and longing for some greater experience. In essence, Faust is suffering from one of the great afflictions of the Romantic hero, *ennui*, a French term that denotes both listlessness and a profound melancholy. He longs for something that will challenge the limits of his enormous intellect. That challenge appears in the form of Mephistopheles—the devil—who arrives in Faust's study dressed as a dandy, a nineteenth-century man of elegant taste and appearance.

Mephistopheles makes a pact with Faust: He promises Faust "ravishing samples of my arts" which will satisfy his greatest yearnings, but in return, if Faust agrees that he is satisfied, Mephistopheles will win Faust's soul. As Faust leaves to prepare to accompany Mephistopheles, the fiend contemplates the doctor's future (Reading 12.6):

READING 12.6

from Johann Wolfgang von Goethe, Faust, Part 1 (1808)

MEPHISTOPHELES... We just say go—and skip. But please get ready for this pleasure trip. [Exit Faust]

Only look down on knowledge and reason, The highest gifts that men can prize, Only allow the spirit of lies To confirm you in magic and illusion,
And then I have you body and soul.
Fate has given this man a spirit
Which is always pressing onwards, beyond control,
And whose mad striving overleaps
All joys of the earth between pole and pole.
Him I shall drag through the wilds of life
And through the flats of meaninglessness,
I shall make him flounder and gape and stick
And to tease his insatiableness
Hang meat and drink in the air before his watering lips;
In vain he will pray to slake his inner thirst,
And even had he not sold himself to the devil
He would be equally accursed.

Mephistopheles recognizes Faust as the ultimate Promethean hero, a man "always pressing onwards, beyond control," whose insatiable ambition will inevitably lead him to "overleap" his limitations. After a tumultuous love affair with a young woman named Gretchen—"Feeling is all!" he proclaims—he abandons her, which causes her to lose her mind and murder their illegitimate child. For this she is condemned to death, but the purity of her love wins her salvation in the afterlife.

In Part 2, Faust follows Mephistopheles into the "other dark worlds" of the Romantic imagination, a nightmare world filled with witches, sirens, monsters, and heroes from the distant past, including Helen of Troy, with whom he has a love affair. But, in Goethe's ultimately redemptive story, Faust is unsatisfied with this unending variety of experiences. What begins to quench his thirst, ironically, is good works, namely, putting knowledge to work in a vast land-reclamation project designed to provide good land for millions of people. (This reminds us of Prometheus' desire to benefit humanity through the gift of fire.) Before achieving his dream, Faust dies, but without ever having actually declared his satisfaction.

In the end, Goethe's Faust is an ambiguous figure, a man of enormous ambition and hence enormous possibility, and yet, like Frankenstein, his will to power is self-destructive. We see these ambiguities in the poem's high seriousness countered by ribald comedy, and in Faust's great goodness countered by deep moral depravity.

Goya's Tragic Vision The impact of Napoleon's Promethean ambition, and the human tragedy associated with it, extended from the Austria of composer Ludwig van Beethoven (1770–1827) to the Spain of painter Francisco Goya (1746–1828). Goya was, at first, enthusiastic about Napoleon's accession to power in France. Yet he, too, came to see through the idealistic veil of the emperor's ostensible desire to establish a fair and efficient government in a still-feudal country that was debased, corrupt, and isolated from the rest of Europe. Indeed, Goya's feelings for Napoleon were far less ambivalent than Beethoven's. Goya came simply to hate the emperor, as most Spaniards did.

When Napoleon decided to send a French army across the Iberian Peninsula to force Portugal to abandon its alliance with Britain, he did not foresee a problem, since Spain had been his ally since 1796. At first, Napoleon's army was unopposed, but by the time the troops reached Saragossa, the Spanish population rose up against the invaders in nationalistic fervor. For the next five years, the Spanish conducted a new kind of warfare, engaging the French in innumerable guerrillas, or "little wars," from which derive the concept of guerrilla warfare.

In March 1808, Napoleon made a fatal error. Maneuvering the Spanish royal family out of the way through bribery, he named his brother Joseph Bonaparte (r. 1808–14) to the Spanish throne. This gesture infuriated the Spanish people. The crown was *their* crown, after all, not Napoleon's. Even as the royal family was negotiating with Napoleon, rumors had spread that Napoleon was planning to execute them. On May 2, 1808, the citizens of Madrid rose up against Napoleon's troops, resulting in hundreds of deaths in battle, with hundreds more executed the next day on a hill outside Madrid. Six years later, in 1814, after Napoleon had been deposed and Ferdinand reinstated as king, Goya commemorated the events of May 2 and May 3 in two paintings, the first depicting the battle and the second the executions of the following day.

The Third of May, 1808 is one of the greatest testaments to the horrors of war ever painted (Fig. 12.21). The night after the events of May 2, Napoleon's troops set a firing squad and executed hundreds of Madrilenos—anyone caught bearing weapons of any kind. The only illumination comes from a square stable lantern that casts a bright light on a prisoner with his arms raised wide above his head in a gesture that seems at once a plea for mercy and an act of heroic defiance. Below him the outstretched arms of a bloody corpse mirror his gesture. To his left, in the very center of the painting, another soon-to-be casualty of the firing squad hides his eyes in terror, and behind him stretches a line of victims to follow. Above them, barely visible in the night sky, rises a solitary, darkened church steeple. Much of the power of the painting lies in its almost Baroque contrast of light and dark and its evocation of Christ's agony on the cross, especially through the cruciform pose of the prisoner. The soldier-executioners represent the grim reality of loyalty to one's state, as opposed to loyalty to one's conscience.

Goya's sense that his world had abandoned reason dominated his final works. In 1819, when Goya was 72 years old, he moved into a small two-story house outside Madrid. The move was inspired at least in part by his relationship with his 30-year-old companion, Leocadia Weiss, which scandalized more conservative elements of Madrid society. It was also a more general expression of Goya's growing preference for isolation.

Goya spent the next four years executing a series of 14 oil paintings directly on the plaster walls of this house, Quinta del sordo. Today they are known as the "black paintings." There is no record that Goya ever explained them to any

of the PAST

The CONTINUING PRESENCE

See Devorah Sperber, After Goya: Self Portrait (1815) divided along the vertical axis with each side mirrored to create two symmetrical images, 2006, at MyArtsLab

Fig. 12.21 Francisco Goya, *The Third of May*, 1808. 1814–15. Oil on canvas, $8'9\%'' \times 13'4\%''$. Museo Nacional del Prado, Madrid. Goya was later asked why he had painted the scene with such graphic reality. His reply was simple: "To warn men never to do it again."

friend or relative, nor did he title them in any written form. Among these works are a painting of a woman who is evidently Leocadia, leaning on a tomb; two men dueling with cudgels; a pilgrimage of terrifying and hideous figures through a nocturnal landscape; a convocation of these same figures in a witches' sabbath around a giant he-goat; two skeletal old people eating soup; and, most terrifying of all, the painting today known as Saturn Devouring One of His Children (Fig. 12.22). Derived from the story of Kronos eating his children, it is among the legends associated with the pre-Olympian Titans. Saturn is the Latin form of the Greek Kronos. At the Quinta del sordo, the Saturn faced the main door, and it seems likely that Goya did not intend the Saturn myth as a "welcoming" image. His horrific giant with skinny legs, massive shoulders, wild hair, and crazed eyes is perhaps more an image of society as a whole, the social order, even Spain itself, devouring its own people.

Fig. 12.22 Francisco Goya, Saturn Devouring One of His Children.
1820–23. Oil on plaster transferred to canvas, $57\%" \times 32\%"$. © Museo
Nacional del Prado, Madrid. All rights reserved. In 1824, Goya finally gave up
on Ferdinand VII's Spain and, under the pretense of needing to visit the thermal
baths, moved to Bordeaux, France, where he remained in self-exile until his
death in 1828.

FROM CLASSICAL TO ROMANTIC MUSIC

What differentiates Classical music from the Romantic music that followed it?

Fascination with the Promethean hero was not confined to literature. It was reflected in music, and especially that of Ludwig van Beethoven, the key figure in the transition from the Classical to the Romantic era in music. His Third Symphony, which came to be known as the Eroica—Italian for "Heroic"—was originally dedicated to Napoleon because of the composer's admiration for the French leader as a champion of freedom. But when, on December 2, 1804, Napoleon had himself crowned as emperor, Beethoven changed his mind, saying to a friend: "Is he then, too, nothing more than an ordinary human being? Now he, too, will trample on all the rights of man and indulge only his ambition. He will exalt himself above all others, become a tyrant!" Thus, on the title page of the symphony he crossed out the words "Intitulata Bonaparte," "Dedicated to Bonaparte."

The Classical Tradition

As Beethoven began his career as a young pianist in Vienna in 1792, he was steeped in the tradition we have come to call Classical music, which reflects the growing distaste for the Rococo and the moral depravity associated with it. Developing first in Vienna about 1760, the "Classical" style shares with Greek and Roman art the essential features of symmetry, proportion, balance, formal unity, and, perhaps above all, clarity. This clarity was a direct result of the rise of a new musical audience, a burgeoning middle class that demanded from composers a more accessible and recognizable musical language than that found in the ornate and complex structures of the Baroque.

The most important development of the age, designed specifically to address the new middle-class audience, was the **symphonic orchestra**. This musical ensemble was much larger than the ensemble used by Baroque composers. The Classical orchestra was divided into separate sections according to type of instrument: the *strings*, made up of violins, violas, cellos, and double basses; *woodwinds*, consisting of flutes, oboes, clarinets, and bassoons; a *brass* section of trumpets and French horns (by the end of the century, trombones were added); and a *percussion* section, featuring the kettledrums and other rhythm instruments. The composer himself usually led the orchestra and often played part of the composition on the piano or clavier in the space now reserved for the conductor. The modern symphony orchestra is a dramatically enlarged version of this new Classical ensemble.

In order to organize such a large group, an overall **score**, which indicated what music was to be played by each instrument, was required. This let the composer view the composition as a whole, while each instrument or section was given its own individual part. The music most often played by the symphonic orchestra was the **symphony**. The

term derives from the Italian *sinfonia*—the three-movement (fast-slow-fast) introduction or overture to Italian operas. A fourth movement might be added after the first two, usually based on the stately rhythms of the minuet. The predictability of the form is the source of its drama, since audiences anticipated the composer's inventiveness as the composition proceeded through three or four movements.

Haydn and Mozart One of the most important contributors to the development of the symphonic form was the composer Joseph Haydn (1732-1809). In 1761, at the age of 29, he was appointed musical director to the court of the Hungarian nobleman Prince Paul Anton Esterházy. Haydn worked for Esterházy for nearly 30 years, isolated at Esterháza Palace in Eisenstadt, about 30 miles south of Vienna. The palace, modeled on Versailles, contained two theaters (one for opera) and two concert halls. In these surroundings Haydn composed an extraordinary amount of music: operas, oratorios, concertos, sonatas, overtures, liturgical music, and above all, the two genres that he was instrumental in developing—the Classical symphony and the string quartet. (He composed 106 of the former and 67 of the latter.) He also oversaw the repair of instruments, trained a chorus, and rehearsed and performed with an orchestra of about 25 musicians.

When Esterházy died in 1790, his son disbanded the orchestra and a London promoter, Johann Peter Salomon, invited Haydn to England. There he composed his last 12 symphonies for an orchestra of some 60 musicians. Among the greatest of the London symphonies is Symphony No. 94, the "Surprise" Symphony. It was so named for a completely unanticipated fortissimo ("very loud") percussive stroke that occurs on a weak beat in the second movement of the piece (track 12.1). This moment was calculated, so the story goes, to awaken Haydn's dozing audience, since concerts usually lasted until well past midnight.

The greatest musical genius of the Classical era was Haydn's younger contemporary and colleague, Wolfgang Amadeus Mozart (1756–91). Mozart wrote his first original composition at age six, in 1762, the year after Haydn assumed his post with Prince Esterházy. When he was just eight, the prodigy penned his first symphony. Over the course of his 35-year life, he would write 40 more, plus 27 string quartets, 20 operas, 60 sonatas, and 23 piano concertos. Haydn told Mozart's father that his son was simply "the greatest composer I know in person or by name," and in 1785 Mozart dedicated six string quartets to the older composer. On several occasions the two met at parties, where they performed string quartets together, Haydn on the violin, Mozart on the viola.

Mozart's music was generally regarded as overly complicated, too demanding emotionally and intellectually for a popular audience to absorb. When the Habsburg emperor Joseph II commented that the opera *Don Giovanni* was beautiful "but no food for the teeth of my Viennese"—meaning too refined for their taste—Mozart reportedly replied, "Then give them time to chew it." Indeed, his work often took time

to absorb. Mozart could pack more distinct melodies into a single movement than most composers could write for an entire symphony, and the lines would arise and grow naturally from the beginning to the end of the piece. But the reaction of Joseph II to another of Mozart's operas is typical: "Too many notes!" Ironically, it is exactly this richness that we value today.

An example of Mozart's complexity is his Symphony No. 40, composed in the course of eight weeks in the summer of 1788. The first movement's form is very easy for the listener to hear, and yet the movement is full of small—and sometimes larger—surprises (track 12.2). The composition shifts dramatically between loud and soft passages, woodwinds and strings, rising and falling phrases, and major and minor keys. Particularly dramatic is the way Mozart leads the listener to anticipate a return to the original melody, only to withhold it.

Among Mozart's greatest works are his last four great operas—The Marriage of Figaro, Don Giovanni, Cosi fan tutte, and The Magic Flute. The first three bring together nobles and commoners in stories that are at the same time comic and serious. What distinguishes them most, however—and the Italian librettist Lorenzo da Ponte (1749–1838) must be given some credit for this—is the depth of their characters. From the lowest to the highest class and rank, all are believable as they sort out their stormy relationships and love lives.

Beethoven: From Classicism to Romanticism

Beethoven's music is a direct reflection of his life's journey, his joys and sorrows, and, in turn, an indication of the shift from the formal structural emphases of Classical music to the expression of more personal, emotional feelings in Romantic music. Earlier composers had expressed emotion in their works, but not in the personal, autobiographical way that Beethoven did.

Beethoven arrived in Vienna from Bonn, Germany, in November 1792. A decade later, in his First and Second Symphonies, completed in 1802, there is a sense that he is consciously taking on the Classical tradition, recapitulating it, summarizing it, and preparing to move on to more exciting breakthroughs. A personal crisis brought on by his increasing deafness instigated an extraordinary period of creativity for Beethoven over the next decade, in which he produced six symphonies, four concertos, and five string quartets, leaving the Classical tradition behind.

In April 1802, Beethoven left Vienna for the small village of Heiligenstadt, just north of the city. Although his hearing had been deteriorating for some time, what had started as humming and buzzing was becoming much worse. He was moody and temperamental by nature, and his deafness deeply depressed him. His frustration reached a peak in early October as he contemplated ending his life. His feelings are revealed in a remarkable document found among his papers after his death, a letter to his brothers today known as the Heiligenstadt Testament (Reading 12.7):

READING 12.7

from Ludwig van Beethoven, Heiligenstadt Testament (1802)

From childhood on, my heart and soul have been full of the tender feeling of goodwill, and I was ever inclined to accomplish great things. But, think that for six years now I have been hopelessly afflicted, made worse by senseless physicians, from year to year deceived with hopes of improvement, finally compelled to face the prospect of a lasting malady... Though born with a fiery, active temperament, even susceptible to the diversions of society, I was soon compelled to withdraw myself, to live life alone . . . It was impossible for me to say to people, "Speak louder, shout, for I am deaf." Ah, how could I possibly admit an infirmity in the one sense which ought to be more perfect in me than in others. . . . I must live almost alone, like one who has been banished . . . If I approach near to people a hot terror seizes upon me, and I fear being exposed to the danger that my condition might be noticed. . . . What a humiliation for me when someone standing next to me heard a flute in the distance and I heard nothing, or someone heard a shepherd singing and again I heard nothing. Such incidents drove me almost to despair; a little more of that and I would have ended my life-it was only my art that held me back . . .

Beethoven soon reconciled himself to his situation, recognizing that his isolation was, perhaps, the necessary condition to his creativity. His sense of self-sufficiency, of an imagination turned inward, guided by an almost pure state of subjective feeling, lies at the very heart of Romanticism. Beethoven's post-Heiligenstadt works, often called "heroic" because they so thoroughly evoke feelings of struggle and triumph, mark the first expression of a genuinely Romantic musical style. When the composer and author E. T. A. Hoffmann said, in 1810, that Beethoven's music evokes "the machinery of awe, of fear, of terror, of pain"-he meant that it evokes the sublime. To this end, it is much more emotionally expressive than its Classical predecessors. In Beethoven's groundbreaking compositions, this expression of emotion manifests itself in three distinct ways: long, sustained crescendos that drive the music inexorably forward; sudden and surprising key changes that always make harmonic sense; and both loud and soft repetitions of the same theme that are equally, if differently, poignant.

Beethoven's Third Symphony, the *Eroica*, is the first major expression of this new style in his work. Much longer than any previous symphony, the 691 measures of the first movement alone take approximately 19 minutes to play compared to 8 minutes for the first movement of Mozart's Symphony No. 40 in G minor. In fact, the first movement is almost as long as an entire Mozart symphony. Dramatically introducing the main theme and recapitulating it after elongated melodies, this movement ends in a monumental climax, establishing the Romantic, Promethean mood of the piece. The finale

brings together the themes and variations of the first movement in a broad, triumphant conclusion featuring a majestic horn. Ultimately, this symphony dramatizes Beethoven's own descent into despair at Heiligenstadt (represented in the second movement), his inward struggle, and his ultimate triumph through art.

Beethoven's Fifth Symphony, like the *Eroica*, brings musical form to the triumph of art over death, terror, fear, and pain. It was premiered on December 22, 1808, and its opening four-note motif, with its short-short-long rhythm, is in fact the basis for the entire symphony (for the first movement see track 12.3):

Throughout the symphony's four movements, this rhythmic unit is used again and again, but never in a simple repetition. Rather, the rhythm seems to grow from its minimal opening phrasings into an expansive and monumental theme by the symphony's end.

A number of startling innovations emerge as a counterpoint to this theme: an interruption of the opening motif by a sudden oboe solo; the addition of piccolo, double bassoon and trombones in the finale; the lack of a pause between the last two movements; and the ending of the piece in a different key from that in which it began—a majestic C major rather than the original C minor. In fact, the Fifth Symphony ends with one of the longest, most thrilling conclusions Beethoven ever wrote. Over and over again it seems as if the symphony is about to end, but instead it only gets faster and faster, until it finally comes to rest on the single note C, played fortissimo by the entire orchestra.

Romantic Music after Beethoven

Beethoven's musical explorations of individual feelings were immensely influential on the Romantic composers who succeeded him. They strove to find new ways to express their own emotions. Some focused on the symphony as the vehicle for their most important statements. Others found a rich vehicle in piano music and song.

Hector Berlioz and Program Music The French composer Hector Berlioz (1803–69) was the most startlingly original of Beethoven's successors, both musically and personally. His compositions were frankly autobiographical; Berlioz attracted attention with new approaches to symphonic music and instrumentation. He wrote three symphonies, all of which are notable for their inventiveness and novelty, and especially for the size of the orchestras Berlioz enlisted to play them. The resulting volume of sound could be deafening. As large as the orchestras were and as intricate their narrative structure, Berlioz was able to unify his symphonies by introducing recurring themes that provided continuity through the various movements.

Felix Mendelssohn and the Meaning of Music Program music was an important part of the work of another Romantic composer after Beethoven. As a young man, Felix Mendelssohn (1809-47) was befriended by Goethe, and their great friendship convinced the composer, who was recognized as a prodigy, to travel widely across Europe from 1829 to 1831. These travels inspired many of his orchestral compositions. These include the *Italian* Symphony (1833), which with its program has become his most popular work; the Scottish Symphony (1842), which is the only symphony he allowed to be published in his lifetime; and the Hebrides (1832), also known as Fingal's Cave. The last is a concert overture, a form that grew out of the eighteenth-century tradition of performing opera overtures in the concert hall. It consists of a single movement and is usually connected in some way with a narrative plot known to the audience. The Hebrides overture, however, does not tell a story. Rather, it sets a scene—one of the first such compositions in Western music—the rocky landscape and swell of the sea that inspired Mendelssohn when he visited the giant cave carved into basalt columns on an island off the Scottish coast.

Mendelssohn himself played both piano and violin. For the piano he composed 48 "Songs without Words," published in eight separate books, which proved enormously popular. The works challenge the listener to imagine the words that the compositions evoke. When asked by a friend to provide descriptive titles to the music, he replied:

I believe that words are not at all up to it [the music], and if I should find that they were adequate I would stop making music altogether. . . . So if you ask me what I was thinking of, I will say: just the song as it stands there. And if I happen to have had a specific word or specific words in mind for one or another of these songs, I can never divulge them to anyone, because the same word means one thing to one person and something else to another, because only the song can say the same thing, can arouse the same feelings in one person as in another—a feeling that is not, however expressed by the same words.

The meaning of music, in other words, lies for Mendelssohn in the music itself. It cannot be expressed in language. The music creates a feeling that all listeners share, even if no two listeners would interpret it in the same terms.

Song: Franz Schubert and the Schumanns Not all Romantic composers followed Beethoven in concentrating on the symphonic form to realize their most important innovations and to communicate most fully their personal emotions. Beginning in about 1815, German composers became intrigued with the idea of setting poetry to music, especially the works of Friedrich Schiller and Goethe. Called *lieder* (singular *lied*), these songs were generally written for solo voice and piano. Their popularity reflected the growing availability and affordability of the piano in middle-class households and the composers' willingness to write compositions that were within the technical grasp of amateur musicians. This early

expansion of the market for music freed composers from total reliance on the patronage of the wealthy.

The *lieder* of Franz Schubert (1797–1828) and Robert Schumann (1810–56) were especially popular. Schubert's life was a continual struggle against illness and poverty, and he worked feverishly. In his brief career, he composed nearly 1,000 works, 600 of which were *lieder*, as well as 9 symphonies and 22 piano sonatas. Schubert failed to win international recognition in his lifetime, for which his early death by typhoid was partially to blame. But his melodies, for which he had an uncanny talent, seemed to capture, in the minds of the many who discovered him after his death, the emotional feeling and depth of the Romantic spirit.

Before marrying Clara Schumann (1819–96) in 1840, Robert Schumann never wrote more than five pieces in a given year. In the year of his marriage, however, he composed 140 songs, including his wedding gift to Clara, the poem *Du bist wie eine Blume*, "You are like a flower," and another song performed at their wedding, *Widmung*, "Dedication," which begins "You are my soul,/ you are my heart," and ends with a brief musical quotation from Schubert. So Clara was the inspiration for much of her husband's most moving music.

By the age of 20, Clara Schumann was so well-known as a piano virtuoso that the Viennese court had given her the title Royal and Imperial Virtuosa. She was one of the most famous and respected concert pianists and composers of her day, despite her difficult marriage to Robert Schumann. Like her husband, she specialized in performing piano works known as **character pieces**, works of relatively small dimension that explore the mood or "character" of a person, emotion, or situation. Robert's greatest piano music comprises thematically related suites of such miniatures, including his *Carnaval* of 1835. After Robert's death, Clara supported her family by performing lengthy concert tours, one of the first artists to do this regularly.

Piano Music: Frédéric Chopin Performance of character pieces often occurred at salon concerts, in the homes of wealthy music enthusiasts. Among the most soughtafter composer/performer pianists of the day was the Polish-born Frédéric Chopin (1810-49). He composed almost exclusively for the piano. Among his most impressive works are his études, or "studies," which address particular technical challenges on the piano. The Fantasie impromptu showcases the expressive range Chopin was capable of even in a brief composition (track 12.4). Like other pianists of the day, Chopin enhanced the emotional mood of the piece by using tempo rubato (literally "robbed time"), in which the piece accelerates or decelerates in a manner "akin to passionate speech," as described by one of his students. While the word fantasie connotes creativity, imagination, magic, and the supernatural, the word impromptu suggests spontaneous improvisation, although, of course, the piece was written down. Combining impulsive, spur-of-the-moment creativity and imaginary and fantastical effects, Chopin's work is the very definition of Romanticism.

12.1 Compare and contrast the French and American revolutions.

The idea of human freedom was fundamental to the Enlightenment, finding two of its greatest expressions in the Declaration of Independence, ratified by the 13 colonies on July 4, 1776, and, in France, the Declaration of the Rights of Man and Citizen, passed by the National Assembly in August 1789. Jefferson's argument that the American colonies should be self-governing was preceded by British taxation of the colonies. In France, the national debt, and taxes associated with paying it, produced events leading to revolution. What do you think accounts for the fact that in America, revolution was followed with relative stability, while in France, chaos and terror followed?

12.2 Describe the Neoclassical style.

In France, Jacques-Louis David, the premier painter of the day, readily adopted the Neoclassical style in his painting *The Oath of the Horatii*, in which he champions heroism and personal sacrifice for the state. What is "classical" about Neoclassicism? How does *The Lictors Returning to Brutus the Bodies of His Sons* begin to challenge these values? The founders of the newly created United States modeled their republic on classical precedents and embraced Neoclassicism as an architectural style. What specific aspects of Neoclassical art and architecture attracted Thomas Jefferson to the Neoclassical style?

As Napoleon took greater and greater control of French political life in the opening decade of the nineteenth century, he turned to antiquity, modeling his government particularly upon the military and political structures of the Roman Empire. He commissioned paintings of himself that served the propagandistic purpose of cementing his image as an invincible, nearly godlike leader. In what ways is David's Napoleon Crossing the Saint-Bernard a work of propaganda?

12.3 Define Romanticism as it manifests itself in both literature and painting.

The Romantics were dedicated to the discovery of beauty in nature through their subjective experience of it. William Wordsworth's poem "Tintern Abbey" embodies

the growing belief in the natural world as the source of inspiration and creativity that marks the early Romantic imagination. Landscape painters were similarly inspired by the natural world. John Constable, painting in the valley of the Stour River in his native Suffolk, considered himself "a worshipper of Nature." What is the "transcendence" that Wordsworth and Constable find in nature? J. M. W. Turner specialized in capturing light, not the objects of nature so much as the medium through which they are seen. What is Turner's conception of the "sublime"? How does it differ from the beautiful and the picturesque? In Germany, the painter Caspar David Friedrich often places solitary figures before sublime landscapes that constantly raise the theme of doubt. Why does doubt excite Friedrich's imagination? Almost everyone recognized that even if Napoleon personified the Romantic hero, he also possessed a darker side. In many eyes, he was a modern Prometheus. How does Johann Wolfgang von Goethe view his Promethean figure Faust? What are the attractions of the Promethean figure? How does Francisco Goya capture its darker side?

12.4 Differentiate between Classical and Romantic music.

Classical music shares with Greek and Roman art the essential features of symmetry, proportion, balance, formal unity, and clarity. The symphony orchestra is the primary vehicle of Classical music. What are the major structural divisions of the Classical symphony? Two of the greatest composers of symphonies were Joseph Haydn and Wolfgang Amadeus Mozart. Why was Mozart's music criticized in his own day?

In such great symphonies as the *Eroica* (Third) and the Fifth, Beethoven defined the Romantic style in music. How would you describe that style? Succeeding generations of composers followed his lead by expanding the musical vocabulary of orchestras and developing new symphonic forms. What were the innovations of Hector Berlioz and Felix Mendelssohn? Other composers, such as Franz Schubert and the Schumanns, set the poems of Romantic poets such as Schiller and Goethe to music in compositions called *lieder*. Frédéric Chopin composed almost solely for the piano and was famous especially for his *études*, studies that address particular technical challenges.

From Romanticism to Realism

fter the fall of Napoleon in 1815, the battle between Classicism and Romanticism raged within France, fueled by political factionalism. Bourbon rule had been restored when Louis XVIII (r. 1814-24), the deposed Louis XVI's brother, assumed the throne. Royalists, who favored this return of the monarchy, championed the more conservative Neoclassical style. Liberals identified with the new Romantic style, which from the beginning had allied itself with the French Revolution's radical spirit of freedom and independence.

Against this political backdrop, the young painter Théodore Géricault (1791-1824), who had trained in Paris in a Neoclassical style, inaugurated his career. Géricault had joined the Royal Musketeers in 1815, assigned to protect the future Louis XVIII from Napoleon. But events quickly overcame Géricault's brief royalist career. On July 2, 1816, a government frigate named the Medusa, carrying soldiers and settlers to Senegal, was shipwrecked on a reef 50 miles off the coast of West Africa. The captain and crew saved themselves, leaving 150 people, including a woman, adrift on a makeshift raft. Only 15 survived the days that followed, days marked by insanity, mutilation, famine, thirst, and finally cannibalism. Géricault was outraged. An inexperienced captain, commissioned on the basis of his noble birth and connections to the monarchy, saved himself, providing a profound indictment of aristocratic privilege.

Géricault set himself the task of rendering the events. He interviewed survivors, and painted mutilated bodies in the Paris morgue. The enormous composition of The Raft of the "Medusa" is organized as a double triangle (Fig. 12.23). The mast and the two ropes supporting it form the apex of one triangle, and the torso of the figure waving in the direction of the barely visible Argus, the ship that would eventually rescue the castaways, the apex of the other. The opposing diagonals form a dramatic "X" centered on the kneeling figure whose arm reaches upward in the hope of salvation. Ultimately, however, the painting makes a mockery of the idea of deliverance, just as its rigid geometric structure parodies the ideal order of Neoclassicism. Géricault's Romanticism assumed a political dimension through his art. He had himself become a Promethean hero, challenging the authority of the establishment.

When Géricault's painting was exhibited at the French Academy of Fine Arts Salon of 1819, it was titled simply A Shipwreck Scene, in no small part to avoid direct confrontation with the Bourbon government. Royalist critics dismissed it. The conservative press wrote that the painting was "not fit for moral society. The work could have been done for the pleasure of vultures." But in its sense of immediacy, its insistence on depicting current events (although his depictions of the victims, with their classicized musculature, idealizes their actual condition), it anticipates a turn, in the Western imagination, toward the depiction of real events—if not their physical actuality, then their emotional truth.

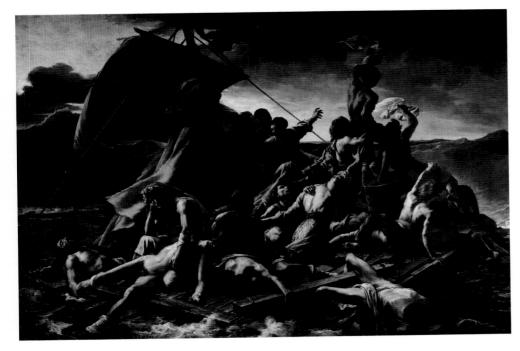

Fig. 12.23 Théodore Géricault, The Raft of the "Medusa". 1818. Oil on canvas, 16'1" × 23'6". Musée du Louvre, Paris.

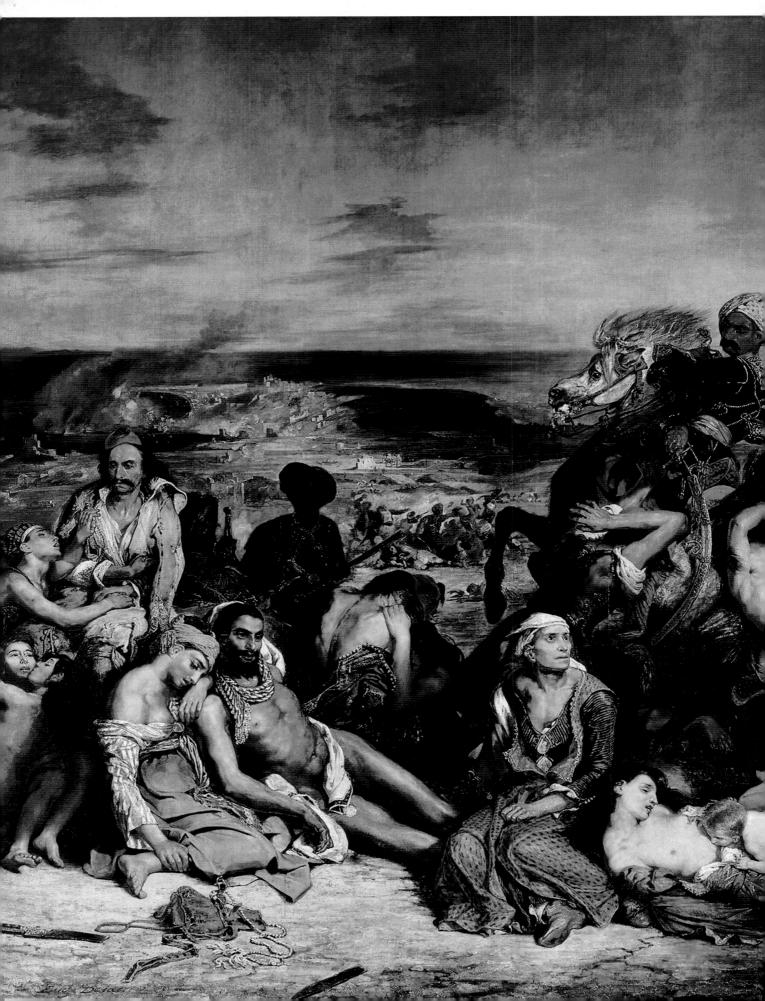

The Working Class and the Bourgeoisie

13

The Conditions of Modern Life

LEARNING OBJECTIVES

- 13.1 Describe how realism manifested itself in nineteenth-century art and literature.
- 13.2 Describe the various ways in which French artists and writers attacked bourgeois values in the 1850s and 1860s.
- 13.3 Define Impressionism and examine how it transformed conventional assumptions about style and content in painting.
- 13.4 Outline the characteristics of the American sense of self as it developed in the nineteenth century.
- 13.5 Examine the impact of Western imperial adventuring on the non-Western world.

fter the defeat of Napoleon in 1815, Louis XVIII (r. 1814-24), whose rule had been restored the year before when Napoleon had been exiled to Elba, could not ignore the reforms implemented by both the revolution and Napoleon himself. His younger brother, the count of Artois, disagreed, and almost immediately a so-called Ultraroyalist movement, composed of families who had suffered at the hands of the revolution, established itself. Advocating the return of their confiscated estates and the abolition of revolutionary and Napoleonic reforms, the Ultraroyalists imprisoned and executed hundreds of revolutionaries, Bonaparte sympathizers, and Protestants in southern France. (The artist Jacques-Louis David, who had supported Napoleon, was in exile during this period.) In order to solidify his control, Louis dissolved the largely Ultraroyalist Chamber of Deputies and called for new elections, which resulted in a more moderate majority.

Relative calm prevailed in France for the next four years, but in February 1820, the son of the count of Artois, who was the last of the Bourbons and heir to the throne, was assassinated, initiating ten years of repression. The education system was placed under the control of Roman Catholic bishops,

press censorship was inaugurated, and "dangerous" political activity banned. At the death of Louis XVIII, the count of Artois assumed the throne as Charles X (r. 1824–30).

In the midst of this turmoil, at the Salon of 1824, a young painter by the name of Eugène Delacroix (1798-1863) exhibited a large painting entitled Scenes from the Massacres at Chios (Fig. 13.1). Delacroix had studied with Théodore Géricault, and had actually served as the model for the facedown nude in the bottom center of The Raft of the "Medusa" (see Fig. 12.23 in Chapter 12). He shared his master's disillusionment with Royalist politics. The full title of Delacroix's painting-Scenes from the Massacres at Chios; Greek Families Awaiting Death or Slavery, etc.—See Various Accounts and Contemporary Newspapers—reveals its close association with journalistic themes. It depicts events of April 1822, after the Greeks had initiated a War of Independence from Turkey, a cause championed by all of liberal Europe. In retaliation, the sultan sent an army of 10,000 to the Greek island of Chios, several miles off the west coast of Turkey. The troops killed 20.000 and took thousands of women and children into captivity, selling them into slavery across North Africa. In the left foreground, defeated Greek families await their fate. To

[▼] Fig. 13.1 Eugène Delacroix, Scenes from the Massacres at Chios. 1824. Oil on canvas, 165" × 139¼". Musée du Louvre, Paris. Delacroix relied on the testimony of a French volunteer in the Greek cause for the authenticity of his depiction.

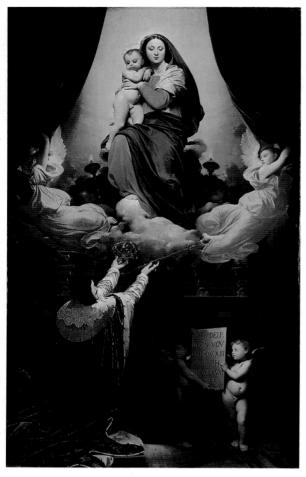

Fig. 13.2 Jean-Auguste-Dominique Ingres, *The Vow of Louis XIII.* 1824. Oil on canvas, 165%" \times 103%". Montauban Cathedral, France. The plaque in the hands of the *putti* reads "Louis XIII puts France under the protection of the Virgin, February 1638."

the right a grandmother sits dejectedly by what is perhaps her dead daughter, even as her grandchild tries to suckle at its dead mother's breast. A prisoner vainly tries to defend a Greek woman tied to a triumphant Turk's horse. The vast space between the near foreground and the far distance is startling, almost as if the scene transpires before a painted tableau.

The stark contrast between Delacroix's Scenes from the Massacres at Chios and an equally large painting by Jean-Auguste-Dominique Ingres (1780-1867) exhibited at the same Salon, The Vow of Louis XIII (Fig. 13.2), emphatically underscores the competing styles of the two artists. Especially in the context of the times, Ingres's painting is a deeply royalist work. It depicts Louis XIII placing France under the protection of the Virgin in February 1638 in order to end a Protestant rebellion. The painting is divided into two distinct zones, the religious and the secular, or the worlds of Church and State. The king kneels in the secular space of the foreground, painted in almost excruciating detail. Above him, the Virgin, bathed in a spiritual light, is a monument to Renaissance Classicism, directly referencing the Madonnas of Raphael. In every way, the painting is a monument to tradition—to the traditions of the Bourbon throne, the Catholic Church, and Classical art.

In his paintings, Ingres never hesitated to adjust the proportions of the body to the overall composition. A good example is his *La Grande Odalisque* of 1814 (Fig. 13.3). An **odalisque** is a female slave or concubine in a Middle Eastern, particularly Turkish, harem. When the painting was exhibited at the Salon of 1819, viewers immediately recognized that his figure's back is endowed with too many vertebrae, that her right arm extends to too great a length, as if disjointed at the elbow, and that her right foot appears amputated from a rather too distant right knee. Ingres could

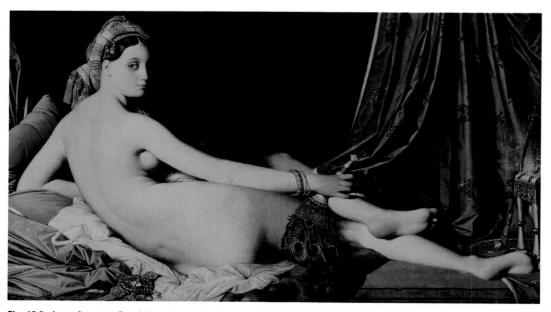

Fig. 13.3 Jean-Auguste-Dominique Ingres, *La Grande Odalisque*. 1814. Oil on canvas, 35%" × 63". Musée du Louvre, Paris. Inv. Rf1158. The painting was commissioned by Napoleon's sister Caroline Murat, queen of Naples.

hardly have cared less. For him, the composition demanded the sweeping curve of both back and arm, the curve of which continues into the folds of the hanging drapery, even as it crosses and works against the emphatic diagonal created by his figure's legs. Equally appealing to him was the dramatic contrast between the dark background and the brilliantly lit flesh of the body, his stunningly realistic realization of satin and silk, and the almost palpable sense of touch elicited by the peacockfeather fan—all rendered without so much as the trace of a brushstroke.

The odalisque continued to occupy Ingres for the rest of his career, as in fact it did nineteenth-century French artists as a group. But when Delacroix took up the theme in the *Odalisque* painted in 1845–50 (Fig. 13.4), the effect was dramatically different. Both works employ the standard iconography of the harem—the unkempt bed, the hashish pipe or hookah, the curtained room. Both figures address the viewer with their eyes. But where the cool blues of Ingres's painting underscore the equally cool, even icy sexual aloofness of his model, the reds of Delacroix's are charged with an intense eroticism, underscored by the fact that his model is turned toward

the viewer rather than away. In fact, where Ingres's odalisque seems untainted, almost pure, Delacroix's appears lasciviously postcoital. And Delacroix's brushwork, the wild, energetic gesture of his touch, is the very opposite of Ingres's traceless

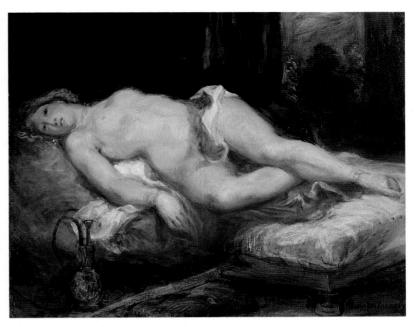

Fig. 13.4 Eugène Delacroix, *Odalisque*. **1845–50**. Oil on canvas, $14\%" \times 18\%"$. © Fitzwilliam Museum, University of Cambridge, England. The comparatively small size of Delacroix's painting lends it a sense of sketchlike immediacy.

mark. In 1854, Delacroix wrote in his journal, "I pity those who work tranquilly and coldly [by whom he means Ingres]. I am convinced that everything they do can only be cold and tranquil." Delacroix preferred what he called "the fury of the

brush," a fury especially evident in paintings such as this one. Described by a contemporary as "plunged deep like sword thrusts," his brushwork in this painting is indeed almost violently sexual.

Thus, Delacroix and Ingres reenact the aesthetic debate that had marked French painting since the time of Louis XIII, the debate between the intellect and emotion, between the school of Poussin and the school of Rubens (see Chapter 10). But Ingres's Neoclassicism and Delacroix's Romanticism entered into this debate not merely as expressions of aesthetic taste but as a political struggle, which already in 1830 had erupted again in a revolution that Delacroix would celebrate in his monumental painting *Liberty Leading the People* (Fig. 13.5).

Three years earlier, after liberals won a majority in the Chamber of Deputies, King Charles X responded by relaxing censorship of the press and government control of education. But these concessions irked him, and in the spring of 1830 he called for new elections. The liberals won a large majority, but Charles was not to be thwarted.

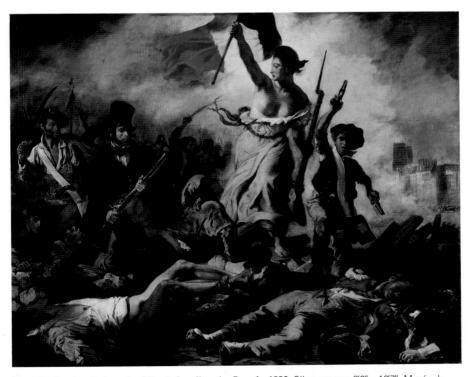

Fig. 13.5 Eugène Delacroix, *Liberty Leading the People*. **1830.** Oil on canvas, 8'6" × 10'7". Musée du Louvre, Paris. Note one of the towers of Notre-Dame Cathedral in the right background of the painting, which contributes to the realism of the image.

On July 25, he dissolved the new Chamber, reinstituted censorship of the press, and restricted the right to vote to the wealthiest French men. The next day, rioting erupted as workers took to the streets, erected barricades, and confronted royalist troops. In the following days, 1,800 people died. Soon after, Charles abdicated the throne and left France for England. In his place, the Chamber of Deputies named the Duke of Orléans, Louis-Philippe, king of their new constitutional monarchy. The two-century-old Bourbon dynasty had fallen.

Delacroix's version of the events of July 1830 is an allegorical representation with realistic details, an emotional call to political action. A bare-breasted Lady Liberty, symbolic of freedom's nurturing power, strides over a barricade, the tricolor flag of the revolution in hand, accompanied by a young street ruffian waving a pair of pistols. On the other side is a middle-class gentleman in his top hat and frock coat, and beside him a man wielding a saber. A worker, dressed in the colors of the revolution, rises from below the barricade. The whole triangular structure of the composition rises from the bodies of two French royalist guards, both stripped of their shoes and one of his clothing by the rioting workers. These figures purposefully recall the dead at the base of Géricault's *Raft of the "Medusa"* (see Fig. 12.23 in Chapter 12).

To the middle-class liberals who had fomented the 1830 revolution, the painting was frighteningly realistic. The new king, Louis-Philippe, ordered that it be purchased by the state, and then promptly put it away so that its celebration of the commoners would not prove too inspiring. In fact, the painting was not seen in public again until 1848, when Louis-Philippe was himself deposed by yet another revolution, this one ending the monarchy in France forever.

Between 1800 and 1848, the city of Paris doubled in size, to nearly 1 million people. Planning was nonexistent. The streets were a haphazard labyrinth of narrow, stifling passageways, so clogged with traffic that pedestrians were in constant danger. The gutters were so full of garbage and raw sewage that cesspools developed overnight in low-lying areas. The odor they produced was often strong enough to induce vomiting. And they bred rats and fleas, both of which carried diseases such as cholera, dysentery, typhus, and typhoid fever. One epidemic in Paris during 1848 and 1849 killed more than 19,000 people. Further complicating the situation, no accurate map of the streets existed prior to 1853, so to venture into them was to set out into unknown and dangerous territory.

By 1848, these conditions prevailed throughout urban areas in Europe, made worse by food shortages and chaos in the agricultural economy. The potato famine in Ireland that killed a million people was merely the worst instance of a widespread breakdown. The agricultural crisis in turn triggered bankruptcies and bank closings, particularly in places where industrial expansion had not been matched by the growth of new markets. In France, prices plummeted, businesses failed, and unemployment was rampant. The situation was ripe for revolution. Soon the streets of Paris were filled with barricades, occupied by workers demanding the right to earn a livelihood and determine their own destiny.

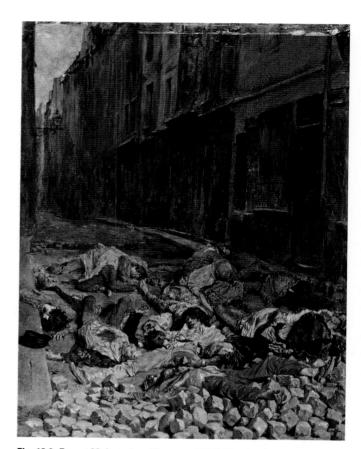

Fig. 13.6 Ernest Meissonier, *Memory of Civil War (The Barricades).* **1849 (Salon of 1850–51).** Oil on canvas, 11½" × 8¼". Musée du Louvre, Paris. Inv. RF1942-31. Meissonier served as a captain of the Republican Guard defending the Hôtel de Ville in the June Days and witnessed the bloodshed with his own eyes. The result is this painting, which a contemporary called an "omelette of men."

The brutal street fighting was so disturbing to Parisians that even such a traditional salon painter as Ernest Meissonier (1815–91), who spent his entire career celebrating French military history, was moved, for once, to depict the truth of battle (Fig. 13.6). The painting is Delacroix's *Liberty Leading the People* stripped of all its glory.

This chapter explores the rise of an increasingly affluent, bourgeois (middle-class) populace in both Europe and the United States, intent on enjoying a style of life far removed from the realities that led to revolution in 1848 and American Civil War. If the paintings of Delacroix and Ingres enacted not only an aesthetic but also a political debate, at the heart of the conflict between the working class and the bourgeoisie were two other often-competing ideologies: liberalism and nationalism. Liberal belief was founded upon Enlightenment values—the universal necessity for equality and freedom at the most basic level. The nationalist agenda, however, focused on regional autonomy, cultural pride, and freedom from monarchical control, especially that of the Habsburgs, who controlled much of central, eastern, and southern Europe. Liberal politics were transnational; nationalism rested upon claims of distinct regional, even local,

ethnic and linguistic identity. These same politics informed the tension between North and South in the United States.

Western nations, revitalized by effective new military, communication, and naval technologies, challenged the cultural identities of other cultures as they sought to expand their influence and reap new economic and political power in far-distant lands during the nineteenth century. The confrontation of Western civilization with other peoples whose values were often dramatically opposed to the West's own—the cultures of China, India, and Japan in particular suggests that by the dawn of the twentieth century, the tradition and sense of centeredness that had defined indigenous cultures for hundreds, even thousands, of years was either threatened or in the process of being destroyed. Worldwide, non-Western cultures suddenly found that they were defined as outposts of new colonial empires developed by Europeans, resulting in the weakening of traditional cultural practices, political leadership, and social systems that had been in place for centuries.

THE NEW REALISM

How did realism manifest itself in nineteenth-century art and literature?

As a result of industrialization, the European workforce increasingly became proletariat—a class of workers who neither owned the means of production (tools and equipment) nor controlled their own work, as opposed to the bourgeoisie, shopkeepers, merchants, and businesspeople. Trades such as clothing and shoe-making, for instance, that had flourished in the West End of London, close to the homes of wealthy customers in the eighteenth century, were replaced by factories, producing goods for the proletariat itself. The introduction of machine manufacture into the textile industry, especially, required fewer skilled workers and more unskilled workers, mostly single young women and widows, who worked for lower wages than men. Some women turned to prostitution as a way to supplement their meager income. In addition, the sexual exploitation of low-paid, uneducated women workers by their male supervisors was commonplace.

Faced with the reality of working-class life, reformist thinkers and writers across Europe reacted by writing polemical works that are meant to be understood as critiques of industrial society. Chief among their targets are the economic engine of the industrial state—its desire to reap a profit at whatever human cost—and the unbridled materialism that, in turn, seemed to drive industrialism's economic engine. This world seemed life-consuming and soul-destroying, a world in which the pulse of machinery was supplanting the pulse of the human heart.

Marxism

Chief among these reformist writers were Karl Marx (1818–83) and Friedrich Engels (1820–95), two young, middle-class

Germans who believed that since the conditions in which one earns a living determined all other aspects of life-social, political, and cultural—capitalism must be eliminated because of its inherent unfairness. Reform was pointlessonly a revolution of the working people would succeed in achieving meaningful change. In fact, Marx and Engels believed revolution was inevitable. The struggle between the bourgeoisie—which Engels defined as "the class of modern capitalists, owners of the means of production and employers of wage labor"—and the proletariat amounted to the conflict between thesis and antithesis—terms derived from the writings of the German philosopher Georg Wilhelm Friedrich Hegel (1770-1831). For Hegel, history proceeds by means of a dialectic: At any given moment, the prevailing set of ideas—the "thesis"—finds itself opposed to a conflicting set of ideas-the "antithesis." This conflict resolves itself in a "synthesis," which inevitably establishes itself as the new thesis, generating its own new antithesis, with the process always moving forward. The ultimate resolution for Marx and Engels lay in the synthesis of a classless society, a utopian society at "the end of history," since the dialectic forces that drive history would then be finally and permanently resolved.

The collaboration of Marx and Engels would ultimately help shape nineteenth- and twentieth-century history across the globe. Their epochal partnership began rather simply in a Parisian café in August 1844, where Marx first met Engels. Marx had been editing a German newspaper and Engels was the heir to his father's textile factory in Manchester, England. The following year, Engels published his Condition of the Working Class in England, a scathing indictment of industrial life, and in early 1848, the two wrote and published a manifesto for the newly formed Communist League in London. In the Communist Manifesto, Marx and Engels argued that class struggle characterized all past societies and that industrial society amplified these class antagonisms. "Society as a whole is splitting up more and more into two great hostile camps, into two great classes directly facing each other: Bourgeoisie and Proletariat."

In its most controversial phrases, the Communist Manifesto called for "the forcible overthrow of all existing social conditions," and concluded, "The proletarians have nothing to lose but their chains. They have a world to win. Working men of all countries, unite." This call to arms would gain support steadily through the ensuing decades, even though Marx and Engels failed to anticipate capitalism's ability to adapt to change and slowly improve the lot of the proletariat. However, the Manifesto, as well as Marx's later Das Kapital (Capital), offered an important testimony to the living conditions of the proletariat and an incisive interpretation of the way capitalism operated.

Literary Realism

The thinking of Marx and Engels actually reflects a widespread concern among social-minded Europeans and Americans for the plight of working people (and, in America, slaves). Chief among their targets were the economic engine of the industrial state—its desire to reap a profit at whatever human cost—and the unbridled materialism that seemed to drive industrialism's economic engine.

Charles Dickens and the Industrial City The novels of the English writer Charles Dickens (1812–70) illuminate the enormous inequities of class that existed in nineteenth-century England, with his heroes and heroines, villains and scoundrels, often approaching the point of caricature. While his sentimentalism sometimes verged on the maudlin, Dickens also had an unparalleled ability vividly to describe English reality. In depicting the lives of the English lower classes with intense sympathy and great attention to detail, Dickens became a leading creator of a new type of prose fiction, literary realism.

In his earliest published book, writing under the pen name Boz, Dickens describes one of the worst slums in London, on Drury Lane (Reading 13.1). A century earlier, it had been a good address, but by the beginning of the 1800s it was dominated by prostitution and gin houses:

READING 13.1

from Dickens, Sketches by Boz (1836)

The filthy and miserable appearance of this part of London can hardly be imagined by those (and there are many such) who have not witnessed it. Wretched houses with broken windows patched with rags and paper; every room let out [rented] to a different family, and sometimes two or even three—fruit and "sweet stuff" manufacturing in the cellars, barners and redherring vendors in the front parlours, cobblers in the back; a bird fancier in the first floor, three families on the second, starvation in the attics, Irishmen in the passage, a "musician" in the front kitchen, and a charwoman and five hungry children in the back one-filth everywhere—a gutter before the houses and a drain behind—clothes drying, and slops emptying from the windows, girls of fourteen or fifteen, with matted hair, walking about barefoot, and in white great-coats, almost their only covering; boys of all ages, in coats of all sizes and no coats at all; men and women, in every variety of scanty and dirty apparel, lounging, scolding, drinking, smoking, squabbling, fighting, and swearing.

The writing style is pure Dickens. Descriptions pile up in detail after detail, in one long sentence, so that the reader, almost breathless at its conclusion, feels overwhelmed, as the author tries to make the unimaginable real. His aim is not simply to entertain, but also to advocate reform.

French Literary Realism: Balzac and Flaubert In France, realist writers such as Honoré de Balzac (1799–1850) and Gustave Flaubert (1821–80) were committed to examining life scientifically—that is, without bias—and describing it in as straightforward a manner as possible. In 1833, Balzac decided to link together his old novels so that they would reflect the whole of French society. He would come to call this series of books *The Human Comedy*. Balzac's plan eventually resulted

in 92 novels, which include more than 2,000 characters. Among the masterpieces are Eugénie Grandet (1833), Father Goriot (Père Goriot) (1834), the trilogy Lost Illusions (1837–43), and Cousin Bette (1846). The primary setting is Paris, with its old aristocracy, new wealth, and rising culture of the bourgeoisie (middle-class shopkeepers, merchants, and businesspeople, as distinct from laborers and wage-earners). The novel is populated by characters from all levels of society—servants, workers, clerks, criminals, intellectuals, courtesans, and prostitutes. Certain individuals make appearances in novel after novel, for instance Eugène Rastignac, a central figure in Father Goriot, who comes from an impoverished provincial family to Paris to seek his fortune, and Henri de Marsay, a dandy who appears in 25 of the novels.

Balzac drew his characters from direct observation: "In listening to these people," he wrote of those he encountered in the Paris streets, "I could espouse their lives. I felt their rags on my back. I walked with my feet in their tattered shoes; their desires, their wants—everything passed into my soul." The story goes that he once interrupted one of his friends, who was telling about his sister's illness, by saying, "That's all very well, but let's get back to reality: to whom are we going to marry Eugénie Grandet?"

The novel Madame Bovary, written by Gustave Flaubert at mid-century, is at its core a realist attack on Romantic sensibility. But Flaubert had a strong Romantic streak as well, for which his Parisian friends strongly condemned him. They suggested that he should write a "down-to-earth" novel of ordinary life, and further suggested that he base it on the true story of Delphine Delamare, the adulterous wife of a country doctor who had died of grief after deceiving and ruining him. Flaubert agreed, and Madame Bovary, first published in magazine installments in 1856, is the result.

The novel's realism is born of Flaubert's struggle not to be Romantic. He would later say, "Madame Bovary—c'est moi!" ("Madame Bovary—that's me!") in testament to his deep understanding of the bourgeois, Romantic sensibility that his novel condemns. Toward the middle of the novel, Emma Bovary imagines she is dying. She has been ill for two months, since her lover Rodolphe ended their affair. Now, she romanticizes what she thinks are her last moments, in a rapturous ecstasy of the kind portrayed by Bernini in *The Ecstasy of Saint Teresa* (Reading 13.2; also see Fig. 10.11 in Chapter 10):

READING 13.2

from Flaubert, Madame Bovary (1856)

One day, when at the height of her illness, she had thought herself dying, and had asked for the communion; and, while they were making the preparations in her room for the sacrament, while they were turning the night table covered with syrups into an altar, and while Felicite was strewing dahlia flowers on the floor, Emma felt some power passing over her that freed her from her pains, from all perception, from all feeling. Her body, relieved, no longer thought; another life was beginning; it seemed to her that her being, mounting

toward God, would be annihilated in that love like a burning incense that melts into vapor. The bed-clothes were sprinkled with holy water, the priest drew from the holy pyx [small box containing the sacrament] the white wafer... The curtains of the alcove floated gently round her like clouds, and the rays of the two tapers burning on the night-table seemed to shine like dazzling halos. Then she let her head fall back, fancying she heard in space the music of seraphic harps, and perceived in an azure sky, on a golden throne in the midst of saints holding green palms, God the Father, resplendent with majesty.

In an 1852 letter describing a dinner conversation earlier in the book between Emma and a young law student who is in love with her, Flaubert wrote: "I'm working on a conversation between a young man and a young lady on literature, the sea, the mountains, music—in short, every poetic subject there is. It could be taken seriously and I intend it to be totally absurd." The same could be said of Emma's faint, in which her paroxysm of religious experience is as staged as her illness itself. Words and phrases such as "an azure sky, on a golden throne" are examples of what Flaubert called le mot juste, "the right word," exactly the precise usage to capture the essence of each situation, in this case a level of cliché that underscores the dramatic absurdity of Emma's experience. Flaubert felt he was proceeding like the modern scientist, investigating the lives of his characters through careful and systematic observation.

Literary Realism in the United States: The Issue of Slavery The issue of slavery haunted American realist writers. They were inspired largely by the abolitionist movement. While the movement had been active in both Europe and America ever since the 1770s (see Chapter 12), it did not gain real momentum in the United States until the establishment of the American Anti-Slavery Society in 1833. The society organized lecture tours by abolitionists, gathered petitions, and printed and distributed anti-slavery propaganda. By 1840, it had 250,000 members in 2,000 local chapters and was publishing more than 20 journals.

One of the most important abolitionist texts of the day is the autobiography of Frederick Douglass (1817–95), Narrative of the Life of Frederick Douglass: An American Slave, published in 1845. The book moves from Douglass's first clear memory, the whipping of his Aunt Hester, which he describes as his "entrance into the hell of slavery," to its turning point, when as a young man Douglass resolves to stand up and fight his master. "From whence came the spirit I don't know," Douglass writes. "You have seen how a man was made a slave; you shall see how a slave was made a man," he says before summing up the fight's outcome (Reading 13.3):

READING 13.3

from Narrative of the Life of Frederick Douglass (1845)

This battle with Mr. Covey was the turning point in my career as a slave. It rekindled the few expiring embers of freedom, and revived within me a sense of my own manhood. It... inspired me again with a determination to be free. The gratification afforded by the triumph was a full compensation for whatever else might follow, even death itself.... I felt as I never felt before. It was a glorious resurrection, from the tomb of slavery, to the heaven of freedom. My long-crushed spirit rose, cowardice departed, bold defiance took its place; and I now resolved that, however long I might remain a slave in form, the day had passed forever when I could be a slave in fact. I did not hesitate to let it be known of me, that the white man who expected to succeed in whipping, must also succeed in killing me.

Douglass guesses at the reason Covey spares him being beaten at the whipping post for raising his hand against a white man: "Mr. Covey enjoyed the most unbounded reputation for being a first-rate overseer and negro-breaker," he says, "... so, to save his reputation, he suffered me to go unpunished." The rest of the book recounts Douglass's escape to New York, and then to New Bedford, Massachusetts, up to the moment that he met William Lloyd Garrison (1805–79), head of the Anti-Slavery Society in Nantucket on August 12–13, 1841, when Garrison heard Douglass speak before large, mostly white audiences. Garrison was so impressed by the speeches Douglass delivered in Nantucket that he immediately enlisted him as a lecturer.

More than 100 book-length slave narratives were published in the 1850s and 1860s. But the most influential abolitionist tract of the day was the novel Uncle Tom's Cabin by Harriet Beecher Stowe (1811–96). It describes the differing fates of three slaves—Tom, Eliza, and George—whose life in slavery begins together in Kentucky. Although Eliza and George are married, they are owned by different masters. In order to live together they escape to free territory with their little boy. Tom meets a different fate. Separated from his wife and children, he is sold by his first owner to a kind master, Augustine St. Clare, and then to the evil Simon Legree, who eventually kills him. Serialized in 1851 in the abolitionist newspaper The National Era, and published the year after, the book sold 300,000 copies in the first year after its publication. Stowe's depiction of the plight of slaves like Tom roused anti-slavery sentiment worldwide and eventually became the best-selling novel of the nineteenth century.

Realist Art: The Worker as Subject

One of the leading proponents of a new realist art was Honoré Daumier (1808–79), an artist known for his political satire who regularly submitted cartoon drawings to daily and weekly newspapers. The development of the new medium of **lithography** made Daumier's regular appearance in

Fig. 13.7 Honoré Daumier, *Rue Transnonain, April 15, 1834.* **1834.** Lithograph, $11\frac{1}{2}$ " × $17\frac{1}{2}$ ". Private collection. A few days after the police killed the residents of 12 rue Transnonain, Daumier exhibited this image in the window of a Paris store, drawing huge crowds.

newspapers possible. He could literally create a drawing and publish it the same day. In his focus on ordinary life, Daumier openly lampooned the idealism of both Neoclassical and Romantic art. No longer was the object of art to reveal some "higher" truth; what mattered instead was the truth of every-day experience, and in Louis-Philippe's France, everyday experience was not always an attractive proposition.

Daumier's Rue Transnonain is not a cartoon; it was, rather, widely understood as direct reportage of the killings committed by government troops during an insurrection by Parisian workers in April 1834 (Fig. 13.7). After a sniper's bullet killed one of their officers, the police claimed it had come from 12 rue Transnonain and they killed everyone inside. Daumier's illustration shows the father of the family, who had been sleeping, lying dead by his bed, his child crushed beneath him, his dead wife to his left and an elder parent to his right. The strong diagonal of the scene draws us into its space, a working-class recasting of Géricault's Raft of the "Medusa" (see Fig. 12.23 in Chapter 12). The impact of such images on the French public was substantial, as the king clearly understood. Louis-Philippe eventually declared that freedom of the press extended to verbal but not pictorial representation.

By focusing on laborers and common country folk rather than on the Parisian aristocracy and bourgeoisie, French realist painting is implicitly political, reflecting the social upheaval that in 1848 rocked almost all of Europe. But Daumier's painting is relatively modest in size. When Gustave Courbet (1819–77) exhibited his painting *The Stone-breakers* (Fig. 13.8) at the Salon of 1850–51, the public was genuinely astonished by the monumental scale of the painting. Such a grand size was usually reserved for paintings of historical events, but Courbet's subjects were the mundane and the everyday.

A farmer's son and largely self-taught artist, Courbet's goal was to paint the world just as he saw it, without any taint of Romanticism or idealism. "To know in order to be able to

Fig. 13.8 Gustave Courbet, *The Stonebreakers.* **1849 (Salon of 1850–51).** Oil on canvas, 5'3" × 8'6". (destroyed in 1945). Galerie Neue Meister, Dresden. © Staatliche Kunstsammlungen Dresden. The painting is believed to have been destroyed during the American fire-bombing of Dresden in World War II.

create," Courbet wrote in his Realist Manifesto of 1855, "that was my idea. To be in a position to translate the customs, the ideas, the appearance of my epoch, according to my own estimation; to be not only a painter, but a man as well; in short, to create living art—this is my goal." In fact, he rejected the traditional political and moral dimensions of realism in favor of a more subjective and apolitical approach to art. This new brand of realism would dominate the art of the following generations.

In The Stonebreakers, Courbet depicts two workers outside his native Ornans, a town at the foot of the Jura Mountains near the Swiss border. They are pounding stones to make gravel for a road. Everything in the painting seems to be pulled down by the weight of physical labor—the strap pulling down across the boy's back, the basket of stones resting on his knee, the hammer in the older man's hand descending, the stiff, thick cloth of his trousers pressing against his thigh, even the shadows of the hillside behind them descending toward them. Only a small patch of sky peeks from behind the rocky ridge in the upper right-hand corner, the ridge itself following the same downward path as the hammer. Together, the older man and his younger assistant seem to suggest the unending nature of their work, as if their backbreaking work has afflicted generation after generation of Courbet's rural contemporaries—"a complete expression of human misery," as Courbet explained it.

Representing Slavery and the Civil War

Many in Europe and across the globe were surprised that war erupted in the United States, believing that some sort of compromise was likely. In no small part, this delusion resulted from a romanticized view of slavery embedded even in abolitionist literature such as *Uncle Tom's Cabin*. For every Simon Legree there is an Augustine St. Clare and his daughter, Little Eva; for every runaway slave, a grateful Christian convert.

A prime example of blindness to the full implications of slavery in antebellum America is evident in the painting Negro Life in the South by Eastman Johnson (1824–1906) (Fig. 13.9). The painting achieved instant success when it was exhibited in New York in 1859. Much of its realism was contributed by the models Johnson employed—the house-hold slaves owned by his father in Washington, D.C.

Negro Life in the South was a curious painting in that it was highly ambiguous—it could be read as either for or against slavery. For some, Johnson's painting seemed to depict slaves as contented with their lot. A banjo-picker plays a song for a mother and child who are dancing together. A young man and woman flirt at the left, while another woman and child look out on the scene from the window above. The white mistress of the house steps through the gate at the right as if to join in the party. However, to an abolitionist, the contrast

The CONTINUING PRESENCE

of the PAST

See Fred Wilson,
Mining the Museum, 1992,
at MyArtsLab

Fig. 13.9 Eastman Johnson, *Negro Life in the South (Kentucky Home)*. **1859.** Oil on canvas, 36" × 45". Collection of the New-York Historical Society. Johnson studied in Europe from 1849 to 1855, culminating in a period in the studio of Thomas Couture in Paris, where Édouard Manet was also a student (see Figs. 13.12 and 13.14).

between the mistress's gown and the more ragged clothing of the slaves, between the dilapidated shed and the finer house behind, demonstrated the sorry plight of the slaves.

But no matter how one interpreted the painting, its aura of peaceful coexistence between the races vanished on October 16, 1859, when John Brown (1800–59), a white abolitionist, led 21 followers, 5 of them African Americans, on a raid to capture the federal arsenal at Harpers Ferry, West Virginia. Their intention was to set off a revolt of slaves throughout the South, but two days later, Lieutenant Colonel Robert E. Lee (1807–79) recaptured the arsenal. Ten of Brown's men were killed in the battle, and he and the rest were hanged.

The prospect of a general slave insurgency, aided and abetted by abolitionists, convinced many in the South that the North was intent on ending slavery, a belief that the election of Abraham Lincoln (1809–65) as president in November 1860 seemed to confirm. And images of contented slaves such as Eastman Johnson had painted in his *Negro Life* seemed to vanish instantly. After the war began in the spring of 1861, Johnson himself began to accompany Union troops to the front. His A *Ride for Liberty: The Fugitive Slaves*, which he painted in 1862 to 1863 from an incident he had witnessed, is entirely different in mood and handling from his earlier painting (Fig. 13.10). The previous sum-

mer, the Confederate army had soundly defeated the North at Bull Run, a stream near Manassas, Virginia. Ever since that defeat, the Northern and Confederate armies had stood their ground between Manassas and Washington, D.C., with only minor skirmishes between the two forces. This delay gave Union commander George B. McClellan the opportunity to train a new Army of the Potomac. His intention in the spring of 1862 was to press on to Richmond, Virginia, and capture the Southern capital. In fact, in late June, before Johnson's painting was completed, now-General Robert E. Lee would drive McClellan away from Richmond, back through Manassas, defeating him once more at Bull Run and moving forward to the outskirts of Washington.

In Johnson's painting, smoke fills the darkening sky. Under the muzzle of the horse, reflections flash off the barrels of the rifles of the advancing Union army. The myth of happy slave families living on Southern plantations is nowhere to be seen as the father urges his horse on, desperate to save his wife and children from the battle. Their drive for liberty, Johnson seems to say, made possible by McClellan's advance, is what the war is all about.

The American Civil War changed the nature of warfare and, in response, the nature of representing war. It was an intensely modern event, mechanized and impersonal in a way that no previous war had been—with hand-to-hand battles, face-to-face, bayonet-on-bayonet being the exception, not the rule. The traditional pageantry of war, "long lines advancing and maneuvering, led by generals in cocked hats and by

Fig. 13.10 Eastman Johnson, *A Ride for Liberty: The Fugitive Slaves*. ca. **1862–63**. Oil on board, 22" × 26¼". Brooklyn Museum of Art, New York. Gift of Gwendolyn O.L. Conkling. The image of a family in flight inevitably evoked associations in viewers' minds with the flight of Mary, Joseph, and the baby Jesus into Egypt, although this is a family of four, not three. (Barely visible is a small child in the arms of its mother.) During the Civil War, over half a million slaves fled from the South, although 4 million remained.

bands of music," as one contemporary put it, was soon a thing of the past.

Photography: Realism's Pencil of Light

Perhaps no medium brought the reality of war home more than the newly discovered medium of photography. The scientific principles required for photography had been known in Europe since at least 1727 when Johann Heinrich Schulze (1684–1744), a German physician, showed that certain chemicals, especially silver halides, turn dark when exposed to light. And the optical principle employed in the camera is essentially the same as that used in the *camera obscura*, an instrument that works by admitting a ray of light through a small hole that projects a scene, upside down, directly across from the hole. While the *camera obscura* could capture an image, it could not preserve it. But in 1839, inventors in England and France discovered a means to fix the image. It was as if the world could now be drawn by a pencil made of light itself.

In England, William Henry Fox Talbot presented a process for fixing negative images on paper coated with light-sensitive chemicals, which he called **photogenic drawing**. In France, a different process, which yielded a positive image on a polished metal plate, was named the **daguerreotype**, after one of its inventors, Louis-Jacques-Mandé Daguerre (1789–1851). Wildly enthusiastic public reaction followed, and the French and English presses reported each advance in great detail.

By the time of the American Civil War, the technology had developed sufficiently that photographic equipment

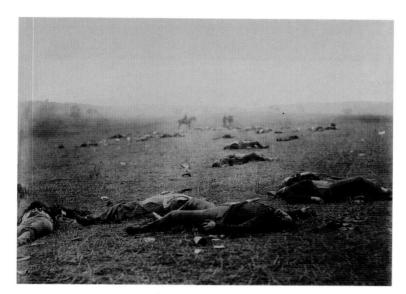

Fig. 13.11 Timothy O'Sullivan (negative) and Alexander Gardner (print), *A Harvest of Death, Gettysburg, Pennsylvania, July 1863*, from Alexander Gardner's *Gardner's Photographic Sketchbook of the War.* 1866. Albumen silver print (also available as a stereocard), 6¼" × 7¹¾6". Courtesy of the Library of Congress. The battle of Gettysburg was the decisive land battle of the American Civil War, a battle that left 51,000 casualties—dead, wounded, captured, or missing—in three days of fighting.

could be transported to the battlefield. On September 19, 1862, Alexander Gardner, an employee of the photographer Mathew Brady (1823–96), visited the battlefield at Antietam, Maryland. Twenty-six thousand Northern and Southern troops had just died in a battle that had no particular significance and decided nothing. Until that day, no American battlefield had ever been photographed before the dead were properly buried, but Gardner took many photographs of the scene. He even rearranged the bodies of the dead for photographic effect—in part a necessity created by the technical limitations of photographing on a smoky battlefield. Gardner's manipulation of scenes for the camera was understood as an attempt to record a more accurate sense of the whole. Brady displayed Gardner's photographs in his New York gallery on Broadway in October—and took full credit for them, to Gardner's dismay. Within a month, Brady was selling the pictures in both album-card size and stereoscopic views.

In July 1863, Gardner, now working on his own, went to the site of the Battle of Gettysburg with an assistant, Timothy O'Sullivan, who shot the most famous photograph to come out of the war, A Harvest of Death, Gettysburg, Pennsylvania (Fig. 13.11). It was published after the war in 1866 in Gardner's Photographic Sketchbook of the War, probably the first booklength photo essay. It is a condemnation of the horrors of war, with the Battle of Gettysburg at its center. O'Sullivan's matter-of-fact photograph is accompanied by the following caption:

The rebels represented in the photograph are without shoes. These were always removed from the feet of the dead on account of the pressing need of the survivors. The pockets turned inside out also show that appropriation did not cease with the coverings of the feet. Around is scattered the litter of the battle-field, accourrements, ammunitions, rags, cups and canteens, crackers, haversacks, and letters that may tell the name of the owner, although the majority will surely be buried unknown by strangers, and in a strange land.

In O'Sullivan's photograph, both foreground and background are purposefully blurred to draw attention to the central corpses. Such focus was made possible by the introduction of albumen paper, which retained a high degree of sharpness on its glossy surface. "Such a picture," Gardner wrote, "conveys a useful moral: It shows the blank horror and reality of war, in opposition to the pageantry. Here are the dreadful details! Let them aid in preventing such another calamity falling upon the nation."

IN PURSUIT OF MODERNITY: PARIS IN THE 1850s AND 1860s

How did French artists and writers attack bourgeois values in the 1850s and 1860s?

Soon after the stunning events of 1848, Pierre-Joseph Proudhon (1809-65), the French journalist who was the first person ever to call himself an "anarchist" and famously coined the phrase "property is theft," wrote: "We have been beaten and humiliated... scattered, imprisoned, disarmed, and gagged. The fate of European democracy has slipped from our hands." Political and moral idealism seemed vanquished. When, in the December 1848 election for president, Charles-Louis-Napoleon Bonaparte (1808–73), the nephew of Napoleon I, was the victor, Proudhon's assessment seemed confirmed. An autocrat, Louis-Napoleon, as he was known, was popular with monarchists and the middle class, who viewed him as a force for restoring order. But following his uncle's lead, the new president staged a coup d'état in 1851, and a year later, he was proclaimed Emperor Napoleon III, a move approved by an overwhelming popular plebiscite (a "yes or no" vote). In fact, the political, moral, and religious emptiness of the bourgeoisie that Napoleon III seemed to embody became the target of a new realism, which criticized what Proudhon called the "fleshy, comfortable" bourgeois lifestyle.

The physical embodiments of this new lifestyle were the new *grands boulevards*, along whose broad sidewalks the bourgeoisie promenaded. The greatest wealth of the city was concentrated here, and so was the city's best shopping. In a memoir of his visit to the Paris Exposition of 1867, Edward King, an American, described how those seeking the trappings of bourgeois life were drawn to these new public venues:

The boulevards are now par excellence the social centre of Paris. Here the aristocrat comes to lounge, and the stranger to gaze. Here trade intrudes only to gratify the luxurious.... On the grands boulevards you find porcelains, perfumery, bronzes, carpets, furs, mirrors, the furnishings of travel, the

copy of Gérome's latest picture, the last daring caricature in the most popular journal, the most aristocratic beer, and the best flavored coffee.

These grands boulevards were the work of the Baron Georges-Eugène Haussmann (1809–91), whom, in 1853, Napoleon III appointed to supervise the daunting task of planning the modernization of Paris by destroying the old city and building it anew—a process that has come to be known as **Haussmannization**. They shared a dream: to rid Paris of its medieval character, transforming it into the most beautiful city in the world. By 1870, their reforms were largely complete, resulting in improved housing and sanitation, and increased traffic flow, all of which encouraged growth in the city's shopping districts. But the vast renovation served another important purpose as well: to prevent the possibility that out-of-control street riots leading to revolutions—like those of 1830 and 1848—would ever happen again.

By widening the streets, Haussmann made it harder to build barricades. By extending long, straight boulevards across the capital, he made it easier to move troops and artillery rapidly within the city. After demolishing the labyrinth of ancient streets and dilapidated buildings that were home to the rebellious working class—25,000 buildings between 1852 and 1859 and after 1860 another 92,000—the government installed enormous new sewers before extending impressively wide boulevards atop them. Great public parks were developed. Before 1848, there were perhaps 47 acres of parkland in Paris, most of it along the Champs-Élysées, but Napoleon III soon opened to the public all the previously private gardens, including the Jardin des Plantes, the Luxembourg Gardens, and the royal gardens. Haussmann amplified this gesture by creating a series of new parks, squares, and gardens. These included the massive redesign of the Bois de Boulogne on the city's western edge and the conversion of the old quarries in the working-class neighborhoods into a huge park with artificial mountains, streams, waterfalls, and a lake, all overlooked by new cafés and restaurants. By 1870, Haussmann had increased the total land dedicated to parks in the city by nearly 100 times, to 4,500 acres.

But the wholesale destruction of working-class neighborhoods throughout Paris had other consequences as well. Almost all of the less expensive housing for workers was erected on the outskirts of the city, and many residents of the demolished areas were subsequently moved to new working-class suburbs. As much as Haussmann wanted to open the city to air and light, he wanted to rid it of crowding, crime, and political disaffection. "Rue Transnonain," he bragged, referring to the site of Daumier's famous lithograph of 1834 (see Fig. 13.7), "has disappeared from the map of the city." The working-class exodus to the outskirts of Paris resulted in a city inhabited almost exclusively by the bourgeoisie and the upper classes. To facilitate further this exodus, Haussmann banned large-scale industry (as opposed to artisan workshops) from the city altogether. By the last quarter of the nineteenth century, Paris had became a city of leisure, a city of the good life, surrounded by a ring of industrial and working-class suburbs, as it remains to the present day.

Charles Baudelaire and the Poetry of Modern Life

The poet Charles Baudelaire (1821–67) recognized the bourgeois crowds on the *grands boulevards* as his audience, but their hypocrisy was his constant target. And his poetry, which was passionately attacked for its unconventional themes and subject matter, was designed to shock bourgeois minds. When Flaubert's *Madame Bovary* first appeared in magazine installments in 1856, its author had been brought to trial, charged with giving "offense to public and religious morality and to good morals." Eight months later, in August 1857, Baudelaire, Flaubert's good friend, faced the same charge for his book of 100 poems, *Les Fleurs du mal*, usually translated "Flowers of Evil." Unlike Flaubert, Baudelaire lost his case, was fined, and was forced to remove six poems concerning lesbianism and vampirism, all of which remained censored for the next century.

The poems in *Les Fleurs du mal* unflinchingly confront the realities of this "underworld" and of life itself. In the poem "Carrion," for example, Baudelaire recalls strolling with his love one day (**Reading 13.4**):

READING 13.4

Charles Baudelaire, "Carrion," in Les Fleurs du mal (1857) (translation by Richard Howard)

Remember, my soul, the thing we saw that lovely summer day?
On a pile of stones where the path turned off, the hideous carrion—

legs in the air, like a whore—displayed indifferent to the last, a belly slick with lethal sweat and swollen with foul gas.

the sun lit up that rottenness as though to roast it through, restoring to Nature a hundredfold what she had here made one.

And heaven watched the splendid corpse like a flower open wide—you nearly fainted dead away at the perfume it gave off.

The poem is an attack on the Romanticized view of death that marks, for instance, Emma Bovary's illusory ecstasy. To look at such reality unflinchingly, with open eyes, is for Baudelaire the central requirement of modern life.

Édouard Manet: The Painter of Modern Life

In 1863, Baudelaire called for an artist "gifted with an active imagination" actively to pursue a new artistic goal: describing the modern city and its culture. Édouard Manet (1832–83) answered the call. Like Baudelaire, he was a *flâneur*. The *flâneur* was a man-about-town, with no apparent occupation, strolling the city, studying and experiencing it coolly, dispassionately. Moving among its crowds and cafés in fastidious and

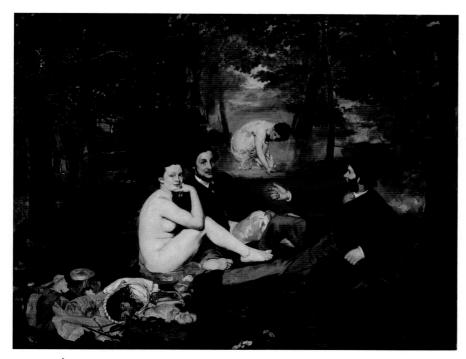

Fig. 13.12 Édouard Manet, Le Déjeuner sur l'herbe (Luncheon on the Grass). 1863. Oil on canvas, 7' × 8'10". Musée d'Orsay, Paris. The model for the reclining young man on the right, whose gesture seems to point simultaneously at both female figures, was Manet's future brother-in-law.

The CONTINUING PRESENCE of the PAST

MyArtsLab

fashionable dress, the *flâneur* had an acute ability to understand the subtleties of modern life and the ability to create art, according to a definitive essay by Baudelaire (**Reading 13.5**):

in contempt, and his greatest devotion is to shocking them. "Il faut épater le bourgeois" ("One must shock the bourgeoisie"), he said. Thus, it came as no surprise to Manet when Le Déjeuner sur l'herbe (Luncheon on the Grass) was rejected by the jury for the Salon of 1863 (Fig. 13.12). It was not designed to please them. The Salon drew tens of thousands of visitors a day to the Louvre and was the world's most prominent art event. The public also reacted with outrage when Manet's painting appeared at the Salon des Refusés, an exhibition hurriedly ordered by Napoleon III after numerous complaints arose about the large number of rejected artworks. While many of the paintings included in the Salon des Refusés were of poor quality, others, including Manet's Le Déjeuner sur l'herbe, were vilified because of their supposedly scandalous content or challenging style. The Paris newspapers lumped them all together: "There is something cruel about this exhibition: people laugh as they do at a farce. As a matter of fact it is a continual parody, a parody of drawing, of color, of composition."

Manet's painting evokes the *fêtes galantes* of Watteau (see Fig. 11.11 in Chapter 11) and a particular engraving executed by Marcantonio Raimondi (Fig. 13.13) after a lost painting designed by Raphael, *The Judgment of Paris* (1520). Manet's three central figures assume the same poses as the wood nymphs seated at the lower right of Raimondi's composition, and so Manet's painting can be understood as a "judgment of Paris" in its own right—Manet judging Paris the city in all its bourgeois

READING 13.5

from Charles Baudelaire, "The Painter of Modern Life" (1863)

Be very sure that this man, such as I have depicted him—this solitary, gifted with an active imagination, ceaselessly journeying across the great human desert—[aims for]... something other than the fugitive pleasure of circumstance. He is looking for that quality which you must allow me to call "modernity"... By "modernity" I mean the ephemeral, the fugitive, the contingent.... This transitory, fugitive element, whose metamorphoses are so rapid, must on no account be despised or dispensed with. By neglecting it, you cannot fail to tumble into the abyss of an abstract and indeterminate beauty.

According to Baudelaire, the *flâneur* is distinguished by one other important trait: his attitude toward the bourgeoisie. He holds their vulgar, materialistic lifestyle

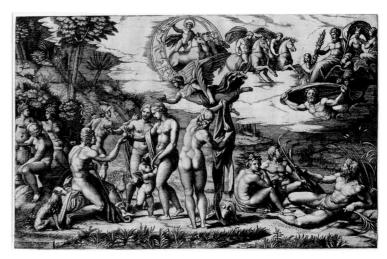

Fig. 13.13 Marcantonio Raimondi after Raphael, *The Judgment of Paris*. ca. 1520. Engraving, 11½6" × 17¾6". Inv. 4167LR. Rothschild Collection. Musée du Louvre, Paris. Paris judges which of the goddesses—Aphrodite, Hera, and Athena—is the most beautiful. His choice has a profound impact, leading as it does to the Trojan War.

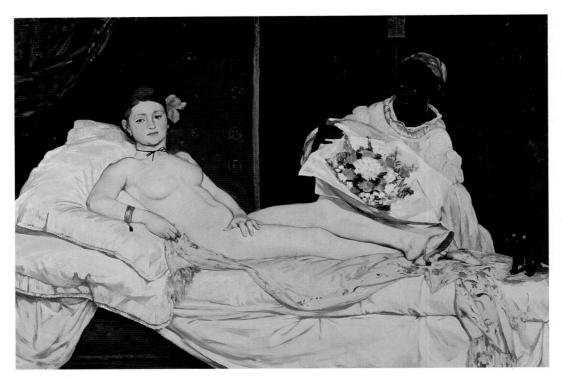

Fig. 13.14 Édouard Manet, *Olympia*. 1863 (Salon of 1865). Oil on canvas, 51" × 74¾". Inv. RF 2772. Musée d'Orsay, Paris. In Titian's *Venus of Urbino* (see Fig. 7.36 in Chapter 7) a dog, symbolizing fidelity, lies at the nude's feet. Here a black cat, symbolizing promiscuity, arches its back as if to hiss in protest at the viewer's arrival.

decadence. It was, in fact, the discord between the seated female's frank nudity—and the fact that she appears to directly confront the gaze of the viewer—and her fully clothed male companions, who seem engaged in a conversation wholly at odds with the sexualized circumstances, that most discomfited the painting's audience. Manet's assault on his fellow Parisians' sensibilities continued in 1863 with *Olympia* (Fig. 13.14), although that painting was not exhibited until the Salon of 1865, where once again it was the object of public scandal and ridicule.

Manet's Olympia is a courtesan, or, more properly, not quite a courtesan. For she possesses the slightly stocky body of the working class—a petite faubourienne, one critic of the day called her, a "little factory girl." Perhaps she is one of the many factory girls who, in 1863, found themselves out of work in Paris, a casualty of the American Civil War. Unable to get raw cotton from the South, the cotton mills of Paris had to shut down. Many girls and women turned to prostitution in order to survive. Viewers at the Salon of 1865 were disturbed by her class—a courtesan satisfied upper-class tastes, prostitutes did not—by the position of her left hand, and, above all, by her gaze. Not only is her gaze as direct as the nude in Le Déjeuner (Manet used the same model in both), but also it is confidently directed down toward us, the viewers. It is as if we have just arrived on the scene, bringing flowers that we have handed to the black maid. We are suddenly Olympia's customers. And if her body is for sale, then we have entered as well into the economy in which human beings are bought and sold—the economy of slavery.

Nationalism and the Politics of Opera

Popular taste in Napoleon III's Second Empire was antithetical to realism, preferring instead the Romanticism of an earlier generation, as illustrated by Emma Bovary's voracious consumption of romantic novels. The dynamics of this confrontation between bourgeois taste and what we have come to call the avant-garde—any group, including artists, on the cutting edge—played itself out in the Second Empire most surprisingly at the opera. As a musical form favored by the aristocracy, and increasingly by the bourgeoisie, opera played an important social as well as musical role in Paris. Established by Louis XIV in 1669, the Académie Nationale de Musique (National Academy of Music) encompassed opera, music, and ballet. The opera was at once a state institution, a symbol of French culture and sovereignty, and a reminder of the country's royal heritage. In a period of rapid change during a century when the aristocracy lost its hold on power throughout Europe, the opera house seemed to be an oasis of conservative stability and aristocratic values. Or it should have been, thought its long-time aristocratic patrons and the nouveau riche (newly rich) bourgeois audience.

Yet change did arrive at the opera in the form of the most creative composers of the period, many of whom were associated with the revolutions of 1848 and the fervent nationalism sweeping the Continent. Since the aristocracy and the bourgeoisie shared a sense of hostility toward liberal nationalism and its notions of social equality and individual rights, a clash between opera's practitioners and audience was bound to happen.

Giuseppe Verdi and the Grand Opera The Italian composer Giuseppe Verdi (1813–1901) led the way in politicizing opera compositions. Verdi believed that opera should be, first of all, dramatically realistic. No longer were arias, duets, or quartets merely displays of the singers' technical virtuosity; rather, they dramatically expressed the characters' temperament or situation in magnificent sustained melodies. A case in point is Verdi's Rigoletto, a tragic opera in three acts, first performed in Venice in 1851, in which the womanizing duke of Mantua, disguised as a student, pays court to Gilda, who, unknown to him, is the daughter of his hunchbacked court jester, Rigoletto. When Rigoletto learns that the duke has seduced her, he conspires to have him killed by a professional assassin, but the plan goes awry when the assassin's sister Maddalena pleads for the duke's life. Because the assassin needs a victim in order to justify his payment, Gilda, who has overheard their conversation, sacrifices her own life to save the duke. For Act III, Verdi composed a quartet in which each of the characters conveys contrasting emotions (see track 13.1). Two scenes are presented simultaneously. The duke tries to seduce Maddalena inside the inn while Rigoletto and Gilda watch from the outside. Rigoletto is demonstrating to the innocent Gilda the duke's moral depravity, and she reacts with shock and dismay. Here a wide range of human emotion occurs in a single scene.

As Italy struggled to achieve national unity, Verdi's operas came to symbolize Italian nationalism. Any time a female lead in his operas would yearn for freedom, the audience would understand her as a symbol of Italian unification, and it would erupt in a frenzy of applause. Even Verdi's name came to be identified with nationalist politics, as an acronym for the constitutional monarchy established in 1861 by Victor Emanuel—V[ictor] E[manuel], R[e] d'I[talia], "Victor Emanuel, King of [a unified] Italy."

To have his operas produced in Paris, Verdi was forced to make changes to satisfy the censors, who were sensitive to nationalist references. He had to accommodate French taste as well. Since all Paris operas traditionally included a secondact ballet, he inserted a gypsy dance around a campfire at an appropriate spot in *Il Trovatore* (*The Troubadour*). *Il Trovatore* (originally premiered in Rome in 1853) was set in Spain and centered on the Count di Luna's young brother, kidnapped and brought up by a gypsy woman, whose own mother had been burned as a witch by the count's father. The secondact ballet was a requirement of the Jockey Club, an organization of French aristocrats who came to the opera after dinner, long after the opera had begun, and expected a ballet when they arrived. As the French journalist Alfred Delvau

explained: "One is more deliciously stirred by the sight of the ballet corps than by the great arias of the tenor in vogue or the reigning prima donna." So Verdi, the most popular opera composer of the day, who also viewed himself as a pragmatist, went along with the idiosyncratic Paris tradition. Considering the large number of Verdi performances in Paris in the 1850s, his changes must have met with success. (In the 1856–57 season, the Théâtre des Italiens in Paris offered 87 performances—54 of them Verdi operas.)

Wagner's Music Drama Meets the Jockey Club The Jockey Club's ability to dictate taste and fashion—which the bourgeoisie anxiously copied—extended, in a notorious example, to Richard Wagner's opera *Tannhäuser* in March 1861. Declaring that his was "the art of the future," Wagner (1813–83) had arrived in Paris in 1859, where he reported that the press found him "arrogant" and guilty of "repudiating all existing operatic music." Nonetheless, he managed to secure Naapleon III's support for a production of *Tannhäuser*, an opera in three acts. Because of the Paris Opéra's rule that foreign works be presented in French, Wagner set about having the opera translated into French.

Tannhäuser's protagonist is a legendary knight minstrel (Minnesinger), the German equivalent of a medieval troubadour. When other minstrels gather for a tournament of song in the great hall of the Wartburg castle, near the Venusberg, a hill in which Tannhäuser has taken refuge for a year under the magic spell of Venus, goddess of love, he insists on returning to Earth in order to compete. Once again he meets his beloved, Elisabeth, who sings to him the famous aria Dich, teure Halle ("Thou, Beloved Hall") (see track 13.2), welcoming him back to the great hall where he formerly sang. She is excited that this beautiful space will once again resonate with music.

Traditionally, the operatic voice carries the melody and the orchestra provides accompaniment. As a result, Wagner felt, the music overwhelmed the text. So, in order to make the text understandable, Wagner shifted the melodic element from the voice to the orchestra. Elisabeth thus sings in a declamatory manner that lies somewhere between aria and recitative, and the orchestra carries the melody, following Elisabeth's shift in mood from ecstatic welcome to sad remembrance of her year-long loss. So radical was this change, the orchestra more or less taking over from the vocalist the primary responsibility for developing the melodic character of the work, that French audiences found Wagner's music almost unrecognizable as opera.

The theme of *Tannhäuser*—the conflicting claims of sexual pleasure and spiritual love—is hopelessly Romantic, which might have appealed to bourgeois and aristocratic French taste, but its music and its approach to the opera as a form did not. Like Verdi, Wagner sought to convey realism, so that his recitatives, arias, and choruses made dramatic sense. And he considered his work a new genre—music drama—in which the actions carried out on stage are the visual and verbal manifestations of the drama created by the instruments in the orchestra, "deeds of music made visible,"

as he put it. This he accomplished by the *leitmotif*, literally a "leading motive." For Wagner this meant a brief musical idea connected to a character, event, or idea that recurs throughout the music drama each time the character, event, or idea recurs. However, as characters, events, and ideas change throughout the action, so do the *leitmotifs*, growing, developing, and transforming.

For a French audience, the music was too new to appreciate fully, and the plot, derived directly from German folklore, was hopelessly foreign. The opera seemed aimed at inflaming French/German hostility. Wagner was informed, furthermore, of the necessity of writing a ballet for the opening of the second act. He refused, although he did agree to begin the opera with a ballet. Already unhappy that an expensive production of a German work was to be staged in their opera, the Jockey Club was doubly outraged that its composer refused to insert the ballet in its traditional place. Wagner seemed nothing short of a liberal nationalist deliberately trying to provoke his conservative French audience.

As rehearsals progressed, the Jockey Club provided its members with silver whistles engraved with the words "Pour Tannhaeuser." They used these whistles in defense of their aristocratic privileges on opening night, March 13, 1861. With Napoleon III present in his box, the Jockey Club interrupted the music for as much as 15 minutes at a time as they hissed and whistled. "The Emperor and his consort stoically kept their seats throughout the uproar caused by their own courtiers," Wagner noted. The opera received the same reception at both its second and third performances. Paris was divided. The composer Berlioz found no virtue in the music, while Baudelaire admired it. After the third performance, which included several lengthy fights and continued whistling from the Jockey Club, Wagner demanded that the opera be withdrawn from performance. The French government accepted its financial losses and agreed.

IMPRESSIONIST PARIS

How did Impressionism transform the traditional style and content of painting?

In July 1870, Otto von Bismarck (1817–98), prime minister of the Kingdom of Prussia, goaded the French emperor Napoleon III into declaring war. Two months later, at the Battle of Sedan, the Germans soundly defeated the French army. The French emperor was imprisoned and exiled to England, where he died three years later. Meanwhile Bismarck marched on Paris, laying siege to the city, forcing its government to surrender in January 1871 after four months of ever-increasing famine during which most of the animals in the Paris zoo were killed and consumed by the public.

Soon Paris found itself once again embroiled in civil war, and once again barricades would fill the streets, as Édouard Manet records in a drawing finished shortly after the events themselves. The new French National Assembly elected in February 1871, at the conclusion of the Franco-Prussian

war, was dominated by monarchists. The treaty it negotiated with Bismarck required France to pay its invader a large sum of money and give up the eastern province of Alsace and part of Lorraine. Most Parisians felt that the assembly had betrayed the true interests of France. In March, they elected a new city government, which they dubbed the Paris Commune, with the intention of governing Paris separately from the rest of the country. In a prelude to civil war, the National Assembly quickly struck back, ordering troops, led by General Lecomte, to seize the armaments of the Commune. By the end of the day, angry crowds in Paris had seized Lecomte and summarily shot him. By nightfall, the National Assembly's troops, and the Assembly itself, had withdrawn to Versailles.

But the National Assembly was not about to let Paris go. Its troops surrounded the city and, on May 8, bombarded it. Paris remained defiant, even festive. Edmond de Goncourt (1822–96), a chronicler of Parisian life, recalled: "I go into a café at the foot of the Champs-Élysées; and while the shells are killing up the avenue... men and women with the most tranguil, happy air in the world drink their beer and listen to an old woman play songs by Thérésa on a violin." Finally, on May 21, as hundreds of musicians entertained crowds in the Tuileries, 70,000 of the assembly's troops stormed the city. Caught unawares, the Communards began erecting barricades, only to discover that Haussmannization allowed the army to outflank them and clear the broad streets with artillery. By May 22, the city was ablaze, and a series of executions began as government troops arrested and killed anyone who seemed even vaguely sympathetic to the Commune. In what become known as "the bloody week," May 21 through May 28, 1871, approximately 20,000 to 25,000 Parisians died. The Commune was crushed, and with it the dreams of an independent Paris.

The 1870s thus began, in France, in a mood that was anything but hopeful. The emperor of the bourgeoisie had been deposed, the country had been humiliated by Prussia, blood had filled the gutters of Paris's streets once again, flowing with the very hopes of the Commune into the sewers that Haussmann had built to make the city a more livable and attractive place. In this atmosphere, many, especially younger artists expressed deep disillusionment with the French art world—the École des Beaux Arts, the Salon, and the Salon des Refusés—seeing it as hopelessly mired in the politics that had led to the disaster of the Commune. Many writers called for the arts to lead the way in rebuilding French culture: "Today, called by our common duty to revive France's fortune," the editor of the Gazette des Beaux-Arts wrote, "we will devote more attention to... the role of art... in the nation's economy, politics, and education."

Moved by such rhetoric, in France a *Société anonyme*—literally, a public corporation—for painters, sculptors, and other artists was founded in December 1873. Membership was open to anyone who contributed 60 francs per year (about \$12, or about \$72 today). Among the founders were the painters Claude Monet (1840–1926), Camille Pissarro (1830–1903), Pierre-Auguste Renoir (1841–1919), Edgar Degas (1834–1917), and Berthe Morisot (1841–95)—initially

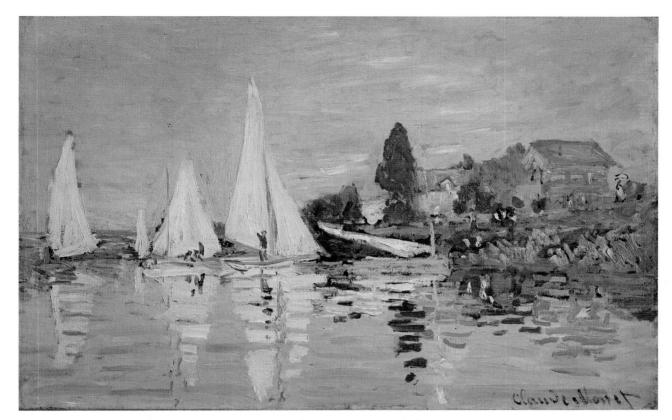

Fig. 13.15 Claude Monet, *The Regatta at Argenteuil.* **ca. 1872.** Oil on canvas, 19" × 29½". Musée d'Orsay, Paris. Monet moved to Argenteuil, a suburb on the Seine just north of Paris, in December 1871, perhaps to leave memories of the Commune behind.

the lone woman in the group. Many of them had served in the military, and their close friend and fellow painter Frédéric Bazille (1841–70) had been killed during the war with Prussia. On April 15, 1874, they held the first of eight exhibitions. The last was held in 1886, by which time the Société had forever changed the face of French painting. In fact, it had transformed Western painting altogether.

Monet's Plein-Air Vision

From the outset, critics recognized that a distinguishing feature of this new group of painters was its preference for painting out-of-doors, en plein air ("in the open air"). The availability of paint in metallic tubes, introduced between 1841 and 1843, was in part responsible. Now paints could be easily transported out-of-doors without danger of drying. It was the natural effect of light that most interested these younger painters, and they depicted it using new synthetic pigments consisting of bright, transparent colors. Before they were ever called "Impressionists," they were called the "École de Plein Air," although the term Impressionist was in wide use by 1876, when the poet Stéphane Mallarmé (1842-98) published his essay "Impressionism and Édouard Manet." (Manet was generally considered the inspirational father of the Impressionists' rejection of Salon painting, although he repeatedly denied invitations to exhibit with them.)

Plein-air painting implied, first of all, the artist's abandonment of the traditional environment of the studio. Of all the Impressionists, Claude Monet was the most insistent that only en plein air could be realize the full potential of his artistic energy. In rejecting the past, the painters of the Société cultivated the present moment, emphasizing improvisation and spontaneity. Each painting had to be quick and deliberately sketchy, in order to capture the ever-changing, fleeting effects of light in a natural setting. He would tell a young American artist: "When you go out to paint, try to forget what objects you have before you—a tree, a house, a field, or whatever. Merely think, here is a little square of blue, here an oblong of pink, here a streak of yellow, and paint it just as it looks to you, until it gives you your own naïve impression of the scene before you." It is not surprising, then, that in Monet's The Regatta at Argenteuil the reflection of the landscape in the water disintegrates into a sketchy series of broad dashes of paint (Fig. 13.15). On the surface of the water, the mast of the green sailboat seems to support a red and green sail, but this "sail" is really the reflection of the red house and cypress tree on the hillside. Monet sees the relationship between his painting and the real scene as analogous to the relationship between the surface of the water and the shoreline above. Both of these surfaces—canvas and water—reflect the fleeting quality of sensory experience.

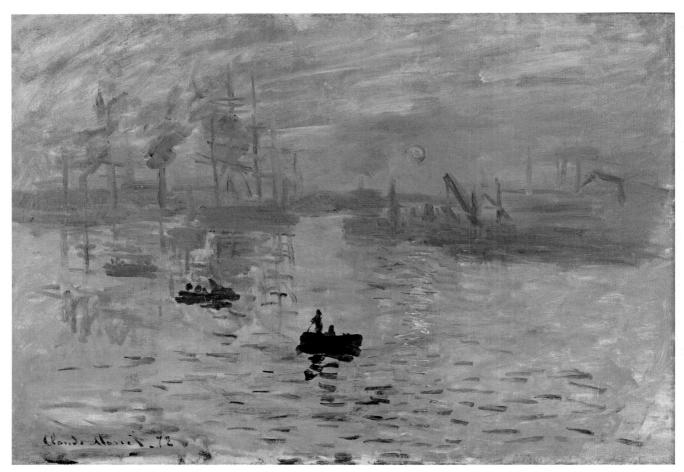

Fig. 13.16 Claude Monet, *Impression: Sunrise*. 1873. Oil on canvas, 19%" × 25½". Musée Marmottan-Claude Monet, Paris. The painting is a view of the harbor in Le Havre, France, on the English Channel.

A painting exhibited by Monet in the first Impressionist exhibition offers more insight into this new approach to art. *Impression: Sunrise* (Fig. 13.16) went a long way toward giving Impressionism its name. The artist applied the paint in brushstrokes of pure, occasionally unmixed, color that evoke forms in their own right. He rendered waves in staccato bursts of horizontal dashes, the reflection of the rising sun on the water in swirls of orange brushstrokes highlighted with white. Violets and blues contrast with yellows and oranges as if to capture the prismatic effects of light. Most of all, one feels the very presence of the painter at work, his hand racing across the surface of the canvas before the morning light vanished. Although Monet would often work and rework his paintings, they seem "of the moment," as immediate as a photograph.

Morisot and Pissarro: The Effects of Paint

Monet's willingness to break his edges with feathery strokes of paint was even more radically developed in the work of Berthe Morisot. Born to a socially well-connected bourgeois family (she was the granddaughter of the Rococo painter Fragonard, noted for his rapid brushwork) (see Fig. 11.15 in Chapter 11), Morisot received an education that included lessons in drawing and painting from

The CONTINUING PRESENCE of the PAST

See Lee nam Lee, The Conversation Between Monet and Sochi, 2009, at MyArtslah

the noted landscape artist Camille Corot. She became a professional painter, and a highly regarded colleague to male artists of her generation. Morisot was the sisterin-law of Manet, and it was she who convinced him to adopt an Impressionist technique of his own. But no one could match her "vaporous and barely drawn lines," as one critic put it. "Here are some young women rocking in a boat," writes a critic of her painting Summer's Day, "... seen through fine gray tones, matte white, and light pink, with no shadows, set off with little multi-colored daubs" (Fig. 13.17). Morisot drapes her bourgeois figures, out for a little recreation, in clothing that is often barely distinguishable from the background, like that worn by the woman in the middle of the boat. She shuns outline altogether—each of the ducks in the water is realized in several broad, quick strokes.

If Morisot's paintings seem to dissolve into a uniform white light, Camille Pissarro's landscapes give us the impression of a view never quite fully captured by the painter. In

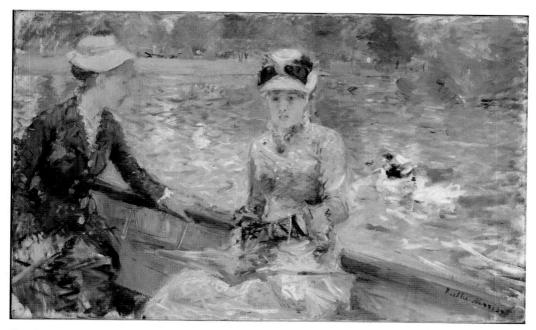

Fig. 13.17 Berthe Morisot, Summer's Day. 1879. Oil on canvas, 18" × 29¾". National Gallery, London. Note the almost arbitrary brushwork that defines the lower halves of the dresses worn by both women, one a set of zigzags, the other a patchwork of straight strokes, emphasizing the distance and difference between the two.

Red Roofs, a random patchwork of red and green, orange and blue appears through a veil of tree branches that interrupt the viewer's vision (Fig. 13.18). Pissarro was deeply inter-

ested in the new science of color theory, and he paid close attention to the 1864 treatise of Michel-Eugène Chevreul (1786-1889), On Colors and their Applications to the Industrial Arts. Chevreul argued that complementary colors of pigment (that is, colors directly opposite each other on the traditional color wheel)—such as red and green, yellow and violet, blue and orangeintensify each other's hue when set side by side. Pissarro adopted a later scheme by the American physicist Ogden Rood, in which the primary colors of light, rather than of pigment, were red, green, and blue-violet. In this he anticipated the color theories that would stimulate Neo-Impressionist painters of the next generation, such as Georges Seurat (see Chapter 14).

Renoir, Degas, Cassatt, and the Parisian Crowd

While Monet and Pissarro concentrated on landscape painting, Pierre-Auguste Renoir and Edgar Degas preferred to paint the crowds in the

cafés and restaurants, at entertainments of all kinds, and in the countryside, to which the middle class habitually escaped at weekends via the ever-expanding railroad lines.

Fig. 13.18 Camille Pissarro, *Red Roofs*, or *The Orchard, Côtes Saint-Denis at Pontoise*. 1877. Oil on canvas, 21½" × 25%". Musée d'Orsay, Paris. When Bismarck advanced on Paris, Pissarro abandoned his home in Louveciennes, on the outskirts of the city, and Bismarck's forces moved in. On rainy days, they created a path across the courtyard with Pissarro's paintings to keep their feet from getting wet. As a result, few of his paintings from before 1871 survive.

Renoir was especially attracted to Chatou, a small village on the Seine frequented by rowers. No longer reserved for the upper class, such riverside settlements became retreats for a diverse crowd of Parisian artists, bourgeoisie, and even workers. Weekend escapes centered on cafés, dance halls, boating, and swimming. Renoir was particularly fond of the Maison and Restaurant Fournaise, a lodging house and restaurant on an island in the river, which served as the setting of Luncheon of the Boating Party (see Closer Look, pages 434-435). In Oarsmen at Chatou (Fig. 13.19), the Restaurant Fournaise is behind us. On the opposite bank of the river is another well-known restaurant, La Mère Lefranc. A sailboat, two single sculls, and a working barge make their way upriver. In the foreground, a rower holds a two-person gig, designed for a rower and a passenger who would steer the boat with two lines attached to the rudder. He gestures as if inviting one of the group on the bank to join him. The man in white is the painter Gustave Caillebotte. The woman is Aline Charigot, Renoir's future wife. As the great historian of French Impressionism Robert L.

Herbert has said of this painting: "Lushness is the word for Renoir's color, as well as the setting: saturated oranges and orange reds against blues and greens.... The picture has the air of a fable, of an ideal world of leisure without work, of sensual pleasure without tarnish." But despite the lushness of Renoir's palette and the loose freedom of his brushwork, the painting, like so many of Renoir's best pictures, is tightly composed. The four figures on the left, together with the sailboat directly above them, form an almost perfect pentagon, from the feet of the two forward figures to the top of the sail. That geometric symmetry contrasts dramatically with the random horizontals and diagonals that make up the right side of the painting. Here is one of the great secrets of Impressionist painting—the looseness and freedom of the brush held in check by orderly design.

Edgar Degas was as dedicated as Renoir to the careful construction of his paintings. Dance Class depicts 21 dancers awaiting their turn to be evaluated by the ballet master, who stands leaning on a tall cane in the middle ground watching a young ballerina making her salute to an imaginary audience (Fig. 13.20). The atmosphere is unpretentious, emphasizing the elaborate preparations and hard work necessary to produce a work of art that will appear effortless on stage. The dancers form an arc, connecting the foreground to the middle ground and drawing the eye quickly through the space of the painting. Degas draws the viewer's attention to the complex structure of his composition—that is, to the fact that he too has worked long and hard at it.

Work is, in fact, one of Degas's primary themes, and it is no accident that the ballet master leans on a cane—as a former

Fig. 13.19 Pierre-Auguste Renoir, *Oarsmen at Chatou.* **1879.** Oil on canvas, $31^{15}/6^{\circ} \times 39^{\circ}/6^{\circ}$. Photograph © National Gallery of Art, Washington, D.C. Gift of Sam A. Lewisohn. 1951.5.2. The man in the boat may be Renoir's brother Edmond.

Fig. 13.20 Edgar Degas, *Dance Class.* **ca. 1874.** Oil on canvas, 32¾" × 30¼". The Metropolitan Museum of Art, New York. Bequest of Mr. and Mrs. Harry Payne Bingham, 1986 (1987.47.1). The dance instructor is Jules Perrot, the most famous male dancer of the middle third of the century, whose likeness Degas took from a photograph of 1861.

dancer, he is understood to be physically impaired from a dance injury. Degas also understood that the young women he depicted were, in fact, full-time child workers, mired in the monotony of répétition, which in French is the word for both "repetition" and "rehearsal." Almost all were from lower-class families and normally entered the ballet corps at age seven or eight when their schooling ceased, leaving most of them illiterate. They had to pass examinations, such as the one Degas depicts here, in order to continue. By the time they were nine or ten, they might earn 300 francs a year (approximately \$60 in 1870, with a buying power of about \$400 today). If and when they rose to the level of performing brief solos in the ballet, they might earn as much as 1,500 francs more than most of their fathers, who were shop clerks, cab drivers, and laborers. Should they ever achieve the status of première danseuse, in their late teens, they might earn as much as 20,000 francs, a status, like today's richly compensated professional athlete, that few reached but all dreamed of. Thus, Degas's Dance Class presents young women in a moment of great stress, struggling in a world in which only the most able survived.

When the American painter Mary Cassatt (1844–1926) moved to Paris in 1874, Degas quickly befriended her. Participating in the Impressionist exhibitions in 1879, 1880, and 1881, Cassatt was a figure painter, concentrating almost exclusively on women in domestic and intimate settings. Among her most famous works are paintings of women at the Paris Opéra. In the Loge is a witty representation of Opéra society (Fig. 13.21). A woman respectably dressed all in black peers through her opera glasses in the direction of the stage. Across the way, a gentleman in the company of another woman leans forward to stare through his own glasses in the direction of the woman in black. Cassatt's woman, in a bold statement, becomes as active a spectator as the male across the way. She is a "modern" woman, and Cassatt celebrates her modernity.

THE AMERICAN SELF

What are the characteristics of the American self as it develops in the nineteenth century?

From 1870 to 1900, New York City was a boomtown of extraordinary diversity. Its port handled most of America's imports and roughly 50 percent of the country's exports. As the nation's financial center, the city teemed with lawyers, architects, engineers, and entrepreneurs of every nationality. In 1892, 30 percent of all millionaires in the United States lived in Manhattan and Brooklyn, side by side with millions of the nation's working-class immigrants. By 1900, fully three-quarters of the city's population was foreign-born, having arrived via Ellis Island, which opened in 1892. Italians, Germans, Poles, and waves of Jews from Hungary, Romania, Russia, and Eastern Europe sought the unlimited opportunities they believed were to be found in America. Many stayed in New York City. As the twentieth century dawned,

Fig. 13.21 Mary Cassatt, *In the Loge*. 1878. Oil on canvas, 32" × 26". Museum of Fine Arts, Boston. The Hayden Collection—Charles Henry Hayden Fund, 10.35. Photograph © 2014 Museum of Fine Arts, Boston. This was the first of Cassatt's Impressionist paintings to be displayed in the United States. American critics thought the picture a promising sketch, but not, as the Impressionist Cassatt intended, a finished painting.

these immigrants, and their descendants, would dramatically change American culture.

The conditions of town life could be, in fact, harsh. Widespread fraud and corruption contributed to the impoverishment of the working class, but so did the profit motive that drove the industrial sector of the economy. By 1890, 11 million of the nation's 12 million families had an average annual income of \$380, well below the poverty line (\$380 would buy about the same as \$9,500 today). Sudden, unexpected events also precipitated widespread economic hardship, as occurred in September 1873, when a Philadelphia banking firm failed, causing investors to panic, banks to shut down, and the New York Stock Exchange to close for ten days. Millions of American workers found themselves without jobs in the 1870s, while business owners began cutting wages—an oversupply of employees meant cheaper labor. Many lost their savings as well as their jobs when unregulated banks, insurance companies, and investment firms went out of business while federal and state governments stood by. As the unemployment rate in New York and other cities passed 25 percent, famine and starvation in the "land of opportunity" became a reality.

It should not be surprising that workers developed new forms of collective action in this harsh economic environment.

CLOSER LOOK

enoir's Luncheon of the Boating Party required the painter to take a slightly different tack than was usual for him. We can identify many of the figures from his circle of friends and acquaintances at Chatou, including members of the Fournaise family at whose restaurant the painting is set. To represent such recognizable figures, Renoir had to abandon the gestural brushwork of Monet and Pissarro except in the background landscape. He composed his figures with firm outlines and modeled them in subtle gradations of light and dark, which clearly define their anatomical and facial features. And he carefully structured the group in a series of interlocking triangles, the largest of which is made up of

Aline Charigot, his future wife, sitting at the table holding her dog. Scholars believe that the painting, begun in the summer of 1880, may represent Renoir's response to Émile Zola's critique in his review of the 1880 Salon charging the Impressionists with selling "sketches that are hardly dry" and challenging them to make more complex paintings that would be the result of "long and thoughtful preparation." For this reason, the theory goes, Renoir assimilates into this single work landscape, still life, and genre painting in a manner probably intentionally recalling seventeenth-century Dutch and Flemish paintings like Rubens's *The Kermis* (see Fig. 10.28 in Chapter 10), which Renoir would have seen at the Louvre.

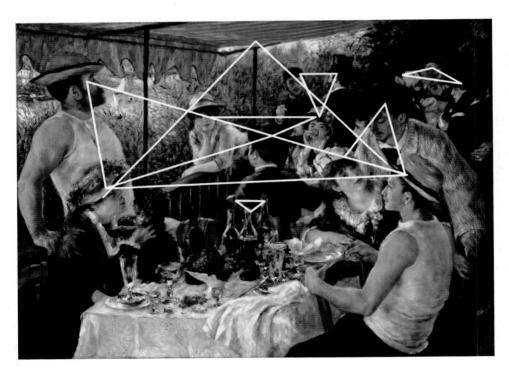

Grounding the interplay of triangles upon which Renoir's painting is based is the still-life composition of three bottles in the center of the table. Outlined here are the various sets of triangular relationships determined by groupings of figures and their visual or verbal interchanges. While the entire composition moves off into space at an angle from left to right, another compositional pyramid is formed by the angles of Caillebotte's and Charigot's hats, meeting roughly at the top of the post supporting the awning at the top middle of the painting.

Something to Think About...

Given the wide variety of people in this composition, how might you describe its social politics? In other words, what sort of broader society does it suggest?

Renoir's Luncheon of the Boating Party

Pierre-Auguste Renoir, *Luncheon of the Boating Party.* **1880–81.** Oil on canvas, 51½" × 69½". Acquired 1923. Phillips Collection, Washington, D.C.

Leaning against the rail and overseeing the entire luncheon is Alphonse Fournaise, son of the restaurant's proprietor.

Alphonsine Fournaise, the proprietor's daughter, rests her elbow on the railing. She is talking with Baron Raoul Barbier, Renoir's friend and a notorious womanizer.

The Italian journalist Adrien Maggiolo, the only male not wearing a hat, leans over an actress by the name of Angèle Legault and the painter Gustave Caillebotte. Maggiolo was a writer for *Le Triboulet (The King's Dunce)*, a journal dedicated to theater and cabaret in Paris.

Charles Euphussi, in the top hat, editor of the *Gazette des Beaux-Arts*, and an avid art collector, chats with a young man in a mariner's cap, perhaps the poet Jules Laforgue, who served as Euphussi's personal secretary.

The actress Jeanne Samary, a star of the Comédie Française, covers her ears as two of Renoir's best friends, the writer Paul Lhote, in the red-striped hat, and Eugène Pierre Lestringuez, who had known Renoir since childhood, flirt with her.

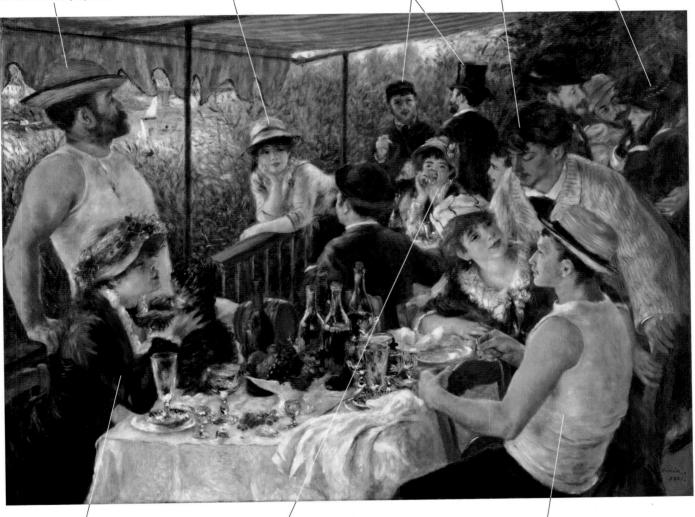

Renoir would marry Aline Charigot in 1890. Serving as their witnesses were Lhote and Lestringuez, depicted in the opposite corner of the painting flirting with the actress Jeanne Samary.

The actress Ellen Andrée was a close friend of Aline Charigot. She performed in the most avant-garde plays of the day at the Théâtre-Libre.

At age 32, when Renoir painted this scene, Caillebotte was the youngest of the Impressionists. He was also by far the wealthiest, having inherited his father's considerable fortune, and he thought it his God-given duty to support his Impressionist colleagues. As a result, he amassed a very substantial collection of works by Degas, Paul Cézanne, Manet, Monet, Pissarro, Renoir, and Alfred Sisley, which he bequeathed to the state upon his death in 1894. His bequest—Renoir was his estate's executor—became the basis for the great collection of Impressionist painting today housed in the Musée d'Orsay in Paris.

Fig. 13.22 Robert Koehler, *The Strike*. 1886. Oil on canvas, $5'11\%'' \times 9\%''$. Deutsches Historisches Museum, Berlin. Koehler's father was a machinist, and he identified with the plight of the working class. The painting was exhibited at the National Academy of Design in 1886, to general approval.

Impromptu strikes, walkouts, and the beginnings of organized labor unions signaled the changing economic and social climate. When the Baltimore & Ohio Railroad cut wages in 1877, its workers staged spontaneous strikes, which spread rapidly to other railroads. In Baltimore, the state militia shot and killed 11 strikers and wounded 40 others.

Owners of railroads and other corporations, together with the political leaders they supported, made sure wage reductions remained in place. The federal government aided them when the U.S. War Department created the National Guard as a quick-reaction force to put down future disturbances. It was an era of unparalleled political unrest, and The Strike by Robert Koehler (1850–1917) suggests something of the mood of the workers and their bosses, as well as the grim environment of industrial-age America (Fig. 13.22). The painting depicts an angry crowd confronting an employer, demanding a living wage from the stern top-hatted man and a worried younger man standing behind him. An impoverished woman with her children looks on at the left; another woman, more obviously middle class, tries to talk with one of the workers, but behind him a striker bends down to pick up a stone to throw. Koehler's realism is evident in the diversity of his figures, each possessing an individual identity. But the background of the work, with its smoky, factory-filled landscape on the horizon, owes much to the Impressionist style.

The May 1, 1886, issue of *Harper's Weekly* included the painting as its central feature. On the same day, a national strike called for changing the standard workday from 12 hours to 8. More than 340,000 workers stopped work at 12,000 companies across the country. In Chicago, a bomb exploded as police broke up a labor meeting in Haymarket

Square. A police officer was killed by the blast and police retaliated, firing into the crowd of workers, killing one and wounding many more. Four labor organizers were charged with the policeman's death and subsequently hanged, demoralizing the national labor movement and energizing management to resist labor's demands.

The Romantic Song of the American Self: Landscape and Experience

The alienation of the urban worker contrasted sharply with the national belief in the healing power of the natural world, so remote, it seemed, from the reality of the factory and tenement. In the first half of the nineteenth century, the American wilderness had inspired a sense of wonder at the natural world, with which American writers shared with

artists like Thomas Cole (1801–48) and Asher B. Durand (1796–1886) an almost ecstatic communion. In many ways, they were shaped by the nation's emphasis on individualism and individual liberty. Free to think for themselves, their imaginations were equally free to discover the self in nature.

The Hudson River Painters Born in England in 1801, Thomas Cole, who would come to be known as the founding father of American landscape painting, emigrated with his family to America in 1818. By 1824, he was painting regularly in the Hudson River valley north of New York City. He loved, especially, Kaaterskill Clove, a deep gorge carved by a stream emptying two lakes at the top of the Catskill escarpment, southwest of Albany, and in 1836 he moved to Catskill, New York, nestled on the left side of the river, just below the escarpment itself. His chief subject, he said, was the tension between "the improvements of cultivation and the sublimity of the wilderness," and no painting better captures that tension than The Oxbow (Fig. 13.23). It shows a famous bend in the Connecticut River in Massachusetts, which describes the boundary between the cultivated fields below and the wilderness of Mt. Holyoke, upon which Cole has positioned himself, going so far as to paint himself into the scene—he is at his easel below the rocks to the left of his pack and umbrella. Thus he acts as mediator between the neatly fenced sunny fields of the valley below and the rugged wilderness behind him, symbolized by the blasted tree stump and the dark clouds of the thunderstorm in the distance.

When Cole died unexpectedly from pneumonia in 1848, he was eulogized by his long-time friend the poet William Cullen Bryant (1794–1878). "To us who remain," Bryant lamented, "the region of the Catskills, where he wandered

Fig. 13.23 Thomas Cole, *The Oxbow (View from Mount Holyoke, Northampton, Massachusetts, After a Thunderstorm*). **1836.** Oil on canvas, 4'3½" × 6'4". The Metropolitan Museum of Art, New York. Gift of Mrs. Russell Sage, 1908 (08.228). The painting suggests, as the storm departs to the left, that civilization will eventually overwhelm the wilderness, a prospect Cole anticipated with distress.

and studied and sketched, and wrought his sketches into such glorious creations, is saddened by a certain desolate feeling, when we behold it or think of it. The mind that we knew was abroad in those scenes of grandeur and beauty, and which gave them a higher interest in our eyes, has passed from the earth, and we see that something of power and greatness is withdrawn from the sublime mountain tops and the broad forests and the rushing waterfalls." Upon hearing Bryant's eulogy, the New York City art collector Jonathan Sturges (1802–74) immediately commissioned Cole's friend and fellow-painter Durand to paint the poet and the painter standing together in Kaaterskill Clove (Fig. 13.24). The two are depicted as "kindred spirits," a reference to the English romantic poet John Keats's "Sonnet to Solitude," in which Keats imagines how the wild beauties of the natural world—there "where the deer's swift leap / Startles the wild bee from the foxglove bell"—are even sweeter when shared with a friend: "it sure must be/ Almost the highest bliss of human-kind,/ When to thy haunts two kindred spirits flee." They stand on a rock outcropping that, like the brush in Cole's hand, points up the gorge; the course of the meandering creek is mirrored in the crooked branches of the tree that frames the top of the painting; an American bald eagle floats over the scene; tree trunks presumably shattered by lightning, wind, or both testify to the force of raw nature, as do the boulders that have tumbled into the stream. The two figures represent the highest order of civilization, but they are shown taking their inspiration from the wilderness itself.

Fig. 13.24 Asher B. Durand, *Kindred Spirits*. 1848. Oil on canvas, $44^{\prime\prime} \times 36^{\prime\prime}$. Crystal Bridges Museum of American Art, Bentonville, AK. As if to comment ironically on the desecration of the wilderness wrought by the burgeoning tourist industry in the Hudson River valley, Durand has painted, as if carved into the birch tree at the left, the names "Bryant" and "Cole."

Emerson, Thoreau, and the Transcendental Self In 1834, a 31-year-old minister, disenchanted with institutionalized religion and just back from England, where he had encountered Coleridge and heard Wordsworth recite his poetry, moved to the village of Concord, Massachusetts. Over the next several years, Ralph Waldo Emerson (1803–82), a Unitarian minister, wrote his first book, Nature, published anonymously in 1836. The book became the intellectual beacon for a group of Concord locals, mostly ministers, that became known as the "Transcendental Club." They all felt that the human spirit was possessed of a certain oneness with nature, an attitude that informs the most famous passage of Nature, when Emerson outlines the fundamental principle of transcendental thought: In the direct experience of nature, the individual is united with God, thus transcending knowledge based on empirical observation (Reading 13.6):

READING 13.6

from Ralph Waldo Emerson, *Nature*, Chapter 1 (1836)

Crossing a bare common, in snow puddles, at twilight, under a clouded sky, without having in my thoughts any occurrence of special good fortune, I have enjoyed a perfect exhilaration. Almost I fear to think how glad I am. In the woods too a man casts off his years, as the snake his slough, and at what period soever of life, is always a child. In the woods, is perpetual youth. Within these plantations of God, a decorum and sanctity reign, a perennial festival is dressed, and the guest sees not how he should tire of them in a thousand years. In the woods, we return to reason and faith. There I feel that nothing can befall me in life, -no disgrace, no calamity (leaving me my eyes,) which nature cannot repair. Standing on the bare ground,—my head bathed by the blithe air, and uplifted into infinite space,—all mean egotism vanishes. I become a transparent eye-ball. I am nothing. I see all. The currents of the Universal Being circulate through me; I am part or particle of God.

The sense of the self at the center of experience—the "eye/I" is also the sense of individualism and self-reliance fundamental to transcendental experience. In fact, in one of his most famous essays, "Self-Reliance," Emerson would declare, "Whoso would be a man must be a nonconformist.... Nothing is at last sacred but the integrity of your own mind." Of all Emerson's contemporaries, none fit this description better than Henry David Thoreau (1817-62). Educated at Harvard, Thoreau was fiercely independent. He resigned his first job as a schoolteacher in Concord because he refused to inflict corporal punishment on his students. He became one of the nation's most vocal abolitionists and was briefly jailed for refusing to pay a poll tax to a government that tolerated slavery. But most famously, for two years, from 1845 to 1847, he lived in a small cabin that he built himself, on Emerson's property at Walden Pond. This experience spawned Walden, or Life in the Woods, a small book published in 1854, dedicated to teaching the

satisfactions and virtues of living simply and wisely in communion with nature. Thoreau's woods are the same woods that Emerson extols in *Nature*. Thoreau writes (Reading 13.7):

READING 13.7

from Henry David Thoreau, Walden, or Life in the Woods, Chapter 2 (1854)

I went to the woods because I wished to live deliberately, to front only the essential facts of life, and see if I could not learn what it had to teach, and not, when I came to die, discover that I had not lived.... I wanted to live deep and suck out all the marrow of life, to live so sturdily and Spartan-like as to put to rout all that was not life.... Time is but the stream I go a-fishing in. I drink at it; but while I drink I see the sandy bottom and detect how shallow it is. Its thin current slides away, but eternity remains.

The eccentricities of Thoreau's life are matched by the inventiveness of his prose, and in the end, Thoreau's argument is for what he calls "the indescribable innocence and beneficence of Nature."

As powerful and as transformative as nature was, Thoreau viewed it as vulnerable to human encroachment, an insight that proved him far ahead of his time. He worried, for instance, that the railroad had destroyed the old scale of distances, a complaint shared by many of his contemporaries. His understanding of the environment's vulnerability and humanity's role in conserving or degrading it illustrates Thoreau's other enduring influence on American literary culture—as a powerful social conscience and spokesman, especially for the environment.

Walt Whitman and the American Self There is no better human symbol for the restless, ambitious American self in the nineteenth century than the poet Walt Whitman (1819–92), who revolutionized American literature as he linked the Romantic, Transcendental, and Realist movements. Whitman was a confirmed New Yorker. He eventually gained fame with his portraits of the city's environment and people. He celebrated the sense of urgency and vigor conveyed by the urban atmosphere in "Crossing Brooklyn Ferry" (Reading 13.8):

READING 13.8

from Walt Whitman, "Crossing Brooklyn Ferry" (1856)

Come on, ships from the lower bay! pass up or down, white-sail'd schooners, sloops, lighters!

Flaunt away, flags of all nations! be duly lower'd at sunset! Burn high your fires, foundry chimneys! cast black shadows at nightfall! cast red and yellow light over the tops of the houses!...

Thrive, cities—bring your freight, bring your shows, ample and sufficient rivers,

Expand....

New York City was the very embodiment of the vast American possibilities that Whitman celebrated in *Leaves of Grass*, the long and complex volume of poems that he self-published in 1855 and continuously revised until 1892. It started out as a slim volume of 12 poems and grew to more than 400 as the author's life changed and as he grew into his self-defined role as "the American poet," speaking for the common man. In the first few years, *Leaves* was not received favorably and it did not sell many copies. But within a decade, new editions became a commercial success and the foundation of his growing reputation as the nation's most important poet. In "Song of Myself," the first and eventually longest of the poems, Whitman spoke to his own and the country's diverse experiences (Reading 13.9):

READING 13.9

from Walt Whitman, "Song of Myself," in Leaves of Grass (1867)

I am large, I contain multitudes....
Of every hue and cast am I, of every rank and religion,
A farmer, mechanic, artist, gentleman, sailor, quaker,
Prisoner, fancy-man, rowdy, lawyer, physician, priest.
I resist anything better than my own diversity....

Whitman openly embraced all Americans in "Song of Myself," from immigrants to African Americans and Native Americans, from male to female, and from heterosexual to homosexual. He celebrated all forms of sexuality, a fact that shocked many readers. One early reviewer called *Leaves* "a mass of stupid filth" and its author a pig rooting "among a rotten garbage of licentious thoughts." And in 1865, Whitman, who worked at the U.S. Interior Department as a clerk, was fired by his boss, the Secretary of Interior, for having violated in that work "the rules of decorum and propriety prescribed by a Christian Civilization."

"Song of Myself" consists of 52 numbered sections with the "I" of the narrator serving as a literary device for viewing the experiences of one man as representative of multitudes. Leaves of Grass is therefore a subjective epic. "Remember," Whitman would tell a friend late in his life, "the book arose out of my life in Brooklyn and New York.... absorbing a million people for fifteen years, with an intimacy, an eagerness, an abandon, probably never equaled."

By the time Whitman issued his final ("deathbed") edition of Leaves of Grass in 1892, the work had grown from 96 printed pages in the 1855 edition to 438. He would come to anguish over the personal suffering of the soldiers who fought in the Civil War in "Drum Taps," and mourn the death of Abraham Lincoln in "When Lilacs Last in the Dooryard Bloom'd," both added to the 1867 edition. To celebrate the opening of the Suez Canal, he added to the 1876 edition the long "Passage to India." Leaves of Grass, in other words, was as expansive and as ever-changing as its author.

THE CHALLENGE TO CULTURAL IDENTITY

What was the impact of Western imperial adventuring on the non-Western world?

The expansive spirit of Whitman did not come without a certain cost. It was this same spirit that fueled economic and political imperialism not only in the United States but around the world. During the second half of the nineteenth century, European nations competed with each other in acquiring territories in Asia, Africa, Latin America, and elsewhere around the globe. In some cases, their management of these areas was direct, with a colonial political structure supervising the governance of the territory. In other cases, control was indirect, focusing on economic domination. The world is still living with the consequences more than a century later.

The Fate of the Native Americans

The first consistent interactions between Native peoples and Europeans in North America occurred during the seventeenth century, but from 1790 to 1860 the population of nonnative-born Americans increased from 4 million to 31 million, with nearly half of them moving to territory west of the Atlantic coast states. America's frontier shifted into regions where the possibilities (and natural resources) seemed limitless. "Go West, young man, and grow up with the country," Indiana journalist John Soule had advised in 1851. The influential New York journalist Horace Greeley (1811-72) took up the first part of the refrain, and soon it became obvious that the American West would be central to America's self-identity. Unfortunately, the original inhabitants of the lands were only an afterthought to artists, political leaders in Washington, and most of all the settlers themselves. Native American culture and tribal identities were almost entirely ignored and disparaged in the process of "going West."

The ultimate fate of tribes was inextricably linked to the fate of the buffalo. By the 1870s, the military was pursuing an unofficial but effective policy of Native American extermination, and it encouraged the slaughter of the buffalo as a shortcut to this end. General Philip Sheridan (1831-88) urged that white settlers hasten the killing of buffalo herds, thereby undercutting the Native American supply of food. The effort to build a transcontinental railroad helped Sheridan's wish to be realized, as over 4 million buffalo were slaughtered by meat hunters for the construction gangs, by hide hunters, and by tourists. In the late summer of 1873, the railroad builder Granville Dodge reported that "the vast plain, which only a short twelvemonth before teemed with animal life, was a dead, solitary, putrid desert." The end of the buffalo signaled the end of Native American culture.

By 1889, the crisis had come to a head. A Paiute holy man by the name of Wavoka declared that if the Indian peoples lived peaceably, if they performed a new circle dance called the "Ghost Dance," the world would be transformed into what it once had been, populated by great herds of buffalo and the ancestral dead. White people would disappear, and with them alcohol, disease, and hunger. Across the West, the message was adopted by various tribes, and the costumes associated with the dance were particularly beautiful. An Arapaho Ghost Dance dress (Fig. 13.25) is decorated with five-pointed stars, no doubt derived, in their design, from the American flag, but also a long-standing symbol in Native American culture of the cosmos. The voke is decorated with a woman and two eagles, one on each side of her. She holds a peace pipe in one hand and a branch in the other. The turtle in the lower section of the dress refers to a myth of origin, in which the turtle brings soil for the world's creation out of the primal waters. The birds on the skirt, magpies in this case, represent messengers to the spirit world. Many Plains Indians also believed that the Ghost Dance costumes had the power to protect them from harm, and thus left them immune to gunfire or other attack.

That belief would come to an end at Wounded Knee Creek, South Dakota, on December 29, 1890. The white population, paying little attention to the fact that their presumed "disappearance" was predicted to be wholly nonviolent, soon reacted with fear and hostility. More than 200 participants in the Ghost Dance were massacred by the Seventh Cavalry of the U.S. Army at Wounded Knee that day, despite their dress, and, at least symbolically, Native American culture on the Great Plains came to an end. A Crow warrior named Two Legs put it this way: "Nothing happened after that. We just lived. There were no more war parties, no capturing horses from the Piegan (tribe) and the Sioux, no buffalo to hunt. There is nothing more to tell."

The British in China and India

While not posing a threat to the actual existence of China and India, Western nations sought to dominate them through aggressive military and economic policies aimed at transferring wealth to their own countries and limiting their sovereignty. During the eighteenth century, both the English East India Company and the French Compagnie des Indes (French East India Company) vied for control of trade with India and the rest of Asia even as they engaged in ruthless competition in Europe and North America. In fact, India's trade was seen as the stepping-stone to even larger markets in China, whose silks, porcelains, and teas were highly valued throughout Europe and America. Rather than being mutually beneficial, however, trade with the West was a profound threat to local, regional, and national leaders in both China and India. Before the end of the nineteenth century. both countries would become outposts in new colonial empires developed by Europeans, resulting in the weakening of traditional cultural practices, political leadership, and social systems.

The European taste for *chinoiserie* (see Chapter 11) had created a bustling export economy in China during the eighteenth century, but more important to the

Fig. 13.25 Arapaho artist, Ghost Dance dress. **1890s**. Buckskin and pigments. Museum of the North American Indian, New York. By the 1890s, hides had become scarce enough that many Ghost Dance dresses were made of cloth—even old flour sacks.

Westerners than the Chinese wares was the opium trade. In order to compensate for the gold and silver spent on the purchase of tea, porcelains, and silks, the British East India Company began selling to the Chinese large quantities of opium, which it grew in India. Produced at a very low cost, opium was a very profitable trade item for the British. Unfortunately for the Chinese, opium addiction rapidly became a severe social problem. In 1839, after the emperor's son died an opium-related death, the Chinese moved to ban the drug.

The British acknowledged that the Chinese had the right to prohibit the Chinese from using opium, but they considered this ban on trading it an unlawful violation of the freedom of commerce. They declared war and subsequently crushed China, attacking most of its coastal and river towns. In the resulting Treaty of Nanjing, China ceded Hong Kong to Britain and paid an indemnity of 21 million silver dollars (roughly equivalent to \$2 billion today). Chinese ports and markets were opened to Western merchants, and by 1880 the import of cheap machine-made products resulted in the

collapse of the Chinese economy. It would not recover for more than a century.

If the British East India Company's involvement in the opium trade brought China to its knees, it exercised policies in India that crippled that economy as well. In the 1760s, India had been one of the most productive economies in the world. Britain imported most of its best cast steel from India, where hundreds of thousands were employed in mills and mines. But by the end of the eighteenth century, India lost its European markets for finished goods after the British East India Company bought Indian raw materials at exploitatively low prices and then undercut Indian manufacturers by selling finished textiles in India at low prices. Backed by the force of the British Army and increasingly efficient mechanized factories in Britain, English merchants profited handsomely at the expense of traditional economic production in India. So, instead of manufacturing cast steel, India found itself producing only iron ore; instead of manufacturing finished textiles, it exported raw cotton. In this economy, from which manufacturing had been almost completely eliminated, work became a scarce commodity. As its population increased in the second half of the nineteenth century, India experienced an unprecedented series of intensive famines, as well as widespread unemployment and poverty. As a result, over the course of the late nineteenth and early twentieth centuries, nearly 1.5 million Indians sold themselves into indentured servitude. Having produced 25 percent of the world's industrial output in 1750, India by 1900 contributed only 2 percent.

The Rise and Fall of Egypt

The occupation of Egypt in 1798 and 1799 by Napoleon's army, and the study of the country that it initiated, the 24-volume Description de l'Égypte, published in Paris between 1809 and 1822, inspired French officials to support the rapid industrialization of the country under the leadership of Mehmet Ali (1769-1849), whose family would rule Egypt until 1953. Cotton was Egypt's chief cash crop. Recognizing that a type of cotton bush, which was used only by a few local Cairo women, produced remarkably long and exceptionally strong fibers, Ali ordered farmers, who had previously been growing wheat, to convert their fields to cotton, and he ordered 500 steam-operated looms from Britain. When, in 1823, Egypt began exporting the cotton, it attracted some of the highest prices in Europe, and by the mid-1830s, Egypt was producing 1,200,000 bolts of cotton a year.

But Britain, with a thriving cotton industry of its own (dependent on the export of raw cotton from the American South), chafed at Egyptian competition. In 1838, Ali informed both the French and the British that he intended to declare Egypt's independence from the Ottoman Empire, and a year later, he invaded Turkey, believing that he would have assistance from the French. The French demurred, and Britain forced Egypt to capitulate and abandon the protective tariffs on its cotton industry. Before long, Egypt, like India

and the American South, no longer exported manufactured cotton products, but only the raw product. Egypt's attempt at modernization had failed.

But Ali's grandson, Khedive Ismail (r. 1863-79), would try again. "My country," he said in 1874, "is no longer in Africa; we are now part of Europe. It is therefore natural for us to abandon our former ways and to adopt a new system adapted to our social conditions." To that end, Ismail borrowed heavily from European banks, at sometimes extraordinarily high interest. He greatly expanded Cairo, building an entire new city on the old city's western edge modeled on Haussmann's Paris, with wide boulevards and modern hotels. To celebrate the opening of the Suez Canal, he hired Italian architects to build an opera house modeled on La Scala in Milan, and commissioned Giuseppe Verdi (discussed earlier in this chapter) to write an opera, Aida, to be premiered at his new theatre. French financing and French engineers were responsible for cutting the canal through from the Mediterranean to the Red Sea, and France owned a majority interest in the project. But the simple truth was that, owing to Ismail's extravagances (including an ill-fated attempt to conquer Ethiopia), Egypt was virtually bankrupt. In 1875, Britain purchased the Egyptian share in the canal, and in 1879, European debtors forced Ismail to abdicate. A large portion of Egypt's revenue was assigned to pay off foreign debt, and Britain, responding to a minor rebellion in the Egyptian military, quickly stepped in to occupy the country. As Sir Alfred Milner, Egyptian Finance Minister from 1889 to 1892, later put it, with typical end-of-thecentury imperialist bravado: "Let it always be remembered that Great Britain did save Egypt from anarchy, and all European nations interested in Egypt from incalculable losses in blood and treasure, to say nothing of the deep dishonour which those losses... would have brought on civilized mankind."

The Opening of Japan

As India was rapidly changing under the British colonial regime in the mid-nineteenth century, Japan sought to accommodate Western industrialization while maintaining the most important aspects of its cultural traditions. Until the American Commodore Matthew Perry sailed into Tokyo Bay on July 8, 1853, Japan had been closed to the West for 250 years. Seeking to gain the Japanese government's assistance in opening trade as well as providing safe havens for stranded sailors, Perry demanded and received concessions. His expedition ultimately led to the Treaty of Kanagawa (1854) and the Harris Treaty (1858) between the United States and Japan, which opened diplomatic and trade relations between the two countries and brought large quantities of Japanese goods to the West for the first time. The Japanese realized that they had to accommodate Perry, the immediate threat, as well as cope with the longer-term challenge from Western nations. Their goal was to modernize along Western lines but maintain sovereignty as well as their ancient cultural traditions. Visitors arriving in Japan in the late nineteenth and early twentieth centuries had to follow carefully laid-out itineraries if they wished to venture beyond the "treaty ports" of Yokohama, just south of Tokyo; Kobe, just outside Osaka; and Nagasaki. The Japanese by this means tried to control the image of their country that visitors took home.

At first, Japan focused on closing the technology gap between its army and navy and Western military powers. Samuel Williams, the Perry expedition's interpreter, described the Japanese army as it appeared to him in July 1853: "Soldiers with muskets and drilling in close array," but also, "soldiers in petticoats, sandals, two swords, all in disorder." In order to modernize their society, the government had to industrialize, which they commenced without delay, and by the late nineteenth century, the Japanese economy was booming, as was the art of woodblock printing, called ukiyo-e ("pictures of the floating world"), a

tradition that had developed steadily since the beginning of the Tokugawa era (1603-1868). The export trade in prints was a vital part of the economy, and Western artists, particularly the Impressionists, were captivated by the effects Japanese printmakers were able to achieve. Very popular among the urban classes in Edo (Tokyo) since the 1670s, woodblock prints were mass-produced and thus affordable to artisans, merchants, and other city dwellers. They depicted a wide range of Japanese social and cultural activity, including the daily rituals of life, the theatrical world of actors and geisha, sumo wrestlers, and artisans along with landscapes and nature scenes. Incorporating traditional themes from literature and history, the prints were also notable for introducing contemporary tastes, fads, and fashions, thus forming an invaluable source of knowledge on Japanese culture over the more than two centuries of its development.

Probably the most famous series of Japanese prints is Thirty-Six Views of Mount Fuji by Katsushika Hokusai (1760-1849). The print in that series known as The Great Wave has achieved almost iconic status in the art world (Fig. 13.26). It depicts three boats descending into a trough beneath a giant crashing wave that hangs over the scene like a menacing claw. In the distance, above the horizon, rises Mount Fuji, symbol to the Japanese of immortality and of Japan itself, framed in a vortex of wave and foam. Although the wave is visually larger than the distant mountain, the viewer knows it will imminently collapse and that Fuji will remain, illustrating both the transience of human experience and the permanence of the natural world. The print also juxtaposes the perils of the moment, as represented by the dilemma of the boatmen, and the enduring values of the nation, represented by the solidity of the mountain. Those values can be

Fig. 13.26 Katsushika Hokusai, *The Great Wave*, from the series *Thirty-Six Views of Mount Fuji*. ca. 1823–39. Color woodblock print, 10%" × 14%". The boatsmen can be understood as working in harmony with the powers of nature, something like samurai of the sea.

understood to transcend the momentary troubles and fleeting pleasures of daily life.

Africa and Empire

To those intellectuals most aware of the larger political climate of the late nineteenth century, the greatest cause for alarm rested not in Vienna, Paris, London, or New York, but rather in Africa, specifically in the imperial policies that the European powers were exercising on that continent. The scramble for control of the continent had begun with the opening of the Suez Canal in 1869, and, by the 1880s, Britain's seizure of control of Egypt as a whole. Then, further to "protect" Egypt, it advanced into the Sudan. Beyond Africa's key strategic placement, its vast land area and untapped natural resources proved an irresistible lure for European nations.

Economic wealth was a deciding factor, for the exploitable resources of the African continent made Europe wealthy. France extracted phosphates from Morocco; Belgium acquired gems, ivory, and rubber from the Congo; and England obtained diamonds from South Africa. In this way, Europe's African colonies became (like India) primarily focused on producing large quantities of raw materials—a commodity-based export economy that left most Africans in dire poverty.

Social Darwinism: The Theoretical Justification for Imperialism In the extended title of the groundbreaking work On the Origin of Species by Means of Natural Selection, or the Preservation of Favored Races in the Struggle for Life, Charles Darwin's use of the word "race" became a critical ingredient in the development of a new nineteenth-century ideology, **social Darwinism.** To those who desired to validate imperialism and the colonial regimes it fostered in Africa and Asia,

social Darwinism explained the supposed social and cultural evolution that elevated Europe (and the white race) above all other nations and races. Europeans, it was argued, were the "fitter" race, and thus were destined not merely to survive but to dominate the world. Such thinking would later characterize the demented ambitions of Adolf Hitler in Germany. Social Darwinism seemed to overturn traditional Judeo-Christian and Enlightenment ethics, especially those pertaining to compassion and the sacredness of human life. It seemed at once to embrace moral relativism—the belief that ethical positions are determined not by universal truths but by social, political, or cultural conditions (such as the imperial imposition of values upon another culture)—and to support the superior evolutionary "fitness" and superiority of the Aryan (or Anglo-Saxon) race.

Darwin himself meant nothing of the kind. Recognizing the ways in which his theories were being misapplied to social conditions, he published The Descent of Man in 1871. In it, he offered a theory of conscience that had a distinctly more ethical viewpoint. Darwin contended that our ancestors, living in small tribal communities, and competing with one another ruthlessly, came to recognize the advantages of altruistic behavior to successful propagation of the tribe. Over generations, the tribe whose members exhibited selfless behavior that benefited the whole group would tend to survive and prosper over tribes whose members pursued more selfish and individualistic goals. "There can be no doubt," he wrote, "that a tribe including many members who, from possessing in a high degree the spirit of patriotism, fidelity, obedience, courage, and sympathy, were always ready to give aid to each other and to sacrifice themselves for the common good, would be victorious over most other tribes, and this would be natural selection." This is not the ethical philosophy that motivated imperialism.

Joseph Conrad's *Heart of Darkness* No writer of fiction examined European imperialist schemes in Africa—and the negative consequences of social Darwinism—more critically than Joseph Conrad (1857–1924). Born Józef Teodor Konrad Korzeniowski in Poland, Conrad began his career as a sailor, joined the British merchant marine in 1886 (at that point anglicizing his name and becoming a British citizen), and worked in the British merchant fleet until 1894. His many novels and stories are based largely on his experiences at sea, and although he did not speak English fluently until he was in his twenties—and never spoke the language without an accent—he is considered by many to be one of the greatest prose stylists in the English language.

In 1889, Conrad became captain of a river steamboat in what was then the Belgian Congo, and his experiences in that job form the basis of his novella *Heart of Darkness* (1899). The story begins with the narrator (presumably Conrad) sitting with five other men on the deck of a yawl on the Thames River just downstream from London, waiting for the tide to turn. Among them is one "Marlow," who presently begins to ruminate on the nature of Roman imperial adventuring in England nearly 2,000 years earlier, which leads him,

then, to entertain the group with the story of his experiences in the Congo on a mission to relieve a man named Kurtz from his duties as the Belgian government's most successful ivory trader. *Heart of Darkness* is thus a framed tale about Africa, narrated by Marlow, as he and his companions sit on the yawl as the sun sets and the evening comes on just outside London.

The themes of Conrad's story are first articulated in Marlow's introductory remarks about the Romans. They were, he says, "men enough to face the darkness." He imagines some "decent young citizen in a toga" rowing up the Thames, surrounded presumably by native Britons who had never dreamed, let alone heard, of Rome. He would, Conrad writes (Reading 13.10):

READING 13.10

from Joseph Conrad, Heart of Darkness (1899)

Land in a swamp, march through the woods, and in some inland post feel the savagery, the utter savagery, had closed round him—all that mysterious life of the wilderness that stirs in the forest, in the jungles, in the hearts of wild men. There's no initiation either into such mysteries. He has to live in the midst of the incomprehensible, which is also detestable. And it has a fascination, too, that goes to work upon him. The fascination of the abomination...

This describes, rather precisely, Kurtz's experience in Africa, where Kurtz is transformed from an idealist dedicated to the proposition of civilizing Africa into a brutal, immoral tyrant, subjugating African natives to his dissipated will. What Marlow comes to understand through Kurtz's example is that colonialism is a dehumanizing enterprise, that in the dynamics of social superiority built into the social Darwinist view of the world is an inherent distaste and disregard for those one considers one's inferiors. In what amounts to an act of premonition, he sees in Kurtz's call to "exterminate all the brutes" the acceptance of the possibility, even inevitability, of genocide. As Marlow says in the introductory section, "The conquest of the earth, which mostly means the taking it away from those who have a different complexion or slightly flatter noses than ourselves, is not a pretty thing when you look into it too much."

Heart of Darkness, as its title suggests, is stylistically dependent on contrasting patterns of light and dark, white Europeans and black Africans, but never in any set pattern of good and evil. Rather the meaning of both is ambiguous, never certain, and always at issue. Ambiguity, in fact, lies at the heart of the story—"darkness" itself being a metaphor for a world without clarity. The most famous line in the book occurs at Kurtz's death: "He cried in a whisper at some image, at some vision—he cried out twice, a cry that was no more than a breath—'The horror! The horror!'" It is not clear—purposefully so—whether the horror lies in the world that surrounds Kurtz or in himself. Or, as the twentieth century was about to suggest, in both.

13.1 Describe how realism manifested itself in nineteenth-century art and literature.

After the restoration of the monarchy in France, Romantic painting took a new direction by depicting with a sense of urgency and immediacy disturbing contemporary events. How does Eugène Delacroix's *Scenes from the Massacres at Chios*, which was exhibited at the Salon of 1824, reflect this new direction? How does Delacroix's painting compare to Ingres's *Vow of Louis XIII*, exhibited at the same Salon? How do the two compare as painters? Delacroix's *Liberty Leading the People* was received by the public as both a threat to the aristocracy and an attack on the middle class. How was it viewed as both realist and idealist?

During much of the nineteenth century, industrialization created wealth for a few but left the vast majority of men and women living bleak and unhealthy lives. How did Charles Dickens react to these conditions? How did Karl Marx and Friedrich Engels react? What events did they foresee in their Communist Manifesto? In France, realist writers such as Honoré de Balzac depicted the full breadth of French society, from its poor to its most wealthy. In the 92 novels that make up Balzac's Human Comedy, some 2,000 characters come to life for the reader. In the novel Madame Bovary, Gustave Flaubert attacked the Romantic sensibilities to which he was himself strongly attracted. How does this French brand of realist writing differ from that of Dickens? In the United States, slavery was the chief target of realist writers. A full-blown realism in French painting found its first expression in Honoré Daumier's cartoon work for daily and weekly newspapers. How do Daumier's cartoons and Gustave Courbet's paintings challenge traditional notions about the nature of art? Finally, the new art of photography arose in the context of the rise of realism in the arts. How did photography affect people's attitudes about war?

13.2 Describe the various ways in which French artists and writers attacked bourgeois values in the 1850s and 1860s.

After the revolutions of 1848, Paris's bourgeois middle class was convinced that it had barely survived the complete collapse of the social order, and so it elected the nephew of Napoleon I, Charles-Louis-Napoleon Bonaparte, president and subsequently proclaimed him Emperor Napoleon III. Napoleon hired the Baron Georges-Eugène Haussmann to modernize the city of Paris. What is Haussmannization and what factors other than the urge to modernize motivated it? The poet Charles Baudelaire sought to shock the bourgeoisie, using imagery that ranged from exotic sexuality to the grim reality of death in the modern city. How did Manet represent his ideal "painter of modern life"? In music, the nationalist tendencies of the era played themselves out in the Paris opera. Giuseppe Verdi's Rigoletto and other works by him came to symbolize Italian nationalism, and the Parisian Jockey Club ostracized the German composer Richard Wagner on nationalist grounds when he tried to produce his opera Tannhäuser. What did the Jockey

Club object to in particular about Wagner's work? What new genre did Wagner believe he had invented? Wagner shifted the melodic element from the voice to the orchestra and organized his opera dramas around the *leitmotif*. What is a *leitmotif*?

13.3 Define Impressionism and examine how it transformed conventional assumptions about style and content in painting.

After the defeat of the French by Prussia, a period of bloody civil war broke out in Paris. In what ways was Impressionism born out of this political climate? Many of the young artists who were identified as Impressionists preferred painting out-of-doors to capture the natural effects of light. What technological innovations made such an approach to painting possible? Monet, Pissarro, Renoir, Degas, and Morisot were the founders of the group. What stylistic tendencies do they share as painters?

13.4 Outline the characteristics of the American sense of self as it developed in the nineteenth century.

As New York City grew to over 3 million people in the last decades of the nineteenth century, poet Walt Whitman celebrated the city's as well as the nation's sense of energy, excitement, and unlimited possibility. How would you describe his subject matter? The quintessential New Yorker, Whitman fully recognized the plight of the working class, which in 1877 erupted in a series of strikes across the country. What caused these strikes? How did the natural world help to define American selfhood? How did the paintings of Cole and Durand and the writings of Emerson and Thoreau reflect this?

13.5 Examine the impact of Western imperial adventuring on the non-Western world.

With the decided edge provided by scientific and technological advances, Western nations sought to dominate the resources and economies of Asia and Africa in order to transfer wealth to their own countries. In America, what eventually led to the demise of Native Americans? Britain's policy of imperialism included using aggressive military and economic policies to take control either directly or indirectly of non-Western nations. What role did opium play in British relations with China? How was India's economy damaged by British policies? How did Khedive Ismail fare in his attempts to modernize Egypt? After the forced "opening" of Japan, one of the few Asian nations never colonized by the West, the country embarked on new trade and diplomatic relationships with Europe and the United States, while also beginning a rapid effort to modernize its own economy and government. After 1868, a flood of Japanese products reached the West for the first time. What export had special appeal to European artists? Europe's imperialists justified their colonization of Africa through the philosophy of social Darwinism. What is social Darwinism? How did Joseph Conrad react to the theory in his novella Heart of Darkness?

Toward a New Century

Paris's Exposition Universelle of 1889 was a fitting to the nineteenth century as well as a precursor to the twentieth. It commemorated imperial supremacy, modern technology, and national pride one century after the beginning of the French Revolution. As he opened the Fair, French president Sadi Carnot hailed a "new era in the history of mankind" that the revolutionary events of 1789 had initiated, and "the century of labor and progress" that had unfolded since then.

Over 28 million people visited the Paris fair in 1889. They looked with pride on the fair's "colonial" section, where reproductions of housing from around the world attested to the seemingly limitless ambition and power of imperial nations such as France to command the world's resources and peoples (Fig. 13.27). They excitedly dreamed of the future promised by that marvel of architecture and technology unveiled at the fair—Gustav Eiffel's Tower (Fig. 13.28), a 984-foot-tall, open-frame structure at the entrance of the fair that dominated the city. Almost twice the height of any other building in the world, the tower was meant "to raise to the glory of modern science and to the greater honor of French industry,

an arch of triumph," according to Eiffel. Once the tower was completed, spotlights positioned on the third level illuminated various Paris monuments, an effect even more dramatically realized 11 years later at the 1900 *Exposition Universelle*, when the entire city of Paris was electrified. Electricity also allowed fair visitors to ascend almost 1,000 feet to an observation platform at the top of the tower in a hydraulic elevator designed by the Otis Elevator Company.

The future was the chief attraction of the Paris *Exposition*, and *invention* was the key word of the day. In the Palace of Machines, the American inventor Thomas Edison (1847–1931) exhibited 493 new devices, including a huge carbon-filament electric lamp made from many smaller lamps. Edison's phonograph was also a great attraction, and thousands of visitors lined up each day to hear the machine. Other inventions fascinated the public—in the Telephone pavilion, one could listen to live performances of the Comédie Française through two earphones that created a convincing stereo effect.

Yet for all the fair's promise, when, in 1889, Carnot hailed the dawn of "a new history of mankind," he had little inkling of the darker side of technology and nationalism that had already been unleashed as European nations competed, in the last decades of the nineteenth century, for imperial control of Africa, the Middle East, Asia, and India. Over the next 50 years more than 60 million people would be killed in two world wars with unparalleled efficiency. Ideologies would grow more strident and dangerous in the ensuing decades, becoming virulently transnational in scope. France's president himself would become a victim of a new ideology in 1894 when an Italian anarchist assassinated him to avenge the execution of several French anarchists who had participated in bombings. While nationalism held an increasing, often irrational sway over human behavior, political theories such as anarchism and, later, fascism and communism would also lead to violent and destructive actions by individuals and groups aiming to reshape society to their own standards. A new era had dawned—one of global confrontation.

Fig. 13.27 Japanese house (left) and Chinese house (right) in the "History of Habitation" exhibit, *Exposition Universelle*, Paris. 1889. Library of Congress, Washington, D.C. LC-US262-106562. The juxtaposition of East and West underscores the growing decentralization of culture at the turn of the century.

Fig. 13.28 Les Fêtes de Nuit à l'Exposition (detail). 1900. Smithsonian Institution, Washington, D.C. From L'Exposition de Paris (1900). In 1900, the entire city of Paris was lit for the first time by electric light, and the Eiffel Tower, erected for the Exposition of 1889, was the centerpiece of "les fêtes de nuit", the nighttime celebrations at the fair.

CONSTRUCTION AE

GIC

The Modernist World

The Arts in an Age of Global Confrontation

LEARNING OBJECTIVES

14.1 Outline the various ways in which modernism manifests itself in art and literature.

14.2 Describe the Great War's impact on the art and literature of the era.

f the rhythm of life had long been regulated by the physiology of a man or a horse walking, or, on a sailing voyage, by the vagaries of weather (calm, storm, and wind direction), after 1850 it was regulated by the machine—first by the steam engine and the train; then, in 1897, by the automobile; and then, finally, by the airplane. At the dawn of the twentieth century, the world was in motion. As early as 1880, one French advertising company boasted that it could post a billboard ad in 35,937 municipalities in five days' timea billboard of the kind advertising Astra Construction in The Cardiff Team (Fig. 14.1), a painting by Robert Delaunay (1885-1941). The painting depicts the men of the Cardiff (Wales) rugby team leaping up at a rugby ball in the center of the painting. They represent the internationalization of sport; the first modern Olympic Games had taken place in 1896 in Athens, followed by the 1900 Games in Paris, staged in conjunction with the Exposition Universelle, and rugby was a medal sport in each. The rugby ball is framed by the famous Grande Roue de Paris. Built for the 1900 Exposition Universelle, at 100 meters (328 feet) in height, it was the tallest Ferris wheel in the world, surpassing by 64 feet the original Ferris wheel, built for Chicago's Columbian Exposition in 1893, and although it would be demolished in 1920, the Grande Roue remained the world's tallest Ferris wheel until it was surpassed by three Japanese Ferris wheels in the 1990s. On July 1, 1913, the year that Delaunay painted The Cardiff Team, a signal was broadcast from the top of the Eiffel Tower, seen towering over Delaunay's work, establishing worldwide Standard Time. By 1903, Orville Wright had been airborne 59 seconds, and by 1908, he would fly for 91 minutes. A year later, Louis Blériot crossed the English Channel by plane (although it would be another 18 years before Charles Lindbergh would cross the Atlantic by air). The airplane in Delaunay's painting is a "box-kite" design built in a Paris suburb beginning in 1907 by the Voisin brothers, Gabriel and Charles, the first commercial airplane manufacturers in Europe. Finally, the signboard "MAGIC" refers to Magic City, an enormous dance hall near the Eiffel Tower. Delaunay's Cardiff Team captures the pulse of Paris in the first decades of the twentieth century, and the heartbeat of modern life.

Delaunay called his work "Simultanism," a term derived from Michel-Eugène Chevreul's 1839 book on color, The Principle of Harmony and Contrast of Colors—in the original French title the word translated as "harmony" is simultanée—but the term signified more than just an approach to color theory. The name referred to the immediacy of vision, and suggested that in any given instant, an infinite number of states of being existed in the speed and motion of modern life. Everything was in motion, including the picture itself.

The still photograph suddenly found itself animated in the moving picture, first in 1895 by the Brothers Lumière, in Paris, and then after 1905, when the Nickelodeon, the first motion-picture theater in the world, opened its doors in Pittsburgh, Pennsylvania. By 1925, the Russian filmmaker

▼ Fig. 14.1 Robert Delaunay, L'Equipe de Cardiff (The Cardiff Team). 1913. Oil on canvas, 10'8%" × 6'10". Collection Van Abbemuseum, Eindhoven. Everything in the painting seems to rise into the sky as if, for Delaunay, the century is "taking off" much like the airplane. Even the construction company's name, "Astra," refers to the stars.

Sergei Eisenstein would cram 155 separate shots into a four-minute sequence of his film The Battleship Potemkin—a shot every 1.6 seconds. In 1900, France had produced 3,000 automobiles; by 1907, it was producing 30,000 a year. The technological advances represented by the automobile were closely connected to the development of the internal combustion engine, pneumatic tires, and, above all, the rise of the assembly line. After all, building 30,000 automobiles a year required an efficiency and speed of production unlike any ever before conceived. Henry Ford (1863-1947), the American automobile maker, attacked the problem. Ford asked Frederick Taylor (1856-1915), the inventor of "scientific management," to determine the exact speed at which the assembly line should move and the exact motions workers should use to perform their duties; in 1908, assembly-line production as we know it was born.

Amid all this speed and motion, the world also suddenly seemed a less stable and secure place. Discoveries in science and physics confirmed this. In 1900, the German physicist Max Planck (1858–1947) proposed the theory of matter and energy known as quantum mechanics. In quantum mechanics, the fundamental particles are unknowable, and are only hypothetical things represented by mathematics. Furthermore, the very technique of measuring these phenomena necessarily alters their behavior. Faced with the fact that light appeared to travel in absolutely contradictory ways, as both particles and waves, depending upon how one measured it, in 1913, the Danish physicist Niels Bohr (1885–1962) built on quantum physics to propose a new theory of complementarity: two statements, apparently contradictory, might at any

moment be equally true. At the very end of the nineteenth century, in Cambridge, England, J. J. Thompson detected the existence of separate components in the previously indivisible atom. He called them "electrons," and by 1911, Ernest Rutherford had introduced a new model of the atom—a small, positively charged nucleus containing most of the atom's mass around which electrons continuously orbit. Suddenly matter itself was understood to be continuously in motion. Meanwhile, in 1905, Albert Einstein had published his theory of relativity and by 1915 had produced the General Principles of Relativity, with its model of the non-Euclidean, four-dimensional spacetime continuum. Between 1895 and 1915, the traditional understanding of the physical universe had literally been transformed—and it was not a universe of entities available to the human eye.

THE RISE OF MODERNISM IN THE ARTS

What are some characteristic features of modernism in art and literature?

The arts responded to this radical shift in understanding. In painting, those who followed upon the Impressionist generation—the Post-Impressionists, as they were soon known—saw themselves as inventing a new future for painting, one that reflected the spirit of innovation that defined modernity. In Paris, the studio of Spanish-born Pablo Picasso (1881–1973) was quickly recognized by artists and intellectuals as the center of artistic innovation in the new century. From around Europe and America, artists flocked to see his work, and they carried his spirit—and the spirit of French painting generally—back with them to Italy, Germany, and America. New art movements—new "isms," including Delaunay's Simultanism—succeeded one another in rapid fire. Picasso's work also encouraged radical approaches to poetry and to music, where the discordant, sometimes violent distortions of his paintings found expression in sound.

Post-Impressionist Painting

Among the Post-Impressionists were Paul Cézanne, Paul Gauguin, and Georges Seurat, all of whom exhibited at various Impressionist shows, and Vincent van Gogh, who arrived in Paris only in time to see the eighth and last Impressionist exhibition. But rather than creating Impressionist works that captured the optical effects of light and atmosphere and

Fig. 14.2 Georges Seurat, A Sunday on La Grande Jatte. 1884–86. Oil on canvas, 81%" × 121%". Helen Birch Bartlett Memorial Collection, 1926.224. Photograph © 2006, The Art Institute of Chicago. All rights reserved. Capuchin monkeys like the one held on a leash by the woman on the right, were a popular pet in 1880s Paris.

the fleeting qualities of sensory experience, they sought to capture something transcendent in their act of vision, something that captured the essence of their subject.

Pointillism: Seurat and the Harmonies of Color One of the most talented of the Post-Impressionist painters was Georges Seurat (1859-91), who exhibited his masterpiece, A Sunday on La Grand Jatte, in 1886, when he was 27 years old (Fig. 14.2). It depicts a Sunday crowd of Parisians enjoying the weather on the island of La Grand Jatte in the Seine River, just northeast of the city. The subject matter is typically Impressionist, but it lacks that style's sense of spontaneity and the immediacy of its brushwork. Instead, La Grand Jatte is a carefully controlled, scientific application of tiny dots of color-pointilles, as Seurat called them-and his method of painting became known as pointillism to some, and Neo-Impressionism to others.

In setting his "points" of color side by side across the canvas, Seurat determined that color could be mixed, as he put it, in "gay, calm, or sad" combinations. Lines extending upward could also reflect these same feelings, he explained, imparting a cheerful tone, as do warm and luminous colors of red, orange, and yellow. Horizontal lines that balance dark and light, warmth and coolness, create a sense of calm. Lines reaching in a downward direction and the dark, cool hues of green, blue, and violet evoke sadness.

With this symbolic theory of color in mind, we can see much more in Seurat's La Grand Jatte than simply a Sunday crowd enjoying a day at the park. There are 48 people of

various ages depicted, including soldiers, families, couples, and singles, some in fashionable attire, others in casual dress. A range of social classes is present as well, illustrating the mixture of people on the city's day of leisure. Although overall the painting balances its lights and darks and the horizontal dominates, thus creating a sense of calm, all three groups in the foreground shadows are bathed in the melancholy tones of blue, violet, and green. With few exceptions—a running child, and behind her a couple—almost everyone in the painting is looking either straight ahead or downward. Even the tails of the pets turn downward. This solemn feature is further heightened by the toy-soldier rigidity of the figures. Seurat's painting suggests more than it portrays. As one critic of the time wrote of La Grande Jatte, "one understands then the rigidity of Parisian leisure, tired and stiff, where even recreation is a matter of striking poses."

Symbolic Color: Van Gogh Seurat's influence on French painting was profound. The Dutch painter Vincent van Gogh (1853-90) studied Seurat's paintings while living in Paris in 1886-87, and experimented extensively with Seurat's color combinations and pointillist technique, which extended even to his drawings, as a means to create a rich textural surface.

Van Gogh was often overcome with intense and uncontrollable emotions, an attribute that played a key role in the development of his unique artistic style. Profoundly committed to discovering a universal harmony in which all aspects of life were united through art, he found Seurat's emphasis on contrasting colors appealing. It became another ingredient in his synthesis of techniques. He began to apply complementary colors in richly painted zones using dashes and strokes that were much larger than Seurat's pointilles. In a letter to his brother Theo in 1888, Van Gogh described the way the complementary colors in Night Café (Fig. 14.3) work to create visual tension and emotional imbalance:

In my picture of the Night Café I have tried to express the idea that the café is a place where one can ruin oneself, run mad, or commit a crime. I have tried to express the terrible passions of humanity by means of red and green. . . . Everywhere there is a clash and contrast of the most alien reds and greens. . . . So I have tried to express, as it were, the powers of darkness in a low wine shop, and all this in an atmosphere like a devil's furnace of pale sulphur. . . . It is a color not locally true from the point of view of the stereoscopic realist, but color to suggest the emotion of an ardent temperament.

Color, in Van Gogh's paintings, becomes symbolic, charged with feelings. Added to the garish conflict of colors

Fig. 14.3 Vincent Van Gogh, Night Café. 1888. Oil on canvas, 28½" × 36½". Yale University Art Gallery. Bequest of Stephen Carlton Clark, B.A. 1903. 1961.18.34. Van Gogh frequented this café on the Place Lamartine in Arles. Gas lighting, only recently introduced, allowed it to stay open all night. Drifters and others with no place to stay would frequent it at night. Notice how many patrons seem to be asleep at the tables.

The CONTINUING PRESENCE of the PAST

Auvers-sur-Oise (Crow in the

at MyArtsLab

Fig. 14.4 Vincent Van Gogh, The Starry Night. 1889. Oil on canvas, 28¾" × 36¼". Museum of Modern Art, New York. Acquired through the Lillie P. Bliss Bequest. (472.1941). Saint-Rémy, where Van Gogh painted this work, lies at the foot of a small range of mountains between Arles and Aix-en-Provence. This part of France is plagued in the winter months by the mistral, strong winds that blow day after day out of the Alps down the Rhône River valley. The furious swirls of Van Gogh's sky and the blowing cypress trees suggest that he might be representing this wind, known to drive people mad, in contrast to the harmony of the painting's color scheme.

is Van Gogh's peculiar point of view, elevated above the room, which sweeps away from the viewer in exaggerated and unsettling perspective. Night Café in this regard reflects not just a mundane view of the interior of a café lit by lamps, but also Van Gogh's "ardent" reaction to it.

For many viewers and critics, Van Gogh's paintings are the most personally expressive in the history of art, offering unvarnished insights into the painter's unstable psychological state. As he was painting Night Café, Van Gogh was living in the southern French town of Arles, where, over the course of 15 months, he produced an astounding quantity of work: 200 paintings, over 100 drawings and watercolors, and roughly 200 letters. Many of these letters, especially those addressed to his brother Theo, help us to interpret his paintings, which have become treasured masterpieces, each selling for tens of millions of dollars. Yet at the time he painted them, almost no one liked them, and he sold almost none of his art.

To viewers at the time, the dashes of thickly painted color, an effect known as impasto, seemed thrown onto the canvas as a haphazard and unrefined mess. And yet, the staccato rhythms of this brushwork seemed to Van Gogh himself deeply autobiographic, capturing almost stroke by stroke

the pulse of his own volatile personality. Although his work grew ever bolder and more creative as the years passed, Van Gogh continued to suffer from the emotional instability and depression that had tormented him most of his adult life. In December 1888, his personal emotional turmoil reached fever pitch when he sliced off a section of his earlobe and presented it to an Arles prostitute as a present. After a brief stay at an Arles hospital, he was released, but by the end of January, the city received a petition signed by 30 townspeople demanding his committal. In early May, he entered a mental hospital in Saint-Rémy, not far from Arles, and there he painted Starry Night, perhaps his most famous composition (Fig. 14.4). Here the swirling cypresses (in which red and green lie harmoniously side by side) and the rising church steeple unite earth and sky. Similarly, the orange and yellow stars and moon unite with the brightly lit windows of the town. Describing his thoughts about the painting in a letter to his brother, Van Gogh wrote, "Is it not emotion, the sincerity of one's feeling for nature, that draws us?" But finally, in July 1890, after a number of stays in hospitals and asylums, he committed suicide in the fields outside Auvers-sur-Oise, where he was being treated by Dr. Paul Gachet, who was the subject of several of the great artist's last portraits.

Fig. 14.5 Paul Cézanne, Still Life with Plaster Cast. ca. 1894. Oil on paper on board, $26\%'' \times 32\%''$. The Samuel Courtauld Trust, Courtauld Institute of Art Gallery, London. Cézanne's challenge to tradition is highlighted by the tension between his radical approach to the representation of space and his inclusion, at the heart of the painting, of a plaster cast of a seventeenth-century Cupid sculpted by Pierre Puget (1620–94).

Fig. 14.6 Paul Cézanne, *Mont Sainte-Victoire*. **1902–04.** Oil on canvas, 28% " \times 36%6". Photo: Graydon Wood. Philadelphia Museum of Art: The George W. Elkins Collection, 1936. E1936-1-1. Cézanne painted this from the top of the steep hill known as Les Lauves, just north of Aix-en-Provence but within walking distance of the city center. He built his own studio on a plot of land halfway up the hill, overlooking the city.

The Structure of Color: Cézanne Of all the Post-Impressionists, Paul Cézanne (1839–1906) was the only one who. after 1890, continued to paint en plein air. In this regard, he remained an Impressionist, and he continued to paint what he called "optics." The duty of the painter, he said, was "to give the image of what we see," but innocently, "forgetting everything that has appeared before." Since the Renaissance, Western art had been dedicated to representing the world as the eye sees it—that is, in terms of perspectival space. But Cézanne realized that we see the world in far more complex terms than just the retinal image before us. We see it through the multiple lenses of our lived experience. This multiplicity of viewpoints, or perspectives, is the dominant feature of Still Life with Plaster Cast (Fig. 14.5). Nothing in the composition is spatially stable. Instead we wander through the small space in the corner of Cézanne's studio just as the painter's eye would do. His viewpoint constantly moves, contemplating its object from this angle, then that one. The result of this vision is a representation of nature as a series of patches of color that tend to flatten the surface of his paintings. Note, for instance, how the fruit and onions on the table are modeled by radical shifts in color rather than gradations from light to dark (traditional chiaroscuro).

Cézanne returned to the same theme continually—particularly still lifes and Mont Sainte-Victoire, the mountain overlooking his native Aix-en-Provence in the south of France (Fig. 14.6). In the last decade of his life, the mountain became something of an obsession, as he climbed the hill behind his studio to paint it day after day. He especially liked to paint after storms, when the air was clear and the colors of the landscape were at their most saturated and uniform intensity. Cézanne acknowledges the illusion of space in the mountain scene by means of three bands

of color. Patches of gray and black define the foreground, green and yellow-orange the middle ground, and violets and blues the distant mountain and sky. Yet in each of these areas, the predominant colors of the other two are repeated—the green brushstrokes of the middle ground in the sky, for instance—all with a consistent intensity. The distant colors possess the same strength as those closest. Together with the uniform size of Cézanne's brushstrokes—his patches do not get smaller as they retreat into the distance—this use of color makes the viewer very aware of the surface qualities and structure of Cézanne's composition. It is this tension between spatial perspective and surface flatness that would become one of the chief preoccupations of modern painting in the forthcoming century.

Escape to Far Tahiti: Gauguin In 1891, the painter Paul Gauguin (1848–1903) left France for the island of Tahiti, part of French Polynesia, in the South Pacific. A frustrated businessman and father of five children, he had taken up art with a rare dedication a decade earlier, studying with Camille Pissarro and Paul Cézanne. Gauguin was also a friend of Van Gogh, with whom he spent several months painting in

Fig. 14.7 Paul Gauguin, *Mahana no atua* (*Day of the God*). 1894. Oil on canvas, 27%" × 35%". The Art Institute of Chicago. Helen Birch Bartlett Memorial Collection (1926.198). Photograph © 2007 The Art Institute of Chicago. All rights reserved. There is no record of Gauguin ever exhibiting this work. It was first exhibited at the Boston Art Club in 1925.

Arles during the Dutch artist's most productive period. He had also been inspired by the 1889 Exposition Universelle, where indigenous peoples and housing from around the world were displayed. "I can buy a native house," he wrote his friend Émile Bernard, "like those you saw at the World's Fair. Made of wood and dirt with a thatched roof." To other friends he wrote, "I will go to Tahiti and I hope to finish out my life there... far from the European struggle for money... able to listen in the silence of beautiful tropical nights to the soft murmuring music of my heartbeats in loving harmony with the mysterious beings in my entourage."

Gauguin's first trip to Tahiti was not everything he dreamed it would be, since by March 1892 he was penniless. When he arrived back in France, he had painted 66 pictures but had only four francs (about \$12 today) to his name. He spent the next two years energetically promoting his work and writing an account of his journey to Tahiti, entitled Noa Noa (noa means "fragrant" or "perfumed"). It is a fictionalized version of his travels and bears little resemblance to the details of his journey that he recorded more honestly in his letters. But Noa Noa was not meant to be true so much as sensational, with its titillating story of the artist's liaison with a 13-year-old Tahitian girl, Tehamana, offered to him by her family. He presents himself as a primitif. In French, the word primitif suggests the primal, original, or irreducible. Gauguin believed that "primitive" ways

of thinking offered an entry into the primal powers of the mind, and he considered his paintings visionary glimpses into the primal forces of nature.

Gauguin arranged for two exhibitions at a Paris gallery in November 1893 and another in December 1894. He opened a studio of his own, painted olive green and a brilliant chrome yellow, and decorated it with paintings, tropical plants, and exotic furnishings. He initiated a regular Thursday salon where he lectured on his paintings and regaled guests with stories of his travels, as well as playing music on a range of instruments.

In this studio, he painted Mahana no atua (Day of the God) of 1894 (Fig. 14.7). Based on idealized recollections of his escape to Tahiti, the canvas consists of three zones. In the top zone or background, figures carry food to a carved idol, representing a native god, a musician plays as two women dance, and two lovers embrace beside the statue of the deity. Below, in the second zone, are three nude figures. The one to the right assumes a fetal position suggestive of birth and fertility. The one to the left appears to be daydreaming or napping, possibly an image of reverie. The middle figure appears to have just emerged from bathing in the water below, which constitutes the third zone. She directs her gaze at the viewer and so suggests an uninhibited sexuality. The bottom, watery zone is an irregular patchwork of color, an abstract composition of sensuous line and fluid shapes. As in Van Gogh's

work, color is freed of its representational function to become an almost pure expression of the artist's feelings.

Gauguin returned to Tahiti in June 1895 and never came back to France, completing nearly 100 paintings and over 400 woodcuts in the eight remaining years of his life. He moved in 1901 to the remote island of Hivaoa, in the Marquesas, where in the small village of Atuona he built and decorated what he called his House of Pleasure. Taking up with another young girl, who like Tehamana gave birth to his child, Gauguin alienated the small number of priests and colonial French officials on the islands but attracted the interest and friendship of many native Marquesans, who were fascinated by his nonstop work habits and his colorful paintings. Having suffered for years from heart disease and syphilis, he died quietly in Hivaoa in May 1903.

Pahlo Picasso's Paris: At the Heart of the Modern

Picasso's Paris was centered at 13 rue Ravignon, at the Bateau-Lavoir ("Laundry Barge"), so nicknamed by the poet Max Jacob. This was Picasso's studio from the spring of 1904 until October 1909, and he continued to store his paintings there until September 1912. Anyone wanting to see his work would have to climb the hill topped by the great white cathedral of Sacre Coeur in the Montmartre quarter, beginning from the Place Pigalle, and finally climb the stairs to the great ramshackle space, where the walls were piled deep with canvases. Or they might see his work at the Saturday evening salons of expatriate American writer and art collector Gertrude Stein (1874–1946) at 27 rue de Fleurus behind the Jardin du Luxembourg on the Left Bank of the Seine. If you knew someone who knew someone, you would be welcome enough. Many Picassos hung on her walls, including his portrait of her, painted in 1906 (Fig. 14.8).

In her book The Autobiography of Alice B. Toklas (1932) actually her own memoir disguised as that of her friend and lifelong companion—Stein described the making of this picture in the winter of 1906 (Reading 14.1):

READING 14.1

from Gertrude Stein, The Autobiography of Alice B. Toklas (1932)

Picasso had never had anybody pose for him since he was sixteen years old. He was then twenty-four and Gertrude had never thought of having her portrait painted, and they do not know either of them how it came about. Anyway, it did, and she posed for this portrait ninety times. There was a large broken armchair where Gertrude Stein posed. There was a couch where everybody sat and slept. There was a little kitchen chair where Picasso sat to paint. There was a large easel and there were many canvases. She took her pose, Picasso sat very tight in his chair and very close to his canvas and on a very small palette, which was of a brown gray color, mixed some more brown gray and

Fig. 14.8 Pablo Picasso, Gertrude Stein. Autumn-Winter 1906. Oil on canvas, $39\%" \times 32"$. Bequest of Gertrude Stein, 1946 (47.106). The Metropolitan Museum of Art, New York. © 2014 Estate of Pablo Picasso/Artists Rights Society (ARS), New York. According to Stein, in painting her portrait, "Picasso passed [on]... to the intensive struggle which was to end in Cubism."

the painting began. All of a sudden one day Picasso painted out the whole head. I can't see you anymore when I look, he said irritably, and so the picture was left like that.

Picasso actually finished the picture early the following fall, painting Stein's face in large, masklike masses in a style very different from the rest of the picture. No longer relying on the visual presence of the sitter before his eyes, Picasso painted not his view of her, but his idea of her. When Alice B. Toklas later commented that some people thought the painting did not look like Stein, Picasso replied, "It will."

The Aggressive New Modern Art: Les Demoiselles d'Avignon In a way, the story of Gertrude Stein's portrait is a parable for the birth of modern art. It narrates the shift in painting from an optical art—painting what one sees—to an imaginative construct—painting what one thinks about what one sees. The object of painting shifts, in other words, from the literal to the conceptual. The painting that most thoroughly embodied this shift was Les Demoiselles d'Avignon, which Picasso began soon after finishing his portrait of Stein (Fig. 14.9).

Completed in the summer of 1907, Les Demoiselles d'Avignon was not exhibited in public until 1916. So if you wanted to see it, you had to climb the hill to the Bateau-Lavoir. And many did, because the painting was notorious, seen—correctly—as an assault on the idea of painting as it had always been understood. At the Bateau-Lavoir, a common insult hurled by Picasso and his friends at one another was "Still much too symbolist!" No one said this about Les Demoiselles. It seemed entirely new in every way.

CONTINUITY & CHANGE

The painting represents five prostitutes in a brothel on the carrer d'Avinyo (Avignon Street) in Picasso's native Barcelona. As the figure on the left draws back a curtain as if to reveal them, the prostitutes address the viewer with the frankness of Manet's *Olympia* (see Fig. 13.14)

Fig. 14.9 Pablo Picasso, Les Demoiselles d'Avignon. May—July 1907. Oil on canvas, $95\%" \times 91\%"$. Acquired through the Lillie P. Bliss Bequest. The Museum of Modern Art/Licensed by SCALA/Art Resource, New York. © 2008 Artists Rights Society (ARS), New York. Central to Picasso's composition is the almond shape, first used for Gertrude Stein's eyes and repeated in the eyes of the figures here and in other forms—thighs and arms particularly. The shape is simultaneously rounded and angular, reinforcing the sense of tension in the painting.

CONTINUITY & CHANGE

La Grande Odalisque, p. 414

in Chapter 13), a painting Picasso greatly admired. In fact, in January 1907, as Picasso was planning Les Demoiselles, Olympia was hung, for the first time, in the Louvre, to much public comment and controversy. It was placed, not coincidentally, alongside

Ingres's La Grande Odalisque (see Fig. 13.3 in Chapter 13). Both figures turn to face the viewer, and the distortions both painters work upon their figures—Manet's flat paint, Ingres's elongated spine and disconnected extremities—probably inspired Picasso to push the limits of representation even further.

Also extremely important to Picasso was the example of Cézanne, who, a year after his death in October 1906, was honored with a huge retrospective at the 1907 Salon d'Automne. Cézanne, Picasso would say, "is the father of us all." In the way Picasso shows one object or figure from two different points of view, the compressed and concentrated space of *Les Demoiselles* is much like Cézanne's (see Fig. 14.5). Consider the still-life grouping of melon, pear, apple,

and grapes in the center foreground. The viewer is clearly looking down at the corner of a table, at an angle completely inconsistent with the frontal view of the nude who is parting the curtain. And note the feet of the nude second from the left. Could she possibly be standing? Or is she, in fact, reclining, so that we see her from the same vantage point as the still life?

Picasso's subject matter and ambiguous space were disturbing to viewers. Even more disturbing were the strange faces of the left-hand figure and the two to the right. X-ray analysis confirms that originally all five of the figures shared the same facial features as the two in the middle left, with their almond eyes and noses drawn in an almost childlike profile. But sometime in May or June 1907, after he visited the ethnographic museum at the Palais du Trocadéro, across the river from the Eiffel Tower, Picasso painted over the faces of the figure at the left and the two on the right, giving them instead what most scholars agree are the characteristics of African masks. But equally important to Picasso's creative process was a retrospective of Gauguin's painting and sculpture, at the 1906 Salon d'Automne, with their Polynesian imagery (see Fig. 14.7). At any rate, Picasso's intentions were clear. He wanted to connect his prostitutes to the seemingly authentic—and emotionally energizing—forces that Gauguin had discovered in the "primitive." Many years later, he described the meaning of African and Oceanic masks to Les Demoiselles:

The masks weren't just like any other pieces of sculpture. Not at all. They were magic things.... They were against everything—against unknown, threatening spirits. I always looked at fetishes. I understood; I too am against everything. I too believe that everything is unknown, that everything is an enemy!... All the fetishes were used for the same thing. They were weapons. To help people avoid coming under the influence of spirits again, to help them become independent. They're tools. If we give spirits a form, we become independent.... I understood why I was a painter. All alone in that awful museum [the Trocadéro] with masks, with dolls made by the redskins, dusty manikins. Les Demoiselles d'Avignon must have come to me that very day, but not because of the forms; because it was my first exorcism painting—yes absolutely!

Les Demoiselles, then, was an act of liberation, an exorcism of past traditions, perhaps even of painting itself. It would allow Picasso to move forward into a kind of painting that was totally new.

Picasso scholar Patricia Leighten has argued convincingly that the African masks in Les Demoiselles are designed not only to challenge and mock Western artistic traditions but also to evoke and criticize the deplorable exploitation by Europeans of black Africans, particularly in the Congo—a theme taken up by Joseph Conrad in his 1899 novella Heart of Darkness (see Chapter 13). A scandal had erupted in 1905 when the French government's administrators in the Congo, Fernand Gaud and Georges Toqué, were accused of a wide variety of atrocities. In addition to their salaries, these administrators received bonuses for rubber collected under them, and they coerced natives to furnish them with rubber by pillaging their villages, executing "lazy" or uncooperative villagers, kidnapping their wives and children, and perpetrating even more scandalous assaults. Gaud and Toqué were accused specifically of dynamiting an African guide in celebration of Bastille Day and of forcing one of their servants to drink soup they had made from a native's head. Thus Picasso's painting confronts a variety of idealizations: the idealization of the world as reflected in traditional European art, the idealization of sexuality—and love—and the idealization of the colonizing mission of the European state. It acknowledges, in other words, the artist's obligation to confront the horrific truths that lie behind and support bourgeois complacency.

The Invention of Cubism: Braque's Partnership with Picasso

When the French painter Georges Braque (1882–1963) first saw Les Demoiselles, in December 1907, he said that he felt burned, "as if someone were drinking gasoline and spitting fire." He was, like Picasso, obsessed with Cézanne, so much so that he went to paint the following summer in Cézanne country in the south of France. When he returned to Paris in September, he brought with him a series of landscapes, among them Houses at l'Estaque (Fig. 14.10). Picasso was fascinated with their spatial ambiguity and cubelike shapes.

Note in particular the central house, where (illogically) the two walls that join at a right angle are shaded on both sides of the corner yet are similarly illuminated. And the angle of the roof line does not meet at the corner, thus flattening the roof. Details of windows, doors, and moldings have been eliminated, as have the lines between planes, so that one plane seems to merge with the next in a manner reminiscent of Cézanne. The tree that rises on the left seems to merge at its topmost branch into the distant houses. The curve of the bush on the left echoes that of the tree, and its palmlike leaves are identical to the trees rising between the houses behind it. The structure of the foreground mirrors that of the houses. All this serves to flatten the composition even as the lack of a horizon causes the whole composition to appear to roll toward the viewer rather than recede in space.

Seeing Braque's landscapes at a gallery in November 1908, the critic Louis Vauxcelles wrote: "He [Braque] is contemptuous of form, reduces everything, sites and figures and houses to geometric schemas, to cubes." But the movement known as **Cubism** was born out of collaboration. "Almost every evening," Picasso later recalled, "either I went to Braque's studio or Braque came to mine. Each of us had to see what the other had done during the day." The two men were inventors, brothers—Picasso even took to calling Braque "Wilbur," after the aeronautical brothers Orville

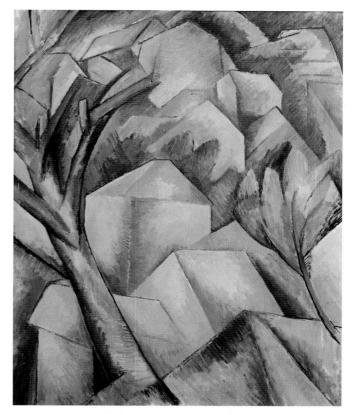

Fig. 14.10 Georges Braque, Houses at l'Estaque. 1908. Oil on canvas, 28¾" × 23¾". Estate of Georges Braque. © 2014 Artists Rights Society (ARS), New York/ADAGP, Paris. Hermann and Margit Rupf Foundation. Braque's trip to l'Estaque in the summer of 1908 was a form of homage to Cézanne, whose style he consciously radicalized in such works as this.

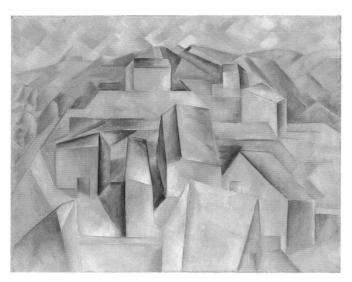

Fig. 14.11 Pablo Picasso, Houses on a Hill, Horta de Ebro. 1909. Oil on canvas, 25\%" × 31\%". Jens Ziehe/Nationalgalerie, Museum Berggruen, Staatliche Museen, Berlin. © 2014 Estate of Pablo Picasso/Artists Rights Society (ARS), New York. This is one of a series of some 15 paintings Picasso executed at Horta de Ebro (known today as Horta de Sant Joan) in the hills above Valencia during the summer of 1909.

of the PAST

See Mark Tansey,

at MyArtsLab

and Wilbur Wright. When Picasso The CONTINUING PRESENCE returned to Paris from Spain in the fall of 1909, he brought with him landscapes that showed just how much he had learned from Braque (Fig. 14.11).

Picasso and Braque pushed on, working so closely together that their work became indistinguishable to most viewers. They began to

decompose their subjects into faceted planes, so that they seem to emerge down the middle of the canvas from some angular maze, as in Braque's Violin and Palette (Fig. 14.12). Gradually they began to understand that they were questioning the very nature of reality, the nature of "truth" itself. This is the function of the trompe-l'oeil nail casting its shadow onto the canvas at the top of Braque's painting. It announces its own artifice, the practice of illusionistically representing things in three-dimensional space. But the nail is no more real than the violin, which is about to dissolve into a cluster of geometric forms. Both are painted illusions, equally real as art.

From 1910 to 1912, Picasso and Braque took an increasingly abstract approach to depicting reality through painting. They were so experimental, in fact, that the subject nearly disappeared. Only a few cues remained to help viewers understand what they were seeing—a moustache, the scroll of a violin, a treble clef.

Increasingly, Picasso and Braque added a few words here and there. Picasso used words from a popular song, "Ma Jolie" ("My pretty one"), to identify portraits of his current lover, or "Jou," to identify the newspaper Le Journal. "Jou" was also a pun on the word jeu ("play"), and it symbolized the play

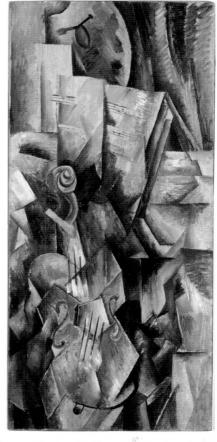

Fig. 14.12 Georges Braque, Violin and Palette. Autumn 1909. Oil on canvas, 361/8" × 167/8". The Solomon R. Guggenheim Museum, New York. 54.1412. © 2014 Artists Rights Society (ARS), New York/ADAGP, Paris. As in Picasso's Les Demoiselles, the primary tension in the painting is created by the juxtaposition of the rounded and angular forms.

between the reality of the painting as an object and the reality of the world outside the frame. This kind of ambiguity led Braque and Picasso to introduce actual two- and threedimensional elements into the space of the canvas, in what they came to call collage, from the French coller, "to paste or glue." These elements—paper, fabric, rope, and other material—at least challenged, if they did not completely obliterate, the space between life and art.

Thus in Picasso's 1912 Guitar, Sheet Music, and Wine Glass (Fig. 14.13), at the bottom of the page, the headline of Le Journal reads, "La bataille s'est engagé," "The battle is joined." Literally, it refers to a battle in the Balkans, where Bulgaria attacked the Turks, November 17 through 19. But the "battle" is also metaphorical, the battle between art and reality (and perhaps between Braque and Picasso as they explored the possibilities of collage). Similarly, the background's trellis-and-rose wallpaper is no more or less real than the fragment of the actual musical score, the faux-bois ("false wood") guitar, and the Cubist drawing of a glass, cut out of some preexisting source like the other collage elements in the work. Collage is the great equalizer, in which all the elements are united on the same plane, both the literal plane of the canvas and the figurative plane of reality.

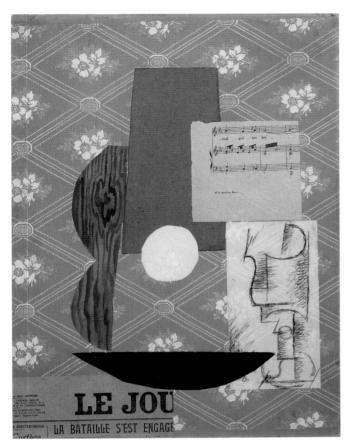

Fig. 14.13 Pablo Picasso, Guitar, Sheet Music, and Wine Glass. 1912. Charcoal, gouache, and papiers-collé, 187/8" × 143/8". The McNay Art Museum, San Antonio, TX. Bequest of Marion Koogler McNay. Art © 2014 Estate of Pablo Picasso/Artists Rights Society (ARS), New York. The newspaper fragment at the bottom of the painting derives from the front page of Le Journal, November 18, 1912.

Futurism: The Cult of Speed

News of the experimental fervor of Picasso and Braque spread quickly through avant-garde circles across Europe, and other artists sought to match their endeavors in independent but related ways. On February 20, 1909, for instance, the Paris newspaper Le Figaro published on its front page the Founding and Manifesto of Futurism, written by the Italian Filippo Marinetti (1876-1944). It rejected the political and artistic traditions of the past and called for a new art. Marinetti quickly attracted a group of painters and sculptors to invent it. These included the Italian artists Giacomo Balla (1871-1958), Umberto Boccioni (1882-1916), Carlo Carrà (1881-1966), Luigi Russolo (1885-1947), who was also a musician, and Gino Severini (1883–1966). The new style was called Futurism. The Futurists repudiated static art and sought to render what they thought of as the defining characteristic of modern urban life—speed. But it was not until Marinetti took Boccioni, Carra, and Russolo to Paris for two weeks in the fall of 1911, arranging visits to the studios of Picasso and Braque, that the fledgling Futurists discovered how they might represent it—in the fractured idiom of Cubism.

However, the work the Futurists created was philosophically remote from Cubism. It reflected Marinetti's Manifesto, which affirmed not only speed, but also technology and violence. In the manifesto, Futurism is born out of a high-speed automobile crash in the "maternal ditch" of modernity's industrial sludge, an intentionally ironic image of rebirth and regeneration. Where the Cubist rejection of tradition had largely been the invention of two men working in relative isolation, the Futurist rejection was public, bombastic, and political. As the Futurists traveled around Europe between 1910 and 1913 promoting their philosophy in public forums and entertainments, their typical evening featured insultslinging and scuffles with the audience, usually an arrest or two, and considerable attention in the press. In fact, it could be said that Marinetti was among the first artists to understand the power of publicity in stimulating public interest, in creating what we have come to call "buzz."

One of the great masterpieces of continuity & CHANGE Futurist art is Boccioni's Unique Forms of Continuity in Space (Fig. 14.14), a work oddly evocative of the very Nike of Samothrace (see Fig. 2.45 in Chapter 2) that Marinetti in his manifesto found less compelling than a speeding car. Boccioni probably intended to represent a nude, her musculature stretched and

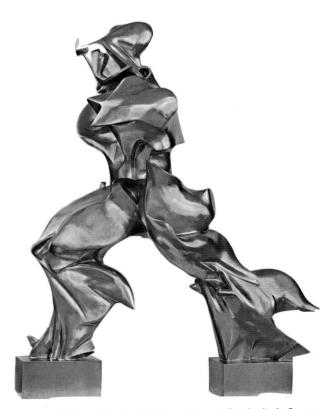

Fig. 14.14 Umberto Boccioni, Unique Forms of Continuity in Space. 1913. Bronze, 43%" \times 34%" \times 15%". The Museum of Modern Art, New York. Acquired through the Lillie P. Bliss Bequest. (231.1948). Between 1912 and 1914, Boccioni made 12 important sculptures. Five have survived, of which this is one

drawn out as she moves through space. "What we want to do," he explained, "is show the living object in its dynamic growth."

A New Color: Matisse and the Expressionists

When the painter Henri Matisse (1869-1954) saw Les Demoiselles, he is said to have considered it an "audacious hoax," an "outrage [ridiculing] the modern movement." It is little wonder, as the two painters' aesthetic visions were diametrically opposed. Gertrude Stein had introduced the two men in April 1906. Twelve years older than Picasso, Matisse was the favorite of Gertrude Stein's brother Leo. He had established himself, at the Salon des Indépendants in 1904, as the leader of a radical new group of experimental painters known as the Fauves-or "Wild Beasts." Fauvism was known for its radical application of arbitrary, or unnatural, color, anticipated in a few of Van Gogh's paintings and in the pool of color in the foreground of Gauguin's Mahana no atua (see Fig. 14.7). Picasso and Matisse saw each other regularly at the Steins' apartment, but their relationship was competitive. In fact, it is useful to think of Matisse's monumental Dance (Fig. 14.15) as something of a rebuttal of the upstart Picasso's Demoiselles. Matisse had painted a similar circular dance before, with six figures, but when he repeated the motif in Dance, the number is five, like Picasso's five prostitutes. Matisse also replaces Picasso's squared and angular composition with a circular and rounded one. Where Picasso's painting seems static, as if asking us to hold our breath at the scene before us, Matisse's is active, moving as if to an unheard music. Most astonishing is Matisse's color—vermilion (red-orange), green, and blue-violet, the primary colors of light. In effect, Matisse's modernism takes place in the light of day, Picasso's in the dark of night; Matisse's with joy, Picasso's with fear and trepidation.

Like that of the Fauves, the German Expressionists' interest in color can be traced to the art of Van Gogh and Gauguin. But unlike the Fauves, they often drew their subject matter from their own psychological makeup. They laid bare in paint the torment of their lives. There were Expressionist groups throughout Europe that encompassed the visual arts and other media, but the most important in Germany was *Der Blaue Reiter* ("The Blue Rider"), based in Munich.

Der Blaue Reiter did not come into being until 1911. It was headed by the Russian émigré Wassily Kandinsky (1866–1944) and by Franz Marc (1880–1916), an artist especially fond of painting animals, because he believed they possessed elemental energies. They were joined by a number of other artists, and although they shared no common style, all were obsessed with color. "Color," Kandinsky wrote in Concerning the Spiritual in Art, first published in 1912 in the Blaue Reiter Almanac, "directly influences the soul. Color is the keyboard, the eyes are the hammers, the soul is the piano with many strings. The artist is the hand that plays... to cause vibrations of the soul." The color blue, Kandinsky wrote, is "the typical heavenly color." Marc saw in blue what he thought of as the masculine principle of spirituality. So his Large Blue

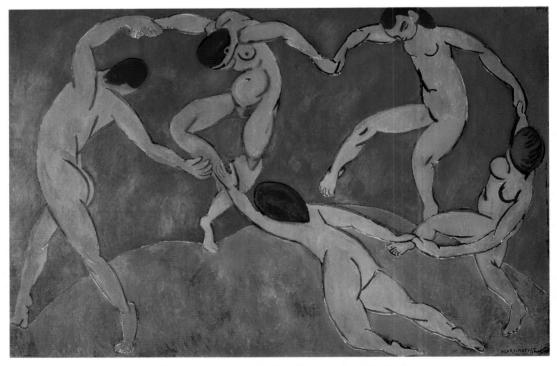

Fig. 14.15 Henri Matisse, Dance II. 1910. Oil on canvas. 8'55%" × 12'9½". Inv. no. 9673. The State Hermitage Museum, Saint Petersburg. © 2014 Succession H. Matisse/Artists Rights Society (ARS), New York. This work and another similarly colored painting of musicians called Music were commissioned by the Russian collector Sergei Shchukin to decorate the staircase of his home in

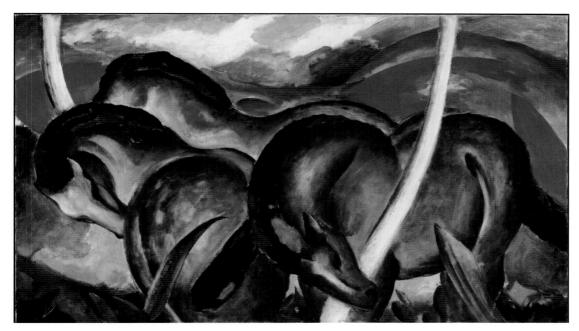

Fig. 14.16 Franz Marc, *The Large Blue Horses*. 1911. Oil on canvas, 3'5%" × 5'11¼". Walker Art Center, Minneapolis. Gift of T. B. Walker Collection, Gilbert M. Walter Fund, 1942. The painting is meant to contrast the beauty of the untainted natural world with the sordidness of modern existence, very much in the spirit of Gauguin.

Horses, with its seemingly arbitrary color and interlocking rhythm of fluid curves and contours, very much influenced by Matisse, is the very image of the spiritual harmony in the natural world (Fig. 14.16).

Kandinsky's chief theme was the biblical Apocalypse, the moment when, according to a long tradition in the Byzantine church, Moscow would become the New Jerusalem. "Der Reiter," in fact, was the popular name for Saint George,

patron saint of Moscow, and the explosions of contrasting colors across Composition VII (Fig. 14.17) suggest that the fateful moment has arrived. Earthly yellow competes with heavenly blue, and red with green. Red, Kandinsky wrote, "rings inwardly with a determined and powerful intensity," while green "represents the social middle class, self-satisfied, immovable, narrow." Linear elements, he felt, were equivalent to dance, and the painting can be interpreted as a rendering of dance set to music. But Composition VII is the last of a series of "compositions"—the title in fact refers to music—on the biblical themes of war and resurrection, deluge and apocalypse, with each painting becoming more and more abstract. Certain passages, however, remain legible, especially when seen in light of the earlier works, such as a boat with three oars at the bottom left, which is, for Kandinsky, an emblem of the deluge. But above all, the painting remains a virtually nonobjective orchestration of line and color.

Modernist Music and Dance

The dynamism and invention evident in modern painting also appeared in music and dance. On May 29, 1913, the Ballets Russes, a company under the direction of the impresario Sergei Diaghilev (1872–1929), premiered the ballet *Le Sacre du printemps* (*The Rite of Spring*) at the Théâtre des Champs-Élysées in Paris. The music was by the cosmopolitan Russian composer Igor Stravinsky (1882–1971) and the

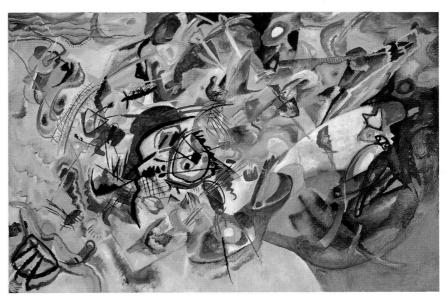

Fig. 14.17 Wassily Kandinsky, *Composition VII. 1913.* Oil on canvas, 6'6¾" × 9'11½". Tretyakov Gallery, Moscow. © 2014 Artists Rights Society (ARS), New York/ADAGP, Paris. Among practitioners of nonfigurative abstract art, Kandinsky was perhaps unique in not forcing his point of view on his colleagues. If his was what he called "the Greater Abstraction," theirs was "the Greater Realism," equally leading to "the spiritual in art."

choreography by his countryman Vaslav Nijinsky (1890–1950). The performance was a scandal. Together with the Futurists' confrontational performances and, earlier, the public outrage at Manet's *Luncheon on the Grass* and *Olympia* in the 1860s, it helped to define modern art as antagonistic to public opinion and an affront to the public's values.

The events of that evening surprised everyone. The night before, a dress rehearsal performed before an audience, in Stravinsky's words, "of actors, painters, musicians, writers, and the most cultured representatives of society" had proved uneventful. But on the night of the public premiere, the first notes of Stravinsky's score evoked derisive laughter. Hissing, booing, and catcalls followed, and at such a level that the dancers could not hear the music. Diaghilev ordered the lights to be turned on and off, hoping to quiet the crowd, but that just incensed the audience further. Finally the police had to be called, as Stravinsky himself crawled to safety out of a backstage window.

What seemed most radically new to Stravinsky's audience was the music's angular, jarring, sometimes violent rhythmic inventiveness. The ballet's story—it is subtitled Pictures from Pagan Russia—centers on a pre-Christian ritual welcoming the beginning of spring that culminates in a human sacrifice. The music reflects the brutalism of the pagan rite with savage dissonance. Part 1 of the work, "The Adoration of the Earth," culminates in a spirited dance of youths and maidens in praise of the earth's fertility. In Part 2, "The Sacrifice," one of the maidens is chosen to be sacrificed in order to guarantee the fertility celebrated in Part 1. All dance in honor of the Chosen One, invoking the blessings of the village's ancestors, culminating in the frenzied Sacrificial Dance of the Chosen One herself (see track 14.1). Just before the dancer collapses and dies, Stravinsky shifts the meter eight times in 12 measures; the men then carry the Chosen One's body to the foot of a sacred mound and offer her up to the gods.

Sometimes different elements of the orchestra play in different meters simultaneously. Such polyrhythms contrast dramatically with other passages where the same rhythmic pulse repeats itself persistently—such as when at the end of the ballet's first part the orchestra plays the same eighth-note chords 32 times in succession. (This technique is known as ostinato—Italian for "obstinate.") In addition to its rhythmic variety, Stravinsky's ballet was also polytonal: Two or more keys are sounded by different instruments at the same time, and the traditional instruments of the orchestra are used in startlingly unconventional ways, so that they sound raw and strange. Low-pitched instruments, such as bassoons, play at the top of their range, for instance, and clarinets at the gravelly bottom of their capabilities. Integrated with these jarring juxtapositions are passages of recognizable Russian folk songs. Stravinsky's music was enormously influential on subsequent composers, who began to think about rhythmic structure in a totally different way.

If the first Paris audience found Stravinsky's music offensive, Nijinsky's choreography seemed a downright provocation to riot: "They repeat the same gesture a hundred times over," wrote one critic, "they paw the ground, they stamp, they stamp, they stamp and they stamp.... Evidently all of this is defensible; it is prehistoric dance." It certainly was not recognizable as ballet. It moved away from the traditional graceful movements of ballerinas dancing *en pointe* (on their toes in boxed shoes) toward a new athleticism. Nijinsky's choreography called for the dancers to assume angular, contorted positions that at once imitated ancient bas-relief sculpture and Cubist painting, to hold these positions in frozen stillness, and then burst into wild leaps and whirling circle dances.

Meanwhile, in Germany, audiences were equally challenged by the work of Arnold Schoenberg (1874–1951). Schoenberg was from Vienna, where he led a group of composers, including Alban Berg and Anton Webern, who believed that the long reign of tonality, the harmonic basis of Western music, was over. On January 2, 1911, the Blaue Reiter painters Kandinsky and Marc attended a Schoenberg concert in Munich. Marc later wrote to a friend, "Can you imagine a music in which tonality is completely suspended? I was constantly reminded of Kandinsky.... Schoenberg seems, like [us], to be convinced of the irresistible dissolution of the European laws of art and harmony."

Schoenberg did in fact abandon tonality, the organization of the composition around a home key (the tonal center). In its place, he created a music of complete atonality, a term he hated (since it implied the absence of musical tone altogether), preferring instead "pantonal." His 1912 setting of a cycle of 21 poems by Albert Giraud, Pierrot lunaire, is probably the first atonal composition to be widely appreciated, although to many it represented, as one critic put it, "the last word in cacophony and musical anarchy" (see track 14.2). Pierrot is a character from the Italian commedia dell'arte, the improvisational traveling street theater that first developed in the fifteenth century. He is a moonstruck clown whose mask conceals his deep melancholy, brought on by living in a state of perpetually unrequited desire. (Picasso often portrayed himself as Pierrot, especially early in his career.) In Pierrot lunaire, five performers play eight instruments in various combinations in accompaniment to a voice that does not sing but instead employs a technique that Schoenberg calls Sprechstimme or "speechsong." "A singing voice," Schoenberg explained, "maintains the pitch without modification; speech-song does, certainly, announce it [the pitch], only to quit it again immediately, in either a downward or an upward direction." In the "Madonna" section of Pierrot lunaire, which addresses Mary at the moment of the pietà, when she mourns over the dead body of her son, the lyrics focus on the blood of Christ's wounds, which "seem like eyes, red and open." The atonality of Schoenberg's music reflects this anguish with explosive force.

Creating long works without the resources of tonality was a very real challenge to Schoenberg—hence the usefulness of 21 short works in the Pierrot lunaire series. By 1924, Schoenberg had created a system in which none of the 12 tones of the chromatic scale could be repeated in a composition until each of the other 11 had been played. This 12tone system reflected his belief that every tone was equal to every other. The 12 notes in their given order are called a tone row, and audiences soon grew accustomed to not hearing a tonal center in the progression and variation of the tone row as it developed in Schoenberg's increasingly serial composition. The principal tone row can be played upside down, backward, or upside down and backward. While the possibilities for writing an extended composition with a single tone row and its variations might at first seem limited, by adding rhythmic and dynamic variations, as well as contrapuntal arrangements, the development of large-scale works became feasible.

Early Twentieth-Century Literature

If one word could express the literature of the early twentieth century, it would be innovation. Like visual artists and composers, writers too were drawn to uncharted ground and experimented with creating new forms in an effort to embrace the multiplicity of human experience. Like Picasso in his *Demoiselles d'Avignon*, they sought a way to capture the simultaneous and often contradictory onslaught of information and feelings that characterized the fabric of modern life. And writers understood that these multiple impulses from the real world struck the brain randomly, inharmoniously, in rhythms and sounds as discordant as the music of Stravinsky and Schoenberg.

Guillaume Apollinaire and Cubist Poetics Picasso's good friend and a champion of his art, Guillaume Apollinaire (1880–1918), was one of the leaders in the "revolution of the word," as this new approach to poetry and prose has been called. Modeling his work on the example of Picasso, Apollinaire quickly latched on to the principle of collage. In his poem "Lundi, rue Christine" ("Monday in the rue Christine"), snatches of conversation overheard on a street in Paris, not far from the École des Beaux Arts, follow one another without transition or thematic connection (Reading 14.2):

READING 14.2

from Guillaume Apollinaire, "Lundi, rue Christine" (1913)

Those pancakes were delicious
The tap is running
A dress as black as her nails
It's absolutely impossible
Look sir
The malachite ring
The ground is covered with sawdust
So it's true

The redhaired waitress was abducted by a bookseller A journalist whom by the way I know only very vaguely Listen Jacques I'm going to tell you something very serious

Goods and passenger steam navigation company

In this short, representative fragment from the poem, Apollinaire has transformed this collage of voices into poetry by the act of arranging each phrase into poetic lines.

Ezra Pound and William Carlos Williams Apollinaire's strategy of juxtaposing fragments of speech heard simultaneously, thereby combining two (or more) unlike words, objects, or images, was, in fact, a fundamental strategy of modern art. It informs, as well, the poetry of the Imagists, a group of English and American poets who sought to create precise images in clear, sharp language. Imagism was the brainchild of American poet Ezra Pound (1885–1972), who in October 1912 submitted a group of poems under the title *Imagiste* to the new American journal *Poetry*. The poet and critic F. S. Flint would succinctly define the Imagist poem in the March 1913 issue of the magazine. Its simple rules were:

- 1. Direct treatment of the "thing," whether subjective or objective.
- 2. To use absolutely no word that does not contribute to the presentation.
- 3. As regarding rhythm: to compose in sequence of the musical phrase, not in sequence of the metronome.

Pound's "In a Station of the Metro," which first appeared in *Poetry* in 1913, is in many ways the classic Imagist poem (Reading 14.3):

READING 14.3

Ezra Pound, "In a Station of the Metro" (1913)

The apparition of these faces in the crowd; Petals on a wet, black bough.

Pound was an avid scholar of Chinese and Japanese poetry, and the poem is influenced both by the Japanese waka tradition, with its emphasis on the changing seasons, and formally, in its brevity at least, by the haiku tradition (see Chapter 9). (Haiku normally consist of 3 lines in 17 syllables, while Pound's poem is made up of 19 syllables in 2 lines.) The poem's first line seems relatively straightforward—except for the single word "apparition." It introduces Pound's predisposition, his sense that Paris is inhabited by the "living dead." It contrasts dramatically with the poem's second and final line, which is an attractive picture of nature. The first line's six-beat iambic meter—daduh, da-duh, and so on—is transformed into a five-beat line that ends in three long strophes—that is, single beats—"wet,

black bough." The semicolon at the end of the first line acts as a kind of hinge, transforming the bleak vision of the moment into a vision of possibility and hope, the implicitly "white" apparition of the faces of the ghostlike crowd transformed into an image of spring itself, the petals on the wet, black bough. The poem moves from the literal subway underground, from burial, to life, reborn in the act of the poetic vision itself. It captures that moment, as Pound said, when a thing "outward and objective" is transformed into a thing "inward and subjective."

In 1934, Pound would publish a collection of essays titled Make It New, and his "make it new" mantra soon became something of a rallying cry for the new American poetry. The sentiment was shared especially by his friend, the poet William Carlos Williams (1883–1963). Williams met Pound when they were both students at the University of Pennsylvania in 1902. Williams was a physician in Rutherford, New Jersey, across the Hudson River from New York City. He was immediately attracted to Imagism when Pound defined it in the pages of Poetry magazine, particularly to the Imagist principle of verbal simplicity: "Use absolutely no word that does not contribute to the presentation." He praised Imagism for "ridding the field of verbiage." His own work has been labeled "Radical Imagism," for concentrating on the stark presentation of commonplace objects to the exclusion of inner realities. His famous poem "The Red Wheelbarrow" is an example (Reading 14.4):

READING 14.4

William Carlos Williams, "The Red Wheelbarrow," from Spring and All (1923)

so much depends upon

a red wheel barrow

glazed with rain water

beside the white chickens

The first line of each stanza of Williams's poem raises expectations which the second line debunks in two syllables. Thus a mere preposition, "upon," follows the urgency of "so much depends." A "red wheel" conjures images of Futurist speed, only to fall flat with the static "barrow." "Rain/water" approaches redundancy. Our expectations still whetted by the poem's first line, the word "white" suggests purity, only to modify the wholly uninspiring image, "chickens." Williams's aesthetic depends upon elevating the commonplace and the everyday into the realm of poetry, thus transforming them, making them new.

THE GREAT WAR AND ITS AFTERMATH

What was the impact of the Great War on the art and literature of the era?

On June 28, 1914, a young Bosnian nationalist assassinated Archduke Francis Ferdinand, heir to the Austrian throne, in the Bosnian capital of Sarajevo. Europe was outraged, except for Serbia, which had been at war with Bosnia for years. Austria suspected that Serbian officials were involved (as in fact they were). With Germany's support, Austria declared war on Serbia, Russia mobilized in Serbia's defense, and France mobilized to support its ally, Russia. Germany invaded Luxembourg and Belgium, and then pushed into France. Finally, on August 4, Britain declared war on Germany, and Europe was consumed in battle.

Although the Germans advanced perilously close to Paris in the first month of the war, the combined forces of the British and French stopped them. From then on, along the Western Front on the French/Belgian border, both sides dug in behind zigzagging rows of trenches protected by barbed wire that stretched from the English Channel to Switzerland, some 25,000 miles of them. In the three years after its establishment, the Western Front moved only a few miles either east or west.

Stagnation accompanied carnage. Assaults in which thousands of lives were lost would advance the lines only a couple of hundred yards. Poison mustard gas was introduced in the hope that it might resolve the stalemate, but it changed nothing, except to permanently maim or kill thousands upon thousands of soldiers. Mustard gas blinded those who encountered it, but it also slowly rotted the body from within and without, causing severe blistering and damaging the bronchial tubes, so that its victims slowly choked to death. Most affected by the gas died within four to five weeks. British troops rotated trench duty. After a week behind the lines, a unit would move up, at night, to the front-line trench, then after a week there, back to a support trench, then after another week back to the reserve trench, and then, finally, back to a week of rest again. Attacks generally came at dawn, so it was at night, under the cover of darkness, that most of the work in the trenches was done—wiring, digging, moving ammunition. It rained often, so the trenches were often filled with water. The troops were plagued by lice, and huge rats, which fed on cadavers and dead horses, roamed through the encampments. The stench was almost as unbearable as the weather, and lingering pockets of gas might blow through at any time. As Germany tried to push both east and west, the human cost was staggering. By the war's end, casualties totaled around 10 million dead—it became impossible to count accurately—and somewhere around twice that many wounded.

Trench Warfare and the Literary Imagination

At the outset of the war, writers responded to the conflict with buoyant enthusiasm, along with thousands of others, their patriotic duty calling them to arms. Life in the trenches soon brought the meaninglessness of such rhetoric crashing down around this new generation of soldiers. Words like "glory" and "honor" suddenly rang hollow. The tradition of viewing warfare as an arena in which heroes exhibit what the Greeks called areté, or virtue (see Chapter 2)—that is, realize their full human potential—no longer seemed applicable to experience, and a new kind of writing about war, an antiwar literature far removed from the heroic battle scenes of poems like Homer's Iliad, soon appeared.

Wilfred Owen: "The Pity of War" $\,A\,$ notable example is the poetry of 25-year-old Wilfred Owen (1893–1918), killed in combat just a week before the armistice was signed in 1918. His work caused a sensation when it first appeared in 1920. "My subject is War, and the pity of War," he wrote in a manuscript intended to preface his poems, "and the Poetry is in the pity." The poems drew immediate attention for Owen's horrifying descriptions of the war's victims, as in "Dulce et Decorum Est," its title drawn from Ode 13 of the Roman poet Horace (see Chapter 3), "It is sweet and fitting to die for one's country." But Owen's reference to Horace is bitterly ironic (Reading 14.5):

READING 14.5

Wilfred Owen, "Dulce et Decorum Est" (1918)

Bent double, like old beggars under sacks. Knock-kneed, coughing like hags, we cursed through sludge,

Till on the haunting flares we turned our backs And towards our distant rest began to trudge. Men marched asleep. Many had lost their boots But limped on, blood-shod. All went lame; all blind; Drunk with fatigue; deaf even to the hoots Of disappointed shells that dropped behind.

GAS! Gas! Quick, boys!—An ecstasy of fumbling, Fitting the clumsy helmets just in time; But someone still was yelling out and stumbling And floundering like a man in fire or lime.— Dim, through the misty panes and thick green light As under a green sea, I saw him drowning.

In all my dreams, before my helpless sight, He plunges at me, guttering, choking, drowning.

If in some smothering dreams you too could pace Behind the wagon that we flung him in. And watch the white eyes writhing in his face, His hanging face, like a devil's sick of sin; If you could hear, at every jolt, the blood Come gargling from the froth-corrupted lungs. Obscene as cancer, bitter as the cud Of vile, incurable sores on innocent tongues,— My friend, you would not tell with such high zest To children ardent for some desperate glory, The old Lie: Dulce et decorum est Pro patria mori.

The quotation from Horace in the last lines is, notably, labeled by Owen a "Lie." And the fact is, Owen's intent is that the reader should share his horrific dreams. His rhetorical strategy is to describe the drowning of this nameless man in a sea of green gas in such vivid terms that we cannot forget it either.

T. S. Eliot: The Landscape of Desolation The American poet T. S. (Thomas Stearns) Eliot (1888–1965) was studying at Oxford University in England when World War I broke out. Eliot had graduated from Harvard with a degree in philosophy and the classics, and his poetry reflects both the erudition of a scholar and the depression of a classicist who feels that the tradition he so values is in jeopardy of being lost. In Eliot's poem The Waste Land, the opening section, called "The Burial of the Dead," is a direct reference to the Anglican burial service, performed so often during and after the war. "April is the cruelest month," the poem famously begins (Reading 14.6):

READING 14.6a

from T. S. Eliot, The Waste Land (1921)

April is the cruelest month, breeding Lilacs out of the dead land, mixing Memory and desire, stirring Dull roots with spring rain. Winter kept us warm, covering Earth in forgetful snow, feeding A little life with dried tubers.

The world, in short, has been turned upside down. Spring is cruel, winter consoling. Eliot sees London as an "Unreal City" populated by the living dead (Reading 14.6b):

READING 14.6b

from T. S. Eliot, The Waste Land (1921)

Unreal City, Under the brown fog of a winter dawn, A crowd flowed over London Bridge, so many, I had not thought death had undone so many. Sighs, short and infrequent, were exhaled, And each man fixed his eyes before his feet. Flowed up the hill and down King William Street. To where Saint Mary Woolnoth kept the hours With a dead sound on the final stroke of nine.

In the crucial middle section of the poem, "The Fire Sermon," Eliot depicts modern love as reduced to mechanomorphic tedium. He describes the sexual encounter between a typist and her "young man carbuncular"—that is, covered with boils—as overseen by the figure of Tiresias. In a note, Eliot insists that Tiresias is "the most important personage in the poem," despite the fact that he is a "mere spectator." In his Metamorphoses (see Chapter 3), Ovid describes how Tiresias spent seven years as a woman. Later, he was asked to settle a quarrel between Zeus and Hera over who enjoyed sex more, men or women. When Tiresias agreed with Zeus that women enjoyed it more, Hera blinded him, but Zeus compensated him by giving him the gift of prophesy. Tiresias, here, blind yet able to see with complete clarity, embodies the modern condition, a doomed individual who can neither hope nor act, but only sit and watch (Reading 14.6c):

Turn upward from the desk, when the human engine

READING 14.6c

waits

from T. S. Eliot, *The Waste Land* (1921) At the violet hour, when the eyes and back

Like a taxi throbbing waiting, l Tiresias, though blind, throbbing between two lives, Old man with wrinkled female breasts, can see At the violet hour, the evening hour that strives Homeward, and brings the sailor home from sea, The typist home at teatime, clears her breakfast, lights Her stove, and lays out food in tins. Out of the window perilously spread Her drying combinations¹ touched by the sun's last rays, On the divan are piled (at her night bed) Stockings, slippers, camisoles, and stays. l Tiresias, old man with wrinkled dugs Perceived the scene, and foretold the rest-I too awaited the expected guest. He, the young man carbuncular, arrives, A small house agent's clerk, with one bold stare, One of the low on whom assurance sits As a silk hat on a Bradford millionaire.2 The time is now propitious, as he guesses, The meal is ended, she is bored and tired, Endeavours to engage her in caresses Which are still unreproved, if undesired. Flushed and decided, he assaults at once; Exploring hands encounter no defense; His vanity requires no response, And makes a welcome of indifference. (And I Tiresias have foresuffered all Enacted on this same divan or bed; I who have sat by Thebes below the wall And walked among the lowest of the dead.)3

¹combinations one-piece underwear.

Bestows one final patronising kiss,

Paces about her room again, alone,

And puts a record on the gramophone.

And gropes his way, finding the stairs unlit . . . She turns and looks a moment in the glass, Hardly aware of her departed lover;

Her brain allows one half-formed thought to pass:

"Well now that's done: and I'm glad it's over."
When lovely woman stoops to folly and

She smoothes her hair with automatic hand,

²Bradford millionaire The industrial town of Bradford thrived on war contracts during World War I, and thus the gentleman described is, for Eliot, the image of a war profiteer.

Thebes . . . lowest of the dead Tiresias was originally from the Greek city of Thebes, but prophesied from Hades. In the poem's last section, "What the Thunder Said," the poet describes a landscape of complete emotional and physical aridity, a land where there is "no water but only rock," "sterile thunder without rain," and "red sullen faces sneer and snarl / From doors of mudcracked houses." At first Eliot dreams of the possibility of rain (Reading 16d):

READING 14.6d

from T. S. Eliot, The Waste Land (1921)

If there were the sound of water only
Not the cicada
And dry grass singing
But sound of water over a rock
Where the hermit-thrush sings in the pine trees
Drip drop drip drop drop drop
But there is no water.

Finally, as the poem nears its conclusion, there is "a flash of lightning. Then a dry gust/ Bringing rain." What this signifies is difficult to say—hope, certainly, but hope built on what premise? The poem is richly allusive—the passages excerpted here are among its most accessible—and the answer seems to reside in the weight of poetic and mythic tradition to which it refers, from Shakespeare to the myth of the Holy Grail and Arthurian legend, what Eliot calls, at the poem's end, the "fragments I have shored against my ruin." Eliot resolves, apparently, as the critic Edmund Wilson put it, "to claim his tradition and rehabilitate it."

Escape from Despair: Dada

Some writers and artists—Picasso, for instance—simply waited out the war. Many others openly opposed it and vigorously protested the social order that had brought about what seemed to them nothing short of mass genocide, and some of these soon formed the movement that named itself *Dada*. The Romanian poet Tristan Tzara (1896–1963) claimed it was his invention. The German Richard Huelsenbeck (1892–1972) claimed that he and the poet Hugo Ball (1886–1927) had discovered the name randomly by plunging a knife into a dictionary. Whatever the case, Tzara summed up its meaning best (**Reading 14.7**):

READING 14.7

Tristan Tzara, "Dada Manifesto 1918" (1918)

DADA DOES NOT MEAN ANYTHING... We read in the papers that the Negroes of the Kroo race call the tail of a sacred cow: dada. A cube, and a mother, in certain regions of Italy, are called: dada. The word for hobbyhorse, a children's nurse, a double affirmative in Russian and Romanian, is also: DADA.

Dada was an international signifier of negation. It did not mean anything, just as, in the face of war, life itself had come to seem meaningless. But it would prove a potent force in modern art.

Dada came into being at the Cabaret Voltaire in Zurich, founded in February 1916 by a group of intellectuals and artists escaping the conflict in neutral Switzerland, including Tzara, Huelsenbeck, Ball, Jean Arp (1896-1966), and the poet, dancer, and singer Emmy Hennings (1885-1948). At the end of May, Ball created a "concert bruitiste" or "noise concert," inspired by the Futurists, for a "Grand Evening of the Voltaire Art Association." Language, Ball believed, was irrevocably debased. After all, the vocabulary of nationalism—the uncritical celebration of one's own national or ethnic identity—had led to the brutality of the war. Ball replaced language with sounds, whose rhythm and volume might convey feelings that would be understood on at least an emotional level. Dressed in an elaborate costume, so stiff that he could not walk and had to be carried onto the stage, he read (Reading 14.8):

Fig. 14.18 Jean Arp, Fleur Manteau (Flower Hammer). 1916. Painted paper, 243/6" x 195/6". Haags Gemeentemuseum, The Hague, The Netherlands. © 2014 Artists Rights Society (ARS), New York/VG Bild-Kunst, Bonn. Arp was from the sometimes German, sometimes French region of Alsace, and spoke both French and German, referring to himself sometimes as Jean (French), sometimes as Hans (German).

READING 14.8

from Hugo Ball, "Gadji beri bimba" (1916)

gadji beri bimba glandridi lauli lonni cadori gadiama bim beri glassala glandridi blassala tuffm i zimbrabim blass galassasatuffm i zimbrabim....

Soon the entire Cabaret Voltaire group was composing such sound poems, which they viewed as a weapon against convention, especially the empty rhetoric of nationalism that had led to the war. Those who believed in the war notably Apollinaire, in Paris—accused them in turn of nihilism, anarchism, and cowardice.

In March 1917, the group opened the Galerie Dada. Arp's relief wall pieces—they were something between

sculpture and painting—were among the most daring works on display (Fig. 14.18). They were constructed "according to the laws of chance." His procedure was to draw random doodles on paper, allowing his pencil to move without any conscious intervention. He would then send these drawings to a carpenter who would cut them out in wood. The pieces were variously painted, then piled—again quite randomly—one on top of another and secured in place. Arp delighted in giving the resulting relief names, of usually two or more words with no logical connection—The Flower Hammer, for instance.

Such works, in their willful denial of the artist's aesthetic sensibilities, were considered by many used to thinking of art in more serious, high-minded terms as "anti-art." These more serious minds were especially offended by the so-called ready-mades of Marcel Duchamp (1887-1968). The term itself derived from the recent American invention, readymade (as opposed to tailor-made) clothes, and Duchamp adopted it soon after arriving in New York in 1915, where he joined a group of other European exiles, including his close colleague Francis Picabia (1879–1953), in still-neutral America. He was

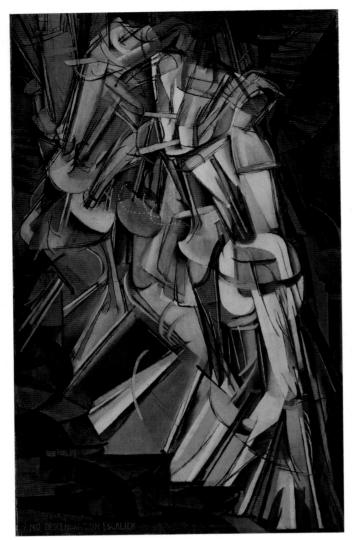

Fig. 14.19 Marcel Duchamp, Nude Descending a Staircase, No. 2. 1912. Oil on canvas, 58" × 35". Philadelphia Museum of Art, Louise and Walter Arenberg Collection. Photo: Graydon Wood, 1994. © 2014 Artists Rights Society (ARS), New York/ADAGP, Paris/Succession Marcel Duchamp. Interestingly, when Duchamp submitted this painting to the 1912 Salon des Indépendants in Paris, the selection committee objected to its literal title and traditional subject matter.

already notorious for his Nude Descending a Staircase, No. 2 (Fig. 14.19), which had been the focus of critical debate in February 1913 at the International Exhibition of Modern Art at the 69th Infantry Regiment Armory in New York. Known simply as the Armory Show, the exhibit displayed nearly 1,300 pieces, including 17 Matisses, 7 Picassos, 15 Cézannes (plus a selection of lithographs), 13 Gauguins (plus, again, a number of lithographs and prints), 18 Van Goghs, 4 Manets, 5 Monets, 5 Renoirs, 2 Seurats, a Delacroix, and a Courbet. It was the first time that most Americans were able to view French modernist painting. One newspaper writer called Duchamp's Nude "an explosion in a shingle factory." American Art News called it "a collection of saddlebags" and offered a \$10 reward to anyone

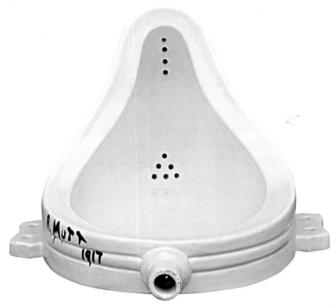

Fig. 14.20 Marcel Duchamp, Fountain. 1917; replica 1963. Porcelain. height 14". Purchased with assistance from the Friends of the Tate Gallery 1999. © Tate, London 2014. © 2014 Artists Rights Society (ARS), New York/ADAGP, Paris/Succession Marcel Duchamp. It is important to recognize that Duchamp has turned the urinal on its side, thus undermining its utility.

who could locate the nude lady The CONTINUING PRESENCE it professed to portray. President Theodore Roosevelt compared it to the Navajo rug in his bathroom. Considering the European artists shown at the exhibition as a whole, he concluded that they represented the "lunatic fringe." But if Duchamp's nude seemed inexplicable to Americans in 1913, today we can easily identify several influ-

of the PAST See Sherrie Levine. Fountain (After Marcel at MyArtsLab Cast bronze, 14" × 25" × 15"

ences that shaped the work. Duchamp was familiar with Picasso and Braque's Cubist reduction of the object into flat planes (see Figs. 14.10 and 14.11). He also knew of the Futurists' ideas about depicting motion, and, perhaps more important, he was familiar with the burgeoning motionpicture industry.

Thus, when Duchamp introduced what he dubbed his "ready-mades," the New York art world was prepared to be shocked. And Fountain (Fig. 14.20) shocked them indeed. An upside-down urinal purchased by Duchamp in a New York plumbing shop, signed with the pseudonym "R. Mutt," it was submitted by Duchamp to the New York Society of Independent Artists exhibition in April 1917. The exhibition committee, on which Duchamp served, had agreed that all work submitted would be shown, and was therefore unable to reject the piece. To Duchamp's considerable amusement, they decided instead to hide it behind a curtain. Over the course of the exhibition, Duchamp gradually let it be known that he was "R. Mutt," and in a publication called The Blind Man defended the piece:

Whether Mr Mutt with his own hands made the fountain or not has no importance. He CHOSE it. He took an ordinary article of life, placed it so that its useful significance disappeared under the new title and point of view—created a new thought for the object.

But Duchamp's ready-made was equally an attack on art and culture as a whole. If *Fountain* is, indeed, a work of art, it is also, insistently, a bathroom fixture, a commodity. By extension, Duchamp seemed to be arguing, works of art had increasingly become commodities in their own right, objects to be bought and sold at will, and were, subsequently, degraded by the marketplace.

The Harlem Renaissance

Soon after Reconstruction, the period immediately following the Civil War, Southern states passed a group of laws that effectively established a racial caste system that relegated black Americans to second-class status and institutionalized segregation. In the South, the system was known as Jim Crow. In the years before the outbreak of World War I, nearly 90 percent of all African Americans lived in the South, threequarters of them in the rural South. Lured by a huge demand for labor in the North once the war began, impoverished after a boll weevil infestation ruined the cotton crop, and threatened especially by the rise of white terrorists like the Ku Klux Klan, whose membership reached some 4 million by the early 1920s, blacks flooded into the North. In the course of a mere 90 days early in the 1920s, 12,000 African Americans left Mississippi alone. An average of 200 left Memphis every night. Many met with great hardship, but there was wealth to be had as well, and anything seemed better than life under Jim Crow in the South. From 1915 through 1918, as war raged in Europe, between 200,000 and 350,000 Southern blacks moved north in what came to be called the Great Migration.

As the Great Migration proceeded, racial tension erupted. The jobs that black workers were promised by recruiters in the South often turned out to be jobs as strikebreakers, and striking workers retaliated. In addition, as veterans returned home after the war to jobs now occupied by blacks, animosity flared. In East St. Louis, Illinois, in 1917, as blacks were arriving at a rate of about 2,000 a week, finding work at the Aluminum Ore Company and American Steel Company where white workers were on strike, riots broke out that resulted in somewhere between 40 and 200 dead, and as many as 6,000 blacks left homeless. In Tulsa, Oklahoma, in 1921, whites burned down 40 city blocks of what was the most prosperous black business district in the Southwest, destroying 23 African-American churches and over 1,000 homes and businesses. The number of African-American dead is today estimated at over 100. Nevertheless, in New York, the Great Migration inspired a cultural community so robust, and so new, that the era has come to be known as the Harlem Renaissance.

"The New Negro" Perhaps the first self-conscious expression of the Harlem Renaissance took place at a dinner party on March 21, 1924, hosted by Charles S. Johnson (1893–1956) of

the National Urban League. The League was dedicated to promoting civil rights and helping black Americans address the economic and social problems they encountered as they settled in the urban North. At Johnson's dinner, young writers from Harlem were introduced to New York's white literary establishment. A year later, the Survey Graphic, a national magazine dedicated to sociology, social work, and social analysis, produced an issue dedicated exclusively to Harlem. The issue, subtitled Harlem: Mecca of the New Negro, was edited by Alain Leroy Locke (1886–1954), an African-American professor of philosophy at Howard University in Washington, D.C. He was convinced that a new era was dawning for black Americans. and wrote a powerful introduction to a new anthology. In his essay, sometimes referred to as the manifesto of the New Negro Movement, Locke argued that Harlem was the center of this new arena of creative expression (Reading 14.9):

READING 14.9

Alain Locke, The New Negro (1925)

[There arises a] consciousness of acting as the advance-guard of the African peoples in their contact with Twentieth Century civilization... [and] the sense of a mission of rehabilitating the race in world esteem from that loss of prestige for which the fate and conditions of slavery have so largely been responsible. Harlem, as we shall see, is the center of both these movements.... The pulse of the Negro world has begun to beat in Harlem.... The New Negro... now becomes a conscious contributor and lavs aside the status of beneficiary and ward for that of a collaborator and participant in American civilization. The great social gain in this is the releasing of our talented group from the arid fields of controversy and debate to the productive fields of creative expression.... And certainly, if in our lifetime the Negro should not be able to celebrate his full initiation into American democracy, he can at least, on the warrant of these things, celebrate the attainment of a significant and satisfying new phase of group development, and with it a spiritual Coming of Age.

In Locke's view, each ethnic group in America had its own identity, which it was entitled to protect and promote, and this claim to cultural identity need not conflict with the claim to American citizenship. Locke further emphasized that the spirit of the young writers who were a part of this anthology would drive this new Harlem-based movement by focusing on the African roots of black art and music, but they would, in turn, contribute mightily to a new, more inclusive American culture.

Langston Hughes and the Poetry of Jazz As the young poet Langston Hughes (1902–67) later put it, "Negro was in vogue." Hughes was among the new young poets whom Locke published in *The New Negro*, and the establishment publishing house Knopf would publish his book of poems, *Weary Blues*, in 1926. Twenty-two years of age in 1924, Hughes had gone to Paris seeking a freedom he could not find at home. He was soon writing poems inspired by the

jazz rhythms he was hearing played by the African-American bands in the clubs where he worked as a busboy and dishwasher. The music's syncopated rhythms can be heard in poems such as "Jazz Band in a Parisian Cabaret" (Reading 14.10):

READING 14.10

from Langston Hughes, "Jazz Band in a Parisian Cabaret" (1925)

Play that thing,
Jazz band!
Play it for the lords and ladies,
For the dukes and counts,
For the whores and gigolos,
For the American millionaires,
And the school teachers
Out for a spree.
......
You know that tune

That laughs and cries at the same time

May I? Mais oui, Mein Gott! Parece una rumba. Play it, jazz band!

In these last lines, Hughes's poem captures all the voices of the Parisian cabaret, just as Apollinaire had captured the cacophony of conversation at his Parisian café on rue Christine (see Reading 14.2).

African Americans like Hughes had been drawn to Paris by reports of black soldiers who had served in World War I, in the so-called Negro divisions, the 92nd and 93rd infantries. Jazz itself was introduced to the French by Lieutenant Jimmy Europe, whose 815th Pioneer Infantry band played in city after city across the country. They had experienced something they never had in the United States—total acceptance by people with white skin. Paris presented itself after the war as the new land of freedom—and opportunity. But Harlem, largely because of the efforts of Johnson and Locke, soon replaced Paris in the African-American imagination.

In Harlem, Hughes quickly became one of the most powerful voices. His poems narrate the lives of his people, capturing the inflections and cadences of their speech. In fact, the poems celebrate, most of all, the inventiveness of African-American culture, especially the openness and ingenuity of its music and language. Hughes had come to understand that his cultural identity rested not in the grammar and philosophy of white culture, but in the vernacular expression of the American black, which he could hear in its music (the blues and jazz especially) and its speech.

The Blues and Jazz

By the time of the Great Migration, jazz had established itself as the music of African Americans. So much did it

seem to define all things American that the novelist F. Scott Fitzgerald (1896–1940) entitled a collection of short stories published in 1922 Tales of the Jazz Age, and the name stuck. By the end of the 1920s, jazz was the American music, and it was almost as popular in Paris and Berlin as it was in New York, Chicago, and New Orleans. It originated in the 1890s in New Orleans, probably the most racially diverse city in America, particularly in the ragtime piano music of Scott Joplin and others. But it had deep roots as well in the blues.

The Blues If syncopated rhythm is one of the primary characteristics of jazz, another is the **blue note**. Blue notes are slightly lower or flatter than conventional pitches. In jazz, blues instrumentalists or singers commonly "bend" or "scoop" a blue note—usually the third, fifth, or seventh note of a given scale—to achieve heightened emotional effects. Such effects were first established in the blues proper, a form of song that originated among enslaved black Americans and their descendants.

The **blues** are by definition laments bemoaning loss of love, poverty, or social injustice, and they contributed importantly to the development of jazz. The standard blues form consists of three sections of four bars each. Each of these sections corresponds to the single line of a three-line stanza, the first two lines of which are the same.

Dixieland and Louis Armstrong in Chicago The bands that played around 1910-20 in the red-light district of New Orleans, the legendary Storyville, quickly established a standard practice. A "front line," consisting of trumpet (or cornet), clarinet, and trombone, was accompanied by banjo (later guitar), piano, bass, and drums. In Dixieland jazz, as it came to be known, the trumpet carried the main melody and the clarinet played off against it with a higher countermelody, while the trombone played a simpler, lower tune. The most popular forms of Dixieland were the standard 12-bar blues and a 32-bar AABA form. The latter consists of four 8-measure sections. Generally speaking, the trumpet plays the basic tune for the first 32 measures of the piece, then the band plays variations on the tune in a series of solo or collective improvisations, keeping to the 32-bar format. Each 32-bar section is called a "chorus."

When Storyville was shut down in 1917 (on orders from the U.S. Navy, whose sailors' discipline they believed was threatened by its presence), many of the bands that had played in the district joined the Great Migration and headed north. Among them was the trumpeter Louis Armstrong (1901–71), who arrived in Chicago in 1922 to play for Joe Oliver's Creole Jazz Band. The pianist and composer Lil Hardin (1898–1971) was the pianist and arranger for Oliver's band, and Hardin and Armstrong were married in 1924. Soon, Armstrong left Oliver's band to play on his own. He formed two studio bands composed of former New Orleans colleagues, the Hot Five and the Hot Seven, with whom he made a series of groundbreaking recordings. One, Hotter Than That (see track 14.3), written by Hardin and recorded in 1927, is based on a 32-bar form over which the performers improvise. In the

third chorus, Armstrong sings in nonsense syllables, a method known as **scat**. This is followed by another standard form of jazz band performance, a **call-and-response** chorus between Armstrong and guitarist Lonnie Johnson, the two imitating one another as closely as possible on their two different instruments.

Swing: Duke Ellington at the Cotton Club The same year that Armstrong recorded Hotter Than That, Duke Ellington, born Edward Kennedy Ellington in Washington, D.C. (1899–1974), began a five-year engagement at Harlem's Cotton Club. The Cotton Club itself was owned by a gangster who used it as an outlet for his "Madden's #1 Beer," which, like all alcoholic beverages, was banned after National Prohibition was introduced in 1920. The Club's name was meant to evoke leisurely plantation life for its "white-only" audience, who came to listen to its predominantly black entertainers.

Ellington had formed his first band in New York in 1923. His 1932 It Don't Mean a Thing (If It Ain't Got That Swing) (see track 14.4) introduced the term swing to jazz culture. (A particularly clear example of a "blue note" can be heard, incidentally, on the first "ain't" of the first chorus of It Don't Mean a Thing.) Swing is characterized by big bands—as many as 15 to 20 musicians, including up to five saxophones (two altos, two tenors, and a baritone)—resulting in a much bigger

sound. Its rhythm depends on the subtle avoidance of downbeats, with the solo instrument attacking the beat either just before or just after it.

By the time Ellington began his engagement at the Cotton Club, commercial radio was seven years old, and many thousands of American homes had a radio. Live radio broadcasts from the Cotton Club brought Ellington national fame, and he was widely imitated throughout the 1930s by bands who toured the country. These included bands led by clarinetist Benny Goodman, soon known as "the King of Swing"; trumpeter Harry James; trombonist Glenn Miller; trombonist Tommy Dorsey; pianist Count Basie; and clarinetist Artie Shaw. These bands also featured vocalists, and they introduced the country to Frank Sinatra, Bing Crosby, Perry Como, Sarah Vaughan, Billie Holiday, Peggy Lee, Doris Day, Rosemary Clooney, and Ella Fitzgerald.

The Visual Arts in Harlem The leading visual artist in Harlem in the 1920s was Aaron Douglas (1898–1979), a native of Topeka, Kansas, who arrived in Harlem in 1925 with a Bachelor of Fine Arts degree from the University of Nebraska, where he had been the only black student in his class. "My first impression of Harlem," he would later write, "was that of an enormous stage swarming with humanity....

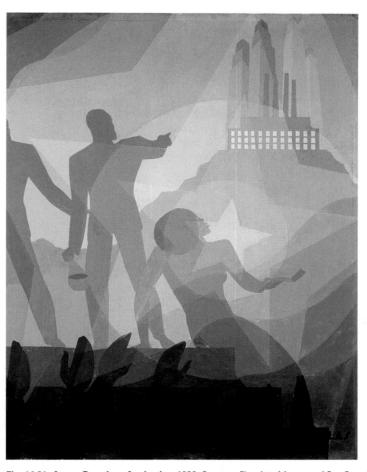

Fig. 14.21 Aaron Douglas, Aspiration. 1936. Courtesy Fine Arts Museum of San Francisco. Art © Heirs of Aaron Douglas/Licensed by VAGA, New York, NY. Douglas's painting is composed as a series of stars within stars, all pointing toward the future and the promise he believed it held for African Americans.

Here one found a kaleidoscope of rapidly changing colors, sounds, movements—rising, falling, swelling, contracting, now hurrying, now dragging along without end and often without apparent purpose. And yet beneath the surface of this chaotic incoherent activity one sensed an inner harmony, one felt the presence of a mysterious hand fitting all these disparate elements into a whole." Douglas's work is a celebration of the African-American contribution to American culture (Fig. 14.21), and his two-dimensional silhouetted figures would become the signature style of Harlem Renaissance art, in which a sense of rhythmic movement and sound is created by abrupt shifts in the direction of line and mass. Aspiration depicts the progression out of slavery, represented by the shackled arms that rise out of the bottom of the painting, out of the South, and toward the promise of the industrial North.

But as Douglas well knew, the realization of such aspiration was hard won. The jazz clubs that were at the center of African-American culture in Harlem were, in fact, restricted to white customers—blacks could enter only as performers or waiters. Access to satisfactory housing was extremely limited as whites created de facto white-only neighborhoods. Except in Harlem, landlords in New York City were unwilling to rent to black tenants, and as early as 1920, a one-room apartment

in Harlem rented to whites for \$40 and to blacks for between \$100 and \$125. These high rental expenses led to extreme population density—in 1920s Harlem, there were over 215,000 people per square mile (by way of comparison, today there are fewer than 70,000 people per square mile in Manhattan as a whole).

These were realities that Jacob Lawrence (1917–2000) did not shy from representing. Lawrence moved to Harlem in 1924 at the age of seven and trained as a painter at the Harlem Art Workshop, where he studied Aaron Douglas's work. When he was just 23 years old, he created a series of 60 paintings narrating the history of the Great Migration. Among the paintings are images of race riots, including the East St. Louis riots of 1917, the bombing of black homes, overcrowded housing, and tuberculosis outbreaks, but he also saw the same kind of hope and aspiration as Douglas, as is evident in his illustration of three girls writing on a chalkboard at school (Fig. 14.22). Using the same angularity and rhythmic repetition of forms that Douglas introduced, the intellectual growth of the girls, as each reaches higher on the board, is presented as a musical crescendo in

higher on the board, is presented as a musical crescendo in a syncopated, four-beat, rhythmic form where the first beat, as it were, is silent and unplayed. The Migration series won Lawrence immediate fame. In 1942, the Museum of Modern Art in New York and the Phillips Collection in Washington, D.C., each bought 30 panels. That same year Lawrence became the first black artist represented by a prestigious New York gallery—the Downtown Gallery.

Russia: Art and Revolution

In 1914, Russia entered the war ill-prepared for the task before it; within the year, Tsar Nicholas II (1868–1918) oversaw the devastation of his army. One million men had been killed, and another million soldiers had deserted. Famine and fuel shortages gripped the nation. Strikes broke out in the cities, and in the countryside, peasants seized the land of the Russian aristocrats. The tsar was forced to abdicate in February 1917.

Vladimir Lenin and the Soviet State Through a series of astute, and sometimes violent, political maneuvers, the Marxist revolutionary Vladimir Ilyich Lenin (1870–1924) assumed power the following November. Lenin headed the most radical of Russian postrevolutionary groups, the Bolsheviks. Like Marx, he dreamed of a "dictatorship of the proletariat," a dictatorship of the working class. Marx and Lenin believed that the oppression of the masses of working people resulted from capitalism's efforts to monopolize the raw materials and markets of the world for the benefit of the privileged few. He believed that all property should be held in common, that every member of society would work for the benefit of the whole and would receive, from the state, goods and products commensurate with their

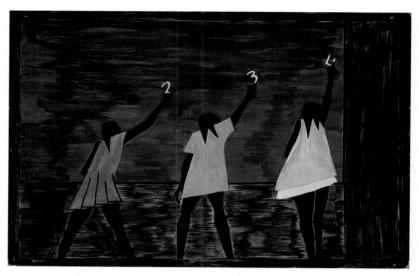

Fig. 14.22 Jacob Lawrence, In the North the Negro had Better Educational Facilities, panel 58 from The Migration of the Negro. 1940–41. Casein tempera on hardboard, 12" × 18". Gift of Mrs. David M. Levy. Museum of Modern Art, New York. © 2014 The Jacob and Gwendolyn Lawrence Foundation, Seattle/Artists Rights Society (ARS), New York. Note that Lawrence dresses the girls in the primary colors of red, yellow, and blue, thus emphasizing the fundamental nature of primary education.

work. "He who does not work," he famously declared, "does not eat."

Lenin was a utopian idealist. He foresaw, as his socialist state developed, the gradual disappearance of the state: "The state," he wrote in The State and Revolution (1917), "will be able to wither away completely when society has realized the rule: 'From each according to his ability: to each according to his needs,' i.e., when people have become accustomed to observe the fundamental rules of social life, and their labor is so productive that they voluntarily work according to their ability." But he realized that certain pragmatic changes had to occur as well. He emphasized the need to electrify the nation: "We must show the peasants," he wrote, "that the organization of industry on the basis of modern, advanced technology, on electrification... will make it possible to raise the level of culture in the countryside and to overcome, even in the most remote corners of land, backwardness, ignorance, poverty, disease, and barbarism." And he was, furthermore, a political pragmatist. When, in 1918, his Bolshevik party received less than a quarter of 1 percent of the vote in free elections, he dissolved the government, eliminated all other parties, and put the Communist party into the hands of five men, a committee called the Politburo, with himself at its head. He also systematically eliminated his opposition: Between 1918 and 1922, his secret police arrested and executed as many as 280,000 people in what has come to be known as the Red Terror.

The Arts of the Revolution Before the Revolution in March 1917, avant-garde Russian artists, in direct communication with the art capitals of Europe, particularly Paris, Amsterdam, and Berlin, established their own brand of modern art. Most visited Paris, and saw Picasso and Braque's Cubism in person, but Kazimir Malevich (1878–1935), perhaps

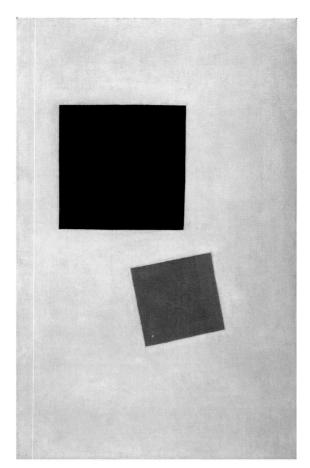

Fig. 14.23 Kazimir Malevich, *Painterly Realism: Boy with Knapsack—Color Masses in the Fourth Dimension.* 1915. Oil on canvas, 28" × 17½". Museum of Modern Art, New York. 1935 Acquisition confirmed in 1999 by agreement with the Estate of Kazimir Malevich and made possible with funds from the Mrs. John Hay Whitney Bequest (by exchange). 816.1935. Malevich always insisted that he painted not in three, but in four dimensions—that time, in other words, played a role in creating a work. Later, he claimed to work in five dimensions, the fifth being "economy," or minimal means.

the most inventive of them all, never did. By 1912, he had created "Cubo-Futurism," a style that applied modernist geometric forms to Russian folk themes. But Malevich was soon engaged, as he wrote, in a "desperate attempt to free art from the ballast of objectivity." To this end, he says, "I took refuge in the square," creating in 1913 a completely nonobjective painting, consisting of nothing more than a black square on a white ground. He called his new art Suprematism, defining it as "the supremacy of... feeling in... art."

The "feeling" of which Malevich speaks is not the kind of personal or private emotion that we associate with, say, German Expressionism. Rather, it lies in what he believed was the revelation of an absolute truth—a utopian ideal not far removed from Lenin's political idealism—discovered through the most minimal means. Thus, his *Painterly Realism: Boy with Knapsack—Color Masses in the Fourth Dimension* (Fig. 14.23) is not really a representation of a boy with a knapsack, nor is it an example of realism. The title is deeply ironic, probably intended to jolt any viewer expecting to see

representational work. The painting is, rather, about the two forms—a black square and a smaller red one—that appear to float above a white ground, even, it seems, at different heights. The painting was first exhibited in December 1915 at an exhibition in Petrograd entitled 0.10: The Last Futurist Exhibition of Paintings. The exhibition's name refers to the idea that each of the 10 artists participating in the show were seeking to articulate the "zero degree"—that is, the irreducible core—of painting. What, in other words, most minimally makes a painting? In this particular piece, Malevich reveals that in relation, these apparently static forms—two squares set on a rectangle—are energized in a dynamic tension.

One of the greatest of Russia's revolutionary innovators was the filmmaker Sergei Eisenstein (1898–1948). After the Revolution, he had worked on the Russian agit-trains, special propaganda trains that traveled the Russian countryside bringing "agitational" materials to the peasants. ("Agitational," in this sense, means presenting a political point of view.) The agit-trains distributed magazines and pamphlets, presented political speakers and plays, and, given the fact that the Russian peasantry was largely illiterate, perhaps most important of all presented films, known as agitkas. These films were characterized by their fast-paced editing style, designed to keep the attention of an audience that, at least at first, had never before seen a motion picture.

Out of his experience making agitkas, Lev Kuleshov (1899–1970), one of the founders of the Film School in Moscow in the early 1920s, developed a theory of montage. He used a close-up of a famous Russian actor and combined it with three different images—a bowl of soup, a dead woman lying in a coffin, and a girl playing with a teddy bear. Although the image of the actor was the same in each instance, audiences believed that he was hungry with the soup, sorrowful with the woman, joyful toward the girl—a phenomenon that came to be known as the *Kuleshov effect*. Shots, Kuleshov reasoned, acquire meaning through their relation to other shots. Montage was the art of building a cinematic composition out of such shots.

Eisenstein learned much from Kuleshov, although he disagreed about the nature of montage. Rather than being used to build a unified composition, Eisenstein believed that montage should be used to create tension, even a sense of shock, in the audience, which he believed would lead to a heightened perception and a greater understanding of the film's action. His aim, in a planned series of seven films depicting events leading up to the Bolshevik Revolution, was to provoke his audience into psychological identification with the aims of the Revolution.

None of his films accomplishes this better than *The Battleship Potemkin*, the story of a 1905 mutiny aboard a Russian naval vessel and the subsequent massacre of innocent men, women, and children on the steps above Odessa harbor by tsarist troops. The film, especially the famous "Odessa Steps Sequence," which is a virtual manifesto of montage, tore at the hearts of audiences and won respect for the Soviet regime around the world (see *Closer Look*, pages 472–473).

471

CLOSER LOOK

he most famous sequence in *The Battleship Potemkin* is the massacre on the Odessa Steps. Odessa's citizens have responded to the mutiny on the *Potemkin* by providing the sailors with food and good company. Without warning, tsarist soldiers carrying rifles appear at the top of the flight of marble steps leading to the harbor. They fire on the crowd, many of whom fall on the steps. Eisenstein's cuts become more and more frenetic in the chaos that ensues.

Eisenstein used 155 separate shots in 4 minutes and 20 seconds of film in the sequence, an astonishing rate of 1.6 seconds per shot. He contrasts long shots of the entire scene and close-ups of individual faces, switches back and forth between shots from below and from above (essentially the citizens' view up the steps and the soldiers' looking down), and he changes the pace from frenzied retreat at the start of the sequence to an almost frozen lack of action when the mother approaches the troops carrying her murdered son, to frantic movement again as the baby carriage rolls down the steps. Some shots last longer than others. He alternates between traveling shots and fixed shots.

Eisenstein also understood that sound and image could be treated independently in montage, or used together in support of each other. A phrase of music might be

of each other. A phrase of music might heighten the emotional impact of a key shot. Or the rhythm of the music might heighten the tension of a sequence by juxtaposing itself with a different rhythm in his montage of shots, as when the soldiers' feet march to an altogether different rhythm in the editing. Eisenstein called this *rhythmic montage*, as he explains:

In this the rhythmic drum of the soldiers' feet as they descend the steps violates all metrical demands. Unsynchronized with the beat of the cutting, this drumming comes in off-beat each time, and the shot itself is entirely different in its solution with each of these appearances. The final pull of tension is supplied by the transfer from the rhythm of the descending feet to another rhythm—a new kind of downward movement—the next intensity level of the same activity—the baby carriage rolling down the steps.

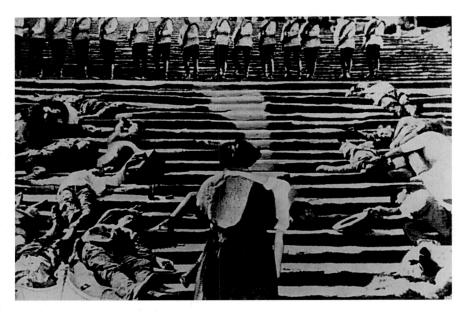

From the "Odessa Steps Sequence" of Sergei Eisenstein's *The Battleship Potemkin*, 1925.

A mother picks up her murdered child and confronts the troops marching down the steps. At the point where she stands, soldiers in front of her, she is framed by the diagonal lines of the steps and the bodies strewn on each side of her. The soldiers continue to advance.

This attention to the rhythm of his film allows Eisenstein to abandon strict temporality. At the start of the baby-carriage scene, for instance, the rhythm of the music slows dramatically and the pace of "real time" is elongated in a series of slow shots. The mother clutches herself. The carriage teeters on the brink. The mother swoons. The carriage inches forward. The mother falls, in agony. This is, as has often been said, "reel time," not "real time."

There was, in fact, no tsarist massacre on the Odessa Steps, although innocent civilians were killed elsewhere in the city. Eisenstein's cinematic re-creation is a metaphor for those murders, a cinematic condensation of events that captures the spirit of events so convincingly that many viewers took it to be actual newsreel footage.

Eisenstein's The Battleship Potemkin, "Odessa Steps Sequence"

From the "Odessa Steps Sequence" of Sergei Eisenstein's The Battleship Potemkin, 1925. The falling body of another mother, shot by the soldiers, falls across her baby's carriage, causing it to roll out of control down the steps. Note the way the steps in the image at the bottom right echo those of the earlier scene in which the mother looks up the same steps holding her dead child.

From the "Odessa Steps Sequence" of Sergei Eisenstein's The Battleship Potemkin, 1925. At the end of the sequence an old woman wearing pince-nez glasses, who has looked on horrified as the baby stroller careens down the stairs, is attacked and slashed by a saber-bearing Cossack.

Something to Think About... How would you compare Eisenstein's montage to Picasso's collage?

Freud and the Workings of the Mind

Eisenstein's emphasis on the viewer's psychological identification with his film was inspired in no small part by the theories of the Viennese neurologist Sigmund Freud (1856–1939). By the start of World War I, Freud's theories about the nature of the human psyche and its subconscious functions were gaining wide acceptance. As doctors and others began to deal with the sometimes severely traumatized survivors of the war, the efficacy of Freud's psychoanalytic techniques—especially dream analysis and "free association"—were increasingly accepted by the medical community.

But Freud understood that free association required interpretation, and increasingly, he began to focus on the obscure language of the unconscious. By 1897, he had formulated a theory of infantile sexuality based on the proposition that sexual drives and energy already exist in infants. One of the keys to understanding the imprint of early sexual feeling upon adult neurotic behavior was the interpretation of dreams. Freud concluded that dreams allow unconscious wishes, desires, and drives censored by the conscious mind to exercise themselves. "The dream," he wrote in his 1900 The Interpretation of Dreams, "is the (disguised) fulfillment of a (suppressed, repressed) wish." And the wish, by extension, is generally based in the sexual.

World War I provided Freud with evidence of another, perhaps even more troubling source of human psychological dysfunction—society itself. In 1920, in Beyond the Pleasure Principle, he speculated that human beings had death drives (Thanatos) that were in conflict with sex drives (Eros). Their opposition, he believed, helped to explain the fundamental forces that shape both individuals and societies; their conflict might also explain self-destructive and outwardly aggressive behavior. To this picture he added, in his 1923 work The Ego and the Id, a model for the human mind that would have a lasting impact on all subsequent psychological writings, at least in their terminology. According to Freud, human personality is organized by the competing drives of the id, the ego, and the superego. The id is the seat of all instinctive, physical desire—from the need for nourishment to sexual gratification. Its goal is immediate gratification, and it acts in accord with the pleasure principle. The ego manages the id. It mediates between the id's potentially destructive impulses and the requirements of social life, seeking to satisfy the needs of the id in socially acceptable ways. For Freud, civilization itself is the product of the ego's endless effort to control and modify the id. But Freud's recognition of yet a third element in the psyche—the superego—is crucial. The superego is the seat of what we commonly call "conscience," the psyche's moral base. The conscience comes from the psyche's consideration of criticism or disapproval leveled at it by the family, where "family" can be understood broadly as parents, clan, and culture. But since the superego does not distinguish between thinking a deed and doing it, it can also instill in the id enormous subconscious guilt.

The Dreamwork of Surrealist Painting

In his 1924 Surrealist Manifesto, the French writer, poet, and theorist André Breton (1896-1966) credited Freud with encouraging his own creative endeavors: "It would appear that it is by sheer chance that an aspect of intellectual life—and by far the most important in my opinion—about which no one was supposed to be concerned any longer has, recently, been brought back to light. Credit for this must go to Freud. On the evidence of his discoveries a current of opinion is at last developing which will enable the explorer of the human mind to extend his investigations, since he will be empowered to deal with more than merely summary realities." Breton had trained as a doctor and had used Freud's technique of free association when treating shell-shock victims in World War I. As his definition indicates, he had initially conceived of Surrealism as a literary movement, with Breton himself at its center. Many of the Surrealists had been active Dadaists, but as opposed to Dada's "anti-art" spirit, their new "surrealist" movement believed in the possibility of a "new art." Nevertheless, Surrealism retained much of Dada's spirit of revolt. They were committed to verbal automatism, a kind of writing in which the author relinquishes conscious control of the production of the text. In addition, the authors wrote dream accounts, and

Fig. 14.24 Giorgio de Chirico, *The Child's Brain.* 1914. Oil on canvas, $31\%'' \times 25\%''$. Moderna Museet, Stockholm. © 2014 Artists Rights Society (ARS), New York/SIAE, Rome. De Chirico actually knew almost nothing about Freud, a fact that made his art seem even more authentic to the Surrealists, as if he had arrived at Freudian psychology intuitively rather than intellectually.

Fig. 14.25 Max Ernst, *The Master's Bedroom, It's Worth Spending a Night There* (Letter from Katherine S. Dreier to Max Ernst, May 25, 1920). Collage, gouache, and pencil on paper, $6\%" \times 8\%"$. Yale Collection of American Literature, Beinecke Rare Book and Manuscript Library. Translation from German by John W. Gabriel. From *Max Ernst, Life and Work* by Werner Spies, published by Thames & Hudson, page 67. © 2014 Artists Rights Society (ARS), New York/ADAGP, Paris. Prior to World War I, Ernst studied philosophy and abnormal psychology at the University of Bonn. He was well acquainted with the writings of Freud.

Breton's colleague Louis Aragon (1897–1982), especially, emphasized the importance of chance operations: "There are relations other than reality that the mind may grasp and that come first, such as chance, illusion, the fantastic, the dream," Aragon wrote. "These various species are reunited and reconciled in a genus, which is surreality."

The Surrealists also found precedent for their point of view not only in Freud, but in the painting of Giorgio de Chirico (1888–1978) and the Dadaist Max Ernst (1891–1976). When Breton saw de Chirico's painting *The Child's Brain* (Fig. 14.24) in the window of Paul Guillaume's gallery in March 1922, he jumped off a bus in order to look at it. He bought the canvas and immediately published a reproduction in his magazine *Littérature*. The painting seemed to embody, precisely, Freud's theory of the dream. Here, the child's dreaming brain (the id) confronts the repressive threat of both the father figure (the ego)—who, half-naked, is also sexually threatening— and the broader, more societal moral authority represented by the book before him (the superego).

Breton would later look back at Ernst's 1921 exhibition of small collage-paintings like the aptly titled *The Master's Bedroom* (Fig. 14.25) as the first Surrealist work in the visual arts. This painting consists of two pages from a small pamphlet of clip art, on the left depicting assorted animals and

on the right various pieces of furniture. Ernst painted over most of the spread to create his perspectival view, leaving unpainted the whale, fish, and snake at the bottom left, the bear and sheep at the top, and the bed, table, and bureau at the right. This juxtaposition of diverse elements, which would normally never occupy the same space—except perhaps in the dreamwork—is one of the fundamental stylistic devices of Surrealist art.

Picasso's Surrealism Breton argued that Picasso led the way to Surrealist art in his *Les Demoiselles d'Avignon* (see Fig. 14.9), which jettisoned art's dependence on external reality. The great founder of Cubism, Breton said, possessed "the facility to give materiality to what had hitherto remained in the domain of pure fantasy." Picasso was attracted to the Surrealist point of view because it offered him new directions and possibilities. His Surrealism would assert itself most fully in the late 1920s and early 1930s, especially in a series of monstrous bonelike figures that alternated with sensuous portraits of his mistress Marie-Thérèse Walter (1909–77), whom he had met when she was only 17 in January 1927. For eight years, until 1935, he led a double life, married to Olga Khokhlova (1891–1955) while conducting a secret affair with Marie-Thérèse.

Picasso was indeed obsessed in these years with the duality of experience, the same opposition between Thanatos (the death drive) and Eros (the sex drive) that Freud had outlined in Beyond the Pleasure Principle. His 1932 double portrait of Marie-Thérèse, Girl before a Mirror (Fig. 14.26), expresses this—she is the moon, or night, at the right, and the sun, or light, on the left, where her own face appears in both profile and three-quarter view. Her protruding belly on the left suggests her fertility (indeed, she gave birth to their child, Maya, in 1935, soon after Picasso finally separated from Olga), although in the mirror, in

typical Picasso fashion, we see not her stomach but her buttocks, her raw sexuality. She is the conscious self on the left, with her subconscious self revealing itself in the mirror. Picasso's work addresses Surrealism's most basic theme—the self in all its complexity. And he adds one important theme—the self in relation to the Other, for Picasso is present himself in the picture, not just as its painter, but in his symbol, the harlequin design of the wallpaper. But the painting also suggests that the self, in the dynamic interplay between the conscious and unconscious selves, might actually be the Other to itself.

Fig. 14.26 Pablo Picasso, *Girl Before a Mirror*. **1932.** Oil on canvas, $64 \times 51\frac{1}{4}$ ". Gift of Mrs. Simon Guggenheim (2.1938). Museum of Modern Art, New York. © 2014 Estate of Pablo Picasso/Artists Rights Society (ARS), New York. The long oval mirror into which Marie-Thérèse gazes, supported on both sides by posts, is known as a *psyche*. Hence Picasso paints her psyche both literally and figuratively.

Fig. 14.27 Salvador Dalí, *The Persistence of Memory*. 1931. Oil on canvas, 9½" × 13". The Museum of Modern Art, New York. Given anonymously. © Salvador Dalí, Fundació Gala-Salvador Dalí, Artists Rights Society (ARS), New York 2014. Dalí called such paintings "hand-painted dream photographs."

Salvador Dalí's Menacing Vision This sense of self-alienation is central to the work of the Spanish artist Salvador Dalí (1904–89), who in 1928, at age 24, was introduced to the Surrealists. Already eccentric and flamboyant, Dalí had been expelled from the San Fernando Academy of Fine Arts two years earlier for refusing to take his final examination, claiming that he knew more than the professor who was to examine him. He brought this same daring self-confidence to the Surrealist movement.

Dalí followed, he said, a "paranoiac critical method," a brand of self-hypnosis that he claimed allowed him to hallucinate freely. "I believe the moment is at hand," he wrote in a description of his method, "when, by a paranoiac and active advance of the mind, it will be possible (simultaneously with automatism...) to systematize confusion and thus to help to discredit the world of reality." He called his images "new and menacing," and works such as the famous *Persistence of Memory* (1931; Fig. 14.27) are precisely that. This is a self-portrait of the sleeping Dalí, who lies sluglike in the middle of the painting, draped beneath the coverlet of time. Ants, which

are a symbol of death, crawl over a watchcase on the left. A fly alights on the watch dripping over the ledge, and another limp watch hangs from a dead tree that gestures toward the sleeping Dalí.

By the mid-1930s, Breton and the Surrealists parted ways with Dalí over his early admiration for Adolf Hitler and his reluctance to support the Republic in the Spanish Civil War. To this could be added Dalí's love of money, for which he earned the name Avida Dollars (Greedy Dollars), an anagram of his name created by Breton. In 1938, he was formally expelled from the Surrealist movement.

The Stream-of-Consciousness Novel

Perhaps the most important literary innovation of the era was the **stream-of-consciousness** novel. The idea had arisen in the late nineteenth century, in the writings of both William James (1842–1910), the novelist Henry James's older brother, and the French philosopher Henri Bergson (1859–1941). For Bergson, human consciousness is composed of two somewhat contradictory powers: intellect, which sorts and

categorizes experience in logical, even mathematical terms; and intuition, which understands experience as a perpetual stream of sensations, a duration or flow of perpetual becoming. Chapter XI of James's 1892 *Psychology* is actually entitled "The Stream of Consciousness." "Now we are seeing," James writes, "now hearing; now reasoning, now willing; now recollecting, now expecting; now loving, now hating; and in a hundred other ways we know our minds to be alternately engaged. . . . Consciousness . . . is nothing jointed; it flows. A 'river' or a 'stream' are the metaphors by which it is most naturally described. *In talking of it hereafter, let us call it the stream of thought, of consciousness, or of subjective life.*"

The rise of the stream-of-consciousness novel in the twentieth century can be attributed to two related factors. On the one hand, it provided authors with a means of portraying directly the psychological makeup of their protagonists, as their minds leap from one thing to the next, from memory to self-reflection to observation to fantasy. In this it resembles the free association method of Freudian psychoanalysis. But equally important, it enabled writers to emphasize the subjectivity of their characters' points of view. What a character claims might not necessarily be true. Characters might have motives for lying, even to themselves. And certainly no character in a "fiction" need be a reliable narrator of events. Nothing need prevent characters from creating their own fiction within the author's larger fictional work. Thus, in the stream-of-consciousness novel, the reader is forced to become an active participant in the fiction, sorting out "fact" from "fantasy," distinguishing between the actual events of a story and the characters' "memory" of them.

James Joyce and *Ulysses* No writer was more influential in introducing the stream-of-consciousness narrative than James Joyce (1882–1941), the Irish writer who left Ireland in 1905 to live chiefly in Paris, and no novel better demonstrates its powers than his *Ulysses*.

Early chapters of *Ulysses* had originally been serialized in the American *Little Review*, but postal authorities in both Britain and the United States had banned it for obscenity. Joyce's cause was taken up by Sylvia Beach, owner of an English-language-only bookstore and lending library on the rue l'Odéon frequented by almost every American writer in Paris. After meeting Joyce at the bookstore, she agreed to publish *Ulysses* in an edition of 1,000, the first two copies of which were delivered on the eve of Joyce's fortieth birthday, February 2, 1922.

The novel takes place largely on one day, June 16, 1904, in 18 episodes spread about an hour apart and ending in the early hours of June 17. It loosely follows the episodes of Ulysses from the *Odyssey* of Homer, with Stephen Dedalus figuring as the new Telemachus, Leopold Bloom as Ulysses, and Molly Bloom as Penelope. Like Penelope in the *Odyssey*, Molly has a suitor, the debonair Blazes Boylan. To win back her affection, Bloom must endure 12 trials—his Odyssey—in the streets, brothels, pubs, and offices of Dublin. Each character is presented through his or her own stream-of-consciousness

narration—we read only what is experienced in the character's mind from moment to moment, following his or her thought process through the interior monologue. Molly Bloom's final soliloquy, the last episode of the book, underscores the experimental vitality of Joyce's prose. It opens with Molly contemplating her husband's request to be served breakfast in bed in the morning. A full-blown stream-of-consciousness monologue in which the half-asleep Molly mulls over her entire sexual life, it concludes with her rapturous remembrance of giving herself to Bloom on Howth Head, the northern enclosure of Dublin Bay, 16 years earlier (Reading 14.11):

READING 14.11

from James Joyce, Ulysses (1922)

I was a flower of the mountain yes so we are flowers all a womans body yes that was one true thing he said in his life and the sun shines for you today yes that was why I liked him because I saw he understood or felt what a woman is and I knew I could always get round him and I gave him all the pleasure I could leading him on till he asked me to say yes and I wouldnt answer first only looked out over the sea and the sky I was thinking of so many things he didnt know of . . . poor donkeys slipping half asleep and the vague fellows in the cloaks asleep in the shade on the steps and the big wheels of the carts of the bulls and the old castle thousands of years old yes and those handsome Moors all in white and turbans like kings asking you to sit down in their little bit of a shop and Ronda with the old windows of the posadas glancing eyes a lattice hid for her lover to kiss the iron and the wineshops half open at night and the castanets and the night we missed the boat at Algeciras the watchman going about serene with his lamp and O that awful deepdown torrent O and the sea the sea crimson sometimes like fire and the glorious sunsets and the figtrees in the Alameda gardens yes and all the queer little streets and the pink and blue and yellow houses and the rosegardens and the jessamine and geraniums and cactuses and Gibraltar as a girl where I was a Flower of the mountain yes when I put the rose in my hair like the Andalusian girls used or shall I wear a red yes and how he kissed me under the Moorish wall and I thought well as well him as another and then I asked him with my eyes to ask again yes and then he asked me would I yes to say yes my mountain flower and first I put my arms around him ves and drew him down to me so he could feel my breasts all perfume yes and his heart was going like mad and yes I said yes I will Yes.

In its near-total lack of punctuation—there are eight sentences in the entire episode, the first of which is 2,500 words long—as well as its uncensored exploration of a woman's sexuality, Joyce's final episode remains revolutionary, as does the novel as a whole.

Marcel Proust and the Novel of Memory If Joyce was the first to use stream of consciousness as a narrative device, it was Marcel Proust (1871–1922) who first imagined the novel as a mental space. Proust grew up in Paris near the Champs-Élysées, spending holidays with relatives in the country towns of Auteuil and Illiers. These two villages inspired Proust's fictional village, Combray, site of the narrator's childhood memories in his monumental seven-volume novel À la recherche du temps perdu (literally In Search of Lost Time, but known in the English-speaking world for decades as Remembrance of Things Past, a title invented by the novel's translator from Shakespeare's Sonnet XXX: "When to the sessions of sweet silent thought/ I summon up remembrance of things past"). After a bout of depression that followed the deaths of his father in 1903 and his mother in 1905, Proust gave up his social life almost entirely, retreating to his quiet, cork-lined apartment on the boulevard Haussmann and devoting almost all his waking hours to the composition of his novel.

Calling the novel "psychology in space and time," he planned to explore the deepest recesses of the unconscious and bring them to conscious life. Thus the famous moment that concludes the "Overture" to Swann's Way, the first volume of À la recherche, published in 1913, when the narrator, Marcel, tastes a madeleine, "one of those short, plump little cakes . . . which look as though they have been moulded in the fluted scallop of a pilgrim's shell" (Reading 14.12):

READING 14.12

from Marcel Proust, Swann's Way (1913)

I raised to my lips a spoonful of the tea in which I had soaked a morsel of the cake. No sooner had the warm liquid, and the crumbs with it, touched my palate than a shudder ran through my whole body, and I stopped, intent upon the extraordinary changes that were taking place. An exquisite pleasure had invaded my senses, but individual, detached, with no suggestion of its origin. And at once the vicissitudes of life had become indifferent to me, its disasters innocuous, its brevity illusory—this new sensation having had on me the effect which love has of filling me with a precious essence; or rather this essence was not in me, it was myself. I had ceased now to feel mediocre, accidental, mortal. Whence could it have come to me, this all-powerful joy? I was conscious that it was connected with the taste of tea and cake, but that it infinitely transcended those savours, could not, indeed, be of the same nature as theirs. Whence did it come? What did it signify? How could I seize upon and define it?

What Marcel comes to understand is that, in a process of free association, the taste of the madeleine had evoked his experience of tasting the same little cake, given him by his aunt Léonine on Sunday mornings at Combray, and thus the entire landscape of Combray itself. The past, in other words, comes alive in the present, freeing Marcel from the constraints of time and opening to him the recesses of his subconscious.

The philosopher Henri Bergson, whom Proust considered "the first great metaphysician" of the modern era, had argued that past, present, and future were part of an organic whole, in which the past is a "continuous progress... which gnaws into the future and which swells it as it advances." The role of art, he argued, was to capture "certain rhythms of life and breath" which invite us to "join in a dance. Thus," he wrote, "they compel us to set in motion, in the depth of our own being, some secret chord which was only waiting to thrill." Just as the madeleine struck this same secret chord in Marcel, Proust hoped his fiction would strike it in his reader. In the last volume of À la recherche, Time Regained, not published until 1927, he wrote:

I thought more modestly of my book and it would be inaccurate even to say that I thought of those who would read it as "my" readers. For, it seemed to me that they would not be "my" readers but the readers of their own selves, my book being merely a sort of magnifying glass like those which the optician at Combray used to offer his customers—it would be my book but with its help I would furnish them with the means of reading what lay inside themselves.

It is through the book and the acts of memory that it restores to the present—and hence the future—that time, in all its flux, is finally "regained."

14.1 Outline the various ways in which modernism manifests itself in art and literature.

Post-Impressionist painters like Seurat, Van Gogh, Cézanne, and Gauguin were dedicated to advancing art in innovative directions. The new century was marked by technological innovation epitomized by the automobile, the motion picture, the airplane, and, perhaps most of all, by new discoveries in physics. The focal point of artistic innovation was Pablo Picasso's studio in Paris. There, in paintings like the large canvas Les Demoiselles d'Avignon, he transformed painting. In what ways is Les Demoiselles a radical departure from contemporary art? Picasso's project was quickly taken up by Georges Braque, and the two worked together to create the style that came to be known as Cubism. What are the primary features of Cubism? How would you describe collage as a technique? The Futurists, led by Filippo Marinetti, would introduce the idea of speed and motion into painting. How is their work an attack on traditional values? Henri Matisse meanwhile helped to create the Fauve movement. What is Fauvism's chief concern? How would you compare the paintings of Matisse and Picasso? The German Expressionists employed the exploration of color of Henri Matisse and the Fauves to create an art that centered on the psychological makeup of its creators. How do Wassily Kandinsky's theories about color inform the paintings of the Blaue Reiter group?

In music and dance, the composer Igor Stravinsky and the Ballets Russes of impresario Sergei Diaghilev would shock Paris with the performance of *Le Sacre du printemps*, while in Germany, Arnold Schoenberg dispensed with traditional tonality, the harmonic basis of Western music, and created new atonal works. What is the 12-tone system that Schoenberg used? What is *Sprechstimme*, and how did he use it?

As in the visual arts and music, a spirit of innovation dominated the literary scene as well. The French poet Guillaume Apollinaire experimented with poetic forms. What techniques does he share with his friend Picasso? Ezra Pound and the Imagists sought to capture the moment, in the most economic terms, when the "outward and objective" turns "inward and subjective." What directive of the Imagists was particularly attractive to William Carlos Williams?

14.2 Describe the Great War's impact on the art and literature of the era.

The realities of trench warfare along the Western Front in northeast France and northwest Germany had an immense impact on the Western imagination. The almost unbounded optimism that preceded the war was replaced by a sense of the absurdity of modern life, the fragmentation of experience, and the futility of even daring to hope. How does Wilfred Owen's "The Pity of War" reflect these feelings? Among the most powerful realizations of this condition is T. S. Eliot's poem The Waste Land. How does it depict modern love? Many found the war incomprehensible, and they reacted by creating an art movement based on negation and meaninglessness: Dada. What beliefs did Dada's sound poetry reflect? What role did chance operations play in their work? One of their most influential spokesmen, Marcel Duchamp, turned found objects into works of art, including the urinal Fountain, which he called "ready-mades." What are "ready-mades"? During the war, in America, African Americans migrated north in great numbers. This Great Migration served as a catalyst for the Harlem Renaissance. How did Alain Leroy Locke's concept of the "New Negro" contribute to the philosophy of the era? How did jazz reflect the same spirit? How is the Great Migration depicted in the visual art of Aarton Douglas and Jacob Lawrence? In Russia, political upheaval offered the promise of a new and better life. In painting, what principles were reflected in Kazimir Malevich's Suprematism? In film, Sergei Eisenstein's new montage techniques were created to attract a largely illiterate audience through fast-paced editing and composition. What is montage? The psychological theories of Freud manifested themselves in the Surrealist project of André Breton and his colleagues, who pursued the undercurrent of Freudian sexual desire that they believed lay at the root of their creative activity. What did Breton see in the work of Giorgio de Chirico and Max Ernst? How did Picasso come to be associated with Surrealism?

After the war, writers struggled to find a way to express themselves authentically in a language that the war seemed to have left impoverished. The life of the unconscious was the subject of the stream-of-consciousness novel, which rose to prominence in the same era, including James Joyce's *Ulysses* and Marcel Proust's À *la recherche du temps perdu*. What are the attractions of the stream-of-consciousness style?

Guernica and the Specter of War

n February 1936, the Spanish Popular Front, a coalition of republicans, communists, and anarchists that promised amnesty to all those previously imprisoned, was elected to office in Spain. This dismayed the *Falange* ("Phalanx"), a rightwing fascist organization with a private army that had the sympathy of the Spanish army stationed in Morocco. In July, the *Falange* retaliated, the army in Morocco rebelled, and General Francisco Franco (1892–1975) led it into Spain from Morocco in a *coup d'état* against the Popular Front government.

In the civil war that ensued, Germany and Italy supported Franco's right-wing Nationals, while the Soviet Union and Mexico sent equipment and advisors to the leftist Republicans. The United States remained neutral, but liberals from across Europe and America, including the writer Ernest Hemingway, joined the republican side, fighting side by side with the Spanish.

Hitler conceived of the conflict as a dress rehearsal for the larger European conflict he was already preparing. He was especially interested in testing the Luftwaffe, his air force. Planes were soon sent on forays across the country in what the German military called "total war," a war not just between armies but between whole peoples. This allowed for the bombing of civilians.

On April 26, 1937, a German air-force squadron led by Wolfram von Richthofen, cousin of the famous Red Baron of World War I, bombed the Basque town of Guernica, in northern Spain. The attack was a *Blitzkrieg*, the sudden, coordinated

air assault that the Germans would later use to great effect against Poland and England in World War II. It lasted for three and a quarter hours. The stated target was a bridge used by retreating Republican forces at the northern edge of the town, but the entire central part of Guernica—about 15 square blocks—was leveled, 721 dwellings (nearly three-quarters of the town's homes) were completely destroyed, and a large number of people were killed. In Paris, Pablo Picasso heard the news a day later. Complete stories did not appear in the press until Thursday, April 29, and photographs of the scene appeared on Friday and Saturday, April 30 and May 1. That Saturday, Picasso began a series of sketches for a mural that he had already been commissioned to contribute to the Spanish Pavilion at the 1937 Exposition Universelle in Paris. Only 24 days remained until the Fair was scheduled to open.

In the final painting, Picasso links the tragedy of Guernica to the ritualized bullfight, born in Spain, in which the preordained death of the bull symbolizes the ever-present nature of death itself (Fig. 14.28). The work portrays a scene of violence and helpless suffering. Picasso's choice of black-and-white instead of color evokes the urgency and excitement of a newspaper photograph. When the exposition closed, the painting was sent on tour and was used to raise funds for the Republican cause. *Guernica* would become the international symbol of the horrors of war and the fight against totalitarianism. It was finally returned to Spain in 1981, when civil liberties were restored in Picasso's native land.

Fig. 14.28 Pablo Picasso, *Guernica*. 1937. Oil on canvas, 11'5½" × 25'5½". Museo Nacional Centro de Arte Reina Sofia, Madrid. © 2014 Estate of Pablo Picasso/Artists Rights Society (ARS), New York.

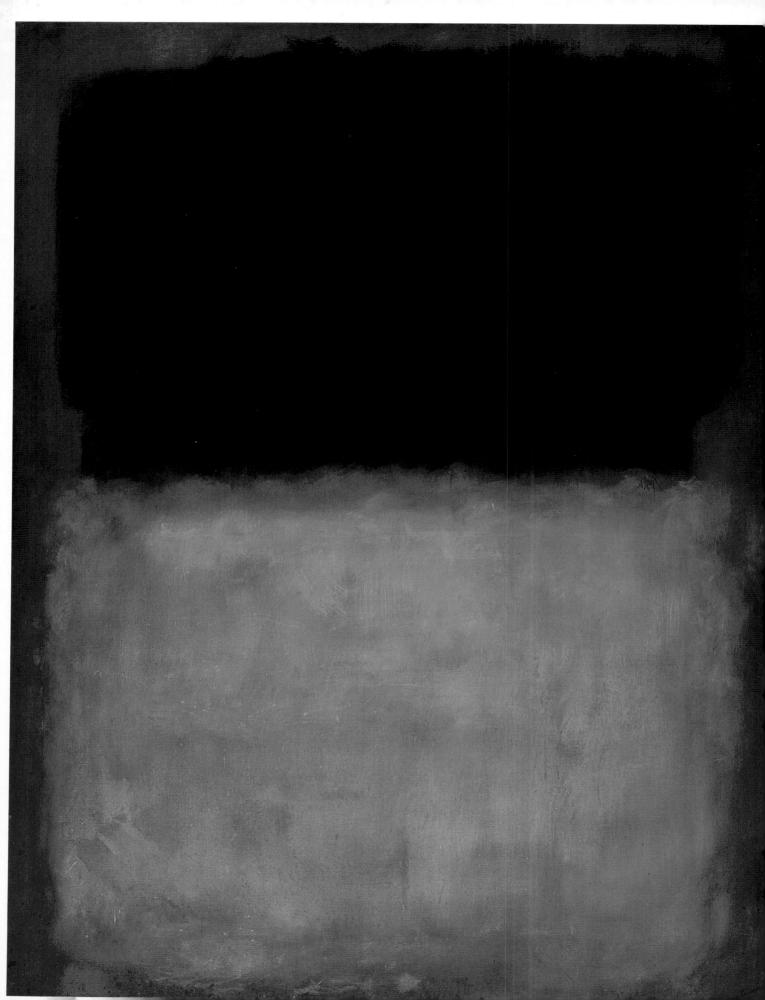

Decades of Change

15

The Plural Self in a Global Culture

LEARNING OBJECTIVES

15.1 Outline the principles of existentialism and how they manifest themselves in art and literature.

15.2 Compare and contrast the varieties of Abstract Expressionism and describe how the Beats and Pop Art challenged its ascendency.

15.3 Examine the role politics played in the art and literature of the 1960s and 1970s.

15.4 Characterize the ways in which pluralism and diversity are reflected in postmodern art and literature.

f, after World War II, the urban landscape of Europe was in no small part destroyed—from Dresden to London, whole cities were flattened—the European psyche was even more devastated. Similarly, Japan was haunted for generations by the bombing of Hiroshima and Nagasaki. The human loss, of course, took a far greater emotional toll than the specter of ruined buildings. By the time the war was over, somewhere in the vicinity of 17 million soldiers had died, and at least that many civilians had been caught up in fighting that, for the first time, directly engaged unarmed civilian populations. Hitler had exterminated 6 million Jews, and millions of other people had died of disease, hunger, and other causes. The final toll approached 40 million dead.

America reacted with mixed feelings. It was, after all, victorious, and celebrate it did, in no small part with one of the greatest economic booms in history. But the profound pessimism that characterized the European and Japanese response to the war found its expression at home as well, in the work, for instance, of Mark Rothko (1903–70), who had begun painting in the early 1940s by placing archetypal figures in front of large monochromatic bands of hazy, semitransparent color. By the early 1950s, he had eliminated the figures, leaving only the background color field.

The scale of these color-field paintings is intentionally large. *Green on Blue*, for instance, is over 7 feet tall (Fig. 15.1). "The reason I paint [large pictures]," he stated in 1951,

is precisely because I want to be very intimate and human. To paint a small picture is to place yourself outside your experience, to look upon an experience as a stereopticon view or reducing glass. However you paint the larger picture, you are in it. It isn't something you command.

Viewers find themselves enveloped in Rothko's sometimes extremely somber color fields. These expanses of color become, in this sense, stage sets for the human drama that transpires before them. As Rothko further explains:

I am interested only in expressing the basic human emotions—tragedy, ecstasy, doom, and so on—and the fact that lots of people break down and cry when confronted with my pictures shows that I communicate with those basic human emotions. The people who weep before my pictures are having the same religious experience I had when I painted them.

The emotional toll of such thinking finally cost Rothko his life. His artistic vision became darker and darker throughout the 1960s, and in 1970, he committed suicide in his studio.

[▼] Fig. 15.1 Mark Rothko, Green on Blue. 1956. Oil on canvas, 89¾" × 63¾". Collection of the University of Arizona Museum of Art, Tucson, Gift of E. Gallagher, Jr. Acc. 64.1.1. © 1998 Kate Rothko Prizel & Christopher Rothko/Artists Rights Society (ARS), New York. The religious sensibility of Rothko's painting brought him, in 1964, a commission for a set of murals for a Catholic chapel in Houston, Texas.

But not all was doom and gloom. In America, the 1950s were also years of unprecedented prosperity, a fact reflected in the proliferation of new goods and products—literally hundreds of the kinds of thing that Duane Hanson's Supermarket Shopper has loaded into her shopping cart in his hyperrealistic sculpture of 1970 (Fig. 15.2): CorningWare, Sugar Pops, and Kraft Minute Rice (1950); sugarless chewing gum and the first 33-rpm long-playing records, introduced by Deutsche Grammophon (1951); Kellogg's Sugar Frosted Flakes, the Sony pocket-sized transistor radio, fiberglass, and nylon (1952); Sugar Smacks cereal and Schweppes bottled tonic water (1953); Crest toothpaste and roll-on deodorant (1955); Comet cleanser, Raid insecticide, Imperial margarine, and Midas mufflers (1956); the Wham-O toy company's Frisbee (1957) and Hula Hoop (1958); Sweet'n Low sugar substitute, Green Giant canned beans, and Teflon frying pans (1958). Tupperware, which had been introduced in 1945, could be found in every kitchen after its push-down seal was patented in 1949. In July 1955, Walt Disney opened Disneyland in Anaheim, California, the first large-scale theme park in America. That same year, two of the first fast-food chains opened their doors-Colonel Sanders's Kentucky Fried Chicken (KFC) and McDonald's. In 1953, the first issue of Playboy magazine appeared, featuring Marilyn Monroe as its first nude centerfold, and by 1956, its circulation had reached 600,000. Sales of household appliances exploded, and women, still largely relegated to the domestic scene, suddenly found themselves with leisure time. Diner's Club and American Express introduced their charge cards in 1951 and 1958 respectively. Both cards required payment in full each month, but they paved the way for Bank Americard, introduced in 1959 (eventually evolving into the Visa card), which allowed individual borrowing—and purchasing—at an unprecedented level.

Television played a key role in marketing these products and services since advertisers underwrote entertainment and news programming by buying time slots for commercials. In television commercials, people could see products firsthand. Although television programming had been broadcast before World War II, it was suspended during the war and did not resume until 1948. By 1950, four networks were broadcasting to 3.1 million television sets. By the end of the decade, that number had swelled to 67 million. Even the food industry responded to the medium. Swanson, which had introduced frozen pot pies in 1951, began selling complete frozen "TV dinners" in 1953. The first, in its sealed aluminum tray, featured turkey, combread dressing and gravy, buttered peas, and sweet potatoes. It cost 98 cents, and Swanson sold 10 million units that year. Consumer culture was at full throttle.

Still, Rothko's pessimism was not without justification. Against this backdrop of prosperity and plenty—which could, alternatively, be viewed as consumerism run amok—more troubling events were occurring. After the war, the territories controlled by the Nazis had been partitioned, and the Soviets had gained control of Eastern Europe, which they continued to occupy. Berlin, fully enclosed by Soviet-controlled East Germany, was a divided city, and it quickly became a focal

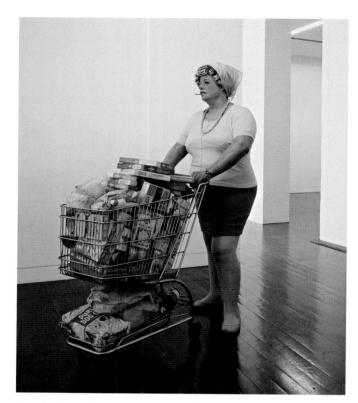

Fig. 15.2 Duane Hanson, Supermarket Shopper. 1970. Fiberglass, height 65". Neue Galerie – Sammlung Ludwig, Aachen, Germany. Art © Estate of Duane Hanson/Licensed by VAGA, New York, NY. Hanson's sculptures are so lifelike that museum visitors often speak to them.

point of tension when the Soviets blockaded land and river access to the city in 1948. U.S. President Harry S. Truman responded by airlifting vital supplies to the 2 million citizens of West Berlin, but the crisis would continue, culminating in the construction of the Berlin Wall in 1961.

Events in Asia were equally troubling. In China, the communists, led by Mao Zedong (1893–1976), drove the pro-Western nationalists, led by Chiang Kaishek (1887–1975), off the mainland to the island of Taiwan and established the pro-Soviet People's Republic of China on October 1, 1949. Korea was likewise partitioned into a U.S.-backed southern sector and a Soviet-backed northern sector, culminating in the 1950 invasion of the South by the North and the Korean War (1950–53), which involved American and Chinese soldiers, the latter supported by Russian advisors and pilots, in another military conflict. As the tension between the Soviet Bloc and the West escalated throughout the 1950s, nuclear confrontation seemed inevitable.

Artists and writers responded by creating a rebellious, individualistic art. In the 1960s, a growing dissatisfaction with the status quo inspired a sense of righteous indignation that manifested itself not only in the anti-Vietnam War movement but also in the civil rights movement, the burgeoning feminist movement, and the atmosphere of youthful rebellion embodied in the rise of rock-and-roll music and

the accompanying use of psychedelic drugs by musicians and audiences alike. In this world, the very possibility of arriving at definitive answers to the pressing problems of the day seemed more and more unlikely. Everything seemed open to interpretation, and "meaning" itself became contingent and open-ended. By the turn of the century, the increasing globalization of the world's cultures threatened the integrity of indigenous cultures, but even more complex questions began to emerge. Artists all over the world have found themselves in a double bind—how, they ask, can they remain true to their native or ethnic identities and still participate in the larger world market? What happens to their work when it enters a context where it is received with little or no understanding of its origins? How, indeed, does the global threaten the local? In the world of global media—motion pictures, television channels such as CNN, and Internet search engines like Google—is the very idea of the "self" threatened by technology and technological innovation?

EUROPE AFTER THE WAR: THE EXISTENTIAL QUEST

What are the chief characteristics of existentialism, and how do they manifest themselves in art and literature?

The Holocaust and the devastation at Hiroshima and Nagasaki dramatically increased the profound pessimism that had gripped intellectual Europeans ever since the turn of the century. How could anyone pretend that the human race was governed by reason, that advances in technology and science were for the greater good, when human beings were not only capable of genocide, but also possessed the ability to annihilate themselves?

The Philosophy of Sartre: Existentialism

During and after World War II, the French philosopher Jean-Paul Sartre (1905–80) argued for what he termed existentialism. "Existence precedes essence" was Sartre's basic premise; that is, humans must define their own essence (who they are) through their existential being (what they do, their acts). "In a word," Sartre explained, "man must create his own essence; it is in throwing himself into the world, in suffering it, in struggling with it, that—little by little—he defines himself." Life is defined neither by subconscious drives, as Freud had held, nor by socioeconomic circumstances, as Marx had argued: "Man is nothing else but what he makes of himself. Such is the first principle of existentialism."

For Sartre there is no meaning to existence, no eternal truth for us to discover. The only certainty is death. Sartre's major philosophical work, the 1943 *Being and Nothingness*, outlines the nature of this condition, but his argument is more accessible in his play *Huis Clos (No Exit)*. As the play opens, a valet greets Monsieur Garcin as he enters the room that will be his eternal hell (**Reading 15.1**):

READING 15.1

from Jean-Paul Sartre, No Exit (1944)

GARCIN (enters, accompanied by the VALET, and glances around him):

So here we are? VALET: Yes, Mr. Garcin.

GARCIN: And this is what it looks like?

VALET: Yes

GARCIN: Second Empire furniture, I observe . . . Well,

well, I dare say one gets used to it in time.

VALET: Some do, some don't.

GARCIN: Are all the rooms like this one?

VALET: How could they be? We cater for all sorts: Chinamen and Indians, for instance. What use would

they have for a Second Empire chair?

GARCIN: And what use do you suppose I have for one? Do you know who I was? . . . Oh, well, it's no great matter. And, to tell the truth, I had quite a habit of living among furniture that I didn't relish, and in false positions. I'd even come to like it. A false position in a Louis-Philippe dining room—you know the style?—well, that had its points, you know. Bogus in bogus, so to speak.

VALET: And you'll find that living in a Second Empire drawing-room has its points.

GARCIN: Really? . . . Yes, yes, I dare say . . . Still I certainly didn't expect—this! You know what they tell us down there?

VALET: What about?

GARCIN: About . . . this-er-residence.

VALET: Really, sir, how could you believe such cock-andbull stories? Told by people who'd never set foot here.

For, of course, if they had-

GARCIN: Quite so. But I say, where are the instruments

of torture?

VALET: The what?

GARCIN: The racks and red-hot pincers and all the other

paraphernalia?

VALET: Ah, you must have your little joke, sir.

GARCIN: My little joke? Oh, I see. No, I wasn't joking. No mirrors, I notice. No windows. Only to be expected. And nothing breakable. But damn it all, they might have left me my toothbrush!

VALET: That's good! So you haven't yet got over your—what-do-you-call-it?—sense of human dignity? Excuse my smiling.

The play was first performed in May 1944, just before the liberation of Paris. If existence in existential terms is the power to create one's future, Garcin and the two women who will soon occupy the room with him are in hell precisely because they are powerless to do so. Garcin's "bad faith" consists of his insistence that his self is the creation of others. His sense of himself derives from how others perceive him. Thus, in the most famous line of the play, he says, "l'enfer, c'est les autres"—"Hell is other people." In the drawing room, there need be no torturer because each character tortures the other two.

The Theater of the Absurd

Sartre's *No Exit* was the first example of what in the 1960s became known as the **Theater of the Absurd**, a theater in which the meaninglessness of existence is the central thematic concern. *No Exit* was the first example, but many other plays of a similar character followed, written by Samuel Beckett (1906–89), an Irishman who lived in Paris throughout the 1950s; the Romanian Eugène Ionesco (1909–94); the Frenchman Jean Genet (1910–86); the Englishman Harold Pinter (1930–2008); the American Edward Albee (1928–); and the Czech-born Englishman Tom Stoppard (1937–). All these playwrights share a common existential sense of the absurd plus, ironically, a sense that language is a barrier to communication, that speech is almost futile, and that we are condemned to isolation and alienation.

The most popular of the absurdist plays is Samuel Beckett's Waiting for Godot, first performed in French in 1953 and subtitled A Tragicomedy in Two Acts. The play introduced audiences to a new set of stage conventions, from its essentially barren set (only a leafless tree decorates the stage), to its two clownlike characters, Vladimir and Estragon, whose language is incapable of affecting or even coming to grips with their situation. The play demands that its audience, like its central characters, try to make sense of an incomprehensible world in which nothing occurs. In fact, the play's first line announces, as Estragon tries without success to remove his boot, "Nothing to be done." In Act I, Vladimir and Estragon await the arrival of a person referred to as Godot (Reading 15.2a):

READING 15.2a

from Samuel Beckett, Waiting for Godot, Act I (1953)

VLADIMIR: What do we do now?

ESTRAGON: Wait.

That is exactly what the audience must do as well—wait. Yet nothing happens. Godot does not arrive. In despair, Vladimir and Estragon contemplate hanging themselves but are unable to. Then they decide to leave but do not move. Act II takes place the next day. But nothing changes—Vladimir and Estragon again wait for Godot, who does not arrive, and again they contemplate suicide. There is no development, no change of circumstance, no crisis, no resolution. The play's conclusion, which repeats the futile decision to move on that ended Act I, demonstrates this (Reading 15.2b):

READING 15.2b

from Samuel Beckett, Waiting for Godot, Act II (1953)

VLADIMIR: Well? Shall we go? ESTRAGON: Yes, let's go. (They do not move.) (Curtain.) The promise of action and the realization of none—that is the Theater of the Absurd.

AMERICA AFTER THE WAR: TRIUMPH AND DOUBT

What various approaches to painting distinguish the Abstract Expressionists, and how did the Beats and Pop Art challenge them?

After the War, the U.S. State Department sponsored mammoth exhibitions of paintings and sculpture by contemporary American artists that toured Europe—focusing on Paris, especially—in order to demonstrate the spirit of freedom and innovation in American art (and, by extension, American culture as a whole). The individualistic spirit of these artists, whose work was branded Abstract Expressionism, was seen as the very antithesis of Communism, and their work was meant to convey the message that America had triumphed not only in the war, but in art and culture as well. New York, not Paris, was now the center of the art world. These artists included immigrants like Mark Rothko (see Fig. 15.1), Arshile Gorky (1904-48), Hans Hoffmann (1880-1966), Milton Resnick (1917-2004), and Willem de Kooning (1904-97), as well as slightly younger American-born artists like Franz Kline (1910-62) and Jackson Pollock (1912-56). All freely acknowledged their debts to Cubism's assault on traditional representation, German expressionism's turn inward from the world, Kandinsky's near-total abstraction, and Surrealism's emphasis on chance operations and psychic automatism. Together the Abstract Expressionists saw themselves as standing at the edge of the unknown, ready to define themselves through a Sartrian struggle with the blank canvas, through the physical act of applying paint and the energy that each painted gesture reveals.

Action Painting: Pollock and de Kooning

In 1956, Willem de Kooning commented that "every so often, a painter has to destroy painting. Cézanne did it. Picasso did it with Cubism. Then Pollock did it. He busted our idea of a picture all to hell. Then there could be new paintings again." Around 1940, Pollock underwent psychoanalysis in order to explore Surrealist psychic automatism and to reveal, on canvas, the deepest areas of the unconscious. This depiction of a mental landscape would soon develop into large-scale "action painting," as described by the critic Harold Rosenberg in 1942 (Fig. 15.3). The canvas had become, he said, "an arena in which to act." It was no longer "a picture but an event." Pollock would drip, pour, and splash oil paint, house and boat paint, and enamel over the surface of the canvas, determining the top and bottom of the piece only after the process was complete. The result was a galactic sense of space, what Rosenberg called "all-over" space, in which the viewer can almost trace Pollock's rhythmic gestural dance around the painting's perimeter.

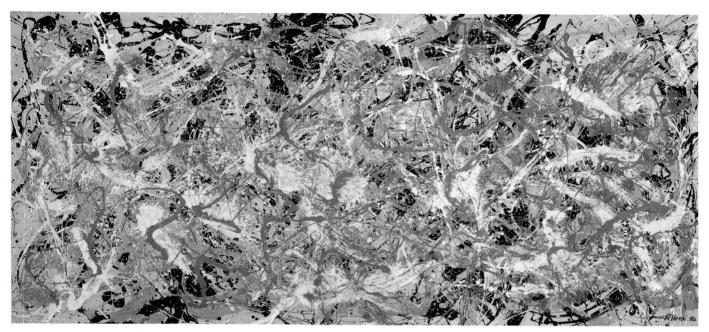

Fig. 15.3 Jackson Pollock, Number 27. 1950. Oil on canvas, 4'1" × 8'10". Collection, Whitney Museum of American Art, New York. Purchase. © 2014 The Pollock-Krasner Foundation/Artists Rights Society (ARS), New York. The year Number 27 was painted, Life magazine ran a long, profusely illustrated story on Pollock, asking, "Is he the greatest living painter in the United States?" It stimulated an astonishing 532 letters to the editor, most of them answering the question with a definitive "No!"

De Kooning was eight years Pollock's senior and had begun in the late 1930s and early 1940s in a more figurative vein. His pictorial space is composed of shapes and forms, rather than the woven linear skein of Pollock's compositions. But by 1950, in paintings like Excavation (Fig. 15.4), the surface of de Kooning's paintings seemed densely packed with freefloating, vaguely anatomical parts set in a landscape of crumpled refuse, earthmoving equipment, concrete blocks, and I-beams. None of these elements is definitively visible, just merely suggested. Excavation is a complex organization of open and closed cream-colored forms that lead from one to the other, their black outlines overlapping, merging, disappearing across the surface. Small areas of brightly colored brushwork interrupt the surface.

When, in 1951, Excavation was featured in an exhibition of abstract

painting and sculpture at the Museum of Modern Art in New York, de Kooning lectured on the subject "What Abstract Art Means to Me." His description of his relationship to his

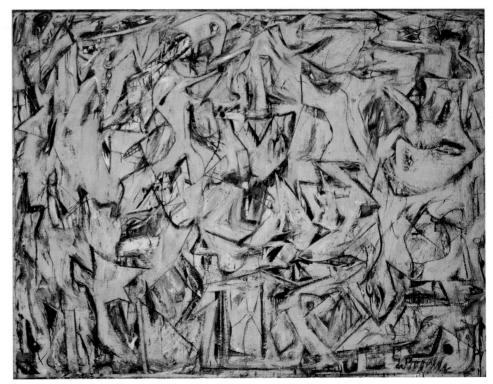

Fig. 15.4 Willem de Kooning, *Excavation.* **1950.** Oil on canvas, 81" × 100½". Unframed. Mr. and Mrs. Frank G. Logan Purchase Prize Fund; restricted gifts of Edgar J. Kaufmann, Jr., and Mr. and Mrs. Noah Goldowsky, Jr., 1952.1. Reproduction, The Art Institute of Chicago. All rights reserved. © 2014 The Willem de Kooning Foundation/Artists Rights Society (ARS), New York. This is one of de Kooning's largest paintings. "My paintings are too complicated," he explained. "I don't use the large-size canvas because it's too difficult for me to get out of it."

environment is a fair explanation of what we see in the painting: "Everything that passes me I can see only a little of, but I'm always looking. And I see an awful lot sometimes." De Kooning's abstraction differs from Pollock's largely in this. As opposed to plumbing the depths of the psyche, he represents the psyche's encounter with the world. De Kooning's primary concern is the relationship of the individual to his or her environment. The tension between the two is the focus of his works.

Women Abstract Expressionists

Although excluded from the inner circle, a number of the women associated with Abstract Expressionism were painters of exceptional ability. Elaine de Kooning (1918–89), who married Willem in 1943, was known for her highly sexualized portraits of men. Lee Krasner (1908–84), who married Jackson Pollock in 1945, developed her own distinctive all-over style of thickly applied paint consisting of calligraphic lines. Inspired by de Kooning, Joan Mitchell (1926–92) began painting in New York in the early 1950s, but after 1955, she divided her time between Paris and New York, moving to Paris more permanently in 1959. Ten

years later, she moved down the Seine to Vétheuil, living in the house that Monet had occupied from 1878 to 1881. Although she denied the influence of Monet, her paintings possess something of the scale of Monet's water-lily paintings, and her brushwork realizes in large part what Monet rendered in detail. Like Monet, she was obsessed with water, specifically Lake Michigan, which as a child she had constantly viewed from her family's Chicago apartment. "I paint from remembered landscapes that I carry with me—and remembered feelings of them, which of course become transformed." As occurs in most of her works, the unpainted white ground of *Piano mécanique* takes on the character of atmosphere or water, an almost touchable and semitransparent space that reflects the incidents of weather, time, and light (Fig. 15.5).

In 1952, directly inspired by Pollock's drip paintings, 24-year-old Helen Frankenthaler (1928–2011) diluted paint almost to the consistency of watercolor and began pouring it onto unprimed cotton canvas to achieve giant stains of color that suggest landscape (Fig. 15.6). The risk she assumed in controlling her flooding hues, and the monumentality of her compositions, immediately inspired a large number of other artists. More organic and free-flowing than

Fig. 15.5 Joan Mitchell, *Piano mécanique*. 1958. Oil on canvas, 78" × 128". Collection of the National Gallery of Art, Washington, D.C., Gift of Addie and Sidney Yates. © Estate of Joan Mitchell. Photograph © Board of Trustees, National Gallery of Art, Washington, D.C. Samuel Beckett was one of Mitchell's closest friends after she moved to Paris in 1959.

Fig. 15.6 Helen Frankenthaler, *The Bay.* 1963. Acrylic on canvas, 6'8¾" × 6'9½". The Detroit Institute of Arts, Founders Society Purchase, Dr. & Mrs. Hilbert H. DeLawter Fund. © 2014 Estate of Helen Frankenthaler/Artists Rights Society (ARS), New York. This is one of the first paintings in which Frankenthaler used acrylic rather than oil paint, resulting in a much stabler surface.

the color-field paintings of Mark Rothko (see Fig. 15.1), they nevertheless have much in common with Rothko's work. Both evoke the landscape—Rothko the horizon, and Frankenthaler something akin to an aerial photograph of the Earth.

The Beat Generation

From a certain point of view, Abstract Expressionism seemed self-indulgent, turning inward to the depths of the self to the exclusion of the world, and a group of American poets, writers, and artists whom we have come to call "Beats" or "hipsters" soon challenged its ascendancy. Beat was originally a slang term meaning "down and out," or "poor and exhausted," but it came to designate the purposefully disenfranchised artists of 1950s America who turned their backs on what they saw as the duplicity of their country's values. The Beat generation sought a heightened and, they believed, more authentic style of life, defined by alienation, nonconformity, sexual liberation, drugs, and alcohol.

Robert Frank and Jack Kerouac The Beats' material lay all around them in the world, as they sought to expose the tensions that lay under the presumed well-being of their society. One of their contemporary heroes was the Swiss photographer Robert Frank (1924–), who with the aid of a Guggenheim fellowship had traveled across America for two years, publishing 83 of the resulting 2,800 photographs in 1958 as The Americans. The book outraged a public used to photographic compilations such as the 1955 exhibition The Family of Man, which drew 3,000 visitors daily to the Museum of Modern Art in New York in celebration of its message of universal hope and unity. Frank's photographs offered something different. They capture everyday, mundane things that might otherwise go by unseen, with a sense of spontaneity and directness that was admired, especially, by the writer Jack Kerouac (1922-69), who had chronicled his own odysseys across America in the 1957 On the Road.

On the Road describes Kerouac's real-life adventures with his friend Neal Cassady (1926–68), who appears in what Kerouac called his "true-story novel" as Dean Moriarty. Cassady advocated a brand of writing that amounted to, as he put it in a letter to Kerouac, "a continuous chain of undisciplined thought." In fact, Kerouac wrote the novel in about three weeks on a single long scroll of paper, improvising, he felt, like a jazz musician, only with words and narrative. But, like a jazz musician, Kerouac was a skilled craftsman, and if the novel seems a spontaneous outburst, it nevertheless reflects the same careful attention to craft as that reflected in Robert Frank's *The Americans*. Frank, after all, had taken over 2,800 photographs, but he had published only 83 of them. One senses, in reading Kerouac's rambling adventure, something of the same editorial control.

Ginsberg and "Howl" The work that best characterizes the Beat generation is "Howl," a poem by Allen Ginsberg (1926–97). This lengthy poem in three parts and a footnote has a memorable opening (**Reading 15.3**):

READING 15.3

from Allen Ginsberg, "Howl" (1956)

I saw the best minds of my generation destroyed by madness, starving hysterical naked,

dragging themselves through the negro streets at dawn looking for an angry fix,

angelheaded hipsters burning for the ancient heavenly connection to the starry dynamo in the machinery of night,

who poverty and tatters and hollow-eyed and high sat up smoking in the supernatural darkness of cold-water flats floating across the tops of cities contemplating jazz

who bared their brains to Heaven under the El and saw Mohammedan angels staggering on tenement roofs illuminated,

who passed through universities with radiant cool eyes hallucinating Arkansas and Blake-light tragedy among the scholars of war,

who were expelled from the academies for crazy & publishing obscene odes on the windows of the skull, who cowered in unshaven rooms in underwear, burning their money in wastebaskets and listening to the Terror through the wall . . .

Ginsberg's spirit of inclusiveness admitted into art not only drugs and alcohol but also graphic sexual language, to say nothing of his frank homosexuality. Soon after "Howl" was published in 1956 by Lawrence Ferlinghetti's City Lights bookstore in San Francisco, federal authorities charged Ferlinghetti with obscenity. He was eventually acquitted. Whatever the public thought of it, the poem's power was hardly lost on the other Beats. The poet Michael McClure (1932–) was present the night Ginsberg first read it at San Francisco's Six Gallery in 1955:

Allen began in a small and intensely lucid voice. At some point Jack Kerouac began shouting "GO" in cadence as Allen read it. In all of our memories no one had

been so outspoken in poetry before—we had gone beyond a point of no return—and we were ready for it, for a point of no return. None of us wanted to go back to the gray, chill, militaristic silence, to the intellective void—to the land without poetry—to the spiritual drabness. We wanted to make it new and we wanted to invent it and the process of it as we went into it. We wanted voice and we wanted vision. . . .

Ginsberg read on to the end of the poem, which left us standing in wonder, or cheering and wondering, but knowing at the deepest level that a barrier had been broken, that a human voice and body had been hurled against the harsh wall of America and its supporting armies and navies and academies and institutions and ownership systems and power-support bases.

Here, in fact, in the mid-1950s were the first expressions of the forces of rebellion that would sweep the United States and the world in the following decade.

Cage and the Aesthetics of Chance

Ginsberg showed that anything and everything could be admitted into the domain of art. This notion also informs the music of the composer John Cage (1912–92), who by the mid-1950s was proposing that it was time to "give up the desire to control sound . . . and set about discovering means to let sounds be themselves." Cage's notorious 4'33" (4 minutes 33 seconds) is a case in point. First performed in Woodstock, New York, by the pianist David Tudor on August 29, 1952, it consists of three silent movements, each of a different length, but when added together totaling 4 minutes and 33 seconds. The composition was anything but silent, however, admitting into the space framed by its duration all manner of ambient sound whispers, coughs, passing cars, the wind. Whatever sounds happened during its performance were purely a matter of chance, never predictable. Like Frank's, Cage's is an art of inclusiveness.

That summer, Cage organized a multimedia event at Black Mountain College near Asheville, North Carolina, where he occasionally taught. One of the participants was the 27-year-old artist Robert Rauschenberg (1925–2008). By the mid-1950s, Rauschenberg had begun to make what he called **combine paintings**, works in which all manner of material—postcards, advertisements, tin cans, pinups—are combined. If Rauschenberg's work does not literally depend upon matters of chance in its construction, it does incorporate such a diverse range of material that it creates the aura of representing Rauschenberg's chance encounters with the world around him. And it does, above all, reflect Cage's sense of all-inclusiveness. Bed literally consists of a sheet, pillow, and quilt raised to the vertical and then dripped not only with paint but also with toothpaste and fingernail polish in what amounts to a parody of Abstract Expressionist introspection (Fig. 15.7). Even as it juxtaposes highbrow art-making with the vernacular quilt, abstraction with

Fig. 15.7 Robert Rauschenberg, Bed. 1955. Combine painting: oil and pencil on pillow, quilt, and sheet on wood supports, 6'3¼" × 31½" × 8". Gift of Leo Castelli in honor of Alfred H. Barr, Jr. (79.1989). Art © Robert Rauschenberg Foundation/Licensed by VAGA, New York, NY. The mattress, pillow, quilt, and sheets are believed to be Rauschenberg's own and so may be thought of as embodying his famous dictum: "Painting relates to both art and life. . . . (I try to act in that gap between the two)."

realism, Bed is a wryly perceptive transformation of the dream space evoked by Surrealism.

The Art of Collaboration Theater Piece #1, as the multimedia event at which Rauschenberg first met Cage in 1952 came to be known, is remembered by almost everyone who took part somewhat differently. It seems certain that the poets M. C. Richards (1916–99) and Charles Olson (1910–70) read poetry from ladders, Rauschenberg played Edith Piaf records on an old windup phonograph with his almost totally "White Paintings" hanging around the room, and Merce Cunningham (1919–2009) danced through the audience, a dog at his heels, while Cage himself sat on a stepladder, sometimes reading a lecture on Zen Buddhism, sometimes just listening. "Music," Cage declared at some point in the event, "is not listening to Mozart but sounds such as a street car or a screaming baby."

The event inaugurated a collaboration between Cunning-ham (dance), Cage (music), and Rauschenberg (decor and costume) that would span many years. Their collaboration is unique in the arts because of its insistence on the *independence*, not interdependence, of each part of the dance's presentation. Cunningham explains:

In most conventional dances there is a central idea to which everything adheres. The dance has been made to the piece of music, the music supports the dance, and the decor frames it. The central idea is emphasized by each of the several arts. What we have done in our work is to bring together three separate elements in time and space, the music, the dance and the decor, allowing each one to remain independent.

So Cunningham created his choreography independently of Cage's scores, and Rauschenberg based his decor on only minimal information offered him by Cunningham and Cage. The resulting dance was, by definition, a matter of music, choreography, and decor coming together (or not) as a chance operation.

The music Cage composed for Cunningham was also often dependent on chance operations. For instance, in 1959, Cage recorded an 89-minute piece entitled *Indeterminacy* (track 15.1). It consisted of Cage narrating short, humorous stories while, in another room, out of earshot, David Tudor performed selections from Cage's 1958 Concert for Piano and Orchestra and also played pre-recorded tape from another 1958 composition, Fontina Mix. For a later collaboration, Variations V, Cage's score consisted of sounds randomly triggered by sensors reacting to the movements of Cunningham's dancers. This resulted in what Gordon Mumma, a member of Cunningham's troupe, called "a superbly poly: -chromatic, -genic, -phonic, -morphic, -pagic, -technic, -valent, multiringed circus."

Johns and the Obvious Image Whereas the main point for Cunningham, Cage, and Rauschenberg was the idea of composition without a central focus, Rauschenberg's close friend and fellow painter Jasper Johns (1930–) took the opposite

Fig. 15.8 Jasper Johns, *Three Flags.* **1958.** Encaustic on canvas, 30%" × 45%" × 5". 50th Anniversary Gift of the Gilman Foundation, Inc., The Lauder Foundation, A. Alfred Taubman, an anonymous donor, and purchase. 80.32. Collection of Whitney Museum of American Art, New York. Photo by Geoffrey Clements. Art © Jasper Johns/Licensed by VAGA, NY. Each of the three flags diminishes in scale by about 25 percent from the one behind. Because the flags project outward, getting smaller each time, they reject pictorial perspective's illusion of depth and draw attention to the surface of the painting itself.

tack. Throughout the 1950s, he focused on the most common, seemingly obvious subject matter—numbers, targets, maps, and flags—in a manner that in no way suggests the multiplicity of meaning in his colleagues' work. Johns's painting *Three Flags* is nevertheless capable of evoking in its viewers emotions ranging from patriotic respect to equally patriotic outrage, from anger to laughter (Fig. 15.8). But Johns means the imagery to be so obvious that viewers turn their attention

to the wax-based paint itself, to its almost sinuous application to the canvas surface. In this sense, the work—despite being totally recognizable—is as abstract as any Abstract Expressionist painting, but without Abstract Expressionism's assertion of the primacy of subjective experience.

Architecture in the 1950s

If the Beat generation was antiestablishment in its sensibilities, the architecture of the 1950s embodied the very opposite. What is known as the *International Style*—characterized by pure forms, severe, flat surfaces, and a lack of ornamentation—dominated architectural taste. One of its principal practitioners was Ludwig Mies van der Rohe (1886–1969). His aesthetic use of refined austerity, summed up by the phrase "less is more," is clearly evident in his 1950 Farnsworth House (Fig. 15.9), with its insistence on the vertical and the horizontal elements. It is virtually transparent, opening out to the surrounding countryside, with views of the Fox River, and also inviting the countryside in.

The design of the American architect Frank Lloyd Wright (1867–1959) for the Solomon R. Guggenheim Museum in New York is a conscious counter-statement to Mies's severe rationalist geometry, which, in fact, Wright despised (Fig. 15.10). Situated on Fifth Avenue directly across from Central Park, the museum's organic forms echo the natural world. The plan is an inverted spiral ziggurat, or stepped tower, that dispenses with the right-angle geometry of standard urban architecture and the conventional approach to museum design, which led visitors through a series of interconnected rooms. Instead, Wright whisked museumgoers to the top of the building via elevator, allowing them to proceed downward on a continuous spiral ramp from

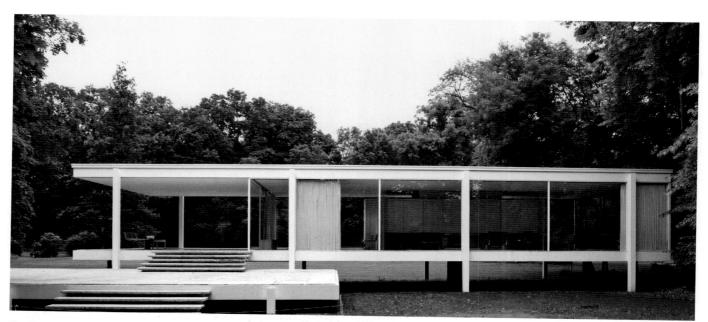

Fig. 15.9 Ludwig Mies van der Rohe, Farnsworth House, Fox River, Plano, Illinois. 1950. The house was commissioned as a weekend retreat. Its bathroom and storage areas are behind non-load-bearing partitions that divide the interior space.

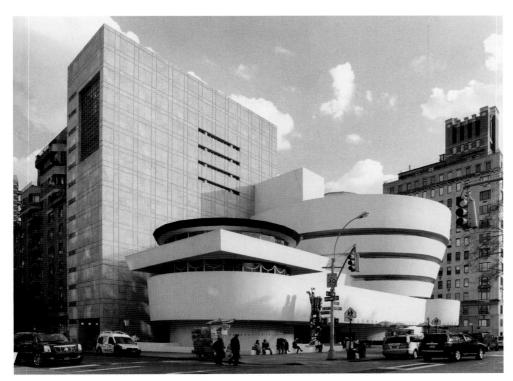

Fig. 15.10 Frank Lloyd Wright, The Solomon R. Guggenheim Museum, New York, 1956—1959. The tower behind Wright's original building was designed much later, in 1992, by Gwathmey Siegel and Associates. It contains 51,000 square feet of new and renovated gallery space, 15,000 square feet of new office space, a restored theater, a new restaurant, and retrofitted support and storage spaces. Wright had originally proposed such an annex to house artists' studios and offices, but the plan was dropped for financial reasons.

which, across the open rotunda in the middle, they could review what they had already seen and anticipate what was to come. The ramp is cantilevered to such an extent that several contractors were frightened off by Wright's plans. The plans were complete in 1943, but construction did not

begin until 1956 because of a prohibition of new building during World War II and permit delays stemming from the radical nature of the design. It was still not complete at the time of Wright's death in 1959. In many ways Wright's Guggenheim Museum represents the spirit of architectural innovation that still pervades the practice of architecture to this day.

Pop Art

In the early 1960s, especially in New York, a number of artists created a "realist" art that represented reality in terms of the media—advertising, television, comic strips—the imagery of mass culture. The famous paintings of Campbell's Soup cans created by Andy Warhol (1928–87) were among the first of these to find their way into the gallery scene

(Fig. 15.11). In the fall of 1962, Warhol exhibited 32 uniform 20" × 16" canvases at the Ferus Gallery in Los Angeles. Each depicted one of the 32 different Campbell's Soup "flavors." Even as the paintings debunked the idea of originality—are they Campbell's or Warhol's?—their literalness

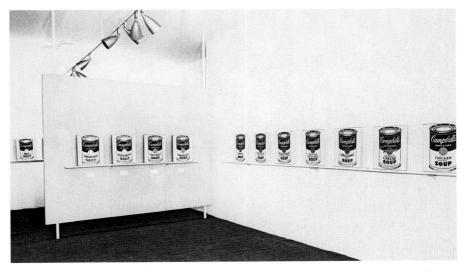

Fig. 15.11 Andy Warhol, installation view of *Campbell's Soup Cans*, Ferus Gallery, Los Angeles. 1962. Founding Collection, The Andy Warhol Museum, Pittsburgh. © 2014 The Andy Warhol Foundation for the Visual Arts, Inc./Artists Rights Society (ARS), New York. In order to evoke the way we encounter Campbell's soup on the grocery shelf, Warhol placed the cans on narrow shelves on the gallery walls.

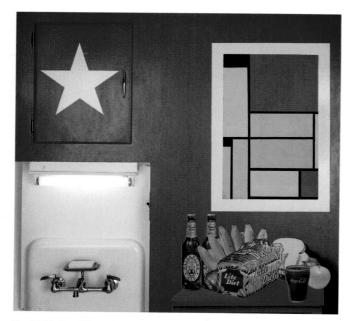

Fig. 15.12 Tom Wesselmann, Still Life #20. 1962. Mixed media, 48" × 48" × 5½". Albright-Knox Art Gallery, Buffalo, New York. Gift of Seymour H. Knox, Jr. Art © Estate of Tom Wesselmann/Licensed by VAGA, New York, NY. An actual sink faucet and soap dish are incorporated into the composition. Its fluorescent light can be turned on or off.

redefined the American landscape as the visual equivalent of the supermarket aisle. The works were deliberately opposed to the self-conscious subjectivity of the Abstract Expressionists. It was, in fact, as if the painter had no personality at all. As Warhol himself put it, "If you want to know all about Andy Warhol, just look at the surface of my paintings and films and me, and there I am. There's nothing behind it."

The term Pop Art quickly became attached to work like Warhol's. Coined in England in the 1950s, it soon came to refer to any art whose theme was essentially the commodification of culture—that is, the marketplace as the dominant force in the creation of "culture." Thus, Still Life #20 (Fig. 15.12) by Tom Wesselmann (1931–2004) is contemporaneous with Warhol's Soup Cans, although neither artist was aware of the other until late in 1962, and both are equally "pop." Inside the cabinet with the star stenciled on it—which can be shown either opened or closed—are actual household items, including a package of SOS scouring pads and a can of Ajax cleanser. Above the blue table on the right, covered with two-dimensional representations (cut out of magazines) of various popular varieties of food and drink, is a reproduction of a highly formalist painting by the Dutch artist Piet Mondrian. The implication, of course, is that art—once so

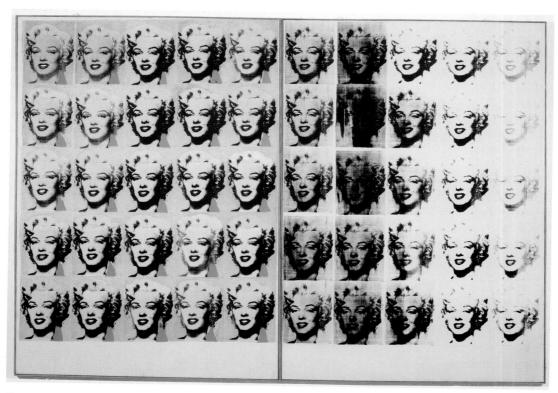

Fig. 15.13 Andy Warhol, Marilyn Diptych. 1962. Oil, acrylic, and silkscreen on enamel on canvas, $6'8\%'' \times 4'9''$. Tate, London. © 2014 Tate, London. © 2014 The Andy Warhol Foundation for the Visual Arts/Artists Rights Society (ARS), New York. Warhol was obsessed with Hollywood, especially with the false fabric of fame that it created. The image of Marilyn is a direct transfer of a 1953 publicity shot for the film Niagara.

Fig. 15.14 Roy Lichtenstein, Oh, Jeff...I Love You, Too... But.... 1964. Oil on magma on canvas, 4' × 4'. © Estate of Roy Lichtenstein. The large size of these paintings mirrors the scale of the Hollywood screen and the texture of the common billboard.

Fig. 15.15 Roy Lichtenstein, Little Big Painting. 1965. Oil on synthetic polymer on canvas, 70" × 82" × 2½". Purchase, with funds from the Friends of the Whitney Museum of American Art. 66.2 Collection of the Whitney

Fig. 15.15 Roy Lichtenstein, *Little Big Painting*. 1965. Oil on synthetic polymer on canvas, $70^{\circ} \times 82^{\circ} \times 21^{\circ}$. Purchase, with funds from the Friends of the Whitney Museum of American Art. 66.2. Collection of the Whitney Museum of American Art, New York. © Estate of Roy Lichtenstein. This "detail" of an imaginary larger painting is nonetheless a giant in its own right.

far removed from everyday life, not even, in this case, referring to the world—has itself become a commodity, not so very different from Coke or a loaf of Lite Diet bread. In fact, the structure and color of Wesselmann's collage subtly reflect the structure and color of Mondrian's painting, as if the two are simply two different instances of "the same."

By late 1962, Warhol had stopped making his paintings by hand, instead using a photo-silkscreen process to create the images mechanically and employing others to do the work for him in his studio, The Factory. One of the first of these is the Marilyn Diptych (Fig. 15.13). Marilyn Monroe had died, by suicide, in August of that year, and the painting is at once a memorial to her and a commentary on the circumstances that had brought her to despair. She is not so much a person as she is a personality, the creation of a Hollywood studio system whose publicity shot Warhol would repeat over and over again here to the point of

The enlarged comic-strip paintings of Roy Lichtenstein (1923–97) are replete with heavy outlines and Ben Day dots, the process created by Benjamin Day at the turn of the century to produce shading effects in mechanical printing. Widely used in comic strips, the dots are, for Lichtenstein, a conscious parody of Seurat's pointillism (see Chapter 14). But they also reveal the extent to which "feeling" in popular culture is as "canned" as Campbell's Soup. In Oh, Jeff... (Fig. 15.14), "love" is emptied of real meaning, as the real weight of the message is carried by the final "But..." Even the feelings inherent in Abstract Expressionists' brushwork came under Lichtenstein's attack (Fig. 15.15). In fact, Lichtenstein had taught painting to college students, and

he discovered that the "authentic" gesture of Abstract Expressionism could easily be taught and replicated without any emotion whatsoever—as a completely academic enterprise.

One of the most inventive of the Pop artists was Claes Oldenburg (1929–), born in Sweden but raised in New York and Chicago. In 1961, he converted the storefront studio in New York's Lower East Side into *The Store*, which he filled with life-size and over-life-size enameled plaster sculptures of everything from pie à la mode to hamburgers, hats, caps, 7-Up bottles, shirt-and-tie combinations, and slices of cake. "I am for an art," he wrote in a statement accompanying the exhibition,

that is political-erotica-mystical, that does something other than sit on its ass in a museum.

I am for an art that grows up not knowing it is art at all, an art given the chance of having a starting point of zero.

I am for an art that embroils itself with the everyday crap & still comes out on top. I am for an art that imitates the human, that is comic, if necessary, or violent, or whatever is necessary.

I am for an art that takes its form from the lines of life itself, that twists and extends and accumulates and spits and drips, and is heavy and coarse and blunt and sweet and stupid as life itself.

Admiring the way that cars filled the space of auto show-rooms, Oldenburg soon enlarged his objects to the size of cars and started making them out of vinyl stuffed (or not) with foam rubber. These objects toy not only with our sense of scale—a 5-foot-high toilet, for instance, or a giant

Fig. 15.16 Claes Oldenburg, *Soft Toilet.* **1966.** Vinyl, kapok, Liquitex, wood, $55\frac{1}{2}$ " \times $28\frac{1}{4}$ " \times 30". Collection of the Whitney Museum of American Art, New York. © 1966 Claes Oldenburg. Oldenburg's art is epitomized by his slightly but intentionally vulgar sense of humor.

lightplug—but with the tension inherent in making soft something meant to be hard (Fig. 15.16). They play, further, in almost Surrealist fashion, with notions of sexuality as well—the analogy between inserting a lightplug into its socket and sexual intercourse was hardly lost on Oldenburg, who delighted even more in the image of cultural impotence that his "soft" lightplug implied.

THE WINDS OF CHANGE

What role did politics play in the art and literature of the 1960s and 1970s?

In 1954, the U.S. Supreme Court ruled that racially segregated schools violated the Constitution. In *Brown v. Board of Education*, the Court found that it was not good enough

to provide "separate but equal" schools. "Separate educational facilities are inherently unequal," the Court declared, and were in violation of the Fourteenth Amendment to the Constitution's guarantee of equal protection. The Justices called on states with segregated schools to desegregate "with all deliberate speed."

Within a week, the state of Arkansas announced that it would seek to comply with the court's ruling. The state had already desegregated its state university and its law school. Now it was time to desegregate elementary and secondary schools. The plan was for Little Rock Central High School to open its doors to African-American students in the fall of 1957. But on September 2, the night before school was to start, Governor Orval Faubus ordered the state's National Guard to surround the high school and prevent any black students from entering. Faubus claimed he was trying to prevent violence. Eight of the nine black students who were planning to attend classes that day decided to arrive together on September 4. Unaware of the plan, Elizabeth Eckford arrived alone (Fig. 15.17). The others followed, but were all turned away by the Guard. Nearly three weeks later, after a federal injunction ordered Faubus to remove the Guard, the nine finally entered Central High School. Little Rock citizens then launched a campaign of verbal abuse and intimidation to prevent the black students from remaining in school. Finally, President Dwight D. Eisenhower ordered 1,000 paratroopers and 10,000 National Guardsmen to Little Rock, and on September 25, Central High School was officially desegregated. Nevertheless, chaperoned throughout the year by the National Guard, the nine black students were spat at and reviled every day, and none of them returned to school the following year.

By April 1963, the focal point of racial tension and strife in the United States had shifted to Birmingham, Alabama. In protest over desegregation orders, the city had closed its parks and public golf courses. In retaliation, the black community called for a boycott of Birmingham stores. The city responded by halting the distribution of food normally given to the city's needy families. In this progressively more heated atmosphere, the Southern Christian Leadership Conference (SCLC), led by the Reverend Martin Luther King, Jr. (1929-68), decided that Birmingham would be their battlefield. In the spring of 1963, groups of protesters, gathering first at local churches, descended on the city's downtown both to picket businesses that continued to maintain "separate but equal" practices, such as different fitting rooms for blacks and whites in clothing stores, and to take seats at "whites-only" lunch counters. The city's police chief, Eugene "Bull" Connor, responded by threatening to arrest anyone marching on the downtown area. On April 6, 50 marchers were arrested. The next day, 600 marchers gathered, and police confronted them with clubs, attack dogs, and the fire department's new water hoses, which, they bragged, could rip the bark off a tree. But day after day, the marchers kept coming, their ranks

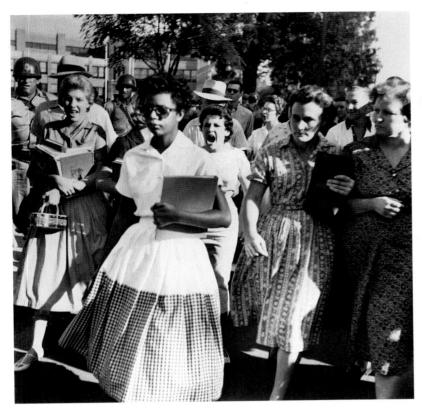

Fig. 15.17 One of the "Little Rock Nine," Elizabeth Eckford, braves a jeering crowd, September 4, 1957. Alone, as school opened in 1957, Elizabeth Eckford faced the taunts of the crowd defying the Supreme Court order to integrate Central High School in Little Rock, Arkansas. The image captures perfectly the hatred—and the determination—that the civil rights movement inspired.

swelling. A local judge issued an injunction banning the marches, but on April 12, King led a march of 50 people in defiance of the injunction. Crowds gathered in anticipation of King's arrest, and, in fact, he was quickly taken into custody and placed in solitary confinement in the Birmingham jail.

Soon after King's incarceration, the situation in Birmingham worsened. A local disc jockey urged the city's African-American youth to attend a "big party" at Kelly Ingram Park, across from the 16th Street Baptist Church. It was no secret that the "party" was to be a mass demonstration. At least 1,000 youths gathered to face the police, most of them teenagers but some as young as seven or eight years old. As the chant of "Freedom, freedom *now*!" rose from the crowd, the Birmingham police closed in with their dogs, ordering them to attack those who did not flee.

Police wagons and squad cars were quickly filled with arrested juveniles, and as the arrests continued, the police used school buses to transport over 600 children and teenagers to jail. By the next day, the entire nation—in fact, the entire world—had come to know Connor, as televised images documented his dogs attacking children and his fire hoses literally washing them down the streets.

The youth returned, with reinforcements, over the next few days. By May 6, over 2,000 demonstrators were in jail, and police patrol cars were pummeled with rocks and bottles whenever they entered black neighborhoods. As the crisis mounted, secret negotiations between the city and the protesters resulted in change: Within 90 days, all lunch counters, restrooms, department-store fitting rooms, and drinking fountains would be open to all, black and white alike. The 2,000 people under arrest would be released immediately.

It was a victory, but Birmingham remained uneasy. On Sunday, September 15, a dynamite bomb exploded in the basement of the 16th Street Baptist Church, a center for many civil rights rallies and meetings, killing four girls—one 11-year-old and three 14-year-olds. As news of the tragedy spread, riots and fires broke out throughout the city and two more teenagers were killed.

The tragedy drew many moderate whites into the civil rights movement. Popular culture had put them at the ready. In June 1963, the folkrock trio Peter, Paul, and Mary released "Blowin' in the Wind," their version of the song that Bob Dylan (1941–) had written in April 1962. The Peter, Paul, and Mary record sold 300,000 copies in two weeks. The song famously ends:

How many years can some people exist, Before they're allowed to be free? How many times can a man turn his head, Pretending he just doesn't see? The answer, my friend, is blowin' in the wind, The answer is blowin' in the wind.

At the March on Washington later that summer—an event organized by A. Philip Randolph, who had conceived of a similar event over 20 years earlier, that time to promote passage of the Civil Rights Act—Peter, Paul, and Mary performed the song live before 250,000 people, the largest gathering of its kind to that point in the history of the United States. Not many minutes later, Martin Luther King delivered his famous "I Have a Dream" speech to the same crowd. The trio's album *In the Wind*, released in October, quickly rose to number one on the charts. The winds of change were blowing across the country.

Black Identity

It is probably fair to say that an important factor contributing to the civil rights movement was the growing sense of ethnic identity among the African-American population. Its origins can be traced back to the Harlem Renaissance (see Chapter 14), but throughout the 1940s and 1950s, a growing

sense of cultural self-awareness and self-definition was taking hold, even though African Americans did not share in the growing wealth and sense of well-being that marked postwar American culture.

Sartre's "Black Orpheus" One of the most important contributions to this development was existentialism, with its emphasis on the inevitability of human suffering and the necessity for the individual to act responsibly in the face of that predicament. Jean-Paul Sartre's 1948 essay "Orphée Noir" or "Black Orpheus" was especially influential. The essay defined "blackness" as a mark of authenticity:

A Jew, a white among whites, can deny that he is a Jew, declaring himself a man among men. The black cannot deny that he is black nor claim for himself an abstract, colorless humanity: he is black. Thus he is driven to authenticity: insulted, enslaved, he raises himself up. He picks up the word "black" ["Négre"] that they had thrown at him like a stone, he asserts his blackness, facing the white man, with pride.

If, like the Jews, blacks had undergone a shattering diaspora, or dispersion, across the globe, traces of the original African roots were evident in everything from American blues and jazz to the African-derived religious and ritual practices of the Caribbean that survived as Vodun, Santeria, and Condomblé. For Sartre, these were all manifestations of an original "Orphic" voice, which, like the master musician and poet Orpheus of Greek legend, who descended into Hades to rescue his beloved Eurydice, had descended into the "black substratum" of their African heritage to discover an authentic—and revolutionary—voice.

Ralph Ellison's Invisible Man Probably the book most instrumental in introducing existentialist attitudes to an American audience was the novel *Invisible Man* by Ralph Waldo Ellison (1913–94), published in 1952 and written over a period of about seven years in the late 1940s and early 1950s. In part, the novel is an ironic reversal of the famous trope of Ellison's namesake, Ralph Waldo Emerson, in his essay *Nature* (see Chapter 13): "I become a transparent eye-ball. I am nothing. I see all." "I am an invisible man," Ellison's prologue to the novel begins (Reading 15.4a):

READING 15.4a

from Ralph Ellison, Invisible Man (1952)

No, I am not a spook like those who haunted Edgar Allan Poe; nor am I one of your Hollywood-movie ectoplasms. I am a man of substance, of flesh and bone, fiber and liquid—and I might even be said to possess a mind. I am invisible, understand, simply because people refuse to see me. . . . That invisibility to which I refer occurs because of a peculiar disposition of the eyes of those with whom I come in contact. A matter of the construction of their inner eyes, those eyes with which they look through their physical eyes upon reality.

Ellison's story is told by a narrator who lives in a subterranean "hole" in a cellar at the edge of Harlem into which he has accidentally fallen in the riot that ends the novel. As "underground man," his self-appointed task is to realize, in the narrative he is writing (the novel itself), the realities of black American life and experience. At the crucial turning point of the novel, after seeing three boys in the subway, dressed in "well-pressed, too-hot-for-summer suits. . . . walking slowly, their shoulders swaying, their legs swinging from their hips in trousers that ballooned from cuffs fitting snug about their ankles; their coats long and hip-tight with shoulders far too broad to be those of natural western men," he muses (Reading 15.4b):

READING 15.4b

from Ralph Ellison, Invisible Man (1952)

Moving through the crowds along 125th Street, I was painfully aware of other men dressed like the boys, and of girls in dark exotic-colored stockings, their costumes surreal variations of downtown styles. They'd been there all along, but somehow I'd missed them. . . . They were outside the groove of history. and it was my job to get them in, all of them. I looked into the design of their faces, hardly a one that was unlike someone I'd known down South. Forgotten names sang through my head like forgotten scenes in dreams. I moved through the crowd, the sweat pouring off me, listening to the grinding roar of traffic, the growing sound of a record shop loudspeaker blaring a languid blues. I stopped. Was this all that would be recorded? Was this the only true history of the times, a mood blared by trumpets, trombones, saxophones and drums, a song with turgid, inadequate words?

The blues is not enough. The narrator's new self-appointed task is to take the responsibility to find words adequate to the history of the times. Up to this point, his own people have been as invisible to him as he to them. He has opened his own eyes as he must now open others'. At the novel's end, he is determined to come out of his "hole." "I'm shaking off the old skin," he says, "and I'll leave it here in the hole. I'm coming out, no less invisible without it, but coming out nevertheless. And I suppose it's damn well time. . . . Perhaps that's my greatest social crime, I've overstayed my hibernation, since there's a possibility that even an invisible man has a socially responsible role to play."

Asserting Blackness in Art and Literature One of Ellison's narrator's most vital realizations is that he must, above all else, assert his blackness instead of hiding from it. He must not allow himself to be absorbed into white society. "Must I strive toward colorlessness?" he asks.

But seriously, and without snobbery, think of what the world would lose if that should happen. America is woven of many strands; I would recognize them and let it so remain. . . . Our fate is to become one, and yet many—This is not prophecy, but description.

There could be no better description of the collages of Romare Bearden (1911-88), who had worked for two decades in an almost entirely abstract vein, but who in the early 1960s began to tear images out of Ebony, Look, and Life magazines and assemble them into depictions of black experience. The Dove (Fig. 15.18)—named for the white dove that is perched over the central door, a symbol of peace and harmony—combines forms of shifting scale and different orders of fragmentation. For example, a giant cigarette extends from the hand of the dandy sporting a cap at the right, and the giant fingers of a woman's hand reach over the windowsill at the top left. The resulting effect is almost kaleidoscopic, an urban panorama of a conservatively dressed older generation and hipper, younger people gathered into a scene bursting with energy—the "one, and yet many." As Ellison wrote of Bearden's art in 1968:

Bearden's meaning is identical with his method. His combination of technique is in itself eloquent of the sharp breaks, leaps of consciousness, distortions, paradoxes, reversals, telescoping of time and surreal blending of styles, values, hopes, and dreams which characterize much of [African] American history.

The sense of a single black American identity, one containing the diversity of black culture within it that Bearden's work embodies, is also found in the work of the poet and playwright Amiri Baraka (1934-2014). Baraka changed his name from LeRoi Jones in 1968 after the assassination of the radical black Muslim minister Malcolm X in 1965. Malcolm X believed that blacks should separate themselves from whites in every conceivable way, that they should give up integration as a goal and create their own black nation. As opposed to Martin Luther King, who advocated nonviolent protest, Malcolm advocated violent action if necessary: "How are you going to be nonviolent in Mississippi," he asked a Detroit audience in 1963, "as violent as you were in Korea? How can you justify being nonviolent in Mississippi and Alabama, when your churches are being bombed, and your little girls are being murdered? . . . If violence is wrong in America, violence is wrong abroad."

Baraka's chosen Muslim name, Imamu Amiri Baraka, refers to the divine blessing associated with Muslim holy men that can be transferred from a material object to a person, so that a pilgrim returning from Mecca is a carrier of baraka. Baraka's 1969 poem "Ka'Ba" seeks to bestow baraka

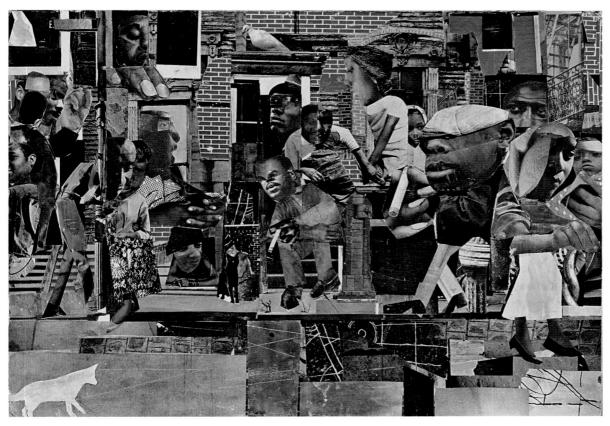

Fig. 15.18 Romare Bearden, *The Dove.* 1964. Cut-and-pasted photoreproductions and papers, gouache, pencil and colored pencil on board, 13%" × 18%". Blanchette Rockefeller Fund (377.1971). Museum of Modern Art, New York. Art © Romare Bearden Foundation/Licensed by VAGA, New York, NY. The white dog at the lower left appears to be stalking the black cat at the foot of the steps in the middle, in counterpoint to the dove above the door.

upon the people of Newark, New Jersey, where Baraka lived (Reading 15.5):

READING 15.5

Amiri Baraka, "Ka'Ba" (1969)

A closed window looks down on a dirty courtyard, and Black people call across or scream across or walk across defying physics in the stream of their will.

Our world is full of sound Our world is more lovely than anyone's tho we suffer, and kill each other and sometimes fail to walk the air.

We are beautiful people With African imaginations full of masks and dances and swelling chants with African eyes, and noses, and arms tho we sprawl in gray chains in a place full of winters, when what we want is sun.

We have been captured, and we labor to make our getaway, into the ancient image; into a new Correspondence with ourselves and our Black family. We need magic now we need the spells, to raise up return, destroy, and create. What will be the sacred word?

The sacred word, the poem's title suggests, is indeed "Ka'Ba." But, despite the spiritual tone of this poem, Baraka became increasingly militant during the 1960s. In 1967, he produced two of his own plays protesting police brutality. A year later, in his play *Home on the Range*, his protagonist Criminal breaks into a white family's home only to find them so immersed in television that he cannot communicate with them. The play was performed as a benefit for the leaders of the Black Panther party, a black revolutionary political party founded in 1966 by Huey P. Newton (1942–89) and Bobby Seale (1936–) and dedicated to organizing support for a socialist revolution.

Other events, too, reflected the growing militancy of the African-American community. In August 1965, violent riots in the Watts district of South Central Los Angeles lasted for six days, leaving 34 dead, over 1,000 people injured, nearly 4,000 arrested, and hundreds of buildings destroyed. In July 1967, rioting broke out in both Newark and Detroit. In Newark, six days of rioting left 23 dead, over 700 injured, and close to 1,500 people arrested. In Detroit, five days of rioting resulted in 43 people dead, 1,189 injured, over 7,000 people arrested, and 2,509 stores looted or burned. Finally, it seemed to many that Martin Luther King's pacifism had come back to haunt him when he was assassinated on April 4, 1968.

It was directly out of this climate that the popular poetry/music/performance/dance phenomenon known as rap, or hip-hop, came into being. Shortly after the death of King, on

Malcolm X's birthday, May 19, 1968, David Nelson, Gylan Kain, and Abiodun Oyewole founded the group the Last Poets, named after a poem by the South African poet Willie Kgositsile (1938-) in which he had claimed that it would soon be necessary to put poetry aside and take up guns in the looming revolution. "Therefore we are the last poets of the world," Kgositsile concluded. In performance, the Last Poets were deeply influenced by the musical phrasings of Amiri Baraka's poetry. They improvised individually, trading words and phrases back and forth like jazz musicians improvising on one another's melodies, until their voices would come together in a rhythmic chant and the number would end. Most of all, they were political, attacking white racism, black bourgeois complacency, the government, and the police—whoever or whatever seemed to stand in the way of significant progress for African Americans. As Ovewole put it, "We were angry, and we had something to say."

Equally influential was the performer Gil Scott-Heron (1949–2011), whose recorded poem "The Revolution Will Not Be Televised" appeared on his 1970 album *Small Talk at 125th and Lenox* (Reading 15.6):

READING 15.6

from Gil Scott-Heron, "The Revolution Will Not Be Televised" (1970)

You will not be able to stay home, brother.
You will not be able to plug in, turn on and cop out.¹
You will not be able to lose yourself on skag² and skip out for beer during commercials because
The revolution will not be televised.

The revolution will not be televised.

The revolution will not be brought to you by Xerox in 4 parts without commercial interruptions. . . .

There will be no highlights on the Eleven O'Clock News and no pictures of hairy armed women liberationists and Jackie Onassis blowing her nose.

The theme song will not be written by Jim Webb or Francis Scott Key,

nor sung by Glen Campbell, Tom Jones, Johnny Cash, Englebert Humperdink, or Rare Earth. The revolution will not be televised.

¹ turn on and cop out: A play on the motto of Timothy Leary (1920–96), advocate and popularizer of the psychedelic drug LSD, who in the 1960s urged people to "turn on, tune in, drop out."

² **skag:** Slang for heroin.

Scott-Heron's poems, spoken to music, would influence the development of hip-hop even more than the Last Poets, and his work was often "sampled" by later hip-hop disc jockeys who created rhythmic musical works by looping small portions of recorded songs on two turntables. Equally important to hip-hop were break dancing and graffiti writing. Although widely condemned as destruction of public and private property, by the early 1980s graffiti had entered the mainstream art market, particularly in the work of Jean-Michel Basquiat (see *Closer Look*, pages 502–503).

The Vietnam War: Rebellion and the Arts

Even as the civil rights movement took hold, the Cold War tensions with the Soviet Union were increasingly exacerbated by the United States' involvement in the war in Vietnam. By the mid-1960s, fighting between the North Vietnamese Communists led by Ho Chi Minh and the pro-Western and former French colony of South Vietnam had led to a massive troop buildup of American forces in the region, fueled by a military draft that alienated many American youth, the population of 15- to 24-year-olds that over the course of the 1960s increased from 24.5 million to 36 million.

Across the country, the spirit of rebellion that fueled the civil rights movement took hold on college campuses and in the burgeoning antiwar community. Events at the University of California at Berkeley served to link, in the minds of many, the antiwar movement and the fight for civil rights. In 1964, the university administration tried to stop students from recruiting and raising funds on campus for two groups dedicated to ending racial discrimination. Protesting the administration's restrictions, a group of students organized the Free Speech Movement, which initiated a series of rallies, sit-ins, and student strikes at Berkeley. The administration backed down, and the Berkeley students' tactics were quickly adapted by groups in the antiwar movement, which focused on removing the Reserve Officers' Training Corps from college campuses and helped to organize antiwar marches, teach-ins, and rallies across the country. By 1969, feelings reached fever pitch, as over a half million protesters, adopting the tactics of the civil rights movement in 1963, marched on Washington.

Kurt Vonnegut's Slaughterhouse-Five

Antiwar sentiment was reflected in the arts in works primarily about earlier wars, World War II and the Korean War, as if it were impossible to deal directly with events in Southeast Asia, which could be seen each night on the evening news. Joseph Heller's novel Catch-22 was widely read, and the Robert Altman (1925-2006) film M*A*S*H, a smash-hit satiric comedy about the 4077th Mobile Army Surgical Hospital in Korea, opened in 1970 and spawned an 11-year-long television series that premiered in 1972. But perhaps the most acclaimed antiwar work was the 1969 novel Slaughterhouse-Five by Kurt Vonnegut (1922–2007). It is the oddly narrated story of ex-World War II GI Billy Pilgrim, a survivor, like Vonnegut himself, of the Allied fire-bombing of Dresden (where 135,000 German civilians were killed, more than at Hiroshima and Nagasaki combined). Pilgrim claims to have been abducted by extraterrestrial aliens from the planet of Trafalmadore. At the beginning of the book, the narrator (more or less, Vonnegut himself) is talking with a friend about the war novel he is about to write (Slaughterhouse-Five), when the friend's wife interrupts (Reading 15.7):

READING 15.7

from Kurt Vonnegut, Slaughterhouse-Five (1969)

"You'll pretend that you were men instead of babies, and you'll be played in the movies by . . . John Wayne. . . . And war will look just wonderful, so we'll have a lot more of them. And they'll be fought by babies. . . . She didn't want her babies or anyone else's babies killed in wars. And she thought wars were partly encouraged by books and movies.

In response, Vonnegut creates, in Pilgrim, the most innocent of heroes, and subtitles his novel *The Children's Crusade: A Duty-Dance with Death.* Pilgrim's reaction to the death he sees everywhere—"So it goes"—became a mantra for the generation that came of age in the late 1960s. The novel's fatalism mirrored the sense of pointlessness and arbitrariness that so many felt in the face of the Vietnam War.

Artists Against the War

By the fall of 1969, a large number of artists had organized in opposition to the war. In a speech at an opening hearing that led to the creation of the antiwar Art Workers' Coalition, art critic and editor Gregory Battcock outlined how the art world was complicit in the war effort:

The trustees of the museums direct NBC and CBS, the *New York Times*, and the Associated Press, and that greatest cultural travesty of modern times—the Lincoln Center. They own AT&T, Ford, General Motors, the great multi-billion dollar foundations, Columbia University, Alcoa, Minnesota Mining, United Fruit, and AMK, besides sitting on the boards of each other's museum. The implications of these facts are enormous. Do you realize that it is those art-loving, culturally committed trustees of the Metropolitan and the Modern museums who are waging the war in Vietnam?

In other words, the museums embodied, in the minds of many, the establishment politics that had led to the war in the first place. On October 15, 1969, the first Vietnam Moratorium Day, artists managed to close the Museum of Modern Art, the Whitney Museum, and the Jewish Museum, but the Metropolitan and the Guggenheim refused to close.

The Art Workers' Coalition also quickly reacted to reports that American soldiers, the men of Charlie Company, had slaughtered men, women, and children in the Vietnam village of My Lai on March 16, 1968. More than a year later, in November 1969, as the army was investigating Charlie Company's platoon leader, First Lieutenant William L. Calley, Jr., photographs taken at My Lai by the army photographer Ron Haeberle appeared in the Cleveland Plain Dealer. Four days later, in an interview by Mike Wallace on CBS-TV, Paul Meadlo, who had been at My Lai, reported that Calley had rounded up 40 or 45 villagers and ordered them shot. "Men, women, and children!" Wallace

CLOSER LOOK

▶ harles the First by Jean-Michel Basquiat (1960–88) is an homage to the great jazz saxophonist Charlie Parker, one of a number of black cultural heroes celebrated by the graffiti-inspired Basquiat. Son of a middle-class Brooklyn family (his father was a Haitian-born accountant, his mother a black Puerto Rican), Basquiat left school in 1977 at age 17 and lived on the streets of New York for several years, during which time he developed the "tag"-or graffiti pen-name-SAMO, a combination of "Sambo" and "same ol' shit." SAMO was most closely associated with a three-pointed crown (as self-anointed "king" of the graffiti artists) and the word "TAR," evoking racism (as in "tar baby"), violence ("tar and feathers," which he would entitle a painting in 1982), and, through its anagram, the "art" world as well. A number of his paintings exhibited in the 1981 New York/New Wave exhibit at an alternative art gallery across the 59th Street Bridge from Manhattan attracted the attention of several art dealers, and his career exploded.

Central to his personal iconography is the crown, which is a symbol of not only his personal success but also that of the other African-American heroes that are the subject of many of his works—jazz artists, as is the case here, and "famous Negro athletes," as he calls them, such as the boxer Sugar Ray Leonard and baseball's Hank Aaron.

Something to Think About . . .

Many viewers are at least initially put off by the apparent sloppiness of Basquiat's distinctive style. But Basquiat adopted this style for a purpose. What do you imagine his purpose might have been?

The price of a halo at 59¢ suggests that martyrdom is "for sale" in Basquiat's world.

Beneath the crown that Basquiat had introduced in his SAMO years is a reference to Thor, the Norse god; below it, the Superman logo; and above it, a reference to the Marvel comic X-Men heroes. Thor is, in fact, another X-Man hero. Marvel describes the X-Men as follows: "Born with strange powers, the mutants known as the X-Men use their awesome abilities to protect a world that hates and fears them." Basquiat clearly means to draw an analogy between the X-Men and his African-American heroes.

> The "X" in Basquiat's work is never entirely negative. In Henry Dreyfuss's Symbol Sourcebook: An Authoritative Guide to International Graphic Symbols, Basquiat discovered a section on "Hobo Signs," marks left, graffiti-like, by hobos to inform their brethren about the lay of the local land. In this graphic language, an "X" means "O.K.; All right."

This phrase is a reference to the other "Charles the First"—King Charles I of England, beheaded by Protestants in the English Civil War in 1649 (see Chapter 10). But it also suggests, especially considering the crossed-out word "young," Basquiat's sense of his own martyrdom. In fact, four months before his 28th birthday, in 1988, he would become the victim, according to the medical examiner's report, of "acute mixed drug intoxication (opiates-cocaine).'

> The "S," especially crossed out, also suggests dollars, \$.

Basquiat's Charles the First

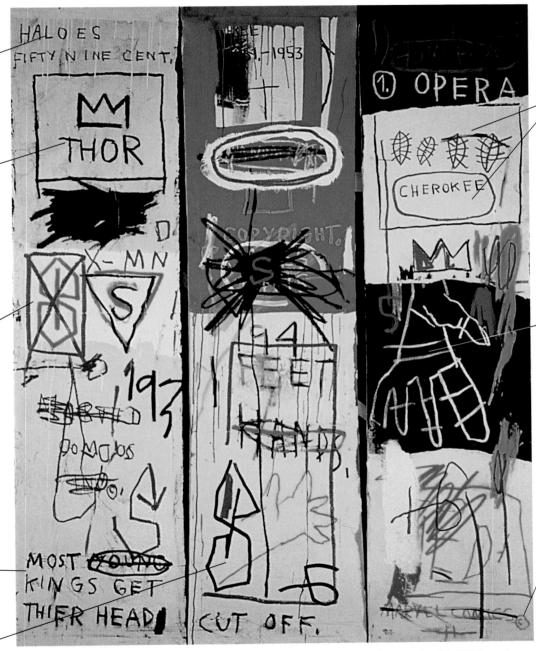

Jean-Michel Basquiat, *Charles the First.* **1982.** Acrylic and oil paintstick on canvas, three panels, $78'' \times 62\%''$ overall. © 2014 The Estate of Jean-Michel Basquiat/ADAGP, Paris/ARS, New York.

Beneath the word "Opera," and apparently on a par with the most aristocratic of musical genres, is the title of one of Charlie Parker's greatest tunes, "Cherokee," topped by four feathers in honor of Parker's nickname, "Bird." The feathers and song also evoke the Cherokee Indians' forced removal from Georgia to Oklahoma on the so-called Trail of Tears in 1838.

The hand probably represents the powerful hand of the musician, and equally the painter.

The copyright sign, ©, which also appears spelled out at the top of the middle panel, is repeated again and again in Basquiat's work and suggests not just ownership but the exercise of property rights and control in American society, which Basquiat sees as the root cause of the institution of slavery (to say nothing of the removal of the Cherokee nation to Oklahoma).

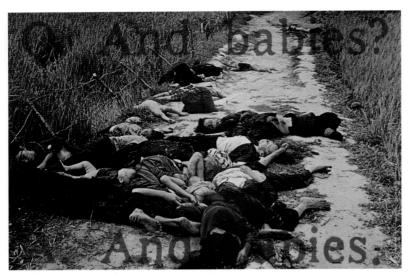

Fig. 15.19 Ron Haeberle, Peter Brandt, and the Art Workers' Coalition, *Q. And Babies? A. And Babies.* 1970. Offset lithograph, 24" × 38". Museum of Modern Art, New York. Gift of the Benefit for the Attica Defense Fund. Brandt was the poster's designer.

asked. "Men, women, and children," Meadlo answered. "And babies?" "And babies." The transcript of the interview was published the next day in the *New York Times*, accompanied by the photograph. Quickly, the Art Workers' Coalition added Wallace's question and Meadlo's response to the image (Fig. 15.19), printed a poster, and distributed it around the world.

The Feminist Movement

At the same time that the antiwar and civil rights movements galvanized political consciousness among both men and women, "the Pill" was introduced in the early 1960s. As women gained control over their own reproductive functions, they began to express the sexual freedom that men had always taken for granted. The struggle for gender equality in the United States found greater and greater expression throughout the 1960s until, by the early 1970s, a full-blown feminist era emerged.

The Theoretical Framework: Betty Friedan and NOW In 1963, a freelance journalist and mother of three, Betty Friedan (1921–2006), published The Feminine Mystique. In many ways, hers was an argument with Freud, or at least with the way Freud had been understood, or misunderstood. While she admits that "Freudian psychology, with its emphasis on freedom from a repressive morality to achieve sexual fulfillment, was part of the ideology of women's emancipation," she is aware that some of Freud's writings had been misused as a tool for the suppression of women. Latent in Friedan's analysis, but central to the feminist movement, is her understanding that in Freud, as in Western discourse as a whole, the term "woman" is tied, in terms of its construction as a word, to man (its medieval root is "wifman," or "wife [of] man"). It is thus a contested term that does not refer to the biological female but to the sum total of all the patriarchal society expects of the female,

including behavior, dress, attitude, and demeanor. "Woman," said the feminists, is a cultural construct, not a biological one. In *The Feminine Mystique*, Friedan rejects modern American society's cultural construction of women. But she could not, in the end, reject the word "woman" itself. Friedan would go on to become one of the founders of the National Organization for Women (NOW), the primary purpose of which was to advance women's rights and gender equity in the workplace. In this, she dedicated herself to changing, in American culture, her society's understanding of what "woman" means.

Feminist Poetry The difficulties that women faced in determining an identity outside the patriarchal construction of "woman" became, in the 1960s, one of the chief subjects of poetry by women, particularly in the work of the poets Anne Sexton (1928–74), Sylvia Plath (1932–63), and Adrienne Rich (1929–2012). Sexton's work is exemplary. She was an affluent housewife and mother, living

in a house with a sunken living room and a backyard swimming pool in the Boston suburb of Weston, Massachusetts. But she was personally at odds with her life, and as her husband saw his formerly dependent wife become a celebrity, their marriage dissolved into a fabric of ill will, discord, and physical abuse. The poem with which she opened most readings, the ecstatically witty "Her Kind," published in 1960 in her first book of poems, *To Bedlam and Part Way Back*, captures the sense of independence that defined her from the beginning (Reading 15.8):

READING 15.8

Anne Sexton, "Her Kind" (1960)

I have gone out, a possessed witch haunting the black air, braver at night; dreaming evil, I have done my hitch over the plain houses, light by light: lonely thing, twelve-fingered, out of mind. A woman like that is not a woman, quite. I have been her kind.

I have found the warm caves in the woods, filled them with skillets, carvings, shelves, closets, silks, innumerable goods; fixed the suppers for the worms and the elves: whining, rearranging the disaligned. A woman like that is misunderstood. I have been her kind.

I have ridden in your cart, driver, waved my nude arms at villages going by, learning the last bright routes, survivor where your flames still bite my thigh and my ribs crack where your wheels wind. A woman like that is not ashamed to die. I have been her kind.

Feminist Art Despite the advances made by women in the arts in the 1960s, real change was slow in coming. Although in 1976 approximately 50 percent of the professional artists in the United States were women, only 15 in 100 one-person shows in New York's prestigious galleries were devoted to work by women. Eight years later, the Museum of Modern Art reopened its enlarged facilities with a show entitled An *International Survey of Painting and Sculpture*. Of the 168 artists represented, only 13 were women.

So used was the public to seeing art in purely formalist terms—in terms, that is, of line, color, and composition—that when an artist like Judy Chicago (1939–) tried to invest her work with feminist content, the public refused to recognize it. Her series of 15 Pasadena Lifesavers (Fig. 15.20) exhibited in 1970 at Cal State Fullerton expressed, she felt, "the range of my own sexuality and identity, as symbolized through form and color." Their feminist content was affirmed by a statement on the gallery wall directly across from the entrance, which read:

Judy Gerowitz hereby divests herself of all names imposed upon her through male social dominance and freely chooses her own name Judy Chicago.

But male reviewers ignored the statement. As Chicago says in her 1975 autobiography, *Through the Flower:* My Struggle as a Woman Artist: "[They] refused to accept that my work was intimately connected to my femaleness." But, in part, their misapprehension was her own doing. As she explains in *Through the Flower*, "I had come out of a formalist background and had learned to neutralize my subject matter.

Fig. 15.21 Judy Chicago, *The Dinner Party.* **1979.** Mixed media, $48^{\circ} \times 48^{\circ} \times 3^{\circ}$ installed. Collection of the Brooklyn Museum of Art, Gift of the Elizabeth A. Sackler Foundation. Photograph © Donald Woodman. © 2014 Judy Chicago/Artists Rights Society (ARS), New York The names of 999 additional women are inscribed in ceramic tiles along the table's base.

Fig. 15.20 Judy Chicago, Pasadena Lifesavers Red Series #3. 1969–70. Sprayed acrylic lacquer on acrylic, 60" × 60". Collection of Locks Gallery, Philadelphia, PA. Photo © Donald Woodman. © 2014 Judy Chicago/Artists Rights Society (ARS), New York. To many viewers, the geometry of Chicago's forms completely masked their sexual meaning.

In order to be considered a 'serious' artist, I had had to suppress my femaleness. . . . I was still working in a frame of reference that people had learned to perceive in a particular, non-content-oriented way."

Chicago's great collaborative work of the 1970s, The Dinner Party (Fig. 15.21), changed all that. In its bold assertion of woman's place in social history, the piece announced the growing power of the women's movement itself. More than 300 women worked together over a period of five years to create the piece, which consists of a triangular table, set with 39 places, 13 on a side, each celebrating a woman who has made an important contribution to world history. The first plate is dedicated to the Great Goddess, and the third to the Cretan Snake Goddess. Around the table the likes of Eleanor of Aquitaine and Artemisia Gentileschi are celebrated. Where the Pasadena Lifesavers had sheltered their sexual content under the cover of their symbolic abstraction, in The Dinner Party, the natural forms of the female anatomy were fully expressed in the ceramic work, needlepoint, and drawing. But, as Chicago is quick to point out, "the real point of the vaginal imagery in The Dinner Party was to say that these women are not known because they have vaginas. That is all they had in common, actually. They were from different periods, classes, ethnicities, geographies, experiences, but what kept them within the same historical space was the fact that they had vaginas."

Fig. 15.22 Guerrilla Girls, *Do women have to be naked to get into the Met. Museum?* 1989. Poster. © 1989, 1995 by the Guerrilla Girls, Inc. The figure is a parody of Jean-Auguste-Dominique Ingres' 1814 Neoclassical painting *La Grande Odalisque*, in the collection of the Louvre, Paris (see Fig. 13.3).

Despite Chicago's success with *The Dinner Party*, it remained very difficult for women to enter the art world. In 1985 an anonymous group of women who called themselves the Guerrilla Girls began hanging posters in New York City to draw attention to the problem (Fig. 15.22). They listed the specific galleries who represented less than 1 woman out of every 10 men. Another poster asked: "How Many Women Had One-person Exhibitions at NYC Museums Last Year?" The answer:

Guggenheim 0 Metropolitan 0 Modern 1 Whitney 0

One of the Guerrilla Girls' most daring posters was distributed in 1989. It asked, "When racism & sexism are no longer fashionable, what will your art collection be worth?" It listed 67 women artists and pointed out that a collection of works by all of them would be worth less than the art auction value of any *one* painting by a famous living male artist. Its suggestion that the value of the male artists' work might be drastically inflated struck a chord with many.

By the late 1990s, the situation had changed somewhat. Many more women were regularly exhibited in New York galleries and more major retrospectives were devoted to their work. But, internationally especially, women continued to get short shrift. Where a retrospective by a major male artist—Robert Rauschenberg, for instance—might originate in New York at the Guggenheim and travel to international venues around the world, most retrospectives of women artists remained much more modest—a single nontraveling show at, say, the New Museum in New York or the Los Angeles County Museum of Art.

THE POSTMODERN ERA

How are pluralism and diversity reflected in postmodern art and literature?

It is difficult to pinpoint exactly when "modernism" ended and "postmodernism" began, but the turning point came in the late 1960s. Architects began to reject the pure, almost hygienic uniformity of the International Style, represented by the work of Mies van der Rohe (see Fig. 15.9), favoring more eclectic architectural styles that were anything but pure. A single building might incorporate a classical colonnade and a roof line inspired by a piece of Chippendale furniture. Or it might look like the Rasin Building in Prague (Fig. 15.23). Built on the site of a Renaissance structure destroyed in World War II, the building in its teetering sense of collapse evokes the postwar cityscape of twisted I-beams, blownout facades with rooms standing open to the sky, and sunken foundations, all standing next to a building totally unaffected by the bombing. But that said, the building is also a playful, almost whimsical celebration, among other things, of the marvels of modern engineering—a building made to look as if it is at the brink of catastrophe, even as it is completely structurally sound. So lighthearted is the building that it was called the "Dancing House," or, more specifically, "Ginger and Fred," after the American film stars Ginger Rogers and Fred Astaire. The more solid tower on the corner seems to be leading the transparent tower—Ginger—by the waist, as the two spin around the corner.

The building was the idea of the Czech architect Vlado Milunić (1941–), and he enlisted the American architect Frank Gehry (1929–) to collaborate on the project. To many eyes in Prague, a city renowned for its classical architecture, it seemed an absolutely alien American element dropped into the city. But Milunić conceived of the

Fig. 15.23 Frank Gehry and Vlado Milunić, The Rasin Building, also known as the "Dancing House" or "Ginger and Fred," Prague, Czech Republic. 1992–96. The building was championed by Vaclav Havel (1936–2011), the Czech playwright who served as president of first Czechoslovakia and then the Czech Republic from the fall of the Soviet Union in 1989 until 2003. Havel had lived next door since childhood.

building as addressing modern Prague even as it engaged the city's past. He wanted the building to consist of two parts: "Like a society that forgot its totalitarian past—a static part—but was moving into a world full of changes. That was the main idea. Two different parts in dialogue, in tension, like plus and minus, like Yang and Yin, like man and woman." It was Gehry who nicknamed it "Ginger and Fred."

The use of many different, even contradictory elements of design is the hallmark of **postmodern** architecture. The English critic Peter Fuller explained the task of the postmodern architect this way:

The west front of Wells Cathedral, the Parthenon pediment, the plastic and neon signs on Caesar's Palace in Las Vegas, even the hidden intricacies of a Mies curtain wall, are all equally "interesting." Thus the Post-Modern designer must offer a shifting pattern of changing strategies and substitute a shuffling of codes and devices, varying ceaselessly according to audience, and/or building type, and/or environmental circumstance.

But perhaps the clearest and most seminal statement of the postmodern aesthetic is that of the architect Robert Venturi

(1925–), whose 1966 "Gentle Manifesto" described criteria for a new eclectic approach to architecture that abandoned the clean and simple geometries of modern architecture. In its place, Venturi argued for "an architecture of complexity and contradiction. . . . It must embody the difficult unity of inclusion rather than the easy unity of exclusion."

Pluralism and Diversity in Postmodern Painting

By the end of the 1960s, artists felt free to engage in a wide spectrum of experimental approaches to painting, ranging from the stylized imagery introduced by Pop artists to the street style of graffiti writers (see the Closer Look on Jean-Michel Basquiat, pp. 502-503), and from full-blown abstraction to startlingly naturalistic realism. Indeed, the exchange of ideas between proponents of realism and those of abstraction during the post-World War II era had far-reaching effects. Rather than an either/or proposition, there is abundant cross-fertilization between the approaches. We can see this in the work of the contemporary German artist Gerhard Richter (1932–), who moves freely between the two-sometimes repainting photographs, black-and-white and color, and sometimes creating large-scale abstract works. Richter uses photographs, including amateur snapshots and media images, because, he says, they are "free of all the conventional criteria I had always associated with art . . . no style, no composition, no judgment." To him, they are "pure" pictures, unadulterated by the intervention of conscious aesthetic criteria. Meadowland (Fig. 15.24), an oil painting on canvas, might as well have been taken from the window of a passing car. The questions it raises

Fig. 15.24 Gerhard Richter, *Meadowland*. 1992. Oil on canvas, 35%" × 37½". The Museum of Modern Art, New York. Blanchette Rockefeller, Betsy Babcock, and Mrs. Elizabeth Bliss Parkinson Funds (350.1985). © Gerhard Richter 2014. In 1964, Richter began collecting the source photos for all his paintings and arranging them on panels. When the resulting work, *Atlas*, was exhibited in 1995 at the Dia Center for the Arts in New York, it contained 683 panels and close to 5,000 photographs.

are quite simple: Why did he select this photograph to translate into a painting? How and when does the eye sense the difference between a painting and a photographic surface?

In comparing Meadowland to the artist's abstractions, which he concentrated on throughout the 1980s and 1990s, we can begin to answer these questions. Works such as Ice (2) (Fig. 15.25) are obviously paintings. One senses that Richter begins with a realistic image, and before the ground completely dries, he drags another layer of paint through it with a squeegee or palette knife. The result is like viewing an object close up while passing it at high speed. But the resulting work is above all a painterly surface, not a photographic one. Nevertheless, in Richter's words.

abstract paintings . . . visualize a reality which we can neither see nor describe but which we may nevertheless conclude exists. We attach negative names to this reality; the unknown, the ungraspable, the infinite, and for thousands of years we have depicted it in terms of substitute images like heaven and hell, gods and devils. With abstract painting we create a better means of approaching what can be neither seen nor understood because abstract painting illustrates with the greatest clarity, that is to say with all the means at the disposal of art, "nothing." . . . [Looking at abstract paintings] we allow ourselves to see the un-seeable, that which has never before been seen and indeed is not visible.

Given this artistic strategy, Richter's photograph-based works are paintings of the graspable and visible. Why did he select the photograph upon which Meadowland is based? Precisely because it is so mundane, a prospect we have so often seen before. How and when do we recognize Meadowland as a painting and not a photograph? When we accept photographic clarity—or photographic blurring, for that matter—as one of the infinite methods of painting. Richter's photographic paintings are thus the very antithesis of his abstractions, except that both styles are equal statements of the artist's vision. Together, in them, Richter explores not only the conditions of seeing but also the possibilities of painting. Richter might be the ultimate postmodernist: "I pursue no objects, no system, no tendency," he writes. "I have no program, no style, no direction. . . . I steer clear of definitions. I don't know what I want. I am

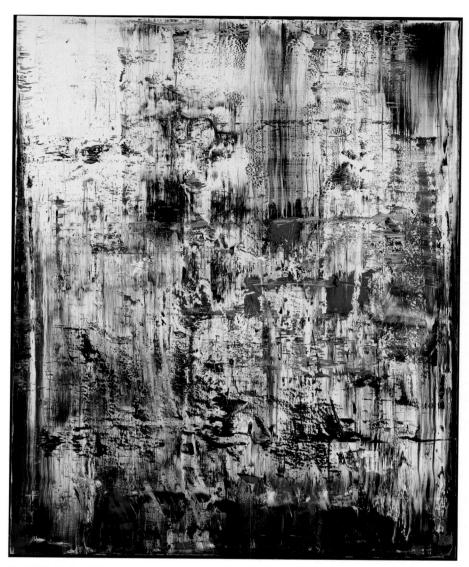

Fig. 15.25 Gerhard Richter, *Ice* **(2). 1989.** Oil on canvas, 80" × 64". Through prior gift of Joseph Winterbotham; gift of Lannan Foundation, 1997.168. Reproduction, the Art Institute of Chicago. All rights reserved. © Gerhard Richter 2014. In the abstractions, the blurred effect of the photograph-based work has been heightened. We seem to be looking at the world through a sheet of ice.

inconsistent, non-committal, passive; I like the indefinite, the boundless; I like continued uncertainty."

Another approach to the question of the relation between abstraction and representation is seen in the works of Pat Steir (1940–). In 1989, she adapted Pollock's drip technique to her own ends, allowing paint to flow by force of gravity down the length of her enormous canvases to form recognizable waterfalls. *Yellow and Blue One-Stroke Waterfall* (Fig. 15.26) is 14 feet high, its format reminiscent of Chinese scroll paintings of waterfalls. Steir explained

Fig. 15.26 Pat Steir, Yellow and Blue One-Stroke Waterfall. 1992. Oil on canvas, 14'6¼" × 7'6¾". The Solomon R. Guggenheim Museum, New York. Gift, John Eric Cheim, 1999. 99.5288. Steir's work is deeply informed by her interest in Tibetan and Chinese religious lore, and she is interested in creating something of their meditative space.

the rationale behind her series of waterfall paintings in an interview in 1992:

I don't think of these paintings as abstract.... These are not only drips of paint. They're paintings of drips which form waterfall images: pictures.... [Nor are] they realistic.... I haven't sat outdoors with a little brush, trying to create the illusion of a waterfall. The paint itself makes the picture.... Gravity make the image....

These paintings are, in a sense a comment on the New York School [i.e., the first generation of Abstract Expressionists, including Pollock and de Kooning], a dialogue and a wink.

They [her waterfall paintings] say, "You didn't go far enough. You stopped when you saw abstraction." . . . I've taken the drip and tried to do something with it that the Modernists denied.

The painting is thus at once, and paradoxically, both abstract and representational.

Pluralism and Diversity in Postmodern Literature

In a world of complexity and contradiction, the pursuit of meaning is equally difficult. For the postmodern writer, meaning is always plural and fleeting, and attempting to find any permanent or stable meaning can lead only to frustration. The postmodern hero seeks meaning, but accepts the fact that the search is never-ending. At the beginning of his study of the Western experience of order, entitled *The Order of Things* (in English translation), French historian Michel Foucault (1926–84) quotes a passage from an essay by the Latin American writer Jorge Luis Borges (1899–1986) that embodies, from Foucault's point of view, the profusion of meaning that defines postmodern thought, an impossible taxonomy from "a certain Chinese encyclopedia" entitled Celestial Emporium of Benevolent Knowledge (Reading 15.9):

READING 15.9

from Jorge Luis Borges, "The Analytical Language of John Wilkins," in *Other Inquisitions* 1937–1952, trans. Ruth L. C. Simms (1964)

On those remote pages it is written that animals are divided into (a) those that belong to the Emperor, (b) embalmed ones, (c) those that are trained, (d) suckling pigs, (e) mermaids, (f) fabulous ones, (g) stray dogs, (h) those that are included in this classification, (i) those that tremble as if they were mad, (j) innumerable ones, (k) those drawn with a very fine camel's hair brush, (l) others, (m) those that have just broken a flower vase, (n) those that resemble flies from a distance.

The impossibility of Jorge Luis Borges's (1899–1986) encyclopedia is based on how impossible it is for contemporary thought to recognize difference with no relation to opposition or relation to a common ground. Each element in Borges's taxonomy requires a complete shift in the reader's point of view. There is, as Foucault points out, "no common locus" beneath this taxonomy, no center around which to organize its elements. But it is precisely this possibility of "thinking that" that is the goal of postmodern literature. To this point in this survey of the Western humanities, we have referred to a historical series of shifting geographic centers, each one providing a common cultural locus for thought. Postmodern thought alters the situation. The postmodern world consists of multiple centers of thought, each existing simultaneously with and independently of the others.

Borges's short story "Borges and I" may be the first post-modern exploration of this state of affairs. Although he published widely in almost every imaginable form, his reputation as one of the leaders of modern Latin-American literature rests almost entirely on a series of some 40 short stories, tales, and sketches—"fictions," as he called them. Many of these sometimes very brief fictions take on a quality of dreamlike mystery (Reading 15.10):

READING 15.10

Jorge Luis Borges, "Borges and I" (1967) Translated by J. E. I.

The other one, the one called Borges, is the one things happen to. I walk through the streets of Buenos Aires and stop for a moment, perhaps mechanically now, to look at the arch of an entrance hall and the grillwork on the gate; I know of Borges from the mail and see his name on a list of professors or in a biographical dictionary. I like hourglasses, maps, eighteenth century typography, the taste of coffee and the prose of Stevenson; he shares these preferences, but in a vain way that turns them into the attributes of an actor. It would be an exaggeration to say that ours is a hostile relationship: I live. let myself go on living, so that Borges may contrive his literature, and this literature justifies me. It is no effort for me to confess that he has achieved some valid pages, but those pages cannot save me, perhaps because what is good belongs to no one, not even to him, but rather to the language and to tradition. Besides, I am destined to perish, definitively, and only some instant of myself can survive in him. Little by little, I am giving over everything to him, though I am quite aware of his perverse custom of falsifying and magnifying things. Spinoza knew that all things long to persist in their being; the stone eternally wants to be a stone and the tiger a tiger. I shall remain in Borges, not in myself (if it is true that I am someone), but I recognize myself less in his books than in many others or in the laborious strumming of a guitar. Years ago I tried to free myself from him and went from the mythologies of the suburbs to the games with time and infinity, but those games belong to Borges now and I shall have to imagine other things. Thus my life is a flight and I lose everything and everything belongs to oblivion, or to him. I do not know which of us has written this page.

This is the story in its entirety. Borges describes himself as a bodily self divided from his persona as a writer. In the post-modern world, meaning shifts according to place and time and, Borges teaches us, point of view—not only the writer's but also our own. Meaning might well be determined by a myriad of semantic accidents or misunderstandings, or by a reader whose mood, gender, or particular cultural context defines, for the moment, how and what he or she understands. Postmodern writing produces texts that willingly place themselves in such an open field of interpretation, subject to uncertainty.

The literature of Latino and Hispanic culture in the Americas is infused with a sense of cross-fertilization—like Borges, a sense of different, even competing selves. From the beginning of the sixteenth century, the Hispanization of Indian culture and the Indianization of Hispanic culture in Latin and South America created a unique cultural pluralism. By the last half of the twentieth century, Latino culture became increasingly Americanized, and an influx of Hispanic immigrants helped to Latinize American culture. The situation has been summed up by the Puerto Rico-born poet Aurora Levins Morales (1954–) in "Child of the Americas," a poem in which she comes to the same "difficult unity of inclusion" as that described by Robert Venturi in relation to postmodern architecture (Reading 15.11):

READING 15.11

Aurora Levins Morales, "Child of the Americas" (1986)

I am a child of the Americas,

- a light-skinned mestiza of the Caribbean,
- a child of many diaspora, born into this continent at a crossroads.

I am a U.S. Puerto Rican Jew.

a product of the ghettos of New York I have never known. An immigrant and the daughter and granddaughter of immigrants.

I speak English with passion: it's the tongue of my consciousness,

a flashing knife blade of crystal, my tool, my craft.

I am Caribeña, island grown. Spanish is my flesh, Ripples from my tongue, lodges in my hips: the language of garlic and mangoes,

the singing of poetry, the flying gestures of my hands. I am of Latinoamerica, rooted in the history of my continent:

I speak from that body.

I am not African. Africa is in me, but I cannot return.
I am not taína. Taíno¹ is in me, but there is no way back.
I am not European. Europe lives in me, but I have no home there.

l am new. History made me. My first language was spanglish.

I was born at the crossroads and I am whole.

¹Taíno: The first Native American population encountered by Christopher Columbus.

Cross-Fertilization in the Visual Arts

"Language is a virus," declared the American author William S. Burroughs (1914–97), referring, at least in part, to the fact that American English has become the international language of business, politics, the media, and culture—a plague upon indigenous languages, threatening their extinction. In this context, the collision of global cultures could hardly be

ignored. Increasingly, artists have responded by acknowledging that life in a global world increasingly demands that they accept multiple identities as Aurora Levins Morales has. Many find themselves in a double bind—how, they ask, can they remain true to their native or ethnic identities and still participate in the larger world market? What happens to their work when it enters a context where it is received with little or no understanding of its origins? How, indeed, does the global threaten the local? Is the very idea of the "self" threatened by technology and technological innovation?

The postmodern blurring of the boundaries between classical art and contemporary culture is epitomized in art by the controversial painting *The Holy Virgin Mary* by the

Fig. 15.27 Chris Ofili, *The Holy Virgin Mary.* **1996.** Acrylic, oil, polyester resin, paper collage, glitter, map pins, and elephant dung on linen, 96"×72". (CO 24.) Collection: Museum of Old and New Art, Hobart, Australia. Courtesy the Artist and Victoria Miro, London. © Chris Ofili. While on display in Brooklyn, the painting was smeared with white paint by an angry 72-year-old spectator.

British-born Nigerian painter Chris Ofili (1968–) which is a case in point (Fig. 15.27). Ofili portrays the Virgin as a black woman, and surrounding her are *putti* (winged cherubs) with bare bottoms and genitalia cut out of pornographic magazines. Two balls of elephant dung, acquired from London Zoo, support the painting, inscribed with the words "Virgin" and "Mary," a third clump defining one of her breasts. The son of black African Catholic parents, both of whom were born in Lagos, Nigeria, and whose first language was Yoruba, Ofili has used this West African culture as a source of inspiration for his art.

The display of sexual organs, especially in representations of female divinities, is common in Yoruba culture,

and Ofili's putti are meant to represent modern examples of this indigenous tradition, symbolizing the fertility of the Virgin Mary. As for elephant dung, in 1992, during a trip to Zimbabwe, Ofili was struck by its beauty after it was dried and varnished. He also came to understand that it was worshiped as a symbol of fertility in Zimbabwe, and he began to mount his paintings on clumps of dung as a way, he said, "of raising the paintings up from the ground and giving them a feeling that they've come from the earth rather than simply being hung on a wall."

The Holy Virgin Mary artwork thus reflects Ofili's African heritage. But he understood that the African association of genitalia and dung with fertility and female divinities would be lost on his Western audience. Indeed it was. When the painting was exhibited at the Brooklyn Museum in late 1999, it provoked a stormy reaction. The Catholic cardinal in New York called it a blasphemous attack on religion, and the Catholic League called for demonstrations at the Museum. New York's Mayor Rudolph W. Giuliani threatened to cut off the museum's funding as well as evict it from the city-owned building it leased. (He was forced to back down by the courts.) For Ofili, the conflict his painting generated was itself emblematic of the collision of cultures that define his own identity. At the same time, it can be said that the controversy helped to make Ofili even more prominent and did little to diminish the "marketability" of his art. In 2003, he was chosen to represent Great Britain at the Venice Biennale, perhaps the most prominent contemporary global art exhibition.

Fig. 15.28 Shahzia Sikander, *Pleasure Pillars*. **2001.** Watercolor, dry pigment, vegetable color, tea, and ink on wasli paper, $12" \times 10"$. Courtesy Sikkema Jenkins & Co., New York. As part of her ongoing investigation of identity, Sikander has taken to wearing the veil in public, something she never did before moving to America, in what she labels "performances" of her Pakistani heritage.

Similarly, the Pakistani painter Shahzia Sikander (1969–) addresses her heterogeneous background in works such as *Pleasure Pillars* (Fig. 15.28) by reinventing the traditional genre of miniature painting in a hybrid of styles. Combining her training as a miniature artist in her native Pakistan with her focus on contemporary art during her studies at the Rhode Island School of Design, Sikander explores the ten-

CONTINUITY&CHANGE

sion inherent in Islam's encounter with the Western world, Christianity, and the neighboring South Asian tradition of Hinduism. In the center of *Pleasure Pillars*, Sikander portrays herself with the spiraling horns of a powerful ram. Below her head are two bodies, one a Western Venus, the other Devi, the Hindu goddess of fertility, rain, health, and nature, who is said to hold the entire universe in her womb. Between them, two hearts pump blood, a reference to her dual sources of inspiration, East and West. Eastern and Western images of power also inform the image as a lion kills a deer at the bottom left, a direct artistic quotation from an Iranian miniature of the Safavid dynasty (1501–1736), and, at the top, a modern fighter jet roars past. For Sikander and Ofili both, identity is itself contested ground, the very condition of being in a postmodern world.

Of all the world's indigenous peoples, native North Americans have been among the most isolated and marginalized. Diverse but sequestered on arid reservations, enmeshed in poverty and unemployment, their traditions and languages on the brink of extinction, Native Americans seemed the consummate "Other." However, in 1968, in Minneapolis, Minnesota, a gathering of local Native Americans, led by Dennis Banks, George Mitchell, and Clyde Bellecourt, decided to address these problems through collective action, and founded the American Indian Movement (AIM). Almost a quarter-century later, Banks recalled what motivated them:

Because of the slum housing conditions; the highest unemployment rate in the whole of this country; police brutality against our elders, women, and children, Native Warriors came together from the streets, prisons, jails and the urban ghettos of Minneapolis to form the American Indian Movement. They were tired of begging for welfare, tired of being scapegoats in America and decided to start building on the strengths of our own people; decided to build our own schools; our own job training programs; and our own destiny. That was our motivation to begin. That beginning is now being called "the Era of Indian Power."

AIM was, from the outset, a militant organization. On Thanksgiving Day 1970, AIM members boarded the Mayflower II at its dock in Plymouth harbor as a countercelebration of the 350th anniversary of the Pilgrims' landing at Plymouth Rock. A year later, they occupied Mount Rushmore National Monument. In AIM's point of view, the site, which was sacred to their culture, had been desecrated by the carving of the American presidents Washington, Jefferson, Roosevelt, and Lincoln into the mountain. The occupation was designed to draw attention to the 1868 Treaty of Fort Laramie, which had deeded the Black Hills, including Mount Rushmore, to the Lakota Sioux. The U.S. military had ignored the treaty, forcing the Lakota onto the Pine

Fig. 15.29 David P. Bradley (Ojibwe), Indian Country Today. 1996–97. Acrylic on canvas, 70" × 60". Museum purchase through the Mr. and Mrs. James Krebs Fund. Photograph courtesy Peabody Essex Museum. In the foreground is the Rio Grande River, teeming with fish, the lifeblood of the region.

Ridge reservation on the plains south of the Black Hills. There, on December 29, 1890, with the Battle of Wounded Knee, conflict erupted (see Chapter 13). In 1973, AIM militants took control of Wounded Knee and were quickly surrounded by federal marshals. For over two months, they exchanged gunfire, until the AIM militants surrendered. Of course, not everyone agreed with AIM's tactics, but the group did help to revitalize Native American cultures throughout the hemisphere and furthered an interest in traditional art forms.

Although Native American communities are arguably better off today than they were in 1970—in no small part because of the emergence of reservation-based casino gamblingmany concerns remain. Contemporary life in the Southwestern pueblos is the subject of Indian Country Today (Fig. 15.29) painted by David P. Bradley (1954-), a Native American of Ojibwe descent who has lived for the last 30 years in Santa Fe, New Mexico. Behind the pueblo, to the left, the parking lot of an Indian-run casino is filled with tourist buses. Behind it, in the distance, is the city of Santa Fe. The train passing behind the pueblo is the Santa Fe Railroad's "Chief"—the very image of Anglo-American culture's appropriation of Native traditions. To the right of the central mesa is the Four Corners Power Plant in northwestern New Mexico, one of the largest coalfired generating stations in the United States and one of the greatest polluters. (Note the smoke reemerging on the far side of the mesa.) Behind the plant is an open-pit strip mine. Fighter jets rise over the landscape, reminders of the nearby Los Alamos National Laboratory, where classified work on the design of nuclear weapons is performed.

In the center of the pueblo, Bradley depicts a traditional kachina dance taking place. Performed by male dancers who impersonate kachinas, the spirits who inhabit the clouds, the rain, crops, animals, and even ideas such as growth and fertility (see Chapter 1), the dances are sacred and, although tourists are allowed to view them, photography is strictly prohibited. The actual masks worn in ceremonies are not considered art objects by the Pueblo. Rather, they are thought of as active agents in the transfer of power and knowledge between the gods and the men who wear them in dance.

Kachina figurines are made for sale to tourists, but they are considered empty of any ritual power or significance. This commercialization of native tradition is the real subject of Bradley's painting. The native peoples' ability to withstand this onslaught is suggested by the giant mesa, endowed with kachina-like eyes and mouth, that overlooks the entire scene, suggesting that the spirits still oversee and protect their people.

A Multiplicity of Media: New Technology

Just as the electronic media have revolutionized modern culture, ranging from Thomas Edison's first audio recording to the motion picture, radio, television, and digital technology, and from the Internet to the iPod, so too have the arts been revolutionized by these media. This transformation was most fundamentally realized in the visual arts through the medium of video.

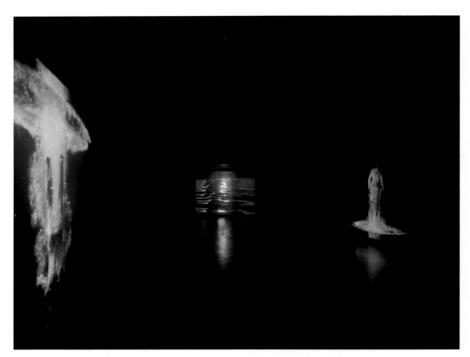

Fig. 15.30 Bill Viola, Five Angels for the Millennium. 2001. Video/sound installation, five channels of color video projection on walls in a large, dark room (room dimensions variable); stereo sound for each projection; image size $7'5'' \times 10'6''$ each. Edition of three. Photo: Mike Bruce, courtesy Anthony d'Offay, London.

Temporal media like video art are often concerned with the passing of time itself, the life cycle from birth to death. Video artist Bill Viola (1951–) has been fascinated, throughout his career, by the passage of time. His principal metaphor for this passage is water, which flows, like time, but can also be seen, and seems to make both time and space tangible and palpable. His video installation piece *Five Angels for the Millennium* (Fig. 15.30) is composed of five individual video sequences that show a clothed man plunging into a pool of water. The duration of each video is different, with long sequences of peaceful aqueous landscape suddenly interrupted by the explosive sound of the body's dive into the water. Viola describes the process of making the piece:

Five Angels came out of a three-day shoot in Long Beach that I had undertaken for several other projects. All I knew was that I wanted to film a man plunging into water, sinking down, below, out of frame—drowning. A year or so later, going through this old footage, I came across five shots of this figure and started working with them—intuitively and without a conscious plan. I became completely absorbed by this man sinking in water, and by the sonic and physical environment I had in mind for the piece.

When I showed the finished work to Kira [Perov], my partner, she pointed out something I had not realized until that moment: this was not a film of a drowning man. Somehow, I had unconsciously run time backwards in the five films, so all but one of the figures rush upwards and out of the water. I had

inadvertently created images of ascension, from death to birth.

Because the videos are continuously looped and projected onto the gallery walls, their different durations make it impossible to predict which wall will suddenly become animated by the dive—the one behind you, the one in front of you, the one at your side. The experience is something like being immersed in both water and time simultaneously, in the flow of the moment. For Viola, video differs from film in exactly this sense. The most fundamental aspect of video's origin as a medium is the live camera. Video is in the moment. And Viola's installation literally spatializes time, even as time becomes as palpable as the watery surfaces he depicts.

Today, of course, video art per se no longer exists—the medium has become entirely digital, and, in fact, although it is far more expensive, artists working with time-based media have preferred, given the higher quality of the image, to work with film. One of the most

remarkable experiments with the medium of film is the nine-screen installation Ten Thousand Waves (Fig. 15.31) by the British artist and filmmaker Isaac Julien (1960–). Ten Thousand Waves was inspired by the drowning of 23 Chinese cockle pickers from Fujian province in southeast China in Morecambe Bay, Lancashire, on the evening of February 5, 2004. Their tragedy is juxtaposed with a Chinese fable, "The Tale of Yishan Island," in which the Chinese goddess and protector of sailors, the Fujian goddess Mazu—played by Chinese actress Maggie Chung—saves five boats of fishermen from a storm at sea by directing them to an island that, after they are saved, they can never find again. Layered on these two stories is a third story of a contemporary goddess—a sort of reenactment of Wu Yonggang's 1934 silent film The Goddess (about a woman who became a prostitute to support herself and her son), which tracks her as she moves from the historic Shanghai Film Studio sets of the 1930s into the present-day Pudong district of Shanghai.

Julien's multiscreen images at first seem chaotic, but they underscore that the fixed viewpoint of cinematic experience is highly institutionalized—the onslaught of visual stimulus in Julien's installation is actually very much like "the architecture of complexity" that Robert Venturi described. In that sense, Julien's installation thus represents a kind of "visual liberation." Its Dolby surround sound environment—the dialogue of helicopter pilots attempting their rescues of the cockle pickers, the poetry of Wang Ping, the atonal music of Maria de Alvear and fusion mix of Jah Wobble & the Chinese Dub Orchestra—immerses us in a cacophony of sonic

Fig. 15.31 Isaac Julien, *Ten Thousand Waves I.* 2010. Installation view, ShanghART Gallery, Shanghai. Nine-screen installation. 35mm film, transferred to High Definition, 9.2 surround sound. Duration 49 mins, 41 secs. Edition of 6 plus 1AP. Courtesy the Artist and Victoria Miro, London, Metro Pictures, New York, and Galería Helga de Alvear, Madrid. © Isaac Julien. Photography © Adrian Zhou. Here, Maggie Chung, in her role as Mazu, flies over Morecambe Bay searching for the drowning cockle pickers. Julien shot the scene by hoisting Chung on pulleys and filming her flying against a green screen, rendering the ropes invisible.

Fig. 15.32 Phil Collins, still from part one of The Smiths karaoke trilogy, *The World Won't Listen*. 2004–07. Synchronized three-channel color video projection with sound, 56 minutes. FILM STILL. Courtesy Shady Lane Productions and Tanya Bonakdar Gallery, New York. The music for the Smiths karaoke was performed by Columbia's biggest rock group, Aterciopelados ("The Velvety").

structures that parallels aurally the visual constructedness of the film. We are caught up in the "ten thousand waves" of Chinese history.

Julien's work is emphatically a condemnation of the exploitation of workers in the new global marketplace,

a global marketplace in which culture itself has become a commodity. And perhaps no cultural commodity has traversed global boundaries more effectively than rock and roll. Beginning in 2004, the English artist Phil Collins created posters inviting people to perform karaoke renditions of all the songs from the Smiths' classic 1987 album The World Won't Listen, first in Bogotá, Colombia, then in Istanbul, Turkey, and finally in Jakarta and Bandung, Indonesia. "In all the locations," Collins told the Dallas Museum's curator of contemporary art, where the three sessions were first screened simultaneously, "some people had a very rudimentary grasp of English. But they knew the songs so devastatingly well through repetition, every breath and every ad lib, which, considering the importance of lyrics in the songs . . . is pretty amazing." The performers sing in front of travelogue leisure-world backdrops (Fig. 15.32) ranging from lakeside villas to tropical resorts to American national parks, each entering, as they sing, even if only for a moment, the glamorous world of pop idols. "Other people sometimes find karaoke embarrassing, or laughable, or delusional," Collins explains, "but I find it moving and incredibly courageous. . . . It's like a mild form of heroism." What Collins's trilogy suggests, finally, is a human community of far-flung "fans," but believers, too, in lyrics like those that conclude the song "Rubber Ring": "Don't forget the songs/ That made you cry/ And the songs that saved your life."

There can be little doubt that rock-and-roll culture has had a considerable impact on the arts over the course of

Fig. 15.33 Pipilotti Rist, three stills from *I'm Not The Girl Who Misses Much.* 1986. Single-channel video (color, sound), 5 min. © Pipilotti Rist. Courtesy the artist, Hauser & Wirth, and Luhring Augustine. As much as Rist's video is a parody of music videos in general, it also evokes the horror of John Lennon's assassination in 1980 and the terrible irony that would come to inform the lyrics of "Happiness is a Warm Gun."

the last 50 years. Pipilotti Rist (1962-) began working with video in 1986 with a single-track video, I'm Not The Girl Who Misses Much (Fig. 15.33), a parody of the videos that had begun to air on television with the advent of MTV in 1983. The video transforms the lyrics to John Lennon's song Happiness Is a Warm Gun (1968) from "She's not a girl," to "I'm not the girl." Rist, who played percussion, bass, and flute in the all-girl rock band Les Reines Prochaines (The Next Queens) from 1988 to 1994, bounces up and down as she dances, manipulating her voice by speeding it up to a frenetic pace and slowing it down to the pace of a funeral march, her image sliding in and out of focus. Her blatant dismissal of high production values is equally a dismissal of the social values of MTV itself, where women had quickly been diminished to mere sexual objects.

In an installation by Rist first screened at the Venice Biennale in 1997, Ever Is Over All (Fig. 15.34), a woman is seen walking down a street, dressed in a conservative blue dress and bright red shoes à la Dorothy in The Wizard of Oz. She is carrying a large red flower—in fact, a flower known as a redhot poker, images of which are simultaneously projected around the corner of the room. A soft, even soothing "la, la, la" of a song accompanies her. With a broad smile on her face, she lifts the long-stemmed flower in her hand and smashes it into the passenger window of a parked car. Glass shatters. She moves on, smashing more car windows. Up from behind her comes a uniformed woman police officer, who passes her by with a smiling salute. Her stroll down the boulevard plays in a continuous loop in the gallery. This is the new Oz, the Emerald City that

Fig. 15.34 Pipilotti Rist, Ever Is Over All. 1997. Audio video installation, National Museum of Foreign Art, Sofia, Bulgaria, 1999; sound with Anders Guggisberg; single-channel video. Museum of Modern Art, New York. Courtesy the artist, Hauser & Wirth, and Luhring Augustine. The person playing the part of the hit woman is the Swiss journalist and documentary filmmaker Silvana Ceschi.

Fig. 15.35 Janine Antoni, Touch. 2002. Color video, sound (projection), 9:36 min. loop. The Art Institute of Chicago. Gift of Donna and Howard Stone, 2007.43. A short segment of Touch, narrated by Antoni, is included in the Art21 segment "Janine Antoni in 'Loss and Desire'" at www.pbs.org/art21/artists/antoni/index.html.

we discover "somewhere over the rainbow," where the tensions between nature and civilization, violence and pleasure, the legal and the criminal, impotence and power all seem to have dissolved.

The artist Janine Antoni (1964-) works in a variety of media, including performance and video, often making art out of everyday activities such as eating, bathing, and sleeping. The tension between the mundane qualities of her activities and the technical sophistication of their recording results in a sense of almost magical transformation comparable to that of the Surrealists. In the video Touch (Fig. 15.35), Antoni appears to walk along the horizon, an illusion created by her walking on tightrope stretched between two backhoes on the beach directly in front of her childhood home on Grand Bahama Island. She had learned to tightrope walk, practicing about an hour a day, as an exercise in bodily control and meditation. As she practiced, she realized, she says, that "it wasn't that I was getting more balanced, but that I was getting more comfortable with being out of balance." This she took as a basic lesson in life. In Touch, this sense of teetering balance is heightened by the fact that she appears to be walking on an horizon line that we know can never be reached as it continuously moves away from us as we approach it. We know, in other words, that we are in an impossible place, and yet it is a place that we have long contemplated and desired as a culture—the same horizon that Romantic painters such as Caspar David Friedrich looked out upon in paintings like Monk by the Sea (see Fig. 12.18 in Chapter 12). When, in the course of the full-length video, both Antoni and the rope disappear, we are left, as viewers, contemplating this illusory line and what it means. And we come to understand that the horizon represents what is always in front of us. "It's a very hopeful image," Antoni says, "it's about the future, about the imagination."

15.1 Outline the principles of existentialism and how they manifest themselves in art and literature.

After World War II, Europe was gripped by a profound pessimism. The existential philosophy of Jean-Paul Sartre was a direct response. What did Sartre mean by the phrase "Existence precedes essence"? He agreed that the human condition is defined by alienation, anxiety, lack of authenticity, and a sense of nothingness, but he said that this did not abrogate the responsibility to act and create meaning. Sartre's play *No Exit* and Samuel Beckett's *Waiting for Godot* are examples of the Theater of the Absurd. What are the characteristics of this brand of theater?

15.2 Compare and contrast the varieties of Abstract Expressionism and describe how the Beats and Pop Art challenged its ascendency.

In America, Jackson Pollock and Willem de Kooning inspired a generation of artists to abandon representation in favor of directly expressing their emotions on the canvas in totally abstract terms. How did Abstract Expressionist painters like Mark Rothko and Helen Frankenthaler differ from Pollock and de Kooning?

At the same time, the Beat generation, a younger, more rebellious generation of writers and artists, began to critique American culture. The Swiss photographer Robert Frank's *The Americans* revealed a side of American life that outraged a public used to seeing the country through the lens of a happy optimism. Allen Ginsberg lashed out in his poem "Howl" with a forthright and uncensored frankness that seemed to many an affront to decency. What was the nature of the collaboration between the composer John Cage, the dancer Merce Cunningham, and the artist Robert Rauschenberg? What characterizes Rauschenberg's combine paintings? What defines Cage's 4'33" as music? In what ways do the American Beats reflect the existentialism of Jean-Paul Sartre?

Pop Art reflected the commodification of culture and the marketplace as a dominant cultural force. In what terms did Andy Warhol compare Marilyn Monroe to Campbell's Soup? How did Tom Wesselmann suggest that painting itself was a commodity? How did Roy Lichtenstein parody Abstract Expressionist painting? Claes Oldenberg created witty reproductions of American goods. How did he change them?

15.3 Examine the role politics played in the art and literature of the 1960s and 1970s.

By 1963, the Southern Christian Leadership Conference (SCLC), led by the Reverend Martin Luther King, Jr., had decided that Birmingham, Alabama, would be the focal point of the burgeoning civil rights movement. One of

the most important factors contributing to the success of the civil rights movement was the growing sense of ethnic identity among the African-American population. How did Jean-Paul Sartre contribute to this newfound sense of self? How did it find expression in the writings of Ralph Ellison and Amiri Baraka?

As American involvement in the war in Vietnam escalated throughout the 1960s, artists and writers responded in a number of ways. What tack did Kurt Vonnegut take in his 1969 novel *Slaughterhouse-Five?* How did the Art Workers' Coalition respond? What steps did they take?

In 1963, in her book *The Feminine Mystique*, Betty Friedan attacked the patriarchal construction of the idea of "woman." What was the primary object of her attack? Poets and painters fought to find a place in an art world that almost totally excluded women from exhibition and even gallery representation. How did Judy Chicago and the Guerrilla Girls address the situation?

15.4 Characterize the ways in which pluralism and diversity are reflected in postmodern art and literature.

Postmodern architecture is characterized by a condition of contradiction that is inclusive and not exclusive. In the arts, this sense of inclusiveness authorizes works in which identity and meaning are plural and multiplicitous, crossing stylistic and cultural boundaries. In Jorge Luis Borges's short parable "Borges and I," the "I" accuses "Borges" of falsification and exaggerating. Whom are we to trust, or are we to trust anyone, and how would you say that defines the postmodern condition? How does "spanglish" reflect cross-cultural negotiation in Aurora Levins Morales's poem "Child of the Americas"?

The globalization of culture has led many to feel they have multiple identities. How do artists like Chris Ofili mediate between their British training and their Nigerian roots? In the late 1960s, the American Indian Movement (AIM) sought to restore power to Native American peoples, the plurality of whose cultures was itself enormous. How does David P. Bradley address the confrontation between native and Anglo cultures? Finally, how does Shahzia Sikander negotiate the boundaries between Islam and the West?

Artists have also used new electronic media to create new artistic spaces. Bill Viola creates video installations that take advantage of the medium's ability to evoke the world of dreams, memories, and reflections, and Viola's work in particular immerses the viewer in the flow of time and the cycle of life and death. How do installations such as Isaac Julien's Ten Thousand Waves and Phil Collins's The World Won't Listen address the contemporary historical moment? How do Pipilotti Rist's videos address popular culture?

The Environment and the Humanist Tradition

hat is the role of art today? What does the museum offer us? What about literature, the book, the poem? Is the museum merely a repository of cultural artifacts? Is the poem a tired and selfindulgent form of intellectual narcissism? Can opera move us even more meaningfully than popular music? How can the arts help us to understand not only our past, but also our present and our future? These are questions that artists, writers, and musicians are continually asking themselves, and questions that students of the humanities, coming to the end of a project such as this one, might well ask themselves as well.

Consider an installation by the Danish artist Olafur Eliasson (1967-), The Weather Project (Fig. 15.36). When he installed it in the mammoth Turbine Hall of Tate Modern, London, in the winter of 2003, it was roundly criticized as "mere" entertainment, in no small part because it attracted over 2 million visitors. At the end of the 500-foot hall hung a giant yellow orb, 90 feet above the floor. The ceiling itself was covered with mirrors, thus apparently doubling the size of the space. The "sun" was actually a semicircle of some 200 yellow sodium streetlights, which, when reflected in the ceiling mirrors, formed a circle. Artificial mist machines filled the hall with a dull, wintry fog. What was the attraction?

In no small part, it seemed to reside in the very artificiality of the environment. Visitors to the top floor of the gallery could easily see the trussing supporting the mirrored ceiling as well as the construction of the sun shape. The extraordinary visual effects of Eliasson's installation were, in the end, created by rather ordinary means. But this ordinariness, in turn, suggested profound and somewhat disturbing truths about our world and our environment. If Eliasson could

create this almost postapocalyptic environment—with its dead, heatless sun, perpetual fog, and cold stone groundwith such minimal means, what might we, as a world, create with the advanced technology so readily at our disposal? In other words, as viewers lay on the floor of the museum, and saw themselves reflected on the ceiling above, were they viewing themselves in the present, or seeing themselves in the future? What hath humanity wrought?

Fig. 15.36 Olafur Eliasson, The Weather Project, installation view at Tate Modern, London. 2003. Monofrequency lights, projection foil, haze machine, mirror oil, aluminum, and scaffolding. Courtesy of the artist, Tanya Bonakdar Gallery, New York, and neugerriemschneider, Berlin. © Olafur Eliasson 2003.

The Weather Project was, then, something of a chilling experience, both literally and figuratively. "I regard . . . museums," Eliasson has said, "as spaces where one steps even deeper into society, from where one can scrutinize society." It is perhaps relevant for you to consider this book as such a space. To conclude, what is it about your world that you have come to understand and appreciate more deeply and fully? ■

PHOTO CREDITS

Front Cover Prado, Madrid, Spain/Bridgeman Images Back Cover © Photo Scala, Florence

Chapter 1

1.1 akg-images; 1.2 © Ministère de la Culture - Médiathèque du Patrimoine, Dist. RMN-Grand Palais/image IGN; 1.3 Erich Lessing/akg-images; 1.4, 1.5 Gianni Dagli Orti/Museum of Anatolian Civilisations Ankara/The Art Archive; 1.6 © RMN-Grand Palais (musée du Louvre)/Droits réservés; 1.7, p32 CL A & B © Werner Forman Archive; 1.8 Yan Arthus-Bertrand/Altitude/Photo Researchers, Inc.; 1.9 © English Heritage. NMR Aerofilms Collection; Map 1.3 Courtesy of National Geographic; 1.10 Christopher Gable and Sally Gable © Dorling Kindersley; 1.11 John Deeks/Photo Researchers, Inc.; 1.13 age fotostock/SuperStock; 1.14 © Nik Wheeler/Corbis; 1.16 Courtesy of the Oriental Institute of the University of Chicago 1.17a & b. 1.23 © The Trustees of The British Museum; 1.18, 1.26, 1.27 © Photo Scala, Florence; 1.19 © RMN-Grand Palais (musée du Louvre)/Franck Raux; 1.20 Soprintendenza Archeologica/IKONA; p27 (CPP) © Marjane Satrapi/L'Association, photograph Westimage; 1.21 © Livius.Org; 1.22 © Tibor Bognar/Photononstop/Corbis; page 29 (CPP) © Andy Goldsworthy. Courtesy Galerie Lelong, New York. Photo by Julian Calder; 1.24 Photograph © 2015 Museum of Fine Arts, Boston; 1.25 © Photo Scala, Florence/ BPK Bildagentur für Kunst, Kultur und Geschichte, Berlin; 1.28 Craig & Marie Mauzy, Athens mauzy@otenet.gr; 1.29 Alfredo Dagli Orti/Musée Archéologique Naples/The Art Archive.

Chapter 2

2.1, 2.2, 2.5, 2.6, 2.9, 2.11, 2.14a, 2.18, 2.19a, 2.20, 2.24a, 2.26, 2.35 Craig & Marie Mauzy, Athens mauzy@otenet.gr; 2.3,
2.34 © 2013. Photo Scala, Florence/BPK, Bildagentur für Kunst, Kultur und Geschichte, Berlin; 2.4, 2.15, p55 CL C, 2.27, 2.39 Nimatallah/akg-images; 2.7 Stephen Conlin © Dorling Kindersley; 2.10, 2.25 Studio Kontos Photostock; 2.12, 2.21 Photograph © 2015 Museum of Fine Arts, Boston; 2.13 © Marco Cristofori/ Corbis; 2.16, 2.17 Image copyright © The Metropolitan Museum of Art/Art Resource/Photo Scala, Florence; p53, 2.38, 2.46 © Photo Scala, Florence; p54 CL A Canali Photobank, Milan, Italy p55 CL D © Gianni Dagli Orti/The Art Archive/Alamy; p55 CL E Courtesy of the Library of Congress; 2.19b Museum of Classical Archaeology, University of Cambridge; 2.22 © Photo Scala, Flor ence /Ministero per i Beni e le Attività culturali; 2.23, 2.37, 2.41, 2.42 Erich Lessing/akg-images; 2.28 Alfredo Dagli Orti/Musée Archéologique Naples/The Art Archive; 2.30, 2.31, 2.32 © The Trustees of The British Museum; 2.33 © Martin von Wagner Museum, University of Wurzburg, Photo P. Neckermann/E Oehrlein; 2.40 © Vanni Archive/Corbis; p77 (CPP) © Thomas Struth; 2.43 © DeAgostini Picture Library/Scala, Florence; 2.44 © Photo Scala, Florence - courtesy of Sovraintendenza di Roma Capitale; 2.45 © RMN-Grand Palais (musée du Louvre).

3.1 Henri Stierlin/akg-images; 3.2 ©1996 Harry N. Abrams, Inc.; 3.3, 3.21 Erich Lessing/akg-images; 3.4, 3.6, 3.12 © Araldo de Luca/Corbis; 3.5, 3.27, 3.33 Image copyright © The Metropolitan Museum of Art/Art Resource/Photo Scala, Florence; 3.7 © Photo Scala, Florence - courtesy of Sovraintendenza di Roma Capitale; 3.8 Gianni Dagli Orti/Musée Archéologique Naples/The Art Archive; 3.09 Walter Bibikow/Getty Images; 3.11 © Patrick Durand/Sygma/ Corbis; 3.13 Dr. James E. Packer; 3.14 © Roberto Matassa/age fotostock/Robert Harding World Imagery; 3.15 © Werner Forman Archive; 3.16 © Dennis Cox/Alamy; 3.17, 3.36 © Photo Scala, Florence - courtesy of the Ministero Beni e Att. Culturali; 3.18, 3.23, 3.24 © Vincenzo Pirozzi, Rome fotopirozzi@inwind.it; 3.20 © Hemera Technologies/Alamy; 3.25 D. E. Cox/Stone/Getty Images; p103 (CPP) © Cai Guo-Qiang. Photo by Masanobu Moriyama, courtesy Cai Studio; p108 CL A O. Louis Mazzatenta/ National Geographic Stock; p109 CL B Keren Su/Getty Images; p109 CL C Laurent Lecat/akg-images; 3.28 The Nelson-Atkins Museum of Art, Kansas City, Missouri. Photo: John Lamberton; 3.29 © Asian Art & Archaeology, Inc./Corbis; 3.30 Gerard Degeorge/akg-images; 3.31 © Photo Scala, Florence; 3.32 National Museum of Karachi, Karachi, Pakistan/Giraudon/Bridgeman Images; 3.34 © Atlantide Phototravel/Corbis.

4.1 A.F.Kersting/akg-images; 4.2 Erich Lessing/akg-images; p125 Alfredo Dagli Orti/Musée Archéologique Naples/The Art Archive; 4.4, 4.6, 4.9 © Photo Scala, Florence; 4.8 Bibliotheque des Arts Decoratifs, Paris, France/Archives Charmet/Bridgeman Images; 4.11 © Alfredo Dagli Orti/The Art Archive/Corbis; 4.12, p137 CL D Image copyright © The Metropolitan Museum of Art/Art Resource/Photo Scala, Florence: 4.13, 4.14 © Altun Images, Istanbul; 4.16 Studio Kontos Photostock; 4.17, 4.18 © Cameraphoto Arte, Venice; p136 CL A Seattle Art Museum, Eugene Fuller Memorial Collection. Photo: Paul Macapia; p136 CL B Cincinnati Art Museum, Fanny Bryce Lehmer Fund. Acc. #1977.65/Bridgeman Images; p137 (CPP) © Wijdan, Courtesy October Gallery, London. © The Trustees of the British Museum; 4.19 © Ahmed Jadallah/Reuters/Corbis; 4.20 © Peter Langer - Associated Media Group -All rights reserved; 4.21 © Achim Bednorz, Cologne; 4.22 © Ian Griffiths/Robert Harding World Imagery; 4.23 © Wolfgang Kaehler/Corbis; 4.24 © Guenter Rossenbach/Corbis.

Chapter 5

5.1 © Werner Forman Archive; 5.2, 5.21 © The Trustees of The British Museum; 5.3 © The British Library Board: Cotton Nero D., f.94v; 5.4 © The Board of Trinity College, Dublin, Ireland/Bridgeman Images; 5.5 © The British Library Board: Cotton Vespasian A. I, f.30v; 5.6, 5.8, 5.11 Erich Lessing/akg-images; 5.9 Stephen Biesty © Dorling Kindersley; p160 CL A, B, C, D Musée de la Tapisserie, Bayeux, France/With special authorisation of the city of Bayeux/Bridgeman Images; p161 CL E, 5.10 Erich Lessing/akg-images; p163 © Roberto Matassa/age fotostock/Robert Harding World Imagery; p163 (CPP) © 2014 Artists Rights Society (ARS), New York/VG Bild-Kunst, Bonn. Image copyright © The Metropolitan Museum of Art/Art Resource/Photo Scala, Florence; 5.12 © Photo Scala, Florence; 5.15 Photononstop/SuperStock; 5.16 © White Images/Scala, Florence; 5.17 Stephen Conlin © Dorling Kindersley; 5.19 © Michael Jenner/Robert Harding World Imagery; 5.20 Joanna Cameron © Dorling Kindersley; 5.22 © Photo Pierpont Morgan Library/Art Resource/Scala, Florence; 5.23 @ Achim Bednorz, Cologne; 5.24 © Angelo Hornak.

Chapter 6

6.1 © Adam Woolfitt/Corbis; 6.2, 6.3, 6.10, 6.11, 6.15 © Achim Bednorz, Cologne; 6.4 © Dean Conger/Corbis; 6.5 © Angelo Hornak; 6.7 John Bryson/Photo Researchers, Inc.; 6.9 © Stuart Black/ Robert Harding World Imagery/Corbis; 6.12, 6.20 © Photo Scala, Florence; 6.13 Museo Civico, Bologna, Italy/Giraudon/Bridgeman Images; 6.14 Sonia Halliday Photographs; 6.16, 6.17 © RMN-Grand Palais (domaine de Chantilly)/René-Gabriel Ojéda; 6.18a & b, 6.19, 6.21, 6.22, p196-7 CL A, B & C @ Quattrone, Florence; p191 (CPP) Courtesy Ronald Feldman Fine Arts, New York/www. feldmangallery.com; p193 Studio Kontos Photostock; 6.23 Image copyright © The Metropolitan Museum of Art/Art Resource/Photo Scala, Florence; 6.24 Erich Lessing/akg-images; 6.25 Eileen Tweedy/Victoria and Albert Museum London/The Art Archive; 6.26 Bibliothèque nationale de France, Paris; 6.27 Courtesy of the

Chapter 7

7.1 Folco Quilici © Fratelli Alinari; 7.2 © Arte & Immagini srl/ Corbis; 7.3, 7.5 Erich Lessing/akg-images; 7.4, 7.25 Canali Photobank, Milan, Italy; p212 Nimatallah/akg-images; 7.6 © Museo dell'Opera del Duomo, Florence/Photo Scala, Florence; 7.7, 7.12, p239 © Photo Scala, Florence; 7.10, 7.11, 7.14, 7.17, 7.22, 7.29, 7.36 © Quattrone, Florence; p216 Alfredo Dagli Orti/Musée Archéologique Naples/The Art Archive; 7.13 © Achim Bednorz, Cologne; p218 © Patrick Durand/Sygma/Corbis; 7.15 © Museo dell'Opera del Duomo, Florence/Photo Scala, Florence; 7.16 Royal Collection © 2011 Her Majesty Queen Elizabeth II/Bridgeman Images; p244 (CPP) © Julie Green; 7.18 © RMN-Grand Palais (musée du Louvre)/Michel Urtado; 7.19, 7.31, 7.32, 7.33a, 7.34, 7.38 © Cameraphoto Arte, Venice; 7.20, p227 © Vincenzo Pirozzi Rome fotopirozzi@inwind.it; 7.23, p234 CL A Foto Musei Vati-cani/IKONA; 7.26 Image copyright © The Metropolitan Museum of Art/Art Resource/Photo Scala, Florence; 7.27 A. Bracchetti/P. Zigrossi/Foto Musei Vaticani/IKONA; 7.28 Courtesy National Gallery of Art, Washington, DC; 7.30 ONB Vienna: Cod. 4809, fol. 1v-2r; p234 CL B IAM/akg-images; 7.35 © Photo Scala, Florence courtesy of the Ministero Beni e Att. Culturali; 7.37 Alfredo Dagli Orti/Palazzo Pitti, Florence/The Art Archive; 7.39 Courtesy of the Library of Congress.

8.1 De Agostini Picture Library/Bridgeman Images; 8.2, 8.10, 8.12, 8.15, 8.16, 8.21 © Photo Scala, Florence/BPK Bildagentur für Kunst, Kultur und Geschichte, Berlin; 8.3, 8.4 Image copyright © The Metropolitan Museum of Art/Art Resource/Photo Scala, Florence; 8.6, 8.7, 8.19 © National Gallery, London/Scala, Florence, 8.6, 8.7, 8.19 © National Gallery, London/Scala, 8.10 © National Gallery, 8.10 © Nat ence; p256-7 CL (all) Prado, Madrid, Spain/Bridgeman Images; p257 (CPP) © Raqib Shaw. Courtesy White Cube. Image copyright © The Metropolitan Museum of Art/Art Resource/Photo Scala, Florence; 8.8 Unterlinden Museum Colmar/The Art Archive; 8.9 © Musee D'Unterlinden/Photo Scala, Florence; 8.11 Yale University Art Gallery. Library Transfer, Gift of Paul Mellon, B.A. 1929, L.H.D.H 1967; 8.13 Erich Lessing/akg-images; 8.14 © Bettmann/ Corbis; 8.17 British Library, London/Giraudon/Bridgeman Images; 8.18 Trevor Hill © Dorling Kindersley; 8.20 © Vincenzo Pirozzi, Rome fotopirozzi@inwind.it; 8.22 German National Museum, Nuremberg; 8.23 © Photo Scala, Florence.

Chapter 9

9.1 De Agostini Picture Library/G. Dagli Orti/Bridgeman Images; 9.2 © Gianni Dagli Orti/Corbis; 9.3, 9.4 Biblioteca Nacional, Madrid/Bridgeman Images; 9.5 skg-images; p279 (CPP) © Anselm Kiefer. Collection of the Modern Art Museum of Fort Worth, Museum purchase, The Friends of Art Endowment Fund; 9.6 Carlos S Pereyra/age Fotostock/Superstock; 9.7 © MJ Photography/Alamy; 9.8 Francesca Yorke © Dorling Kindersley; 9.9 Museo de América, Madrid; p282 (CPP) © Enrique Chagoya. Photo: Ruben Guzmán; 9.10 © Danny Lehman/Corbis; 9.11 © Richard Maschmeyer/Robert Harding World Imagery/Corbis; 9.12 © Dirk Bakker/Bridgeman Art Library; 9.13 © The Trustees of The British Museum; 9.15, 9.16 Image copyright © The Metropolitan Museum of Art/Art Resource/Photo Scala, Florence; 9.18 Weltmuseum, Vienna; 9.19 Photograph by Ruben Guzmán courtesy of Frederick John Lamp. The Frances and Benjamin Benenson Foundation Curator of African Art. Yale University Art Gallery; 9.20 The University of Iowa Museum of Art, Iowa City. The Stanley Collection X1986.489 and X1986.488; 9.21, 9.32 Photograph © 2015 Museum of Fine Arts, Boston; 9.22 Freer Gallery of Art, Smithsonian Institution, Washington, DC: Purchase, F1942.15a; 9.24 © Photo Scala, Florence; 9.26 Photo Galileo Picture Services LLC, NY; 9.27 © View Stock/ Alamy; p298 CL B, C, D © Corbis; 9.28 Photo © The Cleveland Museum of Art. 1974.31; 9.29, 9.30 The Nelson-Atkins Museum of Art, Kansas City, Missouri. Photograph by John Lamberton; **9.31** © Photo Art Resource/Scala, Florence; **9.33** Demetrio Carrasco © Dorling Kindersley; 9.34 © Paul Quayle; 9.35 Steve Vidler/Super-Stock, Inc.; 9.36 Photo Galileo Picture Services LLC, NY; 9.37 © Estate of Nam June Paik. Collection Stedelijk Museum Amster-

Chapter 10

10.1, 10.9, 10.27, 10.28 Erich Lessing/akg-images; 10.2 © Musec dell'Opera del Duomo, Florence/Photo Scala, Florence; 10.3, 10.4 Foto Musei Vaticani/IKONA; 10.5 Kunsthistorisches Museum, Vienna; 10.6 © Isabella Stewart Gardner Museum, Boston, MA/ Bridgeman Images; 10.7 © Quattrone, Florence; 10.8 © Cameraphoto Arte, Venice; 10.10, 10.12, 10.15 © Vincenzo Pirozzi, Rome fotopirozzi@inwind.it; 10.11, 10.14 Canali Photobank, Milan, Italy; 10.13 © Photo Scala, Florence - courtesy of the Ministero Beni e Att. Culturali; 10.16 The Detroit Institute of Arts. Gift of Leslie H. Green. 52.253. Photo © 1984 Detroit Institute of Arts/Bridgeman Images; p330 (CPP) Courtesy the artist. © Albright Knox Art Gallery/Art Resource, NY/Scala, Florence; 10.17 Photo: Charles Roelofsz/RKD Images. Bob P. Haboldt & Co., Inc. Art Gallery, NY; p334 (CPP) Courtesy the artist and Cheim & Read; 10.18, 10.32 © Photo Scala, Florence; 10.19 Courtesy National Gallery of Art, Washington, DC; 10.20 © Photo Scala, Florence/BPK, Bildagentur für Kunst, Kultur und Geschichte, Berlin; 10.21 Collection Rijksmuseum, Amsterdam. On loan from the City of Amsterdam; p338 CL A Mauritshuis, The Hague, The Netherlands/Bridgeman Images; 10.22 Yale University Art Gallery, New Haven. Fritz Achelis Memorial Collection, Gift of Frederic George Achelis, B.A. 1907; 10.23 The Royal Collection © 2011 Her Majesty Queen Elizabeth II/Bridgeman Images; 10.24 © The Art Gallery Collection/Alamy; p342 (CPP) Photo Luís Vasconcelos/Courtesy Unidade Infinita Projectos; 10.25Artedia/Leemage.com; 10.26 © RMN-Grand Palais (Château de Versailles)/Daniel Arnaudet/Gérard Blot; 10.29 © RMN-Grand Palais (musée du Louvre)/René-Gabriel Ojéda; 10.30 Bibliotheque Nationale, Paris, France/Bridgeman Images; 10.31 © RMN-Grand Palais (musée du Louvre)/Christian Jean; 10.33 Chateau de Versailles/Lauros-Giraudon/Bridgeman Images.

Chapter 11

11.1 By permission of the Trustees of the Goodwood Collection; 11.2 © Angelo Hornak; 11.3a & b © Photo Scala Florence/Heritage Images; 11.4 © National Gallery, London/Photo Scala, Florence; 11.5 © Graham Jordan/Adams Picture Library/Alamy; 11.6 Private Collection; 11.7 © The Trustees of the British Museum; 11.8 © Krzysztof Melech/Alamy; 11.9 Hermitage, St. Petersburg/ Bridgeman Images; 11.10 © RMN-Grand Palais/Agence Bulloz; 11.11 © Peter Willi/Bridgeman Images; 11.12, p370-371 CL A Erich Lessing/akg-images; 11.13 Alte Pinakothek, Munich/Bridgeman Images; p370 (CPP) © Jeff Koons; p371 CL B © Photo Scala, Florence; 11.14, 11.22 Image copyright © The Metropolitan Museum of Art/Art Resource/Photo Scala, Florence; 11.15 The Wallace Collection, London/Bridgeman Images; 11.16 © RMN-Grand Palais (musée du Louvre)/Stéphane Maréchalle; 11.17 © RMN-Grand Palais (musée du Louvre)/Hervé Lewandowski; 11.18 British Library/The Art Archive; 11.19 © Victoria and Albert Museum, London; 11.20 The David Collection, inv.B275. Photo: Pernille Klemp; 11.21 Photo © The Cleveland Museum of Art, John L. Severance Fund. 1998.103.14; 11.23 akg-images; 11.24 © RMN-Grand Palais (musée du Louvre)/Thierry Le Mage.

12.1 © Massachusetts Historical Society, Boston, MA/Bridgeman Images; 12.2 Yale University Art Gallery. Trumbull Collection; 12.3 © RMN-Grand Palais (Château de Versailles)/Gérard Blot; 12.4 Giraudon/Bridgeman Images; 12.5, 12.6 © RMN-Grand Palais (musée du Louvre)/Gérard Blot/Christian Jean; 12.7 © Lebrecht Music and Arts Photo Library/Alamy; 12.8 © RMN-Grand Palais (musée des châteaux de Malmaison et de Bois-Préau)/Gérard Blot; 12.9 Courtesy of the Maryland Historical Society (1960-108-1-1-36); 12.10 Courtesy of the Library of Congress; p393 © Gianni Dagli Orti/The Art Archive/Alamy; 12.11 Courtesy of the Architect of the Capitol, Washington, DC; 12.12 Private Collection, Archives Charmet/Bridgeman Images; p394 (CPP) © 2000 Kara Walker. Photo: Ellen Labenski. Courtesy of Sikkema Jenkins & Co., New York. Solomon R. Guggenheim Museum, New York. Purchased with funds contributed by the International Director's Council and Executive Committee Members: Ann Ames, Edythe Broad, Henry Buhl, Elaine Terner Cooper, Dimitris Daskalopoulos, Harry David, Gail May Engelberg, Ronnie Heyman, Dakis Joannou, Cindy Johnson, Barbara Lane, Linda Macklowe, Peter Norton, Willem Peppler, Tonino Perna, Denise Rich, Simonetta Seragnoli, David Teiger, Ginny Williams, and Elliot K. Wolk 2000.68; 12.13 Image by

courtesy of the Wedgwood Museum Trustees, Barlaston, Staffordshire, (England); 12.14 © Victoria and Albert Museum, London; 12.15 © National Gallery, London/Photo Scala, Florence; 12.16 Yale Center for British Art, Paul Mellon Collection. B1977.14.4702; 12.17 © Tate, London 2014; 12.18, 12.19 © Photo Scala, Florence/BPK, Bildagentur für Kunst, Kultur und Geschichte, Berlin; p400 CL A © Roy Rainford/Robert Harding; p401 CL B Smith College Museum of Art, Northampton, Massachusetts; 12.20 © RMN-Grand Palais (musée du Louvre)/Thierry Le Mage; 12.21, 12.22 © White Images/Scala, Florence; p405 (CPP) Courtesy Devorah Sperber. Limited edition prints commissioned by CALCO GRAFÍA NACIONAL de Madrid; 12.23 © RMN-Grand Palais (musée du Louvre)/Michel Urtado.

13.1, 13.3 © RMN-Grand Palais (musée du Louvre)/Thierry Le Mage; 13.2 Lauros-Giraudon/Bridgeman Images; 13.4 © Fitzwilliam Museum, University of Cambridge, UK/Bridgeman Images; 13.5 © RMN-Grand Palais (musée du Louvre)/Hervé Lewandowski; 13.6, 13.13 © RMN-Grand Palais (musée du Louvre)/Droits réservés: 13.7 Private Collection; 13.8 Galerie Neue Meister, Dresden, Germany, © Staatliche Kunstsammlungen Dresden/Bridgeman Images; 13.9 © Collection of the New-York Historical Society/Bridgeman Images; p421 (CPP) © Fred Wilson. Photography courtesy the artist and Pace Gallery; 13.10 © Brooklyn Museum of Art, New York; 13.11, 13.27 Courtesy of the Library of Congress; 13.12, 13.14 © RMN-Grand Palais (musée d'Orsay)/Hervé Lewandowski; p425 (CPP) Courtesy of the artist; 13.15, 13.16, 13.18 Erich Lessing/ akg-images; p430 (CPP) © ART LEE Leenam; 13.17 © National Gallery, London/Photo Scala, Florence; 13.19 Courtesy National Gallery of Art, Washington, DC; 13.20, 13.23 Image copyright © The Metropolitan Museum of Art/Art Resource/Photo Scala, Florence; 13.21 Photograph © 2015 Museum of Fine Arts, Boston; p434 CL A & B © The Phillips Collection, Washington, DC/Bridgeman Images; 13.22 Deutsches Historisches Museum, Berlin/Bridgeman Images; 13.24 © White Images/Scala, Florence; 13.25 Museum of the North American Indian, New York/Bridgeman Images; 13.26 © Historical Picture Archive/Corbis; 13.28 akg-images.

Chapter 14

14.1 Collection Van Abbemuseum. Photo: Peter Cox, Eindhoven; 14.2 Photograph © 2006, The Art Institute of Chicago. All Rights Reserved; 14.3 Yale University Art Gallery. Bequest of Stephen Carlton Clark, B.A. 1903; 14.4 Image copyright © The Metropolitan Museum of Art/Art Resource/Photo Scala, Florence; p450 Committee of the Corcoran Gallery of Art/Bridgeman Images; 14.5 © Samuel Courtauld Trust, The Courtauld Gallery, London/Bridgeman Images; 14.6 © Photo The Philadelphia Museum of Art/Art Resource/Scala, Florence; 14.7 Photograph © The Art Institute of Chicago; 14.8 © 2014 Estate of Pablo Picasso/Artists Rights Society Callego; 14.3 © 2014 Estate of Paolo Ficasso/Artists Rights Society (ARS), New York. Image copyright © The Metropolitan Museum of Art/Art Resource/Photo Scala, Florence; p454 © RMN-Grand Palais (musée d'Orsay)/Hervé Lewandowski; 14.9 © 2014 Artists Rights Society (ARS), New York/VG Bild-Kunst, Bonn. Image copyright © The Metropolitan Museum of Art/Art Resource/Photo Scala, Florence; p454 © RMN-Grand Palais (musée du Louvre), Thierry Le Mage; 14.10 © 2014 Artists Rights Society (ARS), New York/ADAGP, Paris. Rupf Foundation, Bern/Giraudon/Bridgeman Images; 14.11 © 2014 Artists Rights Society (ARS), New York/VG Bild-Kunst, Bonn. © Photo Scala, Florence/BPK, Bildagentur für

Kunst, Kultur und Geschichte, Berlin: p456 (CPP) @ Mark Tansey. Courtesy Gagosian Gallery. Digital Image Museum Associates/ LACMA/Art Resource NY/Scala, Florence; 14.12 © 2014 Artists Rights Society (ARS), New York/ADAGP, Paris. Photo: Solomon R. Guggenheim Museum, New York; 14.13 © 2014 Artists Rights Society (ARS), New York/VG Bild-Kunst, Bonn. © McNay Art Museum/Art Resource, NY/Scala, Florence; p457 © RMN-Grand Palais (musée du Louvre); 14.14, 14.23 © Digital image, The Museum of Modern Art, New York/Scala, Florence; 14.15 © 2014 Succession H. Matisse/Artists Rights Society (ARS), New York Photo © The State Hermitage Museum. Photo by Vladimir Terebenin, Leonard Kheifets, Yuri Molodkovets; 14.16 Walker Art Center, Minneapolis, Gift of T. B. Walker Collection, Gilbert M. Walter Fund, 1942; 14.17 © 2014 Artists Rights Society (ARS), New York/ ADAGP, Paris. Erich Lessing/akg-images; 14.18 @ 2014 Artists Rights Society (ARS), New York/VG Bild-Kunst, Bonn. Haags Gemeentemuseum, The Hague, Netherlands/Bridgeman Images; 14.19 © Succession Marcel Duchamp/ADAGP, Paris/Artists Rights Society (ARS), New York 2014. © Photo The Philadelphia Museum of Art/Art Resource/Scala, Florence; 14.20 © Succession Marcel Duchamp/ADAGP, Paris/Artists Rights Society (ARS), New York 2014. Photo © Tate, London 2014; p466 (CPP) © Sherrie Levine. Courtesy Paula Cooper Gallery, New York and Simon Lee Gallery, London. Walker Art Center, Minneapolis. T.B. Walker Acquisition Fund, 1992; 14.21 Art © Heirs of Aaron Douglas/Licensed by VAGA, New York, NY. Fine Arts Museums of San Francisco. Museum purchase, the estate of Thurlow E. Tibbs Jr., The Museum Auxiliary, American Art Trust Fund, Unrestricted Art Trust Fund, partial gift of Dr. Ernest A Bates, Sharon Bell, Jo-Ann Berverly, Barbara Carleton, Dr. & Mrs. Arthur H. Coleman, Dr. & Mrs. Coyness Ennix, Jr, Nicole Y. Ennix, Mr & Mrs Gary Francois, Dennis L. Franklin, Mr. & Mrs. Maxwell C. Gillette, Zuretti L. Goosby, Mr. & Mrs. Richard Goodyear, Marion E. Greene, Mrs Vivian S. W. Hambrick, Laurie Gibbs Harris, Arlene Hollis, Louis A. & Letha Jeanpierre, Daniel & Jackie Johnson, Jr, Stephen L. Johnson, Mr. & Mrs. Arthur Lathan, Mr. & Mrs. Gary Love, Lewis & Ribbs Mortuary Garden Chapel, Glenn R. Nance, Mr. & Mrs. Harry S. Parker III, Mr. & Mrs. Carr T. Preston, etc.; 14.22 © 2014 The Jacob and Gwendolyn Lawrence Foundation, Seattle/Artists Rights Society (ARS), New York. © Digital image, The Museum of Modern Art, New York/Scala, Florence; p472 CL A, C, p473 CL E, H, K Goskino/The Kobal Collection; p472 CL B, p473 CL D, G Courtesy Everett Collection/Rex Features; p473 CL F, I, J Henry M. Sayre; 14.24 © 2014 Artists Rights Society (ARS), New York/SIAE, Rome. © Cameraphoto Arte, Venice; 14.25 © 2014 Artists Rights Society (ARS), New York/ADAGP, Paris. Letter from Katherine S. Dreier to Max Ernst, May 25, 1920. Yale Collection of American Literature, Beinecke Rare Book and Manuscript Library. Translation from German by John W. Gabriel. From "Max Ernst, Life and Work by Werner Spies, published by Thames & Hudson, Page 67; 14.26 © 2014 Artists Rights Society (ARS), New York/VG Bild-Kunst. Bonn. © Digital image, The Museum of Modern Art, New York/ Scala, Florence; 14.27 © Salvador Dalf, Fundació Gala-Salvador Dalf, Artists Rights Society (ARS), New York 2014. © Digital image, The Museum of Modern Art, New York/Scala, Florence; 14.28 © 2014 Artists Rights Society (ARS), New York/VG Bild-Kunst, Bonn. © Photo Art Resource/Scala, Florence/John Bigelow Taylor.

Chapter 15

15.1 © 1998 Kate Rothko Prizel & Christopher Rothko/Artists Rights Society (ARS), New York. The University of Arizona Museum of Art, Tucson, Gift of E. Gallagher, Jr. Acc. 64.1.1; 15.2

Neue Galerie - Sammlung Ludwig, Aachen, Germany, Art © Estate of Duane Hanson/Licensed by VAGA, New York, NY; 15.3 © 2014 The Pollock-Krasner Foundation/Artists Rights Society (ARS). New York. Whitney Museum of American Art, NY. Purchase. © 2008 ARS Artists Rights Society, NY; 15.4 © 2014 The Willem de Kooning Foundation/Artists Rights Society (ARS), New York. Reproduction, The Art Institute of Chicago. All Rights Reserved; 15.5 © Estate of Joan Mitchell. Image courtesy National Gallery of Art, Washington, DC; 15.6 © 2014 Estate of Helen Frankenthaler, Inc./Artists Rights Society (ARS), New York. The Detroit Institute of Arts, Founders Society Purchase, Dr. & Mrs. Hilbert H. DeLawter Fund/Bridgeman Images: 15.7 Art @ Robert Rauschenberg Foundation/Licensed by VAGA, New York, NY. © Digital image, The Museum of Modern Art, New York/Scala, Florence; 15.8 Art © Jasper Johns/Licensed by VAGA, New York, NY. Whitney Museum of American Art, New York; 50th Anniversary Gift of the Gilman Foundation, Inc., The Lauder Foundation, A. Alfred Taubman, Laura-Lee Whittier Woods and purchase. 80.32; 15.9 © 2014 Artists Rights Society (ARS), New York/VG Bild-Kunst, Bonn. Grant Smith/VIEW Pictures/akg-images; 15.10 © Andrew Garn; 15.11 © 2014 The Andy Warhol Foundation for the Visual Arts Inc./Artists Rights Society (ARS), New York; 15.12 Art © Estate of Tom Wesselmann/Licensed by VAGA, New York, NY. © Albright Knox Art Gallery/Art Resource, NY/Scala, Florence; 15.13 © 2014 The Andy Warhol Foundation for the Visual Arts Inc./Artists Rights Society (ARS), New York. © Tate, London 2014; p494 (CPP) © Mike Bidlo, photo © Jesse David Harris; 15.14 © Estate of Roy Lichtenstein; 15.15 © Estate of Roy Lichtenstein. Collection of the Whitney Museum of American Art, New York. Purchase, with funds from the Friends of the Whitney Museum of American Art. 66.2; 15.16 Copyright © 1966 Claes Oldenburg. Whitney Museum of American Art, NY; 15.17 © Bettmann/Corbis All Rights Reserved; 15.18 Art © Romare Bearden Foundation/Licensed by VAGA, New York, NY. © Digital image, The Museum of Modern Art, New York/Scala, Florence; 15-CL © The Estate of Jean-Michel Basquiat/ADAGP, Paris/ARS, New York 2014; 15.19 © Digital image, The Museum of Modern Art, New York/Scala, Florence; 15.20, 15.21 © 2014 Judy Chicago/Artists Rights Society (ARS), New York. Photo © Donald Woodman; 15.22 Copyright © by Guerrilla Girls, Inc. Courtesy www.guerrillagirls.com; 15.23 © Curva de Luz/Alamy; 15.24, p508 (CPP) © Gerhard Richter. Digital image, The Museum of Modern Art, New York/Scala, Florence; 15.25 © Gerhard Richter. Reproduction, The Art Institute of Chicago. All Rights Reserved; 15.26 © Pat Steir. Courtesy the artist and Cheim & Read. Photo: Solomon R. Guggenheim Museum, New York; 15.27 The Saatchi Gallery, London. Courtesy the Artist and Victoria Miro, London. © Chris Ofili; p511 Nimatallah/akg-images; 15.28 © Shahzia Sikander, Courtesy of Sikkema Jenkins & Co., New York; 15.29 © David Bradley. Museum Purchase 1999. Peabody Essex Museum, Salem, Massachusetts. Acq. 06/17/1999; 15.30 Mike Bruce/Courtesy Anthony d'Offay, London; 15.31 Courtesy the artist and Victoria Miro, London, Metro Pictures, New York and Galería Helga de Alvear, Madrid © Isaac Julien. Photography © Adrian Zhou; 15.32 Courtesy Shady Lane Productions and Tanya Bonakdar Gallery, New York; 15.33a, b, c © Pipilotti Rist. Courtesy the artist, Hauser & Wirth and Luhring Augustine; 15.34 Courtesy the artist, Hauser & Wirth and Luhring Augustine. Photograph: Angel Tzvetanov. 15.35 Courtesy of the artist and Luhring Augustine, New York; 15.36 Courtesy the artist; neuggerriemschneider, Berlin and Tanya Bonkadar Gallery, New York © Olafur Eliasson 2003.

TEXT CREDITS

Chapter 1

Reading 1.2, page 20: From "The Law Code of Hammurabi" from COLLECTIONS FROM MESOPOTAMIA AND ASIA MINOR, 2/e, 1997 by Martha T. Roth. Reprinted by permission of the Society of Biblical Literature; Reading 1.3a, 1.3b and 1.3c, pages 21–24: Excerpts from THE EPIC OF GILGAMESH, translated, with an Introduction and Notes, by Maureen Gallery Kovacs Copyright © 1985, 1989 by the Board of Trustees of the Leland Stanford Jr. University. All rights reserved. With the permission of Stanford University Press, www.sup.org; Reading 1.4, page 25 Deuteronomy 6:6-9, from the NEW REVISED STANDARD VER-SION BIBLE, copyright 1985, 1989, Division of Christian Educa-tion of the National Council of the Churches of Christ in the United States of America. Used by permission. All rights reserved; Reading 1.5, page 30: From ANCIENT EGYPTIAN LITERA-TURE: A BOOK OF READINGS, vol. 1, The Old and Middle Kingdoms by Miriam Lichtheim, Copyright © 1973 by University of California Press. Reproduced with permission of University of Cali-

Chapter 2

Reading 2.1, page 48: "Achilles and Priam" from THE ILIAD by Homer, translated by Robert Fagles, translation copyright © 1990 by Robert Fagles. Used by permission of Viking Penguin a division of Penguin Group (USA) LLC; **Reading 2.2a and b**, page 58: From SAPPHO: A NEW TRANSLATION by Mary Barnard. Copyright © 1958 by The Regents of the University of California. © renewed 1986 by Mary Barnard. Print reproduced with permission of University of California Press via Copyright Clearance Center. Electronic rights by permission of Barnardworks; Reading 2.5a and b, pages 69–70: "Antigone" by Sophocles, from THREE THEBAN PLAYS by Sophocles, trans. by Robert Fagles, translation copyright © 1982 by Robert Fagles. Used by permission of the Penguin Group (USA)

Chapter 3

Reading 3.4, page 105: From THE BOOK OF SONGS translated by Arthur Waley (Allen & Unwin, 1937). © Copyright by permission of The Arthur Waley Estate; Reading 3.5, page 105: "There are ways but the Way is uncharted" from THE WAY OF LIFE by Lao Tzu, trans. by Raymond B. Blakney, translation copyright © 1955 by Raymond B. Blakney, renewed © 1983 by Charles Philip Blakney. Used by permission of Dutton Signet, a division of Penguin Group (USA) LLC and the Estate of Raymond Bernard Blakney; Reading 3.6, page 107: LAMENT by Liu Xijun, copyright © 2003 by Tony Barnstone and Chou Ping, from LITERATURES OF ASIA, ed. by Tony Barnstone, Pearson Education 2003; Reading 3.7, page 107: "To Be a Woman" by Fu Xuan, copyright © 2003 by Tony Barnstone and Willis Barnstone, from LITERATURES OF ASIA, ed. by Tony Barnstone, Pearson Education 2003.

Reading 4.1, page 123: Romans 5:1–11, from the NEW REVISED STANDARD VERSION BIBLE, copyright 1985, 1989, Division of Christian Education of the National Council of the Churches of Christ in the United States of America. Used by permission. All rights reserved; **Reading 4.4.** page 135: Surah 76. From HOLY QUR'AN trans. by M.H. Shakir (1982). Reprinted by permission of Tahrike Tarsile Qur'an, Inc., New York.

Reading 5.1, page 150: From BEOWULF, translated by Burton Raffel, copyright © 1962, 1963, renewed © 1990, 1991 by Burton Raffel. Used by permission of Dutton Signet, a division of Penguin Group (USA) LLC, and of Russell & Volkening as agents for the author; Reading 5.2, page 154: Terry, Patricia, SONG OF ROLAND, 2nd Ed., © 1992, Reprinted and Electronically reproduced by permission of Pearson Education, Inc., Upper Saddle River, New Jersey; **Reading 5.4**, page 166: Howard, Donald R.; Dietz, Margaret Mary, Translators, ON THE MISERY OF THE HUMAN CONDITION—POPE INNOCENT III, 1st Ed., © 1969. Reprinted and Electronically reproduced by permission of Pearson Education, Inc., Upper Saddle River, New Jersey; Reading 5.5, page 170: From Comtessa de Dia's "Cruel are the Pains I've Suf fered" trans. by Robert Kehew, from LARK IN THE MORNING: THE VERSES OF THE TROUBADOURS, ed. by Robert Kehew, trans. by Ezra Pound, W.D. Snodgrass, and Robert Kehew. Copyright © 2005 by The University of Chicago. Reprinted by permission of the University of Chicago Press. All rights reserved.

Chapter 6

Reading 6.2, pages 198-199: "Inferno" from THE DIVINE COM-EDY by Dante Alighieri, translated by John Ciardi. Copyright 1954, 1957, 1959, 1960, 1961, 1965, 1967, 1970 by the Ciardi Family Publishing Trust. Used by permission of W. W. Norton & Company, Inc. This selection may not be reproduced, stored in a retrieval system, or transmitted in any form or by any means without the

prior written permission of the publisher; Reading 6.3, pages 200–201: From THE DECAMERON OF GIOVANNI BOC CACCIO, trans. Frances Winwar, Modern Library Edition 1955; copyright © 1930 by The Limited Editions Club, Inc.; renewed 1957. Used with the permission of Easton Press; Reading 6.4, page 202: "Sonnet 134" from THE POETRY OF PETRARCH trans.
David Young. Translation copyright © 2004 by David Young. Reprinted by permission of Farrar, Straus and Giroux, LLC: Excerpts from Sonnet 134 and Sonnet 338 from THE POETRY OF PETRARCH, trans. by David Young. Translation copyright © 2004 by David Young, CAUTION: Users are warned that this work is protected under copyright laws. The right to reproduce or transfer the work via any medium must be secured with Farrar, Straus and Giroux, LLC; Reading 6.5, page 203: "Prologue" from the THE PORTABLE CHAUCER, edited and translated by Theodore Morrison, translation copyright 1949, © 1975, renewed © 1977 by Theodore Morrison. Used by permission of Viking Penguin, a division of Penguin Group (USA) LLC.

Chapter 7

Reading 7.1, page 220: The poem "A Song for Bacchus" by Lorenzo de Medici, translated by A.S. Kline, copyright © 2004 and used by permission. All Rights Reserved; Reading 7.2, page 221: From the book ORATION ON THE DIGNITY OF MAN by Giovanni Pico della Mirandola, translated by A. Robert Caponigri. Copyright © 1956. Published by Regnery Publishing. All rights reserved. Reprinted by special permission of Regnery Publishing, Washington, D.C.; Reading 7.8, page 244: From THE NOBILITY AND EXCELLENCE OF WOMEN, AND THE DEFECTS AND VICES OF MEN by Lucrezia Marinella, ed. and trans. by Anne Dunhill. Copyright © 1999 by The University of Chicago. Reprinted by permission of the University of Chicago Press. All rights reserved; Reading 7.9, page 244–245: "Terze Rime, Capitolo 13" from POEMS AND SELECTED LETTERS by Veronica Franco, ed. and trans. by Ann Rosalind Jones and Margaret F. Rosenthal. Copyright © 1998 by The University of Chicago. Reprinted by permission of the University of Chicago Press. All rights reserved.

Chapter 8

Page 249: THE AUTUMN OF THE MIDDLE AGES by Johan Huizinga, translated by Rodney J. Payton and Ulrich Mammitzsch. Copyright © 1996 University of Chicago Press.

Chapter 9

Reading 9.4, page 295: "Summer Day in the Mountains" by Li Bai, copyright © 2003 by Willis Barnstone, Tony Barnstone and Chou Ping, "Broken Lines" by Du Fu, copyright © 2003 by Tony Barnstone and Chou Ping, from LITERATURES OF ASIA, ed. by Tony Barnstone, Pearson 2003; Reading 9.7, page 303: "This Perfectly Still" by Tomonori from ANTHOLOGY OF JAPANESE LITERA-TURE, compiled and edited by Donald Keene, copyright © 1955 by Grove Press, Inc. Used by permission of Grove/Atlantic, Inc. Any third party use of this material, outside of this publication, is prohib-

Chapter 10

Reading 10.2, page 322: "The Trial of Veronese" from Holt, Elizabeth Gilmore, LITERARY SOURCES OF ART HISTORY. © 1947 Princeton University Press, 1975 renewed PUP. Reprinted by permission of Princeton University Press; Reading 10.4, pages 325-326: From THE COMPLETE WORKS OF SAINT TERESA OF JESUS, Vol. 1, trans. and ed. by E. Allison Peers. New York: Sheed & Ward, 1946. Reprinted by permission of the Rowman & Littlefield Publishing Group; Reading 10.6, page 347: Excerpt from TARTUFFE by Moliere, translated into English verse by Richard Wilbur. English translation copyright © 1963, 1962, 1961 and renewed 1991, 1990 and 1989 by Richard Wilbur. Reprinted by permission of Houghton Mifflin Harcourt Publishing Company. All rights reserved.

Chapter 11

Reading 11.10, page 375: Extract from THE SOCIAL CONTRACT AND DISCOURSE by Jean-Jacques Rousseau, trans. by Maurice Cranston, reprinted by permission of Peters Fraser & Dunlop (www.petersfraserdunlop.com) on behalf of the Estate of Maurice Cranston.

Chapter 12

Reading 12.7, page 408: "Heiligenstadt Testament" (1802) from Forbes, Elliott, THAYER'S LIFE OF BEETHOVEN 2 VOLUMES, © 1964 Princeton University Press, 1992 renewed PUP. Reprinted by permission of Princeton University Press.

Chapter 13

Reading 13.4, page 424: From Les Fleurs du mal by Charles Baudelaire. Trans. from the French by Richard Howard. Reprinted by permission of David R. Godine, Publisher, Inc. Translation Copyright © 1982 by Richard Howard.

Chapter 14

Reading 14.2, page 461. Extract from "Rue Christine Monday" is taken from GUILLAUME APOLLINAIRE: SELECTED POEMS trans, by Oliver Bernard, New edition published by Anvil Press Poetry in 2004. Reprinted by permission of the publisher; Reading 14.3, page 461. "In a Station of the Metro" by Ezra Pound, from PERSONAE, copyright ©1926 by Ezra Pound. Published by Faber and Faber Ltd. Reprinted by permission of Faber and Faber Ltd and New Directions Publishing Corp; **Reading 14.4**, page 462. "The Red Wheelbarrow" by William Carlos Williams from THE COL-LECTED POEMS: VOLUME 1, 1909-1939, copyright © 1938 by New Directions Publishing Corp. Reprinted by permission of New Directions Publishing Corp. and Carcanet Press Ltd; Reading 14.6a, b, c, and d, pages 463-464: From COLLECTED POEMS 1909-1962 by T.S. Eliot. Published and reprinted by permission of Faber and Faber Ltd. Copyright © the Estate of T.S. Eliot; Reading 14.9, page 467: Reprinted with the permission of Scribner Publishing Group from THE NEW NEGRO by Alain Locke. Copyright © 1925 by Albert & Charles Boni, Inc. All rights reserved: Reading 14.10, page 468: "Jazz Band in a Parisian Cabaret" from THE COLLECTED POEMS OF LANGSTON HUGHES by Langston Hughes, edited by Arnold Rampersad with David Roessel, Associate Editor, copyright © 1994 by the Estate of Langston Hughes. Used by permission of Alfred A. Knopf, an imprint of the Knopf Doubleday Publishing Group, a division of Random House LLC and David Higham Associates. All rights reserved. Any third party use of this material, outside of this publication, is prohibited. Any third party use of this material, outside of this publication, is prohibited. Interested parties must apply directly to the above for

Chapter 15

Reading 15.1 and text, page 485: Excerpt from NO EXIT AND THE FLIES by Jean-Paul Sartre, copyright © 1946 by Stuart Gilbert. Copyright renewed 1974, 1975 by Maris Agnes Mathilde Gilbert. Published in Great Britain as IN CAMERA AND OTHER PLAYS by Jean-Paul Sartre, trans. by Stuart Gilbert and Kitty Black. Translation copyright © 2000 by Stuart Gilbert, published by Hamish Hamilton 1952. Used and reproduced by permission of Alfred A. Knopf, an imprint of the Knopf Doubleday Publishing Group, a division of Random House LLC, and Penguin Books, Ltd. All rights reserved. French language edition published as HUIS CLOS © 1945 and 1976 by Editions Gallimard. Electronic rights by permission of Editions Gallimard, www.gallimard.fr. Used by permission. Any third party use of this material, outside of this publication, is prohibited. Interested parties must apply directly to Random House LLC, Penguin Books, Ltd, and Editions Gallimard for permission; Reading 15.3, page 490: First twenty-one lines from "Howl" from COL-LECTED POEMS 1947–1980 by Allen Ginsberg. Copyright © 1955, 1984, 1985 and 2006 by Allen Ginsberg and Allen Ginsberg LLC. Reprinted by permission of HarperCollins Publishers and The Wylie Agency (UK) Ltd; Page 495: Copyright © Claes Oldenburg 1961. Reprinted by permission of Oldenburg van Bruggen Studio, New York; Page 497: Excerpt from "Blowin' in the Wind" by Bob Dylan copyright © 1962 by Warner Bros. Inc.; renewed 1990 by Special Rider Music. All rights reserved. International copyright secured. Reprinted by permission; Reading 15.4a and b, page 498: Excerpts from INVISIBLE MAN by Ralph Ellison, copyright © 1947, 1948, 1952 by Ralph Ellison. Copyright renewed 1975, 1976, 1980 by Ralph Ellison. Used by permission of Random House, division of Random House LLC. All rights reserved; Reading 15.5, page 500: Copyright © Nov 22, 1999 Amiri Baraka. Reprinted by permission of Basic Books, a member of the Perseus Books Group.; Reading 15.6, page 500: From SO FAR, SO GOOD "The Revolution Will Not Be Televised" copyright © 1990, by Gil Scott-Heron, reprinted by permission of Third World Press, Inc., Chicago, Illinois; Reading 15.8, page 504: "Her Kind" from TO BEDLAM AND PART WAY BACK by Anne Sexton. Reprinted by permission of SLL/Sterling Lord Literistic, Inc. Copyright by Anne Sexton; Reading 15.9, page 509: "The Analytical Language of John Wilkins" from OTHER INQUISITIONS: 1937–1952, by Jorge Luis Borges, trans. by Ruth L.C. Simms, copyright © 1964, renewed 1993. By permission of the University of Texas Press; Reading 15.10, page 510: "Borges and I" by Jorge Luis Borges, trans. by James E. Irby, from LABYRINTHS, copyright © 1962, 1964 by New Directions Publishing Corp. Reprinted by permission of New Directions Publishing Corp. and Pollinger, Ltd (www.pollingerltd.com) on behalf of the Estate of Jorges Louis Borges, collected in SELECTED POEMS, copyright © 1962, 1999 by Maria Kodama. Electronic rights administered by The Wylie Agency LLC, used by permission. All rights reserved; Reading 15.11, page 510: Aurora Levins Morales, "Child of the Americas" from Aurora Levins Morales and Rosario Morales, GETTING HOME ALIVE (Firebrand Books, 1986). Copyright © 1986 by Aurora Levins Morales and Rosario Morales. Reprinted with the permission of The Permissions Company, Inc., on behalf of Aurora Levins Morales, www. permissionscompany.com.

INDEX

Alfonso VI of León and Castile, king, 166

Antioch, 167

Antiphonal, 126 Note: Boldface names refer to artists. Pages Alhazen, Perspectiva, 215 Antiquities of Athens (Revett/Stuart), 392 in italics refer to illustrations. Ali, Mehmet, 441 Allegory of Bad Government (Lorenzetti), 190 Allegory of Good Government (Lorenzetti), 190, 190–191 Antiquities of Rome (Kennett), 392 Anti-Vietnam War, 484 0.10: The Last Futurist Exhibition of Paintings Antoinette, Marie, 387 (Malevich), 471 Antoni, Janine, 517, 517 Antwerp, Belgium, 249, 250 Anu (god), 20 "Allegory of the Cave" (Plato), 66 4'33" (4 minutes 33 seconds), 490 Allegro, 333 12-tone system, 461 16th Street Baptist Church, 497 Alleluia, dies sanctificatus" (Léonin), 167 Aphrodite (Venus), 58, 74 Aphrodite of Knidos, 74, 74 Alms, 135 217-218 Alpha, 124 Aachen, 155 Apocalypse, 121, 123 Altamira, Spain, 2, 7 Abacus, 52 Altar of Augustan Peace, 89, 89 Altar of Zeus, 76–77, 77, 79, 81 Altars and altarpieces, 258–260 Altdorfer, Albrecht, 261, 261–262 Apollinaire, Guillaume, 461, 461, 465, 468 Abbas, 141, 142 Apollo, 117, 234-235 Abbasid dynasty, 141, 142 Apollo (Phoebus), 48, 51, 53 Abbey Church of Sainte-Foy, 162-163, Apollodorus of Damascus, 95 162-165 Apollo, Sanctuary of, 51
The Apotheosis of St. Ignatius (Pozzo), 324
Apoxyomenos (The Scraper), 73, 73
Apse, 127, 127, 132, 134
Aqua Claudia, 93 Abbey of Saint-Denis, 175–177, 176 Abbot Suger, 175, 176, 178, 178, 328 Abd ar-Rahman, 141–142 Abd ar-Rahman III, 142 Altman, Robert, 501 Alumbrados, 323 Alvarado, Pedro de, 278 Amaterasu, 302 Abelard, Peter, 185 Amaterasu Omikami (Japanese god), 13, Aqueducts, 93, 168, 168 13-14 Abhaya mudra, 143 The Ambassadors (Holbein), 272, 272–273 Ambrose, 126, 129 Aquinas, Thomas, 175, 185-186 Abraham of Ur, 24, 119 Aragon, Louis, 475 Absolutism, 314, 342-349 Ambulatory, 119, 128, 128, 164 Amenhotep III, 34 Ara Pacis Augustae, 89, 89-90 Absolutism vs. liberalism, 359-360 Arapaho Ghost Dance dress, 440, 440 Abstract Expressionism, 486, 488-489, Amenhotep IV, 34 Arcade, 93 492, 495 Archaic style, 53, 53 Archaiologia, 41, 45, 47, 80 Arches, 93, 93, 96, 96–98 America, after the War, 486-496 Abu Temple, 16, 16-17 Académie des Sciences, 351 Académie Nationale de Musique, 426 American Anti-Slavery Society, 419 American Art News, 466 Architectural elements Academy of Athens, 130 American Civil War, 422, 426 Persian, 27 ambulatory, 119, 128, 128, 164 American Indian Movement (AIM), Achilles, 47-48 apse, 127, 127 Acropolis, 38-39, 39, 60-64, 61-62 512-513 aqueducts, 93 American Revolution Actaeon, 92 arcade, 93 Declaration of Independence, 384-385 Action painting, 486-488 arches, 93, 96, 96-98 Declaration of the Rights of Man and Adams, Abigail, 394-395 architrave, 54 atrium, 100, 100-101, 126, 127 Citizen, 386–388 Adams, John, 384-385 The Americans (Frank), 489-490 Ade, or beaded crown, 286, 286 barrel vault, 164 American self, 433, 436-438 Ad locutio, 89 base, 54 bay, 93, 93 Adoration of the Magi (Giotto), 197, 197 Adriaenszoon, Adriaen, 338 characteristics of, 433, 436 landscape and experiences, 436-439 Architrave, 54 buttress, 93, 93, 179-180 Americas Adyton, 52, 54 Archivolt, 162 Anasazi, 11, 11 Aztecs, 280, 280, 283 capitals, 44 Aegean, 40-49, 41-42, 45. See also Greece Aegeus, King, 45 Aeneas, 81, 85, 89, 90 clerestory, 127 colonnades, 39, 39–40 columns, 52, 54–55, 61– 62, 62, 64, 94, before contact, 280–283 Inca culture, 283–284, 285 Arena, 94 Aeneid (Virgil), 81, 85, 85, 90–91 **Aeschylus,** 68–69 96-98 Mayan culture, 282-283 cubicula, 100, 100 Aesthetics of chance, 490-492 Neoclassicism in, 392-393 domes, 132, 132 Olmecs, 280, 280 Africa entablature, 54, 64 Peru, 283-284 Benin culture, 286-287 Aria, 332 slave trade, 288, 288-291 espalier, 101 Congo, atrocities in, 455 Ariadne, 45 Teotihuacán, 281, 281 Amida Buddha, 304, 306 facade, 92, 94, 94, 96 and Empire, 442-443 finials, 252 Ife culture, 285-286, 285-286, 289 flying buttresses, 179–180 frieze, 54, 63, 77, 77–78, 89 groin vault, 93, 93, 177, 177 Amiens Cathedral, 180, 181 Islam in, 141 Am I Not a Man and a Brother? (Hackwood), map of, 285 Arjuna, 113 395, 395 music, 287-288 jambs, 93, 93, 164 Amitabha Buddha, 304 Nok people, 7–8 Jewish Second Temple, 119 San people wall painting, 10, 10 slave trade, 288, 288–291 Ammit, 36 keystone, 93, 93 Amphora, 48, 48, 52 Amsterdam, 333, 338, 340. See also African Americans, 383, 422, 467–468, 497. See also Black identity lintels, 8-9, 162 metopes, 63, 64 Netherlands narthex, 127, 127, 128, 132 Analects (Confucius), 106 in Harlem, 469 African masks, 454–455 nave, 117, 117, 127, 127, 179 oculus, 98, 99, 214, 214 "The Analytical Language of John Wilkins" (Borges), 509 Agamemnon, 47–48 parapet, 62 Agathias, 133 Anaphora, 287 parodos, 71 Anasazi, 11, 11 Agency, 3-4 pediment, 51, 63-64, 64, 65 Sculpture The Anatomy Lesson of Dr. Tulp (Rembrandt), 337, 338–339, 351 Age of Enlightenment, 354 pendentives, 132, 132, 231 piers, 93, 93 Agitkas, 471 Anavysos Kouros, 37, 37, 53, 53 Agonizesthai, 52, 53 platform, 52, 54 pointed arches, 179 Ancestral rites, 104 Agora, 39, 39, 70, 94 "Ancient Morning Hymn" (Ambrose), 129 Agriculture, 5, 49-50 proscenium, 70, 71 rib vaulting, 179, 179 The Angel of the Annunciation, Agrippa, Marcus, 89, 90, 98 Reims Cathedral, 173, 183, 183 Aida (Verdi), 441 rotunda, 98 Angel Subduing Demon, Church of Sainte-Ain Ghazal, 11 round arch, 93, 93 Madeline, 173 Anglican Church, 266–267, 348 Anglo-Saxons, 147, 147–153, 152, 155 Animal interlace, 149, 151 Animal style, 149 Akbar, 291 shafts, 54 Akhenaten, 34-35, 35 skene, 70, 71 Akhenaten and His Family, 35 Akkad, 18, 18–19 spandrels, 93, 93 stoa, 39, 39 Akrotiri, 41, 41 stylobate, 52, 54, 61, 62 Animism, 12 À la recherche du temps perdu (Proust), 479 transept, 127, 127 Annunciation (Grünewald), 252, 259, 259 Albee, Edward, 486 triglyphs, 64, 64 vaults, 93, 94 Alberti, Leon Battista, 215, 217-218, 218, 243 Annunciation, Reims Cathedral, 182, 183 "Annus Mirabilis" (Dryden), 354, 355 Albrecht, Archbishop of Mainz, 264 voussoirs, 93, 93 Architecture. See also Housing; Pyramids Antae, 51 Aldred, 151 Alexander the Great, 71-72, 72, 235, 261 Antagonist, 68 Athenian Treasury, 51, 51 Baroque, 326, 342, 342–343 Anthemius of Tralles, 132, 132 Alexander the Great (Lysippus), 72 Alexander VI, pope, 227 Anthropomorphism, 12 Byzantine Empire, 131-132, 131-132 Alexandria, Egypt, 75-76 Antigone (Sophocles), 69, 69

Christian, 117 city-states, 50–51 classical, 54-55 Counter-Reformation, 312, 312-313 domestic in Imperial Rome, 98–99 domestic in Renaissance Florence, 217–218 Egyptian, 28, 28, 31-34 England, 352-354 Florence, Renaissance, 213-214, 217-218, gothic style, 179–180, 187–188 Greek, 48, 49, 50–51, 50–51, 53–56, 60–61, 60–64, 64, 68–69 Greek sanctuaries, 50-51 Han Dynasty, China, 107-111, 110 Hellenistic, 71-79 India, 111, 112, 115, 115, 293-294, 294 India, 111, 112, 115, 115, 293–294, 294 Islamic, 118–119, 137 Japanese, 305–306, 306, 308, 308–309 Jewish Second Temple, 96, 121–122, 122 London, England, 352, 353–355, 354 Mayan culture, 283, 283 medieval castles, 168, 168 medieval monasteries, 156 Ming dynasty, China, 296–300 Minoan, 43–44 Mogul in India, 293-294 Mycenaean culture, 45-47, 46 Neoclassical style, 392 Neoclassicism, 388 Reformation, 275, 275 Renaissance, 247 Renaissance Rome, 227 Renaissance Venice, 238, 238-239, 247 Romanesque, 164-165, 164, 165, 168 Rome, Imperial, 89, 92, 92-102, 96 rural Roman, 247 Saint Mark's Cathedral, 145 Teotihuacán, 281, 281 Arch of Titus, Rome, 96, 96-98 Arcimboldo, Giuseppe, 313 Arena Chapel (Giotto), 195–197, 196–197 Ares (Mars), 48, 53 Areté, 47–49, 66, 463 Aretino, Pietro, 319, 319 Aristophanes, 67-68 Aristotle, 40, 59, 71, 72, 74-76, 78, 234-235, 392 Ark of the Covenant, 25, 25–26, 97 Arkwright, Richard, 359 Armory Show, 466
Armstrong, Louis, 468–469
Arnolfini, Giovanni, 253–255, 254–255
Arouet, François-Marie, 376
Arp, Jean, 465, 465 The Arrival and Reception of Marie de' Medici at Marseilles (Rubens), 344, 344 Art. See also Literature; Paintings; Pottery; Amarna style of, 35 avant-garde, 426 blackness, 498-500 Classical style of, 73–74 Counter-Reformation, 315-316 Dada, 464-467 existentialism, 484 feminist, 505–506 mannerism, 315-324 merchant patronage, 250-260 of military culture, 304-305 modernism, 448-462 mosaics. See Mosaics Neoclassicism, 388 politics, 496-497 pop, 493-496 pop, 493–490 postmodern, 506–507 Pure Land Buddhism, 304, 306 radiant style, 186–190 realistic, 417, 419–421 rebellion and, 501

in Russia, 470–471

Carolingian culture, 156-157

Art. (continued)	reason and, 351	Bon, Giovanni, 239	Christianity in, 130-134
Surrealism, 475–476 syncretic style of, 151	Rembrandt, 336–340, 338–339 sculpture, 325–327	Bonne of Luxembourg, 199	Hagia Sophia, 132, 132
visual, 469–470	at Versailles, 342, 342, 343–348	The Book of Changes, 104, 105, 106 The Book of History, 106	influences, 145
visual, cross-fertilization, 510-513	Barrel vault, 93, 93, 164	Book of Hours (Jean Le Noir), 199	map of at time of Justinian's death, 131 mosaics, 134, 134
Artaxerxes, 60	The Barricades (Meissonier), 416	Book of Hours (Limbourg), 188	St. Catherine's Monastery, 133, 133
Artemis (Diana), 50 Articles of Confederation, 385	Base, 54 Baseline, 18	Book of Kells, 152, 152	
Artists vs. war, 501, 504	Basie, Count, 469	The Book of Rites, 106 The Book of Songs, 105, 106, 295, 296	Cabaret Voltaire, 465
Art of Dying Well, 259	Basilica Nova, 117, 117	Book of the City of Ladies (de Pizan), 204, 204	Cabral, Pedro, 284 Caccini, Giulio, 332
Art of Love (Ovid), 91–92	Basilica of Maxentius and Constantine,	The Book of the Courtier (Castiglione), 222,	Ca' d'Oro, Contarini Palace, 238–239, 239
Artusi, Giovanni, 332 Art Workers' Coalition, 501	117, <i>117</i> Basilica Ulpia, 95, 95, 99	222, 243, 243	Cage, John, 311, 490–492
Aryans, 112	Basil the Great, 130	The Book of the Deeds (de Pizan), 204 "Borges and I" (Borges), 510, 510	Cai Lun, 111 Calanus, 72
Ashikaga family, 308	Basquiat, Jean-Michel, 500, 502-503, 503,	Borges, Jorge Luis, 509–510, 509–510	Calendar, Mayan, 282
Ashoka, 114–115 Ashurbanipal, king, 21	507 B	Bosch, Hieronymus, 255–258, 256–257, 349	Calendar round, 282
Aspiration (Douglas), 469, 469	Basso continuo, 332 Battcock, Gregory, 501	Bossuet, Jacques-Bénigne, 314 Boston Custom House, 383–384	Caliphs, 139–140, 141
Assteas, red-figure krater depicting a comedy, 68	"Batter My Heart" (Donne), 329, 329	Boston Tea Party, 384	Call-and-response, 288, 469 Callicrates, 61, 61, 62
Astra Construction, 447	Battle of Gettysburg, 423, 423	Botkin Class Amphora, 48, 48	Calligraphic Qur'an frontpiece, Istanbul, 137
Atahuallpa, emperor, 284 Aten, 34–35, <i>35</i>	Battle of Issus (Altdorfer), 261, 261 The Battleship Potemkin (Eisenstein), 448,	Botticelli, Sandro, 219, 219–220, 226	Calligraphy, 136–137
Athanadoros, 81	471–472, 472–473	Boucher d'Argis, Antoine-Gaspard, 374 Boucher, François, 369, 369, 372, 372, 378	The Calling of St. Matthew (Caravaggio), 328, 328–329
Athena (Minerva), 50, 53, 60	Baudelaire, Charles, 424-425	Bougainville, Louis-Antoine de, 376–377	Calvinism, 333
Athena Nike, 62 Athena Parthenos sculpture, 61	Bay, 93	Boulton, Matthew, 358–359	Calvinist church, 275
Athenian Acropolis, 102	The Bay (Frankenthaler), 489 Bayeux Cathedral, 160	Bourgeoisie, 417	Calvin, John, 265–266
Athenian Treasury, 51, 51	Bayeux Tapestry, 159–162 160, 161	Boxing, 52 Bradley, David P., 513, 513	Calvin's Consistory, 265–266 Cambridge University, 185
Athens, 39–40, 55, 56–73. See also Acropolis;	Bays, 93	Brady, Mathew, 423	Camera obscura, 422
Greece; Hellenistic world; Parthenon Atmospheric perspective, 216	Bazille, Frédéric, 429	Brahman, 113	Camerata of Florence, 332
Atonality, 460	Beaded crown, Yoruba culture, 287 Bearden, Romare, 499, 499	Brahmins, 113	Campbell's Soup Cans (Warhol), 493, 493
Atrium, 100, 100–101	Beat generation, 489–490	Bramante, Donato, 226–227, 227 Brandt, Peter, 504	Campin, Robert, 250, 251–252, 251–252 Canal, 102, 102
Atsuta Shrine, 14 Attalids, 76, 77	Beatrice, 199	Braque, Georges, 455-456, 455-457, 466,	Canaletto, 353, 353, 355, 361, 363
Attalos I, 78	Beatriz de Dia, 170 Beckett, Samuel, 486	470 P	Candide (Voltaire), 376
Attiret, Jean Denis, 379	Bed (Rauschenberg), 490–491, 491	Brass-casting, 286–287 Brasswork, Ife culture, 285, 287	The Canon (Polyclitus), 63, 63
"Au Clair de la Lune" (Lully), 346	Beethoven, Ludwig van, 404, 407-409	Brecht, Bertolt, 311	Canterbury, 149 The Canterbury Tales (Chaucer), 202,
Augustine, 126, 129–130, 184, 252, 263, 267	Being and Nothingness (Sartre), 485	Breton, André, 474	202–203
Augustine (Benedictine prior), 151	Belgium, Renaissance in, 251–253 Belitili (god), 17	The Brioche (Chardin), 373, 373 Briseis, 47	Cantus firmus, 214, 233
Augustus, 81, 89–94, 95–96, 98, 102	Bellecourt, Clyde, 512	British East India Company, 292, 441	Canzona, 331, 332 Canzona Duodecimi Toni (Josquin des Prez),
Augustus of Primaporta, 88, 89 Aurangzeb, 294	Benedict of Nursia, 156–157	"Broken Lines" (Du Fu), 295, 295	331, 332
Aurelio, Niccolò, 240	Benin City, 286, 287 Benin culture, 286–287, 287	Bronze age culture, 40–49, 41–42	Canzona in the Twelfth Mode (Josquin des
Aurelius, Marcus, 94–96, 97	Beowulf, 150, 150, 152, 155	Bronze work, 104, 104–105, 153 Brothers and Sisters of the Common	Prez), 331
Austen, Jane, 366, 366–367	Berg, Alban, 460	Life, 260	Canzoniere (Petrarch), 201 A capella, 158
The Autobiography of Alice B. Toklas (Stein), 453, 453	Bergson, Henri, 477	Brown, John, 422	Capella Giulia, 316
The Autumn of the Middle Ages (Huizinga),	Berlioz, Hector, 408 Bernard of Clairvaux, 168, 185	Brown, Lancelot, 364–365	Capet, Hugh, 159
249–250	Bernini, Gianlorenzo, 275, 325–327,	Brown v. Board of Education, 496 Bruce, Thomas, 65	Capetian France, 159–162 Capitals, 44
Avant-garde, 426	326–327, 331	Bruges, Belgium, 249-250, 253-255	Capitolo 13 (Franco), 244–245, 244–245
Avenue of the Dead, 281, 281 Averroës, 234	Beyond the Pleasure Principle (Freud), 474, 476	Bruges crane, 248–249	Captain Frans Banning Cocq Mustering
"Awesome Is This Place" (Dufay), 214	Bhagavad Gita, 113	Brunelleschi, 210–211, 211, 213, 217 Brunelleschi's Dome, 213–214	His Company (The Night Watch)
Axis, 63	Bible, 122, 155-156, 267, 267. See also	Bruno, Giordano, 357	(Rembrandt), 337, 337 Captain Singleton (Defoe), 366
Aztecs, 276–277, 277–279, 283 Aztecs confronting the Spaniards, 278	Hebrew Bible	Brutus, Lucius Junius, 86, 87	Carasi family, 329
Azuchi-Momoyama period, 308–309	Bible, Romans 5:1-11, 123 Bichitr, 292, 292–293	Bryant, William Cullen, 436 Bubonic plague. See Black Death	Caravaggio, 328–329, 328–331, 344,
D 21 26	Billfrith, 151	Bucchero, 85	345, 351 Caravaggisti, 328, 330–331
Ba, 31, 36 Babylon, 19–20	Bindusara, 114	Buddha Amida, 304, 306	The Cardiff Team (Delaunay), 447, 447
Babylonian captivity, Hebrew, 26, 121	The Birth of the Gods (Theogony) (Hesiod), 50 Bismarck, Otto von, 428	Buddha, images of, 143, 143 Buddhism	Cardinal Virtues (Raphael), 232
Bacchus, 50, 67	Bismillah, 135, 136-137	Chan Buddhism, 296, 300	Carolingian culture, 152–159 Carpaccio, Vittore, 236, 237
Bacchus, cult of, 129 Bachelor of arts degree, 184	Bismillah in the form of a parrot, 136	in China, 142–143	Carpet page from Lindisfarne Gospels
Bacon, Francis, 355–356	Black Death, 176, 199–205, 210, 255, 259 Black-figure vases, 56, 57	in India, 114–115	(Eadfrith), 151, 151
Baga Mandori, 290	Black identity, 497–500	in Japan, 302–309 Mahayana Buddhism, 304	Carrà, Carlo, 457
Bagarotto, Laura, 240, 241 Balance, concept of, 104	Blackness	map of spread of, 142	Carter, Howard, 35 Cartesian dualism, 356
Balla, Giacomo, 457	art, 498–500	monuments, 115	Cartoons, 196, 232
Ballet de la Nuit, 347	literature, 498–500 "Black Orpheus" (Sartre), 498	Pure Land Buddhism, 304, 306	Caryatids, 62
Ball, Hugo, 464–465	Blake, William, 394, 394	sculpture, 143, <i>143</i> Bull, 33	Casas Grandes, 278
Baltimore & Ohio Railroad, 436 Balzac, Honoré de, 418	Blaue Reiter Almanac, 458	Bull Leaping (Toreador Fresco), 42, 42	Casket with scenes of courtly love, 169, 169 Cassady, Neal, 489
Banda dance, 290, 290–291	The Blind Man (Mutt), 466 Blitzkrieg, 481	Bull, sacrifice of, 129	Cassatt, Mary, 311, 433, 433
Banda mask, 290, 290-291	The Bloody Massacre (Revere), 383, 383	Bulls in Minoan culture, 42, 43 Buon disegno, 214	Castagno, Andrea del, 201
Baptistery, Florence, Italy, 209–212	"Blowin' in the Wind" (Peter, Paul, and	Buon fresco, 196–197	Castell, Robert, 364, 400 Castiglione, Baldassare, 222, 243
Baraka, Amiri, 499, 500 Barbier, Raoul, 435	Mary), 497	Burbage, James, 269	Castiglione, Giuseppe, 379
Bard, 47	Blue notes, 468 The Blue Rider (Der Blaue Reiter), 458	Burbage, Richard, 269–270	Castles, medieval, 168, 168
Barlaeus, 338	Blues music, 468	Burial mounds, 115 Burial ship, 146–147, 147–148, 149	Casulana, Madalena, 245
Baroque	Boccaccio, Giovanni, 197, 199-203, 247	Burial ship, purse cover from, 149, 151	Catch-22 (Heller), 501 Catharsis, 75, 78
architecture, 342, 342–343 dance, 346–347	Boccioni, Umberto, 457, 457	Burke, Edmund, 400	Cathedrals, gothic, 176–184
of England and Spain, 348–349	Bodhisattvas, 114, 143, 143 Body, cult of the, 53	Burnet, Thomas, 400	Catholic Church, 119, 264, 272-273, 275,
in Italy, 324–331	Boffrand, Germain, 367, 367	Burroughs, William S., 510 Bushido, 305	283, 310–311, 324, 331, 414. See also
literature, 324–325 music, 331–333, 340, 341, 346–347	Bohr, Niels, 448	Buttress, 93, 93, 179-180	Counter-Reformation Cavalier, 348
in northern Europe, 333–341	Boleyn, Anne, 269, 272 Bolshevik Revolution, 471	Byron, Lord, 403, 403-404	Cave art, 1, 2, 3, 3-4, 10
opera, 332	Bonaparte, Napoleon, 388, 390–392. See also	By the Rivers of Babylon (Palestrina), 316, 316 Byzantine Empire	Cave painting with bird-headed man, bison,
painting, 325, 328–336, 343–344,	Napoleon	architecture, 131–132, 131–132	and rhinoceros, 3 Cave painting with giraffes, zebra, eland, and
343–349, 348–349	Bon, Bartolomeo, 239	art, 134, 134	abstract shapes, San people, 10

Cave painting with horses, Chauvet Cave, 1 Chinoiserie, 377, 440 Combine paintings, 490 China, 377-379 Celibacy, 310 Europe, 377-379 Chi Rho Iota page, Book of Matthew, Book of Comédie-ballets, 346 Cella, 51-52, 61 Kells, 152 Comedy, 67-68 South Pacific, 376-377 Celtic culture, map of, 147 Cemetery at Ur, 17, 17 "Come, Holy Ghost, our souls inspire" Crossing Brooklyn Ferry (Whitman), 438, 438 Chiton, 56, 62 (Luther), 272
Commentaries (Ghiberti), 212
Committee for General Security, 388 Chivalric code, 155 Chivalry, 153–154 Chopin, Frédéric, 409 Crucifixion (Grünewald), 258, 259 Cenami, Giovanna, 253–255, 254–255 Central Italy, 190 Crucifixion, in *Isenheim Altarpiece*, 260 "Cruel Are the Pains I've Suffered" (Beatriz Central-plan church, 128, 128 Chorale music, 268, 341 Commodus, 96 de Dia), 170 The Century of Louis XIV (Voltaire), 376 Choral music, 167 Commune, 191-192 Crusades, 145, 167-168, 187 Communist Manifesto (Marx/Engels), 417 Ceramic figures, Neolithic era, 7-8 Chorus, 67-68, 68-69, 70 Cruz, Juan de la, 323 Ceres, 50 Chorus structure, 68 Como Cathedral, 313 Cubicula, 100, 100 Como, Perry, 469 Composition VII (Kandinsky), 459, 459 Cereta, Laura, 243-244 Cubism, 455-456, 461 Chrétien de Troyes, 170-171, 198 Cerro Gordo volcano, 281 Cervantes, Miguel de, 324, 351 Cézanne, Paul, 448, 451, 451, 454–455 Cult of the Virgin, 171, 176, 177–178 Christe eleison, 158-159 Concerning Famous Women (Boccaccio), 204 Concerning the Spiritual in Art (Kandinsky), 458 Christian churches, 126, 126-129 Cults, 129 Christianity. See also Monastery, medieval in Anglo-Saxon society, 147–148 architecture, 117, 117, 126–129, 127 Augustine, 126, 129–130, 184 Cultural hegemony, 290 Cultural identity, 438–443 Concert bruitiste, 465 Chador, 139 Cultural patronage, 305–308 Cultural syncretism, 294 Chamber of Deputies, 413, 415–416 Concert for Piano and Orchestra (Cage), 491 Chambers, William, 378 Chan Buddhism, 296, 300 Concerto, 332–333 Concrete, 94 Byzantine Empire, 130–134 Culture Chandragupta Maurya, 114 Carolingian culture, 120, 153 Condition of the Working Class in England Hispanic, 510 Chang'an, China, 294, 294-295 Christian Rome, 116-117, 119 (Engels), 417 Latino, 510 early philosophy, 129–130 evangelists, 123–124 Change, 75, 80 Condottiero, 221 Culture, early, 2-10 Culture identity, non-Western cultures, 417 Chansons de geste, 153 Confessions (Augustine), 129-130 Character pieces, 409 Chardin, Jean-Baptiste-Siméon, 373–374, Gospels, 123-124 Confucianism, 106, 107, 295 Confucius, 105–106 Cuneiform writing, 18 Cunningham, Merce, 491 Gospels, 123–124 Islamic influence, 119–121 in Japan, 308–309 Jewish influence, 123–124 Judaic culture, 121–122 liturgy standardization, 158 Congo, atrocities in, 455 Connor, Bull, 496 Cupid and Psyche (Natoire), 367, 367 373-374 Chariot racing, 52 Charlemagne, 148, 153–154, 154, 155, 159. See also Carolingian culture Charles I, king, 348, 348 Cuzco, 283-284 Conrad, Joseph, 443, 443 Cyclades, 41, 41-42 Constable, John, 397, 397-399 Cyclopean masonry, 46 miracle and emotion, 258-260 Constantine I, 117, 119 Cyclopes, 46 Constantinople, 121, 130, 131, 145 Cyclops (Euripides), 67 Charles II, king, 351 myths in, Greek and Roman, 128-129 Constitutional Convention, 388 Contarini family, 238 Cyrus II, 27 Charles III, king, 159 Nicene Creed, 159 pagan styles, merging with, 151-152 Charles IV, king, 349 Continental Congress, 384 Contrapposto, 62, 63, 124, 182, 216, 228 Conversation piece, 255 Charles the First (Basquiat), 502, 503 Ravenna, 134 Dactyl, 90 Charles the First (Basquiat), 302, 305 Charles the Great. See Charlemagne Charles V, emperor, 227, 233, 261, 310, 314 Charles VIII, king, 225 Charles X, king, 413, 415 Chartres Cathedral, 174–175, 175–183, rise of, 122–130 Dactylic hexameter, 90, 92 Roman and Greek influences on, Dada, 464-467 126-129 Conversion of St. Paul (Caravaggio), 329, 329 'Dada Manifesto 1918" (Tzara), 464 in Rome, 116-117, 119 Cook, James, 376-377 Daedalus, 45 sculpture, 125, 125 Copernicus, Nicolaus, 357 Daguerre, Louis-Jacques-Mandé, 422 Daguerreotype, 422 Daimyo, 305, 308, 309, 310 176-178, 181-183 symbols and iconography, 124-125, 125 Córdoba, 141, 141-142 Chatras, 115 Christos, 117, 124 Coricancha, 283-284 Chattri, 293 Christ Preaching (Rembrandt), 340, 340 Christ's Tomb, 123, 123 Coricancha stone wall, 283, 284 d'Alembert, Jean le Rond, 374, 374-375 Corinth, 50, 51 Dalí, Salvador, 477 Dance, 346-347 Chaucer, Geoffrey, 202-203 Corinthian order, 52, 54, 55, 94, 98 Cornaro Chapel, 325, 326, 327 Chronicles of Japan, 302 Church of England, 266, 348 Chauvet cave painting, 1, 3–4, 15 Chauvet, Jean-Marie, 1 Cheng Sixiao, 297, 297 Dance Class (Degas), 432, 432-433 Church of San Luigi dei Francesi, 328 The Coronation of Marie de' Medici (Rubens), Dance II (Matisse), 458 Chevreul, Michel-Eugène, 431, 447 Cicero, Marcus Tullius, 87, 267 The Dancing Couple (Steen), 335, 335 Chicago, 468-469 Cieza de León, Pedro de, 284 Corporation of Imagemakers, 250 Dancing House (Gehry/Milunic), 506, 507 Correggio, 320, 320, 323 Cortés, Hernán, 277–279, 278, 284 Cosí fan tutte (Mozart), 407 Cosquer Cave, 2 Cotton Club, 469 d'Andrea, Novella, 184, 185 Dante Alighieri, 198, 206, 267 Chicago, Judy, 505, 505-506 Cimabue, 194, 194-197 Cities, gothic style and, 173 Chicago's Columbian Exposition, 447 "Child of the Americas" (Morales), 510, 510
The Children's Crusade: A Duty-Dance with
Death (Vonnegut), 501
The Child's Brain (de Chirico), 474, 475 Dao de Jing, 105, 105 Daoism, 105, 295, 296 The City of God (Augustine), 130, 130 City-states, 39, 40, 49–60 Darby, Abraham, 359 Civilization, 2 Civil Rights Act, 497 Council at Whitby, 157 Darby, Abraham III, 359 Civil War Council of Churches, 213 Darius and Xerxes Receiving Tribute, 27 China in age of encounter, 294-302 American, 422, 426 Council of Clermont, 167 Darius III, 72, 261 British in, 440-441 Council of Five Hundred, 59 Darius, king, 27, 27, 59, 72 slavery and, 421-422 bronze work, 104, 104-105 Classical music, 406-409 Council of Trent, 275, 316-317, 319, 324, Dark Ages, 49 The Dark Night of the Soul (John of the Buddhism, 142-143 Classical orders, 54-55, 54-55 Count Emicho of Leiningen, 168
Counterpoint, 183, 310, 332, 337, 341
Counter-Reformation
architecture, 312, 312–313
art and, 316–317 Cross), 323
Darling, Patrick, 286
The Damley Portrait of Elizabeth I (Zuccaro), Confucianism, 296 Classical style of art, 73-74 cross-cultural contact, 377-379 Clay, Jean, 400 Clay soldiers, 108–109 culture of, 417 273 Clement VII, pope, 226, 233, 261 Daoism, 296 Darwin, Charles, 359 dragons in art, 302, 302 Clerestory, 127 Council of Trent, 275, 316–317, 319, Darwin, Erasmus, 359 early culture, 103-106 Cliff dwellings, 11 Family life in, 105
Great Wall of China, 103, 103, 106
Han Dynasty, 107–111
housing, 110, 110
imperial, 106–111 324, 331 Das Kapital (Marx), 417 Cloisonné, 149 Cloister, 157 Inquisition, 321–323 Daumier, Honoré, 419-420, 420, 424 Clooney, Rosemary, 469 Mannerism, 315-324 David (Bernini), 327, 327, 331 David (Donatello), 216, 216, 227 Cluniac order, 166 music of, 310-311 David (Michelangelo), 228, 228, 327 Cluny, Abbey of, 166, 166 overview of, 275 David and Court Musicians, Vespasian Psalter, 152, 152 Courbet, Gustave, 420, 420–421 Court at Versailles, 342, 343–348 introduction to, 83–85, 102–103 literature, 103–106, 107, 295, 300–301 Cluny and the monastic tradition, 166, 166 Cluny III, 166-167 Courtly love, 169–170
Courtly love, casket with scenes of, from Limoges, 169, 169–170
Cousin Bette (Balzac), 418 David, Jacques-Louis, 381, 381, 386, 386–392, 389–391, 413 Coatlicue, Aztec, 276-277, 277-278 luxury arts, 302, 302 Coffers, 98 Coleridge, Samuel Taylor, 395 map of, 103 Da Vinci, Leonardo, 222-225, 223-226, 247 Ming dynasty, 296-300, 334 Day, Doris, 469 music, 106, 107 painting, 298–300 Cole, Thomas, 436, 437 Coyolxauhqui, 277 Cranach, Lucas, 263 Day of the God (Gauguin), 452, 452 Collegia, 184 Collins, Phil, 515, 515 Day, Thomas, 395 papermaking, 111 Crane in Bruges, 248-249 poetry, 105, 107, 300–301 Qin Dynasty, 103–105 Colonel Jack (Defoe), 366 Dead, in art, 33 Creation myth, 11-12, 45, 286 Dead Sea Scrolls, 121 Colonization. See Encounter, Age of Qing dynasty, 297, 301 religion in, 105 Colonnaded street in Thamugadi, 83 Colonnades, 39, 39–40 Death masks, 47, 47, 283 Creation of Adam (Michelangelo), 229-230, 231, 372 Death of Sarpedon, 57, 57 Decameron (Boccaccio), 199–202, 200, 247 de Chirico, Giorgio, 474, 475 Shang Dynasty, 103–105, 104 silk, 110, 110 Creation of Eve (Michelangelo), 229, 231 Color Credo, 159 harmonies of, 449 Declaration of Independence, 384–385 The Declaration of Independence, 4 July 1776 (Trumbull), 385 Crete, 41, 42-45 soldiers and horses, Emperor Shihuangdi structure of, 451 Cribbed roof construction, 11 tomb, 108-109, 108-109 symbolic, 449-451 Critique of Judgment (Kant), 395, 400 Critique of Pure Reason (Kant), 399 Crito (Plato), 65 The Colors of Mount Taihang (Hui), 379, 379 Colossal Buddha, 143 Song dynasty, 295-296, 298-299 Declaration of the Rights of Man and Tang dynasty, 294, 294–295 Colossal buddha, 143 Colossal head, Olmec, 280, 280 Colosseum, Rome, 94, 94, 218, 225 Column of Trajan, Rome, 95, 97, 160 Columns, 52, 54–55, 61–62, 62, 64, 94, Citizen, 386-388 women in, 107 Yuan dynasty, 296 Cromlech, 8 Dedicatory statues, Abu Temple, 16, 16 Zhou Dynasty, 105-106 Cromwell, Oliver, 348 Deductive method, 356 Deductive reasoning, 356 Chinese house, Exposition Universelle, 445 Crosby, Bing, 469 Cross-cultural contact, 376-379 The Defects of Women (Passi), 244 Chinggis Khan, 296

Defense of Liberal Instruction for Women Donne, John, 329, 329, 350 Ellington, Duke, 469 Estates, 386 Don Quixote (Cervantes), 324, 365 (Cereta), 243, 243-244 Ellington, Edward Kennedy, 469 Estates General, 386 Defoe, Daniel, 366 Doomsday Book, 162 Ellison, Ralph Waldo, 498, 498-499 Ethelwald, 151 Degas, Edgar, 428, 431-433, 432 Dorians, 49, 51 The Embarkation from Cythera (Watteau), 368, 369–371, 370–371 Et in Arcadia Ego (Poussin), 346 De Goncourt, Edmond, 428 Doric columns, 62, 62 Etruscans, 85 De humani corporis fabrica (Wesel), 339 Deism, 356 Embryo in the Womb (da Vinci), 223 Emergence tales. See Creation myth Emerson, Ralph Waldo, 438, 438 Doric order, 52, 54, 54, 61, 64 Études, 409 Dorsey, Tommy, 469 Eucharist, 128, 134 Euclid, 70, 76, 235 De Kooning, Willem, 486–488, 487 Delacroix, Eugène, 413, 413–416, 415 Doryphoros (Spear Bearer), 37, 37, 63, 63-64, 74, 89, 124, 182 Emotion, and Christian miracle, 258-260 Eudaimonia, 40 Delagive, 342 Double axes, 43, 44 Emperor Justinian with Maximian, Clergy, Eugénie Grandet (Balzac), 418 Delamare, Delphine, 418 Eugenius IV, pope, 214 Eumenes I, 76 Double entendres, 245 Courtiers and Soldiers, 134 Delaunay, Robert, 447, 447 Douglas, Aaron, 469, 469 Empirical investigation, 74 Del Monte, Cardinal, 328 Douglass, Frederick, 419 Empirical method, 355-356 Eumenes II, 77 Delphi, 51 The Dove (Bearden), 499, 499 Empress Theodora with Courtiers and Ladies of Euphiletos, 52 Delphic oracle, 60 Delvau, Alfred, 427 Doyen, Gabriel-François, 372 Her Court, 134 Euphronius, 57, 57 Dragons, in Chinese art, 302, 302 Enchinus, 52 Euphussi, Charles, 435 Demes, 59 Drama. See Theater Encounter, Age of Euripides, 59, 67, 68, 70, 75 Demeter (Ceres), 50 Drummers (Robbia), 220, 220 "Drum Taps" (Whitman), 439 Drusus, 90 Americas, 277-284 Europe. See also Renaissance; specific countries Democracy, 59-60 China, 294-302 after the War, 485–486 Anglo-Saxons artistic style and culture, Democritus of Thrace, 65 India, 291-294 Dryden, John, 354–355, 355 Dryden, John, 354–355, 355 Dry landscape gardens, 306 Ducal courts, 187–188, 221–225 Duccio, 192–194, 193 Demokratia, 59 introduction to, 277-279 149-153 De Piles, Roger, 346 Japan, 302-309 Black Death, 176, 199-205, 210, 259 De Pizan, Christine, 204-205 map of world exploration, 279 Carolingian culture, 152-159 Der Blaue Reiter, 458 Portuguese, 284-291 courtly love, 169-170 Descartes, René, 356 Duchamp, Marcel, 465-467, 466 cross-cultural contact, 377-379 Spain, 280–284 Description de l'Égypte, 441 The Desire (Casulana), 245 Dufay, Guillaume, 214, 233, 331 West Africa, 277–279, 284–291, 285 Encyclopédie (Diderot), 374, 374–375 Crusades, 145, 167-168, 187 Du Fu, 295 India and Europe, 291-294 Determinatives, 32 "Dulce et Decorum Est" (Owen), 463, 463 Engels, Friedrich, 417 introduction to, 147-148 Deuteronomy, 25, 25 Dunciad (Pope), 363 England pilgrimage churches, 148, 162–167 post-World War II period, 485–486 Devi, goddess, 113-114 Duomo. See Florence Cathedral Durand, Asher B., 436–437, 437 absolutism vs. liberalism, 359–360 Devi Mahatmayam, 113 Romanesque, 164–165, 164–165 vernacular literature, 198–205 architecture, 352-354 Dhammapada, 114 Durán, Diego de, 278, 278 Baroque court arts in, 348-349 Dharma, 113 Durendal, 155 civil war in, 348 Euxitheos, 57, 57 Dharmachakra mudra, 143 Dürer, Albrecht, 255, 260, 260, 284, 340 deductive method, 356 drama, 269–270 Evangelists, 123-124 Dhyana mudra, 143 Durga, 114, 114 Evans, Arthur, 43-44, 44 Diaghilev, Sergei, 459-460 Durrington Wells, 9, 9 empirical method, 355-356 Evelyn, John, 333 Dialectic, 417 Durrington Wells in relation to Stonehenge, English Garden, 364–365 Ever Is Over All (Rist), 516, 516 Dialectical method, 66, 185 Industrial Revolution, 358-359 Eweka, 286 Diana (goddess), 50 Dutch Reformed Church, 333 literacy and new print culture, 365-367 Excavation (de Kooning), 487, 487 Dyck, Anthony van, 348 Diaries (Murasaki Shikibu), 303, 303 maps of, 147 Existentialism, 484 Dias, Bartholomeu, 284 Dylan, Bob, 497 painting, 272–273 satire, 262–263, 361–364 An Experiment on a Bird in the Air-Pump Diaspora, 26, 498 Dynamics, 331 Diaspora, 20, 490 Díaz, Bernal, 279, 280, 280 Dich, teure Halle (Wagner), 427 Dickens, Charles, 392, 418 (Wright), 358 Scientific Revolution, 351, 355-358 Exposition Universelle, 445, 445, 452 Ea (god), 17, 23 English East India Company, 440 English Enlightenment, 354–367 Expressionism, 77, 78, 79, 81, 458-459 Eadfrith, bishop, 151, 151 Dictionary of the English Language (Johnson), Early Spring (Guo Xi), 298-299, 301 English language, 150 Facade, 94, 96 The Eastern Buddhist (Suzuki), 311 Enki (god), 17, 23 Enkidu, 21–22, 24 Faience, 43 Diderot, Denis, 374, 374-375 Eastern Orthodox Church, 121 Falange, 481 The Dinner Party (Chicago), 505, 505-506 Ebony, Look, and Life, 499 Eckford, Elizabeth, 496, 497 The Ecstasy of St. Teresa (Bernini), 326, Enlightenment, 416, 443 Family life, 89-90, 105, 242-243 Dinocrates, 76 absolutism vs. liberalism, 359-360 The Family of Man exhibition, 489 Dinteville, Jean de, 272 deductive method, 356 Fantasie impromptu (Chopin), 409 Diocletian, 117 326, 418 empirical method, 355–356 English, 354–367 Farce, 67 Diogenes the Cynic, 235 Ecumenical church, 126 Farnsworth House (Mies van der Rohe), Dionysus, 65, 67, 68, 70, 72, 101 Edison, Thomas, 445 English Garden, 364–365 in France, 367–376 492, 492 Dionysus (Bacchus), 50 Education, 183, 185, 242, 295 Edward the Confessor, 160 Eghaverba, Jacob, 286–287 Fasting, 135 Dionysus, cult of, 129 Industrial Revolution, 358-359 Father Goriot (Balzac), 418 Faust (Goethe), 404, 404 Discalced carmelites, 323 introduction to, 354 The Ego and the Id (Freud), 474 Discourse on Method (Descartes), 356 literacy and new print culture, 365-367 Discourse on Political Economy (Rousseau), 378
Discourse on the Method of Rightly Conducting
the Reason and Seeking for Truth in the
Sciences (Descartes), 356 Fauvism, 458 Egypt. See also Pyramids literature, 359-364 Feast in the House of Levi (Veronese), Alexander the Great, 71-72, 72 rationalism, 355-358 321-322, 322 Amarna style, 35 satire, 361-364 Federal Convention, 392 ancient, 27-36 Scientific Revolution, 351, 355–358 Federal style, 392 Discourse on the Origin of Inequality among architecture, 28, 28, 31-34 Enlil (god), 17, 20, 23 Feet, 90 Men (Rousseau), 375, 375 culture, stability of, 27-28, 53 Ennui, 404 Female deities, 43 Disney, Walt, 484 floods, 28-30 En plein air, 451 Female nudity, 74 Disputà (Raphael), 232 Middle Kingdom, 29 Entablature, 54, 64 The Feminine Mystique (Friedan), 504 Dispute over the Sacrament (Raphael), 232 Nebamun Hunting Birds, Thebes, Entasis, 52, 61 Feminism, 204-205, 243 Dissections, 338 29, 29 Environmental movement, 519 Feminist movement Dissertation on Oriental Gardening New Kingdom, 29, 34–36 Nile River culture, 28–30, 29 Epic, 20-24. See also Homer feminist art, 505-506 (Chambers), 378 Epic conventions, 47 feminist poetry, 504 Dissolution Act of 1536, 266 Old Kingdom, 29, 31-34 Epic of Gilgamesh, 20-24, 21-22 theoretical framework, 504 Dissolution of the Monasteries, 267 pictorial formulas in art, 31, 33 Epicurus, 234 Feng shui, 297 Diversity religion, 30-31 Epistolary novel, 366 Ferdinand, Archduke Francis, 462 postmodern literature, 509-510 rise and fall of, 441 Epithets, 21 Ferguson, James, 358 postmodern paintings, 507–509 Divine Comedy (Dante), 198–199, 206, sculpture in, 34, 37, 37 Equestrian statue of Charlemagne, 154 Ferguson, William M., 11 Equiano, Olaudah, 393, 393–394 Tutankhamun tomb, 35, 35 267 Divine Office, 156, 159 Ferris wheel, 447 Eiffel Tower, 447, 454 Equites, 87-88, 89 Fêtes galantes, 369 Eight Immortals of the Wine Cup, 295 Erasmus, Desiderius, 262-263, 264 Fetish, 290 Dixieland jazz, 468 Ein feste Burg ist unser Gott (Luther), Erechtheion, 62, 62 Dixit dominus from Psalm, 158 Feudal hero, 154 Erechtheus, 62 Djingareyber Mosque, 140, 141 Dodge, Granville, 439 Doge's Palace, 237, 238, 238 Feudalism, 46, 148, 154–155 Einstein, Albert, 448 Eriksson, Leif, 159 Feudal system, 46 Eisenhower, Dwight D., 496 Eroica (Beethoven), 408 Feudal values, 153–154 Ficino, Marsilio, 217, 218 Eisenstein, Sergei, 448, 471–472, 472–473, Eros, 50 Dogma, church, 126 Esigie, 288-289 Fief, 148 Dome, Brunelleschi's, 213-214 El Dorado, 284 Espalier, 101 Fielding, Henry, 366 Dome of Heaven, 115, 115 Eleanor of Aquitaine, 169-170, 175, 177 Essay on Human Understanding (Locke), Figurine of a women from the Cyclades, 41 Dome of the Rock, 118-119, 119, 136 Elevation, 52 360, 360 Film School in Moscow, 471 Domes, 132, 132 An Essay on Man (Pope), 363, 363 Essay on the Morals and Customs of Nations Elgin Marbles, 65 Fingal's Cave (Mendelssohn), 409 Dominic, 175, 185 El Greco, 323, 323 Finials, 252 Domus, 100-101 Eliasson, Olafur, 519, 519 (Voltaire), 378 First Estate, 386 Donatello, 216, 216, 227 Eliot, T. S., 463-464, 463-464 Essays in Zen Buddhism (Suzuki), 311 First Impressions (Austen), 367 Don Giovanni (Mozart), 407 Elizabethan stage, 269-271 Essays on the Picturesque (Price), 401 First Triumvirate, 87 Dong Qichang, 300, 301 Elizabeth I, queen, 267, 269, 273, 348 Essenes, 121 Fitzgerald, Ella, 469

Fitzgerald, F. Scott, 468	Declaration of the Rights of Man and	Giorgione de Castelfranco, 239-241, 240	painting, 41, 52
Five Angels for the Millennium (Viola), 514, 514	Citizen, 386–388 French satire, 376	Giornata, 197 Giotto, 195, 196–197, 198–199, 209	and Persia, 59–60 philosophy, 64–67
Five Good Emperors, 94, 97	Fresco	Giovanni Amolfini and His Wife (Van Eyck),	polis, 39–40, 64–67
Flaubert, Gustave, 418-419, 424	The Apotheosis of St. Ignatius (Pozzo), 324	253–255, 254–255	pottery, 48, 48
Flemish Renaissance, 251-253. See also	Arena Chapel, Padua (Giotto), 195-197,	Giraud, Albert, 460	religion in, 50, 56
Renaissance, in Northern Europe	196–197	Girl before a Mirror (Picasso), 476, 476	Rome, influence on, 85
Floods, Egypt, 28–30	Bull Leaping (Toreador Fresco), from the palace complex at Knossos, Crete,	Giuliani, Rudolph W., 511 Giza, Egypt, 28, 28	sacred sanctuaries, 50–51 sculpture, 37, 53, 53–56, 63, 63–64
Florence Cathedral, 208–209, 213–214	42, 42	Glaber, Raoul, 162	Sparta, life in, 51, 59–60, 64
Florence, Italy. See also Black Death;	buon fresco, 196-197	Glaucon, 66	temples of Hera at Paestum, 52, 54, 61
Renaissance, in Florence	Last Supper (da Vinci), 224, 224–225	Glazing, 225, 253	theater, 67–71
architecture, 217–218 as archrival of Siena, 191–192	Libyan Sibyl (Michelangelo), 230, 231 Maestà (Martini), 193, 193	Global confrontation, age of. See Modernism; World War I	Greek cross, 227 Greek polis, 49–60
guilds in, 191	Miniature Ship Fresco, 41, 41–42	Global interaction, 277–311	Greek vs. Roman portraits, 87–88
introduction to, 175–176	Sistine Chapel, 226, 227-231, 229-230,	Globe Theatre, 269-270, 270	Greeley, Horace, 439
Lorenzo the Magnificent, 218-221	317, 318–319, 329	The Goddess Durga Killing the Buffalo Demon,	Green on Blue (Rothko), 483, 483
map of, 190	The Tribute Money (Masaccio), 215, 215–216	Mahisha, 114, 114 Gods/goddesses, 30–31, 43, 50, 113, 114,	Greffe, Bruges, Belgium, 188 Gregorian chant, 158
Medici family, 209–221, 228 music, 214	Freudian psychology, 504	114, 284–286, 302. See also Religion	Gregory I, pope, 151, 158, 172
naturalism in painting, 192–195	Freud, Sigmund, 474	Goedaert, Johannes, 334, 334, 377	Grimm, Baron von, 368
naturalistic representation, 214-216	Friedan, Betty, 504	Goethe, Johann Wolfgang von, 404,	Groin vault, 93, 93, 177, 177
painting, 192–195, 215, 215–216, 219,	Friedrich, Caspar David, 399, 399, 402,	404, 409 Gold and silver, 284	Gros, Antoine-Jean, 402, 403 Ground-line, 18
223–226 Renaissance in, 209–221	402, 409, 517 Friezes, 54, 63, 77, 77–78, 89	Golden Age of Greece, 40, 60–71	Groundlings, 269
republic of, 190	Fujiwara clan, 302	Golden House, 94	Group portrait, 336–337
scientific perspective, 214-216, 215	Fuller, Peter, 507	Golden Mean, 75	Grünewald, Matthias, 258-259, 258-259
sculpture, 210–211, 211–212, 216, 216,	Funerary architecture. See Tombs	Gonzaga, Federico, 320	Guang, 104, 104
220, 220, 228 Florence, Renaissance, 192–195	Funerary customs, 35, 46–47, 53, 115, 115, 146–147, 147–148, 150, 283. See also	Goodman, Benny, 469 Good Manners of the Wise King Charles V (de	Guernica (Picasso), 481, 481 Guerrilla Girls, 506, 506
Florentine Academy of Design, 330	Tombs	Pizan), 204	Guidobaldo della Rovere, 240
Flower Hammer (Arp), 465, 465	Funerary masks, 35, 47, 47	The Good Shepherd, 124, 125	Guido of Arezzo, 167
Flowers in a Wan-li Vase with Blue-Tit	Futurism, 457–458	Good Shepherd, Christ as, 124, 125	Guilds, 191
(Goedaert), 334, 334, 377 "Flowers of Evil" (Baudelaire), 424	Fu Xi, 104 Fu Xuan, 107	Gordon, George, 403, 403 Gorky, Arshile, 486	Guitar, Sheet Music, and Wine Glass (Picasso), 456, 457
Fluxus movement, 311	Fyre and Lightning (Morley), 268	Go Shirakawa, 305	Gulliver's Travels (Swift), 361–362, 362
Flying buttresses, 179–180, 180	1 you than 2 granting (2.22-22-77), 2.22	Gospels, Christian, 123-124	Guo Si, 298
Folk music, 497	Gabrieli, Giovanni, 331–332	Gothic church, 145	Guo Xi, 298–299
Fonteo, Giovanni Battista, 313	Gachet, Paul, 450	Gothic style architecture, 174–175, 177, 179–182,	Gutenberg Bible, 267 Gutenberg, Johannes, 267, 267
Fontina Mix (Cage), 491 Foot-race at Panathenaic Games, 52	"Gadji beri bimba" (Ball), 465 Gaius Julius Caesar. See Julius Caesar	187–188	Outenberg, Johannes, 201, 207
Forbidden City, 296–300, 297, 298	Galerie Dada, 465	cathedrals, 176–184	Hackwood, William, 395
Ford, Henry, 448	Galerie des Glaces, 342	Chartres Cathedral, 174-175, 175-183,	Hades (Pluto), 50
Foreshortening, 211	Galilei, Galileo, 357	181–183 in cities, 173	Hadith, 138, <i>13</i> 8 Hadrian, 94, 98, 98, 122
Fortified city, 32, 33 Fortissimo, 408	Gama, Vasco da, 284 Ganelon, 154	definition, 175	Hadrian's villa, 102
Forty-Two Line Bible, 267	Garden of Earthly Delights (Bosch), 255–258,	in French Ducal courts, 187–188	Haeberle, Ron, 501, 504
Forum of Trajan, 95, 97, 98, 99	256–257, 349	introduction to, 175-176	Hagesandros, 81
Forum Romanum, 94–95	Garden of the Daisen-in of Daitokuji, Kyoto	music, 183–184	Hagia Sophia, 132, <i>132</i> Haiku, 303
Foucault, Michel, 509 Foundation myth. See Creation myth	(Soami), 307, 307 Gardens, 101, 342, 342	overview of, 173 vs. Romanesque, 173	Најј, 135, 138
Founding and Manifesto of Futurism	Garden Scene, 101	Saint-Denis, 175–177, 176	Halley's Comet, 160
(Marinetti), 457	Gardner, Alexander, 423, 423	scholasticism, 185–186	Hall of Mirrors, Versailles, 342, 344
Fountain (Duchamp), 466, 466-467	Gardner's Photographic Sketchbook of the War	sculpture, 180–183, 181–183, 184	The Hall of Supreme Harmony, 300
The Four Horsemen of the Apocalypse (Dürer),	(Gardner), 423, 423 The Gates of Paradise (Ghiberti), 212,	stained glass, 176, 176, 178, 178 university, rise of, 185	Hamlet (Shakespeare), 270–271, 270–271
260, 260 Fournaise, Alphonsine, 435	212–213	Goya, Francisco, 404–406, 404–406	Hammurabi of Babylon, 19
Four Noble Truths, 114	Gaud, Fernand, 455	Grammophon, Deutsche, 484	Hand, 320
The Four Seasons (Vivaldi), 333	Gauguin, Paul, 448, 451-454, 452, 458	Grand Canal, Versailles, 342	Han Dynasty, China, 105–106, 107–111, 110
Fragonard, Jean-Honoré, 372, 373	Gauls, 78–79	Grands boulevards, 423–424 Grand Staircase, Palace of Minos, 44, 44	Hangzhou, China, 295–296 Hanson, Duane, 484, 484
France. See also Exposition Universelle; French Revolution; Paris, France;	Gay, Peter, 383 Gazelle trap, 32	Gravitas, 222, 245	Haram Mosque, 139
Versailles	Gazette des Beaux-Arts, 428	Grazia, 222	Hardin, Lil, 468
agriculture in, 5	Gehry, Frank, 506-507, 507	Great Fire, London, 354–355	Hardouin-Mansart, Jules, 342
Capetian France, 159-162	General Principles of Relativity (Einstein),	Great Goddess, 43	Hardrada, Harold, of Norway, 160
Carolingian culture, 159–162 cave art locations map, ii	448 Genesis, 24–25	Great Migration, 467 Great Mosque of Córdoba, 141, 141–142	Harlem Art Workshop, 470 Harlem: Mecca of the New Negro, 467
enlightenment, 367–376	Genet, Jean, 486	Great Mosque of Damascus, 142	Harlem Renaissance, 467–468, 497, 498
French garden, 342, 342	Geneva, Switzerland, 265–266	Great River Valley civilizations, 2	Harold of Wessex, 160–161
literary realism, 418–419	Genre scenes, 335–336, 345	The Great Stupa, 115, 115	Harper's Weekly, 436
Francesco Petrarca (Castagno), 201, 201	Gentileschi, Artemesia, 330, 330–331,	Great Wall of China, 103, 103, 106 Great War. See World War I	Harris Treaty, 441 Hartmanszoon, Hartman, 339
Francis I, king, 310 Franco, Cirillo, 319	350, 351 "Gentle Manifesto" (Venturi), 507	The Great Wave (Hokusai), 442, 442	A Harvest of Death, Gettysburg, Pennsylvania
Franco, Francisco, 481	Geocentric, 357	Greece, 38-81. See also Acropolis; Athens;	(O'Sullivan), 423, 423
Franco-Prussian war, 428	George I, 361	Hellenistic world	Hathor (god), 31, 32
Franco, Veronica, 244–245	George II, king, 363	amphora, 48, 48, 52 architecture, 49, 50–51, 50–56, 60–61,	Haussmann, Baron Georges-Eugène, 424, 428, 441
Frankenthaler, Helen, 488–489, 489 Frankish kingdom. See Carolingian culture;	Georgics (Virgil), 90, 90 Géricault, Théodore, 411, 413, 416, 420	60–64, 64, 68–69	Haussmannization, 424
Charlemagne	Germany, 258–260, 399, 402, 448, 458,	Athenian pottery, 56–58, 57	Haydn, Joseph, 407
Franklin, Benjamin, 359	460, 462	Bronze age culture, 40–49	Haymarket Riot, 436
Frank, Robert, 489-490	Germany, Renaissance in, 258–260. See also	Christianity, influence on, 126–129	The Hay Wain (Constable), 397, 397
"Fred and Ginger" (Gehry/Milunic), 506, 507	Renaissance, in Northern Europe Gertrude Stein (Picasso), 453	city-states, 39, 40, 49–60 classical orders, 54–55, 54–55	Hazlitt, William, 398 Head, Nok, 7
Free association, 474 Free commune, 191–192	Gertrude Stein (Picasso), 433 Ghana, 141	cult of the body, 53	Head of a King (or Oni), 285, 285
Free organum, 167	Ghent, Belgium, 253–255	Delphi, 51	Head of an Akkadian Man, 18, 18
Free Speech Movement, 501	Ghiberti, Lorenzo, 210–213, 211–212	democracy, rise of, 59–60	Head of an Oba, 287, 287
French Compagnie des Indes, 440	Ghost Dance, 439–440	Egyptian influence on sculpture, 53–56 gods and goddesses, 50	Heart of Darkness (Conrad), 443, 443 Hebrew Bible, 23–24, 25, 121, 126, 129.
French ducal courts, gothic style in, 187–188 French East India Company, 440	Gibbon, Edward, 392 Gibbs, James, 364	golden age of, 40, 60–71	See also Bible
French garden, 342, 342	Gilpin, William, 401, 401	Hellenistic period. See Hellenistic world	Hebrew Bible (Deuteronomy), 25
French National Assembly, 428	Gin Lane (Hogarth), 363, 363	Homeric epics, 21, 47–49	Hebrews, 26. See also Jewish people
French Revolution, 445 Declaration of Independence, 384–385	Ginsberg, Allen, 311, 490, 490 Giocondo, Francesco del, 225	literature, 47–49, 50, 58 Olympia and the Olympic Games, 52–53	Hebrides (Mendelssohn), 409 Hector, 47–48
Declaration of Independence, 384–383	Olocolido, Francesco del, 223	orympia and the orympic cames, se-ss	

Heel, Dudok van, 337	Homeric epics, 47–49	India	literature, 244-245
Hegel, Georg Wilhelm Friedrich, 392, 417	Hominins, 4	Alexander the Great, 71-72	map of, 190, 210
Hegelian dialectic, 417	Homophonic harmony, 268	architecture, 111, 113, 115, 115, 292-293,	
Heiankyo, Japan, 302, 304, 305	Homo sapiens, 4	293	painting, 192–195
Heian period, 302–304	Hooke, Robert, 357, 357	British in, 440–441	Renaissance feminists, 243–244
Heijo Palace, 302	Hopi people, 11, 12	Buddhism, 114–115	Iwan, 294
Heiligenstadt Testament (Beethoven), 407, 408		culture of, 417	Izanagi, 13
Hei-tiki, 377	Horarium, 156-157, 159	Hindu in, 113, 114	Izanami, 13
Helen of Troy, 47, 49	Horn, Walter, 153	introduction to, 82	
Heliocentric (sun-centered) theory, 357	Horus, 30–31	Islam in, 291–293	Jacobello dalle Masegne, 184
Hellas, School of, 60	Horus (god), 31, 32	literature, 113	Jacobins, 388
Hellenistic world. See also Greece	Hotter Than That (Armstrong), 469	map of, 111	Jahangir in Darbar, 292, 292
Alexander the Great, 71–72, 72, 89, 235, 261	House model, Han dynasty, 107, 110	Maurya Empire, 114–115	Jahangir Seated on an Allegorical Throne
Alexandria, 75–76	House of G. Polybius, 101	sculpture, 111, 113, 114, 114-115, 115	(Bichitr), 292, 292-293
amphora pottery, 48, 48, 52	House of the Double Axes, 43, 44	Indian Country Today (Bradley), 513, 513	Jahangir, shah, 291-293, 294
architecture, 71	House of the Silver Wedding, 100, 100	Indigenous cultures, of West Africa, 284–288	Jahan, shah, 292, 293, 293-294
Aristotle, 40, 59, 71, 72, 74–76, 78,	Houses at l'Estaque (Braque), 455, 455	Inductive reasoning, 355	Jambs, 93, 93, 164
234–235	Houses on a Hill, Horta de Ebro (Picasso), 456	Indulgences, 264	Jamb statues, Chartres Cathedral, 182
Pergamon, 76–79, 81	Housing. See also Architecture	Industrial Revolution, 358–359	James I, king, 292-293, 348
and Rome, 81	China, 107, 110	Infanta Margarita, 349	James II, king, 348
sculpture, 73–74, 73–74, 77–79, 81	cliff dwellings, Mesa Verde, Anasazi,	Inferno (Dante), 198, 198, 199, 199	James, Harry, 469
Heller, Joseph, 501	11, 11	Ingelbrecht of Mechlin, 252–253	James, Henry, 477
Heloise, 185	domestic architecture in Florence, 217–218	Ingres, Jean-Auguste-Dominique, 414,	James, William, 477
Hemingway, Ernest, 481	kiva, 11, 11	414–416	Janssen, Zacharias, 357
Hennings, Emmy, 465	Naiku Shrine housing, Japan, 13	Ink Orchids (Cheng Sixiao), 296, 296	Jan van Eyck's Studio (Stradanus), 250, 25
Henrietta Maria, 348	"Howl," (Ginsberg), 490, 490	In medias res, 47	Japan
Henry IV, king, 344	Hubris, 50	Innocent III, pope, 165–166, 255, 258	in age of encounter, 302-309
Henry VIII in Wedding Dress (Holbein), 273	Huelsenbeck, Richard, 464–465	Innocent VIII, pope, 221	architecture, 13, 305-309, 306, 308
Henry VIII, king, 264, 266–269, 272,	Hughes, Langston, 467, 467–468	In Praise of Folly (Erasmus), 262-263,	Azuchi-Momoyama period, 308-309
273–274	Huis Clos (Sartre), 485	262–263	Buddhism, 302
Hephaestus (Vulcan), 50	Huitzilopochtli, 277–278	Inquisition, 321–323	Christianity in, 308-309
Hera (Juno), 50	Hui, Wang, 379, 379	Inscription on the Taj Mahal (Jahan, shah),	closing of, 309
	Huizinga, Johan, 249–250	294	culture of, 417
Heraclitus of Ephesus, 66, 235 Heraclius, 140	Human body, sculptural realization of, 182	In Search of Lost Time, 479	Ferris wheel, 447
	The Human Comedy (Balzac), 418	Institutes of the Christian Religion (Calvin),	foreign influences, 308-309
Hera, temples of, 52, 54, 61	Humanism, 66, 201, 207, 217–221, 242–245,	265	gods/goddesses, 302
Herbert, Robert L, 432	260, 268–271	Insulae blocks, 83, 101	Heian period, 302-304
Her Kind (Saxton), 504, 504	Humbert, King, 100	The Interesting Narrative of the Life of Olaudah	Kamakura period, 304-305
Hermes (Mercury), 50, 57	"Hundred-Guilder Print" (Rembrandt),	Equiano or Gustavas Vassa the African	map of, 303
Herod, king, 121	340, 340	(Equiano), 393	Muromachi period, 305-308, 306
Herodotus, 60	Hundred Birds Admiring the Peacocks (Yin	The Interior Castle (Teresa of Ávila), 323	myth, role of in Shinto religion, 12–14
Heroic couplets, 202	Hong), 300, 300	Interior of Tintern Abbey (Turner), 396	Noh drama, 308, 311
Heroic sculpture, 73	Hunter-gatherers, 4	Intermezzo, 347	opening of, 441–442
Hesiod, 50, 90	Huygens, Constantijn, 356	The Interpretation of Dreams (Freud), 474	painting, 308–309, 309
Hestia (Vesta), 50	Hydria, 57, 57	In the Loge (Cassatt), 433, 433	poetry, 303
Hiberno-Saxon, 151	Hypnos, 57	In the North the Negro had better educational	Shinto religion, 12–14
Hideyoshi, 303, 305, 308, 309	Hypostyle, 139	facilities (Lawrence), 470	tea ceremony, 307
Hierarchy of scale, 18	Hypostyle mosque, 142	In the Wind (Peter, Paul, and Mary), 497	writing system, 303
Hieratic, 133, 134		Inti, 284	Zen gardens, 307
Hieratic scale, 18	Iambic tetrameter, 126	Intonazione, 245	Japanese house, Exposition Universelle, 445
Hieroglyphs, 29, 32	Ibn al-Athïr, 167	Invisible complement, 327, 331	Jashemski, Wilhelmina, 101
Highlands Tour (Gilpin), 401	Ice (Richter), 508, 508	Invisible Man (Ellison), 498, 498	Jazz, 467–468
High relief sculpture, 64, 65, 65, 73	Ichthys, 124	Ionesco, Eugène, 486	"Jazz Band in a Parisian Cabaret" (Hughes)
High Renaissance, 225–232	Iconography, 124–125, 125	Ionia, 50, 59	468, 468
Hijra, 138 Hilda, abbess of Whitby, 157	Icons, 133	Ionic columns, 55, 62, 62	Jean-Baptiste Colbert Presenting the Members
	Ictinus, 61, 61, 64	Ionic order, 52, 55, 64, 94	of the Royal Academy of Science to Loui
Hildegard of Bingen, 157, 158 Hildegard's Vision, Liber Scivias, 158	Id, 474	Iran, Neolithic pottery, 6–7, 7	XIV (Testelin), 351, 351
Himeji Castle, 308, 308	Idealism, 66–67	Ireland, map of, 147	Jean, Duke of Berry, 188-190
Hindu, 113	Identity, 75	Irony, 263	Jean Le Noir, 199
Hippias, 59	Ides of March, 87	Isaac, Heinrich, 218, 220	Jefferson, Thomas, 247, 247, 384-385,
Hiragana, 303	Idia, 289, 289	Isabella, queen, 227, 280	387-388, 392-394
Hispanic culture, 510	Idyllic Landscape, 89	Isenheim Altarpiece (Grünewald), 258-259,	Jesu, der du meine Seele (Bach), 341
Histoire Naturelle (Leclerc), 375	Ife culture, 285–286, 285–286, 289	259–260	Jesus, 121, 123
Historia Animalium (Aristotle), 75	Igala people, 289	Isidorus of Miletus, 132, 132	"Jesus, It Is by You that My Soul" (Bach),
Historical narrative, 18	Ignatius of Loyola, 275, 324	Isis, 30	341
Histories (Herodotus), 60	Ignudi, 231	Isis, cult of, 129	Jewish Diaspora, 122
History of Ancient Art (Winckelmann), 395	"I Have a Dream" speech (King), 497	Islam	Jewish Kabbalah, 325
History of Rome (Livy), 86	Ile-de-France, 175, 176 Iliad, 47–49, 48	in Africa, 141	Jewish people, 121-122, 123-124, 168. See
History of the Indies of New Spain (Durán),		architecture, 118-119, 137	also Hebrews
278, 278	The Iliad (Homer), 21, 47, 48, 48, 49, 90	bismillah, 135, 136, 136-137	Jewish Temple, 119, 123
History of the Peloponnesian Wars	Illumination, 188, 189	calligraphy, 136–137	The Jewish War (Josephus), 121
(Thucydides), 60	Il Trovatore (Verdi), 427 Imagines, 88, 100	Christianity, influence on, 119–121	Jihad, 138
Hitler, Adolf, 443	Imitatio Ruris, 364	expansion of, 120, 121	Jockey Club, 427–428
Hobbes, Thomas, 359–360	I'm Not The Girl Who Misses Much (Rist),	hijra and Muslim practice, 138	Johannes Tetzel, Dominican Monk
Hodder, Ian, 6	516, 516	in India, 291–293	(Anonymous), 264
Hoffmann, E. T. A., 408	Impasto, 450	introduction to, 135	John of the Cross, 323
Hoffmann, Hans, 486	Imperial Forums, 117	map of expansion, 120	Johns, Jasper, 491-492, 492
Hogarth, William, 363, 363	Imperial Forums, 117 Imperialism, theoretical justification,	the mosque, 138–139, 140	Johnson, Charles S., 467–468
Hokusai, Katsushika, 442, 442	442–443	Qur'an, 135–138, 267	Johnson, Eastman, 421–422, 421–422
Holbein, Hans, 272–273, 272–273	Imperial Palace, Beijing, 296	in Spain, 141	Johnson, Lonnie, 469
Holiday, Bellie, 469	Imperial Palace, Beijing, 296 Imperial Rome, 85	spread of, 139–142	Johnson, Samuel, 378
Holland, 333–336	Imperium, 89	women in, 139	Jongleurs, 153
Holy Roman Empire, 153. See also Charles		Ismail, Khedive, 441	Josephus, 121
V, emperor	Impressionism, 428–433	Israel, map of under David and Solomon, 26	Josquin des Prez, 233-236
Holy Sepulchre, Church of the, 123, 123	"Impressionism and Édouard Manet"	Italian Inquisition, 321–322	Joyce, James, 478, 478
Holy Sonnets (Donne), 329	(Mallarmé), 429	Italian Renaissance city-states, 210	Judaic culture, 121-122
The Holy Virgin Mary (Ofili), 511, 511	Impression: Sunrise (Monet), 430, 430	Italian sonnet, 202	The Judgment of Paris (Raimondi), 425, 425
Homely Letters to Diverse People (Franco,	"In a Station of the Metro" (Pound), 461,	Italian Symphony (Mendelssohn), 409	Judith and Maidservant with Head of Holoferne
V.), 244	461 Inco culture 283, 284, 284	Italy. See also Renaissance; specific cities	(Gentileschi), 330, 331
Home on the Range (Baraka), 500	Inca culture, 283–284, 284	Baroque in, 324–331	Julian the Apostate, 130
Homer, 21, 47–49, 90, 113	Inca Temple of the Sun, 283–284	education of women, 242	Julien, Isaac, 514, 515
11 12 22 12	Indeterminacy (Cage), 491	family life, 242–243	Julius Caesar, 76, 87, 95

Julius Caesar (Shakespeare), 87, 95	Landscape painting, 298–299, 335	Light and dark, play of, 328–330, 335,	Louis XVI, king, 384, 386
Julius Excluded from Heaven (Erasmus), 262,	Language, 18, 21, 150, 198-205	336–340	Louis-Napoleon, 423
262	Lantern, 214, 214	Limbourg brothers, 189, 189	Louis-Philippe, king, 416, 420
Julius II, pope, 226–227, 228, 232, 236, 262	Laocoön and His Sons, 81, 81	Lincoln, Abraham, 422	Lower Egypt, 32
	Lao Zi, 105	Lindbergh, Charles, 447	Lucian, 101
Jung, Carl, 311		Lindisfarne Gospels (Eadfrith), 151, 151	Lully, Jean-Baptiste, 346
Juno, 50	Lapatin, Kenneth, 43		Lumière, Brothers, 447
Jupiter, 50	Lapith overcoming a centaur, Parthenon, 65	Linga, 113	
Jupiter and Io (Correggio), 320	The Large Blue Horses (Marc), 458-459,	Lintels, 8–9, 164	Lunar Society, 358
Jura Mountains, 421	459	Lion Gate, 46, 46	Luncheon of the Boating Party (Renoir), 432,
Justinian, emperor, 130–132	Large Seated Buddha with Standing Bodhisattva,	Lion of Saint Mark (Carpaccio), 237, 237	435
Justiman, emperor, 130–132	143	Lion-tamers, 31, 33	Luncheon on the Grass (Manet), 424, 425
		Lippershey, Hans, 357	"Lundi, rue Christine" (Apollinaire), 461,
Ka, 31, 35	Lascaux cave painting, 2, 3		461
Kaaba, 138, 139	Las Meninas (Velázquez), 349, 349	Literacy, 111, 155–156	
"Ka'Ba" (Baraka), 499, 500	Last Judgment (Michelangelo), 318-319,	Literary imagination, 462–467	L'uomo universale, 222, 243
Kachinas (katcinas), Zuni, 12, 13	319, 344	Literary realism	Lushness, 432
Kain, Gylan, 500	Last Judgment, Abbey Church of Sainte-Foy,	in France, 418-419	Luther, Martin, 232, 261-264, 268, 272, 274
	164, 182	in United States, 419	See also Reformation
Kaishek, Chiang, 484			Luxury arts, in China, 301–302
Kamakura period, Japan, 304–305	Last Supper (da Vinci), 224, 224–225	Literati, 296	
Kami, 13	Latin cross, 127	Literature. See also Poetry	Lyric poems, 58
Kan'ami Kiyotsugu, 303	Latino culture, 510	Anglo-Saxon, 150	Lyric poetry, Sappho, 58
Kandinsky, Wassily, 458–460, 459	Latin Vulgate Bible, 156	Baroque, 324–325	Lysippus, 73, 73, 77, 81, 88
	Latrobe, Benjamin Henry, 392–393, 393	Benin culture, 286-287	Lysistrata (Aristophanes), 68
Kano-School screen painting, 309		Black Death, 199–205	*
Kant, Immanuel, 383, 395, 399-400, 402	La Venta, Olmec colossal head, 280		Ma'arra, 167
Katcinas, 12, 13	La Vita Nuova (Dante), 199	blackness, 498–500	
Katherine of Aragon, 266, 269, 272	Law. See Legal codes	Carolingian culture, 153–155	Maccabees, 121
Kay, John, 359	Law Code of Hammurabi, 19, 20	Chinese, 107, 295, 300–301	Mace, 32
Keats, John, 437	"Law of Nature or Natural Law" (Diderot),	Dada, 464–467	Machiavelli, Niccolò, 220, 236-237
	374	existentialism, 484	Madame Bovary (Flaubert), 418-419, 424
Kennett, Basil, 392	Lawrence, Jacob, 470, 470	Greece, 47–49, 58	Madame de Pompadour (Boucher), 369,
Kent, William, 364			369, 372
Kenyapithecus, 4	Law Students, relief sculpture, 184	Harlem Renaissance, 467–468	
Kepler, Johannes, 357–358	Lazarillo de Tormes, 324	India, 113	Madonna Enthroned with Angel and Saints
The Kermis (Rubens), 344, 345-345, 434	Leach, Bernard, 311	Japanese, 303	(Giotto), 195, 195
	Leaves of Grass (Whitman), 439, 439	literary courtesan, 244-245	Madonna Enthroned with Angels and Prophets
Kerouac, Jack, 311, 489–490	Le Brun, Charles, 342, 342, 343, 345	literary imagination, 462-467	(Cimabue), 194-197, 195
Key, 332		medieval courtly love, 169–170	Madrasas, 140-141, 142, 184
Keystone, 93, 93	Le Chinois Galant (Boucher), 378		Madrid Codex, 282, 282
Kgositsile, Willie, 500	Leclerc, Georges-Louis, 375	medieval romance, 170–171	
Khnum (god), 31	Le Déjeuner sur l'herbe (Manet), 424, 425	Mesopotamian, 20–24	Madrigals, 245, 268, 331
Khokhlova, Olga, 475	Lee, Peggy, 469	modernism, 448	Maestà (Duccio), 192-194, 193
Kindred Spirits (Durand), 437, 437	Lee, Robert E., 422	novel, 324	Maestà (Martini), 193, 193
	Leeuwenhoek, Antoni van, 357–358	poetry, 107, 170	The Magic Flute (Mozart), 407
King, Edward, 423		poetry of Jazz, 467–468	Magnus, Albertus, 185
King Lear (Shakespeare), 270	Le Figaro, 457		Magnus Liber Organi, 183, 206
King, Martin Luther, Jr., 496–497, 499	Legal codes, 19-20, 25, 149	politics, 496–497	
K'inich Janaab' Pakal I, 283	Le Havre, France, 430	postmodern, 506–507	Mahabharata, 113
Kinkakuji, (Temple of the Golden Pavilion),	Leicester's Men, 269	Reformation, 268–271	Mahana no atua (Gauguin), 452, 452, 458
306, 306–307	Leighten, Patricia, 455	Renaissance, 236-237, 243-245, 249-250	Mahayana Buddhism, 304
	Leitmotif, 428	Roman, 90–92, 99	Mahisha, 114
Ki no Tomonori, 303, 303		Romanesque, 170-171	The Maids of Honor (Velázquez), 349, 349
Kinsai, China, 295–296	Le Journal, 456	Romanticism, 395	Make It New (Pound), 462
Kiva, 11, 11	L'Enfant, Pierre Charles, 392, 393		Malcolm X, 499
Kline, Franz, 486	Lenin, Vladimir Ilyich, 470	satire, 262–263	
Knights, 168, 168	Le Nôtre, André, 342, 342	trench warfare, 462–467	Male gaze, 74
Knights Hospitaller, 168	Leo III, emperor, 133	in Urbino, Italy, 222	Malevich, Kazimir, 470–471, 471
	Leo III, pope, 153	vernacular, 198–205	Mali, 140, 285
Knossos, 42, 43, 43, 45–47		Lithography, 419–420	Mallarmé, Stéphane, 429
Koehler, Robert, 436	Leonidas, 60	Littérature, 475	Mana, 377
Kogaku Soko, 307	Léonin, 167, 167, 183	Little Big Painting (Lichtenstein), 495	Mandala, 115
Kojiki, 13	Leo Pilatus, 201		Mandorla, 164
Kong Fuzi. See Confucius	Leo X, pope, 232-233, 236, 264, 266	The Little Hymn-Book (Walther), 272	
Korai, 53, 56	L'Equipe de Cardiff, 447	Little Rock Nine (Eckford), 497	Manet, Édouard, 424-426, 425-426,
	Le Sacre du printemps, 459	Liturgy, Church, 126, 152, 158, 183	428–430
Koran. See Qur'an	Les Demoiselles d'Avignon (Picasso), 453–455,	Liu Xijun, 107	Manifesto (Marinetti), 457
Korean War, 484		Lives (Plutarch), 392	Manilla, 289, 289
Kore, Athens, Greece, 56, 56	454, 475	Lives of the Most Excellent Painters, Architects,	Mannerism, 315–324, 317–322
Kouros, 53, 53, 56, 56, 63, 63	Les Fêtes de Nuit à l'Exposition, 445		Manohar, 292
Krak des Chevaliers, Syria, 168, 168	Les Fleurs du mal (Baudelaire), 424, 424	and Sculptors (Vasari), 214, 223-224,	
Krasner, Lee, 488	Le Siècle de Louis XIV, 376	224, 240, 250	Manuscripts, illuminated
Krater, 57, 57	Lestringuez, Eugène Pierre, 435	Livia, 89–90	Book of Hours, 188
	Letter to Michelangelo (Aretino), 319, 319	Livy, 86	Book of Kells, 152, 152
Krishna, 113	Le Tuc d'Audoubert, France, 7	Llamas, 284	Chi Rho Iota page, Book of Matthew, Book
Kritios Boy, 63		Locke, Alain Leroy, 467, 467–468	of Kells, 152
Kshatriyas, 112	Leucippus, 65	Locke, John, 359–361, 360, 364, 384–385,	David and Court Musicians, Vespasian
Kublai Khan, 295, 296–297	Leviathan, 360		Psalter, 152, 152
K'uk B'alam, 283	Leviathan; or the Matter, Forme, and Power of	387, 395, 399	
Kuleshov effect, 471	a Commonwealth, Ecclesiasticall and Civil	The Lofty Message of the Forests and Streams	Lindisfarne Gospels (Eadfrith), 151, 151
Kuleshov, Lev, 471	(Hobbes), 359	(Guo Si), 298	Madrid Codex, 282, 282
	L'Exposition de Paris, 445	London, England, 352-354, 353-355, 363	Night Attack on the Sanjo Palace, 305,
Kyd, Thomas, 269		London: The Thames and the City of London	305, 308
Kyrie (Josquin des Prez), 233	Li, 106, 296	from Richmond House (Canaletto),	The Tale of Genji (Murasaki Shikibu), 304
Kyrie Eleison, 158–159	Li Bai, 295, 295		Марро, 304
	Liberal belief, 416	353, 355	
Labor strikes, 436	Liberalism, 360	Lord Chamberlain's Players, 270	Maps
Labyrinth, 44, 44–45	Liberal politics, 416	The Lord of the Rings (Tolkien), 150	Alexander the Great's empire, 72
	Liber Scivias (Hildegard of Bingen), 158	Lorenzetti, Ambrogio, 190, 190-191, 191,	Anglo-Saxon England and Celtic Ireland
Lacquerware, 301–302	Liberty Leading the People (Delacroix), 415,	207	147
Lady at the Virginal with a Gentleman		Lorenzo the Magnificent, 218–221	Athens, 59
(Vermeer), 341, 341	415–416		Buddhism, spread of, 142
Laforgue, Jules, 435	Library at Alexandria, 76	Lorrain, Claude, 365	Byzantine Empire, at death of Justinian,
La Grande Odalisque (Ingres), 414, 414	Library at Pergamon, 77	Lost Illusions (Balzac), 418	
Laissez-faire, 394	Libretto, 332	Lost-wax casting, 19	131
	Libyan Sibyl (Michelangelo), 230, 231–232,	Louis VII, king, 169, 175, 177	Celtic culture, 147
Lakes Tour (Gilpin), 401	317	Louis IX, king, 145, 176, 186-187	Central Italy, 190
La Madeleine (Vignon), 391, 391		Louis XII, king, 225	Charlemagne's empire, 154, 154
"Lament" (Liu Xijun), 107, 107	Lichtenstein, Roy, 495, 495		China, 103
Lamentation (Grünewald), 258, 259	The Lictors Returning to Brutus the Bodies of	Louis XIII, king, 414, 414–415	Christianity, spread of, 120
The Lamentation (Giotto), 196, 197	His Sons (David), 390, 390	Louis XIV, king, 345, 346–347, 347, 351,	
Lancelot (Chrétien de Troyes), 170–171, 171, 198	Lieder, 409	351, 367	Great River Valley civilizations, 2
Lancelot Crossing the Sword Bridge and	Life of Pericles (Plutarch), 60, 60–61	Louis XIV, King of France (Rigaud), 343, 343,	Greek city-states, 40
	The Life of Teresa of Ávila (Teresa of Ávila),	344–347, 347	Imperial Rome, 84
Guinevere in the Tower, from Romance of		Louis XVIII, king, 411, 413	India, 111
Lancelot, 170-171	325, 325–326	20010 11 1 111 ming; 121 110	

Islam, expansion of, 120	Melismatic organum, 167	cubism, 455–456	Mumma, Gordon, 491
Israel under David and Solomon, 26	Mellaart, James, 6	dance, 459–461	Mumtaz-i-Mahal, 293
Italy, 190 Japan, 303	Memento mori, 166 Memorial heads, 287	Expressionism, 458–459	Müntzer, Thomas, 265
major Paleolithic caves in France and	Memory of Civil War (Meissonier), 416	futurism, 457–458 Harlem Renaissance, 467–468	Murasaki Shikibu, 303 Murata Shuko, 307
Spain, 1	Memphis, "This It Is Said of Ptah,", 30, 30	literature in, 448	Murdock, William, 359
medieval pilgrimage routes, 163	Mendelssohn, Felix, 409	music and dance, 459-461	Muromachi period, 305-308, 306
Mesopotamian capitals, 14, 16–17 Nile River Basin, Egypt, 29	Menhirs, 8, 8 Menkaure with a Queen, 34, 34	Picasso's Paris, 453–455	Museum of Modern Art, 487
Renaissance, Northern Europe, 251	Menorah, 25, 97	in Russia, 470–471 surrealism, 474–475	Music Baroque, 331–333, 340, 341, 346–347
Salisbury Plain, 9	Mephistopheles, 404	Modernist world. See Global confrontation,	at Baroque court, 346–347
slave trade, 288 Sub-Saharan West Africa, 285	Mercantile system, 242	age of	Baroque, secular, 340, 341
Terraferma, Venetian, 237	Merchant patronage, 250–260 Mercury, 50	Modern life American self, 433, 436–438	blues, 468 call-and-response, 288
Venice, Renaissance, 237	Mérode Alterpiece (Campin), 251-252,	cultural identity, 438–443	cantata, 341
world exploration, 279	251–253	Impressionism, 428–433	canzona, 331–332
Marathon, 59, 68 Marc, Franz, 458, 459, 460	Merton, Thomas, 311 Mesa Verde, 11, 11	introduction to, 413–417	Chinese, 107
Margaret of Savoy, 100	Meskalamdug, king, 17	nationalism, 426–428 opera, politics of, 426–428	chorale, 268, 341 choral music, 164
Mariana, queen, 349	Mesoamerica in the Classic Era, 276-277,	paintings, 424–426	in Christian liturgy, 126, 152, 152
Marie-Antoinette conduite au supplice (David), 381, 381	277–283, 281, 283	Paris, 1850s and 1860s, 423–428	classical to romantic, 406-409
Marie-Antoinette en chemise (Vigée-Lebrun),	Mesopotamia Akkad, 18, 18–19	poetry, 424 realism, 417–423	comédie-ballets, 346 concerto, 332–333
381, 381	Babylon, 19–20	A Modest Proposal (Swift), 361–362, 362	Council of Trent, 316–317, 331
Marie, Countess of Champagne, 169, 171	Epic of Gilgamesh, 20–24	Modulation, 333	Counter-Reformation, 316–317
Marilyn Diptych (Warhol), 494, 495 Marinella, Lucretia, 244	Hebrews, 24–27 introduction to, 14–15	Mogul architecture, 293–294	education, 183
Marinetti, Filippo, 457	literature, 20–24	Moguls, 291 Mohenjo-Daro, 111–112, <i>112</i>	in Florence, Italy, 214 folk, 497
Marlowe, Christopher, 269, 271	map of capitals, 14	Moll Flanders (Defoe), 366	gothic style, 183–184
Marlow, William, 378, 378	music in, 18	Mona Lisa (da Vinci), 225, 225	Gregorian chant, 158
Marquis of Dai, 110, 110 The Marriage of Figaro (Mozart), 407	Persian Empire, 27, 59–60 Sumerian Ur, 16–18	Monastery, medieval	Han Dynasty, China, 107
Mars, 50	Messiah, 121–122	architecture, 156 Charlemagne and, 156	Hildegard of Bingen, 157, 158 in the home, 332, 341
Martel, Charles, 153	Messianic, 121	choral music, 167	homophonic harmony, 268
Martini, Simone, 192–194, 193	Metalwork, 27, 46, 46–47	Cluny and the monastic tradition, 166,	homophony, 316
Martin Luther (Cranach), 263 Martin V, pope, 225	Metamorphoses (Ovid), 91–92, 367 Metaphors, 21	166	humanism, 220
Marxism, 417	Metopes, 63, 64, 65	introduction to, 148 Mass, 158–159	jazz, 467–468 Josquin des Prez, 236
Marx, Karl, 417	Mexico, Olmecs, 280, 280	music, 158	in the liturgy, 126, 152, 152
Mary, mother of Jesus, 133, 133 Masaccio, 215, 215–216	Michelangelo, 218	Rule of St. Benedict, 156, 159	madrigals, 245, 268, 331
Masada, 121, 122	Creation of Adam, 229–230, 231 Creation of Eve, 229, 231	St. Gall, 156, 156–157 women in, 157–158	meaning of, 409
Masjid, 138	David, 228, 228, 327	Mondrian, Piet, 494	medieval monastic, 158 in Mesopotamian society, 18
Masked dance, 290, 290–291	Last Judgment, 318–319, 319, 344	Monet, Claude, 311, 428-431, 429-430	monastic, 158
Mask of Agamemnon, 47 Mask of an iyoba, Court of Benin, 289, 289	Libyan Sibyl, 230, 231, 317 mannerism, 317–321	Mongols, 296–300, 297	monophonic songs, 158
Masonry, Inca, 284	Saint Peter's Basilica, new, 227, 264	Monicello, 247, 247 Monir non può il mio cuore (Casulana), 245	music drama, 427 opera, 332
Massachusetts State Constitution, 384	in School of Athens, 235	Monk by the Sea (Friedrich), 399, 399	oratorios, 341
Mass for Pope Marcellus (Palestrina), 316 Mass, medieval, 158–159	Sistine Chapel, 229–230	Monody, 332	passion, 341
Master of arts degree, 184	Sistine Chapel ceiling, 229–230 Studies for the Libyan Sibyl, 230	Mononobe clan, 302 Monophonic songs, 158	plainchant/plainsong, 158, 233, 316
The Master's Bedroom, It's Worth Spending a	Michelozzo di Bartolommeo, 217, 217	Monotheists, 24, 25, 26, 34	polychoral style, 245, 331 polyphonic form, 245
Night There (Max Ernst), 475, 475	Micrographia (Hooke), 357, 357	Montage, 471	polyphony, 167, 184, 316
Mathematical Principles of Natural Philosophy (Newton), 358	Middle Passage, 288 Mies van der Rohe, Ludwig, 492, 492, 506	Montefeltro court, 221–225 Montefeltro, Federigo da, duke, 221	in print, 268
Matisse, Henri, 458, 458-459	"A Mighty Fortress Is Our God" (Luther),	Montefeltro, Guidobaldo da, 221	program music, 333, 408 Reformation, 268
Matobo National Park, 10, 10	268	Monteverdi, Claudio, 332	Renaissance, 214, 245
Matrilineal, 4, 6 Matrilocal, 5	Mihrab, 139 Mihrab niche, Isfahan, Iran, 136, <i>137</i>	Montezuma, king, 278	Romanesque, 167
Matsuri festivals, 13	Milan, Italy, 222–225	Mont Sainte-Victoire (Cézanne), 451, 451 Montuemhet. 37, 37	romantic, 406–409
Maurya Empire, 114–115	Military culture, art of, 304-305	Monuments, 93	secular vs. religious, 331–332 Sistine Chapel Choir, 233
Max Ernst, Dadaist, 475, 475 Maximilian II, 313–314	Miller, Glenn, 469	The Moon Goddess Coyolxauhqui, 278	tragédie en musique, 346
Mayan culture, 282–283	Milner, Alfred, 441 Miltiades, 59	Morales, Aurora Levins, 510, 510–511	in West Africa, 287–288
Mayan Underworld, 283	Milton, John, 360–361, 361	More, Thomas, 262, 268–269 Morisot, Berthe, 428, 430–431, 431	for wind ensembles, 331 Music Bureau, 107
McClellan, George B., 422	Milunic, Vlado, 506-507, 507	Morley, Thomas, 268	Music drama, 427
McClure, Michael, 490 Meadowland (Richter), 507, 507–508	Minamoto clan, 304 Minamoto Yoshitusune, 305	Mosaics	The Music Lesson (Vermeer), 341, 341
Mecca, 139, 139, 141	Minbar, 139	Ark of the Covenant, mosaic floor decorations, Israel, 25	Mustard gas, 462 Mutt, R., 466–467
Medici, Cosimo, 217-218, 239	Minerva, 50, 235	Byzantine murals, 134	Mycenaean culture, 45–47, 46
Medici family, 209–221, 228	Ming dynasty, 296–300, 302, 334	in Church of Santa Costanza, 128, 128	"My Heart Cannot Die" (Casulana), 245
Medici, Giovanni, 226, 232, 236. See also Leo X, pope	Minh, Ho Chi, 501 Miniature, 188–190	in domas, 101	Mysteries of the Snake Goddess (Lapatin), 43
Medici, Giuliano, 236. See also Leo X, pope	Miniature Ship Fresco, 41, 41	Emperor Justinian with Maximian, Clergy, Courtiers and Soldiers, San Vitale,	Mystery cults, 129 Mysticism, 323, 330
Medici, Giulio, 226, 232, 232-233. See also	Miniature tradition, 188-190	Ravenna, 134	Myth, 10–14, 128–129
Clement VII, pope Medici, Maria de, 343, 344, 345	Minoan culture in Crete, 42–45	Empress Theodora with Courtiers and Ladies	,,
Medici, Piero, 218	Minos, legend of, 44–45 Minotaur, legend of, 44–45	of Her Court, San Vitale, Ravenna, 134 Mihrab niche, Isfahan, Iran, 137	Naiku Shrine housing, 13
Medici popes, 226, 232-233, 236	Minuet, 347	San Vitale, Ravenna, 134, 134	Nakatomi clan, 302 Namban, 309
Medieval castle, 168, 168	Mirandola, Pico della, 220-221, 244	Moses, 24–26	Namban six-panel screen, 309, 309
Medieval romance, 170–171 Medina, 136, 138–139	Missa Papae Marcelli (Palestrina), 316	Moses window, Abbey of Saint-Denis, 176	Nam June Paik, 311, 311
Meditations (Descartes), 356	Mitchell, George, 512 Mitchell, Joan, 488	Mosque, 139, 141–142 Motecuhzoma, king, 278	Napoleon Crossing the Saint-Bernard (David)
Meditations on the First Philosophy (Descartes),	Mithraic relief, 129, 129	Motet, 184, 214	391, 391 Napoleon III, emperor, 423–426, 428
356 Meeting of Solomon and Shake (Chihami)	Mithraism, 129	"Mothers of the Faithful," 139	Napoleon in the Pesthouse at Jaffa (Gros), 40
Meeting of Solomon and Sheba (Ghiberti), 213, 213	Mixing bowl, 33 Mnesicles, 62	Motte and bailey castles, 159, 168	Naramsin, 19
Megaliths, 8–10	Moat, 168	Mount Parnassus (Raphael), 232 Moussa, Mansa, 141	Narcissus, 92
Meissonier, Ernst, 416, 416	Modeling, 3, 4, 7	Movable type, 267	Narmer, 31, 32–33 Narrative genre, 18
Melchior, Friederick, 368 Melisma, 316	Modern Devotion, 275	Mozart, Wolfgang Amadeus, 407	Narrative of a Five Years' Expedition against the
Melismatic chant, 158	Modernism art, 448–462	Mudfish, 288, 289 Mudra, 143	Revolted Negroes of Surinam (Stedman)
	-, ,	madia, 175	394

Ovid, 90-92 Num, 10, 12 Number 27 (Pollock), 487 Narrative of the Life of Frederick Douglass: An Paradise Lost (Milton), 360–361, 361 Paradiso (Dante), 198, 206 Owen, Wilfred, 463, 463 American Slave (Douglass), 419 Oarsmen at Chatou (Renoir), 432, 432 The Oxbow (Cole), 436, 437 Narthex, 127, 127, 132 Paranoiac critical method, 477 The Oath of the Horatii (David), 389, Oxford University, 186 National Academy of Music, 426 389-390 Oyewole, Abiodun, 500 Parapet, 62 National Assembly, 384, 386-388 Paraphrase, 233 Oba, 289 The National Era, 419 Paris Exposition, 423, 445. See also Exposition Nationalism, modern life, 426–428 Oba heads, 286-287 Paestum, 52 Universelle Pagan styles, Christianity and, 151–152
Painted banner from the tomb of the wife of National Organization for Women (NOW), Octave, 202 Paris, France 504 Octavian, 89 Octavian, 69 Oculus, 98, 99, 214, 214 Odalisque, 414–415 in 1850s and 1860s, 423-428 Marquis of Dai, 110 National Prohibition, 469 cubism, 455–456 Exposition Universelle, 445, 445 Painterly Realism: Boy with Knapsack— Color National Urban League, 467 Odalisque (Delacroix), 414–415, 415 Oda Nobunaga, 308 Masses in the Fourth Dimension Native Americans, 11-12, 439-440 (Malevich), 471 futurism, 457-458 Natoire, Charles-Joseph, 367, 367 Haussmannization, 424, 428 Impressionism, 428–433 Paris Commune, 428 The Natural History (Pliny the Elder), 99 Naturalism, 4, 53, 124, 192–195, 214–215 "The Painter of Modern Life" (Baudelaire), Odes, 91 425 Odes (Horace), 91, 247 "Odessa Steps Sequence" (Eisenstein), 471, Paintings Naturalistic representation, 214-216 action, 486–488 Baroque, 325, 328–331 Picasso and, 453-455 472-473 Natural law, 374 Parker Pearson, Mike, 9-10 Nature (Emerson), 438, 438 Nave, 117, 117, 127, 127, 179 Odoacer, 130 Baroque court, 343–345, 343–349, 348–349 Parkinson, Sydney, 377 Odo, bishop of Bayeux, 160 Parodos, 70, 71 Odo of Cluny, 167 Oduduwa, king, 286–287 Naxian sphinx, 55 Nebuchadnezzar, 24, 26 Baroque, secular, 333–336 Chinese, 297–302, 298–299 Parthenon, 61, 61-64, 64-65 Parvus mundus, 221 Odysseus, 47, 49, 67 The Odyssey (Homer), 21, 47–49, 67, 90 Oedipus the King (Sophocles), 69 Nefertiti, 35, 35 Pasadena Lifesavers Red Series #3 (Chicago), combine, 490 Nefertum, 30 Egypt, 31 505, 505 Negro Hung Alive by the Ribs to a Gallows Pasiphae, 44 Ofili, Chris, 511, 511
Oh, Jeff. . . 1 Love You, Too . . . But . . . (Lichtenstein), 495, 495 Elizabethan England, 270-271 (Blake), 394, 394 "Passage to India" (Whitman), 439 Florence, Renaissance, 215, 215-216, 219, Negro Life in the South (Johnson), 421, 421 Nelson, David, 500 Passi, Giuseppe, 244 224-225, 224-225 genre scenes, 335-336, 345 Passion, 341 Neoclassical style, 388–390 Oil painting, 253, 253 Pater patriae, 86, 92 Patriarchs, 19, 24, 26 Neoclassicism, 415 in America, 392–393 architecture, 388 Oil Painting (Stradanus), 250, 250 Greece, 41 group portrait, 336–337 Harlem Renaissance, 467–468 Oldenburg, Claes, 495-496, 496 Patricians, 86-87, 89 Old Kingdom, Egypt, 29, 31–34 Patroclus, 47–48 Patronage, 148, 250–260, 305–308 Paul, 123–124 humanist, 218–221 Old Saint Peter's, Rome, 127, 127, 163 "Old Stone Age,", 1 art, 388 Impressionism, 428–433 issue of slavery, 393–395 Indian, 292 Neolithic era, 2, 2, 5–10 Oliver, 154, 155 Paul, 123–124
Paul III, pope, 227, 275, 315, 319, 321
Paul V, pope, 327
Peasants, 149
Peasant War, 265 Japanese, 308–309, 309 Olmecs, 280, 280 Olson, Charles, 491 Neoplatonism, 217 Kano-School screen painting, Japan, 309 Neptune, 50 Kano-School screen painting, Japan, landscape painting, 298–299, 335 light and dark, play of, 328–330, 335 light, drama of, 336–340 mannerism, 317–321, 317–321 Ming dynasty, China, 302 Minoan culture, 42, 42–43 Olympia, 52-53 Nero, 94 Olympia (Manet), 426, 426, 454 Olympia and the Olympic Games, 52–53 Nerva, 94 Peasant Wedding (Rubens), 344 Netherlands, 315, 333–336 Neumatic chant, 158 Neume, 158 Pediment, 51, 63-64, 64 Omega, 124 Peloponnesian War, 60, 62 Omphis, King, 72 On Architecture (Vitruvius), 93 Pendentives, 132, 132, 231 New Kingdom, Egypt, 29, 34-36 On Christian Doctrine (Augustine), 184
On Colors and their Applications to the
Industrial Arts (Chevreul), 431 modern life, 424-426 Penelope, 49 New Method of Science (Bacon), 355 Pentathlon, 52 naturalism, 192–195, 215–216 New Music (Willaert), 245 Peplos, 56, 56 Neoclassical style, 388-390 The New Negro (Locke), 467, 467 Northern Europe, Renaissance, 248–249, 251–252, 254–259 nudity in, 317–321, 319 Peplos Kore, Athens, Greece, 56, 56 On Duty (Cicero), 87
"One of Good Cheer," 220 New Sacristy, San Lorenzo, 233 Pepys, Samuel, 353 "New Stone Age," 2 New Testament, 124, 126, 135 Performance space, 70–71 One-point perspective, 215 pointillism, 449 Pergamon, 76-79, 81 Newton, Huey P., 500 Newton, Isaac, 354, 358, 364 New York City, 506 New York Kouros, 53, 53 On Justinian's Buildings (Procopius of Pericles, 60, 60-61, 66, 69 post-Impressionist, 448–453 Caesarea), 132 Pericles, 60, 60–61, 60, 69 Pericles Funeral Speech (Thucydides), 60 Peristyle, 52, 54 **Pérotin,** Viderunt Omnes, 183 Perry, Matthew, 309, 441 On Painting (Alberti), 215–216, 218 On the Art of Building (Alberti), 218 On the Decline of the Roman Empire (Gibbon), postmodern, 507-509 religious, 316–317 in Renaissance Venice, 237, 237, 239-241 New York Society of Independent Artists, Romanticism, 395 392 Rome, Imperial, 101 Persephone (Proserpina), 50 On the Diseases of Women (Trotula), 185 New York Stock Exchange, 433 Rome, Imperial, 101 Rome, Renaissance, 228–231, 229–230 scientific perspective, 215–216 screen painting, 309, 309 self-portrait, 212, 212, 260, 260 Siena, Italy, 191, 192–195 Persian, 26, 27 On the Family (Alberti), 242 New York Times, 501, 504 Persian Empire On the Misery of the Human Condition Nicene Creed, 125-126, 159 Alexander the Great and, 71-72 (Innocent III), 165, 166, 255, 258 Nicholas II, Tsar, 470 architecture, 27, 27 and Greece, 59–60 Nicomachean Ethics (Aristotle), 75 Night Attack on the Sanjo Palace, 305, 305, 308 Night Café (Van Gogh), 449, 449–450 The Night Watch (Rembrandt), 337, 337 On the Origin of Species (Darwin), 442 On the Road (Kerouac), 489 Palace of Darius and Xerxes, Persepolis, Song dynasty, China, 298-299, 298-299 Opera, 332 still life, 333-334 Iran, 27 Opera, politics of, 426-428 Persistence of Memory (Dalí), 477, 477 vanitas, 334, 335 Nijinsky, Vaslav, 460 Optics (Descartes), 356 Persona, 262 Venice, Renaissance, 237, 237 Nike (Victory) of Samothrace, 79, 79 Nile River Basin map, 29 Optics (Euclid), 70 Perspectiva (Alhazen), 215 Perspective, 70 Perspective drawing, 3, 215 women artists, 330-331 Optimism (Voltaire), 376 women in, 335-336 Opus francigenum, 175 Opus modernum, 175 Nile River culture, 28-30, 29. See also Egypt Yuan dynasty, China, 297, 297 Nîmes, France, 92, 93 Peru, 283–284 Pakal, 283, 283 Oral cultures, 10 Ninety-Five Theses (Luther), 232, 261-262, Oranmiyan, prince, 286 Oration on the Dignity of Man (Mirandola), Peter, Paul, and Mary, 497 Pakistan, 512 264 Petrarch, 201-202, 207 Palace of Minos, 43-44, 44, 45 Nineveh, library at, 21 Petrarchan sonnet, 202 220, 220–221, 244 Palatine chapel, 187 Nirvana, 113, 114 Pharisees, 121 Palazzo, 217 Oratorios, 341 Noa Noa (Gauguin), 452 Palazzo della Signoria, 227–228 Palazzo Medici-Riccardi, 217, 217, 239 Phidias, 60, 63, 73 Oratory of Divine Love, 275 The Nobility and Excellence of Women Phidippides, 59 The Orchard, Côte Saint-Denis at Pontoise Phidip II, king of Macedonia, 71
Philip II, king of Spain, 320, 324, 349
Philip IV, king, 349
Philip the Bold, 188, 204
Philip the Good, 250
A Philosopher Occupied with His Reading (Marinella), 244 No Exit (Sartre), 485, 485–486 Noh drama, 308, 311 Palazzo Rucellai, 217, 217, 22 Palazzo Rucellai, 217–218, 218 (Pissarro), 431 Orchestra, 70, 71 Palazzo Vecchio, 208-209 Orchestration, 331 Noise concert, 465 Ordo virtutum (Play of the Virtues), 158 Palenque, 282-283, 283 Nok people, 7–8 Paleolithic cave, 7 Orfeo (Monteverdi), 332 Non-Western cultures, 417 Paleolithic era, 1, 4–5 Norman, 159, 159-162 Organi, 183 (Chardin), 374, 374 Organs, 331–332, 340–341 Palestrina, Giovanni Pierluigi da, 316 Normans, 159–162 Philosophes, 354, 368 Palette of Narmer, 31, 32–33, 32–33 Palladio, Andrea, 247, 247 Organum, 167 Origin myth, 45 Northern Europe, 260, 333-336. See also Philosophical Enquiry into the Origin of Our Renaissance, in Northern Europe Northern Europe, Renaissance, 248–249 Ideas of the Sublime and the Beautiful Pamela (Richardson), 366 Orisha, 285 (Burke), 400 Panathenaic games, 52 Panathenaic Way, 39, 62 Orthogonals, 215, 216 Northern school, 300 Philosophical Letters (Voltaire), 376 Osiris, 30, 36 Notre-Dame Cathedral, Paris, 167, 180, 180 Pange lingua (Josquin des Prez), 233, 233 Pantheon, Rome, 98–99, 98–99 Philosophy. See also Humanism Ospedale della Pietà, 332 Novel, picaresque, 324 in Athens, 65-66 Novum Organum Scientiarum (Bacon), 355 Ospedali musicians, 332 Papal court, art of, 225–232, 229–230, 328 Confucianism, 106, 107, 296 Nude Descending a Staircase (Duchamp), Ostinato, 460 Papal politics, Machiavelli and, 236 Greek, 64-67 O'Sullivan, Timothy, 423, 423 466, 466 humanist, 220-221 Papal states, map of, 191 Nudity in painting, 317-321, 319. See also Othello (Shakespeare), 270 Papermaking, 111 idealism, 66-67 Ottoman Empire, 441 Sexuality in art

INDEX I-9

Plato's Republic, 66-67, 221	Poliziano, 218	The Prince (Machiavelli), 236, 236-237	Red-figure vase, 56, 57, 58, 58, 67
Socrates, 64-65, 66, 235	Pollock, Jackson, 486-488, 487	Principia, 358	Red Roofs (Pissarro), 431
Sophist tradition, 66	Polo, Marco, 279, 295-296	The Principle of Harmony and Contrast of	"The Red Wheelbarrow" (Williams), 462, 462
Phoebus, 50	Polychoral style, 245, 331	Colors (Chevreul), 447	Refectory, 157
Phonograms, 32	Polyclitus, 37, 63, 63, 73, 74, 89	Printing press, 267–268, 296	,,
Photogenic drawing, 422	Polydoros, 81		Reformation, 261, 263–264. See also
Photography, 422–423	Polygamy, 139	Printmaking, 260	Counter-Reformation; Luther, Martin
Photo-silkscreen process, 495		Procopius of Caesarea, 132	architecture, 275
	Polyphonic form, 245	Program music, 333, 408	on celibacy, 310
Physics, 358	Polyphonic mass, 316	Proletariat, 417. See also Working class	in Geneva, 265–266
Physics (Aristotle), 74–75	Polyphony, 167, 183, 316	Prometheus (Gordon/Byron), 403, 403	introduction to, 260-261
Piano mécanique (Mitchell), 488, 488	Polyptych, 258	Pronaos, 51, 51, 52, 54	literature, 268-271
Picabia, Francis, 465	Polyrhythms, 460	Propaganda, 73	Luther and, 263
Picaresque tradition, 324	Polytheistic, 30, 34	Prophet Muhammad, 119, 135. See also Islam	music of, 268
Picasso, Pablo	Polytonal, 460	Prophets, Hebrew, 26	painting, 261, 263
Braque and, 455-456	Pompeii, 99-102	Proportion, 63, 63–64, 73, 73, 75, 78, 89	
Gertrude Stein, 453	Pont du Gard, Nîmes, France, 92, 93	Propylaia, 62	Peasant War, 265
Girl before a Mirror, 476, 476	Ponte, Lorenzo da, 407		printing press, 267–268
		Propylon, 62	satire of Desiderius Erasmus, 262–263
Guernica, 481, 481	Pop art, 493–496	Proscenium, 70, 71	spread of, 265–266
Guitar, Sheet Music, and Wine Glass, 456, 457	Pope, Alexander, 363, 363–364	Proserpina, 50	in Zurich, 265
Houses on a Hill, Horta de Ebro, 456	Pope Leo X with Cardinals Giulio de Medici and	Protagonist, 68	The Regatta at Argenteuil (Monet),
Les Demoiselles d'Avignon, 453–455, 454, 475	Luigi de' Rossi (Raphael), 232, 232	Protagoras, 66	429, 429
Matisse and, 458	Pope Paul V, 357	Protestant rebellion, 414	Registers, 18, 31
surrealism and, 475-476	Pope Urban VIII, 357	Protestant reformation, 314	Reign of Terror, 388
Pictograms, 32–33	Porcelain, 301, 302	Protestatio, 264	
Pictorial formulas, 31, 33	Porcelain vases with cobalt blue underglaze,		Reims Cathedral, 173, 180, 183
Picture plane, 215		Proudhon, Pierre-Joseph, 423	Relics, 163
Picturesque, 400	302	Proust, Marcel, 479, 479	Religion, 129. See also specific religions
	Portals, 163–164, 165	Psalm, 159	Byzantine Empire, 130–132
Pierfrancesco, Lorenzo, 219	Portrait of a Maori (Parkinson, Sydney), 377	Psyche, 66	in China, 105
Pier Paolo dalle Masegne, 184	Portrait of Charles I Hunting (Dyck), 348, 348	Psychology (James), 478	Daoism, 105, 295, 296
Pierrot lunaire (Schoenberg), 460	Portraiture, 225, 270-271, 291-293, 348. See	Psychology, Freudian, 504	in Egypt, 30–31
Piers, 93, 93	also Self-portraits	Ptah, 30, 30	
Pietas, 86-90	Portugal, 284–291	Ptolemy, 76, 235	female deities, 43
Pieterszoon, Claes, 339			in Florence, Italy, 190–195
Pietra dura, 294	Portuguese Warrior Surrounded by Manillas,	Public works, 93	in Greece, 50, 56
	289, 289–290	Pueblo people, 11–12. See also Zuni Pueblo	Hebrew prophets, 26
Pilgrimage, 135, 138, 139	Porus, King, 72	Pure Land Buddhism, 304, 306	India, 113
Pilgrimage churches, 148, 162–164, 162–167	Poseidon (Neptune), 50	Purgatorio (Dante), 198, 206	introduction to, 118-121
Pilgrim's Guide to Santiago de Compostela, 162	Post-and-lintel construction, 8	Puritans, 266, 348	Judaic culture, 121–122
Pinter, Harold, 486	Post-Impressionist painting, 448–453	Purity laws, 121	in Minoan culture, 43
Pissarro, Camille, 428, 430-431, 431	Postmodern architecture, 507	Purse cover, from Sutton Hoo burial ship,	
"The Pity of War" (Owen), 463, 463	Postmodern era, 506–517		monotheists, 24, 25–26
Pius, Antonius, 94	Postmodern literature, 509–510	149, 149, 151	Moses and the Ten Commandments,
Pizarro, Francisco, 284		Pyramids, 28, 28, 281	24–26
	Postmodern paintings, 507–509	Pyramids (Robert), 400, 401	painting, 316–317
Plague. See Black Death	Post-World War II period	Pythagoras, 65, 234	in Rome, 116-117
Plainchant, 158, 233, 316	abstract expressionism, 486, 488–489,	Pythia, 51	Religious imagery, 314
Plainsong, 158	492, 495		Religious tolerance, 142
Planck, Max, 448	action painting, 486-488	Q. And Babies? A. And Babies. (Haeberle,	Rembrandt, 336–340, 338–339, 351
Platform, 52, 54	aesthetics of chance, 490-492	Brandt, Art Workers' Coalition), 504	Remembrance of Things Past, 479
Plath, Sylvia, 504	architecture in the 1950s, 492-493	Qi, 105	
Plato, 65, 66-67, 74-75, 221, 234	Beat generation, 489–490		Remus, 85
Platonic love, 217	Existentialism, 484	Qianlong emperor, 378–379	Renaissance
Playboy, 484		Qibla, 139	architecture, 247
	pop art, 493–496	Qin Dynasty, 106–107	Ducal courts, 187–188
Play of the Virtues (Hildegard of Bingen), 158	Theater of the Absurd, 486	Qing dynasty, 297, 301	feminist literature, 243-244
Pleasure Pillars (Sikander), 512, 512	United States, 486–496	Qin Shihuangdi, emperor, 106, 108, 108–109	high Renaissance, 225-232
Plebeians, 86	Potter's wheel, 7	Quadrivium, 184	Renaissance Classicism, 414
Pliny the Elder, 73, 73, 74, 74, 81, 81, 100	Pottery	Quatrains, 202	Renaissance, Flemish, 252–253
Pliny the Younger, 99	Athenian, 56-58, 57	Quatrefoil, 210	Renaissance, in Florence, 220, 220
Plotinus, 217, 221	Etruscan, 85	Quetzalcóatl, 278, 281	architecture, 213–214, 217–218,
Pluralism	Greece, 48, 48, 56-58, 57	"Quetzal Jaguar," 283	
postmodern literature, 509-510	Greek amphora, 48, 48, 52, 58, 67	Qumran, 121–122	217–218
postmodern paintings, 507-509	Ming dynasty, China, 302, 302, 334		architecture, domestic, 217–218
Plutarch, 51, 60, 60-62, 392	Neolithic era, 6–7, 7	Qur'an, 135–138, 267	Ducal courts, 187, 221–225
Pluto, 50		Qur'an, Surah, 135	Florence Cathedral, 208–209, 213–214
Poetics (Aristotle), 75, 78, 80	Pound, Ezra, 311, 461, 461–462	w.r	Gates of Paradise, 212-213, 213
	Pour Tannhaeuser, 428	Radiant style, 186–188	introduction to, 209
Poet on a Mountaintop (Shen Zhou), 300, 301	Poussin, Nicolas, 345–346, 346	Radulph of Caen, 167	Lorenzo the Magnificent, 218-221
Poetry, 50	Pozzo, Andrea, 324, 325	The Raft of the "Medusa" (Géricault), 411,	Medici family, 228
Anglo-Saxon, 150	Praxiteles, 74, 74	413, 416, 420	music, 214
Athenian, 58	Prayer, 135, 136	Raimondi, Marcantonio, 425, 425	naturalistic representation, 214–216
Benin culture, 287	Predella, 259	Rama, 113	neoplatonism, 217
Chinese, 105, 107, 295, 300-301	Predestination, 265	Ramayana (Way of Rama) (Valmiki), 113	
feminist, 504	Prehistoric era		painting, 192–195, 215, 215–216, 219,
Harlem Renaissance, 467–468		Randolph, A. Philip, 497	224–225, 224–225
humanist, 220	culture, beginnings of, 2–10	The Rape of Europa (Titian), 320, 321, 349	scientific perspective, 214–216
	Egypt, ancient, 27–36	Raphael, 226, 232, 234-235, 317, 345-346,	sculpture, 210-211, 216, 216, 220, 220,
Japanese, 302	Mesopotamia, 14–27	349	228
of jazz, 467–468	myth, role of in prehistorical cultural life,	Rasin Building (Gehry/Milunić), 506, 507	women in, 242-246
lyric poems, 58	10–14	Rational humanism, 375	women in mercantile system, 242
modern life, 424	Prehistoric peoples, 1	Rauschenberg, Robert, 490–492, 491, 506	Renaissance, in Northern Europe
poetry, 105	Première danseuse, 433	Ravenna, 134, 134	
Renaissance, 244-245	The Presentation of Uigur Captives, from the	Rayonnant, 186	art, commerce, and merchant patronage,
Roman, 90-92, 99	series Battle Scenes of the Quelling of		250–260
troubadour poetry, 170		Re (god), 30, 31	emotion and Christian miracle,
Pointed arches, 179	Rebellions in the Western Regions, with	Realism	258–260
	Imperial Poems (Attiret), 379, 379	art, 417, 419–421	Flemish, 251-253
Pointilles, 449	Pre-Socratic tradition, 65	literary, 417–419	German tradition, 258–260
Pointillism, 449	Priam, 48, 48	literature, 417	influence of humanism, 260
Point of imitation, 233	Priam Painter, 57, 57	Marxism, 417	literature, 249–250
Poison gas. See Mustard gas	Priase poems, 287	photography, 422–423	
Polis, 39-40, 64-67	Price, Uvedale, 401	to romanticism, 411	map of, 251
Politics	Pride and Prejudice (Austen), 366, 366–367		painting, 248–249, 251–259
art, 496–497	"Priest-king" sculpture found at Mohenjo-	slavery and Civil War, 421–422	Renaissance, in Rome
literature, 496–497		Reason, 351	architecture, 227
Politics (Aristotle), 40, 59	Daro, 112, 112	Recitativo, 332	introduction to, 225
Politics Drawn from the Very Words of Holy	Primavera (Botticelli), 219, 219–220	Reclining Nude (Titian), 241	literature, 236–237
	Primitif, 452	Records of Three Kingdoms, 13	Medici popes, 226, 230, 232-233
Scripture (Bossuet), 314	Primogeniture, 167	Recumbent god (Dionysus or Heracles), 65	painting, 228–231, 229–230

Sculpture, relief San Fernando Academy of Fine Arts, 477 Colosseum, 94, 94, 218 Renaissance, in Venice Egypt, New Kingdom, 35 San Lorenzo, Florence, 217, 233 Column of Trajan, 95, 97, 160 architecture, 237-241, 238, 247 gothic style, 184 Hellenistic, 73–74, 73–74 San people of Zimbabwe, 4, 10, 10 domestic architecture, 101-102 literature in, 244-245 Santa Costanza, Church of, 128, 128 family life, 89-90 map of, 237 high, 64, 65 Santa Croce Cathedral, 208–209 Greek roots, 86 painting, 237, 237, 239–241, 240–241 poetry, 244–245 music, 245 Imperial Rome, 89, 96 Hellenistic heritage, 81 Santa Maria del Carmine, 215, 215 Santa Maria delle Grazie, 224, 225 Mithraic, 129 idealized womanhood in, 90 Santa Maria del Popolo, 329 Persian Empire, 27 trade routes, 237 women in, 242–246 literature, 90-92, 99 Renaissance Rome, 220, 220 Santa Trinità, Church of, 194, 194 map of, 84 painting, 91, 101–102 Pompeii, 99–102 Santiago de Compostela, 148 Romanesque, 165, 165-166 Renoir, Pierre-Auguste, 428, 431-432, 432, Seal depicting a horned animal, 112 Sant'Ignazio church, Rome, 324-325, 325 Seale, Bobby, 500 Second Estate, 386 sculpture, 88, 89, 96 Romeo and Juliet (Shakespeare), 270 San Vitale, Ravenna, 134, 134 Répétition, 433 Sappho, 58 Repoussé, 45 Second Temple, Jerusalem, 96, 119, 121–122, 122 Rome's Capitoline Hill, 392 Saracens, 154, 155 The Republic (Plato), 66, 80, 221, 392 The Republica (Plato), 60, 80, 221, 392 Republican Rome, 86 "Republic of Virtue" (Robespierre), 388 Resnick, Milton, 486 The Rest on the Flight into Egypt (Lorrain), 365 Resurrection (Grünewald), 259, 259 Resurrection (El Greco), 323, 323 Sargon, king, 18 Romulus, 85, 86 Second Treatise of Government (Locke), 360 Sarpedon, 57 Rood, Ogden, 431 Sarsen Circle, 9 Sect, 121 Roosevelt, Theodore, 466 Sartre, Jean-Paul, 485, 485–486, 498 Satire, 262–263, 361–364 Securitas, 192 "The Rose Blossoms" (Dufay), 214 Self-Portrait (Dürer), 260, 260 Rosenberg, Harold, 486 Saturn Devouring One of His Children (Goya), Self-portraits, 212, 212, 260, 260 Rose window, 178, 179 Selve, Georges de, 272 Reverge play, 270 Revere, Paul, 383, 383 406, 406 Roswitha of Gandersheim, 157 Semur, Hugh de, abbott, 166, 167 Satyr play, 67 Scarification, 285, 289 Rothko, Mark, 483, 483–484, 486, 489 Senate, Roman, 89 Seneca, Lucius Annaeus, 92 Reverse perspective, 134 Revett, Nicholas, 392 Roth, Leland, 342 Scat, 469 Rotunda, 98 Sen no Rikyu, 307 Scenes from the Massacres at Chios (Delacroix), 413, 413-414 Round arch, 93, 93 Revolution, age of Sensuous sculpture, 74 Rousseau, Jean-Jacques, 340, 375, 375, 378 American Revolution, 384-388 Serekh, 33 French Revolution, 384–388 Neoclassicism, 388–395 "The Revolution Will Not Be Televised" (Scott-Heron), 500, 500 Rouvroy, Louis de, 343-346, 344-345 Schiller, Friedrich, 409 Serfs, 149 Schlegel, Friedrich von, 395 Roxanna (Defoe), 366 Schliemann, Heinrich, 46–47, 47 Schoenberg, Arnold, 460–461 Serial composition, 461 Royal Academy of Dance, 346 Servetus, Michael, 266 Royal Academy of Music, 346 Sestet, 202 Scholastica, 157 Scholasticism, 185–186 Royal Academy of Science, 351, 351 Rhetoric, 87 Seth (god), 30, 31 Royal Fifth, 284 Rhetorician, 87 Seurat, Georges, 431, 448, 448–449 Severini, Gino, 457 Sexton, Anne, 504, 504 Sexual chastity, 124 Royal tombs of Ur, 17–18 Rubens, Peter Paul, 343–345, 344, 345, School of Athens (Raphael), 234-235, 317 Rhythmic montage, 472 School of Embroidery, 160 Rib vaulting, 179, 179 School of Hellas, 60 Rich, Adrienne, 504 351, 371, 371 Rucellai, Giovanni, 218 School of Notre-Dame, Paris, 183 Richard II (Shakespeare), 270 Sexuality in art, 326, 329, 345 Rue Transnonain, April 15, 1834 (Daumier), Schubert, Franz, 409 Richards, M. C., 491 Sforza court, 222-225 Schulze, Johann Heinrich, 422 420, 420, 424 Richardson, Samuel, 366 Richardson, Samuel, 366 Richelieu, duc de, 345–346, 346 Richter, Gerhard, 507–508, 507–508 A Ride for Liberty: The Fugitive Slaves (Johnson, E.), 422, 422 Rigaud, Hyacinthe, 343, 343 Rigoletto (Verdi), 427 Schumann, Clara, 409 Schumann, Robert, 409 Sforza, Francesco, 222 Ruisdael, Jacob van, 334, 334, 335 Sforza, Ludovico, 222, 224, 224-225 Rule of St. Benedict, 156, 159 Sfumato, 225 Scientia, 355 Russia Scientific discoveries, 448 Shaft, 54 art, 470-471 Shahadah, 135 Shakaspeare, William, 87, 269–271 Shakti, 113 Shakyamuni Buddha, 114 Scientific method, 74 revolution, 470-471 Scientific perspective, 214-216 Russolo, Luigi, 457 Scientific Revolution, 351, 355-358 Rutherford, Ernest, 448 Rist, Pipilotti, 516, 516 Scite vias domini (Hildegard of Bingen), The Rite of Spring, 459 Ritornello, 333 Ruz, Alberto, 283 Shaman, 10, 103, 104 157, 158 Shamash (god), 19, 20 SCLC (Southern Christian Leadership Sack of Rome, 130, 233, 261 Ritual, 3-4 Conference), 496 Score, music, 406 Scott-Heron, Gil, 500, 500 Shang Dynasty, 103-105, 104 Sacred and Profane Love (Titian), 241, 241, Ritual space, 3 Sharp, Granville, 395 Robbia, Luca della, 220, 220 Robert, Hubert, 400, 401 Robespierre, Maximilien, 388 Robinson Crusoe (Defoe), 366 Shaw, Artie, 469 Shen Zhou, 301, 302 Sacred ground, 32 Sacred Theory of the Earth (Burnet), 400 Sacrifice of Isaac (Brunelleschi), 210, 211 Sacrifice of Isaac (Ghiberti), 210–211, 211 Scottish Symphony (Mendelssohn), 409 Scraper (Lysippus), 73, 73 Shenzong, emperor, 292 The Shepherds of Arcadia (Poussin), 346, 346 Sheridan, Philip, 439 Screen painting, 309, 309 Rocaille, 368 Scriptorium, 151 Rococo, 354, 368-369, 372 Sadducees, 121 Scrolls of Events of the Heiji Period, 304, 305 s-Hertogenbosch, 255-258 Safavi, Tamasp, shah, 291 Saint Anthony (Grünewald), 258, 258, Rohn, Arthur H., 11 Scrovegni Chapel, 195, 196–197 She-Wolf, 85 Roland, 154, 155 Shihuangdi, emperor, 103, 108-109, Scrovegni, Enrico, 197 108-109 Sculpture Saint Catherine's Monastery, 133, 133 Rollo, 159 Aegean, 42, 42 Akkadian, 18, 18–19 Aztecs, 276–277, 278–280 Shi Ji (Historical Records) of Sima Qian, 108 Saint-Denis, Abbey of, 175-177, 176 Roman Basilica Nova, 163 Shinto religion, 12-14, 302, 304 Sainte-Chapelle, royal chapel, 187, 187 Roman de la Rose (de Pizan), 204 Shiva, 113 Sainte-Foy, Abbey Church of, 162-164, Romanesque, 162-165 Baroque, 325 Buddhist, 143, 143 Shoden, 13 architecture, 164-165, 164-165, 168 162-164 Shogun, 306 Sainte-Foy, reliquary effigy of, 163, 163 Short History of Benin (Egharevba), 286–287, 286–287 definition, 163 Carolingian culture, 153 vs. gothic style, 173 literature, 169–171 music, 167 Sainte-Madeleine, Church of, at Vézelay, Christianity, 125, 125 France, 173 Shoshi, empress, 303 Shudras, 112 Cyclades, 42, 42 Saint Mark's Cathedral, 145, 145, 237, 238 Dedicatory statues, Abu Temple, 16, 16 Saint Paul's Cathedral, 354, 355 sculpture, 165 Siena Cathedral, 193 Egypt, 34, 37 Saint Peter's Basilica, new, 226-227, 227, Roman Forum, 94-98 Siena, Italy, 175-176, 190-192, 190-195. See Egyptian influence on Greece, 53-56 A Roman Man, 88 264, 275 also Black Death Saint Sebastian (Grünewald), 258, 258 female, 56 Roman Republic, 86 gothic style, 180–183, 181–183, 184 Greece, 37, 53, 53–56, 63 Hellenistic, 73–74, 73–74, 76–77, 76–78, The Signboard of Gersaint (Watteau), Sakhmet, 30 Salisbury Plain, 8, 9 Romans 5:1-11, 123 370-371, 370-371 Romanticism, 415 Sikander, Shahzia, 512, 512 Salmi spezzati (Willaert), 245 in Germany, 399, 402 Silk, Han Dynasty, 110, 110 81,81 landscape painting, 397-399, 402 Salon, 367 Silk Road, 110, 142-143, 143, 294-295, heroic, 73 Salon concerts, 409 in literature, 395 human body, sculptural realization of, 182 Ife culture, 285, 285–286 India, 112, 114 295, 296 Salon de la Princesse de Soubise (Boffrand), paintings, 395 Silva, Flavius, 122 367, 367 poetry, 396-397 Silver and gold, 284 Salonnière, 368 to realism, 411 Minoan culture, 43 Sima Qian, 108 Salon of 1819, 414 Romantic hero, 402-406 naturalism, 53-56, 124 Similes, 21 Salon of 1824, 413 Rome. See also Renaissance, in Rome; Roman Simone di Bardi, 199 Simultanée, 447 Parthenon, 61, 61-64, 64-65 Salon of 1850, 416, 420, 420 Republic; Rome, Imperial Christianity, 116–117, 119 Hellenistic heritage, 81 at Pergamon, 76, 77, 78-79, 81 Salon of 1851, 416, 420, 420 Simultanism, 447–448 Pure Land Buddhism, 305, 305 Salon of 1863, 425 Sinatra, Frank, 469 Renaissance, Florence, 210-211, 212-213, High Renaissance, 225–232 Salon of 1865, 426 "Sing, My Tongue" (Josquin des Prez), 233 Sinleqqiunninni, 21 216, 216, 228 Salon of 1880, 434 introduction to, 85-88 Romanesque, 164, 164-165, 165 religion in, 116-117 Salutatio, 101 Sinopia, 196 Roman Republic, 87–88, 88 Rome, Imperial, 88, 89, 96 Samary, Jeanne, 435 Samurai and Shogunate, 304–305 Sanctuary of Apollo, 51 Republican Rome, 86 Sistine Chapel, 226, 227–231, 229–230, 317, sack of, 130, 233, 261 self-portrait, 153, 212, 212 318, 319, 319, 328, 329 Rome, Imperial, 90 Sistine Chapel Choir, 233-236 architecture, 89, 89–90, 92, 92–102, 96 Sanctuary of Hera, model of, 51, 51 sensuous, 74 West Africa, 289 Sita, 113 Sandal-bearer, 33 Augustus, 81, 89-94, 98, 102

Sixtus IV, pope, 226, 228, 233 Skene, 70, 71 Stele of Hammurabi, 19, 19 Tea ceremony, 307 Tokugawa Ieyasu, 309 Stele of Naramsin, 19 Telescope, 357 Tell Asmar, Iraq, 16, 16 Tolkien, J. R. R., 150 Sketches by Boz (Dickens), 418 St. Gall, 156, 156-157 Tombs, 17-18, 35-36, 106-109, 108-109 Skopas, 73 Still Life #20 (Wesselmann), 494, 494 Tempera painting, 194, 195 Tonality, 332, 460 Slaughterhouse-Five (Vonnegut), 501, 501 Still lifes, 333-334 Tempest (Giorgione), 240, 240 Tone row, 461 Slavery, 288-291 Still Life with Plaster Cast (Cézanne), 451, 451 Tempietto (Bramante), 227 Tonic note, 332 and Civil War, 421-422 Stoa, 39, 39 Temple, model of found in Sanctuary of Toqué, Georges, 455 literary realism, 419 Stoa of Attalos, 39 Hera, 51, 51, 52 Toreador Fresco (Bull Leaping), 42, 42 Slaves, 149 Stoicism, 92 Temple Mount, Jerusalem, 119 Tostig, Earl of Northumbria, 160 Slave trade, 288, 288-291 The Stonebreakers (Courbet), 420, 420-421 Temple of Athena Nike, 62, 62 Temple of Hera I and II, 52, 54, 61 Touch (Antoni), 517, 517 Smith, Adam, 394 Stone castles, 168 Tournai, Belgium, 251–253 Snake Goddess, 43, 43 Stone crockets, 180 Temple of Inscriptions, 282–283, 283 Temple of Mars the Avenger, 95 Temple of Quetzalcoatl, 281 Town Hall, Bruges, Belgium, 188, 188 Snake Goddess or Priestess, Crete, 43, 43 Stonehenge, 9, 9 Trackers (Sophocles), 67 Snow Storm—Steam-Boat off a Harbour's Mouth (Turner), 399, 399 Stoppard, Tom, 486 Trade routes, 141, 237. See also Silk Road The Story of Adam and Eve (Ghiberti), 213 Tragédie en musique, 346 Tragédie lyrique, 346 Temple of the Golden Pavilion, 305-306, 306 Snyder, Gary, 311 Stowe, Harriet Beecher, 419 Temple of Venus, 95 Soami, Garden of the Daisen-in of Daitokuji, Strabo, 76 Temples, 52, 54, 60-61, 93-96, 281, Tragedy, 68 307, 307 Stradanus, Johannes, 250, 250 305-306 Trajan, 94, 95, 97, 98, 99 Sobek (god), 31 Stravinsky, Igor, 459 Temples of Hera, Paestum, Italy, 52, 54, 61 Trajan's Column, 97, 97 Social castes, 112 Stream-of-consciousness novel, 477-479 Templo Mayor, Mexico City, 277–278, 278, 279 Transcendental self, 438 Social contract, 360 The Strike (Koehler), 436 Transept, 127, 127 The Social Contract (Rousseau), 375, 375, 384 Stuart, James, 55, 392 Travels (Polo), 295, 295-296 Ten Commandments, 24–26 Tenebrism, 323, 329, 331 Social Darwinism, 442-443 Stupa, 115, 115 A Treatise on Government (Aristotle), 392 Social perspective, 18 Sturges, Jonathan, 437 The Tennis Court Oath (David), 386 Treaty of Kanagawa, 441 Stylistic signature, 320 Stylobate, 52, 54, 61 Sublime, 400, 408 Société anonyme, 428 Tenochtitlán, 277–279, 278, 279 The Tree of Jesse, 178, 178 Society of Jesus, 275, 324 Tenshu, 308 Trench warfare, 462–467 Très Riches Heures du Duc de Berry, 189, 189 Socrates, 65, 66, 235 Ten Thousand Waves (Julien), 514, 515 Socratic method, 185 Trial of Veronese, 322, 322 The Tribute Money (Masaccio), 215, 215 Submission to God, 135 Teotihuacán, 281, 281 Soft Toilet (Oldenburg), 496 Sudan, 141 Teresa of Ávila, 323, 325, 325, 330, 350 Soga clan, 302 Suite, 346-347 Terra-cotta soldiers, 108-109, 108-109 Triglyphs, 64, 64 Soldiers and horses, Emperor Shihuangdi Suleiman the Magnificent, 261 Terraferma, Venetian, 237, 237-238 Triptych, 253, 255 tomb, 108–109, 108–109 Soliloquy, 270–271 Sumerian King List, 21, 24 Terze rime (Franco), 244-245 Triremes, 60 Sumerian Ur, 16, 16-18 Testelin, Henri, 351, 351 Triumphal arches, 96, 96-98 Solomon, king, 26, 119 Summa, 186 Tetralogies, 68 Trivium, 184 Solomon R. Guggenheim Museum, 492, Summa Theologica (Aquinas), 186, 186 Tetrarchy, 125 Trobairitz, 169-170 493, 509 "Summer Day in the Mountains" (Li Bai), Tetzel, Johannes, 264, 264 Trojan War, 47, 47–48 The Trojan Women (Euripides), 70 Somerset, James, 395 295, 295 Thales of Miletus, 65 Songbook (Petrarch), 201 Summer's Day (Morisot), 430, 431 Thamugadi, North Africa, 83, 83-85 Trotula, 185 Song dynasty, China, 295-296, 297-298, A Sunday on La Grande Jatte (Seurat), 448 Thanatos, 57 Theater, 67–71, 269–271 Troubadour poetry, 170 298-299 Suniata, 141 Troubadours, 170 "Song of Bacchus" (Medici), 219, 219
"Song of Myself" (Whitman), 439, 439 "Sun King," 343 Theater, Epidaurus, 71 Troy, 47-49 Superego, 474 Song of Roland, 153–154, 154–155, 171, 198, 205 Theater of the Absurd, 486 True History of the Conquest of New Spain Super Flumina Babylonis (Palestrina), 316 Theatre of Shoreditch, 269 (Díaz), 280 Supermarket Shopper (Hanson), 484, 484 Thebes, 30, 34, 35-36 Truman, Harry S., 484 Sonnets (Petrarch), 202, 202 "Sonnet to Solitude" (Keats), 437 Surahs, 135 Thebes, Egypt, 35–36 Themistocles, 59–60 Trumbull, John, 385, 386 Surrealism, 475-476 Trumeau, 164, 164 Turkey, War of Independence, 413 Sophistry, 66 Surrealist Manifesto (Breton), 474 Theocracy, in Egypt, 29 Sophist tradition, 66 Survey Graphic, 467 Sutton Hoo, 147–148, 151 Suzuki, D. T., 311, 311 Theodora, empress, 131, 134, 134 Turner, Joseph Mallord William, 389-399, Sophocles, 67, 68, 69, 69-70 Theodoric the Great, 130 396, 398-399 Sorbonne, 185 Theodosius, 130 Tuscan order, 94 Sorbon, Robert de, 185 Swann's Way (Proust), 479, 479 Theogony (The Birth of the Gods) (Hesiod), 50 Tutankhamun funerary mask, 35 Soule, John, 439 Swift, Jonathan, 361-362, 362 Theotokos and Child with Saint Theodore and Tutankhamun tomb, 35, 35 Southern Christian Leadership Conference The Swing (Fragonard), 372, 373 Saint George, 133, 133 TV Buddha (Nam June Paik), 311, 311 (SCLC), 496, 496 Syllabic setting, 153 Thera, 41, 41 Two Treatises of Government (Locke), Southern school, 300-301 Syllogism, 75 Thermopylae, 60 384-385 Symbolic color, 449–451 Southwest, U.S., Native American cultures, Theseus, 45, 51 Tympanum, 164, 165 11-14 Symbol of coiled mudfish, 289 Typology, 124, 144
Tzara, Tristan, 464, 464–465 Thespis, 68 Soviet Union, 481 Symbols in Christian thinking and art, Third Estate, 386 Spain, 2, 7, 141, 277–283, 348–349 Spandrels, 93, 93 124-125, 125 The Third of May, 1808 (Goya), 405, 405 Tzenuit, 139 Symmetria, 63 Third Temple, Jerusalem, 121 Thirty-Six Line Bible, 267 Spanish Inquisition, 323 Symphonia armonie electrium relelationum Ukiyoe, 442 Spanish massacre Aztec nobles in the temple (Hildegard of Bingen), 158 Thirty-Six Views of Mount Fuji (Hokusai), Ukraine, 27 courtyard, 278 Symphonic orchestra, 406 442, 442 Ulama, 140 Spanish Popular Front, 481 Symphony, 406 Thirty Tyrants, 64 Ultraroyalist movement, 413 Sparta, 51, 60, 64, 68, 71 Symphony of the Harmony of Celestial "This It Is Said of Ptah" (Memphis), 30, 30 Ulysses (Joyce), 478, 478 Spear Bearer (Doryphoros), 37, 37, 74, 124, Revelations (Hildegard of Bingen), 158 "This Perfectly Still" (Ki no Tomonori), Umayyad caliphs, 140, 141, 142 182 Symposium, 51, 67 303, 303 Umma, 138, 139 The Spirit of Zen (Watts), 311 Syncretic style of art, 151 Thompson, J. J., 448 Una bella figura, 222 Uncle Tom's Cabin (Stowe), 419, 421 Spiritual Exercises (Ignatius of Loyola), 324, Syncretism, 128, 151, 294 Thoreau, Henry David, 438, 438 324-325 Unique Forms of Continuity in Space (Boccioni), 457, 457 Thoth (god), 31 Spoils from the Temple in Jerusalem, 96 Tabula rasa, 336, 360 "Thou, Beloved Hall" (Wagner), 427 Spondees, 88 T'ai Chi Ch'uan, 302 Three Essays: On Picturesque Beauty; On United Monarchy of Israel, 26, 26 Spouted Ritual Wine Vessel, 104 Taira, 304-305, 308 Picturesque Travel; and on Sketching United States Sprechstimme, 460 Sprezzatura, 222, 243 Spring (Vivaldi), 333 Taj Mahal, 293, 293-294 Landscape (Gilpin), 401 abstract expressionism. See Abstract Takeno Joo, 307 Three Flags (Johns), 492, 492 Expressionism Through-composed, 245 Through the Flower: My Struggle as a Woman Talbot, William Henry Fox, 422 action painting, 486-488 Spring and All (Williams), 462 The Tale of Genji (Murasaki Shikibu), 304 aesthetics of chance, 490-492 The Spring and Autumn Annals, 106 Tales of the Jazz Age (Fitzgerald), 468 Artist (Chicago), 505 architecture in the 1950s, 492-493 Spruce Tree House, Mesa Verde, 11, 11 Talion, 19 Thucydides, History of the Peloponnesian Beat generation, 489-490 Stage, Elizabethan, 269-271 Talk Concerning the First Beginning, 12 Wars, 60 feminism, 504-506 Stained glass, 176, 176, 178, 178-179 Talking drums, 288 Tiberius, 81, 89, 90 Latino and Hispanic presence in U.S., 510 Stamp Act, 383 Tamerlane, 292 Tintern Abbey (Wordsworth), 396, 396 Stanza della Segnatura, 231–232, 234 Stanza della Segnatura, 231–232, 234 Stanza of Ur, 17, 17–18, 31 Starry Night (Van Gogh), 450, 450 literary realism, 419 Tang dynasty, China, 294, 294–295 Tisha B'Av, 119 Neoclassicism, 392–393 pop art, 493–496 Tang, king, 103 Titian, 240-241, 241, 247, 320, 321, 344, Tannhäuser (Wagner), 427 Vietnam War, and the arts, 501 The State and Revolution (Lenin), 470 St. Catherine's Monastery, 133, 133 Stedman, John Gabriel, 394, 394 Tapestry, 160-161, 160-161 Titus, 96 Universitas, 184 Тари, 377 Tivoli, 102 University, 185 Tarsirsir (god), 16 "To Be a Woman" (Fu Xuan), 107, 107 University of Al-Qarawiyyin, 184 Steen, Jan, 335-336, 336 Tassi, Agostino, 330 To Bedlam and Part Way Back (Saxton), 504 University of Bologna, 184, 184 University of Paris, 175, 184–185 Stein, Gertrude, 453, 453-454 Tatami, 307 Toccata, 245 Steir, Pat, 508, 509 The Toilet of Venus (Boucher), 372, 372 Taxila, India, 72 "Untouchables,", 112 Stele, 19, 19 Taylor, Frederick, 448 Tokugawa era, 442 Upanishads, 113

Upper Paleolithic period, 4-5 Urban II, pope, 167 Urbino, Italy, 221-225 Utnapishtim, 23-24 Utopia (More), 268-269, 268-269 Vaishvas, 112 Valmiki, 113 Van Eyck, Jan, 250, 250, 253-254, 253-255, 341 Van Gogh, Vincent, 311, 448-452, 449-450, 458 Vanishing point, 215 Vanitas paintings, 334, 335 Vantage point, 215 Vaphio Cup, 45, 45 Variations V (Cage), 491 Vasari, Giorgio, 194, 195, 214, 222–224, 240, 250 Vase painting, 67 Vatican Palace, 226 Vaughan, Sarah, 469 Vaults, 93, 94 Vedas, 109 Vedic tradition, 113 Velázquez, Diego, 349, 351 Venantius Fortunatus, 233 Venice, Italy, 237-242, 245, 332. See also Renaissance, in Venice Venturi, Robert, 507 Venus, 50 Venus of Urbino (Titian), 240–241, 241, 426 Venus of Willendorf, 5 Verdi, Giuseppe, 427, 441 Verism, 88 Vermeer, Jan, 328-329, 341 Vernacular, 198-205, 268. See also Language Veronese, 321-322, 322 Versailles, 342, 343-348 The Very Sumptuous Hours of the Duke of Berry, 187 Vesalius, 339 Vespasian, 94 Vespasian Psalter, 152 Vesta, 50 Vesuvius, 100 Viderunt Omnes (Pérotin), 183 Vietnam war, 501 View of Haarlem from the Dunes at Overveen (Ruisdael), 334, 334 View of Richmond Showing Jefferson's Capitol from Washington Island (Latrobe), 392 Vigée-Lebrun, Marie-Louise-Élisabeth, 381, 381 Vignon, Pierre-Alexandre, 391, 391 Villa La Rotonda (Palladio), 247, 247 Villas of the Ancients Illustrated (Castell), 364, 400 Viola, Bill, 514, 514 Violin and Palette (Braque), 456, 456

Virgil, 81, 81, 85, 86, 90, 90, 198–199, 202

Virgin and Child in Majesty (Martini), 193,

Virgin and Child with Angels (Grünewald),

193, 194

259, 259

The Upper Falls of the Reichenbach (Turner),

398, 398

Virgin, cult of the, 171, 176 Virgin Mary, 192–194 Virgin's tunic, 177–178 Vishnu, 113 Vishnu Puranas, 113 Visigoths, 141, 142 Visitation, Reims Cathedral, 182 Visual arts cross-fertilization, 510-513 Harlem, 469-470 Vitruvian Man (da Vinci), 226-227, 247 Vitruvius, 93, 226, 226–227, 247 Vivaldi, Antonio, 332-333 Vizier, 33 Voltaire, 376 Volterra, Daniele da, 319 Volute, 55 Vonnegut, Kurt, 501, 501 von Richthofen, Wolfram, 481 Votives, 31, 33 Voussoirs, 93, 93 The Vow of Louis XIII (Ingres), 414, 414 Voyage around the World (Bougainville), 376 Vulcan, 50 Vulgate, 126 Vulgate Bible, 126, 156 Wabi, 307 Wabicha, 307 Wagner, Richard, 427-428 Wailing Wall, 119 Waiting for Godot, Act I (Beckett), 486, 486 Waiting for Godot, Act II (Beckett), 486 Walden, or Life in the Woods (Thoreau), 438, 438 Wall painting, 91, 101, 101–102. See also Fresco Walpole, Robert, 361, 363 Walter, Marie-Thérèse, 475 Walther, Johannes, 272
The Wanderer above the Mists (Friedrich), 402, 402 artists vs., 501, 504 Franco-Prussian, 428 Korean, 484 Vietnam, 501 Warhol, Andy, 493, 493 War of Independence, 413 Washington, George, 392 The Waste Land (Eliot), 463-464, 463-464 Water tank, possibly a public or ritual bath, Mohenjo-Daro, 111 Watteau, Jean-Antoine, 368, 369-371, 370-371

Watt, James, 359

Watts, Alan, 311

The Way of Life, 105, 105 Way of Tea, 307 The Way to Perfection (Teresa of Ávila), 323

The Wealth of Nations (Smith), 394

The Weather Project (Eliasson), 519, 519

Weary Blues (Hughes), 467

Webern, Anton, 460

Wedgwood, Josiah, 359

Wedgwood, Josiah, 395 Well-Tempered Clavier (Bach), 341 Wen, 106 Wergeld, 149 Wesel, Andreis van, 339 Wesselmann, Tom, 494, 494 West Africa, 284–291, 285 Western Wall, 122 "What Is Enlightenment" (Kant), 383
"When Lilacs Last in the Dooryard Bloom'd" (Whitman), 439 White Heron Castle, 309 'White Paintings," 491 Whitman, Walt, 438-439 Wifman, 504 Wilderness at Kew (Marlow), 378, 378 Willaert, Adrian, 245, 331 Willendorf Venus, 4-5, 5 William, Duke of Normandy, 160-161 William of Orange, 348 Williams, Samuel, 442 Williams, William Carlos, 461–462, 462 William I, the Conqueror, 159 Winckelmann, Johann, 395 Wind ensembles, 331 Woman from Willendorf, 4-5, 5 Womanhood, idealized, 90 Women abstract expressionists, 488-489 Artemisia Gentileschi, 330–331 changing role of in medieval society, 169-170 in China, 107 Christine de Pizan, 204-205 education of, 185, 242 in Elizabethan drama, 270 family life in Italian humanist society, 242-243 female deities, 43 feminism, 204-205, 243-244 Han Dynasty, China, 107 in Heian court, Japan, 303 in humanist society, 242–245 in Imperial Rome, 90 in Islam, 139 in Italian humanist society, 242-245 Laura Cereta, 243-244 Lucretia Marinella, 244 Madalena Casulana, 242 Mary Cassatt, 311 in monastic life, 157–158 Novella d'Andrea, 184, 185 painters, 330–331 in painting, 335–336 Renaissance feminists, 243-244 in Renaissance Venice, 242-245 in The Tale of Genji, 304 Trotula, 185 Veronica Franco, 244-245 Word painting, 245 Women at the Fountain, 57, 57 Women with a Pearl Necklace (Vermeer), 336, 336 Wool Guild, 210, 212, 213 Woolley, C. Leonard, 14–15, *15* Word-painting, 245 Wordsworth, William, 396, 396

Workers, as art subject, 419-421 Working class as art subject, 419-421 and bourgeoisie, 413-445 in literature, 417–419 Marxism, 417 in New York City, 433 removal from Paris, 424 Works (Luther), 263, 263-265 Works and Days (Hesiod), 50, 90 Works in Architecture (Adam/Adam), 392 World exploration, map of, 279 World War I, 467, 474 World War II, 481, 483-484, 493, 501, 507 The World Won't Listen (Collins), 515, 515 Wren, Christopher, 354, 354–356 Wright, Frank Lloyd, 492, 493 Wright, Joseph, 358, 358 Wright, Orville, 447 Wright, Wilbur, 456 Writing, 103, 136-137, 155, 304 Wu, emperor, 107 Wye Tour (Gilpin), 401 Xavier, Francis, 308 Xerxes, 27, 27, 59, 60 Xiuhcoatl, 277 Yahweh, 25, 26 Yeats, William Butler, 311 Yellow and Blue One-Stroke Waterfall (Steir), 508, 509 Yi Jing (The Book of Changes), 104 Yin Hong, 300, 300 Yin yang symbol, 104, 104, 302, 302 Yoko Ono, 311 Yoritomo, 305, 310 Yoruba culture, 285–286, 286 Yoshimasa, shogun, 307, 308 Yoshimitsu, shogun, 307 Young Men on Horseback, 64 Yuan dynasty, China, 297, 297 Yue fu, 107 Zagwe dynasty, Africa, 285–286 Zeami Motokiyo, 308 Zedong, Mao, 484 Zen Buddhism, 296, 300, 311 Zen gardens, 306-307 Zeus, 50 Zeus (Jupiter), 50 Zeuxis, 70 Zhou Dynasty, China, 105-106 Zhu Di, emperor, 297, 301 Zhu Shixing, 142 Zhu Yuanzhang, 296 Ziggurat, 14–15, 28 Ziggurat at Ur, 14, 15, 16

Zinat, 139

Zoroaster, 235

Zoroastrian religion, 129

Zuni Emergence Tale, 12, 12

Zuccaro, Federigo, 273

Zuni Pueblo, 11-12, 12

Zwingli, Ulrich, 265

Zurich, Switzerland, 265

		3
	*	And the second control of the second
100 C		